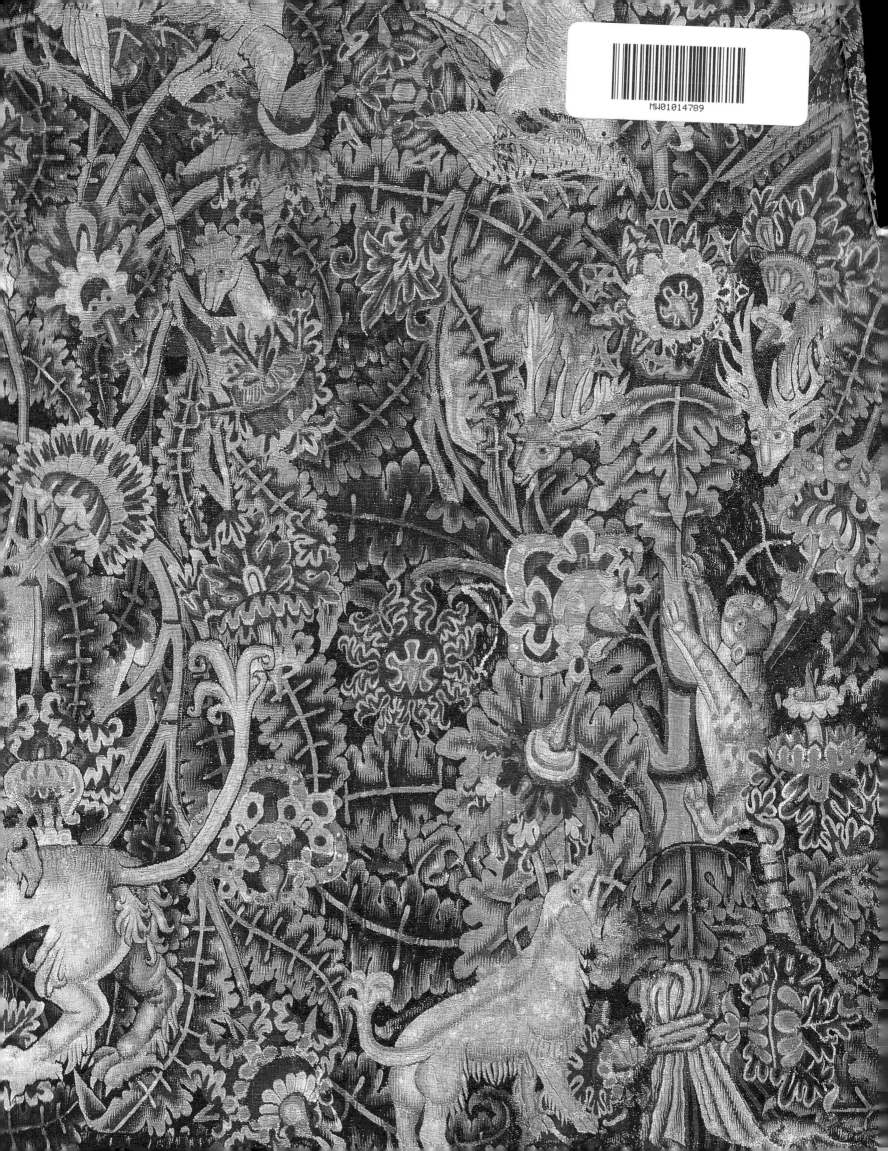

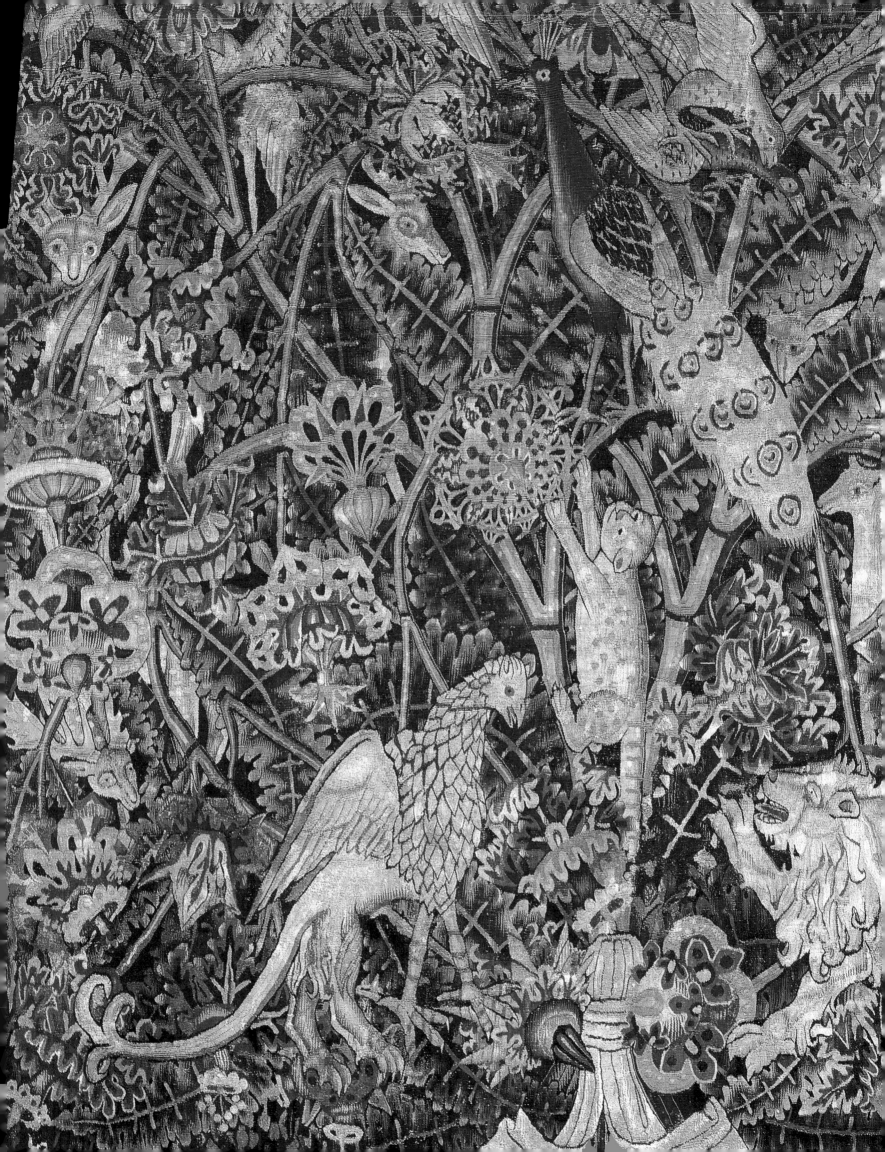

European Tapestries in the Art Institute of Chicago

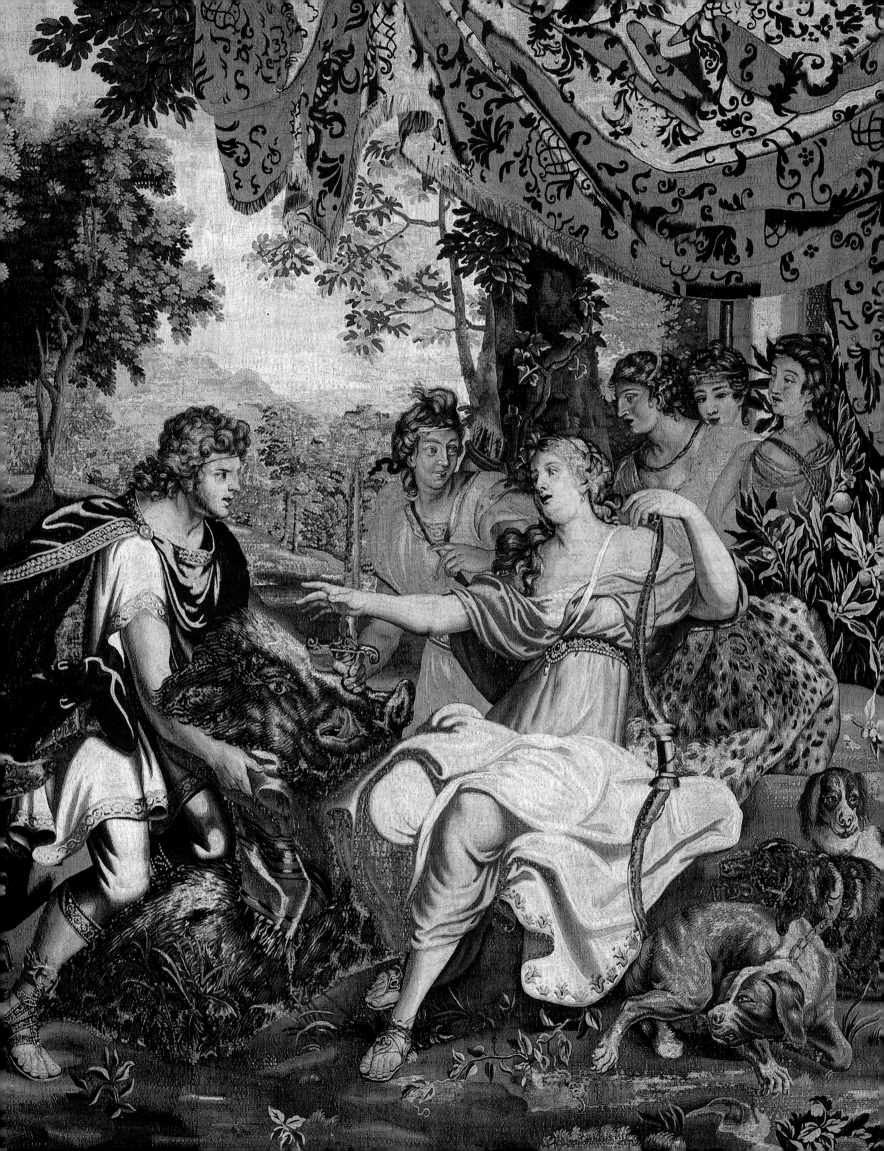

EUROPEAN TAPESTRIES IN THE ART INSTITUTE OF CHICAGO

Koenraad Brosens

With contributions by
Pascal-François Bertrand, Charissa Bremer-David,
Elizabeth Cleland, Guy Delmarcel, Nello Forti Grazzini,
Yvan Maes De Wit, and Christa C. Mayer Thurman

Christa C. Mayer Thurman, *General Editor*

The Art Institute of Chicago

Yale University Press
NEW HAVEN AND LONDON

European Tapestries in the Art Institute of Chicago was published in conjunction with the exhibition *The Divine Art: Four Centuries of European Tapestries in the Art Institute of Chicago*, organized by Christa C. Mayer Thurman and presented at the Art Institute from November 1, 2008, to January 4, 2009.

This book was made possible by grants from the Community Associates of the Art Institute of Chicago and the Andrew W. Mellon Foundation.

First edition
Library of Congress Control Number: 2008930401
ISBN: 978-0-300-11960-2

Published by
The Art Institute of Chicago
111 South Michigan Avenue
Chicago, Illinois 60603-6404
www.artic.edu

Distributed by
Yale University Press
302 Temple Street
P.O. Box 209040
New Haven, Connecticut 06520-9040
www.yalebooks.com

Produced by the Publications Department of the Art Institute of Chicago, Susan F. Rossen, Executive Director

Edited by Amy R. Peltz, Assistant Editor for Scholarly Publications, and Robert V. Sharp, Director of Publications
Production by Carolyn Heidrich, Production Coordinator, and Kathleen E. Kotan, Production Assistant
Photography research by Joseph Mohan, Photography Editor
Designed and typeset by Dean Bornstein, Peacham, Vermont
Separations by Professional Graphics, Inc., Rockford, Illinois
Printed by Die Keure, Bruges, Belgium

Contributions by Pascal-François Bertrand were translated by Alice Jean Coyner. Contributions by Nello Forti Grazzini were translated by Anna L. Taraboletti-Segre and Theresa A. Biancheri.

Jacket: front, *The Battle of Actium* from *The Story of Caesar and Cleopatra* (cat. 19N, detail); back, *July* from *The Medallion Months* (cat. 9B). Endpapers: front and back, *Large Leaf Verdure with Animals and Birds* (cat. 31, details). Frontispiece: *The Offering of the Boar's Head* from *The Story of Meleager and Atalanta* (cat. 21, detail).

Details: page 32, *The Triumph of Caesar* from *The Story of Caesar and Cleopatra* (cat. 19J); page 34, *Christ Appearing to Mary Magdalene ("Noli me tangere")* (cat. 3); page 72, *Caesar in the Gallic Wars* from *The Story of Caesar and Cleopatra* (cat. 19B); page 234: *Autumn* from *The Seasons* (cat. 40A); page 328, *The Annunciation* (cat. 55); page 360, *Table Carpet with Scenes from the Life of Christ* (cat. 61); page 372: *Bear Hunt and Falconry* from a *Hunts* series (cat. 7).

❧ CONTENTS ❧

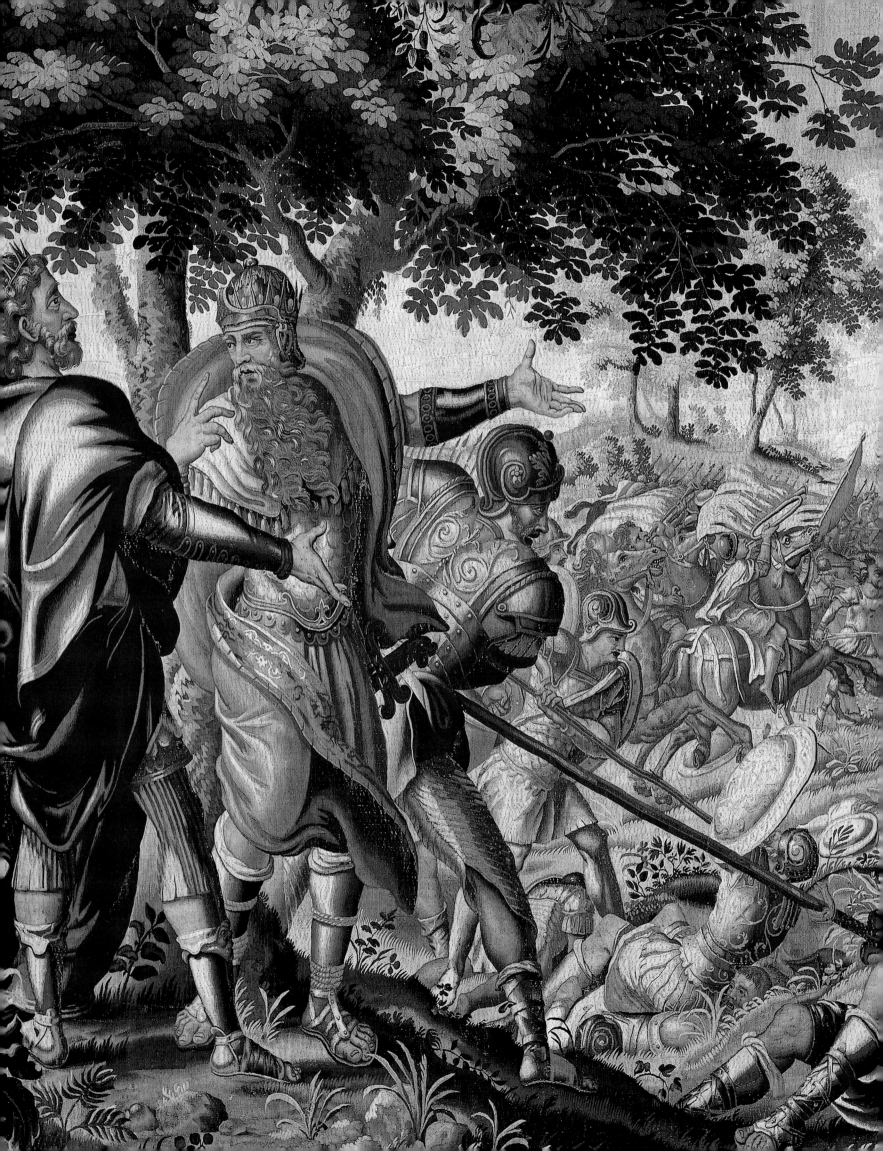

✣ FOREWORD ✣

Guy Delmarcel

THE collection of ancient tapestries at the Art Institute of Chicago comprises at present close to one hundred items that have been purchased by, or, more frequently, donated or bequeathed to, the museum over more than a century. These objects came from many different countries, and were woven by various manufacturers using models and cartoons provided by a diverse assortment of artists. None of them were intended for display in a museum. In fact, a museum's collection is a highly artificial gathering of items, which look a bit like passengers on a railway platform: some may be alike, some may be different, but all remain mute, standing side by side, gazing at each other without reciprocal knowledge of one another's identity, before finally going their separate ways on different trains. The last part of the comparison is particularly true for tapestries, which, due to their sensitivity to light, are normally exhibited only for limited periods of time before being returned to storage. It is the art historian and the curator's task to bring them back to life, trying to find out where and when they were conceived, what original function they served, and what their subsequent destiny has been. Indeed, each tapestry has its own story, sometimes known and quite fascinating, in other cases still undiscovered.

Initially intended to cover the walls of castles and abbeys to keep warmth inside the buildings, tapestries were among the most prestigious objects owned by the upper classes. When some unknown artist or weaver, probably in northwestern Europe in the middle of the fourteenth century, conceived the idea of representing stories on these weavings, as opposed to merely decorative patterns, tapestry embarked on its own glorious career in the figurative arts, rising to the level of wall painting in Southern Europe and, much later, to the level of painting on wood or canvas. Their owners could enjoy the romances represented, but they could also often identify with the heroes of the past, imagining themselves a new Hercules, a new Alexander, or a new Cyrus. The variety of subjects is endless and astonishing, as is duly reflected in the Art Institute's collection. They range from biblical and Christian themes to allegory, ancient history, heraldry, and mythology, as well as representations of daily life and hunting and merely decorative greenwork or verdures—those so-called winter gardens which sometimes constitute the bulk of a collection.

Above all, tapestry is distinguished by its serial aspect. Many weavings in the Art Institute's collection nowadays appear to be independent works of art, but most originally belonged to series of several related pieces woven from cartoons that could be put on the loom repeatedly to produce multiple suites or "chambers." Reconstructing the sets to which such isolated pieces originally belonged was one of the main challenges of the present research. The Art Institute can proudly exhibit several such partial suites, including pieces from a sixteenth-century edition of *The Months*, two weavings from a seventeenth-century edition of *The Seasons*, and the enormous late-Baroque fourteen-piece *Story of Caesar and Cleopatra* ensemble.

Many items in the Chicago collection are masterpieces, highly representative of an epoch or a style. These pieces include the late medieval *Resurrection*, the Renaissance *Medallion Months* and *Pomona Surprised by Vertumnus and Other Suitors*, the aforementioned Flemish *Story of Caesar and Cleopatra*, the Gobelins *Autumn* and *Winter* and *Grotesque Months*, the Beauvais *Elephant* and *Emperor Sailing*, and the Aubusson *Outdoor Market*. Some of these pieces are even of royal or princely origin. But many other tapestries from less well known series or with less distinguished provenances also offer the reader a sometimes surprisingly interesting subject or story.

Scholarly literature about ancient tapestry has greatly increased over the course of the past decades. Numerous books, exhibition catalogues, and articles have provided ever more refined insights into the many questions surrounding the origins, production, and iconography of tapestries. This has led to a widespread diversification and specialization of the field. Christa C. Mayer Thurman, curator of the Art Institute's collection, therefore made the wise decision to enlist the participation of other specialists in the field, thus leading a team of several reputed scholars from the United States as well as from Europe. As a result, this catalogue presents the reader not only an in-depth analysis of the Chicago holdings, but also a broad perspective on tapestry history. Many entries indeed contain fascinating comments about artists, designs, and weavers, opening new and unknown perspectives with implications that reach far beyond the object at hand. Moreover, the authors consistently prepared their contributions with a large cultivated audience in mind, and so this catalogue not only introduces the Art Institute's tapestries to scholars and the public, but also provides the reader a pleasant and instructive handbook of the medium.

The present volume is embedded in a tradition of similar publications, in which the United States has played a leading role over the past forty years. Homage should be paid first of all to Adolfo S. Cavallo, author of the 1967 catalogue of the tapestries in the Museum of Fine Arts, Boston. His pioneering publication traced the outlines of a sound methodology which became a model for future major

catalogues of this type, including Anna G. Bennett's publication on the tapestries held by the Fine Arts Museums of San Francisco (1976; 2nd ed. 1992), Edith A. Standen's catalogue of the post-medieval collection of the Metropolitan Museum of Art, New York (1985), the three volumes thus far published of the holdings of the Patrimonio Nacional, Madrid, by Paulina Junquera de Vega (1986) and Concha Herrero Carretero (2000), Cavallo's own book on the Metropolitan Museum of Art's medieval tapestries (1993), Candace J. Adelson's volume on the tapestries in the Minneapolis Institute of Arts (1994), Nello Forti Grazzini's catalogue of the holdings of the Quirinale in Rome (1994), Lucia Meoni's first volumes on the Medici collection in Florence (1998; 2007), and lastly, the catalogue of the tapestries in the Rijksmuseum, Amsterdam, by Ebeltje Hartkamp-Jonxis and Hillie Smit (2004). We may only hope, now that the Art Institute of Chicago has published its collection, that other major museums will follow its example and disclose their treasures as well.

❧ INTRODUCTION AND ACKNOWLEDGMENTS ❧

Christa C. Mayer Thurman

I⊤ is with an enormous sense of pride and satisfaction that we put forth this volume, the first scholarly catalogue ever undertaken of the Art Institute's collection of European tapestries. In comparison to the vast numbers of such works held in national collections and distributed among countless museums and institutions worldwide, the Chicago assemblage of tapestries is relatively modest in size. But the museum's holdings, which grew somewhat miraculously over the past one hundred years, nonetheless include wonderful examples of the art of tapestry weaving and manufacturing. Formed largely through gifts to the Art Institute from donors who themselves never aspired to build comprehensive representations of the art form, the collection still manages to offer many splendid works whose publication here will, we believe, please scholars and art historians who have long sought a catalogue of these largely unknown and under-published pieces, as well as arouse new interest among the Art Institute's members, patrons, and visitors. The anticipated opening of the museum's Modern Wing in 2009 and the ensuing reinstallation of the permanent collection throughout the other galleries hold forth the possibility that the tapestries presented in this volume may, at long last, begin to be exhibited in spaces suitable for displaying these often immense works of art. Newly conserved—as a result of an extensive thirteen-year undertaking described in this volume—these remarkable pieces deserve to be integrated with related works of art. The showcasing of these tapestries would then be a fitting tribute to the donors who were principally responsible for building the museum's collection, those present-day supporters of the Art Institute who have made possible the conservation of the works and this publication, and the individual scholars whose contributions to this volume have opened up the story of these tapestries for visitors and readers alike.

Although many people consider tapestries a component of the decorative arts, tapestry research, like the study of paintings, the field to which it is most closely related in subject matter and scale, presents a complex topic. Yet art historians have by and large touched upon it only occasionally and arbitrarily, preferring—when they do turn to the topic—to concern themselves only with the style of the pieces and the sources of their designs. Quite a different approach has been reflected in the work of textile historians, curators, and conservators, because they typically choose to emphasize fabric structures, looms, weavers, and manufacturers. Commerce, economics, and the market are yet other subjects that some studies have taken up. Unfortunately, the adoption of one approach seems frequently to have precluded

the inclusion of others. In this volume an effort has been made to draw upon many different approaches and to address various topics.

As the manufacturing of tapestries was a European phenomenon, the expertise in this field can be principally traced to Europe, where the study of these textiles has long been pursued as a scholarly discipline. Only infrequently has serious study of the medium been an option for those attending American universities. On the rare occasion when a student surfaced with a desire to write a dissertation on a tapestry-related topic under the guidance of an art historian, it was inevitable that a critical advisor and reader be selected from the international roster of tapestry scholars. The European individuals who belong to this small and specialized group are thus in high demand. Even rarer are those who have had extensive contact with actual tapestry collections. In recent times Guy Delmarcel has been an exemplar of this select group. Since 2003 he has been professor emeritus of the Katholieke Universiteit, Leuven, Belgium, but before that he succeeded the distinguished Jean-Paul Asselberghs (1935–1973) as Curator of Tapestries and Textiles at the Royal Museums of Art and History in Brussels. A part-time position Delmarcel assumed in 1973 turned into full-time employment from 1975 to 1990. His career took a turn in 1990, however, when he transferred to the Katholieke Universiteit, where he taught art history and the decorative arts, including the vast subject of tapestry, until his retirement in 2003. He thus brings together not only the expertise gained from having curated a tapestry collection but also the experience of teaching students, linking historical knowledge with his curatorial hands-on practice. To this day Guy Delmarcel continues just as passionately and relentlessly with his research. Familiar with and concerned for decades about the unpublished Chicago collection, he was the logical choice to serve as external reader for this volume and to contribute its foreword. The Art Institute and this curator owe him great thanks.

While teaching in Leuven, Delmarcel passed on his passion for tapestry to a number of those who sat at his feet. His tireless search for primary documents and his ability to sift them for nuggets of information, coupled with his remarkable facility with languages, enabled him to correct errors and misunderstandings that had long limited the comprehension and appreciation of tapestries in many countries. Fortunately, his approach took hold in a younger generation of scholars. One of his last and most outstanding students is Koenraad Brosens, who wrote his dissertation under Delmarcel in Leuven and is presently both a postdoctoral fellow for the Belgian Scientific Research Fund (F.W.O.-Vlaanderen) and a Visiting

Professor at the Katholieke Universiteit, Leuven. The Art Institute was fortunate that just at the time when the publication of its tapestry collection could finally be undertaken this bright young scholar appeared on the horizon. Through an arrangement with the Belgian Scientific Research Fund and the university, Koenraad Brosens was able to assume the responsibility of principal author of this volume. As the largest component of the Chicago collection is of Northern European origin, Brosens's appointment was ideal for the "Chicago Tapestry Project." Taking a collection that was haphazardly catalogued or miscatalogued, he mined archives in Belgium and Paris as he pursued connections between Flanders and France and brought forth much new information. His monumental contributions to this catalogue are evident throughout, and I am immensely indebted to Koen for enabling the Art Institute to realize a dream that this curator has nurtured for decades.

But as the Art Institute's collection includes examples of tapestry weavng from other times and places, Guy Delmarcel, Koen Brosens, and I decided to invite other tapestry scholars with particular expertise to participate in this project, so that their scholarship could be incorporated in this volume. Thus, Pascal-François Bertrand, Professeur d'Histoire de l'Art Moderne, Université de Michel de Montaigne–Bordeaux 3, France; Charissa Bremer-David, Curator of Sculpture and Decorative Arts, the J. Paul Getty Museum, Los Angeles; Elizabeth Cleland, Leo and Julia Forchheimer Research Fellow, Antonio Ratti Textile Center, the Metropolitan Museum of Art, New York; and Nello Forti Grazzini, independent scholar, Milan, joined the team during the project's last years. Their contributions speak for themselves, and I am profoundly grateful to each of them.

Yet finding the right scholars for this publication was only part of the challenge, for this long-awaited venture was closely tied to a costly and absolutely essential conservation program involving the works in the Art Institute's collection. After a twenty-five-year search, this effort culminated in the selection of what I believe was the right laboratory, the De Wit Royal Manufacturers in Mechelen, Belgium, operated under the direction of Yvan Maes De Wit. This aspect of the overall project began with my introduction to the director in the early 1990s. I followed up by taking one tapestry to Mechelen as a trial piece in 1995. The treatment of this tapestry proved to be a great success, and I liked and admired the De Wit approach to conservation and the complete, in-house system the firm had developed. Little by little, as funding was raised piecemeal, tapping support from individuals and groups of different sorts, we have over the last thirteen years achieved something extraordinary: the cleaning, conservation, and relining of seventy-eight of the tapestries presented in this book. The leadership of the Committee on Textiles—under Chairman of the Board of Trustees and, at the time, Chairman of the Committee John H. Bryan—was invaluable. Armen Minasian, a member of the Committee, suggested we start with one piece, hoping, even confident, that other Textile Committee members and other museum groups would follow suit and pledge their support.

Ultimately, a subcommittee charged with the task of enlisting others to "adopt a tapestry" was formed with Shirley Welsh Ryan (who succeeded John H. Bryan as Chairman of the Committee), Joseph W. Fell, and Armen Minasian. In the end, a number of individuals and organizations underwrote the conservation treatment of the tapestries presented in this volume. They are acknowledged under the appropriate entries in the catalogue proper, but for their financial assistance I here wish to express our sincere thanks to Nathalie W. Alberts, Neville Bryan, Joseph W. Fell, Barbara Franke, Donna McKinney, Armen Minasian, Janis Notz, Shirley Welsh Ryan, Alice Welsh Skilling, and Nicole Williams, as well as to the following organizations: the Antiquarian Society of the Art Institute of Chicago; the Rosemarie and Dean Buntrock Foundation; the Community Associates of the Art Institute of Chicago; the Fatz Foundation; the Malott Family Foundation in loving memory of Elizabeth Hubert Malott; the City of Oudenaarde, Belgium; the Textile Society of the Art Institute of Chicago; the Textile Society Trip Fund; and the James Tigerman Estate. In addition, the Community Associates generously provided a special grant to cover the cost of the expensive color separations used in the production of this book.

All the pieces that required conservation underwent the treatment process in Belgium. The accomplishments of Yvan Maes De Wit and his team of technicians have been remarkable, for they were able to resolve many tricky problems and challenges that the Art Institute's collection presented them. We acknowledge their expertise and are most grateful for the care the collection received in Mechelen over many years. In addition to Yvan Maes De Wit, I wish to thank the other members of his staff, led by Veerle De Wachter, head of the workshop: An Volckaert and Paul Michielssen, academic advisors; as well as Els Danckaers, Lien De Puysseleyr, Patricia Jonckers, Maria Peeters, Olga Solovova, Ann Van Beveren, Véronique Van den Abbeele, Nelly Van den Brande, Bie Van Gastel, Sandra Vanhille, Sabine Verdickt, Ingrid Van Kelst, Paula Smets, and Mariëtte Wyckmans. Yvan Maes De Wit has also graciously contributed an essay to this book in which he describes in detail the treatment of the Art Institute's tapestries in Mechelen (see pp. 21–29). Thanks are also due to Alain and Nathalie Speltdoorn of Brussels, who performed the post-conservation photography.

In 2004 a grant from the Andrew W. Mellon Foundation provided the Art Institute the essential funding for the publication of this volume, ensuring that Koenraad Brosens and the additional authors could participate. That same year the museum authorized the Department of Textiles to hire Odile Joassin, Associate Research Assistant, for four years. Odile pursued her responsibilities admirably and tirelessly throughout the preparation of entries and the planning of the accompanying exhibition. She made valuable contributions through her provenance and curatorial research, and acted as liaison to all the authors involved in this publication. She was indeed a vital member of the "Chicago Tapestry Project."

The Getty Visiting Research Scholar Program presented me with

an uninterrupted three-month residency in 2004 at the J. Paul Getty Museum to devote myself to this undertaking. During that time, much support and assistance was provided by Charissa Bremer-David of the Getty Museum and the Getty Research Institute, Los Angeles. Located at the Getty are the major components of the French and Company photographic archives and ledger books, which proved to be critical for this project, along with the museum's own special collections, including an extraordinary database on tapestries and microfilm copies of the collection records of William Randolph Hearst and of the noted fine art dealership Duveen Brothers, as well as almost 100,000 auction catalogs, and various resources for provenance research, along with photographic documentation pertaining to historic tapestries. Among those who assisted me while at the Getty, I want to thank in particular Wim De Wit, Head, Special Collections and Visual Resources; Martha Steele, Special Collections Cataloger; Sabine Schlosser, Scholar Program Associate; and especially Karen Guntermann, Research Assistant. Additional thanks go to Charles Salas, Head, Research and Education; Deborah Gribbon, Director of the Getty Museum at the time; and the late Thomas Crow, who was then Director of the Getty Research Institute. Furthermore, I was ably assisted in my examination of French and Company material in 1995 by Onica Busuioceanu, former Senior Special Collections Cataloger at the Getty Research Institute, when the Getty Archives were at their previous location in Santa Monica.

Of related significance were the tapestry files at the Huntington Library, Art Collections, and Botanical Gardens, San Marino, California, made available through Curator Shelley Bennett; the tapestry files at the Los Angeles County Museum of Art, made available through Sharon Takeda, Senior Curator and Department Head, Costumes and Textiles; and the collection records at the Hearst Castle, San Simeon, California, made available through Curator Jana Seely. I am also grateful to Thomas P. Campbell, Curator, Department of European Sculpture and Decorative Arts, and Supervising Curator, Antonio Ratti Textile Center, the Metropolitan Museum of Art, New York; and to Ian Wardropper, Iris and B. Gerald Cantor Chairman, Department of European Sculpture and Decorative Arts, the Metropolitan Museum of Art, who made available additional French and Company photographic albums, as well as the Edith A. Standen Tapestry Research Files at the Metropolitan Museum, and the tapestry database of the Ratti Center.

At the Art Institute my endeavors have been supported by Jack P. Brown, Executive Director of the Ryerson and Burnham Libraries; Bart Ryckbosch, Archivist; and the staff of the Ryerson and Burnham Libraries; and by my colleagues Martha Wolff, Eleanor Wood Prince Curator of European Paintings before 1750, Department of Medieval to Modern European Painting and Sculpture; Suzanne McCullagh, Anne Vogt Fuller and Marion Titus Searle Curator of Prints and Drawings, and Martha Tedeschi, Curator of Prints and Drawings, both in the Department of Prints and Drawings; and Richard F. Townsend, Chair, Department of African and Amerin-

dian Art; along with former colleagues Robert E. Mars, Edward W. Horner, Jr., and Patricia Woodworth, who were most supportive in their respective capacities during the time they worked at the Art Institute. Further thanks go to those in the Office of the President and Director, specifically to Dorothy Schroeder, Vice President for Exhibitions and Museum Administration, and Meredith Mack, Deputy Director and Chief Operating Officer; and to those in the museum's legal department: Julie Getzels, Executive Vice President, General Counsel, and Secretary, and Maria Simon, Associate General Counsel.

I am also indebted to members of the Publications Department, led by Susan F. Rossen, Executive Director. First and foremost, my thanks are extended to Assistant Editor for Scholarly Publications Amy R. Peltz, who was principally responsible for this substantial volume. She was aided in her efforts by Robert V. Sharp, Director of Publications; Carolyn Heidrich, Production Coordinator; Joseph Mohan, Photography Editor; and Kate Kotan, Production Assistant. In the Department of Imaging I want to acknowledge Christopher Gallagher, Associate Director; Robert Hashimoto, Senior Photographer; and Robert Lifson, Photographer; in Graphic Design, Lyn DelliQuadri, Executive Director; in Marketing and Public Affairs, Erin Hogan, Director of Public Affairs; and in Museum Registration, John Molini, Manager of Art Packing, who was assisted by Lorna A. Filippini in the design of the tapestry transportation crates that his crew executed. These crates have since become the model for other museums in the shipment of their works.

For their part in the design and production of this book, I wish to acknowledge two individuals who, over many years, have rendered extraordinary service to the Art Institute. Dean Bornstein, a remarkably talented graphic designer, has executed scholarly catalogues for this museum's collections of early Italian drawings, American art, and, most recently, European paintings, and he has here given us yet another elegant and well-conceived volume. Pat Goley of Professional Graphics, Rockford, Illinois, has guided the creation of exquisite color separations for countless Art Institute books. I am grateful to both of them for their work on behalf of our collection of tapestries.

To present this collection to the public in its newly conserved splendor was a significant challenge in itself, but one that resulted in *The Divine Art: Four Centuries of European Tapestries*, the long-awaited exhibition accompanying this publication. For his efforts on the installation of the tapestries, I thank Markus Dohner, Exhibition Designer, who undertook a task that was formidable, even with the assistance of a computer capable of displaying the entire exhibition superimposed on the floor plan of Regenstein Hall. In the Office of Physical Plant, under Associate Vice President William Caddick, numerous carpenters, electricians, painters, and other crew members contributed their expertise in specific areas. I thank them all, along with Beatrice Chu, Associate Vice President of Design and Construction.

Merely saying thank you seems rather inadequate when one's involvement with the countless critical challenges of such a publication and exhibition stretched over many years, and such is the case with two former members of the Department of Textiles—two very special individuals—Cynthia J. Cannon, Assistant and Secretary in the Department of Textiles from 1969 to 2002, who shared in the difficult organization of this project from the very beginning, and Lorna A. Filippini, who in the capacity of Associate Conservator served the department with distinction from 1976 to 2005. Lorna was succeeded by the present Conservator, Lauren K. Chang. Jane Hutchins, an independent textile conservator, flew in from Vancouver and completed a number of preconservation examinations and reports before Lauren Chang was on board. Departmental Scientist Eva Schuchardt has over many years contributed identifications of fibers. Isaac Facio and Gretchen Spittler assisted in the recent dispatch and receipt of tapestries, as well as with the challenges of the installation.

Through various means over several years, I have corresponded with and exchanged information with numerous scholars. I am grateful to Thomas B. F. Cummins, Professor of Pre-Columbian and Colonial Art History, Department of the History of Art and Architecture, Harvard University; Lucia Meoni, independent scholar, Soprintendenza Speciale Polo Museale Fiorentino; Anna Rapp Buri and Monica Stucky-Schürer, both independent scholars, Switzerland; Julie Jones, Andrall E. Pearson Curator in Charge of the Department of the Arts of Africa, Oceania, and the Americas, and Elena Phipps, Conservator, Department of Textile Conservation, both at the Metropolitan Museum of Art, New York; Sara Taylor, Assistant Research Curator, the Department of Textiles, the Art Institute of Chicago; and Wendy Hefford, former Curator of Tapestry, and Linda Parry, former Deputy Keeper, both in the Furniture, Textiles, and Fashion Department, the Victoria and Albert Museum, London. I am grateful for their specific answers to a number of questions pertaining to the Chicago tapestries. I also extend my thanks to Clare Browne, Curator, European Textiles 1500–1800, the Victoria and Albert Museum, who acted as liaison in providing me access to the files of noted textile scholar Henry Currie Marillier. Their input is also acknowledged in numerous entries throughout this volume. Finally, Starr Siegele, Adjunct Curator of Prints at the Allentown Art Museum, Pennsylvania, provided clear and precise information in regard to the eighteenth and early nineteenth centuries, specifically about Jean-Baptiste Marie Huet and his circle.

In Sitges, Spain, I was very fortunate to be able to access the Charles Deering–Miguel Utrillo Correspondence Archives through the guidance of Dr. Vinyet Paynella, former librarian of the Biblioteca Popular Santiago Rusiñol; she also introduced me to her successor Maria Cavalleria Saborit. I am very indebted to Señora Saborit and her staff and to Sitges historian Roland Sierra. Some great discoveries about the fourteen *Caesar and Cleopatra* tapestries designed by Justus van Egmont did turn up in Sitges. Furthermore, the archives

of Arxiu Mas at the Amatller Institute of Hispanic Art, Barcelona, provided a number of unknown facts; and the staff at Leeds Castle, Maidstone, Kent, England, shared information and photographs. Further research resources included the David and Simon Franses Tapestry Archive, London, and I wish to thank David Franses for providing critical information.

I am grateful to Margaret H. Schwartz, Senior Vice President and Director, European Works of Art, Sotheby's, New York, who very kindly made material from French and Company available to me. Véronique Van Passel, Veerle De Wachter, and An Volckaert arranged for me to consult the De Wit/Blondeel Tapestry Manufacturers Database in Mechelen, Belgium. At the Rubenianum, Antwerp, Belgium, Nora de Poorter enabled my search for data on Justus van Egmont. Amy Meadows, Visual Marketing Manager, responsible for the Marshall Field and Company Archives, Chicago, researched tirelessly every possible venue to connect the 1952 Marshall Field gift with possible donors. These files have recently been transferred to the Chicago History Museum.

On behalf of the contributors to this catalogue, I also wish to thank many individuals who generously shared information, access to research materials and photographs, and more. For Koenraad Brosens, I want especially to acknowledge Guy Delmarcel and Katlijne Van der Stighelen, both of the History of Art Department, the Katholieke Universiteit Leuven. Further thanks are due to Barbara Baert, the late Rotraud Bauer, Pascal-François Bertrand, Thomas P. Campbell, Carol Cavanagh, Nicole de Pazzis-Chevalier, Leo De Ren, Stefan Derouck, Nello Forti Grazzini, Ebeltje Hartkamp-Jonxis, Wendy Hefford, Rachel Hunt, Stefan Kist, Florian Knothe, Lucia Meoni, Paul Miller, D. Katelijne Schiltz, Katja Schmitz-von Ledebur, Marga Schoenmaker-van Weeszenberg, Hillie Smit, Jan Van der Stock, Filip Vermeylen, and Hans Vlieghe. And last but not least expressions of sincerest gratitude are extended to Katrien and Willem Brosens.

On behalf of Pascal-Francois Bertrand, I wish to acknowledge Olaf Thormann, Grassi Museum für Angewandte Kunst, Leipzig; Nicole de Pazzis-Chevalier, Galerie Chevalier, Paris; and Magali Metge. On behalf of Charissa Bremer-David, I want to thank Christophe Leribault, Conservateur en Chef, and Dominique Cordellier, Conservateur, Département des Arts Graphiques, Musée du Louvre, Paris; Ann Friedman, Manager, Grants and Foundations, the Nelson-Atkins Museum of Art, Kansas City, Missouri; Nicole Garnier, Conservateur en Chef du Patrimoine Chargé du Musée Condé, Château de Chantilly; Martin Olin, Research Curator, Nationalmuseum, Stockholm; and Jean Vittet, Inspecteur de la Création Artistique, Mobilier National, Paris; as well as Koenraad Brosens, Guy Delmarcel, and Nello Forti Grazzini. On behalf of Elizabeth Cleland, I want to thank Thomas P. Campbell, Curator, Department of European Sculpture and Decorative Arts, and Supervising Curator, Antonio Ratti Textile Center, and Maryan Ainsworth, Curator, Department of European Paintings, both at the Metropolitan Museum of Art,

New York; and Louise W. Mackie, Curator of Textiles and Islamic Art, Cleveland Museum of Art. On behalf of Nello Forti Grazzini, I would again like to thank Guy Delmarcel, who as critical reader provided very useful suggestions.

In her capacity as Associate Research Assistant, Odile Joassin was generously provided assistance by many individuals. On her behalf, I would like to acknowledge Robyn Fleming of the Thomas J. Watson Library, the Metropolitan Museum of Art, New York; Remko Jansonius, Collections and Archives Manager, Vizcaya Museum and Gardens, Miami, Florida; Amy Meadows, Visual Marketing Manager, Marshall Field and Company Archives, Chicago; Arthur H. Miller, Archivist and Librarian for Special Collections, Donnelley and Lee Library, Lake Forest College, Lake Forest, Illinois; Mark Whittaker, Webmaster, the Marple Hall Website; Francesca Zardini, Galleria Moshe Tabibnia, Milan; and the staff of the following institutions: Archives of American Art, Smithsonian Institution, Washington, D.C.; the Ryerson and Burnham Libraries of the Art Institute of Chicago and Art Institute Archives; Department of Prints and Drawings, the Art Institute of Chicago; the Newberry Library, Chicago; the British Library, London; the Research Center at the Chicago History Museum; the University of Chicago Library; the University of Illinois at Chicago Library; the University Archives, Northwestern University Library, Evanston, Illinois; and the Archives Department of the Clerk of the Circuit Court of Cook County.

Others to whom I am indebted are Julius Lewis, Mary Young, Ludmilla Schwarzenberg Hess, Susan Higinbotham, Alice Arlen, Celia Hilliard, Mary Shea, Sander Allen, Sharon Darling, Martha Thorne, and the members of the Textile Committee and the Textile Society of the Art Institute of Chicago. Last but not least I thank my husband, Arsenio G. Sala, who would have preferred not to have his wife shuttling across the Atlantic with countless tapestry crates to Belgium or being glued to books, files, and the computer for all these many years.

Finally, I wish to dedicate this volume to the three Art Institute directors who were critical to this undertaking: Charles C. Cunningham, James N. Wood, and James Cuno. Charles C. Cunningham, director from 1965 to 1972, brought me to Chicago and asked me to develop the museum's textile collection in every way. "Why don't you start with the tapestries," he said in one of our initial conversations. That was forty-one years ago! Second, James N. Wood, who directed the Art Institute from 1979 to 2004, became rather curious about the museum's tapestry holdings in the early 1990s. But his interest had to confront issues related to the condition of the works of art themselves and the challenge of raising funds for conservation treatment that could not be carried out in house. As I have described above, securing the De Wit laboratory for the conservation of the pieces, agreeing to put Koenraad Brosens under contract as principal author, and letting me accept a visiting position at the Getty Museum for a sustained period of research were all decisions for which I owe Jim Wood an enormous debt of thanks. And thus we come to James Cuno, who succeeded Wood in 2004 as President and Eloise W. Martin Director, and who provided the necessary financial support so that this project could be completed, most especially by enabling the hiring of a research assistant for four years and by committing to the addition of four very gifted tapestry scholars to the authorial team. For all this and more, this book is dedicated to these three distinguished directors of the Art Institute.

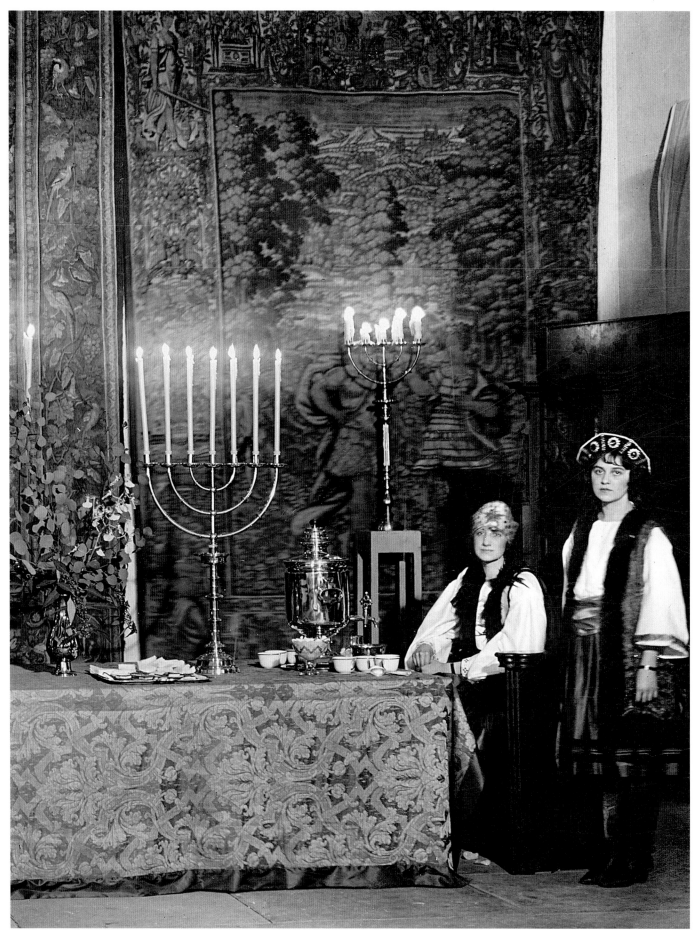

FIG. 1 Members of the Antiquarian Society at the Art Institute of Chicago for the opening of the Hutchinson Wing, January 1923. In the background hangs *Venus and Adonis (?) with a Duck Hunt* (cat. 14a).

❧ A COLLECTION AND ITS DONORS ❧

Christa C. Mayer Thurman

THE great accumulation of personal wealth in the United States between the Civil War and the Great Depression aroused a desire for the fruits of European cultures old and new and provided the means necessary to acquire them. The merchants and industrialists of the Gilded Age—including those of Chicago following the disastrous fire of 1871—purchased European art and artifacts in an ever-increasing volume, supported by an organized and specialized art trade. To some degree the American well-to-do sought to gain the trappings of aristocratic life, a desire reflected in the revival of historic architectural styles and in the importation of actual architectural elements—as at James Deering's extraordinary palazzo, Vizcaya, in Miami, Florida, or Potter Palmer's "Rhine castle" on Lake Shore Drive in Chicago—and sometimes even whole buildings. Textiles and tapestries, necessary furnishings for such a lifestyle, were in most instances acquired more as *staffage* than as important works of art appreciated in and of themselves. Tapestries were frequently cut to fit existing domestic spaces, or used as upholstery, but they formed an integral part of upper-class interior decoration into the 1920s. Working with dealers such as Lehmann Bernheimer in Munich or Jacques Seligmann in New York and Paris in serving the tastes of the time, professional designers and decorators—such as Chicago's Healy and Millet or New York's Tiffany and Company or French and Company—could be relied upon to integrate old and new into elegant settings for the lives of the newly rich. These agents regularly provided the complete contents for grand period houses, even including antique wooden wall paneling and entire rooms. At a broader level, department stores such as Chicago's Marshall Field and Company offered decorating services and dealt extensively in antique furnishings for the upper middle class as well as for the wealthy. Examining the Art Institute's tapestry collection as a whole, one realizes that direct purchases have been relatively infrequent; the great majority of acquisitions have come as gifts or bequests from such collectors. Thus, this essay takes a look at several of the major donors—individuals, families, and groups—who, beginning in 1890, helped to shape this Chicago collection.

The very first notable patrons of the decorative arts at the Art Institute were the members of the Antiquarian Society, the museum's oldest support group, and it was they who underwrote the purchase of three tapestries by Director William M. R. French from "a respectable family in need" in Rome, which were later recorded as "the gift of Charles J. Singer through the Society." The acquisition included a seventeenth-century Flemish tapestry from a series devoted to *The Story of Odysseus* (cat. 18) by Jan van Leefdael of Brussels, as well as two significant, early-seventeenth-century French panels from a series known as *The Story of Artemisia* (cats. 39a–b).[1] The following year, 1891, Mrs. John J. Glessner, a member of the Antiquarian Society and a leading supporter of the arts in the city, proposed that the group should direct its financial support specifically to establish "a nucleus to buy articles pertaining to the industrial arts such as pottery, china, tapestries, embroideries, etc., to be presented to the Art Institute," a motion that was readily approved by its board and applauded by the museum's president, Charles L. Hutchinson.[2]

Following the very first tapestry exhibition held at the Art Institute (*The Charles M. Ffoulke Collection*, January 1–15, 1896), the Antiquarian Society acquired for the museum's permanent collection from the works on view—the private collection of the Washington wool merchant Charles M. Ffoulke (1841–1909)—two Flemish tapestries: *Venus and Adonis* (?) *with a Duck Hunt* and *Pluto and Proserpina with Falconry* (cats. 14a–b). For these the Society provided the funding as a group (fig. 1). Further significant Antiquarian acquisitions took place in 1911—*The Crossing of the River Granicus* (cat. 57), one of the large signed panels of 1619 by Karel II van Mander from *The Story of Alexander the Great* series—and again in 1934 when the Edith Rockefeller McCormick collection was sold in New York. Although Mrs. McCormick's spectacular *Large Leaf Verdure with Animals and Birds* (cat. 31, endpapers, and fig. 2) had been on loan to the Art Institute since 1923, it had to be included in the auction and only returned to Chicago because the Antiquarian Society provided the funding for its purchase from the Jessie Landon Fund. The Antiquarians also occasionally served as a gift agent, as in the case of the acquisition of the *Large Leaf Verdure with Balustrade and Birds* (cat. 34) from Mrs. Potter Palmer II, which entered the museum's collection in 1923 as a loan and twenty years later was accepted as a gift from her through the Society.

Although many individuals have donated tapestries, some names recur with frequency over the years. Principal among them is that of Robert Allerton (fig. 3). Scion of a wealthy Chicago family and involved with the Art Institute of Chicago from 1915 onward, Allerton became one of its major Trustees and chairman of the Decorative Arts Committee. His concerns for the textile collection included not only acquisitions—for which he created a fund in 1923—but also such practical issues as its facilities: in 1926 it was Allerton who established the museum's first textile galleries, endowed in memory of his stepmother and known as the Agnes Allerton Textile Wing.

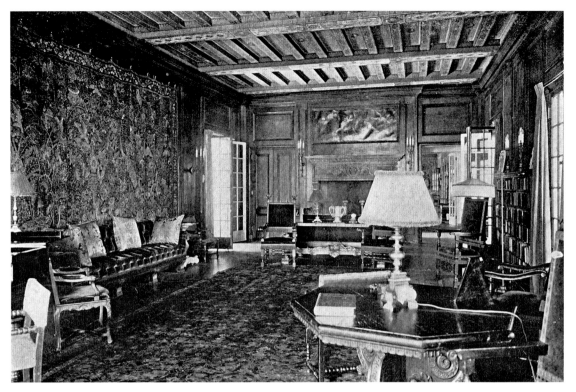

FIG. 2 Interior view of Edith Rockefeller McCormick's Villa Turicum, Lake Forest, Illinois, showing *Large Leaf Verdure with Animals and Birds* (cat. 31). From *Arts and Decoration* 9, 1 (May 1913), p. 241.

Among his very early gifts was a rare tapestry from Oudenaarde in Belgium (cat. 33), one of the few known with the town's mark in its border. Allerton also supported the purchase of *Camel Riders* from a *Wild Man* series (cat. 2), which had been exhibited at the Arts Club of Chicago in 1927 in one of the first exhibitions devoted exclusively to medieval and early Renaissance tapestry, organized by art historian Phyllis Ackerman.[3]

Although the tapestry acquisitions undertaken directly by Allerton or through his fund were limited in number, he also saw to it that pieces that otherwise could have ended up somewhere else found their way to the Art Institute, such as a portiere with the Medici coat of arms (cat. 56). This panel, originally woven for the Pitti Palace in Florence, had been part of Professor Elie Volpi's collection prior to its purchase by Chicagoan Martin A. Ryerson (1856–1932). After Ryerson's death, the piece was given by his wife, Caroline Hutchinson Ryerson, to the University of Chicago, as he had been president of that institution from 1892 to 1922. It hung in Goodspeed Hall there until 1944, when an exchange was made for an unidentified tapestry from Allerton's private collection.[4]

Years later, Allerton's name surfaced again, this time supporting a critical acquisition, *The Elephant* from the *Grotesques* series (cat. 43), and resolving a matter that had dragged on for four years. The piece had arrived on loan in 1952, and correspondence between René Boas (son of the work's previous owner) and the Art Institute's Decorative Arts curators (Hans Huth, Meyric R. Rogers, and Mildred Davison) attests to the museum's difficulty in finding the necessary purchase money. As funding remained a problem, the loan was extended annually until 1956, when the tapestry was finally secured for $3,500

with "funds previously given by Robert Allerton."[5]

Allerton's fellow Trustee Martin Ryerson was a prominent Chicago lumber magnate, lawyer, and investor, and one of the most discerning collectors of his time. Deeply involved with the Art Institute, he donated to the museum over a thousand works of art in all media, and proved a generous benefactor to many other cultural institutions in the city. When the Field Museum abolished its Industrial Art Division in 1906, it was Ryerson who suggested to Edward E. Ayer (1841–1927), another notable Chicago industrialist, that he offer to the Art Institute his collection of textiles, which had been part of the Field Museum's holdings. Ryerson's advice was sound, and the following year the museum acquired, by purchase, the Ayer textiles.[6] Ryerson himself had married Carrie Hutchinson in 1881 and together they built over the next fifty years an extraordinary collection of American and European paintings, Asian and European objets d'art, and a group of early and important devotional tapestries that they displayed in their home on Drexel Boulevard (fig. 4).[7] The Ryersons had acquired the latter pieces in 1893 in Paris at the auction of the Frédéric Spitzer collection.[8] Given that the auction has been lauded as "perhaps the greatest event in the annals of the sales-room," it was indeed a coup for the Ryersons to gain possession of these works.[9] The tapestries entered the Art Institute's collection on the death of Mrs. Ryerson in 1937 (cats. 3, 4, and 55).

The connection between the Art Institute of Chicago and the family of Potter Palmer (1826–1902) and Bertha Honoré Palmer (1849–1918) is likewise reflected in a great many art objects, including a number of tapestries that ultimately became the property of the museum as gifts of their son Honoré (1874–1964). Although

FIG. 3 Robert Allerton (1873–1964).

FIG. 4 Interior view of the Martin A. Ryerson and Carrie Hutchinson Ryerson home, 4851 S. Drexel Boulevard, Chicago, showing *The Annunciation* (cat. 55).

no precise provenance of these pieces is known, there is little doubt that some were part of the objects furnishing their residence in Paris, as several are French and reflect the taste of Bertha Palmer. In 1882, far away from the Prairie Avenue homes of a number of Chicago's wealthiest families, Potter Palmer built for his wife a mansion on Lake Shore Drive—a massive edifice described as "an English Gothic imitation of a Rhine River castle."[10] It was furnished with treasures from various European periods, ranging from Renaissance engravings to Impressionist masterpieces. In addition, two panels from the nine-part *Story of Cyrus*, illustrating the episodes of *The Diversion of the Euphrates* and *Cyrus Defeats Spargapises* (cats. 20a–b), hung at the end of the mansion's 75-foot-long painting gallery (fig. 5). These later entered the museum's collection along with several other tapestries from the Palmers' collection (cats. 23, 41a–b, 44, 51, and 62).

In regard to textiles and tapestries, the Deering/McCormick, Deering/Danielson, and Deering/Howe connections with the Art Institute have proven of enormous benefit. The long-standing relationships began in 1922 when the extraordinary set of fourteen *Caesar and Cleopatra* tapestries (cats. 19a–n) arrived in Chicago from Spain, recorded as a loan from Charles Deering (fig. 8). A Hispanophile whose wealth derived from the Deering Harvester Company—which would merge with the McCormick Harvesting Machine Company to become the International Harvester Company—Deering created in the early decades of the twentieth century in the village of Sitges, south of Barcelona, an elaborate seaside residence, called Marycel (i.e., sea and sky), which he furnished with works purchased from the art markets of Europe and America.

This complex of buildings, built between 1911 and 1915, incorporated existing structures and was executed in a medieval revival style. In a letter to his property manager Miguel Utrillo dated February 26, 1914, Deering expressed his excitement about works of art to be acquired for Marycel: "I am much interested by the silver and the tapestries of Mallorca." He also discussed issues such as funding that he was prepared to send to Utrillo immediately if needed.[11] A year later the local newspaper reported that the fourteen tapestries were hanging "provisionalmente" in the entrance hall at Marycel;[12] it also noted that they represented the history of Caesar and were the work of Gerard Peemans and Willem van Leefdael. The article then continued: "y son aquellos que en una occasion, habian sido solicitados para el Salon de Ciento de Barcelona, procediendo de palacio de un magnate uno de cuyos antepasados los habia adquirido en Flandes como botin de guerra." ([T]hey are those which once were sought for the Salon de Ciento [a grand fifteenth-century meeting chamber in the town hall] in Barcelona, coming from the palace of a magnate, one of whose ancestors acquired them in Flanders as war booty.) War booty . . . from which war? In the seventeenth century Spanish Hapsburg troops spent decades fighting in Flanders and presumably the tapestries came to Mallorca at that time; correspondence dated August 30, 1915, between the dealer Apolonia Burguera and a Sr. D. Olegario Junyent (1876–1958) documents that by 1915 they were hanging at Marycel in Sitges and were Deering's property. It discusses the fourteen tapestries, the purchase price of 350,000 pesetas, and refers to a "Sr. Villalonga," whose family name is associated with titled nobility in Palma de Mallorca, as the seller.[13]

Where these tapestries hung in the Marycel complex can only be partially determined, although it is clear that the fourteen tapestries were divided between two spaces (fig. 6).[14] One area in the building now houses the Biblioteca Popular Santiago Rusiñol.[15] Mildred Davison, former curator of the Department of Textiles, reported in conversation in the 1960s that when the tapestries came to the Art Institute on loan in 1922 they were installed around the museum's Grand Staircase and remained there for a number of years. The loan

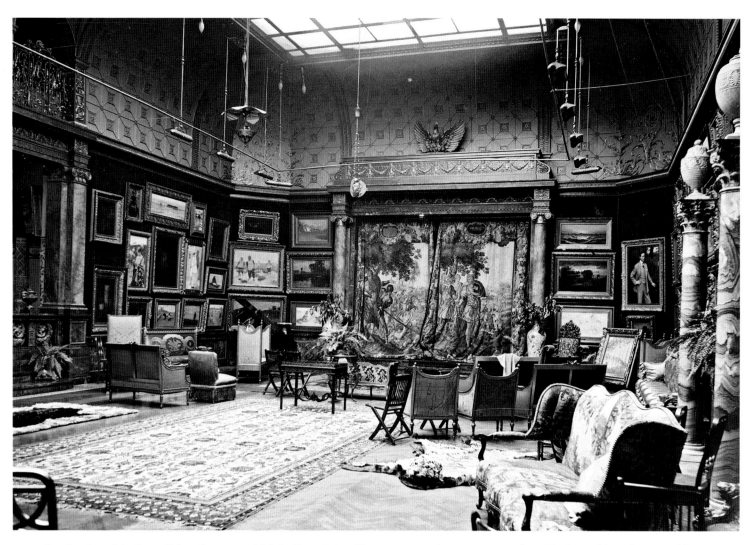

FIG. 5 Interior view of the Potter Palmer house, 1350 N. Lake Shore Drive, Chicago, c. 1900, showing tapestries from *The Story of Cyrus* (cats. 20a–b).

arrangement with Deering and his heirs was in effect until 1944, when the hangings were at last presented to the museum.[16]

In 1918 Charles Deering purchased two tapestry-woven fragments destined for Marycel from French and Company in New York, reversing the normal flow of European art to America. These pieces, comprising the right and left sections from *The Entrance of Psyche into Cupid's Palace*—one scene from a large tapestry set designed by François Boucher—are closely related in size (cats. 46a–b). In a letter dated July 11, 1919, Deering informed Utrillo that "P. W. French and Company will soon be shipping . . . 2 Royal Beauvais tapestries, 5 feet 6 inches x 10 feet 2 inches."[17] Utrillo would have been the one in Sitges to receive the shipment of these antique objects, and thus the two tapestry fragments went directly from New York to Spain. An undated postcard shows the panels propped against two large niches on either side of the main entrance to the Sala d'Or, or Golden Hall, at Marycel (fig. 7). Also put on loan to the Art Institute in 1922, these Boucher panels were given in 1943 by Deering's daughters, Marion (Mrs. Chauncey McCormick, 1886–1965) and Barbara (Mrs. Richard Ely Danielson, 1888–1987).[18]

Charles Deering's half brother James Deering (fig. 9) built in 1916 a Venetian style palazzo, called Vizcaya, which incorporated architectural elements from Europe into a grand ensemble surrounded by elaborate gardens overlooking Miami's Biscayne Bay. Now a national historic landmark and a public museum, Vizcaya, with its high, coffered ceilings, was an ideal place to hang tapestries. The two millefleur panels in the museum's collection (cats. 29–30) were originally one tapestry, but around 1915 Deering had the hanging cut and reworked in order to fit between windows of the banquet hall at Vizcaya (fig. 10).[19] Additional pieces from his collection came to the Art Institute as well, including *The Fall of Phaeton* and *The Arrival of Telemachus on Calypso's Island* (cats. 53a–b), which were inherited by and later offered as gifts to the museum in 1943 and 1944 by William Deering Howe, nephew of James Deering. Also from James Deering—and also given by his nieces, Mrs. Chauncey McCormick and Mrs. Richard Ely Danielson—are *February* and *July* (cats. 9a–b), two tapestries from the *Medallion Months* series designed by an artist in the circle of Bernard van Orley at his workshop in Brussels.

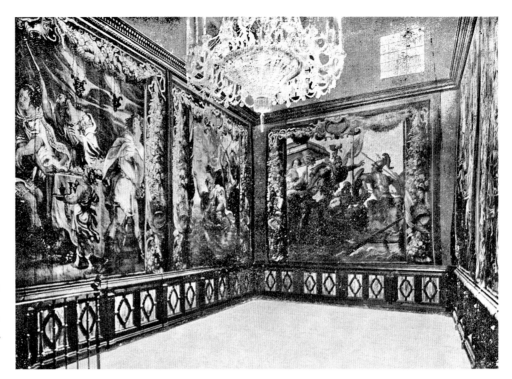

FIG. 6 Interior view of
Charles Deering's residence
Marycel, Sitges, Spain.
Photograph from José Mar-
tino Arroyo, *Marycel* (1918),
p. 58.

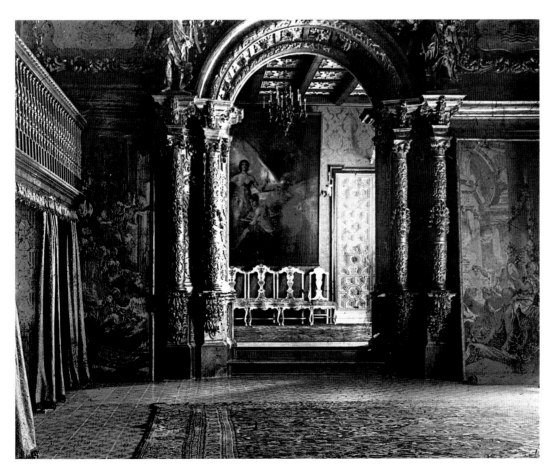

FIG. 7 Interior view of the Sala d'Or,
Marycel, showing tapestry panels
designed by Francois Boucher (cats.
46a–b).

FIG. 8 Charles Deering (1852–1927).

FIG. 9 James Deering (1859–1925).

The newspaper magnate William Randolph Hearst (1863–1951), a passionate and omnivorous art collector who assembled a remarkable group of tapestries, did not himself donate any of his holdings to the Art Institute directly, but he can be identified as the previous owner of six hangings now in this museum's permanent collection. Several of his tapestries were initially offered for sale to the museum in 1940, including two key works that were once the property of the Spanish Duke of Berwick and Alba.[20] One of these, *Pomona Surprised by Vertumnus and Other Suitors* (cat. 11), was quickly acquired by the Art Institute through the generosity of Mrs. Charles H. Worcester and the Charles H. Worcester Fund.[21] The acquisition of the second work—*The Resurrection* (cat. 6) from 1510/20, a reduced version of the eighth in a series of ten known as *The Allegory of the Redemption of Man*—dragged on for years. This tapestry was ultimately acquired in 1946 in part with funds realized from the sale of two chairs originally given by William Deering Howe; but the piece was also an indirect gift of two other, now familiar Deering descendants, Mrs. Chauncey McCormick and Mrs. Richard Ely Danielson.[22] Thus, whether through the use of general acquisition funds or the sale of deaccessioned objects, tapestries that were never part of private Chicago collections entered the museum's holdings bearing the names of donors who, above and beyond their own earlier gifts, provided the necessary resources for their accession. Quite fortuitously, in 1953, two years after Hearst's death, his foundation offered as gifts to a number of major museums other tapestries from his collection. The Art Institute of Chicago was included in this list of institutions and four pieces were added to the tapestry holdings at that time (cats. 12, 40a–b, and 52).

In 1952 four tapestries were offered to the Art Institute as an outright gift of Marshall Field and Company, the preeminent Chicago department store (cats. 17, 21, 25, and 28; see fig. 9). Unfortunately, the records for this gift are incomplete, and one has to surmise that the pieces had been stock of the Field's antiques department. In the postwar era of the 1950s tapestries would have been difficult to market as living styles and interior spaces evolved and houses became smaller. This change is repeatedly reflected in gifts that reached the museum during the 1950s and 1960s, offered by individual donors who needed to move and, possessing one or more tapestries, had to find a home for such "white elephants." It is possible that many of these hangings had originally been purchased at Marshall Field's, which had long prided itself on the quality of the merchandise within its antiques department. During the same period, other such objects found their way to the Art Institute of Chicago after they had been in private collections within the United States for lengthy periods (cats. 13, 24, and 42a–b; see fig. 11).

Occasionally, outright and direct purchases with general museum funds, rather than gifts or bequests, supported tapestry acquisitions. One interesting transaction occurred in 1919 with Ananda Kentish Coomaraswamy (1877–1947). Who was this gentleman with an Indian name who was responsible for the *Pomona* tapestry (cat. 59) by William Morris and Edward Burne-Jones ending up at the Art Institute? Coomaraswamy was born in Sri Lanka (then Ceylon) in 1877 and educated in Great Britain. He became a geologist and mineralogist, as well as a brilliant writer, scholar, and authority on Indian and Sri Lankan culture. In 1902 he married an Englishwoman, Ethel Mary Partridge (1872–1952), better known as Ethel Mairet, a prominent dyer and handweaver.[23] After their divorce in 1910, Coomaras-

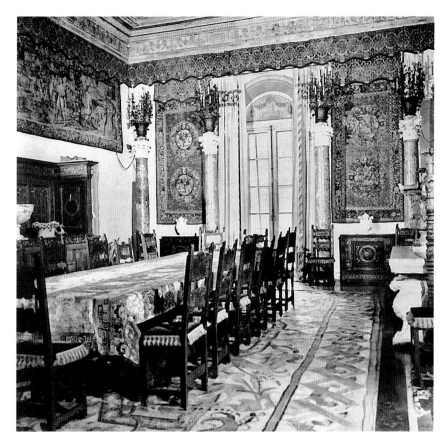

FIG. 10 Interior view of the banquet hall at James Deering's residence Vizcaya, Miami, Florida, showing two millefleur tapestries (cats. 29–30).

wamy came to the United States, and in 1917 he was appointed Keeper of Indian, Persian, and Mohammedan Art at the Museum of Fine Arts, Boston, where he worked until his death in 1947.[24]

In 1919 Coomaraswamy spoke to the Renaissance Society at the University of Chicago on "Indian Painting, Buddhist and Hindu,"[25] and while on that trip must have dropped off the *Pomona* tapestry at the Art Institute. The museum's Day Book quotes Coomaraswamy: "I bought this [i.e., *Pomona*] at the Morris shop a long time ago. It was made in the workshops in Surrey like all their tapestries."[26] As the cartoons for Morris's tapestries were kept by the company, repeated weavings could be executed to order. Morris and Company executive Henry Currie Marrillier recorded these later weavings and his handwritten accounts list "a small pair for Coomaraswamy in 1906."[27] The purchase of this small tapestry by the Art Institute was financed through the Ida E. S. Noyes Fund for $600.[28]

In 1942 another tapestry was entered by the Art Institute registrar as an indefinite loan from French and Company (cat. 58).[29] A few years later the Antiquarian Society considered this English-made tapestry "for the Crane Memorial," a period-room installation with a staircase, entrance hall, doorway, and drawing room from a 1732 town house in London, the so-called Hogarth House.[30] Although the period rooms comprised a pastiche of authentic and imitation architectural elements and furnishings in its Art Institute incarnation, the original rooms in England may well have included tapestries, although they would more likely have been a suite consisting of several pieces with related subject matters, matching colors, and iden-

tical borders. By January 1950 the tapestry was ready to be installed in the Art Institute's "Hogarth rooms," and the Richard T. Crane, Jr., Fund was charged $6,000 to reimburse the Antiquarian Society.[31] It would remain on view there from 1950 to 1975, on the wall alongside the English staircase, an area into which the Department of Textiles expanded during its first phase of renovation and restructuring in the mid-1970s. In order to broaden the base of the museum's tapestry collection, the Centennial Fund established to celebrate the Art Institute's one-hundredth anniversary in 1979 authorized the acquisition of a Peruvian hanging, dating from about the first half of the eighteenth century (cat. 60). It is included in this catalogue because of its European features.

In 2007 the Mr. and Mrs. Charles H. Worcester Fund, which had underwritten the acquisition of *Pomona Surprised by Vertumnus and Other Suitors* (cat. 11) in 1940 from the Hearst collection, made possible the acquisition of a magnificent Beauvais tapestry, *The Emperor Sailing* (cat. 45), the latest addition to the Art Institute's collection. This extraordinary example of French chinoiserie joins the English-produced piece *The Tent* (cat. 58) from an Indo-Chinese series in documenting these pan-European tastes. *The Emperor Sailing* was woven at the same royal workshop that created *The Elephant* (cat. 43), another of the Art Institute's best-loved hangings. The coat of arms in the upper border of Franz Ludwig (1664–1732), Count Palatine von Pfalz-Neuburg and Grand Master of the Teutonic Order, provides confirmation that the piece is part of the suite originally commissioned about 1710.

FIG. 11 Interior of Elmer E. Tolman home, Lake Forest, Illinois, showing in the inner room *The Meeting of Jacob and Rebecca, and Isaac Blessing Jacob* (cat. 13). Photograph from *Arts and Decoration* 19, 1 (May 1923), p. 14.

Diverse in origin and acquired over more than a century, the Art Institute's tapestry collection constitutes a fascinating composite of gifts, bequests, and purchases that present the full spectrum of taste and style, of period and country of origin, from large-scale master-pieces to simpler, more routine expressions. Individual and family connections make it a monument that is special to this museum, its history, and its donors, as well as to Chicago. Together the tapestries assembled here form an entrancing, spectacular, and beautiful survey of "the Divine Art."[32]

NOTES

The author would like to acknowledge with special thanks the assistance of Jack P. Brown, Executive Director of the Art Institute's Ryerson and Burnham Libraries; Odile Joassin, Associate Research Assistant in the Department of Textiles; and Art Institute Archivist Bart Ryckbosch in the preparation of this chapter.

1. Discussion of the Antiquarian Society draws on Hilliard 2002. At first this organization was known as the Chicago Society of Decorative Art, and was modeled after the New York Society of Decorative Art which had been established by Candace Wheeler (1827–1923), an artist and associate of Louis Comfort Tiffany (1848–1933). Wheeler tried to inspire her Chicago friend Mrs. Jonathan Young Scammon (1821–1901) to start a similar group in this city; The Art Institute of Chicago, *Day Book; Old Register No. 33.*
2. Secretary's report, *The Antiquarians of the Art Institute Year Book*, Chicago, 1902, p. 6.
3. Ackerman 1926a.
4. Who initiated this exchange remains a mystery.
5. Art Institute receipt 12970 X613, June 5, 1956 (handwritten notations by departmental secretary Josephine Morse).
6. "M. A. Ryerson, Art Collector and Philanthropist, Dies," *Chicago Tribune*, Aug. 12, 1932, p. 1.
7. Ibid.
8. Frédéric Spitzer (1815–1890) was born in Vienna and settled in 1852 in Paris, where he became an art dealer and also amassed an extensive personal col-

lection of art objects dating from the Middle Ages through the late Renais-sance. The three Chicago tapestries were in his possession prior to his death in 1890.
9. "Many Rarities in Spitzer Collection," *Art News*, Jan. 7, 1929, p. 1.
10. The Palmers owned residences in Chicago, London, and Paris, as well as an estate in Sarasota, Florida.
11. One assumes that this trip had to do with the purchase of these tapestries. Inventory no. 3261.
12. *El Eco de Sitges*, Oct. 24, 1915.
13. I am most grateful to Sitges historian Ronald Sierra for directing me to this letter in the Biblioteca Popular Santiago Rusiñol, Sitges, and to Chief Li-brarian and Historian Maria Cavalleria Saborit.
14. Martino Arroyo 1918, p. 27.
15. Ibid., p. 27, ill. p. 58, where it is captioned "Salon (pequeño) de tapices."
16. Deering died in 1927; the estate was settled in 1929, at which time his two daughters, Mrs. Chauncey McCormick (Marion Deering, 1886–1965) and Mrs. Richard Ely Danielson (Barbara Deering, 1888–1987) inherited the panels. They must have continued the former loan arrangement until 1944 when the set became an outright gift from them to the museum.
17. Correspondence at the Biblioteca Popular Santiago Rusiñol, Sitges.
18. Art Institute receipt 6262.
19. Letter from Paul Chalfin to James Deering, Feb. 26, 1915, and letter from James Deering to Paul Chalfin, Mar. 30, 1915; Archives, Vizcaya Museum and Gardens, Miami. The author would like to thank Remko Jansonius, Collections and Archives Manager of Vizcaya Museum and Gardens, for locating and providing this and other correspondence between James Deer-ing and Paul Chalfin.
20. Starting in 1938, Hearst's advisors and consultants decided that the col-lection would be sold in stages. See Nasaw 2000, p. 541. During the 1941 sale, over one hundred tapestries were offered; Hammer Galleries 1941, pp. 277–78.
21. Art Institute receipt 7037.
22. Art Institute receipts 8053, 8212.
23. The author is grateful for much of this information to Linda Parry, former Curator of Textiles and Dress, the Victoria and Albert Museum, London.
24. Museum of Fine Arts, Boston, Archives.
25. Lipsey 1977, p. 141.

26. The Art Institute of Chicago, Registrar's Office, *Day Book #9*, p. 82.

27. Henry Currie Marillier, "Catalogue of Tapestry Arranged by Subject" (unpublished manuscript), handwritten notes, p. 71, Department of Textiles, the Victoria and Albert Museum, London.

28. Linda Parry, correspondence with the author, Oct. 2005, and Art Institute Board of Trustees Minutes (Oct. 9, 1919). Interestingly, the same fund, established with insurance monies received for a collection of jewelry stolen from the museum, was used to purchase a Burne-Jones sketchbook the following year (1920.1133–61).

29. Prior to being part of the stock of French and Company, the tapestry was owned by the Kent Gallery, London, which had acquired the piece at a Christie's auction held Mar. 14, 1929, lot 91. It had a slightly smaller companion panel the whereabouts of which were unknown until 2004, when it appeared at another Christie's auction (GCPA 0181882). Although the subject is Indo-Chinese and the piece carries the title *Palanquin*, the borders of the piece sold in 2004 match the Chicago tapestry in every way.

30. The acceptance of the tapestry is recorded in the Trustees Minutes of a meeting of the Decorative Arts Committee, Apr. 1949. Yet it seems that the tapestry was initially to fetch $10,000. Curiously, a 1907 Antiquarian Society gift of *Three Scenes from the Passion*, a Franco-Flemish tapestry from around 1500, became part of the payment: i.e., it was used as a trade-in to French and Company to make up the $4,000 difference.

31. In the late 1920s Florence Crane established a memorial fund honoring her late husband, Richard T. Crane, Jr., and endowed the period-room installation, though it was not until 1950 that the "Hogarth rooms" came into being at the Art Institute. In 1921 the Cranes had purchased the interiors of 75 Dean Street, London, known as the "Hogarth House" for use in the immense home in Ipswich, Massachusetts, that Chicago architect David Adler was building for them. The name of the house in London comes from the mistaken attribution of murals located in the staircase hall to William Hogarth. Portions of the English wood-paneled rooms were indeed used at Castle Hill, the Crane's estate in Ipswich, whereas the staircase and first-floor paneling were donated to the Art Institute. An article in the museum's *Scrapbook* shows a small portion of cat. 58 hanging in the stairwell. See "The Pitt Estate in Dean Street: No. 75 Dean Street," in Sheppard 1966, pp. 221–28; *The Art Institute of Chicago Scrapbook* (1950), pp. 105–06. See also Zelleke 2002, pp. 58–59, fig. 6; and Dolan 2002, pp. 141–49.

32. This quotation, the source of the first part of the title of the accompanying exhibition, comes from a Latin inscription on a Brussels tapestry, *Alexander the Great Receiving the Surrender of a City, Perhaps Tyre*, produced by Jacob Fobert (1587 or 1588–c. 1635) after Jacob Jordaens (1593–1678). It measures 425 x 730 cm and its present location is unknown. The inscription appears in the lower cartouche and reads DIVINA PALLADIS ARTE / PICTVRAM SVPERAVIT / ACVS (Through the divine art of Pallas, the needle [actually the shuttle] has conquered painting). See Nelson 1998, p. 67.

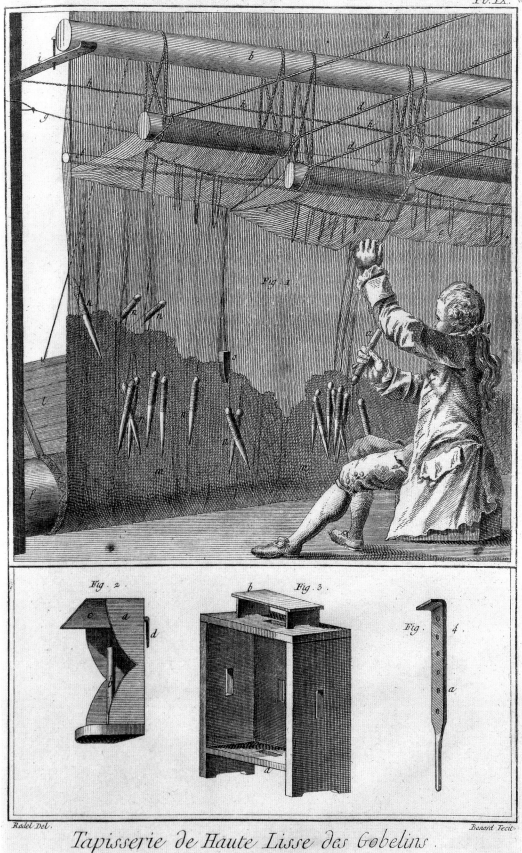

Pl. IX.

Radel Del.

Benard fecit.

Tapisserie de Haute Lisse des Gobelins.

Attitude de l'Ouvrier pour commencer l'Ouvrage.

FIG. 1 Illustration from Diderot and d'Alembert's *Encyclopédie*, showing tapestry weaving on a high-warp loom.

THE TAPESTRY MEDIUM: AN INTRODUCTION

Christa C. Mayer Thurman

WHETHER it is known as *k'o-ssu* in the Far East, kilim in Central Asia, or weft-faced plain weave in the West, the essential technique of tapestry weaving has existed for centuries, having developed independently in many cultures. Though continents apart, the early Egyptian Christians, or Copts, as well as weavers high in the Andes mountains of Peru, were both as familiar with the tapestry technique as those who labored in the workshops of Europe during the Middle Ages. In English the etymology of our word for this type of textile traces back to the fifteenth century and the French term *tapisserie*, which itself originally derived from *tapis*, which meant carpet. The Spanish use essentially the same term, *tapiz*, as do the Germans with their words *Teppich* and *Wandteppich* (wall carpet), the Dutch with *wandtapijt*, and the Italians with *tappezzeria*. All of these names come from the Latin plural *tapetia*, and ultimately from the Greek root, τάπησ, meaning drapery or tapestry used for covering walls, floors, or furniture. Other common words for tapestry tell a different story. Italians, for example, also call these objects *arazzi* (singular, *arazzo*), a word whose currency certainly signified the reputation of the town of Arras, in Picardy, in the production of such works. This word, arras, entered English in the fifteenth century. Likewise, the widespread usage of the term "Gobelin" (or "Gobelins") demonstrates that the renowned French manufactory, established in Paris in the seventeenth century, eventually became synonymous with the art it produced. All too often, however, the term "tapestry" has served to indicate any large, pictorial hanging—regardless of how it was produced—and to this day this unfortunate application of the word has handicapped understanding of the medium. The extraordinary works of art presented in this catalogue are all true examples of the tapestry-weaving technique, even the two table carpets that have been included at the end of this publication (cats. 61–62). Except for these table coverings, all the other pieces in this volume were designed and used as wall hangings.

Like all woven textiles, the structure of tapestry consists of warps and wefts (fig. 2a). The warps are the stationary threads and are made of plied yarns of either wool or linen fiber, almost always undyed. The wefts are principally wool as well, but they carry the color. In a weft-faced plain weave (fig. 2b), the colored weft threads pass over and under through the warps and return alternatingly, so that when tightly combed together they completely hide the warp threads. What truly distinguishes tapestry weaving, however, is that the individual colored weft threads are always introduced as discontinuous elements: that is, they do not run the full width of the tapestry. As

isolated components of the weave structure, the discontinuous wefts offer the advantage of restricting colors to the areas in which they are needed to create the intended image, pattern, or embellishment, and of doing so in a less expensive way, as it is far less costly than running weft threads the full width of the tapestry. All weft threads are inserted between the warp threads by means of bobbins or shuttles, one for each color. The bobbins are passed over and under successive warps for whatever distance is required and are then returned in alternating fashion so that the warps are covered completely. On a high-warp or *haute-lisse* loom—one of the two types used to weave tapestries—the warps are positioned vertically, strung under tension between two large rollers, and the bobbins holding the weft threads remain dangling on the back of the tapestry so that they can be used again, as needed. On the other type of loom, known as low warp or *basse lisse*, the warp threads run horizontally and the bobbins remain lying on the surface of the warp threads until needed again. A classic illustration of weaving on a high-warp loom, drawn from Denis Diderot and Jean le Rond d'Alembert's *Encyclopédie, ou Dictionnaire Raisonné des Sciences, des Arts et des Métiers* of 1751–72 (fig. 1), shows more than a dozen and a half bobbins—each representing a different color of weft thread—hanging from a tapestry. Where two or more areas of color intersect in order to render a passage with tonal variations, the weft threads either interlock or dovetail, or, if the transition between one color and another happens repeatedly between adjacent warps, then the wefts remain separate, producing a slit that requires manual sewing up after the weaving has been completed but before the finished tapestry is removed from the loom (figs. 2c–e). Again, Diderot and d'Alembert's *Encyclopédie* provides an excellent depiction of the closing of a tapestry slit, here depicted on a low-warp loom (fig. 3).

Both types of looms—the high warp and the low warp—consist of substantial wood and metal frames built to accommodate the large size and support the heavy weight of these immense works of art. On the high-warp loom, which was used in nearly all French production centers and in Bruges, the warps are tightly stretched vertically between a top roller and a bottom one, the latter receiving the finished tapestry as it is woven (figs. 1 and 4). When a weaver in the seventeenth century, for example, used a high-warp loom, the design from which he worked, called a cartoon, was hung behind him on a wall in the workshop or studio. The weaver kept the image in sight by way of a mirror suspended before him. Thus, the weaver, positioned behind the warp threads, faced the challenge of transferring the

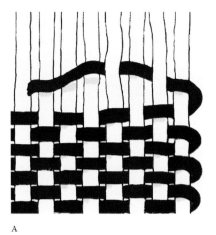

A

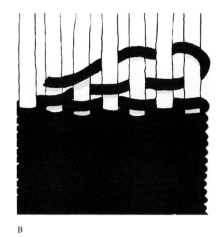

B

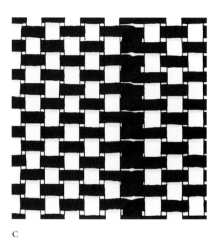

C

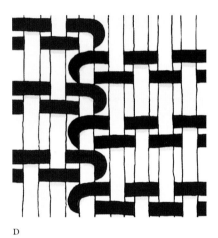

D

E

FIGS. 2A–E Illustrations of weave structures: A) plain weave; B) weft-faced plain weave; C) interlocking tapestry weave; D) dovetail tapestry weave; E) color transition creating a slit in the tapestry weave.

subject matter of the cartoon while working with a mirror image from the reverse side of the tapestry. If the weaver needed to review his progress or judge his success in recreating a design, he was obliged to get up and walk around the loom to see the front of the tapestry.

The low-warp loom, on the other hand, resembles a large table loom. The warp threads are stretched taut between two horizontal beams or rollers that are erected parallel to the floor. Instead of viewing the complete cartoon through a mirror, a weaver working on a low-warp loom would cut the cartoon into strips and place them under the warp threads so that he could see the painted design, a section at a time, through the tightly stretched warp threads. This setup also required that he weave the tapestry from the reverse side, with the tapestry extended in front of him, perpendicular to his body. As the weaving of the tapestry progressed, the finished portion was gathered on the roller nearest the weaver. Whether woven on a high-warp or a low-warp loom, only after the tapestry was finished would the tension be released on the frame and the completed work of art removed from the two beams.

Regardless of the type of loom used, tapestries were most commonly woven so that in the finished work, the warp threads would run horizontally. The weft threads, therefore, had to support the tremendous weight of the work—all the more reason why slits of any

substantial size needed to be sewn closed before the tapestry was hung.

The cartoon itself, the design from which a tapestry would be woven, was by definition a full-size model that showed the desired image or pattern in all its subtlety of form and color. Derived from the Italian *cartone*, the word indicated a large sheet containing a full-scale preparatory design for a work in a different medium. During the fifteenth century, cartoons were predominantly rendered on cloth or linen, probably in a tempera technique such as *Tüchleinmalerei*, as paper was much more expensive. The first documented example of the use of paper for cartoons occurred in Italy, with Raphael's *Acts of the Apostles* series. Cartoons were generally commissioned by tapestry producers, either workshop managers or independent tapestry entrepreneurs. For use on the low-warp loom, a cartoon would ordinarily be cut into strips of about eighty centimeters in width. After the design from any single cartoon strip had been woven, that strip was removed and the completed section of tapestry was rolled onto the beam. The next strip was laid under the unwoven warp threads, and the process was repeated until the entire cartoon had been transferred onto the warp threads.

The integration of the varying diameters of warp and weft threads, especially given the proportion of discontinuous wefts relative to the

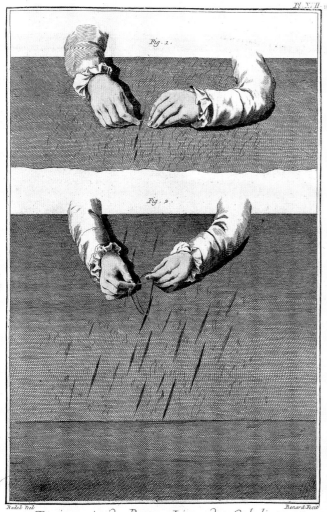

Fig. 1.

Fig. 2.

Radel Del. *Benard Fecit*

Tapisserie de Basse Lisse des Gobelins,
l'Opération de reprendre les relais et de former le las ou nœud qui joint les couleurs.

stationary warp threads, means that this distinct variant of the plain weave results in a textile bearing ridges. It is this feature—the subtle but undeniable surface relief of a tapestry—that catches the light and introduces particular effects throughout the piece once it is completed and hung. The inclusion of silk filaments, or in an especially sumptuous tapestry, embellishments or highlights achieved with gilt- or silvered-metal-strip-wrapped silk threads, has long been another advantage afforded by this type of weaving, for these elements— introduced wherever desired or needed—shimmer in candlelight and enhance the tapestry weave in a most spectacular way. Naturally, as with the production of almost all cloth before the modern era, the dyes used to color the yarns for tapestry weaving were always extracted from vegetable substances such as roots, bark, leaves, flowers, and so on, until Sir William Henry Perkin (1838–1907) created chemical dyes (also referred to as synthetic or aniline dyes) in 1856.[1]

NOTE
1. Robinson 1969, p. 33.

FIG. 3 Illustration from Diderot and d'Alembert's *Encyclopédie*, showing the manual closing of a slit on a low-warp loom.

FIG. 4 Illustration from Diderot and d'Alembert's *Encyclopédie*, showing a complete high-warp loom.

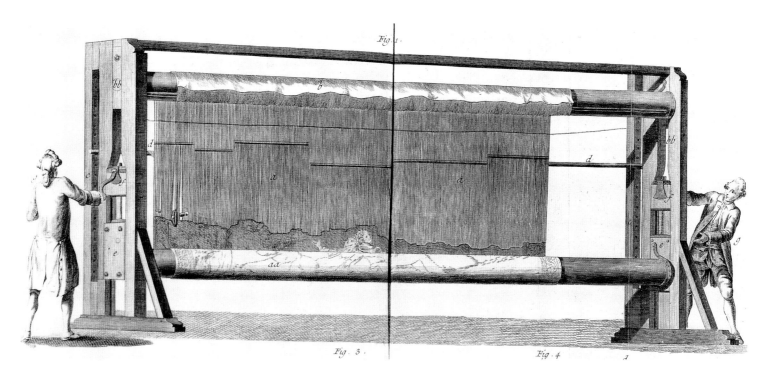

Fig. 1.

Fig. 3. *Fig. 4.*

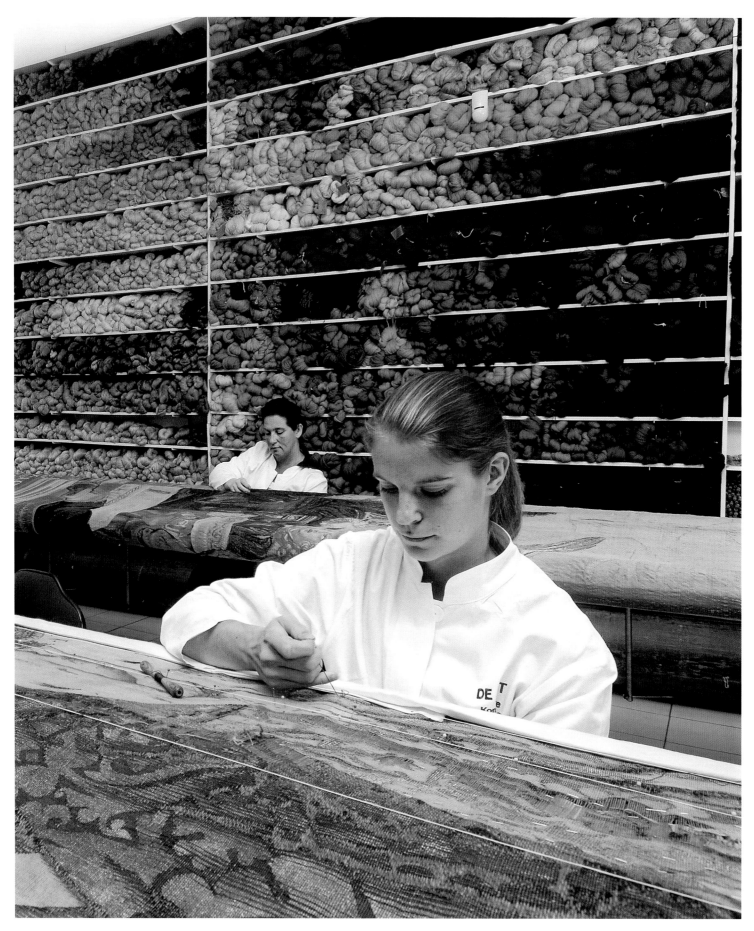

FIG. 1 Conservation room at De Wit Royal Manufacturers, Mechelen, Belgium.

❧ CONSERVATION OF THE COLLECTION ❧

Yvan Maes De Wit

THE conservation of virtually the entire tapestry collection of the Art Institute of Chicago began in February 1996 at the laboratory of De Wit Royal Manufacturers in Mechelen, Belgium, and ended in early 2008. To our knowledge, the treatment of 78 separate works during this period makes this undertaking one of the two largest tapestry conservation projects ever entrusted to a private workshop. The Art Institute's collection was a real challenge for the De Wit laboratory, not only because of the extent of the museum's holdings but also for the richness and diversity of the individual pieces and the issues and concerns that had to be addressed. It was therefore a great honor and source of satisfaction for those of us in Mechelen to earn and retain the trust of the curator in charge, Christa C. Mayer Thurman, over those 12 years and be able to carry out a comprehensive conservation program for the museum.

The project took place in three stages. A first group of tapestries, the esteemed *Story of Caesar and Cleopatra* series (cats. 19a–n)—comprising 14 pieces designed by Justus van Egmont and woven in Brussels in the late seventeenth century—together with two sixteenth-century verdures, were conserved between February 1996 and March 2000 in four successive consignments. Next, the largest part of the museum's collection, 52 tapestries, were treated in nine shipments spaced at regular intervals from early 2000 to June 2007. Finally, nine tapestries were received for conservation in two shipments between June 2007 and early 2008, making a total of 15 consignments.

The tapestries were treated according to a plan developed at the outset of the project. The pieces were carefully examined in Chicago by this author and his assistant, Veerle De Wachter, manager of the De Wit laboratory. After a preliminary discussion and an exchange of views with the curator, a treatment proposal and an estimate of costs were submitted for each tapestry. The tapestries were sent by plane, always accompanied by the curator herself as courier, to the laboratory in Belgium in groups of five or six in specially built crates. Throughout the conservation treatment in Mechelen, Christa Thurman was regularly consulted and kept informed of the progress. At the end of the conservation operation, but before new linings were added to the backs of the artworks, the curator inspected each tapestry. If necessary, a certain amount of correction or visual integration work was carried out at her request. Next, after we had received permission to proceed, the tapestries were lined and photographed. Lastly, the curator accompanied the textiles on their return transport to Chicago, just as she had on their outward journey.

The conservation campaign for the Art Institute's pieces began at a time when a whole series of new techniques and approaches had proven themselves in our laboratory, after having been published and implemented on a large number of important tapestries belonging to other major collections.[1] One of these innovative techniques, cleaning with aerosol suction, was developed in 1991. Along with a new lining system conducted on a specially designed table that has been used since 1987, this method of aerosol cleaning and other conservation integration techniques where the principle of double reversibility has been applied were given extensive trials throughout the early 1990s and have now been utilized at De Wit consistently for almost two decades. Lastly, we were able to draw on the experience gained from a similar project, with many aspects in common: the conservation of 102 tapestries in the collection of the Fondation Toms-Pauli in the Canton of Vaud, Switzerland, which we treated from 1994 to 2002. Uniformity of treatment is therefore one of the major characteristics of the conservation program established for the Art Institute, even though the work itself was conducted over an extended period of time.

Collectively, the treatment of 78 of the Art Institute's tapestries illustrates all the aspects and all the problems that the De Wit laboratory regularly encounters in its conservation work, with one notable exception: the Chicago tapestries fortunately escaped the harmful consequences of the "gluing wave" that was prevalent during the 1970s. The curator in charge decided very wisely to wait for the development of more appropriate techniques.

Causes of Damage to Ancient and Historic Tapestries

The two principal causes of damage that we had to deal with in this conservation program—both of which are common to most antique tapestries—are 1) the decomposition of old silk weft threads through photo-degradation, and 2) the deterioration of brown woolen weft threads. Light is the main enemy of silk threads, because it slowly decomposes them. Sometimes this decomposition is discovered at a very advanced stage, such as, for example, on eighteenth-century tapestries in which the suggestion of light-colored skies has been achieved with a plentiful use of silk threads, as can be seen on several Art Institute tapestries, especially cats. 46a–b and 47. Decomposition was more limited on other pieces, for example, cats. 6 and 11. But, frankly speaking, most of the Chicago tapestries were affected by this recurrent problem.

The use of mordants, an agent long employed during the dyeing

process to obtain dark brown colors, introduced the second serious problem we had to contend with, because their inherent chemicals gradually attack the woolen fibers they helped dye, ultimately leaving bare the natural-colored warps through which they were woven. In the tapestries significantly affected by this problem, the loss of brown wool is most apparent in large areas where the composition required dark colors, as, for example, cat. 58. From a structural viewpoint, the deterioration of the wefts, whether due to the use of dark woolen or silk fibers, significantly diminishes the mechanical stability of any old textile. In actual fact, in the making of tapestries, the weft is placed vertically and is woven through the lengthwise warps. One of the two components of the very structure of the textile, the wefts support the entire weight of a tapestry when it is hung. The wefts are thus subjected to strong vertical traction, and as a result, weak or disintegrated weft threads ultimately break, and in so doing cause significant horizontal tears.

Two additional kinds of damage that we also had to address were 1) mechanical damage due to accidents, rubbing, tearing, or mishandling, and 2) damage resulting from prior restoration work. In order of significance, following photo-degradation and inherent chemical deterioration, incidents involving rubbing and mishandling a tapestry rank as the third major cause of damage. Such damage may be more or less considerable depending on the specific history of each piece and previous methods of conservation. Some tapestries have survived 300 or even over 400 years without significant mechanical damage, as, for example, cats. 52 and 53a. Others show only a succession of holes and tears in some places, as in the two tapestries from the *Story of Cyrus* (cats. 20a–b).

Damage resulting from earlier restoration work may include coarse interventions, improper additions of inappropriate materials (patches, warps, etc.), and unsuitable reweaving—all of which are certainly harmful to an old fabric, but which have limited consequences so long as they can still be reversed, as was the case, for example, on cats. 18 and 19a–n. The biggest problems arise when there is such a density of fixing stitches and superimposed restitching that they cannot be undone without original materials being lost and significant collateral damage, as on cats. 15 and 24. The second major problem arising from previous interventions comes from reweaving operations carried out in the nineteenth century with threads colored with synthetic—often aniline—dyes. The photochemical process has discolored such interventions into characteristic reddish-brown tones, which often disrupt the visual appearance of the original composition and contribute detrimentally to the essential readability of a tapestry. Problems with discoloration were initially evident in cats. 5 and 33.

Examination and Initial Cleaning

The treatment of each of the 78 tapestries in the Art Institute's collection that were conserved at the De Wit laboratory took place in three or four successive stages carried out in four separate treatment

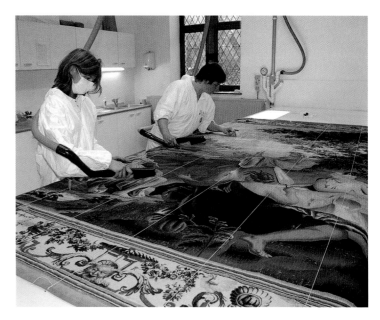

FIG. 2 Dust room at the De Wit laboratory.

locations. The first order of business was the removal of the old linings and the elimination of dust. The dirty tapestries are treated in a specific room, the dust room, which is isolated from the other work premises so as to prevent tapestries that have already been cleaned from being contaminated again (fig. 2). A very large table located in the middle of this room was specially designed for taking off old linings from tapestries and removing dust embedded in the fabric of the tapestry itself. This table has wide, rounded edges, and a large part of its surface is made of glass with a lighting system on the underside that shines through the tapestry so as to make it easier to examine the fabrics undergoing treatment. Special tubes are suspended on both sides of the table, underneath the working surface, making it possible to handle even the largest tapestries without damaging them.

After meticulously taking off the old lining(s), dust is carefully removed through a microsuction system from the reverse side of the tapestry and then from its front. Suction intensity, controlled by a vacuum gauge, is finely adjusted. The suction brushes and pipes are suspended beneath the tapestry so as to avoid any friction with the old fabric. The central exhaust system is installed outside this room, ensuring that the dust from the piece undergoing treatment is immediately carried away from the working space.

After this operation, and before cleaning with water, a great deal of previous, inappropriate interventions are removed on this table in order to release irregular stress from the original fabric of the tapestry, the objective being to spread out the piece as flat as possible. Once separated, the old linings are returned to the curator in charge. Items of identification, such as numbers and labels, are always retained and treated separately with a view to being put back on the new linings. Some tapestries had different superimposed linings (cat. 24), while others had linings in vertical strips (cats. 10 and 19a–n) or no linings at all (cats. 43 and 44). Once most of the impurities and additions have been removed, a tapestry is ready for cleaning with water.

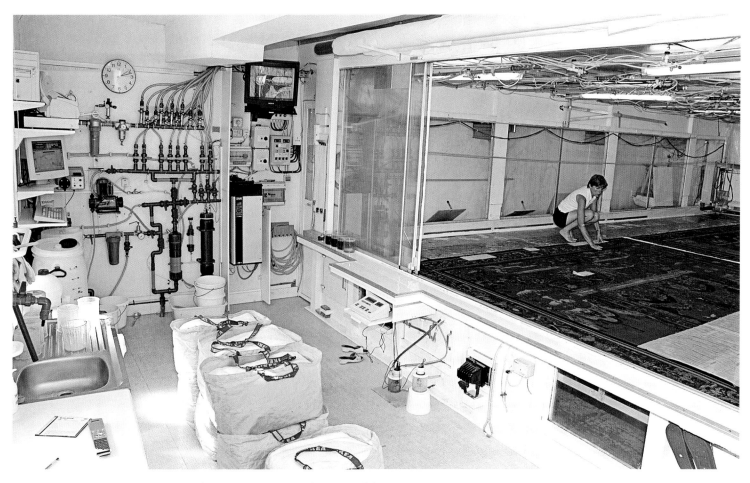

FIG. 3 Aerosol suction cleaning room and monitoring station at the De Wit laboratory.

Cleaning with Water by Aerosol Suction

Allow me to note that Art Institute Curator Christa C. Mayer Thurman, on her initial trip to the De Wit laboratory in 1990, was the first visitor to examine the prototype of our cleaning system by aerosol suction, when then covered a surface area of 2 m². The system was subsequently patented in 1991 and has produced very satisfactory results for clients internationally.

The current system is composed of a huge suction table, 5 x 8.75 m in size and standing 80 cm off the ground (see fig. 3). Its upper surface is formed of a fine stainless-steel mesh screen, and its longitudinal reinforcements permit the staff at De Wit to walk over the entire table surface. This table is completely surrounded with sliding glass panels, which enclose the cleaning zone and create an independent area. Above the suction table, 45 aerosol sprinklers, arranged at about 1.70 m above the screen, mix compressed air and water with an extremely weak concentration (5 parts per 10,000) of a non-ionic detergent, without any additive. This mixture immediately forms a sort of very thick mist, and the aerosol gradually permeates the area enclosed by the glass panels. Four very powerful turbines produce the required level of depression within the table and that depression can be modulated and adjusted automatically using a vacuum

gauge. Prior to this, of course, the tapestry has been unrolled on the screen of this suction table, laid on a thin layer of foam that provides a smooth membrane between the stainless-steel screen and the tapestry. All areas around the tapestry have been previously covered with a polyethylene film so that the suction only concentrates on the piece itself. The cleaning process is immediate and inescapable. The aerosol is drawn down by the depression created underneath the tapestry, while moistening it very gradually. As soon as a specific level of moisture within the fabric is reached, the accumulated water is extracted and pulled downward into the suction table. The continuous flow of aerosol through the old fabric gradually loosens the dirt and immediately extracts it into the bottom of the suction table. Experience has taught us that the average cleaning phase takes an hour. After cleaning, the tapestry is rinsed with softened water for two hours, and next with demineralized water for half an hour, still using the same aerosol suction process.

A whole series of steps have been implemented to monitor and control the operations just described. A digital camera with zoom lens is placed on a movable track inside the glass enclosure, which has been rendered completely opaque by the presence of the aerosol. The camera moves easily along the track just a few centimeters above the surface of the fabric. The digital images transmitted by the camera are

FIGS. 4–5 Details of cat. 57, *The Crossing of the Granicus*, taken before and after cleaning with aerosol suction.

displayed on a screen and recorded on DVD. Samples of the sprayed water and the water extracted from the fabric are taken automatically and placed side by side in jars. These samples are continuously analyzed using probes that measure the temperature (in degrees Celsius), acidity (pH), and conductivity (μS/cm). These parameters are transmitted to a computer that displays this data in the form of a graph, also containing the maximums, minimums, delta, etc.

Thereafter, tapestries are dried using terry cloth towels (twice) and absorbing papers (twice or three times), which are rolled out on the moist fabric and covered with a thin sheet of polyethylene. Through the combined action of the suction and the polyethylene sheet that covers the suction table, these absorbent materials are lightly and evenly pressed against the old fabric. In this way, more than 75% of the water contained in the fabric is extracted within a few minutes. The suction is uninterrupted and continues until the tapestry is completely dry. The air is continually renewed, filtered, heated to 30° Celsius, and then exhausted after use. Even tapestries measuring 40 or 45 m² are completely dry in two hours. The entire cleaning process therefore requires about six hours, to which must be added an average of two hours of preparation time, thus requiring a full eight-hour working day.

As we have been able to prove since 1991, this system offers many exclusive advantages. First of all, damage resulting from harmful mechanical cleaning actions is avoided through the suction process, which holds the fabric steady on the screen. Harmful effects are almost inevitable in conventional cleaning systems with a fabric weighed down and therefore made fragile and vulnerable by the mass of water absorbed. But in the system described here the uninterrupted suction immobilizes the most fragile areas on the screen and preserves them equally well. Is it possible to find a safer action than that caused by an aerosol that settles on a moist fabric and is sucked through it? These properties proved to be particularly useful for the treatment of very sensitive and delicate tapestries, such as

three eighteenth-century works from Beauvais, cats. 46a–b and 47. The continuous suction prevents irregular shrinkage by immobilizing the fabric completely while all of its components are cleaned. In actual fact, the original work is seldom intact, and various consolidation fabrics, more recent guards, modern braids, or fringes have often been added. All such fabrics shrink in different ways in an aqueous medium, as might have occurred on the *Caesar and Cleopatra* tapestries (cats. 19a–n). In some cases, the constant suction has even made it possible to restore the shape of an old fabric that has suffered irregular deformation. The fact that suction intensity can be modulated and the arrangement of the fabric on the suction table can be gradually adjusted before cleaning begins has often enabled us to place the fabric on the table in the flattest possible position so that it recovers its original shape; this was most notably realized on cat. 9a, the shape of which had been altered at some unknown time. The cleaning and drying operations that follow often stabilize the old fabric in its new configuration. Lastly, another particularly convincing advantage of the described system is the absence of lateral bleeding of dyes unstable in water. Unstable colors are prevented from running out laterally because the passage of the aerosol is only vertical and the fabric is never saturated with water. Fortunately, no lateral bleeding of dyes was noticed on any of the 78 cleaned Chicago tapestries, even though a number of them included subsequent interventions of unstable dyes, as was the case with cats. 12 and 15. Experience has also taught that the previous color tests that were once performed at the De Wit laboratory are far from offering the required guarantees. In practice it is actually impossible to test all the colors, and problems may arise from touched-up areas; such intrusions may prove just as damaging and are sometimes difficult to detect.

When this cleaning process is completed, the tapestries regain a large part of their vividness and their original shades of color, particularly in areas where there are flesh tones and in skies, as, for example, on cat. 21, *The Massacre at Jerusalem*, a tapestry from the workshop of

FIGS. 6–7 Details of cat. 20b, *Cyrus Defeats Spargapises*, taken before and after the application of specially dyed linen consolidation fabrics to close mechanical slits in the tapestry.

Gerard Peemans of Brussels. The stains resulting from previous water damage could be eliminated, as evident in the accompanying photographs of another of the Brussels tapestries in Chicago, cat. 57, *The Crossing of the Granicus*, from the workshop of Jan II Leyniers (figs. 4 and 5). The efficacy of this cleaning system is due to the immediate vertical suction of the dirt, which prevents it from resettling on the sides—a recurring problem in the cleaning of large tapestries.

The only regret that I must express is the fact that with the 14 tapestries of the *Caesar and Cleopatra* series (cats. 19a–n) we did not succeed in eliminating from the front of these pieces the traces of the vertical strips of lining that had been sewn onto the back. The various degrees of dirt, due to differences in air permeability between the areas with and without vertical strips, were reduced but could not be totally eliminated (as remains apparent in some of these tapestries). One reason for this may be that these tapestries had at some earlier time undergone an insufficient surface cleaning that ironically served to fix the remaining dirt more deeply into the fibers.

After their cleaning, all tapestries were photographed from both sides, using Ektachrome 6 x 7 cm format film. These photographs, made before any conservation work was begun, were taken with the tapestry laid out on the floor, from an opening 5.5 m high in the ceiling of our large photographic area.

Conservation

As previously emphasized, 78 tapestries of the Art Institute's collection underwent approximately the same basic conservation treatment. Only the aesthetic interventions, which we call visual integration, differed from one piece to the next. Each conservation process is preceded, as much as possible, by the removal of all prior inappropriate interventions that are deemed harmful to the conservation of the old fabric. As described above, this starts with the operation to remove the lining and is continued in a more detailed and meticulous way by our conservation staff working on the restoring frame

(see fig. 1). Past interventions may have actually deformed the fabric to such an extent that they prevent it from being flattened out, as proved to be the case with some members of the *Caesar and Cleopatra* series (cats. 19a–n), or while others were judged to be harmful from an aesthetic point of view, as with *October* from *The Medallion Months* (cat. 10).

The first operation is the resewing and closing of old slits, both those that were broken and those in generally poor condition. It is worth emphasizing at this point that we have always thought of sewing up slits as an integral part of the original structure of the fabric, and consequently we believe that this work should precede all other interventions that will be described below and, above all, should be completed before applying consolidation materials. Only then does the actual conservation work begin, the basic principle of which is the stabilization of the old fabric, with the goal of avoiding or restricting future mechanical degradation as far as possible. This task is primarily carried out with the tapestry on a conservation frame composed of two beams that are spaced at approximately 80 cm apart and on which the tapestry can be rolled and unrolled from right to left and vice versa.

The tapestry is stabilized with consolidation fabrics that are fixed on the reverse of the old fabric and to which all the weak or damaged parts of the old fabric are attached (see figs. 6 and 7). The fabrics used for consolidation are made of a very high quality (20 x 16 threads/cm) pure linen. They are prewashed at 90° Celsius and then specially dyed in the most suitable color. I should also note that all the raw materials used in the treatment of the tapestries in question (whether wool, silk, or linen) are all dyed in our own dyeing laboratory (fig. 8). This laboratory uses a three-color process with high light-resistant and washing-resistant dyes, made by Clariant. Since most dyeing professionals are focused on developing short- or medium–term quality fastness, we decided to develop our own dyeing laboratory that would offer quality guarantees indispensable to this conserva-

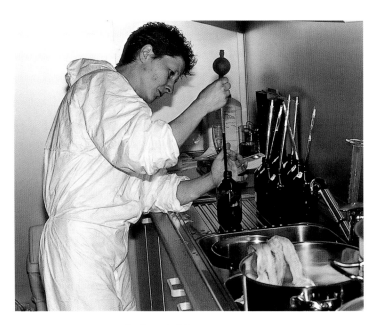

FIG. 8 Dyeing room at the De Wit laboratory.

tion activity. Fine silk is dyed by hand, in the conventional way, while linen textiles and skeins of wool are dyed in a computerized dyeing machine, which provides greater treatment stability.

The consolidation fabrics are attached to the reverse of the tapestry in a network of large vertical lines 45 cm long. Each of these lines is composed of a grid of fixing stitches spaced at intervals of 1.5 cm, using three-ply cotton thread. Each fixing stitch remains invisible and is supported on a single warp thread, the strongest part of the old fabric. The large lines are spaced 15 cm apart in both directions in an overlapping pattern. A similar network of small vertical fixing lines, 6 cm high, follows these large fixing lines. They are also placed in an overlapping pattern and are about 3 to 4 cm apart horizontally and some 2 to 3 cm apart vertically. Made of three-ply twined silk threads, they are attached to one of every two or three warp threads. These two networks, the small consolidation lines and the large ones, surround all the fragile areas and gaps in the old fabric. These vertical lines secure the transition between the strong and fragile areas of the old fabric and in so doing restore its mechanical cohesion and its capacity to resist vertical traction. Once they are stabilized, the gaps themselves—i.e., the areas characterized by the loss of silk or woolen wefts or sometimes the combined loss of warps and wefts—are then treated. In gaps where the wefts are missing, the bare warp threads are subsequently fixed one by one to the consolidation fabric using angle stitches that follow the torsion of the warp threads, using two-ply twined silk threads. In following the twist and therefore the structure of the old threads, these additions provide better support to the old fibers. After this process has been completed, and all fragile areas and gaps have recovered their mechanical stability, the tapestry may once again be hung without damage.

The aesthetic aspect of the conservation work that I have just summarized is far from negligible. All conservation work involves the addition of new material and inevitably the introduction of color

is always a debatable issue, since absolute neutrality is, of course, unachievable. In general it was decided, in consultation with Christa Thurman, to use a silk thread in the color of the missing wefts to fix floating warp threads. Since these angled fixing stitches are spaced about 5 mm from each other, their color contribution remains relatively small, and they are always visually recessed in relation to the adjacent original colors of the composition, as was done, for example, for cat. 18, a piece of a mid-seventeenth-century Brussels tapestry from the workshop of Jan van Leefdael (figs. 9–10). Sometimes, it was decided to intervene with fixing stitches in the natural color of the warp threads, either because that color was the most suitable, as was done with cat. 6; or because we were unaware of the exact missing color, as in some parts of cats. 9a–b, *February* and *July* from *The Medallion Months* (figs. 11–12, 13–15); or even because the losses of weft threads were too limited to decide on an intervention in a chosen color, as was fortunately the case with cat. 12.

The choice of the color of the consolidation fabrics also plays an important part in the overall aesthetic result of these interventions, above all in the areas where both weft and warp threads are missing. A judicious choice of the appropriate color makes it possible, especially in the case of small interventions, to make the latter quite invisible from a distance. The availability of a dyeing workshop in our own facility, as well as a vast range of color samples that have been generated over years of dyeing work, was naturally an enormous help to us when there were gaps in difficult areas, as was the case with the two tapestries from *The Story of Cyrus* (cats. 20a–b).

It is worth pointing out that the choice of the most appropriate tones for the fixing stitches and for the consolidation fabric, in a good many tapestries, contributed so significantly to the legibility of the work that further visual integration work could be dispensed with, as, for example, on cats. 47 and 58. All interventions discussed in this report are entirely reversible and identifiable, because every such measure is carried out on a consolidation fabric on which the slightest fixing stitches are visible on the back. Moreover, we take the utmost care to ensure that the fixing stitches are arranged methodically and evenly, at a distance from each other, while diligently avoiding overstitching.

Visual Integration

However suitable the materials used and the colors selected during the conservation phase may be, gaps in some tapestries can sometimes still remain too apparent, disrupting the legibility of the work and conflicting with the original composition. This was especially notable, for example, in cat. 22, *The Offering of the Boar's Head*, from *The Story of Meleager and Atalanta*. In this situation, the conservation treatment required more extensive visual integration work, which was always performed in consultation with the curator.

On many occasions we simply resorted to using new warp threads specially dyed in an appropriate ocher color. These warp threads are laid and attached on the consolidation fabric inside the gaps, using

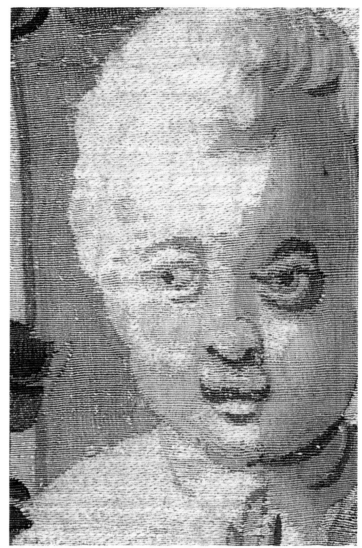

FIGS. 9–10 Details of cat. 18, *Four Servants,* part of *Telemachus Leading Theoclymenus to Penelope*, taken before and after treatment, showing the use of specially dyed silk threads to replace missing wefts.

the same angled fixing stitches. They were inserted alongside the remaining elements of the old fabric and therefore were not harmful to the latter in any way. These warp threads often restore the continuity of the textile structure of the old fabric, and they are instrumental in making large gaps much less visible and disruptive, as, for example, in cat. 9b, *July* from *The Medallion Months*. We should not forget that large surfaces of linen fabric sometimes contrast strongly with their woven surroundings, even when the shade of color is correct, because of their finer and more even structure and the different way that linen catches the light. In some gaps, such as those on cats. 20a–b, from *The Story of Cyrus*, we only resorted to the use of a few warp threads to extend some elements of the adjacent original drawing visually and in so doing, shaded the gaps from view as much as possible.

In agreement with Christa Thurman, it was considered that some gaps, however, required more substantial interventions, always conducted with the aim not of recreating missing parts but of avoiding

a situation in which some missing areas disturb the original elements of the work.

New colored wefts were inserted in such areas. More often than not, these wefts were inserted in parts with new warps, as on cat. 5, among the oldest tapestries in the Chicago collection. They were seldom inserted in parts with bare original warps, and this was only done when the good state of conservation of the latter allowed; such was the case with two of the Art Institute's large leaf verdures, cats. 32 and 33. These wefts are always deliberately spaced from each other and are evenly attached to the consolidation tissue, as can be seen on cat. 5.

The visual integration work is carried out during a separate treatment phase, which follows the conservation phase. One of the main features of this second phase is that it is reversible, regardless of previous conservation interventions. This is an important aspect since we cannot get away from the fact that these purely aesthetic interventions remain a matter of subjective choice. The tapestries were

FIGS. 11–12 Details of cat. 9a, *February* from *The Medallion Months*, taken before and after treatment, showing the use of fixing stitches in the natural color of the warp.

always examined in their entirety beforehand, usually hanging, so as to define the size and the extent of such work as much as possible and only extend it to areas that required this type of intervention. All problems were communicated by e-mail, with supporting photos, and discussed in the laboratory with the curator in charge, who would make the final decision.

Lining

Finally, we come back to the lining of the tapestry. Here, too, De Wit Royal Manufacturers has developed its own technique so as to achieve the greatest possible flatness of the historic fabric, because flatness ensures a better distribution of traction over the entire surface of the tapestry and consequently reduces harmful stress over each of its parts. Our tapestry linings are made of extremely fine, pure linen (23 x 23 yarns per cm); the linen is pre-washed at 90° Celsius and then dyed ocher at our laboratory. It is spread out flat on a large table measuring 5 x 4 m, specially designed for this operation. Rolled beforehand on one or two tubes, the tapestry is unrolled on its lining and spread out flat. The front of the tapestry therefore faces the conservator. A system of boards held down by weights is used to immobilize the tapestry on its lining so that the tapestry and the lining can be moved as a single unit over the table, which has a sliding surface. A longitudinal slit runs along the whole length of the table. The tapestry slides above this slit from right to left, and the conservator will work through this slit to stitch the tapestry to its lining. The fixing stitches of the vertical consolidation lines are applied at successive intervals of 1.5 cm, and they are similar in every way to those used to attach the consolidation fabric. These lines are 45 cm long and once again form an overlapping grid pattern at 15 cm intervals in both directions. These lines are positioned exactly between two equal lines previously used for attaching the consolidation fabric in such a way that, by being superimposed, the double grid of vertical lines follow each other at intervals of only 7.5 cm.

This specially designed table also makes it possible to carry out the fixing operation in a much more efficient way than in the usual methods. Since the conservator is actually facing the tapestry, he or she can use a fine straight needle in contrast to the practice of working on the lining from the reverse side of the tapestry with a curved needle. Use of a straight needle means that the stitching can be applied with great precision by being supported on a single warp thread, which is the stronger element of the fabric. The conservator can better control the fixing process and thereby ensure that the lining textile is more effectively attached in a sound area of the tapestry fabric and that the stitches remain invisible by passing between two weft threads.

Velcro strips were sewn onto the lining beforehand to create a hanging system. Finally, all the various labels and identification tags that were once part of the old linings, having now been cleaned, are put back into place on the new linings.

Conservation File

A separate conservation file, prepared by the De Wit staff for the Art Institute's Department of Textiles, accompanies the return of each tapestry. After a detailed description of the condition of each

FIGS. 13–15 Details of cat. 10, *July* from *The Medallion Months*, taken before, during, and after treatment, showing the use of fixing stitches in the natural color of the warp.

tapestry before treatment, the different treatment phases and their specifics are documented. In addition, each file contains the following information and items: the graph of the cleaning parameters, a DVD with the film of the tapestry being cleaned, 6 x 7 cm Ektachrome transparencies of the front face and the reverse of the tapestry after cleaning and before conservation, 20 x 25 cm Ektachromes of the entire tapestry and often details after treatment, and lastly a set of detail photographs taken before, during, and after treatment. These latter photographs were made from 24 x 36 mm slides and, from 2005 onward, from digital photographs of 6 megapixels. The vertical and horizontal location of each of the latter are achieved by taking a general image of the tapestry, dividing it into strips numbered at 30 cm intervals vertically and at 10 cm intervals horizontally. These photographs are automatically filed on a DVD, first of all according to the type of treatment the tapestries have undergone, and thereafter according to the relative position of the photograph horizontally and then vertically, and finally according to the date each was taken.

For some tapestries, a completed conservation file may contain over 250 photographs.

All the conservators of De Wit Royal Manufacturers, the workshop manager, and myself would like to emphasize the extent to which the very close collaboration between the curator in charge, Christa C. Mayer Thurman, and our entire team in Mechelen—as well as the curator's extremely precise and meticulous monitoring of every aspect of the interventions and her very stringent requirements regarding the care of the Art Institute's tapestries—benefitted this program. We are indeed grateful to her for entrusting us with these extraordinary examples of the art of tapestry making.

NOTE

1. For summaries of these various treatment programs, see http://www.dewit. be. Further information on the conservation of tapestries, including the method practiced at De Wit Royal Manufacturers, can be found in Masschlein-Kleiner and Verrecken 1994, Maes De Wit 1996, and Maes De Wit 2000.

❧ NOTES TO THE READER ❧

Organization of the Catalogue and Format of Entries

The catalogue entries for Franco-Flemish, Flemish, and French tapestries are grouped in separate sections. In the Flemish and French sections, the entries are further organized by city or manufactory of origin, and, finally, by date of production. A fourth section encompasses tapestries from other areas, and is organized first by region and then chronologically. The fifth and final section contains entries on two table carpets, which have been separated from the other objects discussed in this volume because their intended function differs.

The basic information at the beginning of each entry was prepared by the Department of Textiles of the Art Institute of Chicago, sometimes with contributions from the author responsible for the main text of the entry, whose initials appear at its end. The initials are:

CCMT: Christa C. Mayer Thurman
CBD: Charissa Bremer-David
EC: Elizabeth Cleland
KB: Koenraad Brosens
NFG: Nello Forti Grazzini
PFB: Pascal-François Bertrand

The date of manufacture follows the location of production. Where possible, the date of execution of a design or cartoon is also provided after the name of the artist(s) who made it. In both cases, the following dating conventions are used:

1625	if designed or woven in 1625
c. 1625	if designed or woven sometime around 1625
1625–30	if the design or weaving was begun in 1625 and completed in 1630
1625/30	if designed or woven sometime within or around the years 1625 to 1630
c. 1625–30	if the design or weaving was begun sometime around 1625 and definitely completed in 1630
1625–c. 1630	if the design or weaving was begun in 1625 and completed sometime around 1630

The following attribution phrases are used:
After a design by: The tapestry was woven based on a design by the named artist and/or his workshop.
After a cartoon by: The tapestry was woven using cartoons by the named artist and/or his workshop.

Attributed to: Believed to be designed or woven by the artist, workshop, or workshop manager named, but lacking final confirmation.
Produced at the workshop of: The tapestry was produced at the workshop of the family or specific manager named.

Where known, life dates or activity dates are provided upon the first mention in each entry of an artist, manager, weaver, or other person involved in the production of tapestries.

The marks and signatures that appear on the catalogued tapestries are illustrated in the inventory entitled "Marks and Signatures" at the back of the catalogue.

The dimensions of the catalogued tapestries are given first in centimeters, warp before weft, with dimensions in inches following in parentheses. Dimensions for all other tapestries, both those in the collection of the Art Institute and those held by other institutions or individuals, as well as all other objects, are given in centimeters, height before width. Where centimeter measurements were unavailable, inch measurements are provided.

Given the size of these tapestries, the weft measurements recorded in the structure descriptions at the beginning of each entry were generally taken from the ground wefts along the outer edges of each work. Where possible, attempts were made to sample the wefts of all fibers represented in the tapestries. These efforts were limited only by the reach of the stereomicroscope.

The medium and structure descriptions employ terminology familiar to textile historians, curators, and conservators. The Art Institute's system was developed beginning in the 1970s by Lorna A. Filippini, then Associate Conservator of Textiles, and Christa C. Mayer Thurman, Curator and Conservator of Textiles, and has been continuously refined. The system is based on the principles set forth by Irene Emery in *The Primary Structures of Fabrics: An Illustrated Classification* (1966, 1980) and by Dorothy K. Burnham in *Warp and Weft: A Textile Terminology* (1980), as well as on the vocabulary introduced in the 1950s by CIETA (Centre International d'Etude des Textiles Anciens) to standardize the technical terms used in all languages.

Unless otherwise noted, the conservation of each tapestry was performed at De Wit Royal Manufacturers in Mechelen, Belgium, through the generosity of the individual or organization named.

Each catalogue entry contains a references section listing the publications (including exhibition catalogues) in which the tapestry is discussed and/or illustrated. If an exhibition was accompanied by a catalogue, a parenthetical reference to the catalogue follows the exhibition citation. The presence of an illustration in a publication is indicated by the abbreviation (ill.) following the page number(s) on which the image appears. It is assumed that an object is illustrated in any publication in which it appears as a catalogued item.

In descriptions of actions within a tapestry, left and right generally correspond to the viewer's left and right, though they may correspond to those of the characters within the scene, as signaled by phrases such as "his right hand" or "the table's left side."

Infrared Photography

The infrared photographs of cats. 8a and 8b were taken in 1976 by Timothy Lennon, former Conservator of Paintings at the Art Institute, using a Deardorff large-format camera with a Tiffen series 9, 87 C filter and infrared lamps. The dark areas in the images indicate those sections that are original, while the lighter areas were rewoven centuries later based on photographs of the original cartoon.

Biblical Quotations

Biblical quotations are from the King James Version of the Bible, unless otherwise noted.

Quotations in Foreign Languages

Quotations of nonbiblical texts are given in the original language where possible, followed by an English translation in parentheses. The translations were made by the author of the entry in which they appear, unless otherwise noted.

Bibliographical References

The citations listed in the references section, as well as in the endnotes, are primarily given in a short form. For the complete citation, please refer to the bibliography at the back of the book. Sale catalogues are generally not cited in the references section.

Citations of archival documents employ the following abbreviations:
ANP: Archives Nationales, Paris
ARAB: Algemeen Rijksarchief te Anderlecht, Brussels
GCPA: Getty Collection Photography Archive, Los Angeles
MC: Minutier Central, Archives Nationales, Paris
MN: Manufacture National de Beauvais: Prix des ouvrages et comptes des ouvriers, Mobilier National, Paris
NGB: Notariaat Generaal van Brabant, Algemeen Rijksarchief te Anderlecht, Brussels
PR: Parochieregister, Stadsarchief, Brussels
RT: Register der Tresorije, Stadsarchief, Brussels
SAB: Stadsarchief, Brussels

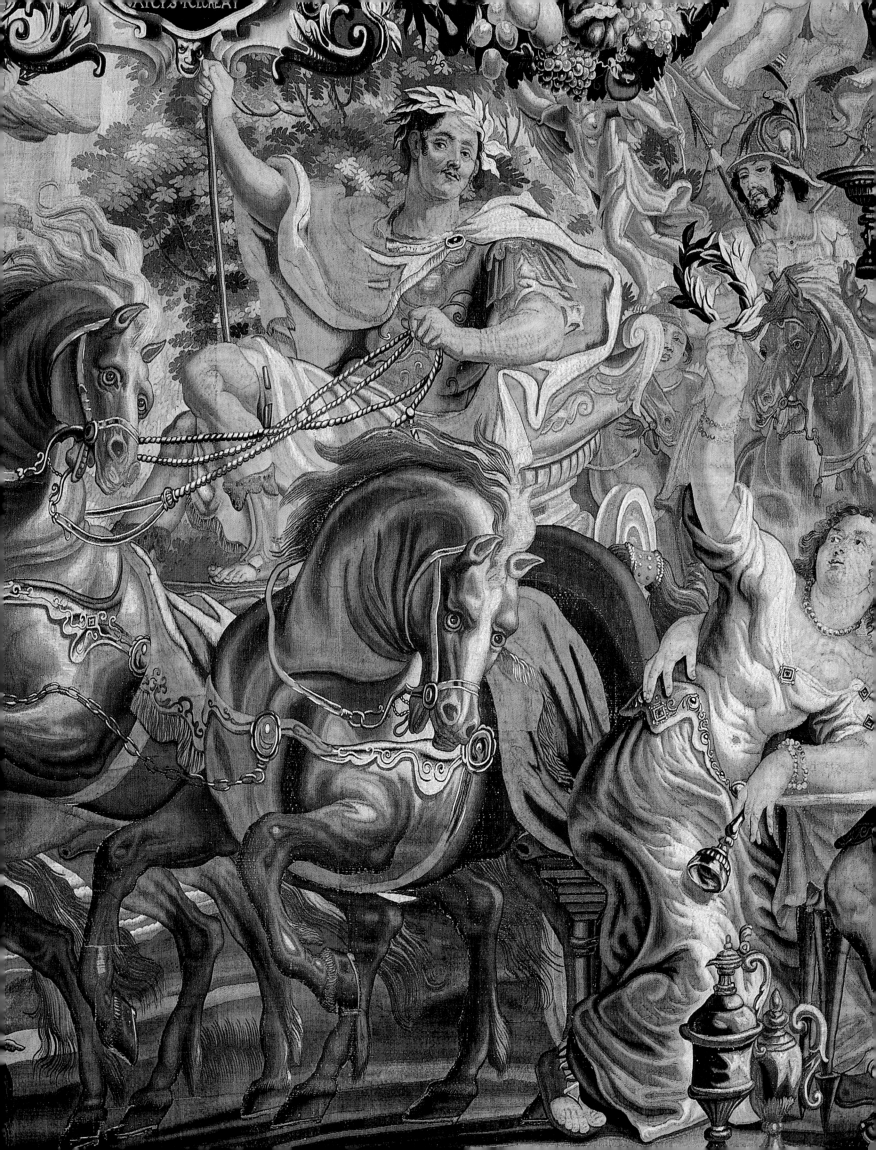

Catalogue of the Collection

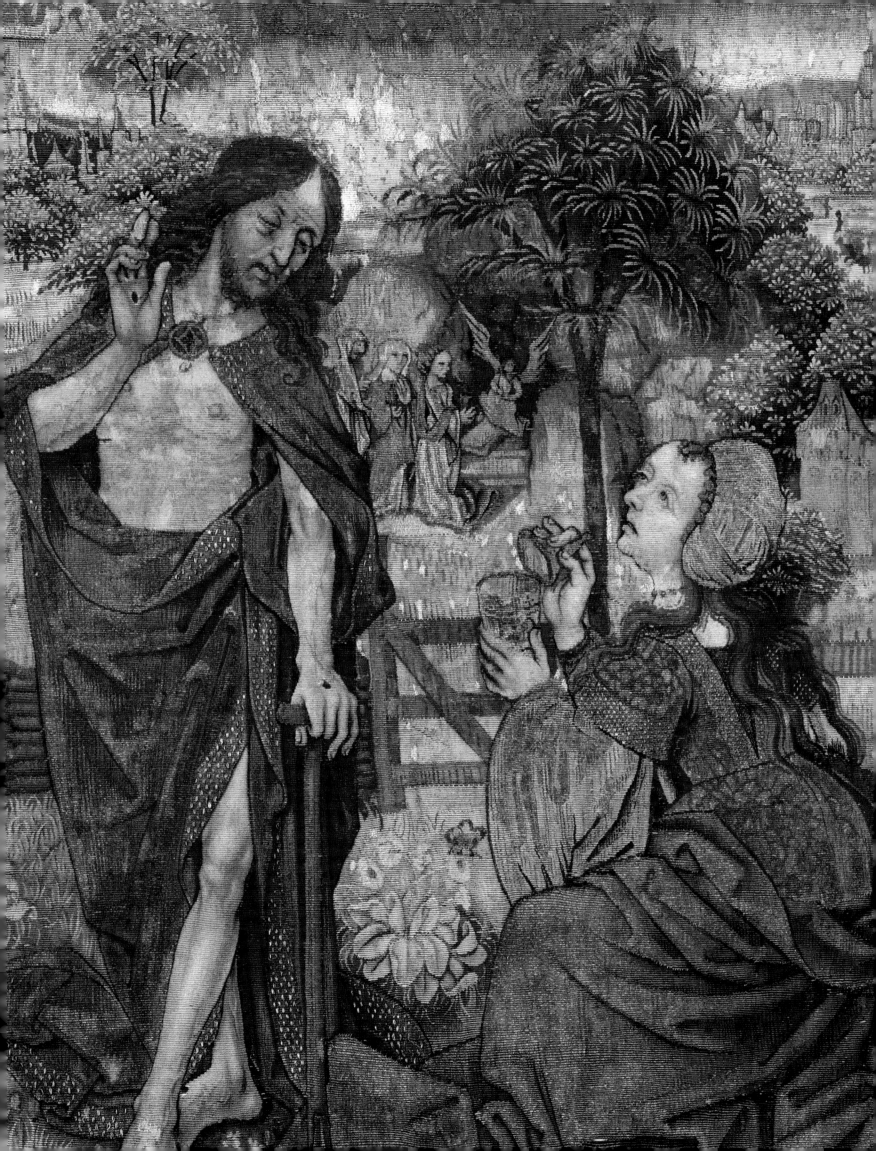

❧ I ❧
FRANCO-FLEMISH TAPESTRIES
1450–1520

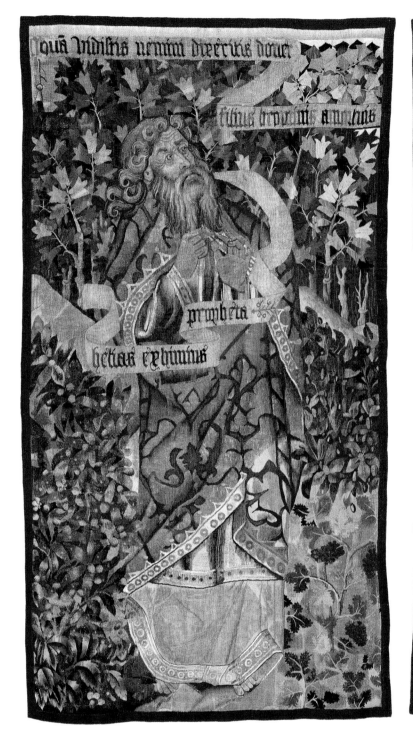

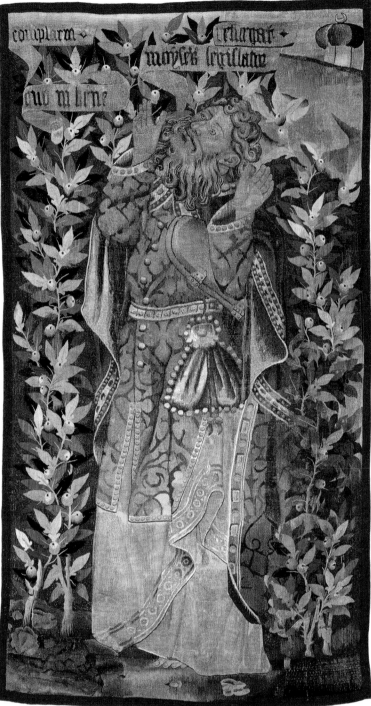

CAT. IA CAT. IB

Two fragments from *The Transfiguration of Christ*

CAT. 1A

Elias

Franco-Flemish, 1460/70
After a design by an unknown artist
Produced at an unknown workshop
INSCRIBED: *qua vidistis nemini dierritis donec / filius hominis amortius; helias exhumes / propheta*
127.5 x 228.7 cm (50³⁄₁₆ x 90¹⁄₁₆ in.)
Gift of Mrs. Gustavus F. Swift, 1959.635

STRUCTURE: Wool and silk; slit, single, and double dovetailed tapestry weave
Warp: Count: 6 warps per cm; wool: S-ply of two Z-spun elements; diameter: 1.0 mm
Weft: Count: varies from 13 to 28 wefts per cm; wool: S-ply of two Z-spun elements; diameters: 0.5–1.6 mm (some wefts, probably repairs or replacements, are pairs and three yarns of S-ply of two Z-spun elements); silk: S-ply of two Z-twisted elements; pairs of S-ply of two Z-twisted elements; diameters: 0.5–1.2 mm

Conservation of this tapestry was made possible through the generosity of the Textile Society Trip Acquisition Fund.

PROVENANCE, REFERENCES, EXHIBITIONS: See below.

CAT. 1B

Moses

Franco-Flemish, 1460/70
After a design by an unknown artist
Produced at an unknown workshop
INSCRIBED: *quo m[ihi] bene conplacuit / moyses legislator / resurgat*
126.2 x 229.5 cm (49¾ x 90⅜ in.)
Gift of Mrs. Gustavus F. Swift, 1959.634

STRUCTURE: Wool and silk, slit and single dovetailed tapestry weave
Warp: Count: 6 warps per cm; wool: S-ply of two Z-spun elements; diameter: 1.0 mm
Weft: Count: varies from 18 to 29 wefts per cm; wool: S-ply of two Z-spun elements; diameters: 0.4–1.3 mm; silk: Z-ply of two S-twisted elements; pairs of S-ply of two Z-twisted elements; diameters: 0.5–0.8 mm

Conservation of this tapestry was made possible through the generosity of the Textile Society Trip Acquisition Fund.

PROVENANCE: Seidlitz and Van Baarn, New York; sold to Mr. (died 1943) and Mrs. Gustavus F. Swift, Jr. (née Marie Fitzgerald, died 1966), Chicago, by 1919; given to the Art Institute of Chicago, 1959.

REFERENCES: Ackerman 1919.

EXHIBITIONS: Art Institute of Chicago, *Tapestries from the Permanent Collection*, 1979.

IN these two tapestry panels, Elias (cat. 1a) and Moses (cat. 1b) appear on matching plant and tree grounds, wearing sumptuous velvet garments patterned with a pomegranate design. Scripture bands float around them. A mosque bearing a crescent moon is visible in the distance on the right of the *Moses* piece. Structural examination of the pieces revealed extensive reweaving of both warps and wefts and many repairs with new wefts, especially in the foliage on the left, the right, and in the upper background.[1] These structural changes prove that *Elias* and *Moses* are fragments, adapted to form a matching pair. A tapestry that was on the European art market in the early twentieth century shows that the original composition depicted *The Transfiguration of Christ* (fig. 1).[2] It is possible that the fragments now in Chicago were once part of this exact tapestry; however, they may also have come from another tapestry based on the same cartoon.

The story of the Transfiguration is recorded in the Gospels of Matthew (17:1–6), Mark (9:1–8), and Luke (9:28–36). According to all three accounts, Jesus, Peter, James, and John ascended a mountain, and there Jesus "was transfigured before them: and his face did shine as the sun, and his raiment was white as the light. And behold, there appeared unto them Moses and Elias talking with him" (Matt. 17:2–3). The intact *Transfiguration* tapestry identifies Elias as *helias exhimius propheta* (Elias the Extraordinary Prophet) and Moses as *moyses legislator* (Moses the Lawmaker; see fig. 1); these inscriptions also appear in the Art Institute's fragments. The Gospels then describe how God appeared in a bright cloud and, according to Matthew, said, "This is my beloved Son, in whom I am well pleased" (Matt. 17:5). The complete *Transfiguration of Christ* shows God in the top left corner, holding a globe, and depicts his words, in Latin, directly below the cloud: *hic est filius meus dilectus in quo m[ihi] bene complacui[t]* (This is my Son, whom I love; with him I am well pleased). Only the last four words appear in the top left corner of the *Moses* fragment. As Jesus and the apostles descended the mountain, Jesus warned, "tell the vision to no man, until the Son of Man be risen again from the dead" (Matt. 17:9). These words are shown in Latin on the *Transfiguration* tapestry—*qua[m] vidistis nemini dixeritis donec filius hominis a mortuis resurgat* (Tell no one what you have seen, until the Son of Man has been raised from the dead)—and in the top part of the *Elias* panel, except for the last word, which appears in the *Moses* fragment.

The Transfiguration, which, according to a tradition dating from the fourth century A.D., took place on Mount Tabor, was the glorious manifestation of Christ's divine nature to his most beloved apostles.[3] He thus strengthened their faith and prepared them for the terrible struggle they were to witness in Gethsemane, the garden in which

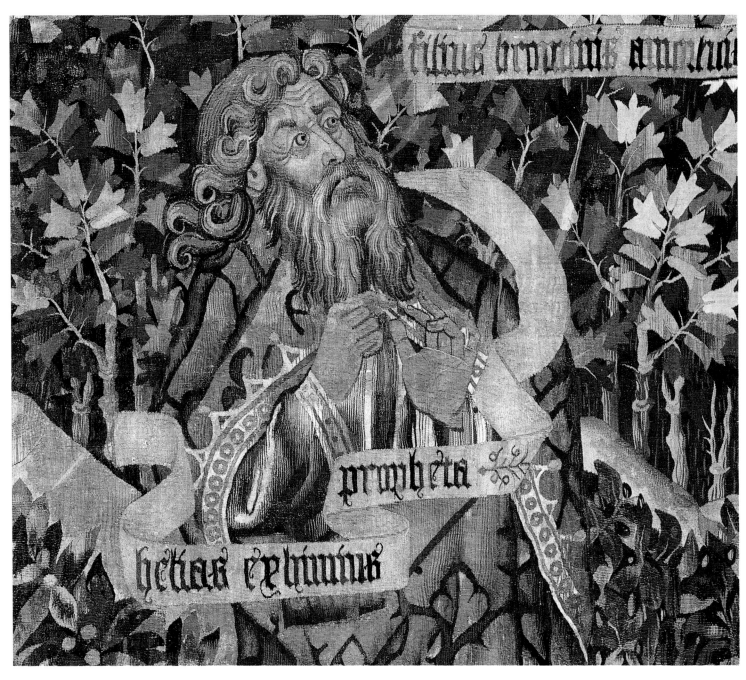

Jesus suffered the Passion and was taken prisoner. The importance of the Transfiguration is emphasized by the presence of God, who for the second time proclaimed Jesus his well-loved son, as well as by the inclusion of Elias and Moses, representatives of the Old Testament who symbolize the Prophets and the Law, respectively.[4] The feast of the Transfiguration of Christ presumably originated in Asia, also in the fourth century A.D., replacing a pagan nature festival. In the Eastern Orthodox Church the Transfiguration rapidly became an important holy day, whereas the Roman Church was slow to adopt it. In 1457, however, Pope Calixtus III issued a papal bull, *Inter Divinae Dispositionis Arcana*, that promoted the feast in commemoration of the Christian victory over the Turks at Belgrade in 1456.[5]

Though Phyllis Ackerman dated the *Elias* and *Moses* panels around 1440, the papal bull can be regarded as a *terminus post quem*, for it has been argued that Calixtus III's promotion of the holy day initiated the depiction of the Transfiguration in western European art.[6] Moreover, the stylistic features of the design support a dating around 1460 or 1470. The heavy eyelids of the figures, the linear and stylized draping of the sumptuous garments, and the rendering of the sky filled with long, low, oval clouds in several shades of blue, link the *Transfiguration* to a substantial group of tapestries that can be dated around 1450 to 1470. This group includes *The Passion of Christ* (c. 1450) and *The Credo* (1475/80), both now in the Musei Vaticani, Rome; and the *Alexander* tapestries woven around 1460

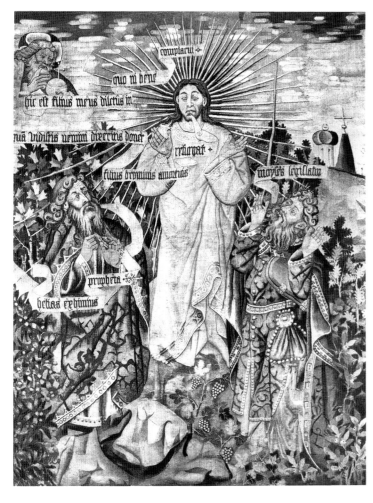

FIG. 1 *The Transfiguration of Christ*, 15th century. Wool and silk; 299.7 x 238.8 cm. Location unknown.

that are presently in the Palazzo Doria, Genoa.[7] These tapestries, like the *Elias* and *Moses* fragments in the Art Institute, were probably produced in Arras, Brussels, or Tournai, or possibly another Flemish or French town.[8]

In 1919 Ackerman attributed the cartoons of the *Transfiguration* to the painter Piat van Roome.[9] She based this attribution on stylistic similarities between *Elias* and *Moses* and a tapestry of *The Passion of Christ* that bears the inscription *PIAT VAI ROM*, which Ackerman believed to be Van Roome's signature.[10] Some years later, Ackerman instead identified the cartoonist as Pieter Roen, who was listed in the records of the Bruges painters' guild several times between 1422 and 1438.[11] But it is now generally believed that the signature *PIAT VAI ROM*, like similar inscriptions on other tapestries, was woven to identify the figure depicted (in the current case of *The Passion of Christ*, Saint Piatus) rather than the cartoonist.[12] Furthermore, there is no archival evidence that either Piat van Roome or Pieter Roen designed tapestries. Consequently, both of Ackerman's attributions must be rejected.

Whatever the identity of the designer, the composition and style of the tapestry indicate that a fifteenth-century print may have inspired his depiction of the Transfiguration. German woodcuts and engravings, in particular those made around 1490 to 1540, greatly influenced fifteenth-century European art, including tapestry design (see cat. 5), and the cartoonist could possibly have based his design on a print in an edition of the *Biblia Pauperum*, one of the most popular religious books of the second half of the fifteenth century.[13] It is not yet possible, however, to match the *Transfiguration* to a specific print. KB

NOTES

1. Condition and conservation report, Mar. 2005, by Lorna Ann Filippini, former Associate Conservator, Department of Textiles, the Art Institute of Chicago; Christa C. Mayer Thurman and Yvan Maes De Wit, 2007; both in conservation files 1959.634–635, Department of Textiles, the Art Institute of Chicago.
2. The tapestry was sold at Galerie Georges Petit, Paris, June 5–7, 1907, lot 1896; and later at Willis's Rooms, London, June 26, 1912, lot 74; object files 1959.634–635, Department of Textiles, the Art Institute of Chicago. The tapestry's present location is unknown.
3. For Mount Tabor as the site of the Transfiguration, see Safrai 1998, p. 197. For the Transfiguration as the manifestation of Christ's divine nature, see Guyot and Cypriano 2002.
4. Van Outryve 1996.
5. Guyot and Cypriano 2002, p. 155.
6. Ackerman 1919. For the effect of Calixtus III's promotion of the holy day on western European art, see Myslivec 1994; Van Lier 1996, pp. 185–89; and Caspers 2001, p. 216.
7. For a thorough discussion and illustrations of these pieces, see Rapp Buri and Stucky-Schürer 2001, pp. 221–45, 297–306.
8. Rapp Buri and Stucky-Schürer 2001, p. 423. Ackerman 1919 tentatively attributed the tapestries to Tournai.
9. Ackerman 1919.
10. Ackerman 1926b, p. 147. The tapestry is in the Royal Museums of Art and History, Brussels; Crick-Kuntziger 1956, pp. 19–22, cat. 4.
11. For Pieter Roen, see Cavallo 1993, p. 215, which also refers to an unpublished manuscript on an *Annunciation* tapestry dated between 1460 and 1480 (The Cloisters, the Metropolitan Museum of Art, New York, inv. 1971.135), which Ackerman wrote around 1926 for Duveen Brothers, who then owned the piece.
12. Steppe 1976; Cavallo 1993, p. 215.
13. For a recent concise survey of German Renaissance printmakers, see Bartrum 1995. The *Biblia Pauperum* recounts events from the New Testament together with parallels from the Old Testament; Wirth 1978. For the use of the *Biblia Pauperum* in fifteenth-century tapestry, see Cavallo 1993, pp. 33–34.

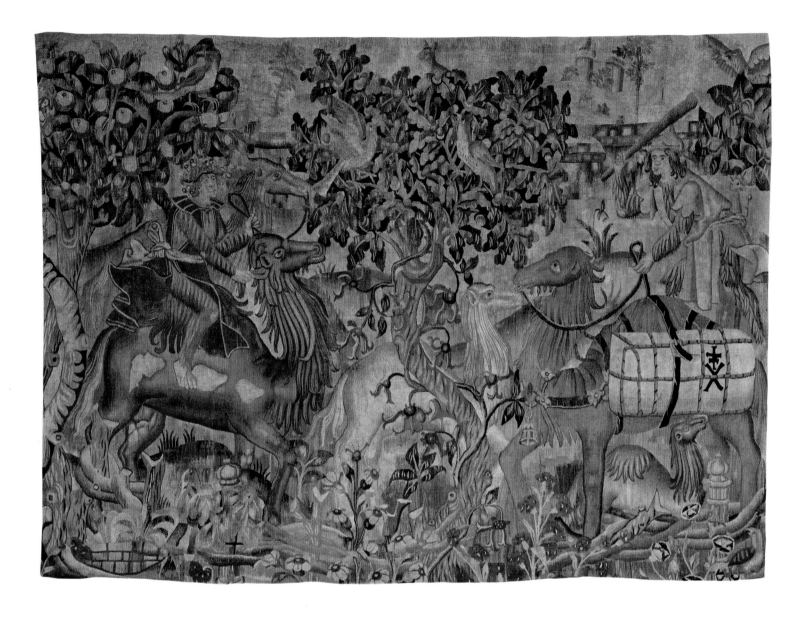

CAT. 2

Camel Riders, presumably from a *Wild Man* series

Franco-Flemish, 1475/1510
After a design by an unknown artist
Produced at an unknown workshop
343.5 x 248.9 cm (135¼ x 98 in.)
Robert Allerton Fund, 1929.611

STRUCTURE: Wool, slit tapestry weave
Warp: Count: 3–4 warps per cm; wool: S-ply of two Z-spun elements; diameters: 1.0–1.2 mm
Weft: Count: varies from 10 to 17 wefts per cm; wool: single S-spun elements; diameters: 0.5–1.2 mm

Conservation of this tapestry was made possible through the generosity of Joseph W. Fell.

PROVENANCE: Demotte, Inc., New York, by 1926; sold to the Art Institute, 1929.

REFERENCES: Ackerman 1926a, p. 49, cat. 18. Cavallo 1993, pp. 590, 592. Hartkamp-Jonxis and Smit 2004, pp. 42–44, fig. 17.

EXHIBITIONS: Arts Club of Chicago, *Loan Exhibition of Gothic Tapestries,* 1926 (see Ackerman 1926a).

TWO extremely hirsute young men clad in side-slit tunics ride fanciful beasts that resemble camels. The man on the left wears a headdress made of vegetation and leads another camel-like animal on a leash. The rider on the right raises a club. Strapped to his mount's flank is a bale stamped with an unidentified merchant's mark. The men move toward each other in an enclosed garden that contains trees, flowering plants, and two smaller camels.

The subject of the tapestry has not been satisfactorily identified. The men's hairiness shows that they are either "wild men" or normal men dressed as these mythical creatures purported to live in the woods and mountains of Europe, but because the tapestry is relatively unknown, it has never been included in modern discussions of the wild man theme.[1] Only Adolfo Salvatore Cavallo, in his monumental

FIG. 1 *A Wild Man and a Wild Woman in an Enclosed Garden* (fragment). Franco-Flemish, 1500/20. Wool; 265 x 200 cm (max.). Rijksmuseum, Amsterdam, BK-17255-A.

FIG. 2 *Wild Folk Family and Animals in a Landscape* (fragment). Franco-Flemish, c. 1500. Wool; 262 x 217 cm (max.). Rijksmuseum, Amsterdam, BK-17255-B.

volume on the Metropolitan Museum of Art's medieval tapestry collection, paid attention to the piece, claiming it depicts a camel caravan led by European merchants dressed as wild men.[2] This description, however, prompts the question: Why are the merchants dressed as wild men? Further examination of the wild man motif suggests a more compelling interpretation.

The wild man evoked fear and loathing, but also envy and admiration.[3] On one hand, like his ancestors in pagan and Classical mythology, the wild man was considered the antithesis of civilized humanity: covered with body hair and incapable of speech, he lived outside society as a godless, devilish brute that carried a stick or club, attacked men, raped women, and devoured human flesh.[4] Yet as early as the twelfth century it was also widely believed that the wild man behaved this way simply because he was unaware of God and society; he lived in prelapsarian innocence, a model of a free yet lost humanity.[5] In keeping with this positive view, the wild man became an appealing example of ruthless bravery, a favored heraldic figure, and a popular ancestor to claim in aristocratic and royal genealogies.[6]

Wild men appeared frequently in fifteenth-century bucolic tapestries produced in Basel and Strasbourg.[7] These hangings represent wild people as benign and peaceful creatures dwelling harmoniously

in wooded paradises, as in two Franco-Flemish pieces woven around 1500 or 1520 now in the Rijksmuseum, Amsterdam (figs. 1–2).[8] One of the Amsterdam tapestries shows a wild man and a wild woman in an enclosed garden, riding fabulous beasts; the other tapestry represents a family of wild people and two camel-like animals in an enclosed garden. Though possibly only a compositional feature, the recurrent motif of the enclosed garden calls to mind the *hortus conclusus*, a representation of the Virgin Mary's untouched womb, and thus evokes the notion that the wild man lived in an unspoiled paradise.[9]

Camel Riders, however, does not belong to this purely bucolic wild man tradition. The confrontational postures of the men, especially the raised club of the man on the right, create an anxious atmosphere uncharacteristic of the idyllic wild man tapestries. Moreover, the merchant's mark stamped on the bale is a contemporary feature that would not have been included in a scene meant to show wild men living in a timeless paradise. The tapestry can instead be interpreted as stressing the value of civilized behavior through a representation of the paradoxical status of the wild man, the physical embodiment of the confrontation of nature and culture.[10]

As a disruptive amalgam of ideas about what it would be like for

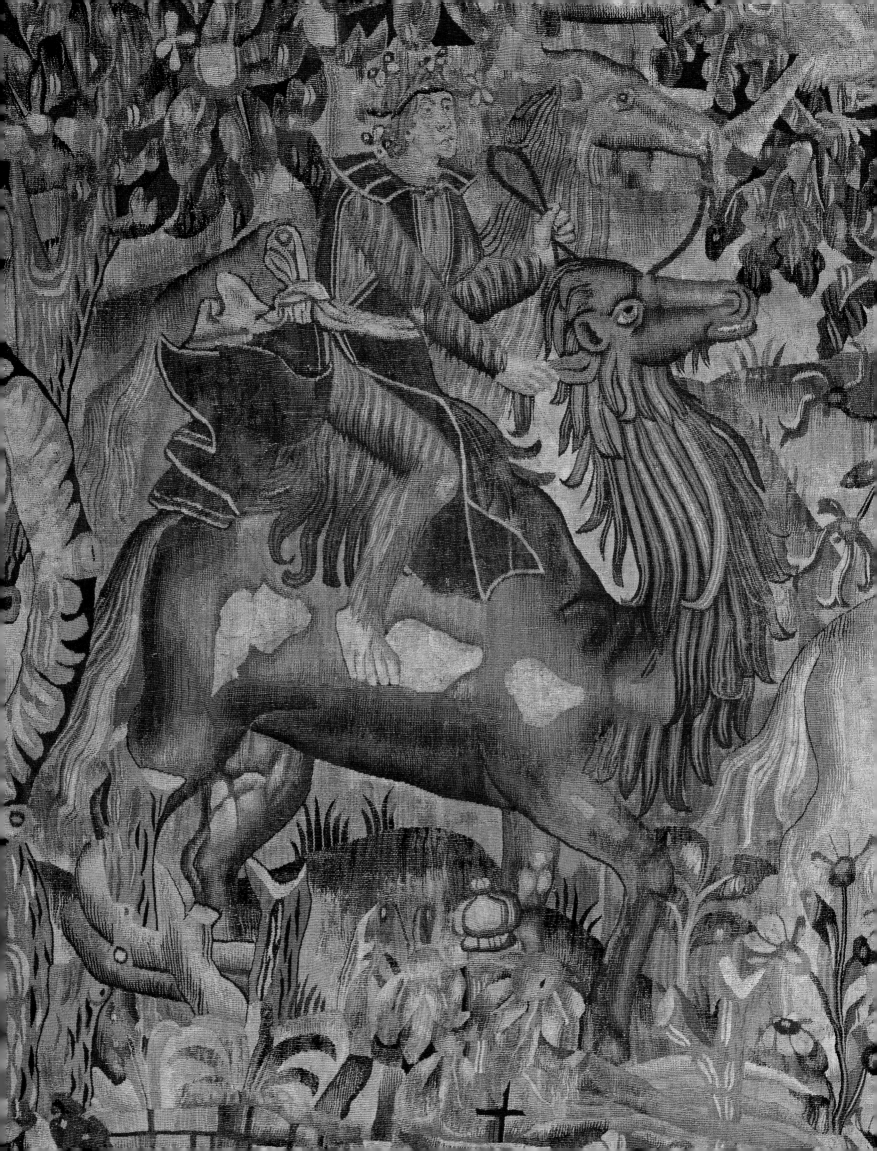

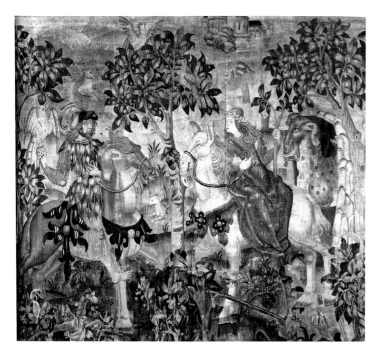

FIG. 3 *Wild Man and Wild Woman*. Probably Tournai, c. 1500. Wool; 286 x 323 cm. Location unknown.

humans to live outside or in opposition to social mores, the wild man—like other imaginary creatures such as dragons, giants, and unicorns—was a perfect costume for celebrations that interrupted everyday social life, often with symbolic inversions.[11] The wild man frequently appeared in courtly art and literature, and men and women often dressed as wild people for chivalric events such as jousts and *pas d'armes* (tournaments staged at well-traveled sites such as bridges and city gates). At a ball organized by Charles VI of France in 1392, the king and a number of courtiers dressed up as wild men and danced a *morisque*, or Morris dance. According to an illumination in a late-fifteenth-century manuscript, torches set their costumes on fire and the king narrowly escaped death.[12] A late-fifteenth-century wild man tapestry in the Musée du Château, Saumur, which shows a large number of aristocrats costumed as wild people at a wedding feast, may also depict a contemporary event.[13]

Men and women also dressed as wild people at bourgeois feasts such as Carnival, charivaris, marriages, and the Twelve Days of Christmas.[14] Wild man costumes were particularly popular in German-speaking lands, where local cults of the figure survive to this day. Yet the practice was also common in cities such as Arras, Bruges, Lille, and Tournai, where tapestry design and production flourished.[15] Here merchants and entrepreneurs organized yearly festivals with banquets, dances, mock jousts, and parades. Delegations from all the towns in the region attended the celebrations. A 1438 account describing a festival held in Lille on Shrove Tuesday and Ash Wednesday reveals that "tout iceulx Valenciennois furent acroutez en hommes sauvaiges portans leurs escus et gros batons neuqueleux et leurs chevaux furent tous desguisez en beste estrange" (all the men from Valenciennes were dressed as wild men carrying shields and clubs,

and their horses were disguised as strange beasts).[16] These feasts and carnivals served a cathartic function, offering a setting in which the aggression, conflict, and violence prevalent in medieval society could be safely expressed.[17]

Camel Riders might therefore be a stylized representation of an urban feast in a Franco-Flemish border town around 1500, similar to *Procession of the Fat Ox*, which shows a Shrove Tuesday procession in Brussels around 1720 (cat. 26). According to this interpretation, the figures on camel-like animals are young merchants, possibly from neighboring towns. Their wild man costumes and mock-joust transform the commercial rivalry of their communities into playful confrontation and harmless ritual. The tapestry could thus be a didactic and ostensive vehicle for self-definition and self-identification by negation: it reveals what urban society is—the peaceful and rational coexistence of merchants operating in regional networks—by showing what it is not—a wild and chaotic series of conflicts.[18]

The compositional and stylistic features of *Camel Riders* show that it was woven in the Southern Netherlands or northern France around 1475 or 1510, and is thus one of only a few known Franco-Flemish wild man tapestries.[19] It can be linked to a piece that recently surfaced on the art market (fig. 3), as well as to the two smaller tapestries in the Rijksmuseum.[20] Hillie Smit has argued that the Chicago *Camel Riders* was most probably woven in the same workshop as the Amsterdam tapestries. However, the present understanding of the late-fifteenth- and early-sixteenth-century Franco-Flemish production landscape is seriously hampered by the dearth of archival sources and comparable tapestries, so there is no conclusive proof that these three wild man tapestries originated in the same workshop.[21] Nonetheless, one may be reasonably confident that all three were woven in the same production center, though it is not possible to attribute them to any specific Franco-Flemish town.

Similarly, the stylistic and iconographic features of *Camel Riders* suggest that its cartoons might have been designed and painted by the same artist or artists who executed the cartoons for the wild man tapestries in the Rijksmuseum, but definitive evidence is lacking. Phyllis Ackerman attributed the cartoon to Arnould Bloyard, a painter registered as a master in the Tournai painters' guild in 1501, citing a number of early-sixteenth-century documents pertaining to Tournai tapestry producers and merchants.[22] These documents cite armorial tapestries featuring wild men, tapestries "à la manière de Portugal et d'Indye" (in the Portuguese and Indian styles), and suites depicting "une histoire de gens et bestes sauvages à la manière de Calcut" (a story of people and savage beasts in the style of Calcutta) and "l'histoire de Carabara ou des Egyptiens" (the story of Carabara or the Egyptians).[23] The exotic suites discussed in the Tournai documents, however, depict Asian figures, not European wild men.[24] Therefore, they cannot be linked to *Camel Riders*, and the attribution of the cartoon to Bloyard is mere speculation. KB

NOTES

1. The standard works on the wild man theme are Bernheimer 1952, Dudley and Novak 1972, Husband 1980, and Hintz 1999. For the wild woman, see Habiger-Tuczay 1999.
2. Cavallo 1993, pp. 590–91.
3. White 1972, p. 22.
4. Rus 2004.
5. White 1972, p. 22; Hintz 1999, pp. 625–26.
6. That the wild man could symbolize ruthlessness is apparent from the 1477 incident in which youths from Basel pillaged villages in Lorraine while carrying a banner featuring a wild man; Kinser 1995, p. 156. Fifteenth-century tapestries showing wild men as bearers or protectors of coats of arms are in, among others, the Augustinermuseum, Freiburg (inv. 11541), and the Royal Museums of Art and History, Brussels (inv. 433); Cantzler 1990, pp. 190, 203. See also Jarry 1970, p. 21, for an armorial tapestry with wild men that was, and may still be, in a private collection in Strasbourg. Among the many aristocrats alleged to have wild men in their genealogies were the Danish kings, reputedly descended from a wild man who was the child of a Swedish maiden who had been kidnapped and impregnated by a bear; Zirkle 1953, p. 80.
7. Azcarate 1948; Tchalenko 1990; Cantzler 1990; Rapp Buri and Stucky-Schürer 1990, pp. 52–54, cats. 4, 19–21, 23–25, 51, 96, 102, 122.
8. Hartkamp-Jonxis and Smit 2004, pp. 42–45.
9. A wild man tapestry in the Germanisches Nationalmuseum, Nuremberg, shows a sea monster abducting a wild woman in front of an enclosed garden; other wild men and women, shocked by the intrusion, take up arms against the assaulter; Husband 1980, pp. 196–200.
10. Vandenbroeck 1987, pp. 7–21.
11. Kinser 1995, p. 147.
12. Husband 1980, pp. 147–49.
13. The signature B FEIRE on the edge of the robe of a wild man at center right of the tapestry led Ackerman (1926b, pp. 151, 159) to believe that the Tournai painter Lambert le Feire created the cartoons. Lestocquoy 1978, p. 80, linked this tapestry with a wild man piece bought in 1441 by an entrepreneur living in the Saumur region.
14. Ferguson 1927; Welsford 1962, pp. 3–80; Planche 1975, p. 102; Rosie 1989; Kinser 1995.
15. For the wild man in France, see Mulertt 1932 and Giese 1932.
16. Fouret 1981, p. 380.
17. Ibid., pp. 389–90. Participants in the Schembart Carnival in Nuremberg had the right to beat spectators; Husband 1980, p. 153.
18. White 1972, pp. 4–5.
19. Jarry 1970, pp. 14–16.
20. Christie's, Paris, *Important mobilier, objets d'art, orfèvrerie, céramiques européennes, et art d'Asie*, sale cat. (Christie's, June 23, 2005), pp. 68–69, lot 330.
21. Cavallo 1993, pp. 57–77.
22. Ackerman 1926a, p. 49, cat. 18.
23. Soil de Moriamé 1891, pp. 175–76, 248, 281–82, 323, 410–20. Soil de Moriamé 1891 remains the prime source for tapestry production in Tournai.
24. Jarry 1970, pp. 16–20. Tapestries of this genre, now known as *Camel Caravan* pieces, are in the Fundação Ricardo do Espírito Santo Silva, Lisbon, and the Museu do Caramulo, Portugal; see GCPA 0240588, 0240593, 0240597, and 0240599 for illustrations. See also Gentil Quina 1998.

CAT. 3

Christ Appearing to Mary Magdalene ("Noli me tangere")

Southern Netherlands, possibly Brussels, 1485/1500
After a design by an unknown artist
Produced at an unknown workshop
INSCRIBED: *NOLI ME TANGERE*
111.2 x 111.5 cm (43¾ x 43⅞ in.)
Bequest of Mr. and Mrs. Martin A. Ryerson, 1937.1098

STRUCTURE: Wool, silk, and gilt-metal-strip-wrapped silk; slit tapestry weave with some 2 : 2 interlacing in alternate alignment of some gilt-metal-strip-wrapped silk wefts
Warp: Count: 10 warps per cm; wool: S-ply of three Z-spun elements; diameters: 0.7–0.8 mm
Weft: Count: varies from 38 to 76 wefts per cm; wool: single Z-spun elements; S-ply of two Z-spun elements; diameters: 0.2–0.5 mm; silk: pairs of Z-twisted elements; three yarns of Z-twisted elements; four yarns of S-twisted elements; S-ply of two Z-twisted elements; pairs of S-ply of two Z-twisted elements; three yarns of S-ply of two Z-twisted elements; Z-ply of three S-twisted elements; diameters: 0.3–0.5 mm; gilt-metal-strip-wrapped silk: gilt-metal strip wrapped in an S-direction on an S-ply of two Z-twisted elements; diameters: 0.3–0.35 mm

No conservation was required.

PROVENANCE: Frédéric Spitzer (died 1890), Paris, to 1890; sold, Chevallier and Mannheim, Paris, Spitzer sale, Apr. 17–June 16, 1893, lot 396, to Martin A. Ryerson (died 1932), possibly by proxy; by descent to Mrs. Martin A. Ryerson (née Caroline Hutchinson, died 1937); bequeathed to the Art Institute, 1937.

REFERENCES: Spitzer 1890–91, p. 160, no. 3 (*Tapisseries*). Spitzer 1893, lot 396. Candee 1935, pp. 59–60 (ill.). Mayer Thurman 1969, p. 29 (ill.). Asselberghs 1971, no. 6. Lupo 1990, p. 259. Bennett 1992, p. 72. Cavallo 1993, p. 449. Cleland 2011b, no. 3.16.

EXHIBITIONS: Art Institute of Chicago, *Masterpieces of Western Textiles*, 1969 (see Mayer Thurman 1969). Art Institute of Chicago, *Tapestries from the Permanent Collection*, 1979. Art Institute of Chicago, *European Textile Masterpieces from Coptic Times through the 19th Century*, 1989–90.

BENEATH a rich blue sky, the grieving Mary Magdalene looks up to discover that the figure in front of her is not a gardener, but the resurrected Christ. The shock registers on her uplifted face in her raised eyebrows and slightly open mouth. Holding a jar of ointment with which she had intended to embalm Jesus's body, the Magdalene has begun to stand, causing her blue mantle to slip down and reveal a sumptuous dress of red and gold brocaded velvet. Christ smiles down upon her, his right hand raised in blessing, his left leaning on the spade that had led her to mistake him for a gardener. The stigmata are clearly visible on Christ's feet and hands, and he is naked except for a splendid red cloak, bordered with gold, and fastened at his neck with an ornate jeweled clasp. Christ's words to Mary Magdalene, *NOLI ME TANGERE* (Touch me not), are woven in gilt-metal-wrapped thread

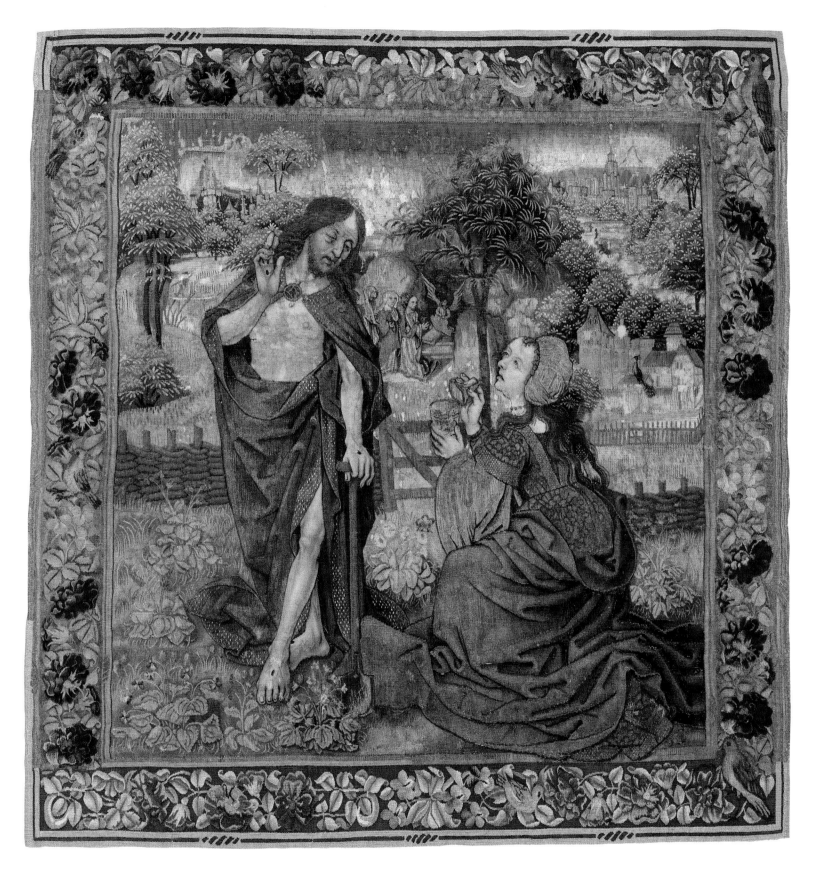

CAT. 3

above his head in the uppermost portion of the central field of the tapestry.

The lush setting, with flowers and fruit carpeting the ground and whittled wooden fences, represents the garden at Calvary outside Jerusalem, where the disciples had taken Jesus's body to be entombed after the Crucifixion. Behind Christ and Mary Magdalene, the rough-hewn sepulchre is visible, and three figures cluster around it, in a depiction of the moments preceding Christ's reappearance, when the three Marys—Magdalene, Jacobi, and Salome—found an angel guarding the open, empty tomb. Further in the distance, glimmering on the hazy horizon, spectacular towers and domes indicate the city of Jerusalem.

Fragments of the original border survive, in which goldfinches and other songbirds nestle among exquisitely rendered roses and pansies. The narrow, trompe l'oeil outer border is decorated with dashes woven in more gilt-metal-wrapped thread, irregularly placed as if to imitate the effect that would be caused by the fall of light and shadow on an actual carved wooden frame. The considerably more gauche modern reweaving that completes the top horizontal border and entirely replaces the bottom horizontal border mimics this effect with less success. The naturalistic details the designer has included throughout the tapestry may have been invested with symbolic significance by contemporary viewers: for example, the peacock in the background behind Christ could indicate the Resurrection, while the goldfinch, pansies, roses, and strawberries have traditionally been interpreted as allusions to, respectively, the Passion, remembrance, and, because of their red color, sacrificial bloodshed.

The jewel-like quality of this small tapestry is accentuated by the rich materials from which it was woven: a combination of glossy silk and a substantial amount of gilt-metal-wrapped thread. This precious metal is used throughout the tapestry, from the highlights on the drapery of the main figures, to details on the petals of flowers in both the central field and the borders. The palette of red, blue, and green holds the tight composition together, leading the viewer's eye on a meandering trail from the distant horizon, through the background narrative, to the foreground figures. The high quality of the workmanship suggests that the tapestry was produced by one of the foremost tapestry weavers of the late fifteenth century, most of whom were located in Brussels, although the lack of archival evidence hinders attribution to any specific workshop.

All four canonical Gospels tell of Mary Magdalene's encounter with the empty sepulcher, though they differ in their details. The tapestry in the Art Institute represents an amalgam of the accounts. For example, only the book of John records Christ and the Magdalene's exchange—"Jesus saith unto her, Mary. She turned herself, and saith unto him, Rab-bo-ni; which is to say, Master. Jesus saith unto her, Touch me not; for I am not yet ascended to my Father" (20:11–17)—whereas only Mark (16:1–8) attributes the discovery of the empty tomb to the three Marys alone. The tapestry designer's version of the reunion scene has also been influenced by vernacu-

lar sources particular to fifteenth-century northern Europe. Popular mystery plays, for instance, narrated the events of the Passion from Mary Magdalene's perspective, while late medieval female mystics cast themselves in her role and imagined in graphic detail the emotions and sensations she might have experienced.[1] The numerous visual representations of the Magdalene, and above all the special attention that artists like Rogier van der Weyden apparently paid to her depiction, also attest to her appeal.[2] Unlike the Virgin Mary, the Magdalene was a worldly figure. As a reformed sinner, granted redemption despite her past, she embodied a combination of the sacred and the profane that rendered her more accessible to the fifteenth-century imagination.[3] It remains uncertain whether the adulterous woman of John 8:1–11; the reformed sinner in the house of the Pharisee in Luke 7:37–50; Mary, the inquisitive sister of Martha in Luke 10:39–42; and the Magdalene were all the same woman. Nevertheless, the interpretation propounded by Jacobus da Voragine in his influential *Legenda Aurea* (c. 1260)—that Mary Magdalene was a former courtesan—continued to be widely believed in the fifteenth century. This may explain why Flemish artists from Van der Weyden onward chose to represent her in ever more sumptuous costumes. The voluminous sleeves; exotic, bejeweled headdress; and the elaborate jewelry she wears in the present tapestry are typical of Netherlandish art at the turn of the sixteenth century, as exemplified by *Noli me tangere* paintings by Jan Provoost, Jacob Cornelisz. van Oostsanen and Joos van Cleve.[4]

The graceful composition, effective use of color, and legible narrative of *Christ Appearing to Mary Magadalene* all imply that a highly talented artist created its cartoon. The design is so successful that it was reused at least once: a slightly larger tapestry of the same subject, on the art market since 1970 and datable to the early sixteenth century, repeats the design, with some alterations (fig. 1).[5] Like the Art Institute's tapestry, it was woven with a rich mixture of wool, silk, and gilt-metal-wrapped thread. Its composition suffers from the addition of a second appearance of the resurrected Christ to the right of the principal figures, and from the inclusion of a leafy bush between the Magdalene and Christ.[6] During this period, Christ's appearance to Mary Magdalene was a popular subject for paintings, prints, and wood carvings; compositionally comparable tapestries of approximately the same date survive in the Metropolitan Museum of Art, New York, in the collection of the Province of Brabant, Service for Cultural and Public Relations, Brussels, and in the parish church at Livré-sur-Changeon, Ile-et-Vilaine, France.[7]

What makes the piece in Chicago and its derivative version somewhat unusual is the stance of the two main figures: whereas in most depictions of this episode, Christ and the Magdalene face each other in profile, in these tapestries the Magdalene, her back to the picture plane, turns to the left to look at Christ while he, facing forward, twists to the right to speak to her. Mary's pose echoes representations of her at the foot of Jesus's body in fifteenth-century paintings of the Descent from the Cross and the Entombment; Christ's pose repeats

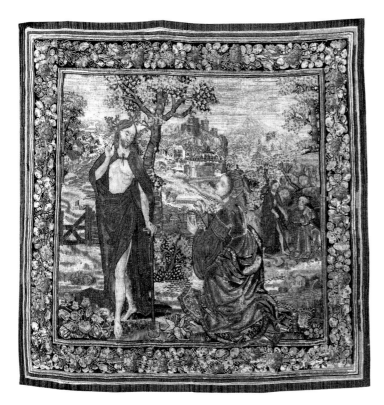

FIG. 1 *Noli Me Tangere*. Southern Netherlands, 1510/30. Wool, silk, and gilt-metal-strip-wrapped thread; 119 x 119 cm. Location unknown.

that of the triumphant Christ at the Resurrection, a type made popular by Van der Weyden and Dieric Bouts, and adapted in cartoons for tapestries like *The Resurrected Christ* in the Metropolitan Museum of Art.[8] By combining these iconographic types in a representation of Christ appearing to Mary Magdalene, the cartoon designer created a sense of arrested time and motion. This clearly talented and inventive artist did not necessarily borrow an existing design, but the recurrence of this combination of poses in the Resurrection episode of the *Scenes from the Passion* tapestry suite in Angers (and in the corresponding embroidered version in Romans) suggests that a pattern with this arrangement was available to artists at the end of the fifteenth century. Indeed, the Angers suite contains many other elements clearly taken from existing painted and printed sources.[9] Furthermore, the device of the triumphal, resurrected Christ turning back to look at Mary Magdalene appears in a composition attributed to Martin Schongauer that exists in both painted and printed forms. Schongauer has long been known to have borrowed numerous compositions from previous generations of Southern Netherlandish painters.[10] His design, in turn, was adapted by the German sculptor Tilman Riemenschneider for a panel in a carved altarpiece.[11] The effective representation of Mary Magdalene from behind reappears in a woodcut in the *Small Passion* series by Dürer, another admirer of the fifteenth-century Southern Netherlandish masters.[12] It is therefore conceivable that the designer who painted the cartoon of the Art Institute's *Christ Appearing to Mary Magdalene* may have based the composition on an influential existing design, subsequently lost,

created by one of the leading artists of the preceding generation, such as Van der Weyden or Bouts.

The appeal of the tapestry in Chicago must have lain above all in its diminutive size and rich materials. Like *The Holy Family with the Infant Christ Pressing the Wine of the Eucharist* (cat. 4), it is a rare surviving example of the sumptuous, small-scale devotional tapestries popular among wealthy patrons in the fifteenth and sixteenth centuries. Plentiful documentary evidence reveals that tapestries of this type were owned by Renaissance patrons as diverse as Philip the Bold, Duke of Burgundy, Lorenzo de' Medici, Henry VIII, Pope Julius III, and Catherine of Austria.[13] Archival evidence also suggests that the Magdalene was a particularly attractive subject to female patrons, perhaps because the devout owner could empathize with her. Johanna of Castile gave one such "paño de devoción de oro y seda y lana que es cómo apareció[ó] [*sic*] Nuestro Señor a la Madalena después de resucitado, que tiene en medio del un arbol que paresce naranjo e otras verdures" (devotional tapestry of gold and silk and wool which shows how Our Lord appeared to Mary Magdalene after He had come back to life, which has in the center a tree that looks like an orange [tree] and other greenery) as a gift to her mother, Isabella the Catholic, retrieving it for her own use after the older woman's death. According to this description recorded in the log of works to be returned to Johanna, the tapestry (present location unknown) was approximately 230 centimeters in width, and thus substantially larger than the Art Institute's *Christ Appearing to Mary Magdalene*.[14] As Cavallo has suggested, it might have resembled the slightly smaller tapestry of the *Noli Me Tangere* in the Metropolitan Museum of Art, in which an orange tree is clearly represented.[15] Isabella also owned a second "paño pequeño de Ras con oro [...] en que esta nuestro Señor como aparesce a la madalena despues de la Resureçion con unas letras negras en que dize noli me tanjere" (small tapestry hanging with gold [...] in which is Our Lord as He appeared to the Magdalene after the Resurrection with some black letters which say *noli me tangere*), which was listed in a 1505 inventory assembled for the purpose of the *almoneda*, or customary sale of royal goods, and sold at her death.[16] Also sold from Isabella's collection was an even smaller woven of painted "lienço quando aparecio nuestro señor a la madalena" (hanging of when Our Lord appeared to the Magdalene).[17] Another Spanish noblewoman, Mencia de Mendoza, Marchioness of Zenete and Duchess of Calabria, who boasted an impressive collection of Southern Netherlandish tapestries, and had spent time in the Hapsburg-Burgundian courts of Charles V and of Margaret of Austria, owned a small tapestry inventoried as "Christ and the Samaritan Woman," which might have resembled the *Noli Me Tangere* tapestries.[18] It is not difficult to imagine that the *Christ Appearing to Mary Magdalene* in the Art Institute, with its superior design, rich materials, and exquisite workmanship, would have found favor in this circle and could have belonged, if not to Johanna of Castile, Isabella the Catholic, or Mencia de Mendoza, at least to a collector of similar status and taste.

EC

1. For mystery plays narrated from the Magdalene's perspective, or that place particular emphasis on her role, see Jean Michel's *Mystère de la Passion*, performed in Angers in 1480 (for the text of the play, see Michel 1959); Robinson [1620] 1899; and Wager 1902; and Hawtry 1904. Among the fifteenth-century female mystics who cast themselves in the Magdalene's role were Margery Kempe (see Kempe [1438] 1940, p. 222) and Colette de Corbie (Van Corstanje et al. 1982, p. 134). For a canticle narrated by the Magdalene, see *The Little Office of Saint Mary Magdalene*, traditionally attributed to Charles II, King of Naples and Sicily (Sicard 1910, vol. 3, pp. 298–303).

2. For Van der Weyden's development of a recognizable Magdalene type, see Campbell 1979, p. 17; Destrée 1930, pp. 128, 137; Frinta 1966, p. 92; and Scott 1986, p. 81.

3. Christine de Pisan exhorted her readers to emulate Mary Magdalene's example in her *Treasure of the City of Ladies or the Book of Three Virtues*, of 1405; Pisan [1405] 1985, pp. 43–44. Isabella, Countess of Warwick, meanwhile, provides a noteworthy example of conspicuous devotion to the Magdalene; see Leyser 1996, p. 234. For the increase in the number of religious institutions dedicated to Mary Magdalene in the Southern Netherlands, and their support by figures such as Margaret of York, Duchess of Burgundy, see Naessens 1984.

4. For Jan Provoost, see Friedländer 1972, no. 153; for Cornelisz. van Oostsanen, see Herzog 1969, no. 13; for Joos van Cleve, see Friedländer 1972, nos. 33, 33a.

5. The tapestry, which measures 119 x 119 cm, was offered for sale at the Palais Galliera, Paris, Mar. 14, 1970, lot 131; at the Fifteenth Antique Fair, Antwerp, Sept. 20–28, 1986 (see *Tableau* 9 (Sept. 1986), advertisement on p. 63); and sold at Sotheby's, London, Oct. 30, 2002, lot 9.

6. The part of the tapestry containing this bush may be substantially rewoven.

7. The Cloisters, the Metropolitan Museum of Art, New York, inv. 1956.47 (Cavallo 1993, cat. 30, pp. 447–51); Province of Brabant Service for Cultural and Public Relations, Brussels, inv. 58588 (Asselberghs 1971, cat. 6); Livré-sur-Changeon, Ile-et-Vilaine (Macé de Lépinay 1986).

8. For the Magdalene's pose, see Robert Campin's *The Entombment* (the Seilern Triptych) in the Courtauld Institute of Art, London, illustrated in Foister and Nash 1996, pl. 12. For the figure type of the Resurrected Christ, see Dieric Bouts's *The Resurrection* in the Norton Simon Museum, Pasadena, California, illustrated in Smeyers 1998, p. 103. For the *Resurrection* tapestry, see the Metropolitan Museum of Art, New York, inv. 49.7.118, illustrated and discussed in Cavallo 1993, cat. 45.

9. Respectively, Angers, Château, and Romans-sur-Isère (Drôme), Church of Saint Bernard; see Musée des Arts Decoratifs 1965, cats. 261bis, 265.

10. The painted version is in the Musée d'Unterlinden, Colmar. The printed version is in the Metropolitan Museum of Art, New York, inv. 32.64.2; see Strauss 1978–, vol. 8, p. 240, no. 26 [130], and Kemperdinck 2004.

11. The panel, from the Münnerstadt Altarpiece, is in the Staatliche Museen, Berlin, and is published in Chapuis 1999, cat. 13F.

12. For the *Small Passion* series, see Strauss 1978–, vol. 10, p. 142, no. 47.

13. See Cleland 2011b.

14. Sanchez Canton 1950, pp. 92, 97, 150. It was also listed in Johanna's own inventory of 1565 as "1 pañecico rico de cómo apareció Nuestro Señor a la Magdalena"; for this inventory, see Herrero Carretero 2005, p. 325. Isabella's collection has recently been reassessed by Delmarcel 2005, pp. 287–303, and Herrero Carretero 2004. See also Cavallo 1993, p. 450.

15. Cavallo 1993, p. 450.

16. Sanchez Canton 1950, p. 122.

17. Ibid., p. 115.

18. Maryan Ainsworth, e-mail message to author, May 2005. Ainsworth's research on Mencia de Mendoza is now in preparation for publication; it was previously presented as a paper titled "The Collection of Tapestries of Mencia de Mendoza" at the Oaxaca Meeting, Apr. 5–8, 2006.

CAT. 4

The Holy Family with the Infant Christ Pressing the Wine of the Eucharist

Southern Netherlands, 1485/1525
After a design by an unknown artist
Produced at an unknown workshop
75.6 x 68.2 cm (29¾ x 26⅞ in.)
Bequest of Mr. and Mrs. Martin A. Ryerson, 1937.1097

STRUCTURE: Linen, wool, silk, and gilt-metal-strip-wrapped silk; slit tapestry weave
Warp: Count: 10 warps per cm; linen: S-ply of two Z-spun elements; diameters: 0.4–0.5 mm
Weft: Count: varies from 28 to 64 wefts per cm; wool: single Z-spun elements; S-ply of two Z-spun elements; pairs of S-ply of two Z-spun elements; diameters: 0.25–0.65 mm; silk: four elements possibly with a slight S- or slight Z-twist; three Z-twisted elements; S-ply of two Z-twisted elements; pairs of S-ply of two Z-twisted elements; three yarns of S-ply of two Z-twisted elements; Z-ply of two S-twisted elements; four yarns, two of S-ply of two Z-twisted elements and two of Z-ply of two S-twisted elements; two to four yarns of Z-ply of two and three S-twisted elements; diameters: 0.2–0.65 mm; wool and silk: paired yarns of S-ply of two Z-spun wool elements and S-ply of two Z-twisted silk elements; paired yarns of S-ply of two Z-twisted silk elements and Z-spun wool element; diameters: 0.3–0.6 mm; gilt-metal-strip-wrapped silk: gilt-metal strips wrapped in an S-direction on an S-twisted silk element; S-ply of two yarns: each a Z-ply of two S-twisted yarns of gilt-metal strips wrapped in an S-direction on a Z-twisted silk element; diameters: 0.3–0.65 mm

No conservation was required.

PROVENANCE: Frédéric Spitzer (died 1890), Paris, to 1890; sold, Chevallier and Mannheim, Paris, Spitzer sale, Apr. 17–June 16, 1893, lot 395, to Martin A. Ryerson (died 1932), possibly by proxy; by descent to Mrs. Martin A. Ryerson (née Caroline Hutchinson, died 1937); bequeathed to the Art Institute, 1937.

REFERENCES: Spitzer 1890–91, p. 159, no. 2 (*Tapisseries*). Spitzer 1893, lot 395. Hunter 1916, pp. 498, 499, 500, fig. II. Candee 1935, pp. 60–61 (ill. opp. p. 61); Mayer Thurman 1969, pp. 25, 27, 28, pl. 12. Wardwell 1975, pp. 19, 21, fig. 3. Mayer Thurman 1992, pp. 34–35 (ill.), 144. Cavallo 1993, pp. 336, 339, fig. 121. Cleland 2011 a. Cleland 2011b, no. 1.4.

EXHIBITIONS: Art Institute of Chicago, *Masterpieces of Western Textiles*, 1969 (see Mayer Thurman 1969). Art Institute of Chicago, *Tapestries from the Permanent Collection*, 1979. Art Institute of Chicago, *European Textile Masterpieces from Coptic Times through the 19th Century*, 1989–90. Art Institute of Chicago, *Textile Masterpieces from the Art Institute of Chicago's Collection*, 1993. Art Institute of Chicago, *Chicago's Dream, A World's Treasure: The Art Institute, 1893–1993*, 1993–94. New York, Metropolitan Museum of Art, *Early Sixteenth Century Devotional Tapestries*, 1995–96.

DRESSED in a plain shift, one sleeve rolled back slightly so as not to interfere with his work, the Christ Child squeezes a bunch of grapes above a chalicelike cup. He holds another sprig of grapes in his left hand, his fingers raised almost in a gesture of benediction. A rock crystal globe in front of him displays a reflection of this hand, which

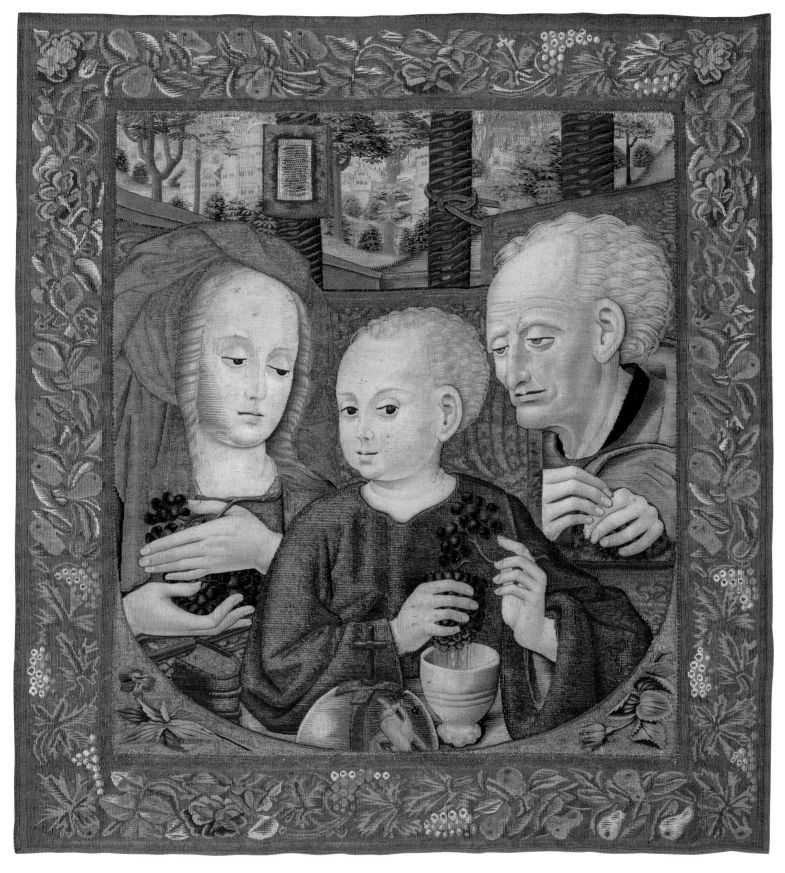

CAT. 4

looks as if it points toward the cross at the top of the orb. Christ's right elbow brushes against a closed book. Flanking him on either side are the Virgin Mary and Joseph, each holding a small bunch of grapes and leaning over a parapet hung with gold cloth. Whereas they watch Christ's labors with hooded eyes and grave expressions, Christ himself looks straight ahead, as if directly at the viewer. Behind the figures, three cloths of honor, richly patterned in the manner of brocaded velvet, hang from three irregularly spaced coiled columns. A parchment notice is posted behind the Virgin, and a rolling, wooded landscape dotted with castlelike buildings is visible through the columns. The bottom corners of the central field have been rounded off, leaving room for a trompe l'oeil pansy and rosebud on a rich golden background, woven as an uninterrupted field of gold- or silver-wrapped thread.[1] The border, which shows grapes, pears, and roses, and is of noticeably lower weaving quality, is a later addition that has been warped into the original tapestry. Otherwise, the workmanship is exquisite. The tapestry's very tight weave allows nuanced modulations of tone such as are visible in the modeling of Christ's face and the representation of his fine golden curls. Gilt-metal thread was used extensively throughout the weaving; Christ's shift, for example, is shot with metal thread, creating an effect of light and shadow over the fabric of the garment. The gilt-metal-wrapped threads remain untarnished, glittering as they catch the light.

This tapestry, known as *The Holy Family with the Infant Christ Pressing the Wine of the Eucharist*, can be interpreted as a commentary on the Christ Child's predestined fate to shed his blood to redeem mankind. The significance of the Child's actions is elucidated in a related tapestry that retains its original border (fig. 1), and is inscribed with a Latin verse from the apocryphal book of Ecclesiasticus, which describes the high priest Simon adorning an altar.[2] The inscription reads *PORREXIT·MANVM·SVAM·INLIBATIONEM· ET·LIBAVIT·DESANGVINE·VVE·ECCL·CI·C·LO* (he stretched out his hand to the cup and poured of the blood of the grape), thus prefiguring the wine of the Eucharist (Ecclus. 50:15). The tapestry in the Art Institute may well have originally included a similar border. In a metaphor current in biblical commentary since the third century A.D., the crushed grapes (sometimes called the mystic grapes) stand for Christ's sacrifice, and their juice represents the transubstantiation of the wine into his blood during the Eucharist.[3] The analogy between the pressing of the mystic grapes and the sacrificial shedding of the Redeemer's blood would certainly not be lost on better-informed contemporary viewers, since the debate about the sanctity of Christ's blood had been reopened in the later fifteenth century, prompting Pope Sixtus IV to publish treatises on the subject, including *De Sanguine Christi* (1467, 1472), and inspiring renewed vigor in the veneration of the reliquaries of the Holy Blood preserved in

FIG. 1 *The Infant Christ Pressing the Wine of the Eucharist.* Southern Netherlands, c. 1500. Linen, wool, silk, and metal-strip-wrapped thread; 50.5 x 46 cm. The Metropolitan Museum of Art, New York. Bequest of Benjamin Altman, 14.40.709.

FIG. 2 *Christ of the Mystic Winepress.* Southern Netherlands, c. 1500. Wool, silk, and metal-strip-wrapped thread; 73.5 x 77.5 cm. The Metropolitan Museum of Art, New York. Gift of Mena Rokhsar, 1994.484.

both Turin and Bruges.[4] Fifteenth- and sixteenth-century carvings, manuscript illuminations, and paintings of this theme more often represented the adult Christ seated or lying within a huge winepress, as if the machine were about to crush him and make his blood flow from the press in place of the juice of the grapes.[5] The tapestry in the Art Institute subtly alludes to this iconographic tradition with its inclusion of the three coiled columns, which imitate the two screws of a giant winepress. The screws are more recognizable in *Christ in the Mystic Winepress*, a formally and stylistically similar tapestry now in the Metropolitan Museum of Art, New York (fig. 2).[6] In the piece in Chicago, details such as the closed book and the framed notice allude to the scriptures that had prophesied this Messiah. The grave expressions of the Virgin and Joseph and, above all, the reflection in the orb of Christ's hand pointing to the cross, are even more pointed indicators of the Child's fate. Similarly, the red rosebud and pansy have traditionally been interpreted as symbols of spilled blood, martyrdom, and remembrance.[7]

Various scholars have suggested that the design of the tapestry might have been based on a painted or printed source, but no such pictorial precedent survives.[8] The motif of the Infant Christ squeezing the juice of the mystic grapes into a cup is unusual: painted representations of the Virgin and Child more often included grapes in the embryonic still life surrounding the figures, or resting unsqueezed in Christ's hands.[9] Although the knowing expression and delicate golden curls of the Child in the Art Institute's tapestry bear some resemblance to elements in the paintings of Jan van Eyck, and although there exist stylistically related tapestries based on figure patterns by Rogier van der Weyden, there is no suggestion among their surviving or documented lost works that either artist created paintings similar to the tapestry in the Art Institute.[10] More comparable to the tapestry's iconography is a painting attributed to Joos van Cleve, in which a full-length, naked Infant Christ eats, rather than squeezes, a bunch of grapes (fig. 3).[11] An engraving by the little-documented Lower Rhenish or Netherlandish artist known as the Monogrammist A is also closer, representing the Christ Child reaching toward grapes (fig. 4).[12] The print, however, has none of the iconic resonance of the tapestry in Chicago: Christ is markedly smaller relative to the rest of the scene and is held by the Virgin, surrounded by figures and paraphernalia on all sides, which considerably diminishes the significance of his actions.

There exist tapestries that allude to the mystic grapes with representations of bunches of grapes in their borders or being handed to the Virgin and Child.[13] A small group is even more closely related to the Art Institute's tapestry. Two of these pieces represent just the Child (figs. 1, 5); in the third, he is accompanied by the Virgin, Joseph, and three angels (fig. 6).[14] The Art Institute's piece and these three other weavings are clearly related, linked not only by their esoteric iconography, but also by stylistic similarities: they represent Christ's features and pose in the same way; share details of setting; have the same small, square format and trompe l'oeil corner framing of delicately rendered flowers; and are richly woven with precious

FIG. 3 Attributed to Joos van Cleve. *Christ Child with Grapes*. Oil on canvas; 27 x 19 cm. Musée du Louvre, Paris.

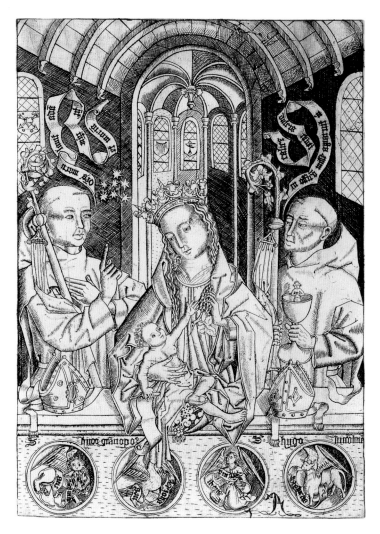

FIG. 4 The Monogrammist A (Lower Rhenish or Netherlandish, active c. 1490). *Infant Christ with the Virgin and Saints*. Engraving; 23.1 x 16.3 cm. Kupferstichkabinett, Kunstmuseum Basel, Aus K.6.20

materials. Furthermore, before the addition of its considerably later border, the tapestry in Chicago would have matched even more closely the diminutive dimensions of these other three tapestries. Each of the other pieces shares distinctive borders, rendered to look like embroidered, crushed velvet; and by calculating the proportion of each of the borders in comparison to the dimensions of its central picture field, it is possible to estimate that *The Holy Family with the Infant Christ Pressing the Wine of the Eucharist* would originally have measured approximately sixty-seven by sixty centimeters.

Tapestries of this iconographic, mystic grapes type are mentioned in fifteenth- and sixteenth-century inventories: in 1509, Johanna of Castile owned matching tapestries representing "dos niños Jesús de oro y sedas y lanas de colores, que eran de la cinta arriba, y tenía el uno en la mano un mundo y en la otra un racimo de uvas presentándole en un vaso, y el otro de la misma manera y hechura" (two Infants Jesus of gold and silk and colored wool which are from the waist upwards and [who] hold in one hand a globe and in the other a bunch of grapes pressed into a cup, and the other of the same manner and style).[15] Edith Standen was the first scholar to link this reference to the *Infant Christ Pressing the Wine of the Eucharist* now in the Metropolitan Museum of Art, New York (fig. 1).[16] It is conceivable that the second tapestry in Johanna's collection—"of the same man-

ner and style" (though not necessarily the same size)—was the slightly smaller *Infant Christ Pressing the Wine of the Eucharist* now in a private collection (fig. 5). In 1532, Johanna gave one of these tapestries as a gift to her daughter-in-law, Isabella of Portugal.[17] The piece given was probably the larger hanging now in the Metropolitan Museum of Art, since it arrived in New York with an additional embroidered frame bearing the arms of the Order of Calatrava, to which Isabella of Portugal probably subsequently donated it, since her husband, Charles V, was master of the order. A fifth tapestry depicting the Infant Christ squeezing grapes, now lost, belonged to Henry VIII. Among the two thousand tapestries inventoried after Henry's death in 1547 was one that must have looked very much like the Art Institute's *Holy Family with the Infant Christ Pressing the Wine of the Eucharist*: a comparable seventy-one by seventy-one centimeters, it was woven with gold-wrapped threads and represented "Christe and one geving him grapes & our Ladie standing by."[18]

The tapestry in the Art Institute and the other surviving tapestries depicting the same theme cannot have been woven from the same

FIG. 5 *The Infant Christ Pressing the Wine of the Eucharist*. Southern Netherlands, c. 1500. Wool, silk, and gilt-metal-strip-wrapped silk; 35 x 33 cm. Private collection.

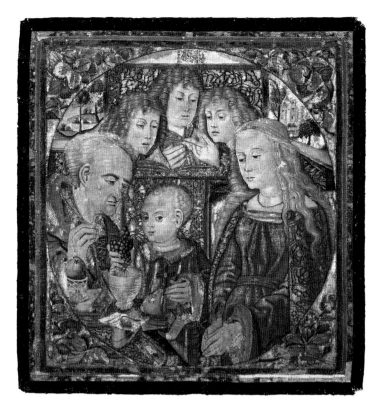

FIG. 6 *The Infant Christ Pressing the Wine of the Eucharist*. Flanders, c. 1500. Wool, silk, and gold filé; 73.3 x 70.8 cm (framed). The Cleveland Museum of Art, John L. Severance Fund, 1973.77.

cartoon because, in two of the tapestries, protagonists have been added; the composition has been shifted; and the shared details differ in their dimensions, relative scale, contours, and enlargement or reduction ratio.[19] For the same reasons, the tapestries cannot have been woven from different cartoons all made from rearrangements of the same patterns for details. Nor could the same painter have designed a new cartoon for each piece, as has sometimes been suggested, for some of the tapestries contain details that appear to be misunderstood versions of elements in the other weavings.[20] In the tapestry in the Art Institute, for example, the inclusion of three off-center coils resembling a background colonnade suggests that the artist who assembled the cartoon did not recognize them as the screws of a giant winepress. Finally, the tapestries also could not have been woven in the same workshop. Recent technical examination has confirmed that the tapestries in Chicago and New York were woven on linen warps, whereas the tapestry in Cleveland was woven on a woolen warp.[21] The hangings also differ in their tightness of weave and the techniques used to represent, for example, the planes of the Virgin's face, or the curls of her hair.[22]

Since the pieces can be linked neither to the same cartoon, nor by designer or workshop, it is possible that all were copied after similar finished tapestries, on different occasions, by different craftsmen. For example, the "square pece of arras of Christe and one giving him grapes and our Ladie standing by" documented in Henry VIII's collection was not woven in the Southern Netherlands, but in London,

at the King's request. Its description in the 1547 inventory notes that it was made "by the arrisman," a Flemish weaver in Henry's employ. In line with the tasks usually assigned to the arrasman, it was probably woven, as Thomas P. Campbell has suggested, after an existing tapestry.[23]

It is possible to suggest a tentative chronology for the four surviving tapestries. The Chicago *Holy Family with the Infant Christ Pressing the Wine of the Eucharist* probably does not reflect the original cartoon, but instead, like the piece in the collection of Henry VIII, is an adaptation based directly on a finished tapestry. It is likely that the original version of this group represented the Infant Christ alone: the examples in New York and in a private collection (figs. 1, 5) in which he is not accompanied by the Virgin and Joseph have a distinctly arresting, iconic quality that emphasizes the iconographic significance of his actions. In addition, the versions that include the complete Holy Family (in the Art Institute and the Cleveland Museum of Art) betray evidence of compositional tampering that was not altogether successful. For example, in the piece in Chicago, to make room for the Virgin to the left of Christ, his right arm had to be made noticeably shorter than his left, and moved closer to his body. Whereas the rock crystal orb is located between Christ's hands in the tapestries in which he appears by himself, here it is shifted to the left of both his hands where, realistically, it ought to reflect the chalice and his right hand squeezing grapes, not what it does mirror: his left hand, which was probably the reflection in the original

composition. Similarly, in the version now in Cleveland (fig. 6), the introduction of the Virgin to the right of Christ forced the artist to shift the cluster of objects in the foreground to the left, swapping the grapes from the Child's right hand to his left. This would have necessitated a complete alteration of the reflection in the orb, but in this instance, the reflection has been dispensed with altogether. The four surviving pieces may not have been the only tapestry versions of this core mystic grapes group current in the early sixteenth century and there is, therefore, little reason to insist that each must have been a response to the other. It is, however, apparent that, for the reasons outlined above, the tapestries now in New York (fig. 1) and in a private collection (fig. 5) probably reflect the original arrangement more closely, with one of them possibly being the initial catalyst for the group, whereas those in Chicago and in Cleveland (fig. 6) are later or more distant adaptations.

This author has recently suggested that the catalyst for these variations might have been Johanna of Castile's mother, Isabella the Catholic, periodically commissioning new versions after a tapestry already in her possession, either from tapissiers in the Southern Netherlands, or perhaps, although less likely, from a succession of Flemish weavers working at the Spanish court.[24] There is, for example, some evidence of French and Flemish tapestry suppliers working in centers such as Barcelona, although their efforts likely focused on the import of tapestries, with any weaving remaining on a modest footing.[25] Tapestry functionaries did work at Isabella the Catholic's court.[26] Their role was presumably also to purchase and conserve rather than create, and it remains debatable whether they might have had the skills to, on occasion, weave smaller pieces themselves, as Campbell has suggested was the case with Henry VIII's Flemish "arrasmen" at the English court.[27] If the Art Institute's *Holy Family* was woven in Spain, this might explain the use of a linen warp rather than the type of woolen warp more commonly used in Flanders, although this was probably also a practical choice, with the finer linen allowing much tighter and more detailed weaving than would a thicker wool warp.

Isabella apparently had a taste for sumptuously woven, small-scale devotional tapestry, as twenty-five such weavings, all less than two hundred centimeters in height and width, were recorded in her possession when she died in 1505.[28] There is ample evidence that she made a practice of commissioning both close replicas and substantially altered versions of significant artworks in her possession.[29] She may have been motivated by the common custom among Renaissance patrons to commission works reproducing the same or similar design to be given to family members.[30] In this instance, the most likely recipients were Isabella's daughters, Johanna of Castile and Catherine of Aragon, both of whom were obliged to travel across Europe to the courts of their prospective husbands, Philip the Handsome of Burgundy and Arthur, Prince of Wales. The widowed Catherine's subsequent marriage to Henry VIII might explain his possession of one of the mystic grapes tapestries, which Henry, or indeed his queen, could have ordered copied by the court weaver. If

this was indeed the case, the tapestry in the Art Institute could have been based on an existing piece and woven at Isabella's request.

The suggestion that the tapestry in Chicago was commissioned and once owned by Isabella the Catholic or one of her daughters remains, at least for the present, an attractive theory at best. But it is certain that the piece, with its rich materials and exquisite workmanship, must have belonged to a patron of similar royal status. Like the Art Institute's late-fifteenth-century *Christ Appearing to Mary Magdalene* (cat. 3), it is a small-scale devotional tapestry of a type prized throughout Europe, particularly in the elite circles of monarchs, prince-dukes, and the highest-ranking ecclesiastics.[31] Part of the tapestry's appeal must have been its portability: its small size meant that it could easily be rolled up and moved with other possessions from one location to another, accompanying an itinerant aristocratic owner. Small tapestries of this sort could be used in a variety of circumstances. Some were made with specific functions in mind, for use as lectern covers and even window hangings.[32] Larry Feinberg has made the intriguing suggestion that *The Holy Family with the Infant Christ Pressing the Wine of the Eucharist* and the other three mystic grapes tapestries, with their square format and diminutive proportions, might have been intended to decorate royal nursery furniture, in particular the broad head- and footboards of cradles.[33] Certainly, the female attendants, or "rockers," of royal infants were issued tapestries and other textiles to hang on the cradles.[34] The dimensions of the piece in Chicago do indeed correspond to those of a surviving cradle, now in Brussels, that was probably used for the infant Philip the Handsome or his sister Margaret of Austria.[35] The tapestries usually presented to rockers were not, however, as distinct in iconography nor as sumptuous in material as the Art Institute's hanging. It is thus more likely that this tapestry was used as a devotional object, rather than for nursery decoration.

The numerous documentary references to other small tapestries functioning specifically as altarpieces lends support to this theory.[36] The piece's eucharistic iconography, small scale, and composition would make it an ideal portable altarpiece: the representation of the Holy Family as half-length figures against cloths of honor locates them in a suitably royal setting, and, in addition to its iconographic and decorative appeal, the boxlike design would make the ledge on which the Infant's chalice rests seem to be an extension of the actual altar that would abut the tapestry. With its intimate scale, engaging details, and the direct stare of the Infant Christ that seems to hold the viewer's gaze, the tapestry would function just as well as an aid to private devotion, for contemplation at close quarters, in the manner of a small panel painting or manuscript.[37] EC

NOTES

1. For useful discussions of this tapestry, see Hunter 1916, pp. 498, 499; Mayer Thurman 1969, pp. 25, 27; Wardwell 1975, pp. 21, 22; Mayer Thurman 1992, pp. 34–35; Cavallo 1993, pp. 336, 338–40; and Cleland 2011a.

2. Metropolitan Museum of Art, New York, inv. 14.40.709; published in Cavallo 1993, pp. 334–41, cat. 22.

3. Saint Hippolytus explores the significance of the grapes in his *Exegeses* and *Homilies* (third century), while Clement of Alexandria returns to the theme throughout his writings (c. 150–220). See for example *The Instructor II* in Clement of Alexandria 1867, p. 200. These discourses are discussed, in context, by Franssen 1987, pp. 54–55, 56.

4. For a detailed discussion of the veneration of the Holy Blood, see Strazzullo 1999.

5. Fifteenth- and early sixteenth-century representations of the mystic winepress are discussed in more detail in Cleland 2011a. For examples, see Michelant 1870, p. 84; Thomas 1936; Lambert 1990; Boon 1992, cat. 246; and Kotková 1999 p. 117, cat. 85.

6. Metropolitan Museum of Art, New York, inv. 1994.484; published in Delmarcel and Duverger 1987, p. 56, and Wixom 1999, cat. 282.

7. Cavallo 1993, p. 337.

8. The suggestion was made by Hunter 1916, p. 500; Wardwell 1975, p. 22; and Cavallo 1993, p. 339.

9. Ainsworth and Christiansen 1988, p. 248, cats. 61, 96; Ainsworth 2005, p. 56.

10. Cleland 2011a.

11. I am grateful to Maryan Ainsworth for drawing my attention to a similar painting (now in a private collection in Valencia; see Benito Doménech 1999, cat. 3), which was probably already in Spain by 1554, when a work fitting its description was inventoried among the belongings of Mencia de Mendoza, Marchioness of Zenete and Duchess of Calabria, at the monastery of La Merced, Valencia.

12. Lehrs 1930, vol. 7, pp. 339–40, no. 10, *Tafelband*, vol. 7, fig. 211, no. 506.

13. For an example of a tapestry with bunches of grapes in its border, see Mayer Thurman 2001, cat. 3; for examples of tapestries with grapes being given to the Christ Child, see Crick-Kuntziger 1956, cat. 18 (in the Royal Museums of Art and History, Brussels), and Metropolitan Museum of Art 1983, cat. 15 (in the pontifical apartments, the Vatican, Rome, inv. 3833).

14. The two tapestries that represent only Christ are *The Infant Christ Pressing the Wine of the Eucharist* (fig. 1) in the Metropolitan Museum of Art, New York, inv. 14.40.709 (50.5 x 46 cm), published in Cavallo 1993, cat. 22; and *The Infant Christ Pressing the Wine of the Eucharist* (fig. 5) in a private collection. The latter piece was part of the Emmet collection, at Amberley Castle, West Sussex, until it was sold by Sotheby's, London (sale at Amberley Castle), Sept. 30, 1981, lot 80 (35 x 33 cm). It was recently in the Dutch Renaissance Art Collection, Amsterdam, and published in Cavallo 1993, fig. 124. The tapestry in which Christ is accompanied by the Holy Family and angels (fig. 6) is in the Cleveland Museum of Art, inv. 1973.77 (79 x 75.9 cm), and is published in Martin Nagy 1985, pp. 28, 30, 58, cat. 10.

15. Published in Herrero Carretero 2005. The inventory was first published in Ferrandis 1943, pp. 171–375. Although an inscription at the top of the document has traditionally led scholars to believe it is a posthumous inventory drawn up after Johanna's death in 1555, recent research by Miguel Ángel Zalama has shown that the document compiled at her death was based on an inventory that had been drawn up over forty years earlier, in 1509; Zalama 2000, pp. 379–82.

16. Cavallo 1993, p. 340, cites Standen's unpublished draft manuscript of 1968/69 in the files of the Department of Medieval Art, the Metropolitan Museum of Art, New York.

17. Cleland 2011a.

18. British Library, Harley ms. 1419, ff. 63v., 217 (Starkey 1998, pp. 207, 273, items 9687, 12029).

19. Cavallo 1993, p. 339, suggested that they share the same cartoon. Cleland 2003, pp. 180–83, adduces comparative measurements, the enlargement and reduction ratios of particular details, and comparative contour tracings that refute Cavallo's argument.

20. Hunter 1916, p. 500, suggested that they share the same designer.

21. I am grateful to Kathrin Colburn, Conservator, Department of Textile Conservation, the Metropolitan Museum of Art, New York, for undertaking technical examination of samples of the *Infant Christ Pressing the Wine of the Eucharist* and the *Christ in the Mystic Winepress* in New York in Feb. 2006. The tapestry in Amsterdam has not undergone technical examination.

22. *The Infant Christ Pressing the Wine of the Eucharist* (Cleveland Museum of Art, inv. 1973.77): 11–12 warps per cm; *The Infant Christ Pressing the Wine of the Eucharist* (private collection): 7–8 warps per cm; *The Infant Christ Pressing the Wine of the Eucharist* (Metropolitan Museum of Art, New York, inv. 14.40.709): 13 warps per cm; and *Christ in the Mystic Winepress* (Metropolitan Museum of Art, New York, inv. 1994.484): 5–6 warps per cm.

23. The royal arrasman mainly repaired tapestries in the king's collection, and employed a number of weavers, many from Flanders, to assist him. Campbell 2007b, pp. 89–92, 125, discusses the role of the court arrasmen in detail.

24. Cleland 2011a.

25. For Barcelona, see Duran i Sanpere 1933, p. 60, and Sanchez Canton 1950, pp. 96, 144. Junquera y Mato 1985, pp. 43–48, lists the names of those whom he believes to have been tapestry weavers active on the Iberian peninsula in the fifteenth and sixteenth centuries.

26. Domínguez Casas 1993, pp. 140–41.

27. Campbell 2007b, pp. 89–92, 125.

28. Sanchez Canton 1950, p. 116. Isabella's collection has recently been reassessed in Delmarcel 2005 and Herrero Carretero 2004.

29. For Isabella the Catholic's taste for painted replicas and variations after panel paintings in her family's collection, see Dijkstra 1990, pp. 82–97, and Ainsworth and Christiansen 1988, cat. 46. For manuscript illuminations created for her based on existing paintings, see Hand and Wolff 1986, pp. 133–39, and Kren 1983, cat. 5.

30. For duplicate tapestries which Philip the Bold commissioned, based on a set that he had given to his brother, John, Duke of Berry, see Prost and Prost 1908–13, vol. 2, item 1484; for the wealthy Bruges merchant Anselm Adornes's near-duplicate paintings intended for each of his daughters, listed in his will of 1470, see De Poorter 1931; and for tapestries commissioned by Margaret of Parma after a set belonging to her brother, see Buchanan 2006, pp. 411, 413.

31. See Cleland 2007, p. 129, and Cleland 2011a.

32. For a surviving tapestry designed to cover a lectern, see Smit 2002, pp. 124, 126, fig. 2; for woven window hangings representing the *Virgin and Christ* and *Saint Eustace*, see f. 259v. of British Library, Harley ms. 1419; published in Starkey 1998.

33. Larry Feinberg, former Patrick G. and Shirley W. Ryan Curator of Painting, Department of Medieval through Modern European Painting and Sculpture, the Art Institute of Chicago, conversation with the author, Mar. 2004.

34. References to the rockers' textiles appear throughout the English royal accounts; Thomas P. Campbell, conversation with the author, Nov. 2004.

35. Royal Museums of Art and History, Brussels, inv. 360; see Soly and Van de Wiele 1999, p. 174.

36. For fifteenth-century references to tapestries made to function as altarpieces, see Pinchart 1878–85, pp. 18, 72, and Laborde 1849–53, vol. 2, p. 274, item 4306.

37. For examples and further discussion of the use of pictorial aids to private devotion, see, for example, Spamer 1930, Ringbom 1984, and Van Os 1994.

CAT. 5

A Falconer with Two Ladies and a Foot Soldier (previously *The Feudal Life*)

Franco-Flemish, possibly Paris or Bruges, c. 1500
After a design by an unknown artist
Produced at an unknown workshop
362.7 x 285.8 cm (142⅞ x 112½ in.)
Gift of Kate S. Buckingham, 1922.5379

STRUCTURE: Wool and silk, slit and double interlocking tapestry weave
Warp: Count: 5 warps per cm; wool: S-ply of three Z-spun elements; diameters: 0.9–1.2 mm
Weft: Count: varies from 11 to 34 wefts per cm; wool: S-ply of two, three, and four Z-spun elements; diameters: 0.7–1.7 mm; silk: pairs of S-ply of two Z-twisted elements; diameters: 0.7–1.2 mm

Conservation of this tapestry was made possible through the generosity of Shirley Welsh Ryan.

PROVENANCE: An unidentified European family, to 1920; sold to Jacques Seligmann and Company, Paris, 1920; transferred to Jacques Seligmann and Company, New York, Nov. 3, 1920; sold to Kate S. Buckingham (died 1937), Chicago, 1922; given to the Art Institute, 1922.

REFERENCES: Göbel 1923, vol. 1, pt. 2, fig. 311. Rogers and Goetz 1945, p. 73, cat. 63, pl. 43. Weigert 1962, p. 77, pl. 26. Mayer Thurman 1969, pp. 24, 25, pl. 9. Joubert 1987, pp. 117, 119, fig. 105. Cavallo 1993, pp. 490–91, 493, fig. 156. Monsour 1999, p. 250, fig. 9. Mayer Thurman 2001, p. 10.

EXHIBITIONS: Art Institute of Chicago, *Masterpieces of Western Textiles*, 1969 (see Mayer Thurman 1969). Art Institute of Chicago, *The Artist Looks at the Landscape*, 1974. Art Institute of Chicago, *Tapestries from the Permanent Collection*, 1979. Moscow, Pushkin Museum, and Leningrad (now St. Petersburg), the Hermitage, *Medieval Art from Late Antique through Late Gothic from the Metropolitan Museum of Art and the Art Institute of Chicago*, 1990. Art Institute of Chicago, *Renaissance Velvets and Silks*, 2002–03.

THIS tapestry presents two women and two men against a millefleur background. One of the men is dressed as a falconer, gauntlet and bird conspicuously displayed.[1] He is richly clad in a patterned, brocaded velvet robe or surcoat, with the wide-cuffed openwork sleeves popular from the 1490s, over a fashionably short doublet, hose, and snub-nosed shoes.[2] The other man, leaning against a pike, wears the less ornate costume of a foot soldier. The dagging of his jerkin (or *pourpoint*) and the ostrich feathers and decorative strapwork of his hat nevertheless lend him a festive air that is reinforced by his two-tone hose, a style common in the fifteenth and sixteenth centuries that often served to distinguish the liveries of different noble houses. The women, standing arm in arm, are no less decorative. Each wears a rich gown and holds her skirt high to reveal a costly brocaded velvet kirtle. The exaggerated wide cut and rolled-back sleeves of the lady in blue typify expensive clothing of the late 1490s, when the wearing of garments made with more fabric than necessary in order to flaunt one's status continued to attract the censure of sumptuary laws.[3] In contrast, the sleeves of the figure to the left of this woman are

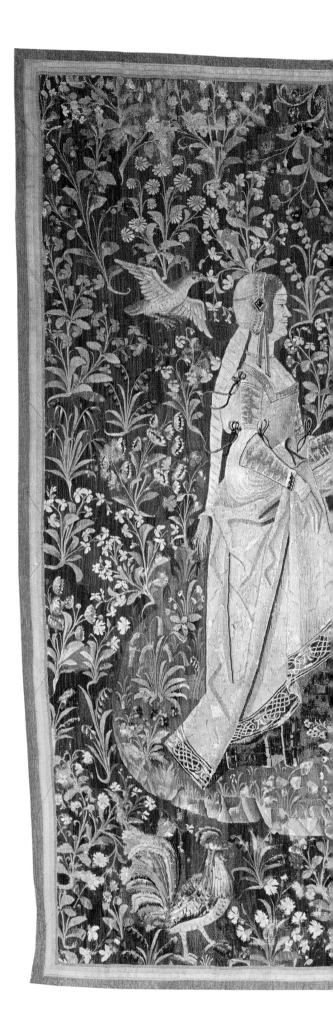

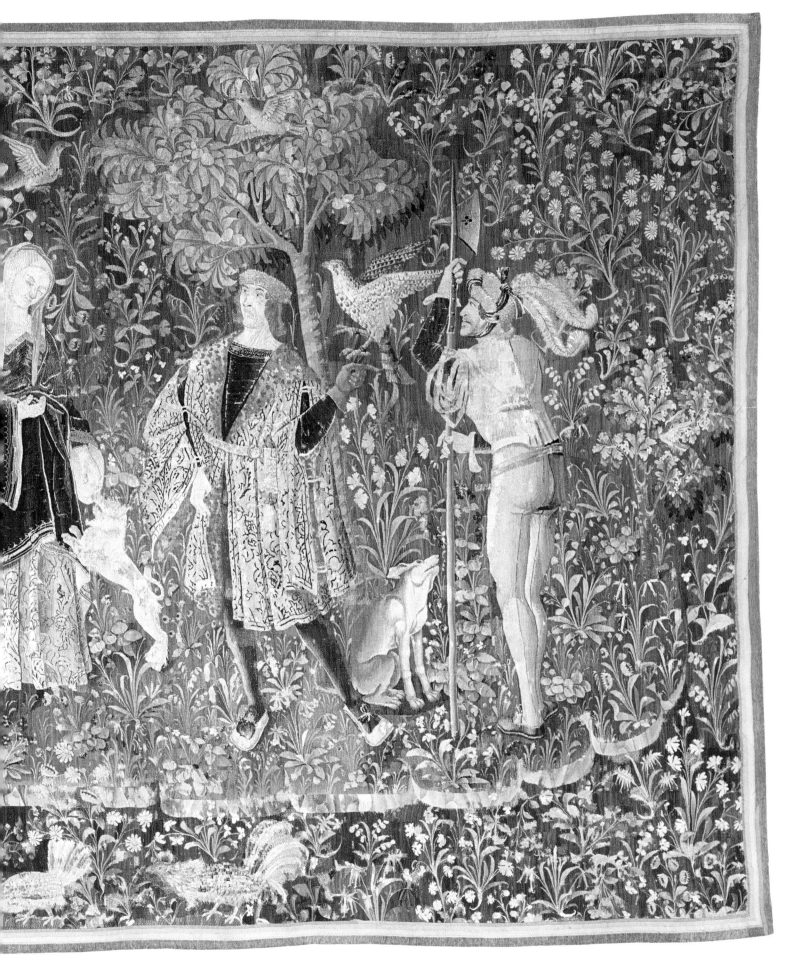

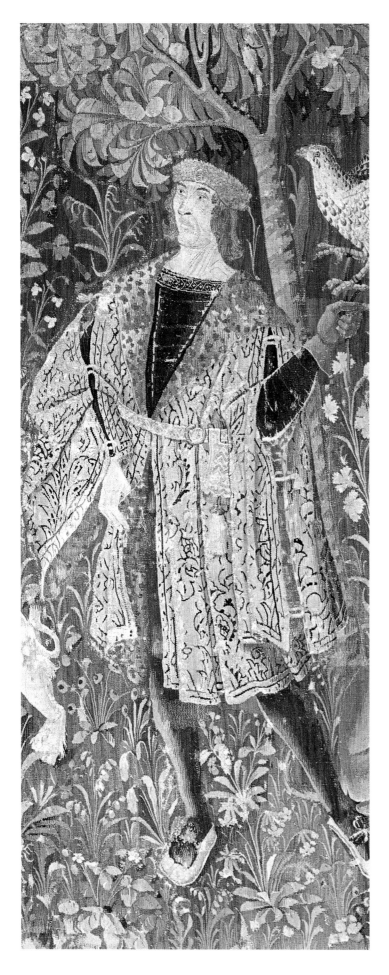

close-fitted, although by no means less rich. Cut open at the elbow in the Italian style to allow her white chemise to spill through, and tied with decorative blue laces, this style was the height of elegance at the turn of the sixteenth century, and also attracted a degree of disapproval, not for any conspicuous waste but rather due to its tight fit and low-cut neckline, which were deemed unseemly and immodest.[4] The woman on the right reaches down to pet a diminutive dog, jumping against her skirts, while a leaner hunting dog gazes faithfully upwards at the soldier from the feet of the falconer.

The figures and animals occupy an island, which they share with, at center, a pear tree and, on the right, a smaller bush with oaklike foliage. Surrounding this patch of land is a flat expanse. The shallow, earthy cross section visible on the front edge of the island reveals that some attempt was made to create an impression of depth. Two cockerels and a hen strut across the foreground of the tapestry, in front of the island, while four birds fly beside and above the figures. The millefleur decoration of delicately rendered flowering plants uniformly covers both the island and the surrounding area, its flattening, decorative effect setting up a visual antagonism with the suggestion of three-dimensional space in the middle ground.

It was probably the decorative qualities of the figures' stances and costumes and their fantastical millefleur setting that appealed to contemporary viewers. This collection of figures did not likely have any particular symbolic or narrative significance. As Adolfo Salvatore Cavallo has pointed out, this type of design cannot have been intended as a realistic representation of contemporary life.[5] Instead, the figures are sufficiently neutral in their poses and interactions to leave the perception of narrative up to the viewer's discretion or imagination.

There is little sense of a recognizable artistic personality behind the design of this tapestry. It is apparent, for example, that one of the figures, the foot soldier, was initially created for use elsewhere: it originally appeared, with four comrades, in an early engraving by Dürer (fig. 1).[6] Cavallo has suggested, less convincingly, that the falconer is also a revision of another man in the same Dürer engraving.[7] Two other tapestries reveal that this group reappears elsewhere. A hanging now in the Metropolitan Museum of Art, New York, depicts the same four figures and two animals, also against a millefleur ground (fig. 2).[8] The men, women, and dogs stand in the same order, although their positions have been shifted slightly: the falconer and soldier have been lowered in the picture plane, and, whereas in the Art Institute's tapestry the women's dog's tail almost touches the tip of the falconer's sleeve, in the New York version it is level with his hand. The piece in New York also differs in background color (it is dark blue, probably faded from an original dark green); no attempt has been made to distinguish an island on which the figures stand; the birds, bush, and pear tree are absent; and a small, page-like figure has been added to the far right of the scene. A tapestry fragment, part

CAT. 5, DETAIL

FIG. 1 Albrecht Dürer. *Five Soldiers and a Turk on Horseback*, c. 1495. Engraving on white laid paper; 13.2 x 14.5 cm. The Art Institute of Chicago, Clarence Buckingham Collection, 1938.1439.

of a suite traditionally called *Scenes of Courtly Life* (*La Vie Seigneuriale*), in the Musée National du Moyen Âge, Paris, offers a further version of the group (fig. 3).[9] The falconer, foot soldier, and hunting dog are again represented against a millefleur ground. Even the bird in the oak bush in the Art Institute's tapestry is recognizable here, in the pear tree. Unfortunately, the tapestry has been severely cut down. It is nevertheless possible to discern, below the pear tree to the left of the falconer, the hind legs and tail of the ladies' dog. Thus it is extremely plausible that the dog was originally jumping up against the skirts of the women in the now missing left portion of the piece.

The tapestries in Chicago and New York are very similar in dimensions, and the fragment in Paris is of comparable height. Moreover, the figures are reproduced at exactly the same size and proportions. But the stark difference in the plants constituting the millefleur motifs in each piece, together with the shifting of the figures in relation to each other and the omission of the island in some tapestries and of the pear tree in others, reveal that these tapestries are not simply three weavings from the same cartoon. Yet it is also not the case that the pieces were produced from three unrelated models, designed by painters who coincidentally all had access to the same figure group

pattern. Rather, a trail of increasingly simplified details shows that these tapestries are directly related to one another and can actually be placed in a chronology, with each subsequent tapestry a pared-down transcription of its predecessor.

The most intricately detailed and refined group of figures appears in the fragment from the *Courtly Life* suite in Paris. The falconer's rich costume displays a wealth of details, from the twin feathers in his hat to the patterning of his purse, the pair of buckles on his belt, and the tasseled laces of his sleeves; and the foot soldier's cap still bears all three feathers and the furry texture of the Dürer print prototype. The hunting dog's tail curls under him and rests over his front paw. The tapestry in Chicago incorporates a slightly simplified version of the Cluny figure group: the falconer has lost the feathers in his hat, and although he retains his belt and purse, one of the belt buckles has been omitted and the design of the purse has been substantially simplified. In an apparent misunderstanding of the Cluny dog, the tapestry in the Art Institute shows his tail spread out behind him. Similarly, the ornately scalloped blade of the foot soldier's pike has been simplified, and his hat now only displays two jauntily angled feathers. His hose, on the other hand, have been enlivened by two-

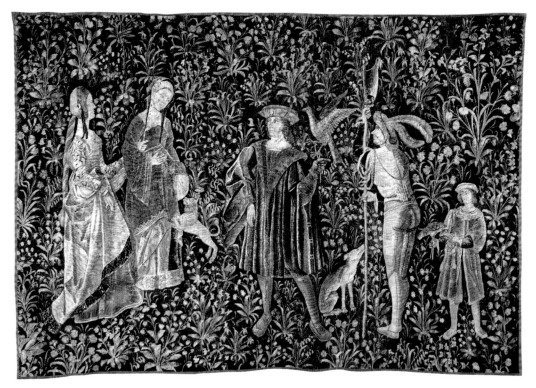

FIG. 2 (left) *A Falconer with Two Ladies, a Page, and a Foot Soldier.* Southern Netherlands, 1500/30. Wool and silk; 250 x 351 cm. The Metropolitan Museum of Art, New York. Bequest of Harriet H. Jonas, 1974.228.2.

FIG. 3 (below) *Departure for the Hunt* [fragment] from *Scenes of Courtly Life.* Southern Netherlands, 1500/25. Wool and silk; 258 x 174 cm. Musée National du Moyen Âge, Paris, Thermes de Cluny, Cl.2183.

tone coloring. The figures in the tapestry in New York are, in turn, pared-down versions of their equivalents in the Chicago tapestry. The falconer's hat remains featherless and he has now lost his belt, purse, and shoelaces. The details of the foot soldier's costume have also been considerably impoverished: though his hose is two-toned, as in the piece in Chicago, of the two remaining feathers in his hat, one has been further reduced to a lackluster downward curve, the strapwork of his hat no longer knots on the crown of his head, and he has lost his dark whiskers, twisted belt end, the smaller blade to the left of the pike shaft, the pointing tip of his right index finger, and his right foot. The costumes of the two ladies reflect comparable simplification: the sleeves of the woman on the left, for example, lack their lacing, and the voluminous sleeves of the lady in blue are no longer convincingly bulky, while the clumsy representation of her raised mantle and exposed underskirt betrays a misunderstanding of the costume's construction. Finally, the dog now has no tail at all, and the pear tree of the Paris and Chicago versions has been left out.

The historical context may explain the relationship between the *Courtly Life* tapestries in the Art Institute, the Musée National du Moyen Âge, and the Metropolitan Museum of Art. By the third quarter of the fifteenth century, tapestry weavers were becoming increasingly adept at finding ways to copy and adapt certain types of cartoons themselves, to avoid the expensive and time-consuming process of commissioning new ones from members of the painters' guilds. In Brussels, the situation came to a head by 1476, when the painters, aware of this new state of affairs and after dialogue with the weavers, petitioned the city magistrates to amend the existing rules regulating cartoon production to recognize and control this practice.[10] The ensuing ruling allowed weavers to create their own

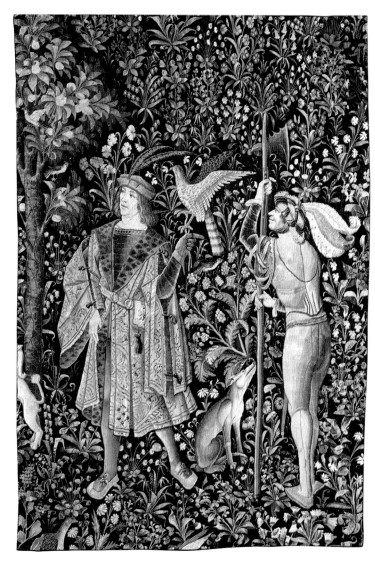

cartoons if they would only be illustrating "toffen, boomen, loef ende ghers, vogelen ende beesten" (drapery, trees, foliage and grass, birds and animals), and to amend or glue extensions onto existing patterns and designs. The increased use of mechanically transferable patterns and models meant that even a craftsman of limited artistic dexterity could replicate a cartoon's design by tracing or pinhole pouncing. The three variations of *A Falconer with Two Ladies and a Foot Soldier* provide an example of how this procedure probably worked in practice: a full-size, cartoon-ready figure pattern would be traced from an existing cartoon onto a fresh paper or plain textile support to create a new cartoon. The remaining space surrounding the transferred figures on the new cartoon could be filled in with miscellaneous flower and foliage designs. Then, to make another new cartoon, the figure pattern could be mechanically transferred a second time, and again extended with a new millefleur background. The mechanical process of tracing or pouncing meant that each time the figure pattern was reused, a little more detail would be simplified or lost. The patterns' accessibility probably also explains such phenomena as the reappearance of the falconer and the foot soldier from the tapestries presently under discussion in an iconographically unrelated composition depicting *The Life of Saint Julian*.[11] The falcon of *A Falconer with Two Ladies and a Foot Soldier* itself reappears in the Metropolitan Museum of Art's *A Huntsman Presenting a Captured Heron to a Lady Falconer*, which also has a red millefleur ground.[12]

In light of the context in which the tapestry in Chicago appears to have been produced, it was probably not a special commission, but instead created on speculation by a weaver-entrepreneur for sale on the open market. Archival evidence reveals that this practice occurred in Brussels; however, stylistic reasons make it probable that *A Falconer with Two Ladies and a Foot Soldier* was woven not in Brabant but rather in Paris or Bruges. Research by Audrey Nassieu Maupas has revealed the vibrancy of the Parisian tapestry weaving workshops during the reign of King Francis I.[13] The piece in the Art Institute shares the singular physiognomies, flat drapery folds, and crisp figure outlines that characterize numerous tapestries attributed to the Paris-based weavers, including *The Life of Saint Julian*. It is therefore tempting to attribute *The Falconer with Two Ladies and a Foot Soldier* to this creative milieu. These same stylistic traits also link the Art Institute's piece to a group of tapestries woven in Bruges which, as noted by Guy Delmarcel, share many of the characteristics of the Parisian weavings.[14] Similar drapery and fruit trees also appear in, for example, *The Life of Saint Anatolius*, woven between 1502 and 1505 in Jean Sauvage's Bruges workshop for the church of Saint-Anatoile, Salins.[15] The link between the two centers must certainly have been strengthened by artists such as Gauthier de Campes (Wouter van Campen), who designed tapestries in Paris, while remaining active in his native Bruges.[16] It is plausible that the pattern reused for the cartoon of the Art Institute's tapestry was based on designs from the De Campes workshop, with the weaving itself probably done in either Paris or Bruges. The style of the costumes and the use of Dürer's foot

soldier reveal that this pattern can only have been in circulation after about 1495. But the Chicago version may have been woven very soon afterwards, for details of the design, such as the millefleur motif and, above all, the shallow island, with its irregular contours and earthy cross section, match tapestries usually dated to the late fifteenth and early sixteenth centuries, such as the Musée National du Moyen Âge *Lady and the Unicorn* suite and the aforementioned *Huntsman Presenting a Captured Heron to a Lady Falconer*.[17] These features suggest a tentative weaving date around 1500.

The accessibility, functional flexibility, and manageable scale of millefleur designs, or verdures, as they were called during this period, lent them a particular appeal. A tapestry like the Art Institute's *Falconer with Two Ladies and a Foot Soldier* was of an appropriate size and subject to hang in the home of a wealthy family. With its decorative elegance, diverting details, and vibrant colors and surface pattern, it represents the highest end of this market. EC

NOTES

1. See Forsyth 1944, pp. 253–59, for more on the medieval taste for falconry.
2. For more on costume in this period, and details about its dating, see Scott 1980, Herald 1981, and Scott 1986.
3. See, for example, Herald 1981, pp. 57–58, 104, 108, for details on sumptuary laws attempting to halt the excessive use of fabric.
4. See, for example, Scott 1980, pp. 65, 70, 141, 157, for the criticisms of lewd or provocatively tight clothing leveled by commentators, chroniclers, and preachers in the late fifteenth and early sixteenth centuries.
5. Cavallo 1993, p. 491.
6. Panofsky 1943, p. 195, was the first to note the reuse of Dürer's figure in the tapestry. For the engraving *Five Soldiers and a Turk on Horseback*, see Strauss 1978–, vol. 10, p. 76, no. 88. Examples of the engraving are in the Art Institute of Chicago (inv. 1938.1439) and the Metropolitan Museum of Art (inv. 19.73.100). The style of the monogram indicates that this is one of Dürer's earliest engravings, and it is usually, therefore, dated no later than 1496.
7. Cavallo 1993, p. 491.
8. Metropolitan Museum of Art, New York, inv. 1974.28.2; Cavallo 1993, pp. 488–94, cat. 36.
9. Musée National du Moyen Âge, Paris, inv. Cl.2183; Joubert 1987, pp. 104–21, cat. 8, fig. 97.
10. The text of the document was first published in Wauters 1878, pp. 48–49. For an English translation, see Richardson, Woods, and Franklin 2007, pp. 205–06, doc. 2.3.3; for a discussion, see Cleland 2007, pp. 112–13.
11. Joubert 1987, p. 117, fig. 107.
12. Metropolitan Museum of Art, New York, inv. 64.277. Cavallo 1993, pp. 498–501, cat. 38, discusses the piece in detail.
13. Evidence for tapestry weaving in Paris at the turn of the fifteenth and sixteenth centuries is discussed in detail in Nassieu Maupas 2004. For analysis of the production of designers working in Paris, such as Gauthier de Campes, see Leproux 2001, pp. 41–107.
14. The stylistic links between these groups of Parisian and Bruges production are outlined in Delmarcel 2004a.
15. Delmarcel and Duverger 1987, pp. 170–79, cat. 2.
16. See Girault 2005.
17. Musée National du Moyen Âge, Paris, invs. Cl.10831–36; Joubert 1987, pp. 66–92, cat. 6.

CAT. 6

The Resurrection from *The Allegory of the Redemption of Man*

Southern Netherlands, possibly Brussels, 1510/20
After a design by an unknown artist, c. 1500
Produced at an unknown workshop
INSCRIBED: *Ecce rex tuus venit tibi zachare ix*; *Vivicabit nos post duos dies ozee vi*
621.3 x 408.6 cm (244⅝ x 160⅞ in.)
Gift of Mrs. Chauncey McCormick, Mrs. Richard Ely Danielson, and William Deering Howe, 1946.47

STRUCTURE: Wool and silk; slit, dovetailed, and double interlocking tapestry weave
Warp: Count: 7 warps per cm; wool: S-ply of three Z-spun elements; diameters: 0.7–1.0 mm
Weft: Count: varies from 22 to 34 wefts per cm; wool: S-ply of two Z-spun elements; diameters: 0.3–1.0 mm; silk: S-ply of two Z-twisted elements; pairs of S-ply of two Z-twisted elements; diameters: 0.3–1.1 mm

Conservation of this tapestry was made possible through the generosity of the Textile Society of the Art Institute of Chicago, the James Tigerman Estate, Barbara Franke, and Nicole Williams.

PROVENANCE: Jacobo Luis Stuart Fitz-James (died 1881), 8th Duke of Berwick, 15th Duke of Alba de Tormes, Madrid, Spain; sold, Hôtel Drouot, Paris, Duke of Berwick and Alba sale, Apr. 7–20, 1877, lot 12. Baron Frédéric Emile d'Erlanger (died 1894), by 1880. Duveen Brothers, to 1922; sold to William Randolph Hearst (died 1951), 1922, for $75,000; ownership transferred to International Studio Art Corporation (Hearst's holding company); sold to French and Company, New York, 1943, for $13,800; sold to the Art Institute, 1946 (purchased with funds from the sale of 1943.1229 and 1943.1230, 1944, gifts of Mrs. Chauncey McCormick [née Marion Deering, died 1965], Mrs. Richard Ely Danielson [née Barbara Deering, died 1982], and William Deering Howe [died 1947]).

REFERENCES: Keuller and Wauters 1881, n.pag. Wood 1912a, p. 215. Cavallo 1958, pp. 147, 148. Cavallo 1967, p. 95. Mayer Thurman 1969, p. 25, pl. 10. Schneebalg-Perelman 1976, p. 185. Mayer Thurman 1979, pp. 11–13, fig. 12. Bennett 1992, pp. 54, 55, 73, fig. 44 (detail only). Cavallo 1993, p. 443. Mayer Thurman and Brosens 2003, pp. 172, 175, fig. 1. Antoine 2007, pp. 23, 52, 53.

EXHIBITIONS: Brussels, *Exposition Nationale Belge*, 1880 (see Keuller and Wauters 1881). New York, Gimbel Brothers Department Store, 1941, cat. 183-6. Art Institute of Chicago, *Masterpieces of Western Textiles*, 1969 (see Mayer Thurman 1969). Fine Arts Museums of San Francisco, *Five Centuries of Tapestry*, 1978.

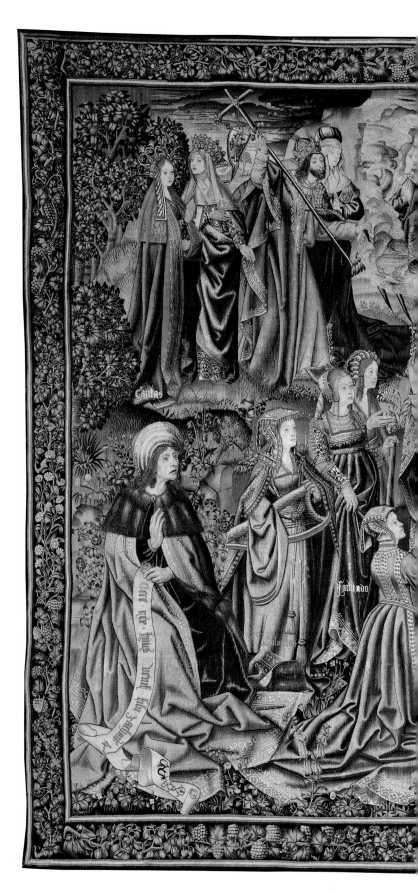

THE risen and triumphant Christ stands on a colorful marble tomb slab as if it were a pedestal, his right hand raised in blessing, his left holding a staff bearing the banner of the Resurrection. Around him cluster allegorical figures of the Virtues, dressed like fashionable ladies of the court. Their names are woven nearby: *Fortitudo* (Courage), *Voluptas* (Pleasure), *Sanitas* (Good Sense), *Diuturnitas* (Long Duration) and *Velocitas* (Quickness). They are watched from above by a host of angels flanking personifications of God the Father

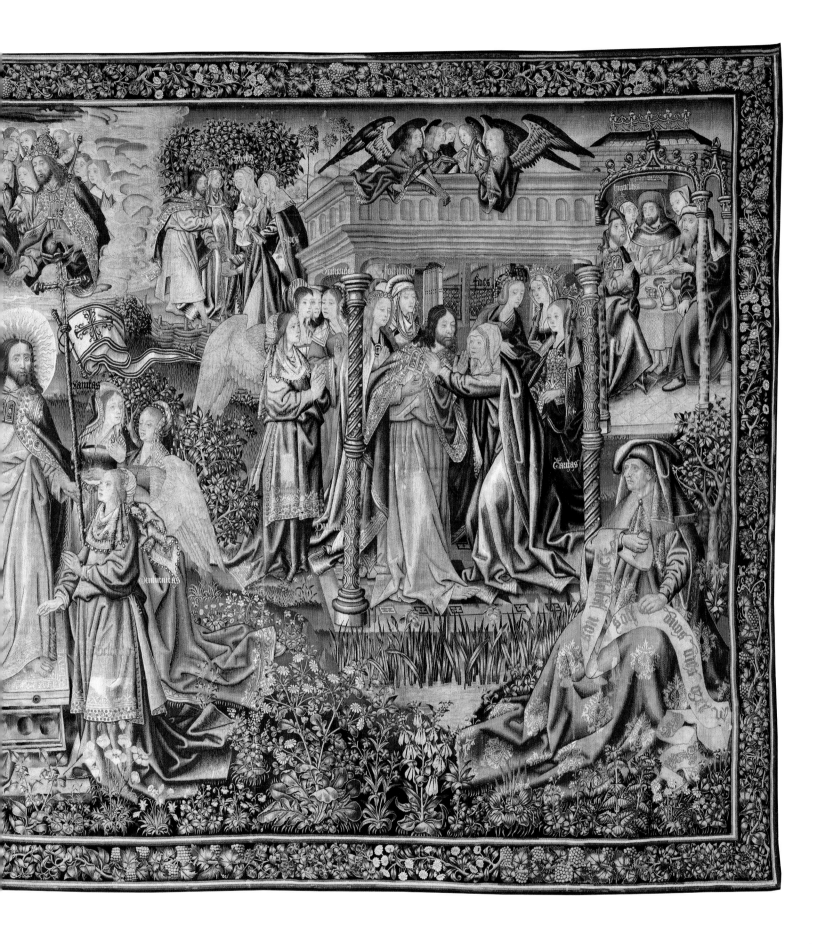

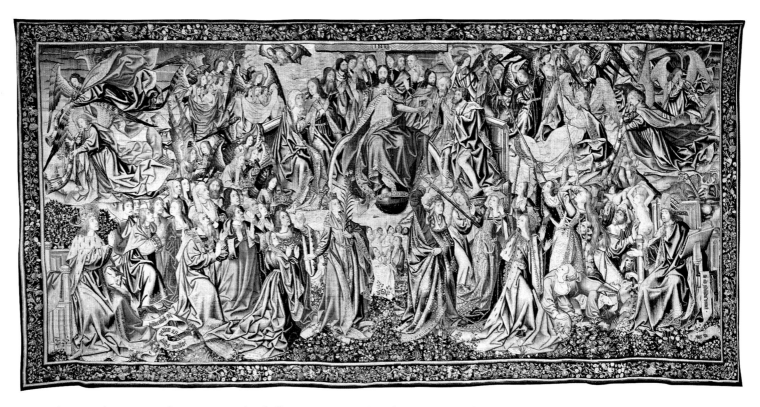

FIG. 1 *The Last Judgment.* Brussels, 1500/20. Wool and silk; 409 x 820 cm. Musée du Louvre, Paris, OA5523.

and the Holy Ghost, who await Christ's Ascension to complete the Trinity. In the upper left corner, the resurrected Christ raises his cross to smite the gates of hell and begin the descent into limbo, as *Caritas* (Charity) and two unnamed Virtues look on. In the background, to the right of the principal group, Christ appears to Mary Magdalene, watched by *Humilitas* (Humility), *Dilectio* (Love) and *Spes* (Hope). Below this secondary group, an ornate architectural canopy encloses a scene of Christ appearing to his mother: the Virgin Mary reaches to embrace her son, as he shows her the wound in his side. They are surrounded by a crowd of personifications, some of whom are identified by texts on banderoles (*Diuturnitas*, *Pulchritudo* [Beauty], *Fortitudo*, *Fides* [Faith], *Spes*, and *Caritas*), and some of whom—such as winged *Velocitas*—are recognizable from their appearance in other episodes in the tapestry. The canopy's roof supports a group of minstrel angels. In the upper right corner, another architectural embellishment houses the Supper at Emmaus, at which the resurrected Christ broke bread with two of his unsuspecting disciples. Christ is seated in the center, flanked on either side by unnamed allegorical personifications. The prophets Zechariah and Hosea are seated in the two lower corners of the tapestry, as if presenting its various narratives. They hold banderoles proclaiming *Ecce rex tuus venit tibi zachare ix* (Behold, thy king cometh unto thee, Zechariah IX; 9:9) and *Vivicabit nos post duos dies ozee vi* (After two days will he revive us, Hosea VI; 6:2). The collection of scenes is set in a lush landscape, with acorn bushes, fruit-laden trees, and roses behind the figures; a small pond with blossoming flags and water irises; and in the foreground, an array of flowering plants, including violets, pansies, car-

nations, poppies, marguerite daisies, broom pods, and strawberries. In the border the same broom pods, daisies, and roses reappear in regular bands, accompanied by clusters of grapes.

Five other tapestries of comparable dimensions and with the same border design survive, and probably comprised a suite (or at least part of one) with this tapestry. These other pieces represent *The Virtues Challenging the Vices* (Museum of Fine Arts, Boston), *The Creation*, *The Crucifixion*, and *Christ's Ascension* (all in the collection of the Baron de Zuylen de Nyevelt de Haar, in the Kasteel De Haar, Haarzuilens) and *The Last Judgment* (Musée du Louvre, Paris; fig. 1).[1] These five tapestries and the tapestry now in the Art Institute were in the collection of the dukes of Berwick and Alba in the Liria Palace, Madrid, until they were sold in the late nineteenth century; it is not known when the tapestries had entered the family's possession.[2]

The subject of this suite is far more complex than a simple cycle of scenes of the Passion of Christ. Its iconography combines biblical events with apocryphal episodes and allegorical personifications. The sources for the narrative in *The Resurrection*, for example, include the apocryphal Gospel of Nicodemus (the inspiration for the image of the Harrowing of Hell), the apocryphal Acts of Thaddeus (on which Christ's appearance to the Virgin Mary is based), as well as the Gospels of Mark, John, and Luke (the former two, both sources for Christ's appearance to Mary Magdalene, and the latter the source for the Supper at Emmaus). The inclusion of the Old Testament prophets Zechariah and Hosea marks the events depicted as fulfilling the prophesies of the coming of the Redeemer. The personi-

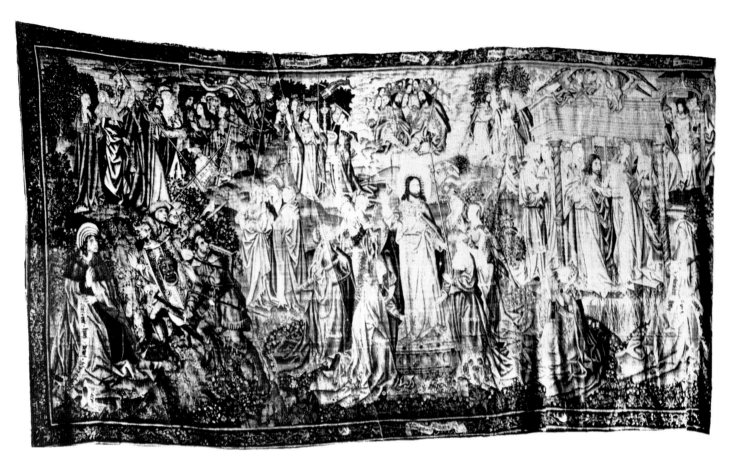

fications of a whole spectrum of Virtues add a contemplative note to the tapestries, inviting the beholder to empathize with the different emotions of each episode. The allegorical figures also fulfill a practical role, endowing the various scenes with a degree of continuity, for each Virtue is always represented in the same attire and with the same attributes, and consequently sometimes recognizable even without the aid of a woven name. These personifications accompany the viewer not only through this particular tapestry, but also through each of the other five pieces of the suite. As such, the tapestry suite functions as a type of pictorial equivalent to the *Elckerlyc* morality play, attributed to Pieter van Diest and published in 1495, which was emulated in the 1520s by its more widely known English counterpart, *Everyman*.[3] Indeed, many scholars have observed that the scenes portrayed in these tapestries share the didactic emphases and even echo the stage directions of some fifteenth- and sixteenth-century mystery plays, sermons, and civic pageants. Moreover, as Anna Gray Bennett has remarked, the "plots [of the tapestries] are as intricately interwoven as the voice lines of late medieval music."[4]

Other weavings after the same cartoons have also survived, and are now located in various collections. Two other versions of *The Resurrection* are known: one remains in Burgos Cathedral in northern Spain (fig. 2); the other is in the collection of the Fine Arts Museums of San Francisco.[5] In all, besides the Berwick and Alba suite from which the Art Institute's *Resurrection* comes, at least six other

fragmentary suites woven after the same cartoons have survived. Research by D.T.B. Wood, Adolfo Salvatore Cavallo, Bennett, and Thomas P. Campbell has clarified the early history of some of these editions. François Fouquet, archbishop of Narbonne, gave a ten-piece suite to the Cathédrale Saint-Just-et-Saint-Pasteur in 1673, of which one piece survives.[6] Campbell has recently suggested that Fouquet obtained this suite from the English royal collection: by 1520 Henry VIII owned a fine, gilt-woven edition of this design, which had apparently been purchased in 1502 by his father, Henry VII, from the Brussels tapestry weaver and dealer Pieter van Aelst (c. 1450–1533).[7] This suite was eventually sold as part of the Commonwealth sale in 1651, and may have passed into Fouquet's hands soon after. The inventory of Cardinal Thomas Wolsey's tapestry collection, drawn up between 1521 and 1523, reveals that Wolsey owned a twelve-piece suite with the same designs, possibly composed in part of weavings from larger cartoons that had been divided to make smaller hangings; two pieces, probably from this purchase, remain at Hampton Court, London.[8] Don Juan Rodriguez de Fonseca, bishop of Palencia and Burgos, owned an eight-piece suite, and, after his death in 1524, left four tapestries to the Cathedral of San Antolín in Palencia, where all remain to this day, and four to the Cathedral of Santa María in Burgos, where two remain and two are now in the collection of the Metropolitan Museum of Art, New York.[9] Another edition belonged to the chapter of the Cathedral of Santa María in Toledo, Spain; five

pieces from this suite have survived and are now in the collection of the Fine Arts Museums of San Francisco.[10] A further edition of the series was apparently sold from the Castello Ventoso in Portugal to the early-twentieth-century French antiquarian Fernand Schutz; one piece from this suite is now at the Worcester (Massachusetts) Art Museum, and another is at the Fogg Art Museum, Harvard University, Cambridge, Massachusetts.[11] It is conceivable that this suite from the Castello Ventoso might have been the ten-piece edition called *The Triumph of the Virtues* earlier inventoried in the collection of the dukes of Braganza, the future kings of Portugal.[12] Cavallo also cites a reference to a set from the Vatican that was reportedly sold to a French collector, Richard, by 1878.[13] The survival of numerous other single pieces from fragmented suites implies that this series was frequently rewoven. Its cartoons must not have included borders, for each of the surviving suites is surrounded by a different arrangement: either the flowers and fruit of the Art Institute's *Resurrection*, or the banderoles of Rodriguez de Fonseca's set in Burgos and Palencia, or, finest of all, the combination of trompe l'oeil jewels with birds, flowers, and grapes, of the tapestry in Narbonne.

The allegorical character of the cycle has prompted speculation about its actual, underlying subject matter. Both Henry VII's 1502 purchase and the pre-1523 inventory of Wolsey's collection refer to their tapestries as depictions of "the olde law and the newe," whereas Rodriguez de Fonseca's bequest to Palencia and Burgos describes them as "tapices de las virtudes" (tapestries of the Virtues).[14] The name modern scholarship has given to the set is *The Allegory of the Redemption of Man*. Cavallo's detailed discussion of the iconography of each of the surviving episodes has prompted him to identify the names of the pieces and their sequence as: 1) *The World Is Created and Man Falls from Grace* (examples are in Haarzuilens, Narbonne, and San Francisco); 2) *The Vices Lead Man in a Life of Sin* (Palencia, San Francisco, and the cathedral of La Seo, Saragossa); 3) *Peace and Mercy Win the Promise of Redemption for Man* (Hampton Court, London; Museu de Lamego, Portugal, with some alterations to the composition; New York; and abbreviated versions in the Burrell Collection, Glasgow, and the Victoria and Albert Museum, London); 4) *Christ Is Born as Man's Redeemer* (New York); 5) *Christ the Savior as a Child* (Palencia and Cambridge); 6) *The Virtues Challenge the Vices as Christ Begins His Ministry* (Boston, Palencia, and an abbreviated version in Hampton Court); 7) *The Virtues Battle the Vices as Christ Is Crucified* (Burgos, Haarzuilens, and San Francisco); 8) *Christ Rises and Rescues Man from Hell* (Burgos, Chicago, and San Francisco); 9) *Christ Ascends to Heaven and Man Is Reconciled to God* (Haarzuilens and Palencia); 10) *Christ Makes His Last Judgment and the Vices Are Vanquished* (Paris; Palazzo Venezia, Rome; and Worcester).[15] Cavallo's convincing analysis identifies the tapestry in the Art Institute as the eighth episode in the cycle.

The sheer number of surviving *Redemption of Man* tapestries testifies to the frequency with which the set was rewoven, each time creating sizeable, and therefore expensive, suites. The piece in Nar-

bonne was woven with a mixture of wool, silk, and gilt- and silvered-metal-wrapped threads; all the other surviving sets, including that to which the tapestry in the Art Institute belongs, do not contain precious threads. The high status of the patrons purchasing these sets implies that a great deal of prestige may have been associated with owning an edition: the Narbonne set might have belonged to Henry VII; the pieces in Hampton Court were probably purchased by a cardinal (Wolsey), and later passed into the collection of Henry VIII; and those now in Palencia, Burgos, and the Metropolitan Museum of Art, New York, belonged to a bishop (Rodriguez de Fonseca). In addition, royal Portuguese provenance has been suggested above for the tapestries in Cambridge and Worcester. When displayed in their complete, ten-piece state, each suite would cover a length of wall between 75 and 90 meters (or approximately 250 to 300 feet) long. In Burgos, Palencia, and Toledo, the tapestries would have decorated the choirs of the cathedrals on religious holidays and feast days. The sets that belonged to the nobility and high-ranking prelates such as Henry VII and Wolsey, on the other hand, may not have functioned in purely liturgical settings but might instead have hung in halls of state and been displayed during courtly ceremonies. Campbell has suggested that Wolsey, for example, may have purchased his sizeable edition for the newly refurbished state rooms at York Place, his London palace.[16]

Unfortunately none of the cartoons for *The Redemption of Man* have survived. Judging from the tapestries based on them, the cartoons had probably been created in the early sixteenth century: many aspects of the designs closely resemble elements in other pieces that have been securely dated to this period. Various scholars have noted that particular figures in the *Redemption of Man* designs also appear in other contemporary tapestries: the prophets in the Art Institute's *Resurrection*, for example, correspond closely with the figures of David and Augustine in *The Mass of Saint Gregory*, which Johanna of Castile gave to Isabella the Catholic.[17] The facial types in the *Allegory of the Redemption of Man* tapestries, likewise, are very close to those in the *Birth of the Redeemer as Fulfillment of the Prophesies* in the Patrimonio Nacional, Spain, which Johanna of Castile bought before 1509; and the clusters of figures in richly embellished clothing, with swaths of drapery collecting at their feet, resemble groups in *The Justice of Herkinbald* (Royal Museums of Art and History, Brussels), commissioned by the Leuven Confraternity of the Holy Sacrament in 1513.[18] The principal designer of the *Redemption of Man* tapestries was very talented, managing to illustrate the highly complex iconographical program through subtly contained narrative scenes enclosed in tight and balanced compositions. He clearly made judicious reuse of elements from existing tapestry cartoons, as well as from the work of the previous generation of Netherlandish artists, reusing figure types and even complete compositions first developed by Rogier van der Weyden and later used by artists such as the Master of the View of Saint Gudula and Colijn de Coter. He was probably based in Brussels, the artistic hub of the Southern Netherlands by

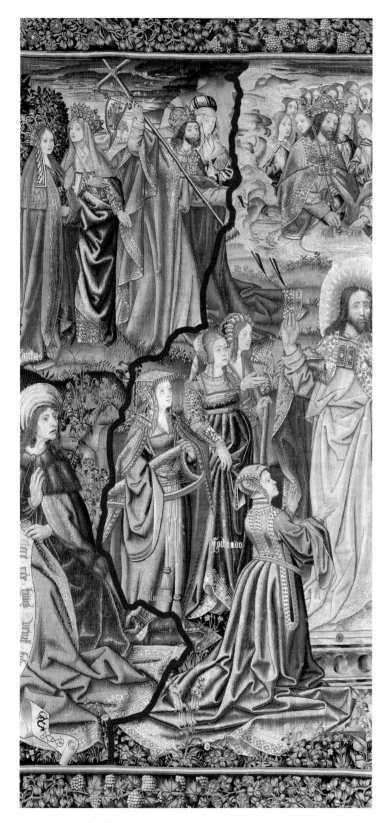

FIG. 3 Cat. 6, detail.

recently, De Coter has been suggested as the designer.[19] Both the Master of the View of Saint Gudula and Colijn de Coter are indeed potential candidates, insofar as they were artists working in Brussels at the turn of the sixteenth century who are known to have had access to Van der Weyden's designs and to have reused them frequently.

While the cartoons can be dated to shortly after 1500, it is considerably more difficult to date the weavings. Henry VII may have purchased one of the first editions of the series as early as 1502, Rodriguez de Fonseca obtained his suite and wrote it into his will and testament before his death in 1524, and Wolsey owned the pieces in Hampton Court by 1523 at the latest. In contrast, the suite subsequently in the collection of the dukes of Berwick and Alba, from which the *Resurrection* in Chicago comes, has traditionally been considered a later, derivative version. This is principally because the *Resurrection* tapestry in this suite is abbreviated compared to those now in Burgos (fig. 2) and San Francisco: it lacks the scenes of the flight of the soldiers guarding the tomb, the mouth of hell and Christ's rescue of Abraham, and Christ at the Fountain of Life, which are all included in the other versions of the *Resurrection*.[20] This is not, however, the result of partially copying older or damaged cartoons, nor of a cheaper, pared-down reweaving. Recent close examination of the piece in the Art Institute revealed that the tapestry was not reduced at the cartoon stage, nor during weaving. Rather, after it was finished, the piece was cut vertically, from the top border all the way to the bottom border, and a wide vertical strip of the weaving, illustrating the now-missing soldiers at the tomb, the mouth of hell, and the Fountain of Life, was removed from the center of the left of the tapestry. The two vertical cut edges, flanking the removed section, have been very carefully stitched together to disguise the reduction: the contour of the seam is not a simple vertical, but instead traces a line exactly where the design of the *Resurrection* in Chicago differs from the compositions of the versions in Burgos and San Francisco (fig. 3). Both the cutting and seaming have been executed with utmost care, worming from left to right as far as possible to follow the contours of plants and drapery, thus rendering the alteration almost imperceptible. Deletions can only be discerned at the tip of Pleasure's harp where it now meets the roses behind Zechariah; in the abrupt shift from stormy red sky and brown cliff-face behind the scene of Christ about to enter hell to the gentle blue clouds behind the heavenly host; and, at the bottom of the tapestry, in the strawberry plant below the Virtue in blue which now merges with the marguerite daisy at the foot of the drapery of Zechariah's garment.

Although the Art Institute's *Resurrection* and the other pieces that once belonged to the dukes of Berwick and Alba do not incorporate any metal-wrapped threads, and are thus unlikely to have comprised the *editio princeps*, they nevertheless display a highly sophisticated and skilled level of tapestry production. The high quality of the weaving and the precise, faithful replication of the exquisite details of the cartoons suggests that this can be ranked among the early editions of *The Allegory of the Redemption of Man*. Other tapestries, such as the

this period, with access both to records of admired tapestry cartoons and to drawn patterns after the works of Van der Weyden and his circle. In the past, it has been suggested that the *Redemption of Man* cartoons be attributed to Hugo van der Goes, Jan Gossaert, the Master of Saint Severin, or the Master of the View of Saint Gudula. Most

set now in San Francisco and the *Last Judgement* in Worcester, are of markedly lower quality, lacking the minute details, rich and varied palette, and adept representation of the variations in texture of brocaded velvet, fur collars, flowering foliage, and carved marble architecture. The representation of the expressionless faces, foreground flowers, and watery pond in the *Resurrection* in San Francisco, for example, seems gauche and stylized compared to the faces on the tapestry in Chicago, while the omission of most of the allegorical figures' names considerably diminishes the clarity of the narrative. The talented weavers responsible for the Art Institute's piece were probably working in one of the most successful tapestry production centers of the period, such as Brussels, probably during the second decade of the sixteenth century. A tapissier might have directed its creation, intending to sell it, ready-made, on the open market. But the quality and scale of the piece suggest that it was more likely produced on commission, perhaps for a significant international patron who moved in circles comparable to those of Cardinal Wolsey and Bishop Juan Rodriguez de Fonseca. EC

NOTES

1. *The Virtues Challenging the Vices* is in the Museum of Fine Arts, Boston, inv. 54.1776, and is illustrated and discussed in Cavallo 1958, and 1967, pp. 91–95, cat. 24. *The Creation*, *The Crucifixion*, and *Christ's Ascension* are in the Kasteel De Haar, Haarzuilens, and are illustrated and discussed in Wood 1912a, pl. 1, fig. 1; pl. 2, fig. 5; and pl. 3, fig. 7, respectively. *The Creation* is also illustrated in Göbel 1923, pl. 123. *The Last Judgment* is in the Musée du Louvre, Paris, inv. OA5523, and is illustrated and discussed in Göbel 1923, pl. 130; Souchal 1973b, pp. 209–14, cat. 93; and Antoine 2007.
2. Hôtel Drouot, Paris, Duke of Berwick and Alba sale, Apr. 7–20, 1877, lots 11–16. For a discussion of the possible provenance of the set, see Cavallo 1967, p. 94.
3. The text of *Elckerlyc* is published in Steenbergen 1956; that of *Everyman* is published in Bates 1940. Wood 1912b compares the tapestries to fifteenth-century mystery plays performed in Coventry, Angers, and Provence; and with pageants, glorious entries, and Flemish civic *Ommegangen* processions. Taylor 1935–36 remarks on similarities with stage directions. Cavallo 1958 and 1967, p. 92, discuss the tapestries' possible links with medieval preachers' sermons and the Passion play produced at Mons (in present-day Belgium) in 1505.
4. Bennett 1992, p. 54.
5. The Fine Arts Museums of San Francisco, inv. 54.14.3, discussed in Bennett 1992, pp. 72–74, cat. 15.
6. Cathedral of Saint-Just-et-Saint-Pasteur, Narbonne, illustrated and discussed in Souchal 1973b, cat. 92, pp. 209–14.
7. Campbell 2007b, pp. 78–79 (Henry VII's purchase), 85–87 (Henry VIII's set).
8. Hampton Court Palace, London, invs. 1035, 1088, illustrated and discussed in Campbell 1996a, pp. 93, 95, 103–07, figs. 11, 12. Campbell 1996a, p. 105, has shown that a tapestry set recorded as depicting the "Story of the 7 Deadly Synnes" that Wolsey purchased in 1521 was not a reference to the "Olde law and the newe" listed in his inventory, disproving the theory of Wood 1912a (p. 210) that this purchase could be linked to the two pieces remaining at Hampton Court. See Marillier 1962, pp. 13–17, and Kendrick 1924, p. 73, cat. 78.
9. Metropolitan Museum of Art, New York, invs. 38.28–.29, illustrated and discussed in Cavallo 1993, pp. 421–45, cats. 29a–b. For the tapestries in

Burgos and Palencia cathedrals, see also Müntz 1902, pp. 98–101; Göbel 1923 pp. 124–25, 156; Steppe 1956, pp. 45–46, 50–52; and d'Hulst 1967, pp. 121–28, cat. 15.
10. Fine Arts Museums of San Francisco, invs. 54.14.1–.4, illustrated and discussed in Bennett 1992, pp. 54–77, cats. 11–15.
11. Worcester Art Museum, inv. 1935.2, illustrated and discussed in Taylor 1935–36.
12. The *Triumph of the Virtues* included in the Braganza inventory is cited in Keil 1949, p. 310. Keil's identification of a different tapestry of *The Last Judgment*—the one displayed in the council hall of Evora Castle in 1483—with the tapestry now in the Worcester Art Museum must be rejected on grounds of date.
13. Cavallo 1993, pp. 440, 441, 442.
14. For Henry VII's purchase, see Campbell 2007b, pp. 78–79. Wolsey's inventory, now in the British Library, Harley ms. 599, f. 2r., is published in Campbell 1996a, p. 119. For the wording of Rodriguez de Fonseca's bequest, see Steppe 1956, p. 46.
15. For the single pieces cited here not allocated to the seven sets discussed above, see the following: For *The Vices Lead Man in a Life of Sin* in the Cathedral of La Seo, see Torra de Arana, Hombía Tortajada, and Domingo Pérez 1985, pp. 233–37. For *Peace and Mercy Win the Promise of Redemption for Man*: 1) Museu de Lamego, Portugal, inv. 1, Quina and Moreira 2006, pp. 96–143 (ill. pp. 97–98); 2) Burrell Collection, Glasgow, illustrated and discussed in Cavallo 1993, pp. 439, 441, fig. 143; 3) Victoria and Albert Museum, London, illustrated and discussed in Kendrick 1924, pp. 34–35, cat. 18; and Wingfield Digby and Hefford 1980, pp. 34–35, cat. 21. For *Christ Makes His Last Judgment and the Vices Are Vanquished* in the Palazzo Venezia, Rome, see Brugnoli 1965, p. 232.
16. Campbell 1996a, p. 105.
17. For further discussion of similarities with other contemporary tapestries, see Cavallo 1958, p. 167, and 1993, pp. 438–39; Bennett 1992, pp. 54–55; Delmarcel et al. 1993, p. 19; and Campbell 2002c, p. 150.
18. *The Birth of the Redeemer as Fulfillment of the Prophesies* is in the Patrimonio Nacional, Spain, invs. 100005808–09, and is illustrated and discussed in Junquera de Vega, Herrero Carretero, and Díaz Gallegos 1986, vol. 1, p. 7 (ser. 2/1), as well as in Smolar-Meynart 2000, pp. 24–29, cats. 5–6. *The Justice of Herkinbald* is in the Royal Museums of Art and History, Brussels, inv. 865, and is illustrated and discussed in Crick Kuntziger 1956, pp. 28–29, cat. 12, as well as in Delmarcel 1976, pp. 78–83, cat. 19.
19. Taylor 1935–36 suggested Van der Goes as artist; earlier, in an article in the Apr. 4, 1877, issue of the newspaper *Le Constitutionnel*, Alfred Michiels proposed Gossaert. Cavallo 1958, pp. 166–67, mooted the Cologne-based artist known as the Master of Saint Severin; whereas in her unpublished draft manuscript of a catalogue of the Metropolitan Museum of Art's medieval tapestry collection (now in the archives of that institution's Department of Medieval Art), Edith Standen identified elements which correspond to paintings attributed to the so-called Master of the View of Saint Gudula. Most recently, Campbell 2002c, p. 150, and Antoine 2007, linked De Coter to *The Redemption of Man* and related tapestries.
20. For characterizations of the Chicago tapestry as derivative and abridged, see Cavallo 1967, p. 95, and 1993, p. 433; Mayer Thurman 1976, pp. 11–13; and Bennett 1992, p. 55.

Bear Hunt and Falconry from a *Hunts* series

Franco-Flemish, c. 1525
After a design by an unknown artist
Produced at an unknown workshop
259.8 x 337.5 cm (102⁵⁄₁₆ x 132⁷⁄₈ in.)
Gift of Laura A. Shedd Schweppe through the Needlework and Textile
Guild, 1928.191

STRUCTURE: Wool and silk; slit and single and double dovetailed
tapestry weave
Warp: Count: 5–6 warps per cm; wool: S-ply of two Z-spun elements;
diameter: 1.0 mm
Weft: Count: varies from 16 to 24 wefts per cm; wool: S-ply of two Z-spun
elements; pairs of S-ply of two Z-spun elements; diameters: 0.3–1.5 mm; silk:
three yarns of S-ply of two Z-twisted elements; diameters: 0.4–0.6 mm

Conservation of this tapestry was made possible through the generosity of
the James Tigerman Estate.

PROVENANCE: Demotte, Inc., New York, to 1928; sold to the Art Institute,
1928.

REFERENCES: Bennett 1929, p. 32, cover ill. Asselberghs 1970, cat. 25.

EXHIBITIONS: Cathedral of Tournai, *Tapisseries héraldiques et de la vie quo-
tidienne*, 1970 (see Asselberghs 1970).

At the center of a fragment of a bigger tapestry, a large bear stands
on its hind legs, trying to escape from a pack of fierce dogs and a
hunter about to heave a spear into its body. In the lower right corner
a fallen hunter uses a shield to protect himself from the bear's fore-
legs. A nobleman watches the dramatic fight from atop a horse on
the extreme left, while, in the upper half of the tapestry, two ladies
and a nobleman, all on horseback and accompanied by servants and
falconers, conduct another hunt. Ponds and two castles occupy the
far distance. A thin, elongated tree runs from the bottom to the top
of the composition, slightly to the right of center.

This tapestry expresses well the passion for hunting so prevalent
among the European aristocracy of the late Middle Ages and early
modern era.[1] Hunting was not only a nobleman's privilege but also,
like jousting tournaments, an essential part of his education and
courtly training, for it provided intellectual and tactical challenges
as well as emotional and physical tests. The hunt's popularity and
importance generated many practical manuals and romance narra-
tives in the fourteenth and fifteenth centuries.[2] The most famous and
influential was the *Livre de chasse* or Book of Hunting (1387–89) by
Gaston Phébus, Count of Foix. In this treatise, Phébus bore witness
to a nobleman's main occupations: "tout mon temps me suis delité
par espcial en trois choses, l'une est en armes, l'autre est en amour,
et l'autre si est en chasce" (I divide my time among three things in
particular: warfare, love, and hunting).[3] Medieval literature, such as
Gace de La Buigne's immensely popular *Roman des Deduis* or Tale
of Hunting (1359–77), drew a fundamental distinction between

la vénerie (hunting with hounds) and *la fauconnerie* (falconry).[4]
Hounds were praised for the fidelity and efficacy they exhibited,
especially when properly trained and encouraged. They operated in
packs, however, and were therefore less precious than a carefully bred
and trained falcon whose success depended solely on its own skills.

Hunts were considered not only peacetime surrogates for warfare
but also important social events.[5] The assembly before the expedi-
tion and the roistering supper after were colorful feasts attended by
aristocrats and hired huntsmen. Hunts could last several days, and
participating lords traveled with large retinues of fellow aristocrats,
and cooks, musicians, and servants. Women also joined the festivi-
ties, usually admiring the hunters from a safe distance, though they
participated more actively in falconry and hunts held in artificial
settings with the animals assembled in enclosures. The presence of
women made the hunt, with its searches, disappointments, and suc-
cesses, a rich source of courtly, erotic imagery—and explains why
medieval moralists usually criticized the sport.

The tapestry in the Art Institute, which combines *vénerie* and *fau-
connerie*, thus displays both the primitive force and the refined con-
duct that were equally associated with the hunt. It dramatizes what
the *Livre de Chasse* and other manuals describe as the key moment
in the bear hunt. Bears could be spotted and hunted near ponds and
rivers where they came to find greens to eat. According to Phébus,
a pack of hounds and two hunters with heavy spears were sufficient
to kill a bear. The very first thrust with the spear, however, had to be
fatal, for the animal would become very dangerous once wounded.

Bear Hunt and Falconry belongs to a rich corpus of late medieval
Franco-Flemish hunt tapestries. Jean Walois (died before 1452), a
tapestry merchant living in Arras who was purveyor to the Burgun-
dian court, owned cartoons of large hunting scenes.[6] These designs
presumably resembled the famous *Devonshire Hunts* (c. 1430) now in
the Victoria and Albert Museum, London, a set that depicts numer-
ous elegantly dressed aristocrats and evokes a garden party atmo-
sphere.[7] Similar hunt tapestries that can be dated to the middle of the
fifteenth century and show thick foliage on red grounds are in the
Minneapolis Institute of Arts and the Burrell Collection, Glasgow.[8]
Important examples of hunt tapestries woven in northern France or
the Low Countries in the late fifteenth or early sixteenth century are
in the Metropolitan Museum of Art, New York, the Musée National
du Moyen Âge, Paris, and private collections.[9] Though in the past
scholars attributed these and similar tapestries to Arras, Brussels, or
Tournai, recent scholarship has shown that the evidence is insuffi-
cient to attribute them to a specific production center.[10]

The tapestry in Chicago has not received adequate art historical
attention.[11] Jean-Paul Asselberghs, who specialized in medieval and
late medieval tapestry, dated the piece to the second quarter of the
sixteenth century and differentiated it from the tapestries he attrib-
uted to Tournai, based on the crudity of its execution.[12] Asselberghs
did not specify his reasons for assigning an early-sixteenth-century
date, but it can be assumed that he based his judgment on the

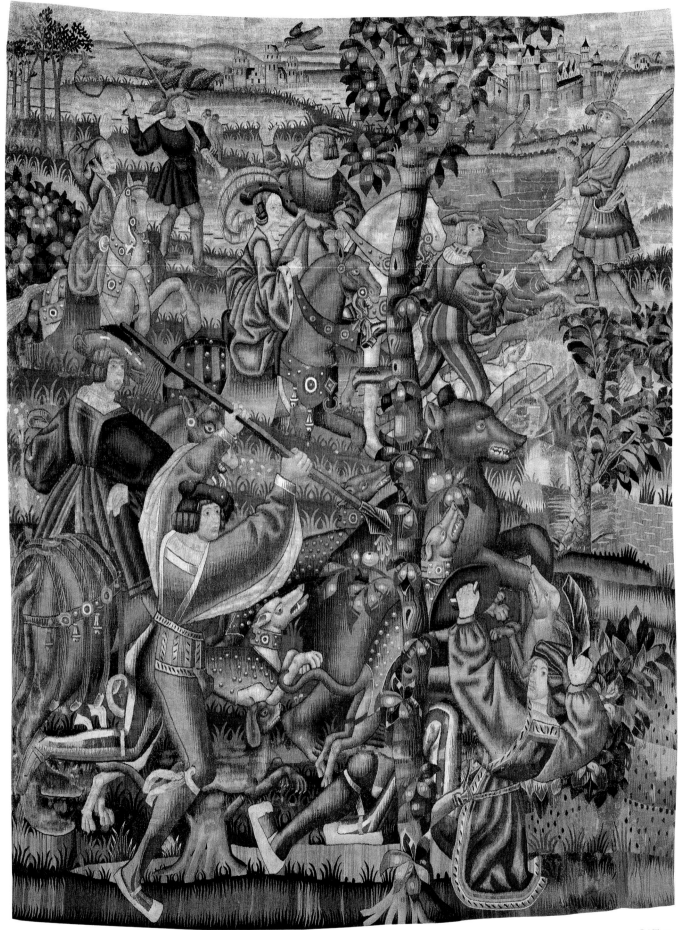

CAT. 7

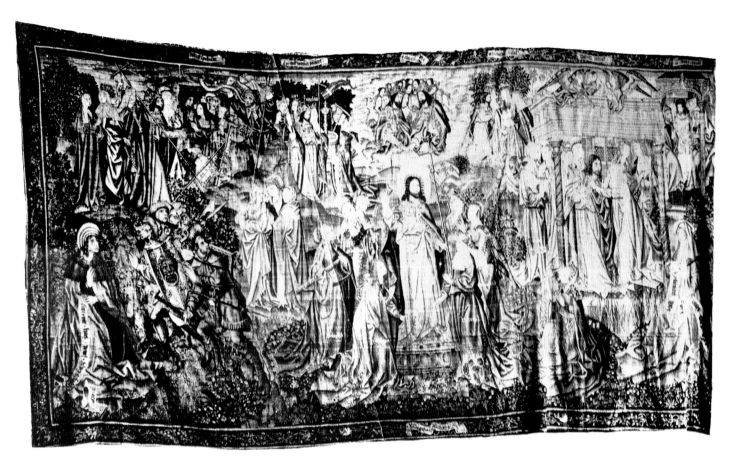

FIG. 2 *The Resurrection*. Wool and silk. Burgos Cathedral, Spain.

fications of a whole spectrum of Virtues add a contemplative note to the tapestries, inviting the beholder to empathize with the different emotions of each episode. The allegorical figures also fulfill a practical role, endowing the various scenes with a degree of continuity, for each Virtue is always represented in the same attire and with the same attributes, and consequently sometimes recognizable even without the aid of a woven name. These personifications accompany the viewer not only through this particular tapestry, but also through each of the other five pieces of the suite. As such, the tapestry suite functions as a type of pictorial equivalent to the *Elckerlyc* morality play, attributed to Pieter van Diest and published in 1495, which was emulated in the 1520s by its more widely known English counterpart, *Everyman*.[3] Indeed, many scholars have observed that the scenes portrayed in these tapestries share the didactic emphases and even echo the stage directions of some fifteenth- and sixteenth-century mystery plays, sermons, and civic pageants. Moreover, as Anna Gray Bennett has remarked, the "plots [of the tapestries] are as intricately interwoven as the voice lines of late medieval music."[4]

Other weavings after the same cartoons have also survived, and are now located in various collections. Two other versions of *The Resurrection* are known: one remains in Burgos Cathedral in northern Spain (fig. 2); the other is in the collection of the Fine Arts Museums of San Francisco.[5] In all, besides the Berwick and Alba suite from which the Art Institute's *Resurrection* comes, at least six other

fragmentary suites woven after the same cartoons have survived. Research by D.T.B. Wood, Adolfo Salvatore Cavallo, Bennett, and Thomas P. Campbell has clarified the early history of some of these editions. François Fouquet, archbishop of Narbonne, gave a ten-piece suite to the Cathédrale Saint-Just-et-Saint-Pasteur in 1673, of which one piece survives.[6] Campbell has recently suggested that Fouquet obtained this suite from the English royal collection: by 1520 Henry VIII owned a fine, gilt-woven edition of this design, which had apparently been purchased in 1502 by his father, Henry VII, from the Brussels tapestry weaver and dealer Pieter van Aelst (c. 1450–1533).[7] This suite was eventually sold as part of the Commonwealth sale in 1651, and may have passed into Fouquet's hands soon after. The inventory of Cardinal Thomas Wolsey's tapestry collection, drawn up between 1521 and 1523, reveals that Wolsey owned a twelve-piece suite with the same designs, possibly composed in part of weavings from larger cartoons that had been divided to make smaller hangings; two pieces, probably from this purchase, remain at Hampton Court, London.[8] Don Juan Rodriguez de Fonseca, bishop of Palencia and Burgos, owned an eight-piece suite, and, after his death in 1524, left four tapestries to the Cathedral of San Antolín in Palencia, where all remain to this day, and four to the Cathedral of Santa María in Burgos, where two remain and two are now in the collection of the Metropolitan Museum of Art, New York.[9] Another edition belonged to the chapter of the Cathedral of Santa María in Toledo, Spain; five

pieces from this suite have survived and are now in the collection of the Fine Arts Museums of San Francisco.[10] A further edition of the series was apparently sold from the Castello Ventoso in Portugal to the early-twentieth-century French antiquarian Fernand Schutz; one piece from this suite is now at the Worcester (Massachusetts) Art Museum, and another is at the Fogg Art Museum, Harvard University, Cambridge, Massachusetts.[11] It is conceivable that this suite from the Castello Ventoso might have been the ten-piece edition called *The Triumph of the Virtues* earlier inventoried in the collection of the dukes of Braganza, the future kings of Portugal.[12] Cavallo also cites a reference to a set from the Vatican that was reportedly sold to a French collector, Richard, by 1878.[13] The survival of numerous other single pieces from fragmented suites implies that this series was frequently rewoven. Its cartoons must not have included borders, for each of the surviving suites is surrounded by a different arrangement: either the flowers and fruit of the Art Institute's *Resurrection*, or the banderoles of Rodriguez de Fonseca's set in Burgos and Palencia, or, finest of all, the combination of trompe l'oeil jewels with birds, flowers, and grapes, of the tapestry in Narbonne.

The allegorical character of the cycle has prompted speculation about its actual, underlying subject matter. Both Henry VII's 1502 purchase and the pre-1523 inventory of Wolsey's collection refer to their tapestries as depictions of "the olde law and the newe," whereas Rodriguez de Fonseca's bequest to Palencia and Burgos describes them as "tapices de las virtudes" (tapestries of the Virtues).[14] The name modern scholarship has given to the set is *The Allegory of the Redemption of Man*. Cavallo's detailed discussion of the iconography of each of the surviving episodes has prompted him to identify the names of the pieces and their sequence as: 1) *The World Is Created and Man Falls from Grace* (examples are in Haarzuilens, Narbonne, and San Francisco); 2) *The Vices Lead Man in a Life of Sin* (Palencia, San Francisco, and the cathedral of La Seo, Saragossa); 3) *Peace and Mercy Win the Promise of Redemption for Man* (Hampton Court, London; Museu de Lamego, Portugal, with some alterations to the composition; New York; and abbreviated versions in the Burrell Collection, Glasgow, and the Victoria and Albert Museum, London); 4) *Christ Is Born as Man's Redeemer* (New York); 5) *Christ the Savior as a Child* (Palencia and Cambridge); 6) *The Virtues Challenge the Vices as Christ Begins His Ministry* (Boston, Palencia, and an abbreviated version in Hampton Court); 7) *The Virtues Battle the Vices as Christ Is Crucified* (Burgos, Haarzuilens, and San Francisco); 8) *Christ Rises and Rescues Man from Hell* (Burgos, Chicago, and San Francisco); 9) *Christ Ascends to Heaven and Man Is Reconciled to God* (Haarzuilens and Palencia); 10) *Christ Makes His Last Judgment and the Vices Are Vanquished* (Paris; Palazzo Venezia, Rome; and Worcester).[15] Cavallo's convincing analysis identifies the tapestry in the Art Institute as the eighth episode in the cycle.

The sheer number of surviving *Redemption of Man* tapestries testifies to the frequency with which the set was rewoven, each time creating sizeable, and therefore expensive, suites. The piece in Nar-

bonne was woven with a mixture of wool, silk, and gilt- and silvered-metal-wrapped threads; all the other surviving sets, including that to which the tapestry in the Art Institute belongs, do not contain precious threads. The high status of the patrons purchasing these sets implies that a great deal of prestige may have been associated with owning an edition: the Narbonne set might have belonged to Henry VII; the pieces in Hampton Court were probably purchased by a cardinal (Wolsey), and later passed into the collection of Henry VIII; and those now in Palencia, Burgos, and the Metropolitan Museum of Art, New York, belonged to a bishop (Rodriguez de Fonseca). In addition, royal Portuguese provenance has been suggested above for the tapestries in Cambridge and Worcester. When displayed in their complete, ten-piece state, each suite would cover a length of wall between 75 and 90 meters (or approximately 250 to 300 feet) long. In Burgos, Palencia, and Toledo, the tapestries would have decorated the choirs of the cathedrals on religious holidays and feast days. The sets that belonged to the nobility and high-ranking prelates such as Henry VII and Wolsey, on the other hand, may not have functioned in purely liturgical settings but might instead have hung in halls of state and been displayed during courtly ceremonies. Campbell has suggested that Wolsey, for example, may have purchased his sizeable edition for the newly refurbished state rooms at York Place, his London palace.[16]

Unfortunately none of the cartoons for *The Redemption of Man* have survived. Judging from the tapestries based on them, the cartoons had probably been created in the early sixteenth century: many aspects of the designs closely resemble elements in other pieces that have been securely dated to this period. Various scholars have noted that particular figures in the *Redemption of Man* designs also appear in other contemporary tapestries: the prophets in the Art Institute's *Resurrection*, for example, correspond closely with the figures of David and Augustine in *The Mass of Saint Gregory*, which Johanna of Castile gave to Isabella the Catholic.[17] The facial types in the *Allegory of the Redemption of Man* tapestries, likewise, are very close to those in the *Birth of the Redeemer as Fulfillment of the Prophesies* in the Patrimonio Nacional, Spain, which Johanna of Castile bought before 1509; and the clusters of figures in richly embellished clothing, with swaths of drapery collecting at their feet, resemble groups in *The Justice of Herkinbald* (Royal Museums of Art and History, Brussels), commissioned by the Leuven Confraternity of the Holy Sacrament in 1513.[18] The principal designer of the *Redemption of Man* tapestries was very talented, managing to illustrate the highly complex iconographical program through subtly contained narrative scenes enclosed in tight and balanced compositions. He clearly made judicious reuse of elements from existing tapestry cartoons, as well as from the work of the previous generation of Netherlandish artists, reusing figure types and even complete compositions first developed by Rogier van der Weyden and later used by artists such as the Master of the View of Saint Gudula and Colijn de Coter. He was probably based in Brussels, the artistic hub of the Southern Netherlands by

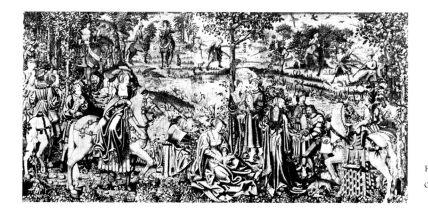

FIG. 1 *Falconry*. Produced at the workshop of Jan de Clerck, c. 1510. Wool and silk. Private collection, France.

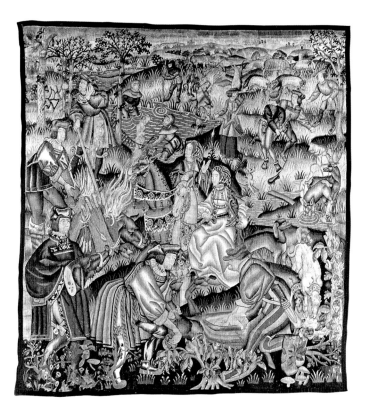

FIG. 2 *The Breaking of the Boar*. Franco-Flemish, c. 1525. Wool and silk; 265 x 238.5 cm. The Burrell Collection, Glasgow, 46.63.

figures' costume and poses and the dynamic composition. The realism of the depiction of the running and falling hunters, and the curving and diagonal lines of the design that carry the viewer's eye into and around the space, are indeed consistent with pictorial developments in the first half of the sixteenth century.[13] The low, square-necked jerkins; the broad, strapped shoes; the wide, slashed sleeves closed at the wrist; the bias-cut hose; the bobbed hair; and the wide, flat hats likewise support the dating of the cartoons to around 1525.[14]

The quality of the weave of *Bear Hunt and Falconry* suggests that it was made in a secondary production center or workshop. It bears a remarkable resemblance to a tapestry depicting *The Breaking of the Boar*, now in the Burrell Collection, Glasgow (fig. 2). The dynamic composition and poses; the visible roots of the trees; the tufts of grass; and the figures' costumes, hairdos, and shoes are identical. It can therefore be assumed that the Art Institute's tapestry and *The*

Breaking of the Boar belonged to the same series and were woven in the same production center.

The cartoon for *Bear Hunt and Falconry* may have been partially recycled from a cartoon used in a *Hunts* suite woven around 1510 by the Brussels tapissier Jan de Clerck, also known as Jan van Antwerpen (fig. 1).[15] The nobleman on the extreme left of the tapestry in Chicago echoes a similarly located rider in De Clerck's *Falconry*. The pose of the hunter heaving his spear resembles, from the waist up, the pose of the kneeling man near the center of *Falconry* who probes bushes with a long stick. Other details, such as the trees' bark and visible roots, and the use of thin, tall trees to define the rhythm of the composition, also suggest a connection between the cartoons used by De Clerck and those used by the anonymous producer of *Bear Hunt and Falconry*.[16]

KB

NOTES

1. Thiébaux 1967; Cummins 1988.
2. Werth 1888; Werth 1889; Strubel and De Saulnier 1994.
3. Phébus 1998, fol. 13r.
4. Cummins 1988, pp. 9–10.
5. Ibid. 1988, pp. 6–8.
6. Lestocquoy 1978, pp. 49–54.
7. Wingfield Digby 1971; Wingfield Digby and Hefford 1980, pp. 12–14.
8. Adelson 1994, pp. 22–35; Wells 1969, pp. 431–57. A critical catalogue of the tapestries in the Burrell Collection is forthcoming.
9. See, respectively, Souchal 1973a, pp. 142–46, 158–62; Cavallo 1993, pp. 359–72; Joubert 1987, pp. 122–26, 168–78, 186–87.
10. For a concise introduction, see Cavallo 1993, pp. 57–77.
11. Bennett 1929 offers only a description of the piece and some general, by now out-of-date, remarks on medieval tapestry.
12. Asselberghs 1970, p. 1, cat. 25.
13. Jan van der Stock, a specialist in fifteenth- and sixteenth-century art, is also inclined to date *Bear Hunt and Falconry* around 1525; conversation with the author, Jan. 2007.
14. Davenport 1976, pp. 374–75, 393, 471.
15. The circa 1510 *Hunts* suite is in a French private collection. Souchal 1973a, pp. 158–62. For further discussion of this set, see Balis et al. 1993, pp. 111–12. For De Clerck, see Roobaert 2002.
16. The *Hunts* series by De Clerck can in turn be linked to a Franco-Flemish tapestry in the Rijksmuseum, Amsterdam (*Picking Oranges*; inv. BK-1953-30); Hartkamp-Jonxis and Smit 2004, pp. 47–49.

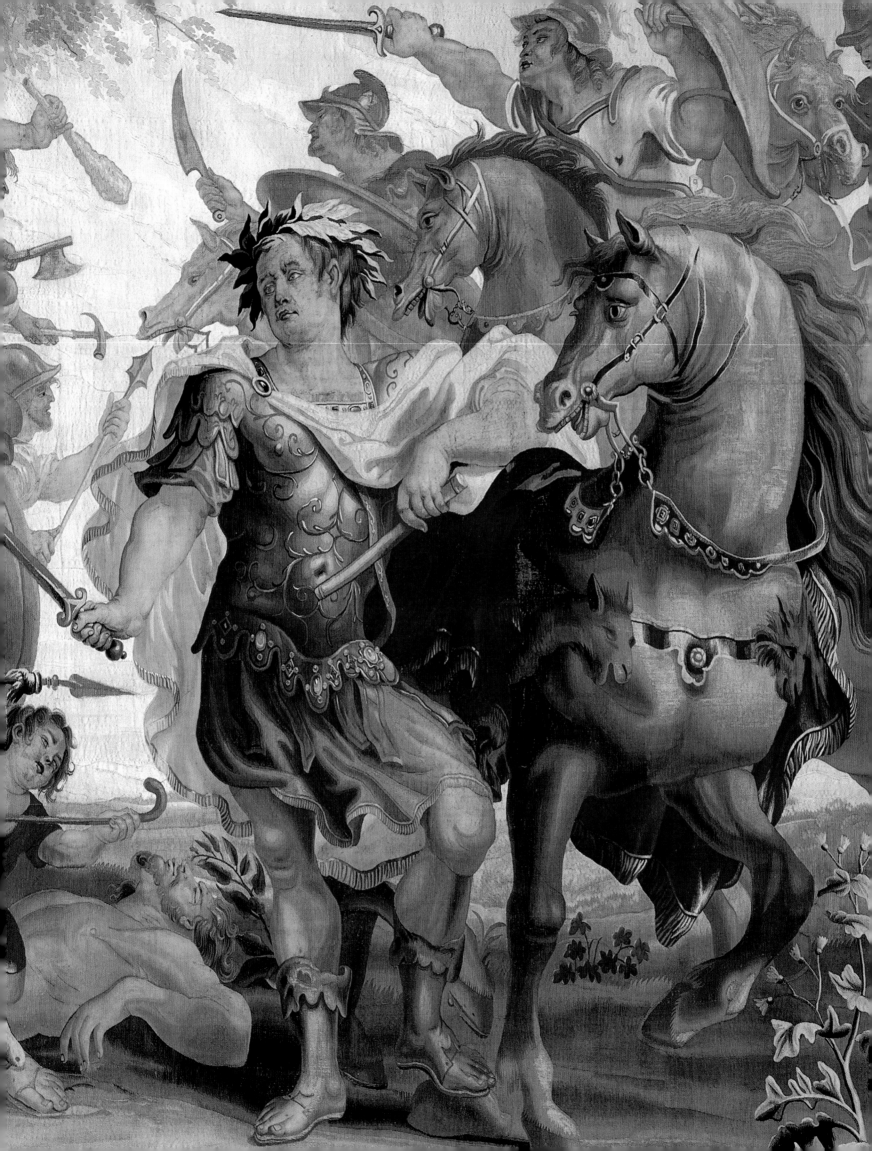

❧ II ❧
FLEMISH TAPESTRIES
1500–1750

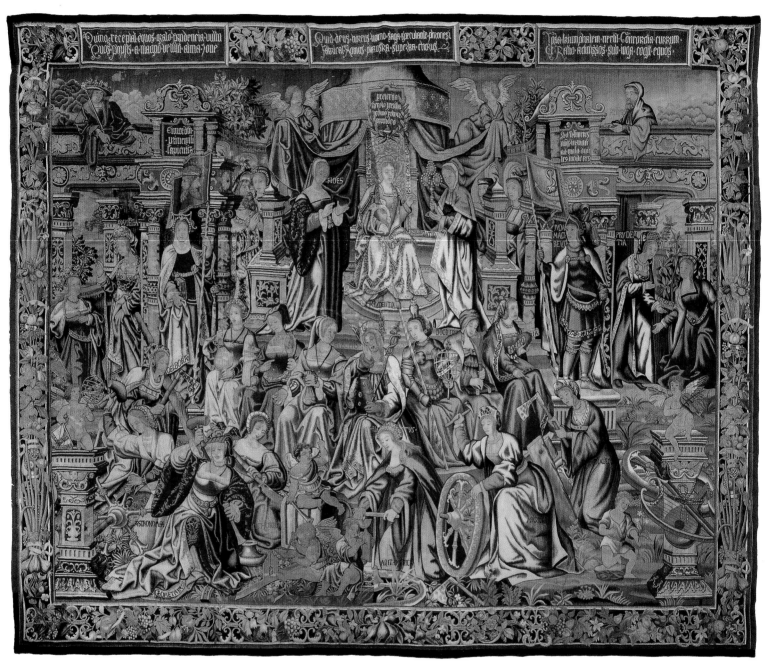

CAT. 8A

From *Los Honores*

Prudentia

Brussels, 1525/32 (left side); Belgium or France, 1905/08 (right side)
Presumably after a design by Bernard van Orley (c. 1488–1541) and unidentified artists, 1520/25
Possibly produced at the workshop of Pieter van Aelst (c. 1450–1533; left side); produced at an unknown workshop (right side)
567.1 x 466.9 cm (223¼ x 183½ in.)
INSCRIBED: *Quinque· receptat· equos· grato· prudencia· vultu / Quos· physis · a· magno· detulit· alma· iove; Quid· deus· horcus· homo· saga· speculante· ph ronesi / Fabricat· Aonius· plaustra· superba· chorus; ipsa· triumphalem· nectit· concordia · currum / et· ratio· admissos· sub· iuga· cogit· equos; Ipsa· triumphal em· nectit· Concordia· currum· / Et· Ratio· admissos· sub· iuga· cogit· equos· ; timor domini / · principium / · sapientiae; praeterita recolo, praesentia ordino, futura prevideo; Si deum timeres, nunquam in manibus ad mala ducentes incideres*
Gift of Col. C. Michael Paul, 1965.1159

PROVENANCE: See below.

STRUCTURE: Wool and silk; slit, dovetailed, and double interlocking tapestry weave
Warp: Count: 7–8 warps per cm; wool: S-ply of three Z-spun elements; diameters: 0.5–1.0 mm
Weft: Count: varies from 16 to 32 wefts per cm; wool: S-ply of two Z-spun elements; diameters: 0.4–1.0 mm; silk: S-ply of two Z-twisted elements (maybe replacement wefts); diameters: 0.4–0.9 mm[1]

REFERENCES: See below.

Justitia

Brussels, 1525/32 (top left corner and center of lower section); Belgium or France, 1905/08 (remaining sections)
Presumably after a design by Bernard van Orley (c. 1488–1541) and unidentified artists, 1520/25
Possibly produced at the workshop of Pieter van Aelst (c. 1450–1533; top left corner); produced at an unknown workshop (remaining sections)
INSCRIBED: *Motus· ob· audaces· Phaetontis· Juppiter· ausus· / Turbat· in· ultrices· ora· cadentis· aquas· ; Cui· pia· supremi· cura· est· cultura· Tonantis · / hunc· beat· eterna· nobilitate· deus· ; Sisyphus· Ixion· Tityus· Phineu[s] / Seua· luunt· iustis· crimina· ; justis / remunero.protego / bonos.castigio.nocere*
511.8 x 454.03 cm (201½ x 178¾ in.)
Gift of Col. C. Michael Paul, 1969.869

PROVENANCE: Cardinal Évrard de La Marck, Prince-Bishop of Liège (died 1538), from 1525/32 to 1538; by descent to his godson, Robert III de La Marck, Count of Arenberg (died 1544); by descent to his sister, Countess Marguerite de La Marck, Princess of Arenberg (died 1599), given to her son, Robert de Ligne, Prince of Arenberg and Barbançon (died 1614); sold to his brother, Charles de Ligne, Prince of Arenberg, Duke of Aarschot (died 1616), 1602; by descent to his son Philippe Charles, Prince of Arenberg,

Duke of Aarschot and Croy (died 1640); by descent to his son, Philippe François, Duke of Arenberg (died 1674); probably by descent to his brother Charles-Eugène, Duke of Arenberg, Aarschot, and Croy (died 1681); probably by descent to his son Philippe-Charles-François, Duke of Arenberg, Aarschot, and Croy (died 1691); by descent to his son Leopold-Philippe, Prince and Duke of Arenberg, Duke of Aarschot and Croy (died 1754) and his wife Marie-Françoise Pignattelli, Princess of Bisaccia and Countess of Egmont (died 1766);[2] probably by descent through the dukes of Arenberg and Aarschot; probably by descent to Engelbert-Auguste, Duke of Arenberg, Aarschot, and Meppem, Prince of Recklinghausen (died 1875); by descent to his son, Engelbert-Marie, Duke of Arenberg, Aarschot, and Meppem, Prince of Recklinghausen (died 1949); probably by descent to his son, Engelbert-Charles, Duke of Arenberg, Aarschot, and Meppem, Prince of Recklinghausen (died 1974). Sold, Sotheby's, London, Duke of Meppem sale, Oct. 17, 1958, lot 138 (*Justitia*), lot 140 (*Prudentia*), probably to Perez and Company, London; sold, Galerie Fisher, Lucerne, June 21–27, 1960, lot 428. Wildenstein and Company, New York, to 1965; sold to Col. C. Michael Paul (died 1980), New York, 1965 (*Prudentia*), by 1969 (*Justitia*); given to the Art Institute, 1965 (*Prudentia*), 1969 (*Justitia*).

STRUCTURE: Wool and silk, slit and dovetailed tapestry weave
Warp: Count: 6 warps per cm; wool: S-ply of three Z-spun elements; diameters: 0.4–0.7 mm
Weft: Count: varies from 16 to 38 wefts per cm; wool: S-ply of two Z-spun elements; pairs of S-ply of two Z-spun elements; paired yarns of S-ply of two Z-spun elements and a single Z-spun element; diameters: 0.4–1.5 mm; silk: S-ply of two Z-twisted elements (may be replacement wefts); diameters: 0.4–1.0 mm; wool and silk: paired yarns of S-ply of two Z-spun wool elements and S-ply of two Z-twisted silk elements; diameters: 1.0–1.4 mm

REFERENCES: Steppe and Delmarcel 1974, pp. 46–47, figs. 7 (1965.1159), 8 (1969.869). Mayer Thurman 1979, pp. 4–6 (1969.869 only), figs. 1–3. Delmarcel 2000, pp. 37–40, figs. 33 (1965.1159), 37 (1969.869).

Prudentia and *Justitia* belong to the *Honores* suite woven between 1525 and 1532 for Cardinal Évrard de La Marck (1472–1538), Prince-Bishop of Liège. The suite was a reedition of the famous *Honores* set commissioned around 1519 or 1520 to celebrate either the election or coronation of Charles V as Holy Roman Emperor. The series has been studied meticulously by Guy Delmarcel, to whose work the present essay is heavily indebted.[3] The *editio princeps* of the series, which is now in La Granja de San Ildefonso, Segovia, consists of nine tapestries.[4] The size of the suite (a total surface area of 403 square meters) and the dazzling number of figures depicted (no fewer than 336) make it the most sumptuous and visually complex tapestry set ever conceived and executed.

Each piece presents a theatrical tableau that prominently features an allegorical female figure standing or sitting in the center of the composition, surrounded by a plethora of other allegorical figures

FLEMISH TAPESTRIES ❖ 75

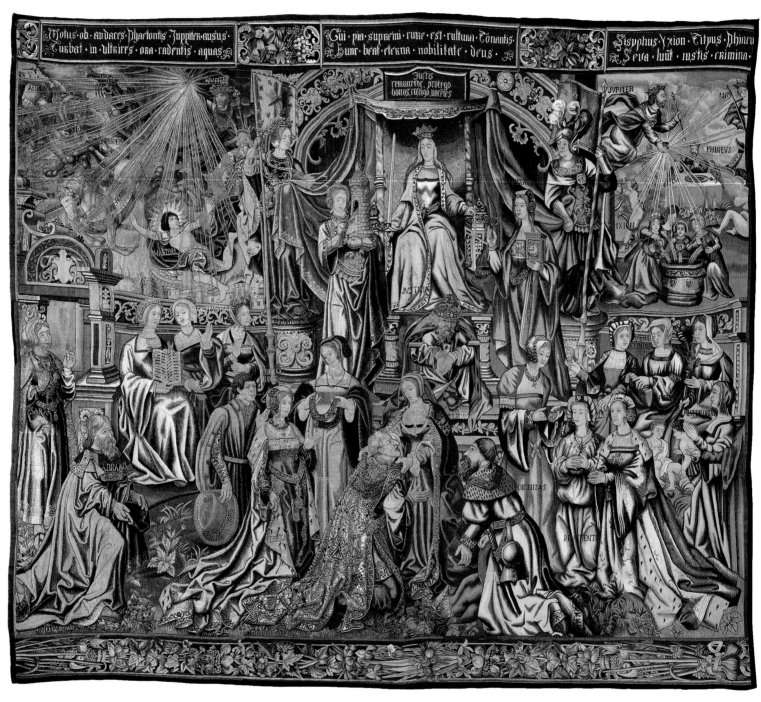

CAT. 8B

derived from various literary and religious sources, whose names are incorporated in the weaving. These figures exemplify the qualities represented by the principal allegorical figure, or their opposites. The set thus forms a didactic program, a manual of morality, that reveals the virtues a ruler must practice to overcome the mutability of *Fortuna* (Fortune), the subject of the first piece in the series, and to avoid *Infamia* (Infamy), the subject of the last tapestry. The sequence of the intermediate pieces is: *Prudentia* (Prudence), *Virtus* (Virtue), *Fides* (Faith)*, Honor* (Honor), *Fama* (Fame), *Justitia* (Justice), and *Nobilitas* (Nobility).[5] This complex iconographic program was presumably created by a team of erudite scholars who consulted an impressive range of ancient and medieval didactic and philosophical writings to compile a lavish mirror for princes.

No archival material discloses the identity of the designer of the *Honores* series. Stylistic features such as the Italian Renaissance-inspired architectural and figural motifs suggest that Bernard van Orley, by far the most prolific tapestry designer of the first half of the sixteenth century, was involved in the creation of the set, but stylistic inconsistencies reveal that other painters also contributed.[6] Documentary evidence reveals that the *editio princeps* was produced at the workshop of Pieter van Aelst, also known as Pieter van Edingen, who dominated the industry between about 1500 and 1530.[7] It is possible that he also produced the reedition of the pieces for the cardinal.

La Marck's set is a simplified version of the *editio princeps;* the tapestries are smaller and have fewer figures. Nonetheless, they still present an elaborate iconographic program, as examination of the two tapestries in the Art Institute shows. *Prudentia* is based on the *Anticlaudianus*, a moral philosophical epic written between 1181 and 1184 by the theologian Alain de Lille. This long allegorical poem relates how Prudence created an ideal man at the urging of the other Virtues, and how, with their help, this new man defeated the Vices.[8] The *Anticlaudianus* begins with a debate in which Concord, Nature, Prudence, and Reason conclude that the creation of a better man is feasible. They concede, however, that only God could give the man a soul, and Prudence is assigned to travel to heaven to request one. The Virtues' debate is depicted in the upper section of the tapestry, where Prudence sits enthroned. The text above her head reads *praeterita recolo, praesentia ordino, futura prevideo* (I collect past things, I arrange present things, I foresee future things), an allusion to Prudence's three main components: *memoria* (memory), *intellegentia* (intelligence), and *providentia* (providence). Ratio (Reason) and Fides (Faith), who replaces Lille's Nature, flank Prudence. This modification shows that the compiler of the iconographic program wanted to convey the message that faith in the revealed religion of Christianity was as necessary to a better man as wisdom and reason, a sentiment underlined by the Latin texts to the left and right of Prudence's canopy. On the left King Solomon points to a cartouche with a biblical verse attributed to him: *timor domini / · principium / · sapientiae* (The fear of the Lord is the beginning of wisdom; Prov. 1:7). On the right the legendary Hermes Trismegistos points to a car-

touche with the text *Si deum timeres, nunquam in manibus ad mala ducentes incideres* (If you fear God, you will never fall into the hands of those who lead to evil). On either side of the debate are standard-bearers. Deborah, on the left, holds a banner depicting the head of Janus encircled by a snake. Her companion is Judas Maccabaeus, whose banner represents a dolphin twisted around an anchor, both emblems of Prudence. Her component virtues sit in a semi-circle at the foot of the stage: Intellegentia (Intelligence), Cautio (Precaution), Circumspectio (Circumspection), Intellectus (Understanding), Providentia (Providence), Docilitas (Docility), and Memoria (Memory).

Below these personifications, the Liberal Arts assemble the chariot in which Prudence will travel to heaven. From left to right are Astronomia (Astronomy), Grammatica (Grammar), Geometria (Geometry), Rhetorica (Rhetoric), Arithmetica (Arithmetic), Musica (Music), and Logica (Logic). They are accompanied by cherubs. The construction of the chariot is mentioned in the central inscription in the top border of the tapestry: *Quid · deus · horcus · homo · sa ga · speculante · phronesi / Fabricat · Aonius · plaustra · superba · chorus* (While Phronesis [Wisdom], the wise woman, speculates on what is God, what hell, what man, / The Aonian choir [the Liberal Arts] construct superb chariots [*sic*]).

The remaining inscriptions in the top border of *Prudentia* relate to the scenes to the left and right of Prudence's standard-bearers. These scenes, however, are incomplete as the tapestry in Chicago does not depict the complete cartoon. The inscription on the left reads *Quinque · receptat · equos · grato · prudencia · vultu / Quos · physis · a · magno · detulit · alma · iove* (Prudence with a smiling face receives five horses / Which bountiful Nature has brought from mighty Jove). The *Anticlaudianus* tells that Jupiter sent Nature the Five Senses from heaven in the shape of horses, and Nature subsequently presented the horses to Prudence to pull her chariot. The meeting between Nature and Prudence is shown in the scene on the left in the tapestry from the La Marck suite; the *editio princeps* also includes Jupiter and the horses. The inscription on the right reads *ipsa · triumphalem · nectit · Concordia · currum · / Et · Ratio · admissos · sub · iuga · cogit · eq uos* (Concord herself fastens together the triumphal chariot / And Reason forces the unbridled horses under the yoke). Though the *editio princeps* features both the chariot and Prudence's journey, the tapestry in the Art Institute only shows Concord inviting Prudence to commence her trip.

Prudentia illustrates a virtue that pertains to the ruler's private ethics—by distinguishing between good and evil he can lead a virtuous life—whereas the other piece in Chicago, *Justitia*, illustrates a virtue relevant to the ruler's public function: by rewarding the good and punishing the bad, he safeguards the social order.[9] The tapestry shows Justice enthroned below a baldachin, flanked by Fortitudo (Fortitude) and Temperantia (Temperance). Above her head, an inscription reads *justis / remunero · protego / bonos · castigio · nocere* (Justice rewards and protects the good, and punishes the evil). The

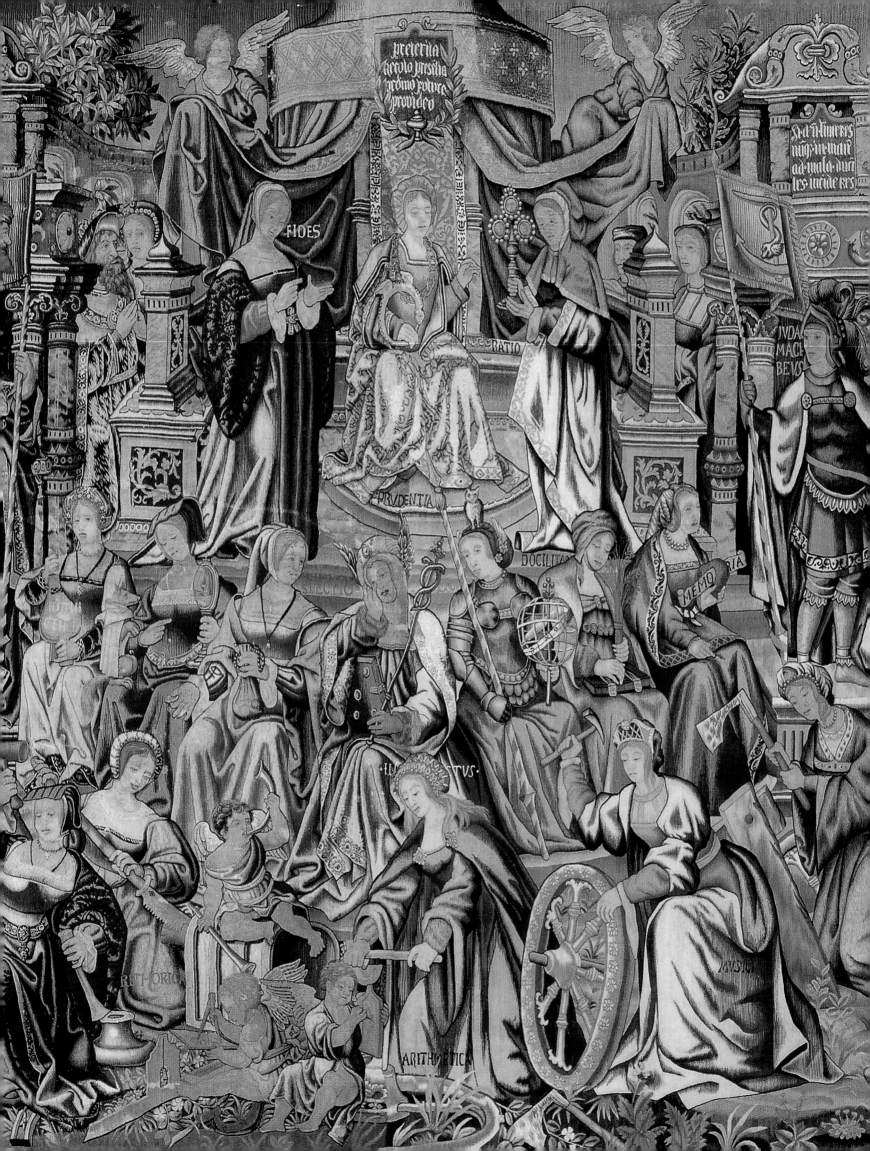

FIG. 1 Infrared photograph of cat. 8a.

FIG. 2 Infrared photograph of cat. 8b.

emperor Nero, whom Justice has captured, sits, defeated, at her feet. This central group is flanked by two standard-bearers who open the baldachin. Tomyris stands to the left; Scipio to the right. Each carries a banner showing a queen bee surrounded by her swarm. This motif presents an image of the ideally constituted monarchic state popular since antiquity: like worker bees, the whole nation follows its benevolent, "stingless" ruler; like a hive without its queen, if the ruler is captured, the whole nation is lost.

The middle section of the tapestry depicts three virtues seated near Fortitude—Veritas (Truth), Observantia (Consideration) and Concordia (Concord)—and three seated near Temperance—Verecundia (Modesty), Fiducia (Trust), and Misericordia (Mercy). In the bottom section three personifications hand out gold chains to the just. At the left Reverentia (Respect) is shown with Rebecca and Isaac, in the center is Gratia (Kindness) with David and Jacob, and at the right Dignitas (Dignity) is accompanied by Rachel and Esther. David's central position connects *Justitia* with the next piece in the *Honores* sequence, *Nobilitas*, in which he plays a leading role. This link is further strengthened by the central inscription in the top border of *Justitia*: *Cui · pia · supremi · cura · est · cultura · Tonantis · / hunc · beat · eterna · nobilitate · deus ·* (He whose pious care is to honor the supreme Thunderer / Him the God blesses with eternal nobility).

The upper corners of *Justitia* illustrate the cruel fate of the wicked with scenes from classical mythology. The fall of Phaeton, son of the sun-god Helios, caused by Jupiter's lightning, is at the left; an inscription in the top border above the scene describes the episode: *Motus · ob · audaces · Phaetontis · Juppiter · ausus · / Turbat · in · ultrices · ora · cadentis · aquas* (Jupiter moved by Phaeton's rash attempts / Throws his countenance into confusion as he falls into the vengeful waters). The upper right corner depicts the punishments of some of the damned,

as the inscription in the top border explains: *Sisyphus · Ixion · Tityus · Phineu[s] / Seua · luunt · iustis · crimina ·* (Sisyphus, Ixion, Tityus, Phineus, and the flock of Danaids / Atone for their savage crimes with just penalties). Ixion's punishment—he was bound to a flaming wheel that traveled across the heavens—is depicted next to Scipio. Phineus, whose food is constantly snatched from him by the Harpies, is to Ixion's right. Below Phineus are the Danaids, condemned to pour water into a basin whose spouts immediately drain it away. The *Justitita* in the Art Institute lacks the extreme right section of the cartoon of the *editio princeps,* which depicts Juno, Ixion, Tityus, and Sisyphus.

Prudentia and *Justitia* were first mentioned in 1532 as part of a suite comprised of "vii pieches de gloria immortalis" (seven pieces showing immortal fame), which hung in the Castle of Huy, one of La Marck's main residences.[10] A very important player on the European political scene during the first half of the sixteenth century, the cardinal was instrumental in the election of Charles V in 1520, and the two men remained close allies until La Marck's death in 1538. It is therefore logical to assume that the cardinal was given an abridged version of Charles V's famous set, or granted permission to obtain one. The 1532 document mentioning La Marck's version, however, shows that it consisted of only seven tapestries. Delmarcel convincingly argued that the two pieces of the original set that were not rewoven for La Marck were *Nobilitas*, as it was closely related to the coronation of Charles V, and *Infamia*, which featured imagery that was particularly appropriate for a young prince, but less so for a cardinal.

Thanks to Delmarcel's extensive archival research, the subsequent history of the reedition can now be reconstructed.[11] After La Marck's death, the series was inherited by his godchild and universal heir Robert III de La Marck, Count of Arenberg. After Robert

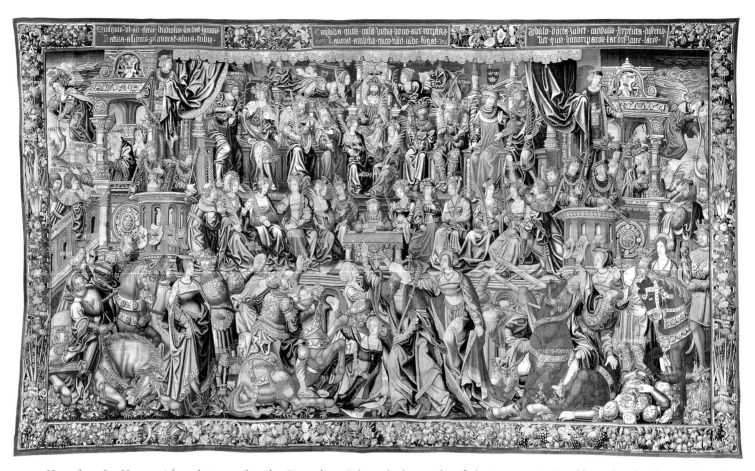

FIG. 3 *Honor* from *Los Honores*. After a design attributed to Bernard van Orley and other, unidentified artists, 1520/25. Possibly produced at the workshop of Pieter van Aelst. Wool and silk; 450.2 x 802.6 cm. Private collection.

III's death, the suite passed to his sister Countess Marguerite de La Marck, Princess of Arenberg, who in 1594 gave the tapestries to her youngest son, Robert de Ligne, Prince of Arenberg and Barbançon. Financial problems, however, forced him to sell the suite to his elder brother, Charles de Ligne, Prince of Arenberg, in 1602. In 1616 "une tapisserie de haute liz de la gloire immortelle en nombre de six fort grandes pieces" (a suite of six rather large *haute-lisse* pieces depicting immortal fame) was listed among Charles's possessions, which implies one tapestry was lost between 1602 and 1616.[12] Charles's son, Prince Philippe Charles of Arenberg, inherited the reduced suite and had it restored in 1638.[13] Philip's son and successor, Duke Philippe François of Arenberg, kept the set in his residence in Brussels, where it was recorded in an inventory in 1649. The suite remained in the possession of the Arenberg family during the second half of the seventeenth century, but a second piece was lost between 1649 and 1711. At least some of the five remaining tapestries may have been in bad condition, for in 1767 the family of Leopold-Philippe, Duke and Prince of Arenberg, considered selling the suite. But this plan never came to fruition, and the five tapestries remained in the family.

In 1878, however, the Brussels historian Alphonse Wauters recorded only three *Honores* tapestries in the Arenberg collection: *Fides, Honor,* and *Virtus*.[14] *Honor* and *Virtus* were in good condition and

featured in a number of exhibitions at the beginning of the twentieth century.[15] In 1905 one Leroy appraised the *Honores* tapestries in the Arenberg collection.[16] He recorded four tapestries. Besides *Honor* and *Virtus*, there were two fragments, both in bad condition: one showing "Phaéton précipité de son char" (Phaeton thrown from his chariot), and another depicting "une femme sur un trône entourée des Vertus théologales, groupes de personnages historiques et figures allégoriques" (an enthroned woman surrounded by theological Virtues, groups of historical personages, and allegorical figures). This latter tapestry was actually composed of *Fides* attached to the left side of *Prudentia*, as a description recorded in 1906 reveals. The fragment showing Phaeton was all that was left of *Justitia*.[17]

The 1905 and 1906 reports indicate that the right half of *Prudentia* had been lost and was completely rewoven after 1905, along with the larger part of *Justitia*.[18] The twentieth-century sections are clearly visible in infrared photographs, which reveal artificial dyes that did not exist when the tapestries were first made (figs. 1–2).[19] *Prudentia* and *Justitia* must have been rewoven between 1905 and 1909, as they were hung in the newly built grand staircase of the Arenberg palace in Brussels in 1909, together with *Honor, Virtus,* and *Fides*.[20] It is not known who rewove the tapestries.

One of the five surviving tapestries, *Honor*, was sold by the Aren-

berg family in 1946.[21] In the second half of the twentieth century this piece was in the collection of Wildenstein and Company, New York, which sold it to a European private collection (fig. 3).[22] The four remaining tapestries, including *Prudentia and Justitia*, were sold by the Arenberg family at auction in 1958.[23] *Fides* and *Virtus* became the property of the Burrell Collection, Glasgow.[24] *Prudentia* and *Justitia* were presumably sold to the London art dealer Perez, and two years later, in 1960, were sold again, at an auction in Lucerne. Like *Honor,* Wildenstein and Company owned the tapestries until Colonel C. Michael Paul purchased them and subsequently gave them to the Art Institute. KB

NOTES

1. Large portions of both cats. 8a and 8b were rewoven at an unknown date in an unknown workshop. The structural analyses were performed in areas thought to be original.
2. Delmarcel 1981, pp. 78–82; Delmarcel 2000, pp. 37–38.
3. Delmarcel 1971; Delmarcel 1977; Delmarcel 1979; Delmarcel 1981; Delmarcel 2000. For a concise synopsis and further discussion of the genesis of the *editio princeps*, see Campbell 2002c, pp. 175–85.
4. The suite is part of the Spanish Patrimonio Nacional; Junquera de Vega, Herrero Carretero, and Díaz Gallegos 1986, vol. 1, pp. 35–44.
5. The set derives its name from the *Honor* piece that was sent to Charles V in 1526 as a sample to encourage him to purchase the whole suite.
6. Delmarcel 2000, pp. 29–36.
7. Campbell 2002c, pp. 131–33.
8. For *Prudentia*, see Delmarcel 2000, pp. 59–69.
9. For *Justitia*, see ibid., pp. 115–23.
10. Steppe and Delmarcel 1974, p. 48.
11. Delmarcel 1981, pp. 78–82, offers the most detailed reconstruction.
12. Steppe and Delmarcel 1974, p. 53.
13. Delmarcel 2002, p. 346.
14. Wauters 1878, pp. 94–95.
15. Delmarcel 1981, p. 80.
16. Ibid.
17. Ibid.
18. Another fragment of the Chicago *Justitia*, showing Abraham and Antoninus, was sold in Brussels in 1921 and was in a private collection in Los Angeles in 1981; Delmarcel 1981, p. 82.
19. Christa C. Mayer Thurman was the first to use infrared photography to determine that these pieces had been partially rewoven; see Mayer Thurman 1979, pp. 4–6.
20. Laloire 1952, pp. 155–56, 160.
21. Steppe and Delmarcel 1974, p. 53.
22. Joseph Baillio, Vice President, Wildenstein and Company, e-mail message to Christa C. Mayer Thurman, 2005; and verbal discussion with Christa C. Mayer Thurman, 2006.
23. Sotheby's, London, Oct. 17, 1958, lots 138–41; Delmarcel 1981, p. 71.
24. A catalogue of the tapestries in the Burrell Collection is forthcoming.

CAT. 9A

February

Brussels, before 1528
After a design by an unidentified Flemish artist in the circle of Bernard van Orley (c. 1488–1541), c. 1525
Produced at an unknown workshop
INSCRIBED: *FEBRVARIVS*; *CIRCIVS*; [*B*]*OREAS*
402 x 427.3 cm (158 x 169 in.)
Gift of Mrs. Chauncey McCormick and Mrs. Richard Ely Danielson, 1950.1578

STRUCTURE: Wool and silk, slit and double interlocking tapestry weave
Warp: Count: 6 warps per cm; wool: S-ply of six Z-spun elements; ; diameters: 0.8–1.0 mm
Weft: Count: varies from 26 to 60 wefts per cm; wool: S-ply of two Z-spun elements; pairs of S-ply of two Z-spun elements; diameters: 0.2–1.0 mm; silk: pairs of S-ply of two Z-twisted elements; diameters: 0.25–0.7 mm

Conservation of this tapestry was made possible through the Allerton Endowment Fund.

PROVENANCE: Marie Particelli (died 1670), Hôtel La Vrillière, Paris, by 1672; by descent to her husband, Louis Phélypeaux de La Vrillière (died 1681), to at least 1684. Jacques Seligmann (with *July*), to 1914; sold, Galerie Georges Petit, Paris, Mar. 16–17, 1914, lot 222, to Lehmann Bernheimer, Munich; sold (with *July*) to James Deering (died 1925), June 18, 1914; by descent to his nieces, Mrs. Chauncey McCormick (née Marion Deering, died 1965) and Mrs. Ely Danielson (née Barbara Deering, died 1982);[1] given to the Art Institute, 1950.

REFERENCES: Ackerman 1933, p. 380 n. 15. Harshe and Rich 1934, p. 7. Standen 1971a, p. 13 n. 15. Standen 1981b, p. 25. Standen 1985, vol. 1, p. 45. Boccardo 1989, pp. 79, 86 n. 21. Adelson 1994, pp. 87, 90 nn. 28, 30, fig. 35. Hartkamp-Jonxis and Smit 2004, p. 71. Vittet 2004, p. 176. Boccardo 2006, pp. 113, 130 n. 11.

CAT. 9B

July

Brussels, before 1528
After a design by an unidentified Flemish artist in the circle of Bernard van Orley (c. 1488–1541), c. 1525
Produced at an unknown workshop
INSCRIBED: *JVLIVS*; *RVMANA CONCINE*; *PESTILENCE*; *QVINANCIE*; *FEBRE*; *PLEURESIS*
399.7 x 448.3 cm (157⅜ x 176½ in.)
Gift of Mrs. Chauncey McCormick and Mrs. Richard Ely Danielson, 1950.1579

STRUCTURE: Wool and silk, slit and double interlocking tapestry weave
Warp: Count: varies from 8 to 10 warps per cm; wool: S-ply of six Z-spun elements; diameters: 0.4–0.7 mm
Weft: Count: varies from 22 to 44 wefts per cm; wool: S-ply of two Z-spun

elements; S-ply of three Z-spun elements; pairs of S-ply of two Z-spun elements; diameters: 0.2–1.0 mm; silk: pairs of S-ply of two Z-twisted elements; three yarns of S-ply of two Z-twisted elements; diameters: 0.15–0.5 mm

Conservation of this tapestry was made possible through the Allerton Endowment Fund.

PROVENANCE: Marie Particelli (died 1670), Hôtel La Vrillière, Paris, by 1672; by descent to her husband, Louis Phélypeaux de La Vrillière (died 1681), to at least 1684. Polycarpe Charles Séchan (with *August* and *October* [now in the Metropolitan Museum of Art, New York] and *September* [now in the Minneapolis Institute of Arts]), to 1875; sold, Hôtel Drouot, Paris, Feb. 22–27 and Mar. 1–4, 1875, lot 906 (with *August*, *October*, and *September*), to Dreyfus de Gonzales; sold, Galerie Georges Petit, Paris, June 1–4, 1896, lot 252 (*July* only). Jacques Seligmann (with *February*), by 1905; sold, Galerie Georges Petit, Paris, Mar. 16–17, 1914, lot 223, to Lehmann Bernheimer, Munich; sold (with *February*) to James Deering (died 1925), June 18, 1914; by descent to his nieces, Mrs. Chauncey McCormick (née Marion Deering, died 1965) and Mrs. Ely Danielson (née Barbara Deering, died 1982);[2] given to the Art Institute, 1950.

REFERENCES: Destrée 1906, vol. 1, pp. 40–41 n. 19, vol. 2, table 7. Breck 1920, p. 3. Göbel 1923, vol. 1, pp. 166–67, vol. 2, table 146. Ackerman 1933, p. 380 n. 15. Harshe and Rich 1934, p. 7. Standen 1971a, p. 13 n. 15. Farmer 1973, p. 19 (ill.). Standen 1981b, p. 25. Standen 1985, vol. 1, p. 45. Boccardo 1989, pp. 79, 86 n. 21. Adelson 1994, pp. 87, 90 nn. 28, 30, fig. 37. Thurman and Brosens 2003, p. 175, fig. 2. Hartkamp-Jonxis and Smit 2004, p. 71. Vittet 2004, p. 176. Boccardo 2006, pp. 113, 130 n. 2.

EXHIBITIONS: Brussels, *Exposition d'Art Ancien Bruxellois*, 1905.[3]

CAT. 10

October

Brussels, 1525/50
After a design adapted from part of a larger design by an unknown Flemish artist in the circle of Bernard van Orley (c. 1488–1541), c. 1525
Produced at an unknown workshop
195.8 x 298.1 cm (77 x 117⅜ in.)
Gift of Mrs. Stanley Keith, 1958.281

STRUCTURE: Wool and silk, slit and double interlocking tapestry weave
Warp: Count: 8 warps per cm; wool: S-ply of four Z-spun elements; diameter: 1.0 mm
Weft: Count: varies from 20 to 36 wefts per cm; wool: single S-spun elements; S-ply of two Z-spun elements; pairs of S-ply of two Z-spun elements; paired yarns of single S-spun elements and S-ply of two Z-spun elements; three yarns of S-ply of two Z-spun elements; diameters: 0.35–1.0 mm; silk: pairs of S-ply of two Z-twisted elements; diameters: 0.7–0.9 mm; wool and silk: paired yarns of S-ply of two Z-spun wool elements and S-ply of two Z-twisted silk elements; paired yarns of S-spun wool elements and S-ply of two Z-twisted silk elements; diameters: 0.5–0.85 mm

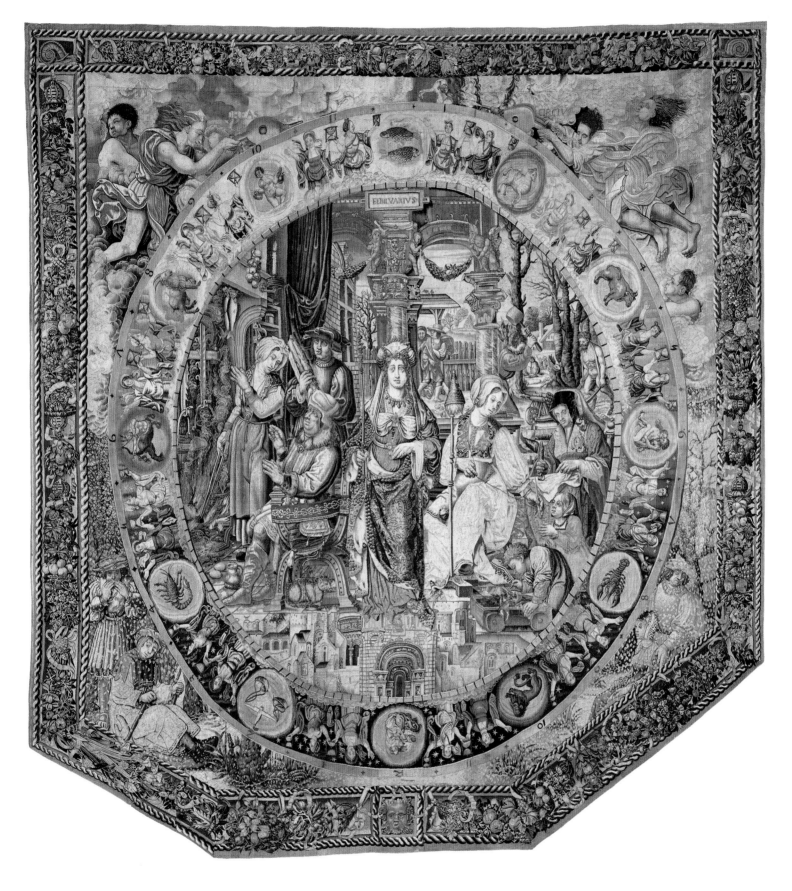

CAT. 9A

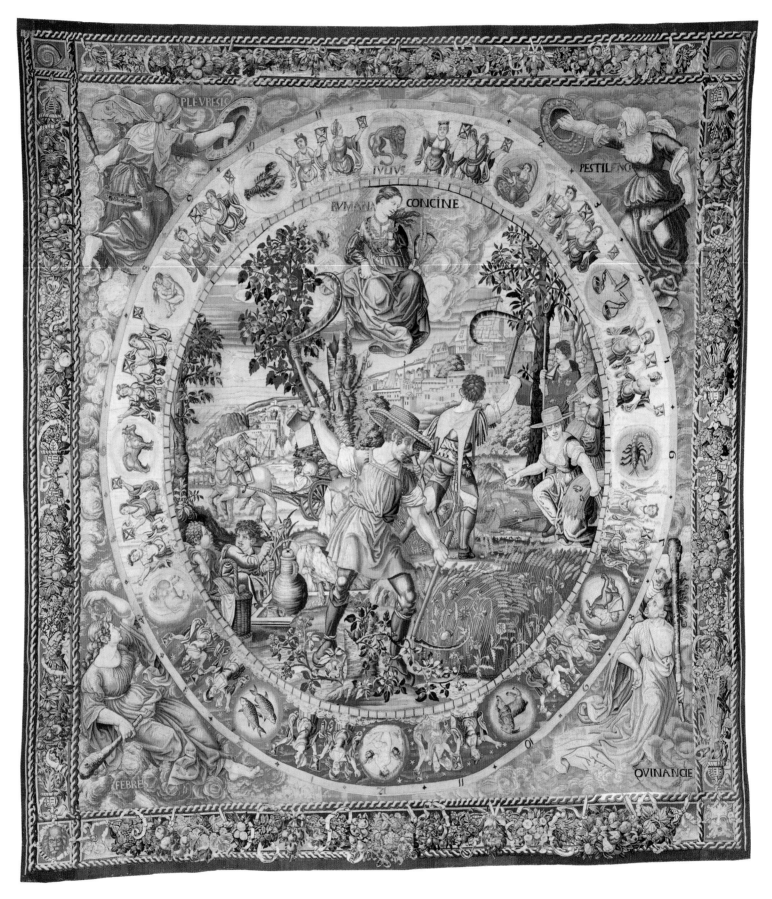

CAT. 9B

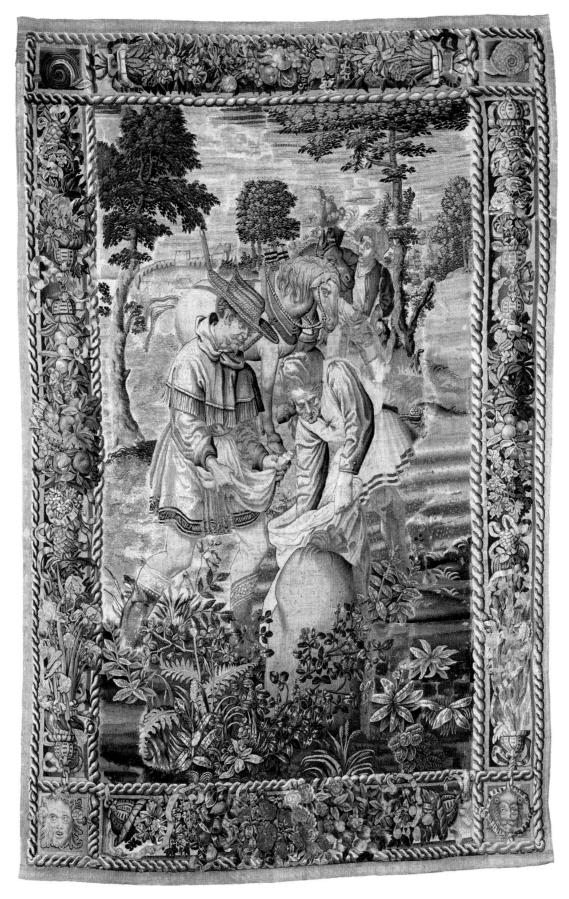

CAT. 10

Conservation of this tapestry was made possible through the generosity of Nicole Williams.

PROVENANCE: Possibly Jacques Seligmann and Company, New York; sold to George Haardt.[4] Probably John Graves Shedd (died 1926) and Mary R. Porter Shedd (died 1942); given or by descent to their daughter Mrs. Stanley Keith (née Helen Shedd, died 1976), to 1958; given to the Art Institute, 1958.

REFERENCES: Standen 1985, vol. 1, p. 52. Adelson 1994, pp. 88, 90 n. 40.

SINCE the earliest times, the months of the year have been associated with the signs of the zodiac, the twelve houses of the constellations through which the sun passes annually. The months were depicted in antiquity mostly by single figures representing religious festivities, the seasons, the weather, or, less frequently, agricultural work. In the early Middle Ages, agricultural labor—as personified each month by a single figure and characterized by the harvesting and sowing of region-specific crops—emerged as the predominant subject of illustrated calendars in both eastern and western Europe.[5] Beginning in thirteenth-century Books of Hours, the figures associated with the months gradually became more secular, showing landscapes through the seasons, and peasants and courtiers at work or enjoying recreational activities. From the fifteenth century on, these images—as in the calendar in the *Trés Riches Heures du Duc de Berry* painted by the Limbourg brothers around 1410—took on an open, celebratory tone toward the manuscripts' owners, depicting their homes, lands, refined lifestyle, and wealth. With the three-tiered *Months* frescoes at the Palazzo Schifanoia in Ferrara, painted in 1470 for Duke Borso d'Este, a humanist component was introduced to the illustrated calendar: the upper register depicts the triumphs of the twelve pagan gods that the Roman poet Marcus Manilius described in the *Astronomica* as patrons of the zodiac signs (book 2, 439–47). From that time on, this humanist element would appear in other fresco and tapestry cycles, especially starting in the early sixteenth century.[6]

The oldest surviving tapestries representing the months were produced in the twelfth century and show a single figure per month, in the Romanesque iconographic tradition. Examples include a fragment representing *April* and *May*, part of a larger frieze (the so-called *Baldishol Tapestry* in the Kunstindustrimuseet, Oslo), perhaps woven in Norway; and the *Tapestry of the Creation* in the Cathedral Museum, Girona, Spain, in which the months form a frame around the tapestry's perimeter.[7] The inventory taken at the death of Philip the Bold, Duke of Burgundy, listed *The Twelve Months*,[8] a piece with a compositional structure perhaps quite similar to that of a fifteenth-century Alsatian bench cover showing the months in which, as in the coeval calendars in Books of Hours, each month of the year is represented by two peasants performing farmwork against stylized country scenery.[9] The earliest surviving large-scale, woven representation of the calendar is the suite known as *The Trivulzio Months*, woven in Vigevano around 1503 to 1509 by Benedetto da Milano from cartoons by Bramantino (c. 1465–1530).[10] Comprising twelve

tapestries, one for each month, the suite was a tribute to its patron, Gian Giacomo Trivulzio, who had conquered Milan in 1499 for Louis XII of France. Celebrated for having brought peace to Lombardy, Trivulzio was praised as the protector of farming, as well as rural and urban festivities. In each tapestry a central figure—either a pagan deity or an allegorical or symbolic figure representative of daily tasks—dominates the composition, which illustrates the monthly activities with realistic scenes of contemporary life combined with humanist reinterpretations of agricultural work and ancient festivities. A four-piece *Ages of Man* suite in the Metropolitan Museum of Art, New York, woven in Brussels around 1520 to 1525, uses the twelve months represented in the background as a metaphor for the twelve phases of human life.[11] From the 1520s, the trend toward twelve-piece, large-scale tapestry suites devoted to the months took root in the Flemish capital as well. The *Hunts of Maximilian* in the Musée du Louvre, Paris, for example, woven after cartoons by Bernard van Orley around 1528 to 1533, refer to the months and their labors, though only hunts are represented.[12]

But the preeminent cycle of this kind is *The Medallion Months*, designed and woven (or at least on looms) in several suites by 1528. The set derives its modern name from the oval or circular—depending on the suite—calendrical band that frames the central scene on each tapestry.[13] The *editio princeps* of the set was probably the one made with gold and silk weft threads for Cardinal Évrard de La Marck, Prince-Bishop of Liège, which hung in Emperor Charles V's dining room while he was lodged in La Marck's palace at Huy in January 1531.[14] It was described in a letter by Baxin Berrictio to Thoma Tiepolo dated February 8, 1531, and included in the 1532 inventory of the Cardinal's tapestries.[15] No further information on this suite is available.

The Art Institute's *February* and *July* belong to the earliest of the four suites known today, woven without metal thread, and share some elements with the other pieces from the suite: the rectangular, vertical format (*February*, originally rectangular, was later modified to its present, irregular hexagonal shape); the oval band depicting the signs of the zodiac, personifications of the hours, and other symbols of the passage of time; and the figural compositions outside the medallion, at the four corners of the tapestry. The other surviving complete tapestries from this suite are *April*, in the Dumbarton Oaks Research Library and Collection, Washington, D.C.; *August* and *October*, in the Metropolitan Museum of Art; and *September*, in the Minneapolis Institute of Arts.[16]

This suite came to light in 1875. Its early history is largely unknown. Jean Vittet has recently demonstrated that it was included in the 1672 inventory taken after the death of Marie Particelli, wife of the French state secretary Louis Phélypeaux de La Vrillière, in whose Paris home it was held until at least 1684.[17] According to the inventory, the suite consisted of twenty pieces. Since the quality of execution and figurative style are typical of Brussels tapestries but none of the pieces bear the city mark, which was required after 1528, it is generally believed

that *The Medallion Months* were woven (or at least on looms) before this date. It is documented that a wool and silk suite of "les douze moys de l'an" (the twelve months of the year)—possibly *The Medallion Months*—was in the process of being woven in Brussels in 1529, but it is not possible to confirm whether this was the suite presently under discussion, or a reweaving.[18]

Also unknown is the identity of the commissioner of a second suite of *The Medallion Months*, woven with wool and silk in a vertical format. These tapestries were narrower than the former surviving suite, of which they reproduced the medallions with the zodiac signs and the hours, as well as the central scenes within the medallions. Because the borders abutted the medallions, however, the corner areas are smaller, and the figures that would have been shown there were eliminated in order to avoid inelegant reductions. Only one piece from this suite is known to have survived intact—*April*, in the Rijksmuseum, Amsterdam (448 x 313 cm; inv. BK-1956-56)—while a fragmentary portion of *June* recently appeared on the art market.[19]

More finely woven than the other editions, but composed of tapestries of reduced height, the most renowned suite of *The Medallion Months* is the so-called *Doria Months*, seven of which have been published, three of them still at the Palazzo Doria, Genoa.[20] The central scenes, though similar to previous editions, are enclosed by perfectly circular medallions. The shorter height of the tapestries prompted the thinning of the medallions and the reduction of their decoration to a simple motif of putti heads, and the placement of only one zodiac sign, the one associated with the month depicted, in the dominant position at the top of the circular band. The four corners outside the medallions show the complementary figures that had been eliminated from the second reedition. This third suite originally belonged to Andrea Doria, admiral and prince of the Republic of Genoa and a significant tapestry patron, and it could have been commissioned in 1527 when the admiral, having returned to the city after a five-year absence, married and began expanding and decorating his palace with the help of Perino del Vaga.

Finally, only two tapestries remain from a fourth suite: *August* (location unknown, on the market several times) and *October*, the third *Medallion Months* piece in the Art Institute. This edition lacks medallion bands, and its figurative components were reduced in number, drastically elongated, and further modified with newly drawn sections.[21]

These four *Medallion Months* suites are framed by similar borders, formed by concave moldings edged on the outside and inside by a trellis made up of metallic chains to which festoons of flowers, fruit, and leaves are attached with white ribbons. In the corners, the chains intersect, forming squares containing, on the top, snails (probably an allusion to the slow passage of time), on the bottom left a lion's muzzle, and on the bottom right a grotesque mask. While the festoons are typical of borders woven in Brussels from the 1520s, the prominent chains around them are less common; there is a precedent, however, in the *Lamentation* of around 1520 to 1525, woven

after a cartoon by Van Orley, now in the National Gallery of Art, Washington, D.C.[22]

The bands encircling the central scenes are characteristic of *The Medallion Months*, particularly of the two oldest surviving editions: beside creating a visually pleasing contrast with the border rectangles, their various motifs are closely linked to the subject matter of the series. First, the bands introduce the image of the zodiac ecliptic and depict the twelve constellations, each against a luminous circle suggestive of the sun. With each monthly tapestry the band rotates so that the relevant zodiac sign occupies the topmost position. Second, alternating with the zodiac signs, twelve pairs of female figures personify the twenty-four hours. The various colors of their robes suggest the changing light at different times of the day.[23] The band's golden outer edge also expands upon the theme of the hours; it is marked with two sets of numbers from one to twelve that represent the numbers of a clock, with twelve noon at the top and midnight at the bottom. Correspondingly, the band's background consists of light clouds at the top, and a dark blue tint at the bottom. The ratio between light and dark varies in each tapestry, just as the length of day and night changes throughout the year. The inspiration for this motif was probably the similarly shaded roundel surrounding each month in the *Ages of Man* tapestries in New York, but there are also earlier occurrences from fifteenth-century Germany and Italy.[24]

Outside the medallions, in the areas framed by the corners of the border, are independent figure groups that further describe the months. They vary from tapestry to tapestry and include the Winds or other personifications (such as the Diseases), deities associated with each month or with the mythological figure depicted inside the medallion, and—in the lower corners—figures engaged in occupations typical of the month shown. As for the central scenes enclosed by the bands (scenes that are identical in all the suites), each contains an assembly of realistic figures within a coherent environment appropriate to the weather of the month. The figures are dressed in contemporary costumes and perform work or engage in recreational activities often (but not always) inspired by the figurative tradition of Flemish and French illustrated calendars.

The scenes in the medallions share another important element. As in *The Trivulzio Months*, a suite that those responsible for the design of *The Medallion Months* might have known, each scene revolves around a central figure that is either a personification of the month or a patron of its activities. Unlike *The Trivulzio Months*, however, the central figure in *The Medallion Months* is invariably a god. He or she may be shown in the sky or among earthly figures, as in Chicago's *February* tapestry; in some pieces the deity plays an active role in the monthly occupations, as Janus does in the *January* piece known through the Doria edition.[25] The sequence of central figures, however, does not follow any common system of associations of gods and months. Indeed, the deities seem to have been chosen based only on their association with the activities and products of a specific month (thus Flora personifies April, the month of flowers; from

the August sky, Ceres, the goddess of grain, presides over threshing; and Bacchus, the god of wine, protects the grape harvest in September), by reference to weather (Eolus, god of the winds, personifies December's harsh conditions), or by connections that may not be immediately evident, but were suggested by Classical literary sources (Juno symbolizes February, the month in which the ancient Romans performed rituals in her honor; and Jupiter, with the attribute of the plow, is represented in the *October* tapestry as a reminder of the Silver Age, when under his rule humanity learned the art of agriculture).

The erudition of these references implies that a learned consultant chose, or helped choose, the *Medallion Months*' iconographic project.[26] The presence of inscriptions next to the figures on the tapestries, in which the gods' Latin names are often misspelled or do not match their identities, suggests, however, that the consultant might not have been present in Brussels when the cartoons and tapestries were executed, and that his instructions were somewhat unclear.[27] It is also possible that the inscriptions were made by another, less well-read person. Furthermore, the fact that *February*'s deity, which was represented in the oldest surviving edition with neither a caption nor attributes, but in the Doria suite was provided with a halo and the inscription *FEBRVA* to clarify her identity, shows that those responsible for manufacturing the cycle were aware, to a certain degree, that some of the figures might not have been easy to identify.

Although no cartoons or preparatory drawings for *The Medallion Months* have survived, the tapestries were probably made after ones that had been painted around 1525, when the traditional rural theme of the months, depicted with lively, naturalistic Flemish flavor, was rendered in a style obviously influenced by early and high Renaissance Italian art, as evidenced by the introduction of Classical deities, the representation of sculptural, large figures fixed in harmonious, eloquent poses, and the creation of the illusion of depth by depicting the scene from a low perspective.[28] This style corresponds to the figurative culture of tapestries made in Brussels in the 1520s, especially of sets by Van Orley, although these exhibit an expressive power and include fantastic imagery—due in part to the influence of Dürer's prints—that are absent from *The Medallion Months*. Nor do Van Orley's works bear a relationship to Leonardo's caricatures, whose influence can be seen in the figures occupying the corners of *July*. This suggests that the cartoonist of *The Medallion Months* may have been in contact with the circle of Quentin Massys, who made Leonardo's caricatures known in Flanders.

Appropriately, the assignment of the *Medallion Months* cartoons to Van Orley, proposed in 1920 by Joseph Breck and accepted by John David Farmer, has been commonly abandoned in favor of attribution to an unidentified cartoonist who either worked for Van Orley (as Guy Delmarcel contends) or had apprenticed with him (as Candace Adelson argues).[29] This does not seem to be the same artist who painted the cartoons (now lost) for *The Ages of Man* in the Metropolitan Museum of Art, as Edith Standen suggested, even though the two series share a set of influences and similar iconographic ele-

ments.[30] Nor does the artist seem to be, as Phyllis Ackerman proposed, the same painter—very close to Van Orley—who created the cartoons for *The Foundation of Rome* shortly after 1524, as well as a second chamber, on the same subject, purchased in 1529 by Henry VIII of England, and partially reconstructed by Tom Campbell.[31]

February

The subject of this tapestry is identified by the sign of Pisces at the top of the oval band, with the Latin inscription *FEBRVARIVS* inscribed underneath. The scene revolves around a central axis, formed by a column bearing a double arch and the central female figure personifying the month. An ancient deity, she is a matron adorned with jewels and clad in a green robe, covered by a red cloak decorated with pearls and embroidered pomegranates. The goddess holds a scepter in her right hand, while her left hand rests on her abdomen; her hair is wrapped in a full white turban, topped by a small golden crown. Like a colossus, she dominates a miniature urban landscape set in the lower register. On either side of and slightly behind the woman, two groups of figures represent domestic labors associated with the month. On the right, a seated woman, who is spinning, with a distaff in front of her, gives a bobbin with the spun thread to a little girl. Close to the girl, a boy kneels to blow on the embers in a brazier. Behind the children, an older woman cuts a thread from a cloth resting on her lap. On the left, a prosperous man wearing a fur-lined blue coat warms himself by a fireplace. A cat sits behind his chair, and next to him, a female servant moves logs with a pair of tongs to feed a lively, smoky fire; she averts her face to avoid getting scorched. Behind her stands a male servant bearing more wood. The classical double arch in the background marks the boundary between the domestic scene and the cold outdoors, represented by bare trees. On the right, a man dressed in red uses a maul to strike a wedge inserted into a fallen tree. Nearby, a horned faun pushes a wheelbarrow, while two small, cloaked figures pass through an opening in a fence.

In the upper corners outside the medallion are personifications of the winds, each carrying bellows and flying in a mass of clouds. On the left is Boreas, the cold north wind, with an unidentified companion. Of the three winds on the right, only *CIRCIVS*, the northwest wind, is fully visible. A dense snow falls from the upper corners into the lower ones, in which sledding couples are portrayed against a wintry landscape.

The lower part of the tapestry has been visibly altered: the border was removed, the corners cut, and the border reattached to fit the tapestry's new, irregular shape. Of the two lower corner squares, only one has survived, moved to the center of the bottom border.

The central figure of this tapestry is generally identified as Februa, the Roman goddess said to be named for the month, because the *February* tapestry in the Doria edition includes the inscription *FEBRVA* at her feet.[32] This inscription is not present in the tapestry in Chicago, but could have been introduced in the Doria piece, together with a trefoil halo around the figure's head, in an attempt

FIG. I *January: Dinner Scene*. Simon Bening, c. 1515. From the *Da Costa Hours*. 17.2 x 12.5 cm. Morgan Library and Museum, New York.

FIG. 2 *Madonna of Foligno*. Raphael, 1511/12. Oil on canvas; 301 x 198 cm. Musei Vaticani, Rome.

to clarify her identity. It is uncertain, however, whether the Romans had a deity named Februa. The month of February was devoted to purification ceremonies and to the dead. Ovid used the Latin word *februa*, in the plural neuter form, to indicate the sacred objects used in the rituals of purification (*Fasti*, book 2, 19–34). The grammarian Sextus Pompeius Festus also linked the name of the month to the verb *februare* (to purify). According to Festus, the month of February was dedicated to and derived its name from Juno Februata, in whose honor the festival of the Lupercalia was held mid-month.[33] Though Ovid also connected Juno to the Lupercalia (in honor of Faunus), he referred to the goddess as Juno Lucina, patron of women's fertility and childbirth (*Fasti*, book 2, 425–52). In the mid-sixteenth century, the learned Italian humanist Lilio Gregorio Gyraldi echoed both these writers. He noted the association of Juno with February, remarking that, in such a role, she could take the epithet of Februa, but he also observed that Juno's epithet Lucina refers to her bringing newborn babies to light, as well as to her luminescence.[34]

These sources help identify this tapestry's central figure as Juno, in her dual role as Februa and Lucina—names which would explain, respectively, the inscription and the halos added to the Doria edition. Whereas she is represented in a pose and costume that are not

completely Classical, her attributes do derive from ancient literary sources.[35] Her hand resting on her abdomen in the traditional pose of a pregnant Madonna may represent her role as goddess of fertility and patron of women in childbirth.[36] The faun in the background refers to the ancient Lupercalia, and the town at the feet of the goddess might be a vision of the underworld, or an allusion to Policletus's colossal statue of Hera/Juno that once stood in Argus. It is also possible that the Roman purification rituals Juno calls to mind were intended as an allusion to Lent, the Christian period of purification before Easter, which often begins in February.

Of the motifs depicted in the central scene, the most common is undoubtedly the old, prosperous man warming himself by the fire. This traditional personification of winter and, since Carolingian times, of the months of January and February, represents not only the frigid weather of the season but also old age and death, in the tradition linking the months to the Ages of Man. In the astrological tradition, as well as in the early Roman calendar, February was in fact the last month of the year. This may explain the apparent reference in the figures on the right to the Three Ages of Man, as well as to the Three Fates, the ancient goddesses of human life and destiny, which was represented by a thread that they spun and cut.

FIG. 3 *Massacre of the Innocents*. Marcantonio Raimondi after Raphael, 1513/15. Engraving; 27.6 x 42.9 cm. The Metropolitan Museum of Art, New York. Rogers Fund, 22.67.21.

Although *February*'s design is clearly Flemish in style, the influence of Classical and Italian sources is also evident throughout, as for example in the arched structure in the background that ennobles the contemporary rural landscape. It is similar to the arch seen in the background of the *Romulus Giving the Law to the Roman People* from *The Foundation of Rome* in the Patrimonio Nacional.[37] Similarly, though the figures in the foreground performing daily tasks are patterned after identifiably Flemish modelli—for example, the pose, clothes, and colors of the man warming himself by the fire recall a similar figure in the *January* illumination (fig. 1) from Simon Bening's *Da Costa Hours* (c. 1515)[38]—the elegance and spontaneity of their gestures show both ancient and Italian Renaissance influences. Not only do Juno's pose and the cloak draped over her legs reference the muses on a Roman sarcophagus now in the Kunsthistorisches Museum, Vienna, but the female servant with tongs standing next to the fireplace also seems to have been inspired by an Italian model: *The Triumph of Caesar*, engraved by Jacopo da Strasburgo after designs by Benedetto Bordon in 1504.[39] Furthermore, the seated woman who is spinning shares the articulated, asymmetrical pose of Raphael's 1511/12 *Madonna of Foligno*, now in the Musei Vaticani, Rome (fig. 2). It is also possible that the dynamic, complex figure of Circius, in the upper right corner, was partially modeled after a female figure on the left of Raphael's *Massacre of the Innocents*, known through prints by Marcantonio Raimondi (fig. 3).[40]

July

The zodiac sign Leo, at the top of the medallion band, and the inscription *JVLIVS* (July) underneath it, identify this tapestry's subject. Inside the medallion a goddess dominates the composition, seated

in the sky and wrapped in a cloud that forms a golden halo around her torso. Her long hair tousled by the wind, she wears a white dress with a blue surcoat and holds a sickle and stalks of wheat in her left hand. Though these items are generally attributes of Ceres, it is not clear that the figure represents this goddess, for Ceres features in the *August* tapestry of the series.[41]

In light of the Latin inscription *RVMANA CONCINE* that appears with the deity, Edith Standen identified her as Runcina, the ancient goddess of mowing and harvesting; the planned inscription, later misspelled in the tapestry, was probably "Romana Runcina."[42] The scene shown beneath the goddess confirms Standen's identification. In front of a promontory with buildings and trees, two farmers, holding two sickles each, reap energetically. In the background on the right, a woman kneels and points to the ground, as if to guide the action of the reaper next to her, as the goddess looks down on her from the sky. Two children enter the scene from the left; before them sits a terracotta jug of water or wine and a basket full of food—presumably refreshments for the farmers to enjoy during a pause in their work. Further in the distance two horses pull a cart transporting the cut wheat, with the driver riding one of them. The iconography of the scene accords with that of illustrated calendars from the Franco-Flemish area, in which reaping, shown in July or August, is a prelude to the threshing and winnowing performed the following month, as is in fact shown in the next episode of *The Medallion Months*. A significant precedent is Bening's *August* illumination from the *Da Costa Hours*, which depicts two reapers, a woman binding the sheaves, and, in the background, a cart drawn by two horses (fig. 4).[43]

The corners outside the medallions are overrun by threatening clouds, which should not be read as a reference to summer weather

FIG. 4 *August: Moving Wheat, Binding Sheaves.* Simon Bening, c. 1515. From the *Da Costa Hours*. 17.2 x 12.5 cm. Morgan Library and Museum, New York.

Sirius, a star that the ancient Romans called *insanus* (insane), *letalis* (deadly), and *pestifer* (pestilential) and believed to harm humanity by altering the balance of humors, drying up blood, and bringing disease. Ancient medical texts explained how to avoid the canicular ills by rebalancing one's humors through bathing, drinking plenty of fluids, and eating fruit. Within this context the personifications of disease in *July* can be explained as a warning against the dangers caused by Sirius.[45] The jug and food basket suggest that farmers could protect themselves while working in the sun by pausing for drinks to return humidity to their blood.

Inspired by actual life in the fields and by traditional Flemish Julian iconography, the scene portrayed in this tapestry, like the scene in *February*, is made more powerful and three-dimensional by the use of Italian *modelli*. The cartoonist's primary reference was Raphael's *Massacre of the Innocents*, engraved by Raimondi.[46] Even with completely modified costumes, *July*'s two reapers clearly repeat the postures of two soldiers in the engraving (see fig. 3). Additionally, a female figure kneeling in the foreground of the print inspired, in the tapestry, the lower half of the woman with the sheaf as well as the upper body of Pestilence, while Pleurisy was loosely inspired by a female figure on the left of the engraving, portrayed in the act of escaping.

The figure of Quinsy, whom the cartoonist portrayed as an angry old woman, deserves special note. Like the wrinkled and dimpled female face springing from behind her, Quinsy derives from the repertoire of caricatures created by Leonardo, known in Flanders through the circa 1495 sheet of *Five Grotesque Heads* that Quentin Massys used for the Saint John Altarpiece of around 1508 to 1511.[47] In addition, the poses of these two figures, especially the peculiar physiognomy of the one further back, suggest that the cartoonist was inspired by Leonardo's sheet, or more probably a copy of it. Quinsy's caricatured face also closely resembles a Leonardo drawing of a head, now lost, reproduced in an anonymous drawing in the Metropolitan Museum of Art.[48] The *July* tapestry of *The Medallion Months* represents the first use of Leonardo's repertoire of caricatures in the tapestry medium, a fact that has not yet received sufficient attention. Later, this influence returned from Flanders to its country of origin: the Bolognese painter Bartolomeo Passerotti must have seen the contorted figure of Quinsy, perhaps in the Doria suite, and copied her face and bare chest in his *Allegra Compagnia* of 1570, now in a private collection.[49]

October

As noted earlier, the *October* tapestry in the Art Institute of Chicago belongs to a suite of remarkably narrower format, which necessitated the elimination of the medallion band and the corner figures, and left room to reproduce only a vertical section of the original central scene. In the foreground a sower holds his apron to form a temporary container for the seeds that a fellow worker scoops from a sack on the ground. Behind this pair, a farmer prods a pair of horses that

but rather as a metaphor for the dangerous diseases that threaten humanity in midsummer and are here personified by four menacing female figures. In the top-left corner a harridan, viewed from the back, wears a red robe and carries a club and a shield, a sword at her side. An inscription (*PLEURESIS*) identifies her as Pleurisy. In the top right corner Pestilence (*PESTILENCE*) has similar clothes and weapons. In the bottom left corner, Fever (*FEBRE*) is represented by a seated woman leaning on her back in exhaustion and bearing a club in her right hand. In the bottom right corner Quinsy (*QVINANCIE*) holds a long club in her left hand.

Though according to Roman mythology Ceres set a plague upon humanity when Pluto raped her daughter Proserpina, Standen's identification of *July*'s goddess as Runcina rather than Ceres does not account for the presence of these personifications. But a convincing explanation can be found in the ancient astrological and physioastrological tradition, according to which humanity was in danger between July 20 and August 20 because the sun entered the constellation Canis Major, the most brilliant star of which is Sirius.[44] The scorching heat of the *canicula*, or dog days, capable of drying grapevines, trees, and wheat, was compounded by the negative influence of

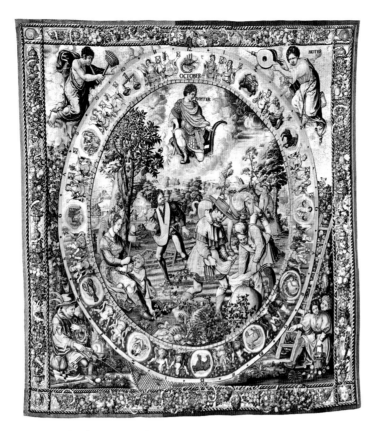

FIG. 5 *October* from *The Medallion Months*. After a design by an unidentified Flemish artist in the circle of Bernard van Orley, c. 1525. Produced at an unknown Brussels workshop. Wool and silk; 439 x 384 cm. The Metropolitan Museum of Art, New York. Bequest of Helen C. Juilliard, 19.172.2.

walk next to him. The border has the same decorative elements as the other *Medallion Months* pieces, but the positions of the mask and the lion's muzzle in the bottom panes are switched.

The scene in the tapestry in Chicago reproduces, with some variations and additions, the right side of the original *October* tapestry, which is known in its entirety through the version from the oldest surviving edition (fig. 5).[50] The zodiac sign Scorpio and the inscription OCTOBER appear at the top of the oval band in the complete design. On the left, a farmer spreads seeds over the rows of a plowed field, while a seated woman holds a spindle and caresses a child. The figures on the right are identical to those in the Art Institute's tapestry; in the full tapestry in New York, however, the horses draw a plow.

The top half of the medallion in the New York tapestry shows Jupiter (whose identity is confirmed by the Latin inscription *IVPI-TER*) in the sky; dressed in the armor of an ancient Roman soldier, he kneels while holding a plow blade. Standen offered no explanation for the chief god's presence in October with such an unusual attribute,[51] but both elements can be easily explained by Jupiter's relation to agriculture and the second age of the world, described by Ovid in the *Metamorphoses* (book 1, 89ff.). According to Ovid, during the Golden Age when Saturn reigned, humanity lived serenely and free of care in a perennial spring, sustained by food that the earth

produced without cultivation or plowing. But mankind's fortune declined in the subsequent Silver Age under the rule of Jupiter, who initiated the seasons, changing the climate and forcing humans to build houses, plow, and sow. The rural occupations depicted in *October* are among those that were most commonly used to represent the month in Franco-Flemish illuminated calendars since the Middle Ages, though at times they were used for the month of September instead, as in the sowing and plowing scene from a Flemish Book of Hours painted around 1490 (Pierpont Morgan Library, New York, ms. S.7, fol. 9r–v).[52]

The sculptural quality of the figures in the Art Institute's *October* shows obvious Italian influences, even though the scene as a whole conforms, more than any other pieces of the cycle, to a Romanism filtered through Van Orley's variety of Flemish realism. Several possible direct references to Italian Renaissance prototypes are evident: the farmer bent over the seed sack, for example, echoes the image of *David* (1515/16), another engraving by Raimondi after Raphael; and the man driving the two horses while looking up and backward recalls a figure next to Attila's horse in Raphael's fresco of *Leo I Repulsing Attila* in the Stanza d'Eliodoro.[53] NFG

NOTES
1. Receipt 9946, Department of Textiles, the Art Institute of Chicago.
2. Ibid.
3. Destrée 1906, vol. 1, pp. 40–41, cat. 19, pl. 22; vol. 2, table 7 (as the property of [Jacques] Seligmann).
4. See a photograph in the Seligmann Archives, the Archives of American Art: Box 187, Georges Haardt, folder 1, 1921–35, n.d.
5. The most helpful sources on the theme of the months are Fowler 1873; Le Sénécal 1921–24; Webster 1938; Levi 1941; Stern 1953; Stern 1955; Mane 1983; Courtney 1988; Cornet 1992; Castiñeiras Gonzáles 1996; Le Goff, Lefort, and Mane 2002; and Hourihane 2007.
6. For more on the gods in the Schifanoia frescoes, see Warburg 1966, pp. 257–63, and Cieri Via 1989. For their introduction in later *Months* tapestry series, see Forti Grazzini and Zardini 2007, esp. pp. 22–27, 60–107.
7. Sjøvold and Seeberg 1976, pp. 7–17, figs. 2–3; Webster 1938, fig. 82.
8. Göbel 1923, vol. 1, pt. 1, p. 85.
9. The months of the second half of the year are in the Victoria and Albert Museum, London. Wingfield Digby 1981, pp. 23–24 n. 12, tables 20 A–B, 24 A.
10. Suida 1953, pp. 73–81, 158–60; Valsecchi 1968; Forti Grazzini 1982b; Forti Grazzini 1984, pp. 50–65, tables 101–51; Forti Grazzini 2000, pp. 21–25. The suite is now held by the Civiche Raccolte d'Arte, Milan.
11. Standen 1969; Standen 1985, vol. 1, pp. 24–44, cats. 2a–d. The same iconography can be seen in a *Months* suite made in Brussels around 1530 to 1540 that is now in the Museu de Tapices, Zaragoza; Torra de Arana, Hombría Tortajada, and Pérez 1985, pp. 263–90.
12. Balis et al. 1993; Delmarcel in Campbell 2002c, pp. 329–39, cats. 37–40.
13. The most complete and authoritative analyses of this set are Standen 1985, vol. 1, pp. 45–53, and Adelson 1994, pp. 78–91.
14. Delmarcel 2001, pp. 206–08, 212.
15. Sanuto 1879–1902, vol. 54, coll. 298–99, quoted in Delmarcel 2001, p. 212: "Nel salotto [...] dove mangiava l'imperator vi erano razzi [...] doro et de seta, che sopra vi erano li 12 mexi in figura humana che facevano li misterii che in simili mesi se fanno, et intorno haveano li 12 signi celesti, et cadaun mese havea el suo sopra la testa, et poi seguivano li altri secondo l'ordine

suo" (In the dining room [...] in which the Emperor ate, there were gold and silk tapestries [...] showing the twelve months with human figures performing the occupations done in such months, surrounded by the twelve zodiac signs, and each month had its proper sign at the top, and the others followed according to their order). For the La Marck inventory, see Steppe and Delmarcel 1974, p. 48.

16. *April* measures 431 x 396 cm and is published in Schneebalg-Perelman 1971, p. 280, fig. 10; Asselberghs 1974, p. 45; Standen 1985, vol. 1, pp. 46, 52, cat. 8; and Adelson 1994, pp. 87, 90 n. 29, fig. 36. *August* and *October* (19.172.1–.2) measure 452 x 399 cm and 439 x 384 cm, respectively; for more on the pieces, see Breck 1920; Göbel 1923, vol. 1, p. 167, vol. 2, table 147; Standen 1981b, pp. 23–25; Standen 1985, vol. 1, pp. 45–53, cats. 3a–b; and Delmarcel 1999a, pp. 106–07. *September* (38.40) measures 451 x 424 cm and is published in Ackerman 1917, pp. 50–53, cat. 403; Göbel 1923, vol. 1, p. 167; Asselberghs 1974, p. 28; Standen 1985, vol. 1, pp. 46, 52, cat. 10; Adelson 1994, pp. 78–91, cat. 7.

17. Vittet 2004, p. 176.

18. See Gilles de La Pommeraye's Sept. 2, 1529 letter to the Connétable Anne de Montmorency, quoted in Delmarcel 2001, p. 16: "j'ay trouvé en ceste ville [Brussels] les douze moys de l'an, de quoy il en y a trois pieces fournies; les sept aultres seront prestes d'icy à six moys. Il n'y a ny or ny argent" (In this village I have found the twelve months of the year, of which three pieces are finished; the seven others should be close to done in six months. They have neither gold nor silver).

19. *April* (448 x 313 cm) was sold at Christie's, London, May 31, 1956, lot 165. Now in the Rijksmuseum, Amsterdam (inv. BK-1956-56), it is published in Göbel 1923, vol. 1, p. 167; Erkelens 1971, pp. 4, 8, fig. 2; Standen 1985, vol. 1, pp. 47, 52, cat. 15; Adelson 1994, pp. 87, 90, cat. 32; and Hartkamp-Jonxis and Smit 2004, pp. 67–71, cat. 18. The fragmentary portion of *June* (332 x 150 cm) has no borders except for the chain around the perimeter, which was reapplied, and the scene was cut on the sides and bottom. It was offered for sale at Sotheby's, London, Oct. 31, 2006, lot 307.

20. Göbel 1923, vol. 1, pp. 164–66, vol. 2, tables 144–45; Ferrero-Viale 1952, pp. 47–48, cat. 30, table 33; Boccardo 1983–85, p. 117; Standen 1985, vol. 1, pp. 46, 52, cat. 11; Boccardo 1989, p. 79, figs. 82–3, tables 20–21; Adelson 1994, p. 88; Patrizi 2000–01; Stagno 2005, pp. 90–93; Boccardo 2006, p. 113. Of this suite, *January*, *February*, and *August* are in the Palazzo Doria, Genoa, and were published in Stagno 2005, pp. 90–93. *November* was exhibited by Count Moroni in Rome in 1856, and described in Barbier de Montault 1878, pp. 231–32. *September* and *October* are in the collection of the Marquis Pallavicini, Genoa, and published in Boccardo 1989, tables 20–21. *April*, sold at Finarte, Milan, Mar. 6–9, 1967, and stolen in 1977 from Galerie Dario Boccara, Paris, is published in Boccara 1971, pp. 60–61. *December* was sold at Christie's, London, Nov. 15, 2001, lot 250.

21. *August* was offered for sale at American Art Association, New York, Nov. 30, 1929, lot 50 (ill.); American Art Association, New York, Nov. 4–5, 1932, lot 254 (ill.); Parke-Bernet, New York, Jan. 15–16, 1954, lot 314 (ill.); and Millon et Robert Commissaires-Priseurs, Drouot Richelieu, Paris, Nov. 19, 1990, lot 128 (ill.); and later sold on the antique market in Paris; Standen 1985, vol. 1, p. 50; Adelson 1994, pp. 88, 90, cat. 39.

22. Campbell 2002c, fig. 136.

23. The colors, however, are not as symbolically various or systematic as Ripa suggested for the personifications of the hours ("Hore del giorno" and "Hore della notte"); Ripa [1603] 1984, pp. 203–04.

24. In a German codex from 1445 (Kassel, Landesbibliothek, 2° mss. Ashon I) the circles enclosing the representations of the months are divided into a light section and a dark section to indicate the hours of day and night. They probably influenced the roundels of Luca della Robbia's *Months*, once on the vault of Piero de' Medici's *studiolo* in the Palazzo Medici in Florence, and now in the Victoria and Albert Museum, London (Pope-

Hennessy 1964, vol. 1, pp. 104–12; Liebenwein 1988, pp. 56–57, fig. 49; Borsi 1991, figs. 21–32), as well as those in the *Months* engraved by Baccio Baldini in Florence, around 1465 (Hind 1938–48, vol. 2, table 129). The different length of day and night is the theme of a fifteenth-century Veronese poem found in a code in the Biblioteca Vaticana (ms. Rossiano 729) and published in Pelaez 1935.

25. *January* is now in the Palazzo Doria, Genoa; see Göbel 1923, vol. 2, table 144; Stagno 2005, p. 79.

26. Adelson 1994, pp. 84–85.

27. Ibid., p. 85.

28. Various quotations from Italian prototypes, particularly Raphael, may be identified in the central and corner scenes of *The Medallion Months*. The most evident is in *December* (see the Doria tapestry sold at Christie's, London, Nov. 15, 2001, lot 250), in which the central figure of Aeolus is a copy of Raimondi's *Emperor*, engraved around 1515 after Giulio Romano; Bernini Pezzini, Massari, and Prosperi Valenti Rodinò 1985, pp. 57, 340.

29. Breck 1920, pp. 3–7; Farmer 1981, p. 311; Delmarcel 1999a, p. 126; Adelson 1994, pp. 86, 87.

30. Standen 1985, vol. 1, p. 46.

31. Ackerman 1933, p. 380, cat. 15; Campbell 1998b. For *The Foundation of Rome*, now in the Patrimonio Nacional, ser. 14, see Junquera de Vega and Herrero Carretero 1986, pp. 93–99, and Delmarcel in Delmarcel et al. 1993, pp. 64–91, cats. 10–13.

32. Göbel 1923, vol. 1, p. 165, vol. 2, table 145; Standen 1981b, p. 25; Standen 1985, vol. 1, p. 46; Adelson 1994, p. 84; Stagno 2005, pp. 91, 93 (ill). Only Boccardo 1989, p. 79, identifies the figure as "Giunone? Februa," though he offers no explanation.

33. Festus 1913, pp. 75–76.

34. Gyraldi 1548, pp. 159, 167.

35. Cartari [1647] 1963, pp. 98, 99, 100, links the matron's scepter, white turban, and the pomegranates on her cape, among other attributes, to Juno.

36. For examples, see Piero della Francesca's fresco of 1450–60 in Monterchi, as well as Walter 1996, pp. 21–27, figs. 12, 16–17.

37. Junquera de Vega and Herrero Carretero 1986, p. 99.

38. Pierpont Morgan Library, New York, ms. M.399, f. 2v; Hefford 2006, fig. 19.

39. The sarcophagus was in Rome in the fifteenth and sixteenth centuries, and its figures were engraved by Marcantonio Raimondi; Bober, Rubinstein, and Woodford 1986, p. 79, cat. 38, figs. 38i–ii. For the engraving by Strasburgo, see Martindale 1980, fig. 69.

40. Shoemaker and Broun 1981, pp. 96–99, 108–09, cats. 21, 26.

41. Standen 1985, vol. 1, p. 48 (ill.).

42. Ibid., vol. 1, p. 46.

43. Hourihane 2007, fig. 232.

44. Pauly and Wissowa 1894–1937, vol. 3, pt. 2, pp. 1479–81, s.v. "Canis Maior", vol. 3a, pt. 1 (1927), pp. 314–51, s.v. "Sirius"; Detienne 1975, pp. 151 ff.

45. On the representation of illness in calendars, usually in the August image, see Forti Grazzini 1982b, pp. 42–46, and Forti Grazzini 1984, pp. 59–60.

46. Shoemaker and Broun 1981, pp. 96–99, 108–09, cats. 21, 26.

47. *Five Grotesque Heads* is now in the Royal Collection, Windsor Castle. For its influence on Massys, see Silver 1984, p. 46, figs. 15–17.

48. Kwakkelstein 1994, fig. 74; Berra 1998, fig. 13.

49. Bora, Kahn-Rossi, and Porzio 1998, pp. 206, 251, cat. 51.

50. Standen 1985, vol. 1, pp. 50–53, cat. 3b; Delmarcel 1999a, p. 107 (ill.).

51. Standen 1985, vol. 1, p. 52.

52. Hourihane 2007, pp. 162–63.

53. Raimondi's engraving of *David* is published in Shoemaker and Broun 1981, p. 125, cat. 34.

CAT. II

Pomona Surprised by Vertumnus and Other Suitors from *The Story of Vertumnus and Pomona*

Brussels, 1535/40
After a design by an unidentified Flemish artist
Produced at an unknown workshop
493.9 x 430.3 cm (194½ x 169½ in.)
INSCRIBED: *Hanc satyri et panes (et) iuvenis Silenus ama(ve)runt / Omnes Vertumnus vincit amore deos*
Gift of Mrs. Charles H. Worcester, 1940.86

STRUCTURE: Wool and silk, slit and double interlocking tapestry weave
Warp: Count: 7 warps per cm; wool: S-ply of three Z-spun elements; diameters: 0.8–1.0 mm
Weft: Count: varies from 18 to 37 wefts per cm; wool: S-ply of two Z-spun elements; pairs of single Z-spun elements; diameters: 0.4–1.4 mm; silk: S-ply of two Z-twisted elements; diameters: 0.4–1.0 mm

Conservation of this tapestry was made possible through the generosity of the Fatz Foundation.

PROVENANCE: Jacobo Luis Stuart Fitz-James (died 1881), 8th Duke of Berwick, 15th Duke of Alba de Tormes, Madrid, Spain; sold, Hôtel Drouot, Paris, Duke of Berwick and Alba sale, Apr. 7–20, 1877, p. 62, lot 36 (as "Le Primtemps [*sic*]"; the rest of the suite was lots 32–35; the group was called "Sujets allégoriques ou saisons" and said to be from the seventeenth century). Possibly Baron Frédéric Emile D'Erlanger (died 1894), Paris, by 1880 (with three other pieces of the suite).[1] French and Company, New York, by 1926; sold to William Randolph Hearst (died 1951), Mar. 26, 1926;[2] ownership transferred to International Studio Art Corporation (Hearst's holding company); sold to the Art Institute, 1940.

REFERENCES: Keuller and Wauters 1881, pp. 17–18. Rogers 1940 (ill.). Anon. 1941, p. 14 (ill.). Crick-Kuntziger 1951, pp. 133–35. Paredes 1999, p. 78 n. 19. Delmarcel 1999a, pp. 113, 129. Thurman and Brosens 2003, pp. 173, 182 n. 9. Buchanan 2007, pp. 152–53.

EXHIBITIONS: Brussels, *Exposition Nationale Belge*, 1880.[3]

THE young woman kneeling in the foreground, holding a branch with leaves and flowers and wearing a white robe with embroidered sleeves, is Pomona, the Roman nymph of apples and orchards. She wears a cloak draped over one leg and turns her head to watch various male figures approach. Standing next to Pomona are three hamadryads, or tree nymphs, who appear troubled by the arrival of the male figures. One of the nymphs has her back to the viewer as she draws near her companions, but her head is turned so that her profile is visible. Another nymph, wearing a blue cloak over a mottled petticoat and a yellow robe, stretches her arms as if to stave off the intruding men. All the other figures in the scene are Pomona's suitors. The young man shown in profile and taking a long step in the center of the foreground is Vertumnus, the Proteus-like god who symbolized the passing of the seasons. He wears a robe, a cloak draped around his chest, and sandals. The less comely suitor following Vertumnus is a naked faun. Depicted from the back, his short tail and hairy goat legs

visible, he looks to his left and spreads his arms out, as if to attract the attention of the two bearded satyrs mounting the slope on which he, Vertumnus, Pomona, and the other nymphs already stand. Still more men, including additional satyrs and a faun, descend from the hill on the left in the middle ground. Among them, one stands out: the figure walking quickly, despite his advanced age, and swirling a cloak around his naked body. This is probably the Silenus mentioned in the tapestry's inscription.

The scene takes place in an open landscape depicted in a brilliantly naturalistic style. The figures in the foreground occupy an uneven green and brown plateau, covered by tiny flowers. The exquisitely detailed hill from which Silenus and other male figures descend features a path that emerges from the forest and splits in two around a large rock topped by trees. On the left, the hill forms the vault of a large, natural arch through which the viewer's gaze is drawn to a river-crossed meadow. To the right, in the distance, houses and trees cluster at the base of bluish hills, under a cirrus-filled sky that fades from blue to off-white.

The border of the tapestry simulates an ornately carved gilt wood frame, with a concave molding filled by garlands of multicolored fruit and flowers. The festoon in the top border is interrupted at the center by a variant royal French coat of arms: eighteen fleurs-de-lis arranged in five vertical rows.[4] The shield is topped by a crown and surrounded by a gold-colored collar with shell-encrusted braids. The left and right borders are similar, but not identical, to each other. Tied by ribbons to the top corners of the trompe l'oeil frame surrounding the tapestry, and climbing from cornucopias set in the bottom corners, the garlands are replaced in the center by a more stylized verdure motif. The bottom border, decorated by garlands held in the corners by putti, is covered at the center by a framed cartouche that bears, in Gothic letters, the Latin inscription summarizing the scene: *Hanc satyri et panes (et) iuvenis Silenus ama(ve)runt / Omnes Vertumnus vincit amore deos* (She was loved by satyrs, fauns, and the youthful Silenus, / but Vertumnus loved her best of all).

This tapestry is part of a *Story of Vertumnus and Pomona* suite that is based on the mythological tale Ovid described in his *Metamorphoses* (before A.D. 8; book 24, 623–771). According to the story, the god Vertumnus is in love with Pomona, a beautiful nymph devoted to gardening and uninterested in courtship. Having tried in vain to woo her in several disguises—reaper, mower, fruit picker, vine dresser, soldier, and fisherman—Vertumnus returns in the guise of an old woman. He kisses Pomona while praising her skill at cultivating orchards, and exhorts her to accept Vertumnus's attentions. To warn Pomona of the dangers of an unyielding heart, Vertumnus tells her the story of Iphis's unrequited love for the cold Anaxarete, which ended with the suitor's suicide and Aphrodite turning the beloved into a statue made of stone. The strategy works, and by the time Vertumnus reappears in his true form, Pomona has fallen in love with him.

The series to which the Art Institute's tapestry belongs is apparently the earliest surviving narrative ensemble illustrating the entirety

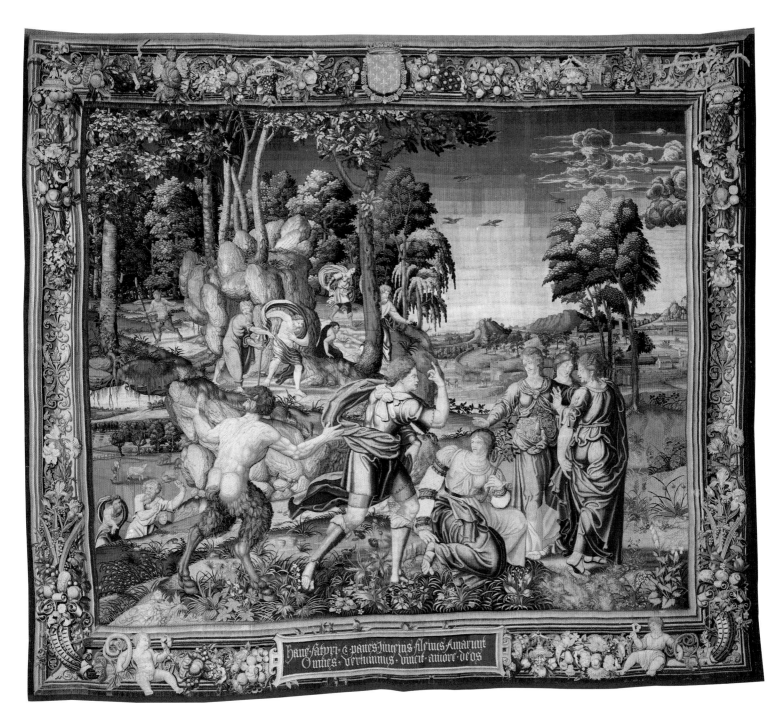

CAT. 11

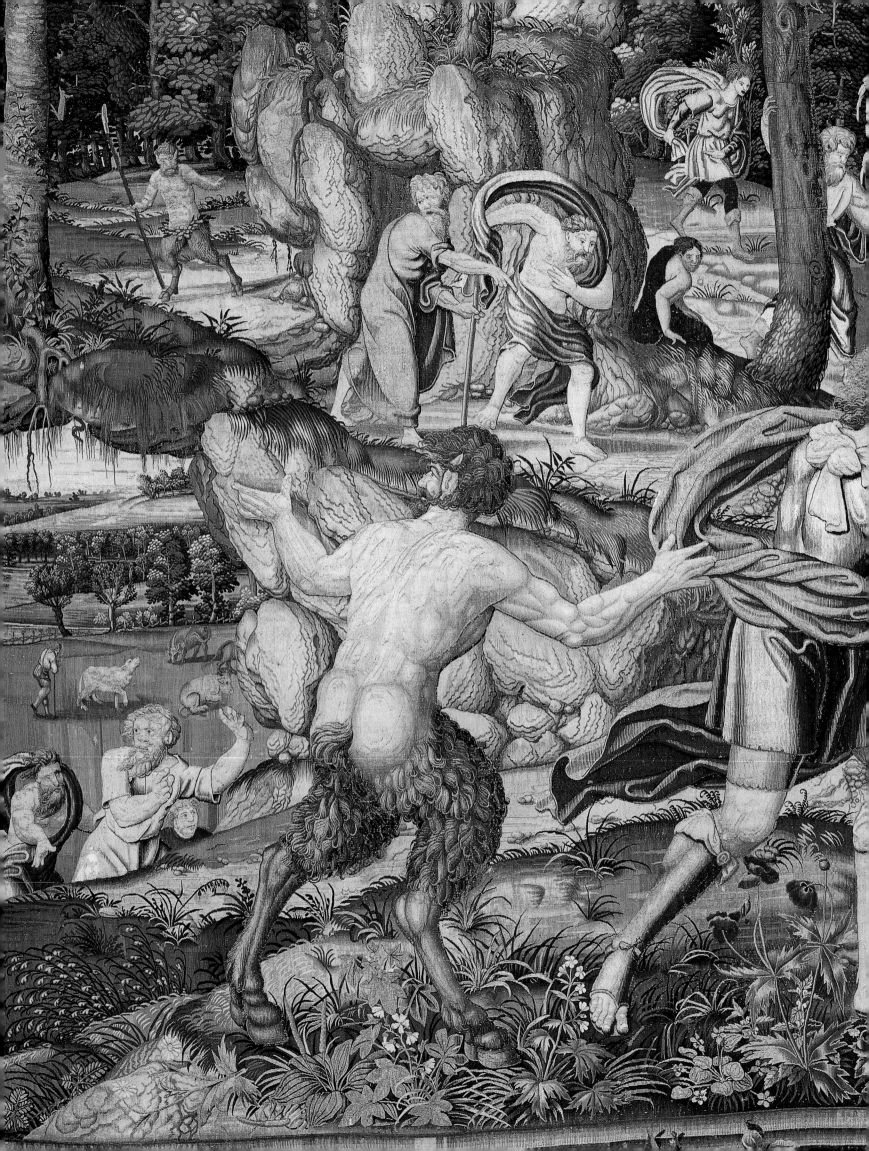

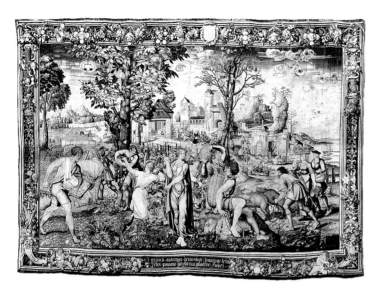

FIG. 1. *Pomona as the Personification of Autumn* from *The Story of Vertumnus and Pomona*. Brussels, 1535/40. Wool and silk; 449.6 x 640.1 cm. Deutsche Bank.

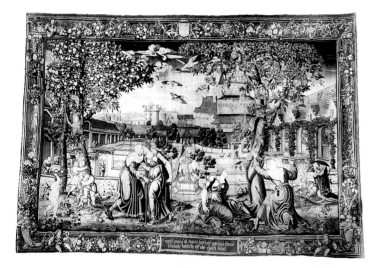

FIG. 2 *Vertumnus, Disguised as an Old Woman, Kisses Pomona and Shows Her a Vine Entwined around the Elm Tree* from *The Story of Vertumnus and Pomona*. Brussels, 1535/40. Wool and silk, 447 x 665.5 cm. Milwaukee Public Museum, 18455.

of Ovid's tale. Italian Renaissance artists indeed produced images of Vertumnus and Pomona, for example *The Triumph of Vertumnus and Pomona*, an etching from the *Hypnerotomachia Poliphili* (Venice, 1499); and a fresco painted around 1519 to 1521 by Jacopo da Pontormo in the central hall of the Medici Villa at Poggio a Caiano, showing Vertumnus and possibly also Pomona, with other rural figures.[5] These representations do not, however, illustrate the myth as it was described by Ovid. In other cases, only one episode from the story was shown: in a painting probably made in Milan around 1511 to 1513, Francesco Melzi, a student of Leonardo, portrayed Vertumnus, disguised as an old woman, appearing to Pomona;[6] and Gian Giacomo Caraglio included an image of the revelation of Vertumnus to Pomona in his set of etchings known as *Loves of the Gods*, dated 1527 (see

below). These two latter representations, it will be seen, were familiar to the cartoonist of the tapestry in the Art Institute.

As its inscription explains, the tapestry in the Art Institute depicts the first part of Ovid's tale (*Metamorphoses*, book 14, 637–42). After an enumeration of Pomona's beloved gardening activities, the poem describes her lack of interest in any of her numerous suitors:

> Quid non et Satyri, saltatibus apta iuventus,
> fecere et pinu praecincti cornua Panes,
> Silvanusque, suis semper iuvenalior annis,
> quique deus fures vel falce vel inguine terret,
> ut poterentur ea? Sed enim superabat amando
> hos quoque Vertumnus, neque erat felicior illis.
> (What did her many suitors—the young Satyrs,
> fit for a dance or two; the pack of Pans,
> with pinecones decorating their wee horns;
> Sylvanus, who acts younger than he is;
> and that divinity whose look or hook
> (I mean Priapus) frightens off all thieves—
> what did her many suitors leave undone
> in unsuccessful efforts to attain her?
> Vertumnus loved her more than all of them,
> but he had no more luck with her than they did.)[7]

The remaining parts of the story are illustrated in the four other tapestries comprising the suite, which was once owned by the dukes of Berwick and Alba. These tapestries are about the same height as the one in Chicago, are framed by similar borders, and were designed by the same cartoonist (see below). The tapestry now in the collection of Deutsche Bank, Frankfurt-am-Main, that represents *Pomona as the Personification of Autumn* (449.6 x 640.1 cm) is the only piece to bear the Brussels mark as well as an unidentified weaver's mark (fig. 1).[8] The other three pieces are now in the Milwaukee Public Museum: *Vertumnus, Disguised as an Old Woman, Kisses Pomona and Shows Her a Vine Entwined around the Elm Tree* (fig. 2); *Vertumnus, Disguised as an Old Woman, Tells Pomona the Story of Iphis and Anaxarete* (fig. 3); and *Vertumnus Kisses Pomona* (fig. 4).[9]

This suite must not be confused with the better known, slightly later, nine-piece *Story of Vertumnus and Pomona*, most likely designed by Pieter Coecke van Aelst (1502–1550) and woven in the 1540s, also in Brussels.[10] Its *editio princeps*, which by 1548 had been sold to Mary of Hungary, Regent of Flanders, is identified with a suite in the Patrimonio Nacional (ser. 16) that bears the mark of Willem de Pannemaker (1515–c. 1581). A reedition showing the same weaver's mark is also in the Patrimonio Nacional (ser. 17), and was probably made for Philip II of Spain in 1561 to 1563. De Pannemaker also wove a third (now lost) edition of the set for Peter Ernst von Mansfeld in 1565.[11] An unidentified weaver's mark is woven on two more reeditions, one now split between the Kunsthistorisches Museum, Vienna (inv. T.XX, eight pieces) and the Museu Calouste Gulbenkian, Lisbon (inv. 2329, one piece), and one in the Patrimonio Nacional (ser. 18).[12]

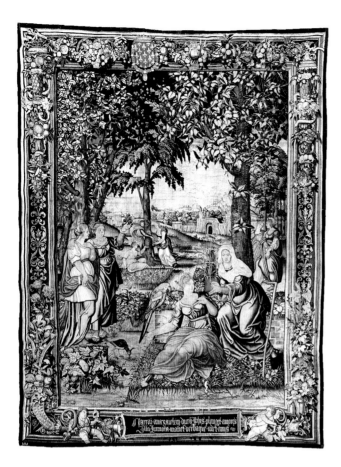

FIG. 3 *Vertumnus, Disguised as an Old Woman, Tells Pomona the Story of Iphis and Anaxarete* from *The Story of Vertumnus and Pomona*. Brussels, 1535/40. Wool and silk; 467.4 x 350.5 cm. Milwaukee Public Museum, 18455.

FIG. 4 *Vertumnus Kisses Pomona* from *The Story of Vertumnus and Pomona*. Brussels, 1535/40. Wool and silk; 426.9 x 335.3 cm. Milwaukee Public Museum, 18455.

Further reeditions were woven from modified recycled cartoons in Brussels at the beginning of the seventeenth century.[13] This series, which shows the various disguises in which Vertumnus approached Pomona, differs greatly in its selection of scenes from the suite to which the tapestry in Chicago belongs, but the chambers share two elements: their figures are consistently shown against a background of gardens portrayed in perspective (although more systematically so in Coecke's design, in which such backgrounds are seen through magnificently structured pergolas supported by telamones and caryatids), and both sets conclude with an embrace between the sitting Vertumnus and Pomona. The subject matter of the series suggests that the suite to which the tapestry in the Art Institute belongs could have celebrated or have been intended as a gift for a sumptuous wedding, and the rustic theme and garden or country setting of the scenes makes it most likely to have decorated a country palace or villa.

As Guy Delmarcel has noted, the coat of arms on the shield in the center of the top border of each tapestry in the suite, with its crown and gold fleurs-de-lis on a blue background, corresponds with the French royal coat of arms.[14] But this was the heraldic emblem used by the French kings only until the beginning of the fifteenth century; at the time of the tapestry's likely manufacture, it had been superceded by the three fleur-de-lis design adopted in the sixteenth

century.[15] The hypothesis that the suite was ordered by the French royal court would thus seem doubtful, were it not supported by the Saint Michael's medal hanging from the shields in the *Vertumnus, Disguised as an Old Woman, Tells Pomona the Story of Iphis and Anaxarete* and the *Vertumnus Kisses Pomona* in Milwaukee, because the chivalric Ordre de Saint-Michel was a French monarchical order. Furthermore, as Francis I revitalized the order, it cannot be ruled out that, as Delmarcel suggests, this French king himself commissioned the suite, albeit for use as a gift, which would have motivated the inclusion of the coat of arms to identify him as the donor. This hypothesis explains the suite's absence from the two known inventories, dated 1542 and 1551, of Francis I's tapestries, and from the subsequent inventories of the French Mobilier de la Couronne in 1663 and 1715.[16] It is also worth noting that Francis I is known to have shown interest in the tale of Vertumnus and Pomona: he built a Pavillon de Pomone (no longer standing) near Fontainebleau Castle, and around 1540 to 1541 had it decorated with two frescoes by Rosso Fiorentino and Francesco Primaticcio: *Vertumnus, Disguised as an Old Woman, Tells Pomona the Story of Iphis and Anaxarete*, and *The Garden of Pomona*.[17]

The quality of weaving, the vivid palette, and the style of the figures all indicate that the tapestry in the Art Institute and the suite to

FIG. 5 *Phaeton's Tomb and the Heliades' Metamorphosis* from *The Story of Phaeton.* Brussels, 1535/40. Wool and silk; 412 x 509 cm. Musée National de la Renaissance, Écouen.

which it belongs were woven in Brussels during the second quarter of the sixteenth century, but surely not before 1528. This location and *ante quem non* date are confirmed by the presence of the Brussels city mark and the weaver's mark on the *Pomona as the Personification of Autumn* from the same suite (now in the collection of Deutsche Bank), for, from 1528 on, all weavers operating in Brussels were required to include these marks on their works.[18] The mark on the tapestry in Chicago, formed by what look like the letters *A* and *f*, is unidentified; however, a very similar, perhaps identical, mark appears on four of the ten tapestries comprising the suite in Vienna known as *The Story of Abraham*, dated around 1545 to 1550, whose other pieces bear the marks of Willem de Kempeneer (1503–1580) and Pieter II van Aelst (active 1540/60).[19] The same manufactory that wove the *Vertumnus and Pomona* suite to which the Art Institute's tapestry belongs very likely also produced a *Story of Phaeton* suite, of which three unmarked pieces—*The Hours Attach Horses to the Sun's Chariot*, *Phaeton's Fall*, and *Phaeton's Tomb and the Heliades' Metamorphosis* (fig. 5)—are in the Musée National de la Renaissance, Écouen, and a fourth piece, depicting *Phaeton's Departure in the Sun's Chariot*, with the Brussels city mark, appeared at auction in 1977.[20] Drawn by the same artist who created the *Story of Vertumnus and Pomona* cartoons (see below), the *Phaeton* suite has identical borders—probably copied from the same models that were the property of the workshop—but without a coat of arms in the top or an inscription in the bottom.

As Marthe Crick-Kuntziger has noted, the borders of *Vertumnus and Pomona* and of *Phaeton* resemble those of the Brussels suites woven after cartoons by Bernard van Orley (c. 1488–1541) and Coecke van Aelst between the 1520s and 1540s—especially the borders of the *Story of Saint Paul* and the *Story of Joshua* both now in the Kunsthistorisches Museum, Vienna (inv T.III, 1535/40; inv. T.XIX, 1540/50, respectively), both from Coecke's cartoons.[21] Even more interesting is that the garlands in the left and right borders of both the *Vertumnus and Pomona* and *Phaeton* tapestries are interrupted in the center by a mock-relief, stylized verdure theme, woven in a golden color on a blue background. A similar pattern, of Italian provenance, was apparently introduced to Brussels tapestry by the borders of the *Deeds and Triumphs of Scipio* suite after cartoons by Giulio Romano (c. 1499–1546), woven for Francis I, probably in the workshop of the brothers Willem and Jan Van der Moyen around 1532 to 1535.[22] Its repetition in the vertical frames of the *Vertumnus and Pomona* series may be explained as an homage to a recent and much admired new series also made for the king of France, who may in fact have been the patron of the Ovidian suite as well. Thus it is possible to establish a reliable chronological framework, placing both the *Vertumnus and Pomona* and the *Phaeton* tapestries no earlier than 1532 to 1535, but also not much later than that, especially in the case of the *Vertumnus and Pomona* chamber, due to the archaic Gothic characters in its inscriptions, as opposed to the Latin capital letters that had already begun to be used in Brussels tapestry in the 1520s. Thus, *The Story of Vertumnus and Pomona* must have been woven around, and no later than, 1535 to 1540.

No cartoons or preparatory designs for the series survive, but the group of six figures in the foreground of the Chicago tapestry—which

gives the impression of a bas-relief animated by the tension between the flatter figures and the more rounded, sculptural ones—recalls the refined, early Tusco-Roman Mannerist style that gained ground in the 1520s and early 1530s, after Raphael's death, in Pope Clement VII's Rome. Flemish painters became acquainted with this style through studying and working in Italy, seeing imported Italian engravings, or encountering Italian cartoons sent to Brussels for the production of tapestries. Indeed, many of the figures in *Pomona Surprised by Vertumnus* are indebted to specific Italian models. For example, the faun in the foreground echoes a similar figure portrayed in *Cephalus Mourning over the Body of Procris*, designed by Romano in 1530 for the *Mythological Hunts* woven around 1530 to 1535 in Brussels.[23] The prototype of the hamadryad viewed from the back on the right side of the tapestry came from *Saturn and Phylira*, a 1527 engraving after Fiorentino by Gian Giacomo Caraglio that was included in Caraglio's *Loves of the Gods*, a set of etchings after Fiorentino and Perino del Vaga.[24] The two figures facing each other—Vertumnus, portrayed in full profile while taking a step, and the hamadryad drawn in a frontal pose with outstretched arms—recall the main characters of *Aeneas before Dido*, one of the episodes included in the *Story of Dido and Aeneas* tapestry series.[25]

In contrast to the Italian-inspired figures, the landscape in the Art Institute's tapestry—minutely detailed, open, realistic, and receding dramatically in space—is typically Flemish and clearly inspired by the suite known as the *Alba Passion* and by the *Hunts of Maximilian*, though it does not achieve the extraordinary amplitude and optical verisimilitude Van Orley conferred on the backgrounds of his tapestries, whose landscapes were painted with the help of Jean II Tons, a specialist in landscape painting.[26] The Chicago tapestry's impressive and unprecedented hill-formed arch seems, in turn, to have inspired a Flemish drawing of 1549 called *Landscapes with Animals* (British Museum, London), which bears the spurious signature of Pieter Coecke van Aelst. This was perhaps a preparatory drawing for a tapestry, now lost, that was woven in Brussels for Sigismund II August of Poland.[27]

Similar stylistic references can be found in other pieces in the *Vertumnus and Pomona* suite. Beautiful and naturalistic landscapes inspired by Van Orley characterize both the *Vertumnus, Disguised as an Old Woman, Kisses Pomona*, in Milwaukee and the *Pomona as the Personification of Autumn* owned by Deutsche Bank. In the former tapestry, isolated and slightly rigid figures are aligned in the foreground before a stunning geometrical garden that recedes dramatically into space. In the latter tapestry the figures in the foreground—situated in a more varied manner than in the Art Institute's piece—strike daring, mannerist poses after Italian models. The young man seated with a basket on his back, his head turned toward the center of the scene, recalls a figure drawn by Francesco Salviati; and the kneeling woman picking grapes, with her torso twisted, head turned, and arm stretched back to hand a cluster of the fruit to another worker, was taken from the *Vertumnus and Pomona* engraving made after a

del Vaga drawing—another piece from Caraglio's *Loves of the Gods*, dated 1527—although the figure in these prototypes is naked.[28] This engraving, which shows the opening of a pergola in the background, seems to have been the source for the same theme in the *Vertumnus Kissing Pomona* in Milwaukee, whose two main figures also seem partially copied (albeit here modestly clad) from another engraving del Vaga designed for Caraglio, *Mars and Venus*, again from *Loves of the Gods*.[29] In the background of the same tapestry, two women shown from behind while leaning on a balustrade recall images from *Knights and Mules*, a tapestry from the *Triumphs of Scipio*, designed by Romano and first woven in Brussels from 1532 to 1535.[30] Finally, in the *Vertumnus, Disguised as an Old Woman, Tells Pomona the Story of Iphis and Anaxaretes* in Milwaukee, the hamadryads in the background walk in the fluid, graceful movements inspired by del Vaga, whereas the two accosted protagonists forming a triangular composition in the foreground recall Melzi's *Pomona and Vertumnus* painting now in Berlin. The Pomona in the tapestry in Milwaukee is seated on the ground in a sophisticated, arched pose modeled after Temperance, one of the Virtues represented by Raphael in the Stanza della Segnatura frescoes in the Vatican Palaces, Rome, around 1509 to 1511. The scenery, with large trees crowded close together, their topmost branches forming a dense screen, is derived from the aforementioned *Hunts of Maximilian*.

These figurative references, which accord perfectly with the circa 1535 preparatory design date, make it possible to attempt to identify the cartoonist of the *Vertumnus and Pomona* series. Meyric R. Rogers suggested that he might be the Flemish Romanist painter and prolific cartoonist Michiel Coxcie (1499–1592), but Coxcie was in Rome, not Flanders, around 1535 and, moreover, had a more classic, harmonious and concentrated style, albeit one rich in references to the High Renaissance.[31] Delmarcel recognized in *Vertumnus and Pomona* (which he dates to around 1530) and in the aforementioned stylistically similar *Phaeton* series, but also in the *Venus and Vulcan* series (see below), a manner equally unlike either the work of Coecke van Aelst or the Italian cartoons circulating in Brussels at the time. He thus deemed it impossible to determine whether the cartoonist was Flemish or Italian.[32] In the opinion of the present author, however, the cartoonist must have been Flemish, because the Italian *modelli* that he copied were primarily the engravings or painted cartoons that circulated in Brussels between 1530 and 1535. Moreover, since the cartoonist's main stylistic reference was del Vaga, it is possible that the artist's unique, Romanist vein, different from the *terribilità* of Coecke van Aelst's contemporaneous cartoons (whose main Italian reference was Romano's style), took shape after Perino's works. In other words, it is possible that the cartoonist of *Pomona Surprised by Vertumnus* was the same artist, or group of artists, who in Brussels, from 1530 to 1535, painted the cartoons for *The Story of Dido and Aeneas*, rendering full-scale the drawings by Perino that were sent from Genoa, as well as adding new scenes, but always in keeping with the Italian artist's style.[33] The *Vertumnus and Pomona* tapestry

in Chicago reveals that the cartoonist was a painter who, though not especially skilled at rendering the human figure without the help of a good prototype, was a very accomplished landscapist.[34]

As Marthe Crick-Kuntziger correctly argued, the same painter must have created the designs of *The Story of Phaeton*.[35] This is particularly evident from *Phaeton's Tomb and the Heliades' Metamorphosis*, now in Écouen, whose ample panoramic landscape closely resembles that the tapestry in Chicago.[36] The physiognomy (full face, round chin, and small nose) of the female figures in *Phaeton* is similar to that of the female figures in *Vertumnus and Pomona*; one of the Heliades is almost identical to the Pomona in *Pomona as the Personification of Autumn*; and the male figures on the right exhibit close similarities to those in Perino's *Story of Dido and Aeneas*—a suite that offers important reference and comparison points for the other episodes of *The Story of Phaeton*. Delmarcel has asserted a strict stylistic similarity between *Vertumnus and Pomona* and *Phaeton*, and the *Story of Venus and Vulcan* series known from a five-piece suite woven in Brussels and presently at Biltmore House, Asheville, North Carolina.[37] As Ella S. Siple demonstrated, the scenes of *Venus and Vulcan* were designed by a Flemish Romanist painter who copied some of his figures from Italian models, mainly etchings.[38] Among the artist's borrowings were figures from Mantegna and Raphael, but references to del Vaga and his *Aeneas and Dido* series can also be recognized. In the present author's opinion, this cartoonist was the same one who designed *The Story of Vertumnus and Pomona*, as can be seen by comparing the very similar muscular bodies and poses of the faun in the Art Institute's tapestry and of Vulcan in the *Complaint to Jupiter* at Biltmore House, or the physiognomies and poses of the farmer leading the pigs on the right of *Pomona as the Personification of Autumn* owned by Deutsche Bank and of Vulcan in *Vulcan Forging and Spreading the Net* at Biltmore House.[39] Less certain, though not to be overlooked, is the possibility that the same cartoonist could also be responsible for the preparatory designs of *The Story of Hippomenes/Melanion and Atalanta* that were drawn with fuller, more crowded compositions in the style of Coecke van Aelst, and more massive male figures.[40]

If the drawings for *The Story of Vertumnus and Pomona* were indeed made in 1535 by a Flemish cartoonist, as suggested by the established chronology and visual evidence, this was probably the first instance in which an artist from this area was commissioned to produce cartoons illustrating an ancient mythological theme in the classicist style of sixteenth-century Italy. The leading Romanist designers working in Flanders at that time—Van Orley and Coecke van Aelst—had not yet tackled such a theme; the suite known as *Fables of Ovid* (now in the Patrimonio Nacional, ser. 19), and the other *Story of Vertumnus and Pomona* were designed by Coecke some ten years later. NFG

NOTES

1. Keuller and Wauters 1881, pp. 17–18.
2. See Mitchell Samuels, founder and manager of French and Company, New York, letter to Meyric R. Rogers, Curator of Decorative Arts, the Art Institute of Chicago, Apr. 29, 1941, in object file 1940.86, Department of Textiles, the Art Institute of Chicago.
3. Keuller and Wauters 1881, pp. 17–18.
4. Delmarcel 1999a, p. 113.
5. Berra 2007, pp. 16, 22–23, figs. 6, 10.
6. Melzi's painting, *Pomona and Vertumnus*, is now in the Gemäldegalerie, the Staatliche Museen, Berlin, inv. 222; Marani 1998, pp. 377–80, fig. 262.
7. Ovid 2004, book 14, 914–23.
8. Hôtel Drouot, Paris, Duke of Berwick and Alba sale, Apr. 7–20, 1877, lot 32 (ill.), as "Le tribut de Pomone"; Keuller and Wauters 1881, pp. 17–18 (ill.). Later it belonged to the Albany (New York) Institute of History and Art and was sold at Parke-Bernet, New York, Mar. 25, 1972, lot 202 (information courtesy of Guy Delmarcel). The inscription in the lower border reads: *Granis autumni decoratus imagine l(a)eta / Felix Pomon(a)e hec forma placere studet* (Pleasantly ornamented with the autumn's granary, [Vertumnus] tries so to please Pomona). The scene freely interprets the description of Vertumnus's disguises in *Metamorphoses*, book 14, 643–53. Pomona, standing in the center foreground with an apple in her hand, is represented as the personification of autumn. A panoramic landscape represents the months through their associated zodiac signs and constellations, farmwork, and seasonal changes. On the left, September is represented by the Scales (for Libra) and plowing. The sower in the foreground is probably Vertumnus in disguise. In the center, October is symbolized by the wine harvest, including grape picking and pressing. Its zodiac sign is Scorpio, represented by the Scorpion. On the right, November is symbolized by the Archer (for Sagittarius), and farmers carrying chickens and leading pigs, while in a village in the background a pig is butchered.
9. All three tapestries were accessioned under inv. 18455. *Vertumnus, Disguised as an Old Woman, Kisses Pomona and Shows Her a Vine Entwined around the Elm Tree* was sold at Hôtel Drouot, Paris, Duke of Berwick and Alba sale, Apr. 7–20, 1877, lot 35, as "L'Automne"; Keuller and Wauters 1881, pp. 17–18 (ill.); Paredes 1999, fig. 1. Its inscription reads: *Fingit anum ut capiat spectat(a)e gaudia form(a)e / Laudat(a)e tandem oscula chara dedit* ([Vertumnus] disguises himself as an old woman in order to enjoy the sight of this beauty [Pomona] whom he praises and kisses pleasantly). The tapestry, which shows two episodes of Vertumnus and Pomona's tale from the *Metamorphoses* in the foreground (book 14, 654–74), presents a magnificent prospect of a large vegetable garden, enclosed by porches and overlooked by a castle. The garden is divided into beds fenced in by walls and separated by paths. This is the first appearance of a motif that would frequently reappear: geometrical gardens, whose orthogonal plan is emphasized by an effect of recession in space, were portrayed countless times in paintings, engravings, and tapestries in sixteenth-century Flanders; Paredes 1999, p. 78. *Vertumnus, Disguised as an Old Woman, Tells Pomona the Story of Iphis and Anaxarete* was sold at Hôtel Drouot, Paris, Duke of Berwick and Alba sale, Apr. 7–20, 1877, lot 34, as "L'Eté." The scene illustrates *Metamorphoses*, book 14, 695–764. The inscription reads: *Narrat Anaxaretem dura(m) Iphis plangit amores / Illa immota manet verbaque ridet anus* ([Vertumnus, in disguise] tells the story of the cold Anaxarete and laments Iphis's life. / Standing still [Pomona] smiles at the old woman's words). *Vertumnus Kisses Pomona* was sold at Hôtel Drouot, Paris, Duke of Berwick and Alba sale, Apr. 7–20, 1877, lot 33, as "Le Printemps [*sic*]"; Keuller and Wauters 1881, pp. 17–18. The scene illustrates *Metamorphoses*, book 14, 766–71; the kiss is, however, the cartoonist's free interpretation. The inscription reads: *In iuvenem ut rediit Vertumnus nympha redarsit / Vertumnoque parem se dat Amore libens* (As soon as he changed back into a young man, Vertumnus

burned with love for the nymph [Pomona], who willingly returns his love). The kiss takes place in front of a pergola that recedes in space in a showy perspectival effect. Next to the lovers, in a clear allusion to Vertumnus and Pomona's story, a peacock displays his feathers to an uninterested peahen, busily pecking at food.

10. Crick-Kuntziger 1927; Steppe 1981a; Horn 1989, esp. vol. 1, pp. 43–47; Paredes 1996; Paredes 1999. For the attribution of the cartoons to Coecke, see Campbell 2002c, pp. 389–90.

11. For the references to the *editio princeps*, see Houdoy 1873, p. 23. Its identification with ser. 16 in the Patrimonio Nacional was recently established in Buchanan 2007, p. 151. For the set made for Philip II, see Steppe 1981a; Buchanan 1999, pp. 140–42; and Delmarcel 1999a, pp. 155, 160, 169 n. 7, 170 n. 36. For the lost von Mansfeld edition, see Piquard 1950, p. 118; Kerkhove 1969–72, pp. 157–60; and Buchanan 2007. Junquera de Vega and Herrero Carretero 1986, pp. 105–15, 116–22, publishes series 16 and 17, respectively.

12. For the suite split between Vienna and Lisbon, see Baldass 1920, tables 146–54, and Museu Calouste Gulbenkian 1982, p. 157, cat. 1004. The Patrimonio Nacional's ser. 18 is published in Junquera de Vega and Herrero Carretero 1986, pp. 123–33.

13. Kerkhove 1969–72. Among the surviving Brussels copies from the early seventeenth century, the largest is an ensemble of tapestries and tapestry fragments woven with gilt-metal thread, all bearing the mark of Maarten II Reymbouts (c. 1570–1619). They most likely belonged to the suite purchased in 1615 by Archduke Albert and Archduchess Isabella, Hapsburg Regents of Flanders; Houdoy 1871, p. 151; Soenen 1991, p. 241. The ensemble includes two fragments that were sold at Finarte, Milan, Dec. 4, 1989, lots 234–35; two fragments that were published in Kerkhove 1969–72, p. 156, figs. 3–4; and two intact tapestries and two fragments published in Boccara, Reyre, and Hayot 1988, pp. 248–50.

14. Delmarcel 1999a, p. 113.

15. For an example of a three fleur-de-lis French royal coat of arms represented on a tapestry in the period during which *Vertumnus and Pomona* was made, see *The Last Supper*, in the Musei Vaticani, Rome, a tapestry woven before 1515 in Brussels after Leonardo's fresco. Francis I had the coat of arms woven into the tapestry before donating it to Pope Clement VII in 1533; Crick-Kuntziger 1952; Erlande-Brandenburg 1973; Fagnart 2001.

16. See Schneebalg-Perelman 1971 and Guiffrey 1885.

17. The frescoes, which have since been destroyed, are known today through drawings and engravings; Golson 1975; Cordellier and Py 2004, pp. 208–12, nn. 85–86.

18. Van Tichelen and Delmarcel 1993, p. 57.

19. For a graphic transcription of the mark on the tapestry in Chicago, see Hôtel Drouot, Paris, *Collection du Duc de Berwick et d'Albe,* sale cat. (Hôtel Drouot, Apr. 7–20, 1877), p. 61; Keuller and Wauters 1881, pp. 17–18; Göbel 1923, vol. 1, table of marks no. 8; and Crick-Kuntziger 1951, p. 133 n. 2. The very similar mark appears on four tapestries in the suite (inv. T. II) in the Kunsthistorisches Museum, Vienna; the weaver's marks of these tapestries are reproduced in Birk 1883, pp. 216–17, and Bauer 1983, table of marks 12/5 (for an entry on the set, see pp. 13–15).

20. For the three tapestries, once in the Karolyi and Toperczer collections, and now in Écouen, see Crick-Kuntziger 1951; Delmarcel 1980, p. 64; Oursel 1994; Brown, Delmarcel, and Lorenzoni 1996, pp. 73–74; and Delmarcel 1999a, pp. 112–13, 128–29. The fourth piece of the set was sold at Sotheby's, London, Nov. 4, 1977, lot 5.

21. Crick-Kuntziger 1951, pp. 133–34. For *The Story of St. Paul* and *The Story of Joshua*, see Bauer and Steppe 1981, pp. 37–53, figs. 14–15, 26–28 (*The Story of St. Paul*), 1–4, 22–25 (*The Story of Joshua*).

22. The suite burned in Paris in 1792, but the border—"fond bleu avec rinceaux d'or" (blue with gold rinceaux)—documented in 1663 (Guiffrey 1885–86, vol. 1, p. 293), was similar to the one that decorates the reedition bought by

Mary of Hungary in 1544 and now in the Patrimonio Nacional, Spain (ser. 26); Junquera de Vega and Herrero Carretero 1986, pp. 176–84.

23. See the drawing by Giulio Romano in the Städelsches Kunstinstitut, Frankfurt, inv. 24336, and the tapestry woven after it, now in a private collection, both published in Delmarcel 1997, p. 391, figs. 5–6; and Campbell 2002a, p. 349, figs. 155–56.

24. Casazza and Gennaioli 2005, p. 166, cat. 38.

25. After del Vaga drew the designs for the *editio princeps* of *Dido and Aeneas*, which Andrea Doria commissioned in Genoa, they were sent to Brussels, where they were rendered full-scale and new cartoons were added to expand the set, and all were woven into tapestries, starting around 1530 to 1535. For more on the *Dido and Aeneas* tapestries designed for Andrea Doria, and their reeditions, see Davidson 1990; Forti Grazzini 1993; Forti Grazzini in Parma 2001, pp. 237–41 n. 123; and Quinci 2004. For *Aeneas before Dido*, of which two weavings exist, see Forti Grazzini 1993, figs. 1, 4.

26. For the *Alba Passion*, a four-piece set woven in Brussels from cartoons by Bernard van Orley, around 1525 to 1528, whose components are in New York, Washington, D.C., and Paris, see Ainsworth in Campbell 2002c, pp. 304–21 nn. 30–33. The *Hunts of Maximilian*, a twelve-piece set conserved in the Musée du Louvre, Paris, was copied from cartoons by Van Orley and woven by the Dermoyen workshop in Brussels, around 1531 to 1533. For more on the set, see Balis, De Jonge, Delmarcel, and Lefébure 1993. For Tons, see ibid., pp. 72–74.

27. Marlier 1966, pp. 111–12, fig. 30.

28. Although the prototype of the young man has not yet been found, a similar figure drawn by Salviati can be found in *The Massacre of the Children of Niobe* in the Ashmolean Museum, Oxford, inv. PII682, reproduced as an engraving in 1541, perhaps by Girolamo Facciola; Monbeig-Goguel 1998, pp. 207–09 nn. 74–75. For del Vaga's preparatory drawing showing the kneeling woman picking grapes in the British Museum, London (inv. 5226–96), and the engraving based on it, see Parma 2001, pp. 190–191 nn. 78, 85.

29. Casazza and Gennaioli 2005, pp. 172–73, cat. 46.

30. See also the drawing by Giulio Romano in the Cabinet des Dessins, Musée du Louvre, Paris, inv. 3539; Jestaz and Bacou 1978, pp. 133–34 n. 21.

31. Rogers 1940, pp. 93–94.

32. Delmarcel 1996, pp. 73–74; Delmarcel 1999a, pp. 128–29.

33. Forti Grazzini 1993, pp. 130–34.

34. See, for example, in the Art Institute's tapestry, the unpleasant pose and disproportionate body of Pomona, or the clumsy running Silenus in the background. Similar unhappily positioned figures may be found in the other tapestries of the series. The same artist might be responsible for a tapestry design for a c. 1535 *Story of Jupiter* set sold at Sotheby's, London, July 11, 2001, lot 36, and published in Campbell 2007b, p. 312, fig. 15.10.

35. Crick-Kuntziger 1951, p. 133. Crick-Kuntziger further hypothesizes that *Vertumnus and Pomona* and *Phaeton* were part of one series (p. 135). The present author does not agree as there is no precedent for a series consisting of scenes from two different ancient myths.

36. Delmarcel 1999a, pp. 112–13.

37. The series represented at Biltmore House is generally dated around 1540 to 1550, but was possibly copied from cartoons made slightly earlier, around 1535 to 1540; Siple 1938. Seventeenth-century English reeditions survive; they were made at Mortlake from 1623; Siple 1939, Hefford 2007, p. 172.

38. Siple 1938.

39. For the physiognomies and poses of Vulcan in the *Complaint to Jupiter* and *Vulcan Forging and Spreading the Net*, see Siple 1938, p. 216, figs. A–B.

40. The set is known from three *Story of Hippomenes/Melanion and Atalanta* tapestries woven in Brussels and sold by Franco Semenzato, at the Palazzo Giovanelli, Venice, Oct. 24, 1987, lots 199, 232, 246.

Christus Appearing to Mary Magdalene
(*"Noli me tangere"*)

Brussels, 1540/45
After a design attributed to Michiel Coxcie (1499–1592) or Giovanni
Battista Lodi da Cremona
Produced at the workshop of Willem de Pannemaker (1515–c. 1581)
MARKED: Brussels city mark, mark of Willem de Pannemaker
268 x 210.3 cm (105½ x 82¾ in.)
Gift of the Hearst Foundation in memory of William Randolph Hearst,
1954.259

STRUCTURE: Wool and silk; slit, single, and double interlocking tapestry
weave
Warp: Count: 8 warps per cm; wool: S-ply of three Z-spun elements;
diameters: 0.7–0.85 mm
Weft: Count: varies from 32 to 56 wefts per cm; wool: S-ply of two Z-spun
elements; diameters: 0.3–0.85 mm; silk: pairs of S-ply of two Z-twisted
elements; diameters: 0.4–0.8 mm

Conservation of this tapestry was made possible through the generosity of
Mrs. John H. Bryan.

PROVENANCE: By descent through the Almenas family, Madrid; by descent
to José María de Palacio y Abárzuza, Conde de las Almenas (died 1940), to
1927; sold, American Art Association, New York, Jan. 13–15, 1927, lot 427, to
William Randolph Hearst (died 1951); ownership transferred to the Hearst
Foundation; given to the Art Institute, 1954.

REFERENCES: Hammer Galleries 1941, cat. 169-6. Mayer Thurman and Bro-
sens 2003, p. 173.

EXHIBITIONS: New York, Gimbel Brothers, *Art Objects and Furnishings
from the William Randolph Hearst Collection, Presented by Saks Fifth Avenue
in cooperation with Gimbel Brothers*, 1941 (see Hammer Galleries 1941).

IN a sun-drenched landscape of cracking masonry, crumbling walls,
and ruins colonized by flowering vegetation, a man stands before
a kneeling woman. The spade in the man's hand and his shallow-
brimmed hat make him resemble a gardener. Yet the conspicuous
wound in his side, the quiet authority of his stance, and his compas-
sionate expression reveal his true identity: like another tapestry in
the Art Institute (cat. 3), this piece illustrates the episode recounted
in the Gospels of Mark (16:9) and John (20:11–17), in which Mary
Magdalene, having gone to the garden at Calvary to anoint Jesus's
body, instead encounters the risen Christ. The present tapestry, how-
ever, seems to depict the moment immediately before the Magda-
lene's joyful recognition of Christ, for it shows him reaching out a
hand to her, his mouth open as if to speak, while the kneeling Mag-
dalene looks up, confused at having found the empty tomb. She ges-
tures toward the opened jar of balm with which she had intended to
anoint Jesus's dead body. The biblical verse narrating this part of the
encounter reads "Jesus saith unto her, Woman, why weepest thou?
Whom seekest thou? She, supposing him to be the gardener, saith

unto him, Sir, if thou hath borne him hence, tell me where thou hast
laid him, and I will take him away" (John 20:15).

The striking red mantles of Christ and Mary Magdalene unite
them visually, making them stand out against the hazy distant land-
scape, cloudy sky, and muted palette of the masonry and foliage. On
the right of the tapestry, behind the Magdalene, the empty sepul-
cher can be seen, the diagonal of the cast-aside tomb slab echoing the
angled lid of the open ointment jar in front of Mary. In the middle
ground, behind the two principal protagonists, three female figures
hurry away from the scene, deep in conversation and gesticulating
animatedly—an allusion to an earlier episode, recounted in Mark
16:1–8, in which Mary Magdalene, Mary Jacobi, and Mary Salome
fled the sepulcher after having found an angel guarding the open and
empty tomb. The same red used in the mantles is picked up by the
background of the sumptuous border, in which swags of apples, cher-
ries, gourds, grapes, and pomegranates are represented, as if suspend-
ed in front of trompe l'oeil ornately carved gilding. At the right of the
bottom selvage, two backwards *B*s flanking a red shield identify the
tapestry as a product of Brussels, while the bottom of the left guard
bears the weaver's mark of Willem de Pannemaker.

One of the most successful and sought-after tapestry weav-
ers working in Brussels between approximately 1535 and 1581, De
Pannemaker came from an established weaving family, his father
Pieter (active 1517–32) having produced tapestry suites for Margaret
of Austria and Maximilian I.[1] Under Willem, the De Pannemaker
workshop continued to receive tapestry commissions from the
Hapsburgs, including the order for the ambitious twelve-piece *Con-
quest of Tunis* now in the Patrimonio Nacional.[2] De Pannemaker also
took on prestigious commissions from Ferrante Gonzaga, Duke of
Guastalla; Cardinal Antoine Perronot de Granvelle, archbishop of
Mechelen; and even from the so-called Iron Duke, Fernando Álvarez
de Toledo, Duke of Alva and governor of the Southern Netherlands
from 1567 to 1573. In addition, De Pannemaker produced tapestries
for the dealers Pieter and Jan van de Walle, who subsequently sold
these weavings to the likes of Henry VIII, Mary of Hungary, Philip
II of Spain, and Cosimo I de' Medici. Numerous surviving tapestries
bear Willem De Pannemaker's mark and attest that the production
of his workshop was invariably extremely fine, often combining
exquisite workmanship with gilt- or silver-metal-wrapped thread.

Although this *Christ Appearing to Mary Magdalene* does not
contain any such threads, De Pannemaker mimics their shimmering
effect, with the cool blues of the central field imitating silver, and
a skillful illusion of gold in the warm browns with cream-colored
highlights used throughout the border and on individual objects in
the main field, such as the Magdalene's ointment jar. Moreover, the
dexterity of the weaving is remarkable, persuasively conveying the
gauzy veil fluttering above Mary Magdalene's curly hair; the effect of
sharp sunlight and cast shadows on the walls of the sepulcher; and a
variety of textures, from the minutely observed flowering plants and
the bark of the tree trunks to the cracked and veined masonry.

No archival evidence elucidates the circumstances under which the Art Institute's tapestry was produced. Comparison with De Pannemaker's dated tapestries suggests that it may be quite an early production, woven around the same time as the series of armorial tapestries against verdure grounds that he produced for Charles V around 1540.[3] The fruit and foliage border of the *Christ Appearing to Mary Magdalene* in Chicago corroborates this date, as it is more typical of the 1540s, lacking the allegorical figures, arabesques, cartouches, grotesques, and putti so common in De Pannemaker's later works. In addition to weaving new designs, his workshop also frequently produced reeditions of particularly popular sets, often even if the *editio princeps* had been woven in another workshop. The nineteenth-century-Spanish provenance of this version of *Christ Appearing to Mary Magdalene* suggests it might have been a commission for one of De Pannemaker's prestigious Iberian patrons, perhaps one of the Hapsburgs, or the Duke of Alva, or the Duke of Medinaceli. Alternatively, the tapestry could easily have been woven for an agent like the Van de Walles, or for sale on the open market. Some circumstantial evidence suggests that the tapestry in Chicago was part of a larger suite of *Scenes from the Lives of Christ and the Virgin*. A *Meeting of Anna and Joachim* with a related composition, comparable dimensions, and the same border design, is known to have existed; a considerably weaker, later copy survives, with an even more recent addition to the right guard, which displays De Pannemaker's mark.[4] There are also reports of a stylistically related, unpublished *Resurrection* tapestry in a private collection in London.[5]

The design of the cartoon suggests that it was made by an artist familiar with the Italianate developments in narrative painting: The garden at Calvary outside Jerusalem, for example, is enclosed by heavy stone ruins rather than the whittled wooden fences of fifteenth-century designs, as in the Art Institute's other *Christ Appearing to Mary Magdalene* (cat. 3). Similarly, lemon trees have replaced strawberry bushes in the garden, and distant Jerusalem is no longer represented by Gothic spires, but rather as a walled city of obelisks, victory columns, and Renaissance-style colonnaded cupolas. Mary Magdalene herself, in a simple dress and plain sandals, is considerably less ornately attired than in fifteenth-century cartoons, and the three plain, classically draped figures seen from behind replace the diverting procession of exotically garbed Marys in the earlier tapestry. The influence of the contemporary Roman school is most striking in the poses of Christ and Mary Magdalene: compared to the dynamic, twisting movements and emotive expressions in the other *Christ Appearing to Mary Magdalene* piece in Chicago, the figures in this tapestry convey a timeless quality and a monumental grandeur. Indeed, the poses of Christ and Mary Magdalene—he walks towards her, and she sits facing him, one arm across her body, the other open-palmed as it gestures toward the ground—have their roots in the *modello* for the *Noli Me Tangere* in the twelve-piece *Scenes from the Life of Christ* suite painted in the workshop of Raphael (fig. 1).[6] Commissioned by Pope Clement VII in the early 1520s and delivered to

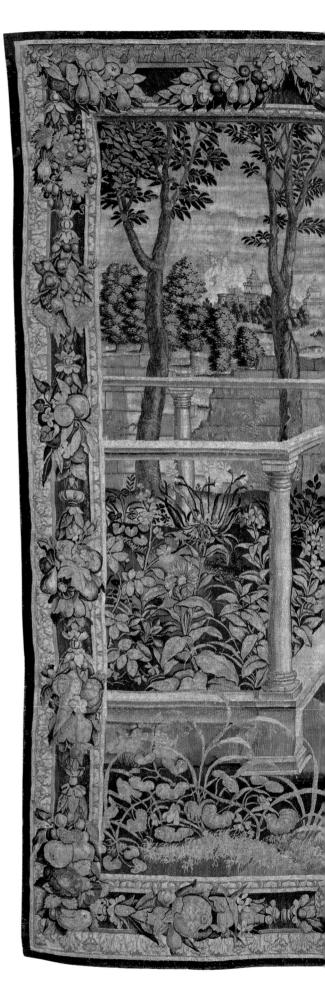

CAT. 12

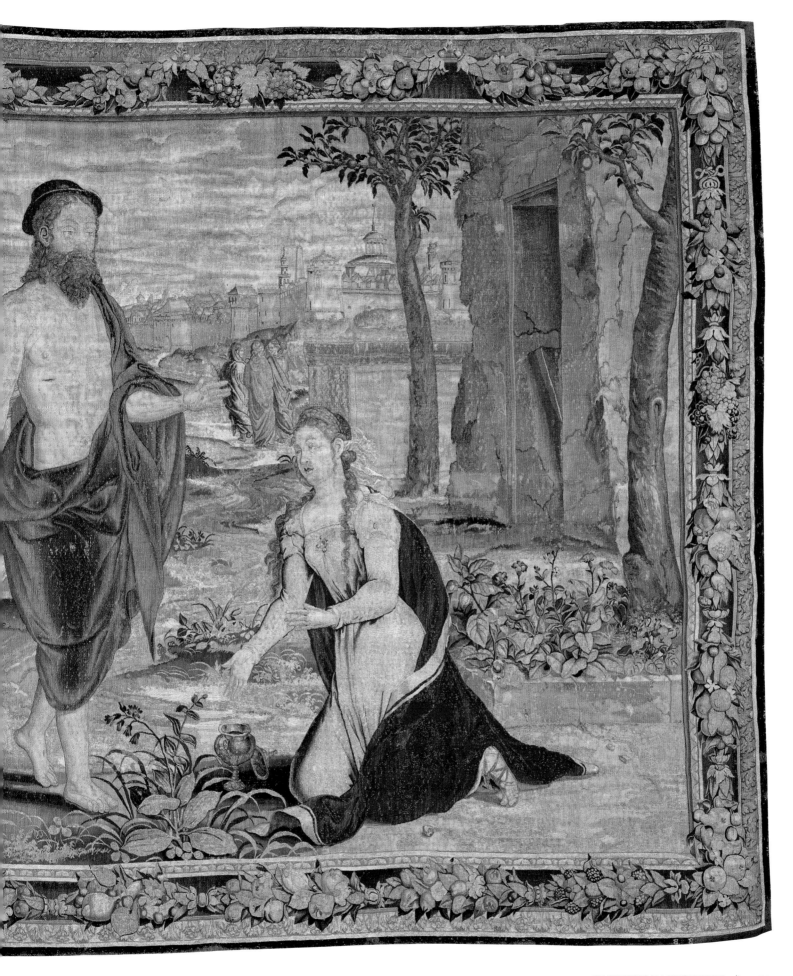

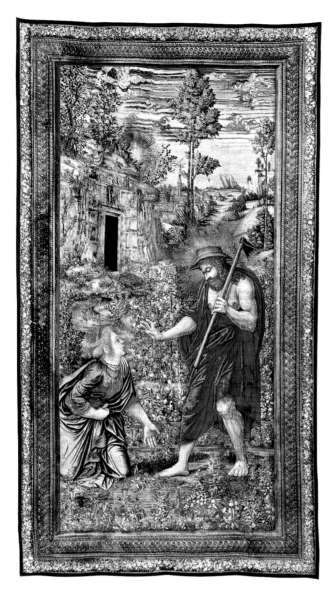

FIG. 1 *Noli Me Tangere* from *Scenes from the Life of Christ* (the *Scuola Nuo-va*). After a design by Raphael. Produced at the workshop of Pieter van Aelst, 1524/30. Wool, silk, and gilt-metal-wrapped thread. Musei Vaticani, Rome.

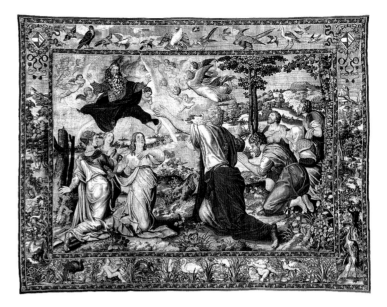

FIG. 2 *God's Covenant with Noah* from *The Story of Noah*. After a design attributed to Michiel Coxcie. Produced at the workshop of Willem de Pannemaker. Wool and silk; 430 x 560 cm. Rijksmuseum, Amsterdam, BK-1955-99.

the Vatican by 1531, these tapestries were woven in Brussels under the direction of Pieter van Aelst (c. 1450–1533). Although Raphael had died in 1520, the *modelli* for this series still reflect his style, having been created in his workshop by various of his followers, including the studio directors Giulio Romano and Giovanni Francesco Penni. After they were drawn, the *modelli* were transported from Rome to Brussels, where Tommaso Vincidor (active 1517–1534/36) supervised a team of local artists in painting them into full-scale tapestry cartoons.[7] The grace of the Raphaelite *Noli Me Tangere* composition could not have been lost on the Brussels artists and, like various other compositions from the *Scuola Nuova* series, it was soon reused by local artists in paintings, tapestry cartoons, and even colored-glass designs.[8]

The leading tapestry designers in Brussels during this period were Pieter Coecke van Aelst (1502–1550) and Michiel Coxcie. De Panne-maker's workshop undertook numerous commissions for tapestries based on their cartoons. The *Christ Appearing to Mary Magdalene* currently under discussion displays stylistic characteristics associated with Coxcie's oeuvre. In particular, Christ's distinctive curly hair and beard and the Magdalene's delicate ringlets reappear in both panel paintings and tapestries after cartoons attributed to Coxcie.[9] More-over, the protagonists' statuesque poses and frozen gestures find their counterparts in other tapestries designed by Coxcie, such as *The Story of Romulus and Remus* set, of which De Pannemaker wove one suite for Philip II in 1550 and sold another edition to Henry VIII before 1547.[10] In particular, details of the Magdalene in the tapestry in Chi-cago, such as her exposed sandal and flexed foot, are strikingly similar to elements in another series attributed to Coxcie, *The Story of Noah*, of which De Pannemaker wove two reeditions, one at the request of Philip II and, subsequently, of his sister, Margaret of Parma (fig. 2).[11] Coxcie was certainly adept at combining figure types invented by Raphael with the detailed, foliage-filled landscapes of his native Flemish tradition.[12]

A case could also be made, however, for attributing the design of the Art Institute's *Christ Appearing to Mary Magdalene* to an Italian artist whose cartoons De Pannemaker also wove. This artist provided the *modelli* for the six-piece *Puttini* series commissioned by Ferrante Gonzaga from De Pannemaker between 1552 and 1557, as well as the *modelli*, based on prototypes by Raphael, for a twelve-piece *Life of Moses* set that was probably woven for Gonzaga in the Brussels work-shop of Willem and Jan Dermoyen around 1545 to 1550.[13] Shared sty-listic characteristics recently prompted the attribution of *The Story of Mercury and Herse*, which was woven in the De Pannemaker work-shop around 1540 for a Spanish patron, to this same master.[14] Since Gonzaga's *Puttini modelli* were transported from Mantua to the De Pannemaker workshop in Brussels by an artist identified as

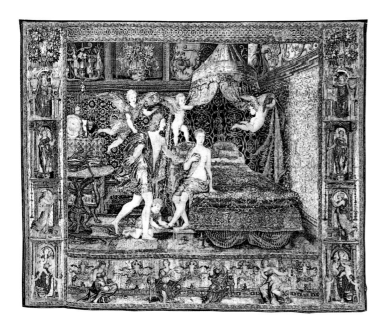

FIG. 3 *Herse's Bedchamber* from *The Story of Mercury and Herse*. After a design possibly by Giovanni Battista Lodi da Cremona. Produced at the workshop of Willem de Pannemaker. Wool, silk, and gilt-metal-wrapped thread; 439 x 538 cm. The Metropolitan Museum of Art, New York. Bequest of George Blumenthal, 41.190.135.

Giovanni Battista Lodi da Cremona, who also acted as Ferrante's agent in negotiating the weaving, Guy Delmarcel and Thomas P. Campbell have tentatively suggested that the unnamed Italian artist to whom the *Puttini*, *Moses*, and *Mercury and Herse* cartoons have been attributed, was in fact this same Giovanni Battista Lodi da Cremona.[15] Comparison of the *Christ Appearing to Mary Magdalene* presently under discussion with these designs is rewarding: the *Puttini* share the same delicate clumps of foliage as the Art Institute's tapestry, foliage that reappears with comparable landscapes and shadow-on-masonry effects in the *Moses* series. In addition, details of the distant Italianate city and the tree-flanked buildings in the Chicago piece closely resemble those in the backgrounds of *The Artillery*, *The Battlefield*, and *The Dinner of the Officers* from the *Fructus Belli* series, the cartoons for which, as Delmarcel has suggested, might be attributed to Lodi, working after Giulio Romano's designs.[16] The tapestry of *Herse's Bedchamber* (fig. 3) in *The Story of Mercury and Herse*, dated, like *Christ Appearing to Mary Magdalene*, to the early 1540s, was woven in the De Pannemaker workshop, possibly for Gastón II de la Cerda or Juan de la Cerda y Silva, the third and fourth dukes of Medinaceli. It shares with the tapestry in the Art Institute facial types; Christ's pose; details like Christ's narrow-brimmed hat; and the convincing location of figures in a space, for example, offering glimpses under the raised flowerbed and Herse's bed, and depicting shadows beyond the tomb entrance and behind the bed canopy. Lodi was certainly based in Brussels, and apparently active as a cartoon designer, from 1540. Until further archival evidence is uncovered, the cases for attribution to Coxcie or to Lodi da Cremona seem equally persuasive. EC

NOTES

1. For more on Willem de Pannemaker's patrons, commissions, and surviving works, see Steppe 1981a; Steppe 1981b; Steppe 1981c; Buchanan 1999, pp. 131–52; and Delmarcel 1999a, p. 368. For a discussion of Willem de Pannemaker's importance within the context of tapestry production in the Southern Netherlands from 1520 to 1560, see Campbell 2002c, pp. 263–457. For Pieter de Pannemaker's tapestries woven for Margaret of Austria and Maximilian I, now all in the Patrimonio Nacional, see Smolar-Meynart 2000, pp. 62–81, cats. 14–18, see Delmarcel 1992.

2. *The Conquest of Tunis* is now in the Patrimonio Nacional, ser. XIII.1–12; see Campbell 2002c, pp. 385–91, 428–34, cat. 50.

3. The suite is now in the Kunsthistorisches Museum, Vienna, invs. XXXIII/1–6; Delmarcel 1999a, pp. 122–23, and Campbell 2002c, p. 268.

4. This later copy was sold at Christie's, London, May 11, 2000, lot 171 (209 x 266 cm).

5. Thomas P. Campbell, Curator, Department of European Sculpture and Decorative Arts, the Metropolitan Museum of Art, conversation with the author, Apr. 2007.

6. The twelve pieces remain in the Musei Vaticani, Rome, inv. 3863; see Campbell 2002c, pp. 237–41, 257–61, cats. 28–29. The set is traditionally called the *Scuola Nuova* to differentiate it from the *Acts of the Apostles* set designed by Raphael, which has also been known as the *Scuola Vecchia*.

7. For Tommaso Vincidor and the work in Brussels, see Standen 1971b, Dacos 1980, and Dacos 1997.

8. Tapestries inspired by the *Noli Me Tangere* in the *Scuola Nuova* set are in the Musée du Louvre, Paris, inv. OA3135 (illustrated in Guimbaud 1928, p. 21), and the Kunsthistorisches Museum, inv. XXXII/3. Another related tapestry was formerly in the Tollin collection and was sold at Galerie Georges Petit, Paris, Tollin sale, May 20–21, 1897, lot 216. For an example of an engraving inspired by the tapestry design, see a work by Johan I Sadeler (published in Strauss 1978–, vol. 70, no. 220); and for colored-glass windows, see the chapel at King's College, Cambridge (published in Wayment 1958).

9. Pieces attributed to Coxcie include *The Fall of Man* and *The Expulsion from Paradise*, two wings from an oil-on-panel polyptych painted around 1540 to 1550, in the Kunsthistorisches Museum, invs. 1031–32, published in Ferino-Pagden, Prohaska, and Schutz 1991, pl. 320; and the *Throne Canopy*, eight tapestry components designed by Coxcie and Hans Vredeman de Vries (1526–1609), also in the Kunsthistorisches Museum, invs. XLV/1–8 (published in Campbell 2002c, pp. 452–57, cat. 54).

10. Campbell 2002c, pp. 397–98.

11. Buchanan 2006 discusses the context of the commissions for Philip II and Margaret of Parma; for the Duchess of Parma's edition, see Hartkamp-Jonxis and Smit 2004, pp. 100–03, cat. 30. The *editio princeps* of the series was woven for King Sigismund II Augustus of Poland, in the workshops of Jan van Tieghem (died in or after 1573) and Jan de Kempeneer (active 1540–after 1556) between 1548 and 1553.

12. For Raphael's influence on Coxcie, see Gnann and Laurenza 1996.

13. The *Puttini* suite is in the Giannino Marzotto Collection, Trissino; Brown, Delmarcel, and Lorenzoni 1996, pp. 184–93, cat. 5. The *Life of Moses* chamber is in the collection of the Centre des Monuments Nationaux, Château-dun; Brown, Delmarcel, and Lorenzoni 1996, pp. 194–205, cat. 6.

14. Two pieces of the suite are now in the Metropolitan Museum of Art, invs. 41.190.134–135. Standen 1985, pp. 87–99, cat. 10, attributes the designs to "a Raphael follower or a Flemish artist under strong Italian influence." Campbell 2002c, pp. 393–94, links the design to the *Puttini* and *Moses* series.

15. Brown, Delmarcel, and Lorenzoni 1996, pp. 185, 191; Campbell 2002c, pp. 392–94.

16. For discussion of the *Fructus Belli* tapestries and attributions of their cartoons to Giovanni Battista Lodi da Cremona, see Brown, Delmarcel, and Lorenzoni 1996, pp. 158–73, cat. 3.

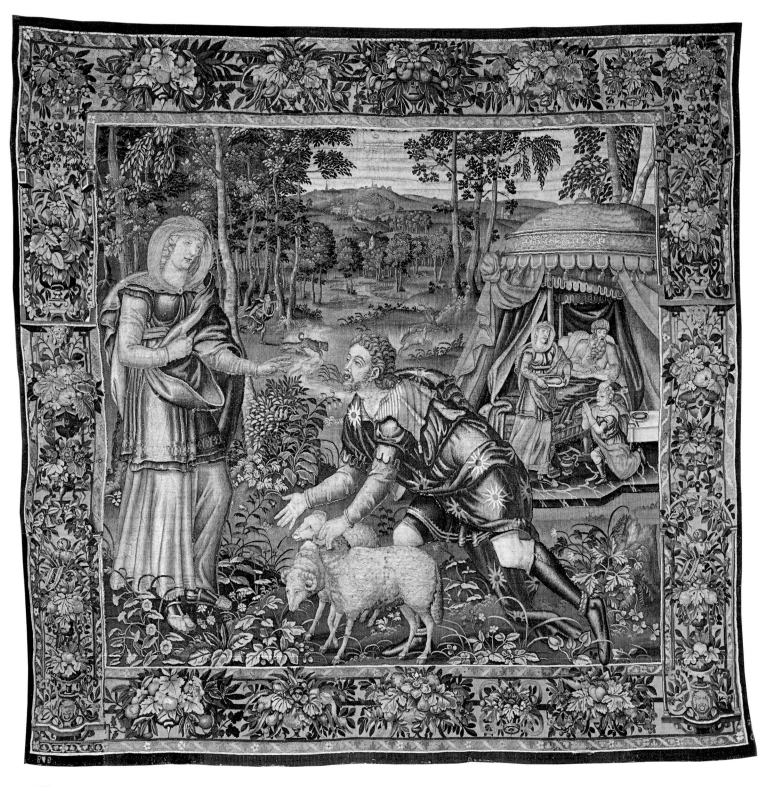

CAT. 13

CAT. 13

The Meeting of Jacob and Rebecca, and Isaac Blessing Jacob from The Story of Jacob

Brussels, 1560/68
After a design by an unidentified Flemish artist, 1555/60
Produced at the workshop of Jan van Tieghem (died 1573 or after)
MARKED: Brussels city mark; mark of Jan van Tieghem
267.65 x 260.35 cm (105⅜ x 102½ in.)
Gift of Sanger Robinson, 1953.476

STRUCTURE: Wool and silk, slit and double interlocking tapestry weave
Warp: Count: 5 warps per cm; wool: S-ply of three Z-spun elements;
diameter: 1.2 mm
Weft: Count: varies from 20 to 34 wefts per cm; wool: S-ply of two Z-spun
elements; diameters: 0.4–1.2 mm; silk: S-ply of two Z-twisted elements;
diameters: 0.5–1.5 mm

Conservation of this tapestry was made possible through the generosity
of the Malott Family Foundation in loving memory of Elizabeth Hubert
Malott.

PROVENANCE: Elmer E. Tolman, Lake Forest, Ill., by 1923;[1] sold, with Tol-
man's house and its contents, to Theodore W. Robinson (died 1948), 1925;
by descent to his son, Sanger Robinson (died 1979); given to the Art Insti-
tute, 1953.

REFERENCES: Anon. 1923, p. 14 (ill.).

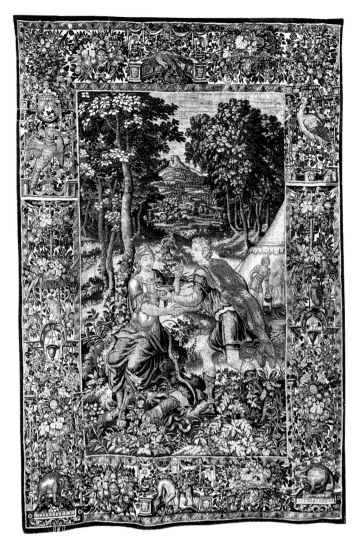

FIG. 1 *Esau Selling His Birthright to Jacob* from *The Story of Jacob*. Brussels, 1550/75. Produced at the workshop of Cornelis Tons. Wool and silk; 387 x 262 cm. The Metropolitan Museum of Art, New York. Bequest of Amy Warren Patterson, 1983.73.1.

IN this tapestry's foreground, which is filled with grasses and small
plants, stands Rebecca, wife of the aging Isaac. She is advising Jacob,
her favorite son, on how to steal the birthright that belongs to his
twin brother Esau. In front of Rebecca, who emphasizes her words
with a hand gesture, Jacob bows with respect. He is clad in a robe
and a star-adorned cloak, an allusion to Genesis 26:4, in which God
appears to Isaac in Gherar and tells him, "I will make thy seed to mul-
tiply as the stars of heaven, and will give unto thy seed all these coun-
tries; and in thy seed shall all the nations of the earth be blessed."
Under Jacob's outstretched arms are two young goats his mother
requested so that she might cook a meal for him to offer Isaac in
exchange for the birthright. A scene further in the distance shows
the blind Isaac lying in bed in a tent and blessing the kneeling Jacob,
having mistaken him for Esau. Rebecca stands nearby, holding a plat-
ter of goat meat. In the background is a wooded landscape in which
Esau hunts with his dogs, unaware of the plot against him. All the
episodes shown are based on Genesis 27:2–29.

The border is edged on its inside and outside by thin ornamental
bands, with spirals of leaves and corollas against a red background.
Inside the border are thick, multicolored tufts of fruit, flowers,
and leaves, supported by a trellis of thin metal bars. Small decora-
tive masks are also visible in the vertical borders. The guard carries
the Brussels city mark and that of Jan van Tieghem, a tapissier who
produced—on his own or in collaboration with leading Brussels
workshops of his time—some of the finest suites ever produced in

that city.[2] In the 1540s, Van Tieghem participated in the produc-
tion of two suites of *The Acts of the Apostles*, after original cartoons
by Raphael.[3] In the 1550s, Van Tieghem wove *The Story of Abraham*,
perhaps from cartoons by Michiel Coxcie (1499–1592); and par-
ticipated in the production of a *Story of Cyrus* suite after cartoons
definitely by Coxcie, as well as a *Story of Moses* chamber presently
in the Kunsthistorisches Museum, Vienna (inv. T.I).[4] Between the
1550s and the early 1560s, in collaboration with other Brussels weav-
ers, Van Tieghem produced the magnificent suites commissioned
by King Sigismund II Augustus of Poland, all now at Wawel Castle,
Kraków: *Genesis*, *Landscapes with Animals*, and *Heraldic Tapestries
with Grotesques*.[5] In 1568, Van Tieghem, a Protestant, was expelled
from Brussels for religious reasons. His cartoons, and the tapestries
in production on his looms, were confiscated, and the former were
sold to other weavers. Van Tieghem moved, first to Cologne and
later to Wesel, where he worked until at least 1573, making several
tapestries for Duke Wilhelm of Hessen-Kassel.

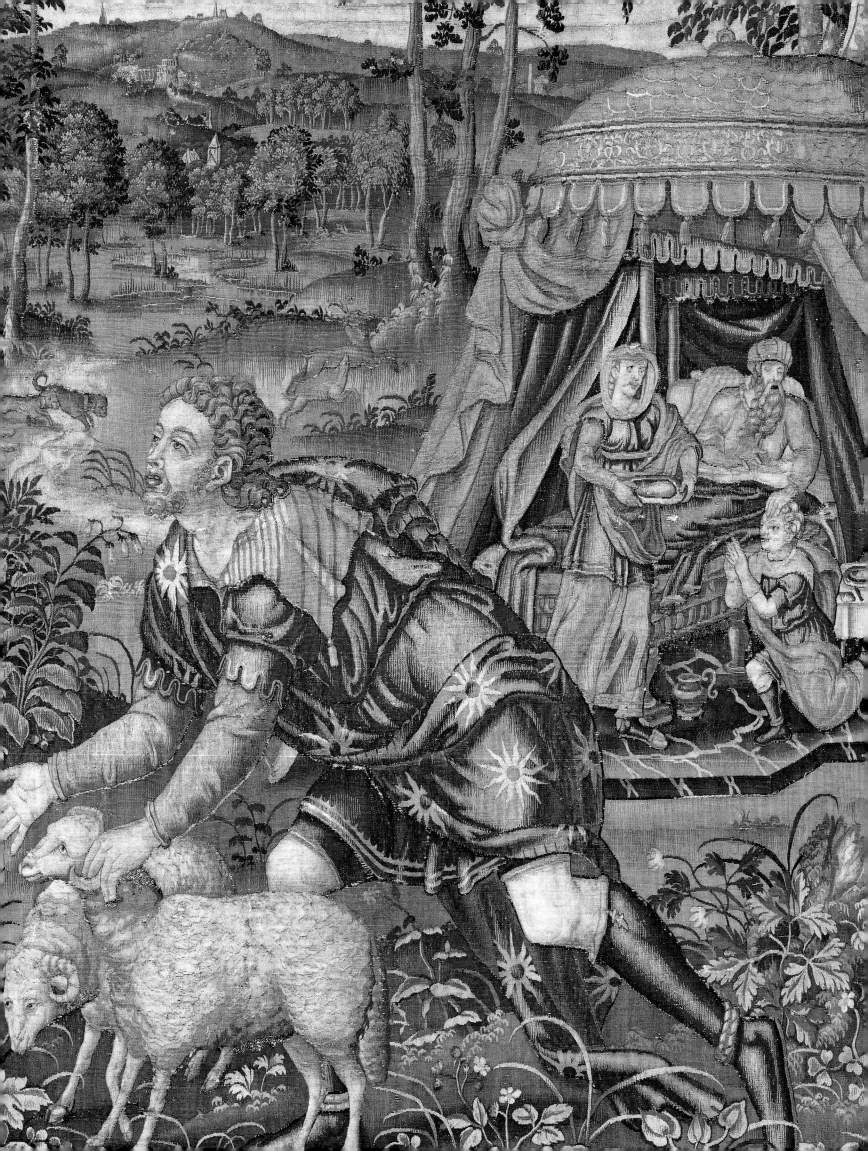

The Van Tieghem piece in the Art Institute, called *The Meeting of Jacob and Rebecca, and Isaac Blessing Jacob*, belonged to a *Story of Jacob* suite. No other tapestry from the same edition has yet been traced, but the other scenes from the series are known through two incomplete chambers that were copied from the same set of cartoons. One of these suites comprises three tapestries, which also bear Jan van Tieghem's mark. The group was in a German private collection in 1969 and at Galerie Ostler in Munich in 1974.[6] The first piece is *Jacob Bids Farewell to Isaac and Rebecca* (308 x 323 cm), and in its background shows Esau hunting, Esau despairing next to Isaac's tent after his father blessed his brother, and Jacob's ladder (Genesis, 27:3–4, 30–46; 28:1–5). The second tapestry depicts *The Meeting of Jacob and Rachel* (308 x 275 cm; one lateral border was removed), with background scenes of Rachel arriving at the well, Jacob helping the shepherds to open the well, and the meeting of Jacob and Laban (Genesis, 28:9–13). *Laban Searching for His Idols and Making a Covenant with Jacob* (308 x 446 cm) is the third piece, and shows Laban's departure in the background (Genesis, 31:33–54; 32:1). The other known *Story of Jacob* edition consists of six pieces, now at the Metropolitan Museum of Art, New York.[7] In addition to the Brussels city mark, the tapestries bear the weaver's mark *CT*, once erroneously attributed to Cornelis Tserraerts but now acknowledged to be the mark of Cornelis Tons (active around 1550–75).[8] The subjects are: *Esau Selling His Birthright to Jacob* (387 x 262 cm), with background scenes of Esau hunting and Rebecca cooking the goats for Isaac (Genesis, 25:27–34); *Rachel Giving Bilhah to Jacob* (386 x 263 cm; Genesis, 30:1–4); *Rachel and Bilhah with Dan* (381 x 262 cm; Genesis, 30:6); *Laban Searching for His Idols* (384 x 323 cm; a copy of the left half of *Laban Searching for His Idols and Making a Covenant with Jacob*, from the edition formerly in a German private collection); *Jacob's Sacrifice* (381 x 201 cm; a copy of the right half of the third tapestry in the previous series); and *Jacob Burying the Idols Under the Oak Tree* (378 x 330 cm; Genesis, 35:2–4).

It is possible that the set also included other subjects commonly represented in tapestry ensembles devoted to the story of Jacob, such as Jacob Wrestles with the Angel, the Marriage of Jacob and Rachel, and the Reconciliation of Jacob and Esau. Most likely, the series included a tapestry depicting Jacob's Dream, a subject usually depicted in Jacob series, even though the angels climbing the ladder already appear, albeit barely visible, in the background of the *Jacob Bids Farewell to Isaac and Rebecca* tapestry. The fine, wide scenes of the suite once in Munich suggest that it may have composed part of the *editio princeps* or, at least, of the earliest surviving edition, produced before that to which the tapestry in Chicago belonged. Furthermore, given that the scene represented in the Munich *Laban Searching for His Idols and Making a Covenant with Jacob* was woven into two rather narrow pieces, *Laban Searching for His Idols* and *Jacob's Sacrifice*, for the Cornelis Tons edition in New York, the question arises whether other, smaller tapestries from the Metropolitan Museum of Art's suite could have also copied sections of larger cartoons. For example,

the small figure of Esau hunting in the background in the *Esau Selling His Birthright to Jacob* in New York is almost identical to the one depicted in the Chicago tapestry, and its scene of Rebecca cooking the goat meat also closely matches the narrative of the Art Institute tapestry (see fig. 1). It is therefore possible that *Esau Selling His Birthright to Jacob* and *The Meeting of Jacob and Rebecca, and Isaac Blessing Jacob* were in fact sections of one large cartoon; its background could have been partially modified during the division, and the image of Esau hunting duplicated.

The story of Jacob was not an unusual subject for a tapestry cycle. Various *Jacob* series were woven by Brussels and Flemish weavers in the sixteenth century. The oldest, but also the most sumptuous and influential in its figure designs, is a ten-piece set conceived by Bernard van Orley (c. 1488–1541) around 1530. It was reproduced in a suite woven by Willem de Kempeneer (1521–c. 1550) in Brussels by 1534, when it was sold to the merchant Joris Wezeleer; this may have been the same edition, bearing Kempeneer's mark, that was sold to Cardinal Lorenzo Campeggi of Bologna before 1539, and is now in the Royal Museums of Art and History, Brussels.[9] A suite of six tapestries, also woven by De Kempeneer and from the same cartoons as the Wezeleer chamber, is now in the Galleria degli Uffizi, Florence.[10] Two further *Jacob* sets, both in a similar classicist style influenced by Michiel Coxcie, were designed just before 1550 for Brussels workshops. From the first set of designs a suite was woven that in the seventeenth century was part of the Barberini collection in Rome. Its three surviving tapestries, *Jacob's Dream*, *Jacob and Rebecca*, and *Isaac Blessing Jacob*, are now in the Fine Arts Museums of San Francisco.[11] The second series was woven several times; among the pieces produced after its cartoons are three Brussels tapestries, each belonging to a different suite—*Jacob Opens the Well to Water Rachel's Flock* (Spaans Gouvernement, Maastricht), *Jacob's Nuptials* (private collection), and *The Reconciliation of Jacob and Esau* (private collection)—as well as a suite of six tapestries woven in Enghien between about 1550 and 1575, now at the Museo Arquéologico Nacional in Madrid.[12] A similar though less elegant style can be seen in another *Jacob* suite probably woven in Oudenaarde between about 1550 and 1575. The edition originally comprised eight pieces, but only five survive.[13] Finally, a set of cartoons of *The Story of Jacob* was produced around 1600, with scenes copied from engravings by Marten de Vos published in Gerard de Jode's *Thesaurus Elegantissimis Imaginibus Expressum* (Antwerp, 1579). Several tapestries were woven from these cartoons at the beginning of the seventeenth century by Nicasius Aerts (died c. 1627) of Brussels, and in the second half of the seventeenth century by Erasmus II de Pannemaker (born 1605) and Gillis Ydens.[14]

It has been reasonably hypothesized that the *Story of Jacob* cartoons, from one of which the tapestry in the Art Institute was copied, initially belonged to Jan van Tieghem, who used them to produce his multiple suites, and then abandoned them and other cartoons when he had to leave Brussels in 1568. The cartoons would then have passed to Cornelis Tons, who wove subsequent series.[15] According to this

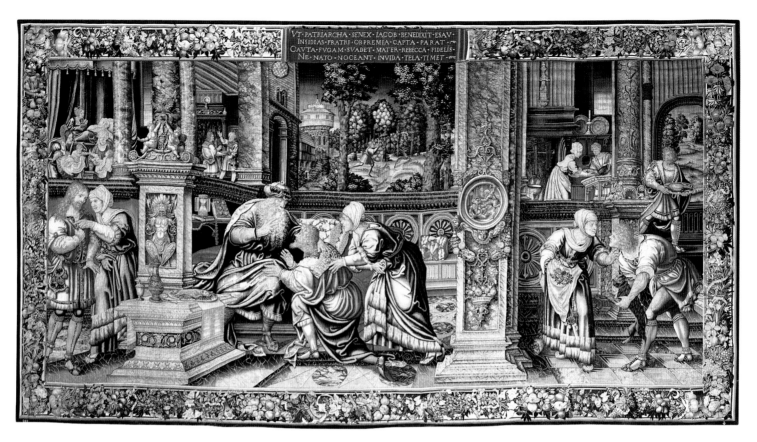

FIG. 2 *Isaac Blessing Jacob* from *The Story of Jacob*. After a design by Bernard van Orley, c. 1530. Produced at the workshop of Willem de Kempeneer, before 1539. Wool and silk; 424 x 680 cm. Royal Museums of Art and History, Brussels.

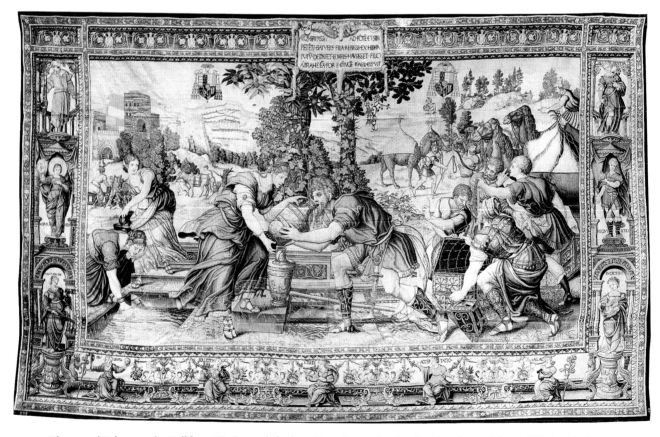

FIG. 3 *Eliezer and Rebecca at the Well* from *The Story of Abraham*. Brussels, 1541/43. Produced at the workshop of Willem de Kempeneer. Wool, silk, and gilt-metal-strip-wrapped thread; 477 x 777 cm. Kunsthistorisches Museum, Vienna, T.II.

narrative, the Munich *Jacob* edition and the Chicago *Meeting of Jacob and Rebecca* tapestry would have been manufactured before 1568—for stylistic reasons, most likely between about 1560 and 1568—and the New York suite after 1568.

The *Meeting of Jacob and Rebecca* tapestry at the Art Institute was clearly inspired by the first scene of Van Orley's Jacob series, *Isaac Blessing Jacob* (see fig. 2). Both tapestries feature background scenes of the small figure of Esau hunting with his dogs in the woods.[16] The classicist and rather slender figures in the foreground of the Chicago tapestry, however, seem less realistic and sculptural than Van Orley's, which are also part of more complex narratives and are shown in more illusionistic architectural settings located in deeply receding space. The posture of the bowing Jacob figure in the Art Institute's piece resembles that of the male protagonist in the *Eliezer and Rebecca at the Well* from a *Story of Abraham* suite whose cartoons—an amalgam of the styles of Van Aelst, Coxcie, and Van Orley—represented authoritative models for Brussels tapestry designers in the 1540s to 1560s (see fig. 3).[17] The figurative references in *The Meeting of Jacob and Rebecca* are similar to those of the other pieces in the suite, which depict different figural groups inspired by Van Orley's *Jacob* cartoons. This artist's influence is also evident in the inclusion of multiple vignettes from one story on a single tapestry's main field, distributed across the foreground and the background. In the *Story of Jacob* woven by Tieghem and later by Tons, however, the classicist style is obvious and calculated, but also simplified and conventional in its gestures and compositional references, which echo the Raphaelite style of the large narrative series conceived by Coxcie around the mid-sixteenth century, such as *Genesis* and *The Story of Cyrus*, but fail to fully achieve their complex syntax, eloquent poses, or expert use of spatial recession. *The Story of Jacob* is also marked by its eschewal of architectural settings for pleasant but repetitive landscapes, delimited laterally by trees and including visual "lunges" toward the hills rising in the background. Similar landscapes were reproduced innumerable times in subsequent Flemish series until the beginning of the seventeenth century. *The Meeting of Jacob and Rebecca*, therefore, exemplifies a style typical of many series woven in Brussels, as well as Oudenaarde and Enghien, in the 1560s. NFG

NOTES

1. As documented by a photograph showing the tapestry in the Tolman residence in May 1923; Anon. 1923, p. 14. See fig. 11 in "A Collection and Its Donors."

2. Van Tieghem's mark was documented in a letter he sent to the Duke of Hessen-Kassel in 1570; Göbel 1923, vol. 1, p. 327, reproduction of weavers' marks, no. 4. For more on the weaver and his work, see Schneebalg-Perelman 1972, pp. 425–32; Brown, Delmarcel, and Lorenzoni 1996, pp. 149–51; and Delmarcel 1999a, p. 369.

3. One edition was purchased by Ercole Gonzaga in 1557 and is now in the Palazzo Ducale, Mantua; Brown, Delmarcel, and Lorenzoni 1996, pp. 148–57. The other edition Van Tieghem was involved in is now held by the Patrimonio Nacional, Spain (ser. 12), and perhaps belonged to Charles V; Junquera de Vega and Herrero Carretero 1986, pp. 63–72. It is also possible

that he wove a third, unmarked suite that Henry VIII of England purchased in 1542, that was destroyed in Berlin in 1945; Campbell 1996b, pp. 69–75.

4. *The Story of Abraham* is now in the Isabella Stewart Gardner Museum, Boston. It is published in Cavallo 1986, pp. 58–65, cats. 11a–e. The *Story of Cyrus* suite, now in the Patrimonio Nacional (ser. 39), is recorded in the Spanish Royal Collection from 1560; Junquera de Vega and Herrero Carretero 1986, pp. 279–89. *The Story of Moses* is published in Mahl 1967. Van Tieghem also took part in the execution of a *Story of the Creation* suite from cartoons by Pieter Coecke van Aelst (1502–1550). Purchased by Cosimo I de' Medici in 1551, the suite is now in the Accademia in Florence; Meoni 1989.

5. See Szablowski 1972 and Hennel-Bernasikowa 1998. Around this time, Van Tieghem also produced *The Story of Adam and Eve*, a section from the *Genesis* set, for Duke Wilhelm IV of Bavaria or his son Albert V; Duverger 1974.

6. Wilckens 1968, pp. 778–86, figs. 1–3; advertisement in *Apollo* 99 (June 1974), p. 11; Standen 1985, vol 1, p. 138.

7. Standen 1985, vol. 1, pp. 137–50, cats. 17a–f.

8. Delmarcel 1988, esp. pp. 97–98.

9. Crick-Kuntziger 1954b; Crick-Kuntziger 1956, pp. 42–48, figs. 32–42; Calberg and Pauwels 1961; Joos 1985.

10. Berti 1980, pp. 1052–55, tapestry cats. 1–6; Meoni 2003, p. 42.

11. Bennett 1992, pp. 111–21, cats. 26–28; Bertrand 2005, pp. 36, 101–02.

12. For *Jacob Opens the Well to Water Rachel's Flock*, see Kalf 1988, pp. 181–83 n. 30. *Jacob's Nuptials* was owned by the antique dealership Blondeel in 1979; Delmarcel 1980, p. 78. *The Reconciliation of Jacob and Esau* is published in Göbel 1923, vol. 2, table 374. It then belonged to a German private collection. For the suite in Madrid, see Delmarcel 1980, pp. 78–89 nn. 35–40.

13. Forti Grazzini in Frugoni 1999, vol. 1, pp. 464–46 nn. 1591–95, vol. 3, tables 1591–95. The tapestries, which display the coat of arms of the Dolfin family of Venice, were donated by Sertorio Sertori in 1593 to the Duomo of Modena, where they have remained until the present day; two scenes are based on prototypes engraved by Maarten van Heemskerck in 1549. The subjects are: *Jacob's Dream*, *Laban Welcomes Jacob*, *The Wedding of Jacob*, *Rachel Hides the Idols from Laban*, and *Jacob's Reconciliation of Jacob with Esau*.

14. An incomplete suite comprising four tapestries that bear Nicasius Aerts's marks (*Esau Selling His Birthright*, *Isaac Blessing Jacob*, *Jacob's Dream*, and *Jacob Leaves Laban's Home*) is in the Philadelphia Museum of Art; Downs 1927, pp. 312, 313; Asselberghs 1974, p. 51. A *Meeting with Rachel* bearing Aerts's mark is in a private collection in Treviso; another weaving of the same tapestry, unmarked, was sold at Piasa and Mercier Commissaires priseurs, Lille, Mar. 31, 2001, lot 217. A fragmentary *Jacob Wrestles with the Angel* was in the collection of the Florentine art dealer Fiorini in 2000. The De Pannemaker-Ydens *Jacob* suite comprises five tapestries now in the treasury of the Cathédrale St. Jean in Lyon. The group is published in Viallet-Reyniès in Nivière 1990, pp. 28–29, cat. 8.

15. Standen 1985, vol. 1, p. 138; Delmarcel 1988, p. 98.

16. See Kempeneer's tapestry in the Royal Museums of Art and History, Brussels; Crick-Kuntziger 1956, table 32; Campbell 2002c, fig. 144.

17. For more on *The Story of Abraham*, see Campbell 2003. See the *Eliezer and Rebecca at the Well* scene from the *editio princeps*, woven around 1541 to 1543 by Willem de Kempeneer for Henry VIII of England, now at Hampton Court (Marillier 1962, pl. 6; Campbell 2003, fig. 15), or the same scene from the best reeditions: that in the Patrimonio Nacional (ser. 29), also woven by Kempeneer (Junquera de Vega and Herrero Carretero 1986, p. 212); and that in the Kunsthistorisches Museum, Vienna (inv. T. II), woven by De Kempeneer in collaboration with other workshops (Baldass 1920, pl. 29).

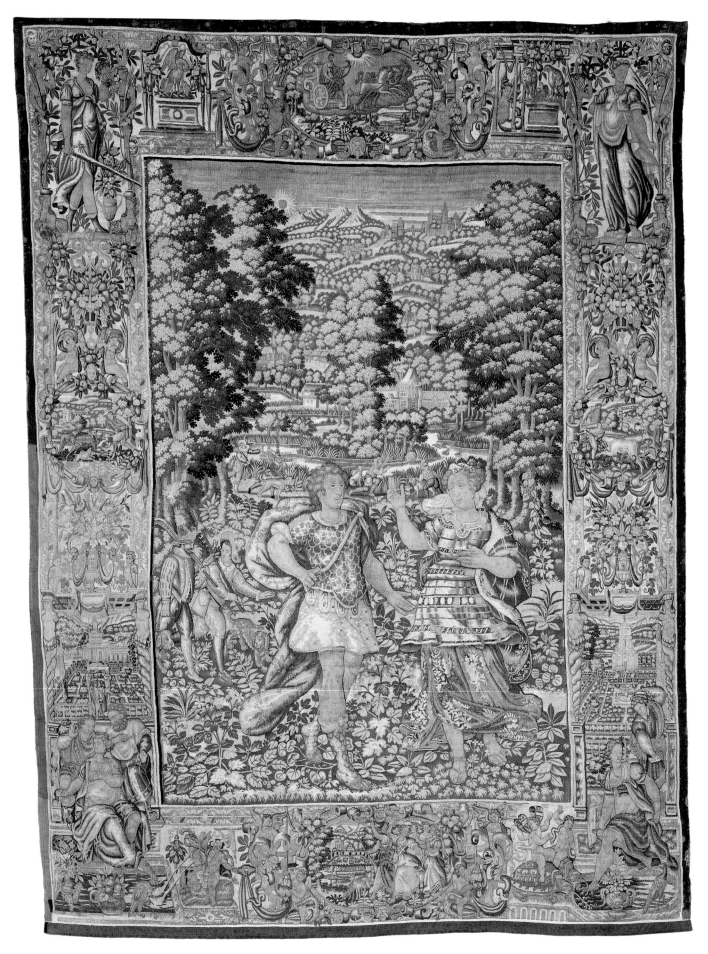

CAT. 14A

Landscapes with mythological scenes and hunts

CAT. 14A

Venus and Adonis (?) with the Duck Hunt

Brussels, c. 1600
After a design by an unknown artist
Presumably produced at the workshop of Jacques I Geubels (died between
1601 and 1605) or his widow Catharina van den Eynde (died before 1629)
MARKED: *C* [*G*?] and *A* superimposed on *I*
262.5 x 344.4 cm (103⅜ x 135⅜ in.)
Gift of the Antiquarian Society of the Art Institute of Chicago, 1896.147

STRUCTURE: Wool and silk, slit and double interlocking tapestry weave
Warp: Count: 7 warps per cm; wool: S-ply of three Z-spun elements;
diameters: 0.7–0.9 mm
Weft: Count: varies from 17 to 30 wefts per cm; wool: S-ply of two Z-spun
elements; pairs of S-ply of two Z-spun elements; diameters: 0.5–1.2 mm; silk:
pairs of S-ply of two Z-twisted elements; diameters: 0.5–1.2 mm

Conservation of this tapestry was made possible through the generosity of
the Antiquarian Society of the Art Institute of Chicago.

PROVENANCE: See below.

REFERENCES: Ffoulke 1913, pp. 71–72 (ill.). Ffoulke n.d., pp. 1–14. Hunter
1914a, p. 119, fig. 2. Candee 1935, p. 78, ill. opp. p. 78. Mayer Thurman in
Keefe 1977, pp. 184–85 (ill.), cat. 241.

EXHIBITIONS: See below.

CAT. 14B

Pluto and Proserpina with Falconry

Brussels, c. 1600
After a design by an unknown artist
Produced at the workshop of Erasmus I de Pannemaker
(c. 1565–1620 or later)
MARKED: *EDP*
384.6 x 345.3 cm (151½ x 135⅞ in.)
Gift of the Antiquarian Society of the Art Institute of Chicago, 1896.148

STRUCTURE: Wool and silk, slit and double interlocking tapestry weave
Warp: Count: 6 warps per cm; wool: S-ply of three Z-spun elements; diam-
eters: 0.7–0.9 mm
Weft: Count: varies from 19 to 60 wefts per cm; wool: S-ply of two Z-spun
elements; diameters: 0.4–1.5 mm; silk: S-ply of two elements with no
appreciable twist; paired elements with no appreciable twist; diameters:
0.3–1.0 mm

Conservation of this tapestry was made possible through the generosity of
the Antiquarian Society of the Art Institute of Chicago.

PROVENANCE, CATS. 14A–B: Charles M. Ffoulke (died 1909), by 1891; sold
to the Antiquarian Society of the Art Institute of Chicago, 1896; given to the
Art Institute of Chicago, 1896.

REFERENCES: Ffoulke 1913, pp. 71–72. Hunter 1914a, p. 119, fig. 3. Keefe
1977, pp. 182–83 (ill.), cat. 240.

EXHIBITIONS, CATS. 14A–B: Art Institute of Chicago, *The Antiquarian
Society of the Art Institute of Chicago: The First One Hundred Years*, 1977 (see
Keefe 1977).

CAT. 15

Diana and Her Nymphs with the Ox Hunt

Brussels, c. 1600
After a design by an unknown artist
Produced at an unknown workshop
528.1 x 358 cm (208 x 140⅞ in.)
Gift of Mrs. Melville N. Rothschild, 1958.278

STRUCTURE: Wool and silk, slit and double interlocking tapestry weave
Warp: Count: 6–7 warps per cm; wool: S-ply of three Z-spun elements;
diameters: 0.8–1.0 mm
Weft: Count: varies from 20 to 34 wefts per cm; wool: S-ply of two Z-spun
elements; diameters: 0.3–1.1 mm; silk: S-ply of two Z-twisted elements; pairs
of S-ply of two Z-twisted elements; three yarns of S-ply of two Z-twisted silk
elements; diameters: 0.7–1.2 mm

Conservation of this tapestry was made possible through the generosity of
Mrs. Richard Franke.

THESE three tapestries, which feature mythological scenes and hunts
set in landscapes that give a strong impression of receding space, are
typical of late-sixteenth- and early-seventeenth-century Flemish pro-
duction. Their borders are wide and compartmentalized, showing a
playful array of baskets of fruit, floral vases, grotesques, putti, and
strapwork, and the corners feature allegorical, biblical, and mytho-
logical figures. In the middle of both the vertical and horizontal
borders of this type of piece are usually cartouches depicting land-
scapes, myths, and scenes from the Bible. Countless individual pieces
and whole suites of this genre are in public and private collections
and continually surface on the art market, attesting to their original
popularity. Such works appealed to wealthy patrons because they
portrayed both hunting, a privilege and favorite pastime of the elite,
and mythological episodes, usually borrowed from Ovid's immensely
popular *Metamorphoses*, which presents tales of erotic violence under
the guise of erudite narration.[1]

Though a great number of such landscapes with mythological
scenes and hunts exist, neither they nor the impressive contempo-
rary biblical sets and series showing stories from ancient history and
mythology have received sufficient art historical attention, as the
entries for *Alexander Kneeling before Jaddus at the Gates of Jerusa-
lem* (cat. 16) and *Alexander Encounters Thalestris, Queen of the Ama-
zons* (cat. 37) argue. This lacuna exists in part because no celebrated

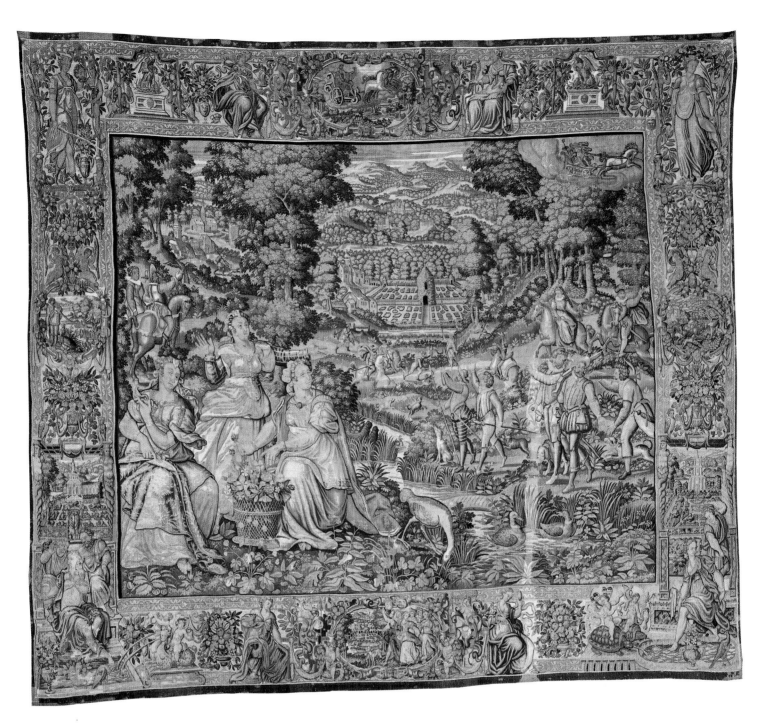

CAT. 14B

Flemish painter and tapestry designer worked between 1580 and 1615, a fact that has led art historians to consider the period a transitional era unworthy of their attention.[2] Moreover, during the last quarter of the sixteenth century, numerous Flemish tapestry producers emigrated from the Southern Netherlands to various European countries, a change that has added to the impression that Flemish tapestry production was in artistic and economic turmoil around 1600.[3] As a result, landscapes with mythological scenes and hunts have only been studied cursorily and piecemeal by tapestry scholars surveying public collections; no succinct survey exists.[4]

In addition, what little research has been published is constrained by the fundamental methodological limitations that characterize any discussion of Flemish tapestry woven during this period. The few available studies focus on iconography, yet given the ambiguous and imprecise representation of characters and scenes, their identification can only be tentative at best, and the rationale for the seemingly haphazard combination of allegorical, biblical, and mythological figures and episodes must remain unexplored.[5] Furthermore, since virtually nothing is known about the identity of the tapestry designers and cartoon painters, stylistic analyses are elementary and tend to concentrate on the frequent use of engravings as sources for tapestry designs. Though a handful of archival documents reveal the names

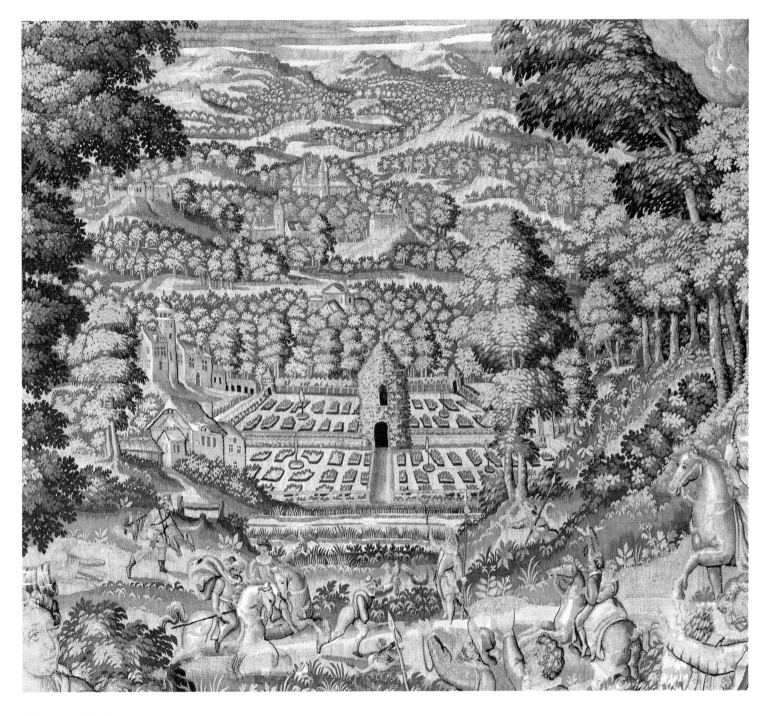

CAT. 14B, DETAIL

of the major tapestry producers working around 1600, they only rarely link these tapissiers unambiguously to specific suites or sets.[6] Consequently, attribution and *termini ante* and *post quem* dating rely predominantly on monograms and borders. These criteria, however, present major pitfalls, as Guy Delmarcel argues.[7] First, the identifications of many of the marks and monograms are merely hypothetical, and have been transformed into established fact only by frequent repetition.[8] Second, the common assumption that a border type can be regarded as a workshop's signature fails to take into account both the practice of circulating border designs among tapestry producers within and across production centers, and the custom of recycling

border designs through the years. Extensive and thus time-consuming archival research and a thorough comparative study of late-sixteenth-century art are required to shed more light on these issues. Given the scope of the present volume, however, this entry can only offer a concise analysis of the three landscapes with mythological scenes and hunts in the Art Institute, thereby raising a number of questions that will remain unanswered.

The identical borders, height, and provenance of *Venus and Adonis (?) with the Duck Hunt* and *Pluto and Proserpina with Falconry* reveal that they are part of the same suite. *Venus and Adonis* represents a young man and woman, both richly dressed, in a landscape

that recedes dramatically. Behind the figures a handful of hunters shoot ducks that swim in a small lake in front of a castle. Forests and mountains fill the far distance. The border is woven with floral vases, grotesques, and putti, and cartouches occupy its centers and corners. The cartouches in the horizontal borders contain mythological scenes: in the oval in the top border, Apollo, god of music and light, plays a lyre as he drives his chariot, whereas the circle on the bottom depicts Apollo's twin sister Artemis, goddess of the hunt, accompanied by attendants. The vertical borders contain a boar hunt on the left and an ox hunt on the right. Judith, with the head of Holofernes, is in the upper left corner. Her counterpart in the upper right corner might be Humility. The bottom corners show Susanna and the Elders (left) and Bathsheba receiving David's letter (right).

Given their lack of attributes, the protagonists in the central field cannot be identified with certainty. At the end of the nineteenth century, when the tapestry entered the Art Institute's collection, the couple was identified as Vertumnus and Pomona, yet this was mere conjecture. It seems more plausible that they are Venus and Adonis, for these mythological figures are closely related to the hunt. In the tenth book of the *Metamorphoses,* Ovid describes how Venus fell in love with the beautiful Adonis, a brave hunter. The goddess warned him about the dangers of his occupation, but he disregarded her warning and was eventually killed by a boar.

Pluto and Proserpina with Falconry also depicts figures in a landscape. In the left foreground Ceres, Proserpina's mother, and two of her companions sit around a flower-filled basket, their attention caught not by the nearby group of falconers and hunters armed with guns and crossbows, but by the scene in the clouds in the upper right corner: Pluto abducting Proserpina in his chariot (*Metamorphoses,* book 5). A formal garden with clearly outlined beds is shown in the background, slightly above the center of the composition. The border of this tapestry is identical to that of *Venus and Adonis,* except for two minor modifications: in the horizontal borders, female figures flank the mythological scenes (Temperance and Hope frame Apollo; Artemis is accompanied by Prudence and an unidentified woman), and in the vertical borders the arrangement and subject of the hunting scenes differ (the boar hunt scene has been moved to the right border and a duck hunt has replaced the ox hunt shown in the left border).

Stylistic features date this pair to around 1600. The poses of the figures; the small, lively hunting scenes; and the use of decentralized vanishing points—all of which also characterize *Diana and Her Nymphs with the Ox Hunt*—show *Venus and Adonis* and *Pluto and Proserpina* to be fine examples of Brussels Mannerist tapestry design. The man and the woman on the very left of *Pluto and Proserpina* provide a *terminus post quem* for the set as they are borrowed from *Falconry* (fig. 1), an engraving by the Antwerp draughtsman, engraver, print publisher, and dealer Adriaen Collaert, after a design by the Flemish artist Hans Bol.[9] The engraving belongs to a series of thirty-one hunting scenes that was first published in Antwerp in

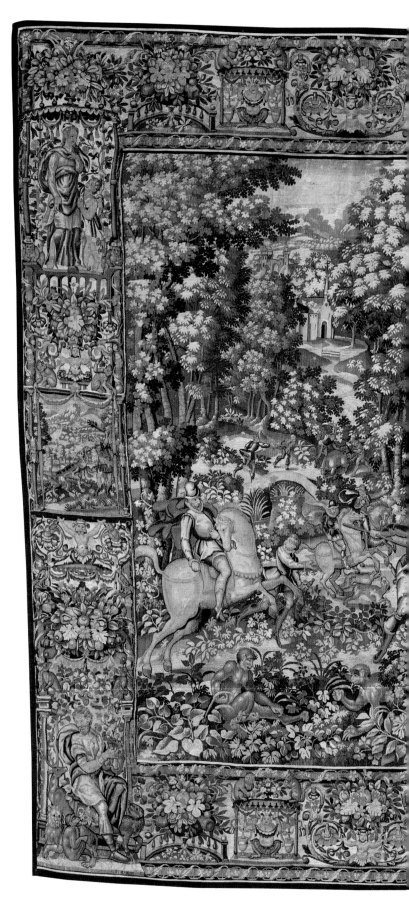

CAT. 15

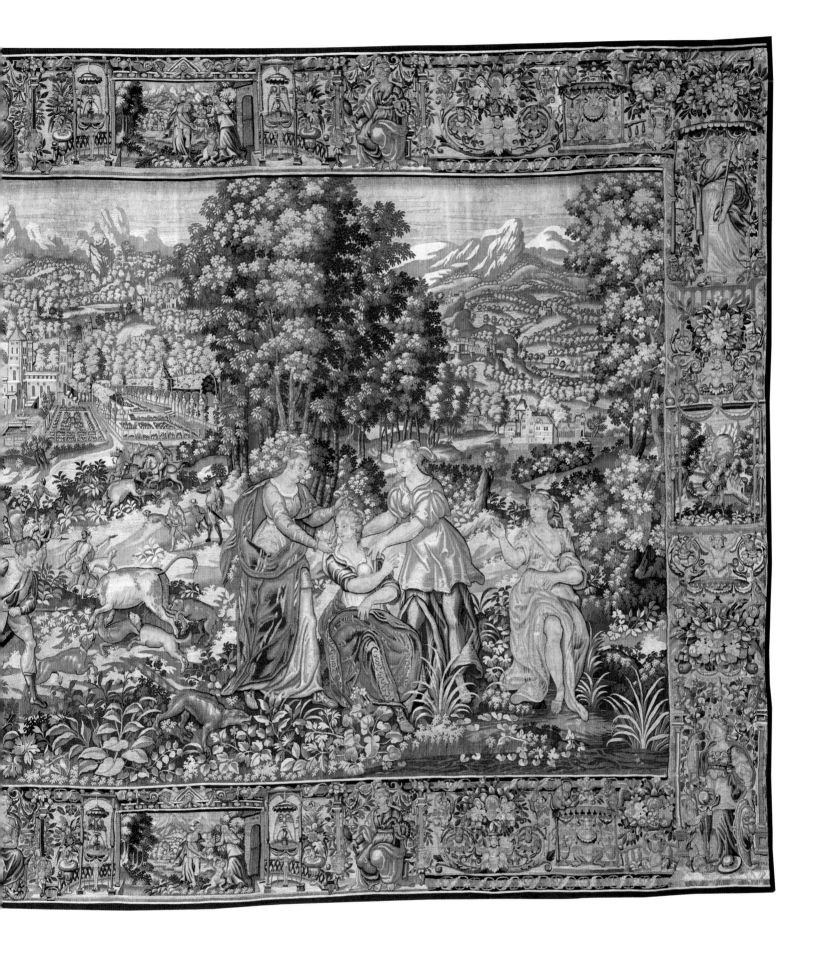

FIG. 1 *Falconry*. Adriaen Collaert after Hans Bol, 1582. Engraving; 7.6 x 21.2 cm. Royal Library of Belgium, Brussels.

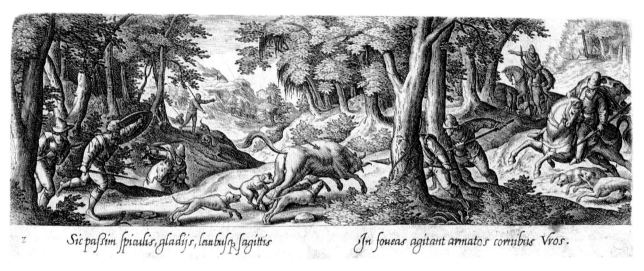

FIG. 2 *Ox Hunt*. Adriaen Collaert after Hans Bol, 1582. Engraving; 7.6 x 21.2 cm. Royal Library of Belgium, Brussels.

1582, which obviously means that the cartoon and tapestry must have been executed after this date. Bathsheba receiving David's letter, the scene shown in the lower right corner, resembles an engraving after Jan Snellinck that Collaert made for the *Thesaurus Veteris et Novi Testamenti* (Antwerp, 1585).[10]

Venus and Adonis features a monogram in its selvage that can be read as a *C* and an *A* superimposed on an *I*. The *C*, however, might originally have been a *G*—the border unfortunately shows traces of loss. The IAG monogram can be securely attributed, on archival evidence, to Jacques I Geubels or his widow Catharina van den Eynde.[11] *Pluto and Proserpina* bears the mark EDP, which presumably belongs to the Brussels tapissier Erasmus I de Pannemaker.[12] The monograms thus confirm that the pieces were woven around 1600.

Features of the borders of the pieces can be related to numerous Brussels sets. A tapestry in the Metropolitan Museum of Art, New York, an unidentified biblical hanging in the Fondation Toms Pauli, Lausanne, and a *Pyramids* tapestry from a *Seven Wonders of the World*

suite, have similar borders.[13] In addition, the biblical scenes shown in the lower corners and the playful putti riding turtles in the border of *Alexander Encounters Thalestris, Queen of the Amazons* (cat. 37) echo elements of the borders of *Venus and Adonis* and *Pluto and Proserpina*. The type can be regarded as derived from a border that was frequently used by Maarten Reymbouts (c. 1570–1619), one of the leading Brussels tapissiers working around 1600, who also produced suites of landscapes with mythological scenes and hunts.[14]

The third mythological landscape tapestry in the Art Institute depicts Diana, the goddess of the moon and the hunt, and three of her nymphs with hunters in pursuit of an ox. The women are clustered on the right half of the tapestry. Diana, identifiable by the crescent moon atop her head, sits, looking at her attendants, one of whom is seated and being dressed by her two companions. The hunters occupy the left half of the tapestry. In the middle distance, slightly above and to the left of center, a formal garden unfolds before a palace. The spacious and rational plots contrast sharply with the dense,

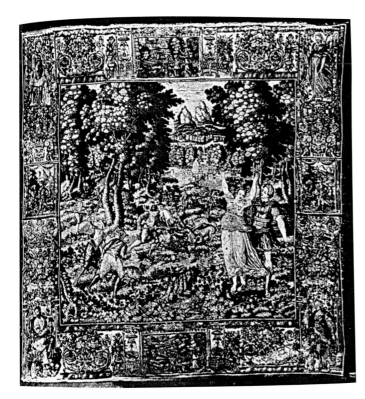

FIG. 3 *Apollo and Daphne with the Fox Hunt*. Wool and silk. Location unknown.

riotous vegetation and trees around the figures. Forests and mountains can be seen in the distance.

The border of *Diana and Her Nymphs with the Ox Hunt* is woven with allegorical figures, grotesques, mythological scenes, putti, and vases of flowers. The cartouches in the vertical borders show two of the Labors of Hercules. Hercules killing the Lion of Nemea, the first challenge, is on the left. The cartouche in the right border features an episode from the eleventh feat, Hercules bearing the Earth while Atlas takes the golden apples of the Hesperides. The cartouches in the top and bottom borders, which are flanked by Virtues, both depict two women meeting in the presence of a satyrlike creature. This scene is presumably Ceres Turning a Boy into a Lizard from the fifth book of Ovid's *Metamorphoses*.[15] The unidentified female figure to the left of each cartouche tramples a snake and holds a sword. Her companion is Prudence, who holds a mirror (an allusion to the ancient injunction to "know thyself") and has a snake twisted around her arm. The upper left corner depicts Venus and a winged Cupid, balanced in the upper right corner by another unidentified female figure holding a palm branch and scales on which she weighs a laurel wreath and an unidentified object. The lower left corner shows Orpheus playing his lyre before the animals (*Metamorphoses*, book 10), and his counterpart in the lower right corner may be Minerva, dressed in armor.

Both the main scene and border of *Diana and Her Nymphs* date the tapestry to around 1600. Indeed, the poses of the women and the use of the palace and garden to create spatial flight are typical of Flemish Mannerist painting and tapestry design of this period. The

hunting scene is copied from one of the Collaert/Bol engravings first published in Antwerp in 1582 (fig. 2), which provides a *terminus post quem* for the execution of the cartoon and tapestry.[16] The palace and garden may also have been borrowed from a contemporary engraving, as they are reminiscent of paintings and engravings by and after the architect, designer, and painter Hans Vredeman de Vries, whose work, as has recently been demonstrated, influenced Flemish tapestry design around the turn of the sixteenth century.[17]

The color scheme and the quality of the weaving suggest that *Diana and Her Nymphs* was woven in Brussels. This localization is corroborated by a smaller version of the piece that appeared on the art market in 1948; it shows only the ox hunt and bears the Brussels city mark.[18] Its border is almost identical to that of the larger tapestry, suggesting that both pieces were produced at the same workshop, at the same time. An *Apollo and Daphne with the Fox Hunt* may have been part of the same suite as the small ox hunt, for the former tapestry was on the art market at about the same time (1949) and has nearly identical borders (fig. 3).[19] Only the scenes in the cartouches differ, but these small variations may be regarded as a contemporary Mannerist feature meant to enliven the suite (see also cats. 14a–b). In contrast to the ox hunt depicted in *Diana and Her Nymphs*, however, the fox hunt in *Apollo and Daphne* is not borrowed from the Collaert/Bol series of engravings.

Features of the border of *Diana and Her Nymphs* can be related to numerous other Brussels sets. The figures shown in the corners, except for Minerva, can be found in the border of a *Story of Alexander* suite that is closely related to *Alexander Encounters Thalestris, Queen of the Amazons* (cat. 37). In particular, the unidentified woman with a palm branch and scales appears frequently in late-sixteenth- and early-seventeenth-century Brussels tapestry. She is shown, for example, in a three-sided border fragment in the Metropolitan Museum of Art.[20] The major Brussels tapestry producer Frans Geubels (c. 1520–by 1585) used her as a stock figure.[21] For example, a suite of *The Story of Tobit and Tobias* that bears the Geubels mark, along with the unidentified monogram *NDW*, shows her in the right border.[22] She also features, with Minerva, in the right border of a *Seven Wonders of the World* suite that bears a monogram that has been attributed to Frans Geubels's son Jacob I Geubels and to his widow Catharina van den Eynde, who continued the Geubels workshop until her death.[23] The attribution of the monogram to the Geubels workshop, however, must be questioned, for it differs notably from the mark Geubels used in archival documents.[24] Finally, the unidentified woman with scales is also depicted in the border of an eight-piece suite of landscapes with mythological scenes and hunts that is dispersed between the Palazzo di Venezia, Rome, and Laarne Castle, Belgium.[25] This suite, which bears an unidentified monogram, includes a depiction of *The Ox Hunt* that is loosely based on the Collaert/Bol engraving. In sum, the frequency with which these border motifs were used prohibits connecting *Diana and Her Nymphs* unambiguously with a specific tapestry workshop or producer; the wide dissemination of

similar designs rather highlights the need for further research into the production networks and organization of the tapestry industry around 1600. KB

NOTES

1. Parry 1964.
2. Two major tapestry exhibitions held at the Metropolitan Museum of Art in New York in 2002 and 2007 can be regarded as symptomatic of this tendency, for, though devoted to European tapestry of the sixteenth and seventeenth centuries, respectively, neither paid substantial attention to Flemish tapestry produced around 1600; see Campbell 2002c and Campbell 2007a.
3. Delmarcel 2002.
4. See, for example, Versyp 1971; Bennett 1992, pp. 148–50; and Bremer-David 2003, pp. 474–85. Despite its ambitious title, Musée International de la Chasse 2002 only includes an arbitrary selection of this group of tapestries and limits itself to a basic discussion of their iconography.
5. Krenz 2005 opens the discussion, yet it has not been formally published.
6. Wauters 1878, pp. 208–09; Schneebalg-Perelman 1960.
7. In his eagerly awaited *Lexicon of Marks and Signatures on Flemish Tapestries* (forthcoming), Delmarcel will discuss these issues in detail.
8. The scholarship on *Alexander Kneeling before Jaddus at the Gates of Jerusalem* (cat. 16) is a lively example of the confusion and uncertainty that can surround the interpretation of a particular monogram.
9. Diels and Leesberg 2005, vol. 1, pp. 225–41.
10. Ibid., cat. 48.
11. De Poorter 1979–80, p. 208.
12. For the De Pannemaker family, see Duverger 1986b and De Tienne 1996.
13. For the tapestry in the Metropolitan Museum of Art, New York, see Mayer Thurman 2001, pp. 26–29. A catalogue of the Fondation Toms Pauli collection is forthcoming; I am grateful to Guy Delmarcel for discussing some of the pieces with me. For *The Seven Wonders of the World*, see photograph no. 1600.208 in the files of the Royal Museums of Art and History, Brussels, which shows the *Pyramids* tapestry in a private collection in Italy; it may still be there today.
14. For Reymbouts, see Wauters 1878, pp. 207, 295–96; Van Tichelen 1987; and Van Lokeren 1998.
15. Ovid describes a similar creature in the episode "Erichthonius Released from his Basket" (*Metamorphoses*, book 2), but the cartouche in *Diana and Her Nymphs* does not show a basket.
16. Diels and Leesberg 2005, vol. 1, pp. 225–41.
17. Uppenkamp 2002, pp. 96–97. See also Fuhring 2002.
18. Parke Bernet, New York, Apr. 30–May 1, 1948, lot 419 (134 x 108 in.).
19. *Apollo and Daphne with the Fox Hunt* was on the Brussels art market; Versyp 1971, pp. 39–43.
20. Mayer Thurman 2001, pp. 22–25.
21. For Frans Geubels and the Geubels family, see Wauters 1878, passim; Meesters 1962; Duverger 1969; De Poorter 1979–80; and Duverger 1981–84.
22. Hartkamp-Jonxis and Smit 2004, pp. 97–100.
23. One piece in the suite is *The Statue of Zeus* at the Nelson-Atkins Museum of Art, Kansas City; another, *The Pyramids,* was sold at Christie's, London, Dec. 17, 1977, lot 110, and again at Sotheby's, London, Oct. 31, 2006, lot 173 (330 x 246 cm); Brett 1949; Standen 1985, vol. 1, pp. 154–61. The monogram is attributed to Jacob I Geubels in Standen 1985, vol. 1, p. 158.
24. The mark is illustrated in De Poorter 1979–80, p. 208.
25. Versyp 1971.

Alexander Kneeling before Jaddus at the Gates of Jerusalem [left section] from The Story of Alexander the Great

Brussels, c. 1600
Adapted from designs attributed to Nicolaas van Orley (died between 1586 and 1591)
Possibly produced at the workshop of Jacques Tseraerts (died before 1613)
MARKED: *S* superimposed on *IAC*
297.5 x 251.8 cm (117½ x 99⅛ in.)
Gift of Mr. Edward Morris, 1964.1088

STRUCTURE: Wool and silk; slit, dovetailed, and double interlocking tapestry weave
Warp: Count: 6 warps per cm; wool: S-ply of three Z-spun elements; diameter: 1.5 mm
Weft: Count: varies from 17 to 28 wefts per cm; wool: S-ply of two Z-spun elements; pairs of S-ply of two Z-spun elements; diameters: 0.5–1.5 mm; silk: S-ply of two Z-twisted elements; pairs of S-ply of two Z-twisted elements; diameters: 0.35–1.0 mm; wool and silk: paired yarns of S-ply of two Z-spun wool elements and S-ply of two Z-twisted silk elements; diameter: 0.8 mm

Conservation of this tapestry was made possible through the generosity of the Fatz Foundation.

A densely packed mass of soldiers fills a rolling plain. In the left foreground a group of the men bears shields, lances, and standards, and a young boy holds a horse with no rider. The line of troops curves around to the right as it recedes into the distance, creating a zigzag composition. In the background, a handful of soldiers in a camp run to a tent in which a man sleeps. The border is wide and compartmentalized. Allegorical personifications, identifiable by their attributes, fill each corner. Justice, with scales and a sword, sits at the upper left, balanced by Geometria, holding a compass and an L-square, at upper right. In the corresponding positions in the lower border are Rhetorica, with a piece of paper, and Musica, who holds a lyre and is surrounded by other musical instruments. The centers of both the horizontal and vertical borders feature scenes from the story of Samson (see below).

The piece depicts only the left section of a cartoon, as can be discerned by comparison with a larger tapestry at the Château de Chenonceau, France, that shows the complete composition.[1] This tapestry consists of two parts sewn together: while the right part is identical to the work in Chicago, the left part depicts a king kneeling before a priest escorted by a handful of assistants. The present arrangement of the two parts, however, is clearly faulty, as the back of one of the priest's assistants, who is shown larger than life, contacts the back of a soldier holding a shield, who is depicted on a smaller scale. The left and right sections of the Chenonceau tapestry should be reversed to restore the composition to its original condition. Thus arranged, the tapestry depicts a king, dismounted from his horse, kneeling before

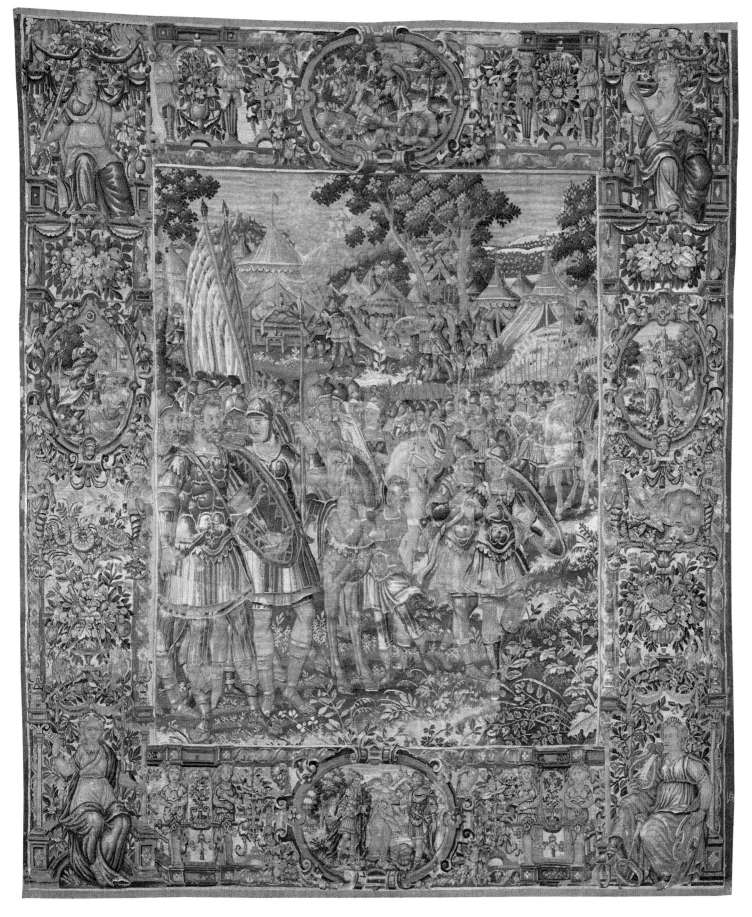

CAT. 16

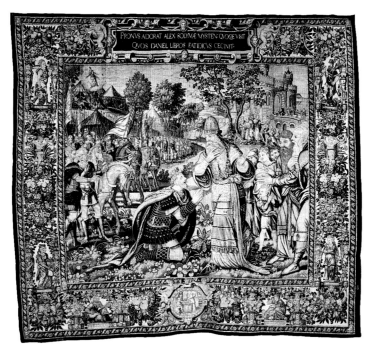

FIG. 1 *Alexander Kneeling before Jaddus at the Gates of Jerusalem* from *The Story of Alexander the Great*, before 1569. After a design attributed to Nicolaas van Orley. Produced at the workshop of Cornelis de Ronde. Wool and silk; 425 x 466 cm. Kunsthistorisches Museum, Vienna, LXXII/8.

a priest as soldiers look on, and resembles *Alexander Kneeling before Jaddus at the Gates of Jerusalem,* a scene in a *Story of Alexander the Great* suite that was produced by the Brussels tapissier Cornelis de Ronde prior to his death in 1569 (fig. 1).[2] The series comprises at least nine episodes, as a suite at the Kunsthistorisches Museum, Vienna, demonstrates. A Latin inscription in the upper border of each piece identifies the scene. In addition to the meeting of Alexander and Jaddus, the scenes are *The Capture of Darius, Alexander and the Family of Darius, Alexander and Darius's Mother, Alexander and Darius's Women, Alexander Wounded in the Leg, Alexander Enthroned, The Battle between Alexander and Porus,* and *Alexander Appoints Perdiccas His Successor.*[3]

The Viennese suite permits the identification of two *Alexander* tapestries that have surfaced on the art market and were possibly part of the same edition as the Art Institute's *Alexander Kneeling before Jaddus: Alexander and the Family of Darius* and *Alexander and Darius's Women.* These tapestries are nearly identical in height to the Chicago piece and, though the secondary scenes in their borders differ, both show scenes from the story of Samson. It was normal for small variations of this sort to occur within the borders of a single suite, as *Venus and Adonis (?) with a Duck Hunt* and *Pluto and Proserpina with Falconry* (cats. 14a–b) show. The *Alexander and the Family of Darius* that surfaced on the art market (fig. 2) clearly echoes the episode in the set produced by De Ronde (fig. 3), but also illustrates the changes in fashion that occurred over the latter half of the sixteenth century.[4] The balanced composition and the muscular figures of the De Ronde piece link it to Brussels tapestry design of the 1550s. By

contrast, the version of the scene recently on the art market shows a crowded composition packed with numerous soldiers and bystanders represented in elongated, Mannerist poses. These characteristics, like the sophisticated zigzag composition of *Alexander Kneeling before Jaddus,* are typical of Brussels tapestry design around 1600. Similarly, *Alexander and Darius's Women* is a Mannerist adaptation of a Renaissance design.[5] Entrepreneurs frequently recycled cartoons, as this allowed them to expand their sale catalogues while sparing the expense of commissioning new designs (see also cats. 20a–b).

The original cartoons for this *Alexander* series have been tentatively attributed to Nicolaas van Orley, a nephew of the famous Brussels painter and tapestry designer Bernard van Orley (c. 1488–1541), as the series is stylistically related to a *Romans and Sabines* set that bears Nicolaas's monogram.[6] Nicolaas, his father Gomar, and his uncles Bernard, Everard, and Philippe, were all involved in the creation of tapestry sets in Brussels from the early sixteenth century until the 1560s, when religious persecution forced some members of the family to leave the Southern Netherlands.[7] Nicolaas went to Stuttgart and then to Strasbourg, where he continued to design tapestry sets.

Though it is not possible to identify the artist who updated the *Alexander* cartoons, the tapestry producer who commissioned the modernizations can be tentatively identified from the monogram in the lower right vertical guard of *Alexander Kneeling before Jaddus.* It appears on a rather large group of tapestries belonging to no less than eleven sets, including *The Wonders of the World* (Metropolitan Museum of Art, New York) and *Galleries with Flower Pots* (private collection).[8] In the past, the monogram has often been read as an *s* superimposed on a *w* and linked to the obscure Brussels tapissier Willem Segers.[9] Guy Delmarcel, however, has convincingly argued that the mark should be read as an *s* superimposed on *IAC,* relating the monogram to either Jacob (Jacques) Segers or, more probably, Jacques Tseraerts ('t Seraerts, T'Seraerts).[10] Indeed, though almost nothing is known about Jacques Segers, archival documents reveal that Jacques Tseraerts was a major Brussels tapestry producer working in the late sixteenth and early seventeenth centuries, and is consequently far more likely than Segers to have produced the substantial group of tapestries bearing the IAC-S monogram.[11] Moreover, Cornelis de Ronde and the Tseraerts family were related: a document from 1569 shows that one "Jacques tserrearts, schilder"—presumably a relative of Jacques Tseraerts, tapissier—was Cornelis de Ronde's son-in-law. This family tie supports the contention that IAC-S should be identified with Jacques Tseraerts, who must have come into possession of the *Alexander* cartoons at some point after De Ronde's death in 1569. This identification of the mark also suggests a weaving date for the Chicago tapestry. Jacques Tseraerts presumably died before 1613, as he is not included in that year's list of the most important tapestry producers—though a Cornelis Tseraerts, possibly Jacques's son and successor, is.[12] Therefore, *Alexander Kneeling before Jaddus* was most likely woven after 1569, when De Ronde died, and before 1613, when Jacques Tseraerts disappears from the historical record.

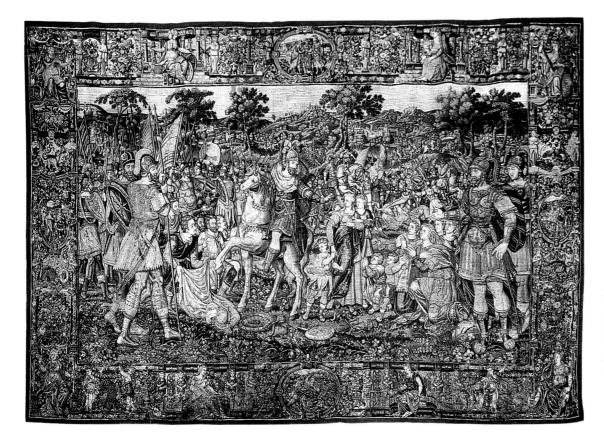

FIG. 2 *Alexander and the Family of Darius* from *The Story of Alexander the Great*. After a design attributed to Nicolaas van Orley. Probably produced at the workshop of Jacques Tseraerts. Wool and silk; 350 x 511 cm. Location unknown.

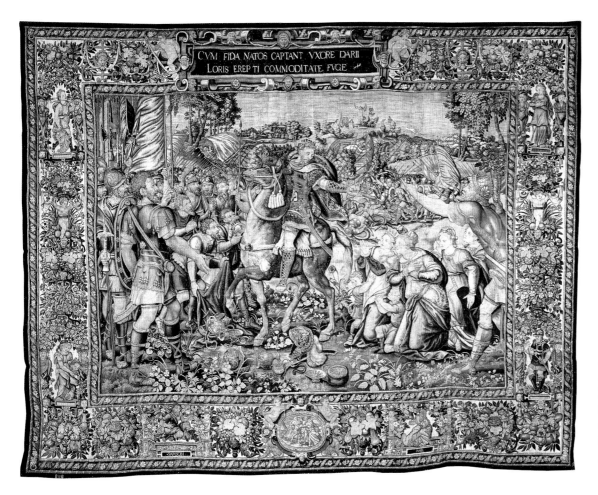

CVM. FIDA. NATOS CAPTANT. VXORE DARII
LORIS EREP TI COMMODITATE FVGE

FIG. 3 *Alexander and the Family of Darius*, before 1659. After a design attributed to Nicolaas van Orley. Produced at the workshop of Cornelis de Ronde. Wool and silk; 425 x 540 cm. Kunsthistorisches Museum, Vienna, LXXII/2.

Analysis of the border of the tapestry in Chicago suggests a connection to another sixteenth-century Brussels tapestry producer. The figures in the scene of Samson Slaughtering the Philistines (Judg. 15:8) in the center of the left border are identical to the protagonists of a *Story of Samson* tapestry produced by the major Brussels tapissier Frans Geubels (1520–1585 or before).[13] Similarly, the man and woman shown in the cartouche in the right border are identical to the couple in the background of *Samson and His Parents Go to Timnah* (Judg. 14:5–6), also from the Geubels *Samson* series.[14] This cut-and-paste technique suggests that the artist who executed the border designs—and who may also have updated the cartoons of the central scenes—had access to the cartoons of Geubels's *Samson* series. It is also possible, however, that both the cartoonist of the *Samson* set and the designer of the *Alexander* borders worked independently from identical sets of *Samson* engravings, for tapestry designers working around 1600 frequently based their compositions on prints. Samson Slaying the Philistines with the Jawbone of an Ass, the scene in the upper border of *Alexander Kneeling before Jaddus*, for example, echoes an engraving after a drawing by the Antwerp artist Maarten de Vos.[15] De Vos, who was regarded as one of the most important Flemish painters of the generation before Peter Paul Rubens (1577–1640), executed no fewer than five hundred drawings, most of which were for prints that were disseminated on a vast scale. The source of the remaining border scene, which presumably shows Samson Announces his Marriage to his Parents (Judg. 14:2), remains unidentified.

Alexander Kneeling before Jaddus belongs to one of the plethora of Flemish *Story of Alexander* tapestry sets. The most famous examples are the fifteenth-century pieces now in the Palazzo Doria, Genoa, but a number of other *Alexander* series were produced in the second half of the sixteenth century, including a suite woven in Brussels that has been linked to Michiel Coxcie (1499–1592), the most prolific tapestry designer in Brussels around 1550, and an anonymous series that was produced in Brussels and possibly Oudenaarde between approximately 1580 and 1610.[16] Two additional *Alexander* sets were woven in Oudenaarde or another minor Flemish production center.[17] Yet another *Alexander* series, represented in the Art Institute's collection by *Alexander Encounters Thalestris, Queen of the Amazons* (cat. 37), further illustrates the popularity of the subject in Flemish tapestry, while *The Crossing of the Granicus* (cat. 57) reveals that Alexander also featured in at least one Dutch tapestry set of the early seventeenth century. Finally, the Gobelins series designed by Charles Le Brun between 1661 and 1668 shows that interest in this historical figure extended to France.[18]

Alexander (r. 336–323 B.C.) was the son of King Philip II of Macedonia, who had unified the city-states of ancient Greece.[19] After Philip's death, Alexander, then age twenty, became king, whereupon he crushed the rebellion of a number of Greek cities and conquered the Persian Empire, including Anatolia, Syria, Gaza, Egypt, and Mesopotamia—all before dying of a mysterious disease at the age of thirty-two.

The young king was a legend in his own time. A number of his contemporaries wrote narratives of his life and deeds. All of these sources, however, were lost and are known only through the works of later authors. Of these accounts, Pseudo-Callisthenes's biography written around 200 B.C. was one of the most influential, together with Quintus Curtius Rufus's *Historiae Alexandri Magni*, written around A.D. 50, the *Life of Alexander* in Plutarch's *Parallel Lives* (c. 100), and Flavius Josephus's *Jewish Antiquities* (93 or 94).[20] In the thirteenth century the *Alexander Romances* became very popular and influential, appearing in numerous revised and amended versions and in at least thirty-five different languages through the ages.[21] A mix of inaccurately reported facts and plain fiction, the *Romances* presented a flattering portrait of the king, whose insatiable ambition, courage, and curiosity made him a prime exemplum for European rulers.[22] Illustrated copies of the work were a *sine qua non* for medieval courtly libraries.[23]

The incident shown in *Alexander Kneeling before Jaddus* is included in neither the *Historiae* nor the *Parallel Lives* because the historical Alexander did not visit Jerusalem. The legendary meeting, however, is reported in the *Jewish Antiquities* (book 2, 302–47).[24] Since the Jews saw in the benevolent and brave Alexander an exemplary ruler, they felt a need to link him to their history and thus invented, as Shaye Cohen put it, a "Jewish supplement to the histories of pagan authors who were not interested in the people of Jerusalem."[25] The compilers of the *Alexander Romances*, motivated by a predilection for exotic incidents, also included the encounter. Whereas the *Jewish Antiquities* does not discuss Alexander's attitude toward monotheism, the *Romances* conflated the king's meeting with Jaddus, the high priest of the Jews, with his polytheistic recognition of the God of Israel and his equally legendary conversion to Judaism.[26] According to the story, Alexander, after having conquered Syria and Gaza, wanted to capture Jerusalem as well. Jaddus dreamed that God encouraged the Jews to surrender. Prompted by this dream, the Jews opened the gates of the city and went out to greet their conquerer, as can be seen in the tapestry produced by De Ronde. Much to the Jews' surprise, Alexander made obeisance to the God of Israel (whose name was engraved on Jaddus's mitre), entered Jerusalem, went to the temple, and honored the priests. Apparently, Alexander had also had a vision (depicted in the upper left corner of the complete *Alexander Kneeling before Jaddus* in Vienna); he dreamed that a robed man—who turned out to be Jaddus—warned him not to harm Jerusalem or the Jews.

KB

NOTES

1. Unfortunately there are no photographs of this tapestry. Its current installation, in which it is partly protected by a reflective plastic screen, makes high-quality photography nearly impossible.

2. Delmarcel and Dumortier 1986.

3. Kunsthistorisches Museum, Vienna, invs. LXXII/1–9; Birk 1884, pp. 184–85.

4. *Alexander and the Family of Darius*, which had been in the collection of French and Company in the first half of the twentieth century (GCPA 0242603), featured in the exhibition of tapestries organized by the Parisian art dealer Yves Mikaeloff in 1989; Mikaeloff 1989, p. 9.

5. French and Company purchased *Alexander and Darius's Women* from the American Art Association by 1926; GCPA 0239174 (erroneously identified as an episode from *The Story of Solomon*).

6. Delmarcel 1999a, p. 138. For the *Romans and Sabines* set, see Standen 1974 and Standen 1985, vol. 1, pp. 127–36.

7. For the Van Orleys, see Borchgrave d'Altena et al. 1943; Ainsworth 1982; and Campbell 2002c, passim.

8. Standen 1985, vol. 1, p. 160, surveys the tapestries bearing the mark. For *Galleries with Flower Pots*, see Delmarcel and Volckaert 1995, cat. 12.

9. Standen 1985, vol. 1, p. 157, enumerates the different interpretations.

10. I am very grateful to Guy Delmarcel for granting me access to the files he has been compiling since the late 1970s; they will shortly result in the publication of his eagerly awaited *Lexicon of Marks and Signatures on Flemish Tapestries*.

11. Wauters 1878, pp. 225, 289–90.

12. Ibid., p. 208.

13. Duverger 1969 discusses Frans Geubels; for his *Story of Samson*, see p. 129, fig. 7.

14. For *Samson and His Parents Go to Timnah*, see Duverger 1969, p. 124, fig. 5.

15. Schuckman 1995, cat. 94. For De Vos, see Zweite 1980 and Schuckman 1995.

16. For the fifteenth-century pieces in the Galleria Doria Pamphilj, see Rapp Buri and Stucky-Schürer 1998; Franke 2000; Rapp Buri and Stucky-Schürer 2001, pp. 230–45; and Stagno 2006. For Coxcie, see De Smedt 1992. Coxcie's tapestry designs were surveyed in Duverger 1992, pp. 178–81, and Campbell 2002b, pp. 394–402. A suite is in the Patrimonio Nacional, Madrid (ser. 35); see Junquera de Vega, Herrero Carretero, and Diaz Gallegos 1986, vol. 1, pp. 248–63, and García Calvo 1997. De Meûter 2001b and Forti Grazzini 2003, pp. 137–53, discuss the anonymous series.

17. De Meûter et al. 1999, pp. 170–76; Hartkamp-Jonxis and Smit 2004, pp. 115–21.

18. Fenaille 1903–23, vol. 2, pp. 161–85; Posner 1959; Thuillier and Montagu 1963, pp. 71–73, 77–95, 258–59, 264–75, 278–79, 288–301; Beauvais 1990.

19. There exists an ever-expanding body of specialized, scholarly studies of Alexander the Great; for a concise introduction to his reign and its impact, see Tarn 1979; Roisman 2003; and Stoneman 2004.

20. Hammond 1983; Hammond 1993.

21. Kratz 1991.

22. Bosworth and Baynham 2000. For an examination of the textual tradition and the conception of Alexander the Great that prevailed in the Middle Ages, see Cary 1987.

23. For illustrated editions of the *Romances*, see Ross 1988.

24. A German edition of the *Jewish Antiquities* was published in Strasbourg in 1574; more than fourteen editions of this translation were issued between 1574 and 1630; Hartkamp-Jonxis and Smit 2004, p. 224.

25. Cohen 1982.

26. Ibid., pp. 58–60; Van Bekkum 1986.

CAT. 17

Antony Presents Artavasdes, King of the Armenians, to Cleopatra from *The Story of Antony and Cleopatra*

Brussels, c. 1640
After a design by an unknown artist
Produced at the workshop of Everard III Leyniers (1597–1680)
MARKED AND SIGNED: Brussels city mark; *E. LEYNIERS*
439.4 x 304.8 cm (173 x 120 in.)
Gift of Marshall Field and Company, 1952.1242

STRUCTURE: Wool and silk, slit and double interlocking tapestry weave
Warp: Count: 8 warps per cm; wool: S-ply of three Z-spun elements; diameters: 0.55–0.65 mm
Weft: Count: varies from 16 to 28 wefts per cm; wool: S-ply of two Z-spun elements; diameters: 0.3–1.0 mm; silk: pairs of S-ply of two Z-twisted elements; diameters: 0.4–1.0 mm

Conservation of this tapestry was made possible through the generosity of the James Tigerman Estate.

IN this tapestry, a ruler crowned with a laurel wreath presents a captured king and his family to a queen enthroned on a multilevel platform. The ruler stands in the center of the composition while the captive king and his son stand on the left, their hands cuffed. Behind them stands the king's wife. The captives are guarded by soldiers, and more soldiers, as well as courtiers, surround the platform. The border is patterned with flowers, plants, and small birds.

When the tapestry entered the Art Institute's collection in 1952, it was believed that the scene was from the life of Mordecai, one of the main personalities in the Old Testament book of Esther.[1] This identification, however, was incorrect, as can be determined by linking the work to an almost identical tapestry at the Kunsthistorisches Museum, Vienna (fig. 1), which belongs to a suite of seven pieces catalogued there as *The Story of Zenobia and Aurelian*, but which actually depicts *The Story of Antony and Cleopatra*.[2] The tapestries in Chicago and Vienna are the sixth in this series: *Antony Presents Artavasdes, King of the Armenians, to Cleopatra*.

The story of Mark Antony and Cleopatra was very popular in seventeenth-century European literature. During the Middle Ages, Cleopatra had been regarded as the embodiment of evil and voluptuousness. From the sixteenth century on, however, writers developed a more favorable view of her, and frequently retold the tragic tale of the Roman general and the Egyptian queen.[3] Shakespeare's *Antony and Cleopatra*, initially performed in 1607 or 1608 and first printed in 1623, fully exploited the dramatic potential of the story.[4] In 1624, the Antwerp theatrical troupe the Violieren performed *Aegyptica ofte Aegyptische tragoedie van M. Anthonivs, en Cleopatra* (Egypt, or the Egyptian Tragedy of M. Antony and Cleopatra). In the 1630s two competing *Cleopatra* plays, one written by Jean Mairet and one by Isaac de Benserade, were staged in Paris, and at the end

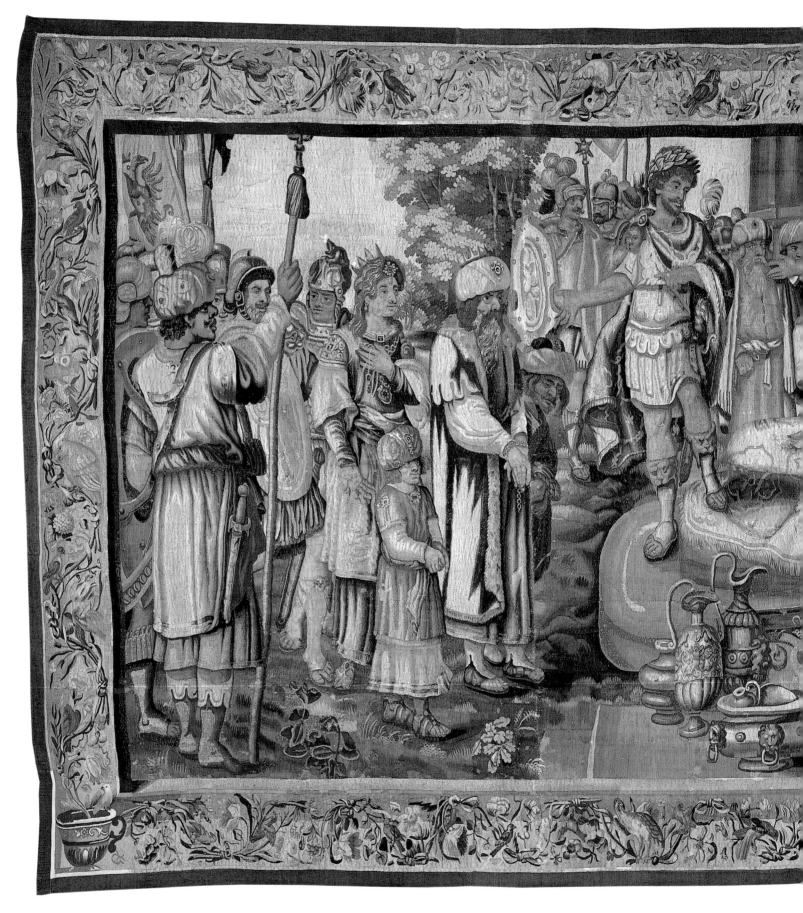

CAT. 17

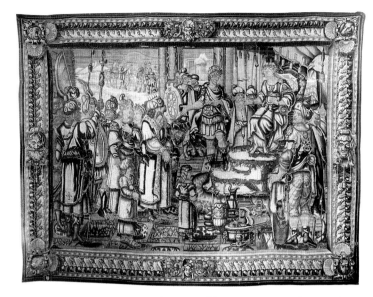

FIG. 1 *Antony Presents Artavasdes, King of the Armenians, to Cleopatra* from *The Story of Antony and Cleopatra*. Produced at the workshop of Hendrik Mattens. Wool and silk; 350 x 457 cm. Kunsthistorisches Museum, Vienna, XCIV/1.

of the seventeenth century, the Dutch poet Jan-Baptist Wellekens wrote two heroic epistles about the ill-fated lovers.[5]

It is therefore not surprising that Antony and Cleopatra feature in several seventeenth-century Flemish and French tapestry sets. Around 1600 Jacques I Geubels (died before 1605), one of the foremost Brussels tapissiers, produced an *Antony and Cleopatra* series, and in 1621 Karel II van Mander (1597–1623) was working on the designs of a set that was to be woven in his own workshop in the Northern Netherlands; the series was completed after his death and editions were woven in Gouda or Schoonhoven in the Northern Netherlands.[6] Around the middle of the seventeenth century Justus van Egmont (1601–1674) created a series that was produced by the Van Leefdael-Van der Strecken-Peemans consortium (see cats. 19a–n); and designs for a third set were executed around 1650 by the French painter Charles Poerson (1609–1667) and produced by the Le Clerc workshop in Brussels.[7] Though these sets have received considerable art historical attention, until now the *Antony and Cleopatra* series to which *Antony Presents Artavasdes* belongs has not been studied.

In the first tapestry of the series, a general addresses a number of soldiers from a podium.[8] He displays a mantle, which inflames his audience. In the background a funeral pyre burns. The scene depicts the oration Mark Antony made after the assassination of Julius Caesar, as reported in chapter thirteen of Plutarch's *Life of Antony* in his famous *Parallel Lives*. Written in Greek around 100, the book pairs philosophical biographies of illustrious Romans with biographies of comparable Greeks. The *Lives,* which must be considered a semifictional work, and therefore not genuine historical scholarship, was a huge success in Plutarch's time as well as in the sixteenth and seventeenth centuries, when it was popularized in most European

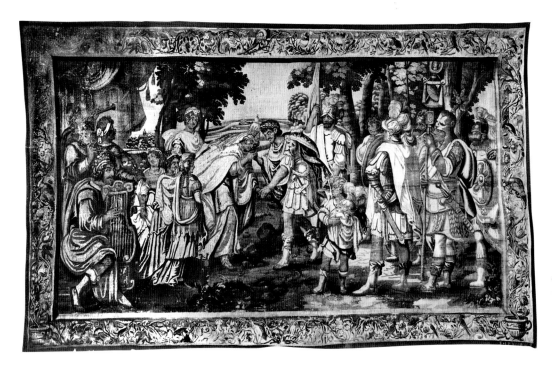

languages: translations in Latin (1470), Italian (1482), Spanish (1491), German (1541), French (1559), English (1579), and Dutch (1601 and 1603) secured the fame of Plutarch and his Greek and Roman heroes in Renaissance and Baroque Europe.[9]

The second piece in the series shows three generals mounted on horseback shaking hands.[10] This scene corresponds to Plutarch's narrative of the establishment in 43 B.C. of the Second Triumvirate, the official political alliance between Lepidus, Octavian (Julius Caesar's adopted son), and Mark Antony (Plutarch, *Life of Antony*, book 19). The third scene of the set shows *The Encounter of Antony and Lucius Caesar's Sister* (Plutarch, *Life of Antony*, book 20).[11] After the triumvirs had divided the Roman world among themselves—Lepidus took control of the western provinces, Octavian remained in Italy, and Antony became ruler of the rebellious eastern part of the empire—they agreed that each of them could slaughter one hundred of his political adversaries. This bloody episode is depicted in the background of the tapestry. Lucius Caesar, one of Antony's adversaries, was spared thanks to his sister's intercession. Her emotional plea for mercy is shown in the foreground.

A tapestry in the collection of the Musée du Louvre, Paris, that has been identified as *Solomon and Sheba* actually shows the fourth scene of the *Antony and Cleopatra* series, *The Meeting of Antony and Cleopatra, Queen of Egypt* (fig. 2), which took place in 48 or 47 B.C. (Plutarch, *Life of Antony*, book 26).[12] The stylistic features of this piece, such as the exaggeratedly muscular and stocky figures and the crowded composition, justify its inclusion in the series. Moreover, *The Meeting of Antony and Cleopatra* also bears the signature *E. LEYNIERS*, and its border and height are almost identical to the border and height of the tapestry in the Art Institute, which strongly sug-

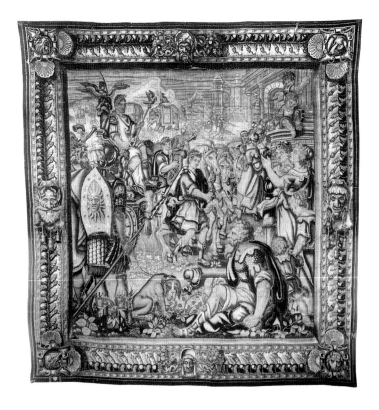

FIG. 3 *Antony Captures the Armenian Ruler Artavasdes and Celebrates a Roman Mock Triumph in Alexandria* from *The Story of Antony and Cleopatra*. Produced at the workshop of Hendrik Mattens. Wool and silk; 347 x 272 cm. Kunsthistorisches Museum, Vienna, XCIV/6.

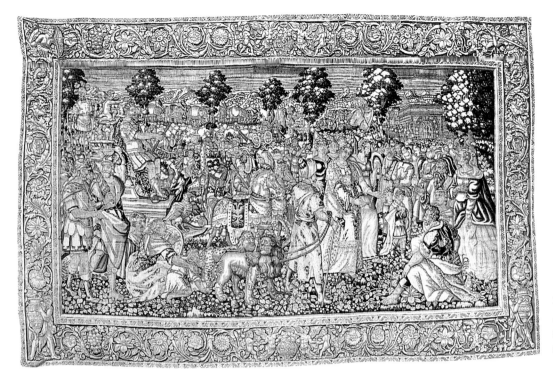

FIG. 4 *The Triumph of Aurelian* from *The Story of Zenobia and Aurelian*. Antwerp or Brussels, 1580/90. Wool and silk; 407 x 650 cm. Location unknown.

gest that these pieces were initially part of the same suite.[13] A second version of *The Meeting of Antony and Cleopatra*, also signed E. LEY-NIERS, recently appeared on the Brussels art market.[14] Yet another copy of the scene, based on a slightly modified cartoon showing the encounter in an interior, was sold in 2000.[15]

On meeting Cleopatra, Antony immediately fell in love with her, despite being married to Octavia, Octavian's half-sister. The affair was a serious blow to the triumvirate, which had been unstable from the outset. Octavian aspired to be the sole ruler of the Roman world, and he slandered Antony to thwart his rival's military and political ambitions. Financed by Cleopatra, Antony conquered Armenia, capturing its ruler, Artavasdes, and celebrated his triumph in Alexandria, the capital of Egypt (Plutarch, *Life of Antony*, book 50), as shown on the fifth tapestry in the series, which forms part of the suite in the Kunsthistorisches Museum (fig. 3).[16] The Chicago piece and the near-identical Viennese version show the subsequent episode: *Antony Presents Artavasdes, King of the Armenians, to Cleopatra*. Another version of this scene recently appeared on the art market, together with a version of *The Meeting of Antony and Cleopatra*.[17]

The triumvirate collapsed shortly thereafter and civil war broke out. Octavian tried to convince Cleopatra to banish Antony and sent Thyrsus, one of his courtiers and according to Plutarch "a man with no mean parts," as an ambassador to the Egyptian queen (Plutarch, *Life of Antony*, book 73). Cleopatra was charmed by Thyrsus's graceful demeanor. Enraged by jealousy, Antony seized the ambassador and had him flogged, as shown in the seventh tapestry in the series.[18] Diplomacy having failed, in 30 B.C. Octavian invaded Egypt. With no place to run, Antony committed suicide. A few days later, Cleopatra followed his example. This tragic outcome does not appear

to have been included in the set. According to a nineteenth-century description of the suite in Vienna, the eighth tapestry shows Antony enthroned watching wolves attack soldiers,[19] but this episode does not derive from Plutarch's narrative.

The *Antony Presents Artavasdes* in the Art Institute was woven around 1640. It bears the signature of the Brussels tapestry producer Everard III Leyniers (1597–1680). With his business partner Hendrik I Reydams (c. 1610–1669), Leyniers ran a major workshop and was involved in the production of several important commissions around the middle of the seventeenth century.[20] Leyniers, however, was not the first tapissier to use the set of *Antony and Cleopatra* cartoons to which the Chicago piece belongs, as the Viennese set bears the monogram of Hendrik Mattens, who was granted exemption from taxation on beer and wine from the Brussels city administration in 1629, an indication that he then directed an important workshop.[21] Hendrik was presumably a son of Jan Mattens, one of the nine leading Brussels tapestry producers in 1613, but little else is known about him.

The younger Mattens was also presumably not the first owner of the *Antony and Cleopatra* cartoons, for stylistic features of the series show that it was created during the last quarter of the sixteenth century, before Mattens was an autonomous workshop manager. The crowded scenes, the placement of meaningful episodes in the background, the so-called muscleman style characterized by exaggeratedly muscular and stocky figures,[22] and the exotic and fantastic costumes date the design between 1575 and 1600—which means that around 1640 Leyniers probably used slightly retouched cartoons, given the damage the originals would have suffered by that point and how tastes would have changed. As the cartoons predate 1600, it is possible that

they had been commissioned by Jacques I Geubels, who produced an *Antony and Cleopatra* series around 1600.[23] Thus, the cartoons of the series were employed by various Brussels tapestry producers for over fifty years. They were also handled by a tapissier working in another production center, possibly Oudenaarde, as the existence of rather crude and simplified versions of the scenes indicate.[24]

No archival material reveals the name of the designer of the *Antony and Cleopatra* series, but a handful of sets woven in Brussels—all yet to be studied—can be attributed to this artist. A *Story of Zenobia and Aurelian* series that was probably created between 1580 and 1590 is reminiscent of the *Antony* set.[25] There are, for example, close parallels between *The Triumph of Aurelian* (fig. 4) and *Antony Captures the Armenian Ruler Artavasdes* (fig. 3), both in the general conception of the composition and the execution of details, e.g., the use of a type for the left feet and toes of the seated men in the right corners. The muscleman style also characterizes a *Trojan War* set, a *Story of Alexander* series, and a *Roman History* set.[26] The latter series has been tentatively attributed to the artist and writer Karel I van Mander (1548–1606) because a figure in the set was copied from an engraving after Van Mander.[27] Yet tapestry designers frequently borrowed figures and scenes from a range of contemporary engravings (see cats. 14a–b, 15), and, in general, Van Mander's style differs from the manner of the artist who created the muscleman tapestry sets. Moreover, the anonymous designer of the *Roman History* series seems to have also been influenced by engravings by Hendrik Goltzius, whose natural anatomical style is echoed in the stocky physiques, formulaic beards, and pointed moustaches of the figures on the tapestry.[28] Future archival research and analysis of Flemish painting around 1600 may shed more light on this issue.

KB

NOTES

1. Object file 1952.1242, Department of Textiles, the Art Institute of Chicago.
2. Kunsthistorisches Museum, Vienna, inv. XCIV/1–7; Birk 1884, pp. 200–01. The suite, which initially had eight pieces, was purchased in 1666 by the dealer Bartholomeus Triangl, who had been ordered by the Viennese court to buy tapestry sets for the wedding of Emperor Leopold I; Bauer 1999, pp. 118–19.
3. Moormann and Uitterhoeve 1999, pp. 136–42; Morrison 1974.
4. Bullough 1966, pp. 3–211.
5. For more on Mairet and Benserade's plays, see Tomlinson 1996 and Tomlinson 1998. Van Marion 2001 discusses Wellekens's epistles.
6. Duverger 1981–84, p. 163, discusses Geubels's set. For the Van Mander design, see Hartkamp-Jonxis 2004b, p. 180. An edition is in the Indianapolis Museum of Art; Weinhardt 1966; Pantzer 1966. Three pieces are in Castle Velké Losiny in the Czech Republic; Brücknerová 2005, pp. 44–49.
7. Reyniès 1997, pp. 111–27; Brosens 2005a; Brosens 2007b.
8. Kunsthistorisches Museum, inv. XCIV/2.
9. Hirzel 1912; Gianakaris 1970; Stadter 1992; Scardigli 1995; Stadter and Van der Stockt 2002.
10. Kunsthistorisches Museum, inv. XCIV/3.
11. Kunsthistorisches Museum, inv. XCIV/5.
12. Musée du Louvre, Paris, inv. OAR 32 (309 x 505 cm). I thank Marie-Hélène de Ribou for allowing me access to the files of the Louvre.

13. The same border was used for a *Months* suite produced at the Leyniers workshop; for the set, see Forti Grazzini 2003, pp. 90–103.
14. Galerie Moderne, Brussels, Feb. 23, 2005, lot 1656 (285 x 495 cm). I am grateful to Jan de Meere for bringing this piece to my attention. The upper border has a cartouche that was also used for a suite of the *Months* produced by Leyniers; Forti Grazzini 2003, pp. 90–103; Sotheby's, London, Oct. 31, 2006, lot 3087 (309 x 246 cm).
15. Neumeister, Munich, Sept. 28–29, 2000, lot 402.
16. Kunsthistorisches Museum, inv. XCIV/6.
17. Sotheby's, London, Oct. 2007, lot 158 (305 x 380 cm), lot 159 (300 x 380 cm).
18. Kunsthistorisches Museum, inv. XCIV/4.
19. Kunsthistorisches Museum, inv. XCIV/7; Birk 1884, p. 201.
20. Brosens 2004a, pp. 65–68.
21. SAB, RT 1234, fol. 63v; published in Wauters 1878, p. 208.
22. Leesberg 1993–94, p. 23.
23. Wauters 1878, p. 292; Duverger 1981–84, p. 163.
24. A suite of five tapestries is in Sweden; Böttiger 1896, pp. 39–40, pls. 27a–b, 28a–b. A photograph of an *Antony Presents Artavasdes* tapestry, with "French Private Collection 1990" written on the back, is in the files of Guy Delmarcel.
25. This suite of four tapestries was offered for sale at Sotheby's, Schloss Monrepos, Oct. 9–14, 2000, lots 78–81; shown at the European Fine Art Fair, Maastricht, in Mar. 2002; and on the art market in 2002 at Galerie Chevalier, Paris. A fifth piece that was part of this suite was sold at Christie's, Paris, Dec. 10, 1995, lot 136. A sixth piece of the suite is in Castle Hluboká, Prague; Blažková and Květoňová 1959–60 (erroneously identified as a *Cleopatra* tapestry). A three-piece suite of the same set is in the Musée d'Art et d'Histoire, Geneva; Tervarent 1958, pls. 70–72. Another *Zenobia* piece that was part of another edition is in the Musée des Beaux-Arts, Rouen, inv. 990.8.1; Grandjean 2001.
26. Two pieces of the *Trojan War* set were at French and Company, which had purchased them from Robert L. Gerry in 1936; GCPA 0240973 and 0240978. *The Coronation of Alexander* is in Castle Frýdlant, Czech Republic; Blažková 1969, pp. 56, 59. *Alexander Kneeling before Jaddus at the Gates of Jerusalem* is in the Diputación Provincial de Madrid; Arriola y de Javier 1976, p. 86. Two pieces from the *Roman History* set are known: *Presentation of Gifts to a King* (collection of Marqués de Castro Nuevo, Madrid) and *A Queen Begs a King for Mercy* (collection of Carmen Lopez de Ceballos de Mazzuchelli, Madrid); Ghent 1959, pp. 45–46; Erkelens 1969, pp. 228, 235. Two unidentified fragments showing soldiers in dramatically receding landscapes can be attributed to the same artist; one panel was in the stock of the Antwerp dealer Blondeel in the 1990s, the other piece was sold at Christie's, London, Nov. 9, 2006, lot 142 (270 x 205 cm).
27. Erkelens 1969. For Van Mander, see Valentiner 1930 and Leesberg 1993–94.
28. For Goltzius, see Falkenburg et al. 1991–92 and Leeflang and Luijten 2003.

Four Servants, part of *Telemachus Leading Theoclymenus to Penelope* from *The Story of Odysseus*

Brussels, c. 1650
After a design by Jacob Jordaens (1593–1678)
Produced at the workshop of Jan van Leefdael (1603–1668)
MARKED AND SIGNED: Brussels city mark; *I V LEEFDAEL*
351.2 x 424.8 cm (138¼ x 167¼ in.)
Gift of Charles J. Singer through the Antiquarian Society of the Art Institute of Chicago, 1890.8

STRUCTURE: Wool and silk, slit and double interlocking tapestry weave
Warp: Count: 8 warps per cm; wool: S-ply of three Z-spun elements; diameter: 0.8–1.0 mm
Weft: Count: varies from 17 to 30 wefts per cm; wool: S-ply of two Z-spun elements; diameters: 0.3–1.0 mm; silk: three yarns of S-ply of two Z-twisted elements; diameters: 0.6–1.0 mm; wool and silk: paired yarns of S-ply of two Z-spun wool elements and S-ply of two Z-twisted silk elements; diameters: 0.5–1.2 mm

Conservation of this tapestry was made possible through the generosity of the Antiquarian Society of the Art Institute of Chicago.

PROVENANCE: An unidentified Italian family, Rome, to 1890; sold to the Art Institute, with Rodolfo Amadeo Lanciani acting as agent, 1890.

REFERENCES: Hunter 1914a, p. 121, fig. 8. Mayer Thurman in Keefe 1977, cat. 245. Nelson 1998, pp. 81–82, 83, 262, pl. 34. Mayer Thurman and Brosens 2003, pp. 172–73, fig. 4.

EXHIBITIONS: Art Institute of Chicago, *The Antiquarian Society of the Art Institute of Chicago: The First One Hundred Years*, 1977 (see Mayer Thurman in Keefe 1977).

IN a marble-tiled room, four women prepare for an event. An older woman, her hair wrapped in a kerchief, sets down a chair. Framed by an elaborately carved column and door, three younger women carry a pitcher, a basket of bread, and a bowl of fruit. Colonnades are visible behind the figures. In the top border of the tapestry, garlands of fruit and flowers flank a shell with a face. In the bottom border similar garlands flank a cartouche containing a view of a landscape. In the right and left borders, which are designed to resemble columns, putti holding baskets of fruit stand on bases decorated with three eagles.

The scene, called *Four Servants,* is part of a larger composition of *Telemachus Leading Theoclymenus to Penelope* from a *Story of Odysseus* series.[1] This identification is based on a watercolor study on paper in the Nationalmuseum, Stockholm (fig. 1), and on two *modelli* on canvas—one in the Musée Granet, Aix-en-Provence (fig. 2), and one in a private collection in Belgium—showing the same incident as part of a larger scene by the famous Antwerp painter Jacob Jordaens, who, like Peter Paul Rubens and Anthony van Dyck, was one of the foremost artists of the Flemish Baroque. Jordaens, the son of an Antwerp linen merchant, became an independent master painter in 1615 when he was inscribed in the Antwerp Guild of Saint

Luke as a *waterschilder* (watercolorist).[2] This technique was used to make decorative paintings to be hung on walls as more affordable substitutes for expensive tapestries; unfortunately, these works were not durable and only a few—none by Jordaens—have survived.

Jordaens's training and experience obviously enabled him to execute tapestry cartoons, as, at the time, these were usually painted in watercolor on heavy paper. In the 1620s he may have executed cartoons after designs by other artists, including Rubens.[3] From about 1630, however, Jordaens painted tapestry cartoons after his own designs. Besides *The Story of Odysseus*, the designs for six other sets have traditionally been attributed to Jordaens and his workshop: *The Story of Alexander the Great* (c. 1630), *Scenes of Country Life* (c. 1635), *Proverbs* (c. 1645), *The Riding School* (c. 1645), *The Story of Charlemagne* (c. 1650), and *Famous Women of Antiquity* (c. 1660).[4] Jordaens also added at least three original compositions to Rubens's *The Story of Achilles* series.[5] Recently, another set, *The Story of Theodosius the Younger*, has been attributed to Jordaens, and it can be assumed that Jordaens and his assistants created still other sets: according to seventeenth-century documents, Jordaens designed a *Story of the Amazons*, and no fewer than thirty cartoons for untraced tapestries were recorded in his estate.[6]

In Jordaens's tapestry sets, as in his paintings, monumental figures and architectural elements crowd the composition. Only occasionally did Jordaens incorporate spatial recession in his scenes; more frequently he emphasized the flatness of the tapestry by clustering all the protagonists and decorative elements in a single plane and minimizing the amount of landscape or interior visible in the background, as in the tapestry in the Art Institute. The basic compositional schemes of Jordaen's *Odysseus* cartoons, however, were enlivened by his sophisticated border designs, in which Athena and Hermes turn inward to observe the action, mediating between the spectator and the central field, thus mitigating the flatness of the scenes.[7] The first tapissiers who wove *Odysseus* tapestries designed by Jordaens used these original borders, which can be found on two tapestries in a Mexican private collection (fig. 3), but later producers such as Jan van Leefdael and Gerard van der Strecken (c. 1610–1677) framed the scenes with different borders that do not interact with the compositions and thus call attention to their lack of perspective. Around 1660 Jordaens's monumental sets slowly went out of date as a new, less dramatic French style influenced Brussels tapestry (see cats. 21–22).

Odysseus (Ulysses in Latin), the ruler of the island kingdom of Ithaca, played a key role in the Trojan War, the lengthy conflict sparked by the abduction of Helen, the beautiful wife of King Menelaus of Sparta, by Paris, the prince of Troy. According to Homer's *Iliad*, the war raged for nine years, during which time the Greeks were unable to capture Troy.[8] Odysseus, who had been a driving force behind the Greek campaigns and was famous for his eloquence and cleverness, concocted a cunning plan to trick the Trojans. He ordered a large wooden horse to be built, in which he and a group of soldiers

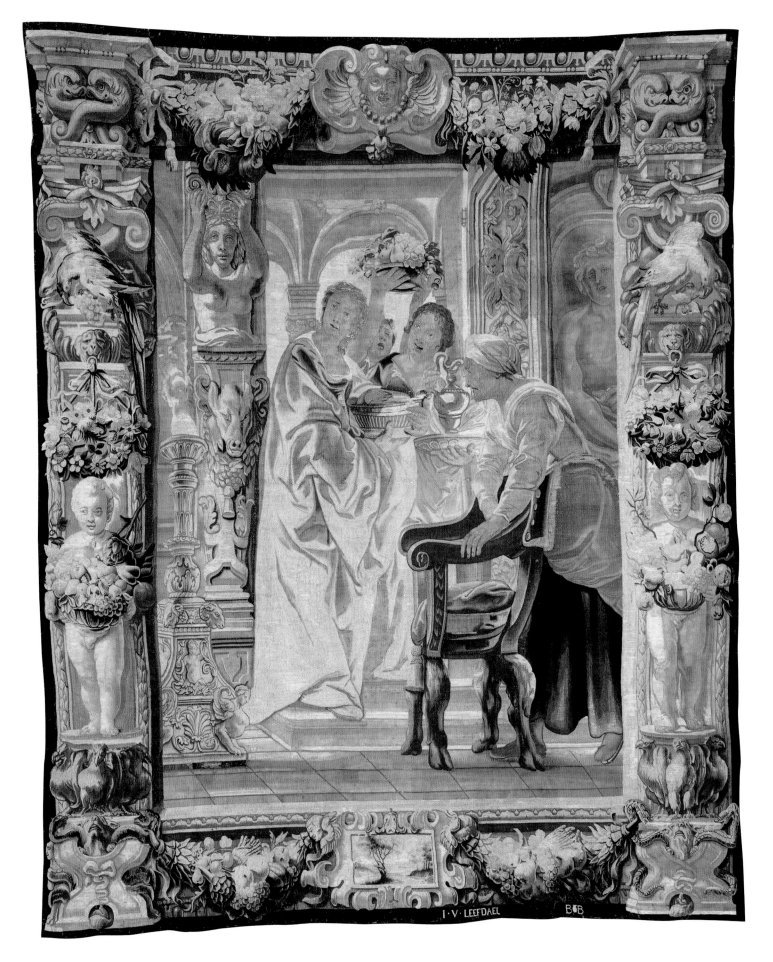

I · V · LEEFDAEL B✻B

CAT. 18

FIG. 1 *Study for Telemachus Leading Theoclymenus to Penelope.* Jacob Jordaens, c. 1635. Brush, brown ink, watercolor and bodycolor over indications in black chalk; 28.3 x 50.7 cm. Nationalmuseum, Stockholm.

FIG. 2 *Modello* for *Telemachus Leading Theoclymenus to Penelope.* Jacob Jordaens, c. 1635. Oil on canvas; 117 x 225 cm. Musée Granet, Aix-en-Provence.

hid, and had the Greek fleet sail away to give the impression that they had admitted defeat. Seeing the horse and thinking it a symbol of respect presented by the routed Greeks, the Trojans took the structure past the walls into the city and celebrated their apparent victory. At night, while the Trojans slept in drunken stupors, the Greek warriors emerged from the horse and slaughtered them. Odysseus's return from Troy, chronicled in Homer's *Odyssey,* took another ten years, beset as it was by peril, misfortune, and fantastic adventure.[9] After about twenty years of waiting for her husband to return, Odysseus's wife Penelope sent their son Telemachus in search of his father. At the end of his unsuccessful journey, Telemachus met the prophet Theoclymenus, and together they returned to Ithaca (Homer, *Odyssey,* book 17). Penelope welcomed her son and his guest and had her servants offer them a meal and a bath, as shown in *Four Servants.*

Theoclymenus then revealed that Odysseus was already in Ithaca and was finally about to come home.

A number of preparatory works by Jordaens pertain to *The Story of Odysseus.* These include the designs for the borders, small studies of the scenes in watercolor on paper (approx. 25 x 50 cm), and *modelli* in oil on paper or canvas (approx. 100 x 150–200 cm). In all, Jordaens created eleven scenes for the series: *Odysseus in the Cave of Polyphemus, Circe Transforming the Men of Odysseus into Swine, Odysseus Threatening Circe, Odysseus Taking Leave of Circe, Hermes Visiting Calypso, Odysseus Building a Raft before Leaving Calypso, Odysseus's Raft Stocked with Provisions by Calypso, Odysseus and Nausicaa, Odysseus at the Court of King Alcinous, Telemachus Leading Theoclymenus,* and *Odysseus's Return to Penelope.*[10]

It is unlikely, however, that all eleven studies were developed

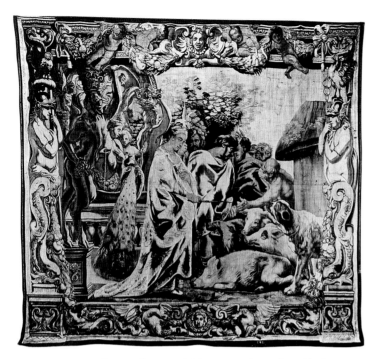

FIG. 3 *Circe Transforming the Men of Odysseus into Swine* from *The Story of Odysseus*. After a design by Jacob Jordaens, c. 1635. Wool and silk. Private collection, Mexico.

into full-scale cartoons. *Odysseus Building a Raft* and *Odysseus's Raft Stocked with Provisions,* for example, both pertain to the same event. When selecting the designs that would form the set, either Jordaens or the commissioner of the series presumably chose the former scene over the latter, as there are no known tapestries depicting *Odysseus's Raft Stocked with Provisions by Calypso,* but a tapestry showing *Odysseus Building a Raft before Leaving Calypso* is part of an edition split between the Palazzo del Quirinale, Rome, and the Palazzo Reale, Turin.[11] Likewise, *Odysseus in the Cave of Polyphemus, Odysseus Taking Leave of Circe,* and *Odysseus and Nausicaa* seem to have been studies for cartoons that were never executed, as no known tapestries represent these scenes. Incidentally, no single tapestry shows the complete composition of *Telemachus Leading Theoclymenus.* A piece in the aforementioned Italian edition shows Penelope welcoming her son and the prophet, but omits the four servants—though they do appear on an *entrefenêtre* that is part of the same suite. The Italian *entrefenêtre* and the tapestry in Chicago make clear that when painting the full-scale cartoon, Jordaens and his assistants referred not only to the *modelli* but also to the watercolor sketch, for the arrangement of the servants on the tapestries reflects the composition of the watercolor study (fig. 1), not the more advanced *modelli* (fig. 2).

Jordaens's *Story of Odysseus* is one of a number of Renaissance and Baroque cycles featuring the Greek hero, including the fifty-eight frescoes (1541–47), now lost, made by Francesco Primaticcio for the Gallery of Odysseus at the Château de Fontainebleau, near Paris; the sixteenth-century Brussels tapestry series by Michiel Coxcie (1499–1592) currently in Hardwick Hall, Doe Lea, Chesterfield, Derbyshire; and the tapestry set (c. 1634) by Simon Vouet (1590–1642)

woven in Paris and now in the Château de Cheverny, France.[12] None of these cycles, however, include *Telemachus Leading Theoclymenus,* nor is the incident mentioned by the Renaissance mythological compendia and dictionaries popular among seventeenth-century painters. Thus, in the choice of subjects Jordaens—or the commissioner of the set—demonstrated his first-hand knowledge of the text of the *Odyssey,* which by the 1630s was available in numerous editions and translations.[13]

Based on technical aspects of the preparatory works and stylistic features of the designs, Jordaens scholars such as Roger d'Hulst, Michael Jaffé, and Kristi Nelson have argued that Jordaens created his *Odysseus* series around 1635, although it is possible that the designs predate 1624.[14] The commissioner of the series is unknown, but tapestries after Jordaens's *Odysseus* designs bearing the signatures of various Brussels producers suggest that either Brussels tapissiers or a merchant subcontracting to Brussels workshops ordered the designs and cartoons. Two *Odysseus* tapestries now in a Mexican private collection bear the Brussels city mark, and each bears the monogram of a different, unidentified tapestry producer.[15] The borders of these pieces follow Jordaens's designs exactly, which implies that they belonged to an early edition of the series.[16] In contrast, the borders of a *Return of Odysseus to Penelope* in the Kurhessische Hausstiftung, Fulda, depart further from Jordaens's original designs, suggesting that it postdates the two pieces in Mexico. The Fulda tapestry bears the initials *C.V.B.,* which stand for the Brussels tapissier Christiaan van Brustom. He and his brother Bernard were exempted from taxation on beer and wine by the Brussels municipality in 1629, an indication of their importance as tapestry producers.[17] They were still listed as tapissiers in February 1640.[18]

Four Servants is signed *I.V.LEEFDAEL,* which indicates that it was produced by Jan van Leefdael, the son of Hendrik van Leefdael, presumably a minor Brussels tapestry weaver.[19] By marrying Johanna van den Hecke at some point prior to 1632, Jan gained entry to the highest echelon of Brussels tapestry production, in which the Van den Heckes were rising stars.[20] In 1644 Van Leefdael served as dean of the tapestry guild, and was granted exemption from taxation on beer and wine by the Brussels city administration, a sign that he was by then running a significant workshop.[21] When he died in 1668, he was succeeded by his son Willem (1632–1688).[22]

Jan van Leefdael formed a partnership with Gerard van der Strecken, who was granted exemption from taxation on beer and wine in 1647.[23] In the 1660s the Van Leefdael-Van der Strecken association was extended to include Van der Strecken's son-in-law Gerard Peemans (1637/39–1725), who in 1663 married Van der Strecken's daughter Maria (1640–1709), and two years later was granted exemption from taxation on beer and wine.[24] The Van Leefdael-Van der Strecken-Peemans production network was supported by close ties of kinship and friendship, as is demonstrated, for example, by Peemans's choice of godfathers for his children. Gerard van der Strecken was not only grandfather but also godfather to Peemans's first son, aptly called

Gerard (born 1663); Jan van Leefdael was godfather to Peemans's second son, Jan (born 1665); and Willem van Leefdael became godfather to Peemans's third son, Willem (born 1671).[25]

The Italian edition of *The Story of Odysseus* bears both Jan van Leefdael's and Gerard van der Strecken's signatures.[26] Archival evidence shows that it was woven in 1665 or 1666—which means that Van Leefdael and Van der Strecken used the *Odysseus* cartoons after the Van Brustom workshop closed. Given the presence of Van Leefdael's signature on the Chicago *Four Servants*, the fact that he died in 1668, and the design of the border, the tapestry can be dated around 1650, which implies that it also belonged to an edition coproduced by Van Leefdael and Van der Strecken.

Van Leefdael and Van der Strecken were presumably the last Brussels tapissiers to make *Odysseus* pieces after Jordaens, for an eighteenth-century document—possibly written by the Brussels tapestry designer Augustin Coppens (1668–1740; see cats. 25–26)—states that "de origineel stukken van Ulisses met de patroonen heeft Comte de Montré naer Spagnien genomen ende syn aldaer verbrandt [*sic*] op zee vergaen" (the original pieces of Ulysses with the cartoons were taken by the Earl of Monterey to Spain and were destroyed by fire [*sic*] lost at sea)—an ironic fortune for cartoons depicting the adventures of a shipwrecked hero.[27] Juan Domingo de Haro y Guzman, Comte de Monterey, was governor of the Spanish Netherlands from 1670 to 1675. As he showed great interest in Flemish tapestry, this eighteenth-century statement is probably accurate.[28] Moreover, it is corroborated by the absence of the cartoons from the 1685 list of cartoons and preparatory works owned by Willem van Leefdael, which includes almost all the sets that had been produced by Jan van Leefdael and Gerard van der Strecken, and subsequently by Willem van Leefdael and Gerard Peemans.[29] KB

NOTES

1. Nelson 1998, pp. 24–28, 73–84.
2. For Jordaens, see d'Hulst 1982; Devisscher and De Poorter 1993.
3. Nelson 1998, pp. 4–5.
4. For Jordaens and tapestry design, see Crick-Kuntziger 1938, d'Hulst 1956, Duverger 1959, Duverger 1959–60, Jaffé 1968, d'Hulst 1974, d'Hulst 1982, Nelson 1983, Nelson 1985–86, Devisscher and De Poorter 1993, and Nelson 1998.
5. Haverkamp Begemann 1975; Lammertse and Vergara 2003.
6. For the attribution of *The Story of Theodosius the Younger* to Jordaens, see Brosens 2007e. For Jordaens's *Story of the Amazons* and his cartoons for untraced tapestries, see Menčik 1911–12, p. xlii; Duverger 1984–2002, vol. 10, p. 497.
7. A chalk and wash drawing in the Hermitage, St. Petersburg (inv. 33.446), is a study for the bottom border.
8. For the *Iliad* and the question of its authorship, see Fowler 2004.
9. For an introduction to the *Odyssey* and further bibliography, see Silk 2004.
10. Nelson 1998, pp. 73–84.
11. Forti Grazzini 1994, vol. 1, pp. 284–302.
12. For the various Renaissance and Baroque cycles depicting Odysseus, see Stanford 1968. Primaticcio's frescoes are known through engravings by Theodoor van Thulden; see Panofsky and Panofsky 1958, pp. 113–90, and Cordellier and Py 2004. For Coxcie, see De Smedt 1992. Coxcie's tapestry designs were surveyed by Duverger 1992, pp. 178–81. Campbell 2002b, pp. 394–402, presents the most recent critical study of Coxcie's sets. Vouet's set is discussed in Duverger 1971b; Roethlisberger 1972; and Lavalle 1990, pp. 496, 498–500.
13. Bolgar 1954, pp. 278–80.
14. D'Hulst 1956, pp. 239–43; Jaffé 1968, pp. 119–20, 177, 229; Nelson 1985–86, pp. 216–18; Nelson 1998, p. 25. Duverger 1971b, pp. 74–98, dates the *Odysseus* series earlier, to 1624, as he links a contract for a Brussels *Odysseus* suite, signed Oct. 5, 1624, with the set created by Jordaens. The name of the designer, however, is not mentioned in the document, so it is possible that the suite was instead made after Coxcie's sixteenth-century cartoons.
15. Nelson 1998, pp. 75, 81.
16. A version of *Telemachus Leading Theoclymenus to Penelope* from the same suite recently appeared on the art market; the piece has no marks or signatures; Hôtel Drouot, Paris, Nov. 22, 2006 (420 x 555 cm).
17. SAB, RT 1234 (Mar. 15, 1629).
18. SAB, RT 1293 (Feb. 10, 1640). Wauters 1878, p. 304, stated erroneously "les deux Van Brustom ne travaillaient plus en 1640, ni Bernard … ni Chrétien" (the two Van Brustoms no longer worked in 1640, neither Bernard nor Christiaan).
19. Jan van Leefdael's dates are based on SAB, PR 330 (Mar. 19, 1603), and SAB, RT 1300 (Nov. 9, 1668). For Hendrik van Leefdael, see ARAB, NGB 1681/2, notary Guillaume Uytterhoeven (July 6, 1629).
20. Jan van Leefdael's contemporary François van den Hecke (1595 or 1596–1675) was married to Johanna Aerts, who was related to Nicasius Aerts, one of the preeminent tapestry producers at the beginning of the seventeenth century. After the death of Johanna van den Hecke (née Aerts), Van Leefdael married Magdalena Poelmans; ARAB, NGB 1819/2, notary Melchior van den Brande (June 5, 1668).
21. SAB, RT 1294 (Dec. 24, 1644).
22. SAB, PR 337 (Sept. 21, 1632), SAB; PR 428 (Aug. 24, 1688).
23. SAB, RT 1294 (Aug. 30, 1647).
24. The Peemans family lived in the parish of Sint-Goriks. At least four sisters and two brothers of Gerard Peemans were baptized between 1636 and 1649: Maria on Apr. 17, 1636 (SAB, PR 252); Johanna on July 29, 1640; Claudius on Jan. 1, 1642; Johanna on Oct. 5, 1643; Franciscus on Sept. 1, 1645; and Johannes on Aug. 15, 1649 (SAB, PR 253). Unfortunately, the parish records for 1637 to 1639 have been damaged, and some have been lost. The marriage of Gerard Peemans and Maria van der Strecken is recorded in SAB, PR 276 (Jan. 13, 1663); SAB, PR 253 (Feb. 15, 1640); and SAB, PR 288 (May 30, 1709). Gerard van der Strecken was married to Maria van Gijsel (died 1683); ARAB, NGB 21, notary Judocus Verheylewegen (Mar. 7, 1683). Gerard Peemans's exemption from taxation is recorded in SAB, RT 1299 (Oct. 15, 1665). This document was published in Crick-Kuntziger 1950, pp. 25–26.
25. Gerard van der Strecken is identified as the godfather of Gerard Peemans in SAB, PR 255 (Oct. 13, 1663). For Willem van Leefdael as godfather to Willem Peemans, see SAB, PR 255 (Jan. 21, 1665 and Dec. 3, 1671).
26. Forti Grazzini 1994, vol. 1, p. 284.
27. This document was published in De Poorter 1978, pp. 461–62.
28. Brosens 2004a, pp. 34, 49, 191, 250, 289, 323.
29. ARAB, NGB 1139/1, notary François van den Eede (Sept. 10, 1685); published in Brosens 2004a, p. 198.

The Story of Caesar and Cleopatra: An Amalgamation of Scenes from *The Story of Cleopatra, The Story of Caesar,* and *The Story of Zenobia and Aurelian*

CAT. 19A

Clodius Disguised as a Woman

Brussels, c. 1680
After a design by Justus van Egmont (1601–1674)
Produced at the workshop of Gerard Peemans (1637/39–1725)
MARKED AND SIGNED: Brussels city mark; *G PEEMANS*
INSCRIBED: *CLAVDIVS AMANS / POMPILIAM IN VESTE / MVLIEBRI NOC-TVRNO / SACRIFICIO DETECTVS / EXPELLITVR*
536.7 x 368.4 cm (211¼ x 145 in.)
Gift of Mrs. Chauncey McCormick and Mrs. Richard Ely Danielson, 1944.22

STRUCTURE: Wool and silk, slit and double interlocking tapestry weave
Warp: Count: 8 warps per cm; wool: S-ply of four Z-spun elements; diameters: 0.8–1.0 mm
Weft: Count: varies from 18 to 32 wefts per cm; wool: S-ply of two Z-spun elements; diameters: 0.4–0.8 mm; silk: pairs and three yarns of S-ply of two Z-twisted elements; diameters: 0.4–1.1 mm

Conservation of this tapestry was made possible through the Department of Textiles Tapestry Conservation Fund.

PROVENANCE: See below.

CAT. 19B

Caesar in the Gallic Wars

Brussels, c. 1680
After a design by Justus van Egmont (1601–1674)
Produced at the workshop of Willem van Leefdael (1632–1688)
MARKED AND SIGNED: Brussels city mark; *G V LEEFDAEL*
INSCRIBED: *IN PVGNA / GAVLENSI DIMICANTIBVS / FEMINIS ET PVERIS / SEMPER EST PEDES / CAESAR*
505.3 x 361.9 cm (199 x 142⅜ in.)
Gift of Mrs. Chauncey McCormick and Mrs. Richard Ely Danielson, 1944.20

STRUCTURE: Wool and silk, slit and double interlocking tapestry weave
Warp: Count: 8 warps per cm; wool: S-ply of four Z-spun elements; diameters: 0.8–1.0 mm
Weft: Count: varies from 18 to 36 wefts per cm; wool: S-ply of two Z-spun elements; diameters: 0.4–1.0 mm; silk: three yarns of S-ply of two Z-twisted elements; diameters: 0.4–0.8 mm; wool and silk: paired yarns of S-ply of two Z-spun wool elements and S-ply of two Z-twisted silk elements; diameters: 0.7–0.9 mm

Conservation of this tapestry was made possible through the generosity of the Textile Society of the Art Institute of Chicago.

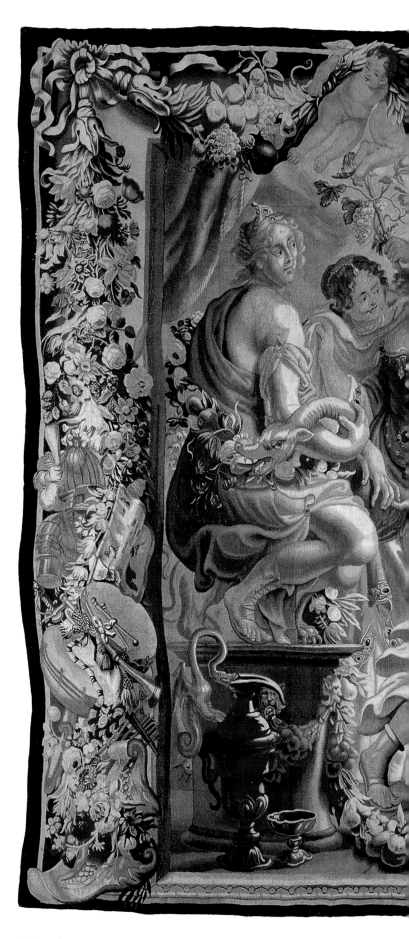

CAT. 19A

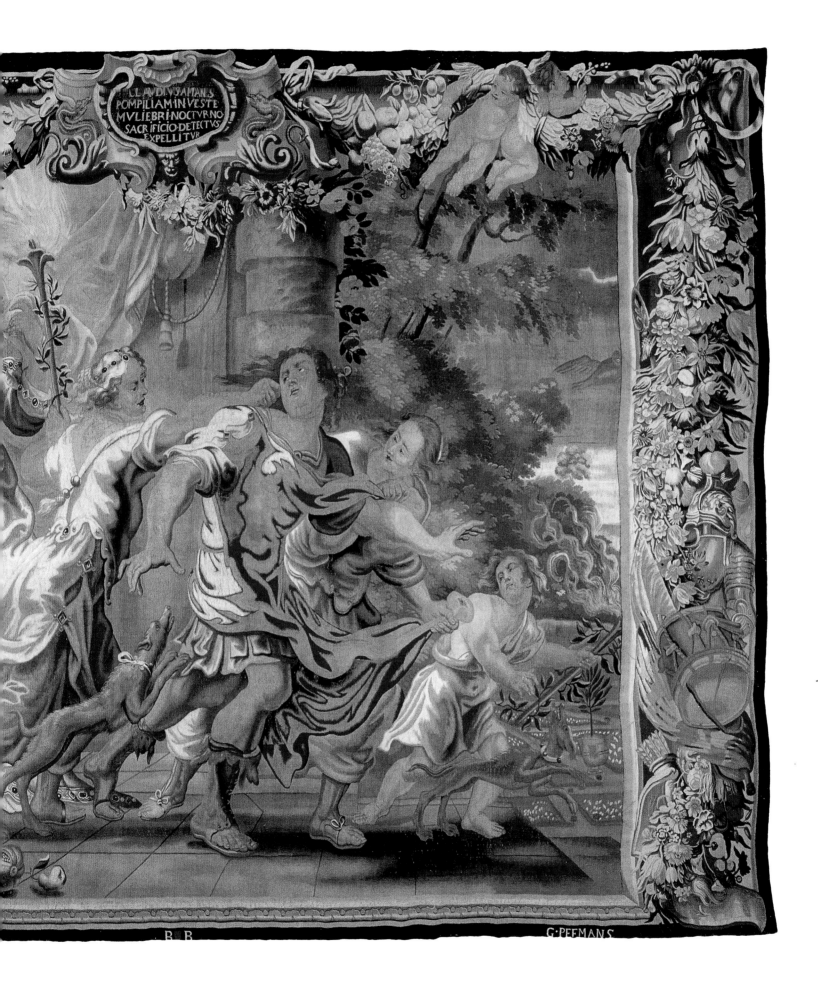

B·B

G·PEEMANS

PROVENANCE: See below.

REFERENCES: Mayer Thurman 1969, p. 29, pl. 14.

EXHIBITIONS: Art Institute of Chicago, *Masterpieces of Western Textiles,* 1969 (see Mayer Thurman 1969).

CAT. 19C

Caesar Defeats the Troops of Pompey

Brussels, c. 1680
After a design by Justus van Egmont (1601–1674)
Produced at the workshop of Gerard Peemans (1637/39–1725)
MARKED AND SIGNED: Brussels city mark; *G PEEMANS*
INSCRIBED: *CAESAR / A SACRIFICIO IN ACIE / VISA SVPRA SVOS / FLAMMA POMPEANOS AD / XLMILLIA VINCIT*
673.5 x 370.2 cm (265⅛ x 145¾ in.)
Gift of Mrs. Chauncey McCormick and Mrs. Richard Ely Danielson, 1944.14

STRUCTURE: Wool and silk, slit and double interlocking tapestry weave
Warp: Count: 8 warps per cm; wool: S-ply of three Z-spun elements; diameters: 0.7–1.0 mm
Weft: Count: varies from 22 to 44 wefts per cm; wool: S-ply of two Z-spun elements; diameters: 0.4–0.9 mm; silk: pairs and three yarns of S-ply of two Z-twisted elements; diameters: 0.6–0.9 mm

Conservation of this tapestry was made possible through the generosity of the Textile Society of the Art Institute of Chicago.

PROVENANCE: See below.

CAT. 19D

Caesar Sends a Messenger to Cleopatra

Brussels, c. 1680
After a design by Justus van Egmont (1601–1674)
Produced at the workshop of Willem van Leefdael (1632–1688)
MARKED AND SIGNED: Brussels city mark; *G V LEEFDAEL*
INSCRIBED: *CAESAR MITITIT / LEGATVM AD / CLEOPATRAM*
310.1 x 363.8 cm (122⅛ x 143¼ in.)
Gift of Mrs. Chauncey McCormick and Mrs. Richard Ely Danielson, 1944.10

STRUCTURE: Wool and silk, slit and double interlocking tapestry weave
Warp: Count: 8 warps per cm; wool: S-ply of three Z-spun elements; diameters: 0.6–0.8 mm
Weft: Count: varies from 18 to 42 wefts per cm; wool: S-ply of two Z-spun elements; pairs of S-ply of two Z-spun elements; diameters: 0.4–1.2 mm; silk: pairs and three yarns of S-ply of two Z-twisted elements; diameters: 0.7–1.2 mm; wool and silk: paired yarns of S-ply of two Z-spun wool elements and S-ply of two Z-twisted silk elements; diameters: 0.8–1.2 mm

Conservation of this tapestry was made possible through the generosity of Armen Minasian and through the Allerton Endowment Fund.

PROVENANCE: See below.

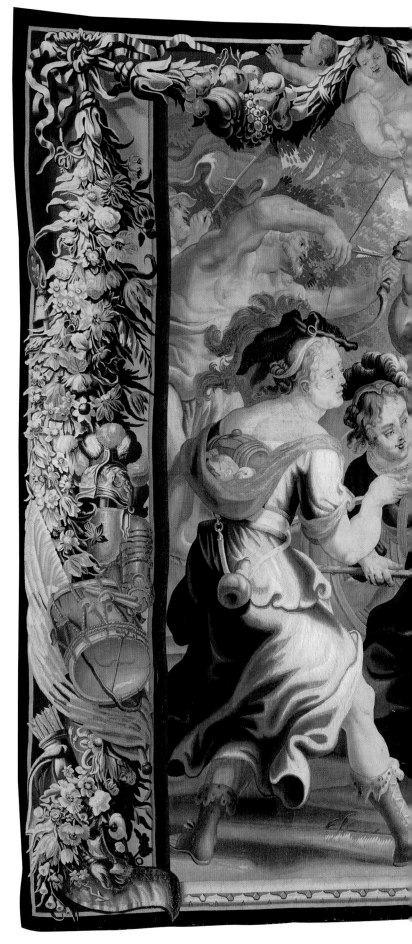

CAT. 19B

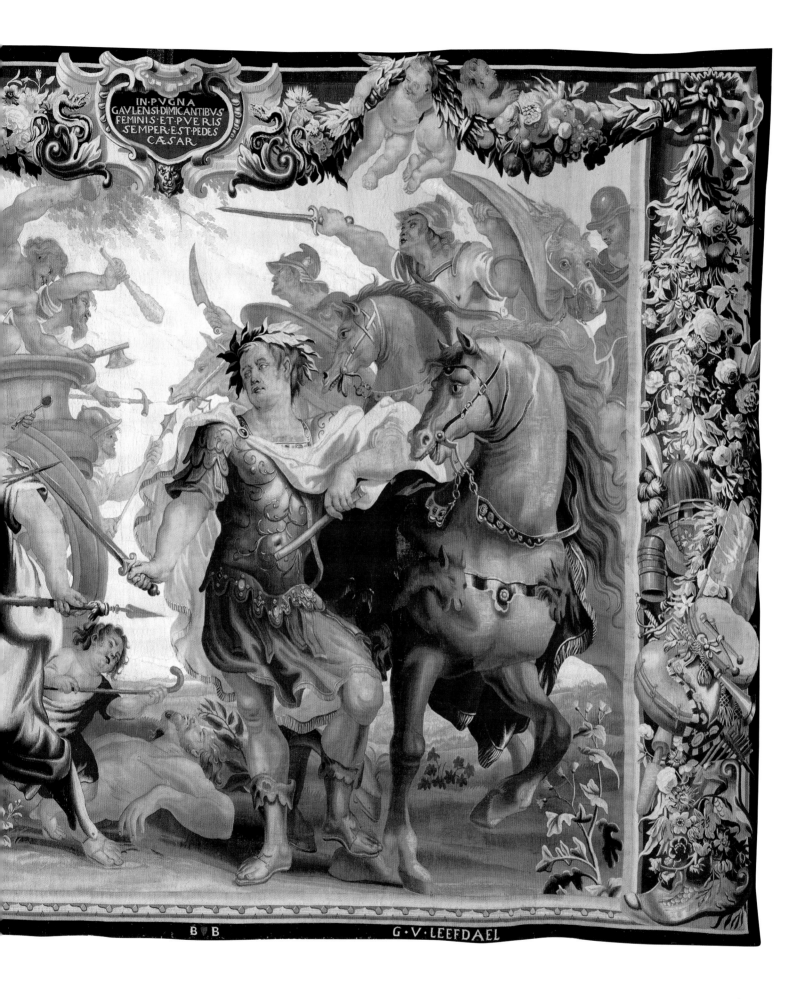

IN·PVGNA
GAVLENSI·DIMICANTIBVS
FEMINIS·ET·PVERIS
SEMPER·EST·PEDES
CÆSAR

B·B G·V·LEEFDAEL

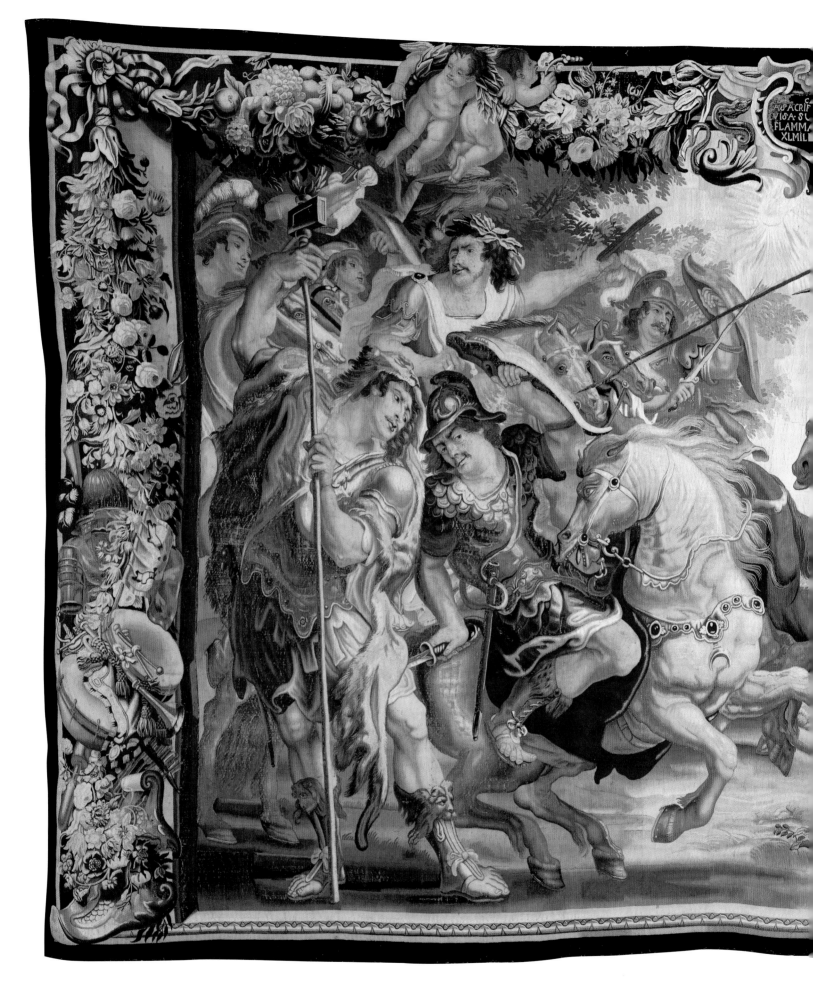

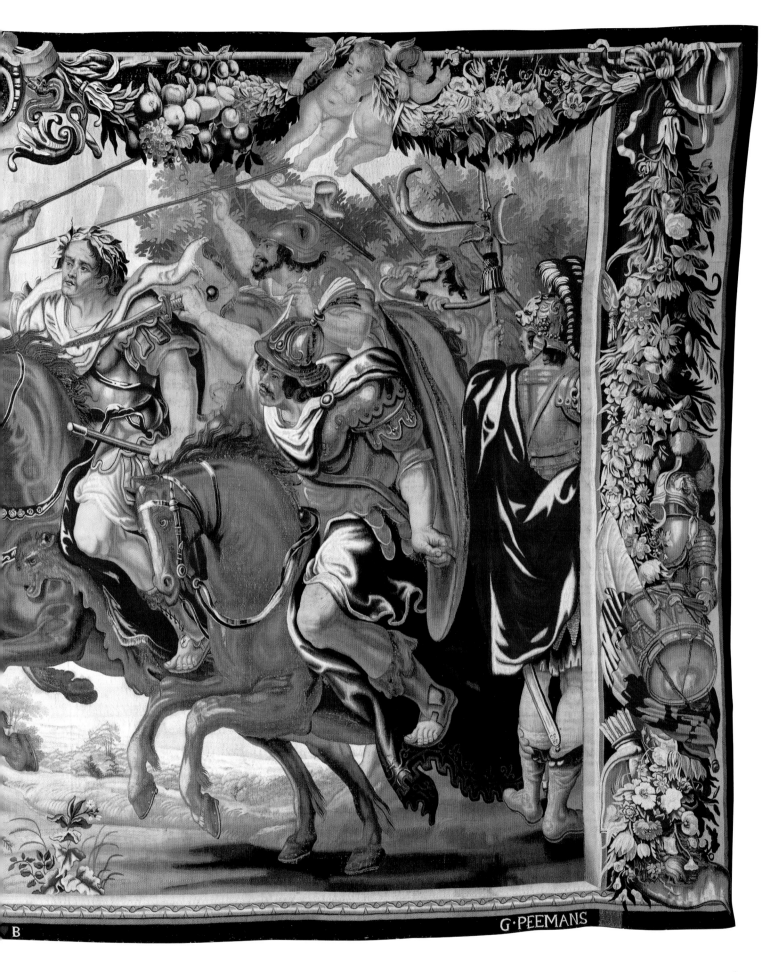

B

G·PEEMANS

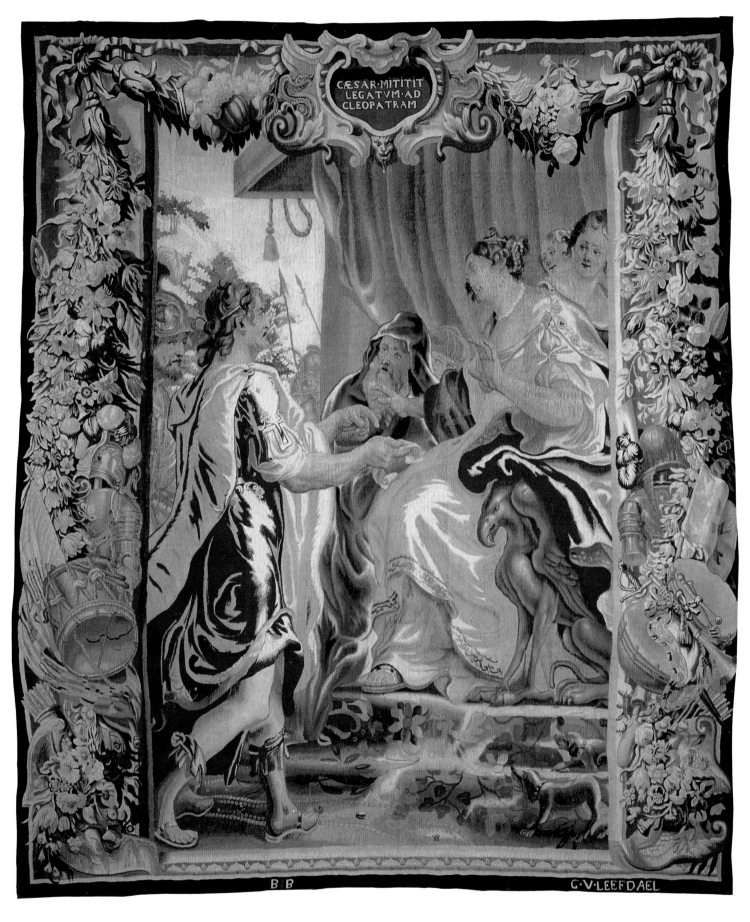

Within the tapestry:

CÆSAR·MITITIT
LEGATVM·AD
CLEOPATRAM

B·B G·V·LEEFDAEL

CAT. 19D

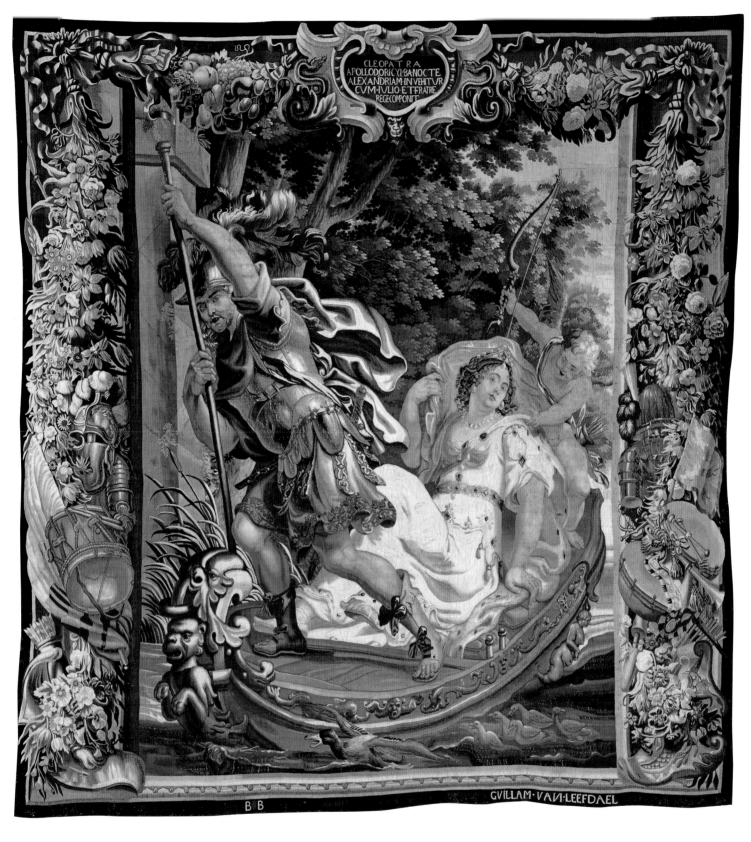

CLEOPATRA
APOLLODORI CYLBANOCTE
ALEXANDRIAM INVEHITVR
CVM·IVLIO·E·T·FRATRE
REGE COMPONIT

B B

GVILLAM·VAN·LEEFDAEL

CAT. 19E

CAT. 19E

Cleopatra Asked to Pay Tribute to Rome

Brussels, c. 1680
After a design by Justus van Egmont (1601–1674)
Produced at the workshop of Willem van Leefdael (1632–1688)
MARKED AND SIGNED: Brussels city mark; *GVILLAM VAN LEEFDAEL*
INSCRIBED: *CLEOPATRA / APOLLODORI CYMBA NOCTE / ALEXANDRIAM*
INVEHITVR / CVM IVLIO ET FRATRE / REGE COMPONIT
343.4 x 361.6 cm (135¼ x 142¼ in.)
Gift of Mrs. Chauncey McCormick and Mrs. Richard Ely Danielson,
1944.16

STRUCTURE: Wool and silk, slit and double interlocking tapestry weave
Warp: Count: 8 warps per cm; wool: S-ply of three Z-spun elements;
diameters: 0.6–0.9 mm
Weft: Count: varies from 20 to 40 wefts per cm; wool: S-ply of two Z-spun
elements; pairs of S-ply of two Z-spun elements; diameters: 0.4–1.0 mm;
silk: pairs, three, and four yarns of S-ply of two Z-twisted elements; diam-
eters: 0.5–1.1 mm; wool and silk: paired yarns of S-ply of two Z-spun wool
elements and S-ply of two Z-twisted silk elements; diameters: 0.6–0.8 mm

Conservation of this tapestry was made possible through the Department of
Textiles Tapestry Conservation Fund and the Allerton Endowment Fund.

PROVENANCE: See below.

CAT. 19F

The Discovery of the Plot to Kill Caesar and Cleopatra

Brussels, c. 1680
After a design by Justus van Egmont (1601–1674)
Produced at the workshop of Gerard Peemans (1637/39–1725)
MARKED AND SIGNED: Brussels city mark; *G PEEMANS*
INSCRIBED: *IVLIO CESARI CVM / CLEOPATRA CONVIVANTI / MORS*
INTENTATVR SED / FRAVS DETEGITVR
525.5 x 370.6 cm (206⅞ x 145⅞ in.)
Gift of Mrs. Chauncey McCormick and Mrs. Richard Ely Danielson,
1944.21

STRUCTURE: Wool and silk, slit and double interlocking tapestry weave
Warp: Count: 8 warps per cm; wool: S-ply of four Z-spun elements;
diameter: 0.8 mm
Weft: Count: varies from 18 to 36 wefts per cm; wool: S-ply of two Z-spun
elements; diameters: 0.4–1.0 mm; silk: pairs and three yarns of S-ply of two
Z-twisted elements; diameters: 0.5–1.2 mm; wool and silk: paired yarns of
S-ply of two Z-spun wool elements and S-ply of two Z-twisted silk elements;
diameters: 0.8–1.0 mm

Conservation of this tapestry was made possible through the Department of
Textiles Tapestry Conservation Fund.

PROVENANCE: See below.

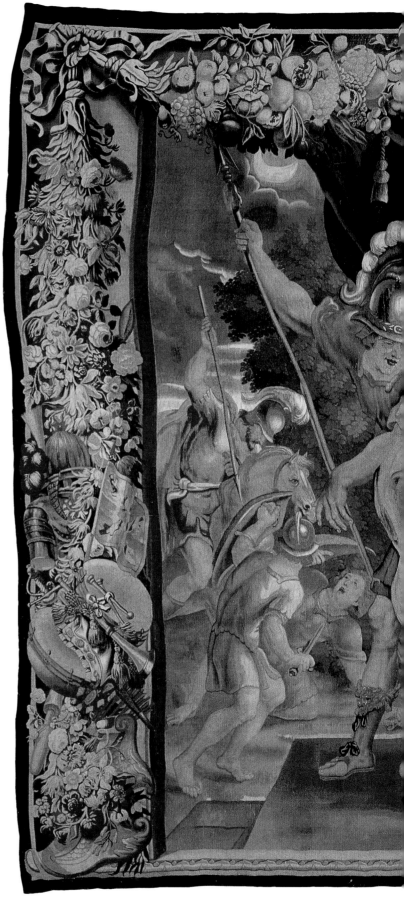

CAT. 19F

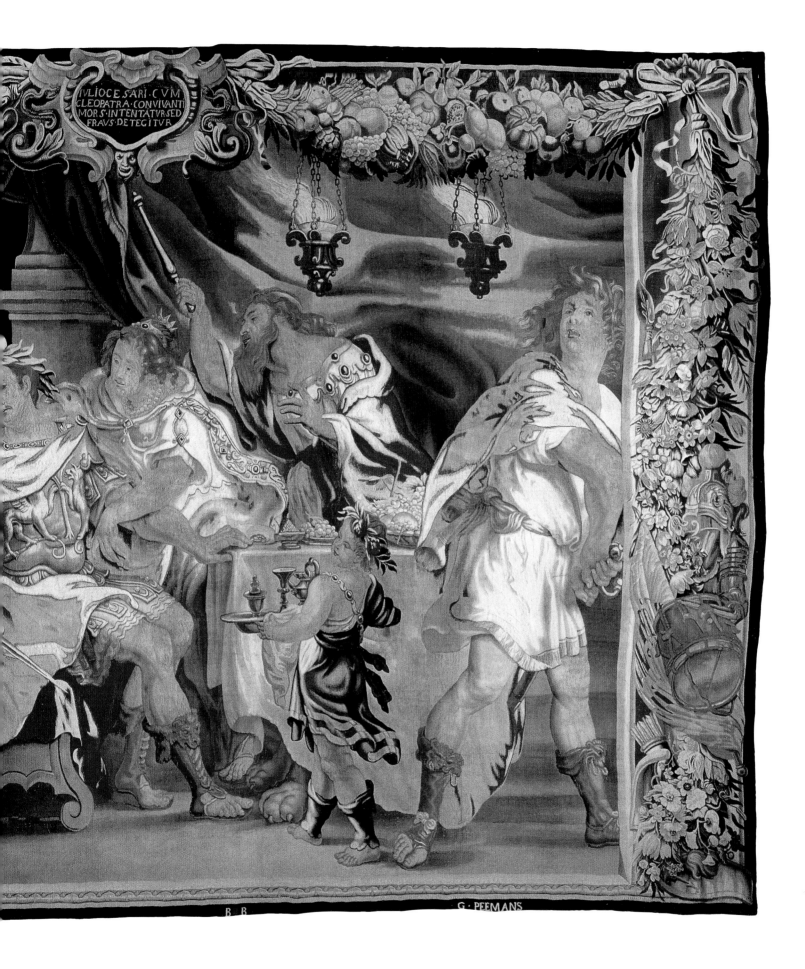

IVLIO CESARI CVM
CLEOPATRA CONVIVANTI
MOR S INTENTATVR SED
FRAVS DETEGITVR

B B

G · PEEMANS

Caesar Embarks by Boat to Join His Army

Brussels, c. 1680
After a design by Justus van Egmont (1601–1674)
Produced at the workshop of Gerard Peemans (1637/39–1725)
MARKED AND SIGNED: Brussels city mark; *GI PEE*
INSCRIBED: *CAESAR CYMBAM / CONSCENDIT / EXERCITVI SE / IVNCTVRVS*
381.7 x 366.3 cm (150¼ x 144⅛ in.)
Gift of Mrs. Chauncey McCormick and Mrs. Richard Ely Danielson,
1944.19

STRUCTURE: Wool and silk, slit and double interlocking tapestry weave
Warp: Count: 10 warps per cm; wool: S-ply of three Z-spun elements;
diameters: 0.5–0.7 mm
Weft: Count: varies from 20 to 48 wefts per cm; wool: S-ply of two Z-spun
elements; diameters: 0.3–0.8 mm; silk: pairs and three yarns of S-ply of two
Z-twisted elements; paired yarns of S-ply of two Z-twisted elements and
single Z-twisted element; diameters: 0.4–0.85 mm

Conservation of this tapestry was made possible through the Department of
Textiles Tapestry Conservation Fund.

PROVENANCE: See below.

REFERENCES: Mayer Thurman and Brosens 2003, p. 175, fig. 5.

Caesar Throws Himself into the Sea

Brussels, c. 1680
After a design by Justus van Egmont (1601–1674)
Produced at the workshop of Willem van Leefdael (1632–1688)
MARKED AND SIGNED: Brussels city mark; *G V LEEFDAEL*
INSCRIBED: *CAESAR IN MOTV ALEXANDRIAE / DOLO LAPSVS IN MARE /
SERVATIS MANV LITERIS / AD NON EXVSTAS NAVES / ADNATAT*
351.2 x 362.4 cm (138¼ x 142¾ in.)
Gift of Mrs. Chauncey McCormick and Mrs. Richard Ely Danielson,
1944.18

STRUCTURE: Wool and silk, slit and double interlocking tapestry weave
Warp: Count: 8 warps per cm; wool: S-ply of three Z-spun elements; diam-
eters: 0.6–0.8 mm
Weft: Count: varies from 22 to 40 wefts per cm; wool: S-ply of two Z-spun
elements; diameters: 0.3–1.0 mm; silk: pairs and three yarns of S-ply of two
Z-twisted elements; diameters: 0.5–1.0 mm; wool and silk: paired yarns of
S-ply of two Z-spun wool elements and S-ply of two Z-twisted silk elements;
diameters: 0.5–1.0 mm

Conservation of this tapestry was made possible through the generosity of
the Textile Society of the Art Institute of Chicago.

PROVENANCE: See below.

Caesar and Cleopatra Enjoying Themselves

Brussels, c. 1680
After a design by Justus van Egmont (1601–1674)
Produced at the workshop of Gerard Peemans (1637/39–1725)
MARKED AND SIGNED: Brussels city mark; *G P*
INSCRIBED: *CAESAR CVM / CLEOPATRA SE / RECREAT*
364.9 x 370 cm (143¾ x 145⅝ in.)
Gift of Mrs. Chauncey McCormick and Mrs. Richard Ely Danielson,
1944.12

STRUCTURE: Wool and silk, slit and double interlocking tapestry weave
Warp: Count: 8 warps per cm; wool: S-ply of four Z-spun elements;
diameter: 0.8 mm
Weft: Count: varies from 22 to 42 wefts per cm; wool: S-ply of two Z-spun
elements; diameters: 0.4–0.8 mm; silk: pairs and three yarns of S-ply of two
Z-twisted elements; diameters: 0.5–1.0 mm

Conservation of this tapestry was made possible through the Department of
Textiles Tapestry Conservation Fund and the Allerton Endowment Fund.

PROVENANCE: See below.

The Triumph of Caesar

Brussels, c. 1680
After a design by Justus van Egmont (1601–1674)
Produced at the workshop of Gerard Peemans (1637/39–1725)
MARKED AND SIGNED: Brussels city mark; *G PEEMANS*
INSCRIBED: *CAESAR TRIVMPHAT / DE AEGYPTO POMTO AFRICA / MMXX
MEMFIS CIVES LVDIS / VARYS RECREAT*
701.9 x 366.2 cm (276⅜ x 144¼ in.)
Gift of Mrs. Chauncey McCormick and Mrs. Richard Ely Danielson,
1944.13

STRUCTURE: Wool and silk, slit and double interlocking tapestry weave
Warp: Count: 9 warps per cm; wool: S-ply of three Z-spun elements;
diameters: 0.6–0.9 mm
Weft: Count: varies from 24 to 36 wefts per cm; wool: S-ply of two Z-spun
elements; diameters: 0.3–1.0 mm; silk: pairs and three yarns of S-ply of two
Z-twisted elements; diameters: 0.4–0.9 mm; wool and silk: paired yarns of
S-ply of two Z-spun wool elements and S-ply of two Z-twisted silk elements;
diameters: 0.6–1.0 mm

Conservation of this tapestry was made possible through the Department of
Textiles Tapestry Conservation Fund and the Allerton Endowment Fund.

PROVENANCE: See below.

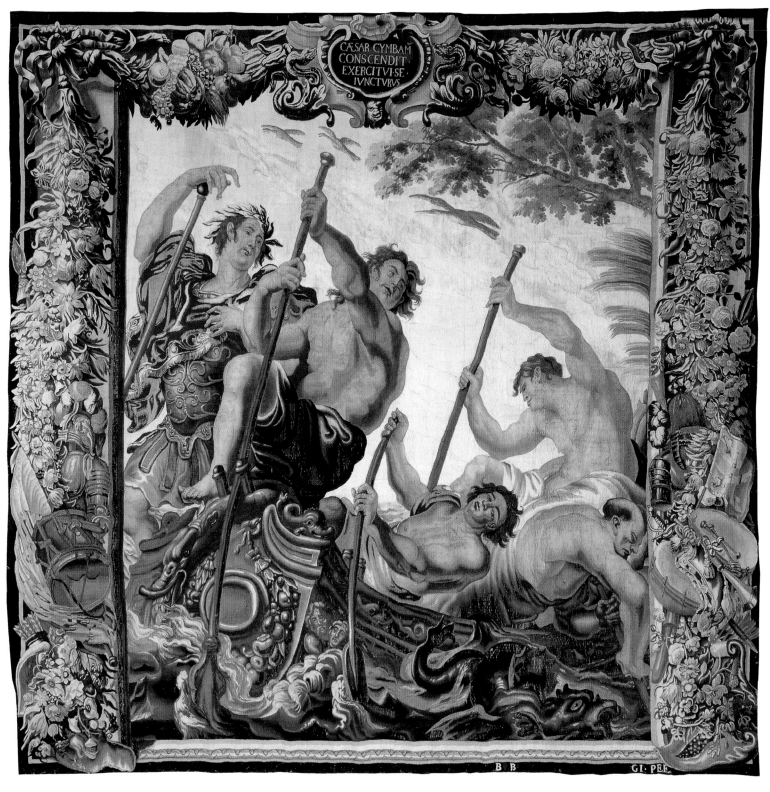

CAESAR CYMBAM
CONSCENDIT.
EXERCITVI·SE·
IVNCTVRVS

CAT. 19G

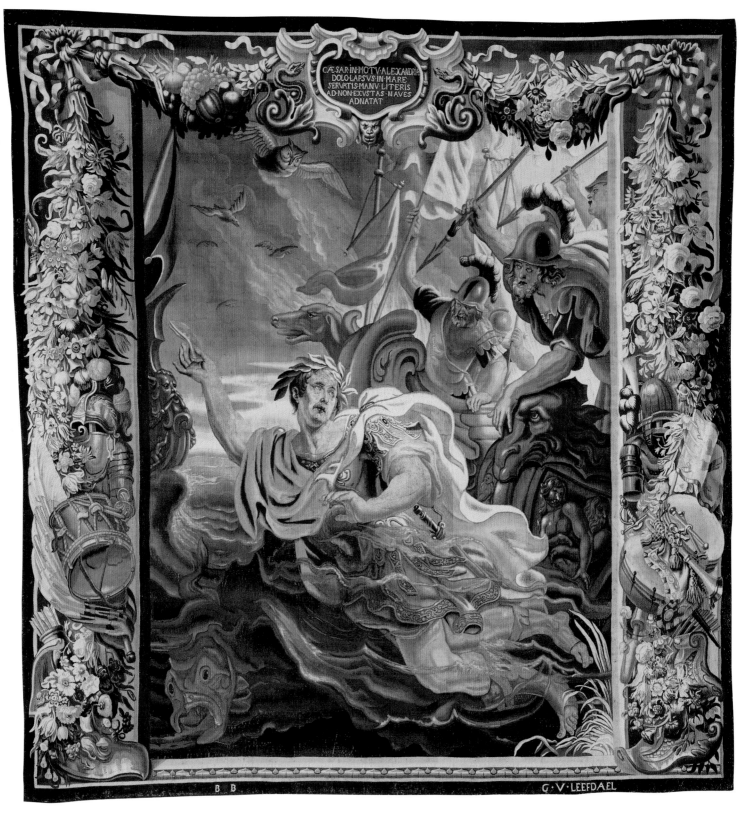

CÆSAR·IN·MOTV·ALEXANDRIÆ
DOLO·LAPSVS·IN·MARE
SERVATIS·MANV·LITERIS
AD·NON·EXVSTAS·NAVES
ADNATAT

B B

G·V·LEEFDAEL

CAT. 19H

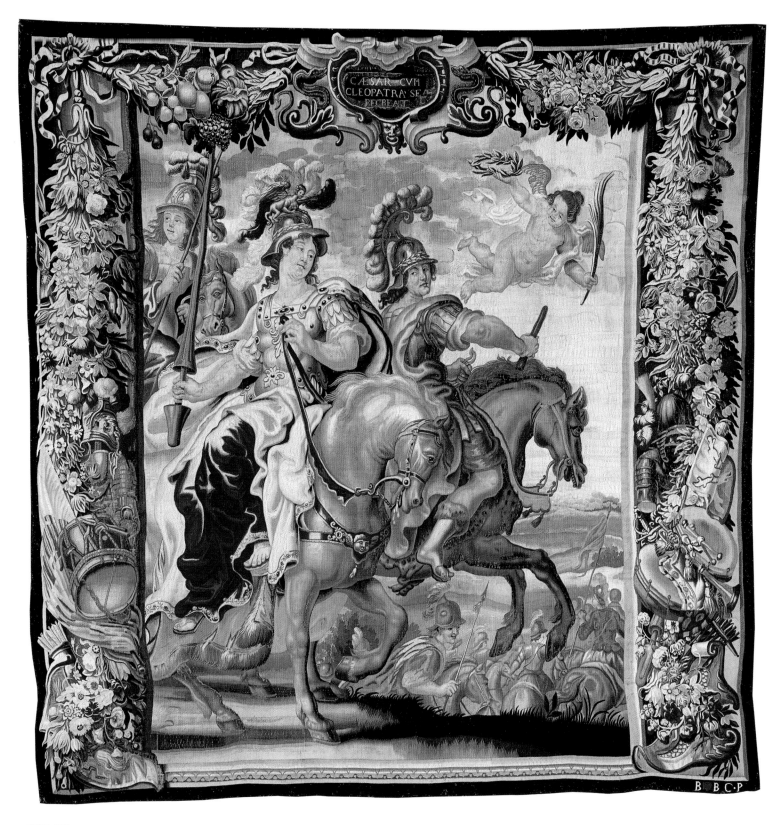

CAT. 191

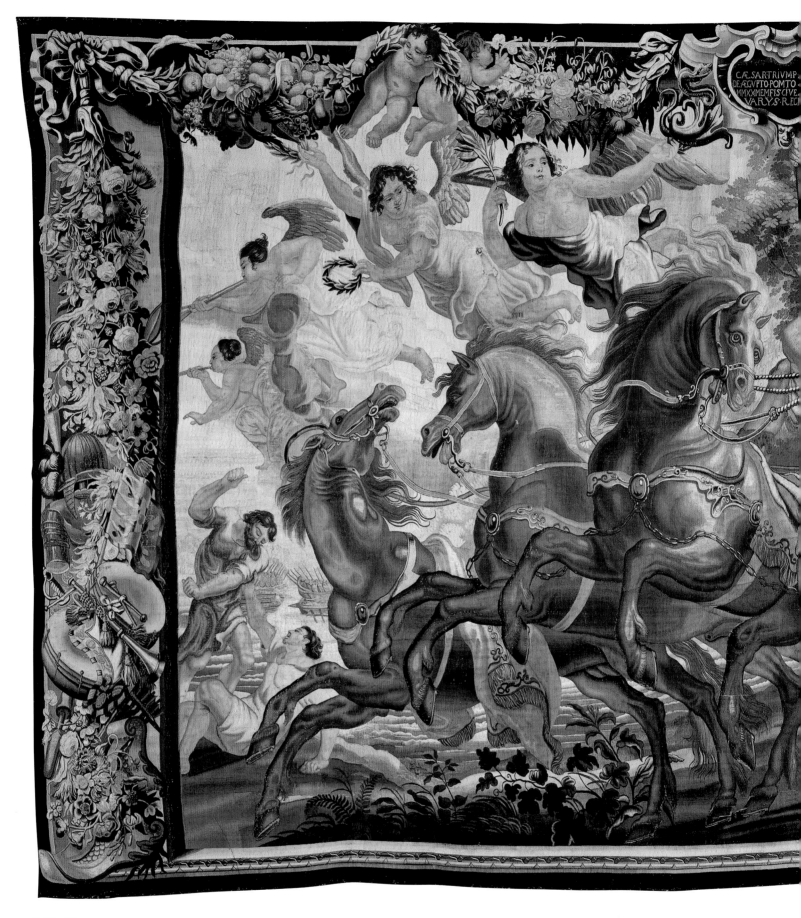

CAT. 19J

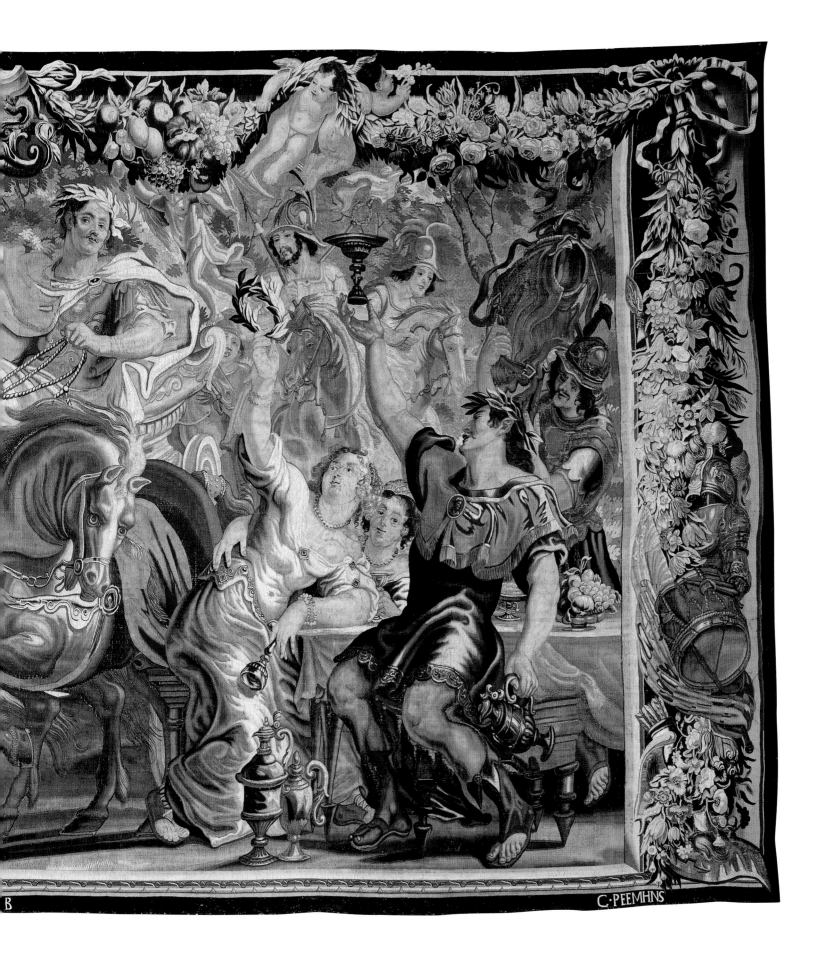

C·PEEMHNS

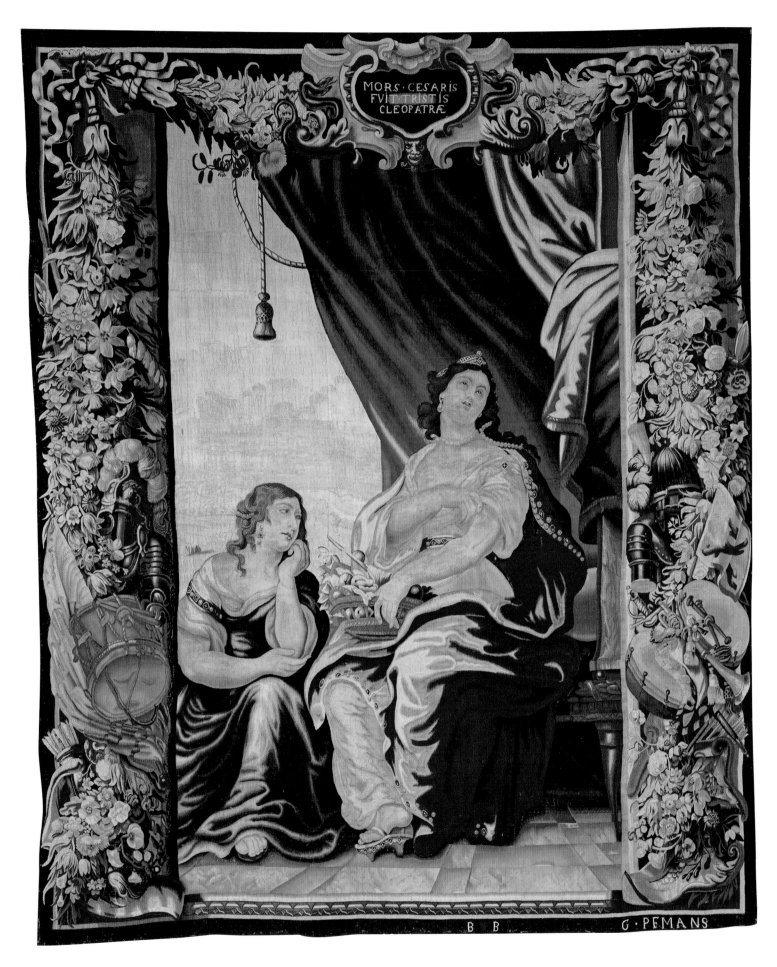

MORS·CESARIS
FVIT·TRISTIS
CLEOPATRÆ

BB G·PEMANS

CAT. 19K

CAT. 19K

Caesar's Death Makes Cleopatra Mourn

Brussels, c. 1680
After a design by Justus van Egmont (1601–1674)
Produced at the workshop of Gerard Peemans (1637/39–1725)
MARKED AND SIGNED: Brussels city mark; *G PEMANS*
INSCRIBED: *MORS CESARIS / FVIT TRISTIS / CLEOPATRAE*
302.1 x 362.4 cm (119 x 142¾ in.)
Gift of Mrs. Chauncey McCormick and Mrs. Richard Ely Danielson, 1944.9

STRUCTURE: Wool and silk, slit and double interlocking tapestry weave
Warp: Count: 8 warps per cm; wool: S-ply of four Z-spun elements; diameters: 0.6–0.8 mm
Weft: Count: varies from 28 to 54 wefts per cm; wool: S-ply of two Z-spun elements; diameters: 0.4–0.8 mm; silk: pairs and three yarns of S-ply of two Z-twisted elements; diameters: 0.4–1.0 mm

Conservation of this tapestry was made possible through the Department of Textiles Tapestry Conservation Fund and the Allerton Endowment Fund.

PROVENANCE: See below.

REFERENCES: Mayer Thurman and Brosens 2003, p. 175, fig. 6.

CAT. 19L

Cleopatra Enjoys Herself at Sea

Brussels, c. 1680
After a design by Justus van Egmont (1601–1674)
Produced at the workshop of Willem van Leefdael (1632–1688)
MARKED AND SIGNED: Brussels city mark; *G V L*
INSCRIBED: *CLEOPATRA / IN MARI SE / RECREAT*
392.4 x 359.6 cm (154½ x 141⅝ in.)
Gift of Mrs. Chauncey McCormick and Mrs. Richard Ely Danielson, 1944.11

STRUCTURE: Wool and silk, slit and double interlocking tapestry weave
Warp: Count: 8 warps per cm; wool: S-ply of three Z-spun elements; diameters: 0.4–0.9 mm
Weft: Count: varies from 18 to 44 wefts per cm; wool: S-ply of two and three Z-spun elements; diameters: 0.4–1.0 mm; silk: three yarns of S-ply of two Z-twisted elements; diameters: 0.6–1.0 mm; wool and silk: paired yarns of S-ply of two Z-spun wool elements and S-ply of two Z-twisted silk elements; diameters: 0.6–1.0 mm

Conservation of this tapestry was made possible through the generosity of the Textile Society of the Art Institute of Chicago.

PROVENANCE: See below.

CAT. 19M

Cleopatra and Antony Enjoying Supper

Brussels, c. 1680
After a design by Justus van Egmont (1601–1674)
Produced at the workshop of Gerard Peemans (1637/39–1725)
MARKED AND SIGNED: Brussels city mark; *G I PEEMANS*
INSCRIBED: *CLEOPATRA CVM / ANTHONIO MENSE / ASSIDET*
321.9 x 362.0 cm (126¾ x 142⅝ in.)
Gift of Mrs. Chauncey McCormick and Mrs. Richard Ely Danielson, 1944.17

STRUCTURE: Wool and silk, slit and double interlocking tapestry weave
Warp: Count: 9 warps per cm; wool: S-ply of four Z-spun elements; diameters: 0.8–1.1 mm
Weft: Count: varies from 18 to 46 wefts per cm; wool: S-ply of two Z-spun elements; diameters: 0.3–0.8 mm; silk: pairs of S-ply of two Z-twisted elements; diameters: 0.6–1.0 mm

Conservation of this tapestry was made possible through the generosity of the Textile Society of the Art Institute of Chicago.

PROVENANCE: See below.

CAT. 19N

The Battle of Actium

Brussels, c. 1680
After a design by Justus van Egmont (1601–1674)
Produced at the workshop of Willem van Leefdael (1632–1688)
MARKED AND SIGNED: Brussels city mark; *G V LEEFDAEL*
INSCRIBED: *CLEOPATRA AB / INNIMICIS IN / MARI INVADITVR*
400.6 x 359.5 cm (157¾ x 141½ in.)
Gift of Mrs. Chauncey McCormick and Mrs. Richard Ely Danielson, 1944.15

STRUCTURE: Wool and silk, slit and double interlocking tapestry weave.
Warp: Count: 9 warps per cm; wool: S-ply of three Z-spun elements; diameters: 0.5–0.9 mm.
Weft: Count: varies from 22 to 37 wefts per cm; wool: S ply of two Z-spun elements; diameters: 0.4–0.8 mm; silk: pairs and three yarns of S-ply of two Z-twisted elements; diameters: 0.6–0.9 mm; wool and silk: paired yarns of S-ply of two Z-spun wool elements and S-ply of two Z-twisted silk elements; diameters: 0.6–1.0 mm.

Conservation of this tapestry was made possible through the Department of Textiles Tapestry Conservation Fund and the Allerton Endowment Fund.

PROVENANCE: Possibly the Villalonga family, Mallorca, to 1914 at the latest; Charles Deering (died 1927), Marycel, Sitges, Spain, by 1914;[1] by descent to his daughters Mrs. Chauncey McCormick (née Marion Deering, died 1965) and Mrs. Richard Ely Danielson (née Barbara Deering, died 1982); given to the Art Institute, 1944.

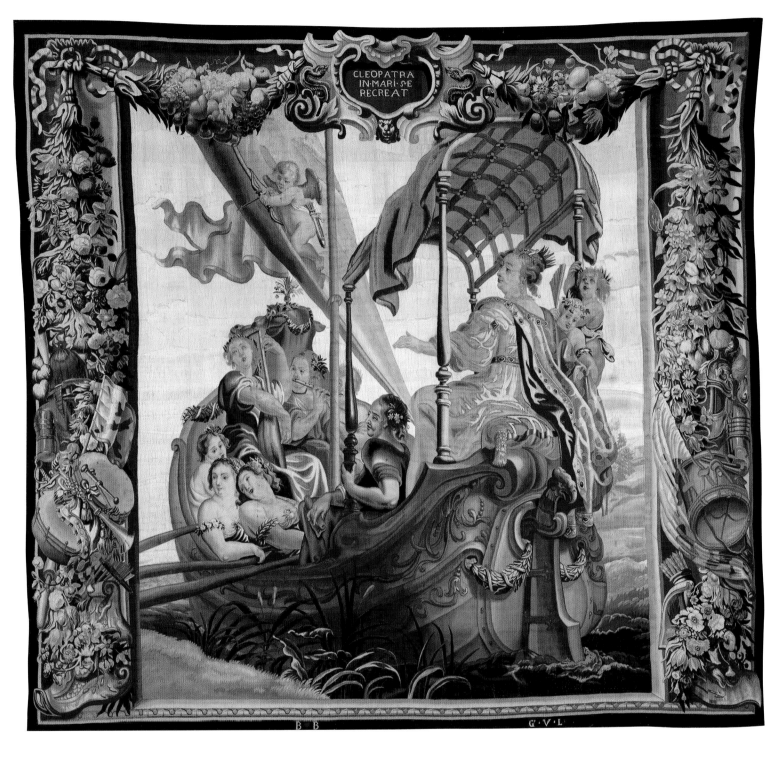

CAT. 19L

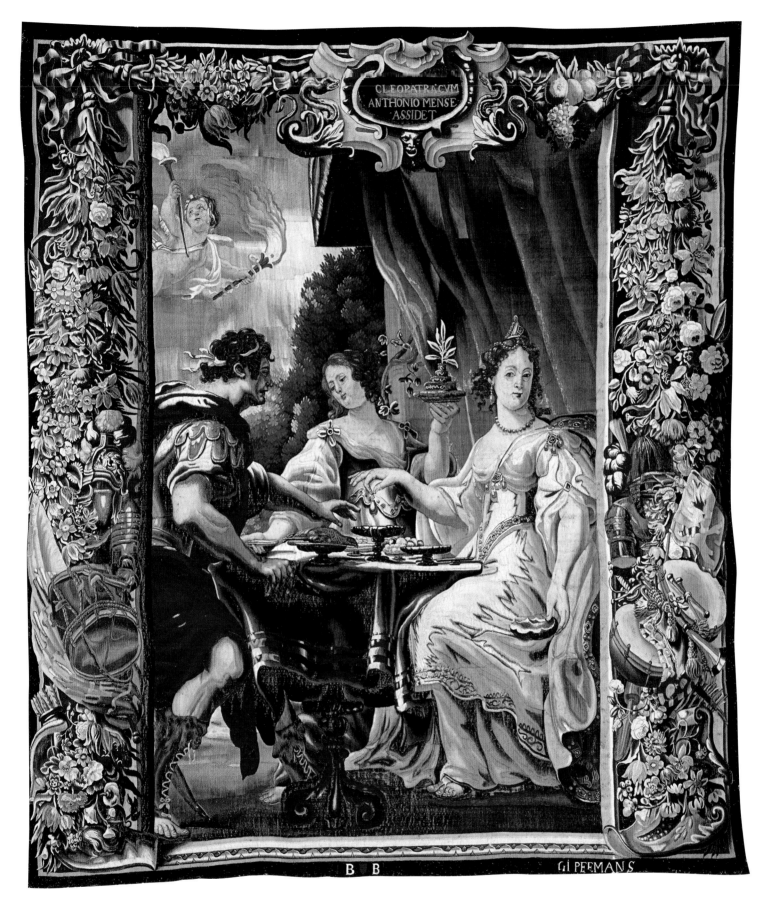

CLEOPATRÆ CVM
ANTHONIO MENSE
ASSIDET

B B

GI PEEMANS

CAT. 19M

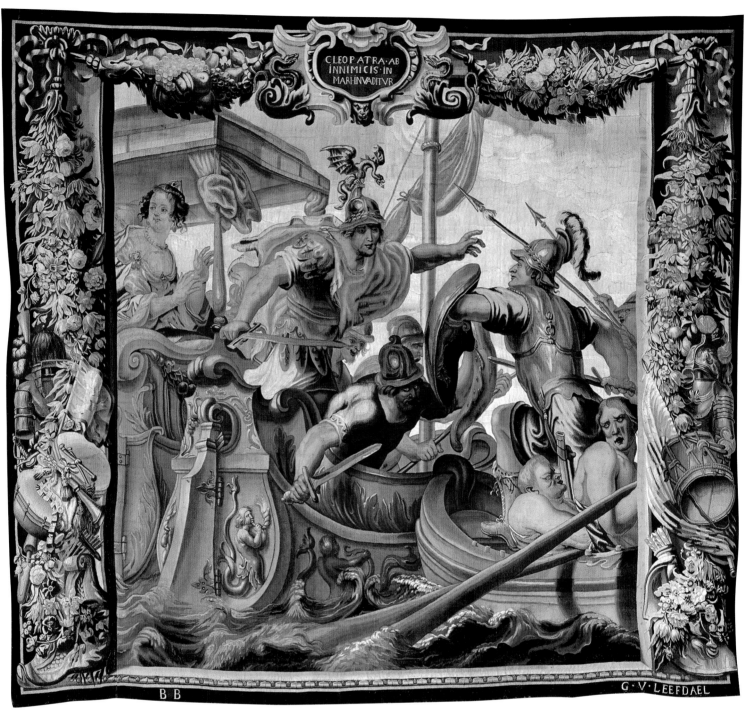

CLEOPATRA·AB
INNIMICIS·IN
MARI·INVADITVR

B B

G·V·LEEFDAEL

CAT. 19N

The Story of Caesar and Cleopatra is a contemporary amalgamation of scenes from three different series—*The Story of Cleopatra, The Story of Caesar,* and *The Story of Zenobia and Aurelian*—all created by the Antwerp painter Justus van Egmont and woven by the Van Leefdael-Van der Strecken-Peemans association (see also cats. 18, 23). Van Egmont was born in Leiden in the Northern Netherlands. After a stay in Italy around 1618, he joined the workshop of Peter Paul Rubens

(1577–1640) in Antwerp. Between 1625 and 1628 Van Egmont collaborated with Rubens, among others, on the famous *Medici Cycle* commissioned by Marie de' Medici for the Palais du Luxembourg in Paris.[2] In 1628 Van Egmont moved to the French capital, where he established a solid reputation, notably as a portrait painter, and belonged to the team of artists led by Simon Vouet (1590–1649) that created tapestry sets for the Parisian workshops.[3] In 1648 Van

Egmont cofounded the French Académie Royale de Peinture et de Sculpture in conjunction with other painters, including Charles Le Brun (see cats. 22, 40a–b). The following year, however, he returned to the Southern Netherlands, presumably staying in Brussels until moving back to Antwerp in approximately 1655. This biographical outline obviously suggests that Van Egmont created the *Cleopatra, Caesar,* and *Zenobia and Aurelian* sets after his return from France in 1649, a hypothesis corroborated by the absence of these three sets from the archival record prior to that year.

Documents show that Van Egmont had finished *The Story of Cleopatra* before June 1651.[4] Jan van Leefdael (1603–1668) and Gerard van der Strecken (c. 1610–1677) must have commissioned the cartoons, for all known *Cleopatra* tapestries are signed by them or by their successors, Willem van Leefdael and Gerard Peemans.[5] The series depicts the love affair of Cleopatra, queen of Egypt (r. 50–30 B.C.), and Mark Antony (c. 83–30 B.C.), a Roman politician and general. Van Egmont's *Cleopatra* set has therefore also been called *The Story of Antony and Cleopatra*. Nine designs, whose subjects are identified by Latin inscriptions in cartouches in the top borders of the tapestries, have been linked to the set: *Cleopatra Asked to Pay Tribute to Rome, The Meeting of Antony and Cleopatra, Cleopatra Dissolving the Pearl, The Triumph of Antony and Cleopatra, The Battle of Actium, The Flight of Antony, The Flight of Antony and Cleopatra, The Death of Antony,* and *The Death of Cleopatra*. Two *Cleopatra* paintings listed in the probate inventory recorded after the death of Van Egmont's widow in 1685 may have been *modelli* for the series.[6]

During the Middle Ages, Cleopatra was regarded unfavorably. From the sixteenth century on, however, writers developed a more positive view of her and frequently retold the tragic love story of the Roman general and the Egyptian queen.[7] The main source for the tale was the *Life of Antony* in Plutarch's *Parallel Lives* (c. 100), which had been popularized in most European languages during the sixteenth century.[8] A number of tapestry sets featuring Antony and Cleopatra were created in the wake of this literary success, including suites produced by Jacques I Geubels (died before 1605) and Everard III Leyniers (1597–1680; see cat. 17), and series designed by Karel II van Mander (1597–1623), Isaac Moillon (1614–1673), and Charles Poerson (1609–1667; see cat. 21).[9] Therefore, when Jan van Leefdael and Gerard van der Strecken commissioned their *Cleopatra* set from Van Egmont, they knew the subject was very much in vogue. The large number of surviving *Cleopatra* suites and individual tapestries produced by Van Leefdael and Van der Strecken prove that the designs they commissioned turned out to be a commercial success.

The Story of Caesar was created by Van Egmont before March 1659.[10] Just as in the case of *Cleopatra,* its cartoons must have been commissioned by Van Leefdael and Van der Strecken, for all known *Caesar* tapestries, including the most complete edition that is in the Diputación Provincial, Madrid, are signed by them or their successors.[11] Eight subjects, identified by Latin inscriptions in cartouches in the top borders, have been established as belonging to Van Egmont's

Story of Caesar set: *Clodius Disguised as a Woman, Caesar in the Gallic Wars, Caesar Crosses the Ionian Gulf, Caesar Defeats the Troops of Pompey, Caesar and Cleopatra Become Rulers of Egypt, The Discovery of the Plot to Kill Caesar and Cleopatra, Caesar Throws Himself into the Sea,* and *The Triumph of Caesar*. Five *Caesar* paintings listed in the probate inventory recorded after the death of Van Egmont's widow were presumably *modelli* for the series.[12]

As one of the famous Nine Worthies—historical figures who, from the beginning of the fourteenth century, were believed to embody the ideals of chivalry—Caesar was an icon throughout the Middle Ages and the early modern era.[13] His story was largely known through Plutarch's *Parallel Lives* and the many dramatic works it inspired. In France, Marc-Antoine de Muret published the Neo-Latin tragedy *Julius Caesar* (1552–53), which was translated into French by Jacques Grévin as *César* (1561).[14] At the beginning of the seventeenth century, Shakespeare's *Julius Caesar* was staged in London; the play was published in 1623.[15] A Dutch translation of Muret's *Julius Caesar* was published in 1645, while Georges de Scudéry's *La mort de César* (1634) was translated into Dutch in 1650.[16] Given this renown, it is not surprising that Caesar, like Cleopatra and Mark Antony, was a popular subject in Flemish and French tapestry prior to 1650.[17] Jan van Leefdael and Gerard van der Strecken's decision to commission a set of cartoons depicting *The Story of Caesar* was, therefore, hardly a risk.

Lastly, *The Story of Zenobia and Aurelian* was painted by Van Egmont from 1664 to 1665. Archival evidence shows that Gerard Peemans ordered the designs.[18] Zenobia became queen of Palmyra (now Tadmor in Syria) on the death of her husband, Odenathus. She claimed descent from Cleopatra and Mark Antony, as well as from Dido, the supposed founding queen of Carthage. As the political heiress of these famous female rulers, Zenobia embarked on a campaign of conquest, but was eventually defeated by the Roman emperor Aurelian.[19] Eight scenes, labeled with Latin inscriptions, have been identified as belonging to the *Zenobia and Aurelian* series: *The Wedding of Zenobia and Odenathus, The Wedding Banquet, Zenobia as a Military Commander, Zenobia as a Huntress, Aurelian Captures the City of Tyana, Aurelian is Wounded during the Siege of Palmyra, Zenobia in Captivity is Led before Aurelian,* and *The Triumph of Aurelian*. Two paintings listed in the probate inventory recorded after the death of Van Egmont's widow may have been *modelli* for the series, and two drawings by Van Egmont pertaining to the *Zenobia and Aurelian* series are in the Art Institute (figs. 1, 2).[20]

As they lived after Plutarch had completed his *Lives,* neither Zenobia nor Aurelian is included in the work. The prime source of their stories is rather the *Historia Augusta,* an enigmatic collection of biographies of Roman emperors of the second and third centuries.[21] A critical edition of this work was published in Latin in 1603 by Isaac Casaubon. But even prior to Casaubon's text, Zenobia was a well-liked figure. Boccaccio had included her in his *De Mulieribus Claris* (c. 1370), and she had also appeared in *The Palace of Pleasure*

(1566), a compendium of old, mostly Italian, stories assembled by William Painter. Her popularity persisted through the seventeenth century; Zenobia stars in Pedro Calderón de la Barca's *La gran Cenobia* (1634/35); in *Zénobie* (1647) by François Hédelin, the abbot of Aubignac; and in Jean-Tristan de Saint-Amant's *Commentaires historiques contenans l'Histoire générale des Empereurs, Impératrices, Césars et Tyrans de l'Empire romain* (1635; reprinted 1644).[22] It is therefore not surprising to find that multiple *Zenobia and Aurelian* tapestry sets were produced in Antwerp, Brussels, and Oudenaarde.[23]

In ordering *The Story of Cleopatra*, *The Story of Caesar*, and *The Story of Zenobia and Aurelian* from one painter, Van Leefdael, Van der Strecken, and Peemans displayed their business acumen. Tapestry entrepreneurs had to develop fashionable sale catalogues and keep them up-to-date. New cartoons, however, were extremely costly.[24] To reduce their expenses, workshop managers therefore devised a number of strategies and ad hoc arrangements, which tend to trouble modern tapestry scholars attempting to establish static and well-defined set classifications. Tapestry producers reused and modernized old cartoons (see cats. 20a–b), leased new designs (see cat. 22), added one or more new designs to existing series, and combined subjects from different but stylistically similar series to create amalgamated sets, as in the case of the present suite. Given that the *Caesar, Cleopatra,* and *Zenobia and Aurelian* series were all painted by Van Egmont, the Van Leefdael-Van der Strecken-Peemans association could expand the number of tapestries in an edition of one series by adding scenes from another series, provided that the Latin inscriptions in the cartouches were modified. The Van Egmont *Cleopatra* suite in the Metropolitan Museum of Art, New York, for example, includes a *Battle of Actium* that bears the inscription *ANTONIVS APERTO / NAVALI PRAELIO / A ROMANIS DEBELLATVR / ET FVGIT* (Antony, at the beginning of the naval battle, is overcome by the Romans and flees); whereas in a *Caesar* edition in the John and Mable Ringling Museum of Art, Sarasota, the same scene bears the inscription *POMPEIVS A / CESARE VICTVS / FVGIT* (Pompey is overcome by Caesar and flees). A now-dispersed edition of *Zenobia and Aurelian* (of which four pieces are in the Royal Museums of Art and History, Brussels) numbered no fewer than fifteen tapestries; some of these pieces were borrowed from *The Story of Cleopatra*.[25] Another edition of *Zenobia and Aurelian,* which is in the Palazzo Mansi, Lucca, and is signed by Gerard Peemans, consists of eighteen tapestries: eight are genuine *Zenobia and Aurelian* compositions; one is a slightly altered version of a *Zenobia and Aurelian* scene; and the remaining seven pieces are *Cleopatra* designs and bear the noncommittal Latin inscriptions *HISTORIA ZENOBIA ET AVRELIANVS* (Story of Zenobia and Aurelian) and *PARS ACCOMODA* (Fitting piece).[26] The *Caesar and Cleopatra* edition in the Art Institute is also an amalgamated set containing *Caesar, Cleopatra,* and *Zenobia and Aurelian* pieces, but Willem van Leefdael and Gerard Peemans provided new Latin inscriptions for a number of scenes in order to present a coherent plot.

Julius Caesar was born in Rome in 100 B.C. He began his political career as a lawyer. In 69 B.C. he was elected a quaestor (treasurer). Six years later, he became pontifex maximus (high priest), assuming responsibility for all Roman religious affairs. His debut as pontifex, however, was marked by scandal. As wife of the high priest, Pompeia was responsible for hosting the yearly Bona Dea festival in their house. These sacred ceremonies were exclusive to women, but Publius Clodius Pulcher, a Roman politician with whom Pompeia was in love, seized the opportunity and arranged a secret rendezvous. Disguised as a young woman he entered Julius Caesar's house, but was unmasked and driven out (Plutarch, *Life of Caesar*, books 9–10).[27] This scene is shown in the first tapestry of the Chicago *Caesar and Cleopatra* suite (cat. 19a): *CLAVDIVS AMANS / POMPILIAM IN VESTE / MVLIEBRI NOCTVRNO / SACRIFICIO DETECTVS / EXPELLITVR* (Claudius [*sic*], in love with Pompilia [*sic*], disguised as a woman, is unmasked and driven out of the house during the nocturnal offering). Caesar divorced Pompeia at once.

Three years later, in 60 B.C., Caesar was elected senior consul of the Roman Republic. He created an informal alliance with Pompeius Magnus, or Pompey the Great, Rome's leading general, and Licinius Crassus, the Republic's richest man—an alliance now known as the First Triumvirate. One year later, Caesar started the Gallic Wars in which all of Gaul and parts of Germania were annexed to Rome. During the battle against the Helvetii in Switzerland, Caesar refused to mount his horse and, in a demonstration of his courage, charged on foot. He encountered fierce resistance from the rampart of wagons, from which not only men but also women and children defended themselves, fighting to their death (Plutarch, *Life of Caesar*, book 18). This episode is shown in the second tapestry of the Chicago edition (cat. 19b), but the Latin inscription of the piece generalizes the event: *IN PVGNA / GAVLENSI DIMICANTIBVS / FEMINIS ET PVERIS / SEMPER EST PEDES / CAESAR* (Women and children fight in the Gallic Wars; Caesar always fights on foot).

While Caesar conquered Gaul, the triumvirate disintegrated: Crassus was killed in a military campaign, and Pompey drifted towards Caesar's political enemies. When Caesar's term as consul ended in 50 B.C., Pompey ordered him to disband his army and return to Rome. Caesar, fearing that he would be rendered politically impotent if he entered Rome without any political or military power, disobeyed Pompey's order. In 49 B.C. civil war broke out. Pompey fled to Greece, pursued by Caesar. In August of the following year the former allies prepared for a clash at Pharsalus in northern Greece. After a sacrificial offering, Caesar reported seeing a flame in the sky fly over his camp and fall into that of his enemy. The next morning, he defeated Pompey. The decisive battle of Pharsalus is the subject of the third tapestry in the Chicago *Caesar and Cleopatra* edition (cat. 19c). The Latin cartouche, which reads *CAESAR / A SACRIFICIO IN ACIE / VISA SVPRA SVOS / FLAMMA POMPEANOS AD / XLMILLIA VINCIT* (Following an offer to the gods, Caesar sees a flame above his soldiers; he defeats Pompey's approximately forty

FIG. 1 *Zenobia Surrounded by Mounted Soldiers*. Justus van Egmont, c. 1664. Black chalk with brush and brown wash and touches of graphite, on cream laid paper, pieced together and laid down on board; 159 x 253 mm. The Art Institute of Chicago, Leonora Hall Gurley Memorial Collection, 1922.1918a.

FIG. 2 *The Marriage of Zenobia and Odenatus*. Justus van Egmont, c. 1664. Black chalk with brush and brown wash, on ivory laid paper, laid down on ivory laid paper; 182 x 319 mm. The Art Institute of Chicago, Leonora Hall Gurley Memorial Collection, 1922.1918b.

thousand soldiers), exaggerates Pompey's military forces; according to Plutarch, Pompey's cavalry contained seven thousand soldiers and his infantry comprised twenty-two thousand men (*Life of Caesar*, books 43–46).

After his defeat, Pompey fled to Egypt where he sought asylum. Ptolemy XIII, however, who was fighting a civil war against his sister, wife, and co-regnant queen, Cleopatra, thought it would be wiser to kill Caesar's enemy rather than welcome him, and had Pompey murdered. Caesar arrived soon after and was enraged by Ptolemy's interference. He deposed the Egyptian king and, seeking an ally on the Egyptian throne, secretly sent for Cleopatra, who had fled the country (Plutarch, *Life of Caesar*, book 48). This latter incident is shown in the Art Institute's suite—*CAESAR MITITIT / LEGATVM AD / CLEOPATRAM* (Caesar sends a messenger to Cleopatra; cat. 19d)—but this inscription is not original to the scene. Other versions of this composition that predate the Chicago piece (for they are signed by Jan van Leefdael and Gerard van der Strecken) bear the inscription *NVNTII SENATVS / ROMANI / PETVNT / A CLEOPATRA TRIBVTVM / QVOD IPSA REFVGIT* (The envoys from the Roman Senate demand tribute from Cleopatra, which she refuses). The literary source of the scene is unknown, but Nello Forti Grazzini assumes that it is based on an inaccurate reading of the Plutarch passage in which Antony sends a messenger to Cleopatra, summoning her to meet him and confirm her loyalty.[28]

Responding to Caesar's request, Cleopatra, accompanied by her aide Apollodorus, returned to Alexandria. Together with Caesar and her brother Ptolemy XIV, she became ruler of Egypt (Plutarch, *Life of Caesar*, book 49). In the Art Institute's edition, this scene bears the inscription *CLEOPATRA / APOLLODORI CYMBA NOCTE / ALEXANDRIAM INVEHITVR / CVM IVLIO ET FRATRE / REGE COMPONIT* (During the night, Cleopatra and Apollodorus enter Alexandria in a boat; together with Caesar and her brother, she becomes ruler; cat. 19e). Supporters of the late King Ptolemy XIII, however, secretly plotted to murder Caesar and Cleopatra during supper. Caesar's barber discovered the plan, and the assailants were intercepted (Plutarch, *Life of Caesar*, book 49). This is the subject of the sixth tapestry in the Chicago suite (cat. 19f): *IVLIO CESARI CVM / CLEOPATRA CONVIVANTI / MORS INTENTATVR SED / FRAVS DETEGITVR* (There is a plot to kill Caesar and Cleopatra during supper, but the plan is discovered).

Caesar and Cleopatra's Egyptian opponents then waged war against them. During a battle in the harbor of Alexandria, Caesar repelled the attack on his fleet with fire, which spread from the dockyards and eventually destroyed the famous Alexandrian library. Later, in a battle at Pharos, an island off Alexandria, Caesar sprang courageously into a small boat to aid his men (Plutarch, *Life of Caesar*, book 49). The inscription on the scene in the Chicago edition reads *CAESAR CYMBAM / CONSCENDIT / EXERCITVI SE / IVNCTVRVS* (Caesar embarks by boat to join his army; cat. 19g), but this is not the phrase originally attached to the scene. Other versions that, based on

their bearing the signatures of Jan van Leefdael and Gerard van der Strecken, predate the example in the Art Institute, bear the inscription *CAESAR IGNOTVS / NAVTAS TVRBINE PAVIDOS / HAC VOCE CAESAREM / VEHITIS ANIMAT* (Caesar, disguised, encourages the storm-fatigued crew by shouting "Caesar is on board"), and are thus meant to depict another incident—one illustrative of the triumvir's cowardice, not his courage. After he landed in Greece in January 48 B.C. in pursuit of Pompey, Caesar feared that his army would not be able to withstand a counterattack. He therefore decided to return to Italy secretly, abandoning his troops in Greece. Disguised as a slave, he embarked by boat, but stormy weather forced the crew to return to Greece, even after Caesar had revealed himself and encouraged the men to persist (Plutarch, *Life of Caesar*, book 38). Willem van Leefdael and Gerard Peemans likely adapted the inscription in the cartouche to make the plot of the suite cohere, for the next tapestry in the edition (cat. 19h) is inscribed *CAESAR IN MOTV ALEXANDRIAE / DOLO LAPSVS IN MARE / SERVATIS MANV LITERIS / AD NON EXVSTAS NAVES / ADNATAT* (The Egyptians attack Caesar's boat, forcing him to jump in the water and escape by swimming to ships that had not been burned, while holding some precious papers in his hand; Plutarch, *Life of Caesar*, book 49).

While civil war raged on in Egypt, Cleopatra and Caesar became lovers. The liaison is shown in the Chicago suite on a tapestry (cat. 19i) inscribed *CAESAR CVM / CLEOPATRA SE / RECREAT* (Caesar and Cleopatra enjoying themselves). Though this description evokes a peaceful and idyllic atmosphere, the scene itself shows the protagonists dressed for battle and leading an army. Furthermore, Caesar has undergone a metamorphosis: he has long hair and wears a helmet, whereas in all the other scenes in *Caesar and Cleopatra* sets his hair is short and he sports a laurel wreath. Likewise, Cleopatra's wardrobe has changed; in no other *Caesar and Cleopatra* tapestries does she wear armor. These anomalies can be easily explained: the design is borrowed from the *Zenobia* series, in which it shows *Zenobia as a Military Commander*.

After his winter of love, which produced a son, Caesar left Egypt. He defeated the Pontic king in Turkey and then returned to Rome to secure his political position and to plan a military campaign against Pompey's supporters, who had fled to Africa. While Mark Antony, who had served as a general in the Gallic Wars, stood in for him in Rome, Caesar defeated opponents in Africa and Spain. He then returned to Rome and celebrated his three triumphs—the Egyptian, the Pontic, and the African—by entertaining the people with gladiatorial spectacles and banquets. According to Plutarch, twenty thousand dining couches were set up in Rome (*Life of Caesar*, book 55). The festivities are depicted in the Art Institute's suite by a tapestry (cat. 19j) that bears the inscription *CAESAR TRIVMPHAT / DE AEGYPTO POMTO AFRICA / MMXX MEMFIS CIVES LVDIS / VARYS RECREAT* (Caesar triumphs over Egypt, Pontus, and Africa; he entertains twenty-thousand people with banquets and various spectacles).

FIG. 3 *The Wrath of Achilles* from *The Story of Achilles*. After a design by Peter Paul Rubens. Produced at the workshop of Frans Raes. Wool and silk; 423 x 376 cm. Royal Museums of Art and History, Brussels.

In 44 B.C. Caesar was appointed *dictator perpetuus* (perpetual dictator). His political opponents, however, assassinated him on March 15, 44 B.C., allegedly to protect the Roman Republic from his supposed monarchical ambitions. Cleopatra and her young son were in Rome when Caesar was killed. Although Plutarch does not mention her grief, Willem van Leefdael and Gerard Peemans accentuated the story's drama by including a tapestry of Cleopatra mourning Caesar's death (cat. 19k); it bears the inscription *MORS CESARIS / FVIT TRISTIS / CLEOPATRAE* (Caesar's death made Cleopatra mourn). This tapestry opens the second part of the Chicago suite, which focuses on Cleopatra. Paradoxically, in regular *Story of Cleopatra* sets, this scene closes the series, as it depicts the queen committing suicide by means of an asp: *CLEOPATRA NE IN / TRIVNPHVM DVCATVR / ASPIDIS MORSV SIBI / MORTEM INFERT* (Cleopatra commits suicide by means of an asp to avoid being part of the triumphal procession). The amalgamated Chicago suite thus required not only a different Latin inscription, but also the omission of the snake that plays a key role in regular versions of the scene.

After Caesar's death, Mark Antony, Octavian, and Lepidus formed the Second Triumvirate and divided the Roman world among themselves. Mark Antony went to the Eastern provinces over which he was to rule, where he met Cleopatra and immediately fell in love with her, despite being married to Octavian's half-sister (Plutarch,

Life of Antony, book 26). This first encounter is depicted in Van Egmont's regular *Cleopatra* series, in which it bears the Latin inscription *ANTONIVS IPSAM / COMPELLENDI / GRATIA MISSVS ILLIVS / AMORE CAPTITVR* (Antony, sent to compel her, is captured by love of her). This scene is also included in the amalgamated Chicago *Caesar and Cleopatra*, but the tapestry (cat. 19l) shows only Cleopatra and bears a different inscription: *CLEOPATRA / IN MARI SE / RECREAT* (Cleopatra enjoys herself at sea).

To impress Antony, Cleopatra promised to organize the most expensive supper he had ever attended. The meal itself was ordinary, but at its end, Cleopatra dissolved a pearl in a cup of vinegar and drank it. This event was not recorded by Plutarch; it derives from Pliny's *Historia Naturalis* (first century A.D., book 9, chapter 58, 119–21). The scene is part of the edition in Chicago (cat. 19m), but its original inscription—*CLEOPATRA GEMMAM / INEFFABLIS / VALORIS ANTONIO IN / POTVM FVNDIT* (Cleopatra dissolves a pearl of greath worth in Antony's drink)—has been replaced by *CLEOPATRA CVM / ANTHONIO MENSE / ASSIDET* (Cleopatra and Antony enjoying supper).

During the winter of 42–41 B.C. Cleopatra became pregnant with twins. The following year, however, Antony returned to Rome and prepared a long-awaited campaign against the Parthians. Yet Octavian failed to support the endeavor. Disappointed, Antony left his pregnant wife in Italy and sailed to Alexandria, where he renewed his relationship with Cleopatra. Meanwhile, the triumvirate disintegrated, and Octavian rose to power in Rome. Eventually Antony broke off relations with Octavian, and in 31 B.C. civil war broke out again. The decisive sea battle was fought at Actium, a promontory in northern Greece. The Egyptian fleet was destroyed by the Romans, and Antony fled to Egypt in Cleopatra's ship (Plutarch, *Life of Antony*, books 64–67). *The Battle of Actium* is part of traditional sets of *The Story of Antony and Cleopatra*, and the scene is also included in the Chicago amalgamation (cat. 19n). The original Latin inscription, *ANTONIVS APERTO / NAVALI PRAELIO / A ROMANIS DEBELLATVR / ET FVGIT* (Antony, at the beginning of the naval battle, is overcome by the Romans and flees), was, however, changed to *CLEOPATRA AB / INNIMICIS IN / MARI INVADITVUR* (Cleopatra is attacked by her enemies at sea). In 30 B.C. Octavian invaded Egypt. Rather than surrender to his enemy, Antony committed suicide. A few days later, Cleopatra followed his example. Their tragic deaths are not included in the Chicago suite.

Van Egmont's *Caesar, Cleopatra,* and *Zenobia and Aurelian* sets exhibit all the characteristics of the Flemish High Baroque: monumental figures, dramatic gestures, expressive faces, and minimal backgrounds.[29] They are thus reminiscent of tapestry designs by Rubens and Jacob Jordaens (1593–1678; see cat. 18). Rubens's sets were still very popular in the 1640s and 1650s, and Van Egmont must have been familiar with them. During his first stay in Antwerp, Van Egmont collaborated with Rubens while the latter was working on the *Eucharist* series.[30] Moreover, in 1653 Jan van Leefdael and Gerard

van der Strecken bought the oil sketches and cartoons of Rubens's *Achilles* series from an Antwerp merchant, which means that Van Egmont could have studied the set in detail.[31] In fact, in his *Caesar* set Van Egmont quoted Rubens's *Story of Achilles*: the soldier grabbing his sword on the right of the tapestry depicting the discovery of the plot to kill Caesar and Cleopatra (cat. 19f) is identical to the soldier shown on the left in *The Wrath of Achilles* (fig. 3). Furthermore, Van Egmont's inclusion in the *Caesar* set of the tapestry showing Clodius's expulsion from the Bona Dea celebration (cat. 19a), may have been inspired by *Achilles among the Daughters of Lycomedes*, another scene of transsexual disguise for the purpose of seduction. It is therefore possible that Van Egmont created his *Story of Caesar* after Van Leefdael and Van der Strecken had acquired Rubens's *Achilles*.

As Van Egmont had been trained in Rubens's manner in the 1620s, it is hardly surprising that his *Cleopatra, Caesar,* and *Zenobia and Aurelian* sets are completely consistent with the Flemish High Baroque style Rubens and Jordaens pioneered. Yet, given Van Egmont's activities in Paris in the 1630s and 1640s, he must have been familiar with the decorative manner of contemporary French painters such as Vouet and Poerson, who aimed at a harmonious balance between restrained figures and airy landscape or architectural settings. It can therefore be assumed that the dramatic and monumental style of the *Cleopatra, Caesar,* and *Zenobia and Aurelian* sets is a deliberate decision made by Van Leefdael, Van der Strecken, and Peemans to revive Rubens's and Jordaens's successful idiom.

Hindsight, however, shows that the commissioners made the wrong choice, for after about 1665, the Flemish High Baroque's dominance of Brussels tapestry—and thus the larger part of the Van Leefdael–Van der Strecken–Peemans sale catalogue—was challenged by the growing popularity of the decorative style, à la Vouet and Poerson, of the French academicians. A number of French merchants residing in Brussels leased Poerson cartoons for four sets to various Brussels tapestry producers.[32] Among these series was *The Story of Antony and Cleopatra* that was produced in the Le Clerc workshop directed by Jan (died 1672) and his son Hieronymus (1643–1722).[33] This workshop also produced an anonymous set of *The Story of Caesar* that is reminiscent of Poerson's manner.[34] The growing popularity of this French style was eventually recognized by the Van Leefdael–Van der Strecken–Peemans association as they strove to keep their sale catalogue up-to-date (see cats. 21, 23). KB

NOTES

1. According to photographs of several pieces in Martino Arroyo 1918, pp. 27 (ill.), 58 (ill.), and a letter from Apolonia Burgera to D. Olegario Junyent, Aug. 30, 1915, in the Rusiñol Library, Sitges.
2. Thuillier and Foucart 1967.
3. Lavalle 1990, p. 491.
4. Blažková and Duverger 1970, p. 97. See also Donnet 1896, p. 291.
5. Standen 1985, vol. 1, pp. 206–17; Forti Grazzini 1994, vol. 1, pp. 199–205, 259–67. An edition of six tapestries signed by Gerard van der Strecken and Willem van Leefdael, from Coker Court, Somerset, England, recently ap-
peared on the art market; see sale cat., Christie's, London (Nov. 11, 2004), lots 35–36 (each lot consisted of two tapestries); sale cat., Christie's, London (Nov. 10, 2005), lots 191–92.
6. Duverger 1984–2002, vol. 12, pp. 316, 318.
7. Moormann and Uitterhoeve 1999, pp. 136–42; Morrison 1974.
8. Hirzel 1912; Gianakaris 1970; Stadter 1992; Scardigli 1995; Stadter and Van der Stockt 2002.
9. For the suites produced by Geubels, see Duverger 1981–84, p. 163. For the series designed by Van Mander, see Hartkamp-Jonxis 2004b, p. 180. An edition of this series is in the Indianapolis Museum of Art; Weinhardt 1966; Pantzer 1966. For the series designed by Moillon, see Reyniès and Laveissière 2005, as well as Brosens and Delmarcel 2005. Finally, for the series designed by Charles Poerson, see Reyniès 1997, pp. 111–27; Brosens 2005a; and Brosens 2007b.
10. Donnet 1896, p. 291.
11. Arriola y de Javier 1976, pp. 46–64. Jan's son Willem van Leefdael and Gerard van der Strecken coproduced at least one edition, as a 1681 document shows; ARAB, NGB 1966[1], notary Judocus van Cutsem (Oct. 21, 1681); published in Brosens 2004a, p. 196.
12. Duverger 1984–2002, vol. 12, p. 318.
13. Christ 1994; Moormann and Uitterhoeve 1999, pp. 63–72.
14. Grévin [1560] 1966; Ginsberg 1973; Dutertre 1992; Bloemendaal 2001.
15. Ayres 1910; Bullough 1966, pp. 215–449.
16. Worp 1972, vol. 2, pp. 121, 126.
17. Duverger 1978; Delmarcel 1985; Duverger 1996; Campbell 1998a.
18. Donnet 1896, p. 289.
19. Bauzou 2001.
20. Duverger 1984–2002, vol. 12, p. 318.
21. For discussion of this curious work, see, among others, Dessau 1889, Baynes 1926, Marriott 1979, and Sansone 1990.
22. Crick-Kuntziger 1950, p. 20. For more on Zenobia's popularity, see Moormann and Uitterhoeve 1999, pp. 242–43, and Lanavère 2001. For Saint-Amant's *Commentaires*, see Perini 2002, pp. 62–63.
23. Crick-Kuntziger 1950, p. 22; Grandjean 2001.
24. Brosens 2004a, pp. 44–45.
25. Crick-Kuntziger 1950, p. 23.
26. Cambini 2001.
27. For the semifictional character of this story, see Mulroy 1988.
28. Forti Grazzini 1994, vol. 1, pp. 201–02.
29. Van Egmont still awaits a thorough study. For an introduction to his style, see Brosens 2004a, pp. 84–85, and, especially, Balis 2006.
30. De Poorter 1978.
31. Duverger 1971a, pp. 157–59. For the *Achilles* series, see Haverkamp Begemann 1975 and Lammertse and Vergara 2003.
32. Reyniès 1997; Brosens 2005a; Brosens 2007b.
33. Reyniès 1997, pp. 111–27; Brosens 2005a.
34. Brosens 2007b.

From *The Story of Cyrus*

CAT. 20A

The Diversion of the Euphrates

Brussels, c. 1670
Adapted from designs by Michiel Coxie (1499–1592)
Produced at the workshop of Gillis Ydens
MARKED AND SIGNED: Brussels city mark; traces of the signature of Gillis Ydens
INSCRIBED: *AD VINCENDAM / BABILONIAM CYRVS / AVERTIT / EVPHRATEM*
325.4 x 404.8 cm (128⅛ x 159⅜ in.)
Gift of Honoré Palmer, 1938.1311

STRUCTURE: Wool and silk, slit and single interlocking tapestry weave
Warp: Count: 8 warps per cm; wool: S-ply of three Z-spun elements; diameters: 0.6–1.0 mm
Weft: Count: varies from 19 to 44 wefts per cm; wool: S-ply of two Z-spun elements; diameters: 0.3–1.5 mm; silk: pairs of S-ply of two Z-twisted elements; diameters: 0.15–0.5 mm

Conservation of this tapestry was made possible through the generosity of the James Tigerman Estate.

PROVENANCE: See below.

CAT. 20B

Cyrus Defeats Spargapises

Brussels, c. 1670
Adapted from designs by Michiel Coxie (1499–1592)
Produced at the workshop of Albert Auwercx (1629–1709)
MARKED AND SIGNED: Brussels city mark; traces of the signature of Albert Auwercx
INSCRIBED: *CYRVS / INCAVTOS SCYTAS / OBRVIT*
384.8 x 412.1 cm (151½ x 102¼ in.)
Gift of Honoré Palmer, 1938.1312

STRUCTURE: Wool and silk, slit and double interlocking tapestry weave
Warp: Count: 7 warps per cm; wool: S-ply of two Z-spun elements; diameters: 0.7–0.8 mm
Weft: Count: varies from 18 to 30 wefts per cm; wool: S-ply of two Z-spun elements; diameters: 0.45–1.0 mm; silk: pairs of S-ply of two Z-twisted elements; diameters: 0.4–0.55 mm

Conservation of this tapestry was made possible through the generosity of the James Tigerman Estate.

PROVENANCE: Potter (died 1902) and Bertha Palmer (née Honoré, died 1918), by 1900; by descent to their son Honoré Palmer (died 1964); given to the Art Institute, 1938.

THESE two tapestries belong to a series depicting *The Story of Cyrus*, as the Latin inscriptions in the cartouches of the pieces make clear. The first tapestry is inscribed *AD VINCENDAM / BABILONIAM CYRVS / AVERTIT / EVPHRATEM* (Cyrus diverts the Euphrates to conquer

Babylon), and shows Cyrus standing in the middle of the tapestry with three of his advisors, supervising soldiers digging a channel. The second tapestry, which bears the inscription *CYRVS / INCAVTOS SCYTAS / OBRVIT* (Cyrus defeats the incautious Scythians), depicts Cyrus and one of his generals surveying a battlefield. A soldier with a lance stands close by. In the background the Scythians flee their camp, which Cyrus's army has invaded. The borders of both tapestries, which contain putti, military equipment, and garlands of flowers and fruit, reveal that they were woven during the third quarter of the seventeenth century.

The main source for the life of Cyrus the Great is the first book of Herodotus's famous *Histories* (fourth century B.C.).[1] Cyrus was the grandson of Astyages, king of the Medes and ruler of the Persians. According to Herodotus, prior to Cyrus's birth, Astyages dreamt that a stream of water flowed from his daughter, filling his capital and flooding the whole of Asia. His magi interpreted this dream as a sign that his future grandson would one day overthrow him. Therefore, when Cyrus was born, Astyages ordered his courtier Harpagus to kill the baby. Harpagus, however, could not bring himself to murder Cyrus, and ordered a herder named Mitradates to dispose of the infant. Mitradates was also unable to kill the child. His wife Cyno came up with a solution: they would pass off the body of their recently stillborn baby as Cyrus's corpse, and raise the prince as their own. Many years later Astyages discovered that his grandson was still alive. As his magi assured him that Cyrus no longer presented a threat to the Median Empire, Astyages ordered Cyrus to return to his biological parents, spared Mitradates, and punished Harpagus: at the end of a banquet, the courtier was informed that he had just eaten his own son. Some years later, the vengeful Harpagus and Cyrus, who had become king of Persia, waged war against Astyages. After three years of fighting, Cyrus overthrew his grandfather, thus fulfilling the original prophecy of the magi.

Cyrus unified the Persian and Median empires and conducted other wars to expand his territory. In one campaign, he marched through central Asia and laid siege to Babylon. After months of fighting, however, the siege had reached an impasse: Cyrus could neither destroy Babylon's fortifications, nor enter the city via the Euphrates that ran through it, because the river was too broad, deep, and swift. But Cyrus and his generals concocted a cunning plan to break through Babylon's defenses: as *The Diversion of the Euphrates* shows, the Medes dug a channel to divert the Euphrates into a basin, lowering the level of the river and enabling Cyrus's army to march into Babylon on the riverbed (Herodotus, *Histories*, book 1, 191).

Cyrus also fought the Massagetae, a tribe that lived in what is now Uzbekistan and was ruled by the queen Tomyris. In another clever

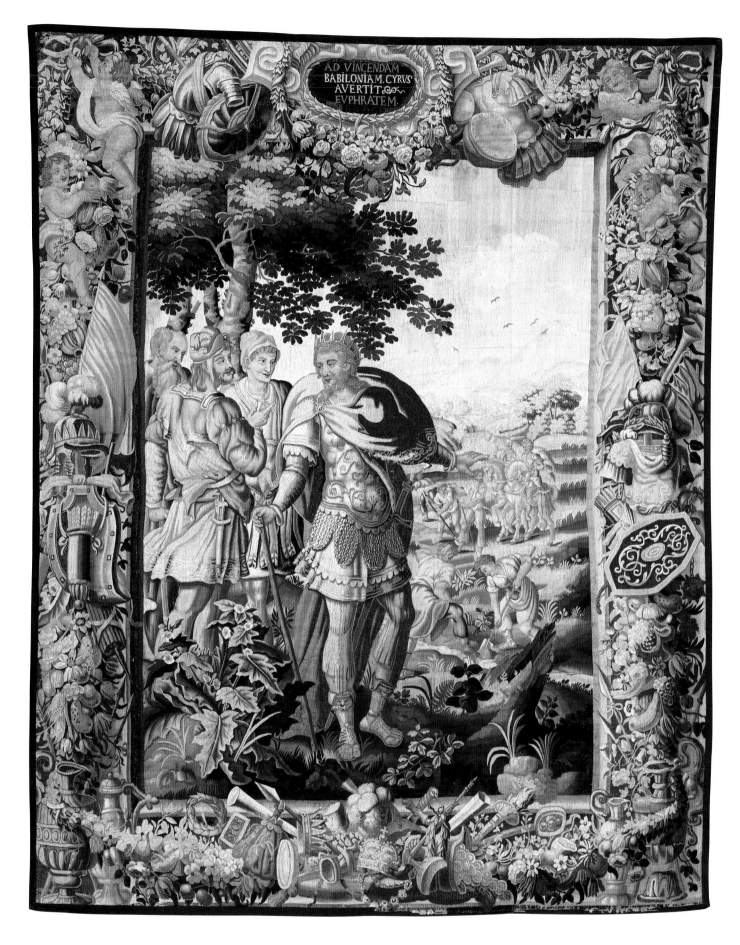

The tapestry bears the inscription:

AD VINCENDAM
BABILONIA M. CYRVS
AVERTIT
EVPHRATEM.

CAT. 20A

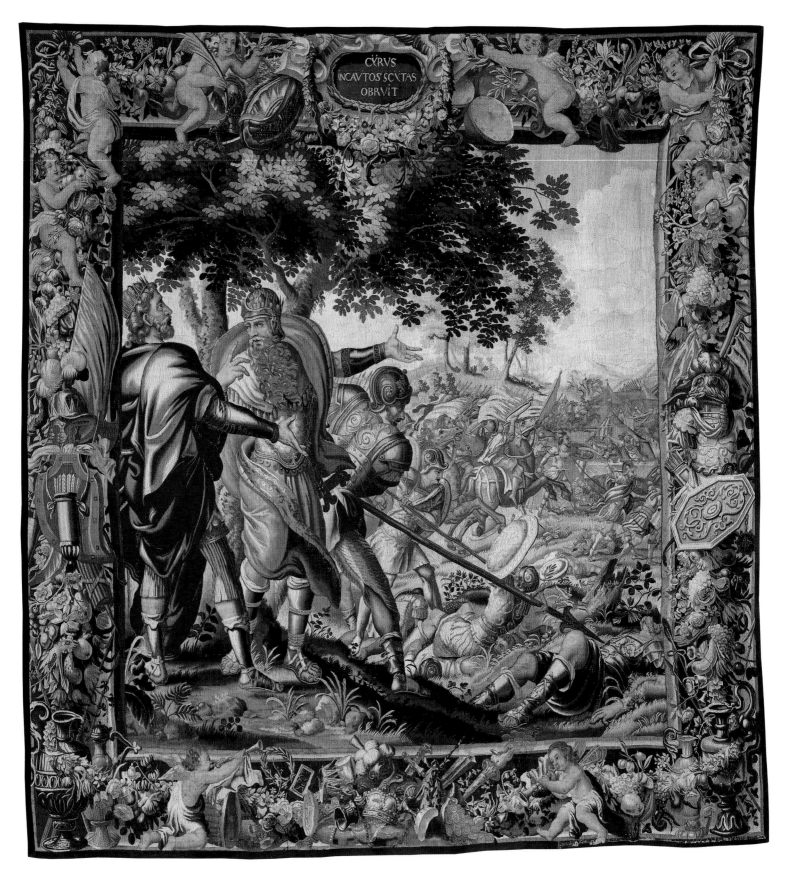

CAT. 20B

stratagem, the emperor withdrew all but a small part of his army from their camp. Seeing what appeared to be an excellent opportunity, Spargapises, Tomyris's son, led about one third of the Massagetaean army in conquering the diminished Persian force. After celebrating their victory with a feast, the Massagetae fell asleep, and Cyrus and his troops returned, overwhelming their drunken enemies and taking Spargapises and many others prisoner (Herodotus, *Histories*, book I, 211), as is shown in *Cyrus Defeats Spargapises*.[2] When Spargapises woke from his drunken stupor, he felt ashamed and humiliated, and begged Cyrus for his liberty. On being released, he committed suicide. In the Persians' subsequent battle against the remainder of the Massagetaean army, Cyrus was killed. Tomyris, mourning her son's death, dipped the head of the late Persian king in a basin of human blood, thus condemning his imperialism and bloodthirstiness.

Herodotus's account of the life of Cyrus mingles fact and fiction. The Greek historian used the Persian king as a moral abstraction who, cast in certain exemplary roles, illustrates various virtues and vices.[3] On one hand, Herodotus depicts Cyrus, the perfect embodiment of *Dei gratia* (fated or God-ordained) rule, as the founder of Persian freedom and prosperity; on the other hand, the historian also shows the king's degeneration from successful conqueror of Asia to inept ruler who blunders into the land of the Massagetae to his own destruction.[4] This dramatic fall provided a cautionary tale for rulers of all times.

Authors besides Herodotus found Cyrus's story appealing. Xenophon based his *Cyropaedia*, or *The Education of Cyrus*, a highly romanticized portrait of the ideal ruler and the best form of government, on the king's exploits, both real and legendary.[5] Rulers of the Hellenistic kingdoms made sure to familiarize themselves with the *Cyropaedia* and tried to follow the example that the ruler set.[6] In the third and second centuries B.C. the writings of the Stoics confirmed Cyrus's almost sacrosanct image, and Cyrus also featured in Pompeius Trogus's *Historiae Philippicae*, written between 2 B.C. and A.D. 2.[7] The original work is now lost, but an abbreviated version is known from an epitome written around A.D. 200 by the Latin historian Justinus that was widely read in late antiquity and the Middle Ages.[8] The Bible also praised Cyrus as a promoter of religious tolerance and a generally humane and intelligent policy. According to the Old Testament books 2 Chronicles, Ezra, and Isaiah, Cyrus not only allowed the Hebrews exiled in Babylonia to return to their promised land to rebuild the temple, but also gave back the precious trove of gold and silver that had been stolen from this sanctuary.[9] It is therefore not surprising that Cyrus was included in the very popular *Speculum Humanae Salvationis*, an early-fourteenth-century compilation of stories and pictures that interpreted the New Testament through prefigurations in the Old Testament.[10]

The iconic status that Cyrus had gained over the centuries is reflected in his popularity as a subject in sixteenth- and seventeenth-century Brussels tapestry. An early *Story of Cyrus* set was painted and woven in Brussels during the second quarter of the sixteenth cen-

CAT. 20B, DETAIL

tury; five tapestries from this series are now in the Isabella Stewart Gardner Museum, Boston.[11] Another *Cyrus* set was created around 1550 by the famous painter and tapestry designer Michiel Coxcie.[12] The most complete edition known today is in the Patrimonio Nacional, Madrid,[13] and was produced between 1555 and 1559 by Jan van Tieghem (died 1573 or after) and his brother-in-law Frans Ghieteels (died 1581 or after).[14] The edition comprises ten tapestries; each bears a Latin inscription clarifying its subject: *Cyrus Is Raised by Mitradates, Astyages Recognizes Cyrus, Cyrus Captures Astyages, Cyrus Captures Croesus, Cyrus Saves Croesus, Cyrus Orders the Lydians to Play Music, Cyrus Frees the Hebrews, Cyrus Sends a Messenger to Tomyris, Tomyris Dips Cyrus's Head in a Basin of Blood*, and *Cyrus Meets Artemisia*. In 1564 Ghieteels sold a *Cyrus* edition of twelve pieces, which suggests that Coxcie created a total of twelve scenes.[15] Indeed, individual tapestries from sixteenth-century *Cyrus* editions that have appeared on the art market permit the identification of two Cyrus scenes created by Coxcie that are not part of the edition in Madrid: *The Diversion of the Euphrates* (fig. 1) and *Cyrus Defeats Spargapises* (fig. 2).[16] The composition of the Chicago *Diversion of the Euphrates* is nearly identical to the late-sixteenth-century version that appeared on the art market (fig. 1), and the right part of the Chicago *Cyrus Defeats Spargapises* is identical to the left part of the edition executed

FIG. 1 *The Diversion of the Euphrates* from *The Story of Cyrus*. After a design by Michiel Coxcie. Produced at an unknown Brussels workshop, c. 1575. Wool and silk; 416 x 309 cm. Location unknown.

around 1575 (fig. 2), which indicates that the two seventeenth-century *Cyrus* tapestries in the Art Institute were based on recycled sixteenth-century cartoons by Coxcie.

During the hundred years separating Coxcie's creation of the *Cyrus* designs around 1550 and the production of the Chicago *Cyrus* tapestries around 1650 to 1675, the cartoons were used by a number of Brussels tapissiers.[17] Four tapestries, now divided between the Fine Arts Museums of San Francisco and the Saint Louis Art Museum, were based on the designs. Belonging to two different editions, the pieces were woven around 1600.[18] Their wide and compartmentalized borders showing a playful array of baskets of fruit, floral vases, grotesques, putti, and strapwork, suggest that they may have been produced by Nicasius Aerts (died c. 1627), one of the most important Brussels tapissiers of the beginning of the seventeenth century.[19] Moreover, a tapestry signed by Bernard Van Brustom (died 1636 or after) that is now in Skokloster Castle, Sweden, is based on Coxcie's cartoon of *Cyrus Captures Croesus*.[20] Bernard and his brother Christiaan (died 1638 or after) were exempted from taxation on beer and wine by the Brussels municipality in 1629, a sign of the importance of their workshop.[21] Interestingly, Bernard was married to the widow of

Nicasius Aerts, a relationship that corroborates the thesis that Aerts possessed Coxcie's *Cyrus* cartoons around 1600.[22]

When the Van Brustom workshop closed around the middle of the seventeenth century, Coxcie's *Cyrus* cartoons seem to have passed to the De Pannemaker workshop. A document from May 1669 shows that Erasmus III (born 1627) and his brother Frans (born 1617) were engaged by the Antwerp merchant Hendrik Lenaerts (died 1669 or 1670) to produce an edition of the "Historie van Sirus."[23] A tapestry of *Cyrus Sends a Messenger to Tomyris* that has surfaced on the art market bears the signature *E.D.P.*, which presumably stands for Erasmus III de Pannemaker.[24]

The De Pannemaker family was also involved in the recycling of another sixteenth-century set, *The Story of Romulus and Remus*, because an edition in Cotehele House, Cornwall, bears the signatures *E.D.P.* and *JAN VAN ROTTOM*.[25] Van Rottom was a minor tapissier who died between 1668 and 1670.[26] Two other *Romulus and Remus* tapestries from the mid-seventeenth century can also be attributed to the Van Rottom workshop.[27] Their borders are the same as the borders of the *Cyrus* pieces in the Art Institute.[28] An unsigned panel depicting *Tomyris Dips Cyrus's Head in a Basin of Blood* (Gruuthusemuseum, Bruges) also shares this border, as do four unsigned *Cyrus* tapestries that were in the collection of French and Company: *The Diversion of the Euphrates, Cyrus Defeats Spargapises* (fig. 3), *Cyrus Sends a Messenger to Tomyris,* and *Tomyris Dips Cyrus's Head in a Basin of Blood.*[29] Given that borders can often be regarded as a workshop's marks, it seems logical to assume that both the French and Company and Chicago *Cyrus* tapestries were woven in the De Pannemaker or Van Rottom workshops. The remnants of the signatures on the Chicago tapestries, however, cannot be reconstructed as *E.D.P.*, *VAN ROTTOM*, or any variant form thereof.

The De Pannemaker and Van Rottom families' circle of friends and colleagues helps determine the correct attribution of these pieces. In 1661 Van Rottom and Gillis Ydens were recorded as subcontractors who had worked for Hendrik I Reydams (c. 1610–1669).[30] In 1667 Van Rottom signed the statutes instituting a *sieckbusse* (sick pay), as did Ydens and Albert Auwercx.[31] According to a contract recorded in 1668, Auwercx, Willem van Leefdael (1632–1688), Erasmus III de Pannemaker, Van Rottom, and Ydens agreed to coproduce a tapestry set depicting *The Story of Diana*.[32] In 1671 Erasmus III and Ydens were involved in a lawsuit against the daughters of an Antwerp tapestry dealer.[33] These documents reveal a connection between the De Pannemaker and Van Rottom families on one hand, and Ydens and Auwercx on the other. The two *Cyrus* tapestries in Chicago can thus be identified as the work of Ydens and Auwercx. Indeed, the signature on *Cyrus Diverts the River Euphrates* can be read as *G.YDENS* (fig. 4), and the name on *Cyrus Captures Spargapises* can be reconstructed as *AVWIERCX* (fig. 5).

Whereas there exists hardly any archival data on the life and work of Ydens, recent research on Auwercx has yielded some important results.[34] He entered the tapestry industry around 1657.[35] As he was

FIG. 2 *Cyrus Defeats Spargapises* from *The Story of Cyrus*. After a design by Michiel Coxcie. Produced at an unknown Brussels workshop, c. 1660. Wool and silk; 399 x 348 cm. Location unknown.

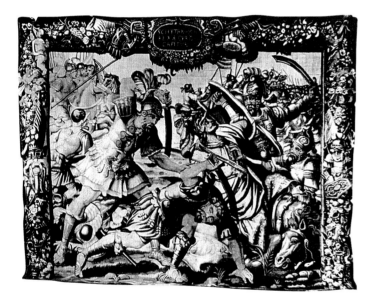

FIG. 3 *Cyrus Captures Spargapises* from *The Story of Cyrus*, c. 1660. After a design adapted by Michiel Coxcie. Wool and silk. Location unknown.

not the son of a tapestry producer, he had to develop his workshop from scratch. Archival material reveals that the acquisition and deployment of social and symbolic capital formed a significant component of his entrepreneurial strategy. Creditworthiness was vitally important to tapestry producers because they continuously faced capital demands and the danger of liquidity crises—they constantly had to invest in designs and cartoons, buy raw materials, and pay wages, but clients frequently postponed payment.[36] A tapissier's creditworthiness consisted to a large extent in his social and symbolic capital: his connections, networks, public offices, and honorary titles.[37]

FIG. 4. Cat. 20a, reconstruction of signature by Koenraad Brosens.

FIG. 5. Cat. 20b, reconstruction of signature by Koenraad Brosens.

Auwercx acquired and managed his social and symbolic capital with the utmost care. He participated in the administration of the tapestry guild and the *sieckbusse*, serving as its paymaster with Willem van Leefdael (1632–1688) in 1667, and as dean of the guild in 1679, 1681, 1687, and 1697.[38] Future archival research may well reveal that he served yet other terms. Auwercx also recognized that family and friends played a crucial role in the furthering of his career. Relatives and friends acted as investors, financial backers, witnesses to contracts and other legal documents, and agents in the assignment of functions and the acquisition of commissions.[39] Friendship and kinship were often made to coincide by appointing friends as witnesses and godparents, and Auwercx participated in this tradition: in 1664 Jan van Leefdael (1603–1668), then director of probably the most important Brussels workshop, became godfather to Auwercx's son Jan.[40] Three years later, in 1667, Daniel II Eggermans (1604–1669), another important tapestry producer, became godfather to Auwercx's son Daniel.[41] In 1671 Willem van Leefdael, who had succeeded his father Jan, became godfather to Willem Auwercx.[42] Five years later, in 1676, Gaspard Leyniers (1634–1703), a tapestry producer and director of Brussels's leading dye works, became godfather to Gaspard Auwercx.[43] Nearly all the tapestry producers who belonged to this Auwercx network lived in the parish of Our Lady of the Chapel, which underscores the importance of proximity in the formation and maintenance of social and professional ties.[44]

Auwercx transformed this considerable social and symbolic capital into economic success. His colleagues and friends supported him in his successful application for exemption from taxation on beer and wine in 1671.[45] Moreover, Auwercx became fully embedded in a wide production network, receiving at least two commissions from Gaspard Leyniers, one in 1688 and one in 1691; producing an edition of *The Story of Diana* in collaboration with Jan van Leefdael, De Pannemaker, Van Rottom, and Ydens; and collaborating with Willem van Leefdael and Jan II Leyniers (1630–1686) on a suite of *The Story of Saint Paul* (1678) presumably based on modernizations of cartoons by Pieter Coecke van Aelst (1502–1550).[46] Auwercx also collaborated with Hendrik I Reydams and/or his son Hendrik II (1650–1719) on

editions of *The Story of Moses* that were based on recycled sixteenth-century cartoons attributed to Giulio Romano (c. 1499–1546).[47]

The recycled *Moses* and *Saint Paul* cartoons used by Auwercx and his friends are listed in a 1718 document that surveys his possessions at the time of his death in 1709, but the *Cyrus* cartoons are not: "Item de hellicht van den pampieren patroon geschildert in waterverff, representerende de historie van Moijses bestaende den geheelen patroon in thien stucken, waervan de wederhellicht toecomt aen Sr. Reijdams. Item twee derde deelen van den pampieren patroon geschildert in waterverff representerende de Historie van Paulus bestaende den geheelen patroon in acht stucken, waervan een derde deel toekomt aen Sr. Philippus Auwercx" (Item: Half of the cartoons, painted in gouache on paper, depicting the story of Moses; the set comprises ten cartoons in total; five cartoons are owned by Mr. Reydams. Item: Two thirds of the cartoons painted in gouache on paper depicting the story of Paul; the set comprises eight cartoons in total; the remaining third part is owned by Mr. Philippe Auwercx).[48] It is possible, however, that Albert's son Philippe (1663–1740) owned the recycled *Cyrus* cartoons around 1700. Since the 1718 document reveals that Philippe owned a number of the *Story of Saint Paul* cartoons while his father was still alive, it can be assumed that Philippe was a partner and shareholder in the Auwercx workshop prior to his father's 1709 death.[49] Fortunately, a probate inventory was recorded after Philippe's death in 1740, and it lists not only the *Moses* and *Saint Paul* cartoons that Philippe had inherited from his father, but also "eenen patroon geschildert op pampier bestaende in sesse stucken representerende d'historie van de coninck Cirus" (cartoons painted on paper comprising six pieces depicting the story of the king Cyrus).[50]

With the death of Philippe Auwercx, Coxcie's *Cyrus* cartoons disappeared. They had served well: used by multiple Brussels tapestry producers, they may have inspired at least three other *Cyrus* tapestry sets woven in Brussels in the seventeenth and eighteenth centuries. The earliest, by an anonymous designer, was produced around 1630 by an unknown Brussels tapestry entrepreneur.[51] The second set, also by an anonymous artist, was woven in the Eggermans workshop around 1650 to 1660.[52] The last *Cyrus* set ever woven was designed by Maximiliaan de Haese (1713–1781) for the Van der Borcht workshop in the third quarter of the eighteenth century.[53]

Tapestry producers such as Auwercx recycled sixteenth-century cartoons because buying and modernizing used cartoons was less expensive than commissioning new designs from contemporary painters. Minor tapestry producers with fewer financial resources therefore seem to have specialized in the practice, although major tapissiers also included modernized cartoons in their sale catalogues.[54] A comparison of the sixteenth-century *Cyrus* tapestries and the seventeenth-century adaptations shows that the latter pieces were updated to please contemporary taste. Since Abraham van Diepenbeeck (1596–1675), Justus van Egmont (1601–1674; see cats. 19a–n), Jacob Jordaens (1593–1678; see cat. 18), Peter Paul Rubens (1577–1640), and Antoon Sallaert (c. 1580–1650)—the most influential and

prolific tapestry designers of the seventeenth century—had created sets with monumental figures and minimal landscape settings, the anonymous artist who modernized the *Cyrus* cartoons rescaled the figures and deleted most landscape and background details (compare the seventeenth-century *Diversion of the Euphrates* in the Art Institute with fig. 1, a sixteenth-century edition). In doing so, the artist and tapissiers sacrificed clarity of subject matter for overall effect: the addition of two soldiers in the modernized *Cyrus Defeats Spargapises* composition (French and Company) obscures the background scene, turning a depiction of the capture of Spargapises into a generic pseudo-Baroque battle scene (compare figs. 2 and 3). The two added soldiers were apparently stock figures, for they also appear in the *Victory of Joshua over the Amelekites* from a sixteenth-century *Story of Moses* series and in the *Siege of Troy* from a sixteenth-century *Trojan War* series.[55] The relationship among the *Cyrus*, *Moses*, and *Trojan War* sets needs further investigation, but for the purpose of this discussion, it suffices to say that tapestry producers made creative and inventive use of cartoons, as the analysis of the Chicago *Story of Caesar and Cleopatra* set (cats. 19a–n) also demonstrates.[56]

By the end of the 1660s, however, both genuine Baroque sets by artists such as Jordaens and Van Egmont and pseudo-Baroque sets like the recycled *Cyrus* series had fallen out of favor on the Brussels market, as letters written by Antoine Le Roy de St. Lambert attest. In 1680 Le Roy was exploring the Brussels tapestry market for Count Ferdinand Bonaventura Harrach. In January he wrote: "J'ai découvert encore une tanture de tapisserie à vendre, laquelle j'ai vu en très bon état et bien doublé de toile grise ayant servi peu d'années. C'est l'histoire de Cyrus […] en 13 pièces […]. La fabrique est de Bruxelles, à grandes figures, qui passent le naturel" (I have discovered a tapestry set that is in good condition; the set is lined and was woven only a few years ago. It is the story of Cyrus […] comprised of thirteen pieces. It was woven in Brussels, with monumental figures that are larger than life).[57] Some weeks later, however, Le Roy had to concede that the larger-than-life figures did not fit the count's overall interior decoration scheme: "Je me suis bien douté, que votre excellence trouverait de la difficulté à prendre l'histoire de Cyrus à cause de la grandeur des figures" (Actually, I thought that your excellency would find the *Story of Cyrus* difficult to take given the monumental size of the figures). By the time Le Roy wrote these letters, a new style developed in France had already begun to influence Brussels tapestry. The French manner was less dramatic and monumental, and tapestries woven *à la française* were more suited to the latest fashion in architecture and interior decoration (see cats. 21–22). KB

NOTES

1. For Herodotus and the *Histories*, see Evans 1991; Bakker, De Jong, and Van Wees 2002; Derow and Parker 2003; and Karageorghis and Taifacos 2004. For an English translation, see Herodotus 1962. Mallowan 1985 offers a modern introduction to the life of Cyrus, and Briant 1996 recounts the history of the Persian Empire.

2. The Massagetae were also called Scythians, so the inscription on the tapestry is appropriate. For the complex history of this people and Herodotus's confusing account of their name, see Sulimivski 1985, Harmatta 1990, and West 2004.

3. Avery 1972.

4. Miller 1993.

5. Xenophon 2001. See also Due 1989, Müller-Goldingen 1995, Nadon 2001, and Johnson 2005.

6. Farber 1979.

7. For the Stoics' view of Cyrus, see Fears 1974. For Pompeius Trogus's *Historiae Philippicae*, see Develin 1985 and Alonso-Núñez 1987, p. 61.

8. Reynolds 1983, pp. 197–99; Alonso-Núñez 1987, p. 56. See also Rühl 1871, Steele 1917, and Seel 1972.

9. Grell 1985.

10. Wilson and Lancaster Wilson 1985; Cardon 1996.

11. Cavallo 1986, pp. 48–53. These tapestries were part of the famous Barberini collection; Bertrand 2005, pp. 100–01, 137–38.

12. For Coxcie, see De Smedt 1992. Coxcie's tapestry designs were surveyed in Duverger 1992, pp. 178–81, and Campbell 2002b, pp. 394–402.

13. The Van Tieghem and Ghieteels set (ser. 39) was presumably acquired by Philip II of Spain around 1557; Junquera de Vega, Herrero Carretero, and Diaz Gallegos 1986, vol. 1, pp. 279–89. See also Palmaers 1995; Delmarcel 1999b, p. 155; and Forti Grazzini, Scalini, and Orsi 1999, pp. 30–37.

14. Delmarcel 1999a, pp. 131–33. For Van Tieghem and Ghieteels, see Wilckens 1968; Duverger 1973; Duverger and Duverger 1981; and Hefford 1986.

15. Ferrero-Viale 1959, p. 269.

16. This *Diversion of the Euphrates*, as well as two other Cyrus tapestries from the same edition, were sold at Sotheby's, London, Nov. 30, 1990, lots 25 (*The Diversion of the Euphrates*), 26 (*Astyages Recognizes Cyrus*), and 27 (*Cyrus Frees the Hebrews*). This *Cyrus Defeats Spargapises*, and four other Cyrus tapestries from the same edition, were sold at Christie's, London, Nov. 8, 1979, lot 150 (*Cyrus Captures Astyages, Cyrus Frees the Hebrews*, and *Tomyris Dips Cyrus's Head in a Basin of Blood*) and at Sotheby's, London, May 20, 1988, lot 17 (*Cyrus Orders the Lydians to Play Music*).

17. A Cyrus set in the Patrimonio Nacional, Madrid (ser. 40) that is very similar to the Coxcie series has been attributed to an anonymous Antwerp workshop; Junquera de Vega, Herrero Carretero, and Diaz Gallegos 1986, vol. 1, pp. 290–96.

18. Asselberghs 1974, p. 32; Bennett 1992, pp. 153–57. Other Cyrus tapestries woven around 1600 have appeared on the art market, including *Cyrus Frees the Hebrews* (Puttick and Simpson, London, Dec. 13, 1929) and *Cyrus Orders the Lydians to Play Music* (Christie's, London, Mar. 27, 1986, lot 197). The former tapestry is depicted in photograph no. 1550.465 in the files of the Royal Museums of Art and History, Brussels.

19. Wauters 1878, pp. 207, 296; Delmarcel 1983 (with bibliography); Delmarcel 1999a, p. 363.

20. Böttiger 1928, pp. 62–63, cat. 49, fig. 48. The Van Brustoms also used the *Story of Odysseus* cartoons created by Jacob Jordaens; see cat. 18.

21. SAB, RT 1234 (Mar. 15, 1629).

22. Ibid.

23. The contract is in the Antwerp Stadsarchief; it was recorded by the notary Ambrosius Sebille on May 2, 1669; and is published in Wauters 1878, pp. 351–52. Interestingly, a Cyrus suite is itemized in the June 23, 1670, inventory of Lenaerts's widow's possessions that is published in Duverger 1984–2002, vol. 9, pp. 258–63.

24. Photograph no. 42064B in the files of the Institut Royal du Patrimoine Artistique, Brussels. It is also possible that Erasmus II (born in 1605) produced this tapestry.

25. I would like to thank Rachel Hunt, House and Collections Manager, Cotehele, for her kind collaboration. The Cotehele tapestries are mentioned in

Thomson 1930, p. 387, and Hefford 1991, n.pag. For the sixteenth-century series, see Mahl 1965 and Delmarcel 1999a, pp. 155–63.

26. For Adriaan and Jan van Rottom, see Duverger 1986a.

27. These tapestries were sold at Knight, Frank, and Rutley, London, Nov. 11, 1927, lots 1–2. One of the pieces bears the signature GILLIS VAN ROTTOM, most probably a relative of Adriaan and Jan.

28. The Romulus and Remus tapestries lack the lower horizontal borders; their omission is presumably an original seventeenth-century feature.

29. Vermeersch 1980, pp. 234–36.

30. ARAB, NGB 4439, notary Van der Borcht (Jan. 17, 1661); published in Duverger 1986a, pp. 133–34.

31. ARAB, NGB 19641, notary Van Cutsem (Oct. 24–27, 1667); published in Duverger 1986a, pp. 143–46.

32. ARAB, NGB 4450, notary Van der Borcht (Apr. 28, 1670); published in Duverger 1986a, pp. 146–47.

33. ARAB, NGB 2043, notary Ledineurs (Aug. 8, 1671); ARAB, NGB 1964^2, notary Van Cutsem (Aug. 22, 1671).

34. Ydens is not listed in Wauters 1878.

35. For the Auwercx workshop, see Brosens 2004a, pp. 302–05.

36. Ibid., pp. 43–48.

37. Bourdieu 1986.

38. The establishment of the sick pay was recorded in ARAB, NGB 1964^1, notary Van Cutsem (Oct. 24–27, 1667); published in Duverger 1986a, pp. 143–46. ARAB, NGB 19641, notary Van Cutsem (Nov. 14, 1667) reveals that Auwercx and Van Leefdael were appointed paymasters. For Auwercx's terms as dean of the guild, see Brosens 2004a, pp. 302–03.

39. Kooijmans 1992, pp. 48–50; Kooijmans 1997.

40. SAB, PR 335, fol. 59v (Nov. 25, 1664) .

41. SAB, PR 346, fol. 128v (Sept. 2, 1667). For Eggermans, see Brosens 2007e.

42. SAB, PR 347, fol. 257v (July 12, 1671).

43. SAB, PR 349, fol. 41r (Apr. 30, 1676).

44. Aymard 1993, pp. 135–37.

45. SAB, RT 1300, fol. 202r–203r (Feb. 2, 1671).

46. For the Leyniers commissions, see Brosens 2004a, pp. 302–03. For the *Story of Saint Paul* suite, see Campbell in Campbell 2002c, pp. 406–10, and Delmarcel 2004b.

47. Huygens 1994, pp. 281–82.

48. ARAB, NGB 4014, notary Aerts (Dec. 3, 1718).

49. It is tempting to draw a parallel between Albert and Philippe Auwercx, and Urbanus and Daniel IV Leyniers: Daniel IV also became a shareholder in the Leyniers workshop during the lifetime of his father Urbanus; Brosens 2004a, p. 55.

50. ARAB, NGB 2979, notary Van Laer (April 25, 1740); published in Brosens 2004a, pp. 260–61.

51. A set of seven tapestries was in the collection of French and Company (GCPA 0240866, 0240869, 0240870–71, 0240873–75).

52. Batlle Huguet 1946, pp. 56–63.

53. Brosens 2004a, p. 112.

54. The major tapissier Urbanus Leyniers owned a number of recycled cartoons "geschildert op papier" (painted on paper) at the time of his death; Brosens 2004a, p. 279.

55. For *The Story of Moses*, see Roethlisberger 1971; Bennett 1992, pp. 111–27; and Huygens 1994, p. 278. For examples of the *Trojan War* tapestries, see Ferrero-Viale 1981 and Ragusa 1988.

56. It is worth noting that the composition of *Cyrus Saves Croesus* is nearly identical to the composition of *The Dispute between Ajax and Odysseus* from *The Trojan War*, and *Cyrus Meets Artemisia* (a fictional encounter) is identical to *Priam Meets Helen* from *The Trojan War*.

57. Menčik 1911–12, p. xlii.

CAT. 21

The Massacre at Jerusalem from *The Story of Titus and Vespasian*

Brussels, 1650/75
After a design by Charles Poerson (1609–1667)
Produced at the workshop of Gerard Peemans (1637/39–1725)
MARKED AND SIGNED: Brussels city mark; *G PEEMANS*
INSCRIBED: *HISTORIA TITI ET VESPASIANI*
514 x 367.7 cm (202⅜ x 144¾ in.)
Gift of Marshall Field and Company, 1952.1243

STRUCTURE: Wool and silk; slit, dovetailed, and double interlocking
tapestry weave
Warp: Count: 9 warps per cm; wool: S-ply of four Z-spun elements;
diameters: 0.7–0.8 mm
Weft: Count: varies from 20 to 38 wefts per cm; wool: S-ply of two Z-spun
elements; diameters: 0.5–1.0 mm; silk: pairs and three yarns of S-ply of two
Z-twisted elements; diameters: 0.6–1.0 mm; wool and silk: paired yarns of
S-ply of two Z-spun wool elements and S-ply of two Z-twisted silk elements;
diameters: 0.8–1.0 mm

Conservation of this tapestry was made possible through the Allerton
Endowment Fund.

PROVENANCE: Camillo Castiglioni (died 1957), Vienna, to 1926; sold,
Frederik Müller et Compagnie, Vienna, July 14–15, 1926, lot 544A. Marshall
Field and Company, Chicago, to 1952; given to the Art Institute, 1952.

REFERENCES: Reyniès 1997. Mayer Thurman and Brosens 2003, p. 178,
fig. 7.

EXHIBITIONS: Possibly Philadelphia, Centennial International Exhibition,
1876. Possibly Chicago, World's Columbian Exposition, 1892.

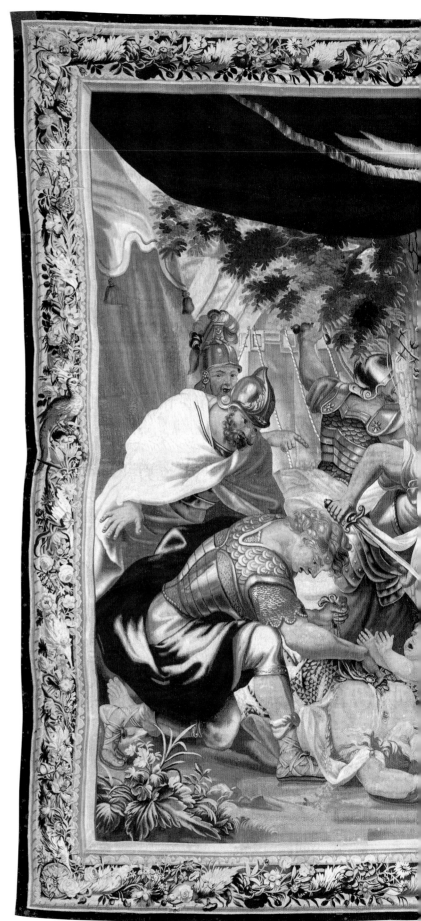

CAT. 21

IN an army encampment in front of a city, soldiers murder civilians.
Two women try to flee while a young boy begs for mercy. To the
right, a figure on horseback—the general Titus—rushes to stop the
carnage, accompanied by his lictors. The border is densely woven
with flowers and plants. In the center of the top border is a cartouche
with a Latin inscription, which reads *HISTORIA TITI ET VESPASIANI*
(The Story of Titus and Vespasian). Both Vespasian and his son Titus
led the Roman troops during the First Jewish-Roman War (66–73), a
major rebellion by the Jews of Judaea against the Roman Empire.

This tapestry, *The Massacre at Jerusalem*, belongs to a set illustrat-
ing *The Story of Titus and Vespasian* that has been attributed to the
French painter and tapestry designer Charles Poerson. The series has
been studied by Nicole de Reyniès, who located about forty *Titus
and Vespasian* tapestries after Poerson's designs.[1] Thirteen pieces bear
the signature of one of the following Brussels tapissiers: Gerard van
der Strecken (c. 1610–1677), Jan van Leefdael (1603–1668), Willem
van Leefdael (1632–1688), or Gerard Peemans. In the third quarter of
the seventeenth century these four men formed an association that
dominated the Brussels tapestry industry (see cats. 18 and 19a–n).
The *Massacre at Jerusalem* in the Art Institute is signed by Peemans.

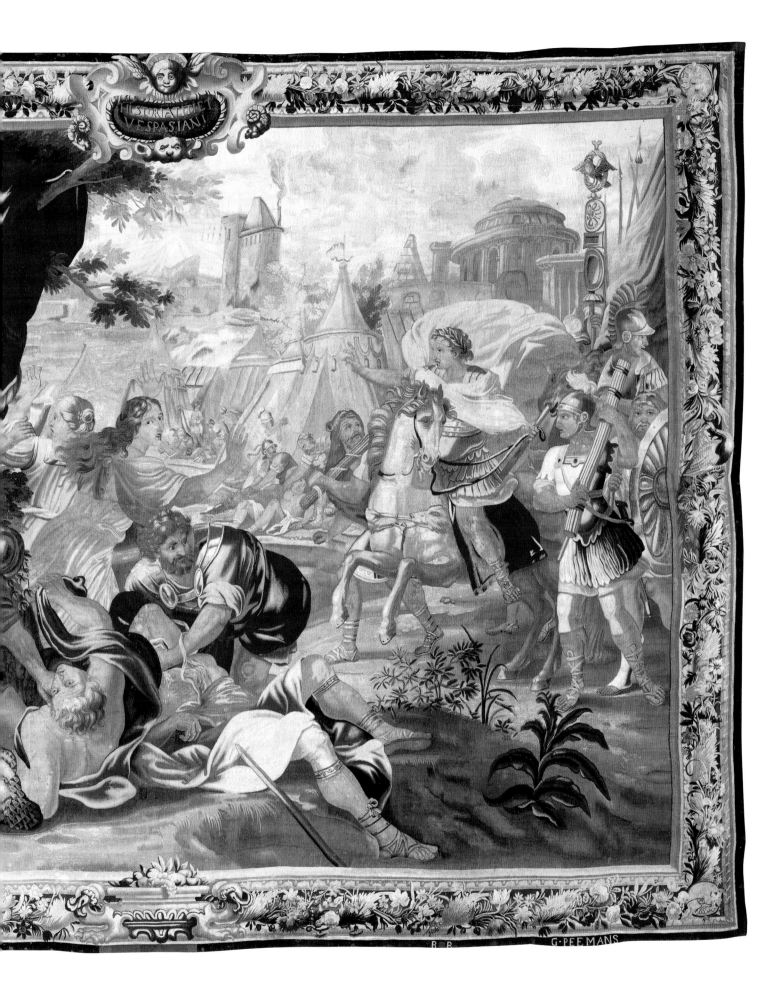

Within the image: HISTORIA TITI VESPASIANI

B·B G·PEEMANS

Though Reyniès assumed that Poerson's *Titus and Vespasian* designs were, like a number of other French cartoons (see cat. 22), exported, leased, or sold to Brussels tapissiers by Jean Valdor (1616–1675), a tapestry entrepreneur from Liège who lived in Paris, it has recently been documented that another trader—Charles de La Fontaine—supplied the Flemish producers with the designs for this set.[2] Born in France around 1610 or 1615, by 1640 de La Fontaine was living in Brussels, where he was involved in the tapestry industry. The Brussels city administration granted him exemption from taxation on beer and wine in 1646. The extension of this privilege in 1651 demonstrates that he played a very important role in the industry, likely due to his direct access to the French market; around 1650 he traveled frequently to Paris, where he sold Brussels tapestries.[3] Archival documents reveal that, in addition to *Titus and Vespasian,* de La Fontaine commissioned and owned the designs and cartoons for three other sets created by Poerson: *The Story of Cleopatra, The Story of Moses,* and *The Story of Clovis.*[4] The Poerson sets embody the new style that dominated Brussels tapestry around 1660 to 1680. Poerson's French academic-decorative manner, inspired by Simon Vouet, supplanted the dramatic and monumental mode of the Flemish High Baroque, epitomized by the work of Justus van Egmont (1601–1674, see cat. 18), Jacob Jordaens (1593–1678, see cat. 18), and Peter Paul Rubens (1577–1640). The Van Leefdael-Van der Strecken-Peemans association had achieved their preeminent position by promoting the Flemish Baroque, yet *The Massacre at Jerusalem* and the numerous other *Titus and Vespasian* tapestries the partners produced reveal that they recognized the growing popularity of the new French style.

Both the sketches and the cartoons of the *Titus and Vespasian* series are recorded in Brussels documents of the second half of the seventeenth and the beginning of the eighteenth centuries. The sketches are included in a list of de La Fontaine's possessions sold at auction in Brussels in 1691: "acht scheitsen representerende d'historie van tijtus, ende vespasianus" (eight sketches depicting the story of Titus and Vespasian).[5] Gerard Peemans was the highest bidder, but the document seems to indicate that his bid was not accepted and that the lot was bought in. Nothing is known about the later history of the sketches.

The ownership of the cartoons, on the other hand, can be traced until about 1750. De La Fontaine presumably sold them to the Van Leefdael-Van der Strecken-Peemans association in the 1660s or 1670s. Ownership must have been divided among the business partners, for a document recorded in 1685 shows that Willem van Leefdael possessed "het derde paert" (a third part) of the cartoons of the set. This was not unusual; in this association each partner usually bought only some of the cartoons in a series, thus reducing each partner's expenses and securing the professional ties among the members of the group. In the course of time—presumably after the deaths of Van der Strecken and Willem van Leefdael—Gerard Peemans acquired all the *Titus and Vespasian* cartoons, as may be inferred from their appearance in the list of cartoons owned by Peemans that were auctioned in Brus-

sels in 1711 following his bankruptcy.[6] The auction also included two suites of the series that had been executed in the Peemans workshop, each comprising eight tapestries; one of the editions was woven with gilt-metal thread.

Though it is not known who bought the *Titus and Vespasian* suites, an unpublished eighteenth-century document reveals that Judocus de Vos (1661–1734), by far the most important Brussels tapestry producer around 1700, bought the cartoons.[7] This document, written in 1727 by De Vos himself, enumerates all the tapestry sets that he could produce; the list includes *Titus and Vespasian.* It is not clear, however, whether he ever received a commission for an edition of the series, because none of the *Titus and Vespasian* tapestries known today bear his signature. Another document shows that between 1716 and 1719 De Vos tried to market a suite of the set in Vienna, but it is possible that this was one of the seventeenth-century suites that had been auctioned at the Peemans sale in 1711. The *Titus and Vespasian* cartoons presumably stayed in the De Vos workshop until it closed around 1750. Thereafter, like all other cartoons, they became useless as the tapestry industry shrank.

Poerson clearly based his series on book two of Tacitus's *Histories* (c. 109–10) and, above all, on Flavius Josephus's *The Jewish War* (c. 75–79).[8] Transmitted in numerous Greek and Latin manuscripts throughout the Middle Ages, *The Jewish War* presents the most detailed account available of the military campaigns led by Vespasian and his son. The first Spanish, Dutch, and French translations were printed in the fifteenth century, and the book remained very popular during the sixteenth and seventeenth centuries.[9] Josephus was a Jewish priest and military leader who, after the fall of the fortified village of Jotapata, allied himself with the Romans. He was granted Roman citizenship and a pension, and became a respected figure at the courts of Vespasian and Titus, which may explain why his supposed eyewitness report of the war is biased in favor of the Romans, especially Titus.

Though it is clear that Poerson's *Titus and Vespasian* series consisted of eight scenes, their subjects and sequence present some identification problems. While the bearded Vespasian and the clean-shaven Titus can be easily distinguished from one another, the iconography of some of the scenes in the series—such as scenes of an oracle, of a siege, and of two women imploring Titus—is not specific, which obviously complicates identification of their subjects. In his 1727 survey, De Vos recorded the following tentative order: (1) *Titus Lays Siege to Jotapata but Has to Withdraw,* (2) *Two Women Disclose Josephus's Hiding Place to Titus,* (3) *Josephus Led before Titus and Vespasian after the Capture of Jotapata,* (4) *Titus's Offering after the Capture of Jotapata,* (5) *The Army of Judaea Proclaims Vespasian Emperor,* (6) *The Massacre at Jerusalem,* (7) *Judaea Captured,* and (8) *Titus and Vespasian's Triumphal Entry into Rome.*[10] The order and identifications differ manifestly from those established by de Reyniès (the numbers in square brackets refer to each tapestry's place in De Vos's sequence): (1) [3] *Josephus Led before Titus and Vespasian after*

the Capture of Jotapata, (2) [4] *Titus's Offering to Venus on the Isle of Paphos,* (3) [6] *The Massacre at Jerusalem,* (4) [2] *Two Women Implore Titus,* (5) [1] *The Siege of Jerusalem,* (6) [7] *Judaea Captured,* (7) [5] *Titus and Vespasian Applauded by the Roman Soldiers* or *Vespasian Shares His Governmental Powers with Titus,* and (8) [8] *Titus and Vespasian's Triumphal Entry into Rome.*[11]

The scene identifications and order put forward by De Vos must be treated with utmost caution, for in some cases they are clearly inaccurate. For example, the military leader represented in the episode De Vos entitled *Titus Lays Siege to Jotapata but Has to Withdraw* can indeed be identified as Titus, but the scene does not depict the first, unsuccessful siege of Jotapata. According to *The Jewish War,* a Roman general named Placidus led the first, unsuccessful attack on the city (book 3, 6), Vespasian directed the second siege (book 3, 7), and Titus only became involved in the very last stage of the fight when Jotapata was taken by treachery. It is therefore more logical to assume, as Reyniès did, that the tapestry depicts *The Siege of Jerusalem,* Titus's greatest achievement as a military leader (Josephus, *The Jewish War,* books 5–6). Similarly, the second scene on De Vos's list is incorrectly titled *Two Women Disclose Josephus's Hiding Place to Titus,* for according to Josephus himself (*The Jewish War,* book 3, 8), he was discovered by just one woman who led a number of Roman soldiers to his hiding place, whereupon they informed Vespasian—not Titus—that the Jewish leader had been discovered. These errors suggest that De Vos must have had to identify the *Titus and Vespasian* scenes and establish their order himself when he bought the cartoons for the set at auction in 1711.

By contrast, the plot presented by Reyniès proves far more reliable. *Josephus Led before Titus and Vespasian after the Capture of Jotapata* (*The Jewish War,* book 3, 8) and *Titus's Offering to Venus on the Isle of Paphos*—the only scene based on the second book of the *Histories*—are correctly placed at the beginning of the series, for they can be regarded as a prologue to the main event: Titus's arduous siege, capture, and destruction of Jerusalem. It is also correct to place *Titus and Vespasian's Triumphal Entry into Rome* (*The Jewish War,* book 7, 5) after *Titus and Vespasian Applauded by the Roman Soldiers* (*The Jewish War* book 7, 5) as both tapestries pertain to the reception of Vespasian and Titus on their return to Rome.

Yet Reyniès's sequence requires a few slight adjustments. First, *The Siege of Jerusalem* is wrongly placed after *The Massacre at Jerusalem,* for the horrific incident (*The Jewish War,* book 5, 13) occurred about six months after the start of the siege (*The Jewish War,* book 5, 6). Josephus describes how Arabian and Syrian soldiers who were part of Titus's army slaughtered the Jews who had fled Jerusalem, opening their bellies in search of pieces of gold, as some of the Jews had swallowed coins before surrendering to the Romans. On hearing of these atrocities, Titus was enraged and threatened to put the offending soldiers to death. According to Josephus, the killings proceeded nonetheless, albeit discreetly. Secondly, Reyniès reluctantly, and unconvincingly, identified *Two Women Implore Titus,* which shows

a burning city in the background, with a number of episodes in *The Jewish War.*[12] However, as neither Josephus nor Tacitus described two women and a young boy imploring Titus, it can be assumed that this scene is Poerson's invention, meant to represent both Titus's destruction of Jerusalem and the future emperor's clement nature. The tapestry may thus be regarded as a companion piece to *The Massacre at Jerusalem,* which also shows Titus's benevolence, and can be placed after *The Siege of Jerusalem.* Finally, *Judaea Captured,* which Reyniès placed immediately after *The Siege of Jerusalem,* is an allegorical representation of Vespasian's and Titus's triumphs over the Jews, and can therefore be regarded as an epilogue—or even a prologue—to the series as a whole. Thus, the tentative sequence presented here is: (1) *Josephus Led before Titus and Vespasian after the Capture of Jotapata,* (2) *Titus's Offering to Venus on the Isle of Paphos,* (3) *The Siege of Jerusalem,* (4) *The Massacre at Jerusalem,* (5) *Two Women Implore Titus,* (6) *Titus and Vespasian Applauded by the Roman Soldiers,* (7) *Titus and Vespasian's Triumphal Entry into Rome,* and (8) *Judaea Captured.*

The iconographic issues that troubled Judocus de Vos in the beginning of the eighteenth century and still trouble modern tapestry scholars must be recognized as a strength of the series, for it reveals an aspect of the entrepreneurial strategy devised by the commissioners of the cartoons. A flexible program featuring common subjects such as scenes of benevolence and triumph allowed clients to construct customized suites rather than obliging them to follow preestablished linear narratives. Customers could choose scenes according to their taste and order them to fit the dimensions of the walls they wanted to cover. Tapestry entrepreneurs could also combine subjects from different but stylistically similar series to create new, amalgamated sets (see cats. 19a–n). For example, at least two tapestries originally from Poerson's *Story of Cleopatra* series were used in *Titus and Vespasian* suites, as these pieces each bear the Latin inscription HISTORIA TITI ET VESPASIANI.[13] Interestingly, one of the pieces, *The Supper,* was part of the suite that included *The Massacre at Jerusalem* in the Art Institute and a tapestry depicting *Titus and Vespasian's Triumphal Entry into Rome.*[14] As *The Supper* is signed by Willem van Leefdael, the Chicago tapestry belonged to an edition that was coproduced by Gerard Peemans and Willem van Leefdael, which implies that it must have been woven between de La Fontaine's introduction of the cartoons in Brussels around 1650 and Van Leefdael's death in 1688. Since Willem van Leefdael removed himself from the partnership with Gerard Peemans and Gerard van der Strecken around 1675, *The Massacre at Jerusalem* was presumably woven prior to 1675.[15] KB

NOTES

1. Reyniès 1997, pp. 171–83. For the *Titus and Vespasian* set, see also Delmarcel et al. 1997, pp. 54–59. A number of tapestries have appeared on the art market since 1997, including a version of *The Massacre at Jerusalem* that was sold at Christie's, New York, Mar. 31, 2000, lot 206, and subsequently at Christie's, New York, Mar. 28, 2007, lot 314.

2. For Valdor as supplier, see Reyniès 1997, pp. 108–09. For de La Fontaine, see Brosens 2007a.

3. SAB, RT 1294, fol. 178v–180r (Sept. 11, 1646); SAB, RT 1296, fol. 85v–87r (July 11, 1651); both documents are published in Brosens 2007b.

4. Brosens 2007b. For these series, see Reyniès 1997, pp. 111–37, 185–93, and Brosens 2005a.

5. ARAB, NGB, 2573, notary Duprenne (Sept. 17, 1691).

6. SAB, Library, file 2375/16.

7. Brosens 2002. The document was discovered by the late Margaret Swain in 1984 but remained unpublished. I am most grateful to Guy Delmarcel for bringing it to my attention, and am currently preparing a study of it. For De Vos, see Brosens 2002 and Brosens 2004a, pp. 117–18, 311–18.

8. Josephus [c. 75–79] 1997.

9. Schreckenberg 1968; Schreckenberg 1979.

10. The complete titles of the scenes are: (1) "Titus fait monter a l'assaut devant la ville de josaphat et est repousé aux perte" (Titus attacks the city of Jotapata but suffers many losses and is forced to withdraw); (2) "la ville de josaphat etant prise et en partie ruiniée par le feu, deux femmes juifs recourent a Titus et luy decouvrent la caverne ou joseph que le Romains cherchoient etoit retiré aux 40 dessiens et sy egorgerent tous plutot que de se rendre aux Romains" (The city of Jotapata is captured and partly destroyed by fire; two women go to Titus and inform him that Josephus, for whom the Romans are searching, is hiding in a pit together with 40 men who would rather commit suicide than surrender to the Romans); (3) "Joseph gouverneur de josaphat prisonniées apres la prise de la ditte ville devant Titus et Vespasien" (Josephus, the governor of Jotapata, as a prisoner before Titus and Vespasian, after the taking of said village.); (4) "L'offrande de titus en action de grace apres la prise de josaphat;" (5) "Vespasien proclamé empereur de Romains par l'armée de la judée;" (6) "Titus accourt pour empecher le massacre que faisoient les arabes et siriens de juifs sous pretexte de trouver de l'or dans leurs entrailles" (Titus stops the slaughtering of the Jews by the Arabs and the Syrians who thought they would find gold in their stomachs); (7) "Un trophé d'armes de la judée conquise" (A trophy of arms of Judaea, captured); and (8) "L'entré triomphante de Titus et Vespasien dans la ville de Rome." De Vos wrote the 1727 list in French, the lingua franca of the European aristocracy that purchased tapestries, but his native language was Flemish, which explains the numerous spelling errors in the document.

11. Reyniès 1997, pp. 174–83.

12. Ibid., pp. 177–78.

13. Ibid., pp. 182–83. *The Supper,* signed G.V.LEEFDAEL, was sold at Sotheby's, New York, May 10–11, 1985, lot 527. The other tapestry, *The Battle,* signed LE CLERC, was part of the collection of the Museum of Fine Arts, Springfield (Mass.), and was sold at Christie's, New York, May 17–18, 2005, lot 368.

14. These three pieces were offered for sale at Frederik Müller et Compagnie, Amsterdam, Castiglione sale, July 14–15, 1926, lots 544a–c. *Titus and Vespasian's Triumphal Entry into Rome* was sold again at Galerie de Chartres, Chartres, Nov. 7, 1971, lot 100, and in 1992 was in the collection of the Parisian tapestry dealer Chevalier; Reyniès 1997, p. 181. Reyniès mistakenly lists the Art Institute's *Massacre at Jerusalem* and the piece from the 1926 Castiglione sale as two different tapestries.

15. Brosens 2003–04, pp. 22–23.

CAT. 22

The Offering of the Boar's Head from *The Story of Meleager and Atalanta*

Brussels, 1673/86
After a design by Charles Le Brun (1619–1690)
Produced at the workshop of Jan II Leyniers (1630–1686)
MARKED AND SIGNED: Brussels city mark; *IAN LEYNIERS*
355 x 344.8 cm (139¾ x 135¾ in.)
Gift of Mrs. Maurice L. Rothschild, 1941.93

STRUCTURE: Wool and silk; slit, dovetailed, and double interlocking tapestry weave
Warp: Count: 9 warps per cm; wool: S-ply of three Z-spun elements; diameters: 0.6–0.8 mm
Weft: Count: varies from 32 to 36 wefts per cm; wool: S-ply of two Z-spun elements; diameters: 0.3–0.9 mm; silk: pairs of S-ply of two Z-twisted elements; diameters: 0.2–0.6 mm

Conservation of this tapestry was made possible through the generosity of the James Tigerman Estate.

PROVENANCE: Lehmann Bernheimer, Munich, in 1917; sold to Maurice L. Rothschild (died 1941), Chicago, by 1917; by descent to his wife, Mrs. Maurice L. Rothschild (née Hulda Bloom, died 1980); given to the Art Institute, 1941.

REFERENCES: Mayer Thurman and Brosens 2003, p. 179, fig. 8.

A toga-clad man offers a boar's head to a woman, also in classical attire, who sits under a canopy resting her arm on a bow. The man is accompanied by an attendant holding a spear and two dogs on leashes. Behind the woman stand four ladies-in-waiting; three dogs rest on the ground to her left. The border shows garlands of leaves and flowers intermingled with helmets, hunting horns, quivers, spears, and vases. Larger quivers occupy the centers of the horizontal borders.

This tapestry is part of a *Story of Meleager and Atalanta* series designed by Charles Le Brun, first painter to the king under Louis XIV (see also cats. 42a–b), and François Bellin (died 1661), a lesser-known landscape painter.[1] Le Brun based most of his series on the version of the legend in Ovid's *Metamorphoses* (book 8, 269–525).[2] Meleager was the son of Oeneus and Althea, the king and queen of Calydon. After Meleager's birth, the Fates put a stick in the fire heating the room where Althea was recovering from labor, and predicted that Meleager would die as soon as the stick burned completely. This episode is the first scene of Le Brun's series. Althea, however, seized the stick and hid it in a safe place. Meleager grew up, became a bold warrior, and married Cleopatra, the daughter of the Greek hero Idas. One day the goddess Artemis, enraged by King Oeneus's failure to honor her appropriately, sent an enormous wild boar to ravage the fields of Calydon. Meleager organized a hunting party to kill the boar, inviting his friends Theseus, Jason, Peleus, and other Greek heroes. Atalanta, the daughter of the king of Arcadia, was the only

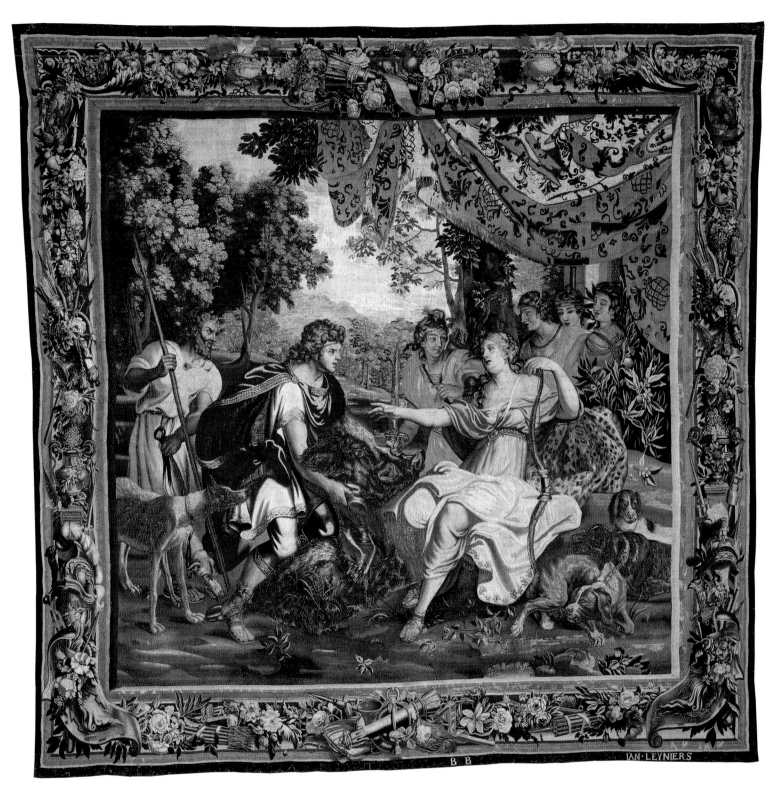

CAT. 22

CAT. 22, DETAIL

woman in the group. As soon as Meleager laid eyes on her, he fell in love. This moment is depicted in *The Preparation for the Hunt*, the second scene in Le Brun's set. The third scene in the series, *The Hunt of Meleager and Atalanta*, depicts Atalanta wounding the boar with an arrow and Meleager killing it with a spear. The prince honored the princess for drawing first blood and declared her queen of the hunt by offering her the boar's head, as is shown in the fourth episode of Le Brun's series. Two of Meleager's uncles, Toxeus and Plexippus, were jealous of the honor granted to Atalanta, and tried to steal the boar's head. Blinded by love and rage, Meleager killed them. Le Brun showed this dramatic moment in the fifth scene in his set. The sixth episode, depicted in the tapestry in the Art Institute, shows Meleager returning the hunting trophy to Atalanta. In the penultimate design in the series, Althea, having heard that her son has killed both her brothers, is struck by grief and rage, and burns the stick she had hidden long ago, killing Meleager. His death is shown in the eighth and final subject of the series.

In his *Vie de Charles Le Brun* of around 1700, Claude III Nivelon,

formerly Le Brun's assistant, stated that the *Meleager and Atalanta* cartoons were commissioned in 1658 by Jean Valdor (1616–1675), an art dealer, diplomat, engraver, and tapestry entrepreneur from Liège who lived in Paris.[3] Valdor's commission coincides with his appointment as director of the newly established tapestry workshop in Maincy, near Melun, Seine-et-Marne. The Maincy manufactory was subsidized by Nicolas Fouquet, the powerful superintendent of finance and chancellor of the exchequer under Louis XIV.[4] Fouquet, who accumulated a vast personal fortune by impoverishing the treasury, invested heavily in the embellishment of his castle at Vaux-le-Vicomte. In the fall of 1658 the minister installed a tapestry workshop, largely operated by émigré Flemish weavers, in a former Carmelite convent in Maincy, and some months later lured Le Brun there.[5] Fouquet's workshop, however, was granted only a short existence. In 1661 the corrupt minister was disgraced and, four years later, sentenced to life imprisonment by Louis XIV.

It is generally assumed that Valdor commissioned the cartoons to supply the newly established workshop in Maincy and that the weaving of the first edition was begun on its looms.[6] But there exist no documents supporting this assumption, and Valdor was probably wary of the many problems likely to plague a newly established manufactory. He may instead have opted to put his costly investment to work in the renowned Gobelins tapestry workshops located in the Paris suburb of Saint-Marcel.[7] In May 1659 Valdor contracted with the Flemish émigré tapestry weaver Jan Jans (1618–1668), who directed a workshop there.[8] Jans, who remained in the French capital, committed himself to work for Valdor for the following six years.[9] Therefore, the *Meleager and Atalanta* cartoons may have been used in Paris rather than Maincy.

In 1662 Jean-Baptiste Colbert, Fouquet's successor, who developed a policy of state entrepreneurship now known as Colbertism, established the Manufacture Royale des Gobelins.[10] Here Colbert grouped the Maincy production unit and the various Parisian tapestry workshops of the Louvre and the Saint-Marcel, as well as assembled a veritable army of artists and skilled craftsmen who produced other luxury goods, such as furniture, gold and silver work, locks, marquetry, and mosaics (see cats. 42a–b). Le Brun was appointed director of this apparatus of royal propaganda, which was charged with crafting the king's image, in 1663.[11]

Le Brun's *Meleager and Atalanta* cartoons were used at the Gobelins in the late 1660s. In February 1669 Jans's son Jan II (1644–1724) received 7,890 livres for the production of six *Meleager and Atalanta* tapestries.[12] Three of these pieces had been in production in 1668, at the time of his father's death. In 1691 Jan II recorded an "estat de touttes les tentures de tapisseries en basse lisse qui ont estée faites aux Gobelins depuis l'établissement de la manufacture" (an inventory of all sets woven at the Gobelins on low-warp looms since the establishment of the manufactory).[13] He listed a *Meleager and Atalanta* edition of eight pieces and further specified that "les tableaux ont esté fourny par feu M. Valdor. [...] Les tableaux ne sont point aux Gobe-

lins; ils ont esté remis entre les mains de M. Valdor" (the cartoons were delivered by the late Mr. Valdor. [...] The cartoons are not at the Gobelins; they were returned to Mr. Valdor).[14]

The cartoons for the series must indeed have been returned to Valdor shortly after 1669, because in April 1672 Valdor, who had by then returned to his hometown, Liège, having become persona non grata in France, leased the designs of six tapestry sets, including those of *The Story of Meleager and Atalanta*, together with their border designs, to the Brussels tapissiers Gerard van der Strecken (c. 1610–1677), Willem van Leefdael (c. 1610–1677), and Gerard Peemans (1637/39–1725, see also cats. 19a–n).[15] The lease indicates that the *Meleager and Atalanta* set consisted of twelve paintings in total; Valdor leased eight of these and agreed to neither lease nor sell the remaining cartoons to other tapestry producers. A clause in the contract entitled Valdor to a third part of the wages paid to a weaver working in the workshops, per edition sold. The cartoons were leased for life, but either party could abrogate the contract at any time, as in fact happened about a year later, in July 1673, when Valdor, represented by the Brussels merchant Gilles Postel, leased the designs for the *Meleager and Atalanta* series and its borders to Everard III Leyniers (1597–1680, see also cat. 17) and his son Jan II (1630–1686).[16] In contrast to the 1672 agreement, the duration of the new lease was limited to the production of four editions. Valdor promised, however, that he would prefer the Leyniers to other tapestry entrepreneurs for the weaving of additional suites. The contract further shows that Valdor was entitled to half the profits resulting from sales of editions sold at more than seventeen or eighteen guilders per ell.[17]

The Offering of the Boar's Head bears Jan II Leyniers's signature in the lower border, which means that it was woven after 1673. Though it would be logical to assume that, after Jean Valdor's death in January 1675, the *Meleager and Atalanta* cartoons were transferred to Valdor's eldest son and successor, Jean-Baptiste (died 1724), they actually remained in the possession of Jan II, who continued to use them. In January 1676, the Marquis de Louvois, represented by Gilles Postel, commissioned Leyniers to produce an edition composed of eight *Meleager and Atalanta* pieces, and around 1679 Leyniers produced another set of eight scenes for the dowry of Ulrika Eleonora of Denmark on her marriage to King Charles XI of Sweden in 1680.[18] As Jan II presumably used the cartoons until his death in 1686, *The Offering of the Boar's Head* can be dated between 1673 and 1686. The *Hunt of Meleager and Atalanta* in West Dean College, Chichester, and the *Death of Meleager* that appeared on the French art market in 1994 were presumably part of the suite that included the tapestry in the Art Institute as they all have identical borders.[19]

After Jan II Leyniers's death in 1686, the *Meleager and Atalanta* designs may have been used by his younger brother Gillis II (1641–1703), who ran a minor workshop.[20] The *Mémoire de Goís*, an eighteenth-century document written by the Portugese diplomat Francisco Mendes de Goís, makes clear that Gillis II Leyniers's sale catalogue included "des Chasses peint par un peintre français"

FIG. 1 *The Offering of the Boar's Head.* Charles Le Brun, c. 1656/1658. Oil on canvas, 212.5 x 280.5 cm. Walker Art Gallery, Liverpool.

(Hunts painted by a French painter)—possibly a description of Le Brun's *Story of Meleager and Atalanta,* which was also known as *The Hunts of Meleager.*[21] By the end of the seventeenth century, however, Le Brun's *Meleager and Atalanta* cartoons had been dispersed. In 1695 four of them were listed in the inventory of the famous Parisian banker, entrepreneur, and art collector Everard Jabach: *The Hunt of Meleager and Atalanta, The Death of Meleager, Althea Throws the Stick into the Fire,* and *The Offering of the Boar's Head.*[22] Interestingly, Jabach and Jean Valdor had had business contact: in 1651 Jabach had conceded to Valdor his privilege to transport goods between Liège and France. Furthermore, Jabach, like Valdor, had been involved in the organization of tapestry production in Aubusson around 1670.[23] The *Hunt of Meleager and Atalanta* and the *Death of Meleager* recorded in Jabach's 1695 inventory were bought by the French painter Alexis-Simon Belle, who stored them at the Gobelins. In 1723 or 1724 they were used for an edition woven without borders at the Gobelins.[24] In 1817 Louis XVIII bought both cartoons and subsequently placed them in the Louvre, where they remain to this day.[25] Though the cartoon depicting *Althea Throws the Stick into the Fire* has not surfaced since 1695, *The Offering of the Boar's Head* can be identified with a painting now in the Walker Art Gallery, Liverpool (fig. 1).[26]

Over thirty *Meleager and Atalanta* tapestries after Le Brun's designs are in public collections or have surfaced on the art market, an indication of the popularity of his series. Its iconographic program—a tragic love affair disguised in hunting scenes—as well as its stylistic features must have appealed to a broad European clientele. Le Brun had trained in Rome between 1642 and 1646 under Nicolas Poussin, who promulgated a purely classical idiom. After his return to France Le Brun developed a unique synthesis of this classical tradition and the Flemish Baroque style.[27] The *Meleager and Atalanta* tapestries exemplify his blend of the dynamic drama typical of mid-seventeenth-century Flemish painting and the restrained theatrical

pathos that characterized French painting of the time. When Valdor leased the *Meleager and Atalanta* cartoons to the Brussels tapestry entrepreneurs Van der Strecken, Van Leefdael, and Peemans in the early 1670s, this French manner had already proven to be very successful; *The Story of Moses, The Story of Cleopatra, The Story of Clovis,* and *The Story of Titus and Vespasian* of Charles Poerson (1609–1667), imported to Brussels by Charles de La Fontaine (born 1610/15) around 1650 or 1660, rank among the most popular sets woven in Brussels around 1675 (see cats. 19a–n, 21). Moreover, Poerson's and Le Brun's tapestry cartoons greatly influenced the leading Brussels painters of the last quarter of the seventeenth century: Lodewijk van Schoor (c. 1650–1702, see cat. 24), Jan van Orley (1665–1735, see cat. 26) and Victor Janssens (1658–1736). Together with his *Story of Alexander* (1661–1668) designs, known indirectly in Brussels via the engravings (1672–78) of Gerard Edelinck and Gerard Audran, Le Brun's *Meleager and Atalanta* designs shaped the style and content of Brussels tapestry made between 1675 and 1725.[28] KB

NOTES

1. Brosens 2003–04 is the most recent study of this series.
2. The exceptions are *Atalanta is Crowned by Meleager* and *The Offering of the Boar's Head*, which Le Brun based on *Méléagre*, a tragedy by Isaac de Benserade (1612–1691), published in Paris in 1641.
3. Nivelon [c. 1700] 2004, p. 232; Jouin 1889, pp. 102–03. For Valdor, see Lacordaire 1853–55; Renier 1865; Denucé 1949; Uhlmann-Faliu 1978; Reyniès 2002, pp. 209, 213; and Szanto 2002.
4. Dessert 1987.
5. The Flemish tapissier Louis Blommaert (died 1660) supervised the daily operations. For the Maincy workshop, see Grésy 1858–60, Cordey 1922, and Lucas de Kergonan 2000. In Mar. 1659 Valdor hired two Parisian tapestry weavers, Jean Dautruche (born c. 1584) and his son Theodore, who moved from the workshop of Raphael de La Planche (died after 1661) in the Paris suburb of Saint-Germain to Fouquet's workshop in Maincy; ANP, MC CXIII, 43 (Mar. 30, 1659). Jean Dautruche was one of the tapissiers involved in the Jan Leeuwarden murder case in 1634. Leeuwarden, like Dautruche a tapestry entrepreneur working at the Saint-Germain workshop, was killed by a Frenchman after a fight in July 1634; Guiffrey 1885; Guiffrey 1892, p. 129. For Fouquet's hiring Le Brun, see Grésy 1858–60, p. 7.
6. Lacordaire 1855, p. 57; Jouin 1889, p. 550; Merson 1895, p. 99; Fenaille 1903–23, vol. 2, p. 33; Cordey 1922, p. 77; Montagu 1962, p. 532; Thuillier and Montagu 1963, p. liv; Reyniès 1996, p. 270. Only Montagu 1967, pp. 21–23, expressed reservations about this assumption, pointing out that all the publications that endorsed it were based on Lacordaire 1855, who quoted no source for the claim.
7. For tapestry production in France during the seventeenth century, see Denis in Campbell 2007a, pp. 123–39, and Bertrand in Campbell 2007a, pp. 341–55.
8. ANP, MC CXIII, 44 (May 2, 1659).
9. In return, Valdor promised to pay Jans the same wages as he was paying "Louis Blomaert travaillant présentement à Maincy" (Louis Bloemaert who currently works in Maincy); ANP, MC CXIII, 44 (May 2, 1659).
10. For more on Colbert, see Mousnier and Favier 1985.
11. For Le Brun at the Gobelins, see Favreau 2007.
12. Guiffrey 1881, p. 288; Fenaille 1903–23, vol. 2, p. 34.
13. Guiffrey 1892, pp. 237–38.
14. In March 1692 a *Meleager and Atalanta* edition comprising eight tapestries and woven with gold thread was listed among the tapestry sets owned by Louis XIV; Guiffrey 1892, pp. 254–56.
15. For Valdor's disgrace on suspicion of his being a spy, see Ravaisson 1874, pp. 400–01. For the lease to the van der Strecken-van Leefdael-Peemans association, see ARAB, NGB 1964/2 (Apr. 9, 1672); published in Brosens 2003–04, pp. 26–28.
16. ARAB, NGB 711/1 (July 28, 1673); published in Brosens 2003–04, pp. 28–30.
17. One ell equals 69.56 cm; Doursther 1840, p. 33.
18. The Marquis de Louvois's commission is recorded in ARAB, NGB 711/2 (Jan. 13, 1676); published in Brosens 2003–04, pp. 31–33. Six of the tapestries made for Ulrika Eleonora's dowry are now in the Royal Collection, Stockholm; Böttiger 1896, pp. 38–39, 48. The other two pieces—*The Hunt of Meleager and Atalanta* and *Atalanta Is Crowned by Meleager*—were sold in 1893 from the collection of the Museum Christian Hammer, Stockholm. The latter piece was bought by a German professor and artist living in Düsseldorf; De Raadt 1894, pp. 117–20.
19. Paris, Hôtel Drouot, Mar. 14, 1994, lot 11. Another tapestry with identical borders is *Meleager Killing his Uncles*, shown at Franses, London in 1974, and sold at Sotheby Parke Bernet, Monaco, June 23–24, 1976, lot 113.
20. See Brosens 2003–04, pp. 23–24, for the history of the designs after 1686.
21. The document is in a Belgian private collection; it is published in Brosens 2004a, pp. 249–59. The passage relating to Gillis Leyniers is also published in Brosens 2003–04, pp. 25–26.
22. De Grouchy 1894, pp. 58–60, nos. 489, 490, 516, 518.
23. Pérathon 1897, pp. 49–67; Bertrand, Chevalier, and Chevalier, 1998, pp. 65–67.
24. Jouin 1889, p. 514; Fenaille 1903–23, vol. 2, p. 35. These pieces are now in the English Royal Collection.
25. Musée du Louvre, Paris, inv. nos. 2899 (310 x 511 cm), 2900 (305 x 485 cm); Compin and Roquebert 1986, vol. 2, p. 41.
26. Montagu 1967; Coburn Whiterop 1967.
27. For Le Brun, see Jouin 1889, Merson 1895, Blunt 1944, Thuillier and Montagu 1963, Thuillier 1967, Montagu 1992, Gareau and Beauvais 1992, and Nivelon [c. 1700] 2004.
28. For *The Story of Alexander*, see Fenaille 1903–23, vol. 2, pp. 166–83, and Posner 1959, pp. 237–48.

September and October [fragment] from *The Twelve Months of the Year*

Brussels, after 1675
After a design by David III Teniers (1638–1685)
Produced at the workshop of Gerard Peemans (1637/39–1725)
144.78 x 283.53 cm (57 x 111⅝ in.)
Gift of Honoré Palmer, 1938.1309

STRUCTURE: Wool, silk, and silvered-metal-strip-wrapped silk; slit and double interlocking tapestry weave with some areas of 2 : 2 plain interlacing of silvered-metal wefts
Warp: Count: 10 warps per cm; wool: S-ply of four Z-spun elements; diameters: 0.7–0.9 mm
Weft: Count: varies from 19 to 42 wefts per cm; wool: S-ply of two Z-spun elements; diameters: 0.3–0.8 mm; silk: pairs of S-ply of two Z-twisted elements; diameters: 0.4–0.8 mm; silvered-metal-strip-wrapped silk: silvered-metal strip wrapped in an S direction on S-ply of two yarns of Z-ply of two slightly Z-twisted silk elements; pairs of yarns of silvered-metal strip wrapped in an S direction on S-ply of two yarns of Z-ply of two slightly Z-twisted silk elements; diameters: 0.4–0.8 mm

Conservation of this tapestry was made possible through the generosity of the James Tigerman Estate.

PROVENANCE: Probably Potter (died 1902) and Bertha Palmer (née Honoré, died 1918); probably by descent to their son Honoré Palmer (died 1964); given to the Art Institute, 1938.

FOUR putti hold a garland of fruit in front of two pillars. The left leg of a fifth putto in the top left corner, a fragment of a wing and a leg, both visible on the left, as well as the putto at the bottom whose legs have been cut off above the knees, indicate that this piece is a portion of a larger tapestry. When it was acquired by the Art Institute in 1938, the work was catalogued as a fragment of a Beauvais tapestry after François Boucher (1703–1770). Charissa Bremer-David, however, identified the piece as a fragment of a tapestry that belonged to *The Months, Seasons, Elements, Day, and Night* (also known as *Allegories of Time*), an allegorical series designed around 1650 by the Antwerp painter and Rubens pupil Jan van den Hoecke (1611–1651).[1] This link helped identify the Chicago piece as part of a tapestry belonging to a suite heavily indebted to Van den Hoecke's series: the *Twelve Months of the Year* set designed by David III Teniers (1638–1685).

The piece in the Art Institute is the right side of a tapestry depicting September and October as winged female personifications sitting in a portico (fig. 1). The woman on the left represents September. She wears a wreath of corn and bears a scale and a horn of plenty filled with apples, grapes, and pears. On the right, October is crowned with oak leaves and holds a scorpion and a basket of mushrooms. The fruits and vegetables in the Months' arms are picked in the fall, as is the fruit in the putti's garlands that frame the scene. The scale and the scorpion refer to Libra and Scorpio, signs of the zodiac that govern

September and October. The wine-making scene in the background continues the autumnal imagery.

The other months in the series are also represented as winged personifications holding appropriate attributes and accompanied by putti. This iconographic program is based on Cesare Ripa's *Iconologia* (Rome, 1593), a dictionary of iconographic forms that was used by artists of the seventeenth and early eighteenth centuries to depict concrete entities and abstract ideas and concepts (see also cat. 24).[2] The publication of French (1644), Dutch (1644), and German (1669–70) translations attests to the popularity of the book, which became a painter's bible.[3] Apart from their gender, September and October follow Ripa's descriptions in every detail: September is "a winged young man, dressed in purple, with a wreath of corn. He holds the sign of Libra in his right hand; in his other hand, he has a horn of plenty filled with grapes, peaches, apples, pears, melons, and other fruits that ripen in this month."[4] Ripa explains that the color of the young man's clothes refers to the purple robes worn by ancient emperors who supplied their people with food, just as September provides fruit. October, according to Ripa, is also "a winged young man," but he is "dressed in brownish-orange garb, with a wreath of oak leaves. He holds the sign of Scorpio in his right hand; in his other hand, he carries a basket filled with mushrooms."[5] The color of his dress is derived from the turning of leaves during fall.

A number of suites of *The Twelve Months* are known. Complete editions including all twelve months are at Prague Castle and in the Banco de España, Madrid.[6] Three pieces, including a *September and October*, appeared on the art market in 1979.[7] Two other pieces, *January and February* and *March and April*, acquired in 1759, are at Holkham Hall, Norfolk.[8] All of these tapestries bear the signature of Gerard Peemans, one of the most important tapestry producers in Brussels around 1670 (see also cats. 19a–n, 21). The suite in Madrid and the three pieces that surfaced on the art market also bear signatures revealing the name of the designer: D[AVID] TENIERS IVN[IOR] PI[N]X[IT] and D[AVID] TENIERS IVNIOR INVE[NIT] PINX[IT]. It is not, however, immediately obvious whether "David Teniers Junior" should be identified with David II Teniers (1610–1690; see cat. 25) or his son David III Teniers.[9] As it can be assumed that the designer added "Junior" to his name to distinguish himself from his father, it is not likely that David II designed the series, for his father David I (1582–1649) was long dead when the set was created around 1675 (see below). David III, on the other hand, was developing his career while his father was still alive, which presumably inspired him to append "Junior" to his signature.

An archival document not only corroborates this thesis but also helps date the designs. In April 1675 David III Teniers wrote a letter to the Oudenaarde tapestry dealer Pieter van Verren in which he stated: "Monsieur Piemans doet Ue de hande kussen, hy heeft een stuck tappyt af van de twaelf maenden, daer ick den patroon af hebbe gheschildert, dat seer wel uyt is ghevallen, wilde wel dat Ue het saeghe." (Mister Peemans sends you his regards. He has finished a tapestry of

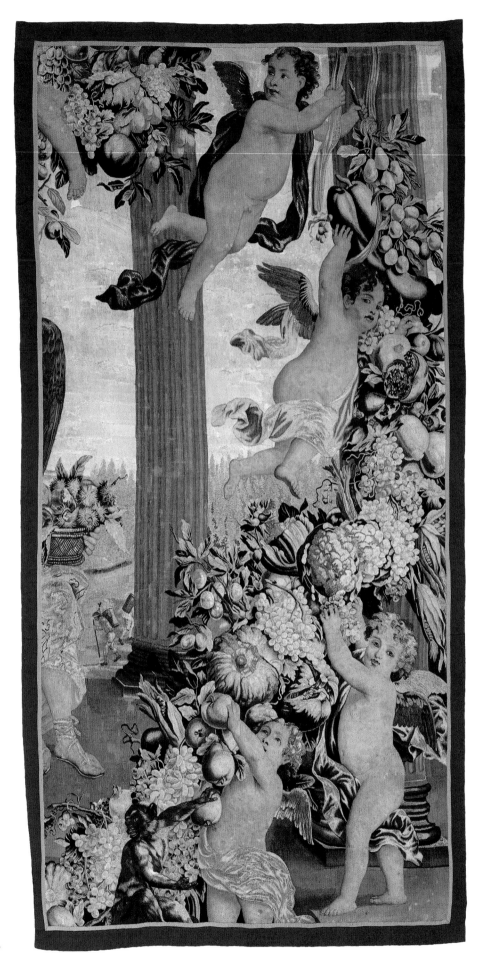

CAT. 23

the twelve months after the cartoons that I have painted. It is beautiful, and I would very much like you to see it.).[10] This quote suggests that Teniers created the series in the winter of 1674–75, shortly after he had been granted exemption from taxation on beer and wine by the Brussels city administration in recognition of his importance as a supplier of new tapestry designs.[11] Teniers's application for exemption had been supported by a number of Brussels tapestry producers, including Gerard Peemans. The professional contact between Peemans and Teniers reached a personal level in March 1675 when "David Teniers Junior" became godfather to Peemans's daughter Maria Elizabeth.[12]

Another archival document—a letter from an agent probing the Brussels tapestry market—reveals that Peemans's workshop produced the first suite of *The Twelve Months* between 1675 and 1679.[13] In 1679 this agent wrote: "L'on travaille présentement à une belle tenture pour le duc de Villa Hermosa. Ce sont les douze mois de Tenier en six pièces [...] Le duc de Pastrana en a eu la première tapisserie, qu'on a été fait, et voici la seconde fois, qu'on la fabrique." ([...] they [Peemans's weavers] are now working on a beautiful suite for the Duke of Villa Hermosa. The suite depicts the twelve months after Teniers and is comprised of six pieces [...] The Duke of Pastrana has bought the first suite that has been made, and this is the second time that it is being produced.).[14]

Peemans remained in possession of the cartoons of the *Months* until February 1711 when they, and three suites of the series, were sold at auction following his bankruptcy.[15] One edition consisted of four pieces; another suite had ten tapestries and was woven with gilt-metal thread; and the third edition, also woven with gilt-metal thread, included six pieces. The suite of ten tapestries, as well as other extant *Twelve Months* tapestries produced by Peemans from David III Teniers's designs, reveal that Peemans sometimes separated the allegorical couples to produce tapestries each showing only one personification. The Chicago piece could thus be a fragment of a tapestry that represented October alone.

The cartoons of *The Twelve Months* were bought by the leading Brussels tapestry producer Judocus de Vos (1661–1734), who also bought Peemans's cartoons of *The Story of Titus and Vespasian* at the 1711 auction (see cat. 21).[16] The *Months* series is included in an unpublished catalogue of his tapestry sets that De Vos compiled in 1727.[17] He executed at least one suite; it is now in Cernin Castle, Prague.[18] These tapestries show that De Vos hired a painter, possibly Zeger-Jacob van Helmont (1683–1726) or Jan van Orley (1665–1735), to update the designs. After the closure of the De Vos workshop around 1750 the cartoons seem to have been acquired by Daniel IV Leyniers (1705–1770), for he executed at least one edition; it is now in the Kunsthistorisches Museum, Vienna.[19] The Leyniers workshop closed in 1768 and the old-fashioned cartoons of *The Twelve Months* presumably decayed shortly thereafter.

By signing the cartoon D[AVID] TENIERS IVNIOR INVE [NIT] PINX[IT], as is revealed by the extant tapestries, David III Teniers

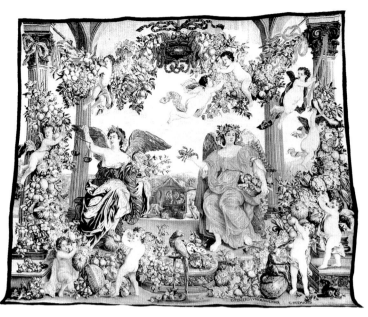

FIG. 1 *September and October* from *The Twelve Months of the Year*. After a design by David III Teniers. Produced at the workshop of Gerard Peemans, c. 1680. Wool and silk; 410 x 480 cm. Location unknown.

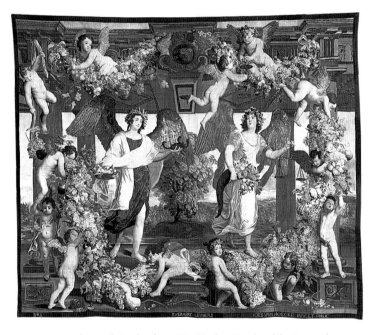

FIG. 2 *September and October* from *The Twelve Months of the Year*. After a design by Jan van den Hoecke. Produced at the workshop of Everard III Leyniers, 1650. Wool and silk; 377 x 450 cm. Kunsthistorisches Museum, Vienna, XLVII/5.

claimed that he "invented" the compositions and thus the iconographic program of *The Twelve Months*. Actually, however, he appropriated and rearranged elements from Van den Hoecke's *The Months, Seasons, Elements, Day and Night*, created twenty-five years earlier.[20] Following Ripa's iconography, Van den Hoecke depicted the abstractions as winged personifications within porticos; they carry suitable

attributes and are framed by winged putti holding garlands of flowers and fruit (fig. 2). Archduke Leopold William of Austria commissioned the series around 1647. Between approximately 1647 and 1650 a team of Antwerp painters transformed Van den Hoecke's sketches into cartoons.[21] According to David III Teniers's statement recorded in 1683, he collaborated on the cartoons of *Night*, *The Elements*, and *September and October*.[22] Van den Hoecke's set was very popular, and it can be assumed that this commercial success inspired Gerard Peemans to commission an imitation of the series from David III, a painter familiar with the original.[23]

Peemans also commissioned David III to produce the cartoons for a companion series known as *The Four Continents*.[24] Like *The Twelve Months*, *The Four Continents* shows female personifications based on Ripa's *Iconologia*. The close stylistic and iconographic parallels between the sets allowed clients to expand and customize their orders. This entrepreneurial strategy, which is typical of Peemans and other major tapestry producers (see cats. 19a–n, 21), paid off, as demonstrated by the Prague Castle suite of *The Twelve Months*, which was extended with two tapestries from *The Four Continents*.[25]

Although David III Teniers's tapestry designs still await thorough study, it is clear that he played a key role in the development of seventeenth-century Flemish tapestry. His work is in line with the French academic-classicist manner that had been introduced to Brussels tapestry designed around 1650 and that was the coup de grâce for the Flemish Baroque designs of artists such as Justus van Egmont (see cats. 18, 19a–n) and Jacob Jordaens. Teniers's rational and balanced compositions with statuesque figures harmoniously integrated into sober architectural or landscape settings also characterize *The Armorial Tapestries,* his most famous designs.[26] David III's refined style and erudite imagery heavily influenced Lodewijk van Schoor (c. 1650–1702), who created numerous tapestry sets in the last quarter of the seventeenth century, including the allegorical series *The Months* and *The Continents and Related Allegories*, which were woven by various Flemish tapissiers (see cat. 24).[27] During the same period, a number of Brussels tapestry producers executed suites of *The Seasons and Elements* and *The Four Continents* after designs by Godfried Maes (1649–1700).[28] Like Van den Hoecke's and Teniers's sets, Van Schoor's and Maes's series showed female personifications inspired by the *Iconologia*, which testifies to the continued popularity of this genre. KB

NOTES

1. Charissa Bremer-David, then Associate Curator, Sculpture and Decorative Arts, the J. Paul Getty Museum, in discussion with Christa C. Mayer Thurman, May 2004.
2. Werner 1977; Stefani 1990.
3. Praz 1975, pp. 472–75.
4. Ripa 1644, p. 320. All translations from Ripa are the author's, unless otherwise noted.
5. Ibid., pp. 320–21.
6. Blažková 1981, pp. 216–17.

7. Sotheby Parke-Bernet and Company, El Quexigal, Madrid, May 25–27, 1979, lots 461 (*May and June*), 462 (*July and August*), and 463 (*September and October*).
8. I thank Guy Delmarcel for informing me about the tapestries.
9. For David II and David III Teniers as tapestry designers, see Vlieghe 1959–60. For David II Teniers, see Davidson 1980, Klinge 1991, and Klinge and Lüdke 2005. David III Teniers's tapestry designs still await thorough study.
10. Quoted in Van Lerberghe and Ronsse 1854, p. 252, and Vlieghe 1959–60, p. 98. Translation by the author.
11. Vlieghe 1959–60, p. 96.
12. SAB, PR vol. 257 (Mar. 29, 1675).
13. The agent was Antoine Le Roy de St. Lambert, working for Count Ferdinand Bonaventura von Harrach.
14. Menčík 1911–12, p. xlii.
15. SAB, Library, File 2375/16. This same file includes a document that shows that "eene schoone ende rycke Camer Tapyten, representerende de twelf Maenden des Jaers gefabricqueert van Mr. Gerardus Peemans" (a beautiful and richly woven suite of tapestries depicting the twelve months of the year made by Gerard Peemans) was again put up for sale in Feb. 1713.
16. For De Vos, see Brosens 2002 and Brosens 2004a, pp. 117–18, 311–18.
17. The list was discovered in 1984 by the late Margaret Swain but remains unpublished. I am most grateful to Guy Delmarcel for bringing this material to my attention; a detailed study of this document is forthcoming.
18. Blažková 1981, pp. 218–20.
19. Kunsthistorisches Museum, Vienna, inv. LIII; Birk 1884, p. 172.
20. This series has been studied extensively; see Bauer 1975, pp. 55–68; Bauer and Delmarcel 1977, pp. 65–84; Bertini and Forti Grazzini 1998, pp. 136–46; Hartkamp-Jonxis and Smit 2004, pp. 131–42; and Schmitz-von Ledebur in Campbell 2007a, pp. 246–52.
21. Van den Hoecke's original 1650 designs and cartoons were in Vienna by 1659, when they were recorded in the archduke's inventory. He had purchased the *editio princeps* of the series, now in the Kunsthistorisches Museum, Vienna, invs. XLVII/1–6, XLVII*. See Bauer and Delmarcel 1977, pp. 65–84.
22. Vlieghe 1959–60, p. 101.
23. Hartkamp-Jonxis and Smit 2004, pp. 131–42.
24. Hyde 1924; Vlieghe 1959–60, pp. 88–89.
25. Blažková 1981, p. 216.
26. Delmarcel 2002, p. 349.
27. Brosens 2004a, p. 92 (with bibliography on Van Schoor).
28. Ibid., pp. 104, 134–36 (with bibliography on Maes).

Abundantia from *The Four Continents and Related Allegories*

Brussels, c. 1680–1700
After a cartoon by Lodewijk van Schoor (died 1702) and Pieter Spierinckx (1635–1711)
Produced at the workshop of Albert Auwercx (1629–1709)
SIGNED: *A · AVWERCX; L.VAN SCHOOR INV PINX*
371.2 x 382.5 cm (146⅛ x 150½ in.)
Gift of Mr. Benjamin E. Bensinger III, 1962.462

STRUCTURE: Wool and silk, slit and double interlocking tapestry weave
Warp: Count: 7 warps per cm; wool: S-ply of three Z-spun elements; diameters: 0.7–0.9 mm
Weft: Count: varies from 28 to 44 wefts per cm; wool: single S-spun elements; S-ply of two Z-spun elements; diameters: 0.2–0.8 mm; silk: pairs of S-ply of two Z-twisted elements; diameters: 0.6–0.8 mm

Conservation of this tapestry was made possible through the generosity of the Fatz Foundation.

PROVENANCE: Lewis and Simmons, London and New York, by 1914; sold to Mr. Edward Townsend Stotesbury (died 1938) and his wife Eva Stotesbury (died 1946), Philadelphia, 1915 or 1916; sold to French and Company, New York, 1925; sold to Horace Hano (died 1927), Philadelphia, 1926. Sold to Benjamin E. Bensinger III, about 1959; given to the Art Institute, 1962.

REFERENCES: Hunter 1914a, pp. 31–32, cat. 44. Hunter 1915, pp. 34–36, cat. 42. Maher 1975, p. 64.

EXHIBITIONS: Buffalo (New York) Fine Arts Academy, Albright Art Gallery, *Exhibition of Tapestries,* 1914 (see Hunter 1914a). Philadelphia, Pennsylvania Museum, *Loan Exhibition of Tapestries,* 1915 (see Hunter 1915).

ABUNDANTIA, a female personification of abundance, sits on a horn of plenty overflowing with fruit, surrounded by three female attendants. Crowned with a garland of flowers, she holds a jeweled necklace in her left hand; other riches are displayed on a table to her right. Her left foot rests on an overturned pot, which scatters its contents over a richly knotted carpet, and she extends her hand to the two attendants on her right. One of the women, a floral circlet in her hair, kneels and offers Abundance a basket brimming with flowers and fruit. The other attendant, who is black, stands behind her companion and bears a horn of plenty filled with sheaves of corn. The third consort, who is also dark-skinned, stands on Abundance's left behind the table. Wearing a feathered headdress, she displays a strand of pearls.

This depiction of Abundance is based on Cesare Ripa's *Iconologia* (Rome, 1593; see also cat. 23). It describes Abundance as a beautiful woman crowned with flowers who holds a sheaf of corn and a horn of plenty filled with fruit. In the Chicago tapestry this vocabulary is enriched by jewels, silver, and coins. Ripa's *Iconologia* also provides the key to the identity of Abundance's attendants. According to Ripa, the Asian climate was very favorable to the cultivation of fruit

and flowers; therefore, the kneeling woman crowned with a circlet of blossoms represents Asia. The black woman bearing a horn of plenty full of sheaves of grain personifies Africa; Ripa stated that Africa had two summers a year, which allowed its inhabitants to harvest repeatedly. The third attendant, who wears a feathered headdress and displays gold, silver, and pearls, can be identified as America, although in linking this continent to these precious items, the designer of the scene departed from Ripa's account, which stressed the brutality and poverty of America and its people. Europe is absent from the gathering, but it can be assumed that Abundance herself was identified with Europe, for, according to Ripa, Europe was the most fertile continent of all.

Abundantia is part of a set of *The Four Continents and Related Allegories.* The set is listed on numerous occasions in the *Memoriael Naulaerts,* the business records of the Antwerp tapestry and art dealer Nicolaas Naulaerts (died 1703) and his successors.[1] The Flemish title for this set in the *Memoriael Naulaerts* reads "Vier deelen van de weereldt met hun appendentien," and the French titles given are "Les quatre parties du monde et autres sujets" and "Les quatre parties du monde et leurs dependances"—titles that can be translated as *The Four Continents and Related Subjects* (or *Allegories*). The *Memoriael Naulaerts* reveals that the series comprised no fewer than fifteen scenes. Four of them were the continents proper: *Europe, America, Africa,* and *Asia.* The remaining "autres sujets" were female personifications of various virtues and other abstractions after Ripa's *Iconologia: Abundance, Fortitude, Fidelity, Wisdom, Magnificence, Monarchy, Nobility, Justice, Prudence, Simplicity,* and *Victory. Abundance* (i.e., *Abundantia*) was the most popular of the related allegories, which can be explained by its close iconographic ties with the core scenes of the continents.

The *Memoriael Naulaerts* also reveals the names of the designers of the series: the Brussels painter Lodewijk van Schoor—whose signature can be seen on the Chicago piece as well as on other *Continents and Related Allegories* tapestries—and the Antwerp landscape painter Pieter Spierinckx.[2] Van Schoor was registered as a master in the Brussels painters' guild in 1678. It can be assumed, however, that he had already worked as an autonomous artist prior to that date, for he was the son of a master painter and therefore not obliged to enter the guild while his father lived.[3] Since Van Schoor witnessed a legal document of the Brussels tapestry producer Erasmus IV de Pannemaker (1651–c. 1715) in 1670, it is reasonable to assume that his involvement in the industry began in the late 1660s.[4] It can also be inferred that Van Schoor became a major tapestry designer, for in 1682 he was granted exemption from taxation on beer and wine by the Brussels municipality.[5] After his house was destroyed by the French mortar attack on Brussels in 1695, Van Schoor moved to Antwerp, where he was recorded as a member of the painters' guild.

Van Schoor created at least thirteen tapestry sets. In the absence of a thorough art historical analysis of his oeuvre, these series can be tentatively divided into two groups.[6] The early group includes *The*

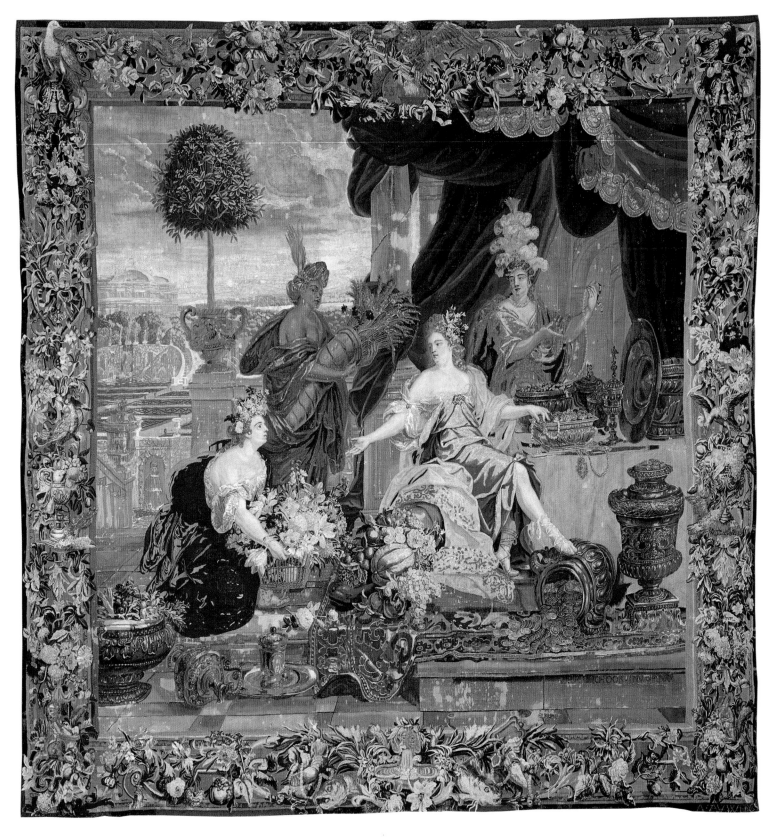

CAT. 24

Four Continents and Related Allegories and *The Allegorical Months,* mentioned by Naulaerts; *The Months or the Occupations of Man*; and *The Seasons and Elements,* woven by Jan-Frans van den Hecke (c. 1640–c. 1705); and *Verdures with Dido and Aeneas, The Story of Narcissus and Echo,* a set of *Hunts,* and *The Story of Jacob,* woven in Antwerp, Brussels, and Oudenaarde workshops in the last quarter of the seventeenth century.[7] These sets exemplify Van Schoor's early manner, characterized by elongated female personifications with small heads, long noses, and broad arms and legs. The protagonists gesture dramatically, but their poses are formulae repeated throughout the set. Thus the figures do not seem to interact.

A *Story of Alexander the Great* set, which Van Schoor himself cited in his 1682 application for fiscal privileges, may be regarded as a turning point in his style. Its cartoons were based on prints after the famous series of paintings of the Macedonian king by Charles Le Brun (1619–1690), and Van Schoor presumably profited from copying Le Brun's erudite compositions and figures.[8] The French influence can be traced in Van Schoor's later cartoons—*The Story of Perseus, Mythological Scenes, Il Pastor Fido,* and *L'Astrée*—that were probably created in the 1680s and 1690s.[9]

This chronology, which places *The Four Continents and Related Allegories* in the group of sets designed before 1682, seems at odds with Naulaerts's 1699 reference to his "nieuwen patroon" (new cartoons) of this series.[10] It can be assumed, however, that the cartoons had been previously commissioned and used by another tapestry producer or entrepreneur before Naulaerts bought them and called them new. This thesis is corroborated by the fact that two tapestries depicting *America* (Museu Nacional de Arte Antiga, Lisbon; Fries Museum, Leeuwarden) bear different dates: *1690* is inscribed on a ship's stern in the Lisbon tapestry, while the tapestry in Leeuwarden shows *1718* on the same spot. These are presumably production dates.[11]

Pieter Spierinckx, the Antwerp landscape painter recorded in the *Memoriael Naulaerts* as codesigner of *The Four Continents and Related Allegories,* played an important role in Brussels tapestry design.[12] He collaborated with Van Schoor on the cartoons of *The Story of Narcissus and Echo, The Story of Jacob, Il Pastor Fido,* and *L'Astrée,* in addition to the cartoons for *The Four Continents and Related Allegories*. In contrast to his contemporary Lucas Achtschellinck (1626–1699), whose work epitomized the monumental yet effectively decorative Brussels school of landscape painting, Spierinckx developed a spacious and pseudo-classicist approach based on the Romano-French landscape style introduced to Antwerp around 1650.[13] Spierinckx's landscapes influenced the Brussels painter Augustin Coppens (1668–1740), the most prolific landscape painter and tapestry designer of the first half of the eighteenth century (see cat. 26).

Nicolaas Naulaerts, who was an art dealer, not a workshop manager, subcontracted the weaving of his *Four Continents and Related Allegories* to various Antwerp, Brussels, and Oudenaarde tapestry producers. Like all tapestry cartoons, Van Schoor's com-

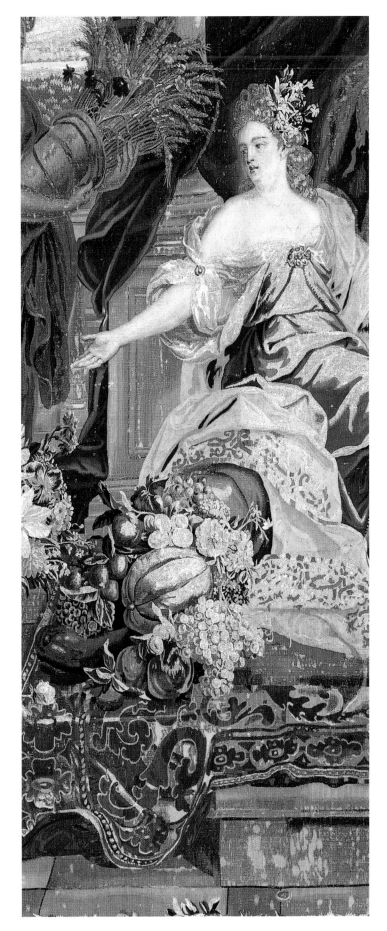

CAT. 24, DETAIL

positions were cut into strips; the *Abundantia* cartoon was cut into five strips while the larger scenes representing the continents were divided into six to eight pieces.[14] Numerous complete suites as well as single tapestries of *The Four Continents and Related Allegories* are known, including a suite encompassing *Europe, America, Africa, Asia, Abundantia,* and *Victoria* attributed to the Oudenaarde producer Alexander Baert and now in the National Museum of Ancient Art, Lisbon.[15] The fine quality of the execution of the Art Institute's tapestry, however, suggests that it was woven in Brussels. Judocus de Vos (1661–1734), by far the most important Brussels tapissier around 1700, executed pieces after Naulaerts's *Four Continents and Related Allegories* cartoons that appeared on the art market in the mid-twentieth century.[16] The *Memoriael Naulaerts*, however, demonstrates that Albert Auwercx (whose life, entrepreneurial strategy, and production are surveyed in cats. 20a–b) produced the vast majority of Brussels suites of Naulaerts's *Four Continents and Related Allegories*. A chamber that bears both Van Schoor's and Auwercx's signatures is in the Kunsthistorisches Museum, Vienna.[17] Three other tapestries (*Europe, Magnificence,* and *Faithfulness*) signed by Van Schoor and Auwercx, with borders similar to those of the edition in Vienna, surfaced on the art market in the 1970s.[18] Another suite of three pieces, *Europe, America,* and *Abundantia,* also signed by both Van Schoor and Auwercx, was sold in Berlin in 1937.[19]

The Four Continents was a very popular theme in late-seventeenth- and eighteenth-century Brussels tapestry.[20] David III Teniers (1638–1685) designed a set of four scenes that was produced by Gerard Peemans (1637/39–1725) in the last quarter of the seventeenth century.[21] Around the same time, Jacob van der Borcht (c. 1650–c. 1710) and Jan Cobus (active around 1686) wove suites of the *Four Continents* designed by the Antwerp painter Godfried Maes (1649–1700); these cartoons were bought by Urbanus Leyniers (1674–1747) around 1715.[22] While both Maes and Teniers represented each continent as a single female personification equipped with the attributes recorded in Ripa's *Iconologia*, Van Schoor modernized the iconographic program by populating each continent with a handful of women, thus introducing narrative into the traditional allegorical framework. Philippe de Hondt (1683–1741) designed yet another Brussels *Four Continents* set around 1735. He discarded the allegorical tradition and represented the continents with densely populated scenes from daily life, highly reminiscent of contemporary French *galante* painting.[23] Neither Teniers, Maes, nor De Hondt added *Related Allegories* to their *Four Continents* sets. ㅤ K B

NOTES

1. Denucé 1936, pp. 124–366, passim.
2. Ibid., p. 177.
3. For Van Schoor, see Brosens 2004a, pp. 91–94.
4. Duverger 1986b, p. 111.
5. SAB, RT 1303, fol. 304r–305r.
6. Brosens 2004a, pp. 92–94.
7. In 1706 Nicolaas Naulaerts's son wrote that "Les 4 parties du monde sont les pieces [*sic*] qu'on prend ordinairement avec les 12 mois de l'année, à cause qu'ils viennent du meme [*sic*] peintre" (*The Four Continents* are usually ordered together with *The Months*, since both sets were designed by the same artist [Lodewijk van Schoor]); Denucé 1936, p. 289. An edition kept in Prague Castle that is based on cartoons by David III Teniers, who had in turn based them on cartoons by Jan van den Hoecke (1611–1651), may be identified with Naulaerts's *Months*. See Blažková 1981, pp. 212–17, who argued that the set was designed in the Teniers workshop. Tapestries of *The Months or the Occupations of Man* are in the Bayerische Verwaltung, Munich, and the Royal Museums of Art and History, Brussels; Göbel 1922, pp. 25–26; Crick-Kuntziger 1933. Tapestries of *The Seasons and Elements* are in the Metropolitan Museum of Art, New York; the Fine Arts Museums of San Francisco; and the Royal Museums of Art and History, Brussels; Standen 1985, vol. 1, pp. 220–23; Bennett 1992, pp. 196–97; Crick-Kuntziger 1954a, pp. 98–102; Crick-Kuntziger 1956, pp. 75–76. *Verdures with Dido and Aeneas* was sold at Christie's, London, Apr. 2, 2003, lot 48.
8. For the Brussels *Alexander* sets after Le Brun, see Vanhoren 1999.
9. A suite of *The Story of Perseus* is in the Kunsthistorisches Museum, Vienna, inv. LXXVI; Birk 1884, p. 188. A tapestry from the set is in the Royal Museums of Art and History, Brussels; Crick-Kuntziger 1954a, pp. 102–06; Crick-Kuntziger 1956, p. 76. A suite of *Mythological Scenes* is in the Kunsthistorisches Museum, inv. LXXIX; Birk 1884, p. 190. See also Bauer 1991, pp. 81–85. Suites of *Il Pastor Fido* are in the Kunsthistorisches Museum, Vienna, invs. XXV, LXXX; Birk 1883, p. 236; Birk 1884, pp. 190–91. A suite of *L'Astrée* is in the Bijlokemuseum, Ghent; Desprechins 1980, pp. 26–41.
10. Denucé 1936, p. 128.
11. Kalf 1981, p. 240; Mendonça 1983, p. 45.
12. For Spierinckx, see Brosens 2004a, pp. 99–100. See also De Meûter 2003 and De Meûter 2001a. Spierinckx's style and oeuvre still await further analysis.
13. For Achtschellinck, see De Callatay 1960; Thiéry and Kervyn de Meerendre 1987, pp. 151–54; and Brosens 2004a, pp. 97–98.
14. Denucé 1936, p. 275.
15. Mendonça 1983, pp. 38–44.
16. See an advertisement in *Connoisseur* 156 (June 1964), pp. xviii–xix.
17. Kunsthistorisches Museum, Vienna, inv. LXIV; Birk 1884, pp. 178–79.
18. Vigo-Sternberg Galleries, London; files, Royal Museums of Art and History, Brussels.
19. Files, Royal Museums of Art and History, Brussels.
20. Hyde 1924.
21. Vlieghe 1959–60, pp. 88–89. An edition was formerly in the collection of French and Company; GCPA 0238143–46.
22. Brosens 2004a, p. 136. An edition signed by Van der Borcht and Cobus, formerly in the collection of French and Company, is now in the Seattle Art Museum, Washington; these pieces were illustrated in an advertisement in *Art Quarterly* 26, 1 (1963), pp. 88–89.
23. Brosens 2004a, pp. 125–26; Brosens 2006–07. See also Blažková 1971 and Swain 1982.

Brussels Teniers Tapestries

CAT. 25

Village Fete (Saint George's Fair) from a Teniers series

Brussels, c. 1710
After a design by David II Teniers (1610–1690)
Produced at the workshop of Gaspard (Jasper) van der Borcht (1675–1742)
MARKED AND SIGNED: Brussels city mark; *A.C.*
449.6 x 320.7 cm (177 x 126¼ in.)
Gift of Marshall Field and Company, 1952.1246

STRUCTURE: Wool and silk, slit and double interlocking tapestry weave
Warp: Count: 8 warps per cm; wool: S-ply of three Z-spun elements;
diameters: 0.7–1.0 mm
Weft: Count: varies from 24 to 40 wefts per cm; wool: S-ply of two Z-spun
elements; three yarns of S-ply of two Z-spun elements; diameters: 0.5–1.0
mm; silk: Z-ply of two yarns of S-ply of two Z-twisted elements; three yarns
of S-ply of two Z-twisted elements; diameters: 0.6–0.9 mm; wool and silk:
paired yarns of S-ply of two Z-spun wool elements and S-ply of two Z-twist-
ed silk elements; diameters: 0.5–0.7 mm

Conservation of this tapestry was made possible through the generosity of
the James Tigerman Estate.

REFERENCES: Mayer Thurman and Brosens 2003, pp. 180–81, fig. 9.

CAT. 26

Procession of the Fat Ox from a Teniers series

Brussels, 1729/68
After a design by Jan van Orley (1665–1735)
Produced at the workshop of Daniel IV Leyniers (1705–1770)
SIGNED: *D.L.*
388.94 x 336.55 cm (153⅛ x 132½ in.)
Gift of Mr. Charles Zadok, 1950.1637

STRUCTURE: Wool and silk, slit and double interlocking tapestry weave
Warp: Count: 6 warps per cm; wool: S-ply of three Z-spun elements;
diameter: 0.8 mm
Weft: Count: varies from 22 to 48 wefts per cm; wool: S-ply of two Z-spun
elements; diameters: 0.5–0.8 mm; silk: pairs of S-ply of two Z-twisted ele-
ments; diameters: 0.3–0.8 mm; wool and silk: three yarns, one yarn of S-ply
of two Z-spun wool elements and two yarns of S-ply of two Z-twisted silk
elements; diameters: 0.6–0.9 mm

Conservation of this tapestry was made possible through the generosity of
the James Tigerman Estate.

PROVENANCE: William Collins Whitney (died 1904), New York; possibly
given to his son, Harry Payne Whitney (died 1930), New York, by 1904, or
sold (with the rest of William Collins Whitney's estate) to James Henry
Smith (died 1907), New York, 1904, and sold to Harry Payne Whitney, 1910;
by descent to Harry Payne Whitney's widow, Gertrude Vanderbilt Whitney
(died 1942), New York; sold, Parke-Bernet Galleries, New York, Apr. 29–30,
1942, lot 143, for $1,300 to Charles Zadok (died 1984), Milwaukee;[1] given to
the Art Institute, 1950.

Village Fete (Saint George's Fair) and *Procession of the Fat Ox* are two
Brussels examples of the eighteenth-century European vogue for tap-
estries depicting country life, now known as Teniers or Tenières. The
genre was named after the seventeenth-century Flemish artist David
II Teniers, who was known as a painter of *boerkens* (peasants) and
village feasts, and whose sympathetic depiction of rural life distin-
guished his work from traditional approaches to the genre.[2] Archival
evidence indicates that Teniers himself designed a tapestry set show-
ing rural scenes that was woven in Brussels.[3] This series, of which *Vil-
lage Fete* is a part, as well as the artist's paintings and prints, inspired
tapestry designers throughout Europe to create similar sets.[4] In the
eighteenth century, hundreds of Teniers were produced in tapestry
workshops in Aubusson, Beauvais, Fulham, Lille, Madrid, and Soho.
Nowadays, Teniers appear regularly on the art market and figure in
all major tapestry collections.

In 1932 the English tapestry connoisseur and director of the Mer-
ton Abbey Tapestry Works Henry Currie Marillier (1865–1951; see
cat. 59) categorized the numerous Teniers tapestries into distinct
series and attributed production of suites of these sets to various
workshops in multiple countries.[5] He demonstrated that Brussels,
where Teniers were woven in no less than seven workshops, was the
main production center for the genre. Despite Marillier's findings
and the work of subsequent scholars, Brussels Teniers continue to
challenge art historians, for many individual pieces and entire suites
do not fit Marillier's classifications, thus presenting attribution and
dating puzzles.[6] A recent study of eighteenth-century Brussels tapes-
try, however, sheds fresh light on the genre. Not only does it present
new data on the designers and workshops, it also provides insights
into the configuration of the industry, information critical to resolv-
ing the problems the Teniers tapestries pose.[7]

Village Fete shows a group of peasants and townspeople partaking
in a feast in front of houses and a tavern identified as the Half Moon
by the sign hanging from its side. In the center of the tapestry, a man
standing on a barrel plays a bagpipe while a young couple dances.
To the right, near the tavern, revellers seated at crowded tables eat
and drink merrily. On the left, several couples leave the celebration,
while in the foreground, another musician sits on a barrel, playing a
hurdy-gurdy to an audience of five children. A flag fluttering from
the attic window of the tavern depicts Saint George, the patron saint
of agricultural workers, an indication that the festivities are taking
place on his saint's day, April 23.

The tapestry belongs to the Teniers set designed by David II
Teniers himself that inspired the genre: a nearly identical tapestry
in Farmleigh House, Dublin, is inscribed *D. TENIERS SERE*[N]

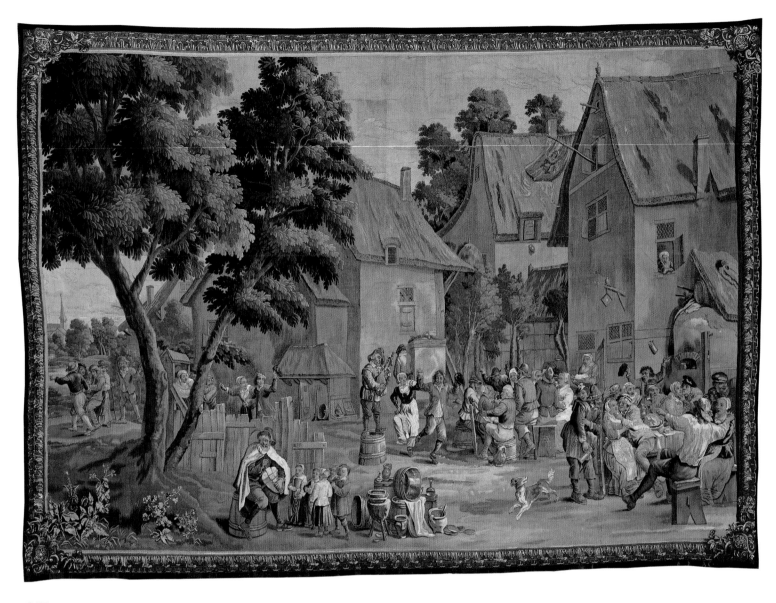

CAT. 25

ISS[IMO] II LEOPOLDO ARCHIDVCI IOANNI AVSTRIACO PICTOR FAM[I]LIA[R]IS ETVTRI[VS]Q[VE] ACVBICVLIS PINX.[8] It states that the tapestry was made by Teniers, court painter and "ayuda de camera" (chamberlain) to Archduke Leopold William of Austria and to Don John of Austria, governors of the Southern Netherlands from 1648 to 1656 and 1656 to 1658, respectively.[9] Teniers's set comprised nine scenes. The suite to which the Dublin *Village Fete* belonged originally consisted of eight pieces. Two, *Return from the Harvest* and *Milking Scene*, are also at Farmleigh House; the present location of the remaining five—*Gypsy Fortune Teller*, *Pig Killing (Winter)*, *Fish Quay*, *Shepherds Resting*, and *Hunters Resting*—is unknown.[10] An edition in the Bayerische Verwaltung, Munich, includes the ninth composition, *Game of Bowls*.[11]

The inscription on the Dublin *Village Fete* reveals that the designs postdate Teniers's 1656 appointment as court painter to Don John. Neither archival documentation nor the stylistic features of the scene allow the date to be pinpointed more precisely, but the tapestry's bor-

der may provide a clue. The repeating pattern of alternating acanthus leaves and flowers on a brown ground can be regarded as a transitional type between the colorful garland and fruit borders popular around 1660 and the stylized picture frame borders that increased in popularity starting around 1700. Thus the Dublin *Village Fete* was probably woven around 1680, a date that is corroborated by the inclusion of the arms of Count Filippo Archinto of Milan (1644–1712) in the upper border. Archival evidence and other tapestries show that in the early 1680s the count was an avid collector of Brussels tapestries, in particular those after designs by the Teniers family: in 1681 he bought a tapestry designed by David II's son David III (1638–1685) that depicted the Archinto coat of arms, and an unpublished document indicates that in 1683 the "comte Arquinto" planned to commission a suite of *Landscapes with Animals and Figures* "wijlen den ouden Teniers" (designed by the late Teniers the Elder), who can be identified as the landscapist David I (1582–1649), father of David II.[12] The signature, border, and coat of arms of the Dublin tapestry,

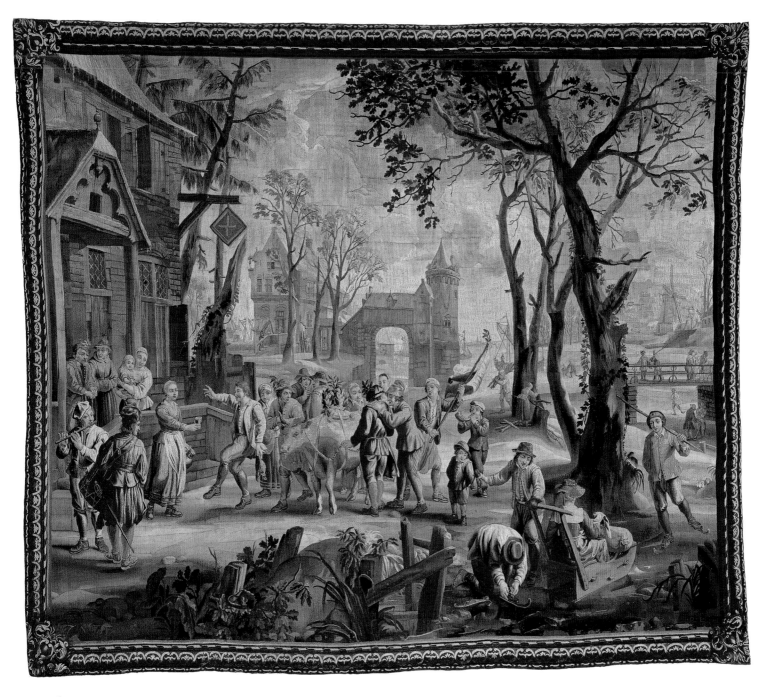

CAT. 26

therefore, suggest that David II Teniers designed the set to which it belongs between 1656 and approximately 1680.

But where and when was *Village Fete* woven? The *A.C.* signature in the lower selvage of the piece reveals that it was made in the "A Castro" workshop in Brussels. This is the Latin translation of the Flemish name Van der Borcht ("from the fortress"). It was used by both Jacob van der Borcht (c. 1655–1693) and his son Gaspard (Jasper) van der Borcht—who coproduced and cosigned his sets with Hieronymous Le Clerc (1643–1722)—to distinguish themselves from their competitor of the same name, the Brussels tapissier Jacob van der Borcht (c. 1650–c. 1710).[13] Because both father and son used the *A.C.* signature, this mark does not permit assigning a specific date to *Vil-*

lage Fete. The picture-frame border, however, sheds some light on the issue. It is a type commonly associated with tapestries produced after 1700. Other tapestries coproduced by Van der Borcht "A Castro" and Le Clerc include a similar border, indicating that this design was especially popular during the first decades of the eighteenth century. At least two suites of *The Art of War*—a set designed by Lambert de Hondt (c. 1655–1708) that depicts aspects of contemporary warfare—have the same border, embellished by coats of arms or military equipment in the center of the vertical borders.[14] Both editions were commissioned around 1710 by English generals to commemorate their successful campaigns in Flanders during the War of the Spanish Succession (1702–13).[15] Furthermore, since *Fish Quay* (fig. 1), a

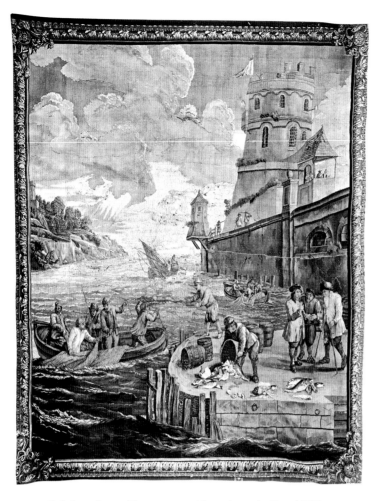

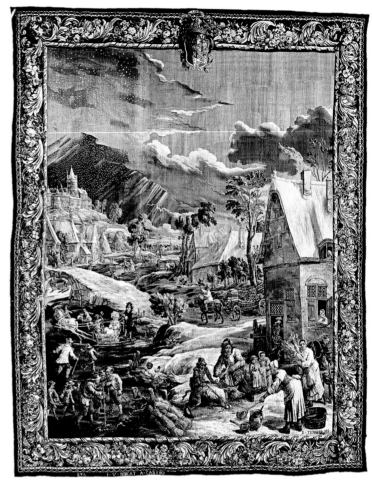

FIG. 1 *Fish Quay* from a Teniers series. After a design by David II Teniers. Produced at the workshop of Hieronymous Le Clerc. Wool and silk; 300 x 243 cm. Location unknown.

FIG. 2 *Pig Killing (Winter)* from a Teniers series. After a design by David II Teniers. Produced at the Van der Borcht workshop. Wool and silk; 408.9 x 330.2 cm. Location unknown.

Teniers tapestry signed *LE CLERC* that was recently on the art market, features the same border and is about the same height as *Village Fete*, it is thus very likely that both tapestries were part of the same edition.[16] Given that Le Clerc died in 1722, this suite must have been woven by 1722 at the latest.

Compositional features of the scene corroborate the theory that *Village Fete* was woven around 1710. In addition to its close resemblance to the Dublin version, which was most likely woven in the early 1680s, the piece is also similar to a tapestry that was part of a suite commissioned from Van der Borcht "A Castro" and Le Clerc in 1701.[17] On the other hand, the composition of the Chicago tapestry differs from various versions that were also woven in the "A Castro" workshop after about 1725. In the latter pieces, the hurdy-gurdy player and children have been shifted to the extreme right, a veranda has been added to the tavern, a number of houses have been eliminated, and David II Teniers's signature has been omitted.[18] These and other alterations to the original designs can be regarded as the result of repairs made to the prototypes, which were highly successful and thus heavily worn, or as compositional modernizations introduced to reduce production time and cost. *Village Fete* therefore reflects

Teniers's original design and thus belongs to the group of tapestries produced in the late seventeenth or early eighteenth century.

Teniers's bucolic tapestry set, as well as his numerous paintings of similar scenes now in public and private collections throughout Europe and the United States, stress the rustic charm of the countryside and the unrefined but basically kind nature of its inhabitants.[19] The masterly rendering of the settings reinforces the impression that the Flemish peasantry lived in Arcadia. *Pig Killing (Winter)*, for example, is an atmospheric and vibrant tableau full of detail (fig. 2). In the right foreground, a family is about to slaughter a pig; on the left, people skate and sled on a frozen pond; in the middle, a man drives a cart; and in the background are a village and a walled town. By focusing sympathetically on the virtuous simplicity and happiness of rural life, Teniers, along with other artists of his time, diverged from conventional depictions of peasants. These traditional *boerkens*, popular in Flemish, French, and German art from about 1450, represent peasants dancing, brawling, and making merry. Examples include numerous fifteenth-century tapestry sets and the work of Pieter Bruegel. It has been argued convincingly that from the fifteenth to the first half of the seventeenth centuries these depic-

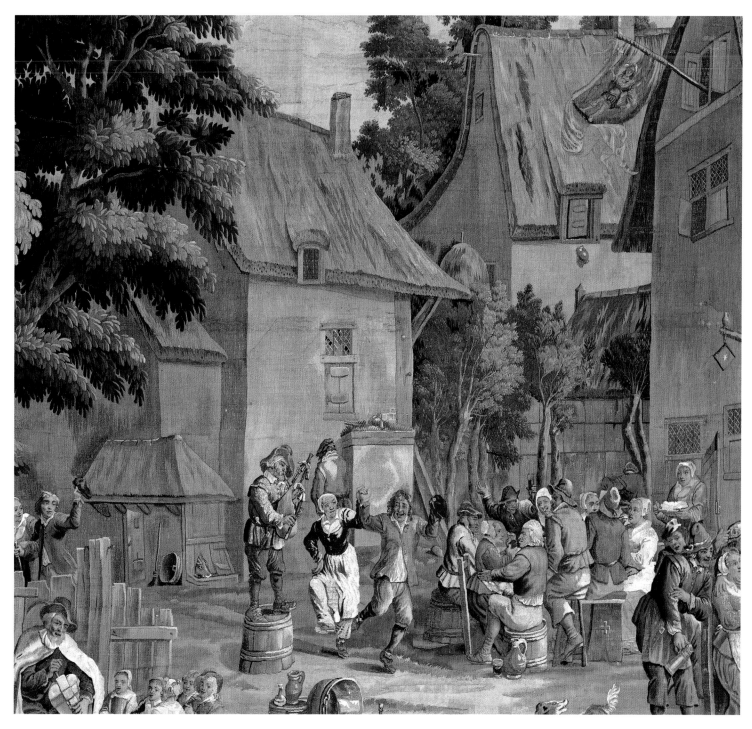

CAT. 25, DETAIL

tions helped the upper-class patrons who commissioned them establish a self-image in opposition to the purported carnality, stupidity, and gluttony of the rural populace.[20] Around 1650, however, Flemish artists like Teniers began to depict peasants in a more positive light, leading orderly and moderate lives.[21]

David II Teniers's set of *boerkens* inspired the production of numerous similar works in Brussels that flooded the European tapestry market in the first half of the eighteenth century. The major Brussels tapestry entrepreneur Judocus de Vos (1661–1734) produced a series very close in design to Teniers's original, and his sale catalogue

included another set of Teniers designed by an unknown painter that offered variations on the original's scenes: *Village Fete, Fish Quay, Return from the Harvest, Hunters Resting, Game of Bowls, Shepherds Resting,* and *Open-Air Players.*[22] Hendrik II Reydams (1650–1719) also wove Teniers tapestries, presumably after designs by Ignatius de Hondt (c. 1675–1710), a lesser-known Brussels painter, though only one, *Fish Quay,* on the art market in 1998, can be attributed securely to the Reydams workshop.[23] Peter van den Hecke (c. 1675–1752) produced Teniers suites as well. The designs, recently attributed to Ignatius de Hondt's younger brother Philippe (1683–1741), included,

among other scenes, *Village Fete, Return from the Harvest, Fish Quay, Pig Killing (Winter)*, and *Pastures*.[24] Meanwhile, the Van der Borcht "A Castro" workshop added scenes to the set created by Teniers that had sparked the trend, and commissioned new designs from the painter Thibaud Michau (1676–1765).[25]

Three more Brussels Teniers may be added to this plethora of different, but closely related, eighteenth-century ensembles. Urbanus Leyniers (1674–1747), who directed a major tapestry workshop beginning in 1712, included no less than four Teniers sets in his sale catalogue.[26] One of these was presumably the set designed by Ignatius de Hondt and originally produced by Reydams around 1700, for the latter became Leyniers's partner in 1712 and put some of the designs he owned at the disposal of the merged workshop. Leyniers also owned a set of Teniers cartoons that were created around 1717 by Jan van Orley (1665–1735) and the landscapist Augustin Coppens (1668–1740), and the designs for another set painted by Zeger-Jacob van Helmont (1683–1726) and Coppens before 1728.[27] The fourth and final Teniers in Leyniers's possession was designed by the obscure Brussels painter Nicolaas de Haen; according to an inventory recorded after Leyniers's death, this suite was "naer d'originele boeren van d'hr Jan van Orleij" (after the original peasants by Mister Jan van Orley).[28] This wording unfortunately fails to make clear whether De Haen's designs were mere copies of Van Orley's originals, or if he had created his own compositions in emulation of Van Orley's designs. After the Leyniers workshop closed, on Christmas Eve 1768, some of the Van Orley and Van Helmont Teniers designs were acquired by the Van der Borcht "A Castro" workshop, which continued to produce tapestries until the end of the eighteenth century.[29]

The second Teniers tapestry in the Chicago collection, *Procession of the Fat Ox*, offers a lively and rare snapshot of early modern European folk culture.[30] It shows a group of peasants and townspeople leading a fat white ox bedecked with garlands through a village in celebration of Shrove Tuesday. A piper, a drummer, and a dancing man head the procession as it passes a tavern called the Sign of the Cross. A barmaid offers the dancer a drink. On the right, a man sits on the edge of a frozen canal, tying on his skates, while another man prepares to push a woman in a sled. A third man already skates over the ice. Following such parades, the ox, as well as other animals, would be butchered so that everyone could enjoy a last, sumptuous meal before Lent, the forty-day period of prayer, contemplation, and fasting preceding Easter.

The *D.L.* mark in the tapestry's lower right corner indicates that it was woven in the Leyniers workshop, for this is the signature of Urbanus's son Daniel IV (1705–1770), who in 1729 started to weave tapestries in collaboration with his father. On December 31, 1744, the senior Leyniers renounced his share in the workshop, whereupon his son produced tapestries until December 24, 1768, when the workshop closed. This implies that tapestries signed V[RBANUS].LEYNIERS D[ANIEL].L or V.L.D.L. can be dated between 1729 and 1744, and those bearing only Daniel's mark, such as the Art Insti-

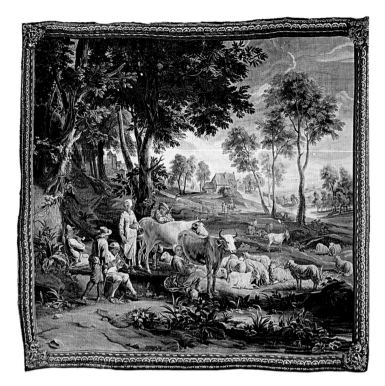

FIG. 3 *Milking Scene* from a Teniers series. After a design by David II Teniers. Produced at the Leyniers workshop. Wool and silk; approx. 360 x 340 cm. Location unknown.

tute's piece, must have been produced between 1729 and 1768.

Procession of the Fat Ox is part of a Teniers set that has at least six episodes. Two Teniers tapestries that were on the American art market in the first half of the twentieth century presumably belong to the same suite as *Fat Ox*: *Milking Scene* (fig. 3), which like the Art Institute's piece was once in the collection of Harry Payne Whitney, and *Fish Quay* (fig. 4), signed *D.LEYNIER*.[31] The borders are identical, and all three pieces are approximately the same height and exhibit similar stylistic features. Consequently, it may be concluded that they were all created by the same designer. Another version of *Fish Quay*, also signed by Daniel IV Leyniers, appeared on the art market in 1999 together with three companion pieces (*Gypsy Fortune-Teller, Hunters Resting*, and *Fruit and Vegetable Market*), which permits the identification of six of the pieces of the same Teniers set.[32]

Is it possible to attribute this ensemble—including the Art Institute's *Fat Ox*—to one of the painters who designed Teniers that were woven by the Leyniers? De Hondt and Van Helmont can be eliminated, since each designed other *Fish Quay* scenes.[33] Therefore, *Fat Ox* must be assigned to either Van Orley or De Haen. The archival evidence is inconclusive. The *Mémoire de Góis*, a unique eighteenth-century document that surveys the sets sold by the Leyniers workshop between 1712 and 1734, records nine different subjects painted by Van Orley: *Ball Game, Fish Quay, Fruit and Vegetable Market, Gypsy Fortune-Teller, Hunters Resting, Milking Scene, Peasants' Household, Return from the Harvest*, and *Village Fete (Wedding Feast)*.[34] Since this inventory lists neither *Fat Ox* nor any other titles that could possibly describe the piece, such as *Winter Scene*, one might think the

Chicago tapestry must have been designed by De Haen. Other documents, however, demonstrate that Van Orley's Teniers set included a winter scene. According to early-eighteenth-century correspondence in a Belgian private collection, Leyniers sold nine Teniers designed by Van Orley, including one depicting "l'Hiver" (Winter) to one Archdeacon Clercx, who was living in Liège in 1725.[35] This edition is also recorded in the *Mémoire de Góis*, but the entry is jotted in the margin and contains neither an attribution to Van Orley nor an enumeration of its subjects.[36] Together with three other pieces that were part of this suite, *Winter* remained in the Château d'Aigremont, Liège, until the 1970s; its present location is unknown. Since no photographs of *Winter* exist, we cannot definitively identify it with *Fat Ox*.[37] Nonetheless, the scene's animated yet harmonious composition and its inclusion of stock figures such as the barmaid are echoed in the *Story of Don Quixote*, a tapestry set Van Orley designed around 1714.[38] On this basis, *Fat Ox* can be attributed to him.

Van Orley was by far the most prolific Flemish tapestry designer in the first half of the eighteenth century. No fewer than fifteen sets—woven in the Le Clerc, Van der Borcht, Van den Hecke, Leyniers, and De Vos workshops—can be assigned to him.[39] Coppens created the landscapes for all these series, and his compositional formulae, which evince a concern for spaciousness and depth, set the tone for what one might call the Indian summer of Brussels tapestry production.[40] As attested by drawings such as *Brussels Ruined by the French Mortar Attack in 1695*, Coppens was an assiduous topographer.[41] The town gate that serves as the focal point in *Fat Ox* and the house in the background of the composition resemble buildings that actually existed on the city's boundary, as recorded in a drawing from Remigio Cantagallino's *Thirty-three Topographical Views of Brussels and Surroundings*, now in the Musées Royaux des Beaux-Arts de Belgique, Brussels.[42] Such precision, however, was sacrificed to compositional imperatives, as Coppens's concern to create a well-balanced image prompted him to rearrange the buildings.

While dozens of Leyniers Teniers are known, *Fat Ox* pieces are extremely rare. Apart from the Chicago version, only one other *Fat Ox*, which is signed by Urbanus Leyniers, can be identified.[43] The tapestry is mentioned only once in the documents concerning the workshop's production; "Le Boeuf gras" was one of the five Teniers tapestries that the municipality of Brussels ordered from Daniel IV Leyniers in 1748 as a gift for Maurice de Saxe, commander of the French troops that conquered Brussels.[44] In December 1751, after the French had turned Brussels over to the Austrians, this set was presumably auctioned off in the city. The *Fat Ox* in the Art Institute cannot be identified as this tapestry ordered in 1748, for the width of the latter (about 505 cm) is larger than that of the former (334 cm).[45]

The theme of the procession of the ox was not part of other Teniers sets made in Brussels. An anonymous tapestry of that subject and a companion piece, *Peasants Seated at a Table (Interior of a Tavern)*, both now in the Würtembergisches Landesmuseum, Stuttgart, have been attributed to Peter van den Hecke, even though this attribution

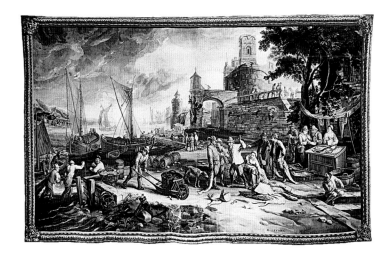

FIG. 4 *Fish Quay* from a Teniers series. After a design by David II Teniers. Produced at the workshop of Daniel IV Leyniers. Wool and silk; approx. 340 x 538 cm. Location unknown.

is supported neither by archival documentation nor by signatures on these or related pieces.[46] The two tapestries may actually be related to Teniers sold by the Naulaerts firm of Antwerp, one of the leading tapestry dealers in the Southern Netherlands around 1700. In 1707 the firm delivered an edition of "les paysans" (the peasants) comprising six tapestries, including a tapestry "où l'on mène le beuf engraissez et les paysans grillent a sandales sur la glace" (on which the fat ox is led [by people] and [on which] peasants are ice-skating" and a tapestry "où l'on est à table et se rejouissent" (on which they are seated at a table and have fun).[47] KB

NOTES
1. Annotated sale catalogue in Ryerson Library, the Art Institute of Chicago.
2. For Teniers, see Davidson 1980, Klinge 1991, and Klinge and Lüdke 2005.
3. De Raadt 1894, p. 85.
4. De Ghellinck d'Elseghem 1994, pp. 71–75, demonstrated that a painting by Teniers now in the State Hermitage Museum, St. Petersburg, served as a model for tapestry designers in Aubusson, Brussels, and Madrid.
5. Marillier 1932a.
6. These include, among others, Standen 1985, vol. 1, pp. 228–30; Campbell 1995; and Hartkamp-Jonxis and Smit 2004, pp. 160–66.
7. Brosens 2004a, pp. 140, 160–65.
8. The tapestry in Farmleigh House is on loan from the Beneficiaries of the Third Earl of Iveagh Estate and Will Trust. I am grateful to Julia Cummins of the Library, Farmleigh House, Castleknock, Dublin, for this information. See also Marillier 1932a, pp. 4–9, pl. 1. The Latin *ACVBICVLIS* possibly refers to one of the numerous organizational functions that Teniers fulfilled at the court; see Welzel 2006, pp. 633–34.
9. Curiously, Göbel 1923, p. 396, contended that this set was designed by Jan van Orley. Vlieghe 1959–60, p. 88 n. 37, however, doubted Göbel's assertion. A version of *Fish Quay* that was in Dresden and presumably destroyed during World War II bore a similar signature (Göbel 1923, p. 398). For Teniers as a court artist, see Vlieghe 1961–66 and Welzel 2006.
10. *Gypsy Fortune-Teller* was still at Farmleigh House in 1932. The remaining four tapestries were sold at Christie's, London, Mar. 14, 1929, from the collection of the Earl of Crawford. In the 1930s, they were in the possession of the New York dealer French and Company. See Marillier 1932, pp. 4, 9.

11. Bayerische Verwaltung, Munich, inv. BNS-W-9.

12. For Count Archinto's purchase of a tapestry depicting his family's coat of arms, see Göbel 1929, vol. 2, fig. 186. For his plan to commission a suite of *Landscapes with Animals and Figures*, see ARAB, NGB 2058/1, notary Johannes Morren (Mar. 4, 1683).

13. For the Le Clerc family and the Van der Borcht/Le Clerc production network, see Brosens 2004a, pp. 118–20, 321–22, and Brosens 2005a, pp. 69–70. For the Van der Borcht families, see Brosens 2004a, pp. 118–20, 123–27, 344–50.

14. Wace 1968, pp. 29–59.

15. Ibid., pp. 52–53.

16. Prior to 1941 *Fish Quay* (300 x 243 cm) was in the collection of Lady Ravensworth, Durham. In 1941 the piece was with French and Company, New York. A third tapestry with identical borders, *Hunters Resting* (300 x 290 cm), was in the stock of the Antwerp dealer Blondeel in 1993.

17. The suite is now in Schloss Mannheim, invs. G 7686–G 7689; see Wiese 2002b and Lüdke 2005, pp. 348–57. The Art Institute's *Village Fete* is also very similar to a *Village Fete* belonging to an edition thought to have been commissioned from Van der Borcht "A Castro" and Le Clerc by Maximilian II Emanuel of Bavaria, governor of the Southern Netherlands from 1692 to 1699 (Bayerische Verwaltung, Munich, inv. BNS-W-8–11); photographs of the suite are in the files of the Royal Museums of Art and History, Brussels.

18. One such piece is inv. LI/5 in the Kunsthistorisches Museum, Vienna; this tapestry was destroyed by fire in 1992. The edition was signed by Jasper's son Jan-Frans van der Borcht (1697–1774). See Birk 1884, p. 171. A further example is inv. 1998 in the Royal Museums of Art and History, Brussels. See Crick-Kuntziger 1956, p. 86. Another example recently surfaced on the art market at Christie's, London, Dec. 14–15, 2005, lot 353.

19. See, for instance, Klinge 1991, cats. 24, 28, 43, 50, 62, 63, 72, 88.

120. Vandenbroeck 1987, pp. 63–116. See also Miedema 1977, which criticized Alpers 1972–73, which contended that such depictions were conceived for the relaxation and amusement of the viewer.

21. Vandenbroeck 1987, p. 108.

22. Marillier 1932a, pp. 12–25. For De Vos, see Brosens 2002 and Brosens 2004a, pp. 117–18, 311–18.

23. For Reydams's tapestries likely after De Hondt's designs, see Brosens 2004a, p. 223. Marillier 1932a failed to list Reydams among the Brussels tapissiers producing Teniers sets. For Ignatius de Hondt, see Brosens 2006–07. The *Fish Quay* that can be securely attributed to the Reydams workshop was sold at the Hôtel des Ventes de Neuilly, Dec. 13, 1998, lot 243 (267 x 395 cm); see also Brosens 2004a, p. 140.

24. For the Van den Hecke Teniers, see Wauters 1878, pp. 356–57, and Brosens 2006–07.

25. For an example of an edition that consists of both old designs by David II Teniers and new scenes, see inv. LI in the Kunsthistorisches Museum, Vienna, which is signed by Jan-Frans van der Borcht; Birk 1884, p. 171. For a survey of scenes painted by Michau, see Denucé 1936, pp. 396–97.

26. For the Leyniers workshop, see Brosens 2004a.

27. Ibid., pp. 160–65. For the set designed by Van Helmont, see Hartkamp-Jonxis and Smit 2004, pp. 160–66.

28. ARAB, NGB 6718, notary Jan-Baptist Jacobi (Apr. 15, 1747); published in Brosens 2004a, p. 278.

29. See Bennett 1992, pp. 207–17, which discusses four Van Helmont scenes woven by Jacob van der Borcht (died 1794), who also signed a tapestry of *Hunters Resting* that had been woven previously in the Leyniers workshop; see Sotheby's, London, Dec. 12, 2001, lot 22.

30. Grauls 1957–58. Only one painting depicting the scene is known: Mathijs Schoevaerdts's *Procession of the Fat Ox,* inv. 179, in the Musées royaux des Beaux-Arts de Belgique, Brussels (43.5 x 61 cm); Pauwels 1984, p. 268 (ill.).

31. When the Payne Whitney collection was sold in 1942, French and Company acquired *Milking Scene* (approx. 360 x 340 cm) and sold it two years later. *Fish Quay* was also formerly with French and Company, New York (approx. 340 x 538 cm). This piece—apparently identical to the *Fish Quay* that was in the stock of the Parisian tapestry dealer Boccara (330 x 525 cm)—is illustrated in Musée Jacquemart-André 1984, p. iii. The same border appears on a *Milking Scene* that was signed by Urbanus and Daniel IV Leyniers (formerly in the collection of the London dealer C. John; 282 x 239 cm); see the advertisement in *Apollo* 119, 268 (June 1984). The height of the latter tapestry indicates that it belongs to another edition.

32. Christie's, London, Mar. 25, 1999, lots 184–87.

33. For the De Hondt version, see Hôtel des Ventes de Neuilly, Dec. 13, 1998, lot 243 (267 x 395 cm); Brosens 2004a, p. 140. For the Van Helmont *Fish Quay*, see Hartkamp-Jonxis and Smit 2004, pp. 160–66.

34. Brosens 2004a, pp. 160–65.

35. Van de Casteele 1883.

36. The original French reads "9 pieces de fin teniers pour clers escolatres de liege haut 4. au cours 27 sans bord" (nine pieces of fine Teniers for arch deacon Clercx from Liège, 4 ells high, 27 wide, without borders); see Brosens 2004a, p. 256.

37. *Winter Scene* was exhibited in Liège in 1881; see Liège 1881, pp. 153–55. The catalogue includes neither a photograph nor a description of the piece. There is also no illustration in Demarteau 1881, p. 263. I am grateful to Anne Renard-Ortmans of the Château d'Aigremont for providing me with information on the edition.

38. For this set, see Brosens and Delmarcel 1998.

39. Brosens 2004a, pp. 102–04, 116–26, 380; Brosens 2005c.

40. Brosens 2004a, pp. 96–100. See also Pierard-Gilbert 1964.

41. Coppens's drawings were engraved by Jan van Orley's brother Richard (1663–1732). For the drawings and prints, see Jacobs 2004, pp. 37–43.

42. Van de Kerckhof in Bussers 2000, p. 224, fig. 107.

43. Sotheby's, London, June 26–28, 2001, lot 285 (330 x 480 cm). This piece is now in the Walters Art Gallery, Baltimore.

44. Wauters 1878, pp. 363–66.

45. "Le Boeuf gras, de 7 ¼ aunes […] sur 5 de haut" (The Fat Ox, 7 1/4 ells […] by 5 high); Wauters 1878, p. 366. One *aune* is 69.56 cm; see Doursther 1840, p. 33.

46. Wiese 2002b. See also Marillier 1932a, pl. 43, and Göbel 1923, vol. 2, fig. 312. According to an eighteenth-century list of the tapestries produced by Van den Hecke, *Procession of the Fat Ox* was not part of his Teniers set; see Wauters 1878, pp. 356–57.

47. Denucé 1936, p. 324.

Mythological Tapestries from the Wauters Workshop, Antwerp

CAT. 27

Pygmalion from *Stories from Ovid*

Antwerp, c. 1675
After a design probably by Daniel Janssens (1636–1682)
Produced at the Wauters workshop
500.3 x 210.8 cm (196⅞ x 83 in.)
Gift of Mrs. Arthur Cutten, 1953.303

STRUCTURE: Wool and silk, slit and double interlocking tapestry weave
Warp: Count: 6 warps per cm; wool: S-ply of three Z-spun elements; diameters: 0.7–1.0 mm
Weft: Count: varies from 16 to 32 wefts per cm; wool: pairs of S-ply of two Z-spun elements; diameters: 0.6–1.2 mm; silk: pairs of S-ply of two Z-twisted elements; diameters: 0.7–1.0 mm

Conservation of this tapestry was made possible through the generosity of Nathalie W. Alberts.

REFERENCES: Hefford 1983, pp. 93–117, fig. 9. Heinz 1995, pp. 77–78, fig. 24.

EXHIBITIONS: Art Institute of Chicago, *Tapestries from the Permanent Collection*, 1979.

CAT. 28

Orpheus Playing the Lyre to Hades and Persephone from *Orpheus and Eurydice* or *The Metamorphoses*

Antwerp, c. 1685
After a design probably by Peter Ykens (1648–1695) and Pieter Spierinckx (1635–1711)
Produced at the Wauters workshop
SIGNED: *M.W.*
328.14 x 299.09 cm (129³⁄₁₆ x 117¾ in.)
Gift of Marshall Field and Company, 1952.1245

STRUCTURE: Wool and silk, slit and double interlocking tapestry weave
Warp: Count: 7 warps per cm; wool: S-ply of three Z-spun elements; diameters: 0.8–1.0 mm
Weft: Count: varies from 18 to 40 wefts per cm; wool: S-ply of two Z-spun elements; pairs of S-ply of two Z-spun elements; diameters: 0.4–1.1 mm; silk: Z-ply of two S-twisted elements; diameters: 0.4–0.8 mm.

Conservation of this tapestry was made possible through the generosity of the James Tigerman Estate.

REFERENCES: Hefford 1983, p. 99. Heinz 1995, p. 74. Mayer Thurman and Brosens 2003, p. 174, fig. 3.

EXHIBITIONS: Art Institute of Chicago, *Tapestries from the Permanent Collection*, 1979.

Pygmalion and *Orpheus Playing the Lyre to Hades and Persephone* are typical examples of late-seventeenth-century tapestries depicting mythological scenes in wooded or parklike settings.[1] From about 1660, these immensely popular light-hearted and slightly erotic mythological sets, usually depicting stories from Ovid's famous *Metamorphoses* (before A.D. 8), were the lifeblood of the majority of Flemish and French workshops. The limited color range of these fashionable series and the absence of intricate large-scale figures made them less costly to execute than history sets. Antwerp and Oudenaarde tapissiers in particular focused on this genre.

Both tapestries were produced at the Wauters workshop, the leading tapestry firm in Antwerp during the second half of the seventeenth century.[2] In 1660 Michiel Wauters (died 1679) and his brother Philip (died 1679 ?) succeeded their late father Jacob as directors of the company. Presumably both Michiel and Philip died in 1679. Michiel's daughter Maria Anna was subsequently appointed head of the firm and formed a partnership with her brothers-in-law Cornelis de Wael (died 1723) and Jeremias Cockx. The Wauters workshop, directed by various boards, operated until 1703, when it was declared bankrupt.

Two contemporary documents that were published in the first half of the twentieth century shed light on the company's operations and production: Michiel Wauters's probate inventory recorded in 1679 and the *Memoriael Wauters-Cockx-De Wael*, a ledger of the firm's business activities between 1682 and 1703.[3] Both the inventory and the ledger show the workshop to have had an impressive and varied body of cartoons and a vast international commercial network with representatives in numerous countries, including Austria, England, France, Germany, Italy, Portugal, Spain, and Sweden. These valuable assets ensured the omnipresence of the Wauters firm's production on the European market.

Drawn by the ready availability of rich archival material, the importance of the Wauters workshop, and the wide dispersal of its suites and individual tapestries, art historians have paid considerable attention to the firm and its production.[4] The mythological tapestries woven by the company, however, remain unexplored, with the exception of *Pygmalion*, which was the subject of a pioneering and thorough study by Wendy Hefford, published in *Museum Studies*, the Art Institute of Chicago's journal, in 1983.[5] In fact, the overwhelming majority of late-seventeenth-century mythological tapestries, whether woven in Antwerp, Brussels, Oudenaarde, or another center, still await proper examination, for the numerous obstacles to assigning correct attributions and manufacture dates make them less appealing objects of study. The entrepreneurial strategies developed by tapissiers and art dealers from about 1650 on blurred the borders

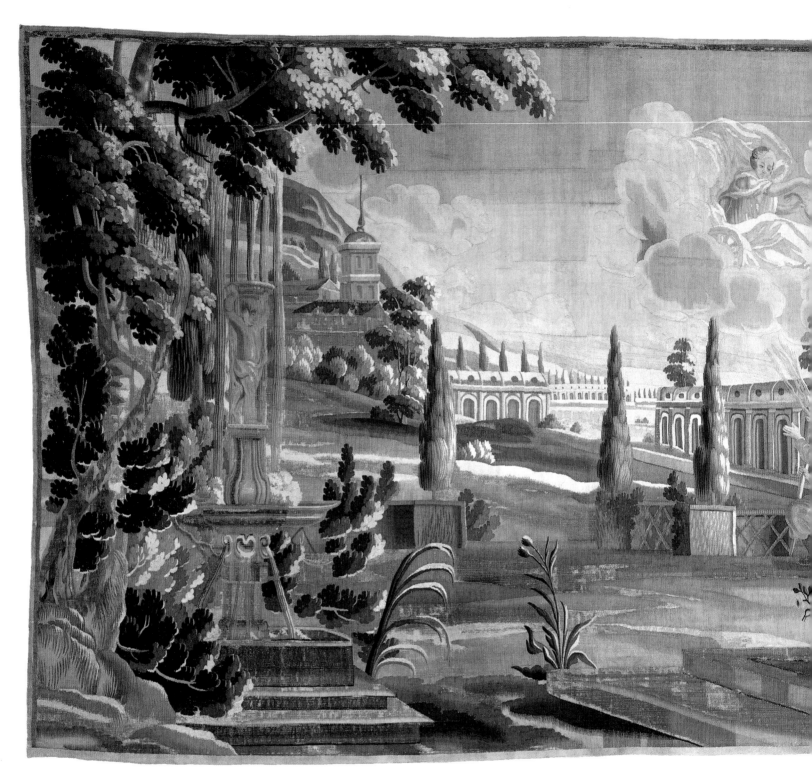

CAT. 27

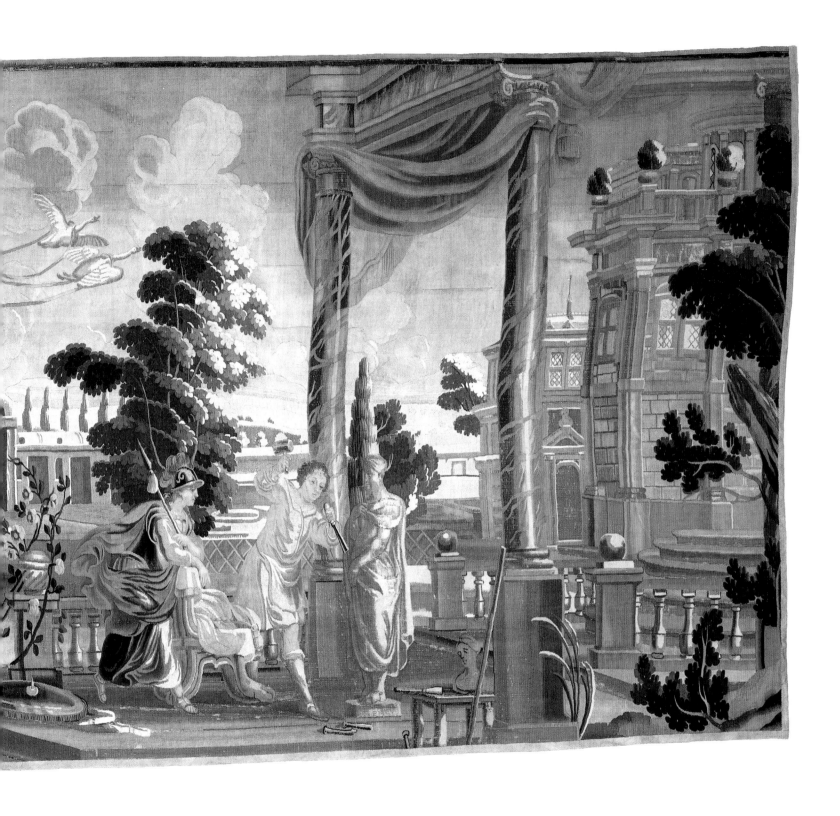

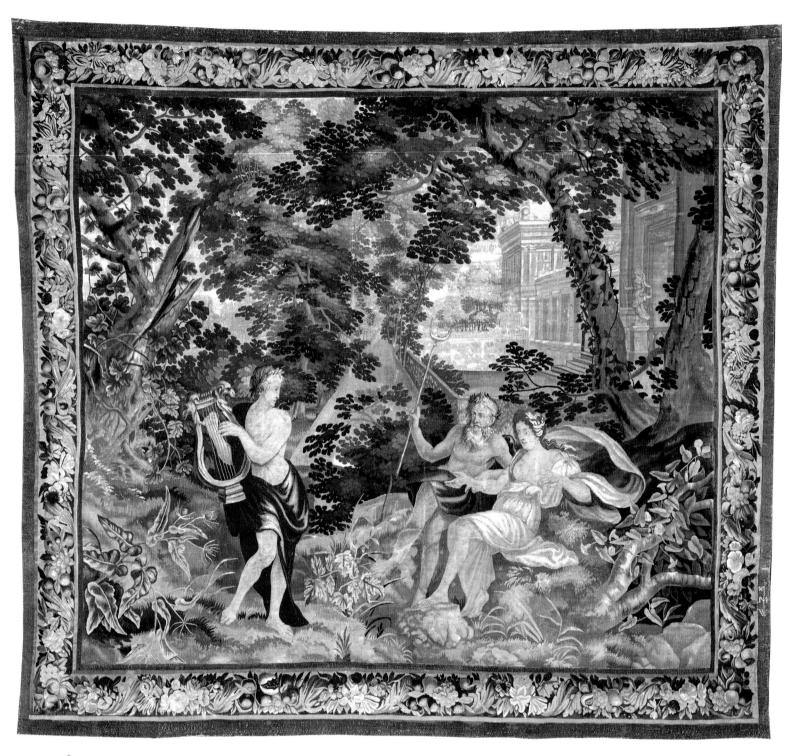

CAT. 28

between Antwerp, Brussels, and Oudenaarde production. Cartoons circulated among workshop managers operating in various cities. As a result, it is often extremely difficult, if not impossible, to pinpoint the origin of mythological suites and independent pieces. Additionally, tapestry producers frequently modified cartoons by adding and removing figures, and continually amalgamated scenes from different sets to expand and customize suites—thus troubling modern tapestry scholars attempting to establish static and well-defined set classifications. Moreover, as many suites have been broken up and sold since the seventeenth century, there are few solid starting points for thorough comparative studies. Finally, Flemish painting of the last quarter of the seventeenth century has not itself been extensively studied, which obviously hampers attempts to attribute individual tapestry designs.

Pygmalion (cat. 27), one of the mythological tapestries in the Art Institute, depicts the story of the famous sculptor, as related in lyrics sung by Orpheus in Ovid's *Metamorphoses* (book 10, 220–297). According to Orpheus, the daughters of Propoetus, inhabitants of the Cypriot city of Amathus, denied Venus's divinity. As punishment, the angry goddess turned the women into prostitutes. The very sight of them made Pygmalion, also living on the island, disdain all real women, and prompted him to create a life-size ivory statue of the ideal woman. The foreground of the tapestry shows Pygmalion carving the statue in a portico of a palace. Minerva, dressed in armor and carrying a lance, watches the sculptor as he works, her shield at her feet. Hefford correctly observed that Minerva has no place in the Pygmalion story. The goddess, however, normally features in scenes showing another sculptor, Prometheus, as he gives life to the first man. The designer of the Pygmalion scene, Hefford hypothesized, might have mistaken Pygmalion's votive torch for an attribute of Prometheus, who, according to another version of his myth, gave fire to mankind. Thinking the figure was Prometheus, the designer may thus have included Minerva in the scene.[6] According to Orpheus's continuation of the tale, Pygmalion fell passionately in love with the finished statue, and successfully requested that Venus transform it into living flesh.[7] The sculptor's plea is depicted in the background of the tapestry: he kneels before Venus as she rides in her chariot, pulled by two swans. A formal garden with an ornamental fountain surrounds both Pygmalion at work and Pygmalion's plea to Venus.

The tapestry's origin has been the subject of much debate. In 1930 Henry Currie Marillier (1865–1951; see cat. 59) studied *Pygmalion* in a group of more than one hundred pieces with a common decorative style and subject: Ovidian mythological scenes.[8] Nearly all these tapestries were in collections in the United Kingdom, which prompted Marillier to conclude that they were of English origin, and to give them the generic title "English *Metamorphoses*." Marillier conceded, however, that only one of the tapestries had an English mark and, furthermore, listed a suite at Boughton House, Northamptonshire, bearing a mark (the signature *M.W.*) that he could not relate to any known English tapissier.[9] In 1935 Marthe Crick-Kuntziger challenged

Marillier's thesis with her unequivocal demonstration that the *M.W.* monogram is the signature of the Antwerp tapestry producer Michiel Wauters.[10] Marillier stood his ground and reasserted the English origin of the *Metamorphoses* tapestries in an article published in 1940, citing in support of his argument the recent appearance on the art market of a *Metamorphoses* suite bearing the English mark.[11] In 1971 a second *Metamorphoses* suite with the English mark surfaced on the art market, which obviously appeared to corroborate Marillier's claim.[12] Yet around the same time, the attribution of purportedly English *Metamorphoses* tapestries bearing the *M.W.* monogram to the Antwerp producer Michiel Wauters became widely accepted.[13]

Hefford resolved the conflict by analyzing the so-called English *Metamorphoses* in close connection with related archival documents. She demonstrated that during the 1670s and 1680s the Wauters workshop made numerous sets after Ovid for the English market, such as *Jupiter and Io*, *Het Stauwerken*, and *The Story of Cadmus*. Hefford convincingly argued that the commercial success of these mythological sets inspired an English workshop manager to copy such series in the late 1680s or 1690s. In general, the English copycat tapestries can be easily distinguished from the Antwerp originals: the English pieces tend to be mirror images of the Flemish designs, their execution is less sophisticated, and they contain a characteristic red dye.[14] Using these criteria, Hefford demonstrated that *Pygmalion* was woven in Antwerp but, because of the fairly basic quality of its execution, presumably for export to England. Its short height also supports this attribution, for the lower walls of English manors were typically covered by wooden panels, reducing the wall space available for tapestries, which were hung on the upper part of the walls. Indeed, Philip Wauters himself labeled tapestries with low heights ("cleyne diepte") as in "de mode van Engellant" (the English manner).[15]

Hefford's analysis of so-called English *Metamorphoses* suites that include versions of *Pygmalion* made clear that the *Pygmalion* subject belonged to a set possibly comprised of eleven episodes from Ovid.[16] Seven subjects can be found in the *Metamorphoses*: *Alpheus and Arethusa*, *Arethusa Telling Her Story to Ceres*, *Cephalus and Procris*, *Narcissus at the Fountain*, *Pygmalion*, *Theseus and Ariadne*, and *Vertumnus and Pomona*. The remaining four episodes illustrate scenes from another book by Ovid, the *Heroides* (Heroines), and focus on the life of Sappho and her lover Phaon: *Venus and Phaon*, *The Departure of Phaon*, *Sappho's Letter to Phaon*, and *Sappho's Suicide*. The series as a whole can therefore be accurately titled *Stories from Ovid*. It is not certain, however, if all eleven subjects originally comprised a single set. On the contrary, the large number of scenes and the existence of a *Sappho* subset suggest that *Stories from Ovid* suites might be seventeenth-century amalgamations of two distinct sets: *The Metamorphoses* and *The Story of Sappho*.[17]

Hefford attributed *Stories from Ovid* to the Flemish painter Daniel Janssens, about whom little is known.[18] Born in Mechelen in 1636, he was registered as a master in that city's painters' guild in 1660. Six

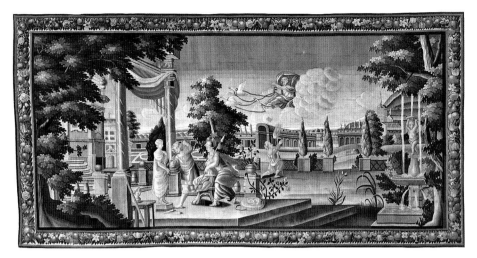

FIG. 1 *Pygmalion* from *Stories from Ovid*. Produced at an English workshop. Wool and silk; 530 x 265 cm. Location unknown.

years later Janssens moved to Antwerp where he lived and worked until about 1675, when he returned to Mechelen. Janssens was virtually workshop designer for Michiel and Philip Wauters, and can, on both documentary and stylistic grounds, be credited with the design of numerous sets produced by the firm, including *Apollo and Daphne*, *Esther*, *Landscapes with Little Figures*, *The Liberal Arts*, *Phaeton*, *Tobias*, and *Ulysses*. Hefford convincingly argued that close stylistic links with these sets permit the attribution of *Stories from Ovid* to Janssens as well. Given Janssens's status as virtual in-house designer, the production of *Stories from Ovid* can therefore be placed firmly in the circle of the Wauters family.

Stories from Ovid is not, however, recorded in any of the archival material pertaining to the Wauters firm. The set is not itemized in Michiel Wauters's 1679 inventory, nor are any suites of the series listed in the *Memoriael Wauters*. But the lack of documentary proof of a Wauters origin for *Stories from Ovid* can be explained. The cartoons may postdate 1679 or may already have been owned by Philip or Maria Anna Wauters, which would explain their absence from Michiel's probate inventory. Furthermore, it is clear that, like other Wauters sets made for the English market, *Stories from Ovid* was copied in England (see fig. 1).[19] Thus, the availability of English-made suites may have discouraged the exportation of chambers produced in Antwerp from about 1682 on, which would explain why the *Memoriael Wauters* does not mention any *Stories from Ovid* suites.

Orpheus Playing the Lyre to Hades and Persephone (cat. 28) shows a mantle-clad youth crowned with a laurel wreath, playing the lyre for a man and woman who sit on his left. The man, who is also crowned with a laurel wreath, is bearded and wears a mantle that covers his loins. He holds a staff topped by a crescent. The woman sitting next to him wears classical dress as well, but lacks attributes. The figures are set in a clearing in the woods. Through the trees, a formal garden and palace are visible. The right selvage bears the *M.W.* signature, indicating that this tapestry was produced at the Wauters workshop.

When it entered the Art Institute's collection in 1952, the piece was called *Orpheus Playing the Lyre to Jupiter and Juno*. Another version of this scene that has surfaced on the French art market

was called *Apollo Playing the Lyre to Peneus and Daphne*.[20] As both Apollo and Orpheus played the lyre, either title could be correct. The bearded man's crescent-topped staff, however, helps conclusively identify the scene, for it reveals that he is Hades, the lord of the underworld. Consequently, the woman beside him must be his consort Persephone, and the tapestry must depict an episode from the story of Orpheus and Eurydice, as recorded in the *Metamorphoses* (book 10, 1–85).

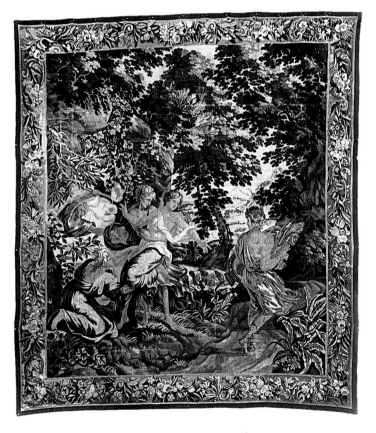

FIG. 2 *Eurydice Pulled Back into the Underworld* presumably from *Orpheus and Eurydice*. After a design attributed to Peter Ykens and Pieter Spierinckx. Presumably produced at the Wauters workshop, c. 1685. Wool and silk; 304.8 x 274.3 cm. Location unknown.

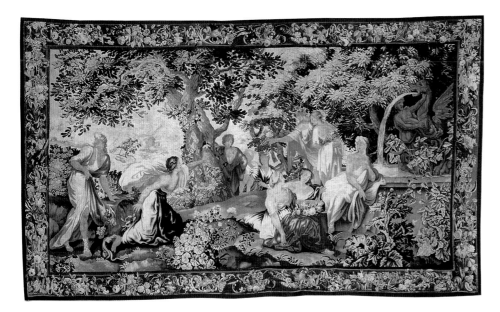

FIG. 3 *Eurydice Bitten by the Snake* from *The Metamorphoses*. After a design attributed to Peter Ykens and Pieter Spierinckx. Presumably produced at the Wauters workshop, c. 1685. Wool and silk; 295 x 509 cm. Location unknown.

Orpheus was the greatest musician and poet of Greek myth. He married Eurydice but soon after their wedding she was killed by a snakebite. Grief-stricken, Orpheus sought out Hades and Persephone to get his dead wife back. As shown in the tapestry in Chicago, Orpheus charmed Hades and Persephone with his music, and they allowed him to take Eurydice back to the world of the living, on the condition that he not look back at his wife while leading her out of Hades's realm. Just before the couple reached the world of the living, however, Orpheus, unable to restrain himself, turned around and looked at Eurydice. She immediately slipped back into the underworld. Orpheus, inconsolable at this second loss, started to lead a solitary life. Ovid tells that one day, while Orpheus sat singing beneath a tree, he was attacked by Ciconian maenads, female devotees of Dionysus, for not honoring the god. They threw rocks and branches at Orpheus, but his music was so enchanting that it charmed even these objects, and the missiles refused to hit him. Eventually, the maenads killed Orpheus with their bare hands and tore his body to pieces (Ovid, *Metamorphoses*, book 11, 1–66).

Having ascertained that the tapestry depicts *Orpheus Playing the Lyre to Hades and Persephone*, the question arises whether the cartoon of the scene belongs to a *Metamorphoses* series or to an autonomous *Orpheus and Eurydice* set. No *Orpheus and Eurydice* series is itemized in Michiel Wauters's inventory, which suggests that *Orpheus Playing the Lyre* must have been part of a mythological series inspired by Ovid.[21] More specifically, it may have been one of the eight cartoons of a set called *The Story of Jupiter and Europa*, for such titles can be misleading: the *Memoriael Wauters* lists a number of *Jupiter and Io* suites none of which, when itemized, contain a single subject connected with the story of Jupiter and Io.[22] It is also possible, however, that the *Orpheus and Eurydice* cartoons may have been created *after* Michiel Wauters's death in 1679 and thus were not included in the *Memoriael Wauters*, for the *M.W.* signature was presumably also used by Michiel's daughter and successor Maria Anna.[23] Thus it is possible

that *Orpheus Playing the Lyre* indeed belongs to an autonomous *Orpheus and Eurydice* series. At about the same time the tapestry in the Art Institute was made, an *Orpheus and Eurydice* series, which included an *Orpheus Playing the Lyre* scene, was woven in Antwerp or Brussels, indicating the popularity and therefore the commercial viability of the Orpheus myth in tapestry.[24]

A hitherto unstudied tapestry showing *Eurydice Pulled Back into the Underworld* must be included in the discussion (fig. 2).[25] Both its subject matter and stylistic features, such as the mannerist and theatrical poses of the figures, the fluttering cloth of their garments, and the dense woodland setting, strongly suggest that this piece and *Orpheus Playing the Lyre* were designed by the same artist and were part of the same set. But the borders of the tapestries differ, indicating that they were not part of the same suite.[26] The existence of this companion subject to *Orpheus Playing the Lyre* favors the supposition that the tapestries are part of an *Orpheus and Eurydice* set rather than a *Metamorphoses* series. Additional archival research and further analysis of late-seventeenth-century Flemish mythological tapestries, however, is required to resolve the debate.

No documents shed any light on the identity of the artist or artists who created the *Orpheus* scenes. Yet stylistic features connect the scenes to a *Metamorphoses* set woven in Antwerp, Brussels, and Oudenaarde that has been attributed, on archival evidence, to the Antwerp painters Peter Ykens and Pieter Spierinckx (see fig. 3).[27] The Ykens-Spierinckx *Metamorphoses* contains typical figures and theatrical poses. The lively gestures of the figures' hands add to the drama of the episodes; resting hands typically show a pointing index finger. The scenes are set in dense woodlands with detailed patches of plants depicted in the foreground. All of these features can also be found in *Orpheus Playing the Lyre* and *Eurydice Pulled Back into the Underworld* (fig. 2), justifying the attribution of these likely *Orpheus and Eurydice* scenes to Ykens and Spierinckx.[28] KB

1. Brosens 2007d.
2. For the Wauters workshop, see Denucé 1936, pp. xlvi–lvi, 86–115; Crick-Kuntziger 1935; Wingfield Digby 1959; Duverger in Provinciaal Museum Sterckshof 1973, pp. 61–78; Delmarcel 1999a, pp. 258–59; and Duverger 1984–2002, vol. 10, pp. 492–97.
3. The probate inventory was first published, though with gaps and inaccuracies, by Van den Branden n.d., pp. 26–32. Denucé 1932, pp. 298–303, presented an error-free version of the document, yet Crick-Kuntziger 1935, pp. 36–38, only referred to Van den Branden's rendition of the inventory. For the most recent and accurate publication of the document, see Duverger 1984–2002, vol. 10, pp. 492–97. The *Memoriael* was published by Denucé 1936, pp. 86–115.
4. See note 2 above and Woldbye 1965, Neumann 1968, Bauer 1994, Patrizi 2004, Hollestelle 2006, and Mulherron and Wyld 2007.
5. Hefford 1983.
6. Ibid., p. 104.
7. Ovid left Pygmalion's ideal woman nameless, and she remained so until the middle of the eighteenth century, when French adapters of Ovid's story christened her Galatea, or "she who is milk-white"; Reinhold 1971. For the fortune of the Pygmalion story in later literature, see Carr 1960.
8. Marillier 1930, pp. 79–91, pls. 29a–37b.
9. Ibid., p. 83.
10. Crick-Kuntziger 1935.
11. Marillier 1940.
12. Vigo-Sternberg Galleries, *Four Hundred Years of English Tapestry*, 1971, pp. 30–33, cats. 17–19; Hefford 1983, p. 115.
13. Wingfield Digby 1959, pp. 234–39; Duverger in Provinciaal Museum Sterckshof 1973, pp. 67–69, cat. 32.
14. Recently, however, Hefford has questioned whether the red dyes are a reliable criterion for an English origin; she will deal with this issue in detail in her forthcoming book on English tapestry, *Mortlake to Soho: English Tapestry 1618–1782*. I am most grateful to her for sharing her latest views on *Pygmalion*.
15. Denucé 1931, p. 200.
16. Hefford 1983, pp. 102–06.
17. Ibid., p. 104.
18. Zoege von Mantteufel 1925.
19. A piece measuring 530 x 265 cm from one such English set was offered for sale by Keshishian, London; advertisement in *The Burlington Magazine* 138,

1120 (July 1996). Hefford 1983, p. 106, has correlated a number of Flemish pieces with their mostly mirror-image English counterparts. An English version of *The Departure of Phaon* was sold at Christie's, London, Apr. 21, 2005, lot 458 (178 x 307 cm).
20. The piece, which measures 260 x 273 cm and has no borders, was with Galerie Chevalier, Paris, in the 1990s. My thanks to Nicole de Pazzis-Chevalier for this information.
21. Duverger 1984–2002, vol. 10, pp. 496–97.
22. Hefford 1983, p. 106.
23. Duverger in Provinciaal Museum Sterckshof 1973, p. 34.
24. Four subjects of this set are known: *Eurydice Bitten by the Snake, Orpheus Playing the Lyre to Hades and Persephone, Eurydice Pulled Back into the Underworld,* and *Orpheus Attacked by the Maenads*; a suite of the pieces was sold at Hôtel Drouot, Paris, June 21, 1932, lots 267a–d. The *Orpheus Playing the Lyre to Hades and Persephone* tapestry was again sold at the Paleis voor Schone Kunsten, Brussels, May 21, 1980, lot 702. Another version of *Eurydice Pulled Back into the Underworld* was sold at Sotheby's, New York, Jan. 12, 1993, lot 297 (259 x 221 cm).
25. French and Company purchased this tapestry from Mrs. Henry E. Huntington (née Arabella Duval, died 1924) of San Marino, California, on Mar. 28, 1917; GCPA 0238968.
26. Another version of *Eurydice Pulled Back into the Underworld*, now without borders, is in the National Museum of Art of Romania, Bucharest. A photograph (no. 1675.226) of this tapestry is in the files of the Royal Museums of Art and History, Brussels.
27. Denucé 1936, p. 177. The series is frequently listed in the *Memoriael Naulaerts*, the business records of the Antwerp tapestry and art dealer Nicolaas Naulaerts (died 1703) and his successors; Denucé 1936, pp. 132–370, passim. Naulaerts, presumably inspired by a personal preference, sometimes named the set simply "Uridice" (Eurydice), although she features in just one scene. This is symptomatic of the confusing and paradoxical naming of mythological sets in late-seventeenth-century archival documents.
28. The men collaborated on a number of successful sets produced in Antwerp and Oudenaarde, such as *Circe* and *Alexander*. Spierinckx further codesigned some important sets with Lodewijk van Schoor (c. 1650–1702) that were woven in Brussels, including *The Four Continents and Related Allegories* (cat. 24), *Mythological Scenes*, and *Il Pastor Fido*. For Spierinckx, see Brosens 2004a, pp. 99–100, and also De Meûter 2001a and De Meûter 2003.

Millefleurs with Medallions

CAT. 29

Bruges, 1540/60
After a design by an unknown artist
Produced at an unknown workshop
162 x 300.8 cm (63¾ x 118½ in.)
Gift of Mrs. Chauncey McCormick and Mrs. Richard Ely Danielson,
1950.1617

STRUCTURE: Wool, cotton, and silk; slit and double interlocking tapestry
weave
Two distinct areas of weaving are present. The central field, bottom border,
and lower medallion are woven with wool warps in slit tapestry weave.
Warp: Count: 4–5 warps per cm; wool: S-ply of three Z-spun elements;
diameters: 1.0–1.5 mm
Weft: Count: varies from 12 to 32 wefts per cm; wool: S-ply of two Z-spun
elements; diameters: 0.6–1.8 mm; silk: S-ply of two Z-twisted elements;
diameters: 0.4–1.2 mm
The entire side and top borders, the narrow spiral border on all four sides,
the border corners, and the upper medallion are woven with cotton warps
and multicolored element wefts in slit and (top border only) double inter-
locking tapestry weave.
Warp: Count: 5 warps per cm. Cotton: Z-ply of three S-ply of two Z-spun
elements; diameter: 1.0 mm
Weft: Count: varies from 9 to 20 wefts per cm; wool: three to five yarns of S-
ply of two Z-spun elements; S-ply of twelve elements of ten Z-spun and two
S-ply of two Z-spun elements; diameters: 0.8–2.0 mm; silk: four yarns of
Z-ply of two S-twisted elements; paired yarns of Z-ply of two S-twisted ele-
ments and Z-ply of three S-twisted elements; three yarns of two Z-ply of two
S-twisted elements and one Z-ply of three S-twisted elements; diameters:
1.0–1.8 mm; wool and silk: three yarns of two S-ply of two Z-spun wool ele-
ments and one S-ply of two Z-twisted silk elements; three yarns of two S-ply
of two Z-spun wool elements and one Z-ply of two S-twisted silk elements;
five yarns of two S-ply of two Z-spun wool elements and three Z-ply of two
S-twisted silk elements; six yarns of five S-ply of two Z-spun wool elements
and one S-ply of two Z-twisted silk elements; diameters: 1.0–1.9 mm

Conservation of this tapestry was made possible through the generosity of
Armen Minasian.

PROVENANCE, REFERENCES, EXHIBITIONS: See below.

CAT. 30

Bruges, 1540/60
After a design by an unknown artist
Produced at an unknown workshop
161.4 x 304.2 cm (63½ x 119¾ in.)
Gift of Mrs. Chauncey McCormick and Mrs. Richard Ely Danielson,
1950.1618

STRUCTURE: Wool, cotton, and silk; slit, dovetailed, and double interlock-
ing tapestry weave
Two distinct areas of weaving are present. The central field, the entire top
and bottom borders, and the lower medallion are woven with wool warps in
slit and (borders only) double interlocking tapestry weave.

Warp: Count: 4 warps per cm; wool: S-ply of three Z-spun elements;
diameter: 1.0–2.0 mm
Weft: Count: varies from 12 to 30 wefts per cm; wool: S-ply of two Z-spun
elements; diameters: 0.5–1.6 mm; silk: S-ply of two Z-twisted elements;
diameters: 0.6–1.0 mm
The entire left and right borders, the narrow spiral border on all four sides,
the border corners, and the upper medallion are woven with cotton warps
and multicolored wefts in slit, dovetailed, and double interlocking tapestry
weave.
Warp: Count: 4–5 warps per cm. Cotton: Z-ply of three S-ply of two Z-
spun elements; diameters: 0.7–1.5 mm
Weft: Count: varies from 9 to 19 wefts per cm; wool: S-ply of five to seven S-
ply of two Z-spun elements; S-ply of twelve elements of ten Z-spun and two
S-ply of two Z-spun elements; three to five yarns of S-ply of two Z-spun ele-
ments; pairs of S-ply of four S-ply of two Z-spun elements; diameters: 0.8–
2.0 mm; wool and silk: paired yarns of S-ply of two Z-spun wool and Z-ply
of three S-twisted silk elements; three yarns past two S-ply of two Z-spun wool
elements and one S-ply of two Z-twisted silk elements; three yarns, two S-ply
of two Z-spun wool elements and one Z-ply of two S-twisted silk elements;
four yarns of three S-ply of two Z-spun wool elements and one Z-ply of two
S-twisted silk elements; four yarns of two S-ply of two Z-spun wool elements
and two Z-ply of two S-twisted silk elements; four yarns of two S-ply of two
Z-spun wool elements and one S-ply of two Z-twisted silk elements and one
Z-ply of two S-twisted silk elements; diameters: 1.0–1.8 mm

Conservation of this tapestry was made possible through the generosity of
Armen Minasian.

PROVENANCE: Lehmann Bernheimer, Munich, to 1912; sold to James Deer-
ing (died 1925), June 4, 1912;[1] by descent to Deering's nieces Mrs. Chauncey
McCormick (née Marion Deering, died 1965) and Mrs. Richard Ely Daniel-
son (née Barbara Deering, died 1982), 1926; given to the Art Institute, 1950.

REFERENCES: Harshe and Rich 1934, p. 16. Harwood 1985, p. 158.

EXHIBITIONS: Art Institute of Chicago, *Tapestries from the Permanent
Collection*, 1979 (1950.1617 only).

THESE two vertically oriented tapestries are identical in composi-
tion. Each has a colorful millefleur ground, on which lie two medal-
lions showing landscape scenes framed by wreaths of flowers and
fruit. At the top of each wreath is a mask, from which hangs a coat
of arms in a strapwork cartouche. Flowers, fruit, and plants fill the
central sections of the border, which is framed by a narrow, repeated
spiral design. Both masks in cat. 29 show the face of a man or satyr
with a long pointed mustache and a beard. The landscapes depict a
sweeping tree in front of a river, a water mill, and other buildings.
The unidentified arms are divided diagonally into a red field on bot-
tom and a white field with two black squares on top. Both masks
in cat. 30 show the winged face of a putto. The medallions, whose
wreaths show straps as well as flowers and fruit, feature a man on
horseback guided by another figure past a small pond in a forest;

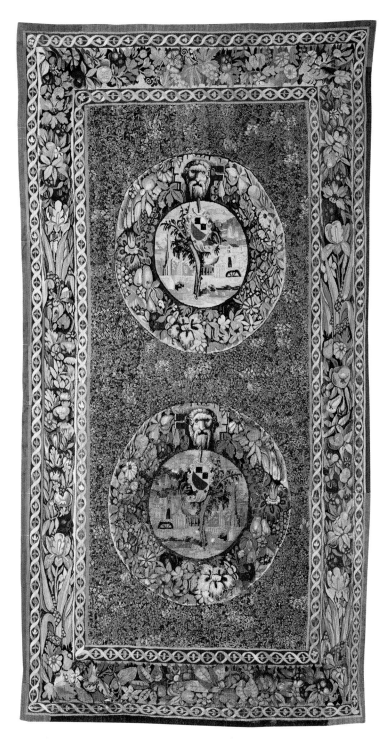

CAT. 29

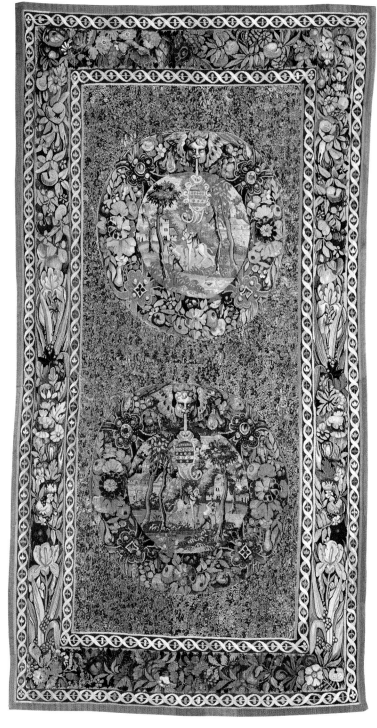

CAT. 30

farms are visible in the background. The arms, also unidentified, consist of six alternating blue and white bands with yellow bezants. On both tapestries, the wreaths of the upper medallions and the scenes they enclose are mirror images in paler shades of the vividly colored lower medallions. Only the coats of arms are not reversed. Structural analysis conducted in July 2002 by Lorna Ann Filippini, then Associate Conservator in the Department of Textiles at the Art Institute, demonstrated that the tapestries have two distinct areas of weaving,

one woven with cotton warps, which must be a nineteenth- or twentieth-century addition, for cotton was not used for tapestries in early modern times (see structure description).

From 1912 to 1926, these two tapestries, as well as a third tapestry also purchased from the Munich dealer Lehmann Bernheimer, were owned by James Deering (see "A Collection and Its Donors"). In 1915 he decided to make the three tapestries into four pieces so they would better fit the dining room of Villa Vizcaya, his Miami

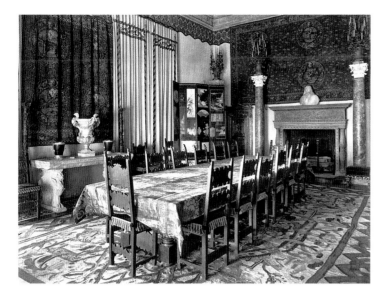

FIG. 1 The Banquet Hall, Vizcaya, Miami, c. 1950, showing above the mantle the tapestry reproduced in fig. 2.

FIG. 3 *Millefleurs with Medallions Showing the Life of Abraham*. Bruges, mid-sixteenth century. Location unknown.

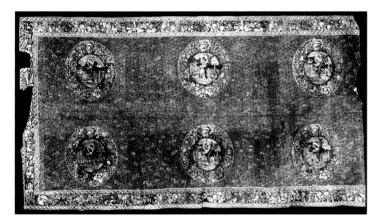

FIG. 2 *Millefleur with Six Armorial Medallions*, 1540/50. Wool and silk; 292.1 x 589.3 cm. Vizcaya Museum and Gardens, Miami.

residence. One piece, still in Villa Vizcaya today, shows six medallions (fig. 1).[2] Another piece, sent by Chauncey McCormick, one of Deering's heirs, to French and Company in 1950, presumably for sale, features four medallions that differ from those of the tapestry still in Villa Vizcaya.[3] It therefore seems to follow that the Art Institute's *Millefleurs with Medallions*, which hung on either side of a window (see fig. 10, "A Collection and Its Donors"), must have been the third piece purchased from Bernheimer.[4]

It is unlikely, however, that the tapestries in Chicago, which show two distinct types of wreaths, originally formed a single piece. Other *Millefleurs with Medallions* similar to Deering's pieces demonstrate that, typically, only one wreath style was used per tapestry.[5] Consequently, the third piece Deering purchased must have been composed of two fragments, amalgamated by Bernheimer or a previous owner. Interestingly, the lower medallion of cat. 29 is identical to the medallions in the center of Deering's largest millefleur tapestry (fig. 2), which reveals that the latter piece and the medallion were pro-

duced as part of the same commission. The medallions in cat. 30, on the other hand, differ from those of both the tapestry with six medallions and the tapestry with four, implying that the Villa Vizcaya dining room was decorated with tapestries that were originally woven for three separate commissions.

Related tapestries include a wide piece with only one medallion, now in the Musée des Gobelins, Paris, and two fragments showing medallions very similar, though not identical, to those of cat. 30.[6] The most important and arguably the finest comparable pieces are a pair of tapestries, on the art market in the 1990s, with medallions showing scenes from the life of Abraham (fig. 3).[7] One of the pieces bears the Bruges town mark—a high-warp loom shuttle—thus revealing the pair's origin.[8] Stylistic features such as the cartouche's strapwork decoration and the rendering of the figures date the tapestries to around the middle of the sixteenth century. Consequently, all *Millefleurs with Medallions* that belong to the Abraham group have been duly attributed to Bruges and dated around 1550.[9] The pieces in the Art Institute presumably postdate the Abraham pair because the satyr and putto masks of the former derive from the putto masks that feature in the more refined wreaths of the latter. The landscapes and village scenes of the Chicago pieces are similarly reminiscent of the more subtle settings of the Abraham tapestries.

As the hangings in the Art Institute were woven around the middle of the sixteenth century, they are among the latest examples of the millefleur genre, which was immensely popular from about 1400 until 1560.[10] Millefleur is a modern term; in the fifteenth and sixteenth centuries, such tapestries seem to have been called verdures, a name now used exclusively to describe pieces with fields completely covered by leaves. In late-fifteenth-century millefleurs, the backgrounds are rendered as flat areas of color, usually dark green or light red, strewn with rich arrays of flowers, plants, and trees, and form

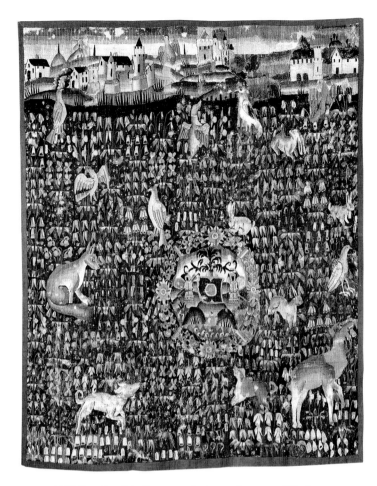

FIG. 4 *Millefleur*. Possibly Bruges, early sixteenth century. Wool; 191 x 231 cm. Location unknown.

settings for depictions of courtly or peasant life, or allegorical, mythological, or religious scenes. Yet millefleur backgrounds were also considered appropriate for heraldic motifs. Famous fifteenth-century examples include *The Arms and Emblems of Philippe le Bon*, woven in Brussels around 1466 and now in the Historisches Museum, Bern; *A Mounted Knight with the Arms of Jean de Daillon*, made in Tournai around 1483 and currently in Montacute House, Yeovil, Somerset; and *The Armorial Bearings and Badges of John, Lord Dynham*, produced in the Southern Netherlands between 1488 and 1501, and now in the Metropolitan Museum of Art, New York.[11]

Of lesser quality and renown but of great importance to any analysis of the *Millefleurs with Medallions* in Chicago is a group of millefleurs that also show one or more identical wreathed medallions with landscapes and coats of arms (see fig. 4).[12] These pieces have been tentatively attributed to Bruges or Tournai and dated to 1500 or later. In the first half of the sixteenth century Bruges emerged as the leading production center for millefleurs. The most famous examples of its output are *The Arms of Salzburg and Matthäus Lang von Wellenburg* (1520/30) and *The Arms of Paolo Giovio* (1543/52), which have wide rectangular compositions featuring wreaths, coats of arms, and landscapes.[13] In the Art Institute's Bruges millefleurs and their related pieces, the genre is taken to its logical extreme: the colorful

flowers and plants cover the ground completely. Around 1550, however, interest in the genre declined, eclipsed by the increasingly popular large leaf verdures (see cats. 31–35).　　　KB

NOTES

1. According to records in the Vizcaya Museum and Gardens Archives, a total of three tapestries (including cats. 29 and 30, which were at that time a single tapestry) were purchased for DM 249,000 ($57,000). Thanks are due to Remko Jansonius, Collections and Archives Manager at Vizcaya, for the time and effort he devoted to locating the relevant records.
2. This tapestry is presumably identical to the millefleur piece published in Göbel 1923, vol. 2, fig. 253.
3. For the four-medallion piece (location unknown), see GCPA 0237326.
4. A letter from Paul Chalfin to James Deering, Miami, dated Feb. 26, 1915, discusses the repair and adaptation of a single tapestry for the dining room (now known as the Renaissance Banquet Hall). Chalfin estimated the cost to be no more than $6,200. My thanks to Christa C. Mayer Thurman and Odile Joassin, who discovered this connection, and to Remko Jansonius for furnishing a copy of this letter. See also Harwood 1985, p. 158.
5. See, for example, Muzeum Narodowe w Warszawie, Warsaw, inv. 192788; photos are at the Royal Museums of Art and History, Brussels, file 1550.208, and French and Company, GCPA 0184108, 0237324, 0237328.
6. For the piece with one medallion, see file no. 1550.213, Royal Museums of Art and History, Brussels. In the 1990s the fragments were in the stock of the associated dealers Blondeel (Antwerp) and Deroyan (Paris); they measure 134 x 90 cm and 141 x 88 cm.
7. Delmarcel and Duverger 1987, p. 189, fig. 3/10; Delmarcel and Volckaert 1995, pp. 6, 8–9; Delmarcel 1996, pp. 193–95 (ill.).
8. Prior to the discovery of the pair, millefleurs of this kind had been attributed to Tournai (Göbel 1923, pp. 285–87) and itinerant weavers who worked for patrons in the Loire valley, where so many examples have been found (Weigert 1956, pp. 81–82).
9. Delmarcel and Duverger 1987, pp. 180–91, cat. 3; see also pp. 192–203, cats. 4–6, for a discussion of related millefleur tapestries.
10. For a concise introduction to the millefleur genre, see Cavallo 1993, pp. 71–73.
11. For illustrations of these pieces, see Cavallo 1993, pp. 58, 69, 272–77; cat. 16; figs. 75, 78.
12. Tapestries of this type have frequently appeared on the art market, for example at Parke-Bernet Galleries, New York, May 11–12, 1940, lot 194; Ader Picard Tajan, Paris, Mar. 25, 1977, lot 179; and Christie's, London, Nov. 11, 2004, lot 15.
13. *The Arms of Salzburg and Matthäus Lang von Wellenburg* is in the Museum Carolino Augusteum, Salzburg, inv. SMCA 117/48; published in Delmarcel and Duverger 1987, pp. 192–96, cat. 4. Editions of *The Arms of Paolo Giovio* are in the Victoria and Albert Museum, London, inv. 256-1895, and the Sammlungen des Fürsten von Liechtenstein, Schloss Vaduz, inv. 8. They are published in Delmarcel and Duverger 1987, pp. 197–203, cats. 5, 6. See also Campbell in Campbell 2002c, p. 283, fig. 125.

CAT. 31

Large Leaf Verdure with Animals and Birds

Southern Netherlands, possibly Bruges, 1525/50
After a design by an unknown artist
Produced at an unknown workshop
599.15 x 336.4 cm (235⅞ x 132⅜ in.)
Gift of the Antiquarian Society of the Art Institute of Chicago through the
Jessie Landon Fund, 1934.4

STRUCTURE: Wool; slit, single dovetailed, and double interlocking tapestry
weave
Warp: Count: 4 warps per cm; wool: S-ply of two Z-spun elements;
diameters: 1.0–1.5 mm
Weft: Count: varies from 15 to 36 wefts per cm; wool: S-ply of two Z-spun
elements; diameters: 0.5–1.3 mm

Conservation of this tapestry was made possible through the generosity of
the Antiquarian Society of the Art Institute of Chicago.

PROVENANCE: Lehmann Bernheimer, Munich, to 1909; sold to Edith
Rockefeller McCormick (died 1932), 1909; sold, American Art Association,
Anderson Galleries, New York, Jan. 6, 1934, lot 909, to the Antiquarian
Society, for $5,400; given to the Art Institute, 1934.

REFERENCES: Price 1913, p. 241 (ill.). Ackerman 1925a, p. 41 (ill.). Ackerman
1932, p. 10, pls. 1–2. Asselberghs 1970, cat. 12. Mayer Thurman in Keefe 1977,
pp. 180–81 (ill.), cat. 238. Artner 1979, p. 15 (ill.). Norton 1984, p. 120 (ill.).
Mayer Thurman 1992, pp. 55–57 (ill.), 145. Hartkamp-Jonxis and Smit 2004,
p. 73 (ill.).

EXHIBITIONS: Cathedral of Tournai, *Tapisseries heraldiques et de la vie
quotidienne*, 1970 (see Asselberghs 1970). Art Institute of Chicago, *The Anti-
quarian Society of the Art Institute of Chicago: The First One Hundred Years*,
1977 (see Mayer Thurman in Keefe 1977).

CAT. 32

*Large Leaf Verdure with Proscenium,
Animals, and Birds*

Southern Netherlands, 1525/50
After a design by an unknown artist
Produced at an unknown workshop
523.2 x 288.9 cm (206 x 113¾ in.)
Gift of George and Russell Tyson from the Estate of Elizabeth Vaughan,
1950.1532

STRUCTURE: Wool and silk, slit and double interlocking tapestry weave
Warp: Count: 4 warps per cm; wool: S-ply of two Z-spun elements;
diameter: 1.0 mm
Weft: Count: varies from 9 to 21 wefts per cm; wool: S-ply of two Z-spun
elements; diameters: 0.7–2.0 mm; silk: S-ply of two Z-twisted elements;
diameters: 1.0–2.0 mm

Conservation of this tapestry was made possible through the Department of
Textiles Tapestry Conservation Fund.

PROVENANCE: Elizabeth Russell Tyson Vaughan (died 1949), Boston; by
descent to her brothers George Tyson, Washington D. C., and Russell Tyson
(died 1963), Chicago, 1949; given to the Art Institute, 1952.

EXHIBITIONS: Art Institute of Chicago, *Tapestries from the Permanent
Collection*, 1979.

CAT. 33

*Large Leaf Verdure with Balustrade,
Animals, and Birds*

Oudenaarde, 1550/75
After a design by an unknown artist
Produced at an unknown workshop
MARKED: Oudenaarde city mark
462.8 x 271.2 cm (182¼ x 106¾ in.)
Gift of Robert Allerton, 1926.762

STRUCTURE: Wool and silk, slit and dovetailed tapestry weave
Warp: Count: 5 warps per cm; wool: S-ply of two Z-spun elements;
diameters: 0.8–1.0 mm
Weft: Count: varies from 14 to 30 wefts per cm; wool: S-ply of two Z-spun
elements; diameters: 0.6–1.3 mm; silk: S-ply of two Z-twisted elements;
diameters: 0.8–1.0 mm

Conservation of this tapestry was made possible through the generosity of
the city of Oudenaarde.

REFERENCES: Asselberghs 1974, pp. 26–27, fig. 14. Delmarcel 1999a, p. 191
(ill.). De Meûter et al. 1999, p. 126 (ill.).

EXHIBITIONS: Oudenaarde City Hall, *La verdure éclatée: Tapisseries
d'Audenarde du XVI au XVIII siècle*, 1999 (see De Meûter et al. 1999).

CAT. 34

Large Leaf Verdure with Balustrade and Birds

Probably Southern Netherlands, 1550/75
After a design by an unknown artist
Produced at an unknown workshop
457.2 x 335.3 cm (180 x 132 in.)
Gift of Mrs. Potter Palmer II through the Antiquarian Society of the Art
Institute of Chicago, 1943.1144

STRUCTURE: Wool and silk, slit and double interlocking tapestry weave
Warp: Count: 5 warps per cm; wool: S-ply of two Z-spun elements;
diameters: 1.0–1.2 mm
Weft: Count: varies from 18 to 22 wefts per cm; wool: S-ply of two Z-spun
elements; diameters: 0.7–1.3 mm; silk: S-ply of two Z-twisted elements; Z-
ply of two S-twisted elements; diameters: 0.7–1.2 mm

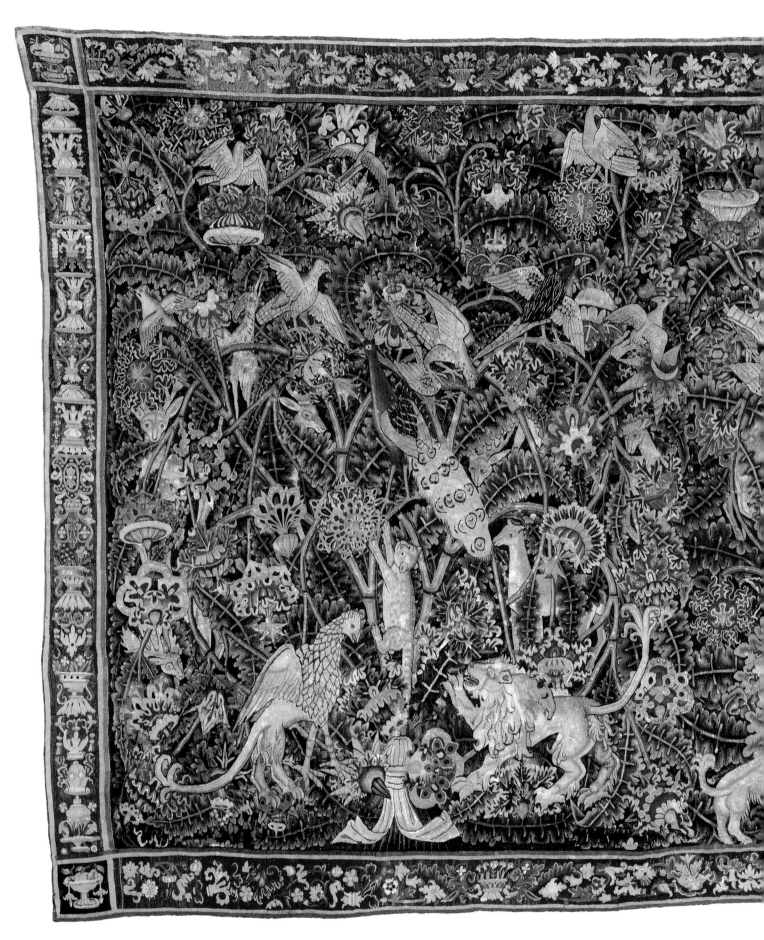

CAT. 31

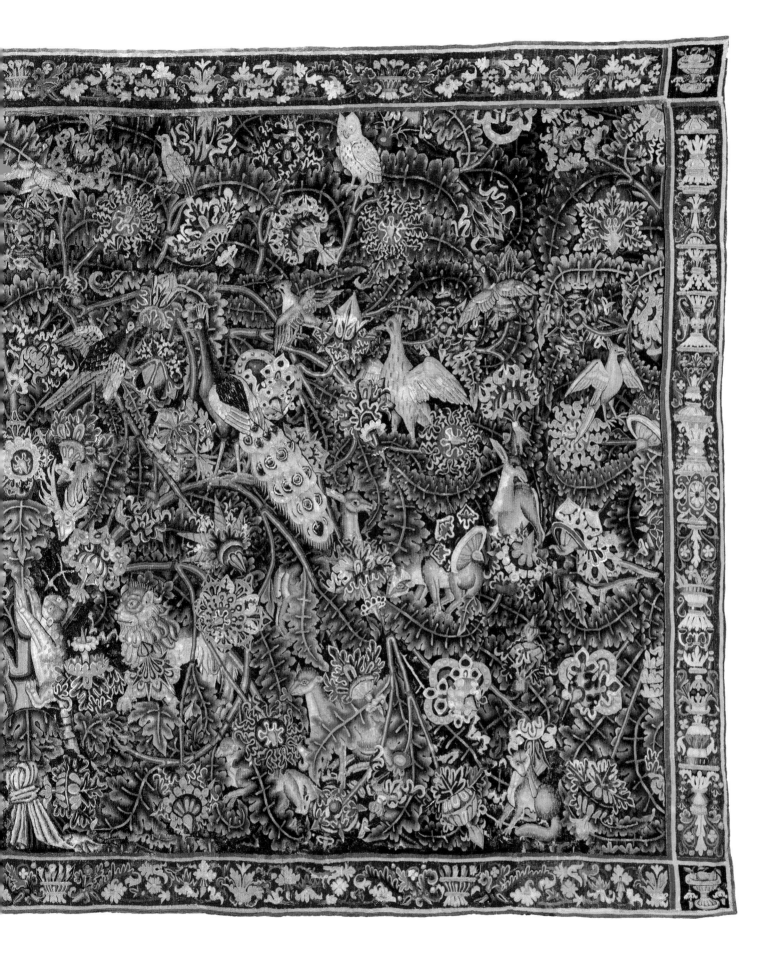

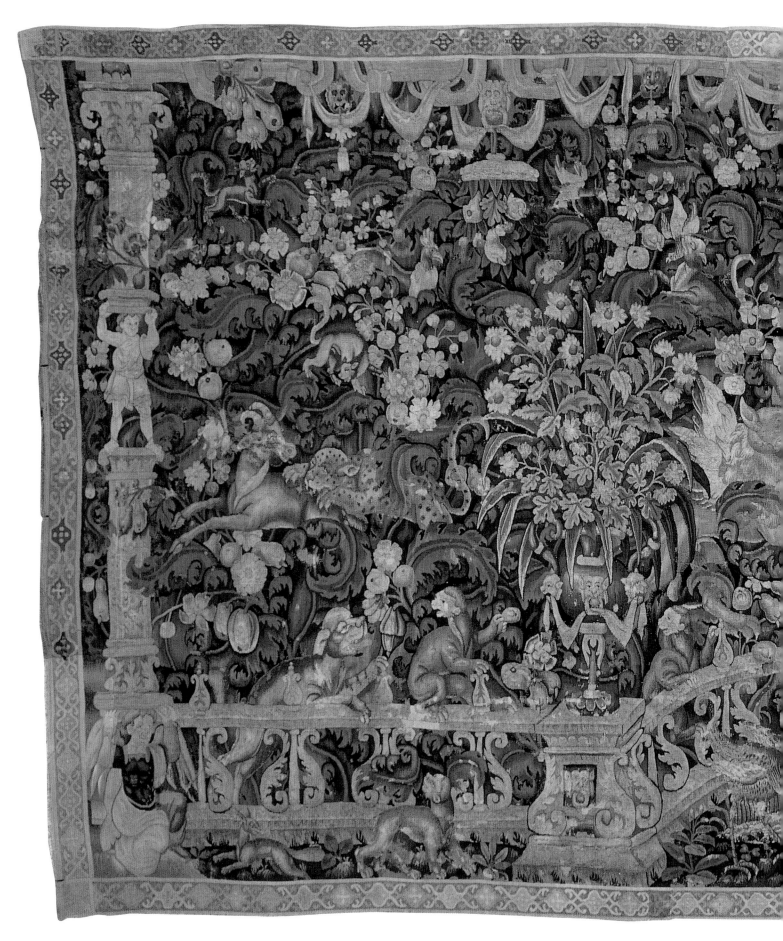

CAT. 32

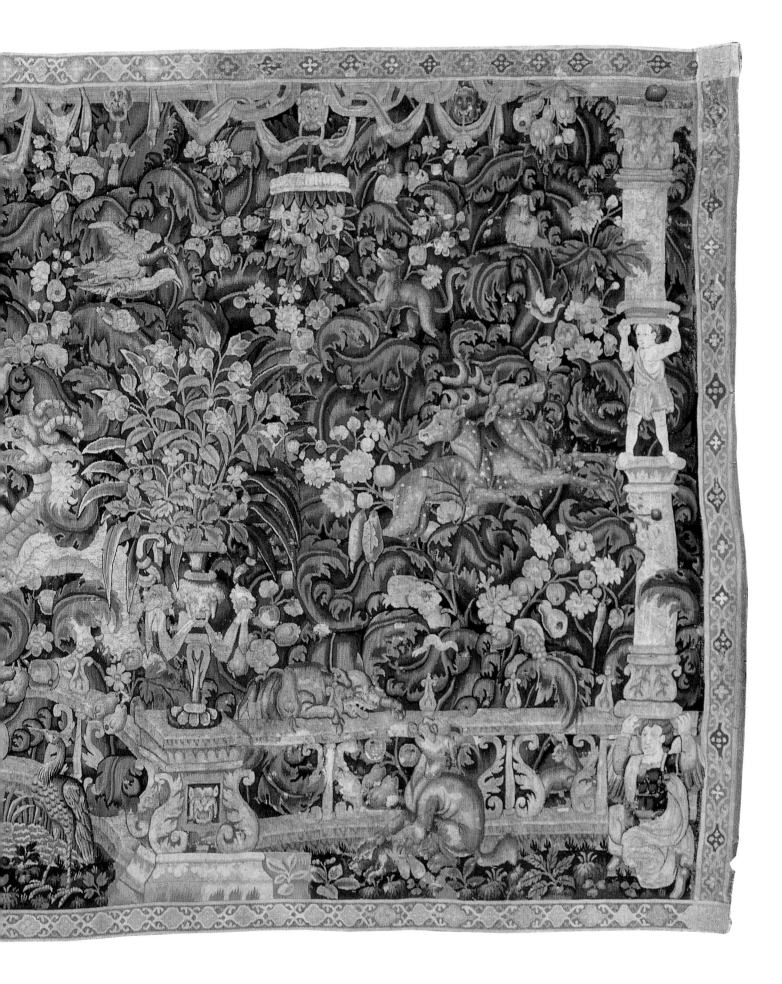

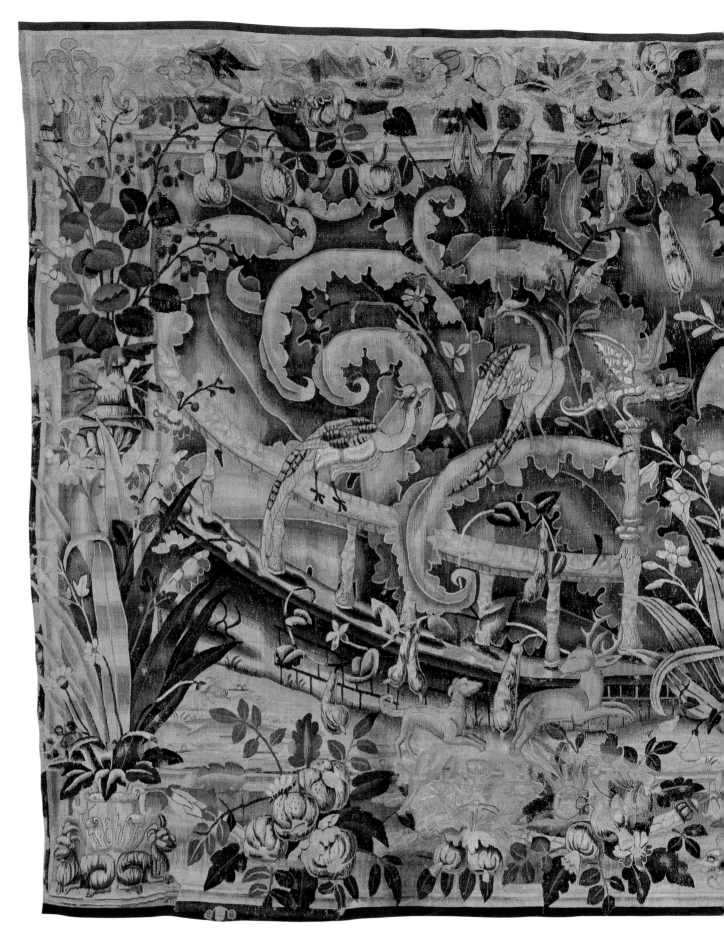

CAT. 33

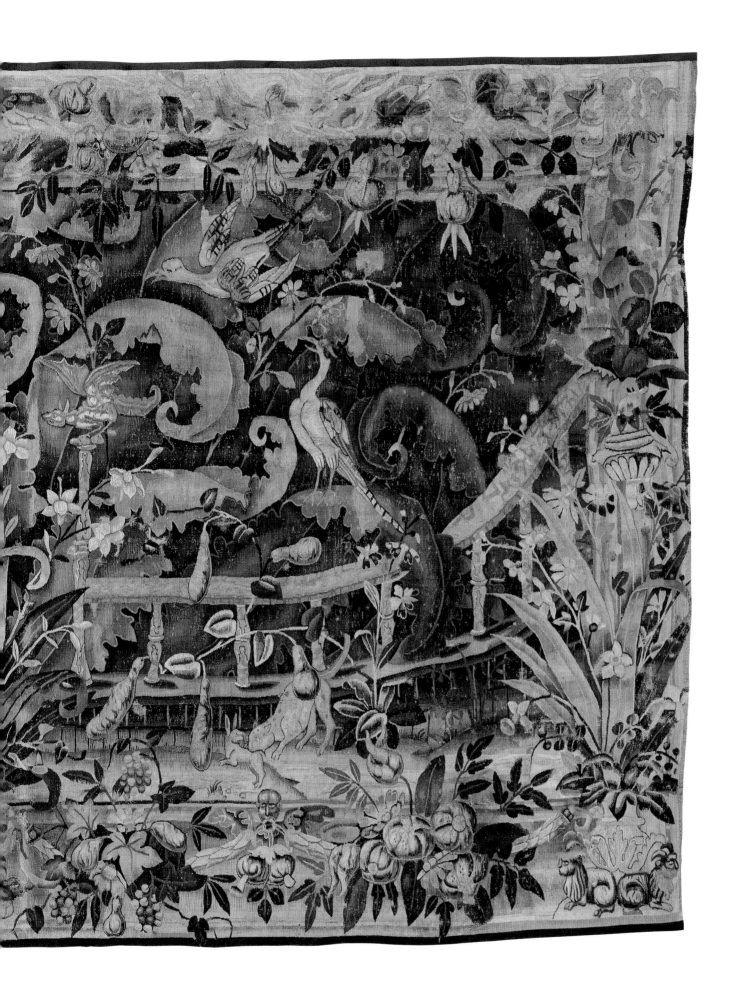

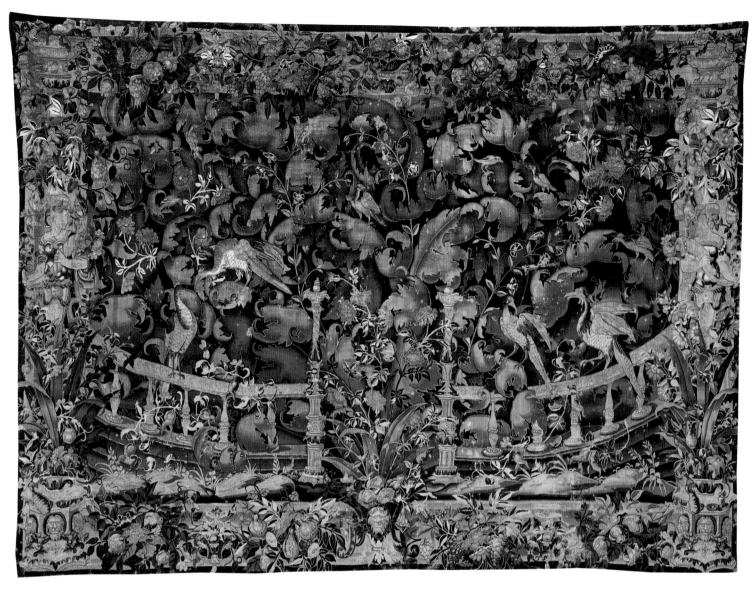

CAT. 34

Conservation of this tapestry was made possible through the generosity of the Antiquarian Society of the Art Institute of Chicago.

PROVENANCE: Possibly from the collection of Potter (died 1902) and Bertha Palmer (née Honoré, died 1918), Chicago; possibly by descent to their son, Potter Palmer II (died 1943), and his wife Mrs. Potter Palmer II (née Pauline Kohlsaat, died 1956), Chicago, by 1923; given to the Art Institute, 1943.

REFERENCES: Art Institute of Chicago 1951, cat. 63 (ill.). Mayer Thurman in Keefe 1977, p. 182 (ill.), cat. 239.

EXHIBITIONS: Probably exhibited at the Art Institute of Chicago, *Tapestries Lent by Mrs. Rockefeller McCormick, Mrs. Potter Palmer, and Robert H. McCormick*, 1923. Art Institute of Chicago, *The Antiquarian Society of the Art Institute of Chicago*, 1951. Art Institute of Chicago, *The Antiquarian Society of the Art Institute of Chicago: The First One Hundred Years*, 1977 (see Mayer Thurman in Keefe 1977). Art Institute of Chicago, *A Birthday Celebration: 100 Years of Antiquarian Society Textile Collecting, 1890–1990*, 1992.

CAT. 35

Large Leaf Verdure with Birds

Possibly Oudenaarde, about 1550/75
After a design by an unknown artist
Produced at an unknown workshop
MARKED: a seven-pointed star
185.4 x 272.5 cm (73 x 107¼ in.)
Gift of Mr. and Mrs. Arthur M. Wood, Mrs. Bertha Palmer Thorne, Rose M. Palmer, and Mrs. Gordon Palmer, 1969.134

STRUCTURE: Wool and silk, slit and double interlocking tapestry weave
Warp: Count: 5 warps per cm; wool: S-ply of two Z-spun elements; diameter: 1.0 mm
Weft: Count: varies from 16 to 28 wefts per cm; wool: pairs of Z-spun elements; single Z-spun elements; S-ply of two Z-spun elements; three yarns of S-ply of two Z-spun elements; diameters: 0.6–1.2 mm; silk: S-ply of two Z-twisted elements; diameters: 0.8–1.0 mm; silk and wool (possibly a later addition): three yarns of two of S-ply of two Z-spun wool elements and one of S-ply of two Z-twisted silk elements; diameters: 1.0–1.3 mm

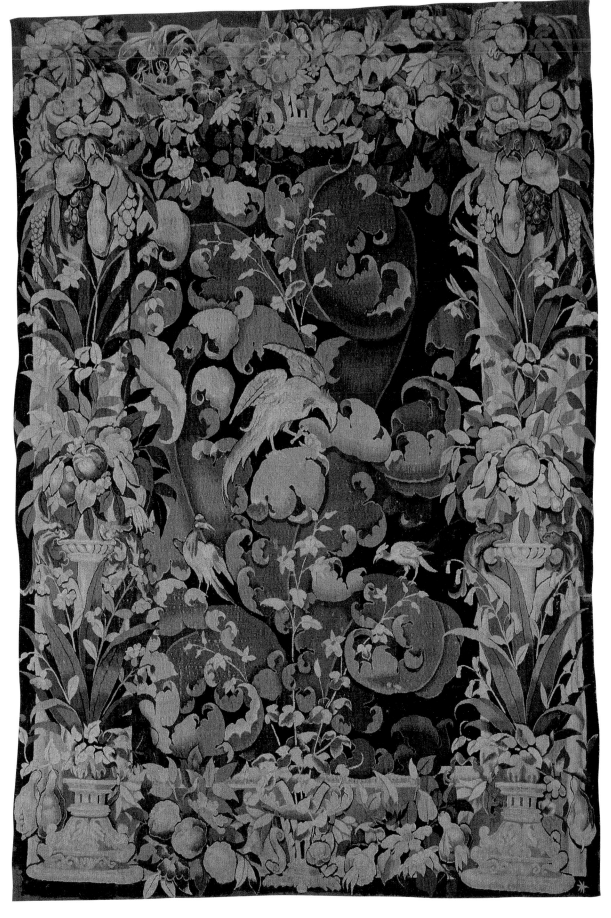

CAT. 35

GIANT, heavily veined, and ragged-edged leaves swirl and curl over these five tapestries, completely filling their fields. The thickets abound with flowering plants, birds, and other animals. Tapestries of this type are known as large leaf verdures.[1] The genre was very popular during the sixteenth century, as is revealed by contemporary European noble and royal inventories and the hundreds of such tapestries that have survived and are now in public and private collections all over the world. Adolfo Salvatore Cavallo, whose research on the large leaf verdures in the Metropolitan Museum of Art, New York, is the most valuable contribution to the literature, argued that the genre originated around 1510 or 1520, perhaps growing out of Renaissance interest in botany and zoology.[2] At this time, Europeans were importing new animals and plants from Asia and the Americas, and writing numerous illustrated botanical and zoological treatises that attempted to provide an encyclopedic knowledge of nature.[3] Both the commissioners and anonymous designers of verdures, however, must have prioritized the aesthetic impact of the dazzling, exotic compositions over scientific accuracy, for most of the plants and many of the animals are fantastic, and their relative proportion and scale are usually unrealistic.[4] This vocabulary did not originate with tapestry designers, for similar flora and fauna motifs can be found in fifteenth-century European bestiaries, illuminated manuscripts, paintings, and prints, and on sculptured capitals and embroidered textile objects as well.[5] An early example of the origin of the large leaf motif in tapestry is *The Franciscan Tree*, woven around 1475. It is comprised of a millefleur background in its bottom half and a winding tree with large, stylized leaves and exotic flowers in its upper half.[6] This piece thus represents the transition from the millefleur genre, in fashion between about 1480 and 1540 (see cats. 29–30), to the large leaf verdure genre that succeeded it, ultimately surpassing it in popularity.

Archival documents show that large leaf verdures held various meanings for their owners. The 1524 and 1532 inventories itemizing the tapestries of Cardinal Évrard de La Marck (see cats. 8a–b) indicate that his rich tapestry collection included five large leaf verdure suites comprising forty-six tapestries in total: "xiii pièces de verdure a groz branchaiges bestes et oyseaulx venant de Marcq" (thirteen pieces of large leaf verdures, animals, and birds from the Marche); "vii pieches de verdure a grosses branchaiges et ymaiges nomme le parcq dinnocence" (seven pieces of large leaf verdures and images called the Garden of Innocence); "huyt pieches de vielle verdure a grosse feuillage" (eight old pieces of large leaf verdures); "cincq pieches de verdure vielle a grande feuillage et armes de monseigneur" (five old pieces of large leaf verdures with the arms of my lord); and, finally "xiii pieces de grandes verdures a grants fueyllaiges auec des personnages saulvaiges" (thirteen large pieces of large leaf verdures with wild men).[7] The title of La Marck's second suite shows that the large leaf motif was sometimes used to represent the unspoiled, natural abundance of the Garden of Paradise, won for humanity by the sacrifice of Christ. Yet clearly not all large leaf verdures had religious significance. The title of the last La Marck suite listed above reveals that the unbridled and fanciful fauna and flora characteristic of verdures could also provide an apt setting for the wild man scenes so popular in Renaissance Europe (see cat. 2). At other times, the motif represented the jungle; for example, two surviving large leaf verdures depict a rhinoceros, arguably one of the most famous exotic animals in the early sixteenth century.[8] Finally, verdures could function as a sort of heraldic mantling, as in La Marck's suite of "large leaf verdures with [his] arms," or they could play a purely decorative role, as evidenced by the La Marck chamber described simply as "eight old pieces of large leaf verdures."[9]

Large Leaf Verdure with Animals and Birds (cat. 31) exemplifies the visual richness of the motif. The tapestry is completely filled by the large leaves, vividly colored flowers, and winding shoots of two purely imaginary plants. Numerous real and fantastic animals, including falcons, griffins, lions, monkeys, peacocks, pheasants, and unicorns, fly, hide, and perch amidst the greenery. A handful of tapestries with the same animals, foliage, and composition are known. The right half of the composition and the vertical borders of *Large Leaf Verdure with Animals and Birds* are almost identical to those of a tapestry in the Rijksmuseum, Amsterdam.[10] Another similar piece, albeit with a different type of border, is in the Musée Municipal, Cambrai, and a related tapestry that has lost its border is at the Rhode Island School of Design Museum, Providence.[11] Yet other pieces of similar design have surfaced on the art market.[12]

Interestingly, the same large leaf motif was used for the background of the tapestries depicting *Synagogue and Ecclesia with the Fountain of Life* and *The Tiburtine and Delphic Sybils with the Fountain of Life*.[13] In these cases animals such as the griffin, the lion, the peacock, and the pheasant stand for Christ, immortality, and redemption. Thus in Fountain of Life tapestries the verdure motif plays a religious and symbolic, rather than merely decorative, role. A number of tapestries, however, show wild man scenes on identical grounds, and the deco-

ration was also used to represent what was thought to be a realistic jungle background.[14] It is therefore impossible to say whether *Large Leaf Verdure with Animals and Birds*, as well as its companion pieces in Amsterdam, Cambrai, and Rhode Island, served a symbolic or a decorative function—in the end, the question may be academic, for these purposes are clearly not mutually exclusive.[15]

A similar ambiguity of function characterizes the other Flemish large leaf verdures in the Art Institute. In *Large Leaf Verdure with Proscenium, Animals, and Birds* (cat. 32), a balustrade crosses the bottom of the tapestry, marking out a small semicircular area. *Large Leaf Verdure with Balustrade, Animals, and Birds* (cat. 33) and *Large Leaf Verdure with Balustrade and Birds* (cat. 34) each also show a balustrade in the foreground, yet the architectural device curves around to form an island filled with flora and fauna more lush than that lying outside the enclosure. In front of the riotous contained area, the former tapestry shows a narrow strip of bare soil and the latter shows rocks. The dramatic contrast between these barren areas and the abundance of life framed by the balustrade suggests that the enclosure may have a symbolic meaning. Several tapestries of this type show a fountain in the center of the enclosed garden, which seems to support the idea that these large leaf verdures are intended to evoke the Fountain of Life.[16] Nonetheless, it remains possible that the balustrades and fountains may simply be a decorative element, retained only to enliven the compositions. Of all the tapestries, *Large Leaf Verdure with Birds* (cat. 35) is the most likely to have functioned as a purely decorative work of art, for it includes no potentially symbolic architecture.

Arguably, the most intriguing issue surrounding the hundreds of large leaf verdures known today is the question of their origin. Very few pieces bear city marks or signatures, and those which do reveal that large leaf pieces were woven in many (Franco-)Flemish production centers. *Large Leaf Verdure with Animals and Birds* (cat. 31) and similar pieces have traditionally been attributed to Tournai, but no archival evidence supports this claim.[17] Hillie Smit linked its borders to those of several contemporary millefleur tapestries woven between approximately 1525 and 1550 that are firmly attributed to Bruges, including *Millefleurs with the Arms of Paolo Giovio* and *Millefleurs with the Arms of Salzburg and of Matthäus Lang von Wellenburg* (see also cats. 29–30).[18] But as Cavallo remarked, it is not certain that such borders were used exclusively in Bruges, so this evidence is not decisive.[19] The border type does, however, reveal that *Large Leaf Verdure with Animals and Birds* was produced in the second quarter of the sixteenth century.

Though it is equally impossible to pinpoint the geographic origin of *Large Leaf Verdure with Proscenium, Animals, and Birds* (cat. 32), which was presumably also woven around 1525 to 1550, a little more is known about the origins of *Large Leaf Verdure with Balustrade and Birds* (cat. 34) and *Large Leaf Verdure with Birds* (cat. 35).[20] When it entered the Art Institute of Chicago's collection, the former was catalogued as French, but when Jean-Paul Asselberghs visited

the museum in 1970, he attributed the piece to Oudenaarde or the neighbouring town of Gerardsbergen (Grammont).[21] Yet, as similar tapestries bear not only the marks of Oudenaarde and Geraardsbergen, but also of Bruges, Enghien (Edingen), and Leiden,[22] it is impossible to identify definitively the production center of the tapestry, though based on the appearance of its verdure motif, it was most likely also woven around 1550 to 1575.[23] *Large Leaf Verdure with Birds* bears a workshop mark showing a seven-pointed star, which can also be found on a related suite of *Large Leaf Verdures with the Labors of Hercules* that bears the Oudenaarde city mark.[24] As a result, cat. 35 has been attributed to Oudenaarde. Its approximate production date is also between about 1550 and 1575.

In contrast, *Large Leaf Verdure with Balustrade, Animals, and Birds* (cat. 33) can be definitely localized and dated. It must have originated in Oudenaarde, for it is one of the exceptional large leaf verdures that bears a city mark: a pointed shield with a yellow ground divided by three horizontal red bars to the topmost of which are attached two suspended circles, one on either side, representing a pince-nez. Asselberghs discovered and identified the mark during his 1970 visit.[25] Moreover, since the Oudenaarde town mark was introduced on January 15, 1545, and the genre declined in popularity around 1575, the tapestry can be dated with confidence to the third quarter of the sixteenth century.[26] KB

NOTES

1. In the past such pieces were often titled *Cabbage Leaves* (*Feuilles de choux* in French or *Koolbladverdures* in Dutch). This name is still frequently used in auction catalogues, but as the leaves are not cabbage leaves, the more general title *Large Leaf Verdures* should be preferred. Though usually void of figures, some pieces show tiny boys; see for example Musée Jacquemart-André 1984, p. 29.

2. Cavallo 1993, pp. 586–93, 600–07. Swinnen 1994 offers an important catalogue of large leaf verdures, but her findings have never been formally published. Franses and Franses 2005 is descriptive rather than analytical. For more on the connection between verdures and botany and zoology, see Wingfield Digby and Hefford 1980, pp. 54–56.

3. Padmos and Vanpaemel 2000, pp. 157–94.

4. Swinnen 1994, p. 93.

5. Cavallo 1993, p. 603; Swinnen 1994, p. 101; Hartkamp-Jonxis and Smit 2004, p. 73.

6. Museo-Tesoro e Collezione Perkins, Assisi; published in Campbell 2002c, pp. 65–69.

7. Steppe and Delmarcel 1974, pp. 48–49.

8. One version is in Kronborg Castle, Elsinore, Denmark; for an illustration, see Franses and Franses 2005, p. 11. The other tapestry is in the Provinciebestuur Oost-Vlaanderen, Ghent; Swinnen 1994, pp. 43–45.

9. The armorial hangings woven for Margaret of Austria in Enghien in 1528 that are now in the Iparművészeti Múzeum, Budapest (invs. 14764–65), are the most famous example of the use of the verdure motif for heraldic mantling; Delmarcel 1980, pp. 14–17; László 1981, pp. 85–86, figs. 45–46.

10. Rijksmuseum, Amsterdam, inv. BK–17257; Hartkamp-Jonxis and Smit 2004, pp. 72–74.

11. For the piece in Cambrai, see Franses and Franses 2005, p. 36. The piece in Providence (inv. 43.259) is discussed in Hay 1988, p. 92.

12. See, for example, Hartkamp-Jonxis and Smit 2004, p. 73, and Franses and Franses 2005, p. 34.

13. *Synagogue and Ecclesia with the Fountain of Life* is in the Noordbrabants Museum, 's-Hertogenbosch, inv. 11.318; published in Kalf 1988, pp. 129–31. *The Tiburtine and Delphic Sybils with the Fountain of Life* was in the inventory of the French dealer Dario Boccara; Boccara 1971, pp. 44–45.

14. Metropolitan Museum of Art, New York, invs. 32.100.391–392; Cavallo 1993, pp. 586–93. Another tapestry that uses the verdure motif as a jungle background was sold at Christie's, London, Nov. 9, 2006, lot 103.

15. Hay 1988, p. 92, discusses their potential symbolic function.

16. See, for example, a tapestry that was on the French art market; illustrated in Musée Jacquemart-André 1984, p. 29.

17. Ackerman 1932, p. 3; Bennett 1936, p. 63; Ackerman 1947, p. 2; Asselberghs 1970, cat. 12; Hay 1988, p. 92; Mayer Thurman 1992, p. 54; Smit in Hartkamp-Jonxis and Smit 2004, p. 72 (as "probably Tournai").

18. Delmarcel and Duverger 1987, pp. 180–203.

19. Cavallo 1993, pp. 503–04.

20. Ibid., pp. 600–07.

21. Jean-Paul Asselberghs, conversation with Christa C. Mayer Thurman, Apr. 1970.

22. For tapestries bearing the marks of Oudenaarde and Geraardsbergen, see Kunsthistorisches Museum, Vienna, inv. XCI 5 (Adelson 1994, p. 119, fig. 52); Kunstgewerbemuseum, Cologne, invs. 965–66; a tapestry in the Museum für Kunst und Gewerbe, Hamburg; Metropolitan Museum of Art, New York, invs. 06.1030a, the left side of a tapestry, and 06.1030b, a fragment of the right side of the same tapestry (Standen 1985, vol. 1, cat. 24); and a tapestry in the Provinciebestuur Oost-Vlaanderen, Ghent. The piece catalogued as inv. XCI 8 in the Kunsthistorisches Museum, Vienna, bears not only the Enghien city mark, but also that of Nicolaas de Dobbeleer, an entrepreneur from the town. Invs. XCI 3 and XCI 6 in the Kunsthistorisches Museum can also be attributed to Enghien; indeed, a suite of *Children Playing* that bears the Enghien city mark (Stadsmuseum Huis Jonathas, Enghien) shows a similar verdure background; Delmarcel 1999a, pp. 196–98. A tapestry in the Österreichisches Museum für Angewandte Kunst, Vienna, bears the Bruges city mark. It is published in Delmarcel and Duverger 1987, p. 138, fig. 102. For the Leiden mark, see Göbel 1923, vol. 1, p. 562; vol. 2, fig. 510.

23. The border of *Large Leaf Verdure with Balustrade and Birds* is nearly identical to that of a large leaf verdure that recently surfaced on the art market at Christie's, London, Nov. 11, 2006, lot 104 (350 x 312 cm). Unfortunately, it bears no marks or signatures.

24. Pieces of the suite are in the Musée du Louvre, Paris, invs. OAR 4–7, and the Provinciaal Paleis van Oost-Vlaanderen, Ghent; Delmarcel 1999a, pp. 203–07. A suite of *The Planets* in the Victoria and Albert Museum, London, also bears the seven-pointed star; De Meûter in De Meûter et al. 1999, pp. 127, 131.

25. Asselberghs 1974, pp. 26, 27, fig. 14. The mark had been noticed before, but scholars had thought it was cut in half and/or possibly a weaver's mark.

26. Delmarcel 1999a, pp. 22, 362, discusses the introduction of the Oudenaarde town mark.

CAT. 36

Armorial with an Unidentified Coat of Arms

Flemish, possibly Sint-Truiden, c. 1550
After a design by an unknown artist
Produced at an unknown workshop
INSCRIBED: *AVE MARIA GRACIA PLENA*
176.5 x 201.1 cm (69½ x 79³⁄₁₆ in.)
Gift of Chester D. Tripp, 1968.744

STRUCTURE: Wool and silk, slit and double interlocking tapestry weave
Warp: Count: 5 warps per cm; wool: S-ply of three Z-spun elements; diameters: 1.0–1.4 mm
Weft: Count: varies from 15 to 32 wefts per cm; wool: S-ply of two Z-spun elements; diameters: 0.4–1.0 mm; silk: S-ply of two Z-twisted elements; pairs of Z-twisted elements; diameters: 1.0–1.5 mm

PROVENANCE: Count and Countess De Kermaingant, to 1926; sold, American Art Association, New York, Nov. 27, 1926, De Kermaingant sale, lot 167, to Abraham M. Adler (died 1985) of Hirschl and Adler Galleries, New York, acting on behalf of Chester D. Tripp (died 1974), Chicago; given to the Art Institute, 1967.

Conservation of this tapestry was made possible through the generosity of the James Tigerman Estate.

AN undulating coat of arms enclosed by strapwork lies on a ground that simulates blue silk damask woven in a pomegranate pattern. The coat of arms is surmounted by a *galero*, a low, broad-brimmed prelate's hat, from which hang tassels—nine to the right of the coat of arms, and nine to the left. The arms are divided into three fields. The top section shows a cross tipped by fleurs-de-lis, the right part contains a tower, and the third section is bordered by half of a Y-shaped cross with a fleur-de-lis on the ends, and a horizontal rule that also ends in a fleur-de-lis extends into the field from the middle of the cross. Inscribed in the outlining strapwork is the Latin phrase *AVE MARIA GRACIA PLENA* (Hail Mary, full of grace). The tapestry is a fragment of a once larger piece, as its (covered) frayed edges and cut-off tassels show.[1] The tassels on right and left are arranged in four rows of, from top to bottom, one, two, three, and three tassels respectively, but their rhythm strongly suggests that a fourth tassel originally completed the bottom row.

Various collectors and scholars have misidentified the arms as those of a member of the Spanish Borja or Mendoza families.[2] Unfortunately, further attempts to identify the arms have been fruitless, so the commissioner of the tapestry remains unknown.[3] The undulating shape of the coat of arms and the strapwork frame suggest, however, that the piece was made for a Spanish noble living around the middle of the sixteenth century, when such forms were popular among the nobility of the Iberian peninsula.[4] For example, a Bruges tapestry depicting a coat of arms with the symbols of Castile and León bears the date 1556 and shows an undulating cartouche very similar to that on the *Armorial with an Unidentified Coat of Arms*.[5] While the

CAT. 36

FIG. 1 *Saint Magdalen, Saint Agnes, and Saint Elisabeth*. Flemish, possibly Sint-Truiden, 1525/30. Wool and silk; 100 x 195 cm. The Burrell Collection, Glasgow 46.125.

number of tassels is not a useful parameter for ascertaining the rank of its commissioner—the number was not subject to prescription during the sixteenth century—the red prelate's hat reveals that he was a cardinal.[6] If the animal shown in the coat of arms is a lion, it is likely that the commissioner's family originated in Castile and León, one of the medieval kingdoms of the Iberian peninsula, because the symbol of Castile is a tower or castle, and the symbol of León, a lion.

It has been assumed that the tapestry was woven in Italy or Spain, but this is mere speculation.[7] Indeed, there is little reason to believe that around 1550 a Spanish ecclesiastic of aristocratic origin would commission tapestries in Italy when throughout the sixteenth and seventeenth centuries numerous Spanish noble families commissioned hundreds of armorials from tapissiers living in the Southern Netherlands, which were controlled by Spain from 1579 to 1713.[8] A handful of sixteenth-century pieces that show various Spanish coats of arms on pomegranate-patterned simulated damask grounds can be attributed to Antwerp, Brussels, or Tournai.[9] The colors and the naive rendering of the arms on the Art Institute's tapestry (visible in, for example, the primitive depiction of the lion-like animal) suggest, however, that it was not made in Antwerp, Bruges, Brussels, or Tournai, but rather in a provincial production center. The combination of a refined background and naive figurative motifs is reminiscent of a pair of tapestries dated to 1525 or 1530 and attributed to Sint-Truiden, a town east of Brussels: *The Virgin of the Apocalypse with Saint Catherine and Saint Barbara*, now in the Metropolitan Museum of Art, New York, and *Saint Magdalen, Saint Agnes, and Saint Elisabeth*, now in the Burrell Collection, Glasgow (fig. 1).[10] Archival material reveals that around 1500 to 1550 Sint-Truiden had a tapestry industry of some renown.[11] It is thus reasonable to surmise that this armorial was also woven there, though further research on minor Flemish production centers and the tapestry industry in sixteenth-century Spain is required before a more definite attribution can be made.[12]

KB

NOTES

1. Condition report by Lorna Ann Filippini, former Associate Conservator, Department of Textiles, the Art Institute of Chicago, Apr. 2005, in conservation file 1968.744.

2. The New York art dealer Joseph Brummer attributed the arms to a member of the Borja family, according to a Dec. 8, 1967, letter that Chester D. Tripp, who owned the tapestry between 1926 and 1967, wrote to the appraiser Irving S. Tarrant of Chicago. This tentative identification was accepted when the tapestry entered the Art Institute's collection. During his 1970 visit to the Art Institute, however, Jean-Paul Asselberghs suggested that the arms belonged to a member of the Mendoza family. See object file 1968.744 in the Department of Textiles. For illustrations of the Borja and Mendoza coats of arms, see Rolland and Rolland 1976, vol. 1, pls. 267–68, vol. 2, pl. 185.

3. I thank Guy Delmarcel and Victoria Ramirez for their assistance.

4. Pardo and Bugallal y Vela 1987, pp. 20, 54.

5. Delmarcel 1996, p. 197. The tapestry (present whereabouts unknown) bears the Bruges city mark and the weaver's signature *A.L.*, which has been identified as that of Arnout van Loo (c. 1525–c. 1585).

6. Only in 1832 did the Catholic Church issue clear heraldic guidelines; Heim 1981, p. 69; Meurgey De Tupigny 2002.

7. For example, in the catalogue for the 1926 De Kermaingant auction, *Armorial with Unidentified Coat of Arms*, cat. 167, is listed as Italian, and Asselberghs tentatively ascribed the piece to Spain; object file 1968.744, Department of Textiles, the Art Institute of Chicago.

8. Brosens 2007d.

9. One such piece is in the Fogg Art Museum, Harvard University, Cambridge, and is published in Asselberghs 1970, cat. 8. For other similar tapestries, see GCPA 0237158; Sotheby's, London, Dec. 3, 1997, lot 16; and Sotheby's, New York, Sept. 30, 2004, lot 258.

10. For the tapestry in the Metropolitan Museum of Art, see Cavallo 1996, pp. 594–99, cat. 51. The tapestry in the Burrell Collection is discussed in detail in Smets 1984. I thank Patricia Collins for organizing a viewing of this piece.

11. Göbel 1923, vol. 1, pp. 462–63; Smets 1984, pp. 323–25.

12. Lafond 1912 is an example of how little is known about the industry in Spain during the sixteenth century. Only late-sixteenth-century Madrilenian tapestry production has recently been studied thoroughly, in Cruz Yábar 1996.

Alexander Encounters Thalestris, Queen of the Amazons from *The Story of Alexander the Great*

Flemish, possibly Tournai, c. 1600
After designs by an unknown artist
Produced at an unknown workshop
392.3 x 276.8 cm (154½ x 109 in.)
Gift of Mrs. Stanley Keith, 1958.280

STRUCTURE: Wool and silk, slit and double interlocking tapestry weave
Warp: Count: 5 warps per cm; wool: S-ply of three Z-spun elements;
diameters: 0.8–1.5 mm
Weft: Count: varies from 10 to 28 wefts per cm; wool: S-ply of two Z-spun
elements; pairs of S-ply of two Z-spun elements; diameters: 0.5–1.8 mm; silk:
S-ply of two Z-twisted elements; pairs of S-ply of two Z-twisted elements;
diameters: 0.5–1.7 mm

Conservation of this tapestry was made possible through the generosity of
Donna McKinney (Mrs. Peter McKinney).

PROVENANCE: Probably John Graves Shedd (died 1926) and Mary R.
Porter Shedd (died 1942), by 1926; given or by descent to their daughter
Mrs. Stanley Keith (née Helen Shedd, died 1978), by 1942; given to the Art
Institute, 1958.

THIS tapestry depicts the legendary meeting of Alexander the Great
and Thalestris, the queen of the Amazons. Alexander stands on the
right, dressed in armor and carrying a staff in his right hand, accom-
panied by a soldier holding the king's horse, Bucephalus. Thalestris,
also dressed in armor, approaches Alexander from the left with three
female warriors. She has laid down her bow and shield and adopted
a humble pose. Alexander's army and the Amazonian troops are rep-
resented in the background. The border is woven with vases of flow-
ers, grotesques, and playful putti. The cartouches in the center of the
horizontal borders are identical and show a scene from the Book of
Tobit, either Tobias's departure from his parents or his return home.
The cartouches in the vertical borders also depict scenes from Tobit.
Tobias and Sarah are shown praying on the left; Tobias's parents
deplore his leaving on the right. All four corners of the border depict
biblical episodes featuring women. While the scene on the upper left
cannot be identified, the subject on the right is Judith with the head
of Holofernes. The bottom corners feature Susanna and the Elders
on the left and Bathsheba receiving David's letter on the right.

Alexander Encounters Thalestris, Queen of the Amazons, is one of
a plethora of Flemish tapestries inspired by the many accounts of the
renowned Macedonian king (see cat. 16). Among these narratives,
the *Alexander Romances*—collections of misreported facts and plain
fiction—stand out for their descriptions of the king's exotic encoun-
ters with fantastic beasts, races, and rulers, including the meeting
with Thalestris shown on the tapestry in the Art Institute.[1] Accord-
ing to the third book of the *Romances*, Thalestris and three hundred
Amazons presented themselves to Alexander and his army, in hopes

of becoming pregnant and raising a race of children as strong, brave,
and intelligent as the king and his soldiers.

The Amazons were a mythic nation of female warriors who sup-
posedly lived in what is now Turkey.[2] Their name was said to derive
from the Greek *a-mazoi* which means "without breast," for according
to legend the Amazons, when young, had their right breasts removed
to facilitate the drawing of the bow, their main weapon. Ancient,
medieval, and early modern European authors and moralists cher-
ished the legendary Amazons for their capacity to turn convention
on its head: women were expected to be passive and dependent upon
males, not brave and autonomous. This role reversal acquired deeper
meaning in the late sixteenth and early seventeenth centuries, when
a number of women dominated European politics: Mary Stuart
reigned as queen of Scotland; Elizabeth I ruled England; and Cathe-
rine de' Medici, Marie de' Medici, and Anne of Austria all played key
roles in French politics. These and other *femmes fortes* elicited a range
of opinions about women's wielding power, ranging from approval
to ambivalence to disapproval.[3] *Alexander Encounters Thalestris* is
an expression of this complexity, as the scene acknowledges the exis-
tence of the fierce Amazons at the same time as it portrays them as
willing to subject themselves to an even braver army of men.

The tapestry in Chicago is the mirror image of a tapestry of the
same subject (now in the Castello di Monselice, the Veneto) that
bears the Brussels city mark and the monogram of the Brussels tap-
estry producer Cornelis Mattens (1576 or 1577–1640). The Mattens
piece was presumably part of a *Story of Alexander the Great* suite of
thirteen tapestries that was in the Gonzaga collection in Mantua
prior to 1627, which provides a *terminus ante quem* for the creation
of the cartoons.[4] Three more pieces of the suite are in the Castello di
Monselice, Padua: *The Battle of Issus*, which shows Alexander's 333
B.C. defeat of the Persian army led by King Darius (Plutarch, *Life
of Alexander*, book 20); *The War Booty*, which depicts the wealth
that Alexander and his troops discovered in Darius's deserted camp
(Plutarch, *Life of Alexander*, book 20); and *The Capture of Tyre* in
332 B.C. (Plutarch, *Life of Alexander*, books 24–25). A fifth tapestry,
The Kings of Cyprus and Phoenicia Surrender to Alexander, now in
the Museum der Stadt, Regensburg, was presumably also part of the
Gonzaga edition. According to Plutarch's and Curtius's accounts,
this episode preceded the siege of Tyre because this Phoenician city
refused to surrender to Alexander, even after its king surrendered
(Plutarch, *Life of Alexander*, book 24). The borders of the pieces are
similar but not identical to those of the Art Institute's *Alexander
Encounters Thalestris*, and their type can be regarded as a derivative
version of a border that was frequently used by Maarten Reymbouts
(c. 1570–1619), one of the major Brussels tapissiers around 1600.[5]

Another Brussels *Alexander* suite is in Sweden, in Skokloster Cas-
tle and the Nationalmuseum, Stockholm.[6] It consists of six pieces
bearing the Brussels city mark; four tapestries have the marks of four
different tapestry producers. One of these marks has been linked to
the Brussels tapissier Jacob I Geubels (died between 1601 and 1605)

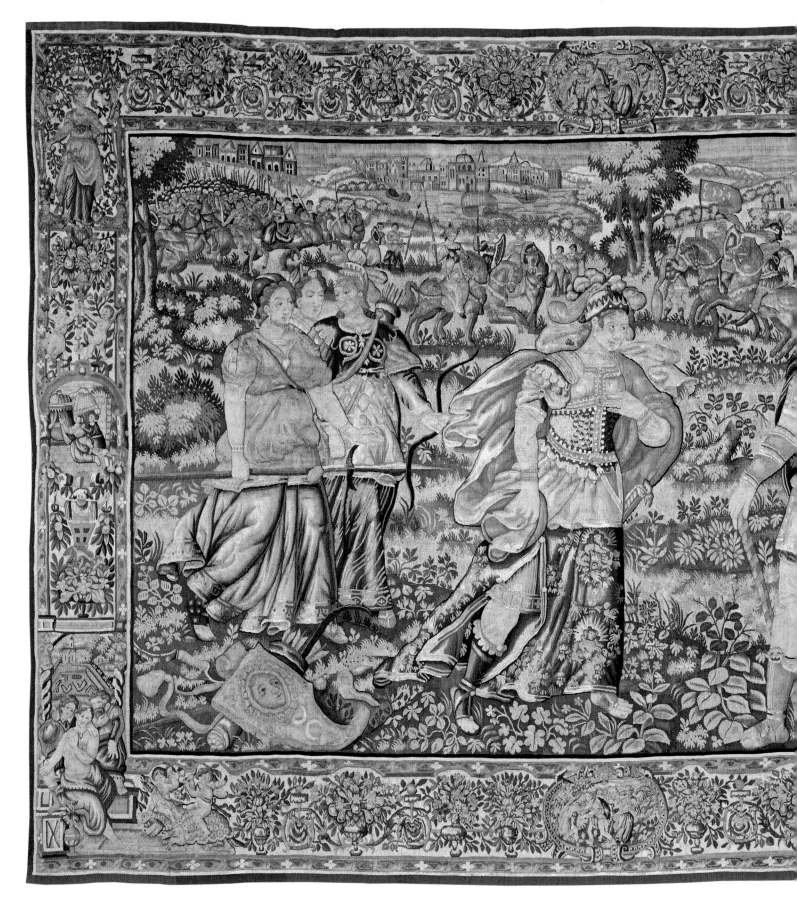

CAT. 37

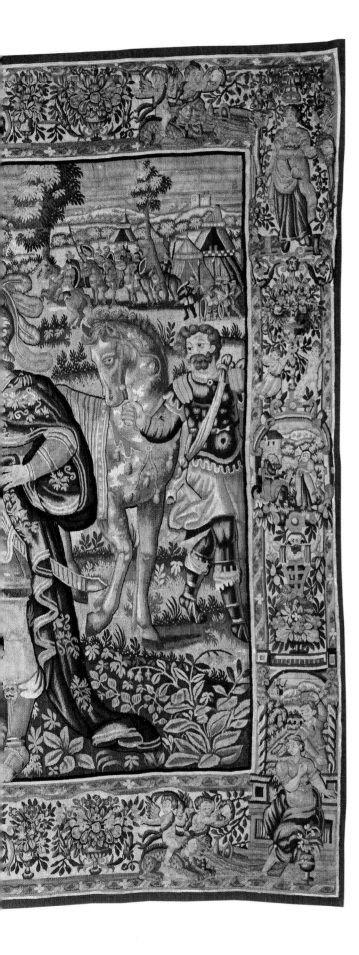

and his wife Catharina van den Eynde, who seems to have directed the workshop after her husband's death until she died prior to 1629.[7] The edition includes four scenes that also feature in the Italian suite (*The Battle of Issus*, *The War Booty*, *The Kings of Cyprus and Phoenicia Surrender to Alexander*, and *The Capture of Tyre*) and two that do not: *Alexander as Ruler of Asia* and *Alexander and Bucephalus*, which shows the stallion, Bucephalus, brought before Alexander, who was able to tame the wild horse (Plutarch, *Life of Alexander*, book 6). The former scene, however, is based on a cartoon that was originally part of the *Story of Cyrus* series designed by Michiel Coxcie (1499–1592) around 1550 (see cats. 20a–b).[8] This is not unusual; tapestry producers frequently amalgamated scenes from different sets to expand and customize suites (see cats. 19a–n).

This strategy was also adopted by the anonymous Brussels producer(s) who executed another *Alexander* suite around 1600 that was part of the Belgian Somzée collection of the nineteenth century.[9] The present location of the tapestries is unknown, but the illustrations and descriptions in the 1901 Somzée auction catalogue reveal that three of the six scenes feature in the suites just mentioned; the other three episodes sold in 1901 were *Alexander and Timocleia*, which showed Alexander granting clemency to Timocleia, who had killed one of his generals for raping her (Plutarch, *Life of Alexander*, book 12); *Alexander Wounded by an Arrow*, which depicted Philippus, Alexander's personal physician, removing an arrow from the king's calf (Plutarch, *Life of Alexander*, book 45); and the so-called *Triumphal Procession of Alexander*.[10] The latter scene, however, is based on a cartoon that belongs to an anonymous *Story of Zenobia and Aurelian* set presumably created around 1550 to 1575, which again shows the ease with which tapestry producers mingled cartoons from different sets to accommodate clients with seemingly new episodes.[11]

Other Alexander pieces based on the same cartoons used by Mattens and Geubels have appeared on the art market, including a version of *Alexander Encounters Thalestris*.[12] These isolated tapestries, as well as the Italian, Swedish, and ex-Somzée suites were all produced in Brussels. The piece in the Art Institute, however, is the mirror image of the Brussels *Alexander and Thalestris* tapestry produced in Brussels, and there exist a handful of other Alexander tapestries that are the mirror images of their Brussels counterparts, including a version of *Alexander and Timocleia* that surfaced on the art market in 1991 (fig. 1).[13] This tapestry and the Chicago *Alexander Encounters Thalestris* have identical borders and are nearly the same height, which suggests that they were once part of the same suite. A version of *The War Booty* that appeared on the art market in the 1990s also has identical borders and is almost the same height, which allows it to be identified as a third piece of this suite (fig. 2).[14] Two more Alexander tapestries that are mirror images of Brussels versions have surfaced on the art market: *The Battle of Issus* (fig. 3) and *The Capture of Tyre* (fig. 4).[15] The borders of these pieces are very similar, though not identical, to those of the tapestry in the Art Institute.

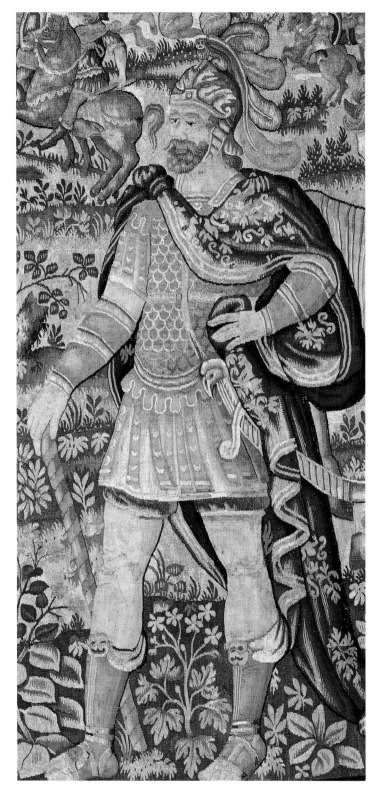

CAT. 37, DETAIL

FIG. 1 *Alexander and Timocleia* from *The Story of Alexander the Great*. Flemish, possibly Tournai, c. 1600. Wool and silk; 282 x 265.5 cm. Location unknown.

FIG. 2 *The War Booty* from *The Story of Alexander the Great*. Flemish, possibly Tournai, c. 1600. Wool and silk; 285 x 385 cm. Location unknown.

A third work with similar borders that was also recently on the art market can be identified as *Alexander and the Family of Darius* (fig. 5); it shows Alexander treating the family of his defeated enemy with great kindness (Plutarch, *Life of Alexander*, book 21).[16] Other versions of *The Battle of Issus* and of *Alexander and the Family of Darius* are known that are reversed vis-à-vis their Brussels counterparts.[17]

The coexistence of the Brussels group of tapestries and a group of tapestries that are their mirror images raises some intriguing methodological questions and problems. The dyes and quality of the weaving suggest that the mirror image pieces were woven in Oudenaarde, yet this does not explain the reversal of the compositions, because both Brussels and Oudenaarde weavers operated low-warp looms.

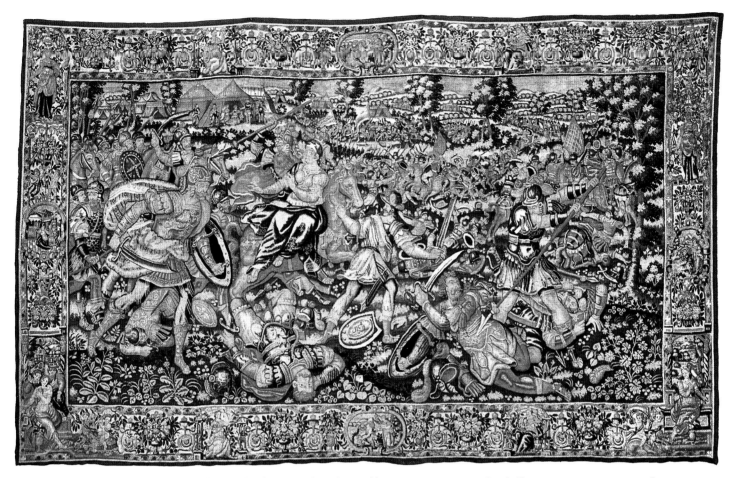

FIG. 3 *The Battle of Issus* from *The Story of Alexander the Great*. Flemish, possibly Tournai, c. 1600. Wool and silk; 271 x 452 cm. Location unknown.

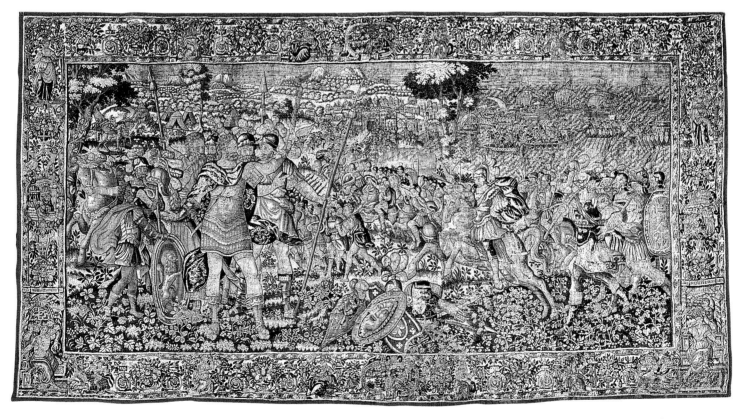

FIG. 4 *The Capture of Tyre* from *The Story of Alexander the Great*. Flemish, possibly Tournai, c. 1600. Wool and silk; 275 x 520 cm. Location unknown.

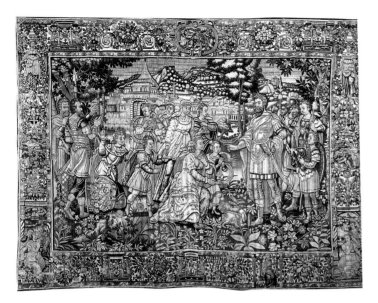

FIG. 5 *Alexander and the Family of Darius* from *The Story of Alexander the Great.* Flemish, possibly Tournai, c. 1600. 236.2 x 330.2 cm. Location unknown.

Nello Forti Grazzini, who recently analyzed this *Alexander* series, argued that the reversal of the compositions might be explained by the Oudenaarde entrepreneurs' use of a set of cartoons copied from a woven suite instead of from the original cartoons, or by their use of cartoons that were the mirror image of the original cartoons.[18]

Though it is possible that two sets of cartoons existed, it is also plausible that there was only *one* set of cartoons that was used on both low-warp and high-warp looms, and thus that the mirror image pieces were not produced in Oudenaarde, but in a production center in which high-warp looms were in use in the seventeenth century, such as Bruges. A mirror image *Alexander and the Family of Darius* (Gruuthusemuseum, Bruges) has been correctly attributed to the town, which reveals that the same set of Alexander cartoons used in Brussels was indeed used in Bruges as well.[19] This, however, does not necessarily imply that the Chicago tapestry and its companion pieces were woven in Bruges. In fact, the mirror image tapestries—except, of course, the piece at the Gruuthusemuseum—resist attribution to Bruges as their border and color scheme are not typical of tapestries woven in that city. There was, however, another nearby production center where tapissiers operated high-warp looms, namely Tournai. Tournai tapestry production in the first half of the seventeenth century has been little studied, but it is known that around 1600 the tapissiers Michiel Vanderbeek and Jacques de Casselles moved from Oudenaarde, their hometown, to Tournai, together with a number of tapestry weavers and cartoons and, possibly, wool and silk threads.[20] Whereas the quality of execution and the color scheme of the Chicago *Alexander Encounters Thalestris* and its companion pieces link them to Oudenaarde, the technique points to a high-warp production center, this group might be attributed to a Tournai workshop directed by an entrepreneur originally from Oudenaarde.

A *Story of Cyrus* tapestry that has surfaced on the art market and is linked to a pair of Brussels *Cyrus* pieces in the Art Institute (see cats. 20a–b) broadens this question of attribution.[21] The tapestry, *The Diversion of the River Euphrates,* is the mirror image of its Brussels counterparts. Moreover, the border of the Cyrus piece is nearly identical to that of the Chicago *Alexander Encounters Thalestris,* which suggests that both the inverted *Cyrus* and the inverted *Alexander* pieces were produced at the same workshop. KB

NOTES

1. Hammond 1993, p. 81. Plutarch (*Life of Alexander,* book 46) also related the episode but refuted its truth, as he adopted a more factual approach.
2. For the mythical character of the Amazons and the archaic Greek origins of the myth, see Blok 1995 and Wagner-Hasel 1986.
3. Dixon 2002a, p. 19.
4. Forti Grazzini 2003, pp. 137–53.
5. For Reymbouts, see Wauters 1878, pp. 207, 295–96; Van Tichelen 1987; and Van Lokeren 1998.
6. Böttiger 1898, vol. 3, p. 19; Böttiger 1928, pp. 27–33, figs. 20–23.
7. Meesters 1962; De Poorter 1979–80; Duverger 1981–84.
8. For Coxcie, see De Smedt 1992. Coxcie's tapestry designs were surveyed by Duverger 1992, pp. 178–81, and Campbell 2002b, pp. 394–402.
9. Parc du Cinquantenaire, Brussels, May 20, 1901, Somzée sale, lots 548–53.
10. The three scenes present in both the ex-Somzée and the aforementioned suites are *The War Booty, The Kings of Cyprus and Phoenicia Surrender to Alexander,* and *Alexander and Thalestris.*
11. A suite of four *Zenobia and Aurelian* tapestries was on the art market in 2002 (Galerie Chevalier, Paris; shown at the European Fine Art Fair at Maastricht, in Mar. 2002; previously Sotheby's, Schloss Monrepos, Oct. 9–14, 2000, lots 78–81). A fifth piece that belonged to this suite was sold at Christie's, Paris, Dec. 10, 1995, lot 136. Another suite of *Zenobia and Aurelian* comprising three tapestries is in the Musée d'Art et d'Histoire, Geneva; Tervarent 1958, pls. 70–72. A piece that was part of another edition is at the Musée des Beaux-Arts, Rouen (inv. 990.8.1); see Grandjean 2001.
12. These pieces include *Alexander Encounters Thalestris,* which was sold at Hôtel Drouot, Paris, Dec. 21, 1992, lot 120 (320 x 395 cm); *Alexander Wounded by an Arrow,* owned by French and Company, New York, from 1944 to 1951; and a version of *The War Booty* measuring 356 x 390 cm that surfaced on the art market in the 1980s, according to photograph no. 1575.212 in the files of the Royal Museums of Art and History, Brussels.
13. Christie's, London, Dec. 12, 1991, lot 2 (282 x 265.5 cm).
14. Hôtel Drouot, Paris, Dec. 2, 1994, lot 200 (300 x 390 cm); subsequently Sotheby's, London, February 29, 1996, lot 17.
15. *The Battle of Issus* was sold at Hôtel George V, Paris, June 17, 1980, lot 201 (271 x 452 cm). *The Capture of Tyre* was sold at Christie's, London, Dec. 14, 1995, lot 229. In 2003 this piece was in the stock of Galleria Turchi, Florence; see Forti Grazzini 2003, pp. 142, 151.
16. This tapestry was sold by French and Company, New York, to Thomas McInnernery on Jan. 20, 1937.
17. These include the *Battle of Issus* sold at Christie's, London, July 9, 1981, lot 161 (see Forti Grazzini 2003, p. 144) and the *Alexander and the Family of Darius* in the Gruuthusemuseum, Bruges, inv. 72.57.XVII (published in Vermeersch 1980, pp. 270–71.)
18. Forti Grazzini 2003, p. 143.
19. Vermeersch 1980, p. 270; De Bodt and Koldeweij 1987, p. 158; Delmarcel and Duverger 1987, pp. 238–39.
20. Soil de Moriamé 1891, pp. 59–61.
21. American Art Galleries, New York, Apr. 28–29, 1922, lot 350.

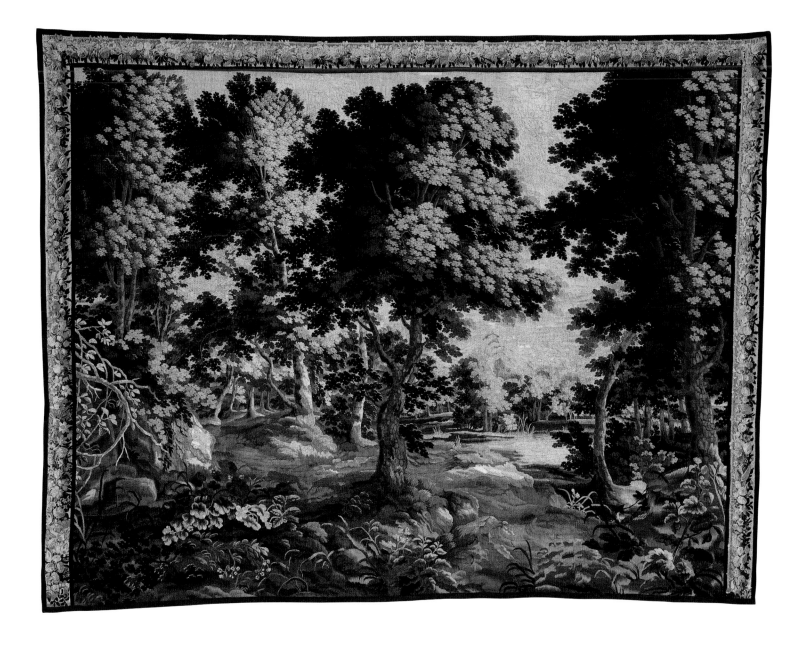

CAT. 38

Woodland with a Pond

Flemish, possibly Brussels, 1660/70
After a design by an unknown artist
Produced at an unknown workshop
384.81 x 296.55 cm (151½ x 116¾ in.)
Gift of Mrs. Moise Dreyfus, 1959.85

STRUCTURE: Wool and silk, slit and double interlocking tapestry weave
Warp: Count: 6–7 warps per cm; wool: S-ply of three Z-spun elements;
diameters: 0.5–0.6 mm
Weft: Count: varies from 18 to 32 wefts per cm; wool: S-ply of two Z-spun
elements; S-ply of three Z-spun elements; diameters: 0.4–1.2 mm; silk: pairs
and single yarns of S-ply of two Z-twisted elements; diameters: 0.25–0.8 mm

Conservation of this tapestry was made possible through the generosity of
the James Tigerman Estate.

A large curving tree with dense foliage appears at the center of this
tapestry. To its left a number of trees recede into the distance. The
right half of the scene is more open, as it depicts a vista across a pond,
framed by large trees with sweeping branches. Flowers fill the bor-
der. The tapestry has no bottom border, but this is believed to be an
original feature.

Though *Woodland with a Pond* was catalogued on its arrival at the
Art Institute as a French tapestry woven in the eighteenth century, its
composition and style link it to Flemish—and especially Brussels—
landscape painting of around 1660.[1] Woodland scenes emerged as a
subgenre of landscape painting in the Southern Netherlands starting
at the beginning of the sixteenth century.[2] By 1600 painters such as
Gillis van Coninxloo, Jan I Brueghel, and Abraham Govaerts special-
ized in the detailed depiction of dense forests in a palette dominated
by a wide range of blue, green, and yellow tones, which create a vivid
and somewhat mysterious atmosphere. Denijs van Alsloot, a Brussels

CAT. 38, DETAIL

contemporary of these artists and court painter to Archduke Albert and Isabella of Spain, developed a more decorative and panoramic variant characterized by the alternation of heavily wooded sections with clear views across ponds.[3] The rhythm of Van Alsloot's wood-scapes is further defined by small groups of elegant trees with arcing branches.

This formula was further developed by a number of Brussels landscape painters. Given the close stylistic resemblance among their works, these artists are usually discussed as the so-called Brussels School of decorative landscape painting.[4] Unlike Van Alsloot, most of these artists also designed tapestry sets.[5] Lodewijk de Vadder (1605–1655) was the most prolific artist of the group.[6] In 1643

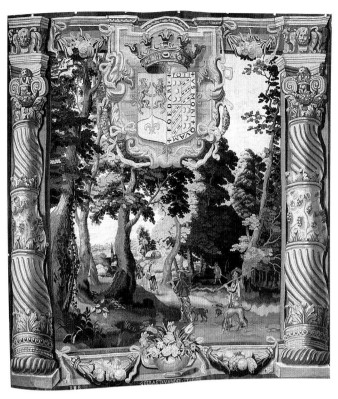

FIG. 1 *The Return from the Hunt and an Unknown Coat of Arms.* Brussels, c. 1650. Wool and silk. Location unknown.

the Brussels tapissier Boudewijn van Beveren praised De Vadder as the "voornaemste schilder van den lande" (the country's preeminent painter), and one year later De Vadder was granted exemption from taxation by the Brussels municipality in recognition of his production of landscape designs for the city's tapestry entrepreneurs.[7] After De Vadder's death in 1655, his exemption from taxation was divided and granted to five Brussels landscape painters: the now obscure Jan Claessens, Daniël van Heil (1604–1662), Willem van Schoor, Jacques d'Arthois (1613–1686), and Lucas Achtschellinck (1626–1699).[8] Though a number of sets can be attributed to Achtschellinck, the tapestry designs made by the other Brussels landscape painters unfortunately remain unknown.[9] Therefore, *Woodland with a Pond* cannot be securely attributed to any one of these artists in particular.

The floral border of the Art Institute's piece suggests that it was woven around 1660 to 1670. The tapestry bears no marks or signatures, but its refined execution, strikingly exemplified by the impressionistic rendering of tree bark and foliage, reveals that it must have been woven in a major production center, possibly Antwerp or Brussels. Indeed, the vocabulary of *Woodland with a Pond* bears a marked similarity to that used in Brussels tapestries woven between about 1650 and 1680. For example, a Brussels suite of four *Landscape Verdures with Rural and Hunting Scenes* of around 1650, now in the Rijksmuseum, Amsterdam, has similar motifs and an identical color scheme, as does a Brussels tapestry showing *The Return from the Hunt and an Unknown Coat of Arms* that was also produced around 1650 (fig. 1).[10] A verdure suite produced at the De Pannemaker workshop

around 1660, and an edition of *Landscapes with Ovid's Metamorphoses* woven by Daniel Abeloos (died in or after 1689) and Jacob van der Borcht (c. 1650–c. 1710) around 1670, can be linked to the Art Institute's tapestry on the same grounds.[11]

Thus *Woodland with a Pond* belongs to a vast group of seventeenth-century Flemish landscape tapestries. The genrelike quality of these sets and the related series depicting *Landscapes with Small Mythological Scenes* has made them less appealing to art historians, but it must be stressed that this type of series was vitally important to the majority of Antwerp, Brussels, and Oudenaarde workshop managers, whose livelihood depended on the production of these popular sets. The limited color range and the absence of large, intricate figures made these tapestries less costly to produce than history sets, which allowed workshop managers to sell them to a broader market.

KB

NOTES

1. Object file 1959.85, Department of Textiles, the Art Institute of Chicago.
2. For the origins and development of the woodland subgenre, see Hanschke 1988; Devisscher 2001, pp. 24–29; and Ertz in Benesz 2003, pp. 148–53.
3. For Van Alsloot, see Larsen 1948; Thiéry 1953, pp. 129–36; De Maeyer 1953; De Maeyer 1955, pp. 162–67; Laureyssens 1967; Thiéry and De Meerendré 1987, pp. 99–107; Brosens 1998; and Ertz in Benesz 2003, pp. 172–73.
4. Ertz in Benesz 2003, pp. 363–67, presents the most recent survey of the Brussels School.
5. Göbel 1923, vol. 1, pp. 421, 428, claimed that Van Alsloot had been an important tapestry designer as well, but De Maeyer 1953 convincingly argued that Van Alsloot created only one tapestry set: a *Grotesques* series that was commissioned by the Archduke. Van Alsloot's father, also named Denijs, was a tapestry producer; Schrickx 1974.
6. For De Vadder, see Thiéry 1953, pp. 133–36; De Callatay 1960, pp. 155–70; Coekelberghs 1975, pp. 109–14; Thiéry and De Meerendré 1987, pp. 113–24; and Ertz in Benesz 2003, pp. 363–64, 368–69.
7. Van Beveren's praise appears in SAB, RT 1294, fols. 64r–65v. De Vadder's exemption is recorded in SAB, RT 1293, fols. 316v–317v. On Mar. 7, 1650, Jan Cordys stated that he had commissioned a set of *Landscape* cartoons from De Vadder (SAB, RT 1296, fols. 15v–16v). A set of *Landscapes* "door vadder geschildert" (painted by De Vadder) was listed among the sets produced by Willem van Leefdael (1632–1688) in 1685; ARAB, NGB 1139¹, notary Van den Eede (Sept. 10, 1685).
8. SAB, RT 1297, fol. 97v. For more on these painters, see Brosens 2004a, p. 97.
9. For the attribution to Achtschellinck, see Brosens 2004a, pp. 97–98. Kervyn De Meerendré in Maes 1987, p. 60, comments on the lack of knowledge regarding the designs made by other Brussels landscape painters.
10. The suite of four *Landscape Verdures with Rural and Hunting Scenes* is published in Hartkamp-Jonxis and Smit 2004, pp. 123–28, cats. 36a–d. *The Return from the Hunt and an Unknown Family Coat of Arms* is in the collection of BNP Paribas Bank (inv. 1889).
11. For the *Verdures*, see Duverger 1986b. For *Landscapes with Ovid's Metamorphoses*, see Crick-Kuntziger 1959.

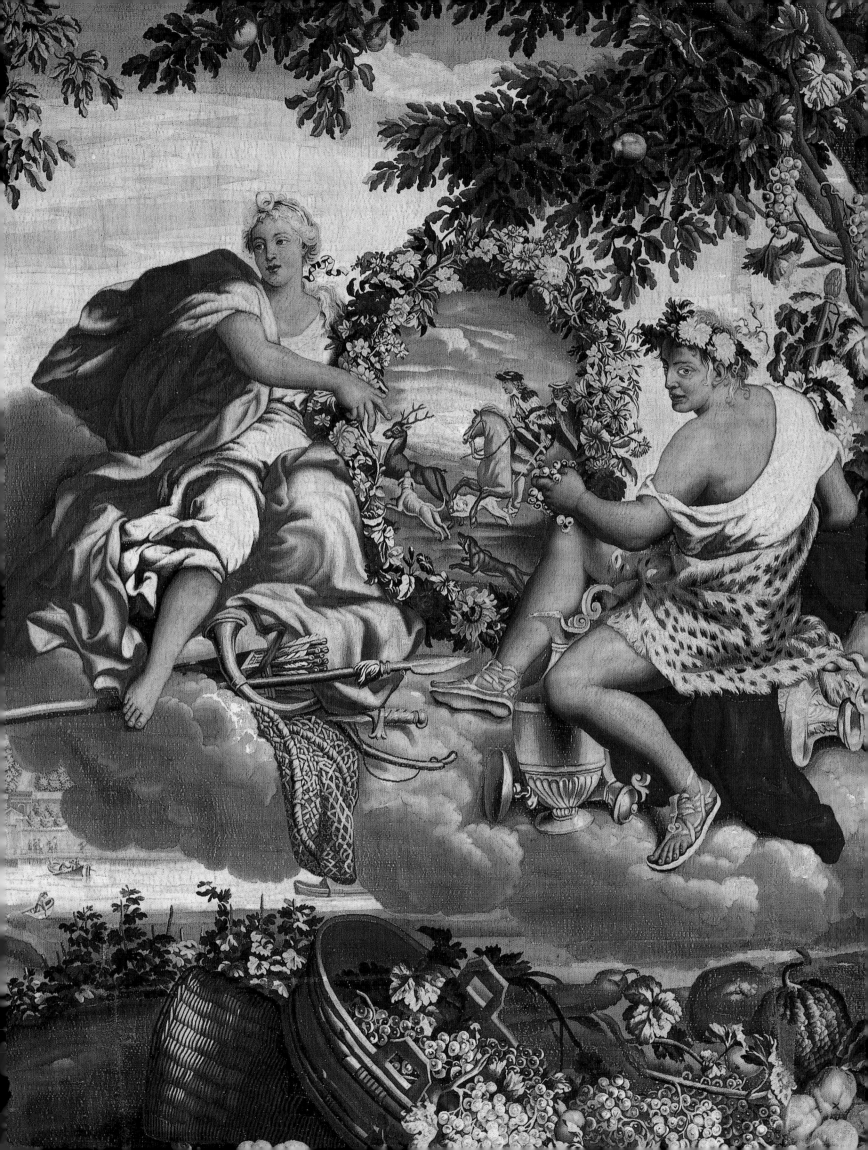

❧ III ❧
FRENCH TAPESTRIES
1600–1800

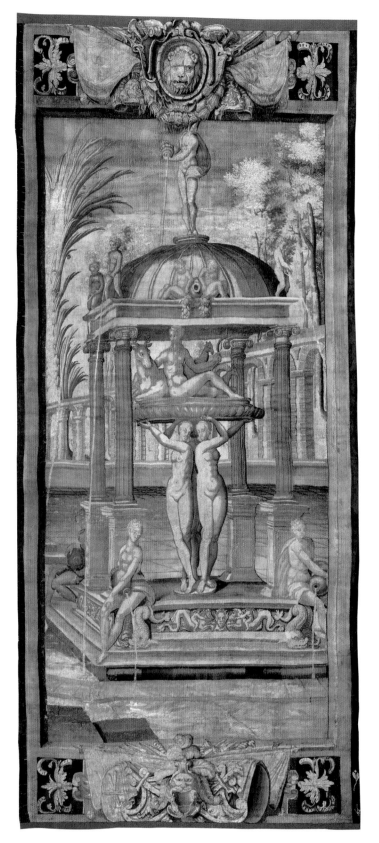

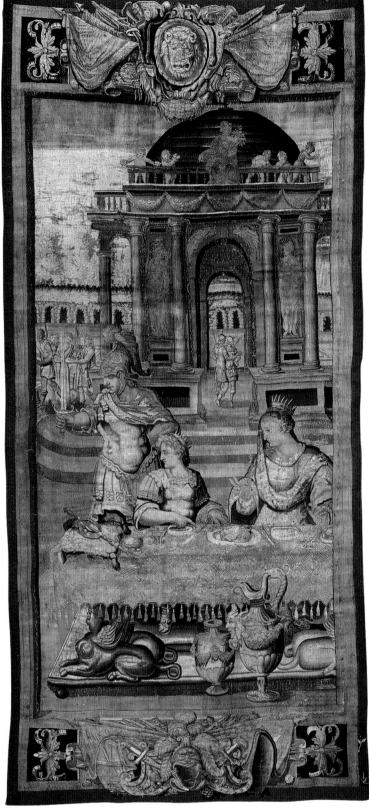

CAT. 39A

CAT. 39B

From *The Story of Artemisia*

CAT. 39A

The Petitions [right part]

Paris, 1607/30
After a design by Antoine Caron (1521–1599)
Produced at an unknown workshop at the Manufacture du Faubourg
Saint-Marcel
MARKED AND SIGNED: a flower; *LVD*
182.2 x 415.7 cm (71⅝ x 163⅝ in.)
Gift of Charles J. Singer through the Antiquarian Society of the Art Institute
of Chicago, 1890.9

STRUCTURE: Wool and silk, slit and double interlocking tapestry weave
Warp: Count: 7–8 warps per cm; wool: S ply of five Z-spun elements;
diameters: 0.8–1.0 mm
Weft: Count: varies from 20 to 46 wefts per cm; wool: S-ply of two Z-spun
elements; S-ply of three Z-spun elements; pairs of S-ply of two Z-spun ele-
ments; diameters: 0.3–1.0 mm; silk: four yarns of S-ply of two Z-twisted
elements; diameters: 0.5–1.0 mm; wool and silk: three yarns, one of S-ply of
two Z-spun wool elements and two of S-ply of two Z-twisted silk elements;
four yarns, one of S-ply of two Z-spun wool elements and three of S-ply of
two Z-twisted silk elements; diameters: 0.5–0.7 mm

Conservation of this tapestry was made possible through the generosity of
the Antiquarian Society of the Art Institute of Chicago.

PROVENANCE, REFERENCES, EXHIBITIONS: See below.

CAT. 39B

The Feast [central part]

Paris, 1607/30
After a design by Antoine Caron (1521–1599)
Produced at an unknown workshop at the Manufacture du Faubourg
Saint-Marcel
MARKED AND SIGNED: a flower; *LVD*
189.7 x 402.1 cm (74¾ x 157⅜ in.)
Gift of Charles J. Singer through the Antiquarian Society of the Art Institute
of Chicago, 1890.10

STRUCTURE: Wool and silk, slit and double interlocking tapestry weave
Warp: Count: 8 warps per cm; wool: S-ply of five Z-spun elements;
diameters: 0.8–1.0 mm
Weft: Count: varies from 20 to 40 wefts per cm; wool: S-ply of two Z-spun
elements; S-ply of three Z-spun elements; pairs of S-ply of two Z-spun ele-
ments; three yarns of S-ply of two Z-spun elements; diameters: 0.3–1.0 mm;
silk: four yarns of S-ply of two Z-twisted elements; diameters: 0.5–0.8 mm;
wool and silk: three yarns, one of S-ply of three Z-spun wool elements and
two of S-ply of two Z-twisted silk elements; four yarns, one of S-ply of three
Z-spun wool elements and three of S-ply of two Z-twisted silk elements;
diameter: 1.0 mm

Conservation of this tapestry was made possible through the generosity of
the Antiquarian Society of the Art Institute of Chicago.

PROVENANCE: An unidentified Italian family, Rome, to 1890; sold to the
Art Institute with Rodolfo Amadeo Lanciani acting as agent, 1890.

REFERENCES: Hunter 1914a, pp. 120–21, figs. 6–7. Jarry 1973, pp. 6–11, figs.
3–4. Mayer Thurman in Keefe 1977, cats. 243–44. Mayer Thurman 1979, pp.
14–15, figs. 15–16. Standen 1985, vol. 1, p. 273. Art Institute of Chicago 1992.
Adelson 1994, p. 184.

EXHIBITIONS: Art Institute of Chicago, *The Antiquarian Society: The First
One Hundred Years*, 1977 (see Art Institute of Chicago 1977). Art Institute
of Chicago, *A Birthday Celebration: 100 Years of Antiquarian Society Textile
Collecting, 1890–1990*, 1992 (see Art Institute of Chicago 1992).

THESE two tapestries from a *Story of Artemisia* suite are *entre-
fenêtres*: tall, narrow pieces meant to hang on the piers separating the
windows of a room. Due to this format, the field of such a tapestry
rarely shows a complete subject, but rather part of a larger compo-
sition. To make the most of their small surface area, *entrefenêtres*
usually have only top and bottom borders, the designs of which are
generally limited to a reprise of the central motifs of the horizon-
tal borders on wider tapestries that depict the whole design. In the
present case, the top border of each piece contains a lion's head in a
medallion flanked on either side by a flag, and the bottom border
shows a helmet decorated with a lion's head in front of various mili-
tary trophies—the motifs most commonly used for the borders of
Story of Artemisia designs.

One of the *entrefenêtres* (cat. 39a) shows an elegant pavilion-
shaped fountain in the center of a circular pool. The pavilion is
composed of a cupola supported by four Ionic columns rising from
a square base. It is decorated principally with nude figures: A naiad
stands on top of the cupola pouring water from an urn, and at each
of the cupola's corners a putto urinates into the pool below.[1] At the
base of each column a naiad pours water from an urn resting on her
lap. Under the cupola the Three Graces hold aloft a large platform
on which a nymph sits bearing a bow, her arm around a stag, and a
dog at her feet. Behind the fountain, an arcade walls in the flagstoned
space. The other *entrefenêtre* presents the queen Artemisia and her
son Lygdamis sitting at a table, looking to the left as if at something
beyond the edge of the tapestry. Behind the boy stands a soldier, who
brandishes a sword in his right hand. Bronze sphinxes form the table
legs. A ewer and a vase figure in the foreground, while a domed edi-
fice dominates the background, its facade ornamented by porticoes
supported by columns. Two colossal statues occupy the niches on
either side of the arched doorway.

The inspiration for the set is *L'histoire de la Royne Arthémise* by
Nicolas Houel, a Parisian apothecary, patron of the arts, and philan-

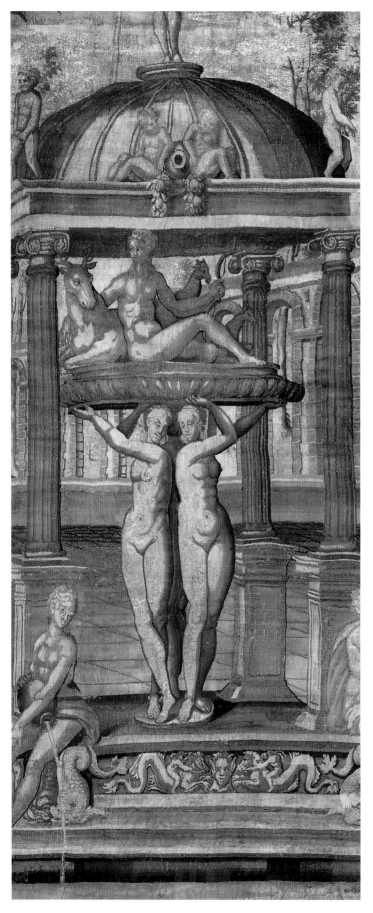

thropist. The work originally consisted of a short text completed by 1563, and accompanied by a small number of drawings (very likely ten or so). On the advice of his friends Houel labored for over ten years through two stages of writing to expand his work into an opus composed of two autonomous parts: a voluminous, four-book manuscript, without illustrations, and a series of about seventy drawings paired with sonnets.[2] In both forms, *L'histoire de la Royne Arthémise* is extremely erudite, a summation of what a gentleman of breeding could know about both antiquity and his own age.[3] Houel planned to give the manuscript to Catherine de' Medici on the occasion of the marriage of her son, Charles IX, to Elisabeth of Austria, which was celebrated in Mézière on November 26, 1570, and fêted in Paris in March 1571, but in the early 1580s, the work was still in Houel's possession.[4]

The prose poem, sonnets, and drawings conflate two ancient queens of Caria, in what is now Turkey, both named Artemisia, into one heroic figure. One Artemisia is well known for having ordered the building of the famous Mausoleum at Halicarnassus—one of the Seven Wonders of the ancient world—in memory of her loving husband, king Mausolus, who died in 353 B.C. The other queen, best known for her participation in the Battle of Salamis, lived slightly over a century earlier. These deeds and many additional anecdotes are used in the tapestry series to glorify Catherine de' Medici, queen of France, widow of Henry II, and regent during Charles IX's minority. The choice of Artemisia was no accident but rather a deliberate transposition of historical figures to the life of Catherine de' Medici. Houel had conceived of his project in the years after Henry II's death, when Diane de Poitiers, the late king's mistress and formerly the most influential woman at court, was forced to retire to her various châteaux—Beynes (near Montfort), Limours (near Chevreuse) and Anet—and Catherine became master of the kingdom.[5] As Houel reminds us, the name Artemisia comes from Artemis, the Greek name for the goddess Diana.[6] According to this analogy, Catherine, extolled under the features of Artemisia, is the new Diana (Diane in French). At the same time, Houel informs his readers that the aim of his poem is to furnish subjects suitable for translation into "belles et riches peintures à tapisseries" (beautiful and rich paintings [cartoons] for tapestries).[7] If Houel knew of *The Story of Diana*, a masterpiece woven in Paris for Diane de Poitiers during Henry II's reign, *The Story of Artemisia* may well have been intended as source material for a rejoinder.[8]

The actions and events portrayed throughout the prose poem are meant to parallel similar episodes in Catherine's life. The pacific government of Mausolus and his wife inspired love and obedience in their people, just as the reign of Henry II and Catherine did. The prose poem's first two books relate both Artemisia's sorrow and Mausolus's funeral, as well as the wisdom the queen exercised in governing her realm and in educating her son to make him an ideal sovereign. Like the devout Artemisia, Catherine gave her husband a royal burial. She also took great care in the education of her chil-

dren, particularly that of the future Charles IX, as the Carian queen did with Lygdamis.[9] Catherine enjoyed much military success, and pacified agitation in France, just as Artemisia brought peace to Caria after an uprising at Rhodes. Moreover, Catherine erected structures at the Tuileries, Monceaux, and Saint-Maur, as Artemisia built many edifices, columns, and pyramids. Nor did Houel hesitate to invent episodes—like Artemisia's meeting with her States General—to match and enhance real events in Catherine's life, such as the Assembly at Orléans. Houel thus presented Artemisia's reign as a model of glorious regency, using her story to exalt and chronicle the French queen's rule.

The drawings accompanying the sonnet version of the work were, according to Houel, executed "by the best men from Italy and France" to serve as models for tapestries.[10] Traditionally, the majority of the pictures are ascribed to Antoine Caron and the remainder to a dozen Fontainebleau artists, including Nicolò dell'Abate, his son Giulio Camillo, and Baptiste Pellerin.[11] Almost all the images are surrounded by a wide border ornamented with arabesques, birds, garlands of flowers, foliage, and medallions. A half-Valois, half-Medici coat of arms occupies the middle of the top border, flanked by two cartouches, sometimes carried by putti, in which Catherine de' Medici's motto is inscribed: "Ardorem extincta testantur vivere flamma" ([they] testify that heat endures, even when the flame is extinguished). This maxim refers to the sentiments expressed by the symbols of mourning (broken mirrors, Saturn's scythe, tears falling on quicklime, and whorls of smoke) that figure in the side borders.[12] The *K*s of Catherine's cipher are inscribed in the upper corners of several of the illustrated sheets. The bottom border of the drawings was left free to receive the caption explaining the subject represented, just as it would be on the tapestry itself.[13]

Tapestries based on the drawings were first executed only at the beginning of the seventeenth century, during the reign of Henry IV. Additional versions of the series were woven during Louis XIII's reign, but after that it fell out of fashion.[14] Owners of suites included the French monarchs Henry IV, Louis XIII, and Marie de' Medici, as well as dukes of Savoy and of Bavaria, ambassadors, cardinals, and various French and foreign princes. The meaning of *The Story of Artemisia*, as well as its political implications, which evolved even as Houel expanded the manuscript, varied with the owner of the edition. As the subjects of most tapestries are designed to be open to multiple interpretations, so that in them different owners may all recognize themselves, their veiled political references cannot be seen, much less understood, without knowing for whom the pieces were woven.[15]

For example, Henry IV chose *The Story of Artemisia* series to celebrate his second marriage, to Catherine de' Medici's cousin, Marie de' Medici. Again, this choice was no accident, but rather a calculated reaffirmation of his ties to the Valois dynasty. Like Lygdamis, Henry IV was an orphan prince adopted by his country's queen: his father, Antoine de Bourbon, died in 1562, and his mother, Jeanne

FIG. 1 *The Petitions*. Antoine Caron, 1563/66. Pen and ink with wash; 51 x 56 cm. Bibliothèque Nationale de France, Paris, Réserves Ad 105, fol. 37.

d'Albret, died ten years later. Catherine, who in 1564 had seen Henry in a dream as the future king of France, took him under her wing and gave him her daughter Marguerite as his first wife. In a further parallel to the story of the Carians, while still a young prince, Henry brought peace to France, subduing those towns that refused his authority, just as Artemisia had done with Rhodes in her time. By ordering the weaving of the hangings which had been planned forty years earlier for Catherine, Henry legitimized his reign by assimilating his own story to that with which the queen had been identified, thus positioning his family, the Bourbons, as worthy successors to the Valois dynasty that had preceded it.

The Story of Artemisia is thus part of a long line of series about classical heroes (such as Caesar and Scipio) composed of a group of Triumphs and one featuring Deeds, or scenes of the prince in his apprenticeship and exercise of power. The subjects chosen for weaving during Henry IV's reign mostly treated Mausolus's burial, portraying the funeral cortege very much like a triumphant procession; or detailed Lygdamis's military education and prowess, representing the French king, by analogy, as a clever strategist and worthy heir to the throne as well as to antiquity. In contrast, the scenes woven for Marie mostly depict Artemisia's regency, her good government, and the education of her son.[16]

The *Artemisia* tapestries in the Art Institute depict two of the queen's deeds, and are based on episodes from the second book of Houel's manuscript.[17] In one of her first political acts, the Carian queen sent heralds to inform her subjects that she would hear their grievances in preparation for the Assembly of the States General at Halicarnassus.[18] The first *entrefenêtre*, which is based on a drawing known as *The Petitions* (fig. 1), depicts the queen welcoming a delegation of deputies bearing those grievances. As the related sonnet describes, the scene is set in the garden of a country house, a spot favored by rulers in part for its symbolic value: since the beginning

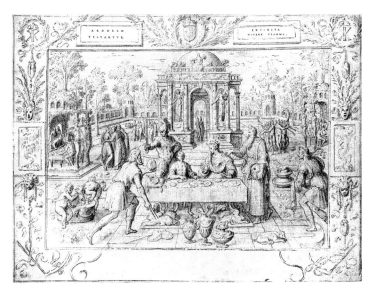

FIG. 2 *The Feast*. Antoine Caron, 1563/66. Pen and ink with wash, 40 x 55 cm. Musée du Louvre, Paris, RF 29728 bis3.

of the fourteenth century, the various beds were considered a visual metaphor for a unified kingdom.[18] The right half of the drawing, on which the *entrefenêtre* in the Art Institute is based, shows just such a formal garden, walled off by arcades, a fountain at its center. The setting is also fitting because, according to Pliny, an author Houel references in the expanded work, Artemis was associated with gardens, and in Latin her name refers to wormwood (*artemisia*).[20] In the left part of the drawing, which is not represented in the *entrefenêtre*, Artemisia stands with her son on the threshold of an imposing dwelling, before an Ionic portico.[21] As Sheila ffolliott points out, the Ionic order was described as feminine by Vitruvius (whom Houel also cites), and thus deemed particularly appropriate to the construction of temples for Diana/Artemis.[22]

The resemblance of the fountain's central group of Graces supporting a nymph to the Diana/Diane of the famous fountain at Anet (now in the Musée du Louvre, Paris) has generated much confusion. It prompted Maurice Fenaille to give the drawing the ambiguous title *The Petitions or The Fountain of Anet*, the first part of which refers to the incident in the rule of Artemisia/Catherine de' Medici, while the second half (which purports to identify the location of the scene) refers to a favored château of Catherine's rival, Diane de Poitiers.[23] Later scholars have attempted to explain this contradictory imagery. Jean Ehrmann attributed the presence of the so-called Anet Fountain to a painter's error, but this explanation is unacceptable, since Houel himself commissioned the drawings, and would not have allowed such a blunder to occur.[24] Sylvie Béguin interpreted the simultaneous reference to both women as an allusion to Catherine's stranglehold on Diane's possessions after Henry II's death.[25] In fact, as ffolliott determined, an amalgamation of images is at the origin of the confusion.[26]

Cellini's *Nymph* (1542/43, now in the Musée du Louvre, Paris) was commissioned by Francis I to decorate the *Porte Dorée* at Fontainebleau, and was only later given by Henry II to his mistress, to

be placed over the entry of the Château d'Anet, at which point it came to signify Diana/Diane. Other representations of the goddess Diana came to be understood, by analogy, as allusions to the king's mistress. The type of reclining nude represented in the Fontainebleau *Nymph*—without the crescent moon that was an attribute of the goddess—also became a symbol of Diane de Poitiers.

Up to this point, ffolliott's scholarship is sound; however, she then argues that Artemisia's garden, as represented in Caron's drawing, refers to Fontainebleau and not Anet, principally because the fountain at the latter lacks the fertility imagery on the fountain depicted. Moreover, ffolliott argues that Diane de Poitiers was not likened to the fertile Diana of Ephesus, nor to Diana the Huntress, but to a figure inspired by the Fontainebleau *Nymph*, in the reclining pose often associated with Venus, the goddess of love. Since the nymph/Diane de Poitiers figure is placed in shadow, under the dome of the fountain, ffolliott concludes that the drawing expresses Catherine de' Medici's political superiority over her late husband's mistress.[27] This may be so, but, as Valérie Auclair notes, it is also obvious.[28] At the death of Henry II, Diane de Poitiers lost her place as the most influential woman at court, and Houel constantly hints at this in his poem by playing on his representation of Catherine as the new Artemisia/Artemis/Diana. Moreover, this is a reductive view of the subject: though Caron may have used a specific fountain as a model (this was standard artistic practice at the time), and though it is possible to see the garden as evocative of Fontainebleau and Catherine de' Medici, or of Anet and Diane de Poitiers, Caron's drawing—which was approved by Houel himself—can represent equally well a generic pleasant spot, or one at a specific residence. Finally, it should be noted that the inventory made in 1627, after the death of the tapissier François de La Planche (1573–1627), mentions "la pièce de la fontaine" (the piece with the fountain) among a list of *Story of Artemisia* tapestries.[29] This can only be *The Petitions*, for no other scenes in the series represent fountains.

The second *entrefenêtre* shows the center part of *The Feast* (fig. 2), a drawing representing an episode that occurs not very long after that shown in *The Petitions*, located between *The Crowning of the Young King* (the drawing of which is now lost) and *The Presentation of the Book and the Sword*, which both illustrate the education of the young king by his mother. Only the prose text of *The Feast* survives, which locates the scene in a garden pavilion with three porticoes. The right and left niches each contain a sculpture of a nymph, while the banquet is laid out in the central portico.[30]

The versions of *The Petitions* and *The Feast* in the Art Institute are reasonably faithful to Caron's drawings. In both pieces the perspective has been changed slightly and the figures have been made larger in relation to the landscape. Other differences include the omission of a dog from the foreground of *The Petitions* and, in *The Feast*, the addition of fringe to the tablecloth, and the omission of a vase in front of the table. Moreover, though the design of the costumes in both tapestries is more elaborate than in the drawings, the palette remains

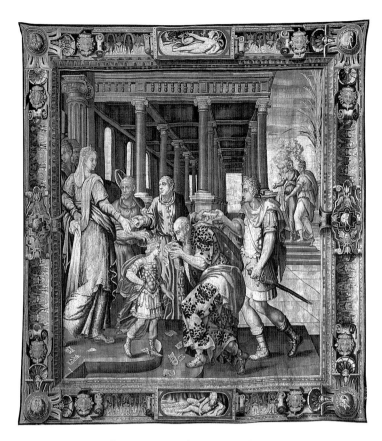

FIG. 3 *The Petitions* from *The Story of Artemisia*. After a design by Antoine Caron. Produced at the Manufacture du Faubourg Saint-Marcel, 1600/25. Linen and silk; 405 x 360 cm. Musée du Louvre, Paris, OA 6068.

limited, dominated by bluish and golden tones. In *The Petitions*, the golden color of some of the statues contrasts with the marblelike color of others. In *The Feast*, the skin tones of Artemisia and Lygdamis are grayish, and the pavilion's dome is bluish, but the red of the soldier's cloak provides a cheerful note that enlivens the scene.

The Petitions and *The Feast* were both woven several times.[31] No known tapestry includes the entirety of the *Petitions* composition. Two tapestries representing part of the subject were in the stock of the Manufacture du Faubourg Saint-Marcel in 1627, one a version woven with gilt-metal thread.[32] The left part of the scene, showing Artemisia administering her government, was apparently more successful, as evidenced by the existence of three tapestries after that portion of the drawing: one at the Musée du Louvre (fig. 3) and two formerly in the Savoy collection, one of which bears the coat of arms of Duke Charles-Emmanuel I.[33] The tapestry in the Art Institute is the only known example showing the garden and fountain in the right part of the drawing. A gilt-metal-thread version of *The Feast* was part of the group of tapestries in the French royal collection that were burned in 1797 to retrieve the gilt-metal thread for its monetary value, so the workers could be given back pay.[34] Three other *Feast* tapestries, a wide one and two narrower ones, are known.[35]

Fierce debate continues to rage over many questions concerning the adaptation of Houel's texts to tapestry, including the identity of

the artists who executed the cartoons after Caron's designs.[36] It is generally agreed that a first series of cartoons was painted by Henri Lerambert (1540/50–1608) and woven by 1600 in the workshop of Maurice Dubout (died 1611), which was located first at the Maison Professe des Jésuites, and then, by 1606, at the Louvre.[37] Weaving for a set of tapestries for Henry IV was underway by 1601. Dubout's workshop also wove the suite ordered in 1606 by the fabulously wealthy Cardinal Montalto, great-nephew of Pope Sixtus V and vice-chancellor of the church.[38] In 1607, Jean de Fourcy, Henry IV's intendant of the Bâtiments du Roi (Office of Royal Buildings and Public Works), instructed the painter Laurent Guyot (c. 1575/80–after 1644) to create another series of cartoons in oil on canvas representing "les exercices qu'elle faisait apprendre au Roy son fils pendant son veuvage" (the lessons that she [Artemisia] taught her son the King during her widowhood)—i.e., the Deeds part of the series—"conformément aux petits dessins en papiers faits de la main et invention de feu Antoine Caron" (according to the small drawings on paper done by hand and created by the late Antoine Caron), for Marc de Comans (1563–1644) and François de La Planche (1573–1627), Flemish tapestry producers in the faubourg Saint-Marcel.[39] The Comans-La Planche workshop went on to weave many suites from these designs. Among the first produced was the gilt-metal-thread edition featuring the coats of arms of France and Navarre and the ciphers of Henry IV and Marie de' Medici, listed as number sixteen in the inventory of the Mobilier de la Couronne, with the complementary tapestries formerly in Naworth Castle that were very recently acquired by the Mobilier National.[40] Other editions produced at the workshop include one listed as number fifteen in the inventory of the Mobilier de la Couronne; a suite of four pieces woven with gilt-metal thread, sold in 1610 to Don Pedro de Toledo, Philippe III of Spain's ambassador (now lost); a six-piece edition bought in late 1612 or early 1613 by Duke Maximilian I of Bavaria; a ten-piece suite purchased in 1620 by Charles-Emmanuel I; and the edition sold to the Barberini family around 1630, but very probably woven before 1627.[41] Indeed, by 1630, seventy-eight tapestries based on *Artemisia* designs were on the looms or part of the stock of the workshop.[42]

The *Petitions* and *Feast* in the Art Institute each bear a mark and a monogram (see "Marks and Signatures") that reveal that they were produced in a workshop at the Saint-Marcel manufactory. The mark consists of a flower that has been called a fleur-de-lis, but which looks more like a buttercup. It is important to identify the species since at least one other flower was recorded among the marks used by Parisian workshops: the pink, or dianthus. This red-petalled flower is considered the mark of one of the largest workshops at the Saint-Marcel manufactory, the so-called Boutique d'Or (gold workshop), which mainly produced the most costly pieces, i.e., those enriched by gilt- or silvered-gilt-metal thread.[43] The Boutique d'Or mark is found on the Savoy *Artemisia* suite (along with the MF mark of the Saint-Marcel manufactory, and the P and fleur-de-lis that constitute the Parisian mark). Two pieces of the Barberini *Artemisia* also bear the

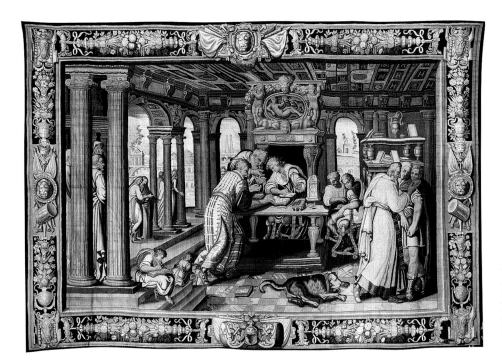

FIG. 4 *The Education of the Young King* from *The Story of Artemisia*. After a design by Antoine Caron. Produced at the Manufacture du Faubourg Saint-Marcel, 1600/25. Linen and silk; 400 x 600 cm. Musée du Louvre, Paris, OAR 90.

Boutique d'Or mark.[44] The fleur-de-lis or buttercup of the tapestries in the Art Institute has been found on five pieces of the Barberini *Aminta*, along with the Paris mark and the monograms of the shop foremen—*PB* (Pierre Brimard), *HT* (Jean Tayer or Hans Taye), an unidentified *HA* (Adriaen de Welde?)—and also on one piece of the *Story of Diana* edition with the coats of arms of Savoy-Carignan and Bourbons-Soissons, woven before 1625.[45]

The monogram on the *Petitions* and *Feast* in Chicago, which can be read as *LVD*, has not been identified. It has also been found, inverted, on a piece in the Minneapolis *Artemisia* suite, along with the mark *MF*, and, upside down, on a tapestry from the *Story of Ulysses* suite at the Château de Châteaudun, accompanied by an *AC*, the monogram of Alexandre de Comans (died 1650), Marc de Comans's son.[46] The border of the Chicago tapestries, however, allows them to be dated with some accuracy. Composed of bouquets or garlands of flowers, sometimes accompanied by pots, and with rams' heads in the corners and lion's heads and trophies of arms in the middle of the side borders, it was the type most frequently used on *Artemisia* tapestries. The aforementioned Munich *Artemisia* suite also has this type of border and was woven before 1613. Heinrich Göbel reproduced a piece with the same border from the Musei Vaticani (*The Riding Lesson*), and dated it to around 1620.[47] All the other recorded *Artemisia* suites with this type of border have been dated between approximately 1610 and 1622: an edition of five pieces formerly in the Château de Noizay (1610/20); a six-piece chamber at Eastnor Castle, Herefordshire, England (1611/22); two pieces from the Château de Suzanne (1611/20); and a piece now in the Musée du Louvre (1610/20, fig. 4).[48] In 1627, *Artemisia* tapestries with this border could still be found in the stock of the Saint-Marcel manufactory.[49]

PFB

NOTES

1. The 1663 French Crown inventory describes "trois petites figures indécentes qui forment des jets d'eau" (three small indecent figures made to spurt water); Jarry 1973, p. 10.

2. Houel began the project in the 1560s, but did not finish until ten years later. The manuscript of the prose poem was written by 1563, with some drawings. The sonnets with the other drawings were completed after two stages of work, 1563 to 1566 and 1566 to 1571. Most of the seventy scenes were added after 1566 and illustrate Lygdamis's education and his taste for hunting, and Artemisia's construction of the mausoleum for his father; Auclair 2000; Auclair 2007.

3. This encyclopedic character constitutes one of the richest aspects of Houel's work, and cannot be adequately addressed in this entry. See especially Monnier and Johnson 1971 and Johnson 1989.

4. Auclair 2000, pp. 158–59.

5. Houel began elaborating his project before Feb. 8, 1563, the date on the epistle to the queen accompanying the manuscript, but did not finish writing it until after May 1566, when Catherine de' Medici and the young Charles IX returned from their grand tour of France.

6. Houel attributes the etymology to the physician, writer, and printer Charles Estienne; ffolliott 1989, p. 141. In *De re hortensi libellus* (Lyon, 1536, p. 47; 1539, pp. 51–52), Estienne wrote that the Latin word *artemisia* (wormwood) derived from the name Artemisia, which itself came from Artemis, the older, Greek name for the goddess Diana.

7. Lacordaire 1853, pp. 23–25. For more on Houel's manuscript, see, for example, Auclair 2000, pp. 159–60.

8. For the *Story of Diana* tapestries woven for Diane de Poitiers and now in the Metropolitan Museum of Art, New York; the Musée des Beaux-Arts, Rouen; the Musée National de la Renaissance, Ecouen; and a private collection in New York; see Bardon 1963a, pp. 66–73; Campbell 2002c, pp. 464–65; and Forti Grazzini 2007.

9. Lygdamis's marriage has even been seen by scholars from Maurice Fenaille to Candace Adelson as an allusion to Charles IX's marriage to Elisabeth of Austria.

10. Houel, fol. 10, quoted in Guiffrey 1898, p. 195.

11. Béguin 1958 attributes forty-four drawings to Caron. See Beaumont-Maillet

in Lambert, Bouquillard, and Beaumont-Maillet 2003, pp. 237–61, cats. 88–100, and Béguin Piccinini 2005, pp. 453–56.

12. For Catherine de' Medici's emblems, see Conihout and Ract-Madout 2002, pp. 229–41.

13. From the end of the Middle Ages through the mid-sixteenth century it was common to include descriptions on tapestries, as on *The Life of Saint Mammes* (a set divided between the Musée du Louvre, Paris, and Langres Cathedral), and *The Story of Diana* woven for the Château d'Anet. But in the case of *The Story of Artemisia*, when the tapestries were woven, Houel's sonnet-captions were omitted, as if the story no longer required explanation.

14. Adelson 1994, p. 169.

15. *The Story of Artemisia* was one of three major sets of tapestries on the Parisian market in the first half of the seventeenth century, considerably limiting the range of choices available to clients wishing to buy from that city's workshops. The reasons buyers were inclined to choose *Artemisia* were extremely varied. Cardinal Montalto ordered a series of twelve pieces, preferring the set over *The Story of Coriolanus* and *The Story of Diana* for reasons of subject and design; Denis 1991. The Barberini family's interest in the tapestry had nothing to do with the life of the illustrious queen or its symbolic potential. Rather, they were attracted by her name, because it was derived from that of the goddess Artemis (Diana in Greek), whose emblem, at least when in the guise of Diana of Ephesus, is the bee—an insect that figures prominently in the family's coat of arms, and thus occupies a central position in Barberine imagery; Bertrand 2005, esp. pp. 41, 112.

16. Adelson 1994, pp. 165, 169, 175–76.

17. The tapestries were woven to replicate the organization of space in the drawings, and not as mirror images. Jarry 1973 erroneously stated the contrary based on photographs of the tapestries that had been reproduced in reverse.

18. The manuscript reads "[e]lle manda ceux qui étaient députés pour parler pour elle aux États, pour la venir trouver en une sienne belle maison qui n'était guère loin de la ville d'Halicarnasse, lieu fort plaisant et de grande recommandation" (she mandated the deputies who were to speak to her at the States [General] to come to her at her beautiful house not far from the town of Halicarnassus, a very pleasant place, having everything to recommend it); Houel, book 2, chap. 1, fol. 39 v, quoted in Jarry 1973, p. 10; Ffolliott 1989, p. 139; Ffolliott 2001, p. 211.

19. The words of the manuscript quite clearly echo the sonnet that accompanies *Les Placets*, on the back of the drawing called *The People's Petitions*:

Mais avant qu'elle vint à tenir ses états
Manda ses députés de faire diligence
De la voir trouver en un lieu de plaisance
Où lors elle prenait son aise & ses ébats
Eux étant arrivés, elle ne faillit pas
De s'enquérir du fait de sa sainte ordonnance
Pour savoir son avoir usé de négligence
À recevoir les cris du populaire bas
À donc pour lui montrer quel était le devoir
Dont on avait usé, soudain on lui fit voir
Un grand bahut rempli de cahiers et mémoires
Où du peuple on avait sa plainte mise au net
Qu'elle vit de bon œil, n'ayant d'autre souhait
Que son peuple tirer de toutes ses affaires
(But before she came to hold her assembly
She ordered her deputies to be diligent
In coming to see her in the pleasant place
Where once she had relaxed and enjoyed herself
When they arrived, she did not fail
to inquire about her solemn order

To know if she had been negligent
In receiving the grievances of her lowly people
Thus to demonstrate that duty had been done
Suddenly they placed before her eyes
A large chest full of notebooks and memoranda
Where her people had clearly set out their complaints
Which she looked on favorably, having no other wish
Than to free her people from all of their concerns).

20. Ffolliott 1989, p. 141. See note 6 above.

21. Jarry 1973, p. 10, speculated that one of the deputies of the delegation bearing grievances, the bearded old man in the foreground, was the queen's chancellor, Michel de l'Hôpital, but this seems doubtful.

22. Ffolliott 1989, p. 141; ffolliott 2001, pp. 211, 220. According to Vitruvius, the Doric order was suitable for the construction of temples to Hercules, Mars, and Minerva, because of the virile character of these gods; the Corinthian order for temples to Flora, Proserpina, Venus, and water nymphs, because they had a sweet and gentle manner; and the Ionic order—neither robust nor delicate—for gods such as Bacchus, Diana, and Juno, whose nature was between these two extremes; Vitruvius 1547, book 1, p. 6.

23. Fenaille 1903–23, vol. 1, p. 165. The title has just recently been revived; see Lambert, Booquillard, and Beaumont-Maillet 2003, pp. 242–43, cat. 89.

24. Ehrmann 1956, p. 11. See Johnson 1989 for the transition from written text to drawn image.

25. Béguin 1958, p. 33, adds that Anet belonged just as much to Catherine de' Medici as it did to Diane de Poitiers. After the death of Henry II, Diane withdrew to her various châteaux (Anet, Beynes, Limours) and traded one of her properties, Chenonceau, for Catherine's Chaumont. In 1562, Diane divided her worldly goods, while retaining usufruct; her daughter Louise, Duchesse d'Aumale, received Anet. The same year, while on her way to the siege of Rouen, Catherine passed quite near Anet, but did not stop there.

26. Ffolliott 1989, pp. 140–42; ffolliott 2001, pp. 215–16.

27. Ffolliott 2001, pp. 217–22.

28. Auclair 2000, pp. 167–68 n. 48.

29. Guiffrey 1892, pp. 86–88, 98. The drawing *Menagerie* attributed to Nicolò dell'Abate shows a fountain, but it does not appear to have ever been woven as a tapestry. The Château d'Anet also figures in another famous suite, the *Valois Tapestries* (c. 1575; Galleria degli Uffizi, Florence), which does not use a historical figure to represent Catherine de' Medici, instead glorifying the queen and the Valois dynasty directly; Bertrand 2006–07.

30. The original text is from the second book of Houel's work (quoted in Jarry 1973, p. 11). It reads: "en un beau jardin rempli des plus beaux arbres où fut fait le festin. Au milieu du jardin était un beau pavillon rempli de colonnes et grandes quantités de figures et autres ornements. En ce pavillon il y avait trois portiques, celui du milieu était soutenu de quatre colonnes de fin marbre blanc. Dans la niche, une vierge d'élégante beauté, à mode de nymphe, du côté dextre. Au senestre côté une nymphe tenant une ruche d'abeilles... Il y avait plusieurs grandes allées... Dans celle du milieu fut dressé le festin. Or comme le Roi Lygdamis était à la plus grande pompe et gloire, se présenta un architecte lui montrant de trois ou quatre sortes de pierres pour sa sépulture, et un philosophe lui recommanda de n'être pas indigne d'une telle dignité" (in a beautiful garden filled with the most beautiful trees, where the feast was held. In the middle of the garden was a beautiful pavilion full of columns and many statues and other decorations. In this pavilion, there were three porticos, the one in the middle supported by four columns of fine white marble. In the niche, an elegantly beautiful, virginal nymphlike figure on the right hand side. On the left hand side, a nymph holding a hive of bees... There were several broad paths... In the middle one, the feast was laid out. When, however, King Lygdamis was at the height of this moment of pomp and glory, an architect presented himself, showing him [the king] three or four kinds of stone for his sepulcher, and a philosopher cautioned

him [the architect] not to be unworthy of such a dignitary). Adelson 1994, pp. 219–20, believes that the drawing refers to the two banquets in the prose version: the one cited above, which takes place after the crowning of Lygdamis, and another one for his tutors, which was held slightly later.

31. Denis 1999, p. 47, lists eleven editions of *The Petitions* and eight of *The Feast*, but says nothing about the present location of these tapestries.

32. Guiffrey 1892. The first tapestry, which was the fourteenth piece in a series of twenty-one tapestries woven with gilt-metal thread, represented only a portion of the subject; the second was the third piece in a series of eight, bordered with "bouquets de fleurs avec des têtes de béliers dans les angles" (bouquets of flowers with rams' heads in the corners).

33. The tapestry in the Louvre is published in Alcouffe et al. 2002, cat. 85. The *Petitions* with the coat of arms of Charles-Emmanuel I is in the Timken Museum of Art, San Diego (472 x 239 cm, left part); the piece without the coat of arms is in the Royal Palace, Turin, and measures 500 x 292 cm (Denis 1991, p. 36). For the Savoy series, see note 41 below.

34. Fenaille 1903–23, vol. 1, p. 169. There were seventeen sets of hangings, consisting of fifty-five tapestries and four gilt-metal thread portieres. An inventory from 1663 described one *Feast* tapestry as follows: "Artémise à table, au milieu de son jardin avec son fils qui écoute un architecte" (Artemisia at table in the middle of her garden, with her son, who listens to an architect).

35. The largest piece, representing the group around the table—"la reine, le jeune roi, le philosophe, l'architecte, le lieutenant du roi" (the queen, the young king, the philosopher, the architect, the king's lieutenant)—was part of a five-piece series from the Château de Suzanne sold at Frederick Müller et Compagnie, Amsterdam, Apr. 27, 1910, lot 1 C (410 x 340 cm, Fenaille 1903–23, vol. 1, p. 211; Göbel 1928, vol. 1, p. 67). The tapestry was sold again at Parke-Bernet Galleries, New York, Jan. 8–10, 1942, lot 429 (ill.); and then at Christie's, New York, Jan. 11, 1996, lot 208 (408 m x 328 cm). A narrower piece (510 x 245 cm), without the coat of arms, was part of the Savoy *Story of Artemisia*, and is now in the Royal Palace, Turin; Denis 1991, p. 36. Adelson 1994, pp. 223–24 n. 8, lists another narrow piece sold at Sotheby's, London, Mar. 25, 1966, lot 16 (ill.).

36. See especially Adelson 1994, pp. 160–288, cat. 16; Denis 1999; and Bertrand 2005, pp. 103–07.

37. Dubout left the workshop of the Hôpital de la Trinité (founded by Henry II), to join Girard Laurent in the Maison Professe des Jésuites workshop in the rue Saint-Antoine, around 1597. The two tapissiers then established themselves in the *grande gallerie* of the Louvre in 1606 and were granted special privileges making their installation official in 1608; Bertrand 2001.

38. The series is now split among the Musée Jacquemart-André de Paris, the Musée des Beaux-Arts de Dijon, and private collections. See Denis in Campbell 2007a, pp. 146–47 n. 17.

39. Coural 1967, pp. 21, 28.

40. The gilt-metal-thread series is now in the Mobilier National, Paris (inv. GMTT 12). It is published in Göbel 1928, vol. 1, p. 67, and Coural 1967, p. 26, nos. 5–6. The complementary pieces from Naworth Castle were sold at Sotheby's, London, July 7, 1999, lots 32–39, to Galerie Chevalier, and then acquired by the Mobilier National. Two pieces were exhibited in 2003 at the Château de Blois; Bassani Pacht et al. 2003, pp. 136–37, cats. 11–12; Brejon de Lavergnée and Vittet 2007.

41. The piece listed as number fifteen in the Mobilier de la Couronne inventory is now in the Mobilier National (GMTT 11). Toledo's suite is cited in Coural 1967, p. 19. Maximilian I's series is in the Residenz, Munich; Göbel 1923, vol. 2, fig. 171; 1928, vol. 1, p. 67; 1928, vol. 2, fig. 34. Charles-Emmanuel I's suite is now split among the Royal Palace, Turin; the Timken Museum of Art, San Diego; and the Château de Blois, and is published in Denis 1999, p. 36. The Barberini suite is in the Minneapolis Institute of Arts; Adelson 1994, pp. 160–288; Bertrand 2005, pp. 103–07.

42. Guiffrey 1892, pp. 85–96.

43. From 1620, the shop was run by Jean Tayer (Hans Taye) whose monogram was *HT* or *IT*. After 1623, this mark no longer appears.

44. See Adelson 1994, pp. 269–88. The two pieces come from the Colonna residence and were woven before 1622.

45. The Barberini *Aminta* is now in the Château de Vaux-le-Vicomte; Bertrand 2005, pp. 118–19. The piece from the Diana edition is now in the Royal Palace, Turin; Di Macco and Giovanni 1989, pp. 147–48, cat. 155.

46. Adelson 1994, p. 250, fig. 107, takes the *LVD* monogram on the Minneapolis suite to be that of Lucas Wandandalle (van den Dalle), whose Flemish name was Van den Daele. He was the foreman of the so-called New Building that, with twenty-four looms, was one of the largest workshops in the faubourg Saint-Marcel in 1627; Guiffrey 1892, p. 92. Adelson 1994, p. 259, fig. 112, reads the same *LVD* on another Barberini *Artemisia* tapestry that is now in the Minneapolis Institute of Arts, but in this case, the right diagonal bar of the *V* is missing or merges with the vertical bar of the *L*. This latter mark, which can also be found on the *Diana* tapestry in the Royal Palace, Genoa (de Reyniès 2002, p. 218, fig. 3), was interpreted by Göbel 1928, vol. 1, pl. 3, as that of the Parisian foreman Jean de la Pierre. For the *AC* monogram, see de Reyniès 2002, p. 218, fig. 3. Alexandre de Comans succeeded his brother Charles, who died in 1635, as the head of the workshop.

47. Göbel 1928, vol. 1, p. 67 (c. 1620); vol. 2, fig. 35. The tapestry was cited in Barbier de Montault 1878. De Strobel 1999, pp. 176–77, fig. 3, dates it within or around 1610 to 1620.

48. Three pieces of the Château de Noizay suite are today in the Hôtel de Sully, Paris, and are published in Saunier 1996, pp. 74–83. The Eastnor edition is now in the Hervey-Bathurst Collection, and is published in Adelson 1994, pp. 184, 221–22, fig. 93. The Château de Suzanne pieces are presently in the New Orleans Museum of Art. They are published in Adelson 1994, pp. 168–69, 275, figs. 76, 124, in which they are dated around 1611 to 1620 (fig. 76) or 1611 to 1617 (fig. 124). According to Göbel 1928, vol. 1, p. 67, the tapestries from the Château de Suzanne (see note 34 above) were part of the same series as the tapestries at Eastnor Castle. The piece in the Louvre represents *The Education of the Young King* and bears the monogram *LVD*—but not the same *LVD* as on *The Petitions* and *The Feast*)—and the mark *MF*. It is published in Denis in Saunier 1996, p. 77, s.v. "*Artémise*."

49. Guiffrey 1892.

From *The Seasons*

CAT. 40A

Autumn

Paris, 1700/20
After a design by Charles Le Brun (1619–1690)
Produced at the workshop of Etienne Le Blond (1652–1727) and Jean de La
Croix (1628–1712) at the Manufacture Royale des Gobelins
SIGNED: *E.LE.BLOND*; *L.CROIX.P.*
530.3 x 380.8 cm (208¾ x 150 in.)
Gift of the Hearst Foundation in memory of William Randolph Hearst,
1954.260

STRUCTURE: Wool and silk, slit and double interlocking tapestry weave
Warp: Count: 11 warps per cm; wool: S-ply of four Z-spun elements;
diameters: 0.8–1.0 mm
Weft: Count: varies from 32 to 36 wefts per cm; wool: S-ply of two Z-spun
elements; diameters: 0.4–0.6 mm; silk: pairs of S-ply of two Z-twisted ele-
ments; diameters: 0.5–0.7 mm

Conservation of this tapestry was made possible through the generosity of
Janis Notz (Mrs. John Notz).

PROVENANCE, REFERENCES, EXHIBITIONS: See below.

CAT. 40B

Winter

Paris, 1700/20
After a design by Charles Le Brun (1619–1690)
Produced at the workshop of Etienne Le Blond (1652–1727) and Jean de La
Croix (1628–1712) at the Manufacture Royale des Gobelins
SIGNED: *L.CROIX.P.*; *E.LE.BLOND*
540.07 x 384.81 cm (212⅝ x 151½ in.)
Gift of the Hearst Foundation in memory of William Randolph Hearst,
1954.261

STRUCTURE: Wool and silk, slit and double interlocking tapestry weave[1]
Warp: Count: 8 warps per cm; wool: S-ply of four Z-spun elements;
diameters: 0.6–0.9 mm
Weft: Count: varies from 25 to 52 wefts per cm; wool: S-ply of two Z-spun ele-
ments; diameters: 0.3–0.9 mm; silk: pairs of S-ply of two Z-twisted elements;
diameters: 0.4–0.8 mm; wool and silk: paired yarns of S-ply of two Z-spun
wool elements and S-ply of two Z-twisted silk elements; diameters: 0.6–0.9 mm

Conservation of this tapestry was made possible through the generosity of
the Textile Society of the Art Institute of Chicago.

PROVENANCE: John Bradshawe-Isherwood I (died 1839), Marple Hall,
Cheshire, by 1838;[2] by descent through the Bradshaw Isherwood family;
by descent to John Henry Bradshaw Isherwood (died 1924), Marple Hall,
Cheshire, to 1924; by descent to his son, Henry Bradshaw Isherwood (died
1940); sold, July 30–31, 1929, lot 312 (*Winter*), 313 (*Autumn*), to Henry
Symons, London; sold to French and Company, New York, 1929; sold to
William Randolph Hearst (died 1951), 1930; ownership transferred to the
Hearst Foundation; given to the Art Institute, 1954.

REFERENCES: Mayer Thurman in Wise 1976, p. 195 (ill.). Mayer Thurman
1992, pp. 59, 62, 63 (ill. of 1954. 260 only). Mayer Thurman and Brosens
2006, pp. 61–71.

EXHIBITIONS: Art Institute of Chicago, *Selected Works of 18th Century
French Art in the Collections of the Art Institute of Chicago*, 1976, cats. 311a–b
(see Mayer Thurman in Wise 1976). Art Institute of Chicago, *Tapestries from
the Permanent Collection*, 1979.

Autumn and *Winter* are part of a *Seasons* series designed by Charles
Le Brun, first painter to the king under Louis XIV of France (see
also cat. 22), around 1663 or 1664. The compositions each present
two deities floating on a cloud, a royal residence in the background,
and attributes associated with the season for which the tapestry is
named.

Autumn shows Diana and Bacchus. The Roman goddess of the
hunt, Diana is identifiable by the bow, arrow, spear, and horn at her
feet, and is an appropriate presence in this depiction of the hunt-
ing season. The goddess holds a floral wreath featuring a stag hunt,
further underscoring the link between fall and the hunt. Her com-
panion, Bacchus, is the god of wine, which explains his presence in
this representation of autumn, the time of the grape harvest. Grapes
and other fruits and vegetables associated with fall can be seen in the
foreground. The seventeenth-century French administrator and art
historian André Félibien, who was historiographer of the Bâtiments
du Roi (Office of Royal Buildings and Public Works), identified the
castle visible in the background as the Château de Saint-Germain-
en-Laye, a royal retreat just outside Paris.[3]

Winter, by contrast, reveals a barren landscape, above which
a winged Saturn and Juventas repose on a large cloud. The god of
agriculture and time, Saturn is depicted with an hourglass. While
his cult was never very popular, Saturnalia, one of the major festivals
of the Roman year, was dedicated to him. Originally held only on
December 17, the holiday was later extended into a weeklong event
in which business was suspended, the roles of masters and slaves
reversed, moral restrictions loosened, and gifts exchanged. The Sat-
urnalia explains Saturn's inclusion in this scene and also accounts for
the appearance of Juventas, who, as her cup suggests, was responsible
for pouring the nectar of the gods on Mount Olympus and attend-
ing the gods' festivities and banquets. The musical instruments and
the mask at her feet allude to ballet performances and masked balls,
favorite pastimes of French kings and their courtiers. Saturn holds a
floral wreath that also refers to leisure and entertainment, as it fea-
tures a ballet scene in its center. In the foreground a variety of winter
vegetables, such as gourds, can be seen along with a cage, nets, a gun,
and the results of a successful hunt, which links *Winter* to *Autumn*.

CAT. 40A

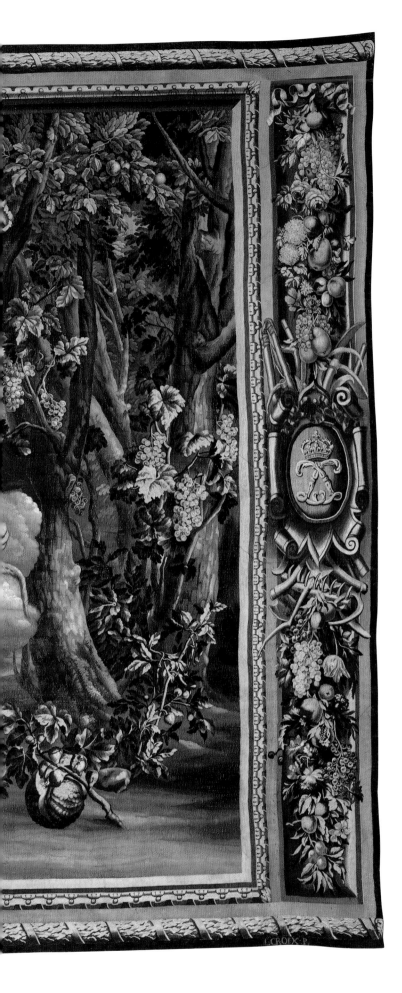

Félibien identified the buildings on the right of the tapestry as part of the Palais du Louvre in Paris.[4] The two tapestries carry identical borders showing interlocking *L*s, the cipher of Louis XIV and Louis XV; these are supplemented by additional devices of armor above and below, juxtaposed and intertwined with floral garlands at both ends. *Winter* is signed *L.CROIX.P.* and *E.LE.BLOND*; *Autumn* bears the signatures *E.LE.BLOND.* and *L.CROIX.P. E.LE.BLOND.* stands for Étienne Le Blond.[5] *L.CROIX.P.* can be read as *[DE] L[A] CROIX P[ÈRE]* (De La Croix the Elder) and refers to Jean de La Croix.[6]

Both Le Blond and La Croix were employed as low-warp tapestry weavers at the Manufacture Royale des Meubles de la Couronne (Royal Manufactory of Furniture for the Crown), which was established in 1662 by Jean-Baptiste Colbert, minister of finance under Louis XIV.[7] The Manufacture Royale, which was charged with creating the king's image,[8] came to be known as the Gobelins, after its location on the premises of a former dye works run by the Gobelins family. Before its temporary closure in 1694 due to the War of the Grand Alliance, the creative genius behind the Gobelins was Charles Le Brun.[9] Le Brun, who studied in Rome between 1642 and 1646, was one of twelve founders of the Académie Royale in 1648. Ten years later he entered the service of Nicolas Fouquet, superintendent of finances and chancellor of the exchequer, who was building an awe-inspiring palace at Vaux-le-Vicomte (see also cat. 22).[10] In 1661, when his palace was completed, Fouquet arranged festivities in honor of Louis XIV. The monarch, however, was outraged by his subordinate's kinglike demeanor—and astounded by Le Brun's genius. Fouquet was arrested, and Le Brun was engaged as first painter to the king, a title he officially received three years later, in 1664.

In 1663 Le Brun became director of the newly established Gobelins manufactory, providing all of its entrepreneurs with fresh designs.[11] He had an apartment on the premises "[a]fin qu'il puisse voir leurs ouvrages à tous momens, qu'il les puisse corriger, et qu'il voye qu'ils avancent, et s'ils ne perdent point leur temps" (so that he could see their [the employees'] work whenever he liked, could correct them, could see that they made progress and did not waste their time).[12] The ambiance at the Manufacture Royale and the omnipresence of Le Brun are tellingly summarized in the *Mercure galant*, a newspaper of the time:

> While legions of workers executed his designs, there were also countless others who did nothing but weave tapestries according to his plans. He confected those of the *Battle and Triumph of Constantine,* those of the *History of the King* and of *Alexander,* those of royal houses and of the *Seasons*, the *Elements* and a host of others. We can conclude that every day he put thousands of hands to work and that his genius was universal.[13]

Le Brun, however, complained in private; according to a friend, the first painter had made clear that "[i]l n'en paraissait pas content, disant que plus il faisait, plus on exigeait de lui, sans témoignage de satisfaction" (he was not happy at the Gobelins, because the more he

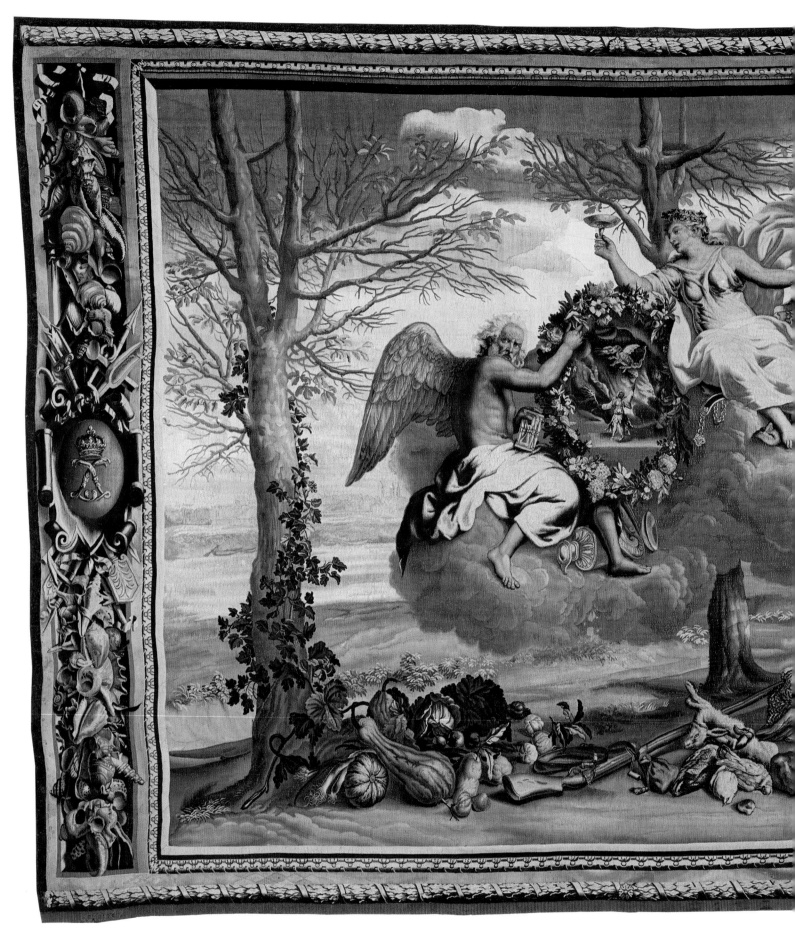

CAT. 40B

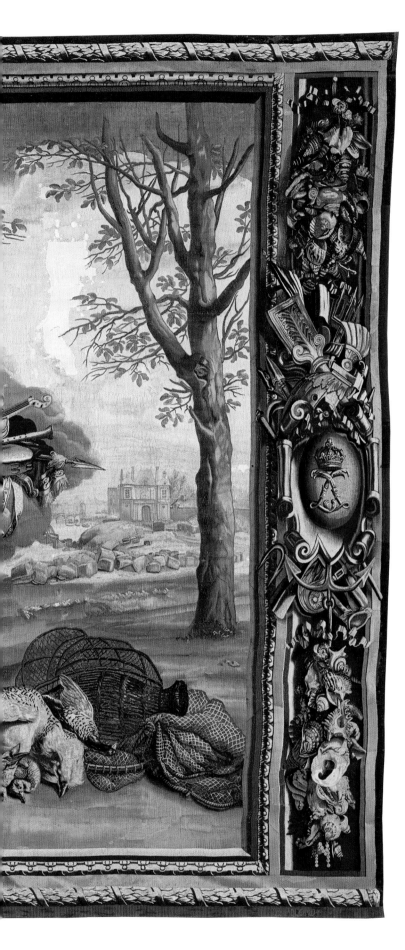

did, the more they wanted him to do, without ever telling him that they were pleased with his work).[14]

Autumn and *Winter* were woven according to Le Brun's designs of *The Seasons* that are mentioned in the *Mercure galant*. The series comprised eight works in all.[15] The four main scenes were published as engravings in 1670. *Spring* depicts Mars and Venus in front of the Château de Versailles (fig. 1). The goddess of love and beauty, Venus was originally a nature deity and patroness of gardens, which explains her inclusion here. Mars is known as the god of war—wars were mostly started or renewed in spring—but he was also associated with spring and fertility, justifying his presence in this scene. *Summer* illustrates Apollo and Minerva before the Château de Fontainebleau (fig. 2). Apollo was the Roman god of music and light, and was sometimes identified with Helios, the sun god, which explains his connection to this time of the year. Minerva, meanwhile, was the goddess of wisdom, medicine, and the arts and sciences, all of which were supposed to have reached their apex during the reign of the Sun King. The floral wreath they hold shows the Louvre. In addition to the four main compositions, *The Seasons* included four *entrefenêtres*—narrower, smaller, upright panels that could be placed between windows. Each shows winged boys working in a garden in which the flowers, fruits, and plants allude to one of the four seasons.[16]

While Le Brun designed all eight works in the suite, Adam Frans van der Meulen (1632–1690), a painter who was born and trained in Brussels but moved to Paris in 1664, created the small scenes that appear in the wreaths held by the gods in *Spring* and *Autumn*.[17] A handful of painters then transformed these plans into two sets of cartoons, enabling suites to be woven simultaneously in the high-warp and low-warp workshops.[18] Archival documents reveal that the original cartoons of *Summer* and *Autumn* used by the low-warp weavers were replaced by copies around 1713 or 1714.[19] This is unsurprising, since cartoons were routinely damaged during the low-warp weaving process and frequently needed to be restored or replaced. When in 1794 an inventory of the Gobelins cartoons was recorded, only a small number were listed; most of them were damaged, and only a few fragments have survived to the present day.[20]

The Seasons appears to have been woven repeatedly at the Gobelins, almost exclusively in the low-warp workshops. Of the seven suites produced between 1669 and 1716 for the Garde-Meuble de la Couronne (the Royal Furniture Warehouse), only one was woven on high-warp looms.[21] Jean de La Croix produced four low-warp editions between 1669 and about 1682; these were woven with gilt-metal thread and have different borders than the tapestries in the Art Institute. The fifth low-warp suite was created by Etienne Le Blond between 1709 and 1711; it remained in storage on the premises of the Gobelins until 1737, when it was delivered to the Garde-Meuble; all four pieces are still in the French national collection.[22] The last low-warp suite was woven by Jean Souet (c. 1653–1724 or later), Jean de La Fraye (c. 1655–1730), and Jean de La Croix and his son Dominique (died 1737) between 1712 and January 1714. This edition remained at

FIG. 1 *Spring*. Sébastien Le Clerc after Charles Le Brun, 1670. Etching; 38.5 x 47.4 cm. Musée du Louvre, Paris.

FIG. 2 *Summer*. Sébastien Le Clerc after Charles Le Brun, 1670. Etching; 38.7 x 48.1 cm. Musée du Louvre, Paris.

the Gobelins until 1748, when the tapestries were shipped to Rome to decorate the French embassy; in 1757 they were moved to Vienna. Although their present location is unknown, it has been assumed that the Art Institute's *Autumn* and *Winter* were originally part of this suite.[23] The *E.LE.BLOND.* signatures on the Chicago pieces, however, demonstrate that they did not belong to this set. Consequently they were never part of the Garde-Meuble's collection, which implies that they were produced as part of a private commission.[24] Given the death dates of La Croix and Le Blond, it seems certain that *Autumn* and *Winter* were woven—or at least started—prior to 1712, and finished in 1727 at the latest.

Though the Chicago *Autumn* and *Winter* were not in the French royal collection, we can safely assume that they were commissioned by a fervent supporter of the Sun King, for the borders and the iconographic program of the pieces celebrate his reign. Indeed, Le Brun's *Seasons* as a whole was part of the propaganda machine that helped create the public image of the French king. Prior to its closure in 1694, the Gobelins played an important role in what Peter Burke has termed the "fabrication of Louis XIV," since most of the luxury items produced there were used to embellish the numerous royal castles and palaces in France and ambassadorial residences abroad.[25]

The nature and raison d'être of the manufactory explains why the imagery and subject matter developed at the Gobelins was at first focused completely on the Sun King. In 1663 Colbert had installed a scholarly committee, the Petite Académie, which was charged with conceiving iconographic programs for new tapestry sets. According to the poet and storyteller Charles Perrault, one of its members, "M. Colbert nous demanda des desseins pour des tapisseries qui devaient se faire à la manufacture des Gobelins. Il en fut donné plusieurs entre lesquels on choisit celui des quatre élements, où on trouva le moyen de faire entrer plusieurs choses à la gloire du roi. . . . On fit ensuite le

dessein de la tenture des quatre Saisons de l'année sur le modèle de celle des quatre elements" (M. Colbert asked us to provide concepts for tapestry sets that would be woven at the Gobelins. We presented him with several. They chose the four elements because it was possible to include references to the glory of the king. . . . We then conceived the four seasons, after the model of the four elements).[26]

André Félibien's 1670 booklet *Tapisseries du Roy: ou sont representez les quatre elemens et les quatre saisons de l'année* (The King's Tapestries: In Which are Represented the Four Elements and the Four Seasons of the Year) reveals how the imagery of *The Seasons* could be read as a panegyric on the virtues of Louis XIV.[27] According to Félibien, the Sun King "[a] rendu les saisons plus belles & plus fécondes" (made the seasons more beautiful and fertile).[28] *Autumn* was "[u]ne allégorie pleine de vérité" (an allegory full of truth), because "[t]ant de vertus qui éclarent en Elle [Sa Majesté], sont les mesmes vertus pour lesquelles l'Antiquité dressoit des Autels" (so many virtues that shine in Him [His Majesty] are the same virtues for which shrines were erected in antiquity)."[29] Explaining *Winter* was more challenging, as it alludes to relaxation and leisure, yet Félibien achieved his ambition to flatter the king by focusing on Saturn's hourglass, explaining, "[q]ue si le Roy prend aussi quelque part à ces passe-temps, c'est sans rien perdre des heures qu'il destine à ses occupations plus importantes" (even if the King participates in these pastimes, he does not waste hours that he reserves for his more important tasks).[30] Surprisingly, Félibien paid little attention to the castles and palaces depicted in *The Seasons*, simply stating that "[o]n a peint dans chaque Tableau une Maison Royale choissee entre les autres, comme celle qui a le plus d'agrément dans la Saison où elle est representée" (a royal residence is painted in each of the scenes, chosen among the other residences because it is the most pleasurable place to stay during the season in which it is featured).[31]

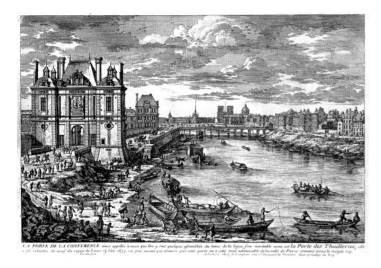

FIG. 3 *View of the Porte de la Conférence*. Perelle workshop, 1661/1715. Engraving, on paper; 20 x 29 cm. Musée national des Châteaux de Versailles et de Trianon, Versailles.

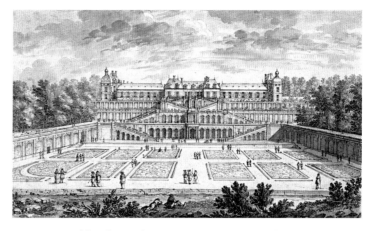

FIG. 4 *View of the Château de Saint-Germain-en-Laye*. Adam Pérelle, seventeenth century. Pen and ink, on paper; 153 x 263 cm. Musée Condé, Chantilly.

It can be argued, however, that either the Petite Académie or Le Brun himself chose these buildings because they held special meaning for Louis XIV and the French monarchy. This is corroborated by a closer examination of the buildings depicted in *Winter*. Félibien identified them as the Louvre, remarking, "[o]n voit la grande Galerie & les gros Pavillons, qui décorent ce superbe Palais" (one sees the Grande Galerie and the great pavilions that decorate this superb palace).[32] A contemporary print issued by the Pérelle worshkop, however, shows that it is not the Louvre but rather the Porte de la Conférence—since the tapestry was woven on a low-warp loom, the buildings are depicted in mirror image (fig. 3).[33] Yet the lost Porte de la Conférence, located on what is now the place de la Concorde, was not a royal residence, so why did the committee or the first painter decide to include this particular building in the series?

The Porte de la Conférence was erected in 1633 by Louis XIV's father, Louis XIII, its name commemorating the conference of Suresnes, near Paris, in 1593.[34] That meeting ended a French civil war and led to the conversion of the Protestant Henry IV, Louis XIV's grandfather, who became recognized as the legitimate king of France—the first of the Bourbon kings who would rule the country until the end of the eighteenth century. In 1649, when Paris was torn apart by the Fronde, the eleven-year-old Louis and his mother Anne of Austria fled the Louvre through the Porte de la Conférence, and it can be assumed that they reentered Paris the same way after the Fronde was decided in favor of the monarchists.[35] The Porte de la Conférence thus symbolized the victory of Bourbon absolutist rule over democratic unrest. In *Winter*, the pavilion that is partly hidden behind the Porte de la Conférence is not a part of the Louvre but instead a section of the now lost Château de Tuileries, Louis XIV's prime residence in Paris before he moved to Versailles in 1682.[36]

In his account of *Autumn*, Félibien was presumably right when he identified the Château de Saint-Germain-en-Laye, which is depict-

ed with a high degree of accuracy (fig. 4), as an enjoyable place to dwell during the fall. Like the Porte de la Conférence, however, it was also of great symbolic significance to Louis XIV. Throughout the sixteenth and seventeenth centuries, the château had been one of the prime residences of the French kings. Louis XIV was born there, took shelter there during the Fronde, and used the château as one of his favorite residences outside the capital between 1661 and 1681.[37] Therefore, it can be seen to have functioned both as a stronghold and symbol of the king's absolute power. The edifices depicted in *Spring* (the Orangerie at Versailles) and *Summer* (Fontainebleau and the Louvre) also alluded to the rich past, magnificent present, and bright future of Bourbon France, linking old absolutist icons with new ones that were still under construction.[38]

Perrault's account of the activities of the Petite Académie thus reveals that the iconographic program of *The Seasons* paralleled that of a closely related set, *The Elements*, the first suite of which was woven between 1666 and 1669.[39] In *Tapisseries du Roy*, Félibien explained the allegorical meaning of the series; basically, it praised Louis XIV for having "[c]hangé tous les Elemens qui étoient dans une confusion horrible" (changed all the elements that were in a frightening state of confusion).[40] *The Elements* was also related formally to *The Seasons*, as each of its tapestries presents two deities floating on a cloud, along with attributes and animals linked to the element in question.

Whereas *The Elements* and *The Seasons* conveyed a message in an allegorical disguise, other tapestry sets that Le Brun designed for the Gobelins were more straightforward. Between 1664 and 1686, the king commissioned no fewer than eight suites of Le Brun's *Story of Alexander*.[41] The Sun King's interest in an emperor who had conquered the world by age thirty is hardly surprising, and, by choosing Alexander as his visual equivalent, he was able to broadcast his ambition throughout Europe. With *The History of the King* woven from 1665 on, Le Brun lifted the allegorical veil completely, present-

ing fourteen authentic incidents from Louis XIV's reign, including a visit to the Manufacture Royale des Gobelins.[42] Another series, *The Months* (also known as *The Royal Palaces* or *The Royal Residences*), produced from 1668 on, also offers documentary views instead of symbolism, demonstrating the monarch's glory through a survey of his most magnificent palaces and castles, including the Château de Saint-Germain.[43]

When the Gobelins reopened in 1699, the royal administration and the entrepreneurs running its tapestry workshops realized that in order to continue operations, the enterprise had to market more tapestry sets that appealed to private customers rather than to the propagandistic impulses of the monarchy. Famous early-eighteenth-century Gobelins tapestry sets such as the *Portieres of the Gods*, which depicted Olympian deities in arabesque settings, and *The Story of Don Quixote* differed completely from Le Brun's allegorical series glorifying the French king.[44] The Art Institute's *Autumn* and *Winter* were thus produced right at the time that the *goût moderne*—now known as the Regency or Rococo style—came to dominate the artistic scene, and they can therefore be regarded as one of the last creations in the monumental style of Louis XIV, which existed to evoke the grandeur of the Sun King's France. KB, CCMT

NOTES

1. The bottom selvage is possibly not original.
2. In 1838 a visitor to Marple Hall briefly described the two tapestries in his journal; Earwaker 1880, vol. 2, p. 77.
3. Félibien 1670, p. 27.
4. Ibid., p. 37.
5. Lacordaire 1897, pp. 42–43.
6. Ibid., pp. 28–29.
7. For more on Colbert, see Mousnier and Favier 1985.
8. Guiffrey 1904.
9. The War of the Grand Alliance (1688–97), also known as the Nine Years' War, drained France of its financial resources and thus put the Gobelins employees out of work. For more on Le Brun's oeuvre, see Jouin 1889, Merson 1895, Musée des Gobelins 1962, Thuillier and Montagu 1963, Gareau and Beauvais 1992, and Nivelon [c. 1700] 2004.
10. For more on Fouquet, see Petitfils 1999.
11. Favreau 2007.
12. Joubert, Lefébure, and Bertrand 1995, pp. 167–68. The professional contact between Le Brun and the Gobelins entrepreneurs also reached a rather personal level: Le Brun was, for example, present as a witness at the wedding of La Croix's daughter Polixène in 1677; Lacordaire 1897, p. 27.
13. *Mercure galant*, Feb. 1690, pp. 257–60; cited in Gareau and Beauvais 1992, p. 36.
14. Lucas de Kergonan 2000, p. 64.
15. Fenaille 1903–23, vol. 2, pp. 69–83.
16. The *entrefenêtres* scenes were upgraded into an autonomous set titled *The Child Gardeners*, first woven in 1685; Fenaille 1903–23, vol. 2, pp. 51–185.
17. Gastinel-Coural 1998, p. 113. For Van der Meulen, see also Richefort 2004.
18. The cartoons used by the high-warp weavers were painted by Baudouin Yvart (1611–1690), who executed the four large compositions; Pierre de Sève, who painted three *entrefenêtres*; and René-Antoine Houasse (1644 or 1645–1710), who executed the remaining *entrefenêtre* of *Spring*; see Fenaille 1903–23, vol. 2, p. 68. Those employed by the low-warp weavers were painted

by Louis de Melun, who executed *Spring* and *Summer*; Claude III Audran (1658–1734), who did *Winter*; and "Ballin"—presumably Jean-Baptiste Belin (1653–1715)—who executed the cartoon of *Autumn*. The *entrefenêtres* were painted by Abraham II Genoels (died 1723), like Van der Meulen a Flemish émigré, and one Dubois. See Gastinel-Coural 1998, p. 70.
19. These copies were executed by an artist whose name is recorded only as "Mathieu"; Gastinel-Coural 1998, p. 70.
20. "L'Hiver, par Le Brun; sujet et tableau à conserver. . . . L'Automne, d'après Le Brun, hors d'état de servir. . . . L'Été, par Le Brun, 2 bandes; rejeté. . . . Le Printemps, d'après Le Brun, 8 bandes, détérioré" (*Winter,* by Le Brun; subject and painting to keep. . . . *Autumn*, after Le Brun, beyond use. . . . *Summer*, by Le Brun, two strips; rejected. . . . *Spring*, after Le Brun, eight strips, deteriorated); Lacordaire 1897, pp. 257, 262–63. Maurice Fenaille (1903, p. 70) recorded a total of twenty surviving fragments. Only two fragments (inv. 3003) are listed in Compin and Roquebert 1986, vol. 3, p. 43. Another fragment is in the Musée des Gobelins, Paris, and has not been published.
21. The high-warp set was produced in about 1680; see Fenaille 1903–23, vol. 2, pp. 74–83. For more on the Garde-Meuble, see Castelluccio 2004.
22. *Winter* and *Summer* are in the Château de Fontainebleau; *Spring* is in the Ministère de la Justice, Paris; and *Autumn* is in the Ministère de l'Agriculture et de la Pêche, Paris.
23. For evidence of these assumptions, see GCPA 0243874 (*Autumn*) and GCPA 0243875 (*Winter*).
24. There are presently three known *Seasons* tapestries that belong to another suite made as a private commission. *Autumn* and *Winter* were at the Galerie Koller, Zürich, in 1997 (present location unknown), and *Spring* was sold at Christie's, Monaco, Dec. 3, 1989, lot 306.
25. Burke 1994.
26. Charles Perrault, *Mémoires de ma vie*, ed. Paul Bonnefon (Paris: Renouard, 1909), p. 39, cited in Gastinel-Coural 1998, p. 113.
27. See also Grivel and Fumaroli 1988.
28. Félibien 1670, p. 1.
29. Ibid., p. 27.
30. Ibid., p. 37.
31. Ibid., p. 1.
32. Ibid., p. 37.
33. Avel 1973, pp. 143–53.
34. Hillairet 1972, vol. 1, p. 379. A map issued in 1648 shows a bird's-eye view of the Porte de la Conférence; see Boutier 2002, pp. 139–41.
35. For the Fronde, see Ranum 1993 and Pernot 1994.
36. For more on the Tuileries, see Sainte Fare Garnot 1988, and Sainte Fare Garnot and Jacquin 1988.
37. For more on the château, see Lacour-Gayet 1935.
38. During the sixteenth and seventeenth centuries, the French kings had favored as their main residences the Château de Fontainebleau, approximately sixty-five kilometers southwest of Paris, and the Louvre in the heart of Paris. Starting in 1661, however, Louis XIV modernized and enlarged his father's hunting lodge at Versailles, and in May 1682 the King and his court moved there, thus making Versailles the seat of government and the capital of France. See Walton 1986.
39. Fenaille 1903–23, vol. 2, pp. 51–66.
40. Félibien 1670, p. 3.
41. Fenaille 1903–23, vol. 2, pp. 166–85; Posner 1959; Thuillier and Montagu 1963, pp. 71–73, 77–95, 258–59, 264–75, 278–79, 288–301; Beauvais 1990.
42. Fenaille 1903–23, vol. 2, pp. 98–127; Thuillier and Montagu 1963, pp. 330–35; Meyer 1980; Gastinel-Coural 1998, pp. 110–20.
43. Sauval 1961; Bremer-David 1986; Mabille 2004.
44. For the *Portières des Dieux*, see Fenaille 1903–23, vol. 3, pp. 1–60, and Forti Grazzini 1994, vol. 2, pp. 416–39. For *Don Quixote*, see Fenaille 1903–23, vol. 2, pp. 157–282; Forti Grazzini 1994, pp. 392–415; and Lefrançois 1994.

Chancelleries

CAT. 41A

Presumably Paris, possibly 1718/21
After a design by an unknown artist
Produced at an unknown workshop, presumably at the Manufacture Royale
des Gobelins
117.2 x 246.1 cm (46⅛ x 96⅞ in.)
Gift of Honoré Palmer, 1938.1304

STRUCTURE: Wool and silk, slit and double interlocking tapestry weave
Warp: Count: 8–10 warps per cm; wool: S-ply of four Z-spun elements;
diameters: 0.5–1.3 mm
Weft: Count: varies from 23 to 43 wefts per cm; wool: S-ply of two Z-spun
elements; pairs of S-ply of two Z-spun elements; diameters: 0.3–1.0 mm;
silk: pairs of S-ply of two Z-twisted elements; diameters: 0.6–1.0 mm; wool
and silk: paired yarns of S-ply of two Z-spun wool elements and S-ply of two
Z-twisted silk elements; diameters: 0.7–1.3 mm

Conservation of this tapestry was made possible through the Department of
Textiles Tapestry Conservation Fund.

PROVENANCE, REFERENCES, EXHIBITIONS: See below.

CAT. 41B

Presumably Paris, possibly 1718/21
After a design by an unknown artist
Produced at an unknown workshop, presumably at the Manufacture Royale
des Gobelins
114.6 x 242.8 cm (45⅛ x 95½ in.)
Gift of Honoré Palmer, 1938.1305

STRUCTURE: Wool and silk, slit and double interlocking tapestry weave
Warp: Count: varies from 8 to 10 warps per cm; wool: S-ply of four Z-spun
elements; diameters: 0.5–1.3 mm
Weft: Count: varies from 23 to 43 wefts per cm; wool: S-ply of two Z-spun
elements; pairs of S-ply of two Z-spun elements; diameters: 0.3–1.0 mm;
silk: pairs of S-ply of two Z-twisted elements; diameters: 0.6–1.0 mm; wool
and silk: paired yarns of S-ply of two Z-spun wool elements and S-ply of two
Z-twisted silk elements; diameters: 0.7–1.3 mm

Conservation of this tapestry was made possible through the generosity of
Armen Minasian.

PROVENANCE: Probably Potter (died 1902) and Bertha Palmer (née Hon-
oré, died 1918), Chicago and Paris; probably by descent to their son Honoré
Palmer (died 1964); given to the Art Institute, 1938.

REFERENCES: Mayer Thurman in Wise 1976, p. 196 (ill. of 1938.1305 only).

EXHIBITIONS: Art Institute of Chicago, *Selected Works of 18th Century
French Art in the Collections of the Art Institute of Chicago*, 1976, cat. 312b
(1938.1305 only; see Mayer Thurman in Wise 1976).

EACH of these tapestries shows a cartouche containing two inter-
twining *L*s, the monogram used by the French kings Louis XIV and
Louis XV, on a ground covered with fleurs-de-lis.[1] The cartouche is
surrounded by strapwork and surmounted by a pair of wings and a
shell. A pair of royal scepters tied with a flowing ribbon cross under
the cartouche. Acanthus leaves, scrollwork, and shells appear at each
tapestry's top and bottom. Neither piece has a border.

Tapestries showing this and similar designs are called *chancelleries*
(see also cat. 44). This name—already in use during the eighteenth
century—either derives from the title shared by the pieces' recipients,
chancelier de France (chancellor of France), or from the name of the
places in which they were hung, the Grande Chancellerie in Paris or
its provincial satellites, the Petites Chancelleries.[2] The chancellor of
France, who was appointed for life, served as chief justice and *garde
des sceaux*, the keeper of the seals used to authenticate declarations
and laws. If a chancellor became ill or was disgraced, he was relieved
from his duties as keeper of the seals, but retained the title of chan-
cellor. The king then appointed a new keeper of the seals.

From 1679 on, Louis XIV and Louis XV presented every newly
appointed chancellor and keeper of the seals with a suite of chancel-
leries showing the symbols of the recipient's authority, i.e., the royal
arms, the scepters, and the chest containing the seals. The pieces were
personalized by incorporating the coat of arms of the recipient in
the borders.[3] Except for one edition that was produced at Beauvais,[4]
all chancelleries given by the French kings were produced at the
Gobelins and can thus be traced in the Gobelins records.[5] Yet not all
chancelleries woven at the Gobelins were commissioned by the king.
In 1722, for example, the Parlement de Paris ordered an unknown
number of pieces from the Gobelins manufactory; as this was not
a royal commission, the order was not registered by the workshop
managers who executed the tapestries.[6] Moreover, chancelleries were
also privately commissioned from Beauvais tapissiers (see cat. 44).
Consequently, chancelleries without borders and thus coats of arms
and signatures, like the pair now in Chicago, present interrelated
attribution and dating challenges.

The design of the Chicago pieces, however, can be used to address
these issues, for various cartoons were used over time. The first
design, which was made in 1679 for the suite presented to Michel Le
Tellier, shows two angels flanking the arms of France (three fleurs-
de-lis) under a canopy and ermine mantle against a field of fleurs-
de-lis,[7] or simply the arms of France surmounted by a crown.[8] The
chest containing the seals occupies the center of the lower border
and is surmounted by a pair of crossed scepters. The vertical borders
show cartouches with the interlaced *L* monograms and putti hold-
ing scepters.

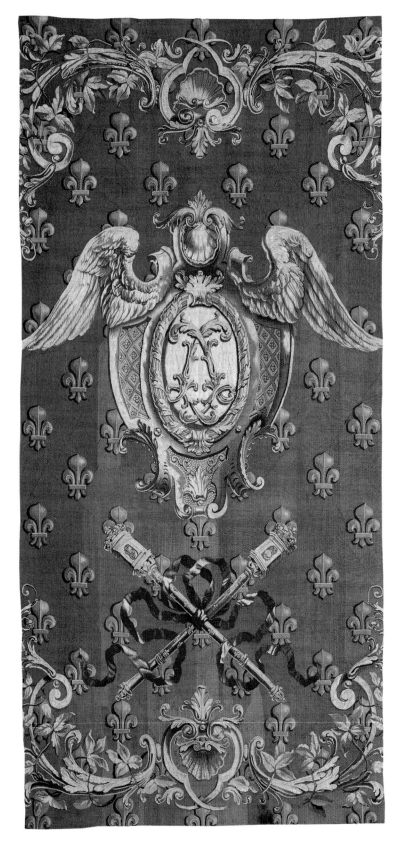

CAT. 41A

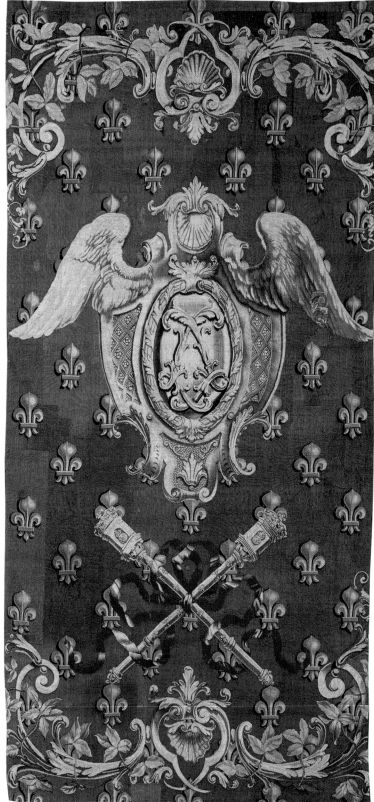

CAT. 41B

The second design, used for the suite woven in Beauvais in 1686 that was presented to Louis Boucherat, is very similar to the first.[9] It shows the arms of France and Navarre in a cartouche surmounted by a crown under a canopy and ermine mantle on a fleur-de-lis ground. Two angels flanking the cartouche support the crown and mantle. In contrast to the Le Tellier suite, here the chest and scepters are not shown in the lower border, but rather rest on it.

The third design, made in 1700 or 1701 by Claude III Audran (1657–1734), Guy-Louis Vernansal (1648–1729), and one Pavillon, was used for most suites woven at the Gobelins in the eighteenth century (see cat. 44, fig. 1).[10] Like the two older designs, it shows the arms of France and Navarre in a cartouche surmounted by a crown, under a canopy and ermine mantle, on a fleur-de-lis ground. Two angels support the mantle. The chest containing the seals and the scepters sits on a pedestal that rests on a platform. Two seated allegorical figures flank the pedestal. These personifications are omitted in smaller chancelleries of this type.[11] The borders show crossed scepters and the coat of arms and monogram of the recipient.[12]

This survey reveals that though the Chicago chancelleries combine a number of features used in the various designs, they are essentially distinct. The most striking difference is the absence of the chest containing the seals. Only one other chancellerie woven after the same cartoon is known (fig. 1). It surfaced recently on the London art market and has borders that are very similar to those of chancelleries woven at the Gobelins between about 1701 and 1737.[13] The tapestry features the arms of Joseph Jean Baptiste Fleuriau d'Armenonville, keeper of the seals from 1722 to 1727, whose suite of ten chancelleries was produced at the Gobelins between 1722 and 1725.[14] The d'Armenonville arms, however, were added *after* the tapestry was woven.[15] It is possible that this was done by the Gobelins tapissiers between 1722 and 1725 to customize a tapestry that they had in stock so that it could be added to the d'Armenonville suite, or that d'Armenonville himself bought this tapestry from one of his predecessors and added his arms to personalize the piece. It is of course also possible that the arms were added sometime in the nineteenth or twentieth centuries. Whatever the case, the border of the d'Armenonville chancellerie is original and demonstrates that the cartoon was used at the Gobelins around 1720. Consequently, it can be assumed that the Chicago pair was also woven in Paris around that time.

In light of this attribution and dating, the absence of the chest containing the seals is highly remarkable, since its importance grew steadily through the various Gobelins chancellerie designs: while just a border element in the first cartoon (1679), it was depicted in the main field in the second design (1686), and emerged in the third cartoon (1700–01) as a prominent feature displayed on a pedestal. The turbulent history of the office of chancellor of France between 1717 and 1722 may explain the absence of the chest. In 1717 Henri-François d'Aguesseau became a chancellor.[16] One year later, however, he was disgraced and the king appointed a new keeper of the seals, Marc-René de Voyer, marquis d'Argenson. D'Aguesseau remained a

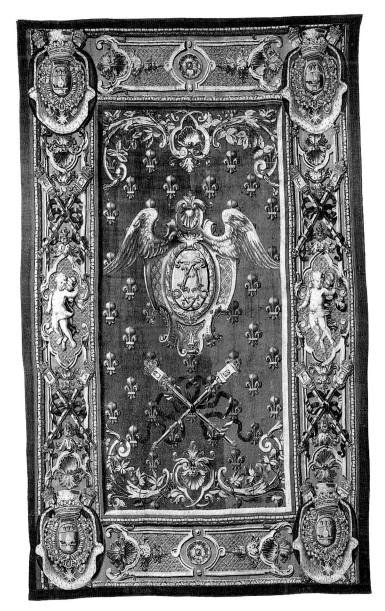

FIG. 1 *Chancellerie with the Arms of Joseph Jean Baptiste Fleuriau d'Armenonville*. Presumably produced at the Manufacture Royale des Gobelins, c. 1725. Wool and silk; 307 x 211 cm. Location unknown.

chancellor and the Gobelins commenced the production of his chancelleries in 1718,[17] delivering the nine-piece suite in March 1721.[18] As no tapestries belonging to this suite have ever been located,[19] their exact appearance is unknown. It is possible that the Chicago chancelleries belonged to this edition, but until the completion of additional archival research on chancellors, keepers of the seals, and their collections of tapestries, this identification remains speculation.

D'Aguesseau's disgrace *prior* to the weaving of his chancelleries obviously prompts an intriguing question: did the tapestries show the chest containing the seals even though their recipient was in fact no longer the keeper of the seals? It can be surmised that they did not, and this assumption supports the theory that the cartoon used to weave the Chicago chancelleries was made to suit d'Aguesseau's peculiar status: chancellor yet not keeper of the seals.

This argument is strengthened by the shells that are prominently shown on the central axis of the design, for they may allude to the shells that dominate the d'Aguesseau coat of arms.[20] Admittedly, shells were common motifs in eighteenth-century French art, but they do not appear in other chancelleries, and their presence could explain a curious feature: the borders of the d'Aguesseau chancelleries did not originally show his coat of arms. This is demonstrated by an archival document revealing that in 1736 the Gobelins delivered twenty-four "armes de M. le Chancelier Daguesseau, tenture de la Chancellerie" (arms of chancellor d'Aguesseau, chancellerie suite).[21] The omission of the arms at the time of initial manufacture may have been the recipient's choice or the king's will. In any case, the d'Aguesseau chancelleries may have been personalized by the inclusion of the shells. KB

NOTES

1. The monogram appears, for example, in the lower corners of a suite of *The History of the King* woven at the Gobelins from 1668 to 1671, as well as in the vertical borders of another edition of the same series produced at the Gobelins from 1732 to 1735; for illustrations, see Campbell 2007a, cat. 41, fig. 176.
2. Barbiche 2001, pp. 153–172.
3. For other examples of chancelleries, see Fenaille 1903–23, vol. 3, pp. 133–51; Standen 1985, vol. 1, pp. 361–64; and Bremer-David 1997, pp. 28–33.
4. The suite of chancelleries presented to chancellor Louis Boucherat around 1686 was produced at the Beauvais workshops; Fenaille 1903–23, vol. 3, pp. 133–34; Badin 1909, pp. 9, 12; Coural and Gastinel-Coural 1992, pp. 16, 21.
5. Fenaille 1903–23, vol. 3, pp. 133–51.
6. Ibid., vol. 3, p. 139.
7. One piece is in the Musée Nissim de Camondo, Paris, inv. 45; published in Machault and Malty 2000, p. 159, fig. 97.
8. Christie's, London, Dec. 14, 2000, lot 124; then Christie's, London, Nov. 9, 2006, lot 399.
9. Three Boucherat chancelleries are known. Two are in the Mobilier National, Paris, and one was on the art market in 1935; Coural and Gastinel-Coural 1992, pp. 16, 21; Bremer-David 1997, p. 33.
10. Fenaille 1903–23, vol. 3, pp. 134–35.
11. Examples are in the J. Paul Getty Museum, Los Angeles (Bremer-David 1997, pp. 28–33) and the Metropolitan Museum of Art, New York (Standen 1985, vol. 1, pp. 361–64).
12. Standen 1985, vol. 1, p. 362.
13. Sotheby's, London, Mar. 21, 2007, lot 26.
14. Fenaille 1903–23, vol. 3, p. 138.
15. With thanks to Christa C. Mayer Thurman and Simon Franses of Franses Limited, who examined the tapestry and shared his findings.
16. For the life and career of d'Aguesseau, see Prevost 1933, Bayart et al. 1953, and Storez 1996.
17. Fenaille 1903–23, vol. 3, p. 136.
18. The suite for d'Argenson was woven simultaneously with the chamber produced for d'Aguesseau; the former received his ten-piece edition in April 1721, only a couple of weeks before his death; Fenaille 1903–23, vol. 3, p. 137. By then d'Aguesseau had been reinstalled as keeper of the seals following d'Argenson's resignation in 1720. In 1722, however, d'Aguesseau was again disgraced and d'Armenonville—whose arms are on the London chancellerie (fig. 1)—became keeper of the seals. In 1737 d'Aguesseau was reinstalled as keeper of the seals and held the position until his retirement in 1750; Barbiche 2001, p. 162.
19. Standen 1985, vol. 1, p. 362.
20. Bayart et al. 1953, pl. 4.
21. Fenaille 1903–23, vol. 3, p. 136.

From *The Grotesque Months*

The Month of June/The Sign of Cancer

Paris, c. 1726
After a design by Claude III Audran (1658–1734), 1708–09
Produced at an unknown workshop at the Manufacture Royale des Gobelins
71.5 x 293.7 cm (28⅛ x 115⅝ in.)
The Bessie Bennett Fund, 1951.260

STRUCTURE: Wool and silk, slit and double interlocking tapestry weave
Warp: Count: 7 warps per cm; wool: S-ply of two Z-spun elements; diameter: 1.0 mm
Weft: Count: varies from 24 to 46 wefts per cm; wool: single S-spun elements; S-ply of two Z-spun elements; pairs of S-ply of two Z-spun elements; diameters: 0.3–0.8 mm; silk: pairs of S-ply of two Z-twisted elements; diameters: 0.4–1.0 mm; wool and silk: paired yarns of S-ply of two Z-spun wool elements and S-ply of two Z-twisted silk elements; diameters: 0.5–0.8 mm

Conservation of this tapestry was made possible through the generosity of the Fatz Foundation.

PROVENANCE, REFERENCES, EXHIBITIONS: See below.

CAT. 42B

The Month of July/The Sign of Leo

Paris, c. 1726
After a design by Claude III Audran (1658–1734), 1708–09
Produced at an unknown workshop at the Manufacture Royale des Gobelins
66.5 x 293.6 cm (26⅛ x 115½ in.)
The Bessie Bennett Fund, 1951.261

STRUCTURE: Wool and silk, slit and double interlocking tapestry weave
Warp: Count: 11 warps per cm; wool: S-ply of two Z-spun elements; diameter: 1.0 mm
Weft: Count: varies from 24 to 46 wefts per cm; wool: single S-spun elements; S-ply of two Z-spun elements; pairs of S-ply of two Z-spun elements; diameters: 0.3–0.8 mm; silk: pairs of S-ply of two Z-twisted elements; diameters: 0.4–1.0 mm; wool and silk: paired yarns of S-ply of two Z-spun wool elements and S-ply of two Z-twisted silk elements; diameters: 0.5–0.8 mm

Conservation of this tapestry was made possible through the generosity of the Rosemarie and Dean Buntrock Foundation.

PROVENANCE: Possibly Anselm Salomon von Rothschild (died 1874), Vienna; possibly by descent to his son, Baron Nathaniel Meyer von Rothschild (died 1905), Vienna; by descent to his brother Salomon Albert Anselm von Rothschild (died 1911), Vienna; by descent to his son Baron Alphonse (Mayer) von Rothschild (died 1942), Vienna; confiscated by the German government and taken to the Hofburg Palace, Vienna, for inventory, Mar. 1938; transferred to the Alt Aussee salt mines near Salzburg, by 1944; captured by Allied troops, 1945. Restituted to the widow of Baron Alphonse (Mayer) von Rothschild, Baroness Clarice von Rothschild (née Sebag-Montefiore, died 1967), Vienna and later New York, 1947; consigned to Rosenberg and Stiebel, New York, 1950; sold to the Art Institute of Chicago, 1951.

REFERENCES: Mayer Thurman in Wise 1976, p. 197, cats. 313a–b. Bremer-David 2002, pp. 29–34 n. 19.

EXHIBITIONS: Art Institute of Chicago, *Selected Works of 18th Century French Art in the Collections of the Art Institute of Chicago*, 1976 (see Mayer Thurman in Wise 1976). Art Institute of Chicago, *Tapestries from the Permanent Collection*, 1979.

THESE two narrow panels belong to a tapestry suite known as *The Grotesque Months* that depicts the twelve months of the year and their associated zodiac signs. Each month is personified by a Roman deity, centrally positioned within a pergola set against a bright ground. Symmetrical arrangements of diapered reserves, floral garlands, leafy scrolls, rinceaux, and straps extend above and below each pergola. The border consists of a narrow row of laurel leaves, set at each center point with a floral boss and at each corner with a stylized acanthus leaf.

June, with the sign of Cancer—a crab, here rather lobster-like—in the oval at the top of the tapestry, bears an image of the messenger god Mercury in flight, his right hand clasping a caduceus, or herald's staff. He is naked but for his billowing mantle and petasos (winged cap); additional wings are tied to his ankles. Above and below Mercury appear his associated attributes. Alluding to the god's role as the guide of travelers and the protector of commerce, an armillary sphere and a globe flank his emblematic rooster standing on top of the pergola, while scrolls entwine telescopes and winged helmets. Suspended from the upper diapered reserve is a trophy of rackets, paddles, and a net filled with balls, a reference to Mercury's athletic skills. Immediately beneath the pergola, in a camaïeu cartouche, is a miniature scene showing an episode in the tale of Mercury's sly betrayal and murder of the giant Argus, guardian of Io, the maiden Jupiter seduced and then turned into a heifer to conceal her from the jealous Juno.[1] Other objects related to the story are portrayed below the cartouche: the reed flute with which Mercury lulled Argus to sleep; the *houlette*, or crook used by herdsmen to toss pebbles at straying livestock; and a goat, which represents the herd Mercury stole in order to disguise himself as a herdsman. A coin-filled purse (alluding to the currency used by travelers and merchants) and a pair of shears (the tool usually used in June to fleece sheep) hang under the crossed flute and *houlette*, above the goat. Two bundles of merchandise, tied with cords into a cylinder and a packet, rest on the central plinth at the bottom of the tapestry; they bear unidentified but traditional markings, of the type commonly shown on parcels or containers of goods in merchant caravan and harbor scenes (see cat. 2).[2]

July, with the sign of Leo—the figure of a lion, here depicted in profile—in a grisaille cartouche near the top of the tapestry, shows the bearded Jupiter seated on a great eagle amid storm clouds, poised

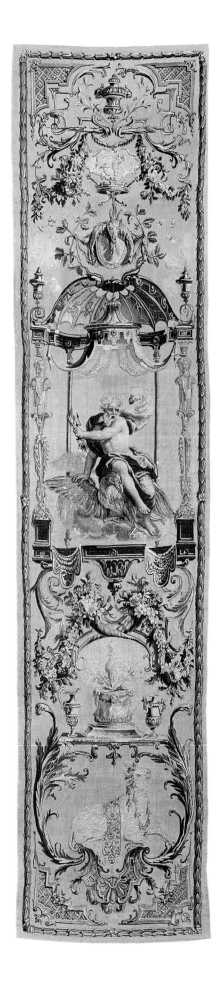

CAT. 42A

CAT. 42B

to hurl a thunderbolt from his right hand. The fleece and head of Amalthea, the goat that suckled the infant god, hang between leafy branches extending upward from the top of Jupiter's pergola. Perforated urns, from which smoking incense issues, surmount its foremost caryatids. The Olympian's crown and crossed scepters stretch between the goat's head and the zodiac sign. The pair of flower-filled cornucopias below the pergola may refer to the goat's horn that, by Jupiter's command, magically filled with whatever its owner desired. The flaming altar, flanked by two vessels, honors this king of the gods. At the bottom of the tapestry, a kneeling white bull with a garland of flowers around its neck and head alludes to Jupiter's metamorphosis into a docile bull to abduct the princess Europa.[3]

These tapestries are in the light, open style inspired by Renaissance artists' rediscovery and reinterpretation of ancient wall paintings (see also cat. 43).[4] Far removed from the traditional academic hierarchy of the painting genres, the style—called grotesque after the *grotti* or caves in which the antique frescos were discovered—employed a vocabulary of attenuated scrolls, baldachins, straps, and trellises, and a mixed cast of pagan deities, theatrical figures, and hybrid creatures subject neither to the rules of gravity nor convention. By the later seventeenth century, the grotesque style appealed to a group of elite members of French aristocratic society, led by Louis, the Grand Dauphin, son and heir of Louis XIV, because its inventive and unorthodox character reflected the qualities they believed the ideal courtier or *honnête homme* (a nobleman with an informed yet agile broadmindedness free of pedantry) should possess.[5]

Grotesque tapestry cycles representing the Twelve Months with their associated classical deities, zodiac signs, and pertinent labors have a long history. In the 1560s the Brussels workshop of Cornelis de Ronde (died 1569) and Jan van der Vyst (active 1560/70) produced a *Grotesque Months* suite showing large-scale deities centrally positioned in pergolas against a red ground.[6] The relationship of months to deities followed the links established in the first century by the Roman poet Marcus Manilius.[7] Another edition of the same series was woven with gilt-metal thread for Henry de Lorraine, the duc de Guise, and entered the French royal collection in 1661. Known as *The Arabesque Months*, it exerted significant influence on the circle of artists working for the crown, as its design was then attributed to the renowned artist Giulio Romano (c. 1499–1546). Weavers at the Manufacture Royale des Gobelins faithfully copied the suite in 1686 to 1688 for display in the Grand Trianon at Versailles, which preserved the design for posterity, as the original was burned in 1797 to retrieve its metal content. Despite the official closure of the Gobelins workshops during the war-torn and fiscally troubled years from 1694 to 1699, between 1696 and 1697 weavers in its low-warp workshops nevertheless executed three stylistically and thematically complementary tapestries of Apollo and the Four Seasons after new designs by Noël Coypel (1628–1707), also destined for the Grand Trianon.[8] The main central panel represented Apollo, the sun god, while the two narrow flanking panels each portrayed two of the Four Seasons.

When the Gobelins reopened in 1699, the new superintendent of the Bâtiments du Roi (Office of Royal Buildings and Public Works), Jules Hardouin-Mansart, commissioned the up-and-coming artist and *ornamentiste* Claude III Audran to design a series of allegorical tapestries of the Four Seasons and the Four Elements in the increasingly popular grotesque style. While adhering to the antique concept of a large, central emblematic deity on a flat-colored background (epitomized by the duc de Guise's *Arabesque Months*, among other suites), Audran altered the balance of the surrounding details, reducing the weight and volume of the allegorical attributes, architectural compartments, rinceaux, scrolls, and symbolic animals. His compositions were therefore lighter in design and more decorative, in keeping with the evolving taste in interior decoration. Known collectively as the *Portieres of the Gods*, the new series was so successful that it remained in production for ninety years, only falling out of favor at the time of the Revolution.[9]

In 1708, the Bâtiments du Roi, acting on behalf of the Grand Dauphin, commissioned a new series from the Gobelins for his bedchamber in the newly constructed Château de Meudon.[10] Audran was appointed as the designer, probably because, since 1699, he had been closely involved in the decoration of both the old and the new châteaux at Meudon, where he worked in the light, open grotesque style.[11] Known as *The Grotesque Months*, the new tapestry cartoons complemented the chamber's architectural fittings, for the set was composed as twelve narrow vertical bands, each depicting a different month, joined together and framed by identical borders that echoed the carved patterns of the adjacent wood paneling.[12] To accommodate the dimensions of the interior walls, six months were woven together with their framing borders as one tapestry, while two sets of three months and their frames each comprised another hanging, for a total of three separate pieces.[13] One design in the series, *The Month of July*, contains many features that originally appeared nine years earlier in the *Portiere of Jupiter*, an allegory for the element of Fire (fig. 1). In the latter, the bearded god sits on an eagle among storm clouds, raising a thunderbolt aloft. He is encircled by a crown and crossed scepters, a flaming altar and smoking incense burners, floral garlands, and a goat skin and head. Two beehives and several flying bees feature prominently at the top of the composition, alluding to the honey the nymph Melissa fed to the infant god. Audran reused all of these details, including the bees (though he omitted the hives), in *The Month of July*. The principal stylistic change in the later composition, and in its companion pieces, was the reduction in scale of the central deity, to a proportion that balances with the narrower whole. Audran also departed from Manilius's associations for two of the months, representing March by Mars and October by Minerva.[14]

The only officially recorded suite based on these cartoons was executed for the Grand Dauphin with wool, silk, and gilt-metal-wrapped wefts on the low-warp looms, and delivered to the Garde-Meuble de la Couronne (Royal Furniture Warehouse) on December

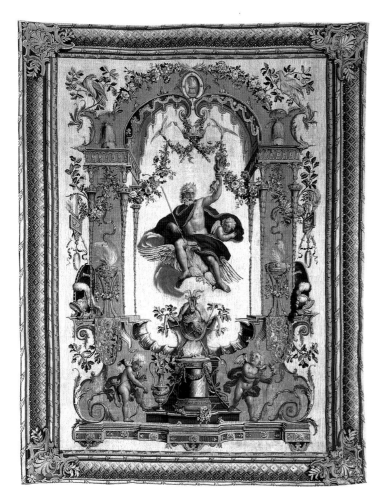

FIG. 1 *Jupiter the Fire* from *Les Portières des Dieux*. After a design by Claude III Audran, 1699–1702. Produced at the Manufacture Royale des Gobelins. Wool and silk. Mobilier National, Paris.

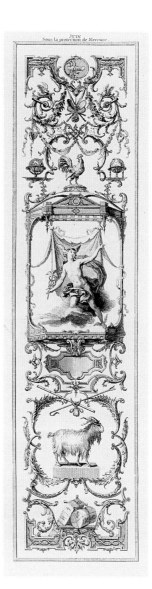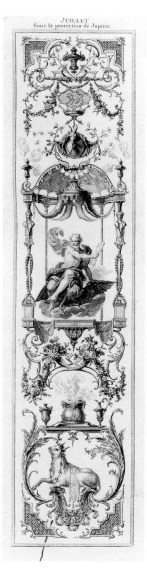

FIGS. 2 AND 3 *June under the Protection of Mercury* (left) and *July under the Protection of Jupiter* (right) from *The Grotesque Months*. Jean Audran after Claude III Audran, 1726. Etching and engraving, on off-white laid paper; sheet: 47 x 33.7 cm. Cooper-Hewitt, National Design Museum, Smithsonian Institution. Purchased for the Museum by the Advisory Council, 1921-6-229-3 (*June*), 1921-6-229-4 (*July*).

30, 1710. As the Grand Dauphin died shortly afterwards, on April 14, 1711, it is uncertain whether the weavings were ever hung at Meudon. Two hangings comprising nine of the twelve months, including *June* and *July*, survive in the Mobilier National, Paris.[15] Though the Gobelins manufactory did not retain the original cartoons, given the prodigious success of Audran's reinterpretation of the grotesque *Portieres of the Gods*, it is not surprising that new editions of *The Grotesque Months* were produced.[16] These subsequent weavings typically followed slightly shortened models, as did the engravings produced in 1726 by Audran's younger brother Jean Audran (1667–1756) that reinvigorated interest in the enduringly popular calendrical series (figs. 2–3).[17] Three related drawings—for *April, June,* and *October*—exist for the reduced designs (fig. 4).[18] In the later tapestries, however, Audran's compositions were sometimes reversed, their dimensions adjusted, and Manilius's associations of months to gods modified. None of these weavings were joined by framing borders, as in the first edition. Each narrow tapestry was instead either stretched across a wooden frame and placed within the *boiserie* (carved wood wall paneling of a room) or tacked as an upholstery panel onto a leaf of a *paravent* (folding screen).[19] Since the unofficial suites were not

formally tracked, it is difficult to reconstruct the production chronology and to identify their purchasers.

Only four of these unofficial suites have survived complete.[20] Most editions have since been dispersed, usually divided into quartets, trios, or pairs of tapestries, like the pair in the Art Institute.[21] The extended Rothschild family, whose members were discerning art collectors and leading arbiters of taste, particularly in the second half of the nineteenth century, shared a penchant for the series. Aside from the Viennese branch that previously owned the two pieces now in the Art Institute, the English branch also acquired *Grotesque Months* tapestries, as the Rothschild collection at Waddesdon Manor, near Aylesbury, England, preserves four panels on a folding screen and two more applied to a pair of window curtains.[22] Perhaps it was the esteemed *goût* Rothschild that ignited a revival of the series, for

FIG. 4 *Design for June*. Claude III Audran, 1709–10. Red chalk, pen and brown ink, on cream laid paper; 38.7 x 10.2 cm. Cooper-Hewitt, National Design Museum, Smithsonian Institution. Purchased for the Museum by the Advisory Council, 1911-28-1-2.

before 1893 the Maison Braquenié tapestry manufactory, located in Aubusson, possessed painted cartoons for *The Grotesque Months* after the engravings by Jean Audran, as well as a painted room elevation proposing how such panels might be used by their patrons. Braquenié must therefore have produced some of the modern tapestries.[23] The Gobelins manufactory also wove a complete set in 1893 to 1896, which was displayed at the Parisian Exposition Universelle in 1900, before being given to Czar Nicholas II in 1901.[24] Furthermore, in 1903, the Gobelins wove a new panel of three months for the Mobilier National in order to replace those missing from the surviving original set commissioned by the Grand Dauphin. Painted canvases after Jean Audran's twelve designs have also appeared on the art market.[25] CBD

NOTES

1. Ovid 1955, book 1, 580–730 (pp. 44–47).
2. See also *Europe* from the *Four Continents* suite woven at the Beauvais manufactory from 1790 to 1791, published in Standen 1985, vol. 2, pp. 578–82. Such marks are also found in many harbor scenes painted on vases produced by the Sèvres porcelain manufactory in the second half of the eighteenth century; Savill 1988, pp. 325–33, 338–42, cats. C300–02, C304. These merchant marks, embedded as details within larger narratives, deserve thorough study.
3. Ovid 1955, book 2, 840–75; book 3, 1–20 (pp. 72–74).
4. Kimball 1943, pp. 106–11.
5. Scott 1995, pp. 120–45.
6. The suite is now in the Kunsthistorisches Museum, Vienna, invs. XI/1–12. See Scheicher 1973, pp. 56–84, and Delmarcel 1999a, p. 87 (ill.).
7. Marcilius's associations are as follows: January with Juno, February with Neptune, March with Minerva, April with Venus, May with Apollo, June with Mercury, July with Jupiter, August with Ceres, September with Vulcan, October with Mars, November with Diana, and December with Vesta.
8. Fenaille 1903–23, vol. 2, pp. 323–61; Machault and Malty 2000, pp. 104–15.
9. Fenaille 1903–23, vol. 3, pp. 1–60.
10. Located five and one-half miles to the west of central Paris, the château was destroyed by fire in 1871 and subsequently demolished.
11. Audran received 495 livres for the new cartoons, which he executed at the Gobelins from 1708 to 1709; Guiffrey 1901, vol. 5, p. 240.
12. Six preliminary sketches by Claude III Audran for the series, one of them showing an early concept for *The Month of June*, are in the National Museum of Fine Arts, Stockholm, invs. CC IV 208, 210, 213, 214, 217, 222. See Moselius 1945, and Forti Grazzini and Zardini 2007, pp. 28–30, figs. 9–14.
13. Fenaille 1903–23, vol. 3, pp. 73–80; Guiffrey 1885a, vol. 1, p. 325, no. 132; Pons 1991, pp. 59–76.
14. According to Forti Grazzini and Zardini 2007, pp. 104–07, Fenaille 1903–23, vol. 3, pp. 73–80, mistook the goddess Vesta for Cybele in *The Month of December/The Sign of Capricorn*.
15. Mobilier National 1965, p. 33, cat. 18.
16. The cartoons were not listed in the 1736 inventory of the Gobelins; Fenaille 1903–23, vol. 3, p. 74.
17. *Mercure de France* (Jan.–June 1726), no. 1229; repr. Geneva, Slatkine Reprints, 1968, vol. 10, p. 323.
18. Cooper-Hewitt, National Design Museum, Smithsonian Institution, New York, inv. nos. 1911-28-1-1–3. Kimball 1943, pp. 106–11, fig. 118. Forti Grazzini and Zardini 2007, pp. 54–55, figs. 36–38, proposed that Claude III Audran produced an unrecorded second set of cartoons for the privately commissioned suites.
19. For an example of such weavings fitted into wall paneling, see Göbel 1928, vol. 2 pt. 2, pl. 132; as fitted onto the six double-sided leaves of a folding screen, see Palais Galliera, Paris, Nov. 26, 1975, lot 115.
20. For a compilation of known examples, see Fenaille 1903–23, vol. 3, pp. 73–80, and Bremer-David 2002, pp. 29–34 nn. 18–19. The suite formerly in the Gunzbourg and Patino collections is now with Moshe Tabibnia, Milan.
21. For an example of a quartet, see Drouot-Richelieu, Paris, Nov. 27, 2000, lot 44.
22. Waddesdon Manor, near Aylesbury, Buckinghamshire, England, invs. 3039 (folding screen) and 2240 (curtains). These Rothschild panels did not, however, constitute a single set, as they include two copies of *The Month of June* and two of *The Month of July*. The Baroness Eugène de Rothschild also possibly owned four panels; see Christie's, London, Dec. 5, 1968, lot 145 (attributed to Aubusson).
23. After the death of H. Braquenié's widow, one suite was sold at Hôtel Drouot, Paris, Dec. 15–16, 1902, lot 1. Following the dissolution of the Braquenié firm, another edition was sold at Sotheby's/Galerie Charpentier, Paris, Oct. 27, 2005, lots 258–59. See also Sirat and Dirand 1998, pp. 192–93. For examples of modern reweavings, see Christie's, London, June 13, 2002, lot 171.
24. Fenaille 1903–23, vol. 5, pp. 32–34.
25. See Christie's, Milan, July 8, 2004, lot 431, and Christie's, New York, May 18, 2005, lot 560.

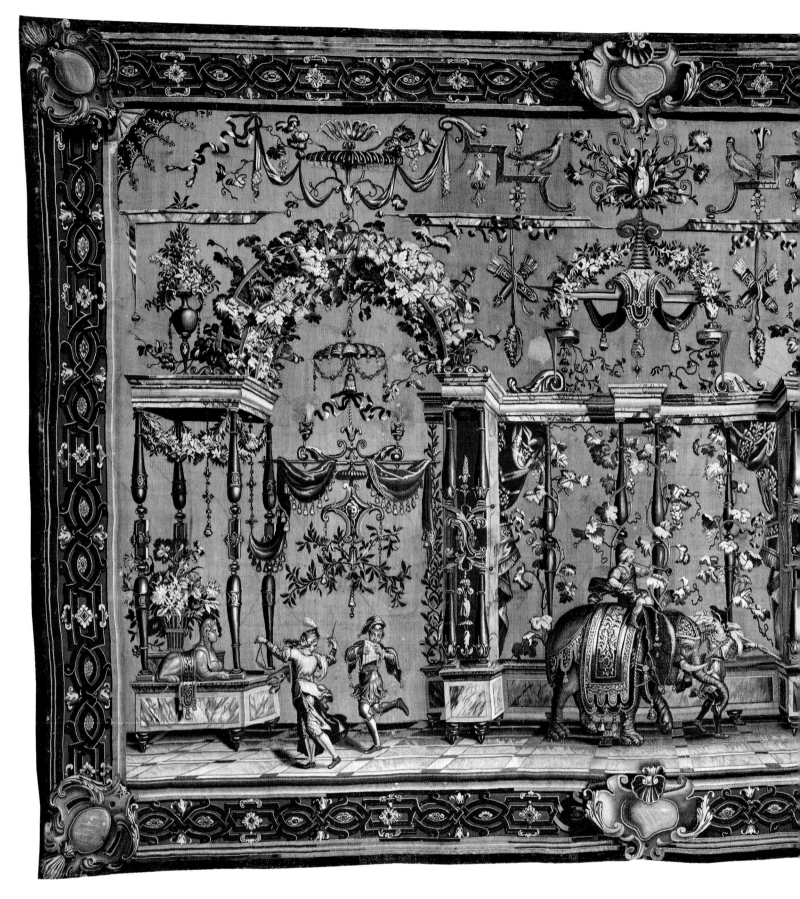

CAT. 43

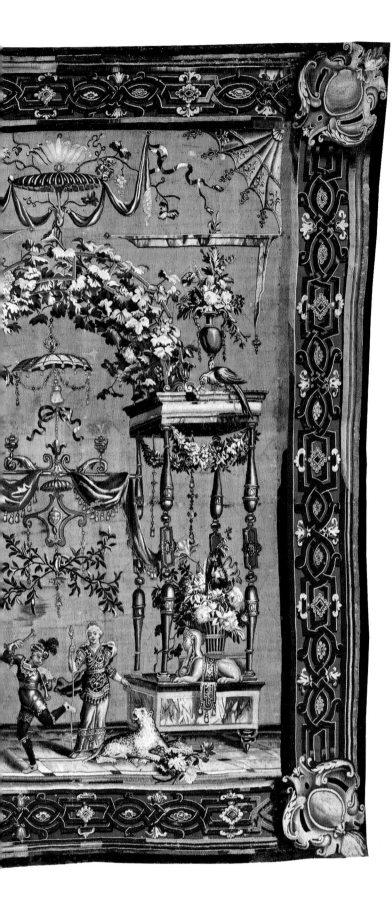

CAT. 43

The Elephant from *The Grotesques*

Beauvais, c. 1688–1732
After a design by Jean Baptiste Monnoyer (1636–1699) in the style of Jean I Berain (1640–1711); border design by Jean I Berain
Produced at the Manufacture Royale de Beauvais under the direction of the Behagle family (directors 1684–1711), Pierre and Etienne Filleul (codirectors 1711–22), or Noël-Antoine de Mérou (director 1722–33)
461.1 x 306.4 cm (181⅝ x 120¾ in.)
Robert Allerton Income Fund, 1956.101

STRUCTURE: Wool and silk, slit and double interlocking tapestry weave
Warp: Count: 7 warps per cm; wool: S-ply of four Z-spun elements; diameter: 1.2 mm
Weft: Count: varies from 20 to 36 wefts per cm; wool: S-ply of two Z-spun elements; pairs of S-ply of two Z-spun elements; diameters: 0.5–1.1 mm; silk: pairs of S-ply of two Z-twisted elements; diameters: 0.7–1.0 mm; wool and silk: paired yarns of S-ply of two Z-spun wool elements and one S-ply of two Z-twisted silk elements; three yarns of one S-ply of two Z-spun wool elements and two of S-ply of two Z-twisted silk elements; diameters: 0.9–1.2 mm

Conservation of this tapestry was made possible through the Allerton Endowment Fund.

PROVENANCE: Boas family residence, Paris; by descent to René Boas, New York, before 1952; sold to the Art Institute, 1956.

REFERENCES: Mayer Thurman 1969, p. 32. Mayer Thurman in Wise 1976, p. 194, cat. 310. Standen 1979, pp. 212, 216, fig 11. Standen 1985, vol. 2, p. 445 n. 43, p. 449. Mayer Thurman 1992, pp. 54, 60–61 (ill.), 145, as *The Tamers*.

EXHIBITIONS: Art Institute of Chicago, *Masterpieces of Western Textiles from the Art Institute of Chicago*, 1969 (see Mayer Thurman 1969). Art Institute of Chicago, *Selected Works of 18th Century French Art in the Collections of the Art Institute of Chicago*, 1976 (see Mayer Thurman in Wise 1976). Art Institute of Chicago, *Tapestries from the Permanent Collection*, 1979. Art Institute of Chicago, *Textile Masterpieces*, 1993.

AN African elephant draped in a richly embroidered caparison, a leopard, three animal handlers, and three dancing musicians perform on a shallow terrace, in front of an arcade composed of marbleized balustrades and attenuated baluster supports, cornices, pilasters, and two trellis arches entwined by leafy grape vines. Two golden sphinxes face each other on the balustrades, one to the far left and the other to the right. Each sits before a tall openwork basket filled with long-stemmed flowers. On the cornices above the baskets stand tall metal vases with floral arrangements. Thick, theatrical curtains hang from the central cornice, from within the two trellis arches, and from the two upper corners of the central field, balancing the composition and creating a stagelike effect. The upper register of the scene is filled with a profusion of gravity-defying moldings, and decorative elements consisting of birds, drapery swags, jewel clusters, parasols, ribbons, vines and flowering branches, and two trophies of arrow-filled quivers and leafy wreaths. Only the receding black and white tiles of

the terrace floor suggest the shallow depth of the stage, as the solid golden backdrop limits the depth of field. A wide band articulated with a geometric pattern of straps and clasps borders the tapestry; the four corners and center points of the top and bottom borders bear oval- or heart-shaped cartouches. The hanging retains its original outer guard.

The Elephant is part of a series called *The Grotesques* that was designed before 1689 by Jean-Baptiste Monnoyer for Philippe Behagle (1641–1705), director of the Manufacture Royale de Beauvais from 1684 to 1705.[1] The series has neither an overarching narrative nor a moralizing theme, but rather evokes theatrical spectacles occurring in the warm glow of a sunny late afternoon, enveloping the viewer in a halcyon atmosphere. The disparate scenes of the set are unified by the vibrant ground color, inspired by the golden leaves of autumn, and the architectural elements of implausible arcades and pavilions.[2] *Grotesques* suites usually consisted of six hangings and, though contemporary documents do not name each subject, modern scholarship now identifies the individual subjects as *The Offering to Bacchus*, *The Offering to Pan* (or alternatively *The Offering to Priapus*), *Musicians and Dancers*, *The Animal Tamers*, *The Camel*, and *The Elephant*.[3] Components of the last four pieces, however, were variously combined in tapestries woven according to the customer's preference. Given the presence of the animals and their handlers in the Art Institute's tapestry, it was previously identified, catalogued, and published under the title *The Tamers* (or its French translation, *Les Dompteurs*). Other subjects also received alternative titles in the past; examples of *The Camel*, for instance, have been known as *The Performers*.[4]

Stylistically, the series was ultimately inspired by the decorated interiors of ancient Roman buildings, particularly those of the Domus Aurea, or Golden House, of the Emperor Nero, built between 64 and 68. In the centuries following Nero's death, the palace was gradually buried and forgotten, only to be unearthed much later, in the late 1480s, at which point the newly discovered underground spaces were likened to caves (*grotti* in Italian). The antique frescoes on the Domus Aurea's walls, with their contrived structures and patterns inhabited by classical deities, hybrid creatures, and monsters, introduced a fantastic style that fell outside the contemporary conventions of allegorical, historical, and religious subjects. This novel visual vocabulary of ornament exerted an immediate impact on contemporary art, as it was taken up by Italian Renaissance artists such as Ghirlandaio and Filippino Lippi, and then later by Raphael (1483–1520) and his workshop. Raphael's celebrated and often copied grotesque decorations for the *loggetta* of Cardinal Bibbiena and the loggia of Pope Leo X, both in the pontifical palace of the Vatican, precipitated a widespread adoption and long-term adaptation of the style.[5]

The versatile, flexible, and inventive characteristics of the grotesque ensured its enduring popularity, as successive generations of artists across an ever-widening geographic area—continuously expanded through the dissemination of prints—reinterpreted the scale and form of its ornamental elements. Whether enlarged to fill architectural surfaces or reduced to illustrate manuscripts and books, the grotesque was bent to every conceivable purpose, from adorning throne baldachins and gunstocks to decorating majolica vessels and jewel caskets. From as early as 1517 to 1520, artists found grotesque motifs suitable for the central fields of tapestries as well as for the surrounding borders.[6] Over the course of the next three hundred years, tapestry designers employed the evolving style to refresh older visual traditions, especially those with emblematic or allegorical associations such as the Seasons and Months of the Year or the Four Elements (see cats. 42a–b).

By the mid-1680s, leading practitioners of the grotesque were responding to the popular taste for public entertainments as well as to the courtly vogue for spectacle and theater by incorporating aspects of stage sets and costume design into their work. The fashionable and influential French *ornamentiste* and engraver Jean I Berain, for example, introduced a cast of playful acrobats, dancers, musicians, and pantomime performers to the repertoire of deities and creatures that populated the whimsical constructions of arbors, brackets, platforms, and trellises in his prints.[7] Such allusions to these ephemeral performances greatly increased the appeal of the grotesque, as it tapped into a shared enthusiasm for entertainment—whether the humorous and more coarse acts of an urban fair or the triumphal celebrations marking the milestones of a reign—that transcended social rank.[8]

In general appearance, the Beauvais *Grotesques* bear a close affinity to the designs of Berain, so much so that for decades scholars have called the set *The Berain Grotesques*.[9] Correspondence dating from 1695, however, credits Jean-Baptiste Monnoyer, or "Baptiste" as he is named in the documents, with the invention of the series.[10] Although Monnoyer was certainly influenced by Berain, he actually borrowed from many visual models and artistic precedents. His genius lay in the adroit blending of compositional elements and figural types copied from the works of seventeenth-century artists as diverse as the classicist Nicolas Poussin and the animal painter Pieter Boel. Monnoyer knew their paintings either directly or through intermediary prints circulating in the artistic circles of Charles Le Brun (1619–1690), whom Monnoyer assisted; the Manufacture Royale des Gobelins, where he worked; or the Académie Royale, of which he was a member.[11]

Monnoyer's compilation and seamless assimilation of visual sources in this series is actually even more extensive than has been previously acknowledged. His model for the elephant in the present composition, for example, derived from Andrea Mantegna (1431–1506) through the intermediary French artist Antoine Caron (1521–1599). Mantegna's pachyderm, decorated with a splendid caparison, an apron with pendant bell, and jewels, first appeared as one of four in his monumental nine-canvas cycle of *The Triumphs of Caesar*, painted from 1484 to 1492 for the Gonzaga dukes of Mantua.[12] The animal is

FIG. 1 *The Triumph of Artemisia*. Antoine Caron, 1561/62. Wash and graphite, on paper; 40.5 x 56 cm. Musée du Louvre, Paris.

presented as part of a triumphal procession, shown in profile with its far foreleg raised in mid-stride, with a mahout, holding a long palm frond, on its back. Images related to the cycle, including the elephant sequence, circulated in printed form even during Mantegna's lifetime. The earliest prints did not, however, show all the detailed ornament of the original and omitted, for instance, the jewelry adorning the elephant's ear.[13] Such a print must have reached Antoine Caron, who used it, in turn, as the model for the pair of elephants pulling the chariot of victory in *The Triumph of Artemisia* (fig. 1), one of a series of designs illustrating a manuscript album of Nicolas Houel's *The Story of Artemisia*, written around 1562 to 1563.[14] In the accompanying sonnet, describing the ancient queen's triumphal entry into Halicarnassus, Houel enhanced the symbolism of the scene by positioning Fame, blowing her trumpet, rather than a mahout, on the back of the foremost elephant.[15] Houel had always intended Caron's designs to serve as models for tapestry cartoons and indeed, between 1601 and 1627, no fewer than seventy-eight hangings after some fifty scenes were woven in Parisian workshops (see cats. 39a–b).

Decades later, as a painter employed by the French crown within the Manufacture Royale des Gobelins, Monnoyer would have had access to Caron's design, the derivative tapestry cartoon (if it still survived), or one of the weavings produced after it.[16] But he must have also consulted one of the later, more detailed engraved reproductions of Mantegna's cycle, for Monnoyer produced a nearly exact copy of the master's original rendering of the animal's bejeweled, pierced, and strangely webbed ear.[17] Despite such fidelity to the Renaissance archetype, Monnoyer characterized his creature theatrically, rather than historically or naturalistically. He also transformed Caron's allegorical figure of Fame into an exotic turbaned, trumpet-blowing mahout, and converted the long-robed female figure, at the beast's side, into an elongated caparison decorated with elaborate passementerie.

Monnoyer's insertion of an elephant into this tapestry series was motivated by the public's growing fascination with the exotic animals that had begun to appear with increasing frequency in Europe, maintained in menageries or performing in traveling troupes. The French court, for example, often visited the menagerie at Versailles, which housed a large tusked elephant, a gift from Pedro II of Portugal to Louis XIV.[18] For thirteen years, the female pachyderm also attracted the curious public, tourists, scientists, and artists including Pieter Boel, whose record of her formidable appearance is now known through an engraving by Gérard I Scotin.[19] When the elephant died in 1681, its corpse was dissected and its skeleton preserved by the Académie Royale des Sciences. The familiarity of this animal among prospective customers may well have improved the marketability of the Beauvais *Grotesque* tapestries, but Monnoyer's theme more likely reflected the collective memory of another elephant, one that had represented the continent of Africa in a court spectacle held at Versailles during the week-long *Fête des Plaisirs de l'Isle Enchantée* (Fete of the Pleasures of the Enchanted Island) in May 1664. In the act titled *The Seasons on Their Animals and Diana and Pan in the Laurel Branches*, courtiers dressed as the Four Seasons rode on animals symbolizing the Four Continents: Spring on a horse representing Europe, Summer on an elephant standing for Africa, Fall on a camel symbolizing Asia, and Winter with a bear representing America (fig. 2). Prints recording the event were circulated and collected by a wide audience across France and the rest of Europe.[20]

Furthermore, the human figures in Monnoyer's cartoon were derived from archetypes as well, for he apparently consulted an engraving by Agostino Veneziano, after a preparatory study made for Raphael's decorative schemes in the aforementioned *loggetta* of Cardinal Bibbiena and the loggia of Pope Leo X at the Vatican. The three dancing musicians in the tapestry originate from a drawing portraying a bacchant dancing with two fauns, which had been graphically reproduced in two separate editions by 1540.[21] Though Monnoyer adopted the vigor of the leaping men and the twisting drapery on the female dancer from this source, he dressed the figures in costumes typical of late-seventeenth-century court ballets.[22] Moreover, he borrowed the figure of the woman standing to the left of the leopard from another source, a woodcut illustration in the 1499 publication of Francesco Colonna's *Hypnerotomachia Poliphili*.[23]

The Beauvais *Grotesque* tapestries were ingeniously flexible, as they could be woven to any desired dimension without the loss of their narrative qualities. Optional extensions to the cartoons allowed for the addition of height in the upper and lower registers of the central fields, and the interchangeable vignettes of performers could be added to lengthen the stagelike arcades.[24] Once removed from the loom, existing weavings could even be cut down, according to Philippe Behagle, to make two or three separate panels, with the surrounding borders adjusted and reapplied accordingly.[25] Customers could also choose among eight border designs, ranging from a simple pattern of curling parsley leaves to a wide, complex band combining

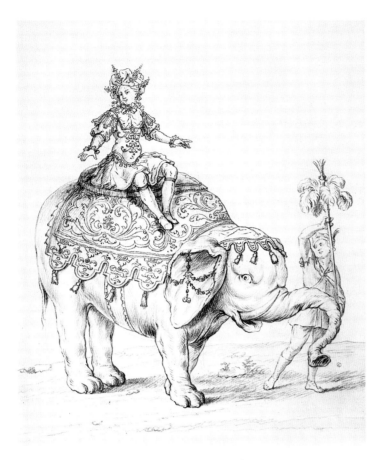

FIG. 2 *Thérèse Du Parc Representing Summer, Riding an Elephant*. After Henri Gissey, 1664. Black chalk and graphite, on paper; 53.6 x 38.2 cm. Nationalmuseum, Stockholm.

FIG. 3 *Grotesques*. Juan Dolivar after Jean I Berain, c. 1690. Plate 48 from *Ornemens Inventez*. Engraving, on paper. The Metropolitan Museum of Art, New York. Rogers Fund, 1915, transferred from the Library, 21.36.141.

grotesque elements and chinoiserie figures.[26] The number and variety of extant Beauvais *Grotesque* tapestries—some 150 pieces—attest to the possible combinations, though few complete sets survive intact.[27] The series proved enormously successful for decades, appealing to a wide clientele of prosperous Europeans, and its long production run, spanning nearly fifty years from the 1680s to 1733, sustained the manufactory through periods of fiscal hardship.[28]

A letter of 1695 acredited Jean Berain with the design of the blue and red geometric border that was chosen for the tapestry in Chicago, describing it as "une bordure d'un goust grotesque du dessein de Berain, à bastons rompus rouge sur un fond bleu" (a border in the grotesque taste after Berain's design, of red strap work against a blue ground).[29] Similar geometric strapwork borders sometimes surround Berain's grotesque engravings (see fig. 3). The letter, moreover, distinguishes this border type from the aforementioned parsley leaf pattern that was ordinarily woven on *Grotesque* tapestries at the time. Not many examples of *Grotesque* hangings with this strapwork border exist today, and it is difficult to estimate what percentage of the total production they composed, or when the border design fell out of fashion. At least a couple of such suites were made during Behagle's tenure, as a few hangings still retain his woven signature, notably a version of *The Animal Tamers* bearing *P. BEHAGLE F.* (P.

Behagle fecit).[30] An exceptional eight-piece suite, also with strapwork borders, shorter in height than the present hanging, remained intact until the first decades of the twentieth century, when it was dispersed from the Mackay family collection. Two tapestries from the suite bear the woven signature *BEHAGLE*.[31]

Another version of *The Elephant* with a strapwork border is known. It is woven to about the same height as the Chicago example, but the lower portion of its central field shows two sets of stone steps leading up from a shallow garden parterre to the marble-tiled terrace, and the ornament of its upper register is comparatively compressed.[32]

CBD

NOTES

The author sincerely thanks Christa C. Mayer Thurman for making available the curatorial files of the Department of Textiles, the Art Institute of Chicago, and her preliminary research, as well as for supporting the research necessary to write this and several other catalogue entries in this volume.

1. Philippe Behagle used four *Grotesque* hangings, woven with gilt-metal thread and estimated at a value of 2,700 livres, as collateral for a loan from the royal administrator Jean Talon in Feb. 1689. See Göbel 1928, vol. 2, pt. 1, pp. 213, 514 n. 30; Coural and Gastinel-Coural 1992, pp. 28–29 n. 18. For

an early sales list of *Grotesque* tapestry suites, see the document written by Behagle titled "Estat du produit de quelques marchandises fabriquées dans la manufacture royale de tapisseryes de Beauvais" (State of production of various goods made in the royal tapestry manufactory of Beauvais), reprinted in Badin 1909, pp. 12–13.

2. In 1696, the ground color was described as "fond de laine feuille morte" (wool ground the color of dead leaves) in a French royal inventory published in Coural and Gastinel-Coural 1992, pp. 21, 29 n. 29. Nineteenth-century and later descriptions employed the phrase *tabac d'Espagne* (Spanish tobacco) when referring to this ground color.

3. *The Offering to Pan* has been alternatively identified as *The Offering to Priapus*. See Hartkamp-Jonxis and Smit 2004, pp. 345–48.

4. Adelson 1994, pp. 307–21.

5. Dacos 1969. See also Toby Yuen's insightful book review (Yuen 1973).

6. See Campbell in Campbell 2002c, pp. 225–229, 246–52; Campbell and Karafel 2002, pp. 371–77; and Meoni 2002a, pp. 514–17.

7. As Louis XIV's official designer attached to the bedroom and cabinet from 1674, Berain was responsible not only for the silver but also for all aspects and forms of royal entertainments and spectacles, including stage sets and costume designs for the king's beloved ballets, carousels, firework displays, masquerades, and operas. For a study of Berain's career and influence, see La Gorce 1986.

8. For a discussion of popular entertainments and Parisian fair culture, see Isherwood 1981, pp. 24–48. Reference courtesy of Koenraad Brosens.

9. For a review of the relationship between Jean I Berain's prints and the Beauvais *Grotesque* series, see Weigert 1946, pp. 66–78; Standen 1979, pp. 210–19; and Bremer-David 1997, pp. 72–79. On the series title *Grotesques de Berain*, see Adelson 1994, pp. 312–13.

10. The Paris-based Swedish diplomat Daniel Cronström informed his correspondent on this point "Elle est du dessein de Baptiste, excellent peintre et dessignateur d'ornement icy" (It is of the design by Baptiste, excellent painter and designer of ornament here), quoted in Weigert and Hernmarck 1964, p. 65. For a more extensive survey of the Beauvais *Grotesque* tapestries mentioned in this correspondence, see Standen 1985, vol. 2, pp. 441–60, and Bremer-David 2007a.

11. Monnoyer found inspiration for the companion cartoon of *The Offering to Pan* in Poussin's *Triumph of Pan* painted in 1636 for Armand Jean du Plessis, Cardinal Richelieu. Poussin, in turn, may have been inspired by a design by Giulio Romano of about 1532 that also circulated as a print; Bernini Pezzini, Massari, and Prosperi Valenti Rodinò 1985, pp. 245, 805 (ill.); Strauss 1978–, vol. 28, p. 47, no. 3; Bennett 1992, pp. 259–61. For the companion *Camel* cartoon, Monnoyer copied Boel's 1669–71 study of the animal; see Foucart-Walter 2001, p. 108, no. 35, and Bremer-David 2007a.

12. First hung in the ducal palace of Mantua and then in the nearby Palace of San Sebastiano, the nine canvases were later acquired by Charles I of England and brought to Hampton Court Palace in 1630, where they remain to this day; Martindale 1979, pp. 147–49, canvas nos. 5–6. Apparently Mantegna had the opportunity to study a live African elephant in 1479, when one landed in the Veneto region, which accounts for the well-proportioned naturalism of his model.

13. A preliminary drawing by Mantegna for the elephants was engraved by Zoan Andrea and then by Giovanni Antonia da Brescia. See Strauss 1978–, vol. 25, pt. 1, pp. 44–45, no. 12-12A, pp. 178–79, no. 235–36; vol. 25, pt. 2, pp. 112–16.

14. Fenaille 1903–23, vol. 1, ills. opp. pp. 110, 199; Ehrmann 1986, pp. 53–85, 78, fig. 68; Adelson 1994, p. 193 n. 17. *The Triumph of Artemisia* is found in book 2, chapter 12, of the manuscript album by Nicolas Houel, folios 57v–59v, A, preserved in the Bibliothèque Nationale, Paris, Département des Manuscrits, MS, fr. 306. On the dating of the manuscript, see Auclair 2000, pp. 155–88.

15. For a study of contemporary tapestries portraying elephant-drawn chariots of Fame based on the Petrarchan cycle, see Cavallo 1993, pp. 470, 472, fig. 148, and Campbell 2004, pp. 376–85. This visual tradition influenced yet another of Caron's illustrations for Houel's *Story of Artemisia* poem, *The Elephant Chariot*.

16. Fenaille 1903–23, vol. 1, ill. opp. p. 200; Rocheblave 1923, pp. 491–503.

17. Monnoyer might have consulted the chiaroscuro engravings published in 1599 by Andrea Andreani. See Karpinski 2001, pp. 39–46.

18. Belozerskaya 2007, pp. 58–73. According to the eyewitness John Locke, the elephant was "a vast mountain of an animal" with, according to his friend Dr. John Covel, a hide like "a toad skin or the husk of some snakes of an ash color, about seven feet high." The former quote is from the travel journal of John Locke, June 23, 1677, and the latter quote is from Covel's journal, as published in Friedman 1989, pp. 177–98.

19. Foucart-Walter 2001, p. 42 fig. 5.

20. Marie 1968, pp. 41–53. For the identity of the female performer, Thérèse Du Parc, who personified Summer and rode the elephant, see Somerset 2003, pp. 191–93.

21. Bernini Pezzini, Massari, and Prosperi Valenti Rodinò 1985, p. 243, p. 804 (ill.), and Strauss 1978–, vol. 26, p. 248, no. 250. Information courtesy of Dominique Cordellier, Musée du Louvre, Paris.

22. See, for instance, the widely circulated, popular prints of Jean Le Pautre, which showed vignettes from theatrical ballet productions such as the "Dame en Habit de Ballet" from *Recueil des Modes de la Cour de France*, Los Angeles County Museum of Art, inv. M.2002.57.138. Image available at http://collectionsonline.lacma.org/mwebcgi/mweb.exe?request=record; id=143690;type=101.

23. Colonna [1499] 1893, fig. 137 ("A superb figure of a nymph, not in antique costume, with a javelin in her right hand.").

24. A factory list of 1710 records that eight *Grotesque* cartoon designs and seven copies after them were then available for the weavers' use. See Coural and Gastinel-Coural 1992, pp. 28, 29 n. 47.

25. Weigert and Hernmarck 1964, pp. 64–68; Standen 1979, p. 211; Bremer-David 2007a.

26. Adelson 1994, pp. 307–21.

27. One of the best-preserved sets of six pieces with the grotesque and chinoiserie border is in Schloss Bruchsal, a branch of the Badisches Landesmuseum, Karlsruhe. See Stratmann-Döhler 2002, pp. 55–62.

28. Weavers started the last piece, *The Offering to Pan*, in Nov. 1732 and finished it in Apr. 1733; Adelson 1994, p. 320 n. 36.

29. Letter from Daniel Cronström dated 20/10 [*sic*] May 1695, reprinted in Weigert and Hernmarck 1964, pp. 76–78.

30. Sold, Drouot Richelieu, Paris, Mar. 29, 2000, lot 112.

31. Standen 1985, vol. 2, pp. 443, 454, nn. 16–17; Franses 1986, pp. 23–26.

32. Sold from the collection of Davide Halevim, Christie's, London, Feb. 14, 2001, lot 64.

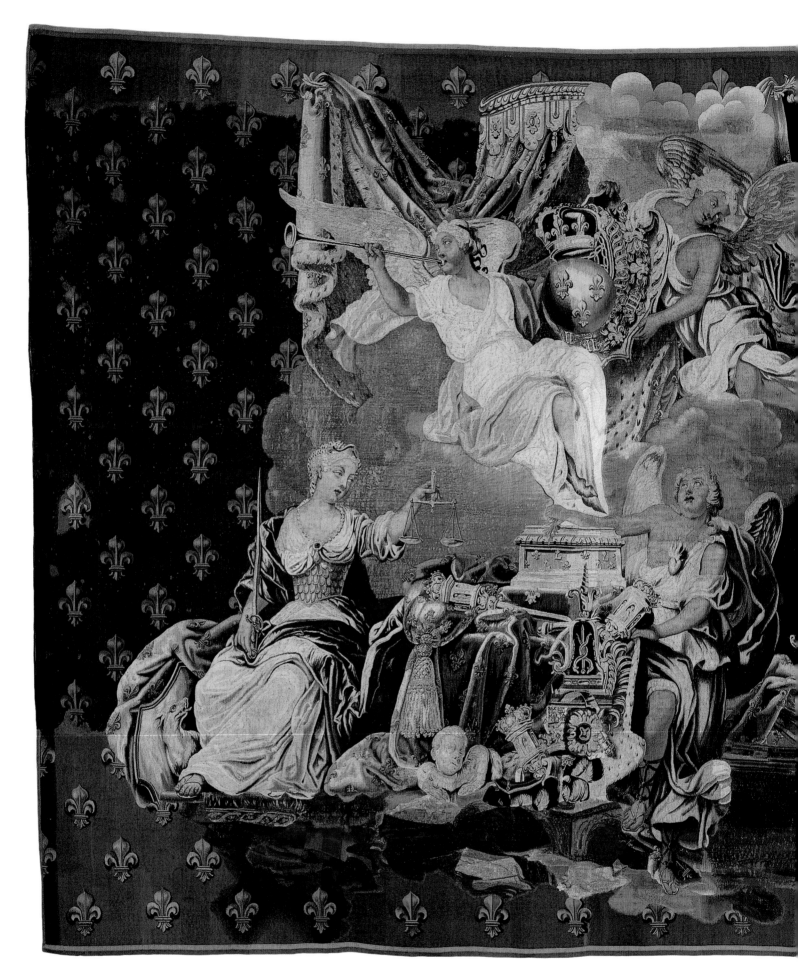

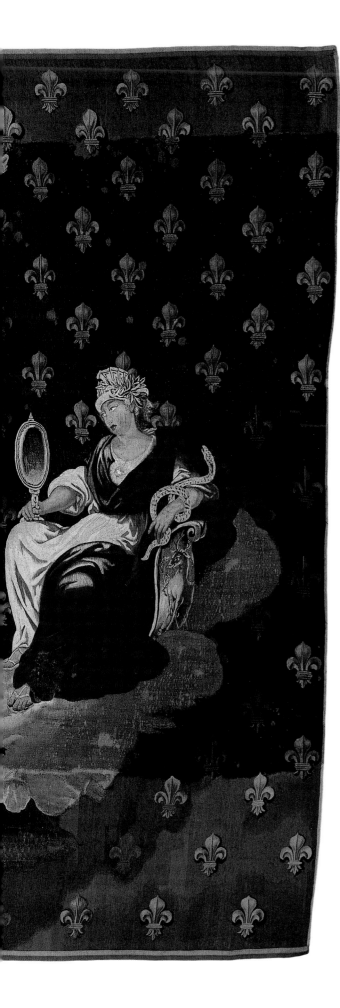

CAT. 44

Chancellerie

Presumably Beauvais, 1718/20
Presumably after a cartoon by Jacques Vigoureux Duplessis (1670/75–1732)
Presumably produced at the Manufacture Royale de Beauvais under the direction of Pierre and Etienne Filleul (codirectors 1711–22), 1718/20
Inscribed: *PAX tibi MAR CE / EV[AN] CELI[S] TA ME[US]*
369 x 281.8 cm (145 x 110⅞ in.)
Gift of Honoré Palmer, 1937.1120

STRUCTURE: Wool and silk, slit and double interlocking tapestry weave
Warp: Count: 8 warps per cm; wool: S-ply of four slightly Z-spun elements; diameter: 1.0 mm
Weft: Count: varies from 19 to 40 wefts per cm; wool: single S-spun elements; S-ply of two Z-spun elements; pairs of S-ply of two Z-spun elements; diameters: 0.3–1.0 mm; silk: pairs of S-ply of two Z-twisted elements; three yarns of S-ply of two Z-twisted elements; diameters: 0.5–1.0 mm; wool and silk: paired yarns of one S-ply of two Z-spun wool elements and one yarn of S-ply of two Z-twisted silk elements; diameters: 0.7–1.0 mm

Conservation of this tapestry was made possible through the generosity of the James Tigerman Estate.

PROVENANCE: Probably Potter (died 1902) and Bertha Palmer (née Honoré, died 1918), Chicago and Paris; probably by descent to their son Honoré Palmer (died 1964); given to the Art Institute, 1937.

REFERENCES: Mayer Thurman in Wise 1976, p. 196, cat. 312a.

EXHIBITIONS: Art Institute of Chicago, *Selected Works of 18th Century French Art in the Collections of the Art Institute of Chicago*, 1976 (see Mayer Thurman in Wise 1976).

FIVE figures float on clouds on a ground covered with fleurs-de-lis. A personification of Fame, recognizable by her trumpet, and an unidentified winged woman, presumably Victoria, appear in the upper part, holding a cartouche that features the arms of France (three fleurs-de-lis) and the right section of the arms of Navarre (golden chains linked together). Above the group are a canopy and ermine mantle. At Fame's feet, a pedestal draped with a fleur-de-lis fabric is visible. A chest and scepter rest on the structure; two more scepters and various ornaments are arranged in front of it. Three personifications flank the pedestal. To the left is Justice, holding a scale and sword. On the right Charity appears with a burning heart. Next to her, Prudence sits with a mirror and serpent, a dog resting at her feet. To the left of Charity's leg an incomplete Latin inscription reads *PAX tibi MAR CE / EV CELI TA ME*. The somewhat unbalanced composition and the incomplete features, such as the arms of Navarre and the Latin inscription, show that the tapestry was altered at an unknown date, probably at the same time that a considerable section was cut from the center of the piece.

Tapestries showing this and similar designs are called *chancelleries*, after the title shared by the pieces' recipients, *chancelier de France* (chancellor of France), or the name of the places in which the pieces

CAT. 44, DETAIL

FIG. 1 *Portrait of Marc-René de Voyer d'Argenson*. France, 1718. Oil on canvas, 63 x 52 cm. Châteaux de Versailles et de Trianon, MV2965.

were hung, the Grande Chancellerie in Paris or its provincial satellites, the Petites Chancelleries (see cats. 41a–b for a more full discussion).[1] The chancellor of France, who was appointed for life, served as chief justice and *garde des sceaux*, or keeper of the seals used to authenticate declarations and laws. From 1679 on, Louis XIV and Louis XV presented each newly appointed chancellor and keeper of the seals with a set of chancelleries showing symbols of the recipient's authority, and personalized with his coat of arms.[2] All but one set of chancelleries given by the French kings were produced at the Gobelins,[3] but not all chancelleries woven at the Gobelins were commissioned by the king, and thus not all are registered in the records. In addition, chancelleries were also privately commissioned from Beauvais tapissiers. Consequently, chancelleries without borders and thus coats of arms and signatures, like the one in Chicago, present interrelated attribution and dating challenges.

The Latin inscription in the present tapestry, however, serves as a key to address these issues. Christa C. Mayer Thurman used the phrase to plausibly identify the tapestry's original owner.[4] The inscription can be completed as *PAX tibi MAR CE / EV[AN] CELI[S] TA ME[US]*, which translates as "Peace be to you, O Mark, my Evangelist."[5] This is the motto of Venice and suggests that the recipient of the piece may have been Marc-René de Voyer de Paulmy

d'Argenson, keeper of the seals from 1718 to 1720, who was born in Venice and declared a godson of the Venetian Republic (fig. 1).[6]

Research has disclosed data supporting the claim that the Chicago chancellerie was woven for d'Argenson. The tapestry, however, did not belong to the ten-piece Gobelins set that he received just a few weeks before his death.[7] One of the Gobelins pieces was (and still may be) at the Château de Vaux-le-Vicomte.[8] It shows that the suite was woven after the third set of chancellerie cartoons used at the Gobelins from 1700 or 1701 onward.[9] This design, created by Claude III Audran (1657–1734), Guy-Louis Vernansal (1648–1729), and one Pavillon,[10] shows the arms of France and Navarre in a cartouche surmounted by a crown, under a canopy and ermine mantle on a fleur-de-lis ground (fig. 2). Two angels support the mantle. The chest containing the seals and the scepters sits on a pedestal that rests on a platform. Two seated allegorical figures, Prudence and Justice, flank the pedestal.[11] While the Chicago chancellerie is clearly based on this design, the composition differs manifestly—even when the alterations are taken into account. Consequently, the tapestry in the Art Institute does not belong to the Gobelins set presented by the king.

An archival document reveals that d'Argenson himself commissioned chancelleries from Beauvais. On November 3, 1732, Noël-Antoine de Mérou, since 1722 director of the royal tapestry manu-

factory in Beauvais, recorded an inventory of sketches and cartoons "qui m'appartiennent et qui n'ont rien de commun avec les desseins [. . .] qui appartiennent à Sa Majesté" (that belong to me and have nothing to do with the cartoons that belong to His Majesty).[12] Among the cartoons were "trois grands tableaux aux attributs de la Chancellerie, faits par le dit Duplessis pour M. d'Argenson, coupés par bandes, par moy repris des sieurs Filleul" (three large paintings with the attributes of the chancellerie made by the aforementioned Duplessis for M. d'Argenson; cut in strips; I bought these from the Filleuls).[13] "The Filleuls" were Pierre and Etienne Filleul, directors of the Beauvais manufactory from 1711 until 1722.[14] Thus this document suggests that the Chicago chancellerie was commissioned by d'Argenson from the Filleuls during his short-lived term as keeper of the seals (1718–1720).

The document further shows that the design of the d'Argenson chancelleries was executed by Jacques Vigoureux Duplessis, a lesser-known artist. In the first decade of the eighteenth century, he was the scenery painter for the Paris Opera.[15] He moved to Brussels by 1715 at the latest, at which time he was registered there as a master in the painters' guild.[16] By 1719 he had returned to France and become involved in designing tapestries for the Beauvais manufactory. Two years later he was appointed "peintre et dessinateur de la Manufacture."[17] In this capacity, Vigoreux Duplessis had to train young artists, and create and restore tapestry designs and cartoons. But the Filleul brothers complained that the artist spent most of his time in Paris[18]—which of course means that he could easily have studied and copied the chancellerie designs used at the Gobelins. Vigoureux Duplessis's contribution to the development of tapestry production in Beauvais was indeed minimal, and the Filleul's succesor Mérou was also displeased with "ce Peintre et dessinateur dont le génie est incompatible et nullement propre à concourir au bien et à l'avantage de la Manufacture" (this painter and designer whose talents are everything but suitable to the development of the manufactory).[19] In 1726 this dissatisfaction led to Vigoureux Duplessis's demotion, and the appointment of Jean-Baptiste Oudry (1686–1755) to the position of chief painter. KB

FIG. 2 *Chancellerie*. After a design by Claude III Audran, Guy-Louis Vernansal, and Pavillon. Produced at the Manufacture Royale des Gobelins, c. 1703. Wool and silk; 411 x 417 cm. Location unknown.

6. Balteau 1939; Bayard, Félix and Hamon 2000, pp. 118–21.
7. Fenaille 1903–23, vol. 3, p. 137.
8. For an illustration, see Hoving 1982, p. 106.
9. For a concise survey of the development of chancelleries, see cats. 41a–b.
10. Fenaille 1903–23, vol. 3, pp. 134–35.
11. These personifications are omitted in smaller chancelleries of this type. Examples are in the J. Paul Getty Museum, Los Angeles (Bremer-David 1997, pp. 28–33), and the Metropolitan Museum of Art, New York (Standen 1985, vol. 1, pp. 361–64).
12. Badin 1909, pp. 25–27.
13. Ibid., p. 26.
14. Ibid., pp. 19–29; Coural and Gastinel-Coural 1992, pp. 31–34.
15. Eidelberg 1977; La Gorce 1983.
16. Pinchart 1878, p. 484.
17. Coural and Gastinel-Coural 1992, p. 32.
18. Ibid.
19. Cited in ibid., p. 36.

NOTES

1. Barbiche 2001, pp. 153–72.
2. For other examples of chancelleries, see Fenaille 1903–23, vol. 3, pp. 133–51; Standen 1985, vol. 1, pp. 361–64; and Bremer-David 1997, pp. 28–33.
3. Fenaille 1903–23, vol. 3, pp. 133–51. The set of chancelleries presented to chancellor Louis Boucherat around 1686 was produced at the Beauvais workshops; Fenaille 1903–23, vol. 3, pp. 133–34; Badin 1909, pp. 9, 12; Coural and Gastinel-Coural 1992, pp. 16, 21.
4. See object file 1937.1120, Department of Textiles, the Art Institute of Chicago.
5. With thanks to Christina Nielsen, Assistant Curator of Medieval Art, Department of Medieval to Modern European Painting and Sculpture, the Art Institute of Chicago, who completed the text, in consultation with, and in an e-mail sent on Oct. 6, 2006, to, Christa C. Mayer Thurman; object file 1937.1120, Department of Textiles, the Art Institute of Chicago.

CAT. 45

CAT. 45

The Emperor Sailing from *The Story of the Emperor of China*

Beauvais, 1716/22
After a design by Guy-Louis Vernansal (1648–1729)
Produced at the Manufacture Royale de Beauvais under the direction of
Pierre and Etienne Filleul (codirectors 1711–22)
MARKED: *BEAUVAIS*
385.8 x 355 cm (151¾ x 139¾ in.)
Mr. and Mrs. Charles H. Worcester Fund, 2007.22

STRUCTURE: Wool, silk, and gilt- and silvered-metal-strip-wrapped silk; slit and double interlocking tapestry weave with some areas of 2 : 2 plain interlacing of gilt- and silvered-metal wefts
Warp: Count: 8–9 warps per cm; wool: S-ply of four Z-spun elements; diameters: 0.6–0.9 mm
Weft: Count: varies from 22 to 38 wefts per cm; wool: S-ply of two Z-spun elements; diameters: 0.3–1.0 mm; silk: pairs of S-ply of two Z-twisted elements; diameters: 0.25–0.6 mm; wool and silk: paired yarns of S-ply of two Z-spun wool elements and S-ply of two Z-twisted silk elements; diameters: 1.0–1.5 mm; gilt- and silvered-metal-strip-wrapped silk: gilt-metal strip wrapped in an S-direction on S-twisted silk elements; single yarns and pairs of silvered-metal strip wrapped in an S-direction on an S-ply of two Z-twisted silk elements; paired yarns of silvered-metal strip wrapped in an S-direction on silk elements of no appreciable twist and S-ply of two Z-twisted silk elements; silvered-metal strip wrapped in an S-direction on silk elements of no appreciable twist; diameters: 0.25–0.8 mm

No conservation was required.

PROVENANCE: Commissioned by Franz Ludwig, Count Palatine von Pfalz-Neuburg (died 1732), Grand Master of the Teutonic Order (1694–32);[1] either bequeathed as personal property or by succession (with two other tapestries) to Clemens August Wittelsbach (died 1761), Grand Master of the Teutonic Order (1732–61), Schloss Ellingen, near Nuremberg (the Teutonic Order's seat), by 1732; transferred with Schloss Ellingen and its contents to Maximilian I of Bavaria (r. 1805–25), Apr. 24, 1809, by Napoleon's decree dissolving the Teutonic Order; ceded with Schloss Ellingen and its contents to the field marshall Karl Philipp, Prince von Wrede (died 1838), 1825. Sold, Hôtel Drouot, Paris, Dec. 10, 1948, lot 77. Akram Ojjeh (died 1991); by descent to his widow, Nahed Ojjeh; sold, Christie's, Monaco, Dec. 12, 1999, lot 21, to an American private collection; sold, Sotheby's, New York, Oct. 24–25, 2002, lot 780, to S. Franses (dealer), London and New York; sold to the Art Institute of Chicago, 2007.

REFERENCES: Standen 1976, pp. 103–17. Standen 1985, vol. 2, p. 465 n. 34, p. 468. Coural and Gastinel-Coural 1992, pp. 32, 33 n. 13. Floret 2002, p. 29 (ill.; as *L'Embarquement de la princesse*). Franses 2006, pp. 40–43 (ill), cat. 7. Art Institute of Chicago 2007, p. 5 (ill.). Bremer-David 2008a (ill.).

EXHIBITIONS: New York, Franses, *Chinoiserie: European Tapestry and Needlework 1680–1780*, 2006 (see Franses 2006).

THIS tapestry originally formed part of a suite called *The Story of the Emperor of China*, which portrayed scenes from the lives of the Manchu Qing dynasty Shunzhi emperor and his son, the Kangxi emperor, who were contemporaries of Louis XIV of France. Called

The Emperor Sailing, this piece shows the elder ruler seated in a *long chuan*, or ceremonial dragon boat, as it pulls into the river from the quay.[2] Members of the imperial family and their attendants watch the launch from an arcaded trellis, in close proximity to a crane, a tortoise, some seashells, and a pelican. The crane and tortoise in particular symbolize their well-wishes to the emperor.[3] A walled city, with a towering multistoried pagoda, is visible upriver. In the middle ground, a procession of small horsemen and figures climbs the rolling hills on the left bank of the river.

This innovative and highly influential tapestry series was ordered by Philippe Behagle, the director of the Beauvais manufactory, around the mid-1680s, in response to the French court's growing interest in the Far East. Drawing upon published travelers' reports and the eyewitness accounts of missionaries, the series represents the two emperors dutifully fulfilling a range of responsibilities, from holding formal audiences and conducting tours of state to engaging in leisure activities involving the arts and sciences. Set against backdrops of palatial buildings, and exotic city- and landscapes, the scenes are filled with foreign peoples, flora, and fauna. As an allegory of good governance, the series makes manifest the perceived parallels, first propounded by French Jesuit missionaries in China, between Louis XIV and the Kangxi emperor.[4] No doubt the programmatic precedent for the series was *The Story of the King,* the monumental Gobelins tapestry cycle designed in the 1660s by Charles Le Brun (1619–1690) to glorify the reign of the youthful Louis XIV.[5] Le Brun's realistic portrayal of historical events in that sequence, as well as his accurate renderings of setting, subject, and dress, challenged the designers of the later series to achieve a similar high degree of veracity even though they had never actually been to China.

It is not known who advised Behagle on the intellectual program for *The Story of the Emperor of China*, but the full series ultimately comprised nine separate subjects subsequently identified by scholars as *The Audience of the Emperor, The Emperor on a Journey, The Collation, The Return from the Hunt, The Astronomers, Harvesting Pineapples, The Emperor Sailing, The Empress Sailing,* and *The Empress's Tea*.[6] A late-seventeenth-century document from Behagle's tenure stated that the series was created by four illustrious painters, though it does not name them.[7] Only in 1731 were three of the four cartoon artists specifically named in a manufactory memorandum as "Batiste" (for Jean-Baptiste Monnoyer; 1636–1699), "Fontenay" (for Jean-Baptiste Belin de Fontenay; 1653–1715), and "Vernensal" (for Guy-Louis Vernansal).[8] The appearance, however, of the woven Latin signature *VERNANSAL.INT.ET.PU* [*sic*] (Vernansal, Inventor and Painter) in four examples of *The Collation*, indicates that Vernansal was the designer and chief cartoon painter.[9] All three artists belonged to the Academié Royale, and routinely worked for both the Crown and the Gobelins manufactory on projects under the supervision of Le Brun. The fourth collaborator is not identified in the Beauvais manufactory's records, but he may have been René-Antoine Houasse (1645–1710), a painter also active in the circle of Le Brun and the

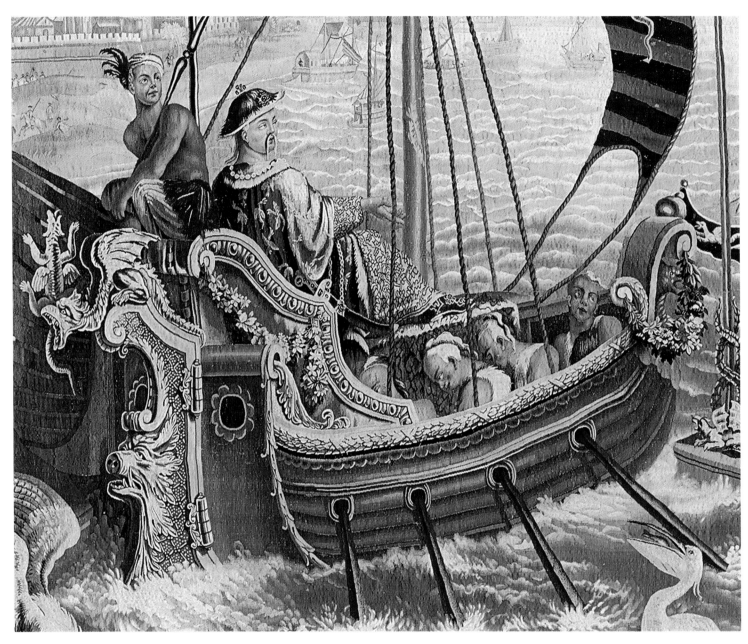

Gobelins, who was paid in 1710 for a tapestry cartoon known as *The Audience of the Siamese*.[10] Before 1690, Houasse also had a working relationship with Behagle and the Beauvais manufactory, for he provided the cartoons for a set after Ovid's *Metamorphoses*.

The visual source for the setting of *The Emperor Sailing* was a view of Nangan, a town located on the Gan Jiang river in southern Jiangxi province, originally published in *Het Gezantschap der Neêrlandtsch Oost-Indische Compagnie aan den Grooten Tartarischen Cham, den tegenwoordigen Keizer van China* (An Embassy Sent by the East-India Company of the United Provinces to the Great Tartar Khan, or Emperor of China), the 1665 travelogue of Johannes Nieuhof, a Dutch East India Company representative (fig. 1).[11] The artist depicted the view from a vantage point on the river, flanking the vista of the city with a low-lying shoreline and tall tree on the left

and hilly outcrops of land on the right. The rigging of three junks projects upwards and bisects the view of the walled city in the middle distance. Behind the crenellated town walls, Nangan's slender, seven-story pagoda towers above the other roof gables, which slope like the wings of birds in flight.

Vernansal adapted the river scene in the print for the distant background of his tapestry design, using it almost like a stage scrim. He substituted the slender poles of the arcaded trellis for the flanking shore and hills of the original view. In contrast, the foreground scene of the boat launch seems pure invention, though many of the figures, their dress, and their accessories were garnered from disparate literary descriptions and visual references. For example, a passage from Nieuhof may have inspired the fantastic vessel:

Nous vismes sur le sus-dit canal une grande quantité de vaisseaux fort étranges, mais les plus rares et les plus gentils de tous furent deux barques, ou caracores que les chinois nomment Longschon, cause qu'elles sont basties en forme de serpens ou de couleuvres, mais avec tant de justesse et d'ornement que je ne crois pas que le vaisseau présenté par Sisostris à l'Idole qu'il honorait, pouvait le surpasser. Les ventres de ces caracores ressemblait fort bien à des couleuvre aquatiques et moussues. La poupe était aussi parsemée d'étranges couleuvres chevelues et entortollées fort artistement . . . Il avait aussi à la queue plusieurs étendards, de bannières de soye et de longues plumes . . . (We saw a large number of strange boats on the aforementioned canal, but the most rare and special were two barques, or coracles, that the Chinese call *Longschon* [dragon] because they are built in the form of a serpent or snake, but with such ornament as surpassed the boat presented by [the ancient Egyptian] Sisostris to the Idol he worshipped. The bulging hulls of the coracles strongly resembled foaming sea serpents. The stern was also carved with strange, long-haired, coiling serpents . . . It also had at the back many standards, silk banners, and long pennants . . .)[12]

In his design, Vernansal conflated the ceremonial racing dragon boats, propelled by oarsmen, with the more common river junks and barges that appeared repeatedly in the Nieuhof prints of river views.

The frontispiece of Nieuhof's publication, showing the enthroned emperor surrounded by his military guard, also provided a wealth of visual details that Vernansal mined for *The Emperor Sailing*.[13] For instance, the position and profiles of the heads and queues of the emperor's rowers derive from those of the captives illustrated in the frontispiece. This same image also provided the prototype for the halberd with the crescent blade and the pike with a sunburst positioned behind the two figures on the left of the tapestry.[14] Furthermore, the high-backed imperial throne in the print was converted in the tapestry design into a throne for the seated female figure. Presumably this woman was intended to represent the empress, for Vernansal replaced the dragons, traditional emblems of the emperor, depicted in Nieuhof's version of the ornately carved chair, with the empress's complementary winged phoenixes.

Vernansal borrowed additional elements from another Nieuhof plate showing Chinese men. The male figure, with one hand resting on his hip, in the plate *Sineese Mannen*, reappears, woven in reverse, in *The Emperor Sailing*, as the character standing to the left of a trellised column (see fig. 2).[15] The *wai tao* (a Manchu-style coat) he wears in the print has been transformed in the tapestry into a *long pao*, or dragon robe, by the addition of an overall pattern of embroidered dragons and clouds.[16] A type of court dress, the *long pao* was reserved exclusively for the use of the highest-ranking members of the imperial family, so the young man wearing this garment might represent the imperial heir, who gestures with an open hand toward his father, the Shunzhi emperor, seated in the boat.

FIG. 1 *Nangan*, published in *Legatia batavica ad magnum Tartariae chamun Sungteium, modernum Sinae imperatorem*, 1668. Johannes Nieuhof. Engraving, on paper. Getty Research Institute, Los Angeles.

Still other sources influenced Vernansal's vision. Chief among early illustrated sinological texts was *China monumentis, quà sacris quà profanis* (China Illustrated with Monuments, Sacred as Well as Profane), a compilation of Jesuit missionary reports published in 1667 in Amsterdam by Athanasius Kircher. A brief passage describing the garments the emperor wore during an audience may have inspired the patterns adorning his clothing in the tapestry: "L'habit royal est très beau et très riche et couvert de quantité de perles et de pierreries précieuses et l'étoffe est toute bigarrée d'oiseaux et de dragons, de plusieurs sortes d'animaux et de fleurs" (The royal suit is very beautiful and rich and covered with a quantity of pearls and precious stones and its fabric is brightly colored all over with birds and dragons, with all sorts of animals and flowers).[17] Actual objects gave tangible substance to these verbal and visual sources, as trade brought luxurious lacquerware, porcelain, and silk to Europe from the Far East. The quantity of imported goods reached astonishing levels, as demand grew through the seventeenth century. For instance, the Dutch East India Company brought an estimated three million pieces of porcelain to Europe in just over fifty years, from 1604 to 1657, a profitable pace that prompted the formation of the rival French Compagnie des Indes Orientales in 1664.[18] Imported Chinese bottles and cups, decorated with cobalt pigment in the so-called blue-and-white style, undoubtedly served as the prototypes for the array of porcelain displayed on the table in *The Emperor Sailing*.

The arrival in France in the mid-1680s of travelers from the Far East heightened the growing mania for things Asian. The French court at Versailles was especially intrigued by a young Chinese convert to Christianity, Michael Alphonsus Shen Fuzong, who was presented to Louis XIV in September 1684. The gazette *Nouveau Mercure galant* recorded the news:

. . . le Pere Couplet Iesuite est de retour de la Chine, où il estoit allé travailler aux Missions, & qu'il en a amené un jeune Indien

de Nanking, Capitale de la Province du mesme nom . . . Le jeune Chinois qu'il a amené parle assez bien Latin, & s'appelle Mikelh Xin. Ils allerent le quinze de ce mois à Versailles, où ils eurent l'honneur de saluer Sa Majesté. Ils virent ensuite jouer les eaux & se trouverent le lendemain au dîner du Roy. Le jeune Indien estoit en ses habits Indiens, ayant une riche Veste de Brocard d'or fond bleu, avec des figures de Dragons & un visage affreux sur le haut de chaque manche. Il avoit par dessus une espece de Tunique de soye verte. Sa Majesté après avoir entendu ses Priéres en Langue Chinoise, luy fit servir une Assiete sur la Table, pour voir la propreté, & l'adresse des Chinoise a manger avec deux petites Baguettes d'yvoire" (. . . Jesuit Father Couplet has returned from China, where he went to work for the missions, and from which he brought a young Indian [sic] from Nanking, capital of the province of the same name. . . . The young Indian whom he has brought speaks Latin well and is called Mikelh Xin. They went to Versailles on the fifteenth of this month where they had the honor of meeting His Majesty. They then saw the jets of water play in the fountains and found themselves dining with the King the next day. The young Indian wore Indian clothes, including a blue jacket richly brocaded in gold with patterns of dragons [a *mang pao*, a functionary's variant of the *long pao*] and fierce faces at the shoulder of each sleeve. He wore over this a type of tunic of green silk. His Majesty, after hearing prayers in Chinese, had him served a dish so that he could observe him eat with two small ivory sticks).[19]

But the appearances of representatives of Phra Narai, king of Siam, were of greater significance. Misunderstandings plagued the first delegation of envoys in 1684, but renewed efforts to bridge differences in protocol and etiquette resulted in a sumptuous audience in the Hall of Mirrors at Versailles for the next delegation of three Siamese ambassadors, on September 1, 1686.[20] The extensive gifts of superlative lacquers, porcelains, and textiles given to Louis XIV, his family, and his chief officers on that occasion ignited a rage for chinoiserie that rippled through the court and fashionable society.[21] Building upon the good will of this reception, the ambassadors were taken the following month on a diplomatic tour to the Beauvais manufactory, where they met Behagle and perhaps exchanged comments about the concept or the cartoons for *The Story of the Emperor of China*.[22]

The exact chronology of the production of this series is not known. It is generally surmised that the cartoons were completed before 1690, when Monnoyer, one of the collaborating artists, left for England. Weaving was certainly well underway in the 1690s, as four suites were completed by 1706.[23] Records state that the first and fourth editions were acquired by two young members of the French court, Louis-Auguste de Bourbon, duc de Maine, and Louis-Alexandre de Bourbon, comte de Toulouse, who were present at Versailles for some of the memorable East-West encounters of the mid-1680s.[24] The set rapidly gained in popularity as the taste for chinoiserie grew.

FIG. 2 *Sineese Mannen*, published in *Legatia batavica ad magnum Tartariae chamun Sungteium, modernum Sinae imperatorem*, 1668, p. 40. Johannes Nieuhof. Engraving, on paper. Getty Research Institute, Los Angeles.

FIG. 3 Proposed elevation showing *The Audience of the Emperor* from the von Pfalz-Neuburg set of *The Story of the Emperor of China*. Pierre-Michel d'Ixnard, c. 1744. Staatsarchiv, Nuremberg.

Based on the number of surviving examples, it can be conservatively estimated that more than eighteen sets were woven by 1732 when the cartoons, "the manufactory's most agreeable," were described as worn beyond recognition—presumably from repeated use.[25]

The *Story of the Emperor of China* suite bearing the coat of arms, woven in gilt-metal thread, of Franz Ludwig, Count Palatine von Pfalz-Neuburg and Grand Master of the Teutonic Order from 1694, originally comprised at least three hangings, including the tapestry now in the Art Institute.[26] In addition to *The Emperor Sailing*, the suite also included *The Audience of the Emperor* and *The Emperor on a Journey*. Like *The Emperor Sailing*, *The Journey* bears the name BEAUVAIS in the lower right corner of the outer guard. The suite was hung in the residence of the Teutonic Order's Grand Master at Schloss Ellingen, near Nuremberg, if not by Pfalz-Neuburg himself, then by his successor, Clemens August Wittelsbach, Grand Master

from 1732.[27] In a later elevation proposal showing how he would refurbish the *Compagniezimmer* in the fashionable Neoclassical style, the architect Pierre-Michel d'Ixnard suggests placing *The Audience of the Emperor* on an inner wall opposite three window bays (fig. 3). The renovation was carried out in 1775 and the interior survives.[28]

The Pfalz-Neuburg suite remained in situ through at least 1838 but at an unknown subsequent point, the tapestries were removed and dispersed.[29] Shortly before 1914, a Berlin dealer sold *The Audience of the Emperor* to Baron Mikhail S. Oliv, a Russian collector living in Saint Petersburg.[30] Its present location has not been traced. *The Emperor on a Journey* surfaced at a Paris sale in 1948 and has since appeared twice more at auction.[31] Six other examples of *The Emperor Sailing* are known, but they all differ from the present version for they portray a white elephant leading the procession on the left bank from the city gate, through the hills, toward the river.[32] CBD

NOTES

1. The commission is recorded as delivered to "l'Electeur de Trèves" (the Elector of Trier), the position Franz Ludwig, Count Palatine von Pfalz-Neuburg held as Elector Archbishop of Trier from 1716 to 1729. He was subsequently Elector Archbishop of Mainz, from 1729 to 1732. See Coural and Gastinel-Coural 1992, pp. 32, 33 n. 13.

2. Traditionally, dragon boat races were held on the fifth day of the fifth lunar month to commemorate the death of the revered patriot and poet Qu Yuan around 288 B.C. For the symbolism of dragon boats and races, see Bartholomew 2006, pp. 279–80.

3. In Chinese art, the tortoise and crane were highly auspicious animals that represented the virtues of longevity and immutability. When portrayed together in the presence of a husband and wife—or emperor and empress— they expressed the wish for a long and happy marriage through the implied rebus or pictorial pun "May you live to be as old as the tortoise and the crane." This rebus was doubled in *Story of the Emperor of China* suites, as most included a tapestry portraying a similar scene of *The Empress Sailing*, complete with tortoise and crane; Bartholomew 2006, pp. 178–81, 226–27; Bremer-David 1997, p. 94, figs. 9.13–.14. The pelican also visible in the tapestry derived, however, from a European model originally executed by the animal painter Pieter Boel, who viewed his subjects live in the royal menagerie at Versailles; Droguet, Salmon, and Véron-Denise 2003, pp. 188–89, fig. 78b.

4. For the political, religious, and territorial motives behind such propaganda, see Landry-Deron 2004, pp. 59–62.

5. Meyer 1980; Zrebiec and Erbes 2000.

6. For the identification of individual subjects and extant weavings, see Cavallo 1967, vol. 1, pp. 170–76; Standen 1976, pp. 103–17; Standen 1985, vol. 2, pp. 461–68; and Bremer-David 1997, pp. 80–97.

7. The document is called "Estat du produit de quelques marchandises fabriquées dans la manufacture royale de tapisseryes de Beauvais" (State of production of some goods made in the royal tapestry manufactory of Beauvais) and is reprinted in Badin 1909, pp. 12–13.

8. The 1731 document is titled "État des tapisseries" (State of the tapestries). It is published in full in Badin 1909, pp. 20–25.

9. Bremer-David 1997, pp. 90, 96 n. 5.

10. Guiffrey 1901, vol. 5, p. 437; Bremer-David 2007b.

11. The present author consulted the 1668 Latin edition dedicated to Jean-Baptiste Colbert, marquis de Seignelay; Nieuhof 1668, p. 68, ill. opp. p. 66.

12. Quoted from the 1665 French edition, *L'Ambasade de la Compagnie hollandaise des Indes orientales dans la Tartarie chinoise et dans l'Empire chinois*, in Jarry 1980, p. 181 (present author's translation).

13. All the illustrations from the 1693 edition of Nieuhof's publication were reprinted in Nieuhof [1693] 1985.

14. In 1688, the Jesuit priest posted in China, Gabriel de Magaillans, observed the number and type of staves that accompanied an imperial procession: "when the emperor goes out to make some sacrifice, or for some other public ceremony, he proceeds in this fashion...[with] two hundred large fans supported by long batons, gilded and painted with various images of the sun and dragons"; Gabriel de Magaillans, *Nouvelle Relation de la Chine contenant la description des particularités les plus considérables de ce grand Empire*, 1688, quoted in Béguin and Morel 1997, p. 101. Bearers of the traditional halberd with a crescent blade had earned the privilege to carry the ancient weapon by advancing through the military ranks.

15. Nieuhof 1668, p. 40.

16. Dickinson and Wrigglesworth 2000, pp. 35–44.

17. Quoted in Jarry 1980, p. 181 (present author's translation).

18. Emerson 2000, pp. 100–10.

19. Quoted in Standen 1976, p. 116 (present author's translation).

20. Love 1996, pp. 171–98.

21. See Francis Watson's introductory essay in Wilson 1999, pp. 1–20.

22. Coural 1977, p. 72.

23. Coural and Gastinel Coural 1992, pp. 24, 162, no. 11.

24. "Estat du produit de quelques marchandises fabriquées dans la manufacture royale de tapisseryes de Beauvais" in Badin 1909, pp. 12–13; Bremer-David 1997, pp. 80–97.

25. "Visite des Bâtiments de la Manufacture et Examen de la Comptabilité" in Badin 1909, p. 78; Standen 1985, vol. 2, pp. 461–68.

26. The Teutonic Order, or Teutonic Knights of Saint Mary's Hospital at Jerusalem, was established in 1190 as a Hospitaller order in the Holy Land during the Third Crusade. In 1198, it was transformed into a military order, or Knights Hospitaller, answerable only to the Pope. The knights wore a white mantle with a black cross on the left shoulder. The Grand Master, elected for life, was allowed to quarter his arms with those of the Teutonic Order; his arms also carried the insignia of a bishop. In the sixteenth century, the order gained the protection of the Hapsburgs and redirected its efforts from fighting Muslims in the Holy Land to fighting the Turks. Following the Reformation, some of the Order's possessions came under the rule of knights who had converted to Lutheranism and Calvinism. Franz Ludwig, however, served as a Catholic Grand Master.

27. Schloss Ellingen was the seat of the Teutonic Order in Franconia from 1216 to 1789. The present main residence dates from the architect Franz Keller's building campaign of 1717 to 1721, which coincides with the period when, following the Thirty Years War (1618–48), the Order commissioned many large projects in the Baroque style.

28. Franz 1985, pp. 108–25, 251–52.

29. The room at Schloss Ellingen is now fitted with different tapestries. Franz 1985, fig. 98.

30. Göbel 1928, vol. 1, p. 221; Trubnikov 1916, pp. 26–44.

31. The tapestry measures 350 x 410 cm (134 x 158 in.). Its provenance is as follows: Sold (from an anonymous collection), Hôtel Drouot, Paris, Dec. 10, 1948, lot 76. Baron James de Rothschild; sold, Palais Galleria, Paris, Dec. 1, 1966, lot 104. Sold, Sotheby's, New York, Nov. 10, 2006, lot 73.

32. Boccara, Reyre, and Hayot 1988, pp. 312–13 (ill.). This tapestry is now in the Kunstindustrimuseet, Copenhagen, inv. no. 50/1988; published in Woldbye 2006, pp. 74–77, cat. 13. See also Jarry 1975, pp. 54–59 (ill.), and Machault and Malty 2000, p. 102 (ill.). The other three examples were sold at Palais Galleria, Paris, May 30, 1973, lot 121D; Christie's, New York, Oct. 21, 2004, lot 1012; and Christie's, London, Nov. 8, 2007, lot 206.

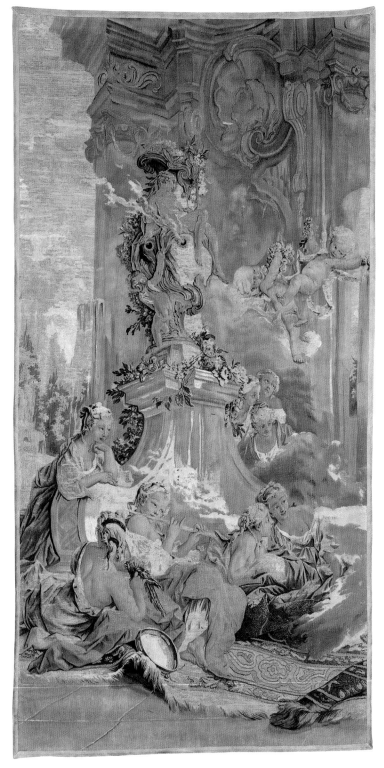

CAT. 46A

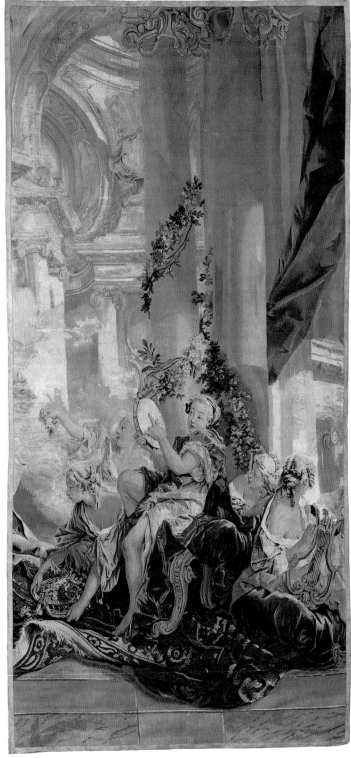

CAT. 46B

From *The Story of Psyche*

Psyche's Entrance into Cupid's Palace [left fragment]

Beauvais, 1756/63
After a cartoon by François Boucher (1703–1770), 1737–39
Produced at the Manufacture Royale de Beauvais under the direction of André Charlemagne Charron (director 1754–80)
172.8 x 341.5 cm (68 x 134⅜ in.)
Gift of Mrs. Chauncey McCormick and Mrs. Richard Ely Danielson, 1943.1236

STRUCTURE: Wool and silk, slit and double interlocking tapestry weave
Warp: Count: 8 warps per cm; wool: S-ply of six Z-spun elements; diameters: 0.8–1.2 mm
Weft: Count: varies from 21 to 52 wefts per cm; wool: S-ply of two Z-spun elements; diameters: 0.3–0.8 mm; silk: pairs of S-ply of two Z-twisted elements; diameters: 0.4–0.8 mm; wool and silk: paired yarns of S-ply of two Z-spun wool elements and one S-ply of two Z-twisted silk elements; diameters: 0.4–1.0 mm

Conservation of this tapestry was made possible through the Allerton Endowment Fund.

PROVENANCE, REFERENCES, EXHIBITIONS: See below.

Psyche's Entrance into Cupid's Palace [right fragment]

Beauvais, 1756/63
After a cartoon by François Boucher (1703–70), 1737–39
Produced at the Manufacture Royale de Beauvais under the direction of André Charlemagne Charron (director 1754–1780)
170.2 x 357 cm (67 x 140 ¾ in.)
Gift of Mrs. Chauncey McCormick and Mrs. Richard Ely Danielson, 1943.1237

STRUCTURE: Wool and silk, slit and double-interlocking tapestry weave
Warp: Count: 8 warps per cm; wool: S-ply of six Z-spun elements; diameters: 0.8–1.2 mm.
Weft: Count: varies from 22 to 46 wefts per cm; wool: S-ply of two Z-spun elements; pairs of S-ply of two Z-spun elements; diameters: 0.3–0.9 mm; silk: pairs of S-ply of two Z-twisted elements; three yarns of two S-ply of two Z-twisted elements and one Z-ply of two S-twisted elements; diameters: 0.3–0.8 mm; wool and silk: paired yarns of one S-ply of two Z-spun wool elements and one S-ply of two Z-twisted silk elements; diameters: 0.4–1.0 mm

PROVENANCE: Possibly commissioned by the French crown for the Ministry of Foreign Affairs, and woven between July 12, 1756 and Mar. 18, 1758.[1] Or possibly commissioned by one Cottin and woven between Sept. 5, 1761 and Apr. 23, 1763.[2] An unidentified European nobleman.[3] William T. Blodgett (died 1875), New York, from 1871; by descent to his daughter, Eleanor Blodgett (died 1930), New York; sold to French and Company,

New York, for $30,000, Feb. 26, 1917;[4] sold to Charles Deering (died 1927), Marycel, Sitges, Spain, as a pair but individually framed, for $47,000, Dec. 17 or 18, 1918;[5] by descent to his daughters, Marion Deering (Mrs. Chauncey McCormick, died 1965) and Barbara Deering (Mrs. Richard Ely Danielson, died 1987); given to the Art Institute, 1943.

Conservation of this tapestry was made possible through the Allerton Endowment Fund.

REFERENCES: French and Company 1917. Mayer Thurman in Wise 1976, pp. 198–99 (ill.), cats. 314a–b. Bremer-David 1997, pp. 117, 119 n. 44.

EXHIBITIONS: Art Institute of Chicago, *Selected Works of 18th Century French Art in the Collections of the Art Institute of Chicago*, 1976 (see Mayer Thurman in Wise 1976). Art Institute of Chicago, *Tapestries from the Permanent Collection*, 1979.

ONCE parts of a single tapestry from the *Story of Psyche* series, these two fragmentary pieces portray the musicians and serving maids who welcomed the mortal Psyche, a young virgin of unsurpassed beauty, upon her unexpected arrival at the enchanted palace of Venus's son, the god Cupid. The intact tapestry *Psyche's Entrance into Cupid's Palace* originally showed the beautiful protagonist and her escort, the winged Zephyr, at the center of the complete composition, in the deity's sumptuous, pillared and vaulted palace set amid lush gardens and fountains (fig. 1). Prepared by an oracle to meet her monstrous husband, Psyche is instead greeted by a sweet, harmonious chorus of female musicians. The two fragments in the Art Institute show the figures to the left and right of Psyche and Zephyr: in the left fragment a flutist, tambourine player, and attendants cluster beneath a tall, smoking perfume burner surmounted by a gilt sculpture of Venus, while other figures with a tambourine, a lyre, and a basket of flowers sit upon a luxurious carpet at the base of a column in the right fragment.

The scene ultimately derives from the ancient Roman fable included in *The Golden Ass* (or *Metamorphoses*), written during the second century A.D. by the poet Lucius Apuleius. The story tells of Psyche, whose beauty provoked the jealousy not only of her sisters but also of the goddess of Love herself, and resulted in Psyche's exile from family and friends. She was transported by Zephyr, the god of the west wind, to a remote hilltop, destined to marry a monstrous creature. Swept instead, by a twist of fate, to Cupid's palace, she unintentionally won his heart. Cupid visited Psyche only at night so she would not learn of his divine identity and reveal the affair to Venus. Warned against looking upon her lover's face but nonetheless compelled by curiosity, one night she risked a glimpse with the aid of an oil lamp and was immediately banished for her disobedience. Separated from Cupid, Psyche was nearly driven to suicide but she persisted in trying

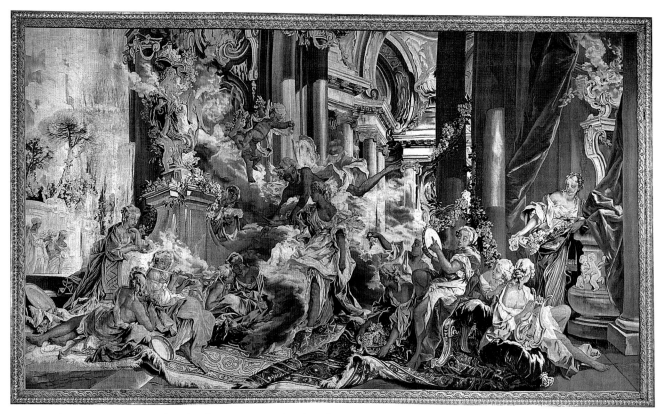

FIG. 1 *Psyche's Entrance into Cupid's Palace* from *The Story of Psyche*. After a design by François Boucher. Produced at the Manufacture Royale de Beauvais, 1743–44. Wool and silk, 298 x 518 cm. Philadelphia Museum of Art. Bequest of Eleanore Elkins Rice, 1939–41–30d.

to recover his trust and love. After surmounting many trials set by Venus, she was ultimately redeemed and attained her apotheosis as Cupid's wife in the divine pantheon.[6]

The figure of Psyche held particular meaning in the classical world, for she exhibited the characteristically human traits of curiosity and persistence as well as the human capacity to feel loneliness, loss, despair, hope, and love. In ancient Greek, the word *psyche* means both the human soul—that which survives the death of the physical body—and the fragile butterfly, which overcomes symbolic death in the cocoon to become a beautiful winged creature that exists on the nectar of sweet flowers.[7] The Greek god of love and desire, Eros, was identified with Cupid in the Roman pantheon, and the offspring of Cupid and Psyche's union was a daughter named Voluptas (Pleasure). The fable of Psyche is therefore an allegory implying that loss and suffering enable one to better appreciate and enjoy the pleasures of love and happiness.

Renaissance artists working in Italy from 1517 through the 1530s, particularly Raphael (1483–1520), his pupil Giulio Romano (c. 1499–1546), and contemporaries influenced by the master, expressed a renewed interest in Psyche's tale through narrative fresco cycles and print series. These images, in turn, quickly inspired tapestry versions. Foremost among the design sources was Raphael's own portrayal of the myth in the Chigi family villa (later the Villa Farnesina) in Rome, for which, from 1517 to 1519, he painted two trompe l'oeil frescoes to look like tapestries nailed to the vault of the loggia. The painted frames simulated the woven borders of tapestries. An extensive series

of thirty-two engravings after Raphael and his followers, printed around 1532 to 1534 by the Master of the Die, became the basis for the famed twenty-six-piece *Psyche* suite, woven with gilt-metal thread in Brussels, that was purchased in 1550 by King Henry II of France.[8] This monumental suite remained in the French royal collection until 1797, when it was burned to retrieve its metal content. Some of the compositions from the series are known today through copies produced in Parisian workshops in the seventeenth century.[9]

The Brussels *Psyche* was well known to the administrators and artists working for the French crown during Louis XIV's reign, and its subject attracted the interest of another generation of designers. The enduring suitability of Psyche's story for tapestry cycles prompted the newly appointed superintendent of the Bâtiments, Arts, et Manufactures du Roi (Office of Royal Buildings and Public Works), François-Michel Le Tellier, marquis de Louvois, to copy another esteemed Renaissance version of the subject at the Manufacture Royale des Gobelins. In 1684, in an effort to prove the young manufactory's virtuosity by emulating in thread the greatest masterpieces of Renaissance painting, Louvois ordered painters from the Académie Royale to create cartoons after Romano's preparatory drawings for his renowned Psyche fresco cycle in the Palazzo del Te, Mantua, painted from 1527 to 1530.[10] From 1686 to 1742, tapestries after Romano's *Marriage Feast of Cupid and Psyche* were woven at the Gobelins, as hangings in a larger series known as *Fable Subjects*.[11]

Meanwhile, forty miles to the north of Paris, the Beauvais manufactory produced a variant *Story of Psyche* by 1690 to establish its

own reputation and meet the demand for this subject among its prosperous private customers. Distinctly different in style from the sixteenth- and early-seventeenth-century precedents woven in Brussels and Paris workshops, as well as from the contemporary Gobelins versions, the Beauvais *Psyche* consisted of new compositions created by painters employed by the manufactory specifically for this purpose. The resulting suites typically comprised a selection of six hangings from a total of ten scenes.[12]

Given both the variety and sheer number of existing *Psyche* weavings, it is a testament to the continuing appeal of the myth that in 1737 administrators working for the French crown should commission yet another set of the subject on behalf of Louis XV from the Beauvais manufactory. The stated purpose of the order was to create high-quality tapestries to be given as diplomatic gifts or to furnish French embassies abroad, according to the needs of the Department of Foreign Affairs.[13] Philibert Orry, chief accountant from 1730 to 1745 and director of the king's buildings department from 1737, stipulated that the compositions of the new weavings were to be fresh, well-chosen to maximize the richness of the tapestry medium, and selected from the less frequently illustrated episodes of the plot.[14] He agreed that Jean-Baptiste Oudry (1686–1755), codirector and artistic supervisor at Beauvais, could assign the execution of the tapestry cartoons to François Boucher, then an up-and-coming artist.[15]

Aware of Orry's warning against repeating the most common scenes, it is likely that both Oudry and Boucher reviewed the existing precedents available to them: the sixteenth-century Brussels *Psyche* hangings in the royal collection, the earlier Beauvais production, and the weavings first ordered by Louvois in the 1680s but still on the looms at the Gobelins. The accomplished Boucher was already familiar with the story of Psyche, having provided two engraved illustrations for a new edition, published in 1734, of Molière's theatrical interpretation of the myth, which was based on Jean de La Fontaine's successful 1669 adaptation of Apuleius's tale.[16] And Boucher must have been aware of the major contemporary decorative project carried out from 1737 to 1739 by Charles Natoire, which comprised ten paintings based on the story of Psyche, located on the spandrels of the oval salon in the Hôtel Soubise, Paris.[17] Boucher himself contributed seven over-door paintings for other rooms in the same palace. For the 1737 Beauvais tapestry commission, Boucher also received extensive and detailed advice from the critic and connoisseur Louis Petit de Bachaumont, who expounded on the choice of possible scenes, proposing specifically *Psyche Received by the Nymphs at Cupid's Palace*, and even suggested Madame Boucher as a model.[18] Bachaumont further recommended that the artist take inspiration from the literary and theatrical sources of the 1660s and 1670s, as well as from Raphael's treatment of the subject, known through intermediary prints in local collections.

By April 1743, Boucher had provided to Oudry five full-size, oil-on-canvas tapestry cartoons titled, according to the Beauvais weavers pay registers, *Psyche's Entrance into Cupid's Palace, The Toilette of*

FIG. 2 *Zephyr Leading Psyche*. François Boucher, 1738/39. Black and white chalk on paper; 31.8 x 27.3 cm. Location unknown.

Psyche, The Treasures of Psyche (Shown to her Sisters), The Abandonment of Psyche, and *Psyche and the Basketmaker*.[19] He omitted two of the most popular episodes from the story—*Psyche Discovers Cupid's Identity by the Light of an Oil Lamp* and *The Marriage of Cupid and Psyche*—even though Bachaumont had proposed including both subjects. Several preliminary drawings by Boucher have been identified for figures within the compositions, notably the energetic study in chalk for Zephyr and Psyche in *Psyche's Entrance into Cupid's Palace* (fig. 2).[20] The pose of the striding Psyche in Boucher's study follows Raphael's figure of Venus in the *Council of the Gods* fresco from the Villa Farnesina *Psyche* cycle, particularly in the tilt of her head and the position of her arms, with the left extended and the right grasping the folds of her robe. Boucher may well have seen Raphael's archetype during his own Roman sojourn from 1727 to 1731, or he may have known the pose from prints after the master.[21] Small preparatory sketches in gouache for *Psyche's Entrance into Cupid's Palace* (now lost) and in brown monochrome for *The Toilette of Psyche* and *The Treasures of Psyche* show the evolution of the artist's early ideas.[22] Additional Boucher sketches exploring the theme of Psyche, especially the grisaille *Psyche Declining Divine Honors*, have been associated with the Beauvais tapestry cycle, but Alastair Laing has argued that they were instead preliminary to the etched prints.

Placed end-to-end, Boucher's cartoons measured 18⁴⁄₁₆ linear Flemish ells, or 1,273 centimeters (501⅛ inches)[23] and cost 5,000 livres, according to a July 1745 report by the Swedish court architect Carl Hårleman.[24] The first cartoon was a wide canvas portraying *Psyche's Entrance into Cupid's Palace* and it served as the design source for the two tapestry fragments in the Art Institute. The painting was completed in time for the September 1739 Salon held at the Louvre Palace, when it was described in the accompanying exhibition booklet as "[u]n grand Tableau en largeur de 14 pieds sur 10 de haut, représentant Psiché conduite par Zephire dans le Palais de l'Amour, par M. Boucher, Professeur. Ce tableau doit être exécuté en Tapisserie pour le Roy, à la Manufacture de Beauvais." ([a] large picture 14 pieds in length by 10 [pieds] in height [454.8 x 324.8 centimeters (179 x 127⅞ inches)] showing Zephyr escorting Psyche into Cupid's Palace, by Mr. Boucher, Professor. This picture is to be made as a tapestry for the king, at the Beauvais Manufactory.)[25] The four companion cartoons were neither exhibited then nor at subsequent Salons. In order to fill the commissions that the manufactory received beginning in July 1741, the cartoon canvases remained at Beauvais, each cut into separate strips or bands for use on the low-warp looms. Their presence at the manufactory can be tracked until 1829, when they were sold.[26] Undoubtedly worn and damaged by then, apparently none now survive, though there exist copies of some of the bands (see below). Boucher's original compositions are therefore known through the extant tapestries, which were woven in reverse.

The two fragments in the Art Institute show the figures to the left and right of the protagonists Psyche and Zephyr, who occupied the central section of the once intact tapestry. At some point, probably before 1871 but certainly before 1917, these sections were cut from the larger tapestry and fitted with newly woven inserts of billowing clouds to disguise the loss of the outstretched head and limbs of the flying Zephyr. The reason for this drastic reduction can only be surmised. Perhaps the midsection of the tapestry was removed, even though it contained the two most important figures, because it showed a damaged or otherwise undesirable coat-of-arms at its top, in the middle of the upper border, above Zephyr.

Although the pieces in the Art Institute are fragments, it is still possible to locate the tapestry from which they came in the production chronology of the *Psyche* suites by considering the height of these surviving parts.[27] The dimensions of the taller fragment (1943.1237) indicate that its original height was approximately 5²⁄₁₆ Flemish ells, or 357.3 centimeters (140⅔ inches), equal to the height of the suite ordered by the French crown in 1756. All the pieces in the suite shared the same border design, woven at the expense of 43 livres, 19 sous, and 3 derniers per vertical length, and each bore the two shields of the Bourbon royal coat of arms, one in the center of the top border and one in the sky of the central field.[28] Though now lacking their original borders, the tapestry fragments in the Art Institute could comprise the remains of the *Psyche's Entrance into Cupid's Palace* from this order.

If this supposition is correct, then it is likely that the intact *Psyche's Entrance into Cupid's Palace* from this suite was in France at the time of the Revolution, when royal symbols were routinely removed from works of art as distasteful vestiges of the ancien régime. The tapestry that was divided to create the two pieces in Chicago was not the only *Psyche's Entrance into Cupid's Palace* to undergo such alteration. The extended hanging formerly in the collection of Edward G. Tuck and, since 1930, in the Musée du Petit Palais, Paris, was originally commissioned by the crown in 1767 and also bore the French royal arms. Destined for Louis, 4th duc de Noailles, it was joined to *The Treasures of Psyche*, its companion hanging, even before it left the manufactory in 1771.[29] At an unspecified later date, a patch of indistinctly rewoven architecture directly above the figures of Zephyr and Psyche was inserted, presumably to replace the royal arms.[30]

As the fragments in the Art Institute no longer retain their original borders, it is also possible that they belonged to another order in the manufactory's production, woven to a height slightly greater than 5²⁄₁₆ Flemish ells. This edition, commissioned in 1761 by Cottin, did not have any coats of arms or an elaborate border. Rather, the weavings were surrounded by simple, narrow blue bands produced at the cost of 2 livres, 12 sous, and 6 derniers per vertical length.[31]

The Beauvais manufactory wove *The Story of Psyche* from 1741 through 1772, producing a total of twelve tapestries of *Psyche's Entrance into Cupid's Palace*. Aside from the weavings already discussed, examples survive in the Corcoran Gallery of Art in Washington, D.C., the J. Paul Getty Museum, Los Angeles, the Philadelphia Museum of Art, and the Swedish royal palace, Stockholm.[32] The tall hanging (measuring 6³⁄₁₆ Flemish ells) commissioned by Frederick the Great of Prussia in 1764 disappeared during World War II, though the companion piece *The Treasures of Psyche* still survives in the Kunstgewerbemuseum, Berlin.[33] Another *Psyche's Entrance into Cupid's Palace*, whose present location is unknown, was formerly in the collection of the dealer Achille Leclercq.[34] Sections of two more editions of this subject were on the art market in the 1980s and 1990s.[35]

At least one late-nineteenth-century copy of *Psyche's Entrance into Cupid's Palace* is known, woven in reverse in relation to its eighteenth-century precedents.[36] This copy was undoubtedly produced by the Maison Braquenié, which is known to have woven other subjects from Boucher's *Story of Psyche* series, specifically *The Toilette of Psyche*.[37] The production must have been facilitated by the firm's ownership in the 1870s of an eighteenth-century Beauvais *Psyche* suite.[38] Furthermore, it seems that Braquenié's precursor, the textile manufacturer Demy-Doisneau, founded in 1823, may well have acquired several of Boucher's original *Psyche* cartoon bands when they were sold by the Beauvais manufactory in 1829 to benefit veterans of the Napoleonic wars.[39] Copies of three bands—including one showing the tambourine player from *Psyche's Entrance into Cupid's Palace*—that were probably used as models for the new editions were sold from the Braquenié collection in 2005.[40] CBD

NOTES

1. MN B-167, folios 185–87. This suite of tapestries may have been the one lent in 1778 to Charles Gravier, comte de Vergennes, secretary of state for foreign affairs from 1774, to decorate the French ambassadorial palace in Venice; Coural and Gastinel-Coural 1992, p. 163, captions 22–23.

2. MN B-169, folios 8–9. Cottin's identity has not yet been established with certainty, though he may have been Jean Cottin, also known as Jean-Baptiste Cotton de Houssayes, a medical doctor and the librarian of the Sorbonne; see Michaud and Michaud 1811–62, vol. 9, pp. 337–38.

3. According to a French and Company bill to Charles Deering, Dec. 17, 1918.

4. The stock sheet (no. 4016) survives in the archives of French and Company preserved at the Getty Research Institute, Los Angeles, no. 840027.

5. Copy of bill of sale dated Dec. 18, 1918, in object file, Department of Textiles, the Art Institute of Chicago. The French and Company stock sheet (no. 4016) dates the sale a day earlier, to Dec. 17, 1918.

6. Apuleius 1977, pp. 185–285.

7. Images of Psyche from antiquity sometimes portrayed her with butterfly wings. See, for example, the Roman marble from the second century A.D. in the Florentine Medici collections, as accurately represented in *The Tribuna of the Uffizi*, painted from 1772 to 1778 by Johann Zoffany, in the Royal Collection, Windsor Castle, inv. 406983. For a copy of the antique sculpture, see http://www.scils.rutgers.edu/~mjoseph/CP/sc 1.jpg.

8. Campbell 2002c, pp. 271, 280, 353, 390; Forti Grazzini 1994, vol. 2, p. 531.

9. Fenaille 1903–23, vol. 1, pp. 287–93.

10. The drawings were then housed in the French royal collection.

11. Fenaille 1903–23, vol. 2, pp. 247–65.

12. Jestaz 1979, pp. 187–207. The Beauvais scenes should be compared to the contemporary Flemish designs produced by Jan van Orley (1665–1732). See Brosens 2005c, pp. 401–06.

13. In Sept. 1737, the Beauvais manufactory was directed to deliver two complete tapestry suites to the Department of Foreign Affairs each year. Each set was to have a value of 10,000 livres, charged against the king's account. See Coural and Gastinel-Coural 1992, pp. 43, 47 n. 19.

14. Fenaille 1903–23, vol. 4, pp. 99–100.

15. Louis Fagon, finance administrator, letter to Oudry, Oct. 1, 1737, in Ananoff and Wildenstein 1976, vol. 1, p. 15, doc. 89.

16. In 1671 Molière produced a *tragedie-ballet* of the story of *Psyche* in collaboration with Pierre Corneille, Jean-Baptiste Lully, and Philippe Quinault. The theatrical enjoyed extended revivals through 1713. See Hiesinger 1976, pp. 7–23, and Bremer-David 1997, p. 114.

17. Hiesinger 1976, pp. 7–23; Laing et al. 1986, pp. 173–77.

18. Ananoff and Wildenstein 1976, vol. 1, p. 18, doc. 130.

19. MN B-165, fols. 1–57; Badin 1909, pp. 31, 60; Bremer-David 1997, pp. 106–19.

20. The chalk study is published in Shoolman Slatkin 1973, pp. 49–50, cat. 38. It was sold from the collection of Richard Krautheimer and Trude Krautheimer-Hess at Christie's, New York, Jan. 10, 1996, lot 91.

21. Bernini Pezzini, Massari, and Prosperi Valenti Rodinò 1985, pp. 151–58, 624 (ill.), 635 (ill.).

22. Reportedly from the Demidoff collection, San Donato, the gouache study was later sold after the death of H. H. A. Josse, at Galerie Georges Petit, Paris, May 28–29, 1894, lot 6. For the sketches in brown monochrome, see Laing et al. 1986, pp. 187–91, and Ananoff and Wildenstein 1976, vol.1, pp. 309–12, cats. 191, 193.

23. At the Beauvais manufactory, one Flemish ell equaled 69.75 centimeters, or nearly 27½ inches.

24. Weigert 1933, p. 232; Böttiger 1898, vol. 4, pp. 95–96.

25. Reprinted in Ananoff and Wildenstein 1976, vol. 1, p. 17, doc. 120. One pied equals 32.5 cm.

26. Badin 1909, pp. 90, 105, docs. 13, 14.

27. For a chronology of production, see Bremer-David 1997, pp. 106–19.

28. MN B-167, fols. 175–89.

29. MN B-169, fols. 259–69. The tapestry is published in Niclausse 1940, p. 49, no. 61, pl. 83, and Chazal, Barbe, and Lemasson 2004, pp. 102–03 (ill.)

30. The only written source to note that there is a patch of "indistinctly woven architecture" is *Antiques* 20, 2 (Aug. 1931), frontispiece.

31. MN B-169, fols. 8–9.

32. The tapestry in the Swedish royal palace is published in Böttiger, 1898, vol. 4, pp. 95–96, and Jones 2000, p. 33. The *Psyche's Entrance* now in Washington was part of a suite originally commissioned by Filippo di Borboni, duca di Parma. The edition descended through the Italian royal household, stored in the ducal palace in Colorno, until it was divided in the 1860s. All but *Psyche's Entrance* remain in the Palazzo del Quirinale, Rome, to this day. The aforementioned tapestry was transferred in Dec. 1865 to the Palazzo Pitti, Florence. In Apr. 1866, Victor Emmanuel II gave the tapestry to a friend of the court, the Russian grand duchess Maria Nikolaevna, who was then residing near Florence in the Palazzo San Donato, the home of the Demidoff family. A watercolor interior view of the palace (formerly at the Shepherd Gallery, New York), dated 1867 and attributed to Emanuele Stöchler, shows the tapestry on the wall of a large salon fitted with red damask woven fabric (possibly the Salle de Louis XVI or the Salle des Tapisseries). Nello Forti-Grazzini reports that by 1900 the tapestry had passed to the Parisian dealers Jules and Charles Lowengard. The American senator William A. Clark purchased it, and then donated it in 1926 to the Corcoran Gallery of Art; Forti Grazzini 1994, vol. 2, p. 492. The Philadelphia *Psyche's Entrance* is published in Hiesinger 1976, pp. 7–23. The tapestry in the Getty is published in Bremer-David 1997, pp. 106–19.

33. Seidel 1900, pp. 185–94; Schulz 1983, pp. 127, 176, 283, cat. 119.

34. After Leclerq's death, the tapestry (300 x 440 cm [118 x 173 ¼ in.]) was sold at Hôtel Drouot, Paris, May 30–June 1, 1904, lot 316.

35. A narrow, borderless example (282 x 252 cm [111 x 99 1/4 in.]) showing Psyche, Zephyr, and eight of the surrounding attendants was sold at Drouot-Richelieu, Paris, Nov. 27, 1992, lot 214. A section showing the lyre player and a serving maid from the far right of a very wide version of *Psyche's Entrance into Cupid's Palace*, set within a narrow border that matches that of the Leclercq example (see note 34 above), was sold from the collection of the Earl of Iveagh, at Christie's, Elveden Hall, Norfolk, May 22, 1984, lot 1767. It measured 284 x 171.5 cm (112 x 67 1/2 in.).

36. Sold anonymously at Christie's, New York, Oct. 26, 2004, lot 309, as "last quarter 19th century"(193 x 271.8 cm [76 x 107 in.]).

37. *The Toilette of Psyche* was sold at Hôtel Drouot, Paris, May 21, 1895, lot 2.

38. Böttiger 1898, vol. 4, p. 97 n. 5.

39. Ananoff and Wildenstein 1976, vol.1, p. 149, docs. 1161–63.

40. Sold, Galerie Charpentier, Paris, Oct. 27, 2005, lots 298, 309–10. All three bands measured a uniform 248 or 249 cm in height.

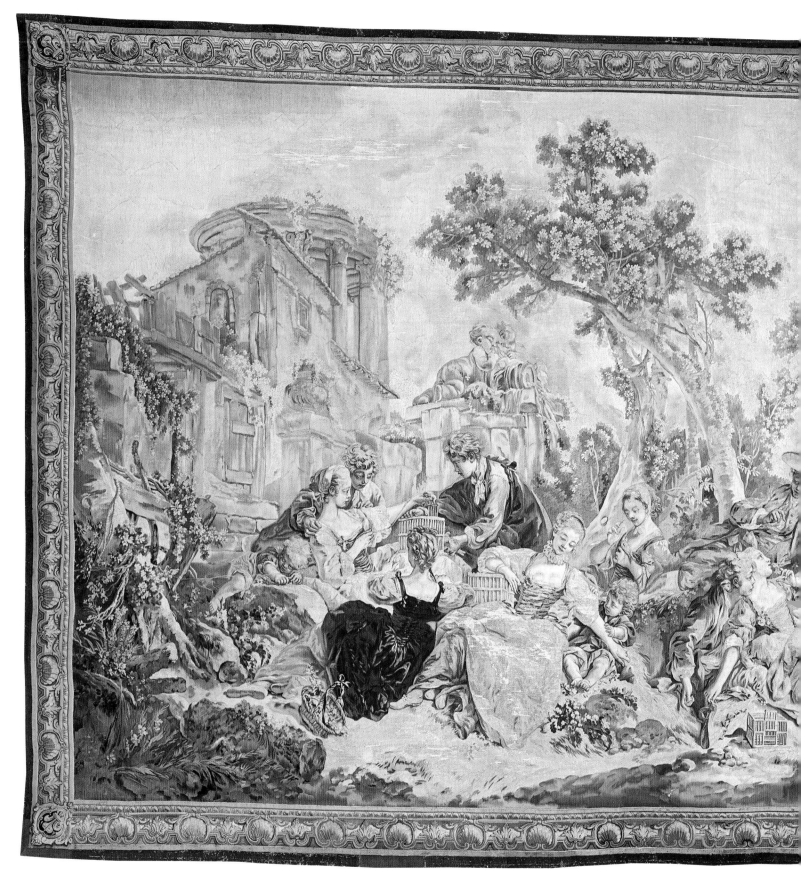

CAT. 47

The Bird Catchers from *The Noble Pastoral*

Beauvais, 1778–80
After a cartoon by François Boucher (1703–1770), 1748
Produced at the Manufacture Royale de Beauvais under the direction of André Charlemagne Charron (director 1754–80) and de Menou (director 1780–93)
MARKED AND SIGNED: *F Boucher 1755* (in reverse); a fleur-de-lis; *D·M·BEAUVAIS·*[1]
572.2 x 369.7 cm (225¼ x 145 ⅝ in.)
Gift of Flora Whitney Miller, Barbara Whitney Henry, and Major Cornelius Vanderbilt Whitney, in memory of their mother, Gertrude Vanderbilt Whitney, 1942.144

STRUCTURE: Wool and silk, slit and double interlocking tapestry weave
Warp: Count: 8 warps per cm; wool: S-ply of four Z-spun elements; diameters: 0.7–1.0 mm
Weft: Count: varies from 18 to 42 wefts per cm; wool: single S-spun elements; S-ply of two Z-spun elements; pairs of S-ply of two Z-spun elements; diameters: 0.3–1.0 mm; silk: pairs of S-ply of two Z-twisted elements; diameters: 0.5–0.7 mm; wool and silk: paired yarns of S-ply of two Z-spun wool elements and one S-ply of two Z-twisted silk elements; diameters: 0.6 0.8 mm

Conservation of this tapestry was made possible through the Allerton Endowment Fund.

PROVENANCE: Commissioned by the French crown by June 1778 and woven between June 27, 1778, and Sept. 17, 1780.[2] Possibly given to Alexandre-Marie-Léonor de Saint-Mauris, prince de Montbarey (died 1796), minister of war (1777–80).[3] William Collins Whitney (died 1904), 871 Fifth Avenue, New York, by 1896;[4] sold, with Whitney's house and its contents, to James Henry Smith (died 1907), 1904; by descent to his nephew; offered for sale with the contents of 871 Fifth Avenue, New York, American Art Association, New York, Jan. 18–22, 1910, lot 330, but sold before the sale to Harry Payne Whitney (died 1930), Jan. 3 or 4, 1910; by descent to his wife, Gertrude Vanderbilt Whitney (died 1942); sold after her death, by his estate, at Parke-Bernet Galleries, New York, Apr. 29, 1942, lot 153 (with the comment "Has been slightly reduced"), to the Gertrude Vanderbilt Whitney Trust (Flora Whitney Miller, Barbara Whitney Henry, and Major Cornelius Vanderbilt Whitney, trustees); given to the Art Institute, 1942.

REFERENCES: Anon. 1901, pp. 132, 140 (ill.). Pène du Bois 1917, pp. 177–82 (ill.), 210. Hunter 1919, pp. 245–48. Hunter 1925, p. 175. Hunter 1926a, pp. 21–28. Hunter 1926b, pp. 83–89 (ill.). Göbel 1928, vol. 2, pt. 1, p. 228. Cavallo 1967, p. 179. Jarry 1972, pp. 222–29, fig. 6. Mayer Thurman in Wise 1976, p. 199, cat. 315. Craven 2005, pp. 100–07, figs. 27, 29. Bremer-David 2008c, p. 318 n. 30.

EXHIBITIONS: Art Institute of Chicago, *Selected Works of 18th Century French Art in the Collections of the Art Institute of Chicago*, 1976 (see Mayer Thurman in Wise 1976).

IN a glade encircled by trees and the ruins of a stone building, a group of four amorous couples, a young woman, and two young boys snare birds under a net, trap them in cages, and tether them with strings. To the right, several wild birds circle above a live decoy, held captive

under a net, its song apparently acting as a lure. The man holding the snare's trigger rope signals his partners for silence. His female companions, seated under a fountain carved with a pair of amoretti clambering over a jug that spills water, take captured birds from cages to tether and tame them.

Traditionally, rural hunters snared or netted wild game birds for food in the months of October or November. Thus the occupation was often used to illustrate calendrical cycles showing the months of the year with their associated labors.[5] By the eighteenth century, however, hunting for bird nests and bird catching had together come to symbolize spring, and depictions of these activities were sometimes included in both painted and woven *Four Seasons* series. François Boucher's earliest use of bird-catching imagery, dating around 1732 to 1734, represented summer by four naked boys and four winged putti handling caged and tethered birds, and a derivative model was later used by the Beauvais tapestry manufactory as an allegory for spring in *Four Seasons* sets.[6]

A widely popular, parallel tradition employed the motif of birds, caged and then released, as well as images of jugs, as erotically charged double entrendres about virginity, carnal lust, and human reproductive anatomy. In seventeenth-century Dutch genre paintings, for example, the freeing of a caged bird by a courting couple usually alluded to their impending loss of virginity, while ceramic jugs represented both the uterus and a nesting site.[7] Contemporary Dutch and French courtesy books, love ballads, and poetry elevated the coarser connotations of these images by transforming them into symbols of the virtues of love and fidelity: the "happily caged bird" or "voluntary prisoner" represents the lover's heart willingly bound in affectionate servitude. Likewise, the tethering of a freed bird could stand for ready acceptance of the amorous fetter. Furthermore, the image of a young shepherd trapping birds in the open countryside came to represent a gallant's pursuit and capture of his beloved.[8] When the fictional shepherd offered his shepherdess a basket of grapes or a bird's nest containing eggs, he symbolically expressed either his bacchanalian, carnal desire or his enduring, steadfast love. She indicated her affections by crowning him with a wreath of roses, the flowers of Venus. The currency of these related literary and visual images are manifested in the allegorical picture *Spring*, painted by Nicolas Lancret (1690–1743) in 1738 for a *Four Seasons* set that Louis XV commissioned for his château at La Muette, the "hunting lodge" where he entertained his mistresses (fig. 1).[9]

In many ways, Boucher's design for the tapestry called *Bird Catchers* followed Lancret's precedent, especially in the wooded landscape in the foreground opening to a bird snare in the middle distance, and in the poses and elegant dress of the seated women. It is possible that Boucher knew Lancret's painting firsthand, as Boucher was commissioned in 1748 to paint a set of *Seasons* and to design two tapestries (never realized), also for the king's apartments at La Muette.[10] Boucher's cartoon for the tapestry in the Art Institute, however, is distinguished by the Italianate architecture that evokes antiquity

through its inclusion of the circular temple at Tivoli, a famed Roman ruin that Boucher had observed and sketched in 1730 during his Italian sojourn.[11] With this motif, and by naming the tapestry series *The Noble Pastoral*, Boucher directly alluded to both pastoral poetry and its popular contemporary theatrical adaptations and derivations that were set in ancient Arcadia.[12]

The Noble Pastoral series normally comprised five hangings, including *The Bird Catchers*. The other subjects were identified in eighteenth-century weavers' pay registers as *The Fountain of Love* (usually a wide tapestry, like *The Bird Catchers*), *The Flutist*, *The Fishermaid*, and *The Luncheon*. Jean-Baptiste Oudry (1686–1755), who codirected the Beauvais manufactory from 1734, must have commissioned Boucher to produce this sixth tapestry series for Beauvais before 1748, as the two surviving, partial cartoons bear inscriptions with Boucher's signature and that year.[13] A document from the end of Charron's directorship at the manufactory states that the cartoons for all five designs were delivered at some point after January 18, 1754, at a cost of 12,300 livres. Between 1755 and 1780, thirteen full or partial sets were woven after them for a total of fifty-four individual hangings.[14]

The Noble Pastoral tapestries appear, at first glance, to illustrate favorite country pastimes, such as picnicking and fishing, and leisurely rural life in keeping with the popular artistic genre called *sujets champêtres* (country subjects), but four of the compositions were inspired instead by a work in the pastoral genre: the prodigiously successful pantomime *Les Vendanges de Tempé* (Grape Harvests of Tempé), first staged by Boucher's friend Charles-Simon Favart, manager and later director of the Opéra Comique, at the Foire Saint-Laurent on August 28, 1745, then restaged in 1752 at the Théâtre Italien as the ballet-pantomime *La Vallée de Montmorency* (The Valley of Montmorency), with sets by Boucher.[15] Though the original text does not survive, a later summary recounts the romance between two peasants living in bucolic Tempé, a valley in Thessaly, Greece, celebrated by ancient writers for its natural beauty.[16] In the second staging, the plot remained basically the same but the setting changed from Greece to France, specifically to the cherry orchards of the Montmorency valley.

The story is one of love triumphant over discord. A Little Shepherd courts and wins the love of Lisette through a variety of playful tricks, so that the happy couple overcomes the objections of a jealous rival, an envious cousin, and angry parents. The Little Shepherd fills Lisette's basket with grapes while she naps and then awakens her by tickling her lips with a straw (scene 4). He then hides in a flowering shrub that shelters a singing bird, whose call encourages Lisette to embark on its capture, leading instead to the capture of the Little Shepherd (scenes 4 and 5). The plot also includes a flute lesson (scene 5). These episodes correspond to the tapestries titled *The Luncheon*, *The Fountain of Love*, *The Bird Catchers*, and *The Flutist*. Only *The Fishermaid* bears no apparent connection to the plot, unless one identifies the stream with that described in the stage set of the panto-

FIG. 1 *Spring.* Nicolas Lancret, 1738. Oil on canvas; 69 x 89 cm. Musée du Louvre, Paris.

mime and construes the large net on a pole as the tool Lisette used in her bird hunt (preface and scene 5), which is, admittedly, a stretch.

Boucher's first pastorals portraying the love stories of shepherds date to 1738, when he supplied two over-door paintings, *The Gallant Shepherd* and *The Obliging Shepherd,* for the redecoration of the Hôtel de Soubise in Paris. In the latter picture, he featured the liberation of a caged bird, introducing a theme to which he intermittently returned throughout his career. Indeed, the pose of the shepherd extending the cage toward his shepherdess was a model Boucher repeated ten years later in the *Bird Catchers* cartoon (fig. 2). His development of the pastoral genre in paintings, designs for prints, tapestry cartoons, models for porcelain figures, stage sets, and costumes coincided with Favart's novel transformation of "low" rustic characters typical of the *opéra comique* by endowing them with the elevated, delicate sensibility of the protagonists in pastoral poetry.[17] Given the diversity and quantity of related images and variations on

the basic plot, it is clear that Boucher's vision and Favart's talent created a new, fresh force in the artistic and theatrical worlds of Paris.[18]

Between the initial performance of the pantomime in 1745 and the later ballet-pantomime of 1752, there seems to have been a fruitful exchange of ideas between Boucher and Favart that resulted in an evolution of the artist's character costumes in his theatrical pastoral paintings and of the director's plot. In Boucher's first pictures inspired by the pantomime—two oval canvases illustrating *The Flute Lesson* (1746) and the *Grape Eaters* (also known as *Are They Thinking of Grapes?*, 1747), which were exhibited at the 1747 Salon—the Little Shepherd and Lisette wear neither stockings nor shoes. By the following year, in the two large *Noble Pastorals* cartoons for Beauvais, Boucher depicted some figures wearing an array of rich garments, ruffled collars, luxurious full skirts, white silk stockings, and heeled shoes. Different from the loose drapery in the antique style with which he customarily robed the classical figures of his mythologi-

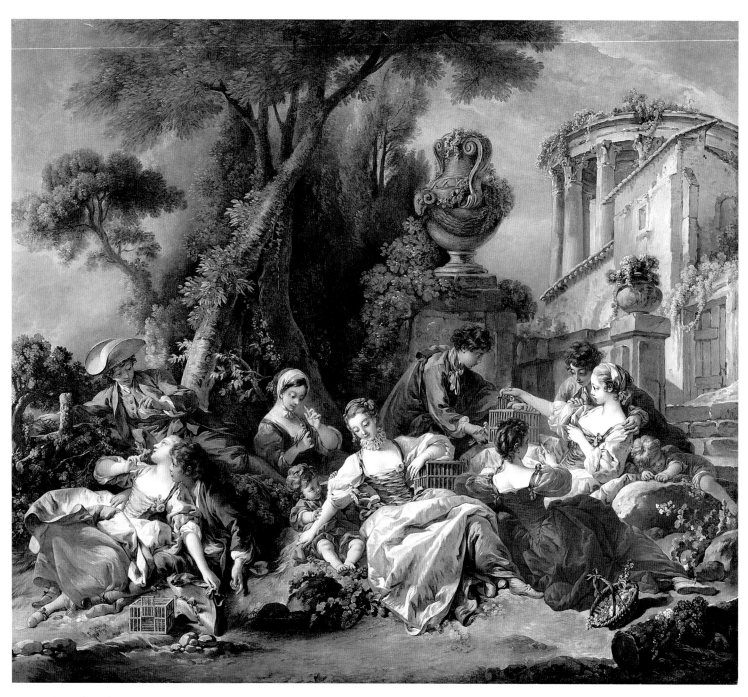

FIG. 2 *The Bird Catchers*. François Boucher, 1748. Oil on canvas; 294.6 x 337.8 cm. J. Paul Getty Museum, Los Angeles, 71.PA.38.

cal pastoral subjects, the characters of Boucher's theatrical pastoral scenes were attired in a range of costumes, spanning the semirustic dress and bare feet of contemporary peasants and the fancy dress and ribboned shoes typical of the fashionable stage.[19] Favart was, in turn, influenced by Boucher. When the artist painted the *Bird Catchers* cartoon he introduced the caging and releasing of birds, an allegorical detail that had not, apparently, figured in the pantomime's original plot. Favart worked this motif into the 1752 production of *The Valley of Montmorency*, along with the payment of a nightingale's nest as ransom, to add a refined—yet readily understood—layer of meaning and symbolism.

For more than twenty-five years, the Beauvais manufactory received orders for full and partial suites of the *Noble Pastoral* tapestries, which created work that occupied multiple looms and countless weavers from 1755 to 1780. In total, eleven editions of the *Bird Catchers* were woven: five belonged to suites commissioned by private patrons; five more figured among the French crown's orders, intended for use in the royal residences or as disbursements through the Ministry of Foreign Affairs; and one formed part of the suite kept in reserve by the Beauvais manufactory. Thanks to the presence of the woven signature of de Menou, the director of the manufactory from 1780 to 1793, and the piece's physical characteristics, the

Art Institute's version of the tapestry can be identified as a hanging from the last of the eleven editions completed, in fulfillment of the fifth and final royal commission. Begun on June 27, 1778, under the direction of André Charlemagne Charron, the suite was finished on October 10, 1781, under his successor, de Menou. Although a royal commission, the pieces, including the Art Institute's *Bird Catchers,* were woven without the royal arms, possibly because the suite had been designated from the beginning as a gift to a private individual. At 366 centimeters (144 inches), it is considerably taller than all other extant versions.[20] A note in the factory's register explains why the left border is not contiguous with the central, narrative field. Apparently, a preexisting border from an incomplete tapestry was repurposed and applied to this weaving. The cost of the right border alone was more than forty-three livres.[21] The same register indicates that *The Fountain of Love* and *The Luncheon* from this set were intended for Alexandre-Marie-Léonor de Saint-Mauris, prince de Montbarey, and minister of war under Louis XVI. The present location of only one companion piece from this suite is known: the narrow weaving of *The Luncheon,* bearing a border matching that of the tapestry in the Art Institute, is preserved in the Musée Condé in the Château de Chantilly.[22]

It appears that few of Boucher's Beauvais *Bird Catchers* tapestries survive, as only five of the eleven pieces woven can currently be located. In addition to the piece in the Art Institute, versions exist in the Calouste Gulbenkian Museum, Lisbon, and in the Huntington Art Collections, San Marino, California.[23] An extra-wide version, formerly in the collection of Sir George Alexander Cooper at Hursley Park, England, was on the art market in 1986, and a much-reduced one from the collection of Georges Hoentschel was sold in 1919.[24]

CBD

NOTES

1. The 1755 date that appears in the central, narrative field of all extant versions of the *Bird Catchers,* including the one in the Art Institute, refers to the year in which the Beauvais manufactory commenced production of the first edition, not the actual production date of the individual tapestry.

2. MN B-171, fols. 51–62, 125. I thank Jean Vittet for his assistance in reviewing this entry in the register.

3. For the prince de Montbarey (or Montbarrey), see Michaud and Michaud 1811–62, vol. 29, pp. 47–48.

4. Acquired before 1896, by that year *The Bird Catchers* was set into the wood paneling of the ballroom at the Whitney residence at 871 Fifth Avenue, New York. The two-story ballroom, designed by McKim, Mead, and White, had been added to the existing residential building originally constructed in 1883 for the sugar mogul Robert L. Smith; Craven 2005, pp. 100–07, figs. 27, 29. See also Anon. 1901, p. 132.

5. See, for example, the peasant bird catcher woven in the lower left corner of the *October* tapestry from the series known as *The Medallion Months,* produced in Brussels around 1525; Standen 1985, vol. 1, pp. 45–53 (ill.).

6. Laing et al. 1986, pp. 127–29; Bremer-David 2008c, pp. 309–12. Boucher also used the same imagery to represent air in a *Four Elements* series. See Ananoff and Wildenstein 1976, vol. 1, pp. 386–87.

7. Müller, Renger, and Klessman 1978, pp. 116–19, 148–49, 158–59.

8. Goodman-Soellner 1986, pp. 127–30.

9. *Spring* is now in the Musée du Louvre, Paris, inv. 5597; Wildenstein 1924, pp. 70–71, fig. 10. Another version of the painting is in the Wallace Collection, inv. P 436; Duffy and Hedley 2004, p. 231 (ill.).

10. Ananoff and Wildenstein 1976, vol. 1, pp. 36–37; Laing et al. 1986, pp. 240–44.

11. Laing 2003, p. 25, fig. 13.

12. The 1753 *Almanach des Beaux Arts* credits Boucher with supplying "Des Pastorales pour la Manufacture de Tapisserie à Beauvais" (some Pastorals for the Tapestry Manufactory at Beauvais), while a manufactory register records the delivery of six *Noble Pastoral* cartoons from Boucher; Ananoff and Wildenstein 1976, vol. 1, p. 57, doc. 513; Badin 1909, p. 37. The factory's *Prix des Ouvrages et Compte des Ouvriers* occasionally identified the series as *Les Beaux Pastorales.* For a discussion of Boucher's pastoral pictures, see Laing 1986a, pp. 55–64.

13. J. Paul Getty Museum, inv. 71.PA.37 (*The Fountain of Love*), inv. 71.PA.38 (*The Bird Catchers*); Jaffé 1997, p. 14; Bordeaux 1976, pp. 75–101.

14. Weigert 1933, pp. 226–42; Badin 1909, pp. 37, 62; Bremer-David 2008c, pp. 312–20.

15. Zick 1965, pp. 3–47.

16. Parfaict 1756, vol. 6, pp. 69–84.

17. Favart 1763, vol. 1, p. ix; Laing et al. 1986, pp. 173–77, 233–37.

18. Bailey, Conisbee, and Gaeghtens 2003, pp. 230–31, cat. 55.

19. Favart's actress wife was known for abandoning the exaggerated, wide skirts and excessive jewelry that her predecessors on stage had preferred—even when cast as maidservants—in favor of costumes more in keeping with the characters she played. The 1756 *Dictionnaire des théâtres des Paris* noted that at the time of the 1752 production of *The Valley of Montmorency,* Madame Favart actually dressed as a shepherdess—albeit a very fashionable, well-heeled shepherdess—when playing Lisette. Two engravings, published as frontispieces, show her in shepherdess costumes for other theatricals. Parfaict 1756, vol. 6, p. 72; Favart 1763, vols. 2–3; Laing 1986b, pp. 56–72.

20. MN B-171, fols. 54–56, "woven without the royal arms" to the height of "5 4/16 Flemish ells" (or aunes and seizièmes, the premetric units of linear measure used at the Beauvais manufactory). Little is known of de Menou; see Coural and Gastinel-Coural 1992, pp. 52, 57.

21. MN B-171, fol. 54. "La pipée aux oyseaux il ne sera pas fait des bordures platte; celle du Joueur de Guittare servira" (The *Bird Catchers* will not be made with its border; that of the *Guitar Player* will serve instead). According to a condition report dated July 13, 2001, in the conservation file, Department of Textiles, the Art Institute of Chicago, the side and bottom borders, and possibly the top of the central, narrative field of *The Bird Catchers* were cut and reapplied. Furthermore, each of the four corners containing the fleur-de-lis emblem has been pieced to the borders.

22. Musée Condé, Château de Chantilly, inv. OA 3. Perhaps the guards bearing the woven signatures *A·C·C· BEAUVAIS* and *D·M· BEAUVAIS* that have been misapplied to the Gobelins tapestry from *The Story of Jason,* hanging on the opposite wall of the château's staircase, originally belonged to *The Luncheon* from this set of *The Noble Pastoral.*

23. Bremer-David 2008c, pp. 312–20; Riso Guerreiro 1970, pp. 229–37.

24. The piece formerly in Sir George Cooper's collection last sold at auction at Sotheby's, Monaco, June 22, 1986, lot 497 (315 x 700 cm). The tapestry that belonged to Georges Hoentschel was sold at Galerie Georges Petit, Paris, Mar. 31–Apr. 2, 1919, lot 363 (150 x 105 cm).

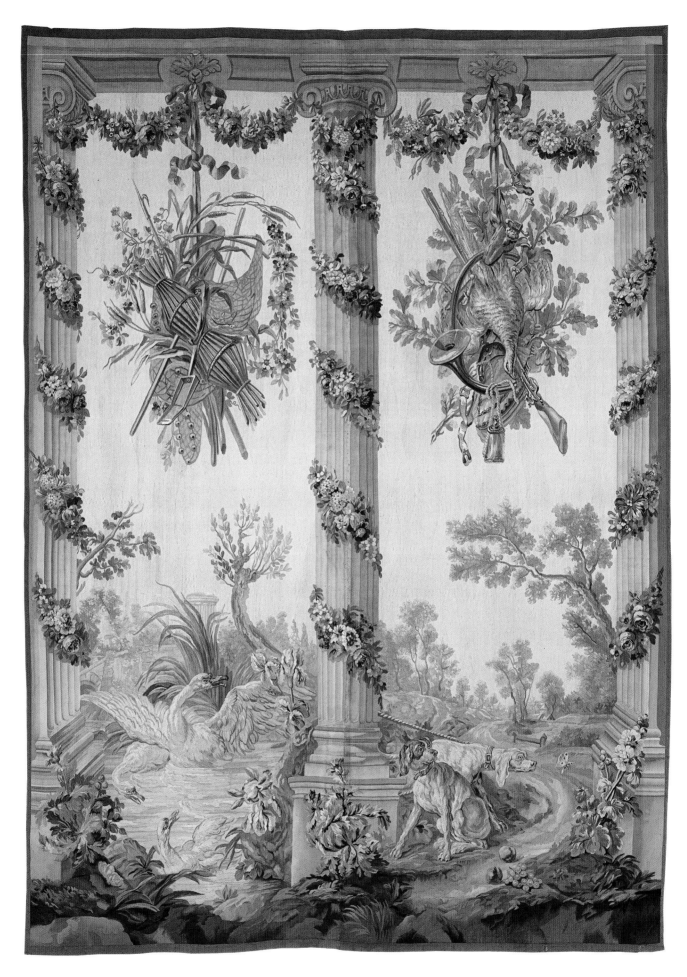

CAT. 48

From a *Porticoes* series

Beauvais or Aubusson, 1775/1800
After designs by Jean-Baptiste Oudry (1686–1755) and/or Jean-Baptiste
Marie Huet (1745–1811), or artists in their circle
Produced at an unknown workshop at the Manufacture Royale de Beauvais
or the Manufacture Royale d'Aubusson
217.8 x 295.2 cm (85¾ x 116¼ in.)
Restricted gift of Mr. and Mrs. Edward McCormick Blair, Mr. and Mrs.
Edward Cummings, Mr. and Mrs. John V. Farwell III, Mr. and Mrs. William
O. Hunt, Mrs. Richard L. Kennedy, Mr. and Mrs. Brooks McCormick, Mrs.
William F. Petersen, Mr. Solomon Byron Smith, Mr. and Mrs. William M.
Spencer, Mr. and Mrs. Theodore D. Tieken, Mr. and Mrs. George B. Young
in memory of Mr. and Mrs. Cyrus H. Adams, 1978.89

STRUCTURE: Wool and silk, slit and double interlocking tapestry weave
Warp: Count: 9 warps per cm; wool: S-ply of three Z-spun elements;
diameters: 0.7–0.8 mm
Weft: Count: varies from 24 to 52 wefts per cm; wool: pairs of S-ply of
two Z-spun elements; diameters: 0.5–0.8 mm; silk: pairs of Z-ply of two
S-twisted elements; diameters: 0.3–0.7 mm; wool and silk: paired yarns of
S-ply of two Z-spun wool elements and one Z-ply of two S-twisted silk ele-
ments; diameters: 0.5–0.7 mm

Conservation of this tapestry was made possible through the generosity of
Alice Welsh Skilling (Mrs. Raymond I. Skilling).

PROVENANCE: Leopold, Prinz Lobkowicz (died 1933), Winternitz Manor,
Bohemia, to 1933; by descent to his daughter, Mrs. Francis Schwarzenberg
(née Princess Amelie Lobkowicz), Bohemia and later Chicago, after 1945;
sold to the Art Institute, 1978.

REFERENCES: Mayer Thurman 1984.

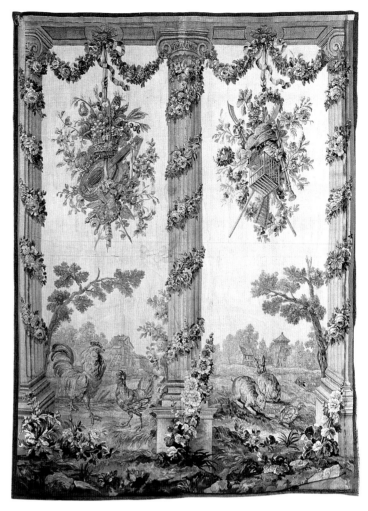

FIG. 1 A panel from a *Porticoes* series. After designs by Jean-Baptiste Oudry
and/or Jean-Baptiste Marie Huet (1745–1811), or artists in their circle. Pro-
duced at the Manufacture Royale de Beauvais or the Manufacture Royale
d'Aubusson. Wool and silk; 212.6 x 298.3 cm. Private collection, Chicago.

THIS late-eighteenth-century tapestry, like its companion piece
presently in a private Chicago collection (fig. 1), could originally
have been used as an *entrefenêtre*, a wall hanging set between the
windows of a large room (see also cats. 39a–b). Both tapestries pres-
ent an illusion of depth, as though the viewer were looking onto a
landscape through an architectural construction of Ionic pilasters
on either side of a central column. The foreground of the Art Insti-
tute's panel features a pair of hunting dogs tied in one bay and, in the
other, three swans in a pond. Related trophies are suspended from
the architrave by ribbons that terminate in bows. Above the pair of
French pointers—one of which stares intently at a butterfly—hang a
dead pheasant, a game satchel, a gun, and a hunting horn, whereas the
trophy over the swans features a fishing trap, nets, and other imple-
ments. On the right a winding road leads into the distance, where
a set of farm buildings can be glimpsed. Tall sea grasses and irises
frame the vignette with the swans; in the background beyond the
pond, a round, classically columned structure stands on a knoll. In
the privately owned companion panel, the left bay contains a rooster
and hen, and the right bay shows a pair of rabbits and a turtle. Once
again, the upper half of the composition is filled by suspended tro-

phies: a basket of flowers and a mandolin hang above the rooster and
hen, and a birdcage, a summer hat, and a trumpet hang above the
rabbits and turtle. On both pieces, intertwining ribbons and floral
garlands descend from the architrave and capitals, and matching gar-
lands, predominantly composed of hollyhocks, irises, and roses, wrap
around the columns and pilasters. Large burdocks are visible in the
immediate foreground of both tapestries, and indeed, those shown
against the bases of the pilasters are almost identical in design. Stitch-
ing down the middle of the center column in both tapestries reveals
that each panel was once cut into two vertical pieces and thereaf-
ter rejoined, perhaps after intervening sections had been removed.
The muted color palette produces an impression of lightness that is
typical of the period, even allowing for the inevitable fading that has
occurred over the years. Both tapestries are finished with a dark blue
outer guard.

The surviving examples of such so-called portico tapestries are
composed of at least fifteen different scenes, seemingly used in inter-
changeable combinations.[1] The composition of the pair of hunting

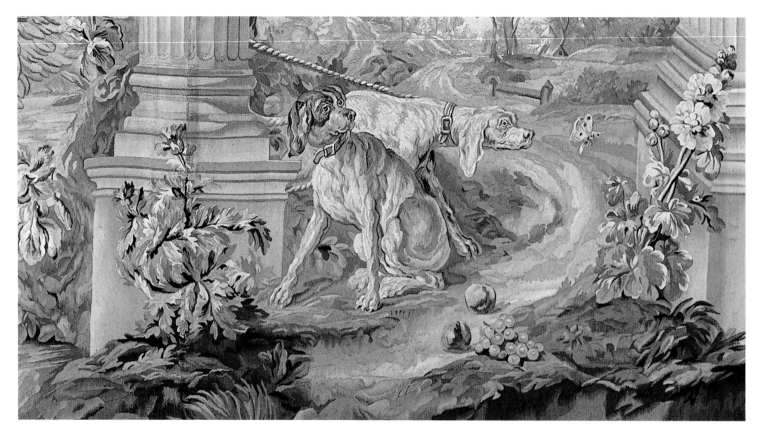

CAT. 48, DETAIL

dogs in the Art Institute's tapestry, for example, also appears in a single-bay panel once owned by P. W. French and Company, with each side framed by a garlanded pilaster.[2] In addition, a very closely related group of tapestries exists at Leeds Castle, Maidstone, Kent.[3] The Leeds group consists of nine different portico scenes contained in five separate hangings: one triple-bay panel; two double-bay tapestries; and two single-bay pieces. Today, all are installed in the Castle's dining room.[4] The triple-bay panel includes both of the scenes presented in the Art Institute's hanging, along with the rooster and hen in the Chicago private collection panel, though it is important to note that all three scenes appear in reverse (fig. 2). One of the Leeds double-bay panels shows a peacock and peahen on the right and two birds (possibly pheasants) on the left. The second double panel combines a pair of cranes opposite another set of large, crested birds, possibly peafowl. Both of these double-bay tapestries are bordered by garlanded pilasters. One of the slightly oversized single panels at Leeds Castle presents a composition of sheep with a ram set between a pair of columns, while the second single panel includes roosters and a bird trap. Stylistically, all of these *entrefenêtres* reflect a much lighter and more open style than seen during previous centuries. A series of such pieces, perhaps originally juxtaposed with wooden paneling featuring carved designs of related subjects, would have created an elegant interior.[5] Their installation in the dining room at Leeds Castle, completed in 1939, represents a fashionable pastiche of late-eighteenth-century styles. Another set of portico tapestries with the same style and arrangement of bays as the Leeds group was recently

on the market.[6] Its triple-bay panel includes, from left to right, the rabbit and turtle scene in the Chicago private collection panel, though in reverse; the pair of cranes as seen in the Leeds group; and farm animals, reversed in relation to photograph number 0243004 in the Getty Collection Photography Archive (see note 1). A double-bay panel includes the scene of a peacock and peahen on the left, as in the Leeds group, and a monkey and an unidentified animal (possibly a badger) on the right. The second double panel includes birds drinking from a birdbath on the left and the dogs seen in the Chicago panel, in reverse. One single panel depicts three goats, whereas the other single panel shows a fox and a cockerel with chicks in a landscape.

In 1984 this author described both the Art Institute's tapestry and its companion in Chicago as composites of design elements exhibiting ties to both Jean-Baptiste Oudry and Jean-Baptiste Marie Huet, and attributed their production to either the Manufacture Royale de Beauvais or the Manufacture Royale d'Aubusson.[7] Jean-Baptiste Marie Huet came from a family of artists that included his grandfather Christophe Huet I, his uncle Christophe II Huet, and his father Nicolas Huet. He trained under the animal painter Charles Dagomer, the engraver Gilles Demarteau, and later, Jean-Baptiste Le Prince.[8] At his first Salon in 1769, Huet demonstrated his aptitude for rendering animals in *Dog Attacking Geese* (Musée du Louvre, Paris, inv. 5411), a work that won him acceptance into the Académie Royale the same year.[9] Depictions of animals continued to play an important part in his paintings and his tapestry and textile designs throughout his career.

FIG. 2 The dining room at Leeds Castle, Maidstone, Kent, Great Britain, showing *Portico* panels.

FIG. 3 *Three Dogs and an Antelope in a Park, with a Dead Pheasant and Duck* (detail). Jean-Baptiste Oudry. Beit Collection, Russborough, Blessington, County Wicklow, Ireland.

The initial attribution to Huet is based on an unsigned preparatory drawing that would have preceded the cartoon from which a tapestry would have been woven. In 1962 Richard P. Wunder, then Curator of Prints and Drawings at the Cooper Union Museum for the Arts of Decoration, New York (today the Cooper Hewitt, National Design Museum), linked Huet's name to an extraordinary pre-1783 work in pen and ink with watercolor additions (fig. 4).[10] Wunder based the attribution on "the tallying of this drawing with preliminary pencil sketches for this very design that are included in a sketchbook by the artist in the Fogg Art Museum."[11] Of the five pastoral scenes sketched here—each set within a separate portico bay—two match the scenes in the Art Institute's *entrefenêtre*: the dogs to the far left of the drawing and the swans at the extreme right. It is possible that this drawing may have inspired a much larger series of portico compositions with similar numbers of animals, all consistent with the style of Huet's oeuvre and executed around 1780, the date proposed for the Art Institute's piece and another tapestry in the *Portico* series currently under discussion.[12] Indeed, Huet produced preparatory drawings that were later turned into cartoons for weavings made at Beauvais, as well as at Aubusson.[13] Huet's connection with Beauvais has been documented by Edith Standen through the suite of seven tapestries known as *Pastorals with Blue Draperies and Arabesques*.[14] Huet's drawing *The Swing* (Musée Grobet-Labadié, Marseilles) was used in conjunction with other compositions he made (namely, *The Harvest* and *Cherry Picking*) in the production of one of the *Pastorals* now in the Metropolitan Museum of Art, New York, and Jules Badin recorded that the Huet cartoons were available in 1780 when the first suite of this series was woven.[15] Produced at Beauvais under the directorship of de Menou, who was active there from 1780 to 1793, the various panels of this series clearly connect landscape, foliage, and garlands in a manner related to the Cooper Hewitt drawing.

Huet made many prints based on the work of other artists, both earlier and contemporary, as teaching tools for his students, and throughout his career he repeatedly recycled motifs within his drawings, paintings, and tapestry and textile designs.[16] His involvement in textiles was greatest at the famous Manufacture de Jouy-en-Josas, near Versailles, where in 1783 he was named chief designer.[17] Huet's reuse of motifs can be seen in the pair of hunting dogs in the Art Institute's tapestry, which can be found in a textile design from Jouy-en-Josas, attributed to Huet and his school, in which the animals are shown in reverse and the country landscape has been replaced with hunting scenes.[18] In addition, Huet may have borrowed designs from Christophe II Huet: the pendant trophies, for example, are reminiscent of two chalk on paper drawings attributed to his uncle: *Trophy with Attributes of the Hunt* (inv. 1959/2.63) and *Trophy with Musical Instruments* (inv. 1959/2.80). Now in the University of Michigan Museum of Art, Ann Arbor, both employ ribbons similar to those in the tapestries.[19]

In spite of the very solid connections between Huet and the *Portico* series, the influence of the earlier master Jean-Baptiste Oudry cannot be discounted. Trained by the painter Nicolas de Largillière, Oudry specialized in historical subjects and portraiture, before being

FIG. 4 *Project for Tapestry Dedicated to Farm Life*. Jean-Baptiste Marie Huet, 1780/95. Pen and black ink, brush and watercolor, on off-white laid paper; 19.7 x 37.7 cm. Cooper Hewitt, National Design Museum, Smithsonian Institution, New York. Purchased for the Museum by the Advisory Council, 1911-28-142.

appointed artistic supervisor of Beauvais in 1726, and then codirector in 1734. His appointment as director, which marked Beauvais's most important period of production, literally saved the manufactory from extinction.[20] In the words of Voltaire, Beauvais was "the kingdom of Oudry."[21] As his paintings and drawings reflect, Oudry created tapestry designs showing animals and landscapes, as, for example, in the series *The Fables of La Fontaine* and in various verdure tapestries.[22] His oeuvre consists of a rich body of work connected to the skillful draftsmanship of the animals in the Art Institute's tapestry and its companion panels.[23] Related animal designs also appear on furniture coverings, especially tapestry-woven upholstery panels attached to chairs and sofas.[24]

One painting in particular directly links Oudry's work and the portico panel in the Art Institute: the original source of the two dogs in the tapestry is the painting *Three Dogs and an Antelope in a Park, with a Dead Pheasant and Duck*, now at Russborough, Blessington, County Wicklow, Ireland (fig. 3).[25] Most likely, the design of the dogs in the tapestry was derived directly from the engraving *Les Chiens en Arrêt*, executed by Gabriel Huquier after Oudry's painting.[26] The engraving retains the same composition as the painting, but also adds a large stag to the hunting trophy hanging from a column. The same pair of dogs can be found in a number of Beauvais tapestry designs that were used for armchairs during the time of Louis XVI.[27] Notably, however, the background of the original painting by Oudry has

been changed: the antelope, the dead fowl, and the substantial stone wall have been removed and replaced by a country scene with a winding road, like that in the Art Institute's piece. Although stylistically and thematically similar to the *Portico* tapestries, the other designs of the armchair group do not match any of the scenes in this group of hangings.

Although the three-swan design in the *entrefenêtre* in the Art Institute cannot be traced to any single work by Oudry, there exist a number of closely related paintings, including *Water Spaniel Attacking a Swan* (1740; Swedish Embassy, Paris), *Swan Attacked by a Dog* (1745; North Carolina Museum of Art, Raleigh, inv. 52.9.131), and *Mastiff Attacking Swans* (1731; Musée d'Art et d'Histoire, Geneva).[28] These canvases, together with related drawings, make apparent the immense influence Oudry exerted upon a great many artists who succeeded him, including Huquier, Jacques-Philippe LeBas, or most importantly, Gilles Demarteau, who around 1765 commissioned François Boucher, Jean-Honore Fragonard, and the twenty-two-year-old Huet to carry out an "interior design program" for his Parisian salon on the rue de la Pelleterie on the Île de la Cité.[29] After Oudry died in 1755, his oeuvre continued to exert such influence over this circle of artists that it often cannot be definitively determined which artist is responsible for which pieces. Additionally, a number of engravings were created after Oudry's paintings, offering designs that were utilized by artists in media other than painting.[30]

Another crucial but thorny issue regarding the *Portico* tapestries is their place and date of manufacture, because both Manufactures Royale, at Beauvais and Aubusson, rivaled each other in quality of production when these pieces were woven.[31] When de Menou succeeded Andre-Charlemagne Charron (director 1754–1780) at Beauvais, he continued to manage the manufactory at Aubusson. Menou's success at the latter may have very well been in part the result of his using the numerous designs that had been purchased for Beauvais, which could easily have included the Huet compositions under discussion—with the result that the two *entrefenêtres* now in Chicago could have as easily been woven at Aubusson as at Beauvais.[32] Furthermore, certain designs were woven simultaneously at both Beauvais and Aubusson during de Menou's directorship.[33] It thus seems that a complex series of unanswered questions still surround these *Portico* panels. CCMT

NOTES

1. Over the years, various tapestries of this type have appeared on the market. On July 5, 1985, Sotheby's London sold a double-bay panel (lot 4) similar in size to the Art Institute's piece, with one scene of a peacock and peahen and another of farm animals that matches a single panel from a photograph (GCPA 0243004) in the Getty Photo Study Database. A double-bay panel that matches the Chicago private collection piece (fig. 1) in everything but dimension was sold at Sotheby's, New York, Jan. 13, 1995, lot 1225 (ill.). Two slightly different triple-bay versions of the portico series were in the collections of Jean Gismondi as of 1988, and the Galerie Chevalier as of 2004. The organization of their overall composition is essentially the same as that of the *entrefenêtre* in Chicago, but with differences in the hanging trophies, especially the treatment of the ribbons; in the modeling of the fluted columns; and in the pilasters. The Gismondi piece presents the peacock and peahen scene in its left bay, a doe and a buck in the center, and a pair of roosters and a trap in the right bay. This tapestry has been described as being in the style of Jean-Baptiste Marie Huet, woven at Aubusson about 1780; Bertrand, Chevalier, and Chevalier 1988, p. 177 (ill.). The Galerie Chevalier example includes a scene of two quail, a hawk killing a hare, and a hen with her chicks. It is unclear whether the variations in the treatment of the architectural elements and other details result from a later interpretation of the portico style or from their having been woven simultaneously at different workshops with different arrangements of animals.
2. GCPA 0243008.
3. The pieces were the property of Lady Baillie until 1974; since that time ownership has passed to the Leeds Castle Foundation. They were purchased in 1939 from the decorating firm Jansen, Paris, and sent to Lady Baillie's London home on Grosvenor Square; invoice no. 21.05 from Jansen, dated Paris, Jan. 20, 1939. Stephane Boudin, then the president of Jansen and an internationally known interior decorator, designed the dining room at Leeds Castle in 1936. Information from David Cleggett, historian at the Leeds Castle Foundation, June 2005, indicates that the panels may have come from either the Hotel Rohan, Vienna, or the Palais Royal, Paris.
4. Marian Strachan, Leeds Castle, England, e-mail message and letter to author, May and June 2004.
5. See Seligmann Collection, stock no. 13.058; photocopies of such carved wooden panels are on file at the Getty Research Institute, Los Angeles.
6. Christie's, London, Nov. 8, 2007, lots 215–17. Before that, the tapestries were purchased in France by Chancellor Robert R. Livingston (died 1813), and descended through his family until they were offered for sale at Parke-Bernet Galleries, New York, Mar. 11, 1961, lots 413–17, from the estate of Angelica Livingston Gerry (died 1960).
7. Mayer Thurman 1984.
8. Hug 2002, p. 57; Rosenberg 1975, pp. 45–46.
9. I am most grateful to Starr Siegele, Adjunct Curator of Prints at the Allentown Art Museum, who, in unpublished research she has conducted over the years, first introduced me to this and other images and to the interconnections among their respective artists.
10. Wunder's dating of the drawing (inv. 1911–28–142) is based upon the year of Huet's appointment at Jouy-en-Josas, "when he was obliged to give up all other commissions"; Wunder 1962, p. 101, fig. 49.
11. Wunder 1962, p. 101, cat. 49. The sketchbook Wunder refers to at the Fogg Art Museum, Harvard University Art Museums (inv. 1955.136), is catalogued as by an anonymous eighteenth-century artist, and has been associated variously with Charles-Nicolas II Cochin, Jean-Charles Delafosse, and Huet, but not Jean-Baptiste Oudry.
12. Mayer Thurman 1984; Bertrand, Chevalier, and Chevalier 1988, p. 177.
13. Bertrand, Chevalier, and Chevalier 1988, pp. 175–76.
14. Standen 1985, vol. 2, pp. 557–63.
15. Ibid., p. 558 (inv. 53.211); Badin 1909, p. 63. See also Coural and Gastinel-Coural 1992.
16. Again, I am grateful to Starr Siegele for information regarding Huet's career.
17. Clouzot 1928, pp. 34–35; see also Fikioris 1970, p. 75.
18. Guérinet n.d., pl. 79.
19. For examples of hanging trophies attributed to Jean-Baptiste Marie Huet, see Gabillot 1892 and inv. 1993.248.1807 in the Art Institute of Chicago. Additionally, in the panel owned by French and Company (GCPA 0243004), one of the farm animals resembles one of the goats in *Landscape with Goats*, a 1735 painting by Christophe Huet in the Musée Condé, Chantilly, inv. RMN270021.
20. Weigert 1962, p. 129.
21. Ibid.
22. Bertrand, Chevalier, and Chevalier 1988, pp. 151–53, 155–56.
23. See, for example, a work in the Fogg Art Museum, Harvard University Art Museums (inv. 1955.136), and also Opperman 1977 and Droguet, Salmon, and Véron-Denise 2003.
24. Standen 1985, vol. 2, pp. 484–98.
25. See Brown 1984, p. 22, and Droguet, Salmon, and Véron-Denise 2003.
26. See Bellaigue 1965, p. 247, fig. 39. In addition, this print was utilized in a drop-front secretary in a private collection (Ibid., p. 247, fig. 37).
27. Badin 1908, pl. 71.
28. For the painting in the Swedish embassy, see Droguet, Salmon, and Véron-Denise 2003, p. 130, fig. 47a, and for the painting in Geneva, see Opperman 1983, p. 60, fig. 32. Drawings of the same subject can be found in the Art Institute of Chicago (c. 1740; inv. 1966.351); and the Cooper Hewitt National Design Museum, New York (inv. 1942–67–1).
29. See Wilhelm 1975, pp. 6–20.
30. For a list of engravings after Oudry's works, see Opperman 1977, vol. 1, pp. 270–304.
31. Bertrand, Chevalier, and Chevalier 1988, p. 177, attributes a tapestry from a "portico" series from the Gismondi collection to Aubusson.
32. Badin 1908, p. 38, and Bertrand, Chevalier, and Chevalier 1988, p. 175.
33. Bertrand, Chevalier, and Chevalier 1988, p. 175.

Apollo Exposing Mars and Venus to the Ridicule of the Olympians from *Ovid's Metamorphoses*

Possibly Aubusson, c. 1650
After a design by an unknown artist
Produced at an unknown workshop
400.5 x 306.7 cm (157½ x 120¾ in.)
Gift of Mr. and Mrs. Benjamin Beris, 1956.102

STRUCTURE: Wool and silk, slit and double interlocking tapestry weave
Warp: Count: 4 warps per cm; wool: S-ply of two Z-spun elements; diameters: 0.8–1.0 mm
Weft: Count: varies from 16 to 32 wefts per cm; wool: single Z-spun elements; S-ply of two Z-spun elements; diameters: 0.4–1.5 mm; silk: S-ply of two Z-twisted elements; diameters: 0.3–0.5 mm; wool and silk: paired yarns of S-ply of two Z-spun wool elements and one S-ply of two Z-twisted silk elements; diameters: 0.7–2.0 mm

AN amorous couple reclines on a blanket in a densely wooded land-scape. They are addressed by a man standing on a cloud in the top right corner of the tapestry. As the beams of light radiating from his head reveal, he is Apollo, the god of the sun. Behind him five other gods witness the scene. They can be identified as, from left to right, Pluto, the lord of the dead and ruler of the underworld, holding a bident; Mercury, the god of trade and profit and the messenger of the gods, with a caduceus and winged hat; Bacchus, the god of agriculture and wine, who wears an ivy wreath; a god who cannot be identified as he is shown without attributes; and, finally, Neptune, with a trident. In the left foreground a man holds a piece of cloth. Cupid, the god of love and Venus's son, is shown in the right foreground, his bow and quiver at his feet. He looks at a shield decorated with a gorgon's head, and wears an oversized helmet and sword. The size of the arms reveals that they are not his. The border of the tapestry is filled with flowers and fruit, and vases appear in the bottom corners.

When this piece entered the Art Institute's collection in 1956, it was attributed to Oudenaarde or Aubusson, and no specific date of manufacture was proposed.[1] The border, however, suggests that the piece was produced around 1650. Its color scheme, dominated by yellow and green, and its rather coarse execution corroborate the assumption that it was woven in a minor production center. Tapestries with similar borders and colors are usually attributed to Aubusson.[2] Nonetheless, as Aubusson tapestries of the first half of the seventeenth century still await thorough study, at this point the attribution remains tentative.[3]

While the tapestry was presumably woven around the middle of the seventeenth century, various stylistic features of the scene suggest that the cartoon was made earlier, possibly around 1620 or 1630. The exaggeratedly muscular and stocky figures, the large hands, the pointed mustache of the man in the left foreground, and the exotic costume of the reclining woman indeed correspond to European

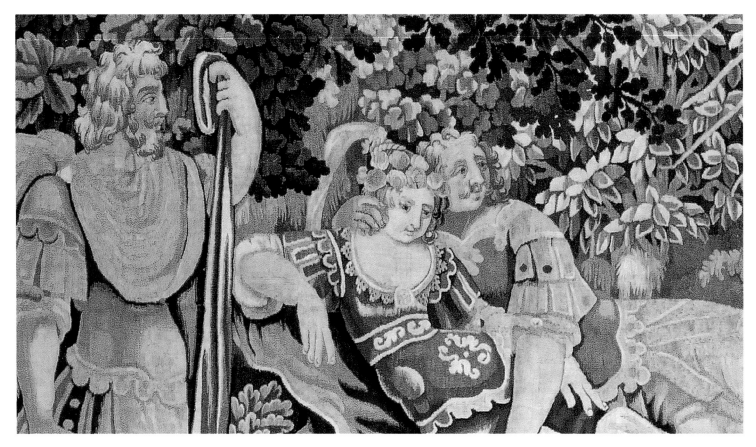

CAT. 49, DETAIL

paintings and tapestry designs of the first quarter of the seventeenth century (see also cat. 17),[4] whereas they differ markedly from the elongated figures and fluttering robes that characterize Aubusson sets designed after 1650.[5]

In 1956 the tapestry was provisionally titled *Lovers and Gods*. In 2004 Nicole de Reyniès identified the reclining lovers as Rinaldo and Armida, characters in Torquato Tasso's famous epic poem *Gerusalemme Liberata* (Jerusalem Delivered, 1581).[6] But this identification must be rejected, for *Jerusalem Delivered* does not include a scene in which Apollo addresses the couple. Rather, the tapestry depicts *Apollo Exposing Mars and Venus to the Ridicule of the Olympians*, a well-known episode included in Ovid's *Metamorphoses* (book 4, 167–89). Mars, the god of war, and Venus, the goddess of love and wife of the god Vulcan, had an affair. Apollo discovered the relationship and informed the cuckolded husband. Vulcan decided to set a trap and made a net with which he caught the guilty lovers, then angrily summoned the other gods to witness the betrayal. The tapestry in the Art Institute combines the different parts of the story in one scene: Apollo surprises Venus and Mars (the arms in the foreground belong to the god of war) as Vulcan, the man on the extreme left, approaches the lovers with a cloth, and the other deities look on in amusement.

The *Metamorphoses* (before A.D. 8), a compilation of stories of transformations derived from ancient literature and mythology,[7] was one of the most popular books in Europe and the prime source

of subjects for most secular art until the later eighteenth century.[8] During the late Middle Ages and the Renaissance, the metamorphoses it described were usually interpreted as religious metaphors and didactic examples. The Dutch artist Maarten van Heemskerck, for example, made a series of paintings of Apollo exposing Mars and Venus to the ridicule of the Olympians that has distinct moralizing implications.[9] From about 1550 on, however, Ovid's tales were also read as amusing love stories, and the episode of *Apollo Exposing Mars and Venus* could also be treated as farce, as in Tintoretto's *Venus Surprised by Vulcan* (1551/52).[10] The line between moralizing and decoration should probably not, however, be drawn too sharply.[11] Thus, the *Apollo Exposing Mars and Venus* in Chicago can be understood as an image of both instruction and entertainment.

Pascal-François Bertrand and de Reyniès have demonstrated that Aubusson tapestry designers working in the first half of the seventeenth century borrowed heavily from contemporary prints.[12] Popular Aubusson and Felletin sets such as *The Story of Ariane* (c. 1640), *The Story of Jeanne d'Arc* (c. 1650), and *The Story of Alaric* (c. 1660) weare copied from, or largely based on, prints illustrating popular books.[13] Given the numerous illustrated editions and translations of the *Metamorphoses* published before 1620 or 1630, when the *Apollo Exposing Mars and Venus* cartoons were created, it is not surprising that the anonymous designer also based his composition on a print.[14] The artist's specific source, however, is comparatively obscure. Though

FIG. 1 *Apollo Exposing Mars and Venus to the Ridicule of the Olympians*. After Hendrik Goltzius, 1615. Engraving, on paper; 16.8 x 25 cm. British Museum, London, 1947–4–12–3 (50).

the prints Bernard Salomon made for the *Métamorphose d'Ovide figurée* (Lyon, 1557) and the sheets Antonio Tempesta made for another edition published in Antwerp in 1606 were by far the most influential illustrations, inspiring artists well into the seventeenth century,[15] the cartoonist of the Art Institute's *Apollo Exposing Mars and Venus* did not borrow from either of these sources, but instead used an anonymous engraving (fig. 1) after the Dutch Mannerist draughtsman, painter, and printmaker Hendrik Goltzius.[16] The Goltzius engraving belongs to a series of fifty-two sheets illustrating Ovid's poem.[17] The first forty sheets were published in 1589 and 1590; the last twelve sheets, including the engraving of *Apollo Exposing Mars and Venus to the Ridicule of the Olympians*, were issued in 1615, thus providing a *terminus post quem* for the creation of the cartoon.[18]

The most obvious difference between the tapestry and the print is the reversal of the composition, but this can easily be explained by the fact that the tapestry was woven on a low-warp loom. The cartoonist faithfully copied Mars, Venus, Vulcan, and the group of gods, but whereas Goltzius drew the figures naked, the tapestry designer dressed them in suits of armor, exotic costumes, and tunics. The unusual headgear worn by Venus in the tapestry cannot be found in the print but is presumably borrowed from other sheets in the series.[19] The tapestry designer altered a number of other elements as well, including the setting of the scene, which he moved from Vulcan's house to the outdoors.[20] He also changed Cupid's pose: whereas Goltzius's Cupid is about to shoot an arrow and thus actively participates in the drama, the tapestry shows him facing away from the other characters, frolicking and playing with Mars's weapons. A putto wearing the god of war's enormous helmet was a popular Renaissance motif—see, for example, Botticelli's famous *Venus and Mars* (c. 1485) in the National Gallery, London—and was revived by Van Dyck in his *Venus at the Forge of Vulcan* (1630/32), now in the Kunsthistorisches Museum, Vienna.[21]

As in most European production centers, during the seventeenth century mythological tapestries were woven in great quantities at Aubusson.[22] It can be assumed that *Apollo Exposing Mars and Venus* formed part of an *Ovid's Metamorphoses* series, but additional research is required to shed more light on the composition of the set.

KB

NOTES

1. Object file 1956.102, Department of Textiles, the Art Institute of Chicago.
2. Bertrand, Chevalier, and Chevalier 1988, pp. 39–53.
3. At the end of the nineteenth century the Aubusson-based historian Cyprien Pérathon published lists of artists and tapestry producers who worked in the Marche region between approximately 1600 and 1650. See Pérathon 1883, Pérathon 1887–90a, and Pérathon 1887–90b. After Pérathon's death, Louis Lacrocq prepared a study on Aubusson tapestries, but it was unfinished at the time of Lacrocq's own death in 1940; Riou 2002, p. 87.
4. Bertrand, Chevalier, and Chevalier 1988, pp. 39–53.
5. Aubusson tapestry production after 1650 was dominated by the work of the French painter and tapestry designer Isaac Moillon (1614–1673); Reyniès and Laveissière 2005. See also Brosens and Delmarcel 2005.
6. Nicole de Reyniès, fax to Christa C. Mayer Thurman, Dec. 21, 2004; object file 1956.102, Department of Textiles, the Art Institute of Chicago.
7. Ovid based the story of *Apollo Exposing Mars and Venus* on Homer's *Odyssey* (book 7, 266–365).
8. Llewellyn 1988, p. 151.
9. See Veldman 1973 and Stadnichuk 1996.
10. Lord 1970; Pallucchini and Rossi 1982, vol. 1, pp. 163–64, cat. 155; vol. 2, p. 384, fig. 204. Tintoretto's *Venus Surprised by Vulcan* is now in the Alte Pinakothek, Munich.
11. Llewellyn 1988, p. 155.
12. Bertrand, Chevalier, and Chevalier 1988, pp. 39–53; Reyniès 2002, p. 70.
13. Bertrand, Chevalier, and Chevalier 1988, pp. 39–53. For *The Story of Alaric*, see Mathias 1996.
14. Henkel 1926–27; Amielle 1989.
15. Henkel 1926–27, pp. 77–81, 87–95, 100–04, 112–14. For Salomon, see also Sharratt 2005, pp. 258–63, 493–500, figs. 208–25. For Tempesta, see Leuschner 2005.
16. For Goltzius, see Falkenburg et al. 1991–92, and Leeflang and Luijten 2003.
17. Strauss 1978–, vol. 3, pp. 313–37; Strauss 1978–, vol. 3, pp. 354–60. Henkel 1930, pp. 115–17, discussed the series briefly and deprecatingly.
18. Goltzius had already designed a version of the scene around 1585; this earlier composition is more Mannerist compared to the version published in 1615; Reznicek 1961, vol. 1, pp. 271–72, cat. 105; vol. 2, figs. 47, 48; Leeflang and Luijten 2003, pp. 50–53, cat. 13.
19. For example, *The Dispute between Jupiter and Juno* and *Tiresias, Having Been Changed into a Woman and Back into a Man, Answers the Question* show women wearing very similar little crowns with long veils. See Strauss 1978–, vol. 3, pp. 335, 336, figs. 76, 77.
20. Though both Homer and Ovid set the story in Vulcan's house, depictions of the scene made around 1600 occasionally placed Mars, Venus, and the other Olympians in an outdoor setting; Angulo Iñiguez 1960, pl. 2, figs. 1–2.
21. Wheelock, Barnes, and Held 1990, pp. 233–35, cat. 58.
22. Pérathon 1894b, pp. 500–42, passim; Pérathon 1899, pp. 570–71.

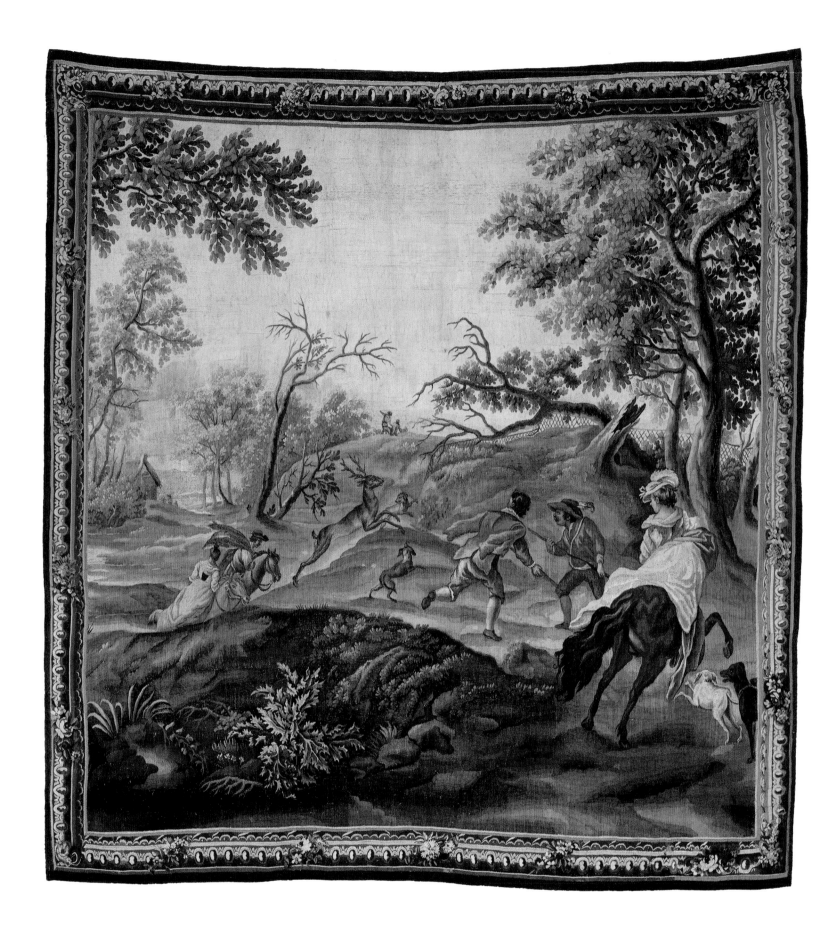

CAT. 50

The Stag Hunt from *Pastoral Hunting Scenes*

Aubusson, c. 1775
After a design by an unknown artist, c. 1766
Presumably produced at the workshop of Léonard Roby
(active c. 1750–c. 1789)
268.6 x 281.62 cm (105¾ x 110⅞ in.)
Gift of Mrs. Alice Patterson, 1958.523

STRUCTURE: Wool and silk, slit and double interlocking tapestry weave.
Warp: Count: 6–7 warps per cm; wool: S-ply of three Z-spun elements;
diameters: 0.8–0.9 mm
Weft: Count: varies from 18 to 32 wefts per cm; wool: single S-spun
elements; pairs of single Z-spun elements; S-ply of two Z-spun elements;
pairs of S-ply of two Z-spun elements; diameters: 0.5–1.2 mm; silk: pairs
of S-ply of two Z-twisted elements; diameters: 0.6–0.8 mm; wool and silk:
paired yarns of a single Z-spun wool element and S-ply of two Z-twisted silk
elements; diameters: 0.5–0.7 mm

Conservation of this tapestry was made possible through the generosity of
the James Tigerman Estate.

THIS tapestry illustrates a stag hunt in an autumn landscape. Two
yapping dogs chase the stag toward two hunters armed with spears.
In the right foreground, a woman on horseback is accompanied by
two dogs, and in the background on the left a man and woman are
also on horseback. The border imitates a late-eighteenth-century pic-
ture frame adorned by flowers.

The Stag Hunt is part of an Aubusson set depicting pastoral hunt-
ing scenes. The series still awaits thorough study, but Pascal-François
Bertrand briefly discussed it in 1988 and his research provides the
key to a more detailed analysis.[1] Bertrand discovered a document
revealing that, in 1766, "Léonard Roby le Jeune, marchand fabri-
cant et tapissier à Aubusson" (Léonard Roby the Younger, Aubusson
dealer-manufacturer and tapissier) acquired "six tableaux de chass-
es d'après Wouverman [sic] et Van Falens" (six paintings of hunts
after Wouwerman and Van Falens).[2] Léonard Roby, who was active
between about 1750 and 1789, was one of the most important tapes-
try producers in Aubusson during the second half of the eighteenth
century. In 1788 Roby, who also executed the *Outdoor Market* that
is now in the Art Institute (cat. 52) and who wove tapestries of the
Amusements champêtres series (see cat. 51), was described as "un des
plus intelligents et des plus zélés" (one of the most intelligent and
industrious) tapissiers.[3]

Unfortunately, the 1766 document does not reveal the name of the
cartoon painter who executed the hunting scenes "after Wouwerman
and Van Falens." It is known that Roby's brother François, as well
as the latter's son François II de Faureix (1744–1820), were tapestry
designers, but as their oeuvre has not yet been studied, it is impos-
sible to attribute the set to which the Chicago *Stag Hunt* belongs
to either painter.[4] Bertrand, however, identified two scenes of the
series as well as the engravings on which they were based. One scene

FIG. 1 *La chasse à l'italienne* (The Hunt in the Italian Manner). Jacques
Philippe Lebas after Philips Wouwerman, 1739. Engraving, on paper; 41.5 x
60 cm. Royal Library of Belgium, Brussels, S.I. 34276.

is *The Stag Hunt*, based on an engraving titled *La chasse à l'italienne*
(The Hunt in the Italian Manner) by the leading French print seller
Jacques Philippe Lebas (1707–1783).[5] The engraving was made in
1739 "d'Après le Tableau original" by the seventeenth-century Dutch
painter and draughtsman Philips Wouwerman (1619–1668, fig. 1).[6]
The painting was in a French private collection from 1722 until 1742,
when it was acquired by August III, Elector of Saxony and King of
Poland, who was an enthusiastic collector of Wouwerman's work.[7]
The second scene Bertrand identified shows *Falconers Resting*, and
is based on an engraving called *Rendez-vous de chasse* (Hunting Ren-
dezvous) made in 1740, also by Lebas, after a painting by Karel (or
Charles) van Falens (1683–1733), a painter born in Antwerp but who
made his career in Paris.[8] The painting was in the possession of Van
Falens's widow when Lebas issued the engraving.[9]

A substantial number of *Stag Hunt* and *Falconers Resting* tapes-
tries are known, as they have appeared frequently on the art market,
and continue to do so.[10] This ubiquity reveals the original popularity
of the series. Fortunately, most of these pieces surfaced together with
companion tapestries, so it is possible to identify the other scenes
composing the series. A *Falconers Resting* tapestry that was on the
American art market in the first half of the twentieth century may
have belonged to the same suite as the *Stag Hunt* in the Art Institute,
for their borders and height are nearly identical (fig. 2).[11] Another
Falconers Resting piece was in the stock of French and Company,
together with a tapestry from the same suite, *Departure for the Hunt*
(fig. 3).[12] This scene is also based on an engraving by Lebas, which
was made in 1742 after a painting by Van Falens.[13] The painting was
in the collection of Heinrich, count von Brühl, a German statesman
in the service of August III. Van Falens's *Departure for the Hunt* can
presumably be identified with a painting that appeared on the art
market in 1999.[14]

In 1951 French and Company acquired another suite of the series,
which included *Falconers Resting*, *Hunters Resting*, and two addi-
tional scenes from the series: *A Hunting Couple* (fig. 4) and *The*

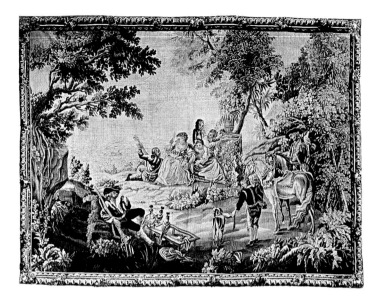

FIG. 2 *Falconers Resting*. Aubusson, c. 1775. Wool and silk; 247 x 332 cm. Location unknown.

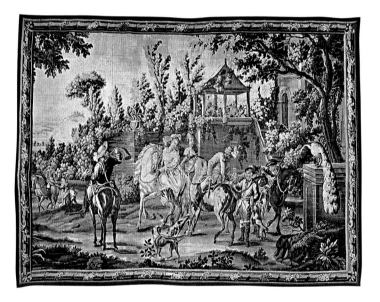

FIG. 3 *Departure for the Hunt*. Aubusson, c. 1775. Wool and silk; 226.1 x 304.5 cm. Location unknown.

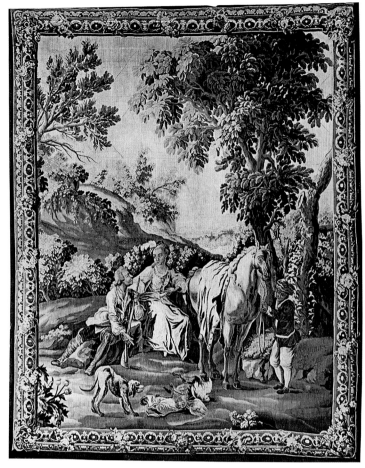

FIG. 4 *A Hunting Couple*. Aubusson, c. 1775. Wool and silk; 315 x 256.5 cm. Location unknown.

Heron Hunt (fig. 5).[15] The last two scenes are based on engravings by Lebas after paintings by Van Falens that were also in Brühl's collection. Lebas's *A Hunting Couple*, issued in 1745, bears the title *Le Chasseur fortuné* (The Fortunate Hunter).[16] The title may allude to the dead birds at his feet or to the fact that he managed to arouse the admiration of his female companion. *The Heron Hunt* is based on an engraving called *La Prise du heron* (The Capture of the Heron), made in 1741.[17]

The sixth and final scene of the series remains unknown.[18] If the cartoon designer based his compositions on the Lebas catalogue, he would have been obliged to borrow from a Wouwerman sheet, for Lebas issued no more than four engravings after paintings by Van Falens. Possibly the sixth scene was based on *The Wild Boar and Bear*

Hunt engraving made in 1741 after a painting that was in a French private collection until August III acquired it in 1749.[19]

The reconstruction of the set shows that it depicts peaceful and idyllic episodes before, during, and after the hunt, rather than heroic scenes of furious activity—hence the title, *Pastoral Hunting Scenes*. The delicate imagery and fragile style of the series epitomize the idealized depiction of everyday events that was so popular with the upper class and thus dominated eighteenth-century French art. This fashion emerged around 1690 to 1700 and was promulgated by artists who clearly aimed to break with tradition, as revealed by the contemporary name for their work, the *goût moderne* or *goût du temps*—now known as the Regency or Rococo style.[20] Painters working in the manner favored the so-called *petits* (lower) *genres*, such as decorative scenes of army camps, contemporary pastimes, the hunt, and peasant life, as well as landscapes, over the traditionally higher historical and religious genres. This eighteenth-century vogue triggered renewed interest in a number of Dutch and Flemish artists of the previous century who had specialized in detailed, stylized, small-scale *petits genre* paintings. Between about 1690 and 1770 peasant scenes by and after David II Teniers (1610–1690) were extremely popular on the French art market (see cats. 25–26), just like the army

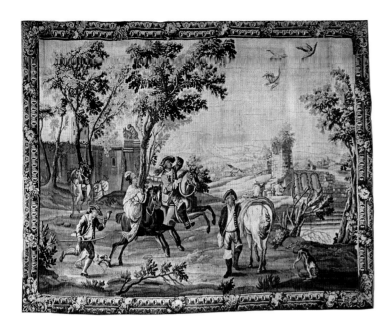

FIG. 5 *The Heron Hunt*. Aubusson, c. 1775. Wool and silk; 208.3 x 254 cm. Location unknown.

and hunting scenes by and inspired by Wouwerman.[21] Not only original paintings but also painted copies and, above all, engravings fed the collecting mania that gripped the Parisian upper class. Lebas's catalogue included about one hundred sheets after Teniers, as well as fifteen engravings after paintings by Wouwerman.[22] In addition, between 1733 and 1759, Jean Moyreau, another significant Parisian print publisher, issued no fewer than eighty-nine prints after works by Wouwerman.[23]

Early-eighteenth-century French painters capitalized on the popularity of the Dutch and Flemish lower genres, not only making paintings in the manner of Teniers and Wouwerman, but also inventing and developing a new yet closely related *petit genre*, the *fête galante*. This genre documents the pastoral and seemingly unconstrained—but in reality calculated and codified—leisure activities of the French aristocracy and bourgeoisie.[24] Today artists such as Antoine Watteau, Nicolas Lancret, and François Octavien are widely recognized as the leading proponents of this pastoral rococo imagery, whereas Charles van Falens is hardly known.[25] Yet in the first third of the eighteenth century, Van Falens was a renowned *petit genre* painter. In 1716 he entered the service of Philippe II, Duke of Orléans, as a restorer. Eight years later he was appointed court painter to Louis XV of France—an avid hunter who prized paintings and tapestries depicting his favorite pastime.[26] After Van Falens's death in 1733, the *Mercure de France* published an obituary revealing that the artist, who not only created paintings in the manner of Wouwerman, but also produced nearly exact copies of the earlier artist's work, was recognized as a true heir to the tradition Wouwerman forged: "Il n'a fait que de petites figures, des animaux et du paysage, dans le goût de Berghem et de Wouvreman [*sic*]" (He only painted small figures, animals, and landscapes, in the manner of Berchem and Wouwer-

man).[27] The *Pastoral Hunting Scenes* reveal Van Falens's posthumous eighteenth-century fame, as do Sèvres artists' use of his compositions around 1760.[28]

The popularity of the *petits genres* in the eighteenth century is also evident in contemporary European tapestry. Numerous workshop managers in Europe produced sets depicting Teniers (see cats. 25–26); various Brussels tapissiers wove sets of *The Art of War* inspired by the *genre militaire* in which Wouwerman often worked; the Brussels tapestry entrepreneurs Hieronymus Le Clerc (1643–1722) and Gaspard (Jasper) van der Borcht ("A Castro"; 1675–1742) produced a *Hunting* series influenced by Wouwerman; and in Spain Flemish émigrés made a series entitled *Cacerías a lo Wouvermans* (Hunts in the Manner of Wouwermans).[29] Meanwhile, the leading Brussels tapestry designer Jan van Orley (1665–1735) created a number of sets in which he adapted his essentially late-seventeenth-century *grand gout*, or monumental style, to the new taste for the pastoral *petit genre*.[30]

In particular, the French *fête galante* was also translated into tapestry. Around 1730 the Brussels tapestry designer Philippe de Hondt (1683–1741) borrowed heavily from prints after Lancret and Octavien to create his successful sets of *The Continents* and *The Elements*.[31] Around 1750 the London furniture and tapestry producer William Bradshaw (1700–1775) made a *fête galante* set that was also based on French prints after Watteau and his circle.[32] In the 1740s and 1750s the Beauvais workshops produced sets after François Boucher (1703–1770), who built on Van Orley's fusion of *grand goût* style and pastoral imagery. Boucher's *Noble Pastoral* series (see cat. 47) served as the model for a similar set of cartoons commissioned by Léonard Roby in 1760. Thus, *Pastoral Hunting Scenes* can be regarded as yet another example of the artistic interchange between Flemish and French painting and tapestry design so common in the eighteenth century. Incorporating the vocabulary of the *fête galante* into the popular *genre de chasse*, the set must have appealed to a broad European public. KB

NOTES

1. Bertrand, Chevalier, and Chevalier 1988, pp. 161–63.
2. ANP, F12 1459A, dossier 17; Bertrand, Chevalier, and Chevalier 1988, p. 193, cat. 52.
3. Gravier 1886, p. 196. For Roby, see also Pérathon 1887–90b, p. 240, and Bertrand, Chevalier, and Chevalier 1988, pp. 160–64, 193–94.
4. Gravier 1886, p. 196. See also Bertrand, Chevalier, and Chevalier 1988, pp. 122, 137, 139, 160, 172, 173, 179, 189.
5. The engraving is illustrated in Bertrand, Chevalier, and Chevalier 1988, p. 163. For Lebas and the engraving after Wouwerman, see Sjöberg and Gardey 1974, pp. 78–87, 266, cat. 500.
6. For Wouwerman, see Duparc 1993 and Schumacher 2006.
7. Schumacher 2006, vol. 1, pp. 233–34, cat. A160; vol. 2, pl. 151. The painting disappeared during World War II. For August III's taste for Wouwerman, see Bürger 2003.
8. For Van Falens, see Brossel 1965; De Wallens 2003; Bürger 2006; and Schumacher 2006, vol. 1, pp. 135–36. Marandet 2003, p. 38, demonstrated that Van Falens was also a dealer in paintings and engravings.
9. Sjöberg and Gardey 1974, p. 157, cat. 154.

10. See, for example, GCPA 0240459 (*The Stag Hunt*) and 0240468 (*Falconers Resting*), both from the suite that was in the stock of French and Company. In addition, isolated versions of *The Stag Hunt* were in the stock of French and Company (GCPA 0240456) and have appeared on the French art market, for example at Galerie Georges Petit, Paris, Dec. 16, 1922, lot 48, and at Hôtel Drouot, Paris, Nov. 24, 2006.

11. GCPA 0240472. Jacques Seligmann and Company sold this piece (247 x 332 cm) to Georges Haardt in 1927. The border of cat. 50 is made up of eleven fragments that presumably formed the original borders.

12. GCPA 0240465, 0240453. French and Company bought the tapestries from Arden Galleries, New York, in 1917.

13. Sjöberg and Gardey 1974, p. 158, cat. 156.

14. Philips, London, Dec. 14, 1999, lot 75 (42.5 x 59.2 cm). A copy of the right part of the painting that is in mirror image, and therefore presumably painted after the engraving, was recently sold at the Dorotheum, Vienna, June 19, 2007, lot 341 (39 x 39 cm).

15. GCPA 0240470, 0240451, 0240475, and 0240474. French and Company bought this set from Mrs. James P. Donohue.

16. Sjöberg and Gardey 1974, pp. 157–58, cat. 157.

17. Ibid., p. 158, cat. 155.

18. Yet another suite of four hunting scenes (GCPA 0240466, 0184446, 0240487, and 0240483) was in the stock of French and Company around 1950. Apart from *Falconers Resting* and *Falconers Hunting*, the edition included two *entrefenêtres*: *Two Hunters Resting* and *Girls Picking Flowers*. These scenes may have been the left and right sections of the sixth scene, but additional research is required to shed more light on this issue.

19. Sjöberg and Gardey 1974, p. 267, cat. 502; Schumacher 2006, vol. 1, p. 236, cat. A166; vol. 2, pl. 155.

20. The classic introduction to the *goût moderne* is Kimball 1943. See also Saisselin 1960.

21. Chatelus 1974, pp. 319–20; Korthals Altes 2000–01.

22. For the Teniers sheets in Lebas's catalogue, see Sjöberg and Gardey 1974, pp. 208–49, cats. 344–448. Mack-Andrick 2005 discusses the popularity of engravings after Teniers. Wouverman's sheets are illustrated in Sjöberg and Gardey 1974, pp. 265–72, cats. 499–513.

23. Atwater 1995, pp. 5–10.

24. Anderman 2004; Moureau 2004.

25. For Watteau and his circle, see Rey 1931; Grasselli, Rosenberg, and Parmantier 1984; Holmes 1991; and Ramade and Eidelberg 2004.

26. He commissioned nine hunting paintings for the Petits cabinets du Roi at Versailles in 1736 (Hazlehurst 1984) and ordered two suites of Jean-Baptiste Oudry's *Chasses royales* between 1736 and 1753 (Opperman 1970).

27. For Van Falens's near-copies of Wouwerman's paintings, see Schumacher 2006, vol. 1, p. 136. "Berghem" refers to the equally fashionable Dutch landscape painter Nicolaes Berchem. For the popularity of Berchem's work in the seventeenth and eighteenth centuries, see Wuestman 1996.

28. De Bellaigue 1980, p. 675.

29. For *The Art of War* series, see Wace 1968; Brosens 2002, pp. 72–73; and Brosens 2006–07, pp. 57–58. The Le Clerc/Van der Borcht set has not yet been studied. A six-tapestry suite of the set was in the stock of French and Company; GCPA 0237454–56, 0237459, 0237461, 0237464. Three of the tapestries were sold at Christie's, Amsterdam, Sept. 22–23 2003, lot 48. For the set made by Flemish émigrés, see Herrero Carretero 2000, pp. 64–89.

30. Brosens 2004a, pp. 102–09.

31. Brosens 2006–07.

32. Beard 2002.

Archery from *Amusements champêtres* (Country Sports)

Aubusson, 1770/90
After a design in the manner of François Boucher (1703–1770) attributed to Jacques-Nicolas Julliard (1719–1790)
Produced at an unknown workshop at the Manufacture Royale d'Aubusson
247.65 x 276.86 cm (97½ x 109 in.)
Gift of Honoré Palmer, 1938.1310

STRUCTURE: Wool and silk, slit and double interlocking tapestry weave
Warp: Count: 5 warps per cm; wool: S-ply of two Z-spun elements; diameters: 0.7–1.0 mm
Weft: Count: varies from 10 to 40 wefts per cm; wool: S-ply of two Z-spun elements; diameters: 0.6–1.7 mm; silk: S-ply of two Z-twist elements; diameters: 0.3–1.3 mm

Conservation of this tapestry was made possible through the generosity of the James Tigerman Estate.

PROVENANCE: Probably Potter (died 1902) and Bertha Palmer (née Honoré, died 1918), Chicago and Paris; by descent to their son Honoré Palmer (died 1964); given to the Art Institute, 1938.

SEATED in the right foreground at the foot of a tree, his quiver resting next to him, a young man wearing a hat flexes his bow while looking at an arrow planted in a target hanging on a tree on the left. In the center of the middle ground, a young boy jumps rope. A wooded landscape and some houses occupy the background. A border of foliage and flowers, with a shell in each corner, frames the scene.

This tapestry is a typical example of the eighteenth-century taste for pastoral scenes, as well as of the success of the royal Aubusson tapestry workshops in that era. It belongs to a group of tapestries known as *Amusements champêtres* (Country Sports), of which around thirty editions are recorded. Heinrich Göbel considered the series, along with the *Tenture chinoise* (Chinese Series) in the manner of Boucher, among the finest designs produced at Aubusson.[1] The *Amusements champêtres* are often attributed to Jean-Baptiste Marie Huet (1745–1811). But this attribution is highly controversial, and the bounds of the group are not very well defined. The *Amusements champêtres* tapestries are, rather, a loose collection of representations of amusements, recreations, and sports, as well as children's games and hunting and pastoral scenes.

Nonetheless, there are some consistencies across editions. For example, the archery scene is almost always paired with the jump rope scene in the background, though the latter scene is not always mentioned in the title of the tapestry.[2] It can also be paired with some other type of diversion. It was not unheard of to pair two scenes, originally intended to be woven separately, in one tapestry, at a client's request. Indeed, this was reasonably common for the subjects *Swing* and *Pastry Seller* (also known as *Dial*) in the *Amusements champêtres* series. Two suites illustrate the practice. The first suite still hangs in the location for which it was ordered: the Marquis de la Ronzière's

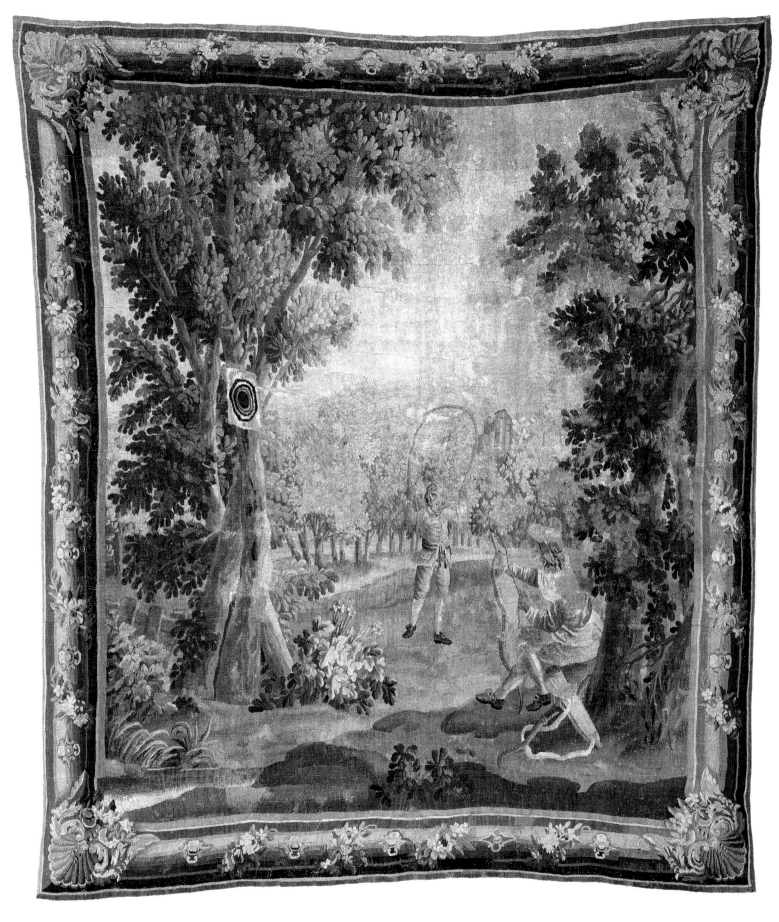

CAT. 51

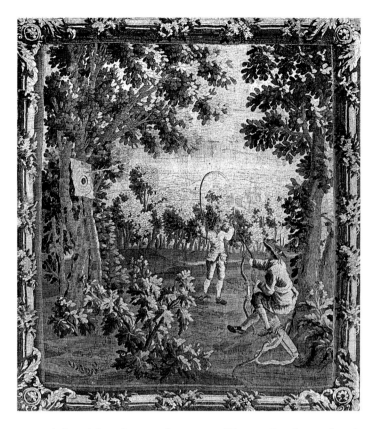

FIG. 1 *Archery*. After a design in the manner of François Boucher attributed to Jacques-Nicolas Julliard. Produced at the Manufacture Royale d'Aubusson, 1770/90. Wool and silk; 243 x 221 cm. Hospices de Beaune.

town house (now the Town Hall) in Charlieu. Its border contains garlands of foliage and flowers, with a shell in each corner, and of its seven pieces, two are composite: one, a very large piece called *Country Feast*, unites the subjects *Country Dance* and *Archery*; the other features two subjects which were often shown together, *Swing* and *Pastry Seller*.[3] The second suite that illustrates the tendency to combine scenes was formerly in the Émile Straus collection; of its four pieces, one is a composite, pairing *Archery* with a pastoral scene of a shepherd and two shepherdesses conversing.[4]

Some chambers of *Amusements champêtres* have an amalgamated quality, for the individual pieces have different border designs. This is particularly noticeable in two suites. One, in the collection of the Hospices de Beaune, was known in the nineteenth century as the "collection dite de Boucher" (collection said to be in the style of Boucher). It comprises two almost square tapestries, *Blindman's Buff* and *Archery* (fig. 1); two *entrefenêtres*, *Standing Shepherdess* (called *The Farmer's Wife*), and *Cook* (which shows the cook from *Country Dance*); and a *Country Scene* with shepherds and shepherdesses near a fountain. The border of the first four pieces is a simplified version of *Archery*'s design, whereas the border of the fifth piece differs, showing flowers and large leaves twined around a rod.[5] The other apparently amalgamated edition comprises eight pieces and appeared in the 1925 de Bella sale. At least three different designs were used for the whorls of foliage and flowers in the borders that frame the tapes-

tries: *Blindman's Buff*, *Fortune Teller*, *Bagpiper*, *Washerwomen*, *Shepherdesses and Sheep*, another *Fortune Teller*, *Swing*, *Archery*, and *Pastoral*.[6] The question remains whether this composite character was intended when the tapestries were designed, was introduced in the maker's shop when the subjects were chosen by a client, or is simply the result of amalgamation in the nineteenth or twentieth century.

The suites mentioned above feature the most frequently woven *Amusements champêtres* subjects: *Archery*, *Blindman's Buff*, *Swing*, *Pastry Seller*, *Fortune Teller*, and *Country Dance*. Two other subjects not present in the above chambers—*Leapfrog* and *Hot Cockles*—were also very popular.[7] Raymond Novion listed twenty or more designs in the *Amusements champêtres* series, but their sheer number makes clear that all could not have belonged to one set, but rather must have been part of two or even three series composed of country sports and pastoral scenes, where the distinction between the two sets is not obvious.[8] Clients could buy or commission scenes from any of the series, combining them to compose a suite to their liking.

The uncertainty surrounding the total number of *Amusements champêtres* series and subjects is matched by the uncertainty regarding which artist painted the models. Scholars suggest Huet most often, but Jean-Baptiste Oudry (1685–1755), Nicolas Lancret (1690–1743), François Boucher, and David II Teniers (1610–1690) are also cited as possible designers.[9] Around 1728, Oudry painted cartoons for an eight-piece *Amusements champêtres* series for the Manufacture Royale de Beauvais. The set included *Leapfrog*, *Blindman's Buff*, *Shepherdess*, *The Game of Pied-de-boeuf*, *Playing at Knucklebones*, *Seesaw Game*, *Broche-en-cul Player*, and *Accordionist*. In 1761, these designs were ceded to the Aubusson manufactory, along with those for two other series.[10] Some of the subjects treated by Oudry can be found in *Amusements champêtres* tapestries woven at Aubusson. The *Blindman's Buff* in a three-piece suite sold in Paris in March 1965 represents a woman at a fountain on the right of the tapestry; its design was clearly inspired by Oudry's *Blindman's Buff*.[11] A first error in attribution of *Amusements champêtres* came from confusing the models Oudry designed with the different models traditionally attributed to Huet.

Göbel, who noted analogous motifs in the paintings of Lancret, stated that the *Amusements champêtres* owed much to the *Pastorals* woven in the manner of Huet and his imitators.[12] Huet, himself one of the best imitators of Boucher, contributed significantly to the spread of the elder painter's manner. Copies of the *Pastorals* models that Huet had provided for the Manufacture Royale de Beauvais were afterwards woven at Aubusson, and the cartoons for the *Pastorals* produced at Aubusson with such success were based on engravings from works by Huet. The tapestries executed using these models are easily identifiable (see fig. 2).[13] Still, Louis Lacrocq voiced reservations about the attribution of the models for *Amusements champêtres* to Huet. Novion shared Lacrocq's doubts, labelling these tapestries —with little conviction, it must be said—"dans le goût de Huet" (in the manner of Huet).[14] With the exception of a reference

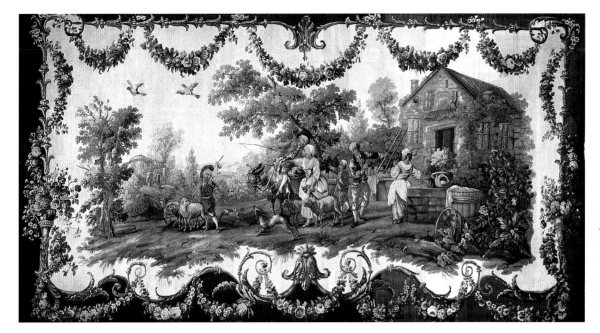

FIG. 2 *Farmer's Farewells* from *Pastorals*. After a design by Jean-Baptiste Marie Huet. Produced at the Grellet workshop at the Manufacture Royale d'Aubusson, 1791. Wool and silk; 223 x 357 cm. Musée Historique, Basel, 1923.320.a.1.

to "Conversation champêtre d'après Huet" (country conversation after Huet) that Cyprien Pérathon found in a book of accounts that belonged to the workshop manager Léonard Goubert (1765–1793), no archival documents mention any *Amusements champêtres* after designs by Huet.[15]

Boucher's influence indeed marked the decorative arts profoundly, providing models for both the Gobelins and Beauvais manufactories, and it is manifest in Aubusson *Amusements champêtres* series as well. This explains why the aforementioned Hospices de Beaune suite was said to be "in the style of Boucher." Versions of *Fortune Teller* and the *Pastry Seller* woven in Aubusson are reminiscent of scenes of the same subject in the *Fêtes italiennes* (Italian Feasts) series woven at Beauvais after Boucher's designs sometime after 1734. Still other subjects evoke the *Noble Pastoral*, another series Boucher designed for the Beauvais manufactory (see cat. 47), and which was then woven by the tapissier Léonard Roby (active by at least 1750–1789) at Aubusson (see cats. 50, 52). *Country Dance* is a composition deriving from both *bambochades*, a type of genre painting featuring landscapes and everyday scenes of people in the Flemish and Dutch tradition practiced by Boucher early in his career, and from several Teniers, genre scenes in the manner of David II Teniers.

Boucher's influence appears most clearly, however, in the models one of his disciples, Jacques-Nicolas Julliard, delivered to Aubusson. Having worked for a time for the Manufacture Royale de Beauvais, Julliard was named Official Painter to the King at the Aubusson manufactory in 1755. Admitted in 1759 to the Académie Royale, he exhibited regularly at the Salons, and, beginning in 1767, he was granted lodging at the Gobelins in recognition of his work for the royal manufactories. The tapestry designs Julliard created for the Aubusson workshops correspond closely in style to his painting, which throughout his career never deviated from the manner of his

master.[16] His subjects included fishing and hunting scenes, games and country sports, and landscapes. For example, from 1770 to 1774, he furnished cartoons for two series of *Landscapes and Country Games*,[17] and the designs were often woven.[18] Taken together, these facts support attributing to Julliard the designs of most of the tapestries known as the *Amusements champêtres*.

Regardless of which artists designed sets of *Amusements champêtres*, it is certain that multiple tapestry entrepreneurs wove suites from the designs. A three-piece suite that, according to Pérathon, was very fine and beautifully colored, could be found at the Abbaye de Bonlieu at the beginning of the twentieth century. It consisted of an *Archery* tapestry, signed M.R.DA... PICON; *Shepherd Guarding Sheep*; and *Seated Shepherds and Shepherdess*.[19] Another version of *Archery*, sold at Versailles on May 16, 1971, bore Roby's name. Four editions of *Country Dance* were signed by four tapissiers: the just-mentioned Picon and Roby, as well as Coulandon and Pierre Dumonteil.[20] Göbel also mentions editions produced by Picqueaux and Jacques Fourrier.[21] Finally, as Pérathon noted, the account books of Léonard Goubert's father (1774–1793) contain references to pieces woven by Coulandon (*Leapfrog*, *Blindman's Buff*, *Jump Roper*), Bacaud (*Oboist*, design by Julliard) and Champaniat (*Fortune-Teller*).[22] The variety of tapissiers' names inscribed on the tapestries just mentioned strongly implies that the cartoons were not the property of a single workshop, but rather, as was typical of the royal manufactories at Aubusson and Felletin, belonged to the manufactory as a whole: the king's painter regularly furnished cartoons, and the individual workshops took turns borrowing them and making grisaille copies to keep for reference. These facts provide an explanation for the differences in quality from one edition to another.[23] PFB

NOTES

1. Göbel 1925, pp. 455–56; Göbel 1928, vol. 1, p. 255. For the Aubusson *Tenture chinoise* in the manner of Boucher, see Bertrand, Chevalier, and Chevalier 1988, pp. 112–17, and Bertrand 1990a.

2. The account books of the tapissier Goubert the Elder (active 1774–93) do, however, mention a *Jumping Rope* woven by Coulandon; Pérathon 1902, p. 297.

3. The other subjects in the suite are *Fortune Teller, Gallant Talk* (called *Shepherds and Shepherdesses*), and three *entrefenêtres*: two *Standing Shepherdess* pieces (one shown with a crook, one with a tray on her head), and *Dog Doing Tricks*; Lacrocq 1920, pp. 166–68; Nivière 1990, pp. 85–86, cats. 103–09.

4. The three other tapestries in the edition are *Blindman's Buff, Pastry Seller*, and *Swing*; sold at the sale of the Émile Straus collection, Paris, June 2–4, 1929, lots 148–51. *Archery* was resold at Drouot Rive Gauche, Paris, Feb. 1, 1980, lot 212.

5. The tapestries (Hospices de Beaune, invs. 87 GHD 577, 578, 581, 582, 586) have been set into wood paneling since 1897. They are published in Fromaget and Reyniès 1993, pp. 48–49.

6. Hôtel Drouot, Paris, de Bella sale, Nov. 20–21, 1925, lots 245–52.

7. *Leapfrog* was part of a three-piece suite (with *Archery* and *Colin-maillard*) sold at Palais Galliera, Paris, June 8, 1971, lot 95. Another suite, which consisted of *Archery, Blindman's Buff*, and *Leapfrog*, was sold at Hôtel Drouot, Paris, Mar. 14, 1986, lots 85, 87–88 (attributed to Huet). A *Hot Cockles* was part of a three-piece suite (with *Blindman's Buff* and *Archery*) sold at Palais Galliera, Paris, Mar. 27, 1965, lots 101–03 (attributed to Huet). Three strips of a grisaille cartoon of *Hot Cockles* were in the collection of the Abbaye de Bonlieu, Creuse, in 1988; 151 x 70 cm. Along with editions of *Pastry Seller* and *Blindman's Buff*, yet other versions of *Leapfrog* and *Hot Cockles* compose a suite called *Rural Games* that is now in the Musée des Arts décoratifs, Paris, invs. 19719 A–D, and is published in Musée des Arts Decoratifs 1934, pp. 109–10.

8. Novion 1975, pp. 104–05. The subjects Novion lists are *Country Dance* (The Fiddler), *Blindman's Buff, Leapfrog, Archery, Swing, Hot Cockles, Jump Rope, Fortune Teller, The Gallant Fisherman, Egg Robbers, Winter Entertainments, Vintagers, Pastry Seller, Country Conversation, Hunters Resting, Kite Flying, Seesaw Game, Flute Lesson, Dog Doing Tricks*, and *Offering of the Bouquet*.

9. See in particular the attributions proposed in sale catalogues.

10. See Bertrand, Chevalier, and Chevalier 1988, p. 153, and Bertrand 1990b.

11. Palais Galliera, Paris, Mar. 27, 1965, lots 101–03. See note 7 above.

12. Göbel 1925, pp. 455–56.

13. Mayer Thurman 1984; Bertrand, Chevalier, and Chevalier 1988, pp. 174–77.

14. Lacrocq 1920, p. 160; Novion 1975, p. 105.

15. Pérathon 1899–1900, p. 420. Pérathon did not, however, mention this reference in his publication of a more detailed version of the document; Pérathon 1894a, p. 175.

16. For Julliard, see Bertrand, Chevalier, and Chevalier 1988, pp. 140–50, and Simmons 1993.

17. ANP, F12 1458 B, dossiers 19–20; F12 1459A, dossier 3. In 1749, Julliard painted a series of models for *Landscapes with Figures* at the request of the Aubusson tapissier Mathieu Dessarteaux, who had a shop in Paris. Julliard delivered another series of cartoons of these same subjects to the Manufacture Royale d'Aubusson between 1755 and 1756. Later, from 1766 to 1769, Julliard painted cartoons for a series of *Seascapes*, including *Fishing*. Between 1778 and 1782, he provided the models for *Pastorals and Hunts with Landscapes and Animals*.

18. Once the respective subjects of these sets are known, it will be possible to determine to which the Chicago *Archery* tapestry belongs.

19. Pérathon 1894a, p. 503, cats. 67–69.

20. The piece signed Picon is published in Göbel 1928, vol. 1, p. 255; vol. 2, fig. 286. The piece with Coulandon's signature is in the Musée de Nancy (Lacrocq 1916, p. 41); the one signed Roby was sold at the Palais des Congrès, Versailles, Apr. 16, 1978, lot 148 (attributed to Teniers), and the piece with Dumonteil's signature (which only shows the part of *Country Dance* representing the *Cook*) was in the stock of Galerie Chevalier, Paris, in 1993.

21. Göbel 1925, p. 455; 1928, vol. 1, p. 255.

22. Pérathon 1902, p. 296.

23. Herewith, a nonexhaustive list of other *Archery* pieces not yet cited in this entry: 1) Collection of Gilda Darthy; sold, Galerie Georges Petit, Paris, May 18, 1923, lot 99 (with another piece, *Shepherd Making His Dog Dance to the Flageolet*, lot 98). 2) Sold, Christie's, London, Oct. 30, 1997, lot 210 (with *Shepherdess with a Lamb and a Dog*, lot 209); sold, Christie's, London, Nov. 16, 2000, lot 96. 3) In the stock of French and Company, New York (with *Swing*; GCPA 0243116, 0184439. 4) Sold, Sale M.D., Paris, May 18–19, 1921, lot 222. 5) Lehmann Bernheimer, Munich; Göbel 1928, vol. 2, fig. 280. 6) Collection of Jacques Seligmann and Company, by 1928, in the stock of French and Company, New York (with a border of the same type as that of the aforementioned example from the Darthy collection; GCPA 0243119). 7) American Art Association, Anderson Galleries, New York, Nov. 30, 1929, lot 30 (with a border very similar to that of the *Archery* tapestry in the Art Institute). 8) In the stock of French and Company, by 1931; GCPA 0243120. 9) Robert Z. Hawkins collection; French and Company; sold to Jean Mikaeloff, 1961; GCPA 0184438. This tapestry is very similar to (or perhaps the same as) a narrow panel without a border that was at Mayorcas, London, in 1978. 10) Sold, Hôtel Drouot, Apr. 26, 1963, lot 182 (no border, signed *MRDB*). 11) Paris, Drouot Rive Gauche, Oct. 24, 1978, lot 136. 12) Nouveau Drouot, Paris, Mar. 4, 1981, lot 171. 13) Palais des Congrès, Versailles, Nov. 14, 1982, lot 61 (as after Huet). 14) Christie's, New York, Sept. 16, 1992, lot 264. 15) Drouot-Richelieu, Paris, Mar. 17, 1995, lot 141 (same border as the piece in the Darthy collection). 16) Drouot-Richelieu, Paris, Apr. 10, 1996, lot 267 (as after Huet). 17) French and Company, as a weaving from the nineteenth century; GCPA 0243118. 18) Christie's, London, Dec. 14, 1995, lot 226. The figures of the archer and the rope jumper are taken from the same cartoon, but the landscape is different. Also, the piece is described as from Aubusson, and dated to the early eighteenth century, but it seems rather Flemish. It is interesting to note that no signed tapestry with the same border type as the *Archery* tapestry in the Art Institute has ever been discovered; this type can, however, be seen in two Aubusson pieces of *The Four Ages* after Lancret (Bertrand, Chevalier, and Chevalier 1988, p. 127).

CAT. 52

The Outdoor Market from *Village Festivals*

Aubusson, 1775/89
After a design by Étienne Jeaurat (1699–1789)
Produced at the workshop of Léonard Roby (active c. 1750–1789)
571.5 x 292.9 cm (224⅞ x 115⅜ in.)
Gift of the Hearst Foundation in memory of William Randolph Hearst,
1954.262

STRUCTURE: Wool and silk, slit and double interlocking tapestry weave
Warp: Count: 6 warps per cm; wool: S-ply of two Z-spun silk elements;
diameters: 0.6–1.0 mm
Weft: Count: varies from 14 to 46 wefts per cm; wool: single S-spun ele-
ments; S-ply of two Z-spun elements; pairs of S-ply of two Z-spun elements;
pairs of single Z-spun elements; diameters: 0.4–1.2 mm; silk: pairs of S-ply
of two Z-twisted elements; diameters: 0.8–1.0 mm; wool and silk: paired
yarns of S-ply of Z-spun wool elements and S-ply of two Z-twisted silk ele-
ments; paired yarns of single Z-spun elements and S-ply of two Z-twisted
silk elements; diameters: 0.5–1.0 mm

Conservation of this tapestry was made possible through the generosity of
Joseph W. Fell.

PROVENANCE: Supposedly the Duke of Laval-Montmorency (died 1798),
Marshal of France, and First Gentleman of the Chamber of Louis XVI; sup-
posedly by descent through the family; supposedly by descent to his great-
great-great grandson, Count Édouard François Maris, duca di Bisaccia (died
1968); Gimpel and Wildenstein, by 1918; sold to William Randolph Hearst
(died 1951), 1922; ownership tranferred to the Hearst Foundation; given to
the Art Institute, 1954.

REFERENCES: Hunter 1918, no. 35. Göbel 1928, vol. 1, p. 182.

THIS tapestry represents a market scene in a village square. On the
left is an inn, with a woman cutting bread on its threshold, while
another woman surveys the scene from a window. In front of the
inn, a young woman sits on a chair, peeling vegetables, and a soldier,
seen in three-quarter view from the back, stands in front of a table at
which a man and a young couple are eating. A female servant stands
behind the diners. To the right of the servant, an old woman plays a
hurdy-gurdy for the young girls dancing in the center of the middle
ground. In front of them a woman, seen from the back, bears a large
tray of brioches on her head. Further to the right, tradesmen have set
up their stalls in front of houses. A young gallant has just bought a
ribbon from a seated merchant wearing a cap, and is offering it to his
female companion. At the neighboring stall, a young woman talks to
an elderly tradeswoman. On the extreme right onlookers surround a
quack doctor and his assistant, both of whom are on horseback. In
front of this group, several children cluster around a pastry vendor's
cylindrical box with a roulette wheel on its top. Tubs, copper pots,
and baskets are strewn across the foreground, and in the background
a church and other buildings may be seen. There is no border.

Known as *The Outdoor Market*, this piece is an exemplary instance
of a tapestry made from a model originally designed for a specific

workshop but rewoven in another one. The research identifying the
reweaving location represents some of the best in tapestry scholar-
ship. In principle, the Manufacture Royale de Tapisserie des Gobe-
lins worked exclusively for the Crown. But workshop managers had
the right to accept orders from individuals, and some even ran their
own private workshops near the manufactory.[1] The cartoons for
these orders were executed at either the client's or the entrepreneur's
expense. For example, one of the two managers of the Gobelins' high-
warp looms, Michel Audran (1701–1771), twice commissioned car-
toons from the painter Étienne Jeaurat. Admitted to the Académie
Royale in 1733, Jeaurat steadily advanced through this institution's
ranks, becoming a professor in 1743, rector in 1765, and chancellor
in 1789, and was also appointed curator of the king's paintings at
Versailles in 1767. The artist came to be known for his genre scenes:
children's games, Parisian life, pastorals, *turqueries*, and village fes-
tivals, like those favored by Watteau. At Audran's request, Jeaurat
first created six or seven paintings for a *Story of Daphnis and Chlöe*
series.[2] He exhibited two of the models (*The Wedding of Daphnis
and Chlöe* and *Vintage, in which Daphnis and Chlöe Are Admired*)
at the Salons of 1737 and 1741, respectively. Jeaurat next painted four
pictures for a *Village Festivals* set around 1750, according to a report
from the architect (and director of the Gobelins from 1755 to 1780)
Jacques-Germain Soufflot (1713–1780), to the Marquis de Marigny,
brother of Madame de Pompadour and head of the Bâtiments du
Roi (the Office of Royal Buildings and Public Works).[3] In 1753, Jeau-
rat exhibited one of the *Village Festivals* cartoons, *Village Wedding*, at
the Salon.[4] The following year, Audran proposed selling the cartoons
for this set to the Crown, at the Gobelins' expense, a proposal that
Marigny at first refused, for, like many Salon visitors, he was very
critical of the cartoons (see below). An arrangement seems to have
been reached shortly thereafter, however, between Marigny and the
Gobelins foremen Audran, Pierre-François Cozette (1714–1801),
and Jacques Neilson (1714–1788), as recorded in a settlement in
1755.[5] According to the agreement, paintings and cartoons were to be
executed by the best painters, and the expenses incurred were to be
split evenly among the three tapissiers. One clause detailed that the
cartoons themselves were to become part of the manufactory's assets,
with one third of the paintings belonging to each of the tapestry
entrepreneurs. Another article specified that the value of the paint-
ings had been estimated according to their present worth, taking into
consideration their actual past and potential future use. This article
further asserted that the successor to a tapestry entrepreneur who
died had to reimburse one-third of this estimated value to the other
tapissiers. A final article stipulated that the widows, children, and
heirs of the entrepreneurs were not entitled to profit from any future
use of the paintings. The restrictiveness of this agreement probably
explains why the paintings were sold in 1775 (after Audran's death),
to an Aubusson tapissier, Léonard Roby, who periodically bought
paintings and cartoons. According to a petition he addressed to the
intendant du commerce, Jean-François Tolozan, in 1760, Roby had

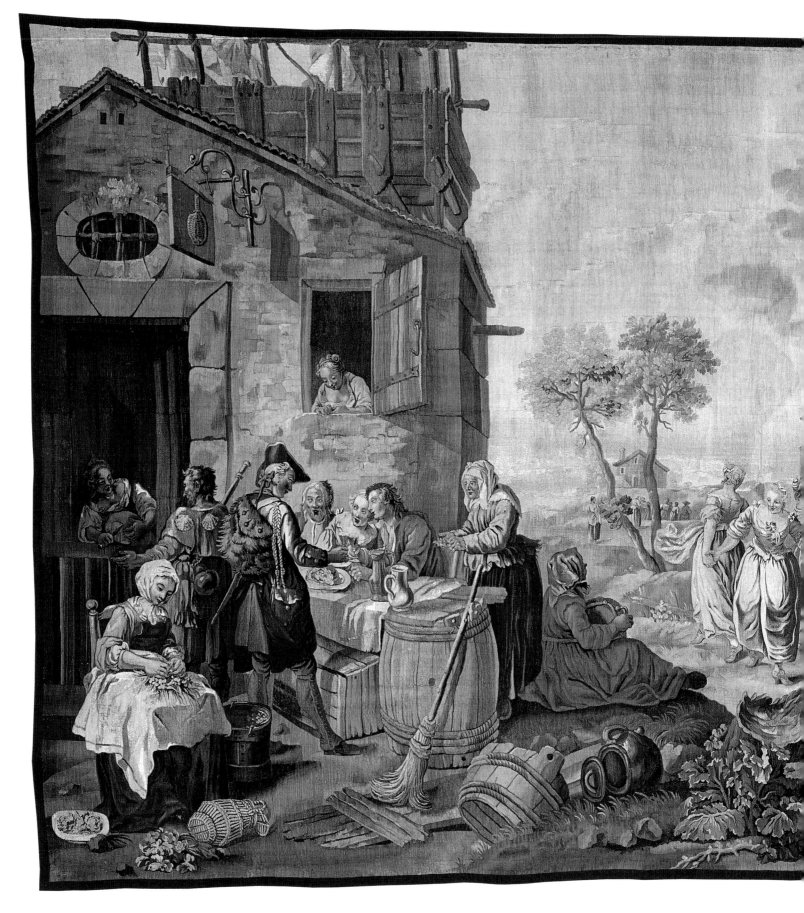

CAT. 52

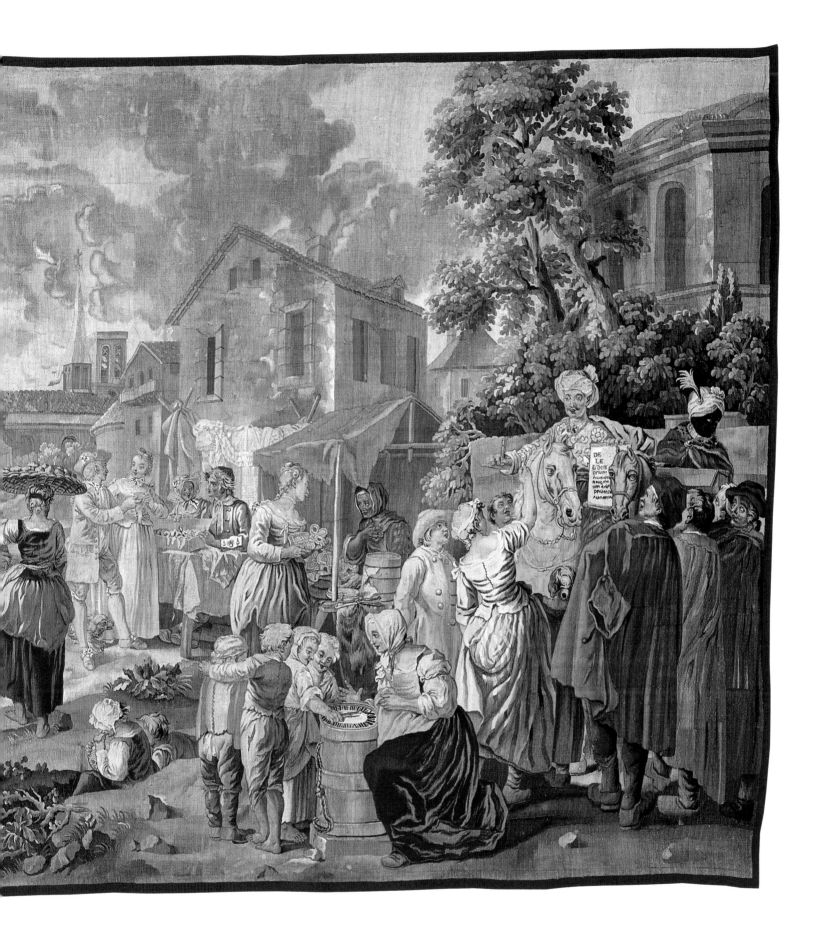

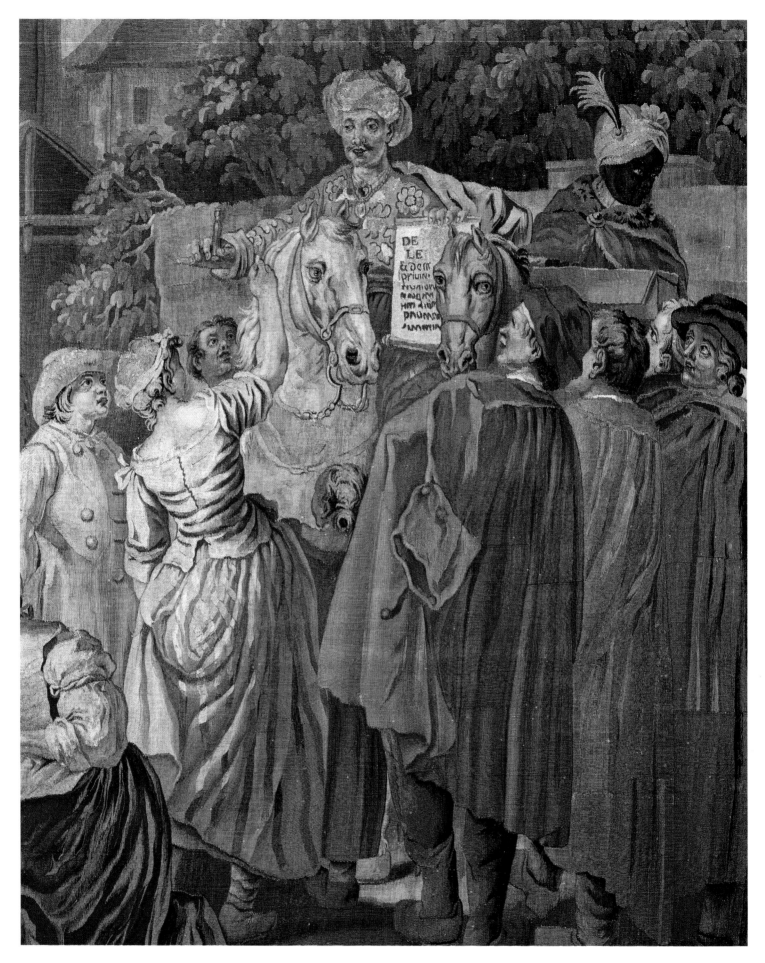

CAT. 52, DETAIL

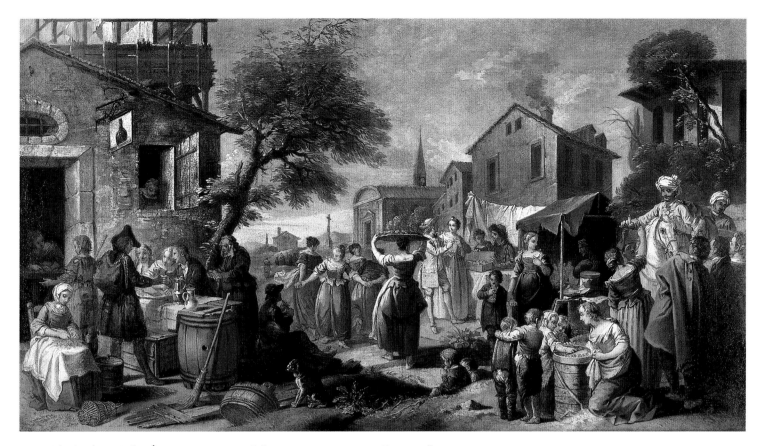

FIG. 1 *The Outdoor Market*. Étienne Jeurat, 1748. Oil on canvas; 59.5 x 107 cm. Private collection.

acquired six models for Boucher's *Pastorals*; then in 1766, models for *Hunts* from works by Philips Wouverman (1619–1668) and Carel Van Falens (1683–1733; see cat. 50); in 1768, paintings and engravings of flowers, ornaments, and trophies; and lastly, in 1775, the four *Village Festivals* cartoons and the six *Story of Daphnis and Chlöe* cartoons.[6] Whether he bought these latter cartoons from Jean Audran (workshop director 1771–94), Michel's son and successor, or from the Crown, is not known.

The *Village Wedding* cartoon exhibited at the Salon of 1753 was the subject of intense criticism. Its style was judged much too serious for a subject that merited—according to commentators—a lively, agile, diverting, and light-hearted treatment. Similarly, the sad and melancholic colors were deemed unsuitable for a genre painting, which was believed to demand a vivacious and brilliant palette.[7] One critic compared Jeurat's cartoon to Rubens's *Kermesse*, now in the Musée du Louvre, Paris, an exemplary genre painting, and lamented the fact that such a gloomy painting was to be reproduced in multiples by the Gobelins. It was these assessments that Marigny repeated in his 1754 report refusing to purchase the cartoons. The painting's current location is unknown, but it was in a private collection in the United States at the beginning of the twentieth century.[8] It was the only known cartoon of the *Village Festivals* until 1995, when Xavier Salmon published the model and the cartoon of *The Outdoor Market*, another tapestry in the series, and the one on which the piece in the Art Institute is based.[9]

The model of *The Outdoor Market*, a medium-sized painting (fig. 1), reveals that the *Village Festivals* tapestries were ordered in 1748, for it bears the inscription *Stephanus / Jeaurat / Pinxit / 1748*, on the crate serving as a bench in front of the soldier standing at the entrance to the inn. The painting was acquired in 1767 by one de Nanteuil, the head of a carriage firm in Paris, at the sale of the collection of the celebrated connoisseur Jean de Julienne. Nanteuil had also bought the model for *Village Wedding*, which is the same size as *The Outdoor Market*, and also signed by Jeurat, but dated 1749.[10] The models for the two other tapestries in the suite have not yet been identified, but were apparently sold at public auction; their current location is unknown.[11] One, sold in Versailles in 1982, represents *Leaving for Market*, and is signed and dated 1748.[12] The other, sold in Paris in 1965, has a narrow vertical format and represents *The Return of the Vegetable Gardeners*.[13] These dates confirm the 1748 order date suggested by the model of *Outdoor Market*.[14]

Only the right part of the cartoon of *The Outdoor Market* survives, now in a private collection. It is signed and dated *Jeurat Pinxit 1753* on the small stone base under the pastry vendor's box in the foreground (fig. 2).[15] As Xavier Salmon has noted, the cartoon varies from the model in a number of ways.[16] For example, in the cartoon, an onlooker was added to the left of the group surrounding the quack doctor holding a sign up to the crowd: "Avec privil[ège] / du Roi / et de Monsieur / premier médec[in] / Kaliotari / guérit avec son ... / toutes les mala[dies] / les plus ... / radicalement tou...

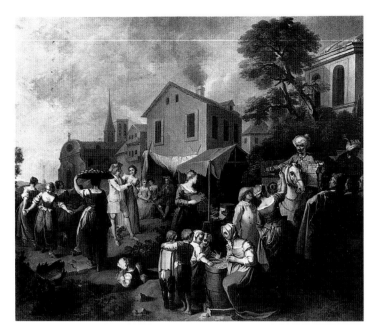

FIG. 2 *The Outdoor Market* [right part]. Étienne Jeaurat, 1753. Oil on canvas; 290 x 341 cm. Private collection.

/ Gouttes, Rhumatis[mes] / Apoplexie, et verter / le prix est de 20 sols et de ...” (With the privil(ege) / of the King / and of Monsieur / first doc[tor] / Kaliotari / cures with his ... / all the ill[nesses] / the most ... / radically *tou*... / Gouts, Rhumatis[ms] / Apoplexy, and *verter* / the price is 20 sols and ...). The young woman speaking with an elderly tradeswoman to the left of this group is accompanied by a child in the model, but in the cartoon she is alone and posed differently. In addition, the woman bearing the brioches uses both her hands to balance the wide tray in the model; in the cartoon, she uses only one hand. Jeaurat also replaced the group around the ribbon seller in the model with a musician playing a flageolet seated beside two women. Apparently this modification was not to the taste of the tapissier who had ordered the cartoons, since it appears in none of the listed editions. In fact, Audran asked Jeaurat to correct it, which he did by painting a small cartoon, to scale, of the group around the ribbon seller. It shows the vendor wearing a cap with the young woman seated beside him and, on the left, the young woman receiving the ribbon from her admirer. The admirer himself is not depicted in this small cartoon, however, since he had not been modified (fig. 3).[17] When the design was woven, the small cartoon would be placed over the larger one, hiding the change, and thus presenting a composition that pleased the tapissier.

The left part of the cartoon must also have departed from the model, as can be discerned by comparing the model to the editions on record. Various minor modifications evident in tapestries of the subject include the substitution of the two small trees in front of a farm in the distance for a single tree situated at the corner of the inn, the replacement of a dog in the foreground by the overturned cauldron, and the transformation of a flutist into the woman playing the hurdy-gurdy. But one major alteration was unnoticed: the

FIG. 3 *The Ribbon Seller*. Étienne Jeaurat, c. 1753. Oil on canvas; 81 x 51 cm. Musée Carnavalet, Paris, P113.

perspective of the inn was inverted. The change is most obvious in the door and window frames, and the sign depicting a bottle, which reveals the inn is called “À la bouteille.”[18] Moreover, a wall was added to the side façade of the house on the right. This alteration reinforces the unity of space in the composition and accentuates the impression of receding space.

The dates on the models and cartoons allow us to trace the history of the tapestries woven from them. As mentioned above, the tapissier ordered the models in 1748 or shortly before. The first cartoons must have been executed in 1750, for in October of this same year Audran began weaving two pieces. The cartoon for *The Outdoor Market* was perhaps one of the last to have been painted, as it is dated 1753. An edition of *Village Festivals* was being woven in August 1758 at the Gobelins.[19] The weaving quality of the version in the Art

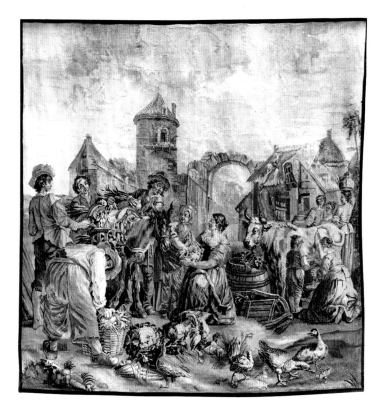

FIG. 4 *Leaving for Market*. Produced at the workshop of Léonard Roby at the Manufacture Royale d'Aubusson, 1775/90. 282 x 275 cm. Musée du Louvre, Paris.

FIG. 5 *Return of the Vegetable Gardeners*, called *Leaving for Market*. Produced at the workshop of Léonard Roby at the Manufacture Royale d'Aubusson, 1775/90. Wool and silk, 300 x 236 cm. Musée du Louvre, Paris.

Institute is good, with small stitches and bright colors. According to conventional wisdom, this points to a Gobelins or Beauvais origin, for these centers are usually believed to be the source of top-quality tapestries, whereas more ordinary work is assumed to have been woven in Aubusson. But, from 1750 on, the Aubusson workshops produced tapestries described as made of "étaim fin" (thin woollen thread) or as "fond de soie" (silk-backed), of a quality rivaling the output of Beauvais and the Gobelins, sometimes to the point where they could pass for the product of these great manufactories.[20] Thus the quality of weaving of the *Outdoor Market* in Chicago may not alone determine its origin.

Moreover, workshop managers at Aubusson employed techniques specifically designed to make their production resemble the work of the more prestigious manufactories. Tapestry entrepreneurs at the Gobelins, such as Audran, wove on high-warp looms, while tapissiers at Aubusson worked on low-warp looms. Bearing in mind that the motifs in a high-warp tapestry will normally be in the same direction as in its cartoon, while those in a tapestry woven on a low-warp loom will be backwards compared to its cartoon, it follows that the image in a tapestry from Aubusson (a low-warp workshop) will normally be the reverse of the same image in a Gobelins product, if they were woven from the same cartoons. Indeed, this is the case for all known examples of *Leaving for Market* and *The Return of the Vegetable Gardeners* (figs. 4–5).[21] By contrast, all the recorded editions of *Village Wedding* and *The Outdoor Market* are in the same

direction as the cartoons, which means that the Aubusson tapissiers who wove them worked from mirror-image copies of the original cartoons. This hypothesis is perfectly plausible, for it was common practice at Aubusson to make grisaille copies of the original cartoons. The inspectors of the manufacture strongly advised the tapissiers at Aubusson to adhere to this relatively inexpensive custom, for cartoons placed under the warp thread during the low-warp weaving process deteriorated very rapidly. Using grisaille-on-paper copies cut into narrow vertical strips allowed the original cartoons to be preserved. The tapissiers, however, had the grisaille versions done backwards, tracing the original cartoons, so that the tapestries executed from them on low-warp looms would have the same orientation as the original cartoons and, perhaps more importantly, the same orientation as tapestries produced at the Gobelins manufactory. This rendered Aubusson production indistinguishable from that of the more prestigious Gobelins, at least on this technical point—an ambiguity that could only work in Aubusson's favor.

The maker's mark thus remains the primary means of determining at which center a given tapestry was produced. Tapissiers at the Gobelins generally wove their names in full into the field of the composition. For example, the suites of *The Story of Daphnis and Chlöe*

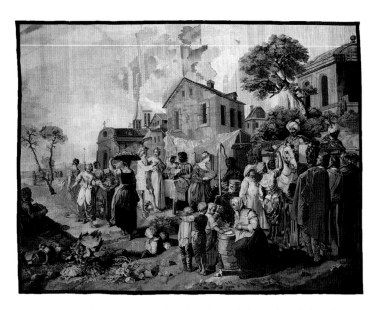

FIG. 6 *The Outdoor Market*. Produced at the workshop of Michel Audran at the Manufacture Royale des Gobelins, 1750/70. Wool and silk; 293 x 389 cm. Grassi Museum für Angewandte Kunst, Leipzig, v1364.

that Audran wove at the Gobelins are practically all signed.[22] But very few *Village Festivals* tapestries bear any marks. Audran signed a three-piece suite and a single tapestry. The suite comprised a *Village Wedding* in two parts, a *Leaving for Market*, and a *Return of the Vegetable Gardeners*, and was sold in Paris in 1893.[23] The single tapestry is an *Outdoor Market* now at the Grassi Museum für Angewandte Kunst, Leipzig, which bears the signatures *AUDRAN* and *Jeaurat. Pinxit.1748* (fig. 6).[24]

Aubusson tapestry entrepreneurs were, in principle, obliged by the rules of the manufactory to sign their work with their names or their initials. Yet the requirement was by no means universally honored. An edition done from a painting in the manner of Carel Van Falens, now in a private collection, is inscribed in its bottom guard with the full name of Léonard Roby, and the tapestries at the Hôtel de Ville of Châlons-sur-Marne, representing two allegories of the former capital of Champagne, are signed *Aubusson* and *Roby jeune*.[25] But the tapestries Roby wove from the *Story of Daphnis and Chlöe* cartoons he bought along with those of *Village Festivals* bear neither a mark nor a signature.[26]

Besides the four Audran *Village Festivals* tapestries, however, no other tapestries in the series bear any marks,[27] except one in which what may be Roby's name appears on the sign held by the quack doctor.[28] From this evidence, does it follow that these subjects were seldom woven at the Gobelins? Are all unsigned *Village Festivals* tapestries from Aubusson, or could there be Gobelins tapestries of *Village Festivals* with no mark? The answer hinges on the possibility of distinguishing Gobelins and Aubusson editions in the absence of marks or signatures. Certain editions of *Village Festivals* are of a quality that seems to bear comparison with Gobelins tapestries. This is the case with four pieces: the two with a narrow border imitating a molded frame that were at Addington Manor, Buckinghamshire,

around 1900 (a *Village Wedding* and the left third of the *Outdoor Market* composition, called *The Recruiting Sergeant*); a *Village Wedding* in two parts framed by a narrow foliate border in what were formerly the Dreyfus-Gonzales and the Velghe collections; and a narrow example of *The Recruiting Sergeant*, with a wider foliate border.[29] This last tapestry, however, was said to be from the Gobelins when in the Ffoulke and Luckenbach collections, but attributed to Aubusson in the notes of French and Company, which had the piece in its possession for a time.[30]

The text on the sign held by the quack doctor in *The Outdoor Market* may well allow us to tell at which center *Village Festivals* tapestries, at least of this design, were produced. As already mentioned, the text is quite legible on the cartoon. It consists of twelve lines, with the first, second, and fifth (the name of the doctor, Kaliotari) in boldface. It is faithfully reproduced in the *Outdoor Market* in Leipzig (fig. 6): the layout is similar and the number of lines is the same. On the other hand, the text has obviously been simplified in other versions of the design, in which only a few words are legible. This is largely the result of the weaving method, which used inverted grisailles on which the text—unlike the rest of the image—was not exactly copied in reverse. For example, the sign in the version in the Art Institute bears the two-line title "DE / LE" (OF / THE) followed by a totally illegible seven-line text "Ex derm / privin. / ro..ion / ... / ... / P... / .N..." This same unreadable text figures in a tapestry that was sold in Paris in 1923 and in another example sold in Alençon in 1987.[31] Finally, the text of the fourth line on a tapestry in the stock of French and Company in 1934, which begins "privin.," contains the name "Roby," revealing that it was woven at Aubusson, where that tapissier worked (fig. 7).[32] As the weaver faithfully recopied the motif, only the clearest words (DE, LE, Roby) appear legibly. It is likely that the omission of a signature, or its discreet inclusion, was a deliberate choice made by the weaver, for Roby proceeded in the same manner for the other tapestries in the suite.[33]

The other known examples of *Village Festivals* were probably also produced at Aubusson, since the series was woven infrequently at the Gobelins (no complete suite from that center is recorded), likely due to the criticism leveled at the cartoons. On the other hand, the designs enjoyed a certain success about fifteen or so years later at Aubusson, once Roby had acquired them, in part because of changes in society. *Village Festivals* is a series of genre scenes, and thus belongs to a category of tapestries not often woven at the Gobelins, but rather at Beauvais and Brussels, centers with a broader clientele, including a bourgeoisie anxious to increase its social standing, using marriage or the purchase of land or high office to satisfy its appetite for noble rank.[34] Social climbing was a well-known phenomenon, the wellspring of Jean-Joseph Vadé's satirical poetry and Florent Carton Dancourt's satirical comedies, such as *Foire de Bezons* (Fair at Bezons, 1695), *Fête de village* (Village Festival, 1700), and *Prix de l'arquebuse* (Prize of the Harquebus, 1715). The second play, initially performed on July 13, 1700, was very popular throughout the eighteenth cen-

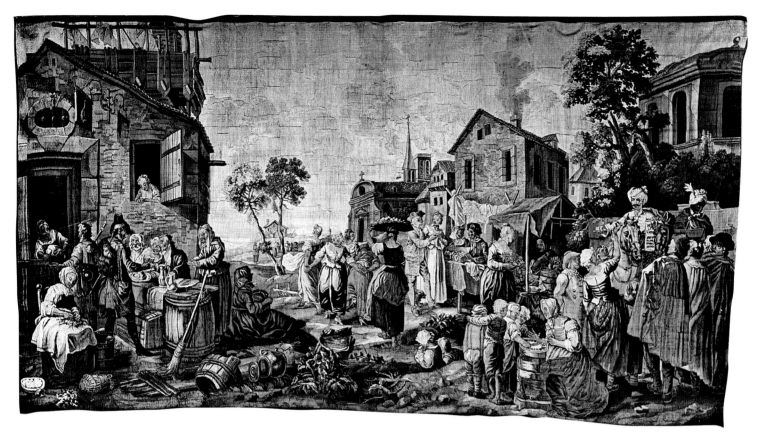

FIG. 7 *The Outdoor Market*. Produced at the workshop of Léonard Roby at the Manufacture Royale d'Aubusson, 1775/90. Wool and silk; 298 x 560 cm. Location unknown.

tury. The plot focuses on the rivalry between a young woman and her aunt over a noble suitor. The aunt, a widow, wants to marry the young gentleman in order to acquire a title, while her niece is motivated by love. The gentleman seems to be doubly cynical, for he is both ready to marry the aunt because she is rich, and to carry on an affair with the niece, whom he loves. The ingénue plays on the situation: if the young man marries her old, rich aunt in hopes of soon becoming a rich widower, why shouldn't she (the young girl) marry an old lawyer with the same idea in mind?[35] Such subjects had their equivalents in painting: genre scenes inspired by Flemish painting, many paintings by Jeaurat (for example, *Citrons de Javotte*, which was exhibited at the Salon of 1753, and known through an engraving by Levasseur), and scenes of village festivals painted in the manner of Watteau, depicted burlesque, somewhat ridiculous episodes, and in doing so shocked conventional moral attitudes.[36] The Art Institute's *Outdoor Market* represents the woven versions of these fashionable subjects. Based on a painting by an artist whose reputation was built on depicting such subjects, and of a quality comparable to that of Gobelins production but, because woven at Aubusson, lower in price, tapestries like *The Outdoor Market* were perfectly suited to seduce a newly wealthy bourgeois clientele. PFB

NOTES

1. For example, Jean II Jans (c. 1644–1723) ran his own private workshop called Le Grand Louis; Fenaille 1903–23, vol. 2, p. 182, no. 1; see also Alcouffe 1969.

2. Standen 1985, vol. 1, pp. 365–68. For the *The Story of Daphnis and Chlöe* suite, see Fenaille 1903–23, vol. 4, pp. 75–84. The cartoons cost 8,600 livres.

3. For the *Village Festivals* suite, see Fenaille 1903–23, vol. 4, pp. 170–72, and Salmon 1995. The cartoons cost 6,000 livres. Soufflot's report reads: "M. Audran vient de faire faire des tableaux pour une tenture particulière à ses frais par M. Jeaurat et il en va monter deux pièces ce qui occupera des ouvriers et diminuera l'ouvrage du roi" (M. Audran has just had paintings done at his own expense by M. Jeaurat for a private edition and he is going to set up two pieces, which will keep the workers busy and reduce work for the king); report from Oct. 29, 1750, quoted in Fenaille 1903–23, vol. 4, p. 171.

4. The Salon catalogue lists the painting as number sixteen and describes it as "[u]n grand tableau en largeur de seize pieds sur neuf de haut représentant une Noce de village" (a large, horizontal painting sixteen feet long by nine high [520 x 292 cm] representing a Village Wedding).

5. Audran and Cozette were the foremen of the high-warp workshop. Jean Audran succeeded his father in 1771, and remained a foreman until 1794. Neilson ran the low-warp workshop until 1794, when Michel-Henri Cozette (1744–1822), Pierre-Francois's son, succeeded him. The three tapestry entrepreneurs received authorization to fill private orders in 1753. Only the Cozette workshop continued to operate after the Revolution. Fenaille 1903–23, vol. 4, p. 78.

6. The *Mémoire de Roby à Monseigneur de Tolozan, intendant du commerce*, written around 1778 to 1779 (ANP, F12 1459A, dossier 17; Bertrand, Chevalier, and Chevalier 1988, pp. 160–64; and Joubert, Lefébure, and Ber-

trand 1995, p. 358 n. 43) reads: "Remontre très respectueusement Léonard Roby le Jeune, marchand fabricant et tapissier à Aubusson que depuis trente ans qu'il a fait fabriquer il a été moins jaloux d'augmenter sa fortune que de concourir à la perfection de la manufacture. Pleinement convaincu qu'il ne pourrait parvenir au but qu'il s'était proposé d'encourager l'émulation des ouvriers et de faciliter leurs opérations qu'en leur procurant différents dessins autres que ceux que le peintre du roi est chargé d'envoyer à la fabrique, il s'est empressé d'en faire emplette de temps en temps. En 1760, il acheta six tableaux représentant les Pastorales de Boucher. En 1766, il fit l'acquisition d'autres six tableaux de chasses d'après Wouverman et Van Falens. En 1768, il acquit différents desseins de fleurs, d'ornements, de trophées et estampes propres à faire exécuter en tapisseries et enfin il se procura en 1775 quatre tableaux représentant les fêtes villageoises peints par M. Jeaurat de l'Académie royale, lesquels ont été exécutés aux Gobelins par M. Audran, et six autres représentant les Amours de Daphné et Chloé, peints et exécutés par les mêmes, tous ces différents ouvrages lui ont coûtés près de mille écus. Persuadé également que le dessein est l'âme de la tapisserie et qu'elle ne peut être bien rendue qu'autant qu'il se trouve près de la fabrique un peintre instruit, . . ." (Demonstration very respectfully submitted by Léonard Roby the Younger, merchant-maker and tapissier at Aubusson, who for the thirty years that he has been a tapestry maker has been less concerned to increase his fortune than to contribute to the perfection of the manufacture. Fully convinced that he would not attain the goal he has set for himself of motivating his workers and facilitating their operations unless he procures drawings other than those that the King's painter is responsible for sending to the manufacture, he was eager to purchase others from time to time. In 1760, he bought six paintings representing the Pastorals by Boucher. In 1766, he acquired six other paintings of hunts after Wouverman and Van Falens. In 1768, he acquired different drawings of flowers, ornaments, trophies and prints suitable for the execution of tapestries, and lastly, in 1775 he procured four paintings representing village festivals painted by M. Jeaurat of the Académie Royale, which had been executed at the Gobelins by M. Audran, and six others representing the Loves of Daphnis and Chlöe, painted and executed by the same people; all of these different works cost him nearly one thousand écus. Persuaded also that drawing is the soul of tapestry and that it can be rendered only to the degree that a trained painter can be found near the manufacture, . . .)

7. See *Jugement d'un amateur sur l'exposition des tableaux de l'an 1753*, addressed to the Marquis de V*** [Villette] and attributed to the Abbé Marc-Antoine Laugier or to Louis-Guillaume Baillet, baron de Saint-Julien, as well as an anonymous critique, *Sentiments sur quelques ouvrages de peinture, sculpture et gravure écrits à un particulier en province* (1754); both cited in Fenaille 1903–23, vol. 4, pp. 170–71, and Salmon 1995, pp. 188–89.

8. Fenaille 1903–23, vol. 4, p. 171. Contra Salmon 1995, p. 189, the painting is reproduced in Fenaille 1903–23, vol. 4, pl. opp. p. 170.

9. Salmon 1995, p. 189.

10. *The Outdoor Market* is published in ibid., p. 190, fig. 3. It was in the collection of Jean de Julienne (died 1766), Paris, and was sold, at his sale, Mar. 30–May 22, 1767, lot 285, to one de Nanteuil, who also bought the model for the *Village Wedding* of the same dimensions. After his death, both were sold, at his sale, Mar. 1, 1792, lot 19 (both pieces). Both were in the sale of the Ph. Sichel collection at Galerie Georges Petit, Paris, June 22–28, 1899, lots 25–26 (the catalogue specifies that *Village Wedding* is signed and dated 1749 in the lower right hand corner). In 1956, the two paintings were in the stock of the dealer Parlo, in Paris. *The Outdoor Market* was sold at Sotheby's, London, Dec. 7, 1994, lot 47 (oil on canvas, 59.5 x 107 cm), to the Paris antiques dealer, Didier Aaron. Salmon 1995, p. 190, fig. 3.

11. Maurice Fenaille, who only knew editions made from these models, thought that they belonged to one and the same composition.

12. Sold, Versailles, June 20, 1982, lot 39, as *Foire de village* (Outdoor Market);

54 x 65 cm. The scene takes place in a farmyard: on the left, servants wash dishes and polish copper; in the center a woman milks a cow; and on the right men and women load vegetables into the packsaddle of a donkey. Another painting titled *Outdoor Market*, signed and dated 1753, was sold at Versailles, Mar. 28, 1963, lot 32 (54 x 65 cm).

13. Sold, Palais Galleria, Paris, Nov. 29, 1965, lot 112. The scene occurs at the entrance to a farm: on the right, a farmwoman carries a truss of straw; in the center, seen from the back, a man pets a guard dog that is chained to its doghouse, a younger man gathers large baskets, and on the left stand two farmwomen.

14. In his study of this painting, Salmon focused on Jeaurat's reuse of motifs from this painting in his later work. For example, the painter took the young woman cleaning the salad in the lower left corner of the composition and made her the sole subject of a painting done in 1752 that was presented at the Salon of 1753 (no. 19 in the Salon catalogue; Salmon 1995, pp. 193–94, fig. 6 [an engraving of the painting by Beauvarlet]). But it is difficult to endorse Salmon's view that the *Outdoor Market* model was not shown at the Salon of 1753 with the *Village Wedding* because Jeaurat did not wish the public to discover that he had recycled the figure, for recycling was a common, widely accepted practice. Indeed, Jeaurat would resort to it again, in 1757, using the motif of the woman at the window of an inn in *Carnival in the Streets of Paris* (Musée Carnavalet, Paris).

15. The model of *The Outdoor Market* is in oil on canvas, and measures 290 x 341 cm. It was in the collection of the Parisian appraiser Freret, who sold it in 1900 to Georges Hersent, also of Paris; Salmon 1995, fig. 4. Salmon conjectures that only one part survives because Audran had the cartoon divided to create two scenes. This is quite likely, but no evidence confirms it, and the cartoon could also have been divided in two for practical reasons, for example to take up less storage space. This common practice should not be confused with another procedure whereby cartoons were cut into narrow vertical strips for use in the low-warp weaving process.

16. Salmon 1995, pp. 192–93.

17. Musée Carnavalet, Paris, inv. P.113 / E. 5125.

18. Salmon did, however, note the inversion of the sign and the window.

19. Memorandum from Audran addressed to Marigny, quoted in Fenaille 1903–23, vol. 4, p. 76.

20. Bertrand, Chevalier, and Chevalier 1988, p. 37.

21. A three-piece suite from the Gobelins that was on the art market in 1893 included both a *Leaving for Market* and a *Return of the Vegetable Gardeners* (see note 23 below). All the known Aubusson versions of these two pieces are inverted. One example of *Leaving for Market*, corresponding to lot 2 in the 1893 sale, was sold again at Semenzato, Venice, May 20, 1983, lot 116 (attributed to Brussels; 268 x 398 cm). An example showing the group of peasants around the donkey and the woman milking a cow is in the Louvre (OAR 70, 282 x 275 cm, said to be from Boucher). A similar one from the Nieuwland-Dubois estate was sold at Galerie Moderne, Brussels, Apr. 26, 1988, lot 1065 (290 x 270 cm, attributed to Lille); then was in the stock of the antiques dealer Bernard Blondeel. A photograph of a fourth example is in Henry Currie Marillier's "Catalogue of Tapestry Arranged by Subject" (unpublished manuscript) in the Department of Textiles, the Victoria and Albert Museum, London. It shows the group of servants doing dishes with, on the right, the door of the inn from *The Outdoor Market* with the woman seated on a chair. A tapestry of *Return of the Vegetable Gardeners*, which repeats the composition of lot 3 in the 1893 sale, is now in the Musée du Louvre, Paris (inv. OAR 63; 300 x 236 cm; said to be after a design by Boucher).

22. See Standen 1985, vol. 1, pp. 365–68.

23. Audran's name is on the last two pieces; it may be on the first as well, but the auction catalogue does not specify. Sold, Hôtel Drouot, Paris, Apr. 8, 1893, lots 2 (*Leaving for Market*; 270 x 385 cm), 3 (*Return of the Vegetable*

Gardeners; 270 x 210 cm), and 4 (*Village Wedding*, in two parts, 270 x 560 cm); Fenaille 1903–23, vol. 4, pp. 171–72. Fenaille 1903–23, vol. 4, claims that lots two and three were part of a single composition. The *Leaving for Market*, signed AUDRAN at lower right, belonged to Count Edward Raczynski, who served as Polish ambassador to the Court of St. James's from 1934 to 1945, and as minister for foreign affairs to the Polish government-in-exile during the war. It was sold at Sotheby's, London, Dec. 15, 1961, lot 54; and sold again at Sotheby's, London, June 10, 1999, lot 13 (290 x 382 cm). The *Return of the Vegetable Gardeners* is most probably the same version as the tapestry signed AUDRAN, formerly in the collection of the Comte de Lirot in Paris (295 x 216 cm), and may be the one that was with the antiques dealer Mayorcas in 1967.

24. The tapestry does not show the left part of the composition with the "sergent recruteur" (recruiting sergeant). Jeaurat's signature appears on the base of the pastry vendor's box, as in the cartoon, and Audran's is on the right, under the figures. Formerly in the F. Nies collection, the piece was given to the city of Leipzig in 1858 and restored by De Wit Royal Manufacturers, Mechelen, in 1996. It is illustrated in Göbel 1928, vol. 1, p. 182; vol. 2, fig. 168; Städtisches Kunstgewerbemuseum zu Lepizig 1931, fig. 35; Bethe 1948, p. 37; Hoyer 1996; Anon. 1998, pp. 956–58; Thormann 2003, pp. 19, 56, 96, 230–31; Camphausen 2007, p. 101.

25. The inscription on the edition after Van Falens reads MRDBSN A LIONAR ROBIS, which stands for Manufacture Royale d'Aubusson Leonard Roby. The tapestry was formerly in the collection of Galerie Chevalier, Paris. The Champagne allegories are discussed in Pérathon 1902, pp. 252–53, and Bertrand, Chevalier, and Chevalier 1988, pp. 168–69.

26. See, for an example of a piece of very ordinary quality, the *Vendanges* at the Victoria and Albert Museum (Kendrick 1924, cat. 48), and the more finely woven six-piece suite from the Château de Vaulserre in the Dauphiné. The latter was sold at Hôtel George V, Paris, Mar. 18–19, 1981, lots 82–87; then sold again at Drouot-Montaigne, Paris, Nov. 22, 1987, lot 233.

27. But the marks were not always noted in sale catalogues (as, for example, in the catalogue for the 1893 sale), and certain editions are known only through photographs reproduced in period catalogues.

28. This is *Outdoor Market*, the example that was in the stock of French and Company in 1934 (298 x 560 cm; no border). See GCPA 0243224 and GCPA 0242998. Like the *Outdoor Market* in the Art Institute, this one was attributed to the Aubusson workshop of Jean Roby (c. 1750–1773). This piece or a similar piece was in private collections in Paris, then Madrid, and then, in 1973, Paris again.

29. Fenaille 1903–23, vol. 4, p. 172. *The Outdoor Market* (called *Recruiting Officer*) was reproduced in *Country Life*, May 16, 1925 (attributed to Gobelins), and was sold by Knight, Frank, and Hutley, London, Sassoon sale, Nov. 13, 1925, lot 63. *Village Wedding* was sold at Hôtel Drouot, Paris, Dec. 12, 1906, Dreyfus-Gonzales sale, lots 1–2, to the collector Velghe (Fenaille 1903–23, vol. 4, p. 172). The first tapestry shows the right part of the composition with the musicians and drinkers (325 x 220 cm); the second, the center of the cartoon with women carrying the pot of porridge and the beginning of the wedding procession (325 x 230 cm).

30. Charles M. Ffoulke acquired the tapestry (280 x 200 cm) in 1904; Ffoulke 1913, p. 249 (ill.). He then consigned it to French and Company, which sold it to Mrs. Luckenbach. The tapestry was then sold at Parke-Bernet Galleries, New York, Lukenbach sale, Nov. 6, 1943, lot 209 (ill.). The tapestry is said to be from Aubusson, and produced around 1765 to 1770, in the accompanying notes in the archives of French and Company in the Getty Research Institute (GCPA 0243223).

31. The tapestry sold in Paris was sold at Galerie Georges Petit, Feb. 16, 1923, lot 85 (ill.; 300 x 575 cm, no border). This is very probably the example bought by Seligmann and Company (see GCPA 0243132 and GCPA 0243133 (said to be from Aubusson, and produced around 1765–70), and sold to Alex-

andrie Finet in 1927. This is the tapestry reproduced in Salmon 1995, pp. 190–91, fig. 2. The tapestry sold in Alençon was sold at the Hôtel des ventes, Alençon July 12, 1987 (250 x 310 cm); the left side of the composition is missing, and was on the Parisian art market, at Hadjer et fils, soon afterward.

32. The text also appears in some form on an *Outdoor Market*, missing its left side, that is said to have belonged to L. Harris in 1927, but the photograph in Henry Currie Marillier's "Catalogue of Tapestry Arranged by Subject" (unpublished manuscript) in the Department of Textiles, the Victoria and Albert Museum, London, is too small to analyze.

33. Aside from the aforementioned edition in two parts of the *Village Wedding* formerly in the Dreyfus collection and then the Velghe collection, we know of two examples said to be from the Gobelins and four that are in all probability from Aubusson: 1) An edition of the left part that forms a pair with an example of the *Outdoor Market*. Both were sold at Christie's, Rome, May 25–26, 1972, lots 252a–b (*Village Wedding*, 310 x 293 cm, and *Outdoor Market*, 308 x 580 cm), said to be from the Gobelins. 2) An example exhibited in 1970 at the Biennale des Antiquaires by M. and G. Petit (Parmain, Jouy-le-Comte), said to be from the Gobelins, left part missing (290 x 455 cm). 3) State Collection of Sweden, 296 x 519 cm (no border); Böttiger 1893, p. 64, pl. 74. 4) Sold, Sotheby's, London, Nov. 24, 1972, lot 41 (274 x 564 cm; as "a fine mid-eighteenth century Spanish 'Teniers' Tapestry," no border). 5) Sotheby's, New York, Sept. 30, 2005, lot 323 (289 x 518 cm; as "A Beauvais Gênre tapestry," no border). 6) An example with an old gold foliated shell border at the Fred Moheban Gallery, New York, in 2001 (335 x 539 cm); a nineteenth- or twentieth-century replica, in a smaller format (225 x 350 cm), was sold at Parke-Bernet Galleries Inc., New York, Oct. 2, 1947, lot 648. No marks have been recorded from any of these tapestries. For *Leaving for Market* and *Return of the Vegetable Gardeners*, see notes 21 and 23 above.

34. Indeed, the Gobelins manufactory remained faithful to the traditional hierarchy of genres, according to which history painting was most esteemed and Jeaurat was described in Locquin 1912, p. 177, as a "mediocre" artist because, in 1747, he renounced history painting to devote himself to "bambochade."

35. Lancaster 1929–42, pt. 4, p. 814. See also Blanc 1984 for another study of Dancourt. Twenty-one performances of *Fête de village* were given in 1700, and it stayed in the repertoire of the Comédie française until 1838, through 360 performances. See Dancourt [1700–17] 1989 for the text of the play.

36. See Wescher 1969.

From *The Story of Telemachus*

The Fall of Phaeton

Aubusson, after 1776
After a design by an unknown artist based on an etching by Antonio
Tempesta (1555–1630), *Phaetontis casus* (The Fall of Phaeton) from Ovid's
Metamorphoses
Possibly produced at the workshop of Gabriel Babonneix (born 1756?) at the
Manufacture Royale d'Aubusson
351.2 x 286.3 cm (138¼ x 112¾ in.)
Gift of William Deering Howe, 1943.1231

STRUCTURE: Wool and silk, slit and double interlocking tapestry weave
Warp: Count: 7–8 warps per cm; wool: S-ply of two Z-spun elements;
diameters: 0.7–1.0 mm
Weft: Count: varies form 17 to 40 wefts per cm; wool: single S-spun ele-
ments; single Z-spun elements; paired yarns of single S-spun and Z-spun
elements; paired yarns of a single Z-spun element and S-ply of two Z-spun
elements; paired yarns of a single S-spun element and S-ply of two Z-spun
elements; three yarns of two Z-spun elements and one S-ply of two Z-spun
elements; diameters: 0.4–1.4 mm; silk: S-ply of two Z-twist elements; pairs
of S-ply of two Z-twist elements; paired yarns of single Z-twist elements and
S-ply of two Z-twist elements; diameters: 0.3–1.0 mm; wool and silk: paired
yarns of single Z-spun wool and S-ply of two Z-twisted silk elements; diam-
eters: 0.8–1.2 mm

Conservation of this tapestry was made possible through the Department of
Textiles Tapestry Conservation Fund.

PROVENANCE, REFERENCES, EXHIBITIONS: See below.

The Arrival of Telemachus on Calypso's Island

Aubusson, after 1776
After a design by an unknown artist based on an engraving after François
Boucher (1703–1770), *L'Arrivée de Télémaque dans l'île de Calypso* (The
Arrival of Telemachus on Calypso's Island)
Possibly produced at the workshop of Gabriel Babonneix (born 1756?) at the
Manufacture Royale d'Aubusson
330.2 x 284 cm (129⁵⁄₁₆ x 113 in.)
Gift of William Deering Howe, 1944.4

STRUCTURE: Wool, silk, and linen; slit, dovetailed, and double interlocking
tapestry weave
Warp: Count: 7 warps per cm; wool: S-ply of two Z-spun elements;
diameters: 0.7–0.9 mm
Weft: Count: varies from 11 to 44 wefts per cm; wool: single S-spun
elements; pairs of single Z-spun elements; diameters: 0.4–1.1 mm; silk: S-ply
of two Z-twisted elements; diameters: 0.2 –1.0 mm; linen: pairs of single Z-
spun elements; diameters: 0.6–1.2 mm; wool and silk: paired yarns of S-spun
wool elements and S-ply of two Z-twisted silk elements; diameters: 0.75–1.2
mm; silk and linen: paired yarns of S-ply of two Z-twisted silk elements and
single Z-spun linen elements; diameters: 0.65–1.1 mm

Conservation of this tapestry was made possible through the generosity of
the Textile Society of the Art Institute of Chicago.

PROVENANCE: Probably George I, King of Greece (died 1913). Lehmann
Bernheimer, Munich, to 1913; sold to French and Company, New York, 1913;
sold to James Deering (died 1925), 1917; by descent to his nephew
William Deering Howe (died 1948); given to the Art Institute, 1943.

REFERENCES: Hunter 1914a, cats. 17–18. Hunter 1915, p. 253 (ill.). Hunter
1918, p. 237. Hunter 1925, p. 202. Mayer Thurman in Wise 1976, p. 200, cat.
316 (1943.1231 only).

EXHIBITIONS: Buffalo (New York) Fine Arts Academy, Albright Art Gal-
lery, *Loan Exhibition of Gothic, Renaissance, Baroque, Eighteenth Century
and Modern American Tapestries,* 1914 (see Hunter 1914a). Art Institute of
Chicago, *Selected Works of 18th Century French Art in the Collections of the
Art Institute of Chicago,* 1976 (1943.1231 only; see Mayer Thurman in Wise
1976).

PHAETON's overweening ambition to guide his father's chariot of
the sun through the sky is recorded in Ovid's *Metamorphoses* (before
A.D. 8), as is the disastrous outcome of his attempt, here presented in
a dramatic scene that captures the tumultuous moment of Phaeton's
condemnation by Zeus (cat. 53a). The son of Helios and the nymph
Clymene, Phaeton had sought his father's permission to drive the
chariot for one day, in recognition and affirmation of his descent
from the sun god, a fact that his mother had kept from him until he
reached manhood. The sun god granted Phaeton's request, but the
young man lost control of the team of horses, scorching the earth as
he drove too close to it. Armed with thunderbolts, Zeus struck Pha-
eton down, thereby ending his reckless command. The serene and
verdant bank of the river Eridanus (the ancient Greek name for the
Po) and the peaceful town depicted in the distance appear to await
the horrible end, as the four tumbling horses seem to sense their
own imminent death. This dramatic scene is framed by a scalloped
valance, known as a lambrequin, and matching side curtains, all held
in place by tasseled cording.[1]

A companion piece (cat. 53b), possibly produced in the same
workshop, depicts Telemachus and Mentor, who is actually the god-
dess Minerva disguised as an old man, arriving on an island inhab-
ited by Calypso and her nymphs. The two visitors have survived a
shipwreck, and the mast, sail, and partially foundered hull of their
vessel can be seen behind the rocky outcropping in the background.
Telemachus and Mentor present themselves to Calypso and a group
of her companions in a clearing amidst a wooded and uneven terrain.
As in *The Fall of Phaeton*, the top and sides of this tapestry are orna-
mented with a scalloped lambrequin and long curtains that create a
proscenium for the encounter.

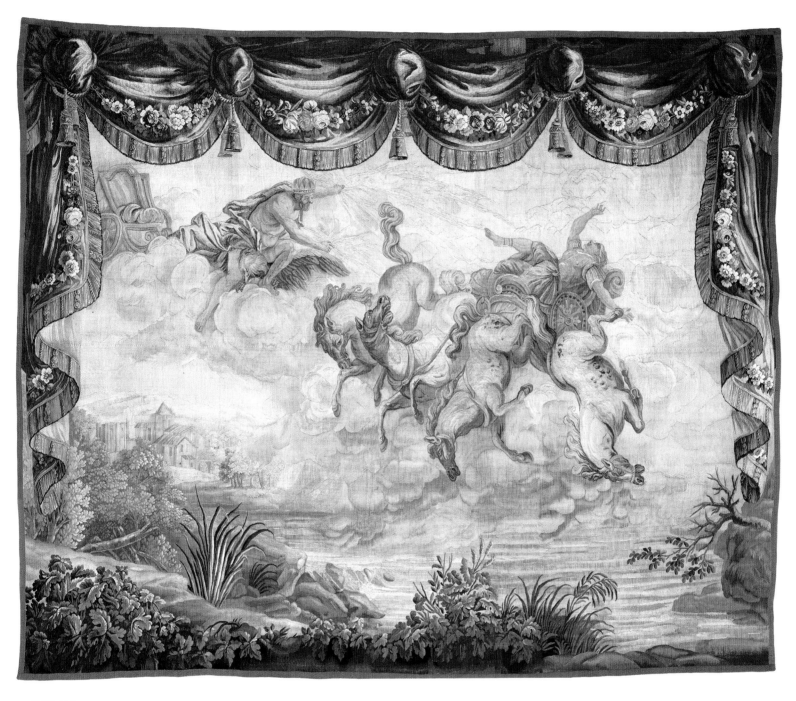

CAT. 53A

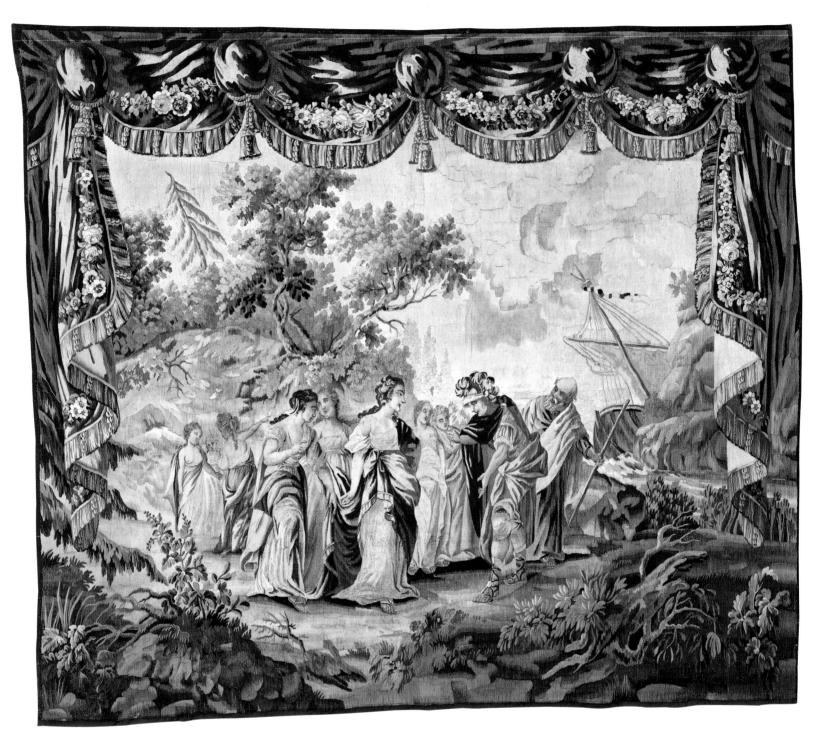

CAT. 53B

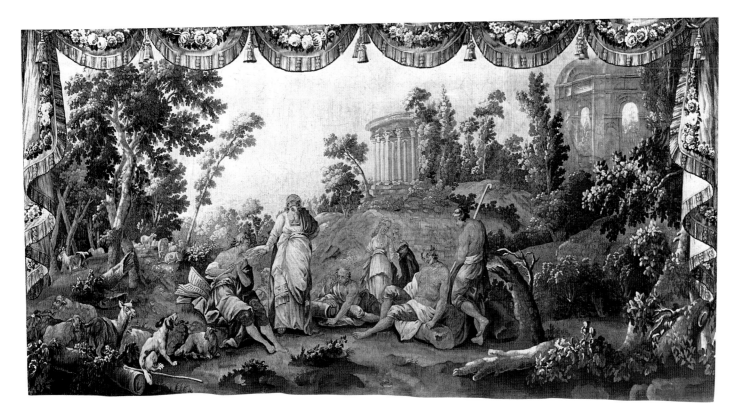

FIG. 1 *Termosiris Instructs Telemachus to Follow Apollo's Example.* Produced at the Manufacture Royale d'Aubusson, c. 1780. Wool and silk; 229 x 505 cm. Location unknown.

In 1918 George Leland Hunter identified these pieces as part of a suite of five tapestries "complete with tapestry rug and furniture coverings, made in the last half of the eighteenth century to decorate the room in Greece where they hung for over a century until recently brought to New York."[2] Three years earlier, Hunter illustrated one of the related "furniture coverings," an armchair whose back and seat covers are upholstered in tapestry that carries the same lambrequin (though at a different scale) as the tapestries, as well as classically draped figures that are also similar in style to those on the hangings.[3] In a 1925 publication Hunter returned to this group again and correctly identified one of the scenes as "The Fall of Phaethon." He also acknowledged that the other four depicted episodes were taken from François Fénelon's *Les Aventures de Télémaque* (1699).[4] In addition to what he then called "Telemachus welcomed by Calypso," he named two more: "Telemachus plays the Flute in Egypt" (fig. 1) and "Telemachus extolled before the Altar of Jupiter, by the Cretan Priest Theopanes" (fig. 2).[5] The final piece, a narrower panel with an identical valance, shows Telemachus with Calypso and a putto (fig. 3).[6]

Although the two panels in the Art Institute's collection bear no identifying marks such as a weaver's or workshop's signature or town mark, Hunter asserted that they were manufactured in Aubusson. The signature *BABOVNEIX MFD* can be found on one of the tapestries from the suite, specifically the one showing Telemachus before the altar of Jupiter.[7] Adolfo S. Cavallo attributed the signature to Louis

Babonneix (active c. 1779), although the justification for this identification is unclear, as it lacks a supporting citation.[8] It is possible that the signature is that of a tapissier named Gabriel Babonneix, who, in marriage certificates issued in Aubusson between 1792 and 1821, is mentioned as a witness at his niece's wedding on January 21, 1804, accompanied by other workshop managers.[9] Unfortunately, due to the absence of additional signatures or any further archival documentation, the suite cannot be conclusively attributed to a particular manufacturer, but it nonetheless seems very probable that it was Gabriel Babonneix.

The son of Odysseus, Telemachus appears in Homer's *Odyssey*: in fact, he narrates the first four books of the epic, though then disappears for part of the story. It was from that point that Fénelon took up the narrative and created his own account of Telemachus's search for his father in *Les Aventures de Télémaque*. Rather than presenting the story of a hero's physical feats and accomplishments, as Homer does with Odysseus, Fénelon's *Les Aventures de Télémaque* focuses on the son's moral conflicts and emotional struggles. Through numerous trials and tribulations, Telemachus learns the moral lessons that shaped his character and eventually reunited him with his father.

Les Aventures de Télémaque was not merely a work of fiction, for Fénelon wrote the book as an ethical guide for the education of Louis, Duke of Burgundy, the grandson and heir of Louis XIV. In eighteenth-century France, Fénelon's narrative carried literary sig-

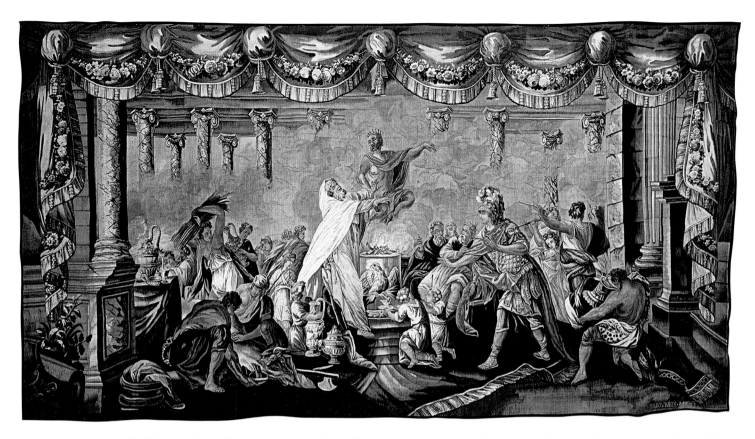

FIG. 2 *Telemachus Extolled before the Altar of Jupiter by the Cretan Priest Theophanes.* Produced at the Babonneix workshop at the Manufacture Royale d'Aubusson, 1780/1800. Wool and silk; 292 x 512 cm. Location unknown.

nificance, along with moral, political, and social implications.[10] *Télémaque* reflects Fénelon's broad concern for humanity and his philanthropic mind, even as the views he expressed in it conflicted with his position as tutor to the king's grandson.[11] When the book was published in 1699, without Fénelon's consent, it was received by the general public mostly as a satire of Louis XIV's reign, although it was also understood to be an examination of the dangers of absolutism more generally.[12] Despite the perceived anti-monarchical sentiment of *Télémaque*, the physical and moral journey undertaken by the main character resonated with the nobility and the monarchy, and to a certain extent was utilized as the ethical guide that Fénelon had originally intended it to be. The popularity of Fénelon's work can be seen in the numerous editions, in French, English, and other languages, issued throughout the eighteenth century. In the 1780s, for example, Pierre-François Didot published various editions, including one in 1784 dedicated to the king.[13] Many editions contained engravings of various episodes from the story, some of which were used to decorate a Sèvres porcelain service commissioned by Louis XVI in 1783.[14] But Louis XVI's personal fondness for Fénelon's *Télémaque* was not the only reason depictions of its episodes were used in the decorative arts. The broad artistic appeal of the subject matter—tracking Telemachus's travels throughout the Mediterranean—as well as its association with the desire for political reform, inspired works in print and on canvas. In 1773 an edition of plates depicting

scenes from the story was published in installments. It comprised engravings by Jean-Baptiste Tilliard after Charles Monnet. The 1783 and 1785 commissioned editions of the text containing the Monnet plates attest to the enduring popularity of these engravings. Indeed, the eighteenth century witnessed numerous painted compositions of scenes from *Télémaque*, including works by Charles Joseph Natoire, Michel Barthélémy Ollivier, Henri Antoine de Favanne, Jacques-Louis David, and Jean Raoux, to name a few.[15] Nine such paintings were commissioned by Urbanus Leyniers (1674–1747) from Jan van Orley (1665–1735) prior to 1724, and several suites of tapestries were woven from cartoons derived from Van Orley's work.[16] The story of Telemachus was thus a popular subject for tapestry long before the Art Institute's two pieces were woven.

Like the Louis XVI Sèvres porcelain, the images from which the *Story of Telemachus* series was derived came from various sources.[17] The narrow panel from the suite is a reduced version of plate 20 from Didot's 1785 edition. Engraved by Tilliard, this scene was described as *L'Amour sous la figure d'un enfant, enflâme Calypso et ses Nymphes* (Cupid in the shape of a child inflames Calypso and her nymphs; see fig. 3). The tapestry Hunter identified as "Telemachus plays the Flute in Egypt" was developed from an engraving entitled *Termosiris enseigne à Telemaque qu'il doit suivre l'example d'Apollon* (Termosiris instructs Telemachus to follow Apollo's example).[18] This work—engraved by Martigny and Charles Emmanuel Patas after François

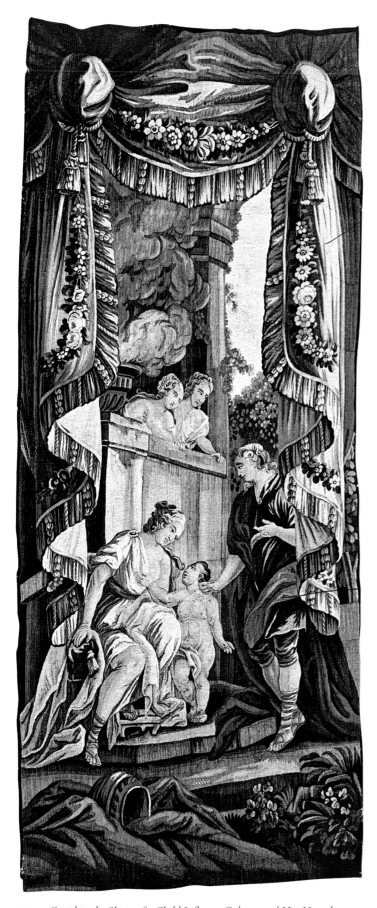

FIG. 3 *Cupid in the Shape of a Child Inflames Calypso and Her Nymphs.* Produced at the Manufacture Royale d'Aubusson, 1780/1800. Wool and silk; 259 x 120 cm. Location unknown.

FIG. 4 *L'Arrivée de Télémaque dans l'île de Calypso*, published in the *Mercure de France*, December 1776. After François Boucher. Engraving, on paper; 10.5 x 11.9 cm. Bibliothèque Nationale, Paris.

Boucher—was published in the November 23, 1776, issue of *Journal de la Librairie*, a weekly journal that listed newly published books, and in the December 1776 issue of the *Mercure de France*, a popular French literary magazine and gazette. This and another engraving after Boucher were among a set of eighteen done after works by Boucher, Monnet, and Charles-Nicolas Cochin the Younger. They do not appear to have been created for a particular edition of *Télémaque*, but rather were intended for sale as individual prints.[19]

A print depicting the *Arrivée de Télémaque dans l'île de Calypso* (fig. 4), after Boucher, appeared in the same December 1776 issue of the *Mercure de France,* together with the engraving *Termosiris enseigne à Télémaque qu'il doit suivre l'example d'Apollon.* It is from the *Arrivée* print that the cartoon for *The Arrival of Telemachus on Calypso's Island* was designed and the hanging woven.[20] The tapestry itself is fairly faithful to the original design, but in reverse, with a few exceptions: in the engraving, for example, several of the women are depicted with exposed breasts, whereas all but one attendant appear covered in the tapestry. In addition, a woman bending over at the far right has been eliminated, more foliage has been added to the foreground, and the space between the women and the background trees has been foreshortened.

The design source for *The Fall of Phaeton*, in contrast, can be traced to plate 12 of a seventeenth-century version of Ovid's *Metamorphoses*. The original etching, entitled *Phaetontis casus* (The Fall of Phaeton; fig. 4), was created by the Florentine painter and printmaker Antonio Tempesta.[21] Tempesta created more than 1,500 different images during his lifetime. His extremely popular prints were widely dispersed across Europe and were utilized by artists throughout the decorative arts.[22] Several tapestries based on Tempesta's prints were woven during his lifetime and the following century. In the middle of the eighteenth century, an unidentified Aubusson workshop produced a suite of tapestries based on engravings by Tempesta and others, including Michel Lasne (died 1667) and François Chaveau (died 1676), from the series *Gerusalemme liberata* (Jerusalem Delivered), which also had been the subject of another suite of tapestries woven during the previous century.[23] By the time the Art Institute's

FIG. 5 *Phaetontis Casus* (The Fall of Phaeton): Plate 12 from the series *Ovid's Metamorphoses*. Antonio Tempesta, seventeenth century. Etching; image: 10.5 x 11.9 cm. Fine Arts Museums of San Francisco, Mr. and Mrs. Marcus Sopher Collection, 1989.1.145.

version of *The Fall of Phaeton* was woven in the late eighteenth century, the Aubusson workshops were already well acquainted with adapting prints, including Tempesta's (for other examples of Aubusson tapestry designs made after engravings, see cats. 49–51). While Tempesta's version of Phaeton and his horses is faithfully reproduced, in reverse, the landscape and the figure of Zeus in the Chicago *Fall of Phaeton* were drawn from an unidentified source or sources. Given that the image of Zeus in Tempesta's engraving is small and lacking in detail, its treatment in the tapestry may simply reflect the preference of the cartoonist. Tempesta's original engraving may also have been reworked, with an altered depiction of Zeus, in the eighteenth century for a later edition of Ovid's *Metamorphoses*.[24]

At least two other tapestries were woven after the engraving of *L'Arrivée de Télémaque dans l'île de Calypso* (both including a lambrequin): one was sold at Sotheby's, London, on July 5, 1985, and the other, of a wider format, was in the Chevalier collection as of 1988.[25] Two additional tapestries corresponding to the scene of *Termosiris enseigne à Telemaque qu'il doit suivre l'example d'Apollon* were also created, but both lacked the lambrequin. These pieces were among the stock of Jacques Seligmann and Company.[26] The combination of the visual appeal of Boucher's work and the widespread availability of the *Journal de la Librairie* and the *Mercure de France* suggest why these two particular scenes were woven multiple times, whereas additional weavings of the three other tapestries have yet to surface.

At first glance, the death scene from the story of Phaeton fails to cohere with the Telemachus narrative. It is possible that the subjects were combined because there existed only a certain number

of cartoons illustrating the story of Telemachus, and an order was placed for a suite consisting of more tapestries than that. Therefore, Tempesta's popular and widely circulated print of *The Fall of Phaeton* was used to complete the chamber. Yet, the preference of the suite's commissioner notwithstanding, there are also internal connections between the two subjects. The theme of Phaeton—particularly his death, as depicted in the tapestry—conveys the consequences of youthful intrepidity and pride, and like Fénelon's *Telemaque*, offers viewers a powerful moral lesson.

CCMT

NOTES

1. *The Fall of Phaeton* and *The Arrival of Telemachus on Calypso's Island* have previously been identified as part of a "Greek drapery" set by George Leland Hunter (1918; 1925). The term "drapery set" appears repeatedly in the literature on French tapestry, as, for example, in "the Blue Drapery Set" or "the Red Drapery Set." In the present case, the phrase alludes to the tapestries' Greek provenance; see Bertrand, Chevalier, and Chevalier 1988, p. 175. The use of curtains or lambrequins in tapestries became popular around 1770; Pérathon 1899, p. 37.

2. Hunter 1918, p. 237.

3. See Hunter 1915, p. 490, fig. 9. This same chair is reproduced in Hunter 1918, p. 316, pl. 10. For a reproduction of a settee attributed to the same set, see Gould 1925, p. 46. The photograph is credited to Charles of London and the coverings are identified as having been woven at Aubusson.

4. Hunter 1925, p. 202.

5. The current location of the first of these is unknown, but it was sold at Christie's, New York, Sept. 24, 1998, lot 220; see GCPA 0240514 and Ramona Planera Malinowski of Van Cleef and Arpels, New York, letter to the author, June 15, 2005. Additionally, a tapestry with a similar composition, dated around 1750 to 1800 and described as probably manufactured in Aubusson, was once in the collection of Count Montesquieu; see GCPA 0243366 for additional provenance. The current location of the tapestry showing "Telemachus extolled before the Altar of Jupiter" is also unknown, but it was sold at Christie's, New York, Apr. 21, 1979, lot 185; see GCPA 0240512 for additional provenance information.

6. The current location of this piece is unknown. It was sold at Christie's, New York, Apr. 21, 1979, lot 183; see GCPA 0240516 for further provenance details.

7. In 1665 the manufactory at Aubusson received its royal charter, and every tapestry woven thereafter was required to include M R D or M R D B (Manufacture Royale D'Aubusson) in the weaving. It is possible that the M F D in the guard should read M R D.

8. See GCPA 0240512.

9. The groom, Jean Clerjaud (born 1770), is also listed as a tapissier, as are the other witnesses, Antoine Reynaud (48 years old), Jean Barraband (70 years old), and Jacques Barraband (59 years old), all identified as residents of Aubusson. Additionally, Gabriel Babonneix's sister was married to a tapissier named Michel Meunier (died 1819). Gabriel's son Louis's profession is, however, listed as "géomètre" (geometrician), and thus he would most likely not have been involved in the tapestry industry; *Transcription d'actes de Mariages de 1792 à 1821, Transcription intégrale d'Huguette Charret en mairie*, p. 42 (2782), p. 56 (3365-66), available at www.gendep23.org/AUBUSSON-c/AUBUSSON/AM-1792-1832_1346.pdf.

10. For an in-depth study of the political and moral implications of Fénelon's *Télémaque* in eighteenth-century France, see Cherel 1917, pp. 300–13.

11. "Archbishop Fénelon, whose *Télémaque* has high literary merits, was a humane and philanthropic thinker. He exposed the essential contradictions between the interests of the people and the interests of a bad king; but he

had, roughly speaking, no remedy for it except that kings should become virtuous and enlightened and that aristocratic assemblies of estates should exercise an intermittent control", Clark 1961, p. 212.

12. Danter 1966, pp. 323, 324 n. 4.

13. The French royal family was not the only one in Europe to take an interest in *Télémaque*: in 1719 a Dutch edition was dedicated to Guillaume Charles Henri Frisco, prince of Orange, and an English one to Prince Frederick, Duke of Gloucester; Cherel 1917, p. 300.

14. See Bellaigue 1986.

15. For a list of paintings depicting scenes from *Télémaque* that appeared at the Paris Salon in the eighteenth century, see Bardon 1963b, pp. 220, 222, 225, 242, 243.

16. Van Orley designed two Telemachus series, one produced by Judocus de Vos and Albert Auwercx, the other produced by Urbanus Leyniers; Neumann 1964; Brosens 2004a. The Brooklyn Museum possesses three tapestries from a set: *Telemachus Arrives at the Temple of Aphrodite at Cythera*, *Telemachus and Mentor Escape from the Island of Calypso*, and *Telemachus Hunting with Antiope* (54.4-2 a–c). There are also a set of five in Vienna and a set of eight in Madrid; Cavallo 1956, p. 12.

17. The engravings used as a source for figures 1 and 3 were also utilized in the center of a plate and on the border of a saucer, respectively, in the Louis XVI service; Bellaigue 1986, pp. 71, 251.

18. "Ayant ainsi parlé, Termosiris me donna une flute si douce, que les échos de ces montagnes qui la firent entendre de tous côtez, attirément bientôt autour de moi tous les Bergers voisins." (This said, Termosiris gave me a flute, of such sweetness, that the echoes of the hills which carried the sound on every side, soon drew all the neighboring shepherds around me); see Fénelon 1734, book 2, p. 27.

19. The text accompanying the engravings indicates that they were dedicated to "Monsieur Jacques Aliamet Graveur du Roi de leur Majestés et Impéri-ales et Royales;" Jean-Richard 1978, pp. 350, 351. Pierrette does not indicate whether the text was included on both the engravings offered for sale and those used as advertisements in the *Mercure*. Henri Cohen noted that two scenes created by Cochin were dedicated to one Wille, possibly Jean-Georges Wille or his son Pierre-Alexandre Wille, while the other engravings were dedicated to Reine-Philiberte Rouph de Varicourt, marquise de Villette; Cohen 1912, p. 386.

20. The source of the image for "Telemachus extolled before the altar of Jupiter by the Cretan priest Theophanes" remains unknown, as is does not appear in any of the sources for the Louis XVI service nor among Monnet's illustrations for *Télémaque*.

21. Strauss 1978–, vol. 36, 649 (151).

22. For more on Antonio Tempesta, see Leuschner 2005.

23. For Tempesta's illustrations for *Gerusalemme liberata*, see Strauss 1978–, vol. 37, 1188 (176)–1247 (177). *Gerusalemme liberata* was written by the popular Italian poet Torquato Tasso in 1575. Examples of the earlier set of tapestries include GCPA 0243410 and 0184461, among others.

24. Tempesta created 150 illustrations for a 1606 edition of Ovid's *Metamorphoses*; it is not known why *Phaetontis casus* was used as a weaving source, rather than one of the 149 other illustrations; see Strauss 1978–, vol. 36, 638 (151)–787 (151).

25. Sotheby's, London, July 5, 1985, lot 1; see Bertrand, Chevalier, and Chevalier 1988, p. 181 (ill.).

26. The archival records of Jacques Seligmann and Company in the Archives of American Art, Washington, D.C., contain photographs of these tapestries: one has had a woven picture-frame border added (Box 188, Georges Haardt, Folder 3, 1921–35, n. d.), whereas the other lacks a border but includes an extended composition on the right and left sides (Box 187, George Haardt, Folder 1, 1921–35, n. d.).

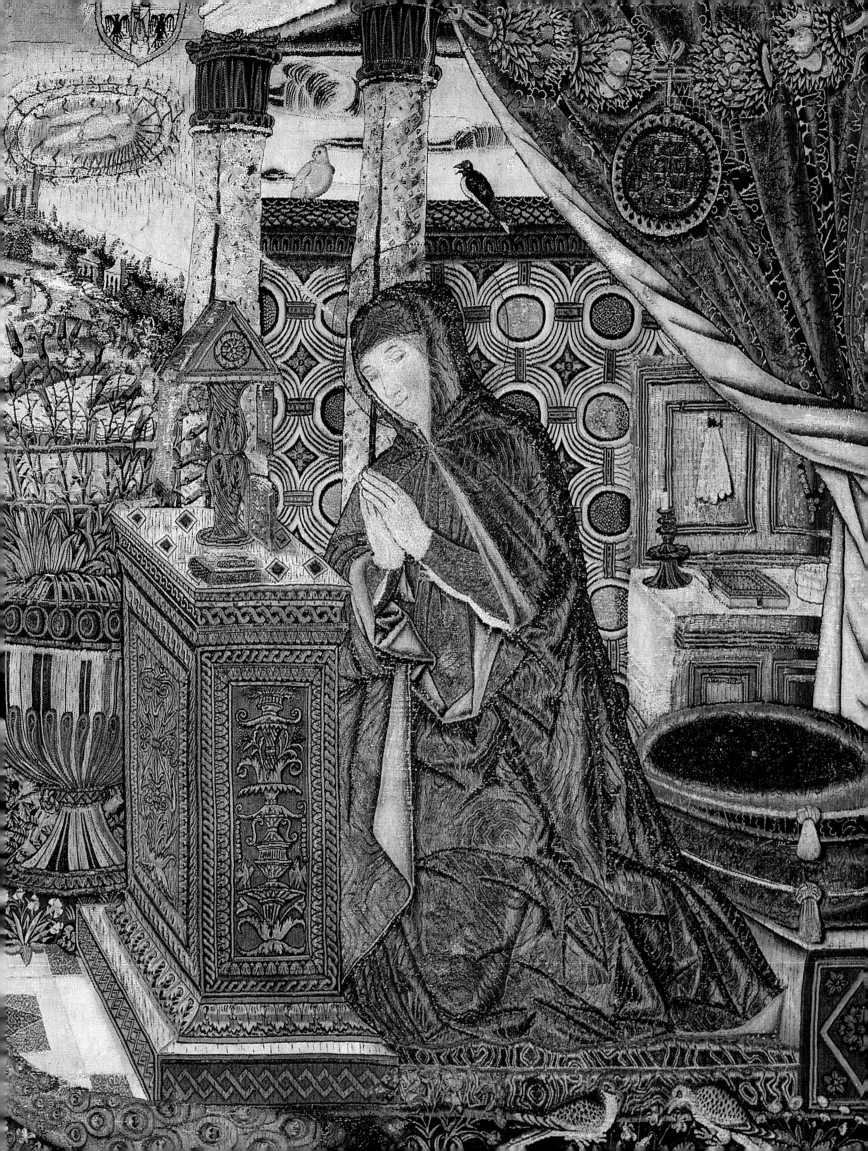

✤ IV ✤
TAPESTRIES FROM BASEL, ITALY, HOLLAND, ENGLAND, AND PERU

CAT. 54

CAT. 54

The Lovers

Basel, 1490/1500
After a design by an unknown artist
Produced at an unknown workshop
INSCRIBED: *ich spil mit üch in trüwe/ des sol üch niemer rüwen*
105.3 x 78.9 cm (41½ x 31⅛ in.)
Gift of Kate S. Buckingham, 1922.5378

STRUCTURE: Hemp, wool, and silk; slit and double interlocking tapestry
weave
Warp: Count: 5–6 warps per cm; hemp: S-ply of two Z-spun elements;
diameters: 0.5–0.9 mm
Weft: Count: varies from 22 to 28 wefts per cm; wool: S-ply of two Z-spun
elements; pairs of S-ply of two Z-spun elements; diameters: 0.5–1.2 mm; silk:
S-ply of two Z-twisted elements; diameters: 0.2–0.3 mm

Conservation was executed by in-house staff.

PROVENANCE: Possibly jointly owned by French and Company and
Macdermid Parish-Watson, both of New York, before 1919. Possibly Joseph
Brummer, New York, before 1919.[1] Henry Corbin Lawrence (died 1919),
New York; by descent to his wife, Lucy Ryerson Lawrence (died 1920); by
descent to her daughters, Gladys Lawrence Hubbard and Lucy Lawrence
Hutchinson; sold, American Arts Association, New York, Henry C.
Lawrence sale, Jan. 27–29, 1921, lot 572, to French and Company; sold to
Kate S. Buckingham, 1921; given to the Art Institute, 1930.

REFERENCES: Kurth 1926, p. 107, fig. 52. Rogers and Goetz 1945, cat. 62, pl.
42. Mayer Thurman 1969, pp. 22–23, pl. 8. Rapp Buri and Stucky-Schürer
1990, pp. 271–72, cat. 72. Mayer Thurman 1992, pp. 36, 38–39 (ill.), 144.
Schuttwolf et al. 1998, p. 86 (ill.). Chicago 2004, pp. 83–84 (ill.).

EXHIBITIONS: Art Institute of Chicago, *Masterpieces of Western Textiles*,
1969 (see Mayer Thurman 1969). Chicago, Continental Bank, *Textiles of
Western Culture from the Art Institute of Chicago*, 1977. Art Institute of
Chicago, *Tapestries from the Permanent Collection*, 1979. Basel, Historisches
Museum, *Zahm und Wild: Basler und Strassburger Bildteppiche des 15. Jah-
rhunderts*, 1990 (see Rapp Buri and Stucky-Schürer 1990). Art Institute of
Chicago, *European Textile Masterpieces from Coptic Times through the 19th
Century*, 1990. Art Institute of Chicago, *Textile Masterpieces from the Art
Institute of Chicago's Collection*, 1993 (see Mayer Thurman 1992). Art Institute
of Chicago, *Chicago's Dream, A World's Treasure: The Art Institute of Chi-
cago, 1893–1993*, 1993–94. Art Institute of Chicago, *Renaissance Velvets and
Silks*, 2002–03.

THIS pleasing depiction of one of the most basic and eternal aspects
of life, a pair of lovers pledging their fidelity to each other, is set against
a dense and colorful hedge of flowering acanthus. An inscription in
Gothic letters—spanning a pair of mirror-image banderoles fram-
ing the lovers' heads—records their vow: *ich spil mit üch in trüwe,
des sol üch niemer rüwen* (I dally with you faithfully; I hope you will
never regret it). The couple's attire reflects the prevailing fashions of
the 1470s and 1480s: the young man wears a tailored doublet with
tight hose that end in long pointed shoes, or *poulaines*, supported by
pattens, and his companion is dressed in a long-sleeved, fur-trimmed
garment bearing an abstracted pomegranate pattern often found in

late-fifteenth-century fabrics woven either of silk or wool pile. Her
horned headdress, draped in netting and crowned with a veil, com-
pletes her attire. Although their clothing styles predate the weaving of
the tapestry, this may be because the tapestry's cartoon was based on
earlier sources, either painted or printed.[2] The couple are both seated
on pillows, the woman's perhaps made either of a linen textile with a
block-printed pattern or possibly a silk, damask-woven fabric, laced
up on one side. The man's cushion, which covers the top of a wood-
en bench, appears to be made of a heavy woolen tapestry-woven or
embroidered fabric; the pillow's corners terminate in pompons. The
young man, wearing what might be interpreted as hunting gloves,
appears to have released a falcon, which, in the space between the
pair of lovers, attacks another bird, possibly a woodcock.[3] Two addi-
tional birds flank the gentleman. Between his legs rests a sword. On
the lady's lap sits a small spotted kid or deer reminiscent of the well-
known animal of medieval legend, the unicorn.[4] Thus, this charming
scene, which appears at first glance to be perfectly straightforward,
is heavily imbued with symbolic connotations. Within the context
of lovers voicing their mutual regard, their courtship and pursuit of
each other are represented metaphorically by the images of falconry
and the chase, on one hand, and the taming of a wild animal into a
lap pet on the other.[5]

In their comprehensive volume on Basel and Strasbourg tapes-
tries, Anna Rapp Buri and Monica Stucky-Schürer updated the con-
tributions of previous researchers, including Rudolf F. Burckhardt,
Heinrich Göbel, and Betty Kurth, among others, and brought them
together with archival documents and extant town records, as well as
with comparative fiber, weave, and dye analyses. Since the publica-
tion of this book in 1990, knowledge of these fascinating, early pic-
torial tapestries from the Upper Rhine region has increased. What
had long been called *Heidnischwerk*, an Old High German or Ale-
mannish term literally meaning "barbarian weavings" and initially
referring to hangings of unknown origin, variously described in the
literature as *tela barbarica* or *barbarico opere*, have begun to receive
the attention they deserve.[6] As a result, tapestries such as *The Lovers*
that had formerly been identified simply as either German or Swiss
in origin can now be confidently attributed specifically to Basel or
Strasbourg.[7] Furthermore, Rapp Buri and Stucky-Schürer have over-
turned the long-held assumption that such tapestries were woven in
convents by nuns; on the contrary, the *Heidnischwerkerinnen* were
frequently single women, oftentimes, although not exclusively, of
high social status, as the tax records and other documents in town
registries and archives have revealed.[8] Although the documents that
could prove this point indisputably have yet to be located, it is clear
that the weavers of *Heidnischwerk*, whether female or, occasion-
ally, male, were not incorporated into a special guild. It is therefore
assumed that they customarily served a three- or four-year appren-
ticeship in the workshop of a skilled master.[9]

Courtly love was a popular theme for the visual arts during the
fifteenth century. Paintings, manuscript illuminations, and graphic

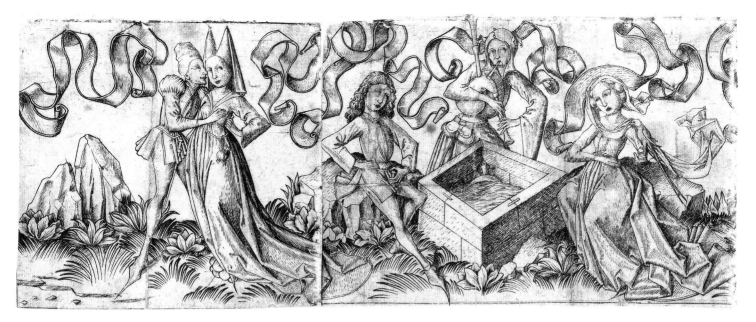

FIG. 1 *Der kleine Liebesgarten*. Meister E. S. Kupferstich, Staatliche Graphische Sammlung, Munich.

works (see fig. 1) treated it frequently, as did tapestries. Always utilizing bright, colorful woolen yarns, and featuring human figures and animals against a dark green background, densely patterned with acanthus leaves and flowering plants, including roses, this type of small-sized tapestry dating from the second half of the fifteenth century on can now be clearly identified. The Art Institute's example is small enough to have been a treasured object of decoration in the household of a well-to-do burgher in the Basel region. The enclosed garden—or *hortus conclusus*—in which the lovers are placed indicates that this tapestry was probably part of a dowry or trousseau, serving both as a status symbol and testament to its owner's virginity, for the Virgin Mary was often depicted seated in such gardens, endowing them with associations of chastity.[10] Alternatively, the tapestry could have been a wedding present. Regardless of the circumstances of its creation, however, the woman is safely situated within the enclosure, but for the adventurous man who has entered her sanctum, intent on communicating the seriousness of their relationship, as recorded in the scriptural bands that document his proposal and her response. In sum, the panel illustrates in an engaging manner the elements of their courtship: male prowess and female receptivity, the promise of fidelity and the hope that it will endure. CCMT

NOTES

1. For the possible ownership of the tapestry by French and Company, Macdermid Parish-Watson, and Joseph Brummer, see the annotated catalogue in *The Lawrence Collection, 1921*, in the Thomas J. Watson Library at the Metropolitan Museum of Art. I thank Robyn Fleming at the Thomas J. Watson Library for providing photocopies of the above material.

CAT. 54, DETAIL

2. Many of the tapestries dated to the fifteenth and early sixteenth centuries and attributed to Basel and Strasbourg do in fact display outmoded styles of dress, some over fifty years out-of-date; see Rapp Buri and Stucky-Schürer 1990, cats. 125–26. This may be explained in part by Basel's location in an area that was exposed to both Franco-Burgundian and Germanic cultures, which together influenced the existing peculiarities of its regional costume, especially during the fifteenth century, when styles of dress became increasingly bizarre the farther east one moved from the Franco-Flemish border— just one sign of the Germanic lands' fragmented state of government. For more on the costume of this period, see Scott 1980.

3. Christina M. Nielsen, Assistant Curator of Medieval Art, Department of Medieval to Modern European Painting and Sculpture, the Art Institute of Chicago, suggested that the young man's gloves are those of a falconer; Nielsen 2004, p. 83. The identification of the bird being preyed upon was offered in Rapp Buri and Stucky-Schürer 1990, p. 271.

4. Indeed, the animal's pose calls to mind the similar posture of the unicorn shown in the *Sight* tapestry from *The Lady and the Unicorn* suite in the Musée National du Moyen Âge, Paris. There is, however, doubt about the actual identity of the animal in the Chicago tapestry: Rapp Buri and Stucky-Schürer 1990 calls it both a "Zicklein" (kid; p. 271), and a "Rehkitz" (buck; p. 272), and Guy Delmarcel, in an e-mail to the author, suggests it is a dog, a symbol of female marital fidelity.

5. Again, my colleague Christina Nielsen has suggested, "These images of trained and tamed beasts were perhaps intended to signal the reining in of strong passions"; Nielsen 2004, p. 83. See also Mayer Thurman 1992, p. 36.

6. Rapp Buri and Stucky-Schürer 1990, pp. 21–22.

7. Ibid., pp. 24–27.

8. Ibid., pp. 47–51. Occasional references to a *Heidnischwerker* indicate that men also performed this work.

9. Ibid., pp. 49–50.

10. The kid on the woman's lap reinforces this symbolism through its resemblance to the unicorn, which was said to associate only with virgins. If the animal is a dog, it suggests a slightly different, albeit related, symbolic meaning (see note 4 above).

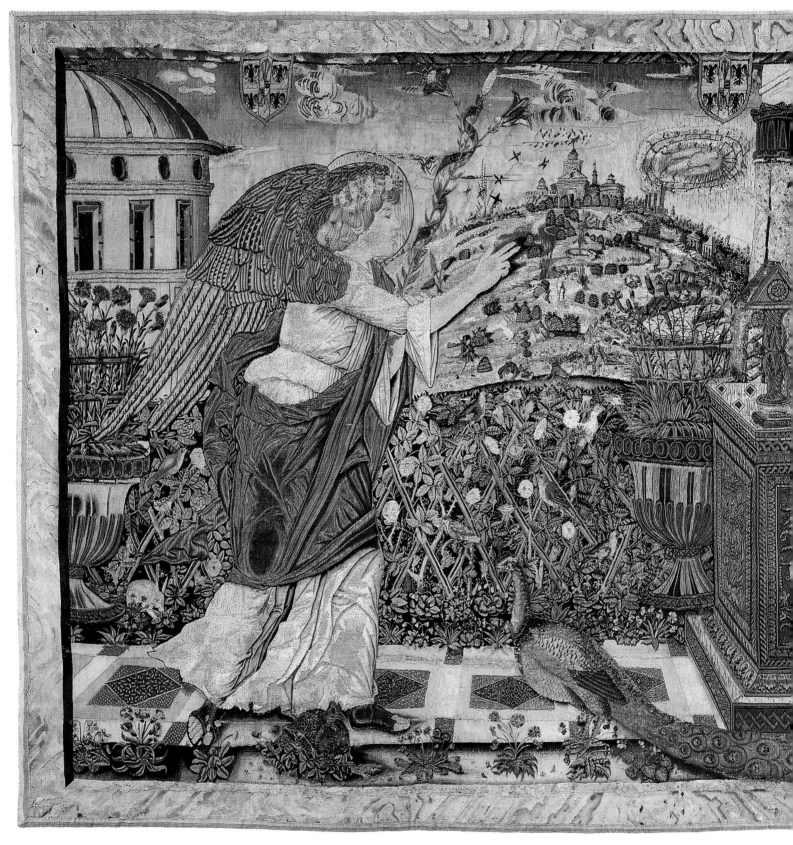

CAT. 55

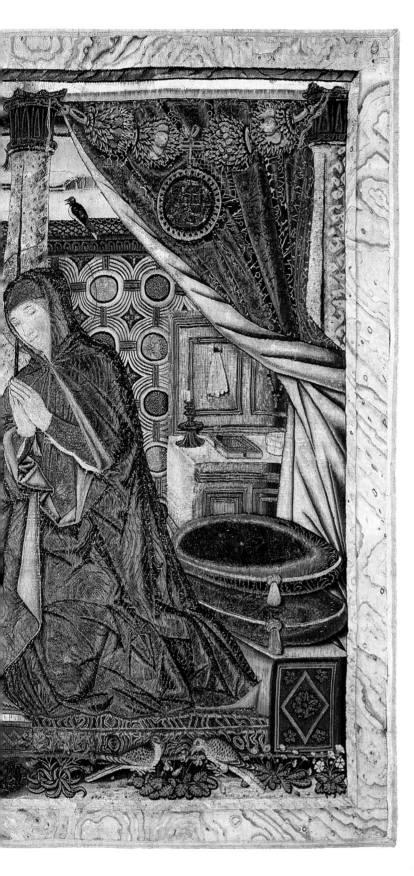

CAT. 55

The Annunciation

Presumably Mantua, 1484/1519
After a design by an artist in the circle of Andrea Mantegna (c. 1430–1506)
Produced at an unknown workshop
INSCRIBED: *ECCE ANCILLA D F M S T, A·G·P*; undeciphered
179.4 x 113.7 cm (70⅝ x 44¾ in.)
Bequest of Mr. and Mrs. Martin A. Ryerson, 1937.1099

STRUCTURE: Wool, silk, and gilt- and silvered-metal-strip-wrapped silk; slit, dovetailed, and interlocking tapestry weave
Warp: Count: 9 warps per cm; wool: S-ply of three Z-spun elements; diameters: 0.6–0.7 mm
Weft: Count: varies from 32 to 88 wefts per cm; wool: single Z-spun elements; S-ply of two Z-spun elements; diameters: 0.2–0.6 mm; silk: multiple single S-twisted elements; S-ply of two Z-twisted elements; pairs and three yarns of S-ply of two Z-twisted elements; pairs and three yarns of S-ply of two elements with no appreciable twist; diameters: 0.2–0.7 mm; gilt- and silvered-metal-strip-wrapped silk: metal strip wrapped in an S-direction on single S-twisted silk elements; diameter: 0.2 mm; metal strip and silk: paired metal strip and S-ply of two silk elements with no appreciable twist; diameters: 0.2–0.3 mm

Conservation of this tapestry was made possible through a donation in honor of Alice Welsh Skilling, and through the generosity of the Textile Society of the Art Institute of Chicago.

PROVENANCE: Possibly commissioned by the Gonzaga family, Mantua, 1469/1519. Frédéric Spitzer (died 1890), Paris, to 1890; sold, Paris, Spitzer sale, Apr. 17–June 16, 1893, lot 394, to Martin A. Ryerson (died 1932), possibly by proxy; by descent to Mrs. Martin A. Ryerson (née Caroline Hutchinson, died 1937); bequeathed to the Art Institute, 1937.

REFERENCES: Müntz 1885, p. 158, fig. 32. Hunter 1914b, pp. 147–52 (ill.). Ackerman 1925a, p. 41. Ackerman 1925b, pp. 188–93 (ill.) Göbel 1923, pt. 2, pl. 389. Göbel 1924, pl. 398. Göbel 1928, pt. 2, pl. 426. Candee 1935, p. 61 (ill.). Weibel 1951, pp. 42–43. Wardwell and Davison 1966, pp. 186, 187, 189. Mayer Thurman 1969, pp. 29–30, pl. 2. Mayer Thurman 1979, pp. 9–10, fig. 9. Wardropper 1987, p. 200. Thornton 1991, pp. 46, 47 (ill.). Mayer Thurman 1992, pp. 32–33, 144 (ill.). Brown, Delmarcel, and Lorenzoni 1996, pp. 33, 34 (ill.). Dufour Nanelli 1997, pp. 43, 120 (ill.). Campbell 2002c, pp. 114–17 (ill.).

EXHIBITIONS: Hartford, Wadsworth Atheneum, *2000 Years of Tapestry Weaving*, 1951–52, traveled to Baltimore Museum of Art, 1952 (see Weibel 1951). Art Institute of Chicago, *Masterpieces of Western Textiles*, 1969 (see Mayer Thurman 1969). Art Institute of Chicago, *Tapestries from the Permanent Collection*, 1979 (see Mayer Thurman 1979). Art Institute of Chicago, *European Textile Masterpieces from Coptic Times through the 19th Century*, 1989–90. Art Institute of Chicago, *Textile Masterpieces from the Art Institute of Chicago's Collection*, 1993 (see Mayer Thurman 1992). New York, Metropolitan Museum of Art, *Tapestry in the Renaissance: Art and Magnificence*, 2002 (see Campbell 2002c). Art Institute of Chicago, *Renaissance Velvets and Silks*, 2002–03.

IN an outdoor setting, the archangel Gabriel announces to the Virgin Mary that she will bear the son of God (Luke 1:26–38). This is one of the most sacred events in the Christian faith, as it is the very beginning of Christ's life and of the Incarnation of the Word. The

scene is thus charged with symbolism.[1] The moment of conception is represented by the dove—standing for the Holy Spirit—in the sky between Gabriel and Mary. As Gabriel raises his right hand in the traditional gesture of blessing, he also points to the dove, from which a ray of light descends to Mary's head.

The archangel holds a lily, a symbol of purity, that is entwined with a ribbon showing the letters *A·G·P*, which stand for "Ave, gratia plena" (Hail, thou that art highly favored), the words with which he greeted Mary (Luke 1:28). Gabriel walks on a marble-tiled path. The paving slab before him shows letters including *A*, *D*, and *I*, but their meaning is not clear. Mary kneels at a richly decorated prie-dieu in front of a loggia, reading a book that rests against a small tabernacle, her hands clasped in prayer.[2] Behind her can be seen a small bench with two cushions, which hold open the curtain that would otherwise block the opening of the loggia. The curtain and a swag of leaves and fruit hang between two columns. In the middle of the festoon is a pendant medallion on which is inscribed *ECCE ANCILLA D(OMINI) F(IAT) M(IHI) S(ECUNDUM) T(UUM)* (Behold the handmaid of the Lord; be it unto me according to thy word), Mary's reply to the archangel (Luke 1:38). In the loggia, in front of a wall inlaid with a repeated pattern of marble circles, is a cabinet on which sit various objects: a book, a rosary, a small box, an unlit candle (a symbol of Christ as "the light of the world"; John 8:12), and a veil. Two birds, possibly a goldfinch and a swallow, both symbols of the soul and the Resurrection, sit on the wall.[3]

In the near foreground are a guinea fowl and a peacock, both of which signify immortality, and two doves that represent the souls of the blessed. Behind the figures stand two large urns with carnations, symbolizing Christ's Passion, and a trellis with birds and rosebushes bearing white and red blossoms, for the Virgin's purity and Christ's Passion, respectively. Behind the trellis, on the left of the scene, a domed building can be seen. In the distance, a castle or temple crowns a hillside. Two shields bearing the coat of arms of Francesco II Gonzaga appear in the upper field of the sky, almost as if hanging from the marbled border that frames the piece.

Since the end of the nineteenth century tapestry scholars have rightfully identified *The Annunciation* as designed and woven in Italy around 1500.[4] It is thus one of the very few Italian tapestries to survive from before the 1540s.[5] In particular, the convincing representation of space that characterizes the composition, one absent from contemporary Flemish tapestry design (compare, for example, *The Annunciation* with cats. 5 and 6), reveals close affinities between the tapestry and fifteenth-century Italian painting.[6] The pioneering tapestry scholars George Leland Hunter and Heinrich Göbel even went so far as to attribute the design to Andrea Mantegna, but stylistic features such as the poorly rendered perspective and the simple frontal arrangement of Gabriel and Mary are not typical of his manner.[7] Rather, tapestry scholars now generally assume that *The Annunciation* was created by an Italian painter working under Mantegna's influence.[8]

The iconography of the scene supports the attribution of the design to an Italian artist. Whereas in the fourteenth and fifteenth centuries French artists usually depicted the Annunciation in an ecclesiastical interior and Flemish and German painters favored bourgeois or ecclesiastical interiors, Italian artists used exterior loggia or portico settings.[9] Moreover, a number of late-fifteenth-century Italian paintings and engravings depicting the Annunciation demonstrate that the designer of the Art Institute's tapestry incorporated various features typical of the imagery used by Italian artists of the time, including the direction of the divine ray, the hillside view, the ribbon entwined with the lily, and the trellis.[10]

The assumption that the tapestry was not only designed but also woven in Italy is supported by a number of features.[11] First, the piece is technically different from contemporary tapestries woven in the Southern Netherlands, as it incorporates a far higher proportion of silk than is normally found in Flemish or Franco-Flemish pieces. In addition, neither the border nor the palette of *The Annunciation* bear any resemblence to Flemish or Franco-Flemish pieces.[12] It is generally accepted that the tapestry was produced in Mantua.[13] This belief is based on the presence of the coat of arms of Francesco II Gonzaga, marquis of that city, and on *The Annunciation*'s stylistic links with the work of Andrea Mantegna, who was court painter to the Gonzaga family between 1460 and 1488. The Gonzagas were avid tapestry collectors and patronized Flemish and Italian weavers in Mantua, who produced pieces of high quality from designs by local artists or artists-in-residence, including Mantegna.[14] For example, an archival document shows that in 1469 Ludovico II Gonzaga commissioned drawings of "due galline de India del naturale, una maschio et una femina" (two guinea fowl from life, a male and a female) for "la tapezeria nostra" (our tapestry) from Mantegna.[15] While it is tempting to link this document to *The Annunciation*, as one such bird appears in the foreground of the tapestry,[16] it is of course quite possible that the drawings were made for a different tapestry design.[17]

The arms of Francesco II Gonzaga suggest that the tapestry was woven between 1484, when Francesco II was elected fourth marquis of Mantua, and 1519, the year of his death. But as unequivocally demonstrated by the analytical research and testing that was performed in connection with the tapestry's conservation, the interior portions of the two coats of arms were altered at several undocumented and unknown times, which reveals that the arms of Francesco II postdate *The Annunciation*'s completion.[18] As was typical among noble families, the Gonzagas personalized the tapestries they acquired by adding their coat of arms: at the end of the fourteenth century Francesco I Gonzaga sent nine unidentified pieces to Paris for this treatment,[19] and prior to 1557 Ercole Gonzaga had his arms added to a Brussels *Acts of the Apostles* suite that he had purchased after it was woven.[20] It is therefore possible that *The Annunciation* was woven prior to 1484—in Mantua or elsewhere in Italy—and that it was neither originally commissioned nor first owned by a member of the Gonzaga family. KB

NOTES

1. Wenzel 1993.

2. Mary may be reading Isaiah's prophecy of the Incarnation; Robb 1936, pp. 483–85.

3. For a discussion of these birds in Annunciation scenes, see Friedmann 1968–69, pp. 7–10.

4. Müntz 1878–84, p. 100, pl. 1, discussed the tapestry before it was sold at the Spitzer sale in 1890; Spitzer 1890–91, p. 159, lot 1.

5. For tapestry in Italy prior to the 1540s, see Thomas P. Campbell, "Patronage and Production in Italy, 1380–1510," in Campbell 2002c, pp. 85–101, and Smit 2002.

6. Forti Grazzini 1982a, p. 60.

7. Hunter 1914b, pp. 147–78, Göbel 1924, pp. 589–90. Mayer Thurman 1992, p. 32, expressed some reservation about the attribution, stating that the piece is "believed to have been designed by Andrea Mantegna."

8. See, for example, Tietze-Conrat 1955, p. 248; Brown, Delmarcel, and Lorenzoni 1996, pp. 33, 43 n. 1; and Thomas P. Campbell, "The *Annunciation*" (cat. 9) in Campbell 2002c, pp. 114–17. Lightbown's assertion that Mantegna's style can be easily recognized in the tapestry is the exception that proves the rule; Lightbown 1986, pp. 133, 488.

9. Robb 1936; Spencer 1955; Colosio 2002 (with thanks to Barbara Baert and Katelijne Schiltz).

10. See, for example, Steinberg 1987, pp. 32, 33, 43, figs. 7, 8, 43; Hind 1938–48, vol. 1, pp. 257, 268–69, 271; and ibid., vol. 4, pls. 408, 441, 447. That Gabriel approaches from the left also supports an Italian origin for the design, because during the course of the fifteenth century, northern Annunciations frequently depicted the archangel approaching from the right; Denny 1977, p. 146.

11. Thomas P. Campbell, "The *Annunciation*" (cat. 9), in Campbell 2002c, p. 117. Ackerman (1925b, p. 193) first attributed the tapestry to the Oudenaarde tapissier Joas Huet based on the letters in the paving slab, and later (Ackerman 1933, pp. 200–03) to the Ferrarese workshops of the Este, after a design by Cosmè Tura, but these attributions are wholly unconvincing.

12. The border is to a certain degree reminiscent of the borders of two small tapestries that were woven in Bologna around 1502 or 1503. One piece is in the Museo di San Petronio, Bologna; the other is in the Victoria and Albert Museum, London. For illustrations and a brief discussion of the pair, see Smit 2002, p. 124, figs. 2, 3.

13. For tapestry production in Mantua, see Braghirolli 1881 and Smit 2002.

14. Brown, Delmarcel, and Lorenzoni 1996; Smit 2002, pp. 114–16, 122; Thomas P. Campbell, "The *Annunciation*" (cat. 9), in Campbell 2002c, pp. 114, 117.

15. Braghirolli 1881, p. 19.

16. As Lightbown 1986, p. 488, does.

17. Göbel 1924, pp. 589–90, hypothesized that the birds were used in a design for a verdure tapestry, and Thomas P. Campbell, "The *Annunciation*" (cat. 9), in Campbell 2002c, p. 116, also duly refrains from connecting the document with *The Annunciation*.

18. Christa M. Thurman, Veerle De Wachter (De Wit Conservation Laboratory), and Ina Vanden Berghe (Royal Institute for the Study and Conservation of Belgium's Artistic Heritage), conservation report, 2007, in conservation file 1937.1099, Department of Textiles, the Art Institute of Chicago. Indeed, the research revealed that the larger part of the coats of arms is embroidered, not woven.

19. Smit 2002, p. 114.

20. Brown, Delmarcel, and Lorenzoni 1996, pp. 148, 157 n. 2. For the suite, see also Delmarcel 1999a, pp. 142–46.

CAT. 56

Medici Armorial

Florence, 1643–44
After a cartoon by Lorenzo Lippi (1606–1665) painted before April 27, 1643
Produced at the Medici workshop under the direction of Pietro van Asselt (c. 1600–1644), before June 15, 1644
216.7 x 311.2 cm (85⅜ x 122½ in.)
Gift of Robert Allerton, 1944.412

STRUCTURE: Wool, silk, and gilt-metal-strip-wrapped silk; slit and double interlocking tapestry weave with wrapping outlining wefts and areas of 4:4 plain interlacing of gilt-metal-strip-wrapped silk wefts
Warp: Count: 7 warps per cm; wool: S-ply of four Z-spun elements; diameters: 0.8–1.1 mm
Weft: Count: varies from 20 to 38 wefts per cm; wool: single Z-spun elements; pairs of single Z-spun elements; S-ply of two Z-spun elements; S-ply of three Z-spun elements; diameters: 0.3–1.1 mm; silk: three single Z-twisted elements; four yarns, two of Z-twisted and two of S-twisted elements; diameters: 0.4–1.0 mm; gilt-metal-strip-wrapped silk: gilt-metal strip wrapped in an S-direction on S-ply of two silk elements of no appreciable twist; diameters: 0.35–0.6 mm; gilt-metal-strip-wrapped silk and silk: three yarns, two single Z-twisted silk elements and one of gilt-metal wrapped in an S-direction on S-ply of two silk elements of no appreciable twist; diameters: 0.9–1.6 mm; gilt-metal-strip-wrapped silk and wool: three yarns, two single Z-spun wool elements and one of gilt-metal strip wrapped in an S-direction on S-ply of two silk elements of no appreciable twist; diameters: 1.0–1.5 mm

Conservation of this tapestry was made possible through the Allerton Endowment Fund.

PROVENANCE: Probably woven for Ferdinando II de' Medici (died 1670), Palazzo Pitti, Florence; by descent through the Medici family, Florence, from 1670. Elie Volpi (died 1938), Florence, to 1910; sold, Maison de Ventes, Florence, Apr. 25–May 3, 1910, lot 388. F. Henry Humbert. Sold to Martin A. Ryerson (died 1932), in Florence, June 1910; by descent to his wife, Mrs. Martin A. Ryerson (née Carrie Hutchinson, died 1937); bequeathed to the University of Chicago, 1938; given to the Art Institute in exchange for a tapestry that had been owned by Robert Allerton, 1944.

AN undulating coat of arms in a strapwork cartouche appears on a ground simulating a draped dark red velvet fabric. The arms show six *palle* (balls) on a gold ground. The *palle* are red, except for the topmost one, which is blue and bears three gold fleurs-de-lis. A festoon of leaves and fruit borders the bottom of the arms, and two putti holding a crown fly above. The border of the tapestry is composed of heavy interlocking *S* and *Z* shapes. Blank cartouches are visible in the center of the vertical and horizontal borders.

The arms belong to the Medici family, which played a key role in the complex political history of Florence and of Italy in general.[1] Their influence was based on the wealth they amassed, notably during the fifteenth century when the family's bank (1397–1494) flourished.[2] The *palle* shown in their coat of arms may represent coins, an allusion to the Medici's banking business, or more probably they represent pills or cupping glasses, a reference to the family's name: *medici* means doctors or apothecaries.[3] A legend offers yet another

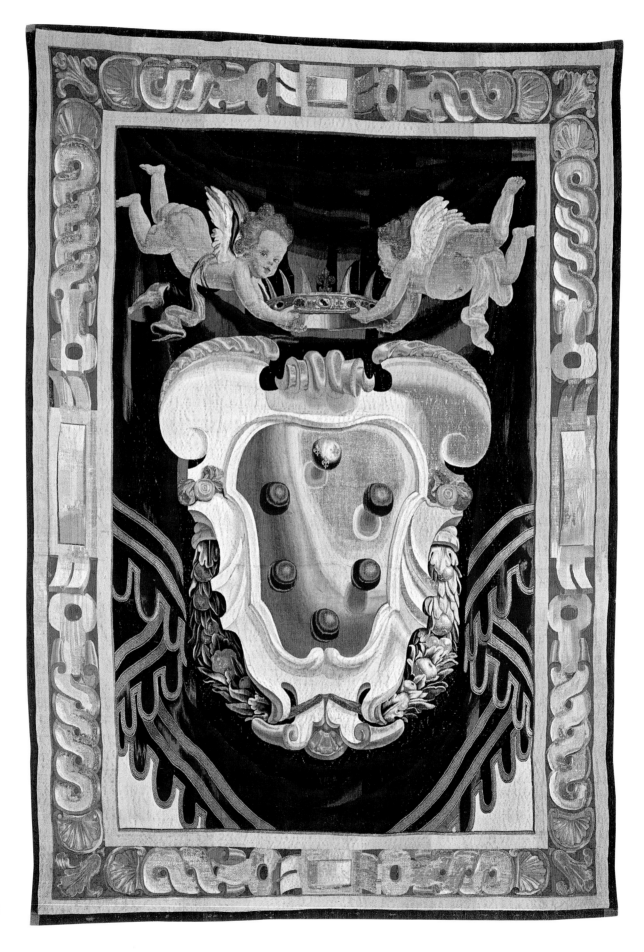

explanation. Around 800 a brave knight named Averardo—reputedly the founding father of the Medici dynasty—killed a savage giant who had been terrorizing the people living near Florence. During the battle, the giant dented Averardo's shield; the knight transformed the dents into *palle* to symbolize his victory. The topmost *palla*, as well as the crown held by the putti, are decorated by fleurs-de-lis, the emblem of Florence. The crown is that of the Medici Grand Dukes of Tuscany. Cosimo I de' Medici received the title of Grand Duke, and the right to wear a royal crown, from Pope Pius V in 1569. An early eighteenth-century drawing confirms that the tapestry depicts the crown accurately.[4]

The Medici were exceptional supporters of the arts.[5] Their patronage of the tapestry industry has been thoroughly studied by Candace Adelson and Lucia Meoni.[6] In 1545 Cosimo I engaged two Flemish tapestry weavers, Jan Rost (active 1535–64) and Nicolas Karcher (c. 1498–1562) in the Piazza San Marco and the via dei Cimatori. Rost and Karcher produced tapestries for the Medici and other families, as well as trained Italian weavers. This led to the establishment in 1554 or 1555 of two workshops directed by Florentine entrepreneurs that were devoted to making sets for Medici villas and palaces. In 1568 these Medici workshops merged and, in 1574, were relocated to the former Rost workshop in the Piazza San Marco. The subsequent directors were the Italian Guasparri Papini (c. 1540–1621), the Flemish émigré Jacopo van Asselt (c. 1578–1629), and the French émigré Pietro Févère (c. 1592–1667). Before he became head of the Medici workshop in 1629, Févère had run a production unit in the Palazzo Vecchio that was also supported by the Medici; from 1629 this unit was manned by Jacopo's son Pietro.

Pietro van Asselt produced the *Medici Armorial* that is now in the Art Institute, as an archival document reveals.[7] On June 15, 1644, one week before his death, Van Asselt received payment for "[t]re portiere di Arazzo con oro con Arme in o/2 de Medici, e corona sopra con dua angiolini che la reggono, e festoni con panno rosso figurato velluto rosso con fregi alle bande e ruotoli di chiaro scuro" ([t]hree portieres woven with gold thread depicting the arms of the Medici in o/2, with a crown on top held by two little angels, with festoons and a red textile simulating a draped red velvet fabric, with a border of chiaroscuro spiral motifs).[8] These three tapestries were recorded in an early-twentieth-century inventory of tapestries formerly in the Medici collection.[9] Whereas one piece was stored in the attic of the Palazzo Vecchio, the other portieres were in the Palazzo Medici Riccardi. In a 1978 letter written to Christa C. Mayer Thurman, Adelson identified the piece in the Art Institute as the tapestry that was in the Palazzo Vecchio.[10] Meoni has recently confirmed Adelson's identification,[11] and intends to discuss the piece thoroughly in her forthcoming book on Florentine tapestry during the reign of Ferdinando II de' Medici.[12]

The two tapestries that still remain in Florence bear Van Asselt's signature. As another archival document shows that the Florentine painter Lorenzo Lippi was paid for designing the cartoon for the

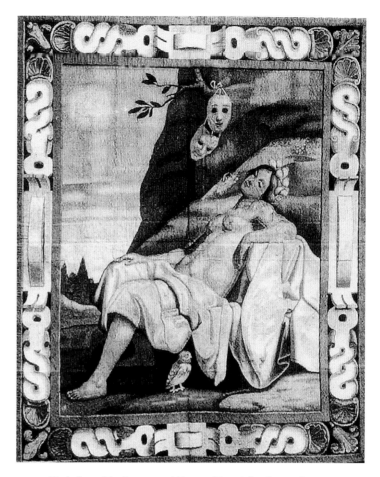

FIG. 1 *Night* from *The Seasons and Times of Day*. After designs by Lorenzo Lippi and Jacopo Vignali. Produced at the workshop of Pietro Févère. Wool and silk; 270 x 240 cm. Biblioteca Mediceo Laurenziana, Florence.

tapestries on April 27, 1643,[13] the piece in the Art Institute must have been woven between April 1643 and June 1644. This date implies that the commissioner of the tapestries was Ferdinando II de' Medici, the great-grandson of Cosimo I and Grand Duke of Tuscany from 1621 to 1670, when lavish entertainments and ceremonial events were a regular feature of Florentine courtly life. The focus of the Medici's conspicuous consumption was the Palazzo Pitti, which the family had acquired unfinished in 1549.[14] The subsequent Medici dukes developed the Pitti, and in 1665, near the end of Ferdinando II's reign, the palace had no fewer than 379 rooms, divided among twenty-two principal apartments, which formed independent residences within the larger structure. The main ceremonial apartment in the palace consisted of five rooms on the main floor known as the Planetary Rooms.

Archival documents reveal that the three *Medici Armorials* made by Van Asselt were used as portieres in the Planetary Room known as the Sala di Giove (Room of Jupiter).[15] The portieres were part of *The Seasons and Times of Day*, a set codesigned by Lippi and another Florentine painter, Jacopo Vignali (1592–1664). Van Asselt produced three tapestries of the suite: *Daybreak*, after a cartoon by Lippi, and *Winter* and *Spring*, both designed by Vignali. Between 1640 and 1643, Févère executed the four remaining tapestries, *Summer*,

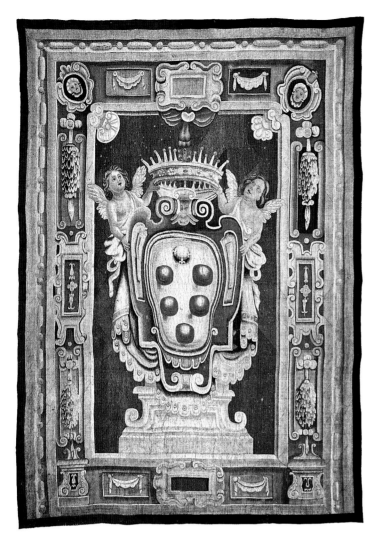

FIG. 2 *Medici Armorial.* After a design by Michelangelo Cinganelli and workshop. Produced at the workshop of Guasparri Papini, c. 1619. Wool and silk; 287 x 205 cm. Accademia delle Arti del Disegno, Florence.

Autumn, The Chariot of the Sun, and *Twilight,* and three portieres showing *Day, Night,* and *Time* (fig. 1). These three portieres were also designed by Lippi prior to April 27, 1643, when he received payment for the cartoons. The borders of all six portieres are identical. While Van Asselt and Févère produced the suite, Pietro da Cortona, one of the leading artists of the Roman Baroque, painted the eight matching lunettes in the Sala di Giove.[16]

As the Pitti and other Medici palaces were used to receive and lodge guests, it is hardly surprising that the family commissioned dozens of heraldic tapestries for these residences; such opulent weavings symbolized their wealth and power. No fewer than forty Medici armorials woven around 1600 are known today.[17] A vast majority served as portieres. An *Armorial with the Arms of the Medici and the Duchy of Austria* and seven *Medici Armorials,* all woven around 1619, are of particular interest, for these earlier tapestries clearly inspired Lippi's design.[18] They show the coat of arms in a cartouche in front of a draped fabric; two putti holding a crown flank the coat of arms

(fig. 2). The borders show classical architectural decorations such as cartouches and shells. These elements reappear in Lippi's portiere, albeit in a more dynamic and playful arrangement more in keeping with the Roman Baroque idiom then fashionable.[19] K B

NOTES

1. For the role of the Medici family in Italian history, see Hale 1977. Hibbert 1974 offers a highly readable popular history of the family.
2. De Roover 1963; Goldthwaite 1987.
3. Hibbert 1974, pp. 30, 313. The number of *palle* on the arms varied from five to twelve through the ages.
4. Hayward 1955.
5. Acidini Luchinat and Scalini 1998.
6. Adelson 1983; Adelson 1985; Adelson 1990; Meoni 1998; Meoni 2002; Meoni 2003; Meoni in Campbell 2007a, pp. 263–75. For a concise bibliography on tapestry production in Florence, see Forti Grazzini 2002, pp. 148–49 n. 56.
7. Pietro van Asselt (Vanasselt, Asselli) was the son and successor of Iacopo van Asselt (died 1629). Iacopo was a Flemish émigré who produced tapestries in Florence in the last quarter of the sixteenth century and visited Paris sometime between 1600 and 1620. From 1621 until his death in 1629 he headed the Medici tapestry workshop; Meoni 2002, pp. 163–65, 169–71.
8. Ibid., p. 171 n. 37. English translation by the present author. The meaning of "in 0/2" is unclear.
9. Ibid., p. 169 n. 34.
10. Object file 1944.412, Department of Textiles, the Art Institute of Chicago.
11. Lucia Meoni, e-mail to Christa C. Mayer Thurman, July 2005 and Mar. 2006.
12. Preliminary findings were published in Meoni 2002, pp. 169–71, which, however, erroneously lists the tapestry as still in Florence.
13. Meoni 2002, p. 171.
14. For the history of the Palazzo Pitti, see Satkowski 1983. The Florentine banker Luca Pitti had started construction of the palazzo in 1458, yet due to financial problems never finished the building.
15. Meoni 2002, p. 171.
16. Campbell 1977, pp. 191–99.
17. Meoni 1998, pp. 360–411, 430–31, cats. 134–71, 183–84; Sotheby's, London, Oct. 31, 2007, lot 81.
18. Meoni 1998, pp. 400–01, cat. 161 (*Armorial with the Arms of the Medici and the Duchy of Austria*), pp. 402–08, cats. 161–68 (*Medici Armorials*).
19. A Medici armorial that was on the American art market (GCPA 0242398) is related to Lippi's composition—it also shows angels, coats of arms, and a crown—but has a landscape background.

CAT. 57

The Crossing of the Granicus from *The Story of Alexander the Great*

Delft, 1619
After a design by, and produced at the workshop of, Karel II van Mander
(1579–1623)
SIGNED: *I KVMANDER FECIT AN 1619*
408 x 419.9 cm (160⅝ x 165½ in.)
Gift of the Antiquarian Society of the Art Institute of Chicago, 1911.439

STRUCTURE: Wool and silk, slit and double interlocking tapestry weave
Warp: Count: 8 warps per cm; wool: S-ply of three Z-spun elements;
diameters: 1.0–1.2 mm
Weft: Count: varies from 24 to 42 wefts per cm; wool: S-ply of two Z-spun
elements; diameters: 0.5–1.2 mm; silk: pairs of S-ply of two Z-twisted
elements; three yarns of S-ply of two Z-twisted elements; diameters:
0.5–1.0 mm

Conservation of this tapestry was made possible through the generosity of
the Antiquarian Society of the Art Institute of Chicago.

PROVENANCE: Prince Anatoli Demidoff (died 1870), Villa San Donato,
Florence, Italy, presumably from 1840; by descent to his nephew Paul Demi-
doff (died 1885); sold at auction from Villa San Donato, Florence, 1880, lot
109 (all nine tapestries). Jennie McGraw Fiske (died 1881), Ithaca, New York,
to 1881; presumably by descent to her husband Daniel Willard Fiske (died
1904) or another relative. Purchased by the Antiquarian Society of the Art
Institute of Chicago for $10,000, 1911; given to the Art Institute, 1911.

REFERENCES: Hunter 1914a, p. 120, no. 5. Hunter 1923, p. 136. Keefe et al.
1977, cat. 242. Hartkamp-Jonxis and Smit 2004, p. 224, fig. 84.

EXHIBITIONS: Art Institute of Chicago, *The Antiquarian Society of the
Art Institute of Chicago: The First One Hundred Years*, 1977 (see Keefe et al.
1977).

THIS tapestry shows a dramatic battle scene. In the center, Alexan-
der the Great, king of Macedonia, mounted on a horse and clad in
shining armor, leads his impressive forces across the Granicus River.
The opposing soldiers, wearing turbans, mount a counterattack. One
of these soldiers, dressed in a leopard skin, bravely waves the flag in
the right foreground. Two of his comrades blow trumpets to spur
on their troops, yet some of the soldiers seem to await their fate in
agony. In the background, Alexander's adversaries shoot arrows at
the Macedonians as they wade through the river. The borders show
vines, birds, and floral wreaths on a red ground.

Alexander (r. 336–323 B.C.) was a legend in his own time and a pop-
ular figure during the Middle Ages and Renaissance, known through
the many narratives his life and deeds inspired (see cat. 16). Since
the historians freely mixed fact with fiction, each account presents a
different Alexander—though all agree that he was a heroic, intrepid,
and just conqueror.[1] Upon ascending the throne at age twenty, the
young king crushed the rebellion of a number of Greek cities and
embarked on a military campaign against the Persian Empire. The

first major battle took place on the banks of the Granicus near Troy,
where the satraps of the Persian Empire had assembled to drive back
Alexander's army. According to multiple accounts, Alexander was
hit by an axe-blow from a Persian general who, just before he could
kill the king, was slain himself. This tapestry, *The Crossing of the
Granicus*, seems to depict this incident, as it shows a Persian horse-
man attacking Alexander with an axe. Eventually Alexander won the
battle and continued on to conquer the Persian Empire, including
Anatolia, Bactria, Egypt, Gaza, Judea, Mesopotamia, Phoenicia, and
Syria—all before dying of a mysterious disease at the age of thirty-
two. Later rulers often saw themselves as new Alexanders, and linked
their deeds with those of the Macedonian king.

The inscription in the tapestry's bottom border reads *I KVMANDER
FECIT AN 1619* (Karel van Mander the Younger made [this] in
1619) and thus attests that it was produced by the Dutch tapestry
designer and workshop manager Karel II van Mander, who played
an important role in the development of seventeenth-century tap-
estry production in the Dutch Republic, or Northern Netherlands.
The Dutch tapestry industry has been studied in depth by Gerardina
van Ysselsteyn, who in 1936 published numerous archival documents
pertaining to Dutch workshops and designers.[2] She demonstrated
that tapestry production in the Northern Netherlands was initiated
and supported by Flemish tapestry entrepreneurs and weavers who
had moved there for religious, political, or economic reasons.[3] The
Brussels producer Willem Andriesz. de Raet moved north as early
as 1543 and directed a workshop in Leiden until his death in 1573.[4]
Between 1570 and 1620 many more Flemish weavers and producers
left the Southern Netherlands to settle in Delft, Dordrecht, Gouda,
Haarlem, Leiden, Middelburg, Schoonhoven, and Utrecht. The city
administrations warmly welcomed the Flemish émigrés as they could
contribute significantly to the local economy. The Antwerp entrepre-
neur François Spiering (1549–1630) and a number of his workmen
immigrated to Delft in 1591, where they set up a successful workshop
that produced tapestries for clients in various European countries.[5]
Spiering's network of friends and collaborators included Karel I
van Mander (1548–1606), a draughtsman, painter, poet, and writer,
who had also moved from the Southern Netherlands to the Dutch
Republic in 1584.[6] After Karel I's death in 1606, Spiering engaged
his son Karel II to design tapestries and paint cartoons. According
to—possibly biased—archival material, however, Van Mander the
Younger was lazy and careless: he displayed a serious lack of interest
in the preservation of cartoons and was often absent from work.[7]

In 1615, en route from The Hague to Delft, Karel II complained to
his traveling companion Huybrecht Grimani, a painter from Delft,
that he had "ten huyse van Franchoys Spierincx binnen Delft als slave
gedient" (served as a slave in the Delft workshop of François Spier-
ing).[8] Van Mander made clear that he wanted to establish his own
workshop and asked Grimani to introduce him to potential back-
ers. In September 1615 Karel II, Grimani, and Nicolaas Snouckaert,
a Flemish noble who had moved to the Northern Netherlands for

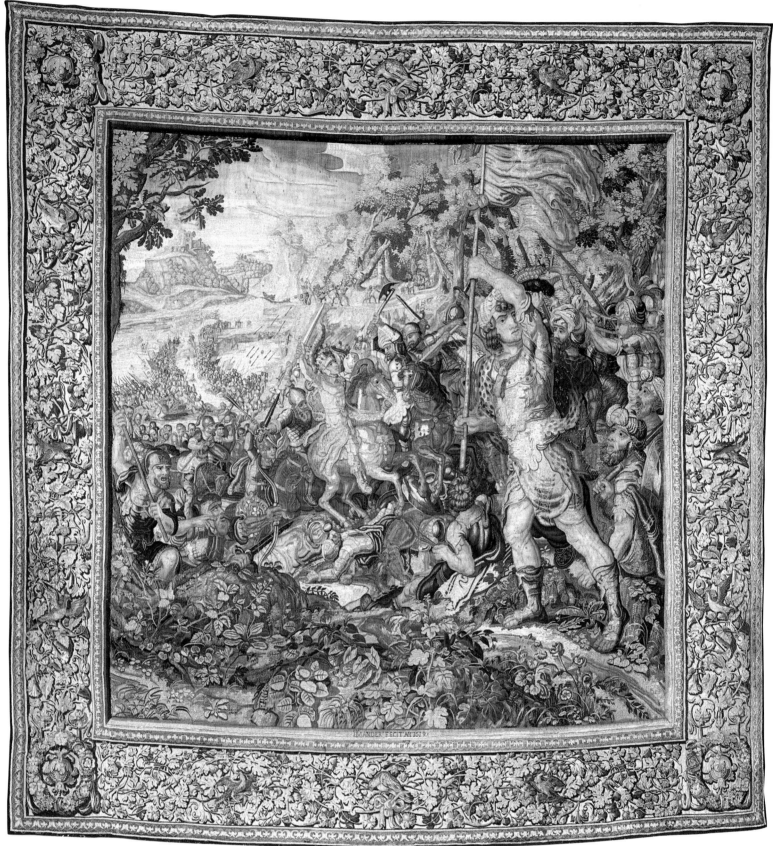

CAT. 57

religious reasons, contracted to produce tapestries in a joint venture. This initiative, in conjunction with Van Mander's obtaining a major commission from King Christian IV of Denmark that Spiering had hoped to receive, sparked a vendetta between Karel II and his former employer. Van Mander's obstinate and impulsive behavior also troubled his relations with his business partners. In July 1621 he lost his leading role in the management of the workshop and was demoted to designer and cartoon painter. In September 1622 Snouckaert and Spiering's son and successor Aert contracted to produce tapestries in a joint venture, which made Karel II a Spiering employee once again. Over the following weeks Van Mander became agitated and even planned to assault his employers, but fell ill and died early in 1623.[9]

A number of documents pertaining to the tragic life and career of Van Mander the Younger also shed light on his tapestry designs and cartoons. In December 1617, at François Spiering's request, the Hof van Holland (the Dutch court), decreed that Karel II "nyet . . . moegen beginnen off aennemen, voor ende aleer hy de historiën van Alexander Magnus ende Schipio ende noch seeckere drie ofte vier andere cameren patronen soude hebben geteyckent" (must not start or take on [new designs] before he has finished the story of Alexander the Great, the story of Scipio, and three or four other sets).[10] This ruling reveals that Spiering had commissioned the designs and cartoons of *The Story of Alexander* and that Van Mander had not finished them before he left the Spiering workshop in September 1615 to strike out on his own.[11] Spiering obviously wanted to prevent his former employee from finishing the cartoons and using them himself. Karel II, however, ignored the ruling, and finished the *Alexander* cartoons, for a document shows that between the establishment of his workshop in September 1615 and his demotion in July 1621, he designed only a handful of tapestry cartoons, but these included "nine scenes" for the *Alexander* series and two sets of cartoons for borders for the set, one labeled "orange," the other "blue."[12] Shortly after Van Mander's death in 1623 the *Alexander* cartoons were sold to "His Royal Majesty of Bohemia," Ferdinand II.[13] Spiering's decision to commission *Alexander* cartoons from Van Mander as well as Van Mander's determination to finish and use these cartoons in his own workshop attest to their belief in the marketability of a *Story of Alexander the Great* series, a conviction that the existence of numerous *Alexander* tapestry cycles shows to be well founded.

Four *Alexander* suites after Karel II's designs were woven between approximately 1615 and 1623,[14] three prior to his demotion in July 1621.[15] One of these three suites was the edition made for King Christian IV, which comprised eight tapestries. The two other suites were stored in the workshop. One consisted of nine pieces; the other, "met blauwe boorden" (with blue borders), comprised eight tapestries. On March 8, 1624, "een stuck van Alexander, met roode boorden, de battalie van Poorus" (a piece of Alexander, with red borders, the Battle of Porus) was recorded in a document pertaining to the transfer of

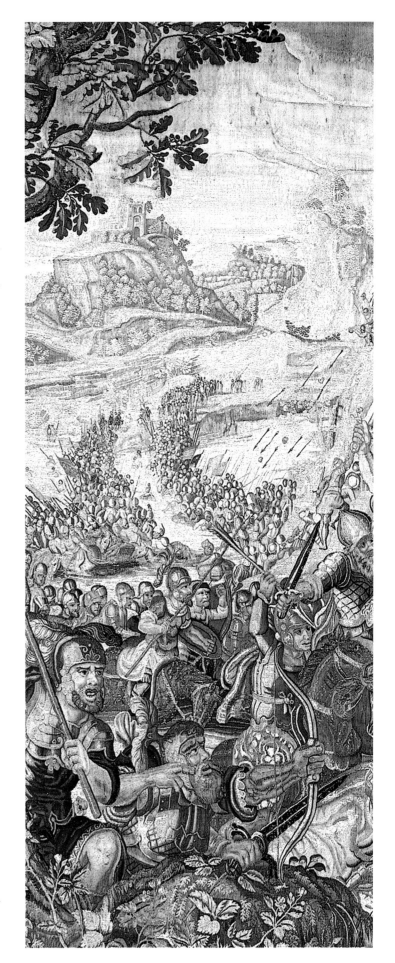

CAT. 57, DETAIL

tapestries from the former Van Mander workshop to Aert Spiering's operation.[16] Some days later, on March 26, 1624, three *Alexander* editions, "binnen Delft bevonden" (found in Delft) and "noch op deese uyer onvercost zijn" (unsold to this hour), were recorded: "een met rooden, een met blauwe, een met oranie boorden" (one with red, one with blue, and one with orange borders).[17] This document shows that, apart from the suite commissioned by the Danish king, none of the four *Alexander* suites after Karel II's designs had sold.[18]

Nine *Alexander* tapestries signed by Van Mander the Younger, including *The Crossing of the Granicus,* surfaced simultaneously on the art market in 1880, at the auction of the collection of Prince Anatole Demidoff.[19] The subjects of the other eight pieces are: *Alexander and Jaddua, Alexander and Roxane* or *Alexander and Cleophis, Porus Surrendering to Alexander, The Satrap of Susa before Alexander, A Triumphant Alexander Facing a Kneeling Warrior, The Burning of Persepolis,* and *An Homage to Alexander.* Six of these tapestries have been located: *Alexander and Jaddua* is in the Rijksmuseum, Amsterdam;[20] *Alexander and Roxane* or *Alexander and Cleophis* and *The Satrap of Susa* are in the Museum für Kunst und Gewerbe, Hamburg; *Porus Surrendering* is in the Stedelijk Museum Het Prinsenhof, Delft; and *An Homage to Alexander* is at the Breakers in Newport, Rhode Island. The two remaining pieces, *A Triumphant Alexander* and *The Burning of Persepolis,* were on the New York and Brussels art markets, respectively. Given that the nine pieces were all in the same collection and measure about the same height, it is logical to assume that they were part of the same suite.[21] This is not, however, the case: whereas *The Satrap of Susa* bears the date 1617,[22] the other pieces are dated 1619 (which, incidentally, reveals that Van Mander finished the *Alexander* cartoons by this year). Moreover, *Porus Surrendering* has a blue border,[23] *The Crossing* has a red border, and the pieces in Amsterdam and Newport have orange-red borders.[24] It is therefore possible that Van Mander's successors sold a suite amalgamated from pieces they had found in the workshop's stock.

Karel II van Mander's oeuvre still awaits thorough study. Although Ebeltje Hartkamp-Jonxis has asserted that his designs "are in Flemish Baroque style, in the manner of the Antwerp painters in Rubens' circle,"[25] the *Alexander* series actually displays Karel II's familiarity with late-sixteenth-century Mannerist painting, as is revealed by the complex compositions, the suggestions of movement, the fanciful rendering of the figures, and the impression of infinite space evoked by his use of bird's-eye view landscapes. At the time Van Mander created his *Alexander* series, tapestry design in the Southern Netherlands was changing fundamentally. Around 1617 or 1618 Peter Paul Rubens (1577–1640) used his dramatic and monumental style to create *The Story of Decius Mus.* The compositions of the series are characterized by a new balance and clarity and contain highly sculpted figures. Jacob Jordaens (1593–1678) and Justus van Egmont (1601–74) further developed this monumental style, and its rapidly growing popularity may explain the apparent lack of interest in Van Mander's more Mannerist *Alexander* series. KB

NOTES

1. Bosworth and Baynham 2000. For an examination of the textual tradition and the conception of Alexander the Great that prevailed in the Middle Ages, see Cary 1987.
2. Van Ysselsteyn 1936 expanded on the pioneering studies of Van der Graft 1869, Bredius 1885, Eisler 1921, and Göbel 1923. Hartkamp-Jonxis 2002 and Hartkamp-Jonxis 2004b offer comprehensive surveys of tapestry production in the Northern Netherlands.
3. Briels 1985.
4. Van Ysselsteyn 1936, vol. 1, pp. 51–54.
5. Ibid., pp. 64–104.
6. Miedema 1972, Reznicek 1993, Leesberg 1993–94. Karel I van Mander is known primarily as the author of the *Schilder-boeck* (Book of Painters) published in Haarlem in 1604, which includes biographies of a wide range of European painters and is one of the most famous art historical sources; see Van Mander [1603–04] 1994–99.
7. Van Ysselsteyn 1936, vol. 2, pp. 148–49 (doc. 319).
8. Bredius 1885, p. 3; Van Ysselsteyn 1936, vol. 2, pp. 174–75 (doc. 375).
9. For the evolution of the Van Mander workshop, see Van Ysselsteyn 1936, vol. 1, pp. 84–94.
10. Ibid., vol. 2, pp. 139–40 (doc. 298).
11. Eisler 1921, p. 201, erroneously states that Spiering had produced an *Alexander* suite prior to 1607, but Van Ysselsteyn 1936, vol. 2, p. 92 (doc. 169), shows that it was not Spiering but Gossaert Simay, a workshop manager in Amsterdam, who had *Alexander* cartoons at that time.
12. Bredius 1885, p. 10; Van Ysselsteyn 1936, vol. 2, p. 173 (doc. 372).
13. Bredius 1885, pp. 7–9; Van Ysselsteyn 1936, vol. 2, pp. 217–19 (doc. 473).
14. "daernae wel viermalen was gewrocht"; Van Ysselsteyn 1936, vol. 2, p. 218 (doc. 473).
15. Ibid., pp. 159–60 (doc. 349).
16. Bredius 1885, pp. 21–22; Van Ysselsteyn 1936, vol. 2, p. 188 (doc. 406).
17. Bredius 1885, p. 21; Van Ysselsteyn 1936, vol. 2, pp. 188–89 (doc. 407).
18. Hartkamp-Jonxis 2004b, p. 225, argues that the three suites recorded on Mar. 26, 1624, included the one that had been sent to Denmark, but she fails to take account of the 1632 document that indicates four *Alexander* suites had been woven.
19. Villa San Donato, Le Roy-Mannheim sale, Mar. 15 and Apr. 10, 1880, lot 109 (all nine tapestries).
20. Hartkamp-Jonxis 2004b, pp. 222–26.
21. According to the catalogue of the 1880 sale, the *hauteur générale* was 420 cm.
22. Hartkamp-Jonxis 2004b, p. 224.
23. Hartkamp-Jonxis 1993.
24. The author would like to thank Carol A. Cavanagh, Communications Assistant, Preservation Society of Newport County, Newport, Rhode Island, for this information.
25. Hartkamp-Jonxis 2004b, p. 180.

The Tent from an *Indo-Chinese* or *Indian Series*

London, 1700/25
After a design by an unknown artist
Produced at the workshop of John Vanderbank (died 1717), Michael
Mazarind, or Leonard Chabaneix (died 1708/09)
482.8 x 230 cm (190⅛ x 90½ in.)
Purchased by the Decorative Arts Committee through the Richard Crane
Fund for European Decorative Arts, 1949.124

STRUCTURE: Wool and silk, slit and double interlocking tapestry weave
Warp: Count: 8 warps per cm; wool: S-ply of four Z-spun elements;
diameters: 0.5–0.85 mm
Weft: Count: varies from 16 to 34 wefts per cm; wool: S-ply of two Z-spun
elements; pairs of S-ply of two Z-spun elements; diameters: 0.5–1.2 mm; silk:
S-ply of two Z-twisted elements; diameters: 0.5–0.6 mm

Conservation of this tapestry was made possible through the generosity of
the Community Associates of the Art Institute of Chicago.

PROVENANCE: Possibly commissioned by Charles Legh (died 1781), Adling-
ton Hall, Macclesfield, Cheshire;[1] by descent through the Legh family; by
descent to Caroline Mary Florence Cotton Legh (died 1940) and her hus-
band Arthur Masterton Robertson Renny Legh (died 1933), Danevale, Kirk-
cudbrightshire, sold, Christie's, London, Mar. 14, 1929, lot 91.[2] Kent Gallery,
London, to 1929; sold to French and Company, New York, Oct. 16, 1929;
sold to the Art Institute of Chicago, 1949.

REFERENCES: Weibel 1930, pp. 13, 30 (ill.), cat. 19. Marillier 1930, p. 33, pl.
13. Mayer Thurman 1969, p. 31, pl. 16. Standen 1981a, p. 124, fig. 6.

EXHIBITIONS: Detroit Institute of Arts, *A Loan Exhibition of European
Tapestries of the Eighteenth Century*, 1930 (see Weibel 1930). Art Institute of
Chicago, *Masterpieces of Western Textiles*, 1969 (see Mayer Thurman 1969).

THIS tapestry shows a number of small islands, scattered as if float-
ing over the surface of the dark ground. Brightly colored chinoiserie
birds, buildings, figures, flowers, plants, and trees occupy the isles,
which diminish in size toward the top of the tapestry, creating an
illusion of depth. On the center island a royal couple sits atop a cush-
ioned platform in a tent, surrounded by four courtiers or visitors. On
an isle to the left, a dignitary on horseback rides under a portable
baldachin held by two servants. Two musicians accompany the party
as it moves toward the royal couple. Another dignitary and his two
attendants also approach the seated figures, but on foot and from
an island to the right. Two more visitors prostrate themselves on an
islet below the central scene. The border presents a rod around which
sprays of flowers and leaves twist. A vase appears in the center of the
horizontal borders, and acanthus leaves occupy the corners.

This tapestry is a fine example of the mania for Asian art and
culture that gripped Europe in the late seventeenth and eighteenth
centuries. Numerous travel books, including Athanasius Kircher's
famous *China Monumentis quà Sacris quà Profanis* (1667) and
Johannes Nieuhof's *Legatio Batavica* (1665), presented encyclo-
pedic knowledge of the East, and fed the growing appetite for the

ceramics, furniture, lacquered screens, miniatures, paintings, and
woven, embroidered, and printed textiles that were being imported
in vast quantities from Asia via the East Indian trading routes. From
about 1660 on these objects generated a new current in the European
decorative arts that aimed at imitating and emulating Asian art.[3] This
Western interpretation of Chinese, Indian, Japanese, and Islamic
designs and motifs became known as chinoiserie.

The tapestry industry was not exempt from this trend. For exam-
ple, a chinoiserie series was produced by Joshua Morris, whose Soho
workshop flourished around 1725, and another by Judocus de Vos
(1661–1734) in the first quarter of the eighteenth century.[4] The ori-
entalist taste is also reflected in the Beauvais series *The Emperor of
China* (see cat. 45), in the *Chinese Scenes* of François Boucher (1703–
1770), designed in 1742 and also woven in Beauvais, and in two series
produced in Germany around the middle of the eighteenth century.[5]
The tapestry in the Art Institute belongs to the *Indo-Chinese* or *Indi-
an Series*, one of two known chinoiserie sets produced in London by
John Vanderbank around 1700 and strongly influenced by Chinese
lacquered screens from the Coromandel coast. Edith Standen, for-
mer curator of tapestries and textiles at the Metropolitan Museum
of Art, New York, published a pioneering and thorough examina-
tion of the *Indo-Chinese Series* in 1981, and presented a concise sum-
mary of her research in 1985.[6] The present essay draws heavily on
Standen's work, but also clarifies some inaccuracies in the debate by
assessing new information that has surfaced since she conducted her
investigation.

Vanderbank was a tapestry entrepreneur born in Paris to Flemish
parents. He moved to London around 1680 and, from 1689 until his
death in 1717, had charge of the English royal tapestry collection as
Yeoman Arrasworker at the Great Wardrobe.[7] In this capacity Van-
derbank supervised the cleaning and repair of tapestries and also pro-
vided new pieces for the Crown. He produced these at his home on
Great Queen Street, which functioned as his workshop. Although
English tapestries of around 1700, including those made by Vander-
bank, are commonly known as Soho tapestries,[8] reflecting the fact
that the most prominent London tapestry entrepreneurs lived and
worked in the district, Vanderbank's workshop was not located in
Soho but in the parish of St. Giles in the Fields.[9]

Both archival documents and signed tapestries demonstrate that
Vanderbank produced two Asian-inspired suites. One of the series,
which Standen titled *Chinoiserie*, shows mostly Chinese motifs tak-
en from travel books, on a dull yellow ground.[10] Two pieces from
this set, one of which bears the signature *IOHN VANDREBANC FECIT*
(John Vanderbank made [this tapestry]), are now at Belton House,
Lincolnshire (fig. 1). Compared to the piece in the Art Institute, the
figures and islands are more three-dimensional, and the overall scene
more realistic. Standen labeled Vanderbank's other Asian-inspired
series—to which the tapestry in the Art Institute belongs—the
Indian or *Indo-Chinese* set, and studied it more extensively, as two
companion pieces from the series are in the Metropolitan Museum

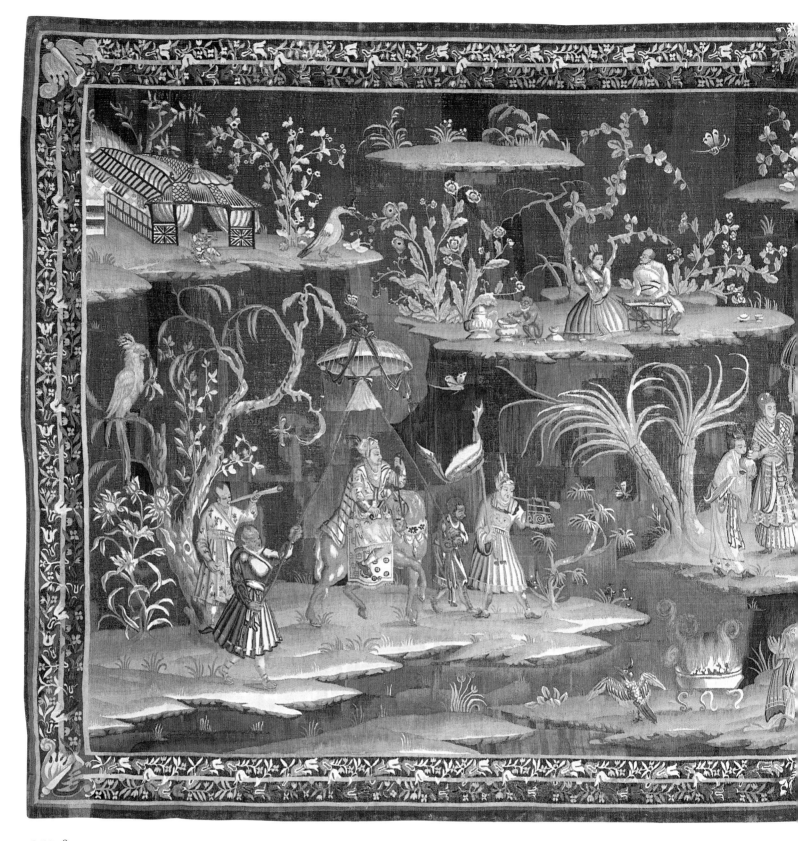

CAT. 58

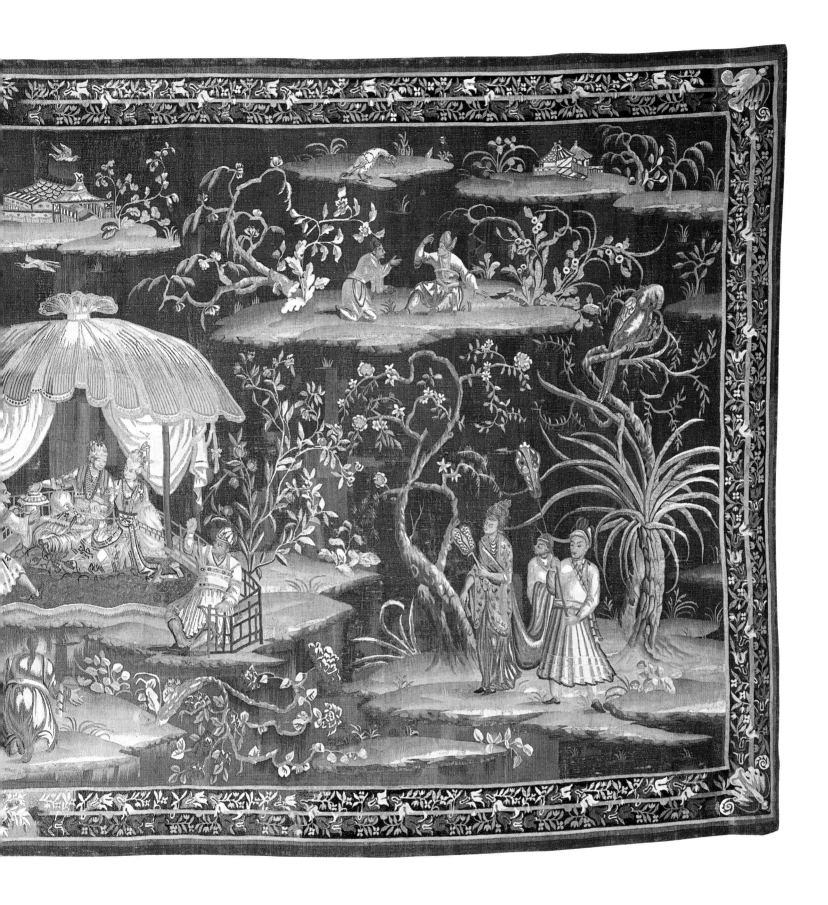

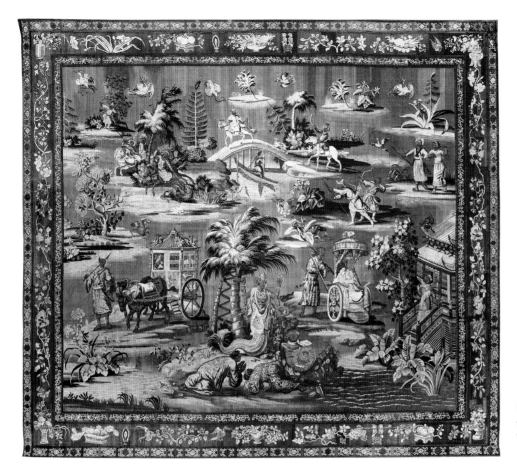

FIG. 1 From a *Chinoiserie Series*. Produced at the workshop of John Vanderbank, London, 1700/25. Wool and silk. Belton House, Lincolnshire.

of Art. Robert Robinson (died 1706), a lesser-known English decorative painter, has been suggested as the cartoonist, but based on stylistic comparisons Standen rightly doubted the attribution.[11] The set depicts Chinese, Indian, and Turkish motifs, which can only rarely be linked to travel books, on a dark ground—usually black or brown.[12] It comprised at least eight subjects, called by modern scholars *The Harpist, The Concert, The Toilette of the Princess, The Palanquin, The Tent, The Tea Party, Couple with a Servant,* and *Couple under a Canopy*.[13] The motifs created by the designer, however, were woven in various combinations. The playful nature of the scenes allowed the tapissier using the cartoons to add, omit, or rearrange animals, buildings, figures, and islands freely, so that he could make individual tapestries or entire suites of any dimensions required. A tapestry that was on the American art market, for example, shows the royal couple of *The Tent* in reverse and seated in a pavilion borrowed from *The Concert*.[14] Only one *Indo-Chinese* tapestry, a version of *The Harpist* in the Victoria and Albert Museum, London, bears John Vanderbank's signature.

A version of *Couple under a Canopy*, formerly in the collection of Victor Maclaren, England, reveals that an edition of the *Indo-Chinese* set was also produced by another workshop manager, as it bears the signature *M.MAZARIND*.[15] The piece has a distinctive border of cups, small teapots, and vases. A scaled-down version of *The Tent* from the same collection has an identical border, indicating that the two Maclaren tapestries were part of a suite produced by Mazarind.[16]

Another version of *The Tent*, in the Davids Samling, Copenhagen, also has the same border.[17] It can thus be surmised that Mazarind produced at least two suites from the *Indo-Chinese* designs. When Standen studied the set, little was known about Mazarind, but she assumed that he was "closely connected with Vanderbank and like him, probably not English."[18]

Standen's assumption that Mazarind was not English was corroborated by Wendy Hefford's research on French Protestant émigrés who worked as tapestry producers in London around 1700. Hefford discovered archival documents revealing not only Mazarind's first name, Michael, but also a link between him and members of the Chabaneix (Chabaney) family of tapissiers from Aubusson.[19] The documents show that between 1702 and 1708 Leonard Chabaneix paid property taxes on a house on Arlington Street that had formerly been assessed to Mazarind; from 1709 on Chabaneix's wife Marie Bertrand (died 1710/11), herself a member of the important Bertrand family of Aubusson tapissiers, continued the payments. It must be noted, however, that the archival material does not link Vanderbank to the Aubusson community, thus challenging the assumption that Mazarind was an associate of Vanderbank.

In 1991 Margaret Swain published important new archival findings on the *Chinoiserie* and *Indian* sets.[20] First, she reported that Vanderbank and Sir John Brownlow, the builder of Belton House, entered into a contract in 1691, whereby Vanderbank engaged himself to produce two tapestries "of Indian figures according to the pattern

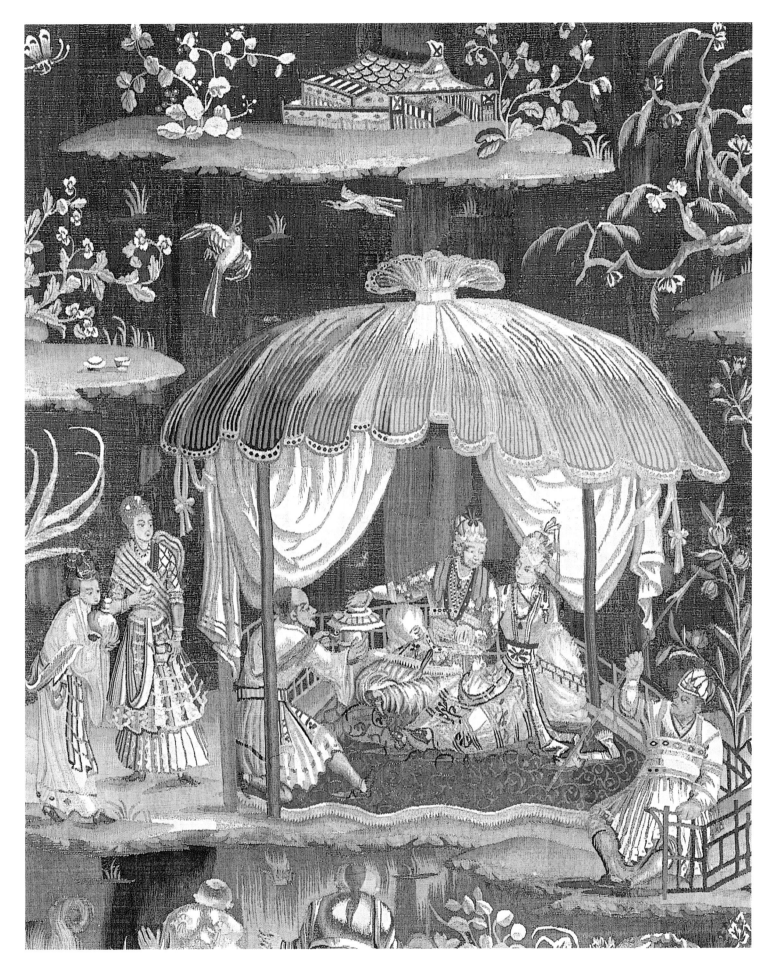

CAT. 58, DETAIL

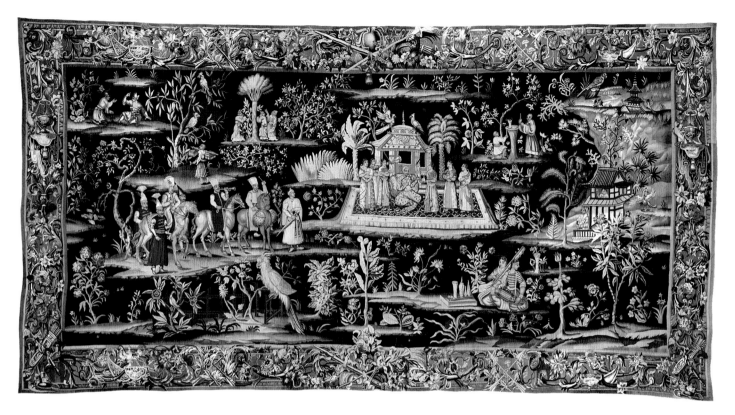

FIG. 2 From an *Indo-Chinese Series*. Produced at the workshop of Leonard Chaboneix, 1700/25. Wool and silk; 275 x 525 cm. Fondation Toms Pauli, Lausanne.

of the Queens which are at Kensington."²¹ An inventory of Kensington Palace, London, taken in 1697 shows that Vanderbank had supplied the English crown with a total of "seven pieces of Tapistry hangings with India ffigures [*sic*] 9 foot deep."²² The tapestries had been delivered between 1690 and 1696. As the Kensington Palace suite has not been identified and the word "Indian" did not have a very exact meaning in the late seventeenth-century—it described Chinese motifs as well as all else exotic—Standen wisely refrained from declaring the royal pieces part of a *Chinoiserie* or an *Indian* suite. But, as the Belton House pieces are still in situ and have the light ground of the *Chinoiserie* type, the set Vanderbank made for Kensington Palace must have been a *Chinoiserie* suite, too.²³

Swain also discovered bills revealing that in 1700 Leonard Chabaneix was commissioned to produce three "Tapissirie Jappan."²⁴ These pieces can be identified as two *Indo-Chinese* panels with distinctive Flemish-type borders, now in the collection of Sir Alfred Beit, Russborough, Ireland, and one tapestry in the Fondation Toms Pauli, Lausanne (fig. 2).²⁵ This commission shows that both Mazarind and Chabaneix used the same set of cartoons and thus strengthens the argument for a link between the Chabaneix and Mazarind workshops—a connection that Swain failed to make as she overlooked the Mazarind subgroup identified by Standen, erroneously stating that all "Chinoiserie" tapestries had been ascribed to Vanderbank.²⁶

Finally, Swain cites a document that demonstrates that two *Indo-Chinese* tapestries still in Hopetoun House, Scotland, had been purchased in January 1701 from John Hibbert, an upholsterer or tapissier

who, like his counterparts in Paris, also traded in tapestries.²⁷ One of these pieces, by an unknown producer, shows *The Harpist*. It differs from Vanderbank's version in the Victoria and Albert Museum but is identical to a version in a suite of four pieces now in the Yale University Art Gallery. This chamber was presumably commissioned by Elihu Yale, the university's namesake, after his return from India in 1699 and before his death in 1721.²⁸ The Yale pieces are not signed but bear the English mark: a red cross on a white shield.

The data presented by Standen, Hefford, and Swain thus show that Vanderbank, Mazarind, and Chabaneix all used the *Indo-Chinese* cartoons in the late seventeenth and early eighteenth centuries. It is therefore plausible that the cartoons circulated among these tapestry producers, who operated in what might have been a pyramidal network with Vanderbank at the top. It is also possible, however, that Vanderbank wove all editions of the *Chinoiserie Series*, whereas Mazarind and Chabaneix originally made the *Indo-Chinese* set; Vanderbank might have bought the cartoons of the latter series after Chabaneix's death. Border types frequently provide a clue to the origin of unsigned tapestries, but the border of the Art Institute's *Tent* does not: a *Palanquin* that recently surfaced on the art market has identical borders and can thus be identified as part of the same suite, but unfortunately it too bears no signature (fig. 3).²⁹ The pair of *Indo-Chinese* tapestries in the Metropolitan Museum of Art with a very similar border also lacks signatures. The attribution of unsigned *Indo-Chinese* pieces to either Chabaneix, Mazarind, or Vanderbank is therefore highly problematic.³⁰ KB

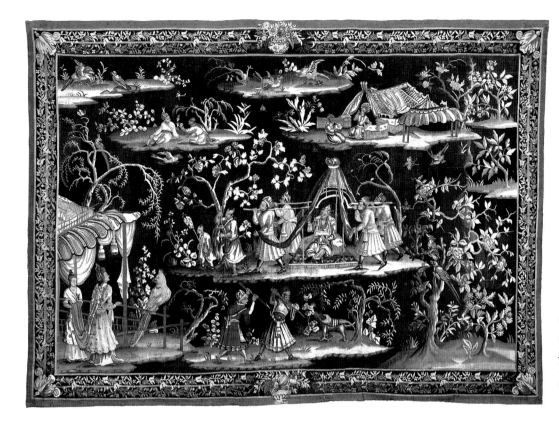

FIG. 3 *The Palanquin* from an *Indo-Chinese Series*. Produced at the workshop of John Vanderbank, Michel Mazarind, or Leonard Chabaneix. Wool and silk; 223.5 x 322.6 cm. Location unknown.

NOTES

1. Around 1739, Legh made extensive additions to Adlington Hall; Legh 1970. The tapestry in the Art Institute may have been purchased around this time, but no archival evidence supports this assumption, and it is questionable whether the cartoons of the series were then still in use.

2. The addition Charles Legh had built around 1739 (see note 1) was demolished in 1928, which may explain why the tapestries were sold a year later.

3. Honour 1961; Jarry 1981.

4. For Morris's series, see Standen 1981a, pp. 139–42. For De Vos's series, see Brosens 2002 and Brosens 2004b.

5. Standen 1986, p. 327 (*The Emperor of China*); Bertrand, Chevalier, and Chevalier 1986 (*Chinese Scenes*).

6. Standen 1981a; Standen 1985, vol. 2, pp. 717–25.

7. Vanderbank was naturalized in 1700. For his life and career, see Shaw 1911, p. 302; Thomson 1914, pp. 138–47; and Sheppard 1966, p. 515.

8. See, for example, Thomson 1914, p. 139.

9. Sheppard 1966, p. 515.

10. Standen 1981a, pp. 131–39.

11. Ibid., p. 131; Standen 1985, vol. 2, p. 717.

12. Many of these grounds have faded as a result of the chemical interaction between the ferrous dyes used to create dark colors and the wool wefts.

13. Standen 1981a, pp. 119–26.

14. Parke-Bernet, New York, June 1, 1967, lot 30.

15. Hunton 1930, pl. 44.

16. Hunton 1930, pl. 43. Empress Catherine of Russia reputedly bought the pair of tapestries in Norfolk; they later belonged to Marie Pavlovna, the Grand Duchess Vladimir, and were sold in Paris. Arthur Grenfell seems to have acquired the pieces around 1915, before they came into the possession of Victor Maclaren; Kendrick 1917, p. 147; Kendrick 1934, p. 66; Wingfield Digby 1955, p. 388.

17. Standen 1981a, p. 124.

18. Ibid., p. 126. Standen 1985, vol. 2, p. 718, reaffirms the hypothesis, saying Mazarind might have been an "associate of Vanderbank."

19. Hefford 1984, p. 106.

20. Swain 1991.

21. Ibid., pp. 85, 89 n. 2.

22. Standen 1981a, p. 119.

23. Swain 1991, p. 85. Swain, however, failed to note that Standen had distinguished between the *Chinoiserie* and *Indo-Chinese* sets.

24. Ibid., pp. 85, 89 n. 4.

25. The Chabaneix pieces have a wide border with lambrequins, trophies, and trumpets that is reminiscent of Brussels and Antwerp borders of around 1680; Delmarcel et al. 1997, p. 32. The tapestry in the Fondation Toms Pauli, Lausanne, is published in Swain 1991, pp. 85–87. See also Standen 1981a, pp. 123 n. 12, 125, fig. 8; and Delmarcel et al. 1997, pp. 31–32.

26. Swain 1991, p. 85.

27. Brosens 2005b.

28. Yale first traveled to Madras, India, as an employee of the English East India Company. In 1687 he was appointed governor of Fort Saint George at Madras, a position he held until his removal in 1692 amid charges of corruption. See Tappan 1925.

29. Like *The Tent*, *The Palanquin* was sold at Christie's, London, in 1929. The pieces were separated in 1931 when French and Company sold *The Palanquin* to Henry Francis du Pont, who sold the piece back to French and Company in 1933. Azure International purchased the tapestry in 1960. It surfaced on the art market in 2004 when it was sold as "the property of a European collector" at Christie's, New York, Oct. 21, 2004, lot 1016.

30. Wendy Hefford's long-awaited, forthcoming book *Mortlake to Soho: English Tapestry 1618–1782* might answer some of the questions posed by the *Chinoiserie* and *Indo-Chinese Series*.

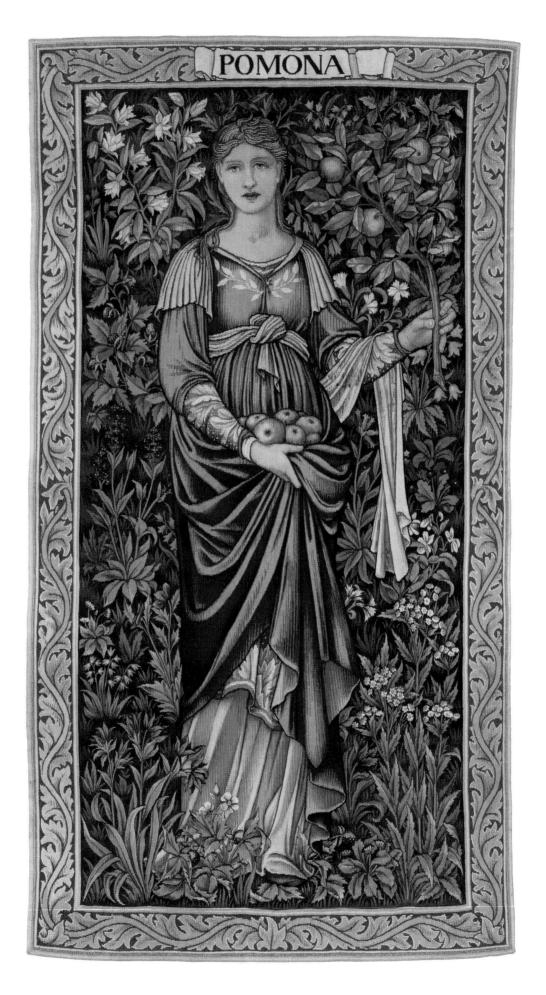

POMONA

CAT. 59

Pomona from *Flora and Pomona*

Wimbledon, Surrey, 1906
After a figure design by Sir Edward Burne-Jones (1883–1898), and a background design by John Henry Dearle (1860–1932)
Woven by Walter Taylor and John Keich at the Merton Abbey Tapestry Works
Inscribed: *POMONA*
92.9 x 165.1 cm (36½ x 65 in.)
Ida E. S. Noyes Fund, 1919.792

STRUCTURE: Cotton, wool, and silk; slit and double interlocking tapestry weave
Warp: Count: 6 warps per cm; cotton: S-ply of three yarns, Z-ply of nine Z-spun elements; diameter: 1.3 mm
Weft: Count: varies from 14 to 22 wefts per cm; wool: three yarns of S-ply of two Z-spun elements; diameters: 0.6–1.5 mm; silk: S-ply of two Z-twisted elements; pairs of S-ply of two Z-twisted elements; diameters: 0.8–1.5 mm

Conservation was performed by in-house staff.

PROVENANCE: Sold to Ananda Kentish Coomaraswamy (died 1947), Wimbledon, Surrey, 1906; sold to the Art Institute, 1919.

REFERENCES: Mayer Thurman 1969, pp. 31, 33, pl. 17.

EXHIBITIONS: Art Institute of Chicago, *Masterpieces of Western Textiles*, 1969 (see Mayer Thurman 1969). Art Institute of Chicago, *Tapestries from the Permanent Collection*, 1979. Art Institute of Chicago, *A Selection of Fabrics from the 1880s–1940s from the Permanent Collection*, 1982–83. Art Institute of Chicago, *European Masterpieces from Coptic Times through the 19th Century*, 1990.

IN this tapestry, a young blonde woman stands in a millefleur setting, cradling several freshly picked apples in the folds of her dress and holding a branch laden with apples in her left hand. Her attire calls to mind the draped clothing of Classical statues. The border features scrolling acanthus leaves, and an inscription in a scroll in the upper border identifies the figure as Pomona, the goddess of the apple orchard.

The compositional and stylistic features of the figure, background, and border make this piece a typical example of British tapestry of around 1900. It was designed in 1892 by Sir Edward Burne-Jones for William Morris (1834–1896), then the director of the Merton Abbey Tapestry Works at Wimbledon. Burne-Jones and Morris were leaders of the British Arts and Crafts movement, which promoted the unity of the arts, valued the pleasure the individual craftsman took in his work, and emphasized quality in materials and construction. The work of both artists, especially that of William Morris, has been studied in great detail.[1] Henry Currie Marillier (1865–1951), director of Merton Abbey from 1905 until its closure in 1940, wrote a history of the firm in 1927, and Linda Parry has published extensively on the textiles and tapestries designed by Morris and his collaborators.[2] This entry draws heavily on the work of these scholars, but also includes new findings by Christa C. Mayer Thurman pertaining to the production date of the tapestry in the Art Institute.

Morris and his lifelong friend and working partner Burne-Jones were deeply influenced by the writings of John Ruskin, an English writer and supporter of the Pre-Raphaelite Brotherhood, an association of painters and sculptors which aimed to revive the principles of truth and usefulness that they thought had guided medieval art. A committed socialist, Morris agreed that art should be for the people and by the people and, like the Pre-Raphaelites, regarded the Middle Ages as a lost golden age.[3] He believed—erroneously—that medieval production methods respected the personality of the individual craftsman, for workers were not mere employees but rather belonged to guilds as autonomous citizens. In Morris's view, a progressive dehumanization of art had begun around 1550, and by 1850 the craftsman had been reduced to a small cog in a mechanized culture. Yet Morris also believed in a rhythmic cycle of art, and by imitating the example of the Middle Ages, he hoped to initiate another fertile spring. To this end, he founded Morris, Marshall, Faulkner and Company in 1861. Morris's particular field of interest was textiles, but the firm also produced murals, wallpaper, stained-glass windows, and furniture. The company utilized purportedly medieval production principles: one workman-artist would execute or at least supervise the manufacture of each object from start to finish. Although the firm received numerous commissions, it never achieved financial health, and in 1875 it was reorganized under the name Morris and Company.

At about the same time, Morris became increasingly interested in medieval techniques of dyeing and tapestry production and contacted Thomas Wardle, the owner of silk-dyeing factories in Staffordshire, the West Midlands. The men's correspondence reveals that in 1877 Wardle planned to establish a large-scale tapestry works, possibly in collaboration with Morris.[4] In a letter to Wardle written in October of that year, Morris admitted "'tis true that we [Morris and Company] ought to have started the tapestry before: but you know the difficulties of *small* manufacturers: I have no doubt we can beat 'tothers"—i.e., the Royal Windsor Tapestry Works, which had opened in 1876. Morris enthusiastically added that Burne-Jones was "very much delighted at the idea" of establishing a tapestry workshop.[5]

A patronizing, discouraging, and opportunistic letter written to Wardle some weeks later, however, shows that Morris's enthusiasm had faded. Referring to an earlier conversation about their plans, Morris said: "I did not fully understand what an entirely individual matter it must be." He had grown dismissive of Wardle's intention to establish "a non-artistic manufactory": "you could do it of course . . . but, *cui bono?*" "Tapestry at his highest," Morris claimed, "is the painting of pictures with coloured wools on a warp." Though he knew of "only one man at present living, . . . who can give you pictures at once good enough and suitable for tapestry—to wit Burne-Jones," Morris knew of no one who could actually weave fine tapestries: "I suspect you scarcely understand what a difficult matter it is

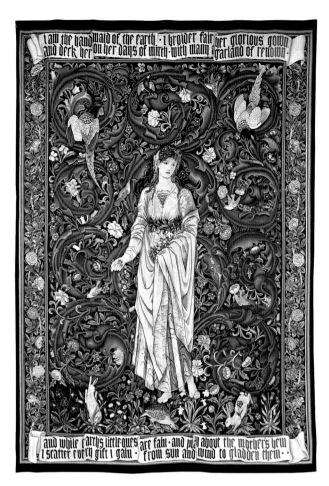

FIG. 1 *Flora* from *Flora and Pomona*. After a figure design by Edward Burne-Jones and a background design by William Morris. Produced at Merton Abbey Tapestry Works, Wimbledon, Surrey, 1885. Wool and silk. The Whitworth Art Gallery, the University of Manchester, T8353.

to translate a painter's design into material." As Morris had "no idea where to lay my hands on such a man" (that is, a capable weaver), he felt "that whatever I do I must do chiefly with my own hands," and informed Wardle that he intended to "set up a frame [loom] and work at it myself." Morris thus simultaneously discarded and monopolized the project, though he added that "I see no difficulty in your doing greeneries and what patterns turned out desirable, and I would make myself responsible for the design of such matters." Though Morris warned that "we shall both lose money over the work: you don't know how precious little people care for such things," he made sure to keep his options open: "As to business arrangements in case of our productions turning out to be marketable, I wait to hear what you have to say about the matter." Wardle's response, if any, is unknown, and no plan materialized.[6]

In an 1894 interview, Morris stated that he had started experimenting with tapestry weaving in 1878,[7] but he actually wove his first piece only in 1879.[8] He set up a high-warp loom in his bedroom, and learned the craft from an intriguing yet unknown "technical work on the subject, written in French somewhere in the seventeenth century."[9] Morris's first production, later called *Cabbage and Vine*, is a large-leaf verdure tapestry that shows his predilection for

the acanthus motif and late-fourteenth- and early-fifteenth-century Franco-Flemish weaving (see cats. 31–35).[10] Morris had familiarized himself with late medieval tapestry by visiting English and French collections,[11] and in 1886, while advising the South Kensington Museum—the predecessor of the Victoria and Albert Museum—on a potential purchase of a fifteenth-century *Trojan War* tapestry, he expressed his preferences clearly: "they belong to the finest period of tapestry . . . being no later in date than c. 1480."[12] Contemporary tapestry design and production in England and France, on the contrary, were ruthlessly criticized: the Royal Windsor Tapestry Works were "doomed to artistic failure," the Gobelins were a "hatching nest of stupidity . . . A more idiotic waste of human labour and skill it is impossible to conceive," the production in Beauvais was "of the same stupidity," and Aubusson "has a decaying commercial industry of the like rubbish."[13]

After he completed the *Cabbage and Vine* tapestry and was pleased with the result, Morris set up a loom at the Morris and Company workshops. The artist John Henry Dearle was appointed supervisor of the tapestry division and began creating tapestry designs.[14] In 1881 the firm moved to Merton Abbey, an old textile-printing establishment, and three tapestry looms and a number of dyeing vats were installed.[15] The first piece woven at the new location was *The Goose Girl* (1883), based on a book illustration by Walter Crane.

While *The Goose Girl* was in production, Morris and Company began work on new designs. In December 1882, the firm paid Burne-Jones for the drawing of the figure in *Pomona*,[16] and by February 1883 Burne-Jones must have also drawn her companion, Flora, for in that month Morris wrote to his daughter Jenny that "Uncle Ned [Burne-Jones] has done me two lovely figures for tapestry."[17] According to Morris's detailed description of the working process, these small-scale studies were photographically enlarged to full-size working cartoons, which Burne-Jones revised and modified.[18] Morris and Dearle drew "the ornamental accessories, the patterns of brocades in the draperies, [and] the flowers and foliage,"[19] enriching Burne-Jones's figural designs with a large-leaf verdure background showing animals and flowers reminiscent of *Cabbage and Vine*. Morris also designed elaborate borders and composed poems that he put on scrolls in the upper and lower borders of the pieces. These verses were later included in his *Poems by the Way* (1891).[20] "A considerable latitude in the choice and arrangement of tints in shading, and etc.," Morris hastened to add, "is allowed to the executants themselves, who are in fact, both by nature and training, artists, not merely animated machines."

The first weaving of *Pomona* and *Flora* occurred between 1884 and 1885.[21] The fusion of Burne-Jones's dreamy and refined goddesses and Morris's dense background and poems set in gothic type resulted in slightly incoherent images (see fig. 1). No other versions were woven during Morris's lifetime, likely because the looms were occupied with the production of the sizeable *Holy Grail* series from 1890 to 1894, and because a financial crisis hit Merton Abbey in the mid-1890s.[22] Around 1900, however, Dearle, now director of the works,

rediscovered the *Flora* and *Pomona* cartoons and modified them to lower production costs and make them harmonize with contemporary interior design. The size of the tapestries was reduced, the poems omitted, and the large-leaf background replaced by a millefleur composition of Dearle's design. In his history of Merton Abbey, Marillier listed six *Pomona* pieces, woven in 1898, 1899, 1900, 1903, 1904, and 1920.[23] Parry added a seventh piece produced in 1937.[24] By contrast, the two scholars enumerated a total of eleven *Flora* tapestries woven between 1896 and 1938, which shows that not all customers bought the two tapestries as a set.[25]

Though it has been assumed that the piece in the Art Institute was one of the *Pomona* pieces woven between 1898 and 1904,[26] Mayer Thurman's scrupulous examination of Marillier's handwritten records revealed that "a small pair for Coomaraswamy" was woven in 1906.[27] The records include the names of the weavers, Walter Taylor and John Keich.[28] Marillier's note details that the Anglo-Indian art historian and philosopher Ananda Kentish Coomaraswamy purchased both *Pomona* and *Flora*—which means that at least twelve *Flora* pieces were produced after Morris's death. A *Pomona* tapestry at the Victoria and Albert Museum and two *Flora* pieces, one recently on the art market and one in an Australian private collection, have the same border as the Chicago hanging.[29] Whereas the *Flora* that surfaced on the art market[30] can be linked to the *Pomona* at the Victoria and Albert Museum, the dimensions of the Australian *Flora* (167 x 93 cm) suggest it could have been the companion of the Art Institute's piece.[31]

KB

NOTES

1. The numerous useful books on Burne-Jones and Morris include Vallance 1897, Christian 1975, Henderson 1977, Thompson 1977, Stansky 1985, Parry 1996, and Wildman and Christian 1998. The William Morris Society, founded in 1956, publishes a biannual journal (*The Journal of William Morris Studies*) and a quarterly newsletter (*The William Morris Society Newsletter*) devoted to Morris and his circle.
2. Parry 1983; Parry 1988; Parry 1996.
3. Gordon 1969 discusses Morris's complex views on the relation among art, life, and society.
4. Morris 1984–86, vol. 1, pp. 403–04.
5. For Morris's letter, see ibid. Morris's prophecy was fulfilled, for by 1894 the Royal Windsor Tapestry Works had closed. He gave a diplomatic reason for the failure: "they had not the advantage of working from Sir Edward Burne-Jones's designs" (Vallance 1894, p. 101).
6. For Morris's letter, see Morris 1984–86, vol. 1, pp. 409–11.
7. Vallance 1894, p. 100.
8. Parry 1983, p. 102.
9. Vallance 1894, p. 100.
10. Valentine 1975, p. 84. The cartoon is in the Victoria and Albert Museum, London (inv. E.3472-1932); the tapestry is in the Society of Antiquaries of London, Kelmscott Manor. Both are published in Parry 1996, pp. 284–86, figs. M.114–15.
11. Morris 1975, p. 161; Morris 1984–86, vol. 3, p. 343.
12. Morris 1984–86, vol. 2, p. 604. See also Morris 1975.
13. Vallance 1897, p. 85.
14. For Dearle, see Parry 1983, pp. 120–22.

15. Parry 1983, pp. 107–14.
16. Parry 1996, p. 291. Between 1861 and 1898 Burne-Jones recorded his accounts with Morris and Company in two passbooks now in the Fitzwilliam Museum, Cambridge.
17. Morris 1984–86, vol. 2, p. 160.
18. Vallance 1894, p. 101.
19. Ibid.
20. The *Pomona* poem (#41) reads:

> I am the ancient Apple-Queen,
> As once I was so I am now.
> For evermore a hope unseen,
> Betwixt the blossom and the bough.
>
> Ah, where's the river's hidden Gold!
> And where the windy grave of Troy?
> Yet come as I came of old,
> From out the heart of summer's joy.

For an interpretation of this poem, see Talbot 1997. The *Flora* lyric (#42) reads:

> I am the handmaid of the earth,
> I broider fair her glorious gown,
> And deck her on her days of mirth
> With many a garland of renown.
>
> And while Earth's little ones are fain
> And play about the Mother's hem
> I scatter every gift I gain
> From sun and wind to gladden them.

21. Parry 1983, p. 108. The pieces were exhibited in 1887 at the Manchester Centenary Exhibition and purchased by the Whitworth Institute the same year. In 1893 Morris surveyed the tapestries that had been produced under his supervision. He stated "I think it must be about fifteen years ago I exhibited two pieces at the Manchester Exhibition. The subjects were Flora and Pomona. Some public body at Manchester bought them, and they are there now" (Morris 1984–86, vol. 4, p. 27). Apparently Morris misremembered, or the typesetter substituted the word *fifteen* for *five*; ibid., vol. 4, p. 27. In an 1894 interview Morris failed to include the *Flora* and *Pomona* pieces in his survey of the Merton Abbey production; Vallance 1894, p. 100.
22. Parry 1983, pp. 114–18; Parry 1996, pp. 294–95.
23. Marillier 1927, pp. 34–37. The *Pomona* tapestry woven in 1920 appeared on the art market at Sotheby's, London, Feb. 12, 1965, lot 45.
24. Parry 1996, p. 291. This piece was woven for the coronation of Edward VIII, and sold at Christie's, South Kensington, Oct. 3, 1989, lot 55.
25. Marillier 1927, pp. 34–37; Parry 1983, p. 186.
26. Parry 1996, p. 291. Other *Pomona* pieces are in Exeter College, Oxford; the Harris Museum and Art Gallery, Preston; and the Victoria and Albert Museum, London.
27. Henry Currie Marillier, "Catalogue of Tapestry Arranged by Subject" (unpublished manuscript), handwritten notes, p. 71, Department of Textiles, the Victoria and Albert Museum, London. For a more detailed account of the provenance of *Pomona*, see "A Collection and Its Donors" in the present volume.
28. Taylor had joined the firm in the 1890s at the age of fourteen; he later became the head of the Central School of Arts and Crafts and was instrumental in teaching many of the most important British weavers; Parry 1983, pp. 106–07.
29. Parry 1996, p. 291.
20. Sotheby's, London, Dec. 4, 1985, lot 140.
31. Menz 2002, p. 96.

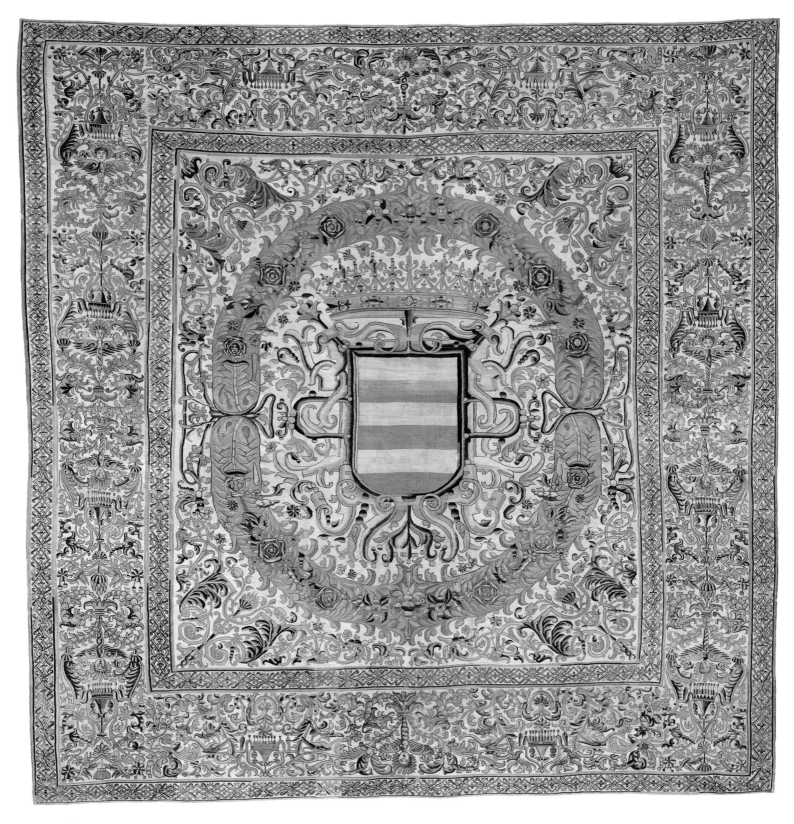

CAT. 60

CAT. 60

Large Hanging with Crown and Escutcheon

Southern Andes, Peru, c. 1700
After a design by an unknown artist
Produced at an unknown workshop
347.55 x 352.43 cm (136¾ x 138¾ in.)
Major Acquisitions Centennial Fund, 1979.507

STRUCTURE: Cotton and wool (presumably camelid hair), single interlocking tapestry weave with eccentric wefts (sections of weaving joined by dovetailing around an inserted or scaffolding warp)[1]
Warp: Count: 6–7 warps per cm; cotton: S-ply of three Z-spun elements; diameters: 0.5–0.8 mm
Weft: Count: varies from 26 to 37 wefts per cm; wool: S-ply of two Z-spun elements; diameters: 0.3–0.9 mm

Conservation of this tapestry was made possible through the generosity of the James Tigerman Estate.

PROVENANCE: Durlacher Brothers, London, to 1913; sold to Jacques Seligmann et Fils, Paris, 1913; possibly sold to Mrs. Harry C. Hunt, California, with Phyllis Ackerman acting as agent, 1925. Benjamin R. Meyer, Beverly Hills, by 1927. Sold, Parke-Bernet Galleries, New York, Mar. 14, 1970, lot 158. John Wise (died 1981), New York, in 1970; sold to Martin and Ullman Artweave Textile Gallery, New York; sold to the Art Institute, 1979.

THIS large tapestry from the southern Andes of Peru is the only such piece in the Art Institute's collection,[2] but it has been included in this catalogue because it exhibits many European features, having been produced in the first half of the eighteenth century by the colonial culture that came to dominate this region following the Spanish conquest of 1532. The tapestry presents, within a central wreath, a seven-pointed crown resting on an escutcheon intended to portray a coat of arms. Although tapestry weaving was a well-developed indigenous art among the Inca, hangings of this nature are rare and can only be attributed to colonial influence.[3] Its place of manufacture, however, has been a puzzle for many years, though a recent exhibition at the Metropolitan Museum of Art, New York—*The Colonial Andes: Tapestries and Silverwork, 1530–1830*—has brought to light information that may ultimately help confirm that it was indeed locally produced in Peru and not woven in Europe and then transported to South America to embellish a viceroy's mansion.[4] Most importantly, the exhibition and its accompanying catalogue established that the Art Institute's tapestry is related to a group of other weavings, especially one that is equally large, very similar in style, and currently in the collection of Mr. and Mrs. Lionel Derteano.[5]

The Derteano hanging and the Art Institute's work share a number of features, foremost among them the structure in which they were woven and their overall layout: a central field surrounded by regular borders of consistent proportions composed of a wide area enclosed by matching, narrow bands. In addition, the tapestries present a similar density of predominantly linear patterning, incorporating various repetitive elements, especially in the borders. The slightly

faded colors of the tapestries, though admittedly different, indicate the use of plant dyes indigenous to the region where the pieces were woven. In the case of the Derteano hanging, the faded blue and red were produced with indigo and cochineal, while the pronounced golden tones of the Art Institute's tapestry reflect an as-yet-unidentified local substance. Until actual documentation can be found to substantiate or correct what at this point are several fundamental assumptions, based on these visual components and the overarching similarities in technique, design, and color, it seems feasible to attribute the Chicago piece to the southern Andean region of Peru. Moreover, it is likely to have been produced at the same workshop as the Derteano tapestry. Although these works are distinctly European in appearance, most scholars today agree that they exemplify weavings produced in the southern Andes.[6]

Some of the evidence for this attribution is directly related to technique. For example, certain distinctive weaving features that commonly appear in European tapestries, such as the use of open slits where color change is required, do not generally occur in these and other colonial tapestries. If slits do appear, they are found only in monochromatic areas. The treatment of hatching is also markedly different in pieces presumed to be of Andean origin. A typical tapestry weaving technique for integrating areas of color, hatching is one of the documented features of the European tradition that began during the Middle Ages and was most likely brought by Spanish colonists to Peru, where European pieces served as models for Andean weavers. Thus, on both visual and technical grounds, these tapestries connect specifically with the southern Andes region.[7]

Further questions are prompted by the layout of the tapestry and its curious combination of elements that echo European Renaissance motifs, such as the grotesques featured in the widest of the borders. The use of these elements recalls the introduction of grotesques in the Classical world and their rediscovery in Italy at the end of the fifteenth century, which generated an explosion in ornamental inventiveness (see cat. 43). Here the patterns suggest caryatids combined with what resembles a caduceus, a winged staff with two snakes entwined around it.[8] The caduceus can symbolize either healing or harm; it appears in this tapestry multiple times in the vertical portions of the border, as well as once in the center of each horizontal area.

The crown above the escutcheon raises other concerns because crowns appear on hangings in various collections.[9] Other tapestries bearing this motif, however, differ in several ways from that on the piece in the Art Institute. In particular, the coats of arms represented on all the other hangings are subdivided into fields displaying heraldic devices of a lion and a castle, symbols of the ancient Spanish kingdoms of León and Castile. These are repeated as well in the outermost band that encloses the shield in an alternating small-scale repeat (fig. 1). In contrast, the coat of arms beneath the crown on the Art Institute's tapestry is composed of six horizontal bands in alternating shades of lighter and darker brown. More surprising, however, is the discovery that what now fills the shield was inserted after the

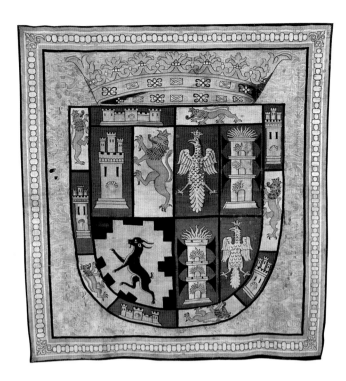

FIG. 1 *Cabrera Armorial*. Peru, 1600/25. Sheep's wool or camelid fiber; 203.2 x 213.4 cm. Fine Arts Museums of San Francisco. Gift of Mr. and Mrs. Robert F. Gill through the Patrons of Art and Music, 1975.4.1.

FIG. 2 Portrait of Nicolás de Ribera y Laredo, first alcalde of Lima. Municipalidad de Lima.

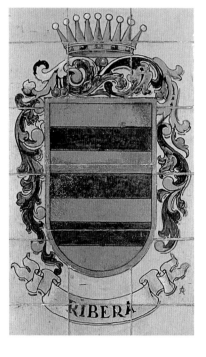

FIG. 3 The Ribera coat of arms in the Ribera chapel in the Cathedral of Lima.

tapestry was first made, at an unknown point in time. That it was not part of the original weaving has been confirmed by an examination of its warp and weft threads, which do not match those of the rest of the tapestry.[10] The substitution of these rows of color for the coat of arms that originally occupied the shield is an example of a phenomenon textile scholars have long understood: rare and expensive tapestries were often altered and "updated" to connect a newly acquired piece with its proud owner.

The present coat of arms has been linked with the name of the conquistador Nicolás de Ribera y Laredo—known as El Viejo—who became a prominent citizen of Lima, Peru, and in 1535 its first alcalde (fig. 2).[11] As the accompanying illustration indicates, however, the Ribera coat of arms bears seven horizontal rows, not six, and thus is actually intended to portray three (darker) bands against a colored field (fig. 3). If we can accept the speculation that the coat of arms on the Art Institute's tapestry was inserted to represent the Ribera family, the question would remain as to which member of his extensive family tree this tapestry belonged, for the number of descendants is vast. One of them was Nicolás Dávalos de Ribera, who served as alcalde of Lima in 1677 and became Conde de Santa Ana de Torres in 1684, a title granted by the King of Spain. In this capacity Dávalos de Ribera became the patron of the Chapel of Santa Ana, the burial site of the Ribera family within the Cathedral of Lima. Above the entrance to this chapel hang the coats of arms of the Ribera and Dávalos families, sculpted in wood and painted in polychrome; additional representations of the arms, in painted tile, also appear (see fig. 3).[12] An account of the extensive Ribera family identified the

blazon as that of the counts of Santa Ana de las Torres and described the color of the field as golden and the bands as green.[13] In contrast, the present inset coat of arms on the tapestry shows two shades of brown, which complicates its attribution to the Ribera family: certainly colors fade and change over time, but the present ones are consistent and uniform, and microscopic examination cannot determine whether either or both have altered.[14]

Another identifying feature that ties the tapestry to the counts of Santa Ana de las Torres is the pronounced garland of roses that encloses the crown and escutcheon. This wreath symbolizes Santa Rosa de Lima, who was beatified in 1667 by Pope Clement IX and canonized four years later by Pope Clement X. The patron saint of Lima, she was the first person native to the Americas to be elevated to sainthood.[15]

It is possible that this very large tapestry may have hung in the entrance hall of the Ribera mansion on Veracruz Street in the area

of Conde de Superunda, today the location of the main office of Electro Lima.[16] Alternatively, the piece might have hung in the Lima cathedral, perhaps near or within the chapel of Santa Ana—if the tapestry belonged to a member of the Ribera family. Baroque in style, the cathedral was designed by Francisco Becerra in 1598.[17]

Finally, there remain unresolved issues of design. First and foremost, though the very detailed work seen in the crown, border elements, and the four corner devices enclosing the escutcheon all relate stylistically, the center wreath, as well as the connecting devices that engage the inner shield and protrude through the wreath on both its right and left sides, look fundamentally different. These devices form a horizontal axis within the inner rectangle, while above and below the shield appear equally curious-looking *S* curves. These elements and the enframing wreath are executed in another style, lacking the elegance and fluidity of the rest of the composition. The wreath, moreover, is filled with blossoms and densely grouped rose leaves. In the search for a design connection, a possible link could be Asia, more specifically, Chinese embroidered textiles.[18] That artistic influences from as far away as Asia were already vital to the New World during the early eighteenth century is indeed remarkable. They reflect the extensive interaction that began in the late sixteenth century via galleon trade from Manila to Acapulco and Seville, bringing ceramics, porcelains, and bolts of silk fabrics. In sum, the appearance of the wreath in this tapestry is a direct reflection of the stylistic influences such commercial trade routes stimulated and help explain the Chinese-looking roses. They in turn suggest Santa Rosa, who connects the tapestry to the city of Lima and the cathedral in which the Ribera chapel is located. CCMT

NOTES

1. The tapestry may once have been considerably larger, as it has been cut into four sections and rejoined.

2. The Art Institute does, however, have two small colonial Andean tapestry-woven coca bags (invs. 1955.1830 and 1955.1842) in its collection.

3. Phipps, Hecht, and Esteras Martín 2004, pp. 235–37.

4. Ibid. The author is grateful to Julie Jones, Andrall E. Pearson Curator in Charge of the Department of the Arts of Africa, Oceania, and the Americas, the Metropolitan Museum of Art, New York, for discussions about this work in 1978 and 2005. Richard F. Townsend, Chair, Department of African and Amerindian Art, the Art Institute of Chicago, has also been enormously helpful. Further exchanges with Elena Phipps, Conservator, Department of Textile Conservation, the Metropolitan Museum of Art, New York, took place in May 2005. See also correspondence from 1991 and 2005 between Christa C. Mayer Thurman and Thomas B. F. Cummins, Chair, Department of the History of Art and Architecture, Harvard University.

5. Phipps, Hecht, and Esteras Martín 2004, pp. 235–37.

6. Ibid., p. 237 n. 4.

7. Ibid.

8. It is also possible that the caduceus is just the twisted body of the caryatid.

9. Examples include inv. 1975.4.1 in the de Young Museum, the Fine Arts Museums of San Francisco; two pieces in the Hearst Castle Collection, San Simeon; and another published in *Hali* (undated material from object file 1979.507, Department of Textiles, the Art Institute of Chicago).

10. For more details of the structural analysis, see the conservation and condition report in the Department of Textiles, the Art Institute of Chicago. Conservator Elena Phipps of the Metropolitan Museum of Art, New York, examined and discussed this piece extensively in June 2005 with Christa C. Mayer Thurman and Lorna A. Filippini, then Associate Conservator of Textiles at the Art Institute; see E. Phipps Report, object file, Department of Textiles, the Art Institute of Chicago. Further acknowledgments and thanks are extended to Elena Phipps and Richard Townsend for their final review of and further clarifying suggestions for this entry.

11. After the tapestry was acquired by the Art Institute, the museum received from the dealer of the piece an unsigned and undated Spanish document written sometime after Oct. 1979, and attributed to "a Spanish authority on heraldry." It identified the coat of arms as that of Nicolás de Ribera; see Ocsi Ullmann of Martin and Ullman Artweave Textile Gallery, New York, letter to the author, Oct. 19, 1979. The historical authenticity of the sculpted portrait of Ribera shown in fig. 2 has recently been called into question by Juliet Wiersema, University of Maryland.

12. Photographs of the Chapel of Santa Ana were provided by Juliet Wiersema in spring 2007 and spring 2008. She would like to acknowledge the assistance of Fernando Lopez of the Museo de Arte Religioso, the Cathedral of Lima, who provided entrance to the conservation area where the coat of arms was being restored.

13. For an in-depth discussion of the Ribera family in Lima, see de la Riva Agüero 1935. Follow-up research was conducted by Sara M. Taylor, Assistant Research Curator, Department of Textiles, the Art Institute of Chicago, who, in addition to addressing several other matters, pinpointed the Ribera family member issue more precisely.

14. A color analysis is pending.

15. Herbermann et al., 1912.

16. Undated and unsigned typewritten document in Spanish, object file 1979.507, Department of Textiles, the Art Institute of Chicago. See correspondence between Christa C. Mayer Thurman and Sara M. Taylor of the Art Institute and Dr. Luis Eduardo Wuffarden, Lima, who agreed with the anonymous authority's assessment, but was also able to expand on a number of points of information provided in the document.

17. Kubler and Soria 1959, pp. 90–91.

18. Cammann 1964.

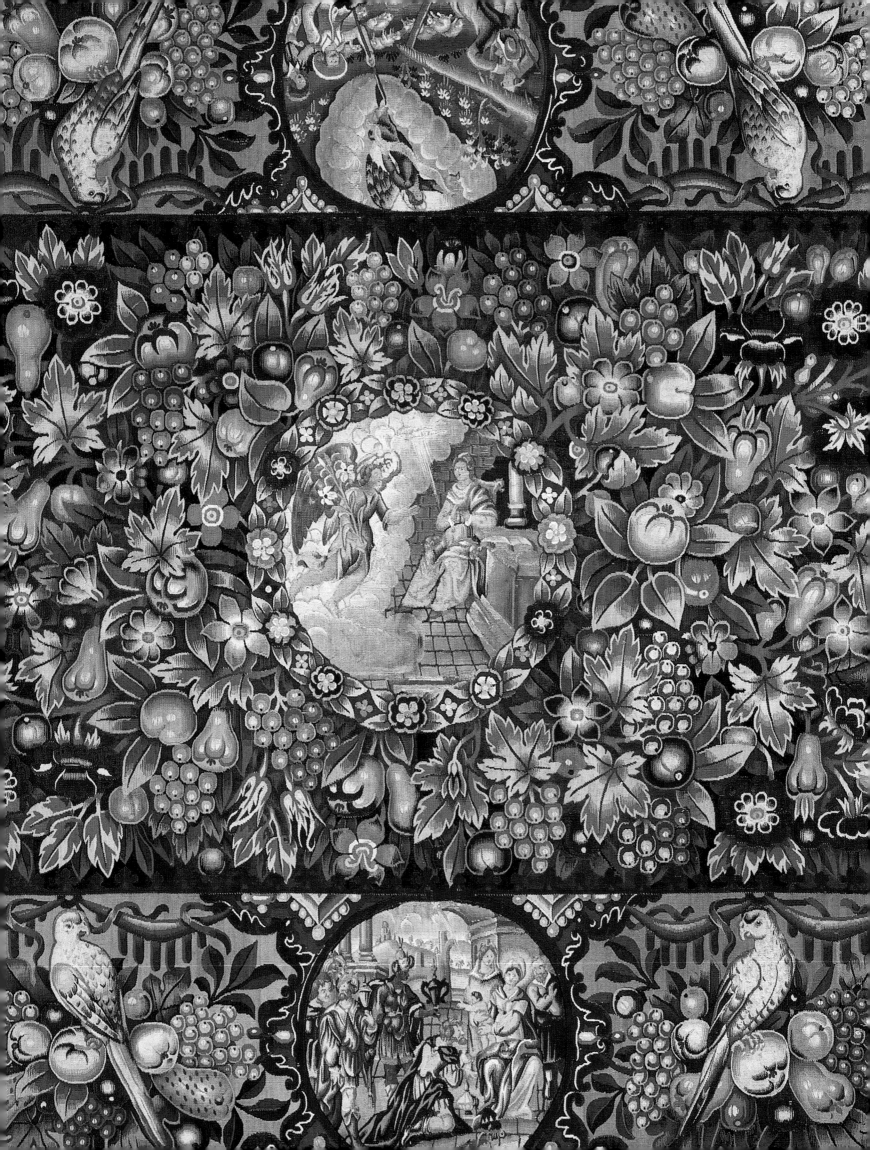

❧ V ❧

TABLE CARPETS

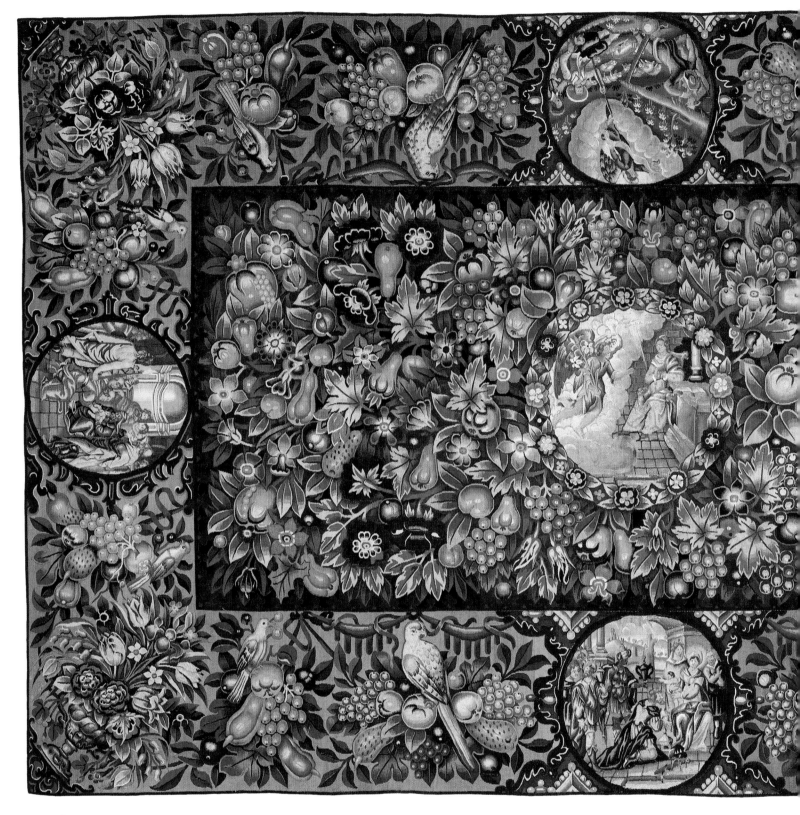

CAT. 61

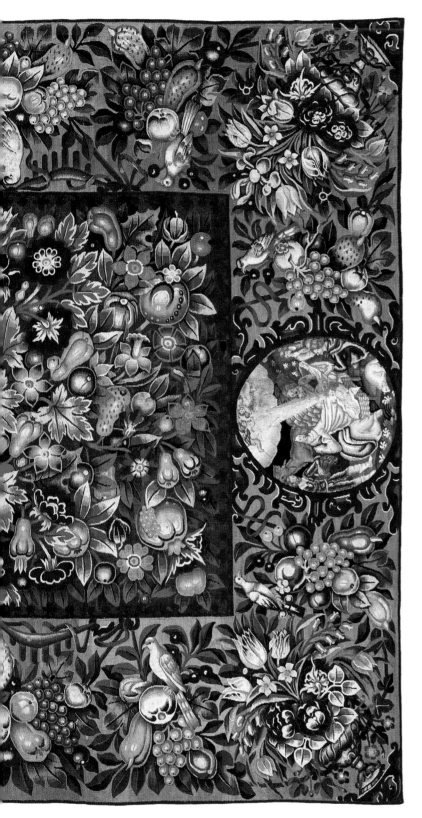

Table Carpet with Scenes from the Life of Christ

Northern or Southern Netherlands, 1600/50
After a design by an unknown artist
Produced at an unknown workshop
264.8 x 163.2 cm (104¼ x 64¼ in.)
Ada Turnbull Hertle Endowment, 1978.58

STRUCTURE: Linen, wool, and silk; slit and double interlocking tapestry weave
Warp: Count: 7 warps per cm; linen: S-ply of three Z-spun elements; diameters: 0.6–0.8 mm
Weft: Count: varies from 27 to 40 wefts per cm; wool: S-ply of two Z-spun elements; diameters: 0.5–0.9 mm; silk: pairs of S-ply of two slight Z-twisted elements; paired yarns of S-ply of two Z-twisted elements and a single S-twisted element; three yarns, two S-ply of two slight Z-twisted elements and one of a single S-twisted element; diameters: 0.6–1.0 mm; linen: S-ply of two Z-spun elements; diameter: 0.5–0.6 mm

Conservation was performed by in-house staff.

PROVENANCE: Baron Jean Germain Leon Cassel (died 1952) and Baroness Marij V. Cassel van Doorn to 1954; sold, Galerie Charpentier, Paris, Cassel van Doorn sale, Dec. 2, 1954, lot 120. Mayorcas Ltd., London, by 1971; sold to the Art Institute, 1978.

REFERENCES: Woldbye and Burgers 1971, pp. 16, 19, cat. 6. Mayer Thurman 1992, pp. 58, 59, 145 (ill.).

EXHIBITIONS: Amsterdam, Rijksmuseum, *Geweven Boeket*, 1971 (see Woldbye and Burgers 1971). Art Institute of Chicago, *Seventeenth Century Textile Treasures from the Permanent Collection*, 1983.

THIS work is a table carpet woven in the tapestry technique. Like most tapestries proper, it features a central field and borders. The rectangular central field is packed with flowers and fruit and is outlined by repeated, inward-facing scalloped tracery. A medallion in the middle of the field shows the Annunciation; it is outlined by a border of repeated small circle- and diamond-shaped floral motifs separated from one another by leaves. Birds, flowers, fruit, and four cartouches occupy the table carpet's borders. The scenes depicted in the cartouches are, clockwise from the center of the top border, the Annunciation to the Shepherds, the Nativity, the Adoration of the Magi, and the Circumcision of Christ. Vases filled with flowers accent the corners.

Nothing is known about the designers of such floral table carpets, and little more is known about their contemporary meaning and use. Some of the scenes featured in the medallions in the central fields and the cartouches in the borders are taken from contemporary engravings and book illustrations, but others appear to be original compositions. The flowers may also have been modeled on engravings. Starting in the late sixteenth century a considerable number of illustrated *florilegia* (botanical compilations) were published and reprinted in Germany and the Northern and Southern Netherlands.[1] Emblem books and Christian literary works attributed all kinds of

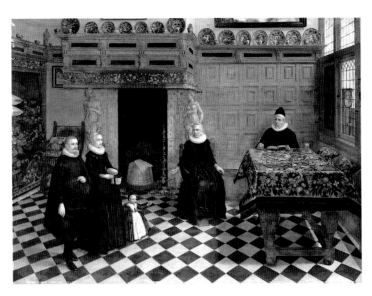

FIG. 1 *A Dutch Interior*. Northern Netherlands, possibly West-Friesland, c. 1630. Oil on panel; 86 x 118 cm. Musée d'Art et d'Histoire, Geneva.

meanings to flowers, fruits, and animals; for example, the wealth of flowers was believed to refer to God's self-manifestation in nature, and butterflies were associated with the Resurrection.[2] It is possible that some owners of floral table carpets and matching upholstery fabrics prized their textiles for their religious symbolism, as the medallions usually depict events from the Old and New Testaments, but it can be assumed that the owners also admired these textiles for their purely decorative qualities.[3] Ultimately, moralizing and decorative functions are not mutually exclusive. Whether they served sacred or secular purposes, table carpets were costly and prestigious objects, either removed or protected by ordinary linens before a meal was served.

The piece at the Art Institute is usually included in a group of about forty floral table carpets that have similar imagery and compositions. Vibeke Woldbye presented a pioneering exhibition of this group in Denmark in 1969, and two years later it traveled to Amsterdam.[4] She dated the floral table carpets around 1630 or 1640 and attributed the pieces to Dutch workshops in Delft, Gouda, and Schoonhoven. Woldbye's insights and assumptions have never been challenged;[5] a recent study of the group still relied heavily on the 1969 and 1971 exhibition catalogues.[6] The floral table carpets, however, present some important and intriguing methodological issues. Only a few bear a date, and none bear a town mark disclosing the production center, or a complete signature revealing the name of the producer. Therefore, Woldbye and her supporters were forced to base their attribution on circumstantial evidence. First they cited archival documents revealing that seventeenth-century Dutch tapestry producers made table carpets and matching upholstery fabrics. They then adduced examples of probate inventories and paintings of Dutch interiors by seventeenth-century artists such as Johannes Vermeer, which show that the Dutch upper classes furnished their houses with floral table carpets and matching bedcovers, bed hangings, and upholstery.

Finally, Woldbye and her supporters linked the archival evidence to the paintings, identifying the floral textiles depicted in the latter with the pieces recorded in the former. For example, an anonymous seventeenth-century painting of a Dutch interior (fig. 1), now in the Musée d'Art et d'Histoire, Geneva, shows a floral table carpet very similar to the piece in Chicago.[7] Advocates for a Dutch origin buttressed their argument with three facts: Most of the extant floral table carpets are in Dutch collections or in Scandinavian countries, prime trading partners of the Dutch in the seventeenth century.[8] Second, flowers were very much in vogue in the Northern Netherlands from about 1600, a trend that led to the rise of flower painting and to the notorious tulipomania, a frenzied speculation in tulip bulbs.[9] Finally, the motifs of some floral table carpets are to a certain degree reminiscent of Dutch linen damask weavings.[10]

Though the internal logic of the preceding argument is unassailable, this entry seeks to challenge the claim that most, if not all, floral table carpets and related fabrics—including the piece in the Art Institute—were produced in Dutch workshops. The archival material pertaining to the production of table carpets in towns such as Delft or Gouda is neither plentiful nor detailed. Of 966 documents published by Gerardina van Ysselsteyn that relate to Dutch tapestry production in the late sixteenth and seventeenth centuries, a mere twenty-four mention table carpets,[11] and none of these twenty-four records refer to "floral" table carpets; a number actually refer to table carpets and cushions featuring coats of arms.[12] Moreover, the presence of a particular kind of table carpet, or, for that matter, of tapestry proper, in relatively great numbers in one country, coupled with its near absence in other countries, does not imply that that kind of piece was made in the country in which it is well represented. The supposedly English *Metamorphoses* tapestries are a case in point: though most of these pieces are currently located in England, the vast majority was actually woven in Antwerp (see cat. 27).[13]

It is also worth questioning the attribution of all floral table carpets to Dutch workshops because archival documents demonstrate that floral table carpets and cushion covers were used not only in the Northern Netherlands, but also in the Southern Netherlands. Like the Dutch, the Flemish showed great interest in botany, patronizing flower painters, cultivating new tulip varieties, and speculating in bulbs.[14] Numerous probate inventories recorded in Antwerp reveal that the upper class of that town owned not only traditional, geometric table carpets (so-called Turkish table carpets), but also floral-patterned textiles described variously as "ses tapyte cussens met Bloemen" (six tapestry cushions with flowers), "ses tappyte sittecussens met Blomwerck" (six tapestry sitting cushions with flower work), "sesse tappyte sittecussens van Fruytagiën" (six tapestry sitting cushions with fruits), and a "goedt tapyte tafelcleet van Bloem ende Looffwerck in syn canten" (good tapestry table carpet with flowers and leafwork in its borders).[15] As the documents do not mention where these table carpets were produced, it is as likely that tapissiers in Antwerp, Brussels, Oudenaarde, Ghent, Geraardsbergen, and/or

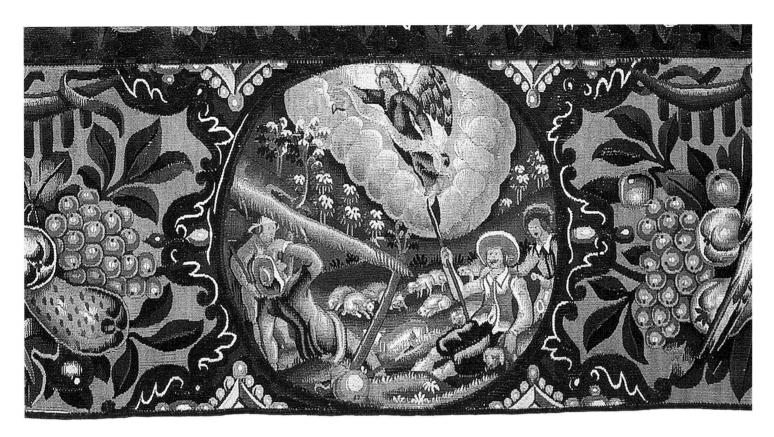

CAT. 61, DETAIL

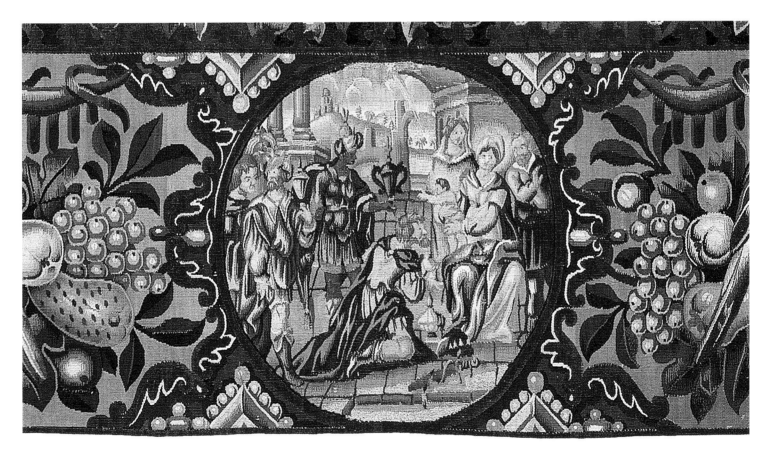

CAT. 61, DETAIL

FIG. 2 *Table Carpet*. Produced at the Van der Borcht workshop, Brussels, c. 1720. Wool and silk; 415 x 410 cm. Kunsthistorisches Museum, Vienna.

FIG. 3 *Pergola*, 1600/50. Wool and silk; 338 x 335 cm. Location unknown.

other tapestry production centers in the Southern Netherlands pro-duced them, as that these items were imported from the Northern Netherlands. The focus on the Dutchness of floral table carpets has overshadowed the fact that tapestry entrepreneurs in the Southern Netherlands also produced table carpets, upholstery fabrics, and related textiles, as is revealed by lesser-known archival documents that have been neglected by tapestry scholars whose attention has been directed toward tapestries proper.

In Brussels, for example, Gerard Peemans (1637/39–1725; see cats. 19a–n; 21; 23) is known to have produced upholstery and even horse blankets.[16] A striking table carpet produced by the Brussels tapissier François van den Hecke (1595 or 1596–1675), now in the Rijksmuse-um, Amsterdam,[17] is not, admittedly, a floral carpet—it has a coat of arms in the center field and animals in the borders—but Antwerp inventories list "een tapijte tafelcleet Brussels werck gefigureert met eenen Fruijtiere ende eenen boort van blommen" (a table carpet made in Brussels depicting fruits with a border of flowers),[18] and "een tapijte taeffelcleedt met Blommen ende Fruijten in 't midden fabriecke van Pannemaecker" (a table carpet with fruits and flowers in the center made by De Pannemaker).[19] A magnificent but over-looked early-eighteenth-century floral table carpet produced in the Van der Borcht workshop in Brussels, and now in the Kunsthisto-risches Museum, Vienna, reveals that a floral tradition did indeed exist in the Southern Netherlands (fig. 2). The inclusion of "chairs with garlands of flowers on a blue background" in an unpublished archival document surveying the sale catalogue of Judocus de Vos (1661–1734), by far the most important Brussels tapestry producer

around 1700, also demonstrates that floral-patterned textiles were made there.[20]

Another city in the Southern Netherlands, Tournai (Doornik in Flemish), which had been one of the leading tapestry produc-tion centers in the fifteenth century, became famous for its table carpets starting in about 1550. Antwerp probate inventories of the seventeenth century list table carpets described as "Dorniecx."[21] It is not known what these looked like, but archival documents reveal that their imagery included "fleurettes orangées à fond bleu" (little orange flowers on a blue background) and "des fleurs rouge et bleu" (red and blue flowers).[22] Floral table carpets were also produced in Oudenaarde, as is revealed by a document attesting that a table car-pet "met eenen krans van roosen, anemonien en andere blommen op eenen zwarten grond" (with a garland of roses, anemones, and other flowers on a black ground) was made there in 1771.[23] Moreover, the imagery used in the so-called Dutch group of floral table car-pets resembles the designs of the rich body of millefleurs tapestries that were woven in the Southern Netherlands in the fifteenth and sixteenth centuries, some of which also include medallions featuring biblical or mythological scenes (see cats. 29–30). In short, floral table carpets and upholstery fabrics were both used and produced in the Southern Netherlands. Indeed, as the Dutch workshops were to a large extent directed and manned by Flemish émigrés (see cat. 57), it is possible that Dutch floral table carpets and floral textiles were based on Flemish prototypes.

At the very least, the above points show that floral table carpets must be studied with utmost care. The many variations within the

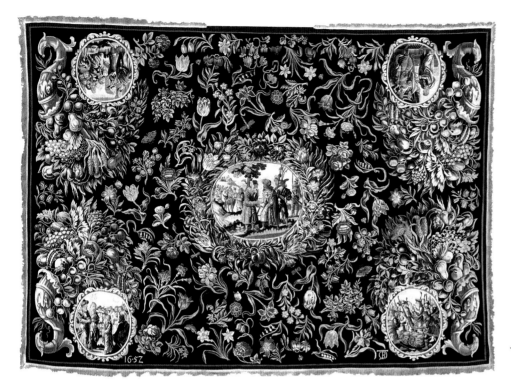

FIG. 4 *Floral Table Carpet with the Story of Joseph*, 1652. Wool and silk; 202.0 x 281.0 cm. Rijksmuseum, Amsterdam, BK-16395.

so-called Dutch group, for example, demand more attention than they have received in the past. To be sure, the vocabulary used in the Chicago piece resembles the imagery of other table carpets, including the exceptional example in the Rijksmuseum, Amsterdam, that bears the date 1652 (fig. 4).[24] Both pieces show an overwhelming mass of strewn flowers and fruit, enlivened with biblical scenes depicted in wreaths of flowers and cartouches. There is, however, also a remarkable difference between these two works that must be taken into account. The central field and borders of the Art Institute's table carpet are two separate entities; they have different patterns and are clearly separated by a small border, whereas the flowers of the less densely packed main field of the Amsterdam piece are not framed by an inner border and thus flow freely across the whole surface. The difference between the more static and traditional layout of the Chicago table carpet and the more organic and refined design of the Rijksmuseum work might be explained by the latter's weaving date, which was probably later, but it may also indicate that the table carpets were woven in different production centers. Interestingly, though the flowers and fruits depicted in the Art Institute's piece cannot be linked to borders woven in Dutch workshops, they resemble very closely the borders of Antwerp, Bruges, and Brussels tapestries made during the first half of the seventeenth century (see fig. 3),[25] which obviously suggests that it may be a Flemish table carpet. A definitive answer would, however, require further archival research on the stylistic origin and development of Flemish floral table carpets, thorough comparative analyses of the floral table carpets currently known, and close examination of both Dutch and Flemish interior paintings. KB

NOTES

1. For a brief survey, see Hartkamp-Jonxis 2004a, p. 276.
2. For an introduction to this kind of symbolism, see Taylor 1996.
3. Hartkamp-Jonxis 2004a, p. 277.
4. Woldbye 1969; Woldbye and Burgers 1971.
5. See, for instance, Kockelbergh 1997, which summarizes Woldbye and Burgers 1971.
6. Hartkamp-Jonxis 2004a
7. Fock 2001, p. 55, fig. 24.
8. Noldus 2005; Hartkamp-Jonxis 2006.
9. Warner 1975; Eeckhout 1996; Kuitert 1996.
10. Hartkamp-Jonxis 2004a, pp. 280–81.
11. Van Ysselsteyn 1936, p. 549. This pioneering publication on Dutch tapestry is still a landmark in the field.
12. For examples of such textiles, see Hartkamp-Jonxis and Smit 2004, pp. 298–313.
13. Hefford 1983.
14. See Duverger 1984–2002, vol.4, pp. 89, 94–95, 100.
15. The excerpts presented here are random samples taken from ibid., pp. 102, 253–54, 345. Hundreds of Antwerp probate inventories were published in Duverger 1984–2002.
16. Vlieghe 1959–60, pp. 79, 86.
17. Rijksmuseum, Amsterdam, inv. BK-1971-116; Hartkamp-Jonxis and Smit 2004, pp. 129–31. For Van den Hecke, see Brosens 2004a, passim.
18. Duverger 1984–2002, vol. 8, p. 303.
19. Ibid., vol. 13, p. 400. For the De Pannemaker family and workshop, see cats. 20a-b.
20. For De Vos, see Brosens 2002 and Brosens 2004a, pp. 117–18, 311–18. For further discussion of the document, see cat. 21.
21. See, for example, Duverger 1984–2002, vol. 4, pp. 143, 446.
22. Soil de Moriamé 1891, pp. 189–91.
23. Vanwelden in De Meûter et al. 1999, p. 99.
24. Rijksmuseum, Amsterdam, inv. BK-16395; Hartkamp-Jonxis and Smit 2004, pp. 289–90.
25. The tapestry surfaced in 2006 at Gallery C. John, London.

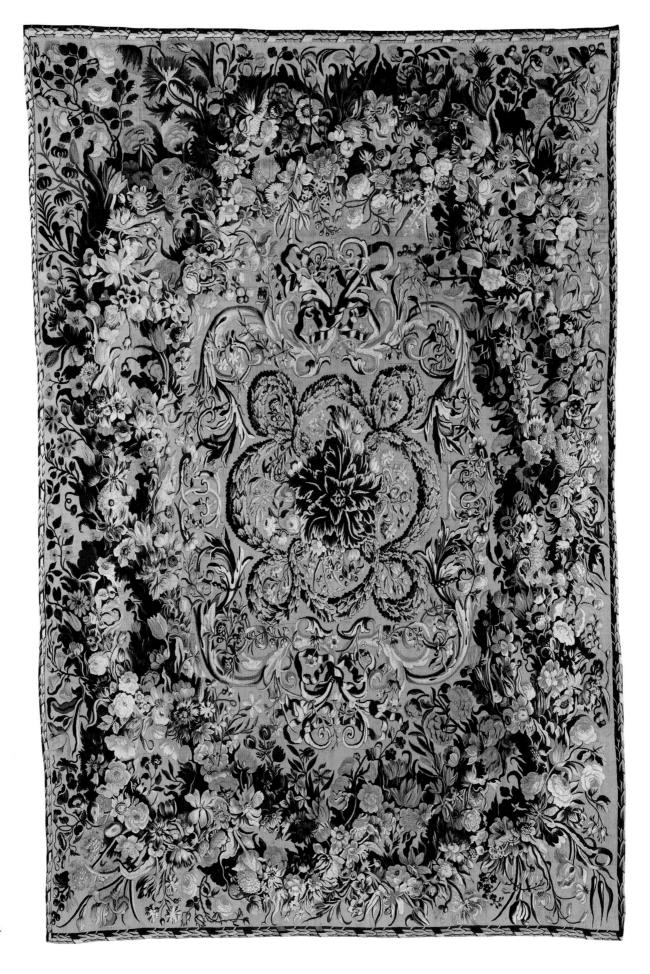

CAT. 62

CAT. 62

Table Carpet with Garlands of Flowers and Rinceaux

Possibly Flemish or French, 1650/75
After a design by an unknown artist
Produced at an unknown workshop
254 x 376.56 cm (100 x 148¼ in.)
Gift of Honoré Palmer, 1937.1119

STRUCTURE: Wool and silk, slit and double interlocking tapestry weave
Warp: Count: 8 warps per cm; wool: S-ply of three Z-spun elements; diameter: 0.65 mm
Weft: Count: varies from 22 to 42 wefts per cm; wool: S-ply of two Z-spun elements; diameters: 0.4–0.8 mm; silk: S-ply of two Z-twisted elements; pairs of two S-ply elements of no appreciable twist; three yarns of two S-plied elements of no appreciable twist; diameters: 0.5–0.9 mm

Conservation of this tapestry was made possible through the generosity of the James Tigerman Estate.

PROVENANCE: Possibly sold (in a set of four tapestries), Hôtel Drouot, Paris, May 27, 1910, lots 131–34.[1] Probably Potter (died 1902) and Bertha Palmer (née Honoré, died 1918), Chicago and Paris; probably by descent to their son Honoré Palmer (died 1964), New York and Chicago; given to the Art Institute, 1937.

REFERENCES: Mayer Thurman in Wise 1976, pp. 190, 193, cat. 309, pl. 4. Bremer-David 1997, p. 103. Hartkamp-Jonxis and Smit 2004, p. 335, fig. 128.

EXHIBITIONS: Art Institute of Chicago, *Selected Works of 18th Century French Art in the Collections of the Art Institute of Chicago*, 1976 (see Mayer Thurman in Wise 1976). Art Institute of Chicago, *European Carpets from the Permanent Collection*, 1982.

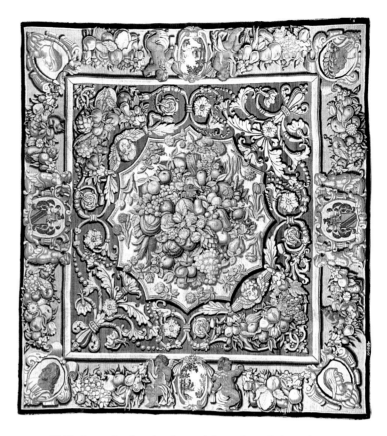

FIG. 1 *Table Carpet*. Produced at the workshop of Hendrik van der Cammen, c. 1650. Wool and silk; 310 x 320 cm. Royal Museums of Art and History, Brussels.

ON a yellowish-cream ground, two densely entwined floral garlands composed of a rich array of colorful flowering bulbs encircle a pattern of interlaced rinceaux, which themselves surround a looped wreath of oak leaves. At the center of the composition is a rosette of acanthus leaves from which flowers emerge. A narrow border of laurel leaves bound by a ribbon frames the tapestry.

There exist a small number of closely related tapestries with identical or similar designs.[2] One piece, in the J. Paul Getty Museum, Los Angeles, was thoroughly studied by Charissa Bremer-David in her 1997 catalogue of French tapestries and other textiles in the Getty's collection.[3] Another similar tapestry is in the Rijksmuseum, Amsterdam, and was discussed by Hillie Smit in the 2004 catalogue of the Amsterdam holdings.[4] Interestingly, Bremer-David and Smit present some conflicting views. The present entry assesses these views and presents a third alternative.

First, the scholars disagree on the function of such textiles. Though Bremer-David stated that such tapestries may have been intended to cover tables, she identified the particular piece in the Getty as a carpet meant to lie on the floor, supporting her argument by reference to the implied angle of the imaginary light source that casts consistent shadows along one side of the textile's floral garlands.[5] Smit, on the other hand, described the Amsterdam tapestry as an "ideal table

carpet," but argued that it and similar pieces were actually wall hangings.[6] She supported her claim with the fact that at the beginning of the twentieth century *Garlands of Flowers and Rinceaux* tapestries surfaced on the art market in groups of two or four, which suggests that they were meant to hang on the wall; it is generally assumed that only textiles destined for such use were produced as suites. Like Bremer-David, Smit also cited the implied angle of the imagined light source, but as evidence that the pieces were wall hangings.

Further research indicates that both Bremer-David's and Smit's identifications are inaccurate; *Garlands of Flowers and Rinceaux* tapestries are neither floor carpets nor wall hangings, but rather table carpets. First, there is no archival or iconographic evidence whatsoever suggesting that tapestries as costly as these pieces would ever have been used on the floor. Moreover, the fragility of the tapestry weave makes it unlikely that they would have been placed underneath tables and chairs or in other places where they might have been walked upon. Three compositional and stylistic features support the thesis that *Garlands of Flowers and Rinceaux* pieces are table carpets. Whereas floral tapestries intended to hang on walls are clearly vertically oriented, these pieces have no orientation.[7] Recent photographs of them always show the cluster of love-lies-bleeding (*Amaranthus caudatus*) in the upper left corner, but as this plant has dark-red pendent racemes, this layout is purely conventional.[8] Nor can the tapestry simply be hung upside down in comparison to its

customary display, for then other flowers would not go in the right direction. Furthermore, the centripetal composition of *Garlands of Flowers and Rinceaux* tapestries directs the viewer's attention away from the corners, where flowers are depicted comparatively sparsely. This structure strengthens the claim that these pieces are table carpets rather than wall hangings, for, when table carpets are used, their corners are folded, so there is no reason to decorate them profusely. Finally, the colorful flower vocabulary and overall composition of *Garlands of Flowers and Rinceaux* tapestries link them to other floral table carpets, specifically those traditionally labeled Dutch (see cat. 61). The obvious dissimilarities—the so-called Dutch pieces usually show individual flowers strewn over a dark ground—suggest a difference in origin rather than function. The fact that *Garlands of Flowers and Rinceaux* tapestries have appeared on the art market in small groups might seem to weaken the thesis that they are table carpets, but all the pieces in each group have similar widths, which is not typical of wall hangings forming a suite.[9]

Identifying the origin and production date of *Garlands of Flowers and Rinceaux* tapestries is as problematic as determining their function. Bremer-David rejected the traditional attribution to Aubusson, circa 1700 or 1725,[10] instead localizing the pieces to Brussels, Lille, or Beauvais and dating them around 1690 and 1720.[11] She supported the link to Brussels and Lille by pointing out the similarity between the love-lies-bleeding on the *Garlands of Flowers and Rinceaux* tapes-

tries and the red pods in many borders woven by the De Pannemakers, who directed workshops in both cities.[12] Bremer-David backed the possible Beauvais attribution with the same feature, for similar pods are also in the border of an *Emperor of China* suite produced in Beauvais between 1697 and 1705. She further strengthened the case for a Beauvais origin by the fact that a yellow ground, later called *tabac d'Espagne* (Spanish tobacco), supposedly similar to the grounds of the *Garlands of Flowers and Rinceaux* tapestries, was used as the ground color for the Beauvais *Berain Grotesques* series produced by 1688.[13] Smit disagreed with Bremer-David's findings slightly, and broadened the scope of the discussion by introducing a decorative painting that includes similar scrolling acanthus leaves in contrasting shades made by Charles Le Brun (1619–1690) for the Château de Vaux-le-Vicomte, Maincy, around 1660.[14] Consequently, Smit considered the Manufacture Royale des Gobelins, Paris, a possible production center for *Garlands of Flowers and Rinceaux* pieces and dated these weavings earlier, around 1660 or 1690.

None of the above arguments, however, are conclusive. The Beauvais *tabac d'Espagne* ground fashionable around 1700 is a stronger saffron yellow than the light yellow ground characteristic of pieces like that in the Art Institute, and one member of the De Pannemaker family, François (1633–c. 1700), worked not only in Brussels and Lille, but also in Douai and Tournai—which means that *Garlands of Flowers and Rinceaux* pieces could have been woven in any of

these production centers.[15] Besides, though motifs such as the scrolling acanthus leaves or the cluster of love-lies-bleeding may be striking and rare, they are not so unusual as to serve as a workshop's or artists's signature, nor can they be used as straightforward indicators of design or production date. Furthermore, the opulent wreaths and their dense arrangement differ markedly from European decorative painting and design of around 1700, which tends to be more delicate and airy, with architectural elements dominating the composition and defining its rhythm. This style is clearly visible in Beauvais upholstery panels made around 1700, such as those woven in 1696 for Count Carl Piper of Stockholm to accompany a suite of the *Berain Grotesques*.[16]

A fresh examination of the overall composition suggests that the *Garlands of Flowers and Rinceaux* tapestries may have been designed at an earlier date, possibly around 1650 or 1660, when Flemish and French flower painting blossomed (see cat. 61). Rinceaux and floral wreath motifs, popularized by engravings made from the 1630s to the 1650s, crept into tapestry weaving around the middle of the seventeenth century.[17] A relatively unknown table carpet produced around 1650, which bears the mark of the Enghien tapissier Hendrik van der Cammen (1603–1676), displays rich rinceaux encircling an array of flowers and fruit on a light ground (Royal Museums of Art and History, Brussels, fig. 1).[18] In addition, around 1650 Jean Valdor (1616–1675) owned the cartoons of *Rabesques*, also known as *Festons et Rainseaux* (*Festoons and Rinceaux*), which were presumably designed by the unknown painter François Bellin.[19] Valdor was an art dealer and entrepreneur from Liège living in Paris, who was involved in the tapestry industry in Aubusson, Beauvais, Maincy, and Paris between 1650 and 1675 (see cat. 22).[20] Unfortunately, it is not known what Valdor's *Festoons and Rinceaux* cartoons looked like, so they cannot simply be identified with the *Garlands of Flowers and Rinceaux* tapestries. Nonetheless, like the Enghien table carpet, the title of Valdor's set reveals that the motifs characterizing the Art Institute's piece were in vogue around 1650.

Rinceaux, flowers, and fruit on a yellow-brown ground were also the dominant features of a lesser-known tapestry suite called *Rinceaux* that was produced at the De La Planche workshop in Paris by 1668.[21] The designs of this series have been tentatively attributed to Charles Errard (1606–1689) or Jean I Cotelle (1607–1676), both renowned *ornamentistes*.[22] In 1680 the Flemish painter David III Teniers (1638–1685) also used rinceaux, flowers, and fruits as a background for a Brussels tapestry showing the arms of the Duke of Medina Celi.[23] In his subsequent armorial tapestries woven in Brussels in 1680, 1683, and 1684, however, Teniers replaced the decorative background with a setting populated by allegorical figures, which shows that the dense arrangement of rinceaux, flowers, and fruits was losing its appeal by that time.[24]

In short, the popularity of the rinceaux motif and flower painting from 1630 onward, the vocabulary of the Enghien table carpet made around 1650, the production of Valdor's *Festoons and Rinceaux*

cartoons at about the same time, and the use of the decoration in Parisian and Brussels tapestry of the 1660s and 1670s, support the assumption that tapestries of *Garlands of Flowers and Rinceaux* were made around 1650 or 1675. Additional archival research is required, however, to shed more light on the origin of this and similar table carpets. KB

NOTES

1. It is not known whether this was a contemporary set or a modern amalgamation.
2. Bremer-David 1997, p. 103.
3. Ibid., pp. 98–105.
4. Hartkamp-Jonxis and Smit 2004, pp. 335–37.
5. Bremer-David 1997, p. 100. Mayer Thurman in Wise 1976, p. 193, also identified the piece in the Art Institute as a floor carpet.
6. Hartkamp-Jonxis and Smit 2004, p. 335.
7. See, for example, *Verdure with Peacocks, Turkeys, and Deer* in the Rijksmuseum, Amsterdam, inv. BK-NM-9543 (Hartkamp-Jonxis and Smit 2004, pp. 229–31); a vertically-oriented *Floral Tapestry* that was on the American art market (Hartkamp-Jonxis and Smit 2004, p. 275, fig. 107); and a *Vase of Flowers* that was on the Belgian art market in the 1990s (Delmarcel and Volckaert 1995, pp. 56–57).
8. Mayer Thurman in Wise 1976, p. 190; Bremer-David 1997, p. 99; Hartkamp-Jonxis and Smit 2004, pp. 335, 336. Sam Segal, a specialist in flower painting, particularly of the seventeenth and eighteenth centuries, has studied this species and the other flowers on the tapestries in detail; his analysis has not been published, but Hartkamp-Jonxis and Smit 2004, p. 337, cites Segal's most important findings and conclusions.
9. For example, the four pieces sold in France in 1910 (Hôtel Drouot, Paris, May 27, 1910, lots 131–34) varied by less than fifteen centimeters in height and by only five centimeters in width. See Bremer-David 1997, p. 103, for examples of other *Garlands of Flowers and Rinceaux* pieces that surfaced on the art market in the twentieth century.
10. Mayer Thurman in Wise 1976, p. 193.
11. Bremer-David 1997, p. 98.
12. Though Bremer-David referred to Segal's botanical analysis (see note 7 above), she incorrectly identified the racemes as pods; Bremer-David 1997, p. 105. For the De Pannemaker workshop and its set of verdures, see Duverger 1986b and De Tienne 1996.
13. Bremer-David 1997, pp. 101–02.
14. Hartkamp-Jonxis and Smit 2004, p. 337.
15. De Tienne 1996, p. 293.
16. Examples are in the Metropolitan Museum of Art, New York; Standen 1985, vol. 2, pp. 459–60, 476–77.
17. See, for example, Coquery in Sonis and Laporte 2002, p. 98, cat. 33, which shows a print depicting a wreath of flowers that was featured in the *Livre de fleurs et de feuilles* (Paris, 1635; Amsterdam, 1639), and p. 108, cat. 54, which displays an engraving called *Motifs de rinceaux* that was published in 1651.
18. Crick-Kuntziger 1956, pp. 63–64, cat. 59, fig. 67; Delmarcel 1980, pp. 24–25, cat. 6.
19. Uhlmann-Faliu 1978, p. 73.
20. For Valdor, see ibid. and Szanto 2002.
21. Coural 1967, pp. 82–89, cats. 34–39.
22. Colombe Samoyault-Verlet in Sonis and Laporte 2002, p. 177.
23. Crick-Kuntziger 1944, pp. 30–32.
24. Delmarcel 1999a, p. 250.

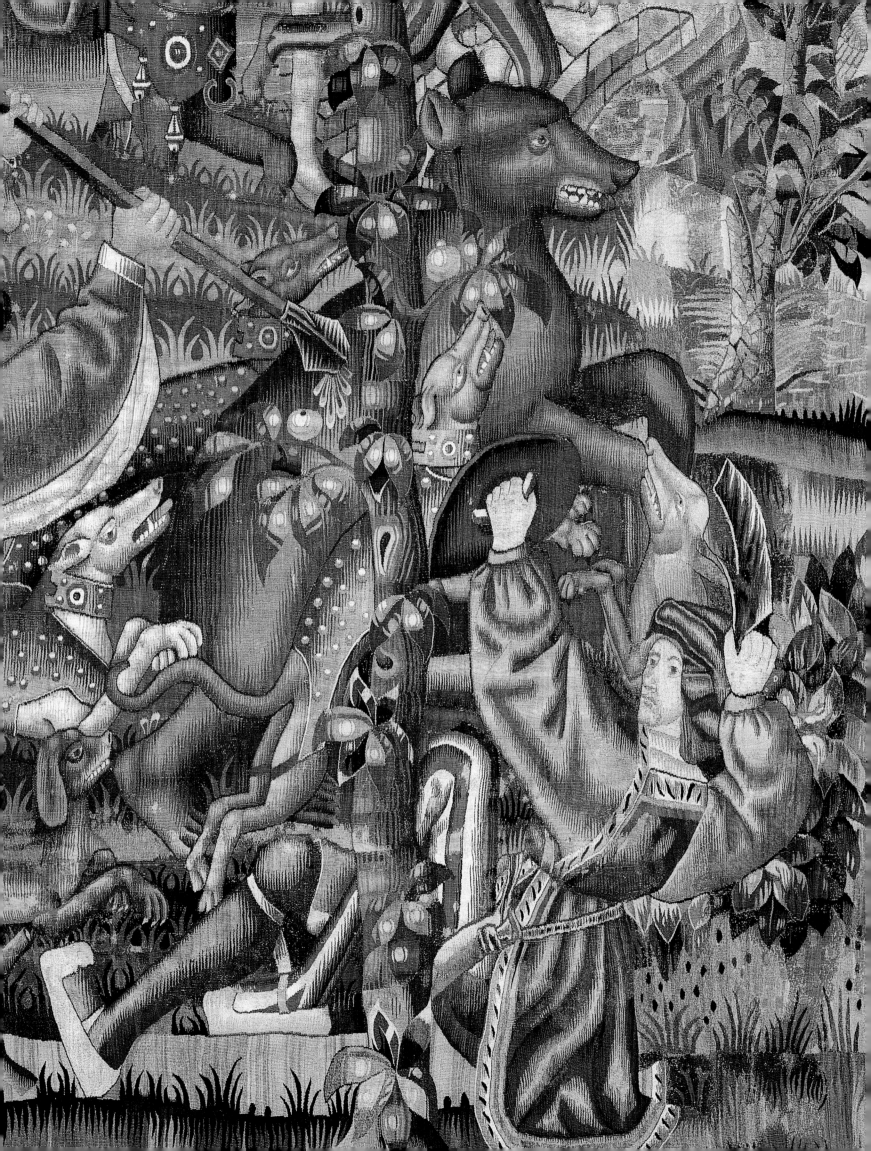

❧ MARKS AND SIGNATURES ❧

CAT. 12

Brussels city mark (in reverse) *Mark of Willem de Pannemaker*

CAT. 13

Brussels city mark *Mark of Jan van Tieghem*

CAT. 14A

Presumably the mark of Jacques I Geubels or Catharina van den Eynde

CAT. 14B

Mark of Erasmus I de Pannemaker

CAT. 16

Mark tentatively identified as that of Jacques Tseraerts

CAT. 17

Brussels city mark (inverted) *Everard III Leyniers*

CAT. 18

Brussels city mark *Jan van Leefdael*

CAT. 19A

Brussels city mark *Gerard Peemans*

CAT. 19B

Brussels city mark *Willem van Leefdael*

CAT. 19C

Brussels city mark *Gerard Peemans*

CAT. 19D

Brussels city mark *Willem van Leefdael*

CAT. 19E

Brussels city mark *Willem van Leefdael*

CAT. 19F

Brussels city mark

Gerard Peemans

CAT. 19G

Brussels city mark

Gerard Peemans

CAT. 19H

Brussels city mark

Willem van Leefdael

CAT. 19I

Brussels city mark

Gerard Peemans

CAT. 19J

Brussels city mark

Gerard Peemans

CAT. 19K

Brussels city mark

Gerard Peemans

CAT. 19L

Brussels city mark

Willem van Leefdael

CAT. 19M

Brussels city mark

Gerard Peemans

CAT. 19N

Brussels city mark

Willem van Leefdael

CAT. 20A

Brussels city mark

Gillis Ydens (traces)

CAT. 20B

Brussels city mark

Albert Auwercx (traces)

CAT. 21

Brussels city mark

Gerard Peemans

CAT. 22

Brussels city mark

Jan II Leyniers

CAT. 24

Lodewijck van Schoor

Albert Auwercx

CAT. 25

Brussels city mark

*Mark of Jacob van der Borcht and
Gaspard van der Borcht*

CAT. 26

Daniel IV Leyniers

CAT. 28

Mark of the Wauters workshop

CAT. 33

Oudenaarde city mark

CAT. 35

A seven-pointed star

CAT. 39A

A flower

Unidentified mark (LVD)

CAT. 39B

A flower

Unidentified mark (LVD)

CAT. 40A

Etienne Le Blond

Jean de La Croix

CAT. 40B

Jean de la Croix

Etienne Le Blond

CAT. 45

Manufacture Royale de Beauvais

CAT. 47

Signature of François Boucher (in reverse)

Manufacture Royale de Beauvais

CAT. 57

Karel II van Mander

Acidini Luchinat and Scalini 1998: Christina Acidini Luchinat and Mario Scalini. *Die Pracht der Medici: Florenz und Europa.* Exh. cat. Kunsthistorisches Museum/Prestel, 1998.

Ackerman 1917: Phyllis Ackerman. "Tapestries." In *Catalogue Mrs. Phoebe A. Hearst Loan Collection,* edited by J. Nilsen Laurvik. Exh. cat. San Francisco Art Association, 1917.

Ackerman 1919: Phyllis Ackerman. *Elias and Moses: A Pair of Panels of about 1440 Probably Woven in Tournai after a Cartoon by Piat van Room in the Possession of Seidlitz and Van Baarn.* Unpublished ms., 1919. Object file 1959.634–635, Department of Textiles, the Art Institute of Chicago.

Ackerman 1925a: Phyllis Ackerman. "A Cosmopolitan Tapestry Centre." *International Studio* 82 (Oct. 1925), pp. 36–45.

Ackerman 1925b: Phyllis Ackerman. "Joas . . . of Audenarde." *Art in America* 13 (June 1925), pp. 188–93.

Ackerman 1926a: Phyllis Ackerman. *Catalogue of a Loan Exhibition of Gothic Tapestries.* Exh. cat. The Arts Club of Chicago, 1926.

Ackerman 1926b: Phyllis Ackerman. "Recently Identified Designers of Gothic Tapestries." *The Art Bulletin* 9, 2 (Dec. 1926), pp. 142–60.

Ackerman 1932: Phyllis Ackerman. *The Rockefeller McCormick Tapestries: Three Early Sixteenth-Century Tapestries, with a Discussion of the History of the Tree of Life.* Oxford University Press, 1932.

Ackerman 1933: Phyllis Ackerman. *Tapestry, the Mirror of Civilization.* Oxford University Press, 1933.

Ackerman 1947: Phyllis Ackerman. "A Tournay Verdure and its Asiatic Antecedents." In *Studies, Museum of Art,* edited by Heinrich Schwarz, pp. 1–16. Rhode Island School of Design Museum, 1947.

Adelson 1983: Candace J. Adelson. "Cosimo I de' Medici and the Foundation of Tapestry Production in Florence." In *Relazioni artistiche: Il linguaggio architettonico,* edited by G.C. Garfagnini, pp. 899–924. Vol. 3 of *Firenze e la Toscana dei Medici nell'Europa del '500.* L. S. Olschki, 1983.

Adelson 1985: Candace J. Adelson. "Documents for the Foundation of Tapestry Weaving under Cosimo I de' Medici." In *Renaissance Studies in Honor of Craig Hugh Smyth,* edited by Andrew Morrogh, vol. 2, pp. 3–17. Villa i Tatti 7. Giunti-Barbèra, 1985.

Adelson 1990: Candace J. Adelson. "The Tapestry Patronage of Cosimo I de' Medici: 1545–1553." 4 vols. Ph.D. diss., New York University, 1990.

Adelson 1994: Candace J. Adelson. *European Tapestry in the Minneapolis Institute of Arts.* The Minneapolis Institute of Arts, 1994.

Ainsworth 1982: Maryan Wynn Ainsworth. "Bernart van Orley as a Designer of Tapestry." 2 vols. Ph.D. diss., Yale University, 1982.

Ainsworth 2005: Maryan Wynn Ainsworth. "Intentional Alterations of Early Netherlandish Painting." *Metropolitan Museum Journal* 40 (2005), pp. 51–65.

Ainsworth and Christiansen 1988: Maryan Wynn Ainsworth and Keith Christiansen. *From Van Eyck to Bruegel: Early Netherlandish Painting in the Metropolitan Museum of Art.* Harry N. Abrams, 1988.

Alcouffe 1969: Daniel Alcouffe. "Deux manufactures de tapisserie au faubourg Saint-Antoine." *Revue de l'Art* 4 (1969), pp. 63–65.

Alcouffe et al. 2002: Daniel Alcouffe, Emmanuel Coquery, Gérard Mabille, and Marie-Laure de Rochebrune, eds. *Un temps d'exubérance: Les arts décoratifs sous Louis XIII et Anne d'Autriche.* Exh. cat. Réunion des musées nationaux, 2002.

Alonso-Núñez 1987: José-Miguel Alonso-Núñez. "An Augustian World History: The Historiae Philippicae of Pompeius Trogus." *Greece and Rome* 34, 1 (Apr. 1987), pp. 56–72.

Alpers 1972–73: Svetlana Alpers. "Bruegel's Festive Peasants." *Simiolus: Netherlands Quarterly for the History of Art* 6, 3–4 (1972–73), pp. 163–76.

Amielle 1989: Ghislaine Amielle. *Recherches sur des traductions françaises des Métamorphoses d'Ovide, illustrées et publiées en France à la fin du XVe siècle et au XVIe siècle.* Collection Caesarodunum 1. Jean Touzot, 1989.

Ananoff and Wildenstein 1976: Alexandre Ananoff and Daniel Wildenstein. *François Boucher,* vol. 1. Bibliothèque des Arts, 1976.

Anderman 2004: Barbara Anderman. "La notion de peinture de genre à l'époque de Watteau." In *Watteau et la fête galante,* edited by Patrick Ramade and Martin Eidelberg, pp. 29–43. Exh. cat. Réunion des musées nationaux, 2004.

Angulo Iñiguez 1960: Diego Angulo Iñiguez. "La fabula de Vulcano, Venus y Marte y 'La fragua' de Velazquez." *Archivo Español de Arte* 33, 129–132 (1960), pp. 149–81.

Anon. 1901: Anonymous. "Mr. William C. Whitney's New York House." *The House Beautiful* 10, 3 (Aug. 1901), pp. 131–42.

Anon. 1923: Anonymous. "A Home in Which Design and Material are Blended." *Arts and Decoration* 19, 1 (May 1923), pp. 14–15.

Anon. 1941: Anonymous. "Art Throughout America / Chicago: Flemish Tapestry." *Art News* 39, (Jan. 4, 1941), pp. 14.

Anon. 1998: Anonymous. "Jahresbericht 1995." *Mitteilungen des städtischen Museums für Kunsthandwerk zu Leipzig/Grassimuseum und seines Freundes- und Förderkreises e. V.* 9 (Mar. 1998), pp. 956–58.

Antoine 2007: Élisabeth Antoine. *La tapisserie du Jugement Dernier.* Collection Solo 36. Réunion des Musées Nationaux/Musée du Louvre, 2007.

Apuleius 1977: Lucius Apuleius. *The Golden Ass, being the Metamorphoses of Lucius Apuleius.* Translated by W. Adlington, revised by S. Gaselee. 1566; repr., Harvard University Press, 1977.

Arriola y de Javier 1976: Maria Pillar Arriola y de Javier. *Coleción de tapices de la Diputación Provincial de Madrid.* Servicios de Extensión Cultural y Divulgación, Diputación Provincial de Madrid, 1976.

Art Institute of Chicago 1923: *Tapestries Lent by Mrs. Rockefeller McCormick, Mrs. Potter Palmer and Robert H. McCormick.* Exh. brochure. The Art Institute of Chicago, 1923.

Art Institute of Chicago 1951: *The Antiquarian Society of The Art Institute of Chicago.* Exh. brochure. The Art Institute of Chicago, 1951.

Art Institute of Chicago 1992: *A Birthday Celebration: 100 Years of Antiquarian Society Textile Collecting, 1890–1990.* Exh. brochure. The Art Institute of Chicago, 1992.

Art Institute of Chicago 2007: Art Institute of Chicago. "New Acquisition." *Art Institute of Chicago News and Events,* May/June 2007, p. 5.

Artner 1979: Alan G. Artner. "A Score of Treasures." *Chicago Tribune,* Apr. 4, 1979, Section I, p. 10.

Asselberghs 1970: Jean-Paul Asselberghs. *Tapisseries héraldiques et de la vie quotidienne.* Exh. cat. Tournai, Cathédrale, 1970.

Asselberghs 1971: Jean-Paul Asselberghs. *Chefs-d'oeuvre de la tapisserie flamande: onzième exposition du Château de Culan.* Exh. cat. J. Dusser, 1971.

Asselberghs 1974: Jean-Paul Asselberghs. *Les tapisseries flamandes aux Etats-Unis d'Amérique.* Musées royaux d'Art et d'Histoire/Koninklijke Musea voor Kunst en Geschiedenis, 1974.

Asselberghs et al. 1969: Jean-Paul Asselberghs, Lily Beauvois-Faure, Jarmila Blažková, Marguerite Calberg, Erik Duverger, Jozef Duverger, A.M. Louise E. Erkelens, Magda Haems-Duverger, E. J. Kalf, Sophie Schneebalg-Perelman, et al. *De bloeitijd van de Vlaamse tapijtkunst: Internationaal Colloquium, 23–25 mei 1961/L'âge d'or de la tapisserie flamande: Colloque International, 23–25 mai 1961*. Paleis der Academiën, 1969.

d'Astier de la Vigerie 1907: Emmanuel Raoul, Baron d'Astier de la Vigerie. *La belle tapisserye du Roy (1532–1797) et les tentures de Scipion l'Africain*. H. Champion, 1907.

Atwater 1995: Vivian Lee Atwater. "Les graveurs et la vogue néerlandaise dans le Paris du XVIIIe siècle." *Nouvelles de l'estampe* 141 (July 1995), pp. 3–10.

Auclair 2000: Valérie Auclair. "De l'exemple à la chronique contemporaine. *L'histoire de la Royne Arthemise* de l'invention de Nicolas Houel." *Journal de la Renaissance* 1 (2000), pp. 155–88.

Auclair 2007: Valérie Auclair. "Changement de programme. De *L'Histoire de la reine Artémise* de Nicolas Houel à la tenture d'Henri IV." In *La Tenture d'Artémise: À l'origine des Gobelins, la redécouverte d'un tissage royal*, edited by Arnauld Brejon de Lavergnée and Jean Vittet, pp. 19–26. Exh. cat. Reunion des musées nationaux, 2007.

Avel 1973: N. Avel. "Les Pérelle: Graveurs de paysages du XVIIme siècle." *Bulletin de la Société de l'Histoire de l'Art français* (1973), pp. 143–53.

Avery 1972: Harry C. Avery. "Herodotus' Picture of Cyrus." *American Journal of Philology* 93, 4 (Oct. 1972), pp. 529–46.

Aymard 1993: Maurice Aymard. "Vriendschap en gezelschapsleven." In *De gemeenschap, de staat en het gezin, 1600–1800*, edited by Roger Chartier. Vol. 6 of *Geschiedenis van het persoonlijk leven*, edited by Georges Duby. Translated by Renée de Roo-Raymakers, pp. 133–68. Agon, 1993.

Ayres 1910: Harry Morgan Ayres. "Shakespeare's *Julius Caesar* in the Light of Some Other Versions." *Publications of the Modern Language Association of America* 25, 2 (1910), pp. 183–227.

Azcarate 1948: Jose De Azcarate. "El tema iconografico del salvaje." *Archivo Español de Arte* 21 (1948), pp. 81–99.

Badin 1908: Jules Badin. *Receuil de 325 Peintures et Tapisseries de la Manufacture Nationale de Beauvais*. A. Guérinet, 1908.

Badin 1909: Jules Badin. *La Manufacture de Tapisseries de Beauvais depuis ses origines jusqu'à nos jours*. Société de Propagation des Livres d'Art, 1909.

Bailey, Conisbee, and Gaehtgens 2003: Colin B. Bailey, Philip Conisbee, and Thomas W. Gaehtgens. *The Age of Watteau, Chardin, and Fragonard, Masterpieces of French Genre Painting*. Exh. cat. Yale University Press/National Gallery of Canada, 2003.

Bakker, De Jong, and Van Wees 2002: Egbert J. Bakker, Irene J.F. de Jong, and Hans van Wees, eds. *Brill's Companion to Herodotus*. Brill, 2002.

Baldass 1920: Ludwig Baldass. *Die Wiener Gobelinssammlung*. E. Hölzel, 1920.

Balis et al. 1993: Balis, Arnout, Krista de Jonge, Guy Delmarcel, and Amaury Lefébure. *Les Chasses de Maximilien*. Réunion des musées nationaux, 1993.

Balis 2006: Arnout Balis. "Venus en de Gratieën: een mythologisch schilderij van Justus van Egmont." In *Munuscula Amicorum: Contributions on Rubens and his Colleagues in Honour of Hans Vlieghe*, vol. 2, edited by Katlijne van der Stighelen, pp. 613–29. Pictura Nova 10. Brepols, 2006.

Balteau 1939: J. Balteau. "Argenson." In *Dictionnaire de biographie française*, edited by J. Balteau, Michel Prévost, and Roman d'Amat. Vol. 3, col. 536–41. Letouzey et Ané, 1939.

Barbiche 2001: Bernard Barbiche. *Les institutions de la monarchie française à l'époque moderne, XVIe–XVIIIe siècle*. Presses Universitaires de France, 2001.

Barbier de Montault 1878: Xavier Barbier de Montault. "Inventaire déscriptif des tapisseries de haute-lisse conservées à Rome." *Mémoires de l'Académie des Sciences, Lettres et Arts d'Arras*, 2nd ser., 10 (1878), pp. 174–284.

Bardon 1963a: Françoise Bardon. *Diane de Poitiers et le mythe de Diane*. Presses Universitaires de France, 1963.

Bardon 1963b: Henry Bardon. "Les Peintures a sujets antiques au XVIII siècle d'après les livrets de salons." *Gazette des Beaux-Arts* (Apr. 1963), pp. 217–49.

Bartholomew 2006: Terese Tse Bartholomew. *Hidden Meanings in Chinese Art*. Asian Art Museum of San Francisco, 2006.

Bartrum 1995: Giulia Bartrum. *German Renaissance Prints, 1490–1550*. British Museum Press, 1995.

Bassani Pacht et al. 2003: Paola Bassani Pacht, Thierry Crépin-Le Blond, Nicolas Sainte Fare Garnot, and Francesco Solinas. *Marie de Médicis: Un gouvernement par les arts*. Exh. cat. Château de Blois/Somogy, 2003.

Bates 1940: Esther Willard Bates, ed. *Everyman: A Medieval Morality Play*. Baker's Plays, 1940.

Batlle Huguet 1946: Pedro Batlle Huguet. *Los tapices de la Catedral Primada de Tarragona*. Sindicato de Iniciativa de Tarragona, 1946.

Bauer 1975: Rotraud Bauer. *Barocke Tapisserien aus dem Besitz des Kunsthistorischen Museums Wien*. Exh. cat. Amt der Burgenländischen Landesregierung, 1975.

Bauer 1983: Rotraud Bauer, ed. *Tapisserien im Zeichen der Kunst Raffaels*. Exh. cat. Kunsthistorisches Museum, 1983.

Bauer 1991: Rotraud Bauer. "Darstellungen aus der Mythologie." In idem., *Wohnen im Schloss: Tapisserien, Möbel, Porzellan und Kleider aus drei Jahrhunderten*, pp. 81–85. Amt der Burgenländischen Landesregierung, 1991.

Bauer 1994: Rotraud Bauer. "Darstellungen aus der Geschichte des Moses." In *Museum im Schottenstift: Kunstsammlungen der Benediktinerabtei zu den Schotten in Wien*, edited by Cornelia Reiter, pp. 102–09. Vienna, 1994.

Bauer 1999: Rotraud Bauer. "L'ancienne collection impériale de tapisseries du Kunsthistorisches Museum de Vienne." In *La tapisserie au XVIIe siècle et les collections européennes: actes du colloque international de Chambord, 18–19 octobre 1996*, edited by Catherine Arminjon and Nicole de Reyniès, pp. 113–26. Cahiers du Patrimoine 57. Éditions du patrimoine, 1999.

Bauer and Delmarcel 1977: Rotraud Bauer and Guy Delmarcel. *Brusselse wandtapijten in Rubens' eeuw uit het Kunsthistorisches Museum, Wenen en de Koninklijke Musea voor Kunst en Geschiedenis, Brussel*. Exh. cat. Koninklijke Musea voor Kunst en Geschiedenis, 1977.

Bauer and Steppe 1981: Rotraud Bauer and Jan-Karel Steppe. *Tapisserien der Renaissance nach Entwürfen von Pieter Coecke van Aelst*. Exh. cat. Amt der Burgenländischen Landesregierung, 1981.

Bauzou 2001: Thomas Bauzou. "Zénobie: la dernière des 'princesses syriennes.'" In *Moi, Zénobie: Reine de Palmyre*, edited by Jacques Charles-Gaffiot, Henri Lavagne, and Jean-Marc Hofman, pp. 27–42. Skira, 2001.

Bayard, Félix, and Hamon 2000: Françoise Bayard, Joël Félix, and Philippe Hamon. *Dictionnaire des surintendants et contrôleurs généraux des finances du XVIe siècle à la Révolution française de 1789*. Comité pour l'histoire économique et financière de la France, 2000.

Bayart et al. 1953: M. Bayart, Serge Gauthier, André Loyen, et al. *Le chancelier Henri François d'Aguesseau, Limoges 1668–Fresnes 1751*. Librairie Desvilles, 1953.

Baynes 1926: Norman Hepburn Baynes. *The Historia Augusta: Its Date and Purpose*. Clarendon Press, 1926.

Beard 2002: Geoffrey Beard. "William Bradshaw: Furniture Maker and Tapestry Weaver." *Metropolitan Museum Journal* 37 (2002), pp. 167–69.

Beauvais 1990: Lydia Beauvais. "Les dessins de Le Brun pour *l'Histoire d'Alexandre*." *Revue du Louvre et des Musées de France* 40, 4 (1990), pp. 285–95.

Béguin 1958: Sylvie Béguin. "La suite d'Arthémise." *L'Oeil*, 38 (1958), pp. 32–39, 74.

Béguin and Morel 1997: Gilles Béguin and Dominique Morel. *The Forbidden City, Center of Imperial China*. Harry N. Abrams, 1997.

Béguin and Piccinini 2005: Sylvie Béguin and Francesca Piccinini. *Nicolò dell'Abate: Storie dipinte nella pittura del Cinquecento tra Modena e Fontainebleau*. Exh. cat. Silvana Editoriale, 2005.

Van Bekkum 1986: W. Jac. van Bekkum. "Alexander the Great in Medieval Hebrew Literature." *Journal of the Warburg and Courtauld Institutes* 49 (1986), pp. 218–26.

De Bellaigue 1965: Geoffrey De Bellaigue. "Engravings and the French Eighteenth-Century Marqueteur." *The Burlington Magazine* 107 (May 1965), pp. 240–50, 357–62.

De Bellaigue 1980: Geoffrey De Bellaigue. "Sèvres Artists and their Sources I: Paintings and Drawings." *The Burlington Magazine* 122, 931 (Oct. 1980), pp. 666–78, 681–82.

De Bellaigue 1986: Geoffrey De Bellaigue. *The Louis XVI Service*. Cambridge University Press, 1986.

Belozerskaya 2007: Marina Belozerskaya. "Menageries as Princely Necessities and Mirrors of Their Times." In *Oudry's Painted Menagerie: Portraits of Exotic Animals in Eighteenth-Century Europe*, edited by Mary G. Morton and Colin B. Bailey, pp. 58–73. Exh. cat. J. Paul Getty Museum, 2007.

Benesz 2003: Hanna Benesz. *Die Flämische Landschaft, 1520–1700*. Exh. cat. Kulturstiftung Ruhr Essen/Luca, 2003.

Benito Doménech 1999: Fernando Benito Doménech. *Pintura europea en colecciones valencianas*. Exh. cat. Generalitat Valenciana/Museo de Bellas Artes, 1999.

Bennett 1992: Anna Gray Bennett. *Five Centuries of Tapestry from the Fine Arts Museums of San Francisco*, rev. ed. Fine Arts Museums of San Francisco, 1992.

Bennett 1929: Bessie Bennett. "A Tapestry of the Bear Hunt." *Bulletin of the Art Institute of Chicago* 23, 3 (Mar. 1929), p. 32.

Bennett 1936: Bessie Bennett. "Verdure de bocages et de bêtes sauvages." *Bulletin of the Art Institute of Chicago* 30, 5 (Sept.–Oct. 1936), pp. 63–65.

Bernheimer 1952: Richard Bernheimer. *Wild Men in the Middle Ages*. Harvard University Press, 1952.

Bernini Pezzini, Massari, and Prosperi Valenti Rodinò 1985: Grazia Bernini Pezzini, Stefania Massari, and Simonetta Prosperi Valenti Rodinò. *Raphael invenit: Stampe da Raffaello nelle collezioni dell'Istituto nazionale per la grafica*. Istituto Nazionale per la Grafica, 1985.

Berra 1998: Giacomo Berra. "Arcimboldi: le teste 'caricate' leonardesche e le 'grillerie' dell'Accademia della Val di Blenio." In *Rabisch: il grottesco nell'arte del Cinquecento*, edited by Giulio Bora, Manuela Kahn-Rossi, and Francesco Porzio, pp. 57–67. Exh. cat. Skira, 1998.

Berti 1980: Luciano Berti, ed. *Gli Uffizi: catalogo generale*, 2nd ed. Centro Di, 1980.

Bertini and Forti Grazzini 1998: Giuseppe Bertini and Nello Forti Grazzini. *Gli arazzi dei Farnese e dei Borbone: Le collezioni dei secoli XVI–XVIII*. Exh. cat. Electa, 1998.

Bertrand 1990a: Pascal-François Bertrand. "La seconde 'tenture chinoise' tissée à Beauvais et Aubusson. Relations entre Oudry, Boucher et Dumons." *Gazette des Beaux-Arts* 116 (1990), pp. 173–84.

Bertrand 1990b: Pascal-François Bertrand. "Les sujets de la tenture des 'Métamorphoses en animaux' d'Oudry." *Bulletin de la Société de l'Histoire de l'Art français* (1990), pp. 95–107.

Bertrand 2001: Pascal-François Bertrand. "Dubout." In *Allgemeines Künstlerlexikon: Die bildenden Künstler aller Zeiten und Völker*, edited by Günter Meissner, vol. 30, pp. 88–89. K. G. Saur, 2001.

Bertrand 2002: Pascal-François Bertrand. "Les ateliers secondaires de tapisserie en France: méthode d'analyse." In *Regards sur la tapisserie*, edited by Guy Massin Le Goff and Étienne Vacquet, pp. 25–42. Actes sud, 2002.

Bertrand 2005: Pascal-François Bertrand. *Les tapisseries des Barberini et la décoration d'intérieur dans la Rome baroque*. Studies in Western Tapestry 2. Brepols, 2005.

Bertrand 2006–07: Pascal-François Bertrand. "A New Method of Interpreting the Valois Tapestries, through a History of Catherine de Médicis." *Studies in the Decorative Arts* 14, 1 (2006–07), pp. 27–52.

Bertrand, Chevalier, and Chevalier 1986: Pascal-François Bertrand, Dominique Chevalier, and Pierre Chevalier. "Eighteenth-Century German Chinoiserie Tapestries." Translated by Barbara Scott. *Apollo* 124, 296 (Oct. 1986), pp. 310–14.

Bertrand, Chevalier, and Chevalier 1988: Pascal-François Bertrand, Dominique Chevalier, and Pierre Chevalier. *Les tapisseries d'Aubusson et de Felletin: 1457–1791*. Solange Thierry, 1988.

Bethe 1948: Hellmuth Bethe. *Führer durch die Gemeinschaftsschau der Leipziger Museen*. Volksbildungsamt der Stadt Leipzig, 1948.

Birk 1883: Ernst von Birk. "Inventar der im Besitze des Allerhöchsten Kaiserhauses befindlichen Niederländer Tapeten und Gobelins." *Jahrbuch der kunsthistorischen Sammlungen des Allerhöchsten Kaiserhauses* 1 (1883), pp. 213–48.

Birk 1884: Ernst von Birk. "Inventar der im Besitze des Allerhöchsten Kaiserhauses befindlichen Niederländer Tapeten und Gobelins." *Jahrbuch der kunsthistorischen Sammlungen des Allerhöchsten Kaiserhauses* 2 (1884), pp. 167–220.

Blanc 1984: André Blanc. *F.C. Dancourt (1661–1725): La comédie française à l'heure du soleil couchant*. Gunter Narr Verlag/Editions Jean-Michel Place, 1984.

Blažková 1969: Jarmila Blažková. "Les marques et signatures trouvées sur les tapisseries flamandes du 16ᵉ siècle en Tchécoslovaquie." In Asselberghs et al. 1969, pp. 41–65.

Blažková 1971: Jarmila Blažková. "La tenture des Continents au Musée des arts décoratifs à Prague." *Artes Textiles* 7 (1971), pp. 174–93.

Blažková 1981: Jarmila Blažková. "Deux tentures des *Mois* à Prague." *Artes Textiles* 10 (1981), pp. 203–20.

Blažková and Duverger 1970: Jarmila Blažková and Erik Duverger. *Les tapisseries d'Octavio Piccolomini et le marchand anversois Louis Malo*. Mémoires et recueils de documents 2. Centre universitaire d'étude de l'histoire de la tapisserie flamande, St.-Amandsberg, 1970.

Blažková and Květoňová 1959–60: Jarmila Blažková and Olga Květoňová. "Antoine et Cléopâtre: Histoire d'un achat de tapisseries à Bruxelles en 1666." *Artes Textiles* 5 (1959–60), pp. 63–77.

Bloemendaal 2001: Jan Bloemendaal. "Tyrant or Stoic Hero? Marc-Antoine Muret's *Julius Caesar*." In *Recreating Ancient History: Episodes from the Greek and Roman Past in the Arts and Literature of the Early Modern Period*, edited by Karl A. E. Enkel, Jan L. de Jong, Jeanine de Landtsheer, and Alicia Montoya, pp. 303–18. Intersections 1. Brill, 2001.

Blok 1995: Josine H. Blok. *The Early Amazons: Modern and Ancient Perspectives on a Persistent Myth*. Religions in the Graeco-Roman World 120. Brill, 1995.

Blunt 1944: Anthony Blunt. "The Early Work of Charles Lebrun—II." *The Burlington Magazine* 85, 497 (Aug. 1944.), pp. 165–73, 186–94.

Bober, Rubinstein, and Woodford 1986: Phillis Pray Bober, Ruth Rubinstein, and Susan Woodford. *Renaissance Artists and Antique Sculpture: A Handbook of Sources*. Harvey Miller, 1986.

Boccara 1971: Dario Boccara. *Les belles heures de la tapisserie*. Clefs du temps, 1971.

Boccara, Reyre, and Hayot 1988: Jacqueline Boccara, Séverine Reyre, and Monelle Hayot. *Âmes de laine et de soie*. Editions d'art Monelle Hayot, 1988.

Boccardo 1983–85: Piero Boccardo. "Fonti d'archivio per una storia degli arazzi a Genova." *Studi di storia delle arti* 5 (1983–85), pp. 113–131, 397–406.

Boccardo 1989: Piero Boccardo. *Andrea Doria e le arti: committenza e mecenatismo a Genova*. Palombi, 1989.

Boccardo 2006: Piero Boccardo. "Le 'tapezzarie finissime di Fiandra' a Genova nel Cinquecento." In *Genova e l'Europa atlantica: Opere, artisti, committenti, collezionisti: Inghilterra, Fiandre, Portogallo*, edited by Piero Boccardo, Clario Di Fabio, and Gianluca Ameri, pp. 110–31. Silvana, 2006.

De Bodt and Koldeweij 1987: Saskia de Bodt and Jos Koldeweij. "Museumaanwinsten: Brugse wandtapijten in de Stedelijke Musea van Brugge." *Antiek* 3 (Oct. 1987), pp. 156–61.

Bolgar 1954: Robert R. Bolgar. *The Classical Heritage and Its Beneficiaries*. Cambridge University Press, 1954.

Boon 1992: Karel G. Boon. *The Netherlandish and German Drawings of the XVth and XVIth Centuries of the Frits Lugt Collection*. Institut Néerlandais, 1992.

Bora, Kahn-Rossi, and Porzio 1998: Giulio Bora, Manuela Kahn-Rossi, and Francesco Porzio, eds. *Rabisch: il grottesco nell'arte del Cinquecento*. Exh. cat. Skira, 1998.

Borchgrave d'Altena et al. 1943: Joseph de Borchgrave d'Altena, Marthe Crick-Kuntziger, Jean Helbig, Jacques Lavalleye, O. Le Maire, Jean Maquet-Tombu, Charles Terlinden, and Henri Velge. *Bernard van Orley 1488–1541*. Charles Dessart, 1943.

Borchgrave d'Altena and Picard 1967: Joseph de Borchgrave d'Altena and Jacques Picard. *Chateaux de Belgique*. Desoer, 1967.

Bordeaux 1976: Jean-Luc Bordeaux. "The Epitome of the Pastoral Genre in Boucher's Oeuvre: *The Fountain of Love* and *The Bird Catcher* from *The Noble Pastoral*." *The J. Paul Getty Museum Journal* 3 (1976), pp. 75–101.

Borsi 1991: Franco Borsi, ed. *'Per bellezza, per studio, per piacere': Lorenzo il Magnifico e gli spazi dell'arte*. Cassa di Risparmio di Firenze, 1991.

Bosseboeuf 1903: L. A. Bossebœuf. "La manufacture de tapisseries de Tours." *Mémoires de la Société Archéologique de Touraine* 43 (1903), pp. 173–362.

Bosworth and Baynham 2000: Brian Bosworth and Elizabeth J. Baynham. *Alexander the Great in Fact and Fiction*. Oxford University Press, 2000.

Böttiger 1896: John Böttiger. *Tapetsamlingen under 1800-talet*. Vol. 3 of *Svenska statens samling af väfda tapeter: Historisk och beskrifvande förteckning*. Fröléen och Comp. (Carl Suneson) Éditeurs, 1896.

Böttiger 1898: John Böttiger. *Résumé de l'édition suédoise*. Vol. 4 of *Svenska statens samling af väfda tapeter: Historisk och beskrifvande förteckning*. Translated by Gaston Lévy-Ullmann. Fröléen och Comp. (Carl Suneson) Éditeurs, 1898.

Böttiger 1928: John Böttiger. *Inventaire descriptif*. Vol. 2 of *Tapisseries à figures des XVIe et XVIIe siècles appartenant à des collections privées de la Suède*. Translated by Alfred Mohn. P.A. Norstedt och Söner, 1928.

Bourdieu 1986: Pierre Bourdieu. "Forms of Capital." In *Handbook of Theory and Research for the Sociology of Education*, edited by John G. Richardson, pp. 241–60. Greenwood Press, 1986.

Boutier 2002: Jean Boutier. *Les plans de Paris des origines, 1493, à la fin du XVIIIe siècle: étude, carto-bibliographie et catalogue collectif*. Bibliothèque nationale de France, 2002.

Braghirolli 1881: Willelmo Braghirolli. *Sulle manifatture di arazzi in Mantova*. Segna, 1881.

Van den Branden n.d.: F. Jos. van den Branden. "Verzamelingen van schilderijen te Antwerpen." *Antwerpsch Archievenblad* 22, pp. 26–32.

Breck 1920: J. Breck. "The Juilliard Tapestries." *Metropolitan Museum of Art Bulletin* 15, 1 (Jan. 1920), pp. 3–7.

Bredius 1885: A. Bredius. "De tapijtfabriek van Karel van Mander de Jonge te Delft. 1616-1623." *Oud-Holland* 3 (1885), pp. 1–22.

Brejon de Lavergnée and Vittet 2007: Arnauld Brejon de Lavergnée and Jean Vittet, eds. *La Tenture d'Artémise: À l'origine des Gobelins, la redecouverté d'un tissage royal*. Exh. cat. Réunion des musées nationaux, 2007.

Bremer-David 1986: Charissa Bremer-David. "Tapestry 'Le Château de Monceaux' from the series *Les Maisons Royales*." *The J. Paul Getty Museum Journal* 14 (1986), pp. 105–12.

Bremer-David 1997: Charissa Bremer-David. *French Tapestries and Textiles in the J. Paul Getty Museum*. The J. Paul Getty Museum, 1997.

Bremer-David 2002: Charissa Bremer-David. "Tapestries in the Wernher Collection." *Apollo* 155, 483 (May 2002), pp. 29–34.

Bremer-David 2003. Charissa Bremer-David. "Flemish (Brussels?) c. 1580–1620." In *Drawings, Prints, and Later Acquisitions*, pp. 474–85. Vol. 9 of *The Frick Collection: An Illustrated Catalogue*. The Frick Collection, 2003.

Bremer-David 2007a: Charissa Bremer-David. "The Camel." In Campbell 2007a, pp. 427–33.

Bremer-David 2007b: Charissa Bremer-David. "The Collation." In Campbell 2007a, pp. 434–39.

Bremer-David 2008a: Charissa Bremer-David. "*The Emperor Sailing*, from *The Story of the Emperor of China*." *The Art Institute of Chicago Museum Studies* 34, 1 (2008), pp. 86–87.

Bremer-David 2008b: Charissa Bremer-David. "Fire Screen (Écran de cheminée): *L'Amour Vendangeur* (Cupid, the Vintager)." In *French Art of the Eighteenth Century at the Huntington*, edited by Shelley M. Bennett and Carolyn Sargentson, pp. 309–12. Yale University Press, 2008.

Bremer-David 2008c: Charissa Bremer-David, "Five Tapestries from *La Noble Pastorale* (The Noble Pastoral)." In *French Art of the Eighteenth-Century at the Huntington*, edited by Shelley M. Bennett and Carolyn Sargentson, pp. 312–20. Yale University Press, 2008.

Brett 1949: Gerard Brett. "The Seven Wonders of the World in the Renaissance." *Art Quarterly* 12 (Autumn 1949), pp. 339–59.

Briant 1996: Pierre Briant. *Histoire de l'Empire perse: De Cyrus à Alexandre*. Fayard, 1996.

Briels 1985: Johannes Gerardus Carolus Antonius Briels. *Zuid-Nederlanders in de republiek, 1572–1630: Een demografische en cultuurhistorische studie*. Danthe, 1985.

Brosens 1998: Koenraad Brosens. "*Wintergezicht* (1611) en *Lentegezicht* (1612) door Denijs van Alsloot en Hendrik de Clerck: een stilistische en iconografische analyse." *Jaarboek van het Koninklijk Museum voor Schone Kunsten van Antwerpen* 1998, pp. 293–308.

Brosens 2002: Koenraad Brosens. "Brussels Tapestry Producer Judocus de Vos (1661/1662–1734)—New Data and Design Attributions." *Studies in the Decorative Arts* 9, 2 (Spring–Summer 2002), pp. 58–86.

Brosens 2003: Koenraad Brosens, ed. *Flemish Tapestry in European and American Collections: Studies in Honour of Guy Delmarcel*. Studies in Western Tapestry 1. Brepols, 2003.

Brosens 2003–04: Koenraad Brosens. "Charles Le Brun's *Meleager and Atalanta* and Brussels Tapestry c. 1675." *Studies in the Decorative Arts* 11, 1 (Fall–Winter 2003–04), pp. 5–37.

Brosens 2004a: Koenraad Brosens. *A Contextual Study of Brussels Tapestry, 1670–1770: The Dye Works and Tapestry Workshop of Urbanus Leyniers (1674–1747)*. Verhandelingen van de Koninklijke Vlaamse Academie van België voor Wetenschappen en Kunsten, n.s. 13. Paleis der Academiën, 2004.

Brosens 2004b: Koenraad Brosens. "The Duke of Arenberg's Brussels *Chinoiserie* Tapestries by Judocus de Vos." *Filo Forme* 9 (Spring 2004), pp. 3–6.

Brosens 2005a: Koenraad Brosens. "Nouvelles données sur l'Histoire de Cléopâtre de Poerson: le réseau Parent et la tapisserie bruxelloise à la française." *Revue belge d'Archéologie et d'Histoire de l'Art* 74 (2005), pp. 63–77.

Brosens 2005b: Koenraad Brosens. "The *Maîtres et Marchands Tapissiers* of the rue de la Verrerie: Marketing Flemish and French Tapestry in Paris around 1725." *Studies in the Decorative Arts* 12, 2 (Spring/Summer 2005), pp. 2–25.

Brosens 2005c: Koenraad Brosens. "The 'Story of Psyche' in Brussels Tapestry c.1700: New Information on Jan van Orley, Jan-Baptist Vermillion and Victor Janssens." *The Burlington Magazine* 147 (June 2005), pp. 401–06.

Brosens 2006–07: Koenraad Brosens. "Eighteenth-Century Brussels Tapestry and the *Goût Moderne*: Philippe de Hondt's Sets Contextualized." *Studies in the Decorative Arts* 14, 1 (Fall–Winter 2006–07), pp. 53–79.

Brosens 2007a: Koenraad Brosens. "Autour de la rue Saint Martin: Les importations et la distribution des tapisseries flamandes à Paris, 1600–1650." In *L'objet d'art en France du XVIe au XVIIIe siècle. Actes du colloque international organisé par l'Université Michel de Montaigne-Bordeaux* 3 (Jan. 12–14, 2006), edited by Marc Favreau, pp. 129–40. Les Cahiers du Centre François-Georges Pariset, 2007.

Brosens 2007b: Koenraad Brosens. "Bruxelles/Paris/Bruxelles. Charles de La Fontaine et la diffusion des modèles des tapisseries de Charles Poerson à Bruxelles." *Revue belge d'Archéologie et d'Histoire de l'Art* 76 (2007), pp. 43–60.

Brosens 2007c: Koenraad Brosens. "Caesar Crowned By Fame." In Campbell 2007a, pp. 459–65.

Brosens 2007d: Koenraad Brosens. "Flemish Production." In Campbell 2007a, pp. 441–53.

Brosens 2007e: Koenraad Brosens. "The Story of Theodosius the Younger Rediscovered: A New Tapestry Set by Jordaens and his Studio." *The Burlington Magazine* 149 (June 2007), pp. 376–82.

Brosens and Delmarcel 1998: Koenraad Brosens and Guy Delmarcel. "Les Aventures de Don Quichotte, tapisseries bruxelloises de l'atelier Leyniers-Reydams." *Revue belge d'Archéologie et d'Histoire de l'Art* 67 (1998), pp. 55–92.

Brosens and Delmarcel 2005: Koenraad Brosens and Guy Delmarcel. "Isaac Moillon, un peintre du roi à Aubusson: Some Reflections and Addenda." *Studies in Western Tapestry*. Retrieved Sept. 29, 2005, http://www.studiesinwesterntapestry.net.

Brossel 1965: C. Brossel. "Charles van Falens (1683–1733): Peintre du Régent et de Louis XV Académicien." *Revue belge d'Archéologie et d'Histoire de l'Art* 34 (1965), pp. 211–26.

Brown 1984: Christopher Brown. "The Beit Collection." *Irish Arts Review* 1, 4 (Winter 1984), p. 22.

Brown, Delmarcel, and Lorenzoni 1996: Clifford M. Brown, Guy Delmarcel, and Anna Lorenzoni. *Tapestries for the Courts of Federico II, Ercole, and Ferrante Gonzaga, 1522–1563*. College Art Association, 1996.

Brücknerová 2005: Karla Brücknerová, ed. *Staletí Gobelínů v Moravských a Slezských Sbírkách* (*Centuries of Tapestry in the Moravian and Silesian Collections/Die Jahrhunderte der Gobelins in den mährischen und schleisischen Sammlungen*). Moravská gobelínová manufaktura, 2005.

Brugnoli 1965: M.V. Brugnoli. "Acquisti dei musei e gallerie dello stato: Manifattura di Bruxelles, 1500 circa." *Bollettino d'Arte*, 50 (1965), p. 232.

Buchanan 1999: Iain Buchanan. "The Tapestries Acquired by King Philip II in the Netherlands in 1549–50 and 1555–59: New Documentation." *Gazette des Beaux-Arts* 134, 2569 (Oct. 1999), pp. 131–152.

Buchanan 2006: Iain Buchanan. "The Contract for King Philip II's Tapestries of the *History of Noah*." *The Burlington Magazine* 148 (2006), pp. 406–15.

Buchanan 2007: Iain Buchanan. "The Tapestries of the Count of Mansfeld." In *Essais et catalogue*. Vol. 2 of *Pierre-Ernest de Mansfeld (1517–1604): Un prince de la Renaissance*, edited by Jean-Luc Mousset and Krista de Jonge, pp. 147–56. Exh. cat. Musée National d'Histoire et d'Art de Luxembourg, 2007.

Bullough 1966: Geoffrey Bullough, ed. *The Roman Plays: Julius Caesar, Antony and Cleopatra, Coriolanus*. Vol. 5 of *Narrative and Dramatic Sources of Shakespeare*. Columbia University Press, 1966.

Bürger 2002: Kathrin Bürger. ". . . wo sich Pferde bäumen, wo der Kampf . . . wütet . . . Philips Wouwerman als Schlachtenmaler." *Weltkunst* 72, 9 (Sept. 2002), pp. 1414–17.

Bürger 2003: Kathrin Bürger. "'. . . wie man einen kostbaren Diamanten kauft . . .' Zur Sammlung der Werke Philips Wouwermans (1619–1668) am Dresdener Hof unter August II und August III." *Dresdener Kunstblätter* 47, 3 (2003), pp. 139–46.

Bürger 2006: Kathrin Bürger. "'. . . Die besten Kenner getäuscht . . .' Carel van Falens (1683–1733) nur ein Kopist und Nachahmer von Philips Wouwerman?" *Dresdener Kunstblätter* 50, 5 (2006), pp. 288–98.

Burke 1994: Peter Burke. *The Fabrication of Louis XIV*. Yale University Press, 1994.

Bussers 2000: Helena Bussers, ed. *Met passer en penseel: Brussel en het oude hertogdom Brabant in beeld*. Exh. cat. La Renaissance du Livre, 2000.

Calberg and Pauwels 1961: Marguerite Calberg and Henri Pauwels. "Découverte de la marque du tapissier sur la tenture de l'histoire de Jacob." *Bulletin des Musées royaux d'Art et d'Histoire/Bulletin van de Koninklijke Musea voor Kunst en Geschiedenis*, ser. 4, 33 (1961), pp. 112–113.

Callatay 1960: Edouard de Callatay. "Etudes sur les paysagistes bruxellois du XVIIe siècle." *Revue belge d'Archéologie et d'Histoire de l'Art* 29 (1960), pp. 155–203.

Cambini 2001: Giacinta Cambini. "Gli arazzi fiamminghi di Palazzo Mansi." In *Lucca città d'arte e i suoi archivi: Opere d'arte e testimonianze documentarie dal Medioevo al Novecento*, edited by Max Seidel and Romano Silva, pp. 333–88. Marsilio, 2001.

Cammann 1964: Schuyler Cammann. "Chinese Influence in Colonial Peruvian Tapestries." *Textile Museum Journal* 1, 3 (1964), pp. 21–34.

Campbell 1979: Lorne Campbell. *Van der Weyden*. Harper and Row, 1979.

Campbell 1977: Malcolm Campbell. *Pietro da Cortona at the Pitti Palace: A Study of the Planetary Rooms and Related Projects*. Princeton University Press, 1977.

Campbell 1995: Thomas P. Campbell. "The Return of the Uppark Tapestries: A Triumph of Transatlantic Co-operation." *Apollo* 398, 141 (Apr. 1995), pp. 32–36.

Campbell 1996a: Thomas P. Campbell. "Cardinal Wolsey's Tapestry Collection." *Antiquaries Journal* 76 (1996), pp. 73–137.

Campbell 1996b: Thomas P. Campbell. "School of Raphael Tapestries in the Collection of Henry VIII." *The Burlington Magazine* 138, 1115 (Feb. 1996), pp. 69–78.

Campbell 1998a: Thomas P. Campbell. "New Light on a Set of *History of Julius Caesar* Tapestries in Henry VIII's Collection." *Studies in the Decorative Arts* 5, 2 (Spring–Summer 1998), pp. 2–39.

Campbell 1998b: Thomas P. Campbell. "Romulus and Remus Tapestries in the Collection of Henry VIII." *Apollo* 146, 436 (June 1998), pp. 42–50.

Campbell 1999: Thomas P. Campbell. "The English Royal Tapestry Collection: 1485–1547." Ph.D. diss., Courtauld Institute of Art, University of London, 1999.

Campbell 2002a: Thomas P. Campbell. "Italian Designs in Brussels, 1530–35." In Campbell 2002c, pp. 341–63.

Campbell 2002b: Thomas P. Campbell. "Netherlandish Designers, 1530–60." In Campbell 2002c, pp. 379–405.

Campbell 2002c: Thomas P. Campbell. *Tapestry in the Renaissance: Art and Magnificence*. Exh. cat. The Metropolitan Museum of Art/Yale University Press, 2002.

Campbell 2003: Thomas P. Campbell. "The 'Story of Abraham' Tapestries at Hampton Court Palace." In Brosens 2003, pp. 59–85.

Campbell 2004: Thomas P. Campbell. "New Evidence on 'Triumphs of Petrarch' Tapestries in the Early Sixteenth Century. Part I: The French Court." *The Burlington Magazine* 146, 1215 (June 2004), pp. 376–85.

Campbell 2007a: Thomas P. Campbell, ed. *Tapestry in the Baroque: Threads of Splendor*. Exh. cat. The Metropolitan Museum of Art/Yale University Press, 2007.

Campbell 2007b: Thomas P. Campbell. *Henry VIII and the Art of Majesty: Tapestries at the Tudor Court*. Yale University Press, 2007.

Campbell and Karafel 2002: Thomas P. Campbell and Lorraine Karafel. "Apollo with the Signs of the Zodiac." In Campbell 2002c, pp. 371–77.

Camphausen 2007: Ute Camphausen. *Ständige Ausstellung Antike bis Historismus*. Passage-Verlag, 2007.

Candee 1935: Helen Churchill Hungerford Candee. *The Tapestry Book*. Tudor Publishing Co., 1935.

Cantzler 1990: Christina Cantzler. *Bildteppiche der Spätgotik am Mittelrhein, 1400–1550*. Ernst Wasmuth Verlag, 1990.

Cardon 1996: Bert Cardon. *Manuscripts of the* Speculum Humanae Salvationis *in the Southern Netherlands (c. 1410–1470): A Contribution to the Study of the 15th Century Book Illumination and of the Function and Meaning of Historical Symbolism*. Corpus of Illuminated Manuscripts 9. Peeters, 1996.

Carr 1960: J. L. Carr. "Pygmalion and the *Philosophes*: The Animated Statue in Eighteenth-Century France." *Journal of the Warburg and Courtauld Institutes* 23, 3/4 (July–Dec. 1960), pp. 239–55.

Cartari [1647] 1963: Vincenzo Cartari. *Imagini delli dei de gl'antichi*. Introduction by Walter Koschatzky. 1647; repr. Akademische Druck, 1963.

Cary 1987: George Cary. *The Medieval Alexander*. Garland, 1987.

Casazza and Gennaioli 2005: Ornella Casazza and Riccardo Gennaioli, eds. *Mythologica et Erotica: Arte e Cultura dall'antichità al XVIII secolo*. Exh. cat. Sillabe, 2005.

Caspers 2001: Charles M. A. Caspers. "Wandelend tussen transsubstantiatie en Transfiguratie." *Trajecta* 10 (2001), pp. 209–24.

Castelluccio 2004: Stéphane Castelluccio. *Le garde-meuble de la couronne et ses intendants du XVIe au XVIIIe siècle*. Comité des travaux historiques, 2004.

Castiñeiras Gonzales 1992: Manuel Antonio Castiñeiras Gonzales. "Gennaio e Giano bifronte: dalle "anni januae" all'interno domestico (secoli XII–XIII)." *Prospettiva* 66 (Apr. 1992), pp. 53–63.

Castiñeiras Gonzales 1996: Manuel Antonio Castiñeiras Gonzales. *El Calendario Medieval Hispano: Textos e imagines, siglos X–XIV*. Junta de Castilla y Léon, Consejería de Educación y Cultura, 1996.

Cavallo 1956: Adolfo Salvatore Cavallo. "Scenes from the History of Telemachus." *Brooklyn Museum Bulletin* 17, 3 (Spring 1956), pp. 8–12.

Cavallo 1958: Adolfo Salvatore Cavallo. "The Redemption of Man: A Christian Allegory in Tapestry." *Bulletin of the Museum of Fine Arts, Boston*, 56 (Autumn 1958), pp. 147–68.

Cavallo 1967: Adolfo Salvatore Cavallo. *Tapestries of Europe and Colonial Peru in the Museum of Fine Arts, Boston*, 2 vols. Museum of Fine Arts, Boston, 1967.

Cavallo 1986: Adolfo Salvatore Cavallo. *Textiles: Isabella Stewart Gardner Museum*. Trustees of the Museum, 1986.

Cavallo 1993: Adolfo Salvatore Cavallo. *Medieval Tapestries in the Metropolitan Museum of Art*. The Metropolitan Museum of Art, 1993.

Chapuis 1999: Julien Chapuis. *Tilman Riemenschneider: Master Sculptor of the Late Middle Ages*. Exh. cat. National Gallery of Art, 1999.

Chatelus 1974: Jean Chatelus. "Thèmes picturaux dans les appartements de marchands et artisans parisiens au XVIIIe siècle." *Dix-huitième siècle* 6 (1974), pp. 309–24.

Chazal, Barbe, and Lemasson 2004: Gilles Chazal, Françoise Barbe, and Patrick Lemasson. *A Arte da Tapeçaria: Coleção do Petit Palais, Paris*. Exh. cat. Art Unlimited, 2004.

Cherel 1917: Albert Cherel. *Fénelon au XVIIIe Siècle en France (1715–1820)*. Librairie Hachette, 1917.

Christ 1994: Karl Christ. *Caesar: Annäherungen an einen Diktator*. C. H. Beck.

Christian 1975: John Gordon Christian. *Burne-Jones: The Paintings, Graphic, and Decorative Work of Sir Edward Burne-Jones, 1833–98*, rev. ed. Exh. cat. Arts Council of Great Britain, 1975.

Cieri Via 1989: Claudia Cieri Via. "I trionfi, il mito e l'amore: la fascia superiore dei Mesi negli affreschi di Palazzo Schifanoia." In *Atlante di Schifanoia*, edited by Ranieri Varese, pp. 37–55. Panini, 1989.

Clark 1961: G. N. Clark. *The Seventeenth Century*. Clarendon Press, 1961.

Cleland 2003: Elizabeth Cleland. *More than Woven Paintings: The Reappearance of Rogier van der Weyden's Designs in Tapestry*. Ph.D. diss. Courtauld Institute of Art, University of London, 2003.

Cleland 2007: Elizabeth Cleland. "Tapestries as a Transnational Artistic Commodity." In *Locating Renaissance Art*, edited by Carol M. Richardson, pp. 102–32. Yale University Press, 2007.

Cleland 2011a: Elizabeth Cleland. "'. . . The blood of the grape': Johanna of Castile and Four Tapestry Versions of *The Infant Christ Pressing the Wine of the Eucharist*." *Studies in the Decorative Arts* 18, 2 (Spring–Summer 2011), forthcoming.

Cleland 2011b: Elizabeth Cleland. "'One lytle pece of Arras . . .': Small-scale Tapestries as Aids to Private Devotion during the Fifteenth and Sixteenth Centuries." *Studies in the Decorative Arts* 18, 2 (Spring–Summer 2011), forthcoming.

Clement of Alexandria 1867: Clement of Alexandria. *The Writings of Clement of Alexandria*. Translated by Rev. William Wilson. T. and T. Clark, 1867.

Clouzot 1928: Henri Clouzot. *Histoire de la Manufacture de Jouy et de la Toile Imprimée en France*. G. Van Oest, 1928.

Coburn Witherop 1967: J. Coburn Witherop. "Atalanta and Meleager by Charles Le Brun." *The Liverpool Libraries, Museums & Arts Committee Bulletin* 12 (1967), pp. 28–31.

Coekelberghs 1975: Denis Coekelberghs. "Contribution à l'étude du paysage italianisant flamand et hollandais au XVIIe siècle: œuvres inédits de A. Goubau, L. De Vadder, J. Both." *Revue des archéologues et historiens d'art de Louvain* 8 (1975), pp. 104–22.

Cohen 1912: Henry Cohen. *Guide de l'Amateur de Livres à Gravures du XVIII Siècle*. Librairie A. Rouquette, 1912.

Cohen 1982: Shaye J. D. Cohen. "Alexander the Great and Jaddus the High Priest According to Josephus." *AJS Review* 7 (1982), pp. 41–68.

Colin 1988: Susi Colin. *Das Bild des Indianers im 16. Jahrhundert*. Beiträge zur Kunstgeschichte 102. Schulz-Kirchner Verlag, 1988.

Colonna [1499] 1893: Francesco Colonna. *The Dream of Poliphilus, Fac-Similes of One Hundred and Sixty-Eight Woodcuts in "Hypnerotomachia Poliphili" (Venice, 1499)*. 1499; repr. by the Department of Science and Art in Photo-Lithography by W. Griggs, 1893.

Colosio 2002: Gianni Colosio. *L'annunciazione nella pittura Italiana da Giotto a Tiepolo*. Teseo, 2002.

Comet 1992: Georges Comet. "Les calendriers médiévaux, une représentation du monde." *Journal des Savants* (1992), pp. 35–98.

Compin and Roquebert 1986: Isabelle Compin and Anne Roquebert. *Ecole française*. Vol. 3 of *Catalogue sommaire illustré des peintures du musée du Louvre et du musée d'Orsay*, edited by Arnauld Brejon de Lavergnée and Isabelle Compin. Réunion des musées nationaux, 1986.

Conihout and Ract-Madout 2002: Isabelle Conihout and Pascal Ract-Madout. "Veuves, pénitents et tombeaux. Reliures françaises du XVIe siècle à motifs funèbres, de Catherine de Médicis à Henri III." In *Les funérailles à la Renaissance: XIIe colloque international de la Société Française d'Étude du Seizième Siècle*, edited by Jean Balsamo, pp. 225–68. Droz, 2002.

Cordellier and Py 2004: Dominique Cordellier and Bernadette Py, eds. *Primatice: Maitre de Fontainebleau*. Exh. cat. Réunion des musées nationaux, 2004.

Cordey 1922: Jean Cordey. "La manufacture de tapisseries de Maincy." *Bulletin de la société de l'histoire de l'art français* (1922), pp. 38–52.

Van Corstanje et al. 1982: Charles van Corstanje, Albert Derolez, Johan Decavele, and Yves Cazaux. *Vita Sanctae Coletae (1381–1447)*. Lannoo/Brill, 1982.

Coural 1967: Jean Coural. *Chefs-d'oeuvre de la tapisserie parisienne: 1597–1662*. Exh. cat. Réunion des musées nationaux, 1967.

Coural 1977: Jean Coural. "La Manufacture de tapisseries de Beauvais." *Monuments historiques de la France* 6 (1977), pp. 65–82.

Coural and Gastinel-Coural 1992: Jean Coural and Chantal Gastinel-Coural. *Beauvais: Manufacture nationale de Tapisserie*. Centre National des Arts Plastiques, 1992.

Courtney 1988: E. Courtney. "The Roman Months in Art and Literature." *Museum Helveticum* 45 (1988), pp. 33–157.

Craven 2005: Wayne Craven. *Stanford White: Decorator in Opulence and Dealer in Antiquities*. Columbia University Press, 2005.

Crick-Kuntziger 1927: Marthe Crick-Kuntziger. "L'auteur des Cartons de 'Vertumne et Pomone.'" *Oud-Holland* 44, 4 (1927) pp. 159–173.

Crick-Kuntziger 1930: Marthe Crick-Kuntziger. "L'énigme des 'Mois de Lucas.'" *Actes du XIIe congrès international d'histoire de l'art*, pp. 497–505. Musées royaux des Beaux-Arts de Belgique, 1930.

Crick-Kuntziger 1933: Marthe Crick-Kuntziger. "Dépôt récent: Une tapisserie de Jan-Frans Van den Hecke." *Bulletin des Musées royaux d'Art et d'Histoire/Bulletin van de Koninklijke Musea voor Kunst en Geschiedenis* 5 (1933), pp. 69–71.

Crick-Kuntziger 1935: Marthe Crick-Kuntziger. "Contribution à l'histoire de la tapisserie anversoise: les marques et les tentures des Wauters." *Revue belge d'Archéologie et d'Histoire de l'Art* 5, 1 (Jan.–Mar. 1935), pp. 35–44.

Crick-Kuntziger 1938: Marthe Crick-Kuntziger. "Les cartons de Jordaens au Musée du Louvre et leurs traductions en tapisseries." *Annales de la Société Royale d'Archéologie de Bruxelles* 62 (1938), pp. 135–46.

Crick-Kuntziger 1944: Marthe Crick-Kuntziger. *De tapijtwerken in het stadhuis te Brussel*. De Sikkel, 1944.

Crick-Kuntziger 1950: Marthe Crick-Kuntziger. "La tenture de L'Histoire de Zénobie, reine de Palmyre." *Bulletin des Musées royaux d'Art d'Histoire/ Bulletin van de Koninklijke Musea voor Kunst en Geschiedenis* 22 (1950), pp. 11–26.

Crick-Kuntziger 1951: Marthe Crick-Kuntziger. "Note sur une Tenture inedite de l'Histoire de Phaéton." *Revue belge d'Archéologie et d'Histoire de l'Art* 20, 1 (1951), pp. 127–137.

Crick-Kuntziger 1952: Marthe Crick-Kuntziger. "La Cène de Léonard de Vinci et la tapisserie 'belge' aux armes de François Ier." *Revue belge d'Archéologie et d'Histoire de l'Art* 21 (1952), pp. 113–126.

Crick-Kuntziger 1954a: Marthe Crick-Kuntziger. "Deux tapisseries bruxelloises d'après des cartons de Louis Van Schoor." *Bulletin des Musées royaux d'Art et d'Histoire/Bulletin van de Koninklijke Musea voor Kunst en Geschiedenis* 26 (1954), pp. 98–106.

Crick-Kuntziger 1954b: Marthe Crick-Kuntziger. *La tenture de l'histoire de Jacob, d'après Bernard van Orley*. Imprimeries générales Lloyd Anversois, 1954.

Crick Kuntziger 1956: Marthe Crick-Kuntziger. *Koninklijke Musea voor Kunst en Geschiedenis te Brussel: Catalogus van de wandtapijten (XIVe tot XVIIIe eeuw)*. Koninklijke Musea voor Kunst en Geschiedenis, 1956.

Crick-Kuntziger 1959: Marthe Crick-Kuntziger. "Les Metamorphoses d'Ovide tissées dans deux manufactures bruxelloises." In *Het herfsttij van de Vlaamse tapijtkunst: Internationaal colloquium 8–10 October 1959/La tapisserie flamande aux XVIIme et XVIIIme siècles: Colloque international 8–10 octobre 1959*, pp. 41–51. Paleis der Academiën, 1959.

Cruz Yábar 1996: María Teresa Cruz Yábar. *La tapicería en Madrid: 1570–1640*. Instituto de Estudios Madrileños, 1996.

Cummins 1988: John Cummins. *The Hound and the Hawk: The Art of Medieval Hunting*. Weidenfeld and Nicolson, 1988.

Dacos 1969: Nicole Dacos. *La Découverte de la Domus Aurea et la formation des grotesques à la Renaissance*. Studies of the Warburg Institute 31. Brill, 1969.

Dacos 1980: Nicole Dacos. "Tommaso Vincidor: Un élève de Raphaël aux Pays-Bas." In *Rélations artistiques entre les Pays-Bas et l'Italie à la Renaissance: Études dédiées à Suzanne Salzberger*, edited by Nicole Dacos, pp. 61–99. Études d'histoire de l'art 4. Institut Historique Belge de Rome, 1981.

Dacos 1997: "Cartons et dessins raphaélesque à Bruxelles: L'action de Rome aux Pays-Bas." *Bollettino d'arte*, 100 (1997), suppl. pp. 1–21.

Dancourt [1700–17] 1989: Florent Carton Dancourt. *Comédies II: La Fête de Village (1700), le Vert-Galant (1714), le Prix de l'Arquebuse (1717)*. Selected and annotated by André Blanc. 1700–17; repr. Société des Textes Français Modernes, 1989.

Danter 1966: Sanford B. Danter. "Archbishop Fénelon's Political Activities: The Focal Point of Power in Dynasticism." *French Historical Studies* 4, 3 (Spring 1966), pp. 320–34.

Davenport 1976: Millia Davenport. *The Book of Costume*. New ed. Crown Publishers, 1976.

Davidson 1980. Jane P. Davidson. *David Teniers the Younger*. Thames and Hudson, 1980.

Van de Casteele 1883: Désiré van de Casteele. "Les tapisseries du Château d'Aigremont." *Bulletin de l'Institut Archéologique liégeois* 17 (1883), pp. 379–98.

Van de Graft 1869: J. van de Graft. *De tapijtfabrieken der XVIe en XVIIe eeuw: gevolgd door eene historische beschrijving der zeven tapijtbehangsels in de Groote vergaderzaal der Provinciale Staten van Zeeland*. Altorffer, 1869.

Delmarcel 1971: Guy Delmarcel. "De structuur van de Brusselse tapijtreeks Los Honores." In *Federatie van de Kringen voor Oudheidkunde en Geschiedenis van België. Handelingen van het 41e congres, Mechelen, 3-6-IX-1970*, edited

by R.M. Lemaire and J. Lorrette, vol. 2, pp. 352–56. Koninklijke Kring voor Oudheidkunde, Letteren en Kunst van Mechelen, 1971.

Delmarcel 1976: Guy Delmarcel, ed. *Brusselse wandtapijten van de pre-Renaissance*. Exh. cat. Musées royaux d'Art et d'Histoire/Koninklijke Musea voor Kunst en Geschiedenis, 1976.

Delmarcel 1977: Guy Delmarcel. "The Dynastic Iconography of the Brussels Tapestries 'Los Honores' (1520–1525)." In *España entre el Mediterráneo y el Atlántico, Granada, 1973*, vol. 2, pp. 250–59. Actas del XXIII Congreso internacional de historia del arte. Universidad de Granada, 1977.

Delmarcel 1979: Guy Delmarcel. "Colecciones del Patrimonio Nacional: Tapices I: Los Honores." *Reales Sitios* 16, 62 (1979), pp. 41–48.

Delmarcel 1980: Guy Delmarcel. *Tapisseries anciennes d'Enghien*. Fédération du Tourisme, 1980.

Delmarcel 1981: Guy Delmarcel. "De Brusselse wandtapijtreeks Los Honores (1520–1525): Een vorstenspiegel voor de jonge keizer Karel V." 3 vols. Ph.D. diss., Katholieke Universiteit Leuven, 1981.

Delmarcel 1983: Guy Delmarcel. "Aerts, Nicasius." In *Allgemeines Künstlerlexikon: Die bildenden Künstler aller Zeiten und Völker*, edited by Günter Meissner, vol. 1, pp. 450–51. E.A. Seeman, 1983.

Delmarcel 1985: Guy Delmarcel. "Présence de Jules César dans la tapisserie des Pays-Bas méridionaux." In *Présence de César: Actes de colloque des 9–11 décembre 1983, Hommage au Doyen M. Rambaud*, edited by Raymond Chevallier, pp. 257–61. Collection Caesarodunum 20 bis. Belles Lettres, 1985.

Delmarcel 1988 : Guy Delmarcel. "La tenture des Guerres Judaïques à Marsala et l'atelier bruxellois C.T." In *La cultura degli arazzi fiamminghi di Marsala tra Fiandre, Spagna e Italia: Atti del convegno internazionale, Marsala, Auditorium di S. Cecilia, 7–9 luglio 1986*, edited by Maria Giuila Aurigemma and Maria Azzarello, pp. 95–107. Soprintendenza per i beni culturali ed ambientali di Palermo, 1988.

Delmarcel 1992: Guy Delmarcel. "De Passietapijten van Margareta van Oostenrijk (ca. 1518–1524). Nieuwe gegevens en documenten." *Revue belge d'Archéologie et d'Histoire de l'Art* 61 (1992), pp. 127–60.

Delmarcel 1996: Guy Delmarcel. 1996. "Brugse wandtapijten na tien jaar: Nieuwe kunstwerken en toeschrijvingen." *Jaarboek Stad Brugge Stedelijke Musea*, pp. 191–201.

Delmarcel 1997: Delmarcel, Guy. "Giulio Romano and tapestry at the court of Manta." *La corte di Mantova nell'età di Andrea Mantegna, 1450–1550: Atti del convegno, Londra, 6–8 marzo 1992, Mantova, 28 marzo 1992*, edited by Mozzarelli Cesare, Robert Oresko, and Leandro Ventura, pp. 383–392. Bulzoni, 1997.

Delmarcel 1999a: Guy Delmarcel. 1999. *Flemish Tapestry*. Thames and Hudson, 1999.

Delmarcel 1999b: Guy Delmarcel. "Le roi Philippe II d'Espagne et la tapisserie: l'inventaire de Madrid de 1598." *Gazette des Beaux-Arts* 134, 1569 (Oct. 1999), pp. 153–78.

Delmarcel 2000: Guy Delmarcel. *Los Honores: Flemish Tapestries for the Emperor Charles V*. Snoeck-Ducaju and Zoon/Pandora, 2000.

Delmarcel 2001: Guy Delmarcel. "Les tapisseries des Ages, des Mois et des Chasses du cardinal Érard de la Marck en 1531." In *Artium Historia*. Vol. 2 of *Liber Amicorum Raphaël de Smedt*, edited by Raphaël de Smedt, Joost Vander Auwera, André Tourneux, and Jacques Paviot, pp. 205–13. Miscellanea neerlandica 24. Peeters, 2001.

Delmarcel 2002: Guy Delmarcel. "Wandtapijten." In *Arenberg in de Lage Landen: Een hoogadellijk huis in Vlaanderen en Nederland*, edited by Mark Derez and Jan Roegiers, pp. 346–52. Universitaire Pers Leuven, 2002.

Delmarcel 2004a: Guy Delmarcel. "Comte rendu: Tapisseries de choeur." Retrieved Apr. 12, 2008, from https://www.studiesinwesterntapestry.net.

Delmarcel 2004b: Guy Delmarcel. "Saint Paul before Porcius Festus, King Herod Agrippa and His Sister Berenice: A Flemish Renaissance Tapestry by Pieter Coecke van Aelst." *Bulletin of the Detroit Institute of Arts* 78, 1–2 (2004), pp. 18–29.

Delmarcel 2005: Guy Delmarcel. "La collection de tapisseries de la reine Isabelle de Castille (1451–1504)." In *El arte en la corte de los Reyes Católicos: Rutas artísticas a principios de la Edad Moderna*, edited by Fernando Checa Cremades and Bernardo José García García, pp. 287–303. Fundación Carlos Amberes, 2005.

Delmarcel et al. 1997: Guy Delmarcel, Philippe Lüscher, Nicole de Reyniès, and Denis Weidmann. *Collection Toms: De fils et de couleurs Tapisseries du XVIe au XVIIIe siècle*. Exh. cat. Abbatiale et Musée de Payerne, 1997.

Delmarcel and Dumortier 1986: Guy Delmarcel and Claire Dumortier. "Cornelis de Ronde, wandtapijtwever te Brussel (†1569)." *Revue belge d'Archéologie et d'Histoire de l'Art* 55 (1986), pp. 41–67.

Delmarcel and Duverger 1987: Guy Delmarcel and Erik Duverger, eds. *Brugge en de tapijtkunst*. Exh. cat. Stad Brugge/Louis de Poortere, 1987.

Delmarcel and Volckaert 1995: Guy Delmarcel and An Volckaert. *Tapisseries flamandes: Cinq siècles de tradition*. Exh. cat. Château de Vianden, 1995.

Delmarcel et al. 1993: Guy Delmarcel, Isabelle van Tichelen, An Volckaert, and Yvan Maes De Wit. *Golden Weavings: Flemish Tapestries of the Spanish Crown*. Exh. cat. Peristromata: Studies in Antique and Modern Tapestry 1. Royal Manufacturers of Tapestry Gaspard De Wit/Bayerisches Nationalmuseum/Stichting de Nieuwe Kerk and the Rijksmuseum, 1993.

Demarteau 1881: Joseph Demarteau. *A travers l'exposition de l'art ancien au Pays de Liège*. Demarteau, 1881.

Denis 1991: Isabelle Denis. "L'Histoire d'Artémise, commanditaires et ateliers. Quelques précisions apportées par l'étude des bordures." *Bulletin de la Société de l'Histoire de l'art français* (1991), pp. 21–36.

Denis 1999: Isabelle Denis. "Henri Lerambert et l'*Histoire d'Artémise*." In *La Tapisserie au XVIIe siècle et les collections européennes: Actes du colloque international de Chambord, 18–19 octobre 1996*, edited by Catherine Arminjon and Nicole de Reyniès, pp. 33–50. Cahiers du Patrimoine, 57. Éditions du patrimoine, 1999.

Denny 1977: Don Denny. *The Annunciation from the Right from Early Christian Times to the Sixteenth Century*. Outstanding Dissertations in the Fine Arts. Garland, 1977.

Denucé 1931: Jan Denucé. *Kunstuitvoer in de 17e eeuw te Antwerpen de firma Forchoudt*. Bronnen voor de geschiedenis van de Vlaamsche kunst 1. De Sikkel, 1931.

Denucé 1932: Jan Denucé. *De Antwerpsche "Konstkamers": inventarissen van kunstverzamelingen te Antwerpen in de 16e en 17e eeuwen*. Bronnen voor de geschiedenis van de Vlaamsche kunst 2. De Sikkel, 1932.

Denucé 1936: Jan Denucé. *Antwerpsche tapijtkunst en handel*. Bronnen voor de geschiedenis van de Vlaamsche kunst 4. De Sikkel, 1936.

Denucé 1949: Jan Denucé. *Na Peter Pauwel Rubens: Documenten uit den kunsthandel te Antwerpen in de XVIIe eeuw van Matthijs Musson*. Bronnen voor de geschiedenis van de Vlaamsche kunst 5. De Sikkel, 1949.

Derow and Parker 2003: Peter Derow and Robert Parker, eds. *Herodotus and his World: Essays from a Conference in Memory of George Forrest*. Oxford University Press, 2003.

Desprechins 1980: Anne Desprechins. "Tapijtenreeks geïnspireerd door "L'Astrée" afkomstig uit de oude Baudeloo-abdij/Suite de tapisseries inspirées par "L'Astrée" provenant de l'ancienne abbaye de Baudeloo." *La Maison d'Hier et Aujourd'hui* 46 (1980), pp. 26–41.

Dessau 1889: Hermann Dessau. "Über Zeit und Persölichkeit der Scriptores Historiae Augustae." *Hermes* 24 (1889), pp. 337–92.

Dessert 1987: Daniel Dessert. *Fouquet*. Fayard, 1987.

Destrée 1906: Joseph Destrée. *Tapisseries et sculptures bruxelloises à l'Exposition d'art ancien bruxellois organisée à Bruxelles au Cercle artistique et littéraire de juillet à octobre 1905*. Exh. cat. G. van Oest, 1906.

Destrée 1930: Jules Destrée. *Rogier de le Pasture van der Weyden*. G. van Oest, 1930.

Detienne 1975: Marcel Detienne. *I giardini di Adone*. Introduction by Jean-Paul Vernant. Translated by Letizia Berrini Pajetta. Giulio Einaudi, 1975.

Develin 1985: Robert Develin. "Pompeius Trogus and Philippic History." *Storia della Storiografia* 8 (1985), pp. 110–15.

Devisscher 2001: Hans Devisscher. "Van Bosch tot Rubens. Zuid-Nederlandse landschapskunst 1500–1675." In *Panorama op de wereld: het landschap van Bosch tot Rubens*, edited by Paul Huys Janssen, pp. 13–41. Noordbrabants Museum/Zwolle, 2001.

Devisscher and De Poorter 1993: Hans Devisscher and Nora de Poorter, eds. *Jacob Jordaens (1593–1678)*, 2 vols. Exh. cat. Gemeentekrediet, 1993.

Dickinson and Wrigglesworth 2000: Gary Dickinson and Linda Wrigglesworth. *Imperial Wardrobe*. Rev. ed. Ten Speed Press, 2000.

Diels and Leesberg 2005: Ann Diels and Marjolein Leesberg. *The Collaert Dynasty*. Vols. 15–16 of *The New Hollstein Dutch and Flemish Etchings, Engravings, and Woodcuts 1450–1700*. Sound and Vision, 2005.

Dijkstra 1990: Jeltje Dijkstra. "Origineel en kopie: Een onderzoek naar de navolging van de Meester van Flémalle en Rogier van der Weyden." Ph.D. diss., University of Amsterdam, 1990.

Dixon 2002a: Annette Dixon, ed. *Women Who Ruled: Queens, Goddesses, Amazons in Renaissance and Baroque Art*. Exh. cat. The University of Michigan Museum of Art, 2002.

Dixon 2002b: Annette Dixon. "Women Who Ruled: Queens, Goddesses, Amazons, 1500–1650: A Thematic Overview." In Dixon 2002a, pp. 119–80.

Dolan 2002: Susan Hill Dolan. "Mr. and Mrs. Richard T. Crane, Jr., House." In *David Adler, Architect: The Elements of Style*, edited by Martha Thorne, pp. 140–49. The Art Institute of Chicago/Yale University Press, 2002.

Domínguez Cassas 1993: Rafael Domínguez Casas. *Arte y Etiqueta de los Reyes Católicos: Artistas, residencias, jardines, y bosques*. Alpuerto, 1993.

Donnet 1896: Fernand Donnet. "Documents pour servir à l'histoire des ateliers de tapisserie de Bruxelles, Audenarde, Anvers, etc." *Annales de la société d'archéologie de Bruxelles* 10 (1896), pp. 267–336.

Doursther 1840: Horace Doursther. *Dictionnaire universel des poids et mesures anciens et modernes*. Hayez, 1840.

Downs 1927: Joseph Downs. 1927 "An exhibition of tapestries." *The Pennsylvania Museum Bulletin* 22, 110 (Feb. 1927) pp. 309–26.

Droguet, Salmon, and Véron-Denise 2003: Vincent Droguet, Xavier Salmon, and Danièle Véron-Denise. *Animaux d'Oudry: Collection des ducs de Mecklembourg-Schwerin*. Exh. cat. Réunion des musées nationaux, 2003.

Dudley and Novak 1972: Edward Dudley and Maximillian E. Novak, eds. *The Wild Man Within: An Image in Western Thought from the Renaissance to Romanticism*. University of Pittsburgh Press, 1972.

Due 1989: Bodil Due. *The Cyropaedia: Xenophon's Aims and Methods*. Aarhus University Press, 1989.

Duffy and Hedley 2004: Stephen Duffy and Jo Hedley. *The Wallace Collection's Pictures: A Complete Catalogue*. Unicorn Press and Lindsay Fine Art Limited, 2004.

Dufour Nanelli 1997: Inna Dufour Nanelli. *Storie di arazzi e di fiori*. Leonardo Arte, 1997.

Duparc 1993: F. J. Duparc. "Philips Wouwerman, 1619–1668." *Oud-Holland* 107, 3 (1993) pp. 257–86.

Duran i Sanpere 1933: Agustí Duran i Sanpere. "Lluis Dalmau." In *La peinture catalane à la fin du moyen âge: Conférences faites à la Sorbonne en 1931*, pp. 55–64. E. Leroux, 1933.

Dutertre 1992: E. Dutertre. "A propos de quelques tragédies de la mort de César des XVIe et XVIIe siècles." *Littératures Classiques* 16 (1992), pp. 199–227.

Duverger 1960: Erik Duverger. *Jan, Jacques, en Frans de Moor: Tapijtwevers en tapijthandelaars te Oudenaarde, Antwerpen, en Gent (1560 tot ca. 1680)*. Interuniversitair Centrum voor de Geschiedenis van de Vlaamse Tapijtkunst Verhandelingen en Bouwstoffen 1. Interuniversitair Centrum voor de Geschiedenis van de Vlaamse Tapijtkunst, 1960.

Duverger 1969: Erik Duverger. "Tapijtwerk uit het atelier van Frans Geubels." In Asselberghs et al. 1969, pp. 91–204.

Duverger 1971a: Erik Duverger. "Tapijten naar Rubens en Jordaens in het bezit van het Antwerps handelsvennootschap Fourment–Van Hecke." *Artes Textiles* 7 (1971), pp. 119–73.

Duverger 1971b: Erik Duverger. "Une tenture de l'histoire d'Ulysse livrée par Jacques Geubels le Jeune au Prince de Pologne." *Artes Textiles* 7 (1971), p. 74–98.

Duverger 1973: Erik Duverger. "Tapisseries de Jan van Tieghem représentant l'Histoire des premiers parents, du Bayerisches Nationalmuseum de Munich." *Bulletin des Musées royaux d'Art et d'Histoire/Bulletin van de Koninklijke Musea voor Kunst en Geschiedenis* 45 (1973), pp. 19–63.

Duverger 1974: Erik Duverger. "Tapisseries de Jan van Tieghem représentant l'Histoire des Premiers Parents, du Bayerisches Nationalmuseum de Munich." In *L'Art brabançon au milieu du XVIe siècle et les tapisseries du château du Wawel à Cracovie: Actes du Colloque International, 14–15 décembre 1972*, pp. 14–15. Musées royaux d'Art et d'Histoire/Koninklijke Musea voor Kunst en Geschiedenis, 1974.

Duverger 1981–84: Erik Duverger. "Enkele archivalische gegevens over Catharina Van den Eynde en over haar zoon Jacques II Geubels, tapissiers te Brussel." *Gentse Bijdragen tot de Kunstgeschiedenis* 26 (1981–84), pp. 161–93.

Duverger 1984–2002: Erik Duverger. *Antwerpse kunstinventarissen uit de zeventiende eeuw*. 13 vols. Fontes historiae artis Neerlandicae 1. Koninklijke Academie voor Wetenschappen, Letteren, en Schone Kunsten van België, 1984–2002.

Duverger 1986a: Erik Duverger. "Een Troje-tapijt uit het Brussels atelier van Jan van Rottom van omstreeks 1660." *Artes Textiles* 11 (1986), pp. 125–48.

Duverger 1986b: Erik Duverger. "Verdures uit het Brusselse atelier van Erasmus (III) en Frans de Pannemaker." *Artes Textiles* 11 (1986), pp. 107–15.

Duverger 1992: Erik Duverger. "De Brusselse stadspatroonschilder voor de tapijtkunst Michiel van Coxcyen (ca. 1497–1592)." In De Smedt 1992, pp. 161–92.

Duverger 1996: Erik Duverger. "Zeventiende-eeuwse Brugse wandtapijten met de geschiedenis van Julius Caesar." *Gentse Bijdragen tot de Kunstgeschiedenis en Oudheidkunde* 31 (1996), pp. 59–80.

Duverger 1953: Jozef Duverger. "Bijdragen tot de geschiedenis van de Oudenaardse tapijtkunst en tapijthandel." *Artes Textiles* 1 (1953), pp. 38–64.

Duverger 1959: Jozef Duverger. "De rijschool of grote en kleine paarden in de XVIIe-eeuwse tapijtkunst." In *Het herfsttij van de Vlaamse tapijtkunst: Internationaal colloquium 8–10 October 1959/La tapisserie flamande aux XVIIme et XVIIIme siècles: Colloque international 8–10 octobre 1959*, pp. 121–76. Paleis der Academiën, 1959.

Duverger 1959–60: Jozef Duverger. "Aantekeningen betreffende tapijten naar cartons van Jacob Jordaens." *Artes Textiles* 5 (1959–60), pp. 47–62.

Duverger 1973: Jozef Duverger. "Notes concernant les tapisseries du seizième siècle au château de Wawel." *Bulletin des Musées royaux d'Art et d'Histoire/Bulletin van de Koninklijke Musea voor Kunst en Geschiedenis* 45 (1973), pp. 65–76.

Duverger 1978: Jozef Duverger. "C. Julius Caesar en zijn daden in de Vlaamse tapijtkunst: Een bijdrage (I)." *Artes Textiles* 9 (1978), pp. 3–25.

Duverger and Duverger 1959: Jozef Duverger and Erik Duverger. *Vlaamse wandtapijten uit Spanje*. Exh. cat. Museum voor Schone Kunsten, 1959.

Duverger and Duverger 1981: Jozef Duverger and Erik Duverger. "Aantekeningen betreffende de zestiende-eeuwse Brusselse tapijtwever Jan Ghieteels." In *Archivum artis Lovaniense: Bijdragen tot de geschiedenis van de kunst der Nederlanden, opgedragen aan prof. em. Dr. J. K. Steppe*, edited by Maurits Smeyers, pp. 239–49. Peeters, 1981.

Earwaker 1880: John Parsons Earwaker. *East Cheshire: Past and Present; Or, A History of the Hundred of Macclesfield in the County Palatine of Chester*, vol. 2. J. P. Earwaker, 1880.

Eeckhout 1996: Paul Eeckhout. "Petit historique des tableaux de fleurs du XVIe au XVIIIe siècle." In *L'empire de Flore: Histoire et représentation des fleurs en Europe du XVIe au XIXe siècle*, edited by Sabine van Sprang, pp. 261–88. Renaissance du Livre, 1996.

Ehrmann 1956: Jean Ehrmann. "Caron et les tapisseries des Valois." *Revue des Arts* 6 (1956), pp. 9–14.

Ehrmann 1964: Jean Ehrmann. "Antoine Caron: tapisserie et tableau inédits dans la série de la reine Artémise." *Bulletin de la Société de l'Histoire de l'Art français* (1964), pp. 25–34.

Ehrmann 1986: Jean Ehrmann. *Antoine Caron: Peintre des fêtes et des massacres*. Flammarion, 1986.

Eidelberg 1977: Martin Eidelberg. "A Chinoiserie by Jacques Vigouroux Duplessis." *Journal of the Walters Art Gallery* 35 (1975), pp. 63–76.

Eisler 1921: Max Eisler. "Die Delfter Gobelinfabrik." *Oud-Holland* 39 (1921), pp. 188–232.

Emerson 2000: Julie Emerson. "Early East-West Trade." In *Porcelain Stories: From China to Europe*, pp. 100–10. Seattle Art Museum, 2000.

Erlande-Brandenburg 1973: Alain Erlande-Brandenburg. "Les tapisseries de François d'Angoulême." *Bulletin de la Société de l'Histoire de l'Art française* (1973), pp. 19–31.

Erkelens 1969: A. M. Louise Erkelens. "Karel van Mander de Oude en latt zestiende eeuwse Brusselse wandtapijten." In Asselberghs et al. 1969, pp. 227–45.

Evans 1991: J. A. S. Evans. *Herodotus, Explorer of the Past: Three Essays*. Princeton University Press, 1991.

Fagnart 2001: Laure Fagnart. "L'arazzo con le insegne di Francesco d'Angoulême e di Luisa di Savoia, conservato nella Pinacoteca dei Musei Vaticani. Alcune ipotesi sull'origine lombarda del cartone." In *Il genio e le passioni: Leonardo e il Cenacolo: Precedenti, innovazioni, riflessi di un capolavoro*, edited by Pietro C. Marani, pp. 165–171. Exh. cat. Skira, 2001.

Falkenburg et al. 1991–92: Hessel Miedema, Reindert Falkenburg, Jan Piet Filedt Kok, and Huigen Leeflang, eds. *Goltzius-Studies: Hendrick Goltzius (1558–1617)*. Nederlands Kunsthistorisch Jaarboek 42–43. Waanders, 1991–92.

Farber 1979: J. Joel Farber. "The Cyropaedia and Hellenistic Kingship." In *The American Journal of Philology* 100, 4 (Winter 1979), pp. 497–514.

Farmer 1973: John David Farmer. "A Painting of the Pentecost by Bernard van Orley." *Bulletin of the Art Institute of Chicago* 67, 5 (Sept.–Oct. 1973), pp. 16–19.

Farmer 1981: John David Farmer. *Bernard van Orley of Brussels*, Ph.D. diss., Princeton University, 1981.

Favart 1763: Charles-Simon Favart. *Theatre de M. Favart, ou recueil des comédies, parodies et opera-comiques qu'il a donnés jusqu'à ce jour*, vols. 1–3. Duchesne, 1763.

Favreau 2007: Marc Favreau. "Charles Le Brun aux Gobelins: Le centre de la création artistique royale sous le règne de Louis XIV (1663–1690)." In *La Maison de l'artiste: Construction d'un espace de représentations entre réalité et imaginaire (XVIIe–XXe siècles)*, edited by Jean Gribenski, Véronique Meyer, and Solange Vernois, pp. 117–31. Presses Universitaires de Rennes, 2007.

Fears 1974: J. Rufus Fears. "Cyrus as a Stoic Exemplum of the Just Monarch." In *The American Journal of Philology* 95 (1974), pp. 265–67.

Félibien 1670: André Félibien. *Tapisseries du Roy: Ou sont representez les quatre elemens et les quatre saisons de l'année*. Mabre-Cramoisy, 1670.

Fenaille 1903–23: Maurice Fenaille. *État Général des tapisseries de la Manufacture des Gobelins depuis son origine jusqu'à nos jours*. 5 vols. Hachette, 1903–23.

Fénelon 1734: François de Salignac de La Mothe Fénelon. *Les avantures de Télémaque, fils d'Ulysse*. J. Wetstein and G. Smith/Jean Hofhout, 1734.

Ferguson 1927: Lucile Ferguson. "Some Early Masks and Morris Dances." *Modern Philology* 24, 4 (May 1927), pp. 409–17.

Ferino-Pagden, Prohaska, and Schutz 1991: Sylvia Ferino-Pagden, Wolfgang Prohaska, and Karl Schutz, eds. *Die Gemäldegalerie des Kunsthistorischen Museums in Wien: Verzeichnis der Gemälde*. Edition Christian Brandstätter, 1991.

Ferrandis 1943: José Ferrandis. *Inventarios reales (Juan II a Juana la Loca)*. Vol. 3 of *Datos documentales para la historia del arte español*. Consejo Superior de Investigaciones Científicas, Instituto Diego Velázquez, 1943.

Ferrero-Viale 1952: Mercedes Ferrero-Viale. "Arazzi." In *Arazzi e tappeti antichi*, edited by Mercedes Ferrero-Viale and Vittorio Viale, pp. 11–157. Exh. cat. Industria Libraria Tipografica Editrice, 1952.

Ferrero-Viale 1959: Mercedes Ferrero-Viale. "Essai de reconstitution idéale des collections de tapisserie ayant appartenu à la maison de Savoie au XVIIe et XVIIIe siècle." In *Het herfsttij van de Vlaamse tapijtkunst: Internationaal colloquium 8–10 October 1959/La tapisserie flamande aux XVIIme et XVIIIme siècles: Colloque international 8–10 octobre 1959*, pp. 269–300. Paleis der Academiën, 1959.

Ferrero-Viale 1981: Mercedes Ferrero-Viale. "Quatre tapisseries inédites de l'Histoire de Troie." *Artes Textiles* 10 (1981), pp. 183–92.

Festus 1913: Sextus Pompeius Festus. *Sexti Pompei Festi, De verborum significatu quae supersunt cum Pauli epitome*. Edited by W. M. Lindsay. Bibliotheca scriptorum graecorum et romanorum Teubneriana. Teubner, 1913.

Fikioris 1970: Margaret Fikioris. "Neoclassicism in Textile Design by Jean-Baptiste Huet." *Winterthur Portfolio 6* (1970), pp. 75–110.

Floret 2002: Élisabeth Floret. "Rare tapisserie de la manufacture de Beauvais." *L'Objet d'Art* 375 (Dec. 2002), p. 29.

Fock 2001: Willemijn Fock, ed. *Het Nederlandse interieur in beeld, 1600–1900*. Waanders, 2001.

Foister and Nash 1996: Susan Foister and Susie Nash, eds. *Robert Campin. New directions in scholarship*. Brepols, 1996.

ffolliott 1989: Sheila ffolliott. "Casting a Rival into the Shade: Catherine de' Medici and Diane de Poitiers." *Art Journal* 48, 2 (1989), pp. 138–43.

ffolliott 2001: Sheila ffolliott. "Women in the Garden of Allegory: Catherine de Medicis and the Locus of Female Rule." In *Villas and Gardens in Early Modern Italy and France*, edited by Mirka Benes and Dianne Suzette Harris, pp. 207–24, 391–96. Cambridge Studies in New Art History and Criticism. Cambridge University Press, 2001.

Forsyth 1944: William Holmes Forsyth. "The Noblest of Sports: Falconry in the Middle Ages." *Metropolitan Museum of Art Bulletin*, n.s., 2, 9 (1944), pp. 253–59.

Forti Grazzini 1982a: Nello Forti Grazzini. *Arazzi a Ferrara*. Cassa di Risparmio, 1982.

Forti Grazzini 1982b: Nello Forti Grazzini. *Gli arazzi dei Mesi Trivulzio: Il committente, l'iconografia*. Comune di Milano, 1982.

Forti Grazzini 1984: Nello Forti Grazzini. *Museo d'Arti Applicate: Arazzi*. Musei e Gallerie di Milano. Electa, 1984.

Forti Grazzini 1993: Nello Forti Grazzini. "Un contesto per l'arazzo con 'Enea davanti a Didone' delle Civiche Raccolte d'Arte Applicata." *Rassegna di Studi e di Notizie* 17 (1993), pp. 99–146.

Forti Grazzini 1994: Nello Forti Grazzini. *Il patrimonio artistico del Quirinale: Gli arazzi*. 2 vols. Electa, 1994.

Forti Grazzini 2000: Nello Forti Grazzini. "Arazzi e arazzieri in Lombardia tra tardo Gotico e Rinascimenti." *Le arti decorative in Lombardia nell'età moderna: 1480–1780*, edited by Valerio Terraroli and Raffaella Ausenda, pp. 11–53. Skira, 2000.

Forti Grazzini 2002: Nello Forti Grazzini. "Flemish Weavers in Italy in the Sixteenth Century." In *Flemish Tapestry Weavers Abroad: Emigration and the Founding of Manufactories in Europe*. Proceedings of the International Conference held at Mechelen, 2–3 October 2000, edited by Guy Delmarcel, pp. 131–61. Universitaire Pers Leuven, 2001.

Forti Grazzini 2003: Nello Forti Grazzini. *Gli arazzi della Fondazione Giorgio Cini*. Marsilio, 2003.

Forti Grazzini 2007: Nello Forti Grazzini. "Deux tapisseries retrouvées de la tenture de "l'Histoire de Diane"." *La Revue des Musées de France: Revue du Louvre* 4 (2007), pp. 41–60.

Forti Grazzini, Scalini, and Orsi 1999: Nello Forti Grazzini, Mario Scalini, and Francesco Orsi. *Arazzi, sculture, mobili, ceramiche*. Vol. 2 of *La collezione Cagnola*, edited by Miklós Boskovits and Giorgio Fossaluzza. Nomos, 1999.

Forti Grazzini and Zardini 2007: Nello Forti Grazzini and Francesca Zardini. *Divinità. Scimme e segni zodiacali: I dodici mesi grotteschi su bande da Claude III Audran*. Exh. cat. Moshe Tabibnia, 2007.

Foucart-Walter 2001: Elizabeth Foucart Walter. *Pieter Boel, 1622–1674, Peintre des animaux de Louis XIV: Le fonds des études peintes des Gobelins*. Exh. cat. Réunion des musées nationaux, 2001.

Fouret 1981: Claude Fouret. "La violence en fête: la course de l'Epinette à Lille à la fin du Moyen Age." *Revue du Nord* 62, 249 (Apr.–June 1981), pp. 377–90.

Fowler 1873: J. Fowler. "On Mediaeval Representations of the Months and Seasons." *Archaeologia* 44 (1873), pp. 137–224.

Fowler 2004: Robert Fowler. *The Cambridge Companion to Homer*. Cambridge University Press, 2004.

Franke 2000: Birgit Franke. "Herrscher über Himmel und Erde: Alexander der Große und die Herzöge von Burgund." *Marburger Jahrbuch für Kunstwissenschaft* 27 (2000), pp. 121–69.

Franses and Franses 2005: David Franses and Simon Franses. *Giant Leaf Tapestries of the Renaissance, 1500–1600*. Exh. cat. S. Franses, 2005.

Franses 1986: Simon Franses. "*La Musique* from the series *Grotesques de Berain*." In *European Tapestries 1450–1750: A Catalogue of Recent Acquisitions, Spring 1986*, pp. 23–26. Exh. cat. S. Franses, 1986.

Franses 2006: Simon Franses. 2006. *Chinoiserie: European Tapestry and Needlework 1680–1780*. Exh. cat. S. Franses, 2006.

Franssen 1987: Paul J. Franssen. *The Mystic Winepress: A Religious Image in English Poetry, 1500–1700*. PhD diss., Rijksuniversiteit Utrecht, 1987.

Franz 1985: Erich Franz. "Ellingen, Deutschordenresidenz." In idem., *Pierre Michel d'Ixnard 1723–1795: Leben und Werk*, pp. 108–25, 251–52. Anton H. Konrad, 1985.

French and Company 1917: French and Company, New York. *Beauvais Tapestries by Jean-François Boucher*. Monograph number 108. Copy preserved in the Department of European Furniture, Sotheby's, New York.

Friedländer 1972: Max J. Friedländer. *Joos van Cleve, Jan Provost, Joachim Patenier*. Vol. 9, pts. 1–2 of *Early Netherlandish Painting*. Translated by Heinz Norden. Praeger, 1972.

Friedman 1989: Ann Friedman. "What John Locke Saw at Versailles," *Journal of Garden History* 9, 4 (1989), pp. 177–98.

Friedmann 1968–69: Herbert Friedmann. "Giovanni del Biondo and the Iconography of the Annunciation." *Simiolus: Netherlands Quarterly for the History of Art* 3, 1 (1968–69), pp. 6–14.

Frinta 1966: Mojmir S. Frinta. *The Genius of Robert Campin*. Studies in Art 1. Mouton, 1966.

Fromaget and Reyniès 1993: Brigitte Fromaget and Nicole de Reyniès, eds. *Les tapisseries des Hospices de Beaune: Inventaire générale des monuments et des richesses artistiques de la France*. Images du patrimoine 126. Association pour la connaisance du patrimoine de Bourgogne, 1993.

Frugoni 1999: Chiara Frugoni, ed. *Il Duomo di Modena*. 3 vols. Mirabilia Italiae 9. Panini, 1999.

Fuhring 2002: Peter Fuhring, ed. *De wereld is een tuin: Hans Vredeman de Vries en de tuinkunst van de Renaissance*. Ludion, 2002.

García Calvo 1997: Margarita García Calvo. "Tapices de Alejandro Magno." *Reales Sitios* 34, 133 (1997), pp. 52–59.

Gareau and Beauvais 1992: Michel Gareau and Lydia Beauvais. *Charles Le Brun: First Painter to King Louis XIV*. Harry N. Abrams, 1992.

Gastinel-Coural 1998: Chantal Gastinel-Coural. "Van der Meulen et la Manufacture royale des Gobelins." In *A la gloire du roi: Van der Meulen, peintre des conquêtes de Louis XIV*, edited by Corinne Déchelette, pp. 110–20. Exh. cat. Musée des Beaux-Arts de Dijon, 1998.

Gaye 1839: Johann Wilhelm Gaye. *1326–1500*. Vol. 1 of *Carteggio inedito d'artisti dei secoli XIV, XV, XVI*. G. Molini, 1839.

Gentil Quina 1998: Maria Antónia Gentil Quina. *A maniera de Portugal e da India: uma série de tapeçaria quinhentista*. Meribérica/Líber, 1998.

Ghellinck d'Elseghem 1994: Anastasie de Ghellinck d'Elseghem. "Peintures de chevalet comme modèles pour des tapisseries: Trois Tenières inspirées d'une kermesse villageoise (1646) de Teniers." *Revue des archéologues et historiens d'art de Louvain* 27 (1994), pp. 71–75.

Gianakaris 1970: C. J. Gianakaris. *Plutarch.* Twayne, 1970.

Giese 1932: Wilhelm Giese. "Zum 'wilden Mann' in Frankreich." *Zeitschrift für französische Sprache und Literatur* 56 (1932), pp. 491–97.

Ginsberg 1973: Ellen S. Ginsberg. "The Legacy of Marc-Antoine de Muret's *Julius Caesar.*" In *Acta Conventus Neo-Latini Lovaniensis: Proceedings of the First International Congress of Neo-Latin Studies, Louvain, 23–28 August, 1971,* edited by J. Ijsewijn and Eckhard Kessler, pp. 247–52. Leuven University Press/Wilhelm Fink, 1973.

Girault 2005: Pierre-Gilles Girault. "Cartonniers de tapisseries à Bruges et Paris vers 1500: Jan Fabiaen et Gauthier de Campes." Retrieved Mar. 12, 2008, from https://www.studiesinwesterntapestry.net.

Gnann and Laurenza 1996: Achim Gnann and Domenico Laurenza. "Raphael's Influence on Michiel Coxcie: Two New Drawings and a Painting." *Master Drawings* 34 (1996), pp. 292–302.

Göbel 1922: Heinrich Göbel. "Das Brüsseler Wirkergeschlecht der van den Hecke." *Der Cicerone* 14 (1922), pp. 17–31.

Göbel 1923: Heinrich Göbel. *Die Niederlande.* Vol. 1 of *Wandteppiche.* Klinkhardt und Biermann, 1923.

Göbel 1924: Heinrich Göbel. *Tapestries of the Lowlands.* Translated by Robert West. Brentano's, 1924.

Göbel 1925: Heinrich Göbel. "Die Wandteppichmanufaktur von Aubusson." *Der Cicerone* 17 (Apr. 15, 1925), pp. 393–403 (pt. 1), (May 1, 1925), pp. 441–59 (pt. 2).

Göbel 1928: Heinrich Göbel. *Die Romanische Länder: Die Wandteppiche und ihre Manufacturen in Frankreich, Italien, Spanien, und Portugal.* Vol. 2 of *Wandteppiche.* Klinkhardt und Biermann, 1928.

Goldthwaite 1987: Richard A. Goldthwaite. "The Medici Bank and the World of Florentine Capitalism." *Past and Present* 114 (Feb. 1987), pp. 3–31.

Golson 1975: Lucile Golson. "Rosso et Primatice au Pavillon de Pomone." In *Actes du Colloque International sur l'art de Fontainebleau: Fontainebleau et Paris, 18, 19, 20 octobre 1972,* edited by André Chastel, pp. 231–40. Editions du Centre national de la recherche scientifique, 1975.

Goodman-Soellner 1986: Elise Goodman-Soellner. "L'Oiseau Pris au Piège: Nicolas Lancret's *Le Printemps* (1738) and the *Prisonnier Volontaire* of P. Ayres (c. 1683–1714)." *Gazette des Beaux-Arts* 107 (Mar. 1986), pp. 127–30.

Gordon 1969: Jan B. Gordon. "William Morris' Destiny of Art." *The Journal of Aesthetics and Art Criticism* 27, 3 (Spring 1969), pp. 271–79.

Goetz 1941: Oswald Goetz. "Meleager and Atalanta." *Bulletin of the Art Institute of Chicago* 35, 7 (Dec. 1941), pp. 112–13.

Goetz 1948: Oswald Goetz. *Masterpieces of French Tapestry: Medieval, Renaissance, Modern.* Exh. cat. The Art Institute of Chicago, 1948.

Gould and Gould 1925: Mr. and Mrs. G. Glen Gould. "The Charm of the Veritable Antique." *Arts and Decoration* 22, 5 (Mar. 1925), pp. 46–47, 76.

Grandjean 2001: Gilles Grandjean. "La reine Zénobie condamnant Meonius." In *Moi, Zénobie reine de Palmyre,* edited by Jacques Charles-Gaffiot, Henri Lavagne, and Jean-Marc Hofman, pp. 319–20. Exh. cat. Skira, 2001.

Grasselli, Rosenberg, and Parmantier 1984: Margaret Morgan Grasselli, Pierre Rosenberg, and Nicole Parmantier. *Watteau, 1684–1721.* Exh. cat. National Gallery of Art, 1984.

Grauls 1957–58: Jan Grauls. "De vette os." *Artes Textiles* 4 (1957–58), pp. 62–85.

Gravier 1886: Léopold Gravier. "Une industrie artistique au dix-huitième siècle: la tapisserie d'Aubusson." *Réunion des Sociétés des Beaux-Arts des Départements à la Sorbonne* 10 (1886), pp. 153–213.

Grell 1985: Chantal Grell. "Hérodote et la Bible: Tradition chrétienne et histoire ancienne dans la France moderne (XVI–XVIIIe siècles)." *Storia della Storiografia* 7 (1985), pp. 60–91.

Grésy 1858–60: Eugène Grésy. "Documents sur les artistes, peintres, sculpteurs, tapissiers et autres, qui ont travaillé au Château de Vaux le Vicomte pour le surintendant Fouquet, d'après les registres de la paroisse de Maincy." *Archives de l'Art français* 6 (1858–60), pp. 1–22.

Grévin [1560] 1966: Jacques Grévin. *César: Edition critique avec introduction et notes.* Edited and introduced by Ellen S. Ginsberg. Droz, 1966.

Grivel and Fumaroli 1988: Marianne Grivel and Marc Fumaroli. *Devises pour les tapisseries du Roi.* Herscher, 1988.

Grouchy 1894: Emmanuel-Henri, vicomte de Grouchy. *Everhard Jabach, collectioneur parisien (1695).* Nogent-le-Rotrou, 1894.

Grunzweig 1931: Arman Grunzweig, ed. *Correspondence de la Filiale de Bruges des Médici.* M. Lamertin, 1931.

Guérinet n.d.: Armand Guérinet, ed. *Les nouvelles collections de l'Union centrale des arts décoratifs au Musée du Louvre, Pavillon de Marsan,* vol. 9, no. 2. Librairie d'art décoratif, n.d.

Guiffrey 1881: Jules J. Guiffrey. *Colbert, 1664–1680.* Vol. 1 of *Comptes des bâtiments du roi sous le règne de Louis XIV.* Imprimerie Nationale, 1881.

Guiffrey 1885a: Jules J. Guiffrey. *Inventaire general du mobilier de la couronne sous Louis XIV (1663–1715),* 2 vols. La Société, 1885–86.

Guiffrey 1885b: Jules J. Guiffrey. "La manufacture royale de tapisseries établie au faubourg Saint-Germain par François et Raphaël de la Planche." *Bulletin Archéologique du Comité des Travaux Historiques et Scientifiques* 3 (1885), pp. 60–76.

Guiffrey 1892: Jules J. Guiffrey. "Les manufactures parisiennes de tapisseries au XVIIe siècle." *Mémoires de la Société de l'Histoire de Paris et de l'Île-de-France* 19 (1892), pp. 43–292.

Guiffrey 1898: Jules J. Guiffrey. "Nicolas Houel, apothicaire parisien, fondateur de la maison de la Charité Chrétienne, premier auteur de la tenture d'Artémise." *Mémoires de la Société de l'Histoire de Paris et de l'Île de France* 25 (1898), pp. 179–270.

Guiffrey 1901: Jules J. Guiffrey. *Jules Hardouin-Mansard et le Duc d'Antin 1706–1715.* Vol. 5 of *Comptes des bâtiments du roi sous le règne de Louis XIV.* Imprimerie Nationale, 1901.

Guiffrey 1904: Jules J. Guiffrey. *Les Gobelin, teinturiers en écarlate au faubourg Saint-Marcel.* Daupeley-Gouverneur, 1904.

Guimbaud 1928: Louis Guimbaud. *La tapisserie de haute et de basse lisse.* Librarie d'Art R. Duchet, 1928.

Guyot and Cypriano 2002: G.H. Guyot and J. L. Cypriano. "Transfiguration." In *New Catholic Encyclopedia,* vol. 12, pp. 153–55. Thomson and Gale, 2002.

Gyraldi 1548: Lilio Gregorio Gyraldi. *De deis gentium varia & multiplex historia.* Ioannem Oporinum, 1548.

Habiger-Tuczay 1999: Christa Habiger-Tuczay. "Wilde Frau." In *Dämonen, Monster, Fabelwesen,* edited by Werner Wunderlich and Ulrich Müller, pp. 603–15. Mittelalter Mythen 2. Fachverlag für Wissenschaft und Studium, 1999.

Hairs 1955: Marie-Louise Hairs. *Les peintres flamands de fleurs au XVIIe siècle.* Elsevier, 1955.

Hairs 1977: Marie-Louise Hairs. *Dans le sillage de Rubens: Les peintres d'histoire anversois au XVIIe siècle.* Université de Liège, 1977.

Hale 1977: J.R. Hale. *Florence and the Medici: The Pattern of Control.* Thames and Hudson, 1977.

Hammer Galleries 1941: Hammer Galleries, New York. *Art Objects and Furnishings from the William Randolph Hearst Collection.* Exh. cat. Hammer Galleries, 1941.

Hammond 1983: Nicholas G. L. Hammond. *Three Historians of Alexander the Great: The So-Called Vulgate Authors, Diodorus, Justin and Curtius.* Cambridge University Press, 1983.

Hammond 1993: Nicholas G. L. Hammond. *Sources for Alexander the Great: An Analysis of Plutarch's Life and Arrian's Anabasis Alexandrou.* Cambridge University Press, 1993.

Hand and Wolff 1986: John Oliver Hand and Martha Wolff. *Early Nether-landish Painting*. The Collections of the National Gallery of Art. National Gallery of Art/Cambridge University Press, 1986.

Hanschke 1988: Ulrike Hanschke. *Die flämische Waldlandschaft: Anfänge und Entwicklungen im 16. und 17. Jahrhundert*. Wernersche Verlagsgesellschaft, 1988.

Harmatta 1990: J. Harmatta. "Herodotus, historian of the Cimmerians and the Scythians." In *Hérodote et les peuples non Grecs: Neuf exposés suivi de discussions*, edited by Walter Burkert, Giuseppe Nenci, and Olivier Reverdin, pp. 115–30. Entretiens sur l'Antiquité classique 35. Fondation Hardt, 1990.

Harshe and Rich 1934: Robert B. Harshe and Daniel Catton Rich. *Handbook of the House, Formal Gardens and Fountains of Vizcaya: An Italian Palazzo in a Tropical Setting, Home of the Late James Deering, Deering Plaza, Miami, Florida*. The Art Institute of Chicago, 1934.

Hartkamp-Jonxis 1993: Ebeltje Hartkamp-Jonxis. "*Alexander the Great and Porus*, 1619." In *Dawn of the Golden Age: Northern Netherlandish Art, 1580–1620*, edited by Ger Luijten and Ariane van Suchtelen, pp. 424–25. Exh. cat. Rijksmuseum/Waanders/Yale University Press, 1993.

Hartkamp-Jonxis 2002: Ebeltje Hartkamp-Jonxis. "Flemish Tapestry Weavers and Designers in the Northern Netherlands: Questions of Identity." In *Flemish Tapestry Weavers Abroad: Emigration and the Founding of Manufactories in Europe*. Proceedings of the International Conference held at Mechelen, 2–3 October 2000, edited by Guy Delmarcel, pp. 15–41. Universitaire Pers Leuven, 2002.

Hartkamp-Jonxis 2004a: Ebeltje Hartkamp-Jonxis. "Floral Table Carpets: A Dutch Product." In Hartkamp-Jonxis and Smit 2004, pp. 273–83.

Hartkamp-Jonxis 2004b: Ebeltje Hartkamp-Jonxis. "Tapestries from the Netherlands: Themes and Styles." In Hartkamp-Jonxis and Smit 2004, pp. 175–93.

Hartkamp-Jonxis 2006: Ebeltje Hartkamp-Jonxis. "Scandinavische connectie. Nederlandse wandtapijten en andere tapisserieweefsels in relatie tot hun Deense en Zweedse afnemers, 1615 tot 1660." *Textielhistorische Bijdragen* 46 (2006), pp. 45–72.

Hartkamp-Jonxis and Smit 2004: Ebeltje Hartkamp-Jonxis and Hillie Smit, eds. *European Tapestries in the Rijksmuseum*. Catalogues of the Decorative Arts in the Rijksmuseum, Amsterdam 5. Rijksmuseum/Waanders, 2004.

Harwood 1985: Kathryn Chapman Harwood. *The Lives of Vizcaya, Annals of a Great House*. Banyan Books, 1985.

Haverkamp Begemann 1975: Egbert Haverkamp Begemann. *The Achilles Series*. Corpus Rubenianum Ludwig Burchard 10. Arcade, 1975.

Hawtry 1904: V. Hawtry, ed. and trans. *Life of Saint Mary Magdalene*. J. Lane, 1904.

Hay 1988: Susan Anderson Hay. *A World of Costume and Textiles: A Handbook of the Collection*. Museum of Art, Rhode Island School of Design, 1988.

Hayward 1955: J. F. Hayward. 1995. "An Eighteenth-Century Drawing of the Grand-Ducal Crown of Tuscany." *The Burlington Magazine* 97, 631 (Oct. 1955), pp. 308–12.

Hazlehurst 1984: F. Hamilton Hazlehurst "The Wild Beasts Pursued: The *Petite Galerie* of Louis XV at Versailles." *The Art Bulletin* 66, 2 (June 1984), pp. 224–36.

Hefford 1979: Wendy Hefford. "'Bread, Brushes, and Brooms': Aspects of Tapestry Restoration in England, 1660–1760." In *Acts of the Tapestry Symposium, November 1976*, edited by Anna Grey Bennet, pp. 65–75. The Fine Arts Museums of San Francisco, 1979.

Hefford 1983: Wendy Hefford. "The Chicago *Pygmalion* and the 'English Metamorphoses.'" *The Art Institute of Chicago Museum Studies* 10 (1983), pp. 93–117.

Hefford 1984: Wendy Hefford. "Soho and Spitalfields: little-known Huguenot tapestry-weavers in and around London, 1680–1780." *Proceedings of the Huguenot Society of London* 24, 2 (1984), pp. 103–12.

Hefford 1986: Wendy Hefford. "Another Aeneas Tapestry." *Artes Textiles* 11 (1986), pp. 75–87.

Hefford 1991: Wendy Hefford. *The Cotehele Tapestries*. The National Trust, 1991.

Hefford 2006: Wendy Hefford. "I 'Mesi' di Mortlake, una serie di arazzi inglesi a Genova." In *Genova e l'Europa atlantica: Opere, artisti, committenti, collezionisti: Inghilterra, Fiandre, Portogallo*, edited by Piero Boccardo, Clario Di Fabio, and Gianluca Ameri, pp. 167–81 Silvana, 2006.

Hefford 2007: Wendy Hefford. "The Mortlake Manufactory, 1619-49." In Campbell 2007a, pp. 171–83. The Metropolitan Museum of Art/Yale University Press, 2007.

Heim 1981: Bruno Bernard Heim. *Heraldry in the Catholic Church: Its Origin, Customs and Laws*. 2nd ed. Van Duren, 1981.

Heinz 1995: Dora Heinz. *Europäische Tapisseriekunst des 17. und 18. Jahrhunderts: Die Geschichte ihrer Produktionsstätten und ihrer künstlerischen Zielsetzungen*. Böhlau Verlag, 1995.

Henderson 1977: Philip Henderson. *William Morris: His Life, Work, and Friends*. André Duetsch, 1977.

Henkel 1926–27: M. D. Henkel. "Illustrierte Ausgaben von Ovids Metamorphosen im XV., XVI. und XVII. Jahrhundert." *Vorträge der Bibliothek Warburg* 6 (1926–27), pp. 58–144.

Hennel-Bernasikowa 1998: Maria Hennel-Bernasikowa. *Arrasy Zygmunta Augusta/The Tapestries of Sigismund Augustus*. Zamek Królewski na Wawelu, 1998.

Herald 1981: Jacqueline Herald. *Renaissance Dress in Italy, 1400–1500*. The History of Dress 2. Bell and Hyman, 1981.

Herbermann et al. 1912: Charles George Herbermann, Edward A. Pace, Condé Bénoist Pallen, Thomas J. Shahan, John J. Wynne, and Andrew Alphonsus MacErlean. *The Catholic Encyclopedia: An International Work of Reference on the Constitution, Doctrine, Discipline, and History of the Catholic Church*, vol. 13, s.v. "Santa Rosa de Lima." Robert Appleton Co., 1912.

Herodotus 1962: Herodotus. *The Histories of Herodotus of Halicarnassus*. Translated by Harry Carter. Oxford University Press, 1962.

Herrero Carretero 2000: Concha Herrero Carretero. *Siglo XVIII: Reinado de Felipe V*. Vol. 3 of *Catálogo de tapices del Patrimonio nacional*. Patrimonio Nacional, 2000.

Herrero Carretero 2004: Concha Herrero Carretero. *Tapices de Isabel la Católica: Origen de la colección real española*. Patrimonio Nacional, 2004.

Herrero Carretero 2005: Concha Herrero Carretero. "Tapices de devoción de Juana de Castilla (1479–1555)." In *El arte en la corte de los Reyes Católicos: Rutas artísticas a principios de la Edad Moderna*, edited by Fernando Checa Cremades and Bernardo José García, pp. 305–29. Fundacíon Carlos Amberes, 2005.

Herzog 1969: Erich Herzog. *Die Gemäldegalerie der Staatlichen Kunstsammlungen Kassel*. Meisterwerke Deutscher Museen. Peters, 1969.

Hibbert 1974: Christopher Hibbert. *The Rise and Fall of the House of Medici*. Allen Lane, 1974.

Hiesinger 1976: Kathryn B. Hiesinger, "The Sources of François Boucher's Psyche Tapestries." *Philadelphia Museum of Art Bulletin* 72, 314 (Nov. 1976), pp. 7–23.

Hillairet 1972: Jacques Hillairet. *Dictionnaire historique des rues de Paris*. 2 vols. Éditions de Minuit, 1972.

Hind 1938–48: Arthur Mayger Hind. *Early Italian Engraving: A Critical Catalogue with Complete Reproduction of All the Prints Described*. 7 vols. M. Knoedler, 1938–48.

Hintz 1999: Ernst Ralf Hintz. "Der Wilde Mann—ein Mythos vom Andersartigen." In *Dämonen, Monster, Fabelwesen*, edited by Werner Wunderlich and Ulrich Müller, pp. 617–26. Mittelalter Mythen 2. Fachverlag für Wissenschaft und Studium, 1999.

Hirzel 1912: Rudolf Hirzel. *Plutarch*. Dieterich, 1912.

Hollestelle 2006: Harry W. B. Hollestelle. *Tamerlan en Bayazid: Een reeks 17e eeuwse wandtapijten*. S.n., 2006.

Holmes 1991: Mary Taverner Holmes. *Nicolas Lancret 1690–1743*. Exh. cat. The Frick Collection/Harry N. Abrams, 1991.

Honour 1961: Hugh Honour. *Chinoiserie: The Vision of Cathay*. London, Murray, 1961.

Horn 1989: Hendrik J. Horn. *Jan Cornelisz Vermeyen, Painter of Charles V and His Conquest of Tunis: Paintings, Etchings, Drawings, Cartoons, and Tapestries*. 2 vols. Aetas Aurea: Monographs on Dutch and Flemish Painting 8. Davaco Publishers, 1989.

Houdoy 1871: Jules Houdoy. *Les tapisseries de haute-lisse: Histoire de la fabrication lilloise du XVIe au XVIIIe siècle*. Lille, 1871.

Houdoy 1873: Jules Houdoy. *Tapisseries représentant la Conqueste du Royaulme de Thunes par l'empereur Charles-Quint: Histoire et documents inédits*. L. Danel, 1873.

Hourihane 2007: Colum Hourihane, ed. *Time in the Medieval World: Occupations of the Months and Signs of the Zodiac in the Index of Christian Art*. Index of Christian Art Resources 3. Department of Art and Archaeology, Princeton University, 2007.

Hoving 1982: Thomas Hoving. "Magnificent Obsession." *Connoisseur* 211 (Sept. 1982), pp. 99–110.

Hoyer 1996: Eva Maria Hoyer. *Sächsischer Serpentin: Ein Stein und seine Verwendung*. Exh. cat. Museum für Kunsthandwerk, 1996.

Hug 2002 : Laure Hug. "Jean Baptiste Huet and the Decorative Arts." *The Magazine Antiques* 162, 2 (Aug. 2002), pp. 54–61.

d'Hulst 1956: Roger Adolf d'Hulst. "Jordaens and his Early Activities in the Field of Tapestry." *The Art Quarterly* 19 (1956), pp. 237–54.

d'Hulst 1967: Roger Adolf d'Hulst. *Flemish Tapestries from the Fifteenth to the Eighteenth Century*. Arcade, 1967.

d'Hulst 1974: Roger Adolf d'Hulst. *Jordaens Drawings*. Nationaal Centrum voor de Plastische Kunsten van de XVIde en XVIIde Eeuw 5. Arcade, 1974.

d'Hulst 1982: Roger Adolf d'Hulst. *Jacob Jordaens*. Mercatorfonds, 1982.

Hunter 1914a: George Leland Hunter. *Catalogue of a Loan Exhibition of Gothic, Renaissance, Baroque, Eighteenth-Century and Modern American Tapestries*. Buffalo Fine Arts Academy, 1914.

Hunter 1914b: George Leland Hunter. "The Gonzaga Annunciation Tapestry." *Art in America* 2 (Feb. 1914), pp. 147–52.

Hunter 1915a: George Leland Hunter. *Loan Exhibition of Tapestries*. Pennsylvania Museum, 1915.

Hunter 1915b: George Leland Hunter. "Tapestry Furniture Coverings." *Good Furniture* (May 1915), pp. 485–94.

Hunter 1916: George Leland Hunter. "Miniature Tapestries of the Infant Christ." *Arts and Decoration* 6 (Sept. 1916), pp. 497–500.

Hunter 1918: George Leland Hunter. *Loan Exhibition of Tapestries: Cleveland Museum of Art, October 5th to December 1st inclusive, 1918*. The Cleveland Museum of Art, 1918.

Hunter 1919: George Leland Hunter. "Beauvais-Boucher Tapestries." *Arts and Decoration* 10, 5 (Mar. 1919), pp. 245–48.

Hunter 1925: George Leland Hunter. *The Practical Book of Tapestries*. J.B. Lippincott Company, 1925.

Hunter 1926a: George Leland Hunter, "America's Beauvais-Boucher Tapestries." *International Studio* (Nov. 1926), pp. 21–28.

Hunter 1926b: George Leland Hunter. "Beauvais-Boucher Tapestries." *Good Furniture Magazine* (Feb. 1926), pp. 83–89.

Hunton 1930: W. Gordon Hunton. *English Decorative Textiles*. J. Tiranti and Company, 1930.

Husband 1980: Timothy Husband. *The Wild Man: Medieval Myth and Symbolism*. Exh. cat. The Metropolitan Museum of Art, 1980.

Huygens 1994: Frank Huygens. "Mozes in de Zuidnederlandse tapissierskunst: Traditie en vernieuwing in twee tapijten van Jasper Van der Borcht." *Bulletin des Musées royaux d'Art et d'Histoire/Bulletin van de Koninklijke Musea voor Kunst en Geschiedenis* 65 (1994), pp. 257–304.

Hyde 1924: James H. Hyde. "L'iconographie des quatre parties du monde dans les tapisseries." *Gazette des Beaux-Arts* 66 (1924), pp. 253–72.

Isherwood 1981: Robert M. Isherwood. "Entertainment in the Parisian Fairs in the Eighteenth Century." *Journal of Modern European History* 53, 1 (Mar. 1981), pp. 24–48.

Jacobs 2004: Alain Jacobs. *Richard van Orley (Brussel 1663–Brussel 1732)*. Exh. cat. Bibliothèque Royale de Belgique/Koninklijke Bibliotheek van België, 2004.

Jaffé 1997: David Jaffé. *Summary Catalogue of European Paintings in the J. Paul Getty Museum*. The J. Paul Getty Museum, 1997.

Jaffé 1968: Michael Jaffé. *Jacob Jordaens: 1593–1678*. Exh. cat. National Gallery of Canada, 1968.

Jarry 1970: Madeleine Jarry. "L'homme sauvage." *L'Oeil* 183 (Mar. 1970), pp. 14–21.

Jarry 1972: Madeleine Jarry. "The Wealth of Boucher Tapestries in American Museums." *Antiques Magazine* (Aug. 1972), pp. 222–29.

Jarry 1973: Madeleine Jarry. "Tapisseries inédites de la Tenture d'Artémise." *L'Oeil* 220 (1973), pp. 6–11.

Jarry 1975: Madeleine Jarry. "Chinoiserie à la mode de Beauvais." *Plaisir de France* 429 (May 1975), pp. 54–59.

Jarry 1980: Madeleine Jarry. "La Vision de la Chine dans les Tapisseries de la Manufacture Royale de Beauvais: les premières Tentures chinoises." In *Les Rapports entre la Chine et l'Europe au Temps des Lumières: Actes du IIe Colloque international de sinologie*. Vol. 4 of *La Chine au Temps des Lumières*. Cathasia. Belles Lettres, 1980.

Jarry 1981: Madeleine Jarry. *Chinoiserie: Chinese Influence on European Decorative Art, 17th and 18th Centuries*. Vendome Press, 1981.

Jean-Richard 1978: Pierrette Jean-Richard. *L'Oeuvre gravé de François Boucher dans la Collection Edmond de Rothschild*. Éditions des Musées Nationaux, 1978.

Jestaz 1979: Bertrand Jestaz. "The Beauvais Manufactory in 1690." In *Acts of the Tapestry Symposium, November 1976,* edited by Anna Grey Bennet, pp. 187–207. The Fine Arts Museums of San Francisco, 1979.

Jestaz and Bacou 1978: Bertrand Jestaz and Roseline Bacou. *Jules Romain, l'histoire de Scipion: Tapisseries et dessins*. Exh. cat. Réunion des musées nationaux, 1978.

Johnson 2005: David M. Johnson. "Persians as Centaurs in Xenophon's Cyropaedia." *Transactions of the American Philological Association* 135 (2005), pp. 177–207.

Johnson 1989: William McAllister Johnson. "Manuscrits, maquettes et albums inédits: Antoine Caron et la suite d'Arthémise." In *Le livre et l'image en France au XVIe siècle*, pp. 121–34. Cahiers V.L. Saulnier 6. Presse de l'École Normale Supérieure, 1989.

Johnson et al. 1972: William McAllister Johnson, Roseline Bacou, Marie-Hélène Babelon, Nicole Barbier, Michèle Beaulieu, Sylvie Béguin, Dominique Bozo, Rosalys Coope, Claire Constans, Jean Coural, et al. *L'École de Fontainebleau*. Exh. cat. Éditions des Musées Nationaux, 1972.

Jones 2000: Derek Jones. *The Royal Palace, Stockholm*. The Royal Collections, 2000.

Joos 1985: Bert Joos. "De wandtapijten met de Geschiedenis van Jacob: Een verborgen signatuur van Bernart van Orley." *Bulletin des Musées royaux d'Art et d'Histoire/Bulletin van de Koninklijke Musea voor Kunst en Geschiedenis* 56 (1985), pp. 61–73.

Josephus [c. 75–79] 1997: Flavius Josephus. *The Jewish War*. Translated by J. Thackeray. Loeb Classical Library 487. Harvard University Press, 1997.

Joubert 1987: Fabienne Joubert. *La tapisserie médiévale au musée de Cluny*. Réunion des musées nationaux, 1987.

Joubert, Lefébure, and Bertrand 1995: Fabienne Joubert, Amaury Lefébure, and Pascal-François Bertrand. *Histoire de la Tapisserie en Europe, du Moyen Âge à nos jours*. Flammarion, 1995.

Jouin 1889: Henri-Auguste Jouin. *Charles Le Brun et les arts sous Louis XI*. Imprimerie Nationale, 1889.

Junquera de Vega, Herrero Carretero, and Díaz Gallegos 1986: Paulina Junquera de Vega, Concha Herrero Carretero, and Carmen Díaz Gallegos. *Catalogo de tapices del Patrimonio Nacional*, 2 vols. Editorial Patrimonio Nacional, 1986.

Junquera y Mato 1985: Juan José Junquera y Mato. "De Spanjaarden en hun belangstelling voor de wandtapijten." In *Tapisserie de Tournai en Espagne: Brusselse wandtapijten in Spanje in de 16de eeuw*, edited by Juan José Junquera y Mato, pp. 16–52. Exh. cat. Ediciones El Viso, 1985.

Kalf 1981: Elisabeth J. Kalf. "Vier deelen van de weereldt als andersints." *Artes Textiles* 10 (1981), pp. 235–47.

Kalf 1988: Elisabeth J. Kalf. *Zeeland, Noord-Brabant, Limburg*. Vol. 1 of *Waar legwerk hangt: Corpus van wandtapijten in Nederlands openbaar en particulier bezit*. Canaletto, 1988.

Karageorghis and Taifacos 2004: Vassos Karageorghis and Ioannes G. Taifacos, eds. *The World of Herodotus: Proceedings of an International Conference held at the Foundation Anastasios G. Leventis, Nicosia, September 18–21, 2003*. Anastasios G. Leventis Foundation, 2004.

Karpinski 2001: Caroline Karpinski. "Mantegna's *Triumphs* in Andreani's Form." *Apollo* 153, 472 (June 2001), pp. 39–46.

Keefe 1977: John Webster Keefe, ed. *The Antiquarian Society of the Art Institute of Chicago: The First One Hundred Years*. Exh. cat. The Art Institute of Chicago, 1977.

Keil 1949: Luis Keil. "Tapisseries de Flandre au Portugal pendant les XVe et XVIe siècles." In *Miscellanea Leo van Puyvelde*, edited by George Thunis, pp. 309–11. Editions de la Connaissance, 1949.

Kelemen 1961: Pál Kelemen. *Preliminary Study of Spanish Colonial Textiles*. The Textile Museum (Washington, D.C.); Papers 23, 1961.

Kempe [1438] 1940: Margery Kempe. *The Book of Margery Kempe*. Edited by W. Butler-Bowdon. Jonathan Cape, 1940.

Kemperdick 2004: Stephan Kemperdick. *Martin Schongauer: Eine Monographie*. Studien zur internationalen Architektur- und Kunstgeschichte. M. Imhof, 2004.

Kendrick 1917: A. F. Kendrick. "An English Tapestry Panel at Addington." *The Burlington Magazine* 30, 169 (Apr. 1917), pp. 146–47.

Kendrick 1924: A.F. Kendrick. 1924. *Catalogue of Tapestries*. Department of Textiles, the Victoria and Albert Museum. The Board of Education, 1924.

Kendrick 1934: A. F. Kendrick. "The Exhibition of British Art—III—Tapestries and Embroideries." *The Burlington Magazine for Connoisseurs* 64, 371 (Feb. 1934), pp. 65–69.

Kerkhove 1969–1972: A. van den Kerkhove. "Brussels Vertumnus en Pomona-legwerk uit het begin van de XVIIe eeuw." *Gentse Bijdragen tot de Kunstgeschiedenis en de Oudheidkunde* 22 (1969–1972), pp. 151–181.

Keuller and Wauters 1881: H.-F. Keuller and A.-J. Wauters. *Les tapisseries historiées à l'Exposition nationale belge de 1880*. F. Hayez, 1881.

Kimball 1943: Fiske Kimball. *The Creation of the Rococo*. Philadelphia Museum of Art, 1943.

Kinser 1995: Samuel Kinser. "Wildmen in Festival, 1300–1550." In *Oral Tradition in the Middle Ages*, edited by W. F. H. Nicolaisen, pp. 145–60. Medieval and Renaissance Texts and Studies 112. Medieval and Renaissance Texts and Studies, 1995.

Klinge 1991: Margret Klinge. *David Teniers de Jonge: Schilderijen, Tekeningen*. Exh. cat. Snoeck-Ducaju en Zoon, 1991.

Klinge and Lüdke 2005: Margret Klinge and Dietmar Lüdke. *David Teniers der Jüngere 1610–1690: Alltag und Vergnügen in Flandern*. Exh. cat. Staatliche Kunsthalle Karlsruhe/Kehrer, 2005.

Kockelbergh 1997: Iris Kockelbergh. "Aan tafel met de Emmaüsgangers/*Dining with the Men of Emmaus*." In *Rubenstextiel/Rubens's Textiles*, pp. 152–55. Exh. cat. Stad Antwerpen, 1997.

Kooijmans 1992: Luuc Kooijmans. "Vriendschap, een 18de-eeuwse familiegeschiedenis." *Tijdschrift voor Sociale Geschiedenis* 18 (1992), pp. 48–65.

Kooijmans 1997: Luuc Kooijmans. *Vriendschap en de kunst van het overleven in de zeventiende en achttiende eeuw*. B. Bakker, 1997.

Korthals Altes 2000–01: Everhard Korthals Altes. "The Eighteenth-Century Gentleman Dealer Willem Lormier and the International Dispersal of Seventeenth-Century Dutch Paintings." *Simiolus: Netherlands Quarterly for the History of Art* 28, 4 (2000–01), pp. 251–311.

Kotková 1999: Olga Kotková. *Netherlandish Painting 1480–1600*. Vol.1, pt. 1 of *Illustrated Summary Catalogue: The National Gallery in Prague*. The National Gallery in Prague, 1999.

Kratz 1991: Dennis M. Kratz. *The Romances of Alexander*. Garland Library of Medieval Literature, series B, 64. Garland, 1991.

Kren 1983: Thomas Kren, ed. *Renaissance Painting in Manuscripts: Treasures from the British Library*. Exh. cat. Hudson Hills Press/British Library, 1983.

Krenz 2005: Vincent Krenz. *Versus Panniculosus: Réflexions sur la pratique de l'emprunt et la systématique du décor dans un corpus de tapisseries bruxelloises de la Renaissance tardive appartenant à la Collection Toms*. Master's thesis, Université de Neuchâtel, 2005.

Kubler and Soria 1959: George Kubler and Martin Sebastian Soria. *Art and Architecture in Spain and Portugal and their American Dominions, 1500–1800*. Penguin History of Art. Penguin, 1959.

Kuitert 1996: Wybe Kuitert. "La fleur, objet de spéculation au XVIIe siècle: la tulipomanie." In *L'empire de Flore: Histoire et représentation des fleurs en Europe du XVIe au XIXe siècle*, edited by Sabine van Sprang, pp. 100–14. La Renaissance du Livre, 1996.

Kurth 1926: Betty Kurth. *Die Deutschen Bildteppiche des Mittelalters*. 3 vols. Anton Schroll, 1926.

Kwakkelstein 1994: Michael W. Kwakkelstein. *Leonardo da Vinci as a Physiognomist: Theory and Drawing Practice*. Primavera Pers, 1994.

Laborde 1849–53: Léon de Laborde. *Les Ducs de Bourgogne: Étude sur les lettres, les arts et l'industrie pendant le XVe siècle et plus particulièrement dans les Pays-Bas et le Duché de Bourgogne*. Plon frères, 1849–53.

Lacordaire 1853: Adrien-Léon Lacordaire. *Notice historique sur les manufactures impériales de tapisseries des Gobelins et de la tapis de la Savonnerie*. Manufacture des Gobelins, 1853.

Lacordaire 1853–55: Adrien-Léon Lacordaire. "Brevets accordés par les rois Henri IV, Louis XIII, Louis XIV et Louis XV à divers artistes." *Archives de l'Art français* 3 (1853–55), pp. 206–08.

Lacordaire 1855: Adrien-Léon Lacordaire. *Notice historique sur les manufactures impériales de tapisseries des Gobelins et de la tapis de la Savonnerie*. 3rd ed. Manufacture des Gobelins, 1855.

Lacordaire 1897: Adrien-Léon Lacordaire. "Etat civil des tapissiers des Gobelins au dix-septième et au dix-huitième siècles." *Nouvelles Archives de l'Art français* 13 (1897), pp. 1–60.

Lacour-Gayet 1935: Georges Lacour-Gayet. *Le Château de Saint-Germain-en-Laye*. Calmann-Lévy, 1935.

Lacrocq 1916: Louis Lacrocq. "Chronique des tapisseries anciennes d'Aubusson et de Felletin." *Bulletin de la Société Archéologique et Historique du Limousin*, 65 (1916), pp. 13–79.

Lacrocq 1920: Louis Lacrocq. "Chronique des tapisseries anciennes d'Aubusson et de Felletin." *Bulletin de la Société Archéologique et Historique du Limousin*, 68 (1920), pp. 135–171.

Lafond 1912: Paul Lafond. "La tapisserie en Espagne." *La Revue de l'Art Ancien et Moderne* 32 (July–Dec. 1912), pp. 113–24.

La Gorce 1983: Jérôme de La Gorce. "Un peintre du XVIIIe siècle au service de l'Opéra de Paris: Jacques Vigoureux Duplessis." *Bulletin de la Société de l'Histoire de l'Art français*, année 1981, pp. 71–80.

La Gorce 1986: Jérôme de La Gorce. *Berain, Dessinateur du Roi Soleil*. Herscher, 1986.

Laing 1986a: Alastair Laing. "Boucher et la pastorale peinte." *Revue de l'Art* 73 (1986), pp. 55–64.

Laing 1986b: Alastair Laing. "Boucher: Search for an Idiom." In Laing et al. 1986, pp. 56–72.

Laing 2003: Alastair Laing. *The Drawings of François Boucher*. Exh. cat. American Federation of Arts/Scala, 2003.

Laing et al. 1986: Alastair Laing, J. Patrice Marandel, Pierre Rosenberg, Edith A. Standen, and Antoinette Faÿ-Hallé. *François Boucher, 1703–1770*. Exh. cat. The Metropolitan Museum of Art, 1986.

Laloire 1952: Edouard Laloire. *Histoire des deux Hotels d'Egmont et du Palais d'Arenberg (1383–1910)*. F. Van Muysewinkel, 1952.

Lambert 1990: Gisèle Lambert. "Etude iconographique du thème du pressoir mystique à travers la gravure du XVe au XXe siècle." In *Le Pressoir Mystique: Actes du Colloque de Recloses, 27 mai 1989*, edited by Danièle Alexandre-Bidon, pp. 107–28. Editions du Cerf, 1990.

Lambert, Bouquillard, and Beaumont-Maillet 2003: Gisèle Lambert, Jocelyn Bouquillard, and Laure Beaumont-Maillet. *Dessins de la Renaissance: Collection de la Bibliothèque Nationale de France, Département des estampes et de la photographie*. Exh. cat. Bibliothèque Nationale de France/Fundacio Caixa Catalunya, 2003.

Lammertse and Vergara 2003: Friso Lammertse and Alejandro Vergara, eds. *Peter Paul Rubens: Het Leven van Achilles*. Exh. cat. Nai Uitgevers, 2003.

Lanavère 2001: Alain Lanavère. "Zénobie, personnage du XVIIe siècle?" In *Moi, Zénobie: Reine de Palmyre*, edited by Jacques Charles-Gaffiot, Henri Lavagne, and Jean-Marc Hofman, pp. 139–42. Exh. cat. Skira, 2001.

Lancaster 1929–42: Henry Carrington Lancaster. *A History of French Dramatic Literature in the Seventeenth Century*. 5 vols. Johns Hopkins Press/Les Presses Universitaires, 1929–42.

Landry-Deron 2004: Isabelle Landry-Deron. "Portraits croisés Kangxi et Louis XIV." In *Kangxi, Empereur de Chine 1662–1722: La Cité interdite à Versailles*, edited by Pierre Arizzoli-Clémentel, pp. 59–62. Réunion des musées nationaux, 2004.

Larsen 1948: Erik Larsen. "Denis van Alsloot: Peintre de la Fôret de Soignes." *Gazette des Beaux-Arts* 34 (1948), pp. 331–54.

László 1981: Emöke László. *Tapisseries flamandes et françaises en Hongrie*. Révai, 1981.

Laureyssens 1967: Willy Laureyssens. "De samenwerking van Hendrik De Clerck met Denijs van Alsloot." *Bulletin der Koninklijke Musea voor Schone Kunsten van België/Bulletin des Musées royaux des Beaux-Arts de Belgique* 16 (1967), pp. 163–77.

Lavalle 1990: Denis Lavalle. "Tapisseries." In *Vouet*, edited by Jacques Thuillier, Barbara Brejon de Lavergnée, and Denis Lavalle, pp. 487–503. Exh. cat. Réunion des musées nationaux, 1990.

Leeflang and Luijten 2003: Huigen Leeflang and Ger Luijten, eds. *Hendrick Goltzius (1558–1617): Drawings, Prints and Paintings*. Waanders/Rijksmuseum/The Metropolitan Museum of Art/The Toledo Museum of Art, 2003.

Leesberg 1993–94: Marjolein Leesberg. "Karel van Mander as a Painter." *Simiolus: Netherlands Quarterly for the History of Art* 22, 1–2 (1993–94), pp. 5–57.

Lefrançois 1994: Thierry Lefrançois. *Charles Coypel: Peintre du roi (1694–1752)*. Arthena, 19943

Legh 1970: Charles Broughton Legh. *Adlington Hall, Cheshire: The Home of the Leghs of Adlington*. English Life Publications, 1970.

Le Goff, Lefort and Mane 2002: Jacques Le Goff, Jean Lefort, and Perrine Mane, eds. *Les calendriers: leurs enjeux dans l'espace et dans le temps: colloque de Cerisy, du 1er au 8 juillet 2000*. Somogy/Centre culturel international de Cerisy-la-Salle, 2002.

Lehrs 1930: M. Lehrs. *Israhel van Meckenem*. Vol. 7 of *Geschichte und kritischer Katalog des deutschen, niederländischen und französischen Kupferstichs im XV. Jahrhundert*. Gesellschaft für vervielfältigende Kunst, 1930.

Leproux 2001: Guy-Michel Leproux. *La peinture à Paris sous le règne de François Ier*. Presses de l'Université de Paris-Sorbonne, 2001.

Van Lerberghe and Ronsse 1854: Lodewijk van Lerberghe and Jozef Ronsse. "Brieven van patroonschilders voor de tapytfabrieken te Audenaerde." *Audenaerdsche Mengelingen* 6 (1854), pp. 248–72, 387–402.

Le Sénécal 1921–24: Julien Le Sénécal. "Les Occupations des Mois dans l'Iconographie du Moyen-Age." *Bulletin de la Société des Antiquaires de Normandie* 32 (1921–24), pp. 3–218.

Lestocquoy 1978: Jean Lestocquoy. *Deux siècles de l'histoire de la tapisserie (1300–1500): Paris, Arras, Lille, Tournai, Bruxelles*. Mémoires de la Commission départementale des monuments historiques du Pas-de-Calais 19. Commission départementale des monuments historiques du Pas-de-Calais, 1978.

Leuschner 2005: Eckhardt Leuschner. *Antonio Tempesta: ein Bahnbrecher des römischen Barock und seine europäische Wirkung*. Studien zur internationalen Architektur- und Kunstgeschichte 26. M. Imhof, 2005.

Levi 1941: Doro Levi. "The Allegories of the Months in Classical Art." *The Art Bulletin* 23 (Dec. 1941), pp. 251–91.

Levi d'Ancona 1962: Mirella Levi d'Ancona. *Miniatura e miniatori a Firenze dal XIV al XVI secolo*. Olschki, 1962.

Leyser 1996: Henrietta Leyser. *Medieval Women: A Social History of Women in England, 450–1500*. Phoenix Giant, 1996.

Liebenwein 1988: Wolfgang Liebenwein. *Studiolo, storia e tipologia di uno spazio culturale*. Edited by Claudia Cieri Via. Translated by Alessandro Califano. Panini, 1988.

Liège 1881: *Exposition de l'art ancien au pays de Liège: Catalogue officiel*. Exh. cat. L. Grandmont-Donders, 1881.

Van Lier 1996: Jan van Lier. "De iconografie van Elia: Van de synagoge in Doera-Europos tot de Sint-Pieter in Leuven." In *Elia: Profeet van vuur: Mens als wij*, edited by Paul Kevers, pp. 157–89. Acco, 1996.

Lightbown 1986: Ronald Lightbown. *Mantegna: With a Complete Catalogue of the Paintings, Drawings. and Prints*. Phaidon Christie's, 1986.

Lipsey 1977: Roger Lipsey, ed. *His Life and Work*. Volume 3 of *Coomaraswamy*. Princeton University Press, 1977.

Llewellyn 1980: Nigel Llewellyn. "Illustrating Ovid." In *Ovid Renewed: Ovidian Influences on Literature and Art from the Middle Ages to the Twentieth Century*, edited by Charles Martindale, pp. 151–66. Cambridge University Press, 1980.

Locquin 1912: Jean Locquin. *La Peinture d'histoire en France de 1747 à 1785*. H. Laurens, 1912.

Van Lokeren 1998: Sigrid van Lokeren. "Een Brussels wandtapijten-atelier van Martin Reymbouts (ca. 1570–1619): Een kritische status quaestionis." Master's thesis, Katholieke Universiteit Leuven, 1998.

Lord 1970: Carla Lord. "Tintoretto and the *Roman de la Rose*." *Journal of the Warburg and Courtauld Institutes* 33 (1970), pp. 315–17.

Love 1996: Ronald S. Love. "Rituals of Majesty: France, Siam, and Court Spectacle in Royal Image-Building at Versailles in 1685 and 1686," *Canadian Journal of History* 31, 2 (Aug. 1996), pp. 171–98.

Lucas de Kergonan 2000: Michel Lucas de Kergonan. *Histoire de la Manufacture de Tapiseries de Maincy*. Amatteis/Lys, 2000.

Lüdke 2005: Dietmar Lüdke. "Drei Wandteppiche der 'Mannheimer Teniers-Folge': *Kirmes*, *Fischerkai* und *Feiernde Jagdgesellschaft*." In Margret Klinge and Dietmar Lüdke, *David Teniers der Jüngere 1610–1690: Alltag und Vergnügen in Flandern*, pp. 348–57. Exh. cat. Staatliche Kunsthalle Karlsruhe/Kehrer, 2005.

Lupo 1990. Michelangelo Lupo. "Il cardinale Bernardo Cles e gli arazzi fiamminghi." In *Gli arazzi del cardinale: Bernardo Cles e il ciclo della passione di Pieter van Aelst*, edited by Enrico Castelnuovo, pp. 85–284. Temi editrice, 1990.

Mabille 2004: Gérard Mabille. "Le grand buffet d'argenterie de Louis XIV et la tenture des Maisons royales." In *Objets d'art: Mélanges en l'honneur de Daniel Alcouffe*, pp. 181–91. Faton, 2004.

Di Macco and Giovanni 1989: Michaela Di Macco and Romano Giovanni, eds. *Diana Trionfatrice: Arte di Corte del Piemonte del Seicento*. Exh. cat. Umberto Allemandi, 1989.

Macé de Lépinay 1986: François Macé de Lépinay. "*Noli me Tangere*. Une tapisserie bruxelloise du XVe siècle inédite." *Bulletin Monumental* 144 (1986), pp. 33–39.

Machault and Malty 2000: Pierre-Yves Machault and Thierry Malty. *Les routes de la tapisserie en Île-de-France*. Hermé, 2000.

Mack-Andrick 2005: Jessica Mack-Andrick. "Teniers pinxit. Die Rezeption von David Teniers d. J. in der Reproduktionsgraphik des 17. und 18. Jahrhunderts." In Margret Klinge and Dietmar Lüdke, *David Teniers der Jüngere 1610–1690: Alltag und Vergnügen in Flandern*, pp. 76–86. Exh. cat. Staatliche Kunsthalle Karlsruhe/Kehrer, 2005.

Maes 1987: Augusta Maes, ed. *Het Zoniënwoud: Kunst en geschiedenis van oorsprong tot 18de eeuw*. Exh. cat. Europalia 87. De Mulder, 1987.

Maes De Wit 1996: Yvan Maes De Wit. "Les problèmes particulieres du nettoyage de tapisseries." *Ehemaligentreffen der Abegg-Stiftung Riggisberg* (Nov. 1996), pp. 20–31.

Maes De Wit 2000: Yvan Maes De Wit. "The Conservation of the *Los Honores* tapestries of the Patrimonio Nacional of Spain." In Delmarcel 2000, pp. 158–65.

De Maeyer 1953: Marcel de Maeyer. "Denijs van Alsloot (vóór ca. 1573–1625 of 1626) en de tapijtkunst." *Artes Textiles* 1 (1953), pp. 3–11.

De Maeyer 1955: Marcel de Maeyer. *Albrecht en Isabella en de schilderkunst: Bijdrage tot de geschiedenis van de XVIIe-eeuwse schilderkunst in de Zuidelijke Nederlanden*. Verhandelingen van de Koninklijke Vlaamse Academie voor Wetenschappen, Letteren en Schone Kunsten van België, Klasse der schone kunsten 9. Paleis der Academiën, 1955.

Maher 1975: James T. Maher. *The Twilight of Splendor: Chronicles of the Age of American Palaces*. Little, Brown, and Company, 1975.

Mahl 1965: Elisabeth Mahl. "Die Romulus und Remus-Folgen der Tapisseriensammlung des Kunsthistorischen Museums." *Jahrbuch der Kunsthistorischen Sammlungen in Wien* 61 (1965), pp. 7–40.

Mahl 1967: Elisabeth Mahl. "Die 'Mosesfolge' Der Tapisseriensammlung des Kunsthistorischen Museums in Wien." *Jahrbuch der Kunsthistorischen Sammlungen in Wien* 63 (1967), pp. 7–38.

Mallowan 1985: Max Mallowan. "Cyrus the Great (558–529 B.C.)." In *The Median and Achaemenian Periods*, edited by Ilya Gershevitch, pp. 392–419. Vol. 2 of *The Cambridge History of Iran*, edited by W. B. Fisher. Cambridge University Press, 1985.

Van Mander [1603–04] 1994–99: Karel van Mander. *The Lives of the Illustrious Netherlandish and German Painters, From the First Edition of the Schilderboeck (1603–1604)*. 6 vols. Edited by Hessel Miedema. Translated by Derry Cooke-Radmore. Davaco, 1994–99.

Mane 1983: Perrine Mane. *Calendriers et techniques agricoles: France-Italie, XIIe–XIIIe siècles*. Le Sycomore, 1983.

Marandet 2003: François Marandet. "Pierre Rémy (1715–97): The Parisian Art Market in the Mid-Eighteenth Century." *Apollo* 158, 498 (Aug. 2003), pp. 32–42.

Marani 1998: Pietro C. Marani. "Francesco Melzi." In *I Leonardeschi: L'eredità di Leonardo in Lombardia*, ed. Giulio Bora, David Alan Brown, and Marco Carminati, pp. 371–84. Skira, 1998.

Marie 1968: Alfred Marie. "La Menagerie et Les Fêtes des Plaisirs de l'Isle Enchantée." In *Naissance de Versailles, le Château, les Jardins. . .*, vol. 1, pp. 41–53. Vincent, Fréal et Compagnie, 1968.

Marillier 1927: Henry C. Marillier. *History of the Merton Abbey Tapestry Works*. Constable, 1927.

Marillier 1930: Henry C. Marillier. *English Tapestries of the Eighteenth Century: A Handbook to the Post-Mortlake Productions of English Weavers*. The Medici Society, 1930.

Marillier 1932a: Henry C. Marillier. *Handbook to the Teniers Tapestries*. Tapestry Monographs 2. Oxford University, 1932.

Marillier 1932b: Henry C. Marillier. "The Nine Worthies." *The Burlington Magazine* 61, 352 (July 1932), pp. 13–19.

Marillier 1940: Henry C. Marillier. "The English Metamorphoses: A Confirmation of Origin." *The Burlington Magazine* 76, 443 (Feb. 1940), pp. 60–63.

Marillier 1962: Henry C. Marillier. *The Tapestries at Hampton Court Palace*. Rev. ed. Her Majesty's Stationery Office, 1962.

Van Marion 2001: Olga van Marion. "The reception of Plutarch in the Netherlands: Octavia and Cleopatra in the Heroic Epistles of J.B. Wellekens (1710)." In *Recreating Ancient History: Episodes from the Greek and Roman Past in the Arts and Literature of the Early Modern Period*, edited by Karel A. E. Enkel, Jan L. de Jong, Jeanine de Landtsheer, and Alicia Montoya, pp. 213–34. Intersections 1. Brill, 2001.

Marlier 1966: Georges Marlier. *La Renaissance flamande: Pierre Coeck d'Alost*. R. Finck, 1966.

Marriot 1979: Ian Marriott. "The Authorship of the *Historia Augusta*: Two Computer Studies." *The Journal of Roman Studies* 69 (1979), pp. 65–77.

Martin Nagy 1985: Rebecca Martin Nagy. *Textiles in Daily Life in the Middle Ages*. Exh. cat. Cleveland Museum of Art/Indiana University Press, 1985.

Martindale 1979: Andrew Martindale. *The Triumphs of Caesar by Andrea Mantegna in the Collection of Her Majesty the Queen at Hampton Court*. Harvey Miller, 1979.

Martindale 1980: Andrew Martindale. *Andrea Mantegna: I Trionfi di Cesare nella collezione della Regina d'Inghilterra ad Hampton Court*. Rusconi Immagini, 1980.

Martino Arroyo 1918: José Martino Arroyo. *Marycel*. Revista de Arquitectura, 1918.

Masschlein-Kleiner and Verrecken 1994: L. Masschlein-Kleiner and V. Vereecken. "La Conservation des tapisseries." In *S.O.S. Tapisseries*, edited by D. Allard, pp. 21–35. Musées Royaux d'Art et d'Histoire/Koninklijke Musea voor Kunst en Geschiedenis, 1994.

Mathias 1996: Martine Mathias. "A propos d'*Alaric ou Rome Vaincue*, une tenture marchoise du XVIIe siècle d'inspiration littéraire." *Revue du Louvre et des Musées de France* 46 (1996), pp. 35–42.

Mayer Thurman 1969: Christa C. Mayer Thurman. *Masterpieces of Western Textiles from the Art Institute of Chicago*. The Art Institute of Chicago, 1969.

Mayer Thurman 1979: Christa C. Mayer Thurman. "Tapestry: The Purposes, Form, and Function of the Medium from Its Inception until Today." In *Acts of the Tapestry Symposium, November 1976*, edited by Anna Grey Bennett, pp. 3–19. The Fine Arts Museums of San Francisco, 1979.

Mayer Thurman 1984: Christa C. Mayer Thurman. "Research in Progress. A Preliminary Attempt to Answer the Questions of Beauvais versus Aubusson, Jean-Baptiste Oudry (1685–1755) versus Jean-Baptiste Huet (1745–1811)." *Bulletin du CIETA*, 59–60 (1984), pp. 80–95.

Mayer Thurman 1992: Christa C. Mayer Thurman. *Textiles in the Art Institute of Chicago*. The Art Institute of Chicago, 1992.

Mayer Thurman 2001: Christa C. Mayer Thurman. *European Textiles*. Vol. 14 of *The Robert Lehman Collection*, edited by John Wyndham Pope-Hennessy. The Metropolitan Museum of Art/Princeton University Press, 2001.

Mayer Thurman and Brosens 2003: Christa C. Mayer Thurman and Koenraad Brosens. "Flemish Tapestries in the Collection of the Art Insitute of Chicago." In Brosens 2003, pp. 171–84.

Mayer Thurman and Brosens 2006: Christa C. Mayer Thurman and Koenraad Brosens. "*Autumn* and *Winter*: Two Gobelins Tapestries after Charles Le Brun." *The Art Institute of Chicago Museum Studies* 32, 2 (2006), pp. 61–71, 94–95.

McKendrick 1987: Scott McKendrick. "Edward IV: An English Royal Collector of Netherlandish Tapestry." *The Burlington Magazine* 129 (1987), pp. 521–24.

McQueen 1967: E. I. McQueen. "Quintus Curtius Rufus." In *Latin Biography*, edited by T. A. Dorey, pp. 17–43. Routledge and Kegan Paul, 1967.

Meesters 1962: G. L. Meesters. "De herkomst van Janneke Geubels, de vrouw van Petrus Plancius." *Gens Nostra* 17 (1962), pp. 151–53.

Menčik 1911–12: Ferdinand Menčik. "Dokumente zur Geschichte der kaiserlichen Tapezereisammlung, aus dem gräfl. Harrachschen Archive." *Jahrbuch der kunsthistorischen Sammlungen des allerhöchsten Kaiserhauses* 30 (1911–12), pp. 34–46.

Mendonça 1983: Maria José de Mendonça. *Inventário de tapeçarias existentes em museus e palácios nacionais.* Instituto Português Património Cultural, 1983.

Menz 2002: Christopher Menz. *Morris & Co.* Exh. cat. The Art Gallery of South Australia, 2002.

Meoni 1989: Lucia Meoni. "Gli arazzieri delle 'Storie della Creazione' medicee." *Bollettino d'Arte* ser. 6, 74, 58 (Nov.–Dec. 1989), pp. 57–66.

Meoni 1998: Lucia Meoni. *La manifattura da Cosimo I a Cosimo II (1545–1621).* Vol. 1 of *Gli arazzi nei musei fiorentini: la collezione medicea: catalogo completo.* Sillabe, 1998.

Meoni 2002a: Lucia Meoni. "Charity." In Campbell 2002c, pp. 514–17.

Meoni 2002b: Lucia Meoni. "Flemish Tapestry Weavers in Italy in the Seventeenth and Eighteenth Centuries." In *Flemish Tapestry Weavers Abroad: Emigration and the Founding of Manufactories in Europe.* Proceedings of the International Conference held at Mechelen, 2–3 October 2000, edited by Guy Delmarcel, pp. 163–83. Universitaire Pers Leuven, 2001.

Meoni 2003: Lucia Meoni. "Gli arazzi fiamminghi nella collezione de' Medici." In Brosens 2003, pp. 37–47.

Merson 1895: Olivier Merson. "Charles Le Brun à Vaux-le-Vicomte et à la manufacture royale des meubles de la couronne." *Gazette des Beaux-Arts* 13 (1895), pp. 89–104, 399–410; and 14 (1895), pp. 5–14.

Metropolitan Museum of Art 1983: *The Vatican Collections: The Papacy and Art.* Exh. cat. The Metropolitan Museum of Art/Harry N. Abrams, 1983.

Meurgey De Tupigny 2002: J. Meurgey De Tupigny. *New Catholic Encyclopedia*, vol. 6, s.v. "Heraldry." Thomson and Gale, 2002.

De Meûter 2001a: Ingrid De Meûter. "L'oeuvre reconstitué du peintre anversois Pieter Spierinckx (1635–1711), créateur de cartons de tapisserie." *Bulletin des Musées royaux d'Art et d'Histoire/Bulletin van de Koninklijke Musea voor Kunst en Geschiedenis* 72 (2001), pp. 121–52.

De Meûter 2001b: Ingrid De Meûter. "Taferelen uit het leven van de Macedonische vorst Alexander, een nieuw depot in de K.M.K.G." *Bulletin des Musées royaux d'Art et d'Histoire/Bulletin van de Koninklijke Musea voor Kunst en Geschiedenis* 72 (2001), pp. 103–20.

De Meûter 2003: Ingrid De Meûter. "Le peintre anversois Pieter Spierinckx (1635–1711), créateur de cartons de tapisseries." In Brosens 2003, pp. 133–52.

De Meûter et al. 1999: Ingrid De Meûter, Martine Vanwelden, Luc Dhondt, Françoise Vandevijvere, and Jan Wouters. *Tapisseries d'Audenarde du XVI au XVIII siècle.* Exh. cat. Lannoo, 1999.

Meyer 1980: Daniel Meyer. *L'histoire du Roy.* Réunion des musées nationaux, 1980.

Michaud and Michaud 1811–62: Joseph Fr. Michaud and Louis Gabriel Michaud. *Biographie Universelle Ancienne et Moderne*, 2nd ed. Louis Vivès, 1811–62.

Michel [1486] 1959: Jean Michel. *Mystère de la Passion (Angers 1486)*, edited by Omer Jodogne. J. Duculot, 1959.

Michelant 1870: Henri Michelant. *Inventaire des Vaisselles, Joyaux, Tapisseries, Peintures, Livres et Manuscrits de Marguerite d'Autriche.* Hayez, 1870.

Miedema 1972: Hessel Miedema. *Karel van Mander (1548–1606): het bio-bibliografisch materiaal.* Amsterdam, 1972.

Miedema 1977: Hessel Miedema. "Realism and Comic Mode: The Peasant." *Simiolus: Netherlands Quarterly for the History of Art* 9, 4 (1977), pp. 205–19.

Mikaeloff 1989: Yves Mikaeloff. *Tapisseries. Avec la participation exceptionnelle du Musée de l'Ermitage.* Y. Mikaeloff, 1989.

Miller 1993: Debra Miller. "Cyrus and Astyages: An Ancient Prototype for 'Dei Gratia' Rule." *Zeitschrift für Kunstgeschichte* 56, 4 (1993), pp. 545–53.

Mobilier National 1965: Mobilier National, Paris. *Les Gobelins: Trois Siècles de Tapisserie.* Exh. cat. Réunion des musées nationaux, 1965.

Monbeig Goguel 1998: Catherine Monbeig Goguel, ed. *Francesco Salviati (1510–1563), o, la bella maniera.* Exh. cat. Réunion des musées nationaux/Electa, 1998.

Monnier and Johnson 1971: Geneviève Monnier and William McAllister Johnson. "Caron 'antiquaire': à propos de quelques dessins du Louvre." *Revue de l'Art* 14 (1971), pp. 23–30.

Monsour 1999: Michelle Monsour. "The Lady with the Unicorn." *Gazette des Beaux Arts* 134 (1999), pp. 237–54.

Montagu 1962: Jennifer Montagu. "The Tapestries of Maincy and the Origin of the Gobelins." *Apollo* 76, 7 (Sept. 1962), pp. 530–35.

Montagu 1967: Jennifer Montagu. "Atalanta and Meleager: A Newly Identified Painting by Le Brun." *The Liverpool Libraries, Museums and Arts Committee Bulletin* 12 (1967), pp. 17–27.

Montagu 1992: Jennifer Montagu. "Les œuvres de jeunesse de Charles Le Brun: l'influence de Simon Vouet et d'autres." In *Simon Vouet: Actes du colloque international, Galeries nationales du Grand Palais, 5-6-7 février 1991*, edited by Stéphane Loire, pp. 531–43. Documentation française, 1992.

Moormann and Uitterhoeve 1999: Eric M. Moormann and Wilfried Uitterhoeve. *Van Alexandros tot Zenobia: Thema's uit de klassieke geschiedenis in literatuur, muziek, beeldende kunst en theater.* 4th ed. SUN, 1999.

Morris 1975: Barbara Morris. "William Morris and the South Kensington Museum." *Victorian Poetry* 13, 3/4 (Autumn/Winter 1975), pp. 159–75.

Morris 1984–96: William Morris. *The Collected Letters of William Morris.* 4 vols. Edited by Norman Kelvin. Princeton University Press, 1984–86.

Morrison 1974: Mary Morrison. "Some Aspects of the Treatment of the Theme of Antony and Cleopatra in Tragedies of the Sixteenth Century." *Journal of European Studies* 4 (1974), pp. 113–25.

Moselius 1945: Carl David Moselius. "The Carl Johan Cronstedt Collection of Drawings by Claude Audran." *Gazette des Beaux-Arts* 28 (Oct. 1945), pp. 237–56.

Moureau 2004: François Moureau. "La fête galante ou les retraites libertines." In *Watteau et la fête galante*, edited by Patrick Ramade and Martin Eidelberg, pp. 69–78. Exh. cat. Réunion des musées nationaux, 2004.

Mousnier and Favier 1985: Roland Mousnier and Jean Favier, eds. *Un nouveau Colbert: actes du colloque pour le tricentenaire de la mort de Colbert.* Sedes, 1985.

Mulder-Erkelens 1971: A. M. Louise E. Mulder-Erkelens. *Wandtapijten 2: Renaissance, Manierisme en Barok.* Facetten der Verzameling ser. 2, 5. Rijksmuseum, 1971.

Mulertt 1932: Werner Mulertt. "Der "wilde Mann" in Frankreich." *Zeitschrift für französische Sprache und Literatur* 56 (1932), pp. 69–88.

Mulherron and Wyld 2007: Jamie Mulherron and Helen Wyld. "Children's Games: 17th century Tapestries at Cotehele." *The National Trust Historic Houses and Collections Annual* 2007, pp. 45–49.

Müller, Renger, and Klessman 1978: Wolfgang J. Müller, Konrad Renger, and Rüdiger Klessman. *Die Sprache der Bilder: Realität und Bedeutung in der niederländischen Malerei des 17. Jahrhunderts.* Exh. cat. Herzog Anton Ulrich-Museum, 1978.

Müller-Goldingen 1995: Christian Müller-Goldingen. *Untersuchungen zu Xenophons Kyrupädie.* Beiträge zur Altertumskunde 42. Teubner, 1995.

Mulroy 1988: David Mulroy. "The Early Career of P. Clodius Pulcher: A Re-Examination of the Charges of Mutiny and Sacrilege." *Transactions of the American Philological Association* 118 (1988), pp. 165–78.

Müntz 1878–84: Eugène Müntz. *Histoire de la tapisserie en Italie, en Allemagne, en Angleterre, en Espagne, en Danemark, en Hongrie, en Pologne, en Russie, et en Turquie.* Société anonyme de publications périodiques, 1878–84.

Müntz 1885: Eugène Müntz. *A Short History of Tapestry: From the Earliest Times to the End of the 18th Century.* Translated by Louisa J. Davis. Cassell and Company, 1885.

Muntz 1902: Eugene Muntz. "Tapisseries allégoriques inédites ou peu connues." *Fondation Eugène Piot: Monuments et mémoires* 9 (1902), pp. 95–129.

Musée des Arts Décoratifs 1934: *Guide illustré du Musée des Arts Décoratifs.* Pavillon de Marsan, 1934.

Musée des Arts Décoratifs 1965: Musée des arts décoratifs. *Trésors des Eglises de France, Musée des arts décoratifs, Paris, 1965.* Exh. cat. Caisse nationale des monuments historiques, 1965.

Musée des Gobelins 1962: *Charles Le Brun: Premier directeur de la Manufacture royale des Gobelins.* Exh. cat. Ministère d'État/Affaires culturelles, 1962.

Musée International de la Chasse 2002: *Vénerie et volerie en tapisserie de la fin du XVIe au début du XVIIIe siècle.* Exh. cat. Musée International de la Chasse, 2002.

Musée Jacquemart-André 1984: *Les fastes de la tapisserie du XVe au XVIIIe siècle.* Exh. cat. Musée Jacquemart-André, 1984.

Museu Calouste Gulbenkian 1982: *Museu Calouste Gulbenkian: Catálogo.* Lisbon: Fundação Calouste Gulbenkian, 1982.

Myslivec 1994: J. Myslivec. "Verklärung Christi." In *Lexikon der christlichen Ikonographie,* vol. 4, edited by Engelbert Kirschbaum, Günter Bandmann, and Wolfgang Braunfels, col. 416–21. Herder, 1994.

Nadon 2001: Christopher Nadon. *Xenophon's Prince: Republic and Empire in the Cyropaedia.* University of California Press, 2001.

Naessens 1984: Katrien Naessens. *Het Maria-Magdalenaklooster, Bethanië te Brugge: Bijdrage tot de religieuze geschiedenis van Brugge (1459–1584).* Master's thesis, Katholieke Universiteit Leuven, 1984.

Nasaw 2000: David Nasaw. *The Chief: The Life of William Randolph Hearst.* Houghton Mifflin, 2000.

Nassieu Maupas 2004: Audrey Nassieu Maupas. "La Vie de saint Jean-Baptiste d'Angers et la production de tapisseries à Paris dans la première moitié du XVIe siècle." *Revue de l'Art* 145, 3 (2004), pp. 41–53.

Nelson 1983: Kristi Nelson. "Jordaens and Three Alexander Tapestries at the Ringling Museum." *The Ringling Museum of Art Journal* 1 (1983), pp. 204–19.

Nelson 1985–86: Kristi Nelson. "Jacob Jordaens' Drawings for Tapestry." *Master Drawings* 23–24, 2 (1985–86) pp. 214–28.

Nelson 1998: Kristi Nelson. *Jacob Jordaens: Design for Tapestry.* Pictura Nova 5. Brepols, 1998.

Neumann 1964: Erwin Neumann. "Die Begebenheiten des Telemach. Bemerkungen zu den Tapisserien im sogenannten Gobelin: Zimmer des Stiftes Klosterneuburg." *Jahrbuch des Stiftes Kosterneuburgs,* n.s., 4 (1964), pp. 139–53.

Neumann 1968: Erwin Neumann. "Tamerlan und Bajazet: Eine antwerpener Tapisserien-Serie des 17. Jahrhunderts." In *Miscellanea Jozef Duverger: Bijdragen tot de kunstgeschiedenis der Nederlanden,* vol. 2, pp. 819–35. Vereniging voor de Geschiedenis der Textielkunsten, 1968.

Niclausse 1940: Juliette Niclausse. *Tapisseries et tapis de la Ville de Paris.* Gründ, 1940.

Nielson 2004: Christina Nielson. *Devotion and Splendor: Medieval Art at the Art Institute of Chicago. The Art Institute of Chicago Museum Studies* 30, 2 (2004).

Nieuhof 1668: Johannes Nieuhof. *Legatia batavica ad magnum Tartariae chamun Sungteium, modernum Sinae imperatorem.* Amsterdam, 1668.

Nieuhof [1693] 1985: Johannes Nieuhof. *Joan Nieuhof, Bilder aus China 1655–1657.* Delphi 1022. 1693; repr., Greno, 1985.

Nivelon [c. 1700] 2004: Claude Nivelon. *Vie de Charles Le Brun et description détaillée de ses ouvrages,* edited by Lorenzo Pericolo. Hautes études médiévales et modernes 86. Librairie Droz, 2004.

Nivière 1990: Marie-Dominique Nivière, ed. *Tapisseries anciennes en Rhône-Alpes.* Exh. cat. Musée de Brou, Château des Adhémar, and Musée Joseph Déchelette, 1990.

Noldus 2005: Badeloch Noldus. *Trade in Good Taste: Relations in Architecture and Culture between the Dutch Republic and the Baltic World in the Seventeenth Century.* Architectura Moderna 2. Brepols, 2005.

Norton 1984: Thomas E. Norton. *100 Years of Collecting in America: The Story of Sotheby Parke Bernet.* Harry N. Abrams, 1984.

Novion 1975: Raymond Novion. "Contribution à l'iconographie de la tapisserie marchoise." In *De la fin du Moyen Âge à la fin de l'Ancien Régime,* pp. 79–110. Vol. 2 of *Nouvelle Histoire d'Aubusson.* Lecante, 1975.

Opperman 1970: Hal N. Opperman. "The Genesis of the 'Chasses Royales.'" *The Burlington Magazine* 112, 805 (Apr. 1970), pp. 216–24.

Opperman 1977: Hal N. Opperman. *Jean-Baptiste Oudry.* Garland Publishing, 1977.

Opperman 1983: Hal N. Opperman. *J.-B. Oudry, 1686–1755.* Kimbell Art Museum/University of Washington Press, 1983.

Van Os 1994: Henk van Os. *The Art of Devotion in the Late Middle Ages in Europe, 1300–1500.* Exh. cat. Princeton University Press, 1994.

Oursel 1994: Hervé Oursel. "Écouen, Musée National de la Renaissance (. . .). Tenture de trois tapisseries représentant l'histoire de Phaéton." *Revue du Louvre et des Musées de France* 43, 5/6 (Dec. 1994), pp. 91–92.

Van Outryve 1996: Olav E. van Outryve. "Elia, een nieuwe Mozes als middelaar van het verbond." In *Elia: Profeet van vuur: Mens als wij,* edited by Paul Kevers, pp. 83–98. Acco, 1996.

Ovid 1955: Ovid. *The 'Metamorphoses' of Ovid.* Translated by Mary M. Innes. Penguin Books, 1955.

Ovid 2004: Ovid. *Metamorphoses.* Translated and with notes by Charles Martin. W. W. Norton, 2004.

Padmos and Vanpaemel 2000: Tineke Padmos and Geert Vanpaemel, eds. *De geleerde wereld van Keizer Karel: Catalogus tentoonstelling Wereldwijs. Wetenschappers rond Keizer Karel.* Exh. cat. Universitaire Pers Leuven, 2000.

Pallucchini and Rossi 1982: Rodolfo Pallucchini and Paola Rossi. *Tintoretto: le opere sacre e profane.* 2 vols. Alfieri/Electa, 1982.

Palmaers 1995: Marleen Palmaers. "De Brusselse wandtapijtreeks met de Geschiedenis van Cyrus de Grote (Madrid, PN, serie 39) (ca. 1557–1559)." Master's thesis, Katholieke Universiteit Leuven, 1995.

Panofsky 1943: Erwin Panofsky. *Albrecht Dürer.* 2 vols. Princeton University Press, 1943.

Panofsky and Panofsky 1958: Erwin Panofsky and Dora Panofsky. "The Iconography of the Galerie François Ier at Fontainebleau." *Gazette des Beaux-Arts* 52 (1958), pp. 113–90.

Pantzer 1966: Kurt F. Pantzer. "The Provenance of the Tapestries." *Bulletin of the Art Association of Indianapolis* 53, 1 (Mar. 1966), pp. 11–23.

Pardo and Bugallal y Vela 1987: Eduardo José Pardo and Jaime Bugallal y Vela. *Manual de heráldica española.* Aldaba Ediciones, 1987.

Paredes 1996: Cecilia Paredes. "Termes et caryatides dans la 'tenture' de Vertumne et Pomone." *Annales d'Histoire de l'Art et d'Archéologie* 18 (1996), pp. 45–62.

Paredes 1999: Cecilia Paredes. "Des jardins de Venus aux jardins de Pomone: Note sur l'iconographie des décors des tapisseries de Vertumne et Pomone." *Revue belge d'Archéologie et d'Histoire de l'Art* 68 (1999), pp. 75–112.

Parfaict 1756: Claude Parfaict. "Les Vendages de Tempé, Pantomime en un acte, au jeu du Sieur Mathews, Par M. Favart." In *Dictionnaire des Théatres de Paris,* vol. 6, pp. 69–84. Lambert, 1756.

Parma 2001: Elena Parma, ed. *Perino del Vaga: Tra Raffaello e Michelangelo.* Exh. cat. Electa, 2001.

Parry 1964: Hugh Parry. "Ovid's *Metamorphoses*: Violence in a Pastoral Landscape." *Transactions and Proceedings of the American Philological Association* 95 (1964), pp. 268–82.

Parry 1983: Linda Parry. *William Morris Textiles.* Weidenfeld and Nicolson, 1983.

Parry 1988: Linda Parry. *Textiles of the Arts and Crafts Movement*. Thames and Hudson, 1988.

Parry 1996: Linda Parry, ed. *William Morris*. Exh. cat. Philip Wilson, 1996.

Patrizi 2000–01: Florence Patrizi. *Gli arazzi dei dodici mesi dell'anno nelle collezioni di Andrea Doria*. Master's thesis, Università degli Studi "La Sapienza", Rome, 2000–01.

Patrizi 2004: Florence Patrizi. "Sémiramis: la tenture anversoise du cardinal Flavio Chigi (vers 1652–1660)." *Antologia di belle arti*, n.s., 69–70 (2004), pp. 22–38.

Pauly and Wissowa 1894–1937: A. Pauly and G. Wissowa. *Paulys Realencyclopädie der klassischen Altertumswissenschaft*, 7 vols. 1894–1937.

Pauwels 1984: Henri Pauwels, ed. *Inventariscatalogus van de oude schilderkunst*. Koninklijke Musea voor Schone Kunsten van België, Departement Oude Kunst, 1984.

Pelaez 1935: Mario Pelaez. "Un nuovo ritmo latino sui mesi ed altri carmi latini medievali." *Studi Medievali* 8, pp. 56–71.

Pène du Bois 1917: Guy Pène du Bois. "Mistresses of Famous American Collections, the New and the Old Collection of Mrs. Harry Payne Whitney." *Arts and Decoration* (Feb. 1917), pp. 177–82, 210.

Pérathon 1883: Cyprien Pérathon. "Liste des maîtres tapissiers et maîtres peintres de l'ancienne manufacture d'Aubusson." *Mémoires de la Société des sciences naturelles et archéologiques de la Creuse* 5 (1883), pp. 81–97.

Pérathon 1887–90a: Cyprien Pérathon. "Une famille de peintres d'Aubusson." *Mémoires de la Société des sciences naturelles et archéologiques de la Creuse* 6 (1887–90), pp. 151–66.

Pérathon 1887–1890b: Cyprien Pérathon. "Notes sur quelques artistes Aubussonais." *Mémoires de la Société des sciences naturelles et archéologiques de la Creuse* 6 (1887–90), pp. 218–46.

Pérathon 1894a: Cyprien Pérathon. "Essai de catalogue descriptif des anciennes tapisseries d'Aubusson et de Felletin." *Bulletin de la Société archéologique et historique du Limousin* 41 (1894), pp. 488–542.

Pérathon 1894b: Cyprien Pérathon. "Essai de catalogue descriptif des anciennes tapisseries d'Aubusson et de Felletin." *Bulletin de la Société archéologique et historique du Limousin* 42 (1894), pp. 392–457.

Pérathon 1897: Cyprien Pérathon. "Evrard Jabach. Directeur de la Manufacture Royale de tapisseries d'Aubusson." *Mémoires de la Société des sciences naturelles et archéologiques de la Creuse* 5 (1897), pp. 49–67.

Pérathon 1899: Cyprien Pérathon. "Iconographie des tapisseries d'Aubusson." *Réunion des Sociétés des Beaux-Arts des Départements* 23 (1899), pp. 558–88.

Pérathon 1899–1900: Cyprien Pérathon. "Iconographie des tapisseries d'Aubusson." *Mémoires de la Société des sciences de la Creuse*, 12 (1899–1900), p. 389–421.

Pérathon 1902: Cyprien Pérathon. "Essai de catalogue descriptif des anciennes tapisseries d'Aubusson et de Felletin." *Bulletin de la Société archéologique et historique du Limousin* 51 (1902), pp. 246–308.

Perini 2002: Giovanna Perini. "*Belloriana methodus*: A Scholar's *Bildungsgeschichte* in Seventeenth-Century Rome." In *Art History in the Age of Bellori: Scholarship and Cultural Politics in Seventeenth-Century Rome*, edited by Janis Callen Bell and Thomas Willette, pp. 55–74. Cambridge University Press, 2002.

Pernot 1994: Michel Pernot. *La Fronde*. Éditions de Fallois, 1994.

Petitfils 1999: Jean-Christian Petitfils. *Fouquet*. Perrin, 1999.

Phipps, Hecht, and Esteras Martín 2004: Elena Phipps, Johana Hecht, and Cristina Esteras Martín. *The Colonial Andes: Tapestries and Silverwork, 1530–1830*. The Metropolitan Museum of Art/Yale University Press, 2004.

Phoebus 1998: Gaston Phébus. *The Hunting Book of Gaston Phébus: Manuscrit français 616, Paris, Bibliothèque nationale*. Introduction by Marcel Thomas and François Avril. Commentary by Wilhelm Schlag. Manuscripts in Miniature 3. Miller, 1998.

Pierard-Gilbert 1964: Renée Pierard-Gilbert. "Un bruxellois oublié: Augustin Coppens. Peintre, dessinateur et graveur (1668-1740)." *Cahiers bruxellois* 9, 1 (1964), pp. 1–44.

Pinchart 1878: Alexandre Pinchart. "La corporation des peintres de Bruxelles." *Messager des sciences historiques ou archives des arts et de la bibliographie de Belgique* (1878) pp. 315–32, 475–70.

Pinchart 1878–85: Alexandre Pinchart. *Histoire de la tapisserie dans les Flandres*. Vol. 3 of *Histoire générale de la tapisserie*, edited by Jules Guiffrey, Eugéne Müntz, and Alexander Pinchart. Société Anonyme de Publications Périodiques, 1878–85.

Piquarde 1950: Maurice Piquarde. "Le cardinal Granvelle, amateur de tapisseries." *Revue belge d'Archéologie et d'Histoire de l'Art* 19 (1950), pp. 111–26.

Pisan [1405] 1985: Christine de Pisan. *The Treasure of the City of Ladies, or, The Book of the Three Virtues*. 1405; repr., Penguin, 1985.

Planche 1975: Alice Planche. "Du tournoi au théâtre en Bourgogne: Le Pas de la Fontaine des Pleurs à Chalon-sur-Sâone 1449–1450." *Le Moyen Âge: Revue d'Histoire et de Philologie* 81, 1 (Jan.–Apr. 1975), pp. 97–128.

Pons 1991: Bruno Pons. "Le Décor de l'Appartement du Grand Dauphin au Château Neuf de Meudon (1709)." *Gazette des Beaux-Arts* 6, 107 (Feb. 1991), pp. 59–76.

De Poorter 1931: A. de Poorter. "Testament van Anselmus Adornes, 10 Febr. 1470." *Biekorf* 37 (1931), pp. 225–39.

De Poorter 1978: Nora de Poorter. *The Eucharist Series*. Corpus Rubenianum Ludwig Burchard 2. Arcade, 1978.

De Poorter 1979–80: Nora de Poorter. "Over de weduwe Geubels en de datering van Jordaens' tapijtenreeks 'De taferelen uit het Landleven.'" *Gentse Bijdragen tot de Kunstgeschiedenis* 25 (1979–80), pp. 208–24.

Pope-Hennessy 1964: John Wyndham Pope-Hennessy. *Catalogue of Italian Sculpture in the Victoria and Albert Museum*, 3 vols. Her Majesty's Stationery Office, 1964.

Posner 1959: Donald Posner. "Charles Lebrun's *Triumphs of Alexander*." *The Art Bulletin* 41, 3 (Sept. 1959), pp. 237–48.

Praz 1975: Mario Praz. *Studies in Seventeenth-Century Imagery*. 2 parts. Sussidi Eruditi 16, 17. 1964; 2nd, enlarged ed., Edizioni di Storia e Letteratura, 1975.

Pressouyre 1965: M. Leon Pressouyre. "'Marcius Cornator'—Note sur un Groupe de Représentations Médiévales du Mois de Mars." *Mélanges de l'École Française de Rome: Moyen Age et Temps Modernes* 77 (1965), pp. 141–86.

Prevost 1933: M. Prevost. "Aguesseau." In *Dictionnaire de biographie française*, edited by J. Balteau, Michel Prévost, and Roman d'Amat. Vol. 1, col. 827–34. Letouzey et Ané, 1933.

Price 1913: C. Matlack Price. "Italian Derivations in American Architecture, The Revival of Architectural Ideals of the Renaissance." *Arts and Decoration* (May 1914), pp. 240–43.

Prost and Prost 1908–13: B. Prost and H. Prost. *Inventaires mobiliers et extrait des comptes des Ducs de Bourgogne de la Maison de Valois (1363–1477)*. E. Leroux, 1908–13.

Provinciaal Museum Sterckshof 1973: *Antwerpse wandtapijten*. Exh. cat. Provinciaal Museum Sterckshof, 1973.

Quina and Moreira 2006: Maria Quina and Rafael Moreira. *The Flemish Tapestries in the Museu de Lamego*. Instituto Português de Museus, 2006.

Quinci 2004: Katiuscia Quinci. "Enea come 'speculum principis' in un salone di Palazzo Doria." *Ricerche di storia dell'arte* 82–83 (Oct. 2004), pp. 87–116.

De Raadt 1894: Johan Théodore de Raadt. *Mengelingen over heraldiek en kunst*. De la Montagne, 1894.

Ragusa 1988: Elena Ragusa. "Arazzi a Torino: la collezione della Galleria Sabauda." *Bollettino d'Arte* 52 (Nov.–Dec. 1988), pp. 43–56.

Ramade and Eidelberg 2004: Patrick Ramade and Martin Eidelberg, eds. *Watteau et la fête galante*. Exh. cat. Réunion des musées nationaux, 2004.

Ranum 1993: Orest Ranum. *The Fronde: A French Revolution, 1648–1652*. W. W. Norton, 1993.

Rapp Buri and Stucky-Schürer 1990: Anna Rapp Buri and Monica Stucky-Schürer. *Zahm und wild: Basler und Strassburger Bildteppiche des 15. Jahrhunderts*. Von Zabern, 1990.

Rapp Buri and Stucky-Schürer 1998: Anna Rapp Buri and Monica Stucky-Schürer. "Alexandre le Grand et l'art de la tapisserie du XVe siècle." *Revue de l'Art* 119, 1 (1998), pp. 21–32.

Rapp Buri and Stucky-Schürer 2001: Anna Rapp Buri and Monica Stucky-Schürer. *Burgundische Tapisserien*. Hirmer, 2001.

Ravaisson 1874: François Nicolas Napoléon Ravaisson, ed. *Règne de Louis XIV (1681 et 1665 à 1674)*. Vol. 7 of *Archives de la Bastille: D'Après des documents inédits*, edited by François Nicolas Napoléon Ravaisson and Louis Jean Félix Ravaisson. Durand and Pedone-Lauriel, 1874.

Reinhold 1971: Meyer Reinhold. "The Naming of Pygmalion's Animated Statue." *The Classical Journal* 66, 4 (Apr.–May 1971), pp. 316–19.

Renier 1865: J. Renier. "Le 3me Valdor. Calcographe de Louis XIV." *Bulletin de l'institut archéologique liégeois* 7 (1865), pp. 123–70.

Rey 1931: Robert Rey. *Quelques satellites de Watteau: Antoine Pesne et Philippe Mercier, François Octavien, Bonaventure de Bar, François-Jerome Chantereau*. Librairie de France, 1931.

Reyniès 1996: Nicole de Reyniès. "Méléagre (Château de Châteaudum)." In Saunier 1996, pp. 266–83.

Reyniès 1997: Nicole de Reyniès. "Charles Poerson et la tapisserie." In *Charles Poerson 1609–1667*, edited by Barbara Brejon de Lavergnée, Nicole de Reyniès, and Pierre-Nicolas Sainte-Fare-Garnot, pp. 107–39, 171–93. Arthena, 1997.

Reyniès 2002a: Nicole de Reyniès. "De l'estampe à la tapisserie: à propos des sources iconographiques de quelques tapisseries d'Aubusson." In *Regards sur la tapisserie*, edited by Guy Massin-Le Goff and Etienne Vacquet, pp. 60–70. Actes Sud, 2002.

Reyniès 2002b: Nicole de Reyniès. "Les lissiers flamands en France au XVIIe siècle, et considérations sur leurs marques." In *Flemish Tapestry Weavers Abroad: Emigration and the Founding of Manufactories in Europe*. Proceedings of the International Conference held at Mechelen, 2–3 October 2000, edited by Guy Delmarcel, pp. 203–26. Universitaire Pers Leuven, 2002.

Reyniès and Laveissière 2005: Nicole de Reyniès and Sylvain Laveissière. *Isaac Moillon (1614–1673): Un peintre du roi à Aubusson*. Exh. cat. Somogy, 2005.

Reynolds 1983: L. D. Reynolds, ed. *Texts and Transmission: A Survey of the Latin Classics*. Clarendon Press, 1983.

Reynolds 1989: Catherine Reynolds. "'Les Angloys, de leur droicte nature, veullent touzjours guerreer': Evidence for Painting in Paris and Normandy, c.1420–1450." *Power, Culture, and Religion in France, c. 1350–1550*, edited by Christopher Thomas Allmand, pp. 37–55. Boydell Press, 1989.

Reznicek 1961: Emil Karel Josef Reznicek. *Die Zeichnungen von Hendrick Goltzius*. 2 vols. Orbis Artium, Utrechtse kunsthistorische studiën 6. Haentjens Dekker en Gumbert, 1961.

Reznicek 1993: Emil Karel Joseph Reznicek. "Een en ander over Van Mander." *Oud-Holland* 107, 1 (1993), pp. 75–83.

Richardson, Woods, and Franklin 2007: Carol Richardson, Kim Woods, and Michael Franklin, eds. *Renaissance Art Reconsidered: An Anthology of Primary Sources*. Blackwell, 2007.

Richefort 2004: Isabelle Richefort. *Adam-François Van der Meulen (1632–1690), peintre flamand au service de Louis XIV*. Presses Universitaires de Rennes, 2004.

Ringbom 1984: Sixten Ringbom. *Icon to Narrative: The Rise of the Dramatic Close-up in Fifteenth Century Devotional Painting*. 2nd, rev., enlarged ed. Davaco, 1984.

Riou 2002: Charlotte Riou. "Une famille de peintres-cartonniers aubussonnais du XVIIe siècle aux années 1760: les Finet." In *La peinture en province: de la fin du Moyen Age au début du XXe siècle*, edited by Jean-Pierre Lethuillier, pp. 87–98. Presses Universitaires de Rennes, 2002.

Ripa [1603] 1984: Cesare Ripa. *Iconologia*. With an introduction by Erna Mandowsky. 1603; repr., G. Olms, 1984.

Ripa 1644: Cesare Ripa. 1644. *Iconologia of uytbeeldinghen des verstands*. Translated by Dirck Pietersz. Pers, 1644.

Riso Guerreiro 1970: Gloria Nunes Riso Guerreiro. "Some European Tapestries in the Calouste Gulbenkian Collection in Lisbon." *Connoisseur* 173, 696 (Apr. 1970), pp. 229–37.

Riva Agüero 1935: José de la Riva Agüero. *El primer alcalde de Lima, Nicolás de Ribera el Viejo y su posteridad*. Librería e imprenta Gil, 1935.

Robb 1936: David M. Robb. "The Iconography of the Annunciation in the Fourteenth and Fifteenth Centuries." *The Art Bulletin* 18, 4 (Dec. 1936), pp. 480–526.

Robinson 1969: Stuart Robinson. *A History of Dyed Textiles: Dyes, Fibres, Painted Bark, Batik, Starch-Resist, Discharge, Tie-Dye, Further Sources for Research*. M.I.T. Press, 1969.

Robinson [1620] 1899: Thomas Robinson. *The Life and Death of Mary Magdalene: A Legendary Poem in Two Parts about A.D. 1620*. Early English Text Society, Extra Series 78. 1620; Kegan, Paul, Trench, Trübner and Company for the Early English Text Society, 1899.

Rocheblave 1923: S. Rocheblave. "Tapisseries d'Autrefois et d'Aujourd'hui, Une Exposition de Tapisseries Françaises à Strasbourg." *La Renaissance de l'Art français et des industries de luxe* 6, 9 (Sept. 1923), pp. 491–503.

Roethlisberger 1971: Marcel Roethlisberger. "Deux tentures bruxelloises du milieu du XVIe siècle." *Oud-Holland* 86, 2/3 (1971), pp. 88–115.

Roethlisberger 1972: Marcel Roethlisberger. "The Ulysses Tapestries at Hardwick Hall." *Gazette des Beaux-Arts* 79 (1972), pp. 111–25.

Rogers 1940: Meyric R. Rogers. "A Brussels Tapestry of the Mid-Sixteenth Century." *Bulletin of the Art Institute of Chicago* 34, 6 (Nov. 1940), pp. 92–94.

Rogers and Goetz 1945: Meyric R. Rogers and Oswald Goetz. *Handbook to the Lucy Maud Buckingham Medieval Collection*. The Art Institute of Chicago, 1945.

Roisman 2003: Joseph Roisman. *Brill's Companion to Alexander the Great*. Brill, 2003.

Rolland and Rolland 1976: Victor Rolland and Henri Rolland. *V. and H. Rolland's Illustrations to the Armorial General by J. B. Rietstap*. 3 vols. Heraldry Today, 1976.

Roobaert 2002: Edmond Roobaert. "Jan de Clerck dit van Antwerpen, licier et marchand de tapisseries: sa participation à la vie publique et au développement de l'industrie de la tapisserie à Bruxelles." *Annales de la Société royale d'Archéologie de Bruxelles* 65 (2002), pp. 61–104.

Roobaert 2004: Edmond Roobaert. *Kunst en kunstambachten in de 16de eeuw te Brussel*. Archives et bibliothèques de Belgique, numéro spécial/Archief- en bibliotheekwezen in België, extranummer 74. Bibliothèque royale de Belgique/Koninklijke Bibliotheek van België, 2004.

De Roover 1963: Raymond Adrien de Roover. *The Rise and Decline of the Medici Bank, 1397–1494*. Harvard University Press, 1963.

Rosenberg 1975: Pierre Rosenberg. *The Age of Louis XV: French Painting 1710–1774*. Toledo Museum of Art, 1975.

Rosie 1989: Alison Rosie. "*Morisques* and *Momeryes*: Aspects of Court Entertainment at the Court of Savoye in the Fifteenth Century." In *Power, Culture, and Religion in France, c.1350–1550*, edited by Christopher Thomas Allmand, pp. 57–74. Boydell Press, 1989.

Ross 1988: David J. A. Ross. *Alexander Historiatus: A Guide to Medieval Illustrated Alexander Literature*. Athenäeums Monografien, Altertumswissenschaft 186. Athenäum, 1988.

Rühl 1871: Franz Rühl. *Die Verbreitung des Justinus im Mittelalter; eine literarhistorische Untersuchung*. Teubner, 1871.

Rus 2004: Martijn Rus. "La chevelure au Moyen Age: marque du même, marque de l'autre." In *La chevelure dans la littérature et l'art du Moyen Âge: Actes du 28e colloque du CUER MA 20, 21 et 22 février 2003*, edited by Chantal Connochie-Bourgne, pp. 385–91. Sénéfiance 50. Université de Provence, 2004.

Safrai 1998: Zeev Safrai. "The Institutionalization of the Cult of Saints in Christian Society." In *Sanctity of Time and Space in Tradition and Modernity*, edited by Alberdina Houtman, Marcel Poorthuis and Joshua Schwartz, pp. 193–214. Brill, 1998.

Sainte Fare Garnot 1988: Nicolas Sainte Fare Garnot. *Les décors des Tuileries sous le règne de Louis XIV*. Réunion des musées nationaux, 1988.

Sainte Fare Garnot and Jacquin 1988: Nicolas Sainte Fare Garnot and Emmanuel Jacquin. *Le Château des Tuileries*. Herscher, 1988.

Saisselin 1960: Rémy G. Saisselin. "The Rococo as a Dream of Happiness.*" Journal of Aesthetics and Art Criticism* 19, 2 (Winter 1960), pp. 145–52.

Salmon 1995: Xavier Salmon. "Un carton inédit d'Étienne Jeaurat pour la tenture des 'Fêtes de village.'" *Bulletin de la Société d'Histoire de l'Art français* 1995, p. 187–96.

Sanchez Canton 1950: F. Sanchez Canton. *Libros, tapices y cuadros que coleccionó Isabel la Católica*. Consejo Superior de Investigaciones Científicas, 1950.

Sansone 1990: David Sansone. "The Computer and the *Historia Augusta*: A Note on Marriott." *The Journal of Roman Studies* 80 (1990), pp. 174–77.

Sanuto 1879–1902: *I Diarii di Marino Sanuto (MCCCCXCVI–MDXXXIII) dall' autografo Marciano ital. cl. VII codd. 419–477*. 5 vols. Visentini, 1879–1902.

Satkowski 1983: Leon Satkowski. "The Palazzo Pitti: Planning and Use in the Grand-Ducal Era." *The Journal of the Society of Architectural Historians* 42, 4 (Dec. 1983), pp. 336–49.

Saunier 1996: Bruno Saunier, ed. *Lisses et délices: Chefs-d'œuvre de la tapisserie de Henri IV à Louis XIV*. Exh. cat. Caisse nationale des monuments historiques et des sites, 1996.

Sauval 1961: T. Sauval. "Recherches sur la tenture dite des mois ou des Maisons royales." *Bulletin de la Société de l'Histoire de l'Art français* (1961), pp. 59–64.

Savill 1988: Rosalind Savill. *Vases*. Vol. 1 of *The Wallace Collection Catalogue of Sèvres Porcelain*. Trustees of the Wallace Collection, 1988.

Scardigli 1995: Barbara Scardigli, ed. *Essays on Plutarch's* Lives. Clarendon Press, 1995.

Scheicher 1973: Elisabeth Scheicher. "Die Groteskenmonate: Eine Tapisserienserie des Kunsthistorischen Museums in Wien." *Jahrbuch der Kunsthistorischen Sammlungen in Wien* 69 (1973), pp. 55–84.

Schneebalg-Perelman 1960: Sophie Schneebalg-Perelman. "Peintres retoucheurs des tapisseries au XVIIe siècle." *Cahiers bruxellois* 5, 4 (1960), pp. 270–88.

Schneebalg-Perelman 1971: Sophie Schneebalg-Perelman. "Richesses du garde-meuble parisien de François Ier: Inventaires inedits de 1542 et 1551." *Gazette des Beaux-Arts*, 78 (Nov. 1971), pp. 253–304.

Schneebalg-Perelman 1972: Sophie Schneebalg-Perelman. "La tapisserie flamand et le grand témoignage du Wawel." In *Les tapisseries flamandes au Chateau du Wawel à Cracovie: Trésors du roi Sigismond II Auguste Jagellon*, edited by Jerzy Szablowski, pp. 375–437. Fonds Mercator, 1972.

Schneebalg-Perelman 1976: Sophie Schneebalg-Perelman. "Un nouveau regard sur les origines et le développement de la tapisserie bruxelloise du XIVe siècle à la pré-Renaissance." In *Tapisseries bruxelloises de la pré-Renaissance*, edited by Guy Delmarcel, pp. 161–91. Exh. cat. Musées Royaux d'Art et d'Histoire/Koninklijke Musea voor Kunst en Geschiedenis/Mercator Press, 1976.

Schreckenberg 1968: Heinz Schreckenberg. *Bibliographie zu Flavius Josephus*. Arbeiten zur Literatur und Geschichte des hellenistischen Judentums 1. Brill, 1968.

Schreckenberg 1979: Heinz Schreckenberg. *Bibliographie zu Flavius Josephus: Supplementband mit Gesamtregister*. Arbeiten zur Literatur und Geschichte des hellenistischen Judentums 14. Brill, 1979.

Schrickx 1974: Willem Schrickx. "Denijs van Alsloot en Willem Tons in London in 1577." *Artes Textiles* 8 (1974), pp. 47–64.

Schuckman 1995: Christiaan Schuckman. *Maarten de Vos*. Vols. 44–46 of *Hollstein's Dutch and Flemish Etchings, Engravings, and Woodcuts, 1450–1700*. Sound and Vision Interactive, 1995.

Schulz 1983: Werner Schulz, ed. *Kunstgewerbemusem, Berlin: Geschichte, Wiederaufbau, Neuerwerbungen*. Exh. cat. Staatliche Museen zu Berlin, 1983.

Schumacher 2006: Birgit Schumacher. *Philips Wouwerman (1619–1668): The Horse Painter of the Golden Age*. 2 vols. Davaco, 2006.

Schuttwolf 1998: Allmuth Schuttwolf, ed. *Jahreszeiten der Gefühle: Das Gothaer Liebespaar und die Minne im Spätmittelalter*. Gerd Hatje, 1998.

Scott 1995: Katie Scott. "'The Nursery of Kings': Versailles and its Satellites." In idem., *The Rococo Interior, Decoration, and Social Spaces in Early Eighteenth-Century Paris*, pp. 120–45. Yale University Press, 1995.

Scott 1980: Margaret Scott. *Late Gothic Europe, 1400–1500*. History of Dress. Mills and Boon, 1980.

Scott 1986: Margaret Scott. 1986. *A Visual History of Costume: The Fourteenth and Fifteenth Centuries*. Batsford, 1986.

Scott 2002: Katherine Scott. "Herodotus and the Old Testament: A Comparative Reading of the Ascendancy Stories of King Cyrus and David." *Scandinavian Journal of the Old Testament* 16 (2002), pp. 52–78.

Seel 1972: Otto Seel. *Eine römische Weltgeschichte; Studien zum Text der Epitome des Iustinus und zur Historik des Pompejus Trogus*. Erlanger Beiträge zur Sprach- und Kunstwissenschaft 39. H. Carl, 1972.

Seidel 1900: Paul Seidel. *Les collections d'oeuvres d'Art françaises du XVIIIe siècle appartenant à Sa majesté l'empereur d'Allemagne, roi de Prusse*. Giesecke und Devrient, 1900.

Sharratt 2005: Peter Sharratt. *Bernard Salomon: Illustrateur lyonnais*. Travaux d'humanisme et Renaissance 400. Droz, 2005.

Shaw 1911: William A. Shaw. "Letter of Denization and Acts of Naturalization for Aliens in England and Ireland 1603–1700." *Huguenot Society Quarto Series* 18 (1911).

Sheppard 1966: F. H. W. Sheppard, ed. *The Parish of St. Anne Soho*. Survey of London, 33–34. Athlone, 1966.

Shoemaker and Broun 1981: Innis H. Shoemaker and Elizabeth Broun. *The Engravings of Marcantonio Raimondi*. Exh. cat. Spencer Museum of Art, 1981.

Shoolman Slatkin 1973: Regina Shoolman Slatkin. *François Boucher in North American Collections: 100 Drawings*. Exh. cat. National Gallery of Art, 1973.

Sicard 1910: M.M. Sicard. *Saint Marie-Madeleine; la tradition et la critique*. 3 vols. Arthur Savaète, 1910.

Silk 2004: Michael Silk. "The *Odyssey* and its explorations." In *The Cambridge Companion to Homer*, edited by Robert Fowler, pp. 31–44. Cambridge University Press, 2004.

Silver 1984: Larry Silver. *The Paintings of Quinten Massys with Catalogue Raisonné*. Phaidon, 1984.

Simmons 1993: Noah Simmons. "Le paysagiste Nicolas Jacques Julliar (1719–1790). Catalogue sommaire de son œuvre." *Bulletin de la Société de l'Histoire d'Art français* (1993), pp. 149–68.

Siple 1938: Ella S. Siple. "A Flemish Set of *Venus and Vulcan* Tapestries, I: Their Origin and Design." *Burlington Magazine* 73 (Nov. 1938), pp. 212–20.

Siple 1939: Ella S. Siple. "A Flemish Set of *Venus and Vulcan* Tapestries, II: Their Influence on English Tapestry Design." *Burlington Magazine* 74 (June 1939), pp. 268–78.

Sirat and Dirand 1998: Jacques Sirat and Jacques Dirand. *Braquenié: French Textiles and Interiors Since 1823*. Alain de Gourcuff, 1998.

Sjöberg and Gardcy 1974: Yves Sjöberg and Françoise Gardey. *Inventaire du fonds français: Graveurs du XVIIIe siècle*. Bibliothèque Nationale, 1974.

Sjøvold and Seeberg 1976: Aase Bay Sjøvold and Elizabeth Seeberg. *Norwegian Tapestries*. Huitfeldt Forlag, 1976.

De Smedt 1992: Raphaël de Smedt, ed. *Michel Coxcie, pictor regis (1499–1592): Internationaal colloquium, Mechelen, 5 en 6 juni 1992*. Handelingen van de Koninklijke Kring voor Oudheidkunde, Letteren en Kunst van Mechelen 96. Koninklijke Kring voor Oudheidkunde, Letteren en Kunst van Mechelen, 1992.

Smets 1984: Leon Smets. "Twee antependia uit de Begijnhofkerk te Sint-Trui-den." *Historische Bijdragen over Sint-Truiden* 4 (1984), pp. 319–25.

Smeyers 1998: Maurits Smeyers, *Dirk Bouts, Schilder van de Stilte*. Davidsfonds, 1998.

Smit 2002: Hillie Smit. "Flemish Tapestry Weavers in Italy c. 1420–1520: A Survey and Analysis of the Activity in Various Cities." In *Flemish Tapestry Weavers Abroad: Emigration and the Founding of Manufactories in Europe*. Proceedings of the International Conference held at Mechelen, 2–3 October 2000, edited by Guy Delmarcel, pp. 113–30. Universitaire Pers Leuven, 2002.

Smolar-Meynart 2000: Arlette Smolar-Meynart. *Âge d'Or Bruxellois: Tapisseries de la Couronne d'Espagne*. Exh. cat. La lettre volée, 2000.

Soenen 1991: Micheline Soenen. "Les Collections." In *Le Palais de Bruxelles: Huit siècles d'art et d'histoire*, edited by Arlette Smolar-Meynart, pp. 173–266. Crédit communal, 1991.

Soil de Moriamé 1891: Eugène Justin Soil de Moriamé. *Les tapisseries de Tournai: Les tapissiers et les hautelissiers de cette ville*. Mémoires de la Société histori-que et littéraire de Tournai 22. Casterman, 1891.

Soly and Van de Wiele 1999: Hugo Soly and Johan van de Wiele, eds. *Carolus: Keizer Karel V, 1500–1558*. Exh. cat. Snoeck-Ducaju and Zoon, 1999.

Somerset 2003: Anne Somerset. *The Affair of the Poisons: Murder, Infanticide and Satanism at the Court of Louis XIV*. Weidenfeld and Nicolson, 2003.

Sonis and Laporte 2002: Sylphide de Sonis and Sophie Laporte, eds. *Un temps d'exubérance: Les arts décoratifs sous Louis XIII et Anne d'Autriche*. Exh. cat. Petit journal des grandes expositions 340. Réunion des musées nationaux, 2002.

Souchal 1973a: Geneviève Souchal. *Chefs-d'œuvre de la tapisserie du XIVe au XVIe siècle*. Exh. cat. Éditions des musées nationaux, 1973.

Souchal 1973b: Geneviève Souchal. *Masterpieces of Tapestry from the Fourteenth to the Sixteenth Century*. Exh. cat. Translated by Richard A. H. Oxby. The Metropolitan Museum of Art, 1973.

Spamer 1930: Adolf Spamer. *Das kleine Andachtsbild vom XIV. bis zum XX. Jahrhundert*. F. Bruckmann, 1930.

Spencer 1955: John R. Spencer. "Spatial Imagery of the Annunciation in Fif-teenth-Century Florence." *The Art Bulletin* 37, 4 (Dec. 1955), pp. 273–80.

Spitzer 1890–91: Frédéric Spitzer. *La Collection Spitzer: Antiquité, Moyen-Âge, Renaissance*, vol.1. Protat Frères, 1890–91.

Spitzer 1893: Frédéric Spitzer. *Catalogue des objets d'art et de haute curiosité: an-tiques, du Moyen-Age et de la Renaissance composant l'importante et précieuse Collection Spitzer*, vol. 1. E. Ménard et Compagnie, 1893.

Stadnichuk 1996: Nina Stadnichuk. "An Unknown 'Mars and Venus' by Maarten van Heemskerck." *The Burlington Magazine* 138, 1116 (Mar. 1996), pp. 182–85.

Stadter 1992: Philip A. Stadter, ed. *Plutarch and the Historical Tradition*. Rout-ledge, 1992.

Stadter and Van der Stockt 2002: Philip A. Stadter and Luc Van der Stockt, eds. *Sage and Emperor: Plutarch, Greek Intellectuals, and Roman Power in the Time of Trajan, 98–117 A.D.* Symbolae Facultatis Litterarum Lovaniensis, series A, 29. Leuven University Press, 2002.

Städtisches Kunstgewerbemuseum zu Leipzig 1931: *Führer durch das Städtische Kunstgewerbemuseum zu Leipzig*. Städtisches Kunstgewerbemuseum zu Leipzig, 1931.

Stagno 2005: Laura Stagno. *Palazzo del Principe: Villa di Andrea Doria, Geno-va*. Sagep, 2005.

Stagno 2006: Laura Stagno, ed. *Le imprese di Alessandro Magno in Oriente: Col-lezione Doria Pamphilj. Presentazione dell'arazzo restaurato. Atti della Gior-nata Internazionale di Studi. Genova, 11 aprile 2005*. Microart, 2006.

Standen 1969: Edith A. Standen. "The Twelve Ages of Man: A Further Study of a Set of Early Sixteenth-Century Flemish Tapestries." *Metropolitan Mu-seum Journal* 2 (1969), pp. 127–68.

Standen 1971a: Edith A. Standen. "Drawings for the 'Months of Lucas' Tapestry Series." *Master Drawings* 9 (Spring 1971), pp. 3–14.

Standen 1971b: Edith A. Standen. "Some Sixteenth-Century Flemish Tapestries Related to Raphael's Workshop." *Metropolitan Museum Journal* 4 (1971), pp. 109–21.

Standen 1974: Edith A. Standen. "Romans and Sabines: A Sixteenth-Centu-ry Set of Flemish Tapestries." *Metropolitan Museum Journal* 9 (1974), pp. 211–28.

Standen 1976: Edith A. Standen, "The Story of the Emperor of China: A Beau-vais Tapestry Series." *Metropolitan Museum Journal* 11 (1976), pp. 103–17.

Standen 1979: Edith A. Standen. "Some Beauvais Tapestries Related to Berain." In *Acts of the Tapestry Symposium, November 1976*, edited by Anna Grey Bennet, pp. 210–19. The Fine Arts Museums of San Francisco, 1979.

Standen 1981a: Edith A. Standen. "English Tapestries 'After the Indian Man-ner'." *Metropolitan Museum Journal* 15 (1981), pp. 119–42.

Standen 1981b: Edith A. Standen. "Studies in the History of Tapestry 1520–1790." *Apollo* 114, 233 (July 1981), pp. 6–54.

Standen 1985: Edith A. Standen. *European Post-Medieval Tapestries and Related Hangings in the Metropolitan Museum of Art*. 2 vols. The Metropolitan Mu-seum of Art, 1985.

Standen 1986: Edith A. Standen. "Boucher as a Tapestry Designer." In Laing et al. 1986, pp. 325–33.

Stanford 1968: William Bedell Stanford. *The Ulysses Theme: A Study in the Adaptability of a Traditional Hero*. 2nd, rev., ed. Blackwell, 1968.

Stansky 1985: Peter Stansky. *Redesigning the World: William Morris, the 1880s, and the Arts and Crafts*. Princeton University Press, 1985.

Starkey 1998: David Starkey, ed. *The Inventory of Henry VIII: Society of Anti-quaries MS 129 and British Library MS Harley 1419*, vol. 1. Harvey Miller for the Society of Antiquaries of London, 1998.

Staub and Pinson 1984: August W. Staub and Robert L. Pinson. "Fabulous Wild Men: American Indians in European Pageants, 1493–1700." *Theatre Survey* 25 (1984), pp. 43–53.

Steele 1917: R. B. Steele. "Pompeius Trogus and Justinus." *The American Journal of Philology* 38 (1917), pp. 19–41.

Steenbergen 1956: G. Jo Steenbergen, ed. *Den Spiegel der zaligheid van elkerlijk*. Klassieken uit de Nederlandse letterkunde 9. Tjeenk Willink, 1956.

Stefani 1990: Chiara Stefani. "Cesare Ripa: New Biographical Evidence." *Jour-nal of the Warburg and Courtauld Institutes* 53 (1990), pp. 307–12.

Steinberg 1987: Leo Steinberg. "*How Shall This Be?* Reflections on Filippo Lip-pi's *Annunciation* in London. Part I." *Artibus et Historiae* 8, 16 (1987), pp. 25–44.

Steppe 1956: Jan-Karel Steppe. "Vlaamse wandtapijten in Spanje. Recente ge-beurtenissen en publiciteis." *Artes Textiles* 3 (1956), pp. 27–66.

Steppe 1976: Jan-Karel Steppe. "Sieropschriften met signaturen en vermeldingen van de plaats van herkomst in Brusselse wandtapijten van het einde van de 15de en van het begin van de 16de eeuw." In Delmarcel 1976, pp. 193–231.

Steppe 1981a: Jan-Karel Steppe. "Enkele nieuwe gegevens betreffende tapijtwerk van de geschiedenis van Vertumnus en Pomona vervaardigd door Willem de Pannemaker voor Filips II van Spanje." *Artes Textiles* 10 (1981), pp. 125–40.

Steppe 1981b: Jan-Karel Steppe. "De *Galerijen en Tuingezichten* van Erasso. Een tapijtsuite besteld door Graaf Lamoraal van Egmont en zijn echtgenote bij Willem de Pannemaker voor de vrouw van Don Francisco de Erasso, secre-taries van Filips II." *Artes Textiles* 10 (1981) pp. 141–54.

Steppe 1981c: Jan-Karel Steppe. "De Reis naar Madrid van Willem de Pannema-ker, in Augustus-Oktober 1561." *Artes Textiles* 10 (1981) pp. 81–124.

Steppe and Delmarcel 1974: Jan-Karel Steppe and Guy Delmarcel. "Les tapis-series du Cardinal de La Marck, prince-évêque de Liège." *Revue de l'Art* 25 (1974), pp. 35–54.

Stern 1953: Henri Stern. *Le Calendrier de 354; Étude sur son texte et sur ses illus-trations*. Institut francais d'archéologie de Beyrouth. Bibliothéque archéo-logique et historique 55. Geuthner, 1953.

Stern 1955: Henri Stern. "Poésies et Représentations Carolingiennes et Byzanti-nes des Mois." *Revue Archéologique* 45 (Apr.–June 1955), pp. 141–86.

Stoneman 2004: Richard Stoneman. *Alexander the Great*. Routledge, 2004.

Storez 1996: Isabelle Storez. *Le chancelier Henri François d'Aguesseau (1668–1751): Monarchiste et libéral*. Publisud, 1996.

Stratmann-Döhler 2002: Rosemarie Stratmann-Döhler. "Groteskenfolge." In *Tapisserien Wandteppiche aus den staatlichen Schlössern Baden-Württembergs*, edited by Carla Fandrey, pp. 55–62. Schätze aus unseren Schlössen 6. Edition Diesbach, 2002.

Strauss 1978–: Walter L. Strauss, ed. *The Illustrated Bartsch*. Based on *Le peintre gravure* by Adam von Bartsch. 163 vols. as of 2008. Abaris Books, 1978–.

Strazzullo 1999: Franco Strazzullo. *Il Sangue di Cristo: Iconografia e Culto*. Arte tipografica, 1999.

De Strobel 1999: Anna Maria de Strobel. "La constitution de la collection du Vatican, tapisseries françaises et romaines." In *La Tapisserie au XVIIe siècle et les collections européennes: Actes du colloque international de Chambord, 18–19 octobre 1996*, edited by Catherine Arminjon and Nicole de Reyniès, pp. 173–80. Cahiers du Patrimoine 57. Éditions du patrimoine, 1999.

Strubel and de Saulnier 1994: Armand Strubel and Chantal de Saulnier. *La poétique de la chasse au Moyen Âge: les livres de chasse du XIVe siècle*. Presses universitaires de France, 1994.

Suida 1953: Wilhelm Suida. *Bramante pittore e il Bramantino*. Ceschina, 1953.

Sulimivski 1985: T. Sulimivski. "The Scyths." In *The Median and Achaemenian Periods*, edited by Ilya Gershevitch, pp. 149–99. Vol. 2 of *The Cambridge History of Iran*, edited by W. B. Fisher. Cambridge University Press, 1985.

Swain 1982: Margaret Swain. "Royal Tapestries at Holyroodhouse: The *Four Continents*." *Apollo* 116, 245 (July 1982) pp. 20–23.

Swain 1991: Margaret Swain. "Chinoiserie Tapestries in Scotland." *Bulletin du CIETA* 69 (1991), pp. 85–92.

Swinnen 1994: Anniek Swinnen. "Grootbladige Verduretapijten in de 16de eeuw: Een proeve van catalogus." Master's thesis, Katholieke Universiteit Leuven, 1994.

Szablowski 1972: Jerzy Szablowski, ed. *Les tapisseries flamandes au Chateau du Wawel à Cracovie: Trésors du roi Sigismond II Auguste Jagellon*. Fonds Mercator, 1972.

Szanto 2002: Mickaël Szanto. "Libertas artibus restituta. La foire Saint-Germain et le commerce des tableaux, des frères Goetkindt à Jean Valdor (1600–1660)." In *Economia e arte secc. XIII–XVIII: Atti della trentatreesima settimana di Studi, 30 aprile–4 maggio 2000*, edited by Simonetta Cavaciocchi, pp. 149–85. Pubblicazioni dell'Istituto, ser. 2, Ati delle settimane di studi e altri convegni 33. Le Monnier, 2002.

Talbot 1997: Norman Talbot. "The "Pomona" Lyric and Female Power." *Victorian Poetry* 35, 1 (Spring 1997), pp. 71–81.

Tappan 1925: William Tappan. "The Tapestries of Elihu Yale." *International Studio* 82 (Dec. 1925), pp. 209–14.

Tarn 1979: William W. Tarn. *Alexander the Great*. Cambridge University Press, 1979.

Tattersall 1917: C. E. C. Tattersall. "Sir William Burrell's Gothic Tapestries." *Old Furniture* 1 (1917), pp. 111–14.

Taylor 1935–36: Francis Henry Taylor. "A Piece of Arras of the Judgment: The Connection of Maître Philippe de Mol and Hugo van der Goes with the Mediaeval Religious Theatre." *Worcester Art Museum Annual* 1 (1935–36), pp. 1–15.

Taylor 1996: Paul Taylor. "Images de fleurs, images de Dieu?" In *L'empire de Flore: Histoire et représentation des fleurs en Europe du XVIe au XIXe siècle*, edited by Sabine van Sprang, pp. 250–60. La Renaissance du Livre, 1996.

Tchalenko 1990: John Tchalenko. "Earliest Wild-Man Sculptures in France." *Journal of Medieval History* 16, 3 (Sept. 1990), pp. 217–34.

Tervarent 1958: Guy de Tervarent. *Attributs et symboles dans l'art profane 1450–1600*. Droz, 1958.

Thiébaux 1967: Marcelle Thiébaux. "The Medieval Chase." *Speculum* 42, 2 (Apr. 1967), pp. 260–74.

Thiéry 1953: Yvonne Thiéry. *Le paysage flamand au XVIIe siècle*. Peintres flamands du XVIIe siècle 4. Elsevier, 1953.

Thiéry and Kervyn de Meerendre 1987: Yvonne Thiéry and Michel Kervyn de Meerendre. *Les peintres flamands de paysage au XVIIe siècle: Le baroque anversois et l'école bruxelloise*. Lefebvre and Gillet, 1987.

Thomas 1936: Alois Thomas. *Die Darstellung Christi in der Kelter*. Schwann, 1936.

Thompson 1977: Edward Palmer Thompson. *William Morris: Romantic to Revolutionary*. Pantheon Books, 1977.

Thomson 1914: W. G. Thomson. *Tapestry Weaving in England from the Earliest Times to the End of the XVIIIth Century*. B.T. Batsford, 1914.

Thomson 1930: W. G. Thomson. *A History of Tapestry from the Earliest Times until the Present Day*. 2nd ed. Hodder and Stoughton, 1930.

Thormann 2003: Olaf Thormann, ed. *Die Museumschronik von den Anfängen bis zum Jahr 1929*. Vol. 2, pt. 1 of *125 Jahre Museum für Kunsthandwerk Leipzig Grassimuseum*, edited by Olaf Thormann. Passage-Verlag, 2003.

Thornton 1991: Peter Thornton. *The Italian Renaissance Interior, 1400–1600*. Weidenfeld and Nicolson, 1991.

Thuillier 1967: Jacques Thuillier. "Le Brun et Rubens." *Bulletin van de Koninklijke Musea voor Schone Kunsten van België/Bulletin des Musées royaux des Beaux-Arts de Belgique* 16 (1967), pp. 247–68.

Thuillier and Foucart 1967: Jacques Thuillier and Jacques Foucart. *Le stori di Maria de' Medici di Rubens al Lussemburgo*. Rizzoli, 1967.

Thuillier and Montagu 1963: Jacques Thuillier and Jennifer Montagu. *Charles Le Brun 1619–1690: Peintre et dessinateur*. Exh. cat. Ministère d'État/Affaires culturelles, 1963.

Van Tichelen 1987: Isabelle van Tichelen. "La manifattura di Martin Reymbouts." In *Arazzi per la Cattedrale di Cremona: Storie di Sansone, storie della vita di Cristo*, edited by Loretta Dolcini, pp. 54–55. Exh. cat. Electa, 1987.

Van Tichelen and Delmarcel 1993: Isabelle van Tichelen and Guy Delmarcel. "Marks and Signatures on Ancient Flemish Tapestries: A Methodological Contribution." In *Conservation Research: Studies of Fifteenth- to Nineteenth-Century Tapestry*, edited by Lotus Stack, pp. 57–68. Studies in the History of Art 42. National Gallery of Art, 1993.

De Tienne 1996: Pierre De Tienne. "Contribution à une généalogie des tapissiers bruxellois de Pannemaecker." *L'Intermédiaire des Généalogistes* 51, 6 (Nov.–Dec. 1996), pp. 289–301.

Tietze-Conrat 1955: Erika Tietze-Conrat. *Mantegna: Paintings, Drawings, Engravings*. Phaidon, 1955.

Tomlinson 1996: Philip Tomlinson. "*L'art d'embellir les vices*: The Antony and Cleopatra Plays of Mairet and Benserade in the light of Richelieu's Rehabilitation of the Theatre." *Australian Journal of French Studies* 33, 3 (Sept.–Dec. 1996), pp. 349–65.

Tomlinson 1998: Philip Tomlinson. "Dryden's *All for Love* and Jean Mairet's *Le Marc-Antoine ou la Cléopâtre*: Parallels in a European Dramatic Tradition." *The Seventeenth Century* 13, 1 (Spring 1998), pp. 50–68.

Torra de Arana, Hombría Tortajada, and Domingo Pérez 1985: Eduardo Torra de Arana, Antero Hombría Tortajada, and Tomás Domingo Pérez 1985. *Los tapices de la Seo de Zaragoza*. Publicación de la Caja de Ahorros de la Inmaculada 34. Caja de Ahorros de la Inmaculada, 1985.

Trubnikov 1916: A. Trubnikov. "Sobranie E.P. i M.S. Oliv." *Starye gody* 4–5 (Apr. 1916), pp. 26–44.

Uhlmann-Faliu 1978: Odile Uhlmann-Faliu. *Jean Valdor, graveur et diplomate liégeois, marchand-bourgeois de Paris (1616–1675)*. Master's thesis, Université de Paris-Sorbonne Paris IV, 1978.

Uppenkamp 2002: Barbara Uppenkamp. "Der Einfluss von Hans Vredeman de Vries auf Architektur und Kunstgewerbe." In *Hans Vredeman de Vries und die Renaissance im Norden*, edited by Heiner Borggrefe, Thomas Fusenig, and Barbara Uppenkamp, pp. 91–104. Exh. cat. Hirmer, 2002.

Valentine 1975: K. B. Valentine. "Motifs from Nature in the Design Work and Prose Romances of William Morris (1876–1896)." *Victorian Poetry* 13, 3/4 (Autumn/Winter 1975), pp. 83–89.

Valentiner 1930: Elisabeth Valentiner. *Karel van Mander als Maler*. Zur Kunstgeschichte des Auslandes, 132. Heitz, 1930.

Vallance 1894: Aymer Vallance. "The Revival of Tapestry Weaving: An Interview with Mr. William Morris." *The Studio: An Illustrated Magazine of Fine and Applied Art* 3 (1894), pp. 99–101.

Vallance 1897: Aymer Vallance. *William Morris: His Art, his Writings, and his Public Life*. George Bell, 1897.

Valsecchi 1968: Marco Valsecchi. *Gli arazzi dei Mesi del Bramantino*. Cassa di Risparmio, 1968.

Vandenbroeck 1987: Paul Vandenbroeck. *Beeld van de andere, vertoog over het zelf. Over wilden en narren, boeren en bedelaars*. Exh. cat. Ministerie van de Vlaamse Gemeenschap/Koninklijk Museum voor Schone Kunsten Antwerpen, 1987.

Vanhoren 1999: Raf Vanhoren. "Tapisseries bruxelloises d'après les modèles de Charles Le Brun: l'*Histoire d'Alexandre le Grand*." In *La tapisserie au XVIIe siècle et les collections européennes: Actes du colloque international de Chambord, 18–19 octobre 1996*, edited by Catherine Arminjon and Nicole de Reyniès, pp. 61–68. Cahiers du Patrimoine 57. Éditions du patrimoine, 1999.

Vasselle 1971: Pierre Vasselle. "Tapisseries et Gobelins 'flamands' d'Amiens." *Le Vieux Papier* 239 (1971), pp. 1–26.

Vaughan 1999: Alden T. Vaughan. "Early English Paradigms for New World Natives." *Proceedings of the American Antiquarian Society* 102, 1 (1999), pp. 33–67.

Veldman 1973: Ilja Markx Veldam. "Het 'Vulcanus-triptiek' van Maarten van Heemskerck." *Oud-Holland* 87, 2/3 (1973), pp. 95–123.

Vermeersch 1980: Valentin Vermeersch. *Zilver en wandtapijten*. Exh. cat. Gruuthusemuseum, 1980.

Versyp 1971: Jacqueline Versyp. "Zeventiende-eeuwse jachttapijten met het wapen van de Vidoni en aanverwante stukken." *Artes Textiles* 7 (1971), pp. 23–46.

Vigo-Sternberg Galleries 1971: Vigo-Sternberg Galleries, London. *Four Hundred Years of English Tapestries on Exhibition at the Vigo-Sternberg Galleries*. Exh. cat. Vigo-Sternberg Galleries, 1971.

Vitruvius 1547: Vitruvius. *Architecture, ou Art de bien bastir*. Translated by Jan Martin. Jacques Gazeau, 1547.

Vittet 2004: Jean Vittet. "Les tapisseries de Michel Particelli d'Hémery et de son genre Louis Phélypeaux de La Vrillière." In *Objets d'art: Mélanges en l'honneur de Daniel Alcouffe*, pp. 171–79. Faton, 2004.

Vlieghe 1959–60: Hans Vlieghe. "David Teniers II en David Teniers III als patroonschilders voor de tapijtweverijen." *Artes Textiles* 5 (1959–60), pp. 78–102.

Vlieghe 1961–66: Hans Vlieghe. "David II Teniers (1610–1690) en het hof van aartshertog Leopold-Wilhelm en Don Juan van Oostenrijk (1647–1659)." *Gentse Bijdragen tot de Kunstgeschiedenis en de Oudheidkunde* 19 (1961–66), pp. 123–49.

Wace 1968: Alan John Bayard Wace. *The Marlborough Tapestries at Blenheim Palace and Their Relation to other Military Tapestries of the War of the Spanish Succession*. Phaidon, 1968.

Wager 1902: L. Wager, ed. *The Life and Repentaunce of Marie Magdalene*. The University of Chicago Press, 1902.

Wagner-Hasel 1986: Beate Wagner-Hasel. "Männerfeindliche Jungfrauen? Ein kritischer Blick auf Amazonen in Mythos und Geschichte." *Feministische Studien* 5, 1 (May 1986), pp. 86–105.

De Wallens 2003: Gérard de Wallens. "Falens, Charles (Carel) van." In *Allgemeines Künstlerlexikon*, edited by Günter Meissner, vol. 36, pp. 378–79. Saur, 2003.

Walter 1996: Ingeborg Walter. *Piero della Francesca: La Madonna del Parto*. Translated by Roberto Zapperi. F. C. Panini, 1996.

Walton 1986: Guy Walton. *Louis XIV's Versailles*. University of Chicago Press, 1986.

Warburg [1912] 1966: Aby Warburg. "Arte italiana e astrologia internazionale nel Palazzo Schifanoja di Ferrara." In idem., *La rinascita del paganesimo antico: Contributi alla storia della cultura*, edited by Gertrud Bing, pp. 247–72. Translated by Emma Cantimori. La Nuova Italia, 1966.

Wardropper 1987: Ian Wardropper. "Italian Renaissance Decorative Arts in Chicago Collections." *Apollo* 125, 301 (Mar. 1987), pp. 200–05.

Wardwell and Davison 1966: Allen Wardwell and Mildred Davison. "Three Centuries of the Decorative Arts in Italy." *Apollo* 84, 55 (Sept. 1966), pp. 178–89.

Wardwell 1975: Anne Wardwell. "*The Mystical Grapes*, a Devotional Tapestry." *Bulletin of the Cleveland Museum of Art* 62 (Jan. 1975), pp. 17–23.

Warner 1975: Ralph Warner. *Dutch and Flemish Flower and Fruit Painters of the XVIIth and XVIIIth Centuries*. 2nd ed. B. M. Israël, 1975.

Wauters 1878: Alphonse Wauters. *Les tapisseries bruxelloise: Essai historique sur les tapisseries et les tapissiers de haute et de basse-lice de Bruxelles*. Julien Baertsoen, 1878.

Wayment 1958: H.G. Wayment. "The Use of Engravings in the Design of the Renaissance Windows of King's College Chapel, Cambridge." *The Burlington Magazine* 100 (1958), pp. 378–88.

Webster 1938: James Carson Webster. *The Labors of the Months in Antique and Mediaeval Art to the End of the Twelfth Century*. Northwestern University Studies in the Humanities 4. Northwestern University Press, 1938.

Weibel 1930: Adèle Coulin Weibel, ed. *The Twelfth Loan Exhibition: European Tapestries of the Eighteenth Century*. Exh. cat. Detroit Institute of Arts, 1930.

Weibel 1951: Adèle Coulin Weibel. *2000 Years of Tapestry Weaving: A Loan Exhibition*. Wadsworth Atheneum, 1951.

Weigert 1933: Roger-Armand Weigert. "La Manufacture Royale de Tapisseries de Beauvais en 1754." *Bulletin de la Société de l'Histoire de l'Art Français* (1933), pp. 226–42.

Weigert 1946: Roger-Armand Weigert. "Les grotesques de Beauvais." *Hyphé* 1, 2 (Mar.-Apr. 1946), pp. 66–78.

Weigert 1956: Roger-Armand Weigert. *La tapisserie française*. Larousse, 1956.

Weigert 1962: Roger-Armand Weigert. *French Tapestry*. Faber and Faber, 1962.

Weigert and Hernmarck 1964: Roger-Armand Weigert and Carl Hernmarck, eds. *Les relations artistiques entre la France et la Suède 1693–1718: Nicodème Tessin le jeune et Daniel Cronström, correspondance (extraits)*. Engellska Boktryckeriet, 1964.

Weinhardt 1966: Carl. J. Weinhardt. "A Splendid Gift of Tapestries." *Bulletin of the Art Association of Indianapolis* 53, 1 (Mar. 1966), pp. 4–10.

Wells 1969: William Wells. "The Earliest Flemish Tapestries in the Burrell Collection, Glasgow (1380–1475)." In Asselberghs et al. 1969, pp. 431–57.

Welsford 1962: Enid Welsford. *The Court Masque: A Study in the Relationship between Poetry and the Revels*. Russell and Russell, 1962.

Welzel 2006: Barbara Welzel. "David Teniers II and Archduke Leopold Wilhelm." In *Munuscula amicorum: Contributions on Rubens and his Colleagues in Honour of Hans Vlieghe*, edited by Katlijne Van der Stighelen, pp. 631–44. Pictura Nova 10. Brepols, 2006.

Wenzel 1993: Horst Wenzel. "Die Verkündigung an Maria. Zur Visualisierung des Wortes in der Szene oder: Schriftgeschichte im Bild." In *Maria in der Welt: Marienverehrung im Kontext der Sozialgeschichte 10.–18. Jahrhundert*, edited by Claudia Opitz, pp. 23–52. Clio Lucernensis 2. Chronos, 1993.

Werner 1977: Gerlind Werner. *Ripa's Iconologia: Quellen, Methode, Ziele*. Bibliotheca emblematica 7. Haentjens, Dekker, & Gumbert, 1977.

Werth 1888: H. Werth. "Altfranzösische Jagdlehrbücher nebst Handschriftenbibliographie der abendländischen Jagdliteratur überhaupt." *Zeitschrift für romanische Philologie* 12 (1888), pp. 146–91, 381–415.

Werth 1889: H. Werth. "Altfranzösische Jagdlehrbücher nebst Handschriftenbibliographie der abendländischen Jagdliteratur überhaupt." *Zeitschrift für romanische Philologie* 13 (1889), pp. 1–34.

Wescher 1969: Paul Wescher. "Etienne Jeaurat and the French Eighteenth-Century 'genre de mœurs'." *Art Quarterly* 32, 2 (1969), pp. 153–65.

West 2004: Stephanie West. "Herodotus and Scythia." In *The World of Herodotus: Proceedings of an International Conference Held at the Foundation Anastasios G. Leventis, Nicosia, September 18–21, 2003,* edited by Vassos Karageorghis and Ioannes G. Taifacos, pp. 73–89. Anastasios G. Leventis Foundation, 2004.

Wheelock, Barnes, and Held 1990: Arthur K. Wheelock, Susan J. Barnes, and Julius S. Held. *Anthony van Dyck*. Exh. cat. National Gallery of Art/Harry N. Abrams, 1990.

White 1972: Hayden White. "The Forms of Wildness: Archaeology of an Idea." In Dudley and Novak 1972, pp. 3–38.

Wiese 2002a: Wolfgang Wiese. "Folge von ländlichen Szenen." In *Tapisserien: Wandteppiche aus den staatlichen Schlössern Baden-Württembergs,* edited by Carla Fandrey, U. Grimm, and A. Hüber, pp. 139–40. Schätze aus unseren Schlössern 6. Diesbach, 2002.

Wiese 2002b: Wolfgang Wiese. "Teniers-Folge." In *Tapisserien: Wandteppiche aus den staatlichen Schlössern Baden-Württembergs,* edited by Carla Fandrey, U. Grimm, and A. Hüber, pp. 167–70. Schätze aus unseren Schlössern 6. Diesbach, 2002.

Wilckens 1968: Leonie von Wilckens. "Drei unbekannte Jakobsteppiche aus der Manufaktur des Jan van Tiegen." In *Miscellanea Jozef Duverger: Bijdragen tot de kunstgeschiedenis der Nederlanden,* vol. 2, pp. 778–86. Vereniging voor de Geschiedenis der Textielkunsten, 1968.

Wildenstein 1924: Georges Wildenstein. *Lancret*. Les Beaux-Arts, Édition d'études et de documents, 1924.

Wildman and Christian 1998: Stephen Wildman and John Gordon Christian, eds. *Edward Burne-Jones: Victorian Artist-Dreamer*. Exh. cat. The Metropolitan Museum of Art/Harry N. Abrams, 1998.

Wilhelm 1975: Jacques Wilhelm. "Le Salon de Graveur Gilles Demarteau peint par François Boucher et son atelier avec le concours de Fragonard et de J.-B. Huet." *Bulletin du Musée Carnavalet* 28, 1 (1975), pp. 6–20.

Wilhelm 1985: Jacques Wilhelm. "Le décor peint de la grand' salle du château de Balleroy." *Bulletin de la Société de l'Histoire de l'Art français* (1985), pp. 61–84.

Wilhelm 1987: Jacques Wilhelm. "Portraits peints à Paris par Juste d'Egmont," *Bulletin de la Société de l'Histoire de l'Art français* (1987), pp. 25–44.

Wilson and Lancaster Wilson 1985: Adrian Wilson and Joyce Lancaster Wilson. *A Medieval Mirror: Speculum Humanae Salvationis 1324–1500*. University of California Press, 1985.

Wilson 1999: Gillian Wilson. *Mounted Oriental Porcelain in the J. Paul Getty Museum*. 2nd, rev. ed. The J. Paul Getty Museum, 1999.

Wingfield Digby 1955: George Wingfield Digby. "English Tapestries at Burlington House." *The Burlington Magazine* 97, 633 (Dec. 1955), pp. 388–90.

Wingfield Digby 1959: George Wingfield Digby. "Tapestries by the Wauters Family of Antwerp for the English Market." In *Het herfsttij van de Vlaamse tapijtkunst: Internationaal colloquium 8–10 October 1959/La tapisserie flamande aux XVIIme et XVIIIme siècles: Colloque international 8–10 octobre 1959,* pp. 227–40. Palais der Academiën, 1959.

Wingfield Digby 1971: George Wingfield Digby. *The Devonshire Hunting Tapestries*. Her Majesty's Stationery Office, 1971.

Wingfield Digby and Hefford 1980: George Wingfield Digby and Wendy Hefford. *The Tapestry Collection: Medieval and Renaissance: Victoria and Albert Museum*. Her Majesty's Stationery Office, 1980.

Wirth 1978: K. A. Wirth. "Biblia Pauperum." In *Die deutsche Literatur des Mittelalters: Verfasserlexikon,* edited by Wolfgang Stammler, vol. 1, cols. 843–52. De Gruyter, 1978.

Wise 1976: Susan Wise, ed. *Selected Works of 18th Century French Art in the Collections of the Art Institute of Chicago*. Exh. cat. The Art Institute of Chicago, 1976.

Wittkower 1977: Rudolf Wittkower. *Allegory and the Migration of Symbols*. The Collected Essays of Rudolf Wittkower 3. Thames and Hudson, 1977.

Wixom 1999: William Wixom, ed. *Mirror of the Medieval World*. Exh. cat. The Metropolitan Museum of Art/Harry N. Abrams, 1999.

Woldbye 1965: Vibeke Woldbye. "Tapestries from the Workshop of Michel Wauters in Antwerp at Rosenborg Castle in Copenhagen." *Artes Textiles* 6 (1965), pp. 75–92.

Woldbye 1969: Vibeke Woldbye. *Hollandske blomstertæpper i Danmark*. Exh. cat. Kunstindustrimussets Virksomhed, 1969.

Woldbye 2006: Vibeke Woldbye. *European Tapestries, 15th–20th Century: Catalogue of the Collection*. The Danish Museum of Art and Design, 2006.

Woldbye and Burgers 1971: Vibeke Woldbye and Cornelis A. Burgers. *Geweven boeket*. Exh. cat. Rijksmuseum, 1971.

Wood 1912a: D. T. B. Wood. "Tapestries of the Seven Deadly Sins-I." *The Burlington Magazine* 20 (Jan. 1912), pp. 210–22.

Wood 1912b: D. T. B. Wood. "Tapestries of the Seven Deadly Sins-II." *The Burlington Magazine* 20 (Feb. 1912), pp. 277–89.

Worp 1972: Jacob Adolf Worp. *Geschiedenis van het drama en van het tooneel in Nederland*. 2 vols. 1904, repr., Langerveld, 1972.

Wuestman 1996: Gerdien Wuestman. "Nicolaes Berchem in Print: Fluctuations in the Function and Significance of Reproductive Engraving." *Simiolus: Netherlands Quarterly for the History of Art* 24, 1 (1996), pp. 19–53.

Wunder 1962: Richard P. Wunder. *Extravagant Drawings of the Eighteenth Century from the Collection of the Cooper Union Museum*. Lambert-Spector, 1962.

Xenophon 2001: Xenophon. *The Education of Cyrus*. Translated and annotated by Wayne Ambler. Cornell University Press, 2001.

Van Ysselsteyn 1936: Gerardina Tjaberta van Ysselsteyn. *Geschiedenis der tapijtweverijen in de noordelijke nederlanden: Bijdrage tot de geschiedenis der kunstnijverheid*. 2 vols. A. W. Sijthoff's Uitgevermaatschappij, 1936.

Yuen 1973: Toby Yuen. "Nicole Dacos, La Découverte de la Domus Aurea et la Formation des Grotesques à la Renaissance." *The Art Bulletin* 55, 2 (June 1973), pp. 301–03.

Zalama 2000: Miguel Ángel Zalama. *Vida cotidiana y arte en el palacio de la Reina Juana I en Tordesillas*. Secretariado de Publicaciones e Intercambio Editorial, Universidad de Valladolid, 2000.

Zelleke 2002: Ghenete Zelleke. "David Adler: Benefactor and Trustee." In *David Adler, Architect: The Elements of Style,* edited by Martha Thorne, pp. 55–68. The Art Institute of Chicago/Yale University Press, 2002.

Zick 1965: Gisela Zick. "D'après Boucher. Die *Vallée de Montmorency* und die europäische Porzellanplastik." *Keramos* 29 (July 1965), pp. 3–47.

Zirkle 1953: Conway Zirkle. "Book Review of Richard Bernheimer, *Wild Men in the Middle Ages*." *Isis* 44, 1–2 (June 1953), p. 80.

Zoege von Mantteufel 1925: Klaus Zoege von Mantteufel. "Janssens, Daniel." In *Allgemeines Lexikon der bildenden Künstler von der Antike bis zur Gegenwart,* edited by Ulrich Thieme and Felix Becker, vol. 18, p. 414. E. A. Seemann, 1925.

Zrebiec and Erbes 2000: Alice Zrebiec and Scott Erbes. *Conquest and Glory, Tapestries Devoted to Louis XIV*. Exh. cat. Speed Art Museum, 2000.

Zweite 1980: Armin Zweite. *Marten de Vos als Maler*. Mann, 1980.

❧ CONTRIBUTORS ❧

Pascal-François Bertrand is Professor of Art History at the Université Michel de Montaigne 3, Bordeaux. He completed his doctorate in 1988 and received his Habilitation à diriger des Recherches in 2000 from the Université de Paris 10, Nanterre. His extensive publications on the history of tapestry include *Les Tapisseries d'Aubusson et de Felletin: 1457–1791*, written with Dominique and Pierre Chevalier (1988); *Histoire de la tapisserie en Europe du Moyen Âge à nos jours*, coauthored with Fabienne Joubert and Amaury Lefébure (1995); and *Les Tapisseries des Barberini et la décoration d'intérieur dans la Rome baroque* (2005), which deals with the function and use of tapestry in Rome, using the Barberini family as an example. Bertrand is currently working on a study entitled *La Peinture tissée*, which analyzes the connection between painting and tapestry.

Charissa Bremer-David is Curator of Sculpture and Decorative Arts at the J. Paul Getty Museum, Los Angeles. She received her B.A. in Art History from the University of California, Santa Barbara, and her M.A. in Modern European History from the University of California, Los Angeles. Her extensive publications on the Getty's decorative arts collection include the catalogue *French Tapestries and Textiles in the J. Paul Getty Museum* (1997), which presented new research gleaned from the archives of the Beauvais tapestry manufactory now housed in the Mobilier National, Paris. Bremer-David has just finished collaborating on the manuscript for a catalogue on the Getty's collection of Baroque furniture.

Koenraad Brosens earned his Ph.D. from the Katholieke Universiteit, Leuven, with *A Contextual Study of Brussels Tapestry, 1670–1770: The Dye Works and Tapestry Workshop of Urbanus Leyniers (1674–1747)* (2004). In addition to writing many articles on Flemish and French tapestry of the seventeenth and eighteenth centuries, he served as general editor of *Flemish Tapestry in European and American Collections: Studies in Honour of Guy Delmarcel* (2003), for which he also coauthored with Christa C. Mayer Thurman an article on the Art Institute's holdings. Brosens is currently a postdoctoral fellow at the F.W.O.–Vlaanderen (Research Foundation–Flanders, Belgium) and visiting associate professor at the Katholieke Universiteit, Leuven.

Elizabeth Cleland is Leo and Julia Forchheimer Research Fellow in the Antonio Ratti Textile Center at the Metropolitan Museum of Art, New York. Her specialty is medieval and Renaissance tapestry. Cleland has contributed to numerous catalogues, including *Tapestry in the Renaissance: Art and Magnificence* (2002); published articles on tapestry design and function in the fifteenth and sixteenth centu-

ries; and lectured in Europe and the United States. She is currently preparing for publication her doctoral thesis, which explores the relationship between tapestries, paintings, and their designers during the Renaissance.

Guy Delmarcel is Emeritus Professor of the History of Art at the Katholieke Universiteit, Leuven, and a member of the Flemish Academy of Arts and Sciences of Belgium. He has published extensively on the history of Flemish tapestry.

Nello Forti Grazzini is an independent scholar based in Milan. He received his Dottore di Ricerca from the Università Statale di Milano. Forti Grazzini's numerous publications on the history of European tapestry include books, among them one on the production of tapestries in Ferrara during the Renaissance (1982); catalogues of museum and other collections, such as those of the Palazzo Quirinale, Rome (1994) and the Fondazione Cini, Venice (2003); and many articles. He has also organized exhibitions, including one devoted to the tapestries of the Farnese and Bourbon courts (1998, with Giuseppe Bertini). Forti Grazzini is currently researching Milanese tapestry collections during the Baroque period.

Yvan Maes De Wit has directed the De Wit Royal Manufacturers in Mechelen, Belgium, since 1980, representing the fourth generation of tapestry weavers and restorers. He graduated in art history and economics from the Katholieke Universiteit, Leuven, and has written fifteen scientific publications on the conservation of tapestries.

Christa C. Mayer Thurman has been Curator in the Department of Textiles at the Art Institute of Chicago since 1967. Over her career, she has enlarged the department's holdings in every field and organized nearly eighty exhibitions. Among her many publications are two surveys of textiles in the Art Institute (1969 and 1992); retrospectives of the modern artists Lissy Funk (1988) and Claire Zeisler (1975); and a study of western European vestments (1975). Mayer Thurman has also organized several issues of *Museum Studies*, the Art Institute's journal, including ones on Japanese kimonos, Chinese textiles, and Indonesian textiles, and written an issue on the history of textile design in Chicago. For the Metropolitan Museum of Art, she contributed to *European Textiles in the Robert Lehman Collection* (2001) and to *Design in America: The Cranbrook Vision 1925–1940* (1983). In 2000, she received the College Art Association/Heritage Preservation Award for Distinction in Scholarship and Conservation, and in 2004, as a J. Paul Getty Museum Guest Scholar, spent three months researching the Art Institute's tapestry collection.

❧ CONCORDANCE ❧

Accession no.	Catalogue no.	Accession no.	Catalogue no.
1890.8	18	1944.20	19b
1890.9	39a	1944.21	19f
1890.10	39b	1944.22	19a
1896.147	14a	1944.412	56
1896.148	14b	1946.47	6
1911.439	57	1949.124	58
1919.792	59	1950.1532	32
1922.5378	54	1950.1578	9a
1922.5379	5	1950.1579	8b
1926.762	33	1950.1617	29
1928.191	7	1950.1618	30
1929.611	2	1950.1637	26
1934.4	31	1951.260	40a
1937.1097	4	1951.261	40b
1937.1098	3	1952.1242	17
1937.1099	55	1952.1243	21
1937.1119	62	1952.1245	28
1937.1120	44	1952.1246	25
1938.1309	23	1953.303	27
1938.1310	51	1953.476	13
1938.1311	20a	1954.259	12
1938.1312	20b	1954.262	52
1940.86	11	1956.101	43
1941.93	22	1956.102	49
1942.144	47	1958.278	15
1943.1144	34	1958.280	37
1943.1231	53a	1958.281	10
1943.1236	46a	1958.523	50
1943.1237	46b	1959.85	38
1944.4	53b	1959.634	1a
1944.9	19k	1959.635	1b
1944.10	19d	1962.462	24
1944.11	19l	1964.1088	16
1944.12	19i	1965.1159	8a
1944.13	19j	1968.744	36
1944.14	19c	1969.134	35
1944.15	19n	1969.869	8b
1944.16	19e	1978.58	61
1944.17	19m	1978.89	48
1944.18	19h	1979.507	60
1944.19	19g	2007.22	45

❧ PHOTOGRAPHY CREDITS ❧

Illustrations of tapestries in the collection of the Art Institute of Chicago were produced by Alain and Nathalie Speltdoorn of Brussels, or by the museum's Department of Imaging, Christopher Gallagher, Associate Director. All other illustrations of works in the collection of the Art Institute of Chicago were produced by the Department of Imaging.

Unless otherwise noted, comparative illustrations of works from outside institutions appear courtesy of those institutions. The following credits apply to images for which separate acknowledgment is due. Many images in this publication are subject to copyright and may not be reproduced without the approval of the rights holder. Every effort has been made to contact copyright holders for all reproductions.

Introduction and Essays

pp. 6, 9l&r: Archives, the Art Institute of Chicago; p. 10: Chicago History Museum, DN-0004496; p. 11b: Arxiu Mas Archives, the Amatller Institute of Hispanic Art, Barcelona; p. 12l: Charles Deering Estate; p. 12r, 13: Vizcaya Museum and Gardens, Miami; p. 18: Drawing by Isaac R. Facio, Department of Textiles, the Art Institute of Chicago; pp. 20–29: De Wit Royal Manufacturers, Mechelen, Belgium.

Franco-Flemish Tapestries

p. 39: Research Library, The Getty Research Institute, Los Angeles, Calif.; p. 41l&r: © Rijksmuseum, Amsterdam; p. 43: © Christie's Images Limited, 2005; pp. 47, 53l: Courtesy of Sotheby's Picture Library; pp. 51t&b, 60t: © The Metropolitan Museum of Art; p. 52l: Réunion des Musées Nationaux/Art Resource, NY, photograph by Gérard Blot; p. 52r: Kunstmuseum Basel, Martin P. Bühler; p. 53r: © The Cleveland Museum of Art; p. 60b: Réunion des Musées Nationaux/Art Resource, NY, photograph by Franck Raux; p. 65: Research Library, The Getty Research Institute, Los Angeles, Calif. (97.P.7), GCPA 0184519; p. 71t: Photograph from Geneviève Souchal, *Chefs-d'oeuvre de la tapisserie du XIVe au XVIe siècle* (Éditions des Musées Nationaux, 1973), p. 159, cat. 66; p. 71b: © Culture and Sport Glasgow (Museums).

Flemish Tapestries

p. 79: Infrared photographs by Timothy Lennon, Department of Conservation, the Art Institute of Chicago; p. 89r: Scala/Art Resource, NY; pp. 90, 92, 107, 109: © The Metropolitan Museum of Art; p. 97t: Research Library, The Getty Research Institute, Los Angeles, Calif. (97.P.7), GCPA 0238276; p. 97b: Research Library,

The Getty Research Institute, Los Angeles, Calif. (97.P.7), GCPA 0236979; p. 98l: Research Library, The Getty Research Institute, Los Angeles, Calif. (97.P.7), GCPA 0236981; p. 98r: Research Library, The Getty Research Institute, Los Angeles, Calif. (97.P.7), GCPA 0236980; p. 99: Réunion des Musées Nationaux/Art Resource, NY, photograph by Gérard Blot; p. 106l: Scala/Art Resource, NY; p. 106r: © Rijksmuseum, Amsterdam; pp. 112t, 136, 164: © IRPA-KIK, Brussels; p. 112b: ÖNB Vienna, sign. G 29-D; p. 120t&b: Photographs from Ann Diels and Marjolein Leesberg, *The Collaert Dynasty*, vols. 15–16 of *The New Hollstein Dutch and Flemish Etchings, Engravings, and Woodcuts 1450–1700* (Sound and Vision, 2000), p. 237 (*Falconry*), p. 231 (*Ox Hunt*); p.125t: Research Library, The Getty Research Institute, Los Angeles, Calif. (97.P.7), GCPA 0237560; p. 129r: ÖNB Vienna, sign. G 444-D; p. 130t: Documentation du Département des Objets d'art, Musée du Louvre; p. 130b: ÖNB Vienna, sign. G 447-D; pp. 131, 170, 185t, 228br, 233: Courtesy of Sotheby's Picture Library; p. 135t: © National Museum of Fine Arts, Stockholm; p. 135b: Bernard Terlay, CPA; p. 171tl: © Christie's Images Limited, 1979; p. 171bl: Research Library, The Getty Research Institute, Los Angeles, Calif. (97.P.7), GCPA 0184315; p. 181: © National Museums Liverpool, Walker Art Gallery; p. 194l: Research Library, The Getty Research Institute, Los Angeles, Calif. (97.P.7), GCPA 0237511; p. 194r: Research Library, The Getty Research Institute, Los Angeles, Calif. (97.P.7), GCA 0239700; p. 196: Research Library, The Getty Research Institute, Los Angeles, Calif. (97.P.7), GCPA 0239736; p. 197: Research Library, The Getty Research Institute, Los Angeles, Calif. (97.P.7), GCPA 0237512; p. 204t: Courtesy of Keshishian Carpets; p. 204b: Research Library, The Getty Research Institute, Los Angeles, Calif. (97.P.7), GCPA 0238968; pp. 205, 209tr: De Wit Royal Manufacturers, Mechelen, Belgium; p. 209tl: Vizcaya Museum and Gardens, Miami; p. 209b: Research Library, The Getty Research Institute, Los Angeles, Calif. (97.P.7), GCPA 0237325; p. 210: © Christie's Images Limited, 2004; p. 224: © Culture and Sport Glasgow (Museums); p. 228tr: © Christie's Images Limited, 1991; p. 229t: Photograph from Hôtel George V, Paris, *Objets d'art et de très bel ameublement*, sale cat. (June 17, 1980); p. 229b: © Christie's Images Limited, 1995; p. 230: Research Library, The Getty Research Institute, Los Angeles, Calif. (97.P.7), GCPA 0237489.

French Tapestries

pp. 240, 265, 270r, 287, 317: Réunion des Musées Nationaux/Art Resource, NY; pp. 241, 242: Erich Lessing/Art Resource, NY; pp. 250l&r, 251l: Réunion des Musées Nationaux/Art Resource, NY,

photographs by Gérard Blot; p. 251r: Réunion des Musées Nationaux/Art Resource, NY, photograph by Rene-Gabriel Ojeda; p. 255: Courtesy of Sotheby's Picture Library; pp. 260l&r, 261: Photographs by Matt Flynn; p. 266l: © National Museum of Fine Arts, Stockholm; p. 266r: © The Metropolitan Museum of Art; p. 271: © Christie's Images Limited, 2007; p. 275: Photograph courtesy of the Getty Research Institute, Los Angeles (GRI); p. 276t: Photograph courtesy of the Getty Research Institute, Los Angeles (GRI); p. 281: © Christie's Images Limited, 1996; p. 291: Object file 1978.89, Department of Textiles, the Art Institute of Chicago; p. 294: Photograph by Scott Hyde; p. 299: © Trustees of the British Museum; p. 302tl: Research Library, The Getty Research Institute, Los Angeles, Calif. (97.P.7), GCPA 0240472; p. 302r: Research Library, The Getty Research Institute, Los Angeles, Calif. (97.P.7), GCPA 0240474; p. 302b: Research Library, The Getty Research Institute, Los Angeles, Calif. (97.P.7), GCPA 0240453; p. 303: Research Library, The Getty Research Institute, Los Angeles, Calif. (97.P.7), GCPA 0240475; p. 306: Service Patrimoine et Inventaire, Région de Bourgogne, France/Ministère de la culture et de la communication–DRAC de Bourgogne–Service Patrimoine et Inventaire/Ó M., ROSSO, Service Patrimoine et Inventaire, Région de Bourgogne, 1990; p. 307: HMB M. Babey; p. 313: Courtesy Didier Aaron; p. 314l: Photograph from Xavier Salmon, "Un carton inédit d'Etienne Jeaurat pour la tenture des *Fêtes de village*," *Bulletin de la Société de l'histoire de l'art français* 1995, p. 192, fig. 4;

p. 314r: Réunion des Musées Nationaux/Art Resource, NY, photograph by Agence Bulloz; p. 315l&r: Documentation du Département des Objets d'art, Musée du Louvre; p. 316: © Cristoph Sandig, Leipzig; p. 317: Research Library, The Getty Research Institute, Los Angeles, Calif. (97.P.7), GCPA 0243224; p. 323: Research Library, The Getty Research Institute, Los Angeles, Calif. (97.P.7), GCPA 0240514; p. 324: Research Library, The Getty Research Institute, Los Angeles, Calif. (97.P.7), GCPA 0240512; p. 325l: Research Library, The Getty Research Institute, Los Angeles, Calif. (97.P.7), GCPA 0240516; p. 325r: Photograph from Pierrette Jean-Richard, *L'Oeuvre gravé de François Boucher dans la Collection Edmond de Rothschild* (Éditions des Musées Nationaux, 1978), p. 351.

Tapestries from Basel, Italy, Holland, England, and Peru

p. 333: © Staatliche Graphische Sammlung, Munich; p. 339: Photograph from Chiara D'Afflitto, *Lorenzo Lippi* (Edifir, 2002), p. 247; p. 348: © NTPL/Graham Challifour; p. 350: Photograph by C. Bregnard; p. 351: © Christie's Images Limited, 2004; p. 358br: Photograph by Fernando López Sánchez, Curator, Museo de Arte Religioso, Catedral de Lima.

Table Carpets

p. 364: © Musée d'Art et d'Histoire, Geneva; p. 366l: ÖNB Vienna, sign. G 301-D; p. 366r: C. John Ltd., London; p. 367: © Rijksmuseum, Amsterdam; p. 369: © IRPA-KIK, Brussels.

This index comprises the titles of the tapestries catalogued in this volume and of the series to which they belong, as well as the names of their designers and producers. Tapestries that are known to belong to series are listed under the series title, which is given in its full form. Tapestries that do not belong, or are not known to belong, to any series are indexed under their own titles. If known, the name of the designer and the production center follow the series title; otherwise, a general design and production location is given. For ease of reference, most subtleties of attribution employed in the entries are omitted here. Where known, life or activity dates are provided for designers and producers. The catalogue numbers following a designer's or producer's name indicate those tapestries for which he is known to be, or believed to be, responsible. Page numbers in *italic* type refer to illustrations of a catalogued tapestry; page numbers in **boldface** type refer to the main catalogue entry, or main discussion(s) within the catalogue entry, for that tapestry.

The text of this book is set in Adobe Garamond Premier Pro and Hoefler Requiem.
The stock is Job Parilux, an acid-free and FSC-certified paper.
The book is casebound in Brillianta cloth
and printed in an edition of 3,050 copies.

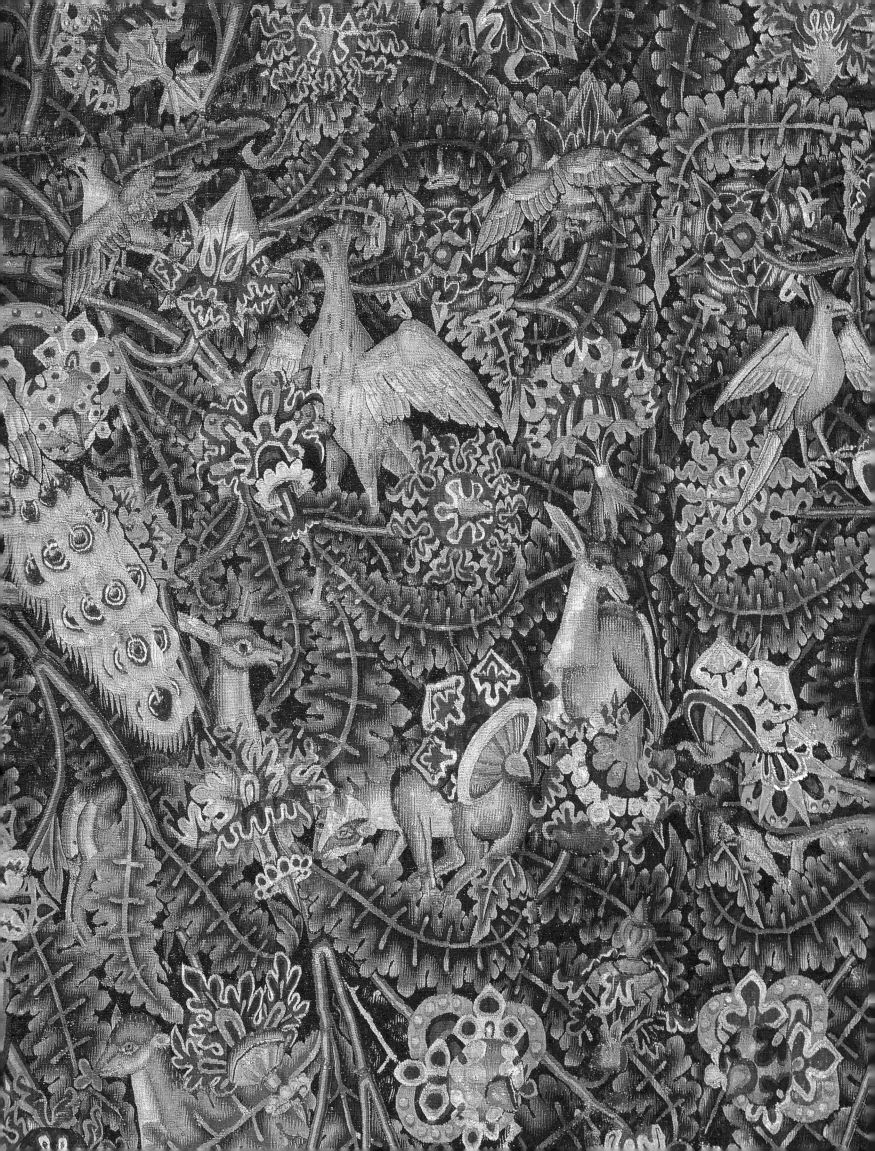

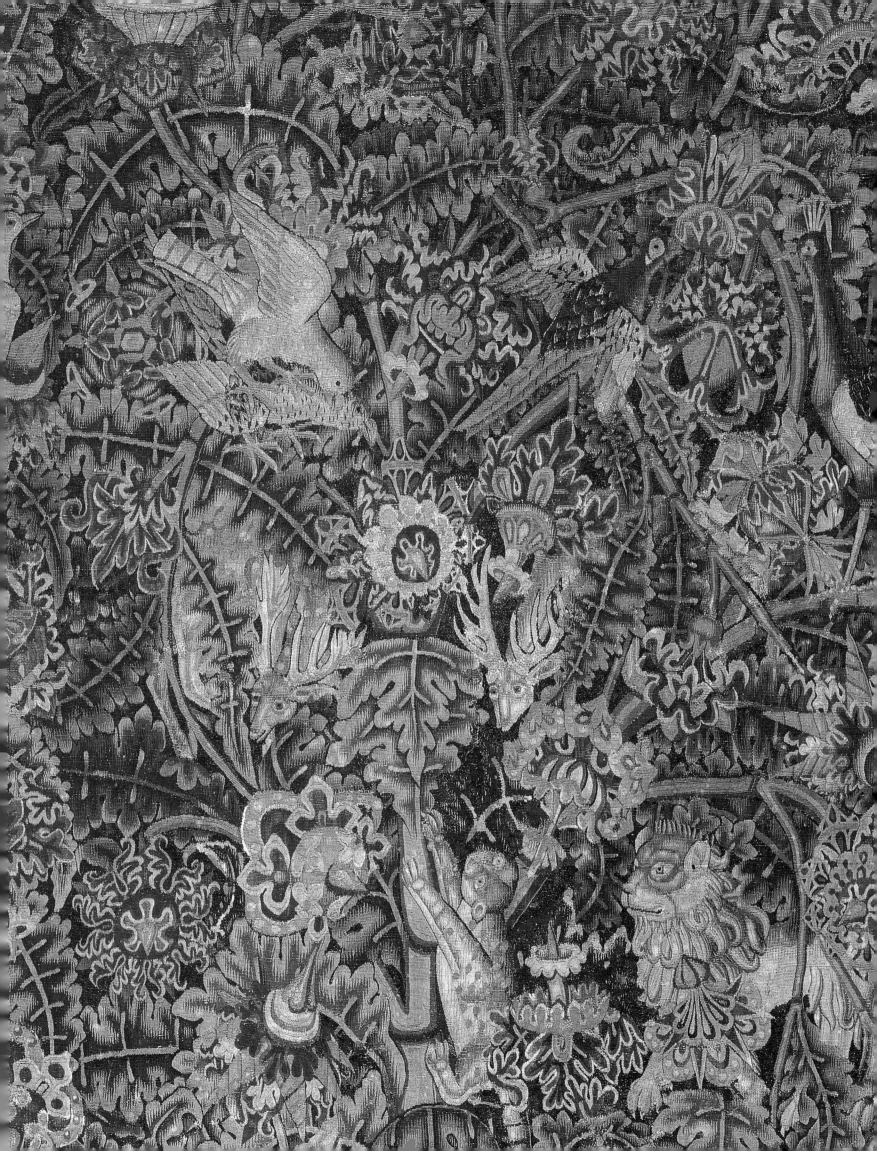